CW00916918

YALE UNIVERSITY PRESS
PELICAN HISTORY OF ART

FOUNDING EDITOR: NIKOLAUS PEVSNER

JUDITH MCKENZIE

THE ARCHITECTURE OF ALEXANDRIA AND EGYPT
c. 300 BC TO AD 700

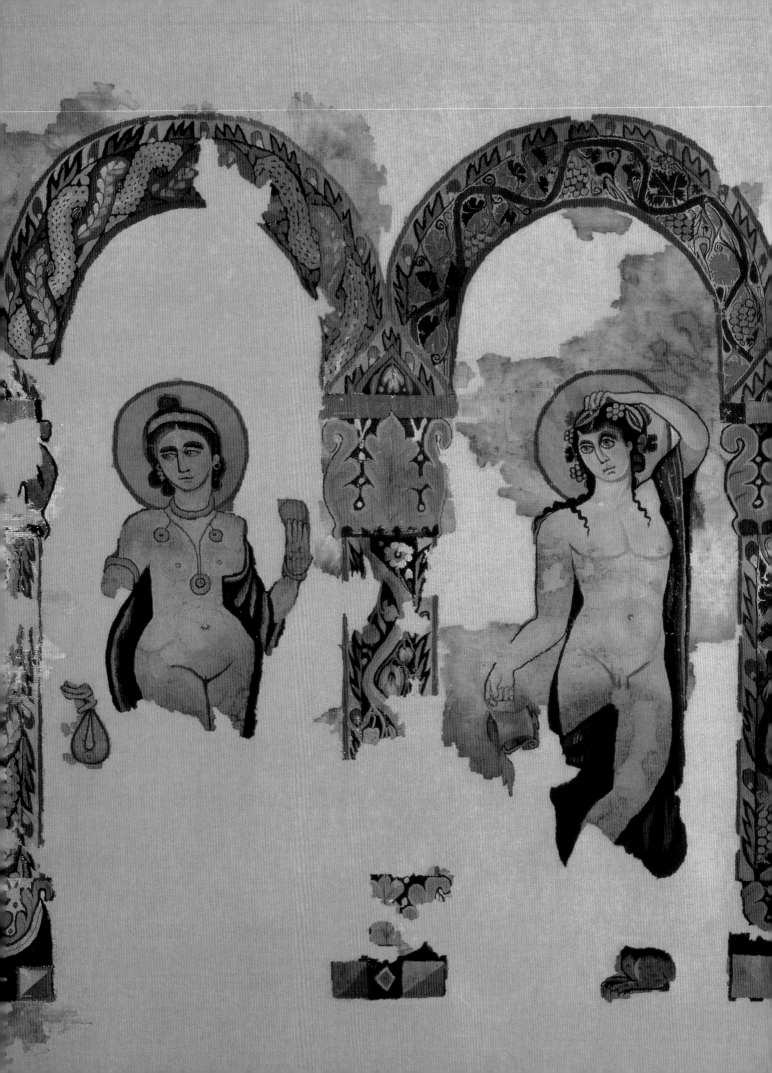

Judith McKenzie

The Architecture
of Alexandria
and Egypt
c. 300 BC to AD 700

Yale University Press
New Haven and London

For Andy and John

and to the memory of Roger Moorey and Margaret McKenzie

Set in Ehrhardt by Best-set Typesetter Ltd, Hong Kong
Printed in China through World Print
Designed by Emily Winter

LIBRARY OF CONGRESS CATALOGING-IN-PUBLICATION DATA
McKenzie, Judith.
 The architecture of Alexandria and Egypt, *c.* 300 B.C. to
A.D. 700/ Judith McKenzie.
 p. cm.
 ISBN 0-300-11555-5 (alk. paper)
 1. Architecture, Ancient–Egypt–Alexandria.
 2. Architecture, Ancient–Egypt. 3. Architecture--
Egypt–Alexandria. I. Title.
NA216.A5M45 2006
722'.2--DC22
 2006004004

TITLEPAGE: Detail of 'Dionysos tapestry', Late Antique
Egyptian wool and linen hanging. h. 2.20 m. Riggisberg, Abegg
Stiftung, inv. 3100a

Contents

Preface

This book covers the history of the architecture of Alexandria, from its foundation by Alexander the Great in 331 BC to soon after the Islamic conquest of AD 642. It aims to show how the distinctive architecture of Ptolemaic Alexandria had a continuing tradition into the Late Antique and early Islamic periods, whilst also giving an indication of how this classical architecture related to its Egyptian setting. The methodology of my approach, with its concentration on trying to ascertain precisely what evidence there is, from not only archaeological remains but also written sources, is probably influenced by my training in science.

This project arose out of my work on the architecture of Petra (which was inspired by the architecture of Ptolemaic Alexandria). When I was in Jerusalem in 1984, the Director of the British School of Archaeology, John Wilkinson, showed me Paul Underwood's article (in *Dumbarton Oaks Papers* 5, 1950) on the circular shrines depicted in Gospel manuscripts which were similar to those painted over half a millennium earlier on the walls of Pompeian houses, and carved from the rose-red cliffs of Petra. It was at this point that I realized that the study of the architecture of Alexandria had considerably greater ramifications than just its influence on the architecture of Petra. When I first arrived in Jordan in 1981 to work at Petra, the expert on early Islamic art and archaeology, Ghazi Bisheh said I should also look at the relationship of the Khasneh at Petra to the depictions in the mosaics of the Great Mosque in Damascus, but at the time, although the similarity was obvious, the route of transmission was not. Having defined the distinctive features of the classical architecture of Ptolemaic Alexandria, I noticed that some of these occurred later in the architecture of the Egyptian Christians in the style generally termed 'Coptic', suggesting local continuity of classical architecture in Egypt into the Late Antique period. However, I first had to complete *The Architecture of Petra* before I could pursue the significance of these observations.

Consequently, having worked on Alexandrian architecture since 1980, I began research for this book in earnest in 1990. Since then, as the work of other scholars has also progressed, it is important to give some indication of how their work relates to mine. To pursue this project an enormous quantity of fragmentary and scattered material had to be collected and analysed, filling nearly two metres of lever-arch files. Some sense of the amount of material involved can be gained from the main academic volumes on ancient Alexandria, each of which presents only a portion of what has had to be analysed for the present study. Peter Fraser's *Ptolemaic Alexandria*, 3 volumes (Oxford 1973), has a volume of notes which is even larger than the text-volume and remains the basic source for the written evidence of the Ptolemaic period. Achille Adriani's *Repertorio d'arte dell'Egitto greco-romano*, Series C, volumes 1–2 (Palermo 1966), is primarily concerned with the *in situ* archaeological remains of the tombs, whilst the fragmentary evidence for other features, such as the street plan, is hidden in the enormous amount of detail. We now also have Patrizio Pensabene's *Elementi architettonici di Alessandria e di altri siti egiziani, Repertorio d'arte dell'Egitto greco-romano*, Series C, volume 3 (Rome 1993), which is the accompanying catalogue of the architectural fragments from the city, as well as the classical fragments from the rest of Egypt, and some Late Antique (Byzantine or 'Coptic') ones. The typological grouping which was necessary for him to present so many fragments has often left the architectural context of the buildings from which they came elusive. Barbara Tkaczow's *Topography of Ancient Alexandria* (Warsaw 1993) provided an important breakthrough, focusing less on tombs than Adriani's volumes but, most importantly, including detailed plans which indicate the precise location of all the archaeological evidence in her catalogue for each period. These plans have been essential tools for cross-checking much of the topographical and archaeological evidence dealt with here.

Our understanding of the topography of the Ptolemaic city has been dominated by the chapter on it in Peter Fraser's book, which remains the basic reference tool for the written sources. The weight of detail in it has not surprisingly left the impression that this was the final word on the subject. However, it seemed worthwhile to unravel the intertwining of later sources with earlier evidence to work out exactly what we know about the main monuments of the city at any one time in their history. From this it was in fact possible to gain a sense of the early development of the city, which had escaped Fraser's analysis. Some of the city's most famous monuments also benefited from further examination and thought. For instance, my re-examination of the archaeological remains of the temple of Serapis and its enclosure, made it possible to suggest reliable reconstructions of both the Ptolemaic and Roman phases which were drawn up by Sheila Gibson from my plans and elevations. The detailed basis of these is published separately in *Journal of Roman Studies* 2004. Some of the results and plans of the Sieglin expedition, along with an analysis of them, were published by Michael Sabottka in his thesis, *Das Serapeum in Alexandria. Untersuchungen zur Architektur und Baugeschichte des Heiligtums von der frühen ptolemäischen Zeit bis zur Zerstörung 391 n. Chr.* (microfiche Berlin 1989) *Ét Alex* 16 (Cairo, in press).

Although Alexandria's major monuments were largely classical, some Egyptian influence can be detected in them. However, the issue of the blending of the two cultural traditions becomes complex when one extends it to ethnicity, and religious and cultural identity, because there is not always a definable relationship between them and material remains. Consequently, I have presented this evidence as it stands

without speculation. I have left this interesting question to other scholars who may in future combine this evidence with the results of their own more detailed studies of other types of evidence (funerary, papyrological and epigraphic).

In recent years, it has been possible for the underwater ruins near the city to be more thoroughly explored thanks to the end of the Cold War and the changed political situation in the region. The now submerged extensive *in situ* harbour works in the Eastern Harbour are being explored by Franck Goddio and his team, published in F. Goddio *et al.*, *Alexandria, The Submerged Royal Quarters* (London 1998). They provide vital new information about the shape of the ancient harbour, but not about the architecture of the palace area (the so-called Royal Quarter) which is still largely on dry land. Jean-Yves Empereur and his team have explored and raised fragments long-known near the site of the Lighthouse, while also finding others, amongst the most important of which are the fallen colossal statues of the Ptolemies dressed as Egyptian pharaohs. On dry land the Centre d'Études Alexandrines has also conducted excavations, largely rescue digs, in association with the Egyptian Supreme Council of Antiquities. This work, being published in *Études alexandrines*, should increase our knowledge of the ancient city in the future. The media coverage surrounding the underwater discoveries has resulted in considerable public awareness of them. However, a distinction needs to be drawn between this and the degree to which our knowledge of the city has actually increased as a result.

The work of both underwater teams has resulted in the recovery of some Egyptian style blocks from buildings, as well as Egyptian sculptures including sphinxes and obelisks. When added to those already known from the city, these new Egyptian style pieces constitute not more than a quarter of the total. Despite this, their discovery has led to the sudden suggestion that the city was largely Egyptian in appearance. At the same time, some other scholars still dismiss any Egyptian influence on the city's architecture. I have tried to present the full range of types of evidence for the city's built environment which show a complex and nuanced interaction between these two main cultural influences.

It needs to be remembered that the vast majority of the carved architectural blocks recorded underwater are from granite shafts of classical columns. However, few of the classical architectural decorative blocks which these would have supported, such as marble capitals and entablatures, were found underwater. They were probably re-used elsewhere by the time the column shafts were dumped. Consequently, there is little new evidence for the classical architectural style of the Ptolemaic city. The main observations which I made about this in *The Architecture of Petra* remain valid and are not repeated in detail here. Many of the architectural fragments discussed in it are now conveniently published together in Pensabene's catalogue. His overview of them, published independently (in *Studi Miscellanei* 28, 1984–5 [1991]), came to similar conclusions to mine concerning the main features of the Ptolemaic style, and thus providing confirmation of the picture indicated by this evidence. The lack of additional evidence means that some key problems or areas of special interest still cannot be studied adequately, such as workshops.

However, it has been possible here to say more about the origins of the distinctive Alexandrian form of the Corinthian order and its relationship to the earlier developments of the Corinthian order in Greece, which were not adequately addressed in my earlier discussion. At the suggestion of the publisher's reader I have also included a discussion of architectural painting in Alexandria and its relationship to Second Style Pompeian wall-painting, with additional observations to those made in *The Architecture of Petra*. Rolf Tybout's *Aedificorum figurae. Untersuchungen zu den Architektur-darstellungen des frühen zweiten Stils* (Amsterdam 1989), which is a detailed study of the origin of early Second Style Pompeian wall-painting, was published shortly before the extent and consistency of the architectural evidence from Alexandria had been presented by myself and Pensabene. Consequently, Tybout concluded that Alexandria did not provide a major or distinctive component of the architecture in these Roman wall-paintings or the method of depicting it.

As I have focused in this book on the city's development and the continuity of its architecture and the depiction of this into the Byzantine period, there is not space for a more detailed discussion of the relationship of Alexandrian baroque architecture to Roman baroque, nor to the later Baroque architecture – a topic which merits a book in its own right.

For a rounded picture of the Ptolemaic monumental architecture it was highly desirable to give consideration to Egyptian temples, which continued to be built under the Ptolemaic kings and the Roman emperors. As these were repeatedly extended and decorated by these rulers they are very difficult to date, making the study of them fraught with difficulties. To examine them for changes which occur with time it was essential to have the correct chronology for them. Consequently, as I am not an Egyptologist, it was only possible to attempt this thanks to the help of John Baines and Martina Minas. Any Egyptology graduate student can distinguish these temples from their Dynastic period predecessors. It was, thus, essential to define their distinguishing characteristics which are not immediately obvious to those more familiar with classical architecture. These tasks were tackled before the publication of Dieter Arnold's *Temples of the Last Pharaohs* (Oxford 1999).

My study of the civic architecture of the cities of Roman Egypt has benefited greatly from recent scholarship on the two main types of evidence which have been combined here in the first comprehensive analysis. The initial guide to the archaeological evidence was provided by the work of Donald Bailey who showed that they clearly did have classical architecture, contrary to the view that new buildings were only Egyptian in style. A valuable contribution has been made more recently by Alan Bowman's analysis of the papyrological sources. Both kindly sent me papers prior to their publication, and provided helpful discussions. The survival of papyri has meant that we have more information about many aspects of these towns and life in them, which are not mentioned here, than for other areas of the Roman empire. These are covered by Roger Bagnall's *Egypt in Late Antiquity* (Princeton 1993) which, so great is the quantity of evidence from the rest of Egypt alone, does not include Alexandria.

The absence of an equivalent work to Peter Fraser's *Ptolemaic Alexandria* for Roman Alexandria, meant that collection of the written evidence for it was more of a challenge, and there are doubtless omissions as a result. After decades of work at Kom el-Dikka, the Polish excavations have uncovered additional Roman houses of the first and second centuries AD promptly published in their new annual, *Polish Archaeology in the Mediterranean*. They had already revealed the later cityscape of this central city block in the fourth to seventh centuries, with baths-building, latrines, cistern, housing, workshops, and large teaching complex with lecture rooms and 'small theatre'. These have been published in volumes in their *Alexandrie* series, most notably: M. Rodziewicz, *Les Habitations romaines tardives d'Alexandrie* (Warsaw 1984), W. Kolataj, *Imperial Baths at Kom el-Dikka* (Warsaw 1992), and Z. Kiss *et al.*, *Fouilles polonaises à Kôm el-Dikka (1986–1987)* (Warsaw 2000) as well as other books and articles, especially in *Études et travaux*. It is only thanks to these prompt Polish publications with their meticulous plans that it was possible to reconstruct these buildings resulting in Sheila Gibson's axonometric drawings which bring to life this insula.

The continuity of distinctive features of Ptolemaic classical architecture in architecture of the Late Antique period (third to seventh centuries AD), commonly referred to as Coptic architecture, meant that it was necessary to examine the apparently lost classical architectural decoration of the intervening Roman period. On visiting the relevant sites I discovered that the missing evidence had survived, but these fragments were often unpublished, or only in obscure publications and thus, prior to the appearance of Pensabene's volume, largely unknown. These fragments showed there was no difference between the classical architectural style of Alexandria and that of the rest of Egypt in the Roman period.

This clearly has serious implications. It has generally been assumed that the style of Alexandria's lost church architecture in the Late Antique period was different from that which has survived elsewhere in Egypt. But if there was no such division in the Roman period, perhaps it also did not occur in the Late Antique period. A further key was provided by the papyrological evidence collected by the Polish scholar A. Lukaszewicz in *Les Édifices publics dans les villes de l'Égypte romaine* (Warsaw 1986). When I analysed the evidence from the lists at the back of it, rearranged by site rather than by building type, I found that those sites with the most classical buildings were at or near those which later had the highest quality carved architectural decoration in the style generally termed 'Coptic'. This suggested continuity of skill for the construction and carving of classical architecture in Egypt from the Roman into the Byzantine period at a local level.

For much of the twentieth century art historians considered that the Late Antique architecture of the sites along the Nile and in the Faiyum (so-called Coptic architecture) was different from that of Alexandria, little of which has survived. This view was influenced by Church historians who assumed that the churches and monasteries of the rest of Egypt were antagonistic to the Church in Alexandria, which was perceived as more Hellenized. However, recent studies of the papyrological evidence have found not only that there is no basis for such a view, but also that the evidence clearly indicates that the Church in the rest of Egypt functioned as part of the same world as that in Alexandria. If there is no longer any basis from our understanding of the history of the Church in Egypt in this period for it being divided into two separate worlds, then there is no longer a basis for applying a model of two different worlds to its architecture. Rather, the lost church architecture of Alexandria should be reflected in the church architecture surviving from the same period in the rest of Egypt.

It was first necessary to analyse the written testimony for church construction in Alexandria before considering the archaeological evidence for the churches of Egypt. This entailed collecting the large body of ecclesiastical and historical sources with passing references to churches in Alexandria. The tedious work then had to be done of checking the date of each text, and the event which it described. Andres Reyes checked the original texts and the terms used. The complex interaction between the different religious and ethnic groups in the city is covered at a level of detail, not given here, in Christopher Haas's *Alexandria in Late Antiquity: Topography and Social Conflict* (Baltimore 1997). However, he gives some churches and temples locations which are largely hypothetical.

The study of the extensive archaeological evidence which survives from churches and other Late Antique architectural decoration outside Alexandria has long been hindered by problems with its chronology. Thus, a re-evaluation of the basis of this chronology was essential. As little of it was dated to the fourth or fifth centuries AD, but much to the sixth or seventh centuries, there was an apparent gap of two hundred years in the production of classical architectural decoration in Egypt. Such a gap was unlikely given the continuity of some features of architectural decoration from the Ptolemaic period, and into the Roman period, which were also observed in Late Antique architecture. As the written sources indicated many churches were built in Alexandria in the fourth and the early fifth centuries AD, it was desirable to see if any of the architectural remains from elsewhere in Egypt were contemporary with them. This is complicated by the fact that the find-places of many of the fragments were not recorded.

Consequently, I had to ascertain for all pieces if the original location was recorded, before concentrating my study on those which were reliably known to have come from specific buildings. The firsthand examination of these pieces was also essential in trying to clarify their chronology, ranging from those in Cairo and other sites in Egypt, through collections in Paris, Berlin, Brussels, and London. This led to an enormous unpublished catalogue and architectural analysis of this material which was vital preparatory work before the overall assessment of this evidence could be made. This was done before the appearance of Peter Grossmann's *Christliche Architektur in Ägypten* (Leiden 2002) which gives some sense of the amount of evidence. His work includes many more churches and more detail than there is space for here, while he concentrates on their plans rather than their decoration. It is now the basic source for a detailed record of the design of Egyptian churches,

supplementing his entries (in English) in A.S. Atiya, ed., *Coptic Encyclopedia* (New York 1991).

I noticed that some of the distinctive motifs of this carved decoration in Egypt are found at a later date on the Church of St Polyeuktos in Istanbul (*c.* AD 524–7). The artistic origins of the designs in its fine marble carvings has been an enigma (unlike their interpretation) as they are unique in the architectural history of Constantinople, so that the excavator Martin Harrison described them as 'dotty'. This was initially very surprising, as Alexandrian architecture was not recognised as having any influence in this period, despite the clear continuity of the pictorial tradition of it. However, its importance as a centre for architectural skill into the sixth century was confirmed when I examined the mathematical texts relevant to construction. Again both types of evidence (written and archaeological) were essential to ascertaining the complete picture.

Having found this previously unrecognized influence of Alexandrian architecture in Byzantine architecture, the final phase of the study was devoted to the pictorial tradition of this architecture, which was the starting point of the project.

The chronological approach used here has, however, had the disadvantage that not all the evidence for each major monument is presented together. Also, as the monuments are being discussed in a wider context, and as there is ultimately a choice here between clarity of argument and a clutter of detail, it has not always been possible to discuss individual monuments in as much detail as some readers would wish. Equally, at the suggestion of the publisher's readers some sections have become more detailed than the author might have desired. The reader referring to the present book only for information about a specific monument will need to make use of the index, and for more detail to references in the notes.

The preparation and checking of such detailed notes, and the drawing and inking of the plans and maps by the author, inevitably delayed the appearance of this book, so it is to be hoped that it has been worth the wait. They are line drawings (without attractive coloured shading) for ease of photocopying by others – both for use in the classroom and reproduction in their academic work, and with captions suitable for projection. They have been made with much care in accordance with the aim of the book to provide a reliable overview concentrated on the presentation of fact rather than supposition, along with the detailed documentation of the evidence.

The work on the text was, except for additions suggested by the readers, completed in January 2003. A few more recent references have been added prior to going to press, when they contain new primary data. A work of this complexity and breadth would not have been possible without the willing help of many colleagues around the world, gratefully acknowledged on p. 459.

Richard Krautheimer begins his introduction to the Pelican History of Art on Early Christian and Byzantine Architecture with the observation: 'This book was difficult to write, and I can truthfully say that I have never faced a harder task.' He faced similar problems to those encountered in the writing of this book: often fragmentary ruins, a wide geographic spread, and obscure publication of material, while at the same time trying to achieve a comprehensive presentation of the subject to the educated public, as well as students and specialists. These difficulties are not apparent is his final result. I can only hope that I have come some way to also achieving that.

Oxford, November 2005

Notes for the Reader

PLACE NAMES

The variety of periods covered has led to inevitable inconsistencies in the spellings of names. For the modern and classical names of sites in Egypt and the rulers of Egypt I have tried to adhere to the spellings in J. Baines and J. Malek, *Cultural Atlas of Ancient Egypt* (Abingdon 2000), except for the more familiar Canopus and Kom el-Dikka. For any one monument in Alexandria (whose name comes from an ancient term) and the ancient authors I have tried to use only one spelling, be it Latin or Greek. As the Latin spellings are often more familiar in English (e.g. Callimachus, Museum) this has inevitably led to inconsistencies.

ABBREVIATIONS FOR WRITTEN SOURCES

The diversity of fields of expertise has meant grappling with various systems of abbreviations. Every attempt has been made in the present work to make these as clear as possible to those not expert in the field of a specific chapter, while at the same time hopefully not irritating too much those who are.

Papyri

The abbreviations used by papyrologists are particularly impenetrable because of their habit of simply referring the reader to the standard abbreviations in: J.F. Oates *et al.*, *Checklist of Editions of Greek and Latin Papyri, Ostraca and Tablets* (5th edn, Oxford 2001). If one is using a library from which this master list is lacking or borrowed it is almost impossible to crack the code. Consequently, when a papyrus is cited here only once the full reference is given, otherwise if it is cited more than once, as often occurs in Chapter 7, then the usual abbreviation is used and given in the list of abbreviations. A similar system is used for inscriptions.

Citations and Translations of Classical and Byzantine Greek and Latin Texts

In Chapters 3, 4 and 8 the editions of the classical sources have not been given in the notes if they are available in the Loeb edition. Some inconsistencies in the titles of these ancient works as cited here result from the attempt to make them as close as possible to the titles used for the Loeb edition. For all other ancient texts the original text has been cited in full, along with the reference to a translation if available. The translations given in Chapters 3, 4 and 8 are those of the Loeb edition when available, except for alterations which have been made by A.T. Reyes to provide greater clarity or precision where architectural terms are involved.

The absence of the convenience of Loeb parallel texts for the Byzantine period is particularly vexing as the translations are usually published without the original text in the same volume. Thus, if one wishes to consult both the original text and the translation, this usually entails finding two books, rather than one, and not always in the same library. Also, in some computerized library catalogues it is often not possible to find these works from the key words of the common abbreviations for them used by Byzantine scholars. Consequently, in Chapter 10 in the first note mentioning each work I have laboriously cited the full reference for both the edition and translation of it, then in later notes I have cited the text, then the name of both the editor and translator, which are also given in the list of abbreviations. This might seem excessive to Byzantine scholars, so I hope they are not too irritated by it, but it is essential for most other scholars. The translations quoted in Chapter 10 have often been altered by A.T. Reyes where architectural terms are involved, and some are completely his translations. The ancient terms used in these texts for buildings are provided in brackets if relevant to the argument, or likely to be of interest to scholars.

Other Abbreviations

Journal titles and most frequently mentioned book titles have been abbreviated, but titles of articles in journals and books are always given in full.

CITY PLANS OF ALEXANDRIA

The city plans of Alexandria were drawn by the author by hand, using the 1934 Survey of Egypt 1 : 10,000 plan as the base plan, reduced to 70 per cent so that a single plan (incorporating the relevant parts of the city) would fit on one A1 sheet. To this were added the copy of Mahmoud-Bey's plan of 1866, as reproduced in G. Jondet, *Atlas historique de la ville et des ports d'Alexandrie, Mémoires présentés à la Société Sultanieh de géographie* 2 (Cairo 1921) pl. 37, and details from other plans when relevant. It is accurate to 0.1 cm (equivalent to 7 m) which is the limit of the accuracy of the paper copies as a result of variations in the humidity.

Chronological Tables

MACEDONIAN DYNASTY	**332–305** BC
Alexander III the Great	332–323
Philip Arrhidaeus	323–316
Alexander IV	316–305

PTOLEMAIC DYNASTY *(KINGS AND QUEENS)*	**306–30** BC
Ptolemy I Soter I (Satrap from 323 BC)	306–282
Ptolemy II Philadelphus	285–246
Ptolemy III Euergetes I	246–221
Ptolemy IV Philopator	221–205
Ptolemy V Epiphanes	205–180
Ptolemy VI Philometor	180–164, 163–145
Ptolemy VIII Euergetes II (Physkon)	170–163, 145–116
Ptolemy VII Neos Philopator	145
Cleopatra III and Ptolemy IX Soter II (Lathyros)	116–107
Cleopatra III and Ptolemy X Alexander I	107–88
Ptolemy IX Soter II	88–81
Cleopatra Berenice	81–80
Ptolemy XI Alexander II	80
Ptolemy XII Neos Dionysos (Auletes)	80–58, 55–51
Berenice IV	58–55
Cleopatra VII Philopator	51–30
Ptolemy XIII	51–47
Ptolemy XIV	47–44
Ptolemy XV Caesarion	44–30

EMPERORS
(**Bold** type indicates the name by which they are usually known)

C. **Julius Caesar**	48–44 BC

JULIO-CLAUDIANS

C. Octavius Caesar (Octavian) **Augustus**	30 BC–AD 14
Tiberius Claudius Nero Caesar	14–37
Gaius Caesar **Caligula**	37–41
Tiberius **Claudius** Drusus Nero Germanicus	41–54
Nero Claudius Caesar Drusus Germanicus	54–68

Galba	68–69
Otho	69
Vitellius	69

FLAVIANS

T. Flavius **Vespasian**	69–79
Titus Flavius Sabinus Vespasianus	79–81
T. Flavius **Domitian**	81–96

M. Cocceius **Nerva**	96–98
M. Ulpius **Trajan**	98–117
P. Aelius **Hadrian**	117–138

ANTONINES

T. Aelius Aurelius **Antoninus Pius**	138–161
Marcus Aurelius Antoninus	161–180
(with **Lucius** Aurelius **Verus**	161–169)
L. Aurelius **Commodus**	180–192

Publius Helvius **Pertinax**	193
Marcus **Didius** Severus **Julianus**	193
Pescennius Niger	193

SEVERANS

L. **Septimius Severus**	193–211
M. Aurelius Antoninus **Caracalla**	211–217
P. Septimius **Geta**	211
Opellius Severus **Macrinus**	217–218
M. Opellius **Diadumenianus**	218
M. Aurelius Antoninus **Elagabalus**	218–222
M. Aurelius **Severus Alexander**	222–235
C. Julius Verus **Maximinus**	235–238

M. Antonius Gordianus Sempronianus (**Gordian I**)	238
M. Antonius Gordianus Sempronianus (**Gordian II**)	238
M. Clodius **Pupienus**	238
Decius Caelius Calvinus **Balbinus**	238
M. Antonius Gordianus (**Gordian III**)	238–244
M. Julius **Philip the Arab**	244–249
C. Messius Quintus **Trajan Decius**	249–251
C. Vibius **Trebonianus Gallus**	251–253
M. **Aemilius Aemilianus**	253
P. Licinius Valerianus (**Valerian**)	253–260
P. Licinius Egnatius **Gallienus**	253–268
(Fulvius Junius **Macrianus** and Fulvius Junius **Quietus**)	260–261
M. Aurelius Claudius (**Claudius II**)	268–270
M. Aurelius Claudius **Quintillus**	270
L. Domitius **Aurelian**	270–275
M. Claudius **Tacitus**	275–276
M. Annius **Florianus**	276
M. Aurelius **Probus**	276–282
M. Aurelius **Carus**	282–283

M. Aurelius **Numerianus**	283–284
M. Aurelius **Carinus**	283–285
C. Aurelius Valerius **Diocletian**	284–305
M. Aurelius Valerius **Maximian**	286–310
C. Flavius Valerius **Constantius I**	305–306
Galerius Valerius Maximianus	305–311
Tetrarchy (Diocletian, Maximian, Constantius, Galerius)	293–305
Severus II	306–307
M. Aurelius Valerius **Maxentius**	306–312
Galerius Valerius **Maximinus Daia**	310–313
Flavius **Constantine**	306–337
C. Valerius Licinianus **Licinius**	308–324

HEIRS OF CONSTANTINE

Constantine II	337–340
Constans I	337–350
Constantius II	337–361
Julian (the 'Apostate')	361–363
Jovian	363–364

HOUSE OF VALENTINIAN

Valens (East)	364–378
Valentinian I (West)	364–375
Gratian (West)	367–383
Valentinian II (West)	375–392
Eugenius (West, usurper)	392–394

THEODOSIAN DYNASTY

Theodosius I	379–395
Arcadius (East)	395–408
Theodosius II (East)	408–450
Honorius (West)	395–423
Johannes (West, usurper)	423–425
Valentinian III (West)	425–455
Marcian (East)	450–457
Leo I (East)	457–474

LAST WESTERN EMPERORS

Petronius Maximus	455
Avitus	455–456
Majorian	457–461
Severus III	461–465
Anthemius	467–472
Olybrius	472
Glycerius	473–474
Julius Nepos	474–475
Romulus Augustulus	475–476

EASTERN EMPERORS OF THE FIFTH TO SEVENTH CENTURIES

Leo II	474
Zeno	474–491
Basiliscus	475–476
Anastasius	491–518
Justin	518–527
Justinian I	527–565
Justin II	565–578
Tiberius II	578–582
Maurice	582–602

Phocas	602–610
Heraclius	610–641
Constantine III and **Heraclonas**	641
Constans II	641–668
Constantine IV	668–685
Justinian II (first reign)	685–695
Leontius	695–698

BISHOPS AND MONOPHYSITE PATRIARCHS OF ALEXANDRIA

Demetrius	*c.* 189–233
Heraklas	233–247
Dionysius	247–264
Theonas	282
Peter	*c.* 300–311
Achillas	312
Alexander	312–328
Athanasius	328–373
Arians: Pistos	336
Gregory	341–344
George	357–361
Lucius	365; 373–380
Timothy I	*c.* 378–384
Theophilus	385–412
Cyril	412–444
Dioscorus (Monophysite) (died in exile 454)	444–451
Proterius	451–457
Timothy Aelurus (Weasel) (Monophysite)	457–460; 475–477
Timothy Salofakiolos (Wobblecap)	460–475; 477–482
Peter Mongos (Stammerer) (Monophysite)	477; 481–489
John Talaia	June–December 482
Athanasius II Keletes (Monophysite)	489–496
John I (Monophysite)	496–505
John II (Monophysite)	505–516
Dioscorus II	516–517
Timothy III (Monophysite)	517–535
Theodosius (Monophysite) (rival: Galianus (Monophysite)	535–566 535)

CHALCEDONIAN (MELKITE) PATRIARCHS OF ALEXANDRIA

Paul	537–540
Zoilus	540–551
Apollinarius	551–555
John II	570–580
Eulogius	581–608
Theodore	608–609
John the Almsgiver	610–619

* The tables were prepared by A.T. Reyes based on: J. Baines and J. Malek, *Cultural Atlas of Ancient Egypt*, rev. edn (New York 2000) 37; H. Chadwick, *The Church in Ancient Society* (Oxford 2001) 714–17; A. Claridge, *Rome* (Oxford 1998) 419–21; R. Cormack, *Byzantine Art* (Oxford 2000) 224–30; C. Scarre, *Chronicle of the Roman Emperors* (London 1995).

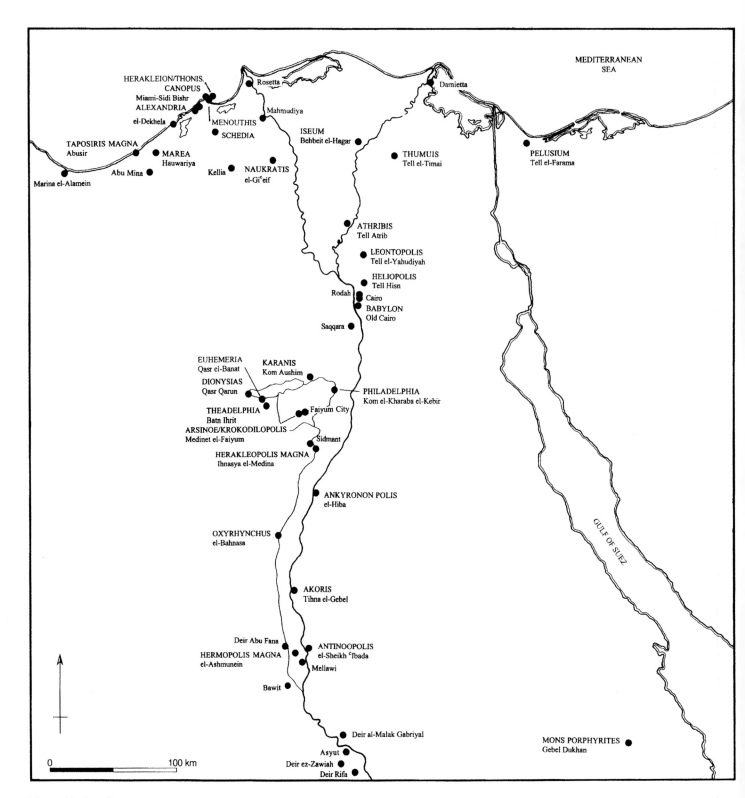

Map 1 Northern Egypt

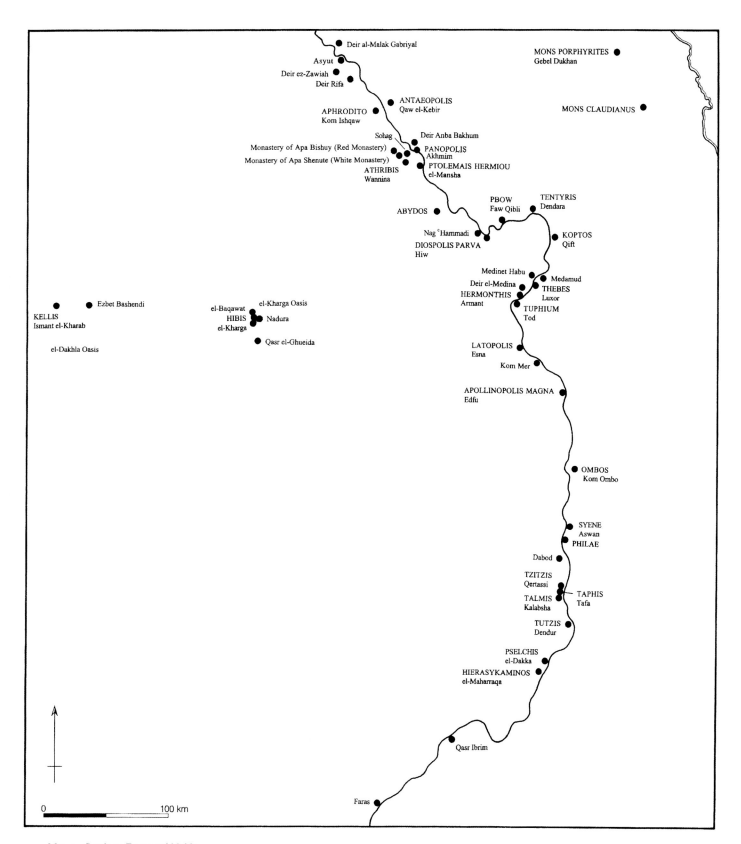

Map 2 Southern Egypt and Nubia

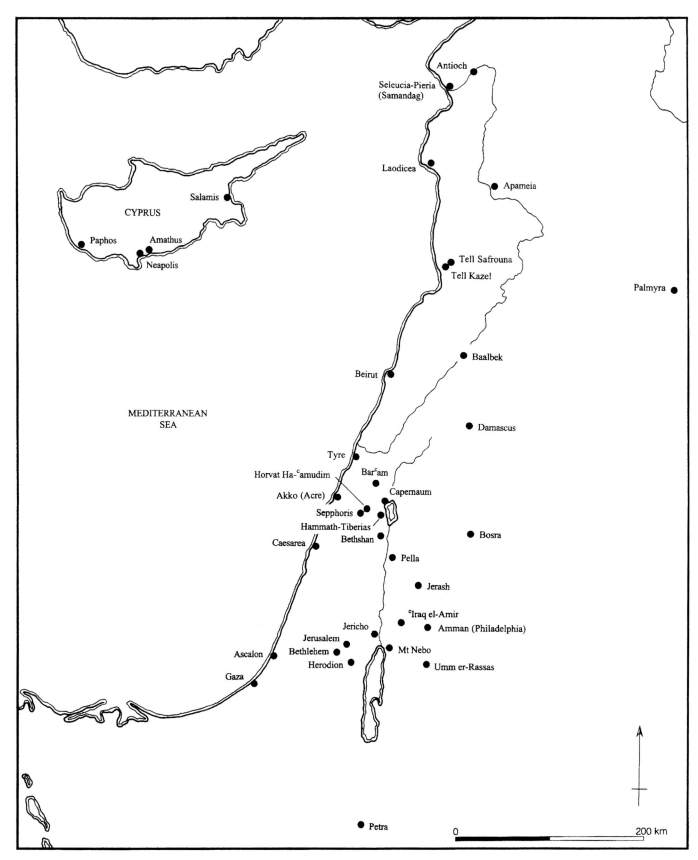

Map 3 Cyprus and the Near East

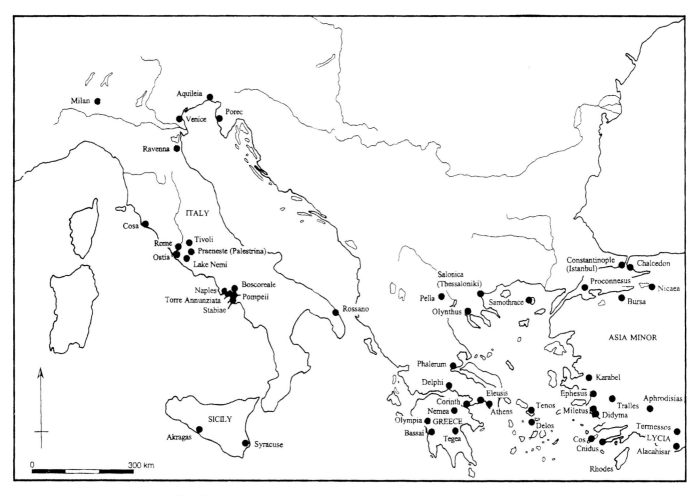

Map 4 Italy, Greece and west coast of Asia Minor

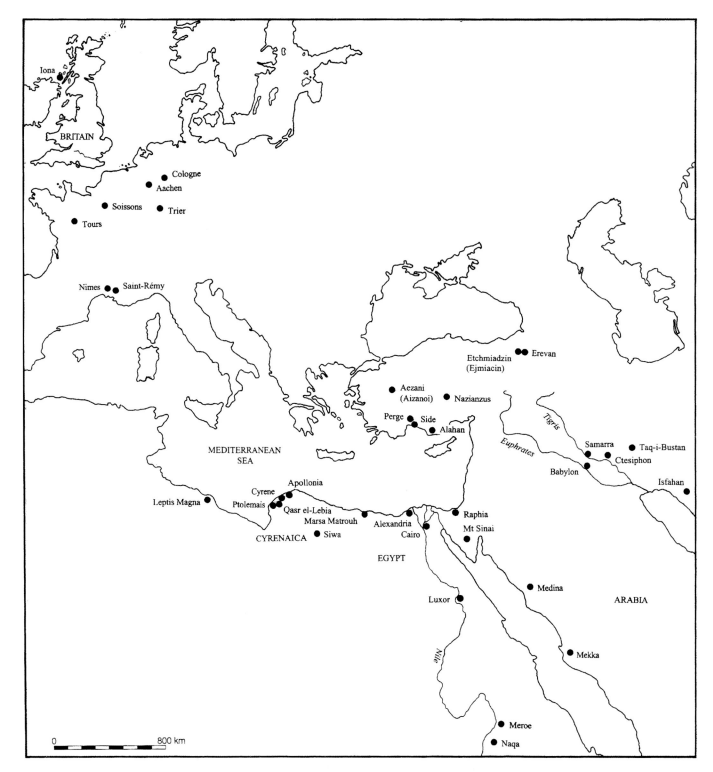

Map 5 Europe, the Mediterranean and the Near East

General Introduction

This is a history of the monumental architecture of ancient Alexandria, as well as the rest of Egypt, from the city's foundation by Alexander the Great in 331 BC to the years after the Islamic conquest of AD 642. The subject is covered from the macro- to the micro-level: from city-planning, building-types and designs, to architectural style. The main aspects addressed are: the interaction between the imported Greek and native Egyptian traditions; the relationship between the architecture of Alexandria and the other cities and towns of Egypt; as well as the relationship of this architecture to that of the wider Mediterranean world; and Alexandria's role as a source of architectural innovation.

Unlike other books on Alexandria, this one focuses on architecture and spans a millennium. It also covers the other sites in Egypt in each period to provide the local context for developments in Alexandria by including: Egyptian temples, classical buildings of the Roman cities and towns, and Egyptian (so-called Coptic) churches. Its geographic breadth is a reflection of Alexandria's previously unrecognized role as a major centre of architectural innovation and artistic influence from the Ptolemaic to the Byzantine periods.

The basic methodology used is unusual in the extent to which it makes use of written sources and relates them to archaeological evidence. The results presented come from extensive detective work involving the collection and analysis of an enormous amount of diverse, scattered and fragmentary evidence, most of which is generally unknown. The material remains give information about architectural style, building designs and topography, while the written testimony generally provides other information, such as a more precise indication of when particular buildings were built and who paid for them. In addition, there are archaeological remains at sites up the Nile, and in the oases, for buildings from some periods when we largely have only the written references to those in Alexandria. Thus, the combination of different types of evidence is essential to glimpsing as much of the complete picture as possible.

A rigorous presentation is also given of precisely what evidence there is for the major monuments in the city in each period (Ptolemaic, Roman and Late Antique), without the overlay of that from later periods or less reliable sources. This has also necessitated the need for the full documentation given in the notes. The city's architecture and its topographical setting provide the essential background to historical events in the city. This book does not set out to be another study of such events, since much of its cultural and social history has been extensively covered by others. Rather, the principal aim of the book is to provide the overview of a handbook on its architecture, while also functioning as a reference book for further work. At the same time, given the inaccuracies in some of the more general books on Alexandria, it is essential to have one volume, for both the scholar and the general reader, in which there is a clear line between fact and supposition or speculation.

It is to be hoped that it will succeed in showing that, contrary to the generally held assumption that the architecture of Alexandria has been lost beyond recall, there is sufficient evidence surviving from Alexandria and related sites so that it can be reconstructed reliably, bringing to life the built environment of the third major centre of the ancient Mediterranean (along with Rome and, later, Constantinople).

The argument presented in this book is lengthy and complex, as a result of its chronological and geographic breadth and the range of material covered. Thus, it is desirable to give a summary of the overall argument. For clarity this consists of a brief outline, followed by a more detailed summary. Because students will often be focusing on only one of the periods covered, a summary of the main concerns of each period is also given at the beginning of each of the chronological parts of the book. For the same reason, to assist students with following the argument there is the occasional reiteration of it to make the individual chapters as self-contained as possible.

The process of the destruction and rediscovery of Alexandria and the evidence for its city plan through the centuries are covered in the first two chapters. This provides the topographical setting for the later chapters which cover each of the three main periods: Ptolemaic, Roman, and Late Antique or Byzantine.

The main concern of the Ptolemaic period (Ch. 3–6) is the interaction of the Greek and Egyptian traditions. The development of Ptolemaic Alexandria is considered (Ch. 3), followed by Cleopatra's city (Ch. 4). It is found to be largely a Greek city, with some local features. The subtle influence of the two traditions on each other is also detected when the two main architectural styles of the Ptolemaic period are examined. The classical architecture develops new and distinctive forms, including the earliest baroque architecture which later spread throughout the Roman world (Ch. 5). At the same time, the Egyptian temples are found to undergo considerable evolution, reflecting the continued vibrancy of the native art and religion (Ch. 6).

The focus of the Roman period (Ch. 7–9), after Egypt became a Roman province in 30 BC, is the relationship of the classical architecture of Alexandria to that at other sites in Egypt and elsewhere in the Roman empire. The little known architecture of the cities and towns of Roman Egypt are examined first (Ch. 7) to provide a local context for developments in Alexandria (Ch. 8), and finally the architectural styles of both are considered (Ch. 9). Although their archi-

tecture has features in common with other urban centres of the Roman empire, the local style of classical architecture is found to continue so that both styles co-exist equally in Alexandria and elsewhere in Egypt. These observations provide the background to the developments which occur in the Late Antique architecture.

For the Late Antique period (Ch. 10–14) the architecture of Egypt (in the style generally termed 'Coptic') is examined, as well as its influence in the wider Byzantine world. Firstly, the written evidence for extensive church building in Alexandria (especially during the fourth and early fifth centuries) is presented (Ch. 10). As there is virtually no archaeological evidence surviving from Alexandria to show what these lost churches looked like, it is necessary to turn to the archaeological evidence for churches elsewhere in Egypt (Ch. 11). Continuity and innovation in the local classical architectural style is discovered, whilst features reflecting contact with the wider Mediterranean world are also observed. Chapter 12 examines the largely unknown writings of Alexandrian mathematicians and engineers on the mathematics relevant to construction, which are found to show a previously unrecognized concentration of architectural knowledge and training in the city.

The influence of the architecture of Alexandria and Egypt on Byzantine architecture elsewhere is considered (Ch. 13), especially in the light of the pre-Justinianic church of St Polyeuktos in Constantinople excavated in the 1960s. Its novel features are found to have evolved in Egypt. They were further developed in Constantinople and dispersed throughout the Byzantine East during the reign of Justinian. This means Alexandria had a more major role than has been realized in the development of Byzantine architecture.

The final chapter (14) covers the continuity of Alexandrian architectural iconography on visual media (mosaics and manuscripts) revealing that it was a more important artistic centre in the East, even after the Islamic conquest, than previously appreciated.

I. The Setting

Chapter 1: How Ancient Alexandria Was Lost

Recent underwater archaeology has given the impression that the ancient city of Alexandria has been lost below the sea. In fact, it is only harbour structures, such as breakwaters and quays, and some islands which are now underwater, along with loose fragments of architecture and sculpture, largely dumped along the shoreline to prevent the approach of Crusader ships. The area of nearly all of the ancient city is still on dry land under the modern city.

Given that the ancient city has not been covered by the sea, some explanation is necessary as to why it has disappeared so thoroughly. This is tackled in the first chapter which describes the process of the loss and rediscovery of ancient Alexandria. At the same time, this sets the scene by giving the reader a sense of the topographical relationship of the ancient city to the modern one. This difficult subject has been kept relatively brief as otherwise it can be elusive when overlaid by too much detail.

Chapter 2: Reconstructing the Plan of Ancient Alexandria: The Archaeological Evidence

Chapter 2 gives an indication of the ancient city's layout from the material remains so far exposed, to provide the topographical setting for the city in the following chapters. More archaeological evidence than is generally realized is now available for the layout of the Ptolemaic, Roman and Late Antique cities on the site. As this archaeological evidence lacks the chronological precision of the written sources for the buildings, the devotion of this separate chapter to it is methodologically necessary. It is essential to show precisely what evidence there is for the plan before the written sources for each period are discussed in separate chapters (3, 4, 8 and 10) and related to it.

In his magisterial three volumes on *Ptolemaic Alexandria* (Oxford 1973), Peter Fraser concluded there was little or no archaeological evidence for the city plan of Alexandria in the Ptolemaic period. Not surprisingly, given his erudition, this judgment was accepted by later British and American scholars. It is only when a detailed analysis of the archaeological evidence is made as a result of many years work, that the city plan begins to become clear. Close examination of it reveals that the grid-plan established by the Arab astronomer Mahmoud-Bey in 1866 is still largely reliable. Polish scholars (e.g., Rodziewicz, Tkaczow) have come to similar conclusions concerning the basic grid, as a result of excavating in the city for many years.

As this general topography is quite difficult to grasp, and as many scholars have remained sceptical of it, it is vital to give a thorough appraisal of the city plan, with detailed justification in the notes. Recent research is combined here with earlier work. The basis for both the Ptolemaic and Late Antique street grids are rigorously established. The evidence for other features of the plan is summarized, such as the areas of the cemeteries in each period, the line of the fortification walls, and the water supply. The relationships of the most important surviving building foundations to the grid are also established. These aspects are presented on up-to-date plans by the author which are the only ones to incorporate the now submerged harbour structures of both the eastern and western harbours, as well as the newly discovered location of the Heptastadium. The new plans in this and later chapters make clear the locations of those buildings which are reliably known, without those which are speculative.

II. Ptolemaic Period

Chapter 3. Ptolemaic Alexandria: Buildings Erected from the Late Fourth Century to the Mid-First Century BC

An attempt is made in Chapter 3 to give some sense of the development of the city and its buildings from its foundation by Alexander the Great in 331 BC until the mid-first century BC. This is done by examining the evidence in chronological order of the first reference to each building's existence to see what picture emerges of the city's development. Surprisingly, this has never been done before. Peter Fraser's chapter on the city's topography in *Ptolemaic Alexandria* remains the basic reference work for detailed footnotes on

the written sources. In it he, like other scholars, used Strabo's description of the city, after the Ptolemaic period, as the framework for his discussion. He concluded that the development of the Ptolemaic city largely escapes us.

Although archaeological evidence is included here when relevant and more can be gleaned from it than has been realized, most of the evidence still comes from the written record. Even if some of the written sources are considerably later than events they mention, the chronologically based approach used here is vindicated by the plausible picture which results.

The analysis undertaken is rewarding, as it gives an impression, at a general level, of the development of the Ptolemaic city during the important early period in the third century BC. This is much as might be expected. It reveals that the initial layout of the city and the main facilities for its maritime trade, defence, Greek cultural events and intellectual life were established during the reigns of Ptolemy I Soter and Ptolemy II Philadelphus, enabling Ptolemy III Euergetes I to concentrate on erecting sanctuaries to the local gods. Although the city's buildings are found to be largely Greek, it is also possible to detect Egyptian influence on the architecture of this city, which is sometimes assumed to be a completely Greek one in a foreign land.

Examination of the evidence for some of the city's famous buildings has also led to new insights, such as untangling the construction phases of the city's most important sanctuary, the Serapeum, and reconstructing it and the adjoining racecourse, the Lageion. These are illustrated with specially prepared axonometric reconstructions and new plans. Analysis of the archaeological evidence has also yielded other results recorded on plans which have not previously been drawn, including one of the approximate shape of the site when Alexander chose it, and an up-to-date record of the *in situ* Ptolemaic remains in the palace area (still on dry land).

The rigorous methodology used here of presenting evidence as much as possible so that it can speak for itself means that it is possible to see precisely what evidence there is for each monument and its chronology. This is essential as publications on Alexandria are plagued by an array of later legend, assumptions, and speculation, especially concerning its major monuments which go back to the Ptolemaic period.

Chapter 4. Cleopatra's Alexandria and the Roman Conquest

Chapter 4 covers the written sources for the city in the time of Cleopatra VII, prior to its conquest by the Romans in 30 BC. They are presented without detailed discussion to give the reader the chance to see what these sources themselves record. This is particularly useful in the case of the evidence concerning the controversial subject of the burning of the Library by Julius Caesar.

Chapter 5. Classical Architectural Style of Ptolemaic Alexandria and its Depiction

Having considered the Ptolemaic city's development and its buildings, attention turns, in Chapter 5, to their architectural style. A distinctive style of classical architecture, which includes the earliest baroque architecture, develops in

Alexandria, as demonstrated in *The Architecture of Petra* (Oxford 1990). However, the coverage here differs by considering, for the first time, how the developments in Alexandria relate to those of the Corinthian order in the Greek homeland. As it had not yet been standardized there, this facilitated the development of new decorative details in Alexandria which are distinctive of its classical architecture, such as capital and cornice types.

At the same time the receptiveness of the Greek architects in Alexandria to local Egyptian influences stimulated the development of the earliest 'baroque' architecture with new structural features, such as broken pediments and curved entablatures. The features of this baroque architecture were later adopted throughout the Mediterranean during the Roman period.

An indication of how the fragments of Alexandrian architecture would have been used in complete compositions is provided by the rock-cut facades at Petra and that depicted in Pompeian wall-paintings. The evidence for the architecture in these wall-paintings of the so-called Second Style in the first century BC being that of Alexandria is summarized (having been presented in more detail in *The Architecture of Petra*). Architectural painting in Alexandria in the third and second centuries BC is analysed in more detail than previously, revealing technical details and compositions used in Alexandria prior to their appearance in Pompeii.

Chapter 6. Traditional Egyptian Architecture

For a full understanding of the monumental architecture of the Ptolemaic period the study of it concludes, in Chapter 6, with the Egyptian temples up the Nile which are usually ignored by non-Egyptologists. As these temples are the main buildings surviving outside Alexandria from the Ptolemaic period they are a vital source for assessing whether this traditional Egyptian sphere absorbed any Greek influence. Although subtle, this influence can be detected in the developments in them, just as Egyptian influence is to be observed in the development of classical architecture in Alexandria.

The characteristics of these temples in the Ptolemaic period, which distinguish them from their Dynastic predecessors, are determined. This reveals that, whilst many of these features already existed in Egyptian architecture before the Ptolemaic period, it is the frequency of their use as standard forms which gives the Ptolemaic examples their characteristic appearance, along with new capital types. A detailed analysis is made of the development of these capitals, which show some Greek influence. Notably, developments in them are discovered under Ptolemy VIII Euergetes II, at a time when the temple wall-reliefs also undergo major changes (but independent of Greek influence). The innovations observed in the Egyptian architecture show the extent to which Egyptian religion and art were vibrant in the Ptolemaic period, which has not generally been appreciated.

The analysis of the periods of building activity reveals that the decline in the use of resources on the Egyptian temples during the Roman period coincides with increased expenditure on classical temples and public buildings many of which dominated the cities and towns.

III. Roman Period

Chapter 7. Classical Architecture in the Cities and Towns of Roman Egypt

In the study of the Roman period the cities and towns of Egypt are considered before Alexandria to provide a local context for developments there. To establish the special characteristics of the architecture of Roman Alexandria it needs to be set within the context of urban architecture and planning in Egypt. The classical architecture of Roman Egypt is almost completely unknown to Roman architectural historians (rather than papyrologists). A comprehensive presentation and analysis of it is made in Chapter 7 by combining, for the first time, the archaeological and papyrological evidence.

The considerable papyrological evidence for classical buildings, which have not otherwise survived, gives information about them, such as their dates and how their construction and maintenance were funded. The papyri provide a picture of city layout and building types which is confirmed by the archaeological evidence. This reveals classical buildings and cityscapes in Egypt in common with other urban centres of the Roman empire. Closer examination of the archaeological evidence reveals some local building designs and construction techniques. Notably, building activity is observed in Egypt in the third century AD, ensuring unbroken continuity of workmanship in classical architecture there into the fourth century.

Chapter 8. Roman Alexandria

Chapter 8 is devoted to examining the architecture of Alexandria itself after the Roman conquest of Egypt in 30 BC. Despite it being the second city of the Roman empire after Rome, this is the first time the written and archaeological evidence for the architecture of Alexandria in the Roman period has been brought together. The presentation of this evidence in an integrated form is difficult because a wider diversity of types of evidence has survived from the Roman city than from the Ptolemaic one, and because, considering the city's former size, the evidence is relatively scant. Despite this, an attempt is made to present it following the chronological development of the city.

Whilst retaining its famous monuments from the Ptolemaic period, new buildings are erected reflecting Roman rule, such as imperial dedications and characteristically Roman types of buildings. Diagrams have been prepared to present new observations and results from the analysis of the evidence. These include those concerning its major temples, such as the orientation of the Caesareum relative to the recently recorded harbour topography, and the reconstruction of the Roman Serapeum (with axonometric drawings and sections by Sheila Gibson and plans by the author), as well as plans showing the identified locations of buildings mentioned in Strabo's description and the *in situ* archaeological remains of the first to third centuries AD.

Alexandria is found, not surprisingly, to be embellished with similar buildings to other cities of the Roman East, although they sometimes have local features. Its classical buildings and cityscape also had much in common with the cities and towns of the rest of Egypt, suggesting that there was less of a division between them than is usually assumed from the mistranslation of the Latin *Alexandria ad Aegyptum* as 'Alexandria beside/next to Egypt', rather than (more accurately) 'Alexandria beside the Nile'.

The later structures surviving at Kom el-Dikka in the city centre, although dated to the fourth to seventh centuries AD, are included in this chapter on the Roman city because its focus is on pagan and secular buildings whereas Chapter 10, which otherwise covers those centuries, is largely concerned with churches. Detailed plans are also included of the results of the Polish excavations at Kom el-Dikka, as well as axonometric reconstructions of the buildings by Sheila Gibson, including the whole city block.

Chapter 9. Classical Architectural Style of Roman Alexandria and Egypt

The study of the Roman period is completed in Chapter 9 with an examination of the architectural styles of Alexandria and the rest of Egypt. The architectural fragments reveal two styles occuring during the first to third centuries AD. One is a direct continuation of the distinctive classical architecture which had developed in Ptolemaic Alexandria. The other is the same as that in use elsewhere in the Roman empire. However, what is even more notable is the discovery that both these styles occur side-by-side not only in Alexandria but also elsewhere in Egypt and, furthermore, that there is no detectable difference between the classical architecture of Alexandria and that of the other cities and towns of Egypt in the Roman period. This confirms the impression gained from the evidence in the previous two chapters.

The analysis of the references in papyri reveals that the number of classical buildings in the cities and towns of Egypt is irrespective of their distance up the Nile. Rather, those sites with the highest number of classical buildings are at or near those which later have the highest quality architectural decoration in the style generally termed 'Coptic'. This suggests a previously unrecognized continuity of proficiency in classical architecture at a local level into the Late Antique period, as also detected in the archaeological evidence.

These observations concerning the Roman period are important when we come to the Late Antique period because of the continuity which they indicate and the lack of a difference between the architecture of Alexandria and that of the rest of Egypt.

IV. Late Antique (or Byzantine) Period

Chapter 10. The Churches of Late Antique Alexandria: The Written Sources

There is a considerable number of written sources mentioning churches being built in Alexandria, from the fourth to seventh centuries AD. In Chapter 10 this evidence is analysed and fully documented. It is presented using a chronological approach. The texts provide considerable information, including who paid for these churches and to

whom they were dedicated. From the details they give about who built them and when, the main periods of church construction in Alexandria can be established. It will surprise some scholars that this reveals that many churches were erected there during the fourth and early fifth centuries.

Unfortunately, the texts rarely give the locations of the churches and give almost no descriptions of what they looked like. This information would normally be provided by archaeological evidence, but almost no remains survive of these churches to show either their overall plans or the style of their architectural decoration. However, there are churches, and the remains of them, surviving from sites up the Nile and in the oases. If, as was found for the Roman period, there is no distinction between their architecture and that of Alexandria in the Late Antique period, then they may be used as a guide to the architecture of the lost Alexandrian churches.

Chapter 11. Church Building in Late Antique Egypt: The Archaeological Evidence

The term 'Coptic' is still used by some scholars, especially in Europe, for the art and architecture of Late Antique Egypt in the third to seventh centuries AD. This term refers to the Church in Egypt which became distanced from that in Constantinople at the Council of Chalcedon in AD 451, although it did not become functionally separate until AD 538.

It had been thought (based on an outdated view of Church history) that the Church in Alexandria was separate from that in the rest of Egypt, and consequently that the architecture of the 'Coptic' churches up the Nile would not be a reflection of the lost Alexandrian churches. However, more recent studies of the written sources, especially papyri, by ecclesiastical scholars have shown that the Church of Alexandria and the rest of Egypt functioned as a single world. Thus, there is no reason why church architecture elsewhere in Egypt (of which there is considerable evidence) would not be a reflection of that in Alexandria, especially as it has been established here that there is no discernable difference between the classical architecture of these other sites and Alexandria in the immediately preceding Roman period.

The evidence for churches in Late Antique Egypt (in the style commonly referred to as 'Coptic') is presented, resulting from a detailed study, for the first time, of both their plans and their architectural decoration together, rather than just one or the other of these aspects. It is essential to establish the basis for the chronology of the evidence within a reliable archaeological context. As a result of the revision of the chronology of some evidence, the previously assumed gap of two centuries between the Roman civic architecture and 'Coptic' church architecture is closed. This then makes it possible to explain the continuity from the Ptolemaic period of some features observed in the architecture of Late Antique Egypt. Notably, the discovery that more evidence may be dated to the fourth and fifth centuries than generally realized, accords with the period of considerable church building in Alexandria found in Chapter 10 to be indicated by the written sources.

Extensive photographs are presented to convey a sense of the high quality of the carved architectural decoration on these churches, which is not generally known. This decoration is found to have features resulting from continuity of the local classical, and sometimes the Egyptian, architectural traditions. The floor plans of these churches have some local features, while also reflecting extensive contact with the wider Byzantine world. The diversity of these plans and the quality of architectural decoration reflect proficiency at a high level in both building design and construction in Egypt, by architects with not only local architectural skill, but also knowledge of architectural design in major cities elsewhere in the Byzantine empire. From these Egyptian churches we can gain an impression of how the lost church architecture of Late Antique Alexandria might have looked.

The types of buildings for which the carved architectural decoration was made, especially niche heads (both pagan and Christian), are considered. The issue of the variety of modes of conversion of pagan religious space in former temples or their enclosures is also touched upon. Both of these aspects reveal a more nuanced and subtle relationship between pagan and Christian culture than has generally been assumed, as well as a longer period of their coexistence.

Chapter 12. Architectural Scholarship and Education in Alexandria

The largely unknown texts on the mathematics relevant to the design and construction of buildings are analysed in Chapter 12. These are written by mathematicians and *mechanikoi* (engineers, architects, and master builders) who largely studied and taught in Alexandria. They reveal a previously unnoticed concentration there of expertise and training (not evidenced elsewhere) in the knowledge of the mathematics of building construction. They also show a notable competence in the mathematics of structures involving curved surfaces, such as domes and semi-domes. Thus, there was sufficient engineering expertise and skill in Alexandria, which continued into the sixth century AD, for it to have played a major role in the Byzantine period. This, obviously, has serious implications for our understanding of Byzantine architectural history.

Chapter 13. Influence of Alexandria on Byzantine Architecture Outside Egypt

Chapter 13 considers the influence of the architecture of Late Antique Egypt. The traditional view of Byzantine architectural history has been that there was an architectural revolution in Constantinople (Istanbul) under the emperor Justinian, because the earliest known examples of new developments occurred on his church of Hagia Sophia, built in AD 532–7. This view was formed prior to the discovery in the 1960s of the remains of the slightly earlier church of St Polyeuktos in Constantinople. Its high quality marble decoration has very unusual motifs. Scholars have agreed on their interpretation (that they allude to Solomon's Temple), but their artistic origin remained a mystery as there are no predecessors for them in Constantinople, and the parallels observed in Sassanian art are not very close. The author

discovered that earlier examples of these motifs occur in Egypt, notably even used on the same architectural members. It is only possible to demonstrate this having established the chronology of the evidence in Egypt in Chapter 11. It leads to the conclusion that there was influence from Alexandria on the architecture of Constantinople. This is less surprising in the light of the analysis presented of the Egyptian churches (Ch. 11) and the evidence of architectural expertise in Alexandria indicated by the texts (Ch. 12).

Thus, Alexandria appears to have played a similar role architecturally in the Byzantine period to that seen in the Ptolemaic period. In the Ptolemaic period, local Egyptian stimuli resulted in the development of the 'baroque' structural forms which were later spread more widely under Roman rule. In the Byzantine period, new forms developed in Egypt and were transmitted to Constantinople before being further developed and carried elsewhere under Justinian.

Chapter 14. Pictorial Tradition of Alexandrian Architecture in Byzantine and Early Islamic Art

The final chapter considers the continuity of the pictorial tradition of the depiction of Alexandrian architecture (which had survived in Pompeian wall-painting) in the East, in manuscripts and wall-mosaics. Whilst the characteristic circular structure (tholos) depicted on the Roman wall-paintings in the first century BC was noted in Gospel manuscripts by Underwood, the direct connection between them is greatly strengthened by the discovery here that the same colours are used in both for the same parts of the tholos. In addition, detailed analysis of these examples and of the Alexandrian architectural scenes in fifth century Byzantine wall-mosaics, such as St George's in Salonica (Thessaloniki), reveals their continued evolution in later centuries. They also occur in the early eighth century in early Islamic wall-mosaics in the Great Mosque in Damascus, and finally, as late as AD 1169, in the Church of the Nativity in Bethlehem.

The occurrence in the East of this genre of scenes on major monuments, while also continuing over such a long period of time, indicates the importance of the Alexandrian artistic tradition there, rather than in the West – where knowledge of it was lost, while the city's Library and scholarship became legendary.

Although not the capital city of an empire in the Roman and Byzantine periods, for the first millennium of its history Alexandria was a major centre of trade and intellectual life and a key source of artistic and architectural innovation, radiating influence like its famous Lighthouse.

The Setting

How Ancient Alexandria Was Lost

The modern visitor to Alexandria is surprized by how little remains of the ancient city. Diocletian's Column (Pompey's Pillar) in the south-west of the city is the sole column to have remained standing through the centuries [1]. It marks the site of the city's most important pagan sanctuary, the temple of Serapis, which now consists of some wall foundations and a few architectural fragments. Other than this, the Ptolemaic and Roman ruins to be visited consist of a few underground tombs from the third century BC to the second century AD. The only substantial remains of buildings are those from the city's later history at Kom el-Dikka in the city-centre. These buildings of the fourth to seventh centuries AD include public buildings, such as a 'small theatre', a baths-building, and lecture rooms of the city's major educational institution, as well as houses and shops.

There is little else of the ancient city to be seen. Even Cleopatra's Needles which stood at the entrance to the Caesareum on the harbourside have gone, one to New York and the other to London. Their positions under the Metropole Hotel (south-east of the better-known Cecil Hotel) are no longer marked. Similarly, although known, the former location of the city's first cathedral, the Theonas Church, at the western end of the main east-west street is not marked in the city itself. The locations of many of the city's other famous buildings are unknown, including the tomb of Alexander the Great and the Library.

Media coverage of the underwater archaeology in the city's eastern harbour has given the impression that the ancient city of Alexandria is lost underwater. However, the only areas which are now underwater are those near the shoreline and structures such as jetties which extended out into the harbour. The former area of nearly all of the rest of the ancient city is still on dry land. The modern main east-west street Sharia el-Horreya (Freedom Street) lies directly above the main east-west street of the original city layout which is also shadowed by some other modern streets.

The early mediaeval Arab city, depicted with ruins within it in [3–4], was built in a contracted area of the Ptolemaic and Roman cities [5a–b]. However, the Ottoman town was not built over the ancient and early mediaeval city, but instead to the north-east of it on the silted up Heptastadium, the causeway joining the island of Pharos to the mainland [5c]. Consequently, the ancient city was still visible in 1800 before the development of the modern city which covers the area of the ancient city and its cemeteries [6].

Some explanation should be given of how this city, of equal importance to Rome and Constantinople, could have left so little trace on the ground compared with them. Some of the city's buildings were simply removed by the robbing of their architectural stones for reuse elsewhere. Buildings were also destroyed by earthquakes and military action. Despite this, some traces of the ancient city survived until *c.* 1800 only to be destroyed by the construction of the modern city during the nineteenth century [7]. By the time scientific exploration began in the twentieth century, the amount and types of evidence left were severely limited.

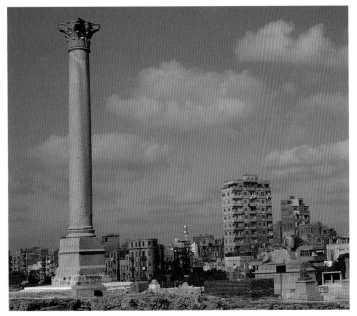

1. Alexandria, Diocletian's Column ('Pompey's Pillar') at the site of the temple of Serapis

2. Alexandria, Fort Qait Bey, built in AD 1477–9 on the site of the lighthouse Pharos

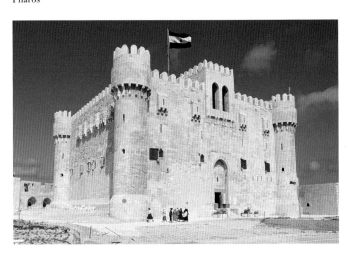

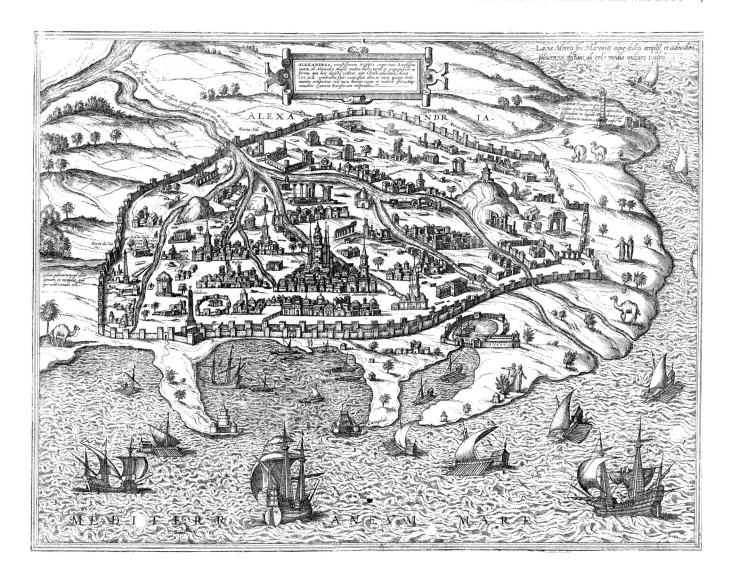

DESTRUCTION BEFORE 1800

3. Alexandria, map of *c.* 1590 showing the Arab city and ruins of the ancient city

The buildings of Alexandria suffered as a result of the custom of reusing architectural stone in later structures, which had a long tradition in Egypt. Many stone architectural elements were removed from Alexandria for reuse in buildings not only in the city itself, and in Cairo, but also in other cities much further afield. In AD 836 the Caliph al-Muʿtasim raided the churches to remove marble capitals and decoration for his new capital of Samarra in Iraq.[1] The columns of the court of the temple of Serapis (the Serapeum), later the court of the church of St John the Baptist, remained standing until the twelfth century and are described by Arab authors.[2] However, in AD 1167 they were broken up and moved down to the harbour. Abd al-Latif of Bagdad (AD 1161–1231) relates: 'I have seen on the sea shore, in the vicinity of the city walls, more than four hundred columns broken into two or three pieces, of stone identical to that used for Diocletian's Column . . . the columns were erected around Diocletian's Column' according to the city's occupants. Under Saladin 'the columns were pulled down, they were broken up and thrown on the sea shore in order to protect the city walls from the waves by reducing their strength or to prevent enemy ships anchoring beside the walls'.[3] A few of these columns, with the cuts intended for the wedges to break them up, were left behind and may still be seen on the Serapeum site [8], where only Diocletian's Column remains intact [9–10].

Most of the mosques of Cairo built before the fifteenth century contain capitals reused from Roman buildings and churches, most of which would have come from Alexandria. In Alexandria itself many fragments of ancient buildings, especially columns, were reused in the construction of the early mediaeval Arab fortification walls which were still standing in 1800 [10–12]. A member of the Napoleonic expedition in Egypt in 1798–9 observed: 'They are innumerable, the granite columns still seen in the mosques, the private houses, the shops, and broken pieces in the Arab city walls, in the quays and in the walls of all modern buildings. There are surely more than ten thousand. The most common are of coarse-grained red granite; some are of fine-grained grey granite. Some, but rarer and smaller, are of basalt'.[4]

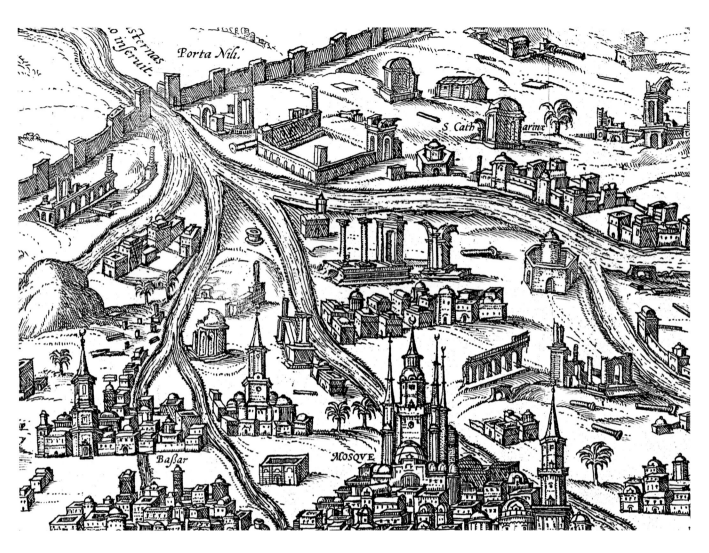

4. Alexandria, detail of map of *c.* 1590 with ruins of the ancient city

Columns and capitals were still available for reuse in mosques and other buildings of the town built on the silted up Heptastadium after the Ottoman conquest of Egypt in 1517.[5] There was a sufficient supply of quality pieces so that they were also removed from Alexandria for reuse in major

5a–c. Alexandria, maps showing the development and location of Alexandria before *c.* 1800: (a) Ptolemaic and Roman city, with island of Pharos joined to mainland by Heptastadium; (b) Early mediaeval Arab city; (c) Ottoman city, largely built on silted up Heptastadium

monunents elsewhere, such as those taken for the Suleymaniye Mosque in Istanbul in *c.* 1556–7.[6]

The city, renowned for the strength of its walls, was extensively damaged when it was sacked by the Crusaders under King Peter I of Cyprus in 1365 with unparalleled savagery and extensive looting.[7] Earthquakes assisted in the final destruction of the remaining standing buildings, including the lighthouse Pharos in 1375.

Subsidence has caused some of the structures built out into the eastern harbour and along its shores to be covered by the sea, with the greatest drop (*c.* 4.5–6.5 m) occurring in the seventh to tenth centuries AD. The sea is thought to have risen 1–1.5 m and the level of the land to have sunk 5–6 m during the last two thousand years. Some wall lines are still

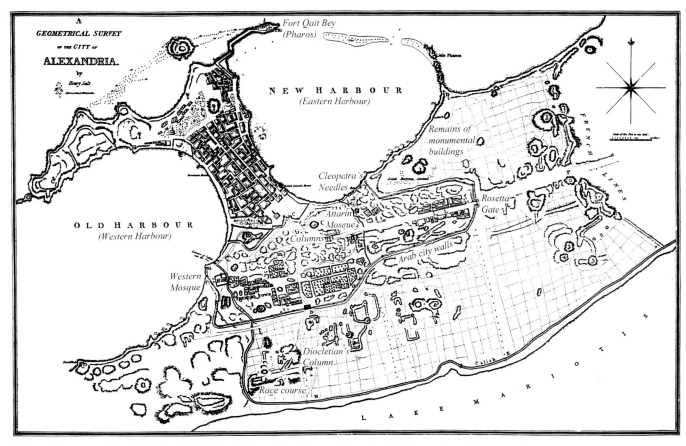

6. Alexandria, map made in 1806 by the British Consul, Henry Salt, with surviving ruins including remains of the street grid

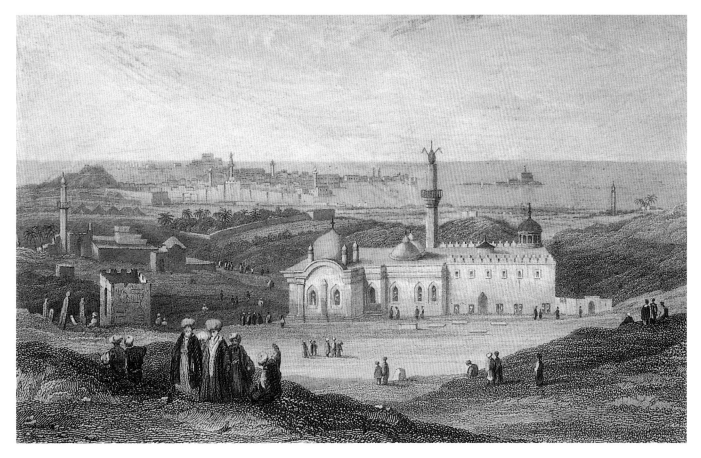

7. Alexandria, early nineteenth-century view from the south-east looking across the Arab town and the harbour to Fort Qait Bey

8. Alexandria, temple of Serapis, remains of red granite column shafts with cuts for wedges to break them up

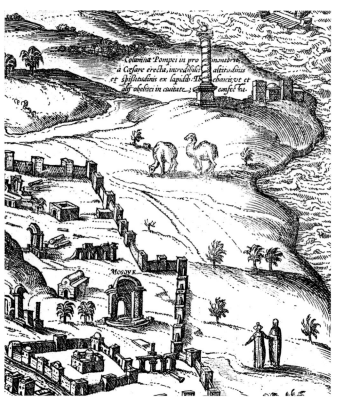

9. Alexandria, detail of map of *c.* 1590 with Diocletian's Column

visible below water on a clear day, especially east of the promontary el-Silsila (ancient Lochias). A resident of the city in 1951 reports that at Stanley Bay beach 'fishermen appeared every day to walk on water' as they moved along the ancient walls which survived below the water.[8]

REMAINS IN *C.* 1800

By the eighteenth century, when European interest in Alexandria began to develop, few ancient buildings were still standing. However, more traces of the city layout were

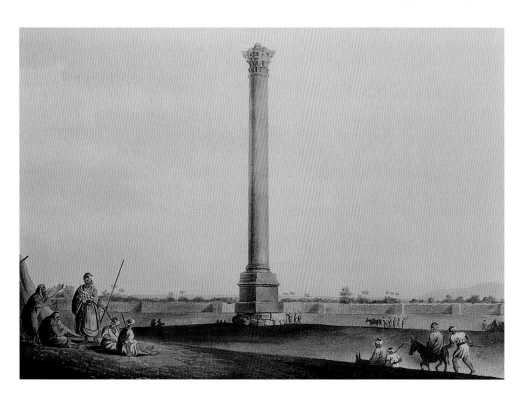

10. Alexandria, Diocletian's Column and the southern Arab city walls in the late eighteenth century

11. Alexandria, late eighteenth-century view of city walls along the Eastern Harbour shore, north-east of Cleopatra's Needles

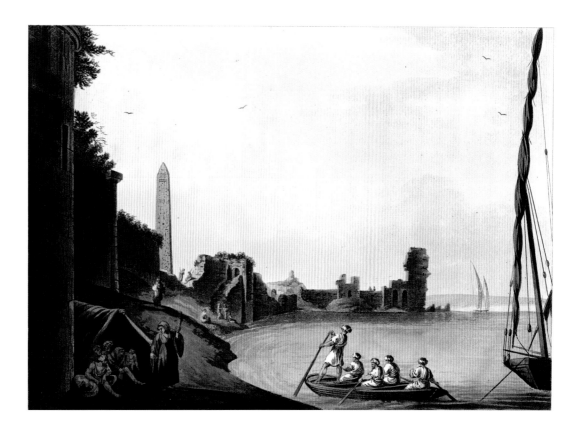

remaining and recorded than is generally realized. Not only were there the remains of the street grid, city walls, cisterns and cemeteries, but also of some buildings including a few major ones. The descriptions of Alexandria given by travellers in the eighteenth and early nineteenth century are consistent with the illustrations they drew of the visible remains of buildings [10–14].[9]

Columns were still standing along parts of the main east-west street [13–14], as well as on some streets parallel to it and on some cross streets. Along the cross street leading to the promontory el-Silsila there were considerable remains of monumental buildings which still could be seen in the 1860s: 'The quantity of shafts, capitals, fragments of columns; as well as the remains of large buildings which have been discovered and which are still discovered today by digging on both sides of this street . . . demonstrate the wealth of the district.'[10]

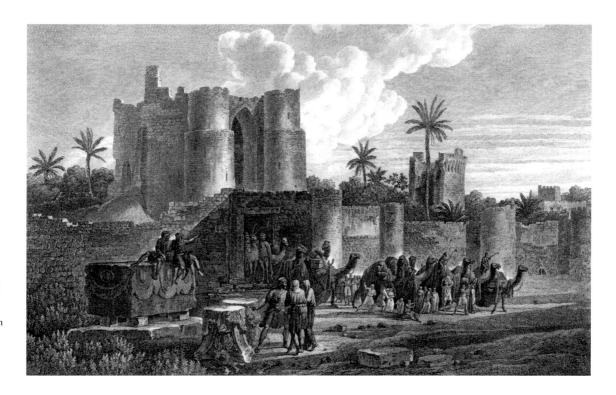

12. Alexandria, Rosetta Gate in the Arab walls, viewed from outside the city from the east in 1785, with column capitals on the ground in the foreground

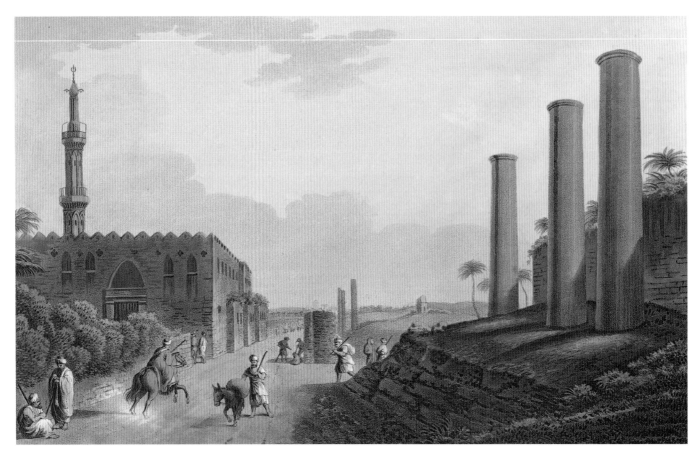

13. Alexandria, late eighteenth-century view, looking east along the main east-west street with red granite columns of the ancient street and the Attarin Mosque

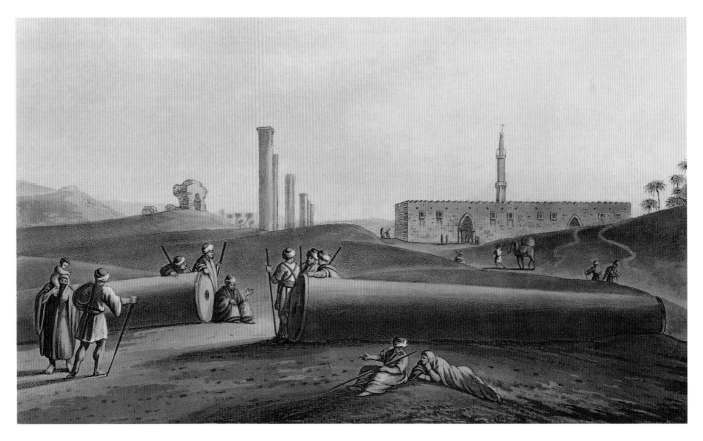

14. Alexandria, late eighteenth-century view, looking west along the main east-west street (in the opposite direction to fig. 13)

15. Alexandria, contour map of hills before levelling for the construction of the modern city

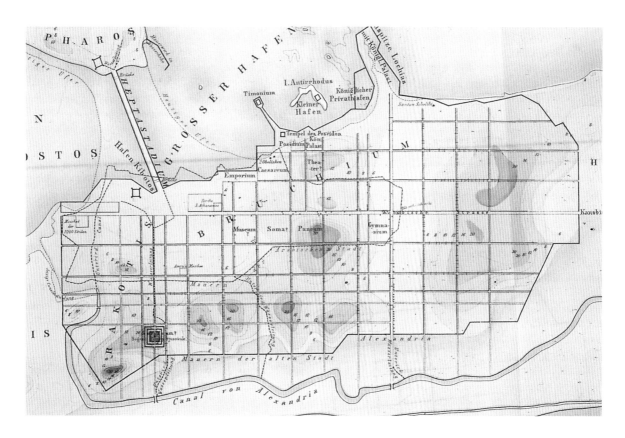

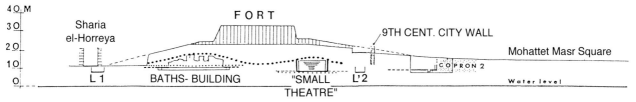

NORTH–SOUTH SECTION

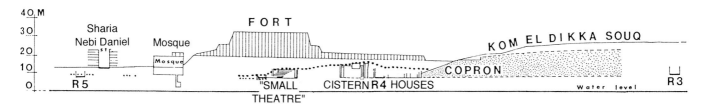

WEST–EAST SECTION

16. Alexandria, Kom el-Dikka mounds before excavation, sections

On the main east-west street the Rosetta Gate survived [6, 12], as well as the remains of a tetrastylon (consisting of a set of four columns) just inside it. North-west of the Rosetta Gate, between it and the eastern harbour, many architectural fragments survived from monumental stone buildings including the remains of a very large structure which was sometimes referred to in these travellers' descriptions as 'the palace'. At the south-western edge of the city the clear outline of the remains of the circus, for chariot-racing, were visible [6].

The locations of the city's two most famous temples, the Serapeum and the Caesareum, which later had been replaced by churches since destroyed, were clear because they were indicated by prominent landmarks. On the hill beside the circus, Diocletian's Column marked the site of the temple of Serapis which was strewn with architectural fragments.[11] Similarly, near Cleopatra's Needles, which had stood in front of the Caesareum, there were wall lines, as well as Egyptian, Hellenistic, Roman and Byzantine architectural fragments.[12]

Other buildings were marked by the Arab structures built over them, such as Fort Qait Bey erected on the site of the Lighthouse in 1477–9 [2, 6]. Through the nineteenth century many architectural fragments of both classical and Egyptian style survived near it, and were also reused in the mole connecting it to the island.[13] The Western Mosque, also known as the Mosque of One Thousand Columns, was built on the site of the Church of Theonas, the city's first cathedral, at the western end of the main east-west street. This mosque included many reused Byzantine capitals and columns,[14] as did the other main mosque, the Attarin Mosque,[15] which was on the main east-west street near the centre of the ancient city [6].

In some areas of the city the man-made deposits, especially of the Arab period, gave a false impression of where high ground had been in antiquity [15]. The mound in the area of Kom el-Dikka was later found to have been formed by Islamic man-made deposits. It was made even higher by the erection of a Napoleonic fort on it [16].[16] The ancient natural high ground was the hill on which the temple of Serapis was built, on bedrock.

The fortification walls of the ancient city were still visible in many places in the early nineteenth century. The much smaller circuit of the walls of the early mediaeval Arab city survived nearly intact at that time,[17] although much of the area inside them was deserted, as the main occupation was in the Ottoman town on the silted up Heptastadium [6].

DESTRUCTION IN THE NINETEENTH CENTURY

The Western Mosque (Mosque of One Thousand Columns) was badly damaged in 1798,[18] and the structures near the Rosetta Gate were destroyed in the fighting between the British and French. The British victory over the French in 1802 ended Napoleon's occupation of the country which had begun in 1798. This was followed by the lengthy rule, from 1805 to 1849, of Muhammad Ali who began the development of the modern city,[19] and so began the gradual process which caused the disappearance of nearly all the traces of the ancient city mentioned above. In 1816 the levelling of the hills was begun,[20] exacerbating the confusion of the archaeological record which had already occurred in earlier periods. In 1819 Muhammad Ali reconstructed the Canal of Alexandria (the Mahmudiya Canal) which connected Alexandria with the Nile.

The development of the modern city covering the ancient one by c. 1878 can be seen in the view of the eastern harbour from Cleopatra's Needles [17]. This new city, severely damaged during the British bombardment of 1882,[21] was rebuilt and continued to expand east over the ancient palace area. Rubble from other parts of the city was brought in for fill along the shore.[22] In 1882–5 the Rosetta Gate and the eastern Arab walls were pulled down for the stone to be reused for the construction of the Hospital (leaving the small sections in the Shallat Gardens and near the modern stadium).[23] It was at about this time that most traces of the buildings in the palace area were finally lost. Expansion of the city to the south-west led to the site of the circus being covered by c. 1890.[24]

The ruins under the eastern harbour were still visible in 1895, as the British archaeologist D.G. Hogarth observed when he visited the city to examine its potential for archaeological exploration: 'In the water itself are to be seen long white lines of masonry, sea-worn and flush with the sand; . . . When the sea is calm and clear, columns, capitals, mouldings and squared blocks may be seen lying pell-mell on the bottom for some distance out below low water mark.'[25] The construction of the Corniche, the road along the edge of the eastern harbour, from 1902 covered some of these wall lines and architectural fragments near the shore, which are marked on early British Admiralty sea charts.[26] This was the final major disruption to the archaeological record with material used as fill coming from the mounds to the east of the city from the area near the Hospital to as far west as Ramleh.[27] By World War I the present city was largely complete, covering over the area of the both ancient city and its cemeteries to the east and west.[28]

Not many archaeological remains of the few major buildings which had survived into the nineteenth century lasted into the twentieth. By 1830 the Western Mosque (Mosque of One Thousand Columns) and the Attarin Mosque had been destroyed without a detailed record having been made of the hundreds of Late Antique capitals that had been preserved in them.[29] In 1866 part of the baths-building at Kom el-Dikka was destroyed when the munitions store in it exploded.[30] During the construction of new buildings, occasionally ruins uncovered in digging their foundations were noted, and towards the end of the ninteenth century some of the architectural fragments found were removed to the Greco-Roman Museum.

EXCAVATIONS AND THE TWENTIETH CENTURY

The pattern of excavation is linked to the development of the modern city.[31] Thus, the early discoveries were largely in the area of the ancient city of the living. However, as most of the discoveries resulting from construction work occurred before formal excavations began in the 1890s they were not well-recorded. Once this area was covered over, the modern city expanded to the east and west over the ancient cemeteries, so that the discoveries from the 1890s through to the 1940s were largely tombs. This meant that the period which coincided with the development of a more scientific approach to archaeology largely occurred when the main discoveries were made in the cemeteries. Consequently, the tombs were recorded in more detail than the city remains had been. This led to a skewing of the evidence, as far more was recorded about the city of the dead than had been for the city of the living.

In 1863–6 Mahmoud-Bey the astronomer [Mahmoud el-Falaki] was able to record the traces of the ancient city street grid and walls because sufficient areas were still visible and available for him to excavate where necessary.[32] Some of the remains in the ancient palace area near the eastern port were recorded before most of that area was covered by buildings. After this, the areas which could be excavated were often too

small to provide much information on the overall picture of the topography of the city, as Hogarth complained in 1895: 'the proximity of houses rendered it generally impossible to continue far in any direction, and one had to work in a general atmosphere of confinement', as seen when Noack was excavating in 1898–9 [18].[33]

The multi-storey buildings erected since the late nineteenth century required deep foundations which have generally destroyed the archaeological evidence below them. Consequently, the few excavations during the twentieth century in the area of the ancient city of the living have been in areas which were not built on, including the cricket ground, the Hospital grounds, and the gardens of the British Consulate. These discoveries have included houses. Recently the redevelopment of the city has also enabled excavations by the Centre d'Études Alexandrines under some buildings which did not have deep foundations, such as cinemas and theatres including the Billardo Palace, Majestic Cinema, Radio Cinema, and the Theatre of Diana [19]. Remains previously recorded while digging the foundations for new buildings include those in the so-called Chantier Finney in the palace area and the stoa on the main east-west street. The clearance of the large site for the Bibliotheca Alexandrina to

17. Alexandria, Cleopatra's Needle marking the site of the Caesareum on the Eastern Harbour, before its removal to New York

18. Alexandria, F. Noack's excavation in 1898–9 of street L2 on the north side of Sharia el-Shahid Salah Moustapha, east of the 'Khartoun Column', looking south, with the remains of street paving at the bottom of the photograph

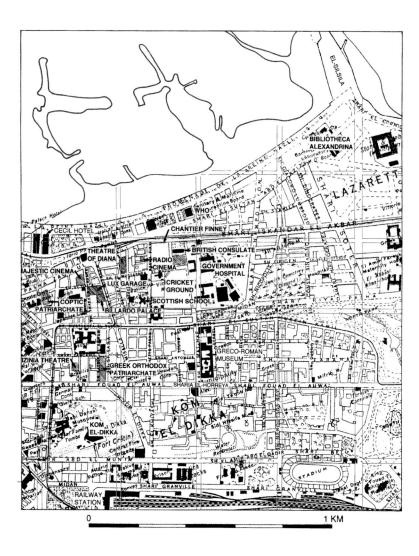

19. Alexandria, plan of central city area with locations of some twentieth-century excavations; with ancient street grid and shoreline

the south of the promontory el-Silsila also led to some discoveries, such as mosaics.

There are only two areas in the city of the living sufficiently well-preserved into the twentieth century to provide substantial information about changes, from one period to the next, in major civic monuments and topography. These are the site of the temple of Serapis and Kom el-Dikka. The temple of Serapis was excavated at the end of the nineteenth and beginning of the twentieth century and, after the clearance of some modern Arab housing, during the Second World War. Re-examination of this evidence reveals the changes to it between the Ptolemaic and Roman phases.

Part of the area of Kom el-Dikka was not built on because it remained a military zone. Its main city block available for excavation was located on the southern side of the main east-west street, directly south of the Caesareum and assumed site of the Forum. Although dismissed by Hogarth as not worthy of further investigation, it has turned out to be one of the most important archaeological sites in the city, as shown by the excavations of the Polish Centre for Mediterranean Archaeology since 1960. Late Antique buildings have been uncovered there, including substantial remains of a large baths-building, an educational complex with lecture rooms and a 'small theatre', as well as houses and workshops. Below

these structures there were earlier houses. Only in recent years have the Ptolemaic and early Roman layers been uncovered over a sufficent surface area for a coherent picture to begin to emerge. For the first time there is sufficient evidence to give an impression of the overall changes which occurred in a city block through time.

Modern technology and the changed military situation, since the end of the Cold War, have made it possible for the remains of harbour structures under water in the eastern harbour to be explored and recorded. Geophysical measuring techniques have been used to locate the Heptastadium. When combined, this information considerably revises our knowledge of the design of the ancient harbours. Underwater exploration has also taken place near the Lighthouse site, Fort Qait Bey, where sculptures and architectural fragments have been raised from the sea bed.

Even when examined together, the information from the twentieth-century excavations on dry land gives a very incomplete picture. Considerably more depth can be given to this picture by combining it with a re-examination of the records made in the nineteenth century before much of the evidence was destroyed (Ch. 2). This provides far more information than is generally realized, especially concerning the city plan.

Reconstructing the Plan of Ancient Alexandria: the Archaeological Evidence

The first detailed plan of ancient Alexandria was made by the Arab astronomer and surveyor Mahmoud-Bey in 1866 [20] based on his analysis of the archaeological remains visible at the time.[1] These included evidence for the streets, city walls, and water supply, which are described in his accompanying text.

When the British archaeologist D.G. Hogarth came to the city in 1895 to assess its archaeological potential, much of the evidence recorded by Mahmoud-Bey was no longer visible. Unable to see this evidence for himself, Hogarth was scathing in his dismissal of Mahmoud-Bey's plan. He also came to the conclusion that the remains did not merit mounting a British expedition to excavate the city. Peter Fraser accepted Hogarth's judgement in his magisterial *Ptolemaic Alexandria* (1973),[2] and later British and American scholars have followed him. Consequently, for over a century, scholars writing in English, unlike their continental colleagues, have assumed that we have little or no knowledge of the Ptolemaic or Roman city plan.

In fact, we have considerably more knowledge of the plan of the ancient city than is generally realized, when the little-known evidence which survived in the nineteenth century is combined with the results of twentieth-century excavations and recent discoveries. This confirms the street grid established by Mahmoud-Bey, while also providing extra information about other features, such as the line of the city walls, locations of the cemeteries, and the shape of the harbours.

These remains include evidence going back to the Ptolemaic period, as well as the Roman and Late Antique periods. As this evidence is not as precisely dated as the references to buildings in the written sources, it is methodologically desirable to discuss the overall plan before considering how the historical sources of each period relate to it (Ch. 3, 4, 8 and 10). As the archaeological evidence gives considerably more information than they about the city plan, it provides the background of the topographical and spatial setting for the

20. Alexandria, plan of ancient Alexandria made by Mahmoud-Bey in 1866

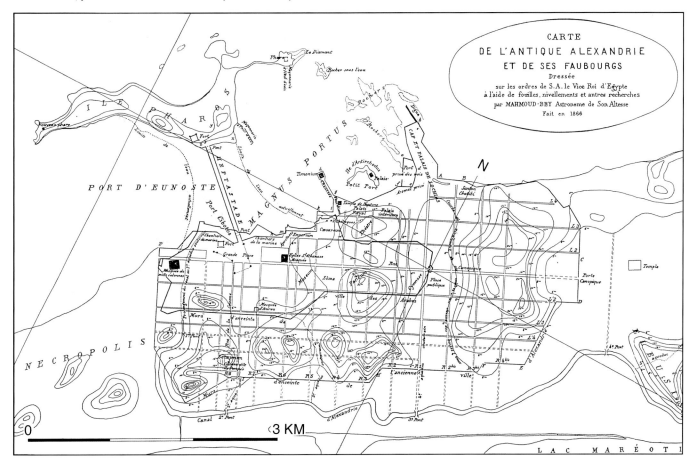

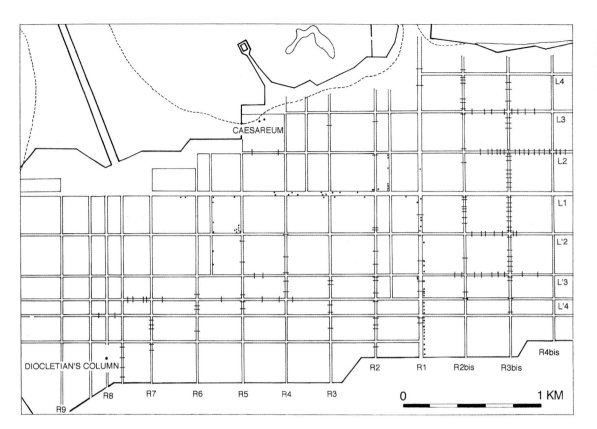

21. Alexandria, lengths of surviving street paving and columns, marked on Kiepert's copy of Mahmoud-Bey's plan

events they describe. It also gives a context for the locations of the remains of buildings which are not always clear in the detailed archaeological reports.

STREET GRID

Mahmoud-Bey was well-acquainted with the topography of Alexandria as he had also made a plan of the modern city. He established the numbering system for the ancient streets used by all scholars since, with the east-west streets preceded by the letter L and the north-south ones by R. In order that the reader here can see for himself the basis for the city plan, these street numbers are marked on the plans.

Examination of Mahmoud-Bey's text reveals that he is very precise in his record of the ancient plan distinguishing between when there is or is not evidence, and when it is fragmentary. Furthermore, he notably was aware of the implications of the stratigraphy: that the paving and columns which he uncovered were Roman, not Ptolemaic, in date.[3] Thus, he made no claim to be recording the Ptolemaic grid. He also recorded some lengths of the city walls and is specific in his text about where these survive.[4] These details were recorded on a second copy of his map which does not seem to have survived but which was copied by other scholars. Sieglin's plan shows where columns and paving had survived,[5] which are also clear on Kiepert's copy [15, 21].[6] Mahmoud-Bey recorded in his text and marked on his map well-preserved paving for main lengthwise (east-west) streets, L1, L2, L3, L'2, L'4, and for main cross (north-south) streets, R1, R2, R3, R5, R6, R7, R2[bis], R3[bis] [21].

A few of the columns on the main east-west street are depicted in illustrations from the late eighteenth century [13–14].[7] Soon after this, in 1806, the British Consul Henry Salt made a map of Alexandria on which he marked considerable remains of the grid and the city walls [6].[8] These suggest that Mahmoud-Bey's observations, made over half a century later, are accurate.

Mahmoud-Bey's record of the grid is also confirmed by later excavations, although they were much more restrained by the city being built up, as Hogarth had complained. Not only have Roman streets been found where Mahmoud-Bey recorded them, but Ptolemaic streets have been found under and in alignment with some of these [22–23].

There is now considerable evidence accumulated for the Roman and Late Antique phases of the streets. The soundings by the German excavator Noack in 1898–9 in the ancient palace area confirmed the location of streets L2, R1, R2 and R3 [18, 24]. Noack also added two streets L*alpha* (between L3 and L4) and L5. Remains of streets R2[bis], R4, R5 and L'2 were found by directors of the Greco-Roman Museum, Breccia and Adriani, in the first half of the twentieth century. Further evidence has been added by Polish work in the city.[9] The lines of some of these streets survive in the modern city

22. Alexandria, plan with streets going back to Ptolemaic period (at some point on their length) marked in solid black, and lengths of city walls recorded by Mahmoud-Bey

23. Alexandria, plan with parts of streets reliably attested in Late Antique period marked in solid black

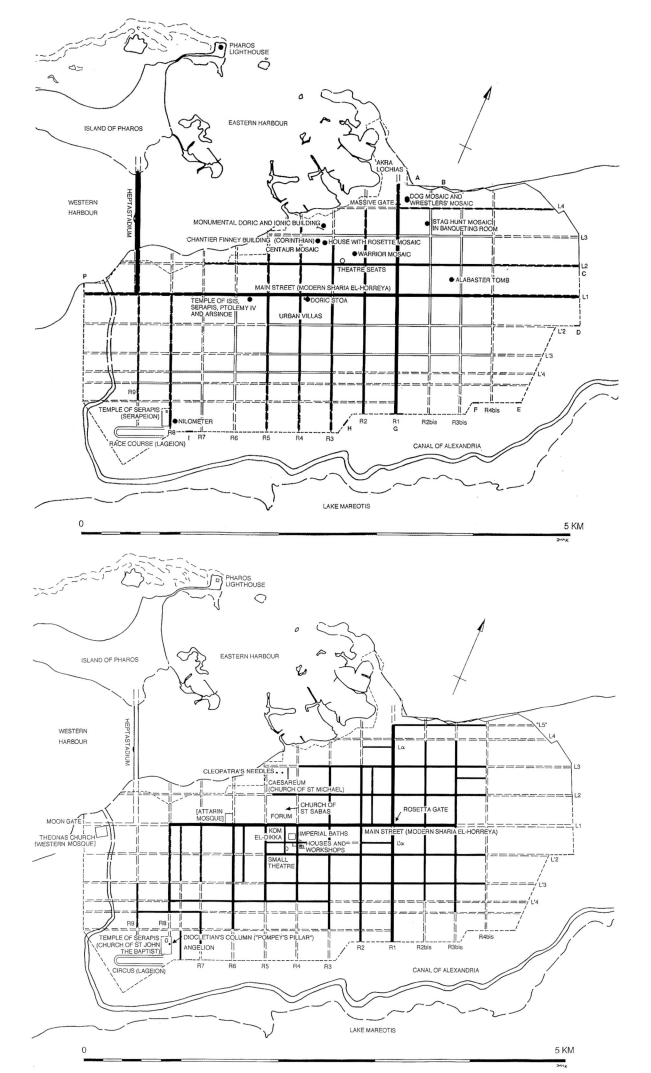

Top map:

PHAROS LIGHTHOUSE

ISLAND OF PHAROS

EASTERN HARBOUR

AKRA LOCHIAS

A B

WESTERN HARBOUR

HEPTASTADIUM

MASSIVE GATE

DOG MOSAIC AND WRESTLERS' MOSAIC

L4

MONUMENTAL DORIC AND IONIC BUILDING

STAG HUNT MOSAIC IN BANQUETING ROOM

L3

CHANTIER FINNEY BUILDING (CORINTHIAN)

HOUSE WITH ROSETTE MOSAIC

CENTAUR MOSAIC

WARRIOR MOSAIC

L2

THEATRE SEATS

C

P

ALABASTER TOMB

MAIN STREET (MODERN SHARIA EL-HORREYA)

L1

TEMPLE OF ISIS, SERAPIS, PTOLEMY IV AND ARSINOE

DORIC STOA

URBAN VILLAS

L'2 D

L'3

L'4

R9

TEMPLE OF SERAPIS (SERAPEION)

NILOMETER

F R4bis E

R8

R2 R1 R2bis R3bis

RACE COURSE (LAGEION)

R7 R6 R5 R4 R3 H G

CANAL OF ALEXANDRIA

LAKE MAREOTIS

0 5 KM

Bottom map:

PHAROS LIGHTHOUSE

ISLAND OF PHAROS

EASTERN HARBOUR

WESTERN HARBOUR

HEPTASTADIUM

"L5"

L4

Lα

CLEOPATRA'S NEEDLES

L3

CAESAREUM (CHURCH OF ST MICHAEL)

L2

CHURCH OF ST SABAS

[ATTARIN MOSQUE]

FORUM

ROSETTA GATE

MOON GATE

THEONAS CHURCH [WESTERN MOSQUE]

KOM EL-DIKKA

IMPERIAL BATHS

MAIN STREET (MODERN SHARIA EL-HORREYA)

L1

HOUSES AND WORKSHOPS

L'α

SMALL THEATRE

L'2

L'3

L'4

R9 R8

TEMPLE OF SERAPIS (CHURCH OF ST JOHN THE BAPTIST)

DIOCLETIAN'S COLUMN ("POMPEY'S PILLAR")

ANGELION

R4bis

CIRCUS (LAGEION)

R2 R1 R2bis R3bis

R7 R6 R5 R4 R3

CANAL OF ALEXANDRIA

LAKE MAREOTIS

0 5 KM

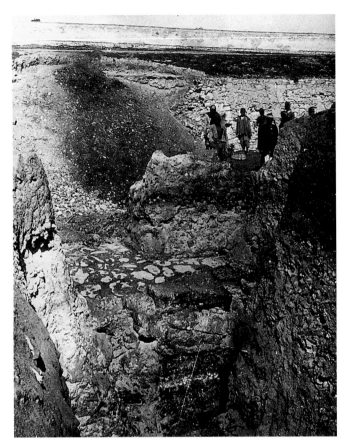

24. Alexandria, F. Noack's excavation in 1898–9 of street L2 (west of R2), looking north showing Late Antique paving with earlier street surfaces below

plan, such as Sharia el-Horreya, which is still the main east-west street. When this evidence is added to Mahmoud-Bey's record and each street where there is evidence marked to the corner of the relevant blocks, this shows there is considerable evidence for the Late Antique grid. It also gives an indication of the area the city occupied in that period (solid black lines in [23]).

There is also evidence surviving from the Ptolemaic period for some of these streets [22].[10] Ptolemaic phases have been identified in Noack's excavations of streets R3, R2, and L2. Other streets going back to the Ptolemaic period include streets R1, R4, R5, L1, L4 and L*alpha*. Street R8 ran beside the enclosure of the Ptolemaic temple of Serapis indicating the street's existence by the reign of Ptolemy III Euergetes I (246–221 BC), when the temple was erected. The fact that street R9 goes back to the early Ptolemaic period is indicated by the recently established position of the Heptastadium as a continuation of it, joining the island of Pharos to the mainland. As the Ptolemaic streets are attested only in small areas, unlike the Late Antique ones, their whole street lengths have been marked as solid black lines on the plan for convenience. This reveals the basic grid plan was established in the Ptolemaic period. The main changes in later periods were within these larger city blocks. Nearly all the remains of Ptolemaic and Roman buildings are on the orientation of this grid.

From the Ptolemaic period these include in particular the temple of Serapis, its enclosure, and the racecourse to its south. This structure, which was as large as the Circus Maximus in Rome, was recorded and drawn by both Henry

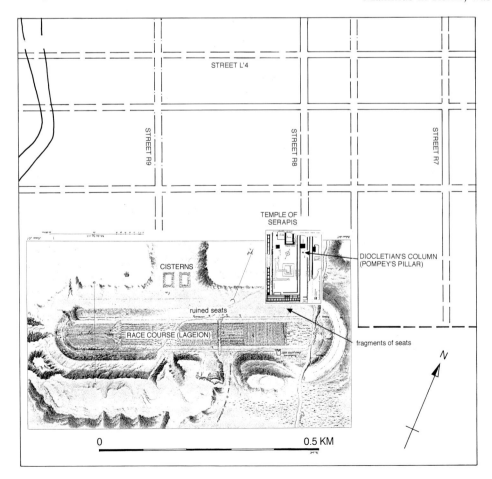

STREET L'4

STREET R9

STREET R8

STREET R7

TEMPLE OF
SERAPIS

CISTERNS

DIOCLETIAN'S COLUMN
(POMPEY'S PILLAR)

ruined seats

fragments of seats

RACE COURSE (LAGEION)

N

0 0.5 KM

25. Alexandria, plan of street grid with temple of Serapis and racecourse (Lageion)

26. Alexandria, Kom el-Dikka, sixth-century AD plan with outline of modern streets

Salt and the Napoleonic expedition in *c*. 1800.[11] It has since been covered by housing. However, the Napoleonic plan of it is quite detailed, with the essential information of scale, north, and Diocletian's Column (Pompey's Pillar) marked. Using these it is possible to relate it to the plan Alan Rowe made in 1957 of the Serapeum foundations[12] and also to the city plan [25]. This reveals that the racecourse, the Lageion which went back to the Ptolemaic period, was on exactly the same orientation as the Ptolemaic Serapeum and the city street grid recorded by Mahmoud-Bey.

Other monumental Ptolemaic remains which were on the orientation of the grid include part of a Doric colonnade from a stoa which stood at right angles to the main east-west street, on its southern side, to the east of the cross-street R4 (location marked on [22]).[13] Further west, west of cross-street R5, and beside the main east-west street, foundation plaques and some remains of a temple of Isis, Serapis, Ptolemy IV Philopator and Arsinoe III were found *in situ* (location marked on [22]). The ancient side street behind it ran parallel to the main east-west street.[14] In the ancient palace area, between the main east-west street and the eastern harbour, walls of Ptolemaic structures oriented on Mahmoud-Bey's grid were found, such as those in the 'Chantier Finney'.[15]

The exact positions and orientations of many other remains in the palace area were not recorded, including the curved seats of a theatre of unknown date (approximate location marked on [22]).[16] More recently, both in the palace area and in the city centre at Kom el-Dikka, some Ptolemaic walls and streets have also been found which are not on the orientation of the grid, suggesting that within some city blocks the orientation did not always rigidly follow the grid.[17]

The dimensions of the basic grid also indicate that it existed in the Ptolemaic period. Mahmoud-Bey measured the inter-axial grid length (the distance between the axes of the north-south streets) as 330 m. This measurement is confirmed by later excavations. The foundations of the Serapeum of Ptolemy III Euergetes I (246–221 BC) are marked by the inscribed foundation plaques at the corners. Not only are these foundations on the same orientation as the street grid, but the gross unit of their layout, 27.50 m, is exactly 1/12 the inter-axial dimension of 330 m.[18] This accords with the basic design of the grid going back to the Ptolemaic period as was indicated by the evidence for some streets. Thus, even if the whole area was not initailly built on, the overall design of the city, especially between cross streets R1 and R9, goes back to a single original layout.

The walls which have survived from Roman buildings are also on the orientation of the grid. For example, the foundations of the Roman phase of the Serapeum are on the identical orientation to the Ptolemaic one, as is the circus built over the earlier Hellenistic racecourse (the Lageion) to its south-west [25]. Similarly, walls which had survived on the site of the Caesareum near Cleopatra's Needles, whilst not dated, were on this orientation,[19] although Cleopatra's Needles and the temple itself were apparently at an angle to the street grid because of the temple's relationship to the harbour. The considerable Late Antique remains at Kom el-Dikka are on the orientation of the grid [26]. These include

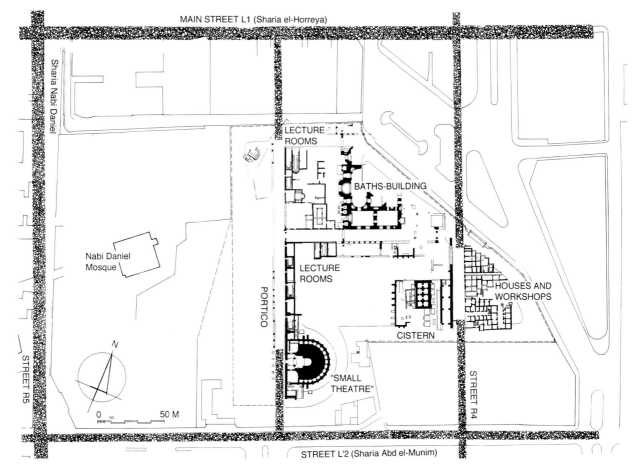

the baths-building, latrines, lecture rooms, the 'small theatre', houses, and shops.

The evidence at Kom el-Dikka gives the positions of some side streets and lanes within a city block. These include the new porticoed thoroughfare built in the fourth century AD in front of the 'small theatre' [26]. This thoroughfare is on the orientation of the grid, but on a completely new alignment, as it is built over earlier Roman housing.[20] This accords with the evidence from streets in other blocks, which indicates that there were not necessarily standard internal divisions within the large city blocks in the Roman period.[21] For the first time, in recent excavations, there is evidence of internal street divisions within a large block in the Ptolemaic and early Roman periods with the discovery that street L'alpha (to the east of R4) at Kom el-Dikka was on the same alignment in the Ptolemaic period [23].[22] However, there is not at present sufficient information to determine the overall internal divisions of the blocks in the Ptolemaic period, although evidence uncovered in recent excavations suggests that the blocks were not necessarily equally divided.

Sufficient evidence survived of the main streets to give some indications of their widths. Mahmoud-Bey recorded the width of the main east-west street L1 and the cross-street R1 as 14 m, and of the other streets as 7 m. Street R1 seems to have been a major cross-street. The paving Noack recorded along its centre was 5.7 m wide, with a hard earthen band along each side, so that the street itself seems to have been 19.85 m wide. The Roman paving recorded by Noack on street R3 was 6.65 m wide, including the curb stones. The paving of R2bis observed by Breccia was 6 m wide. These widths are from the Roman period when the streets had been encroached upon by the buildings along them. This did not occur in street R4 at Kom el-Dikka until the early sixth century when it was narrowed from c. 9 m to 6.5–6.7 m by the construction of shops along its west side. It was further narrowed to c. 3.5 m along the east side by construction in the sixth–seventh century, but this was done in such an orderly manner that the street remained straight.[23] The Roman streets were paved with polygonal blocks of hardstone, both basalt and hard limestone.[24] In the Ptolemaic period the streets would have been wider. A width of 15 m for the Ptolemaic phase of street R3 has been identified by Hoepfner in Noack's section drawing.[25] If the main east-west street was at least twice the width of the secondary streets, this would suggest that it was at least c. 30 m wide. This would accord with the ancient descriptions of it in the first century BC as a plethron or more wide, since a plethron was 100 ancient feet, or c. 30 m.[26]

The unit of measure used for the grid layout was apparently the Egyptian cubit, rather than the Greek foot. The Greeks used feet (or units which were multiples of them – the stade of 600 feet or the plethron of 100 feet) for land measurement, but it has not been possible to detect an obvious length of foot in the street grid of Alexandria. The Egyptians used the cubit (c. 0.525 m) for measuring land. The main Egyptian unit of area for land was the square khet of 100 by 100 linear cubits, which was known in Greek as 1 aroura.[27] In the city plan of Alexandria the distance between the centre axes of the north-south streets was 330 m, and the distance between the centre axes of the east-west streets was 278 m (except on either side of the main east-west street it was 294 m).[28] From these dimensions, the total area of three of these city blocks was 100 arourai, suggesting their layout may have involved units based on Egyptian ones.[29] This is possible as another early Ptolemaic foundation, Philadelphia (Kom el-Kharaba el-Kebir) in the Faiyum, was laid out by Ptolemy II Philadelphus as a Greek city with a grid plan, but using Egyptian cubits.[30] The large city blocks in Alexandria could have been 600 cubits (315 m) long and 500 cubits (262.5 m) wide, with the cross-streets 15 m wide the east-west streets 15.5 m wide, and the main east-west street 32 m wide. These blocks could then have been easily divided using local land measurements.

This original street grid continued into Arab and mediaeval times, with the Arab authors mentioning the regular network of streets. Abū 'l-Fidā' (AD 1279–1332) notes: 'Alexandria is a most beautiful city, that it was built in the form of a chess board and that such a structure of streets made it impossible for a stranger to be lost in the town.'[31] The neat manner in which the encroachment occurred on street R4 at Kom el-Dikka shows how the street remained straight while also being narrowed considerably. If this pattern was followed elsewhere in the city it would explain the retention of the grid into the mediaeval period. The grid is still reflected in some modern streets, not only Sharia el-Horreya which is on the main east-west street L1 and the two main lengthwise streets to the south of it, L'2 (Sharia Abd el-Munim) and L'3 (Sharia el-Khedeiwi el-Auwal), but also each of the cross-streets from R2 to R9 which follow the alignment of ancient ones: R2 (Sharia Neroutsos-Bey and Sharia el-Batalsa), R3 (Sharia el-Mathaf, at a slight angle), R4 (Sharia Pereyra), R5 (Sharia Nebi Daniel, at a slight angle), R6 (Sharia ibn Khaloun), R7 (Sharia Sidi Abu Dirda), R8 (Sharia el-Gineina), and R9 (Sharia el-Taufiqya).

WATER SYSTEM

Many large underground cisterns survived at the time of the Napoleonic expedition, along with the underground water supply channels which filled them each year from the Canal of Alexandria when the Nile rose. Mahmoud-Bey mentions seven hundred cisterns. In 1896 there were still 129 cisterns which could be recorded and measured, some of which have been investigated more recently.[32] Whilst most of these cisterns were re-built in the Byzantine and Islamic periods, some of them go back to the Ptolemaic and Roman periods. The cisterns with reused Roman and Byzantine columns and capitals were built, or rebuilt, in the Byzantine and/or Islamic periods, sometimes with two or three stories of columns supporting arches. The early examples which were not rebuilt are those without columns, but with a single rock-cut storey and often irregular shape.[33]

Water supply channels were recorded by Mahmoud-Bey under some of the main streets, and side streets,[34] and examples of Ptolemaic and Roman date have also been found by

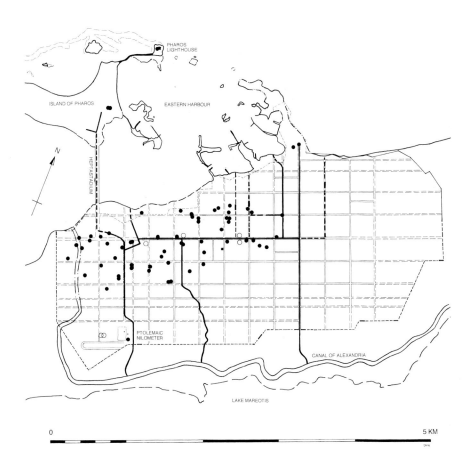

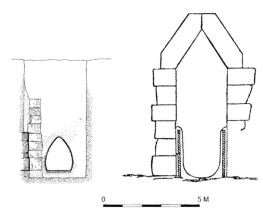

27. Alexandria, plan of water channels and cisterns; cross sections through underground water channels

later excavators [27].[35] They appear to have been part of the original city design.[36] There were also underground drains and sewers, such as those found in the palace area under street L*alpha*, and at Kom el-Dikka under street R4 and an alley off it.[37]

The Canal of Alexandria, which supplied the cisterns via the channels, was recorded on Henry Salt's plan [6] before it was rebuilt by Muhammad Ali as the Mahmudiya Canal. This largely follows the ancient route, but was diverted around the western Arab city walls [15]. The ancient route through the west of the city suggested on the plans here [27] is based on that on Salt's plan. Some modern plans also show an eastern branch from it cutting through the eastern part of the ancient city near cross-street R1, but this was a modern canal constructed in the early twentieth century (possibly on the line of an ancient underground supply channel) and since covered over.[38]

The Heptastadium carried an aqueduct to supply the island of Pharos with fresh water, mentioned by the ancient sources. Mahmoud-Bey suggested the position and angle of the Heptastadium based on the location of the water channels which seemed to lead to and from the aqueduct over it [20],[39] although he complained about not being able to excavate in the built up area to check this. However, recent exploration using geophysical measuring techniques has shown that the Heptastadium was oriented at a different angle to what he had suggested, reaching the mainland further to the west as a continuation of cross-street R9.[40] The water channel to the island would also have followed this revised route [27].

CITY WALLS AND CEMETERIES

Mahmoud-Bey recorded the ancient walls enclosing the grid plan of the city. He is precise in his description of what he saw and his basis for what he marked on his plan, noting which stretches survived and those he had to interpolate between them.[41] He recorded the walls at the places marked on the plan with solid lines, from A to C and at D, E, F, G, H, and I [22]. There is little doubt that the walls recorded by Mahmoud-Bey existed, but they cannot be precisely dated. They would have included lengthy sections which might have been rebuilt or repaired a number of times, incorporating the earlier walls. However, there is general agreement that the walls recorded by him indicate the approximate line of the main Ptolemaic and early Roman circuit.

The northern walls which ran along the shore were still visible to the east of Cleopatra's Needles in 1801 [11].[42] The line of the northern walls recorded by Mahmoud-Bey between P and A [20] is marked with dashed lines in the plan here [22] because the results of more recent work in the area of the Heptastadium and in the eastern part of the eastern harbour are also included. The exact line of the northern walls is not certain for their full length, and allowance needs to be made for the satisfactory functioning of the port, which would have included structures such as wharves and ship-sheds. In the light of the recent discoveries further work is required to clarify these problems. The so-called Tower of the Romans, which survived slightly south of this line until

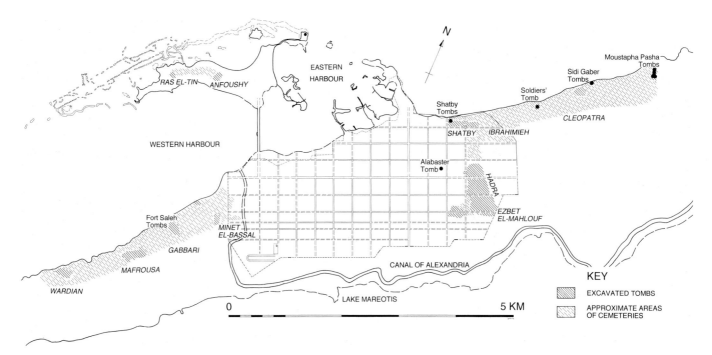

28. Alexandria, plan of Ptolemaic cemeteries and city walls

1905, beside Cleopatra's Needles, could have been rebuilt in the Islamic period incorporating an earlier structure of the Roman and, possibly, Ptolemaic periods.[43]

The remains of a massive gate on cross-street R1, to the north of street L4, were found in 1993 during excavations for the Bibliotheca Alexandrina, which suggests that the promontory el-Silsila (ancient akra Lochias) was closed off by a wall, at least until this gate went out of use in the late Ptolemaic period.[44]

Mahmoud-Bey suggested that the western walls ran south from the point (P in [22] beyond the canal, near the end of the main east-west street) through which Valentia had indicated they ran in 1806 (point G in [6]).[45] Remains of fortifications have recently been discovered in this location which are probably Ptolemaic or Roman, although they could be Late Antique.[46]

Along the south, the city was ultimately bounded by the Canal of Alexandria and Lake Mariut (Lake Mareotis).

29. Alexandria, plan of Roman cemeteries

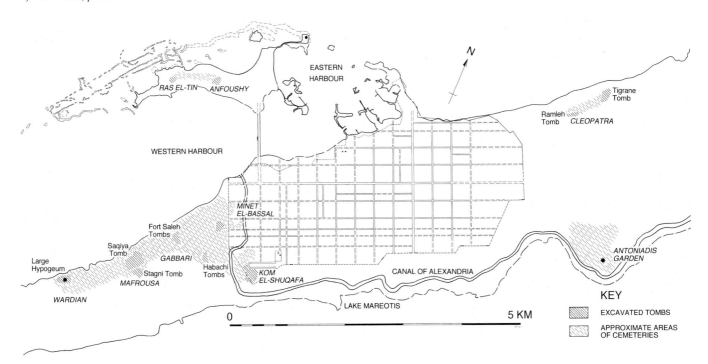

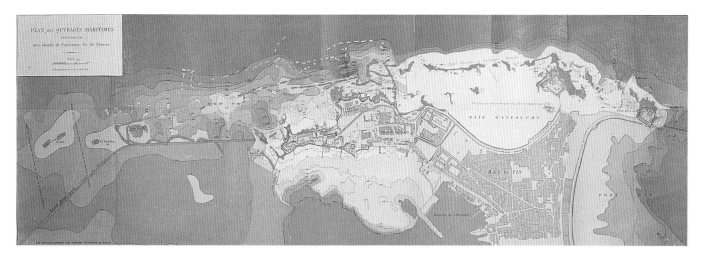

30. Alexandria, harbour works north-east of Pharos island recorded by Gaston Jondet in 1911–15, marked in red and pink

Mahmoud-Bey suggested the walls along the south followed the topography while also joining the points at which he excavated the remains of fortification walls at E, F, G, H and I [22]. These were 5 m thick and consisted of large blocks of masonry.[47]

Mahmoud-Bey marked the line of the eastern wall where it ran north from the main east-west street to the harbour based on the reports of the stone robbers.[48] It should be noted that this is approximately the same as the position for the eastern wall given by Valentia in 1806, when more remains were visible. The circuit of walls marked on Parthey's plan

of 1838 is fairly similar.[49] The placing of the walls this far east would have ensured the control of high ground there.

The location of Mahmoud-Bey's eastern wall has not been accepted by some scholars for the early Ptolemaic period because cemeteries were normally located outside the walls of Greek cities. As a result of this wall being so far east, the early cemeteries at Hadra and Shatby would have been inside the city walls, although at the edge of the area occupied by the living [28]. There were also other early cemeteries located further east, outside the city walls. At Petra in Jordan the tombs are at the edge of the area occupied by the living, but

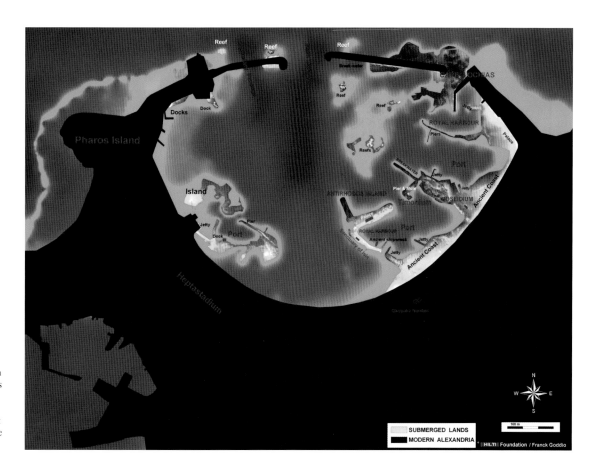

31. Alexandria, Eastern Harbour, harbour works surviving under water recorded by Franck Goddio and the Institut Européen d'Archéologie Sous-Marine

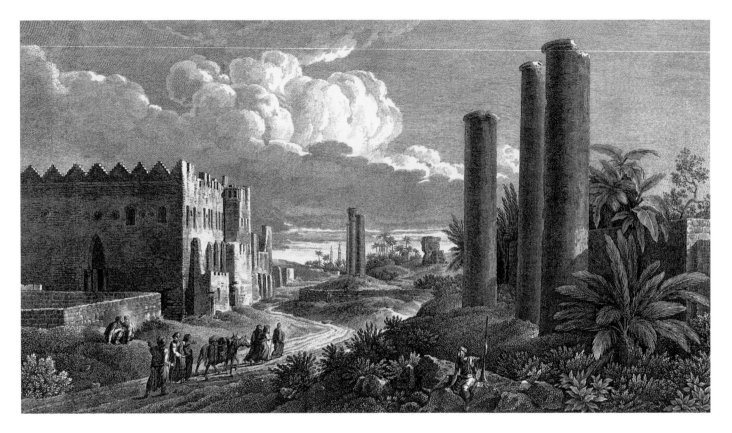

32. Alexandria, ancient columns along main east–west street in 1785, view looking east

33. Alexandria, Sharia el-Horreya, on the alignment of the ancient main east–west street, looking west

not necessarily outside the city walls. Intramural burial also occurred in Asia Minor.[50] At the western edge of Alexandria, part of the cemetery at Minet el-Bassal, which began to be used by the first half of the third century BC, was apparently located inside the ancient city walls [28].[51] Despite this, the suggested line of the western city wall has generally been accepted.

It is sometimes suggested that the first Ptolemaic eastern wall was positioned further west than the one Mahmoud-Bey recorded so that the early cemeteries were all outside the wall, although no traces of this wall have been found. Breccia, followed roughly by Hoepfner and Schwandner, suggested that it was level with street R4[bis], bending towards street R3 to the north and south. Botti suggested a wall further west than this, immediately to the east of street R'2. This position was also used by Grimm so that the Alabaster Tomb was outside the early wall.[52] As no archaeological traces of either of these hypothetical versions of an early eastern wall have been found, its exact location is not known so that (if it existed at all) it cannot be marked on the plan here.

By 30 BC the written sources indicate the eastern part of the city was defended by two walls, which continued into the Late Antique period. It has not been possible to show the inner one of these on the plans here as its exact location is not known. It did not necessarily follow the line of the hypothetical early Ptolemaic eastern wall.

By the first century BC the cemeteries at Hadra and Shatby had apparently been built over as the city expanded east to fill the area inside the walls, as far as Mahmoud-Bey's eastern wall [29]. There were also Ptolemaic cemeteries further east in the modern areas of Ibrahimieh and Cleopatra, at Sidi Gaber and Moustapha Pasha [28], as well as the occassional

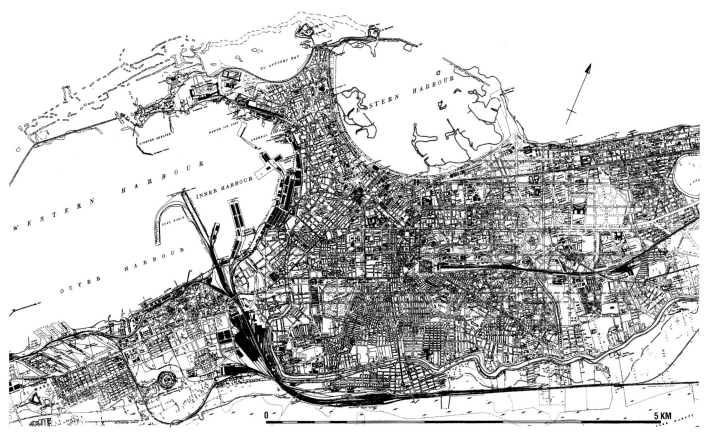

34. Alexandria, plan of ancient city (in red) below modern city

Roman tomb in the area of Cleopatra [29]. There were late Ptolemaic and Roman cemeteries on the island of Pharos at Anfoushy and Ras el-Tin, and to the south-east of the city in Antoniadis Garden. The cemeteries to the west of the city in the modern areas from Gabbari to Wardian, which were also established in the Ptolemaic period, expanded to become the main cemeteries in the Roman period, and extended to their south-east at Kom el-Shuqafa [29]. The parts of these western cemeteries nearest to the city continued in use in the Late Antique period.

HARBOURS

Our knowledge of the shape of the eastern harbour has increased considerably in recent years. Underwater exploration by Goddio and his team has resulted in the rediscovery of the smaller, now submerged, harbours within it which were formed by the addition of man-made jetties and breakwaters to the natural promontories and islands [31]. Apparently most of these structures date back to the Ptolemaic period, although further work on them is required. When the recently discovered location of the Heptastadium on the extension of Mahmoud-Bey's hypothetical street R9 [22] is combined with the plans of the underwater discoveries we have a much more accurate indication of the overall shape and design of the eastern harbour than Mahmoud-Bey was able to record (compare [22] with [20]). To this may be added the harbour works recorded by Jondet in 1911–15 to the north and north-west of the island of Pharos [30] forming the breakwater necessary for use of the western harbour [37].

CONCLUSION

The archaeological evidence surviving into the nineteenth century indicates all the principal features of the ancient city layout which might have been expected, with some traces lasting into the twentieth century. These include the street grid with the main east-west street and a major north-south street, water supply channels, cisterns, drains, city walls, and cemeteries. Remains of major buildings included the racecourse, traces of the city's two most important temples, the Serapeum and Caesareum, monumental structures in the palace area and public buildings in the city centre, as well as workshops and houses. The results of excavations in the twentieth century have confirmed the grid plan established by Mahmoud-Bey in 1866. Even today, the original street grid is still reflected in some modern streets, such as Sharia el-Horreya above the main east-west street L1 [32–34]. Mahmoud-Bey's outline of the harbour has been revised in the light of the combination of earlier records with recent surveys of the submerged harbour works and the Heptastadium.

The city plan provides the topographical setting for the buildings mentioned in the written sources in each of the city's main periods: Ptolemaic, Roman and Late Antique. When each of these is considered in turn we will begin to develop a sense of the evolution of the city and its architecture.

Ptolemaic Period

Introductory Summary

When Alexander the Great arrived in Egypt in 332 BC it was a country in which the Greeks and their enemies the Persians had already been active during the preceding centuries. During the sixth century BC, after the fall of the Assyrian empire and the end of the twenty-sixth (Saite) dynasty, Egypt established increasingly close trading links with the Greeks. In 525 BC it became a satrapy of the Persian empire, until regaining its independence at the end of the fifth century BC. With Greek assistance, it successfully resisted subsequent Persian attacks until 343 BC when they finally conquered it and the reign of the last native pharaoh, Nectanebo II, ended.

From the sixth to fourth centuries BC large numbers of ships trading with Greece passed along the westernmost or Canopic branch of the Nile through the now submerged site of Herakleion or Thonis (c. 23 km east of Alexandria), before reaching the Greek emporium (trading colony) of Naukratis c. 70 km further south [35]. The trading status of both was recognised in the fourth century BC by the Egyptian pharaoh Nectanebo I (380–362 BC) when he erected a stele in each setting out rates payable for import duties and tax.

It is in this context that, in 331 BC, Alexander the Great chose the site for his new city, Alexandria, where there was a natural harbour already in use by c. 400 BC as some kind of port or mooring place. It had the Egyptian name of Raqote (Rhakotis).

Alexander's conquest of Egypt led to three centuries of rule by Greek kings, the Ptolemies, until 30 BC when it became a Roman province. Alexandria was the city in which these kings lived, as well as being renowned as a centre of Greek intellectual life. However, it was also built in a country which already had a highly developed culture of its own, including architecture and religion. Thus, the main question which arises concerning the architecture of the Ptolemaic period is how did the Greek architecture of the new settlers interact with the pre-existing Egyptian architectural tradition, both in the capital and in the country's other urban centres.

To approach this topic the development of the city's layout and buildings are considered before examining the style of their classical architecture. The focus then moves out of the capital to the sites up the Nile and in the oases with Egyptian temples. There are different types of evidence for each of these aspects. For the development of the city and its buildings much of the evidence is provided by written sources, although sometimes supplemented by *in situ* archaeological remains. On the other hand, the only record from the city itself of its classical architectural style in the Ptolemaic period consists of loose architectural fragments. Although it is possible to define many of the characteristic features of this architecture from them, it is necessary to look further afield

to gain a sense of how they would have been used in complete architectural compositions. By contrast, evidence for the Egyptian temples largely comes from buildings which are still standing and usually dated by inscriptions.

The impression which results from the consideration of these different categories of evidence reveals that, although Greek and Egyptian features sometimes appear side by side, more significantly, the Greek and Egyptian traditions had a stimulating influence on each other. The earliest baroque architecture developed in Ptolemaic Alexandria as a result of Greek architects being influenced by the structural forms they could observe in Egyptian architecture and creating a new and distinctive style of classical architecture. At the same time, the traditional Egyptian temples in the rest of Egypt undergo lively developments as a result of their architects being receptive to Greek stimuli.

The foundation of Alexandria and the early development of the layout and buildings of the Ptolemaic city provide the background to the later influence of its architecture. Although much of the evidence for this early period comes from written sources, it is sometimes elucidated by archaeological remains which provide a spatial setting for the city's buildings, even if the precise locations of many famous ones are not always known. By the end of the third century BC Alexandria had most of the facilities typical of a Greek city and the most famous buildings of the Ptolemaic city had been erected.

The basic design of the city is attributed by the historical sources to Alexander the Great. Although he would have not been personally responsible for all the details, this does suggest which features would have been laid out as part of the original plan. These are all the basic features which would be expected in designing a Greek city. They include the layout of the main streets with underground water supply channels, and the line of the fortification walls around this grid of streets. The original design also involved the choice of sites within the city for the agora, the palace, and the citadel. The religious needs of both populations were to be met with temples to both Greek and Egyptian gods. Some local knowledge was also involved in the choice of the site with its natural harbour and the orientation of the streets (to catch the wind). Local influence is also possibly seen in the broad main street (like the avenues of Egyptian temples) and the apparent use of Egyptian units of measure (cubits) for the layout.

Ptolemy I Soter became satrap of Egypt in 323 BC and ruled as king from 306 BC until 282 BC. He was responsible for the construction of the most basic of the city's features: the fortification walls, palace, temples (possibly including the first version of the Serapeum), and the burial place of Alexander. Ptolemy I also founded the city's major research

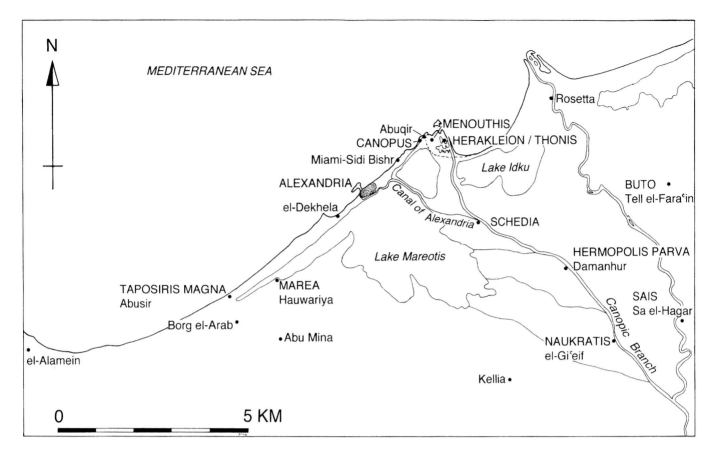

N

MEDITERRANEAN SEA

•Rosetta

Abuqir ⌂MENOUTHIS
CANOPUS ▭HERAKLEION / THONIS
Miami-Sidi Bishr•
Lake Idku
ALEXANDRIA BUTO •
el-Dekhela Canal of Alexandria Tell el-Fara'in
SCHEDIA•
Lake Mareotis HERMOPOLIS PARVA
•Damanhur
TAPOSIRIS MAGNA •MAREA SAIS
Abusir Hauwariya Sa el-Hagar•
Borg el-Arab • Canopic Branch
NAUKRATIS•
•Abu Mina el-Gi'eif
•el-Alamein
Kellia •

0 5 KM

35. Alexandria and surrounding area, map

institution, the Museum. In addition, he possibly began some of the facilities completed early in the reign of Ptolemy II.

During his lengthy reign Ptolemy II Philadelphus (285–246 BC) used the wealth from the territories of his empire to fund the completion of the city's main commercial facilities and the buildings characteristic of a Greek way of life. Early in his reign the essential infrastructure for the city's international maritime commerce was completed, including the lighthouse Pharos and the Heptastadium, the causeway which joined the island of Pharos to the mainland creating two harbours to maximise the use of the port.

The city had purpose-built public buildings for Greek entertainment in use early in the reign of Ptolemy II. Gymnastic, equestrian and musical contests were held by 279/8 BC in the racecourse, the Lageion, which was both a hippodrome (for chariot racing) and a stadium (for athletics). There were dramatic festivals in the Great Theatre by 276–271 BC. The agora, a distinguishing feature of Greek cities, is attested by the mid-third century BC, and was the market place and focal point of civic life. Ptolemy II was responsible for the main development of the facilities for the city's intellectual life: the Museum and the Library. Although the palace had a peristyle court in the Greek tradition, the erection of his famous banqueting tent was in the eastern tradition (as seen in both Egypt and Persia).

The use of Egyptian and Greek features together on buildings in the city appears during the reign of Ptolemy II

Philadelphus. This is most obvious in the royal cult temples in honour of his wife Arsinoe. The Arsinoeion had a single obelisk erected in it. The obelisk is Egyptian, but use of it alone, rather than in a pair, is new, beginning a custom which was continued by the Romans and still seen in cities today, as in St Peter's Square in Rome. At Zephyrion, Arsinoe was worshipped as the Greek goddess Aphrodite in her temple which also contained a mechanical drinking horn in the shape of the Egyptian god Bes. Ptolemy II also established other temples for the royal cult, including those for his mother and father, and for himself and his wife (as the *Theoi Adelphoi*). These would have helped assert his legitimacy as ruler of Egypt, especially in his role as the god-king pharaoh.

As the city already had the main facilities for its commerce and Greek culture by the time he came to the throne, Ptolemy III Euergetes I (246–221 BC) could concentrate expenditure on two of the most important sanctuaries for local gods: the Serapeum (the temple of Serapis) which became the city's most famous temple, and the temple of Osiris at Canopus to the east of the city. The combination of Egyptian and Greek features is seen on both of these sanctuaries but with differences in which tradition was dominant. The location and basic design of the Serapeum is known from its foundations. The new buildings of its main Ptolemaic phase, built with classical architectural orders, included a building to house the cult statue, a stoa-like structure and the peristyle court in which they stood. The sanctuary's location on the hill which

was the city's natural high ground, and the approach to the temple at an angle follow Greek custom, in contrast to the axial design and approach typical of Egyptian temples. However, like its cult statue, although Greek in appearance, the sanctuary also had Egyptian features, including a Nilometer and foundation plaques. By contrast, the temple of Osiris at Canopus (Abuqir) was built in traditional Egyptian style. It had foundation plaques in accordance with Egyptian custom but inscribed in Greek. A subtle combination of Greek and Egyptian features is observed at Hermopolis Magna (el-Ashmunein) in the royal cult sanctuary built with Greek architectural orders. Its new design with the temple approached along the axis of its peristyle court, reflecting the axial approach of Egyptian temples, is later used in the Roman East.

Ptolemy IV Philopator (221–205 BC) constructed further temples to local gods. Those marked by bilingual foundation plaques in Greek and Egyptian hieroglyphs, include a shrine to Harpocrates (son of the Egyptian gods Osiris and Isis) in the Serapeum, and a 'Greco-Egyptian' temple on the main street for the worship of Serapis, Isis, the king and his wife. Ptolemy IV strengthened his legitimacy through the dynastic cult with the erection of this temple and of the royal burial compound in the city centre, the Sema, which contained the tomb of Alexander as well as the Ptolemaeum for the remains of the Ptolemies. He also erected a temple in honour of the Greek poet Homer. By the end of the third century BC, the city had other sanctuaries for major Greek cults, such as that of Demeter and the Thesmophorion.

Descriptions of two structures from the reign of Ptolemy IV show the complex combination of Greek and Egyptian features with the creation of new architectural forms later used in Roman architecture. His floating palace had a main peristyle court in the Greek tradition, but with a clerestory like that used in Egyptian temples, creating a room reminiscent of the 'Egyptian *oecus*' later described by the Roman architect Vitruvius. At the same time, both the Greek and Egyptian styles were used separately to decorate different dining rooms on the boat. The fountain house (nymphaeum) dedicated to Arsinoe (II or III) is the earliest example of the design of the nymphaea later seen in Roman architecture built of coloured stone, in a semi-circular plan with a colonnaded facade framing marble statues of nymphs, and with running water.

Thus, by the end of the third century BC, Alexandria had all the different buildings necessary for its civic, intellectual, and religious life, as well as for its commerce and defence. Although most of these buildings are specific to a Greek way of life, Egyptian influence becomes increasingly apparent, especially in sanctuaries. Even when Greek in appearance, these contain some obviously Egyptian elements, while new designs reflect subtle Egyptian influence.

While we do not know the specific location of some buildings which were within the palace area, such as the tomb of Alexander and the Museum, some archaeological evidence survives from the part of the city identified by later writers as the palace area. This includes the remains of monumental classical buildings with conventional Doric and Ionic orders

of the late third century BC similar to those found in Greece. There were also some interior orders with the distinctive form of the Corinthian order which developed in Ptolemaic Alexandria by the second century BC. The remains in this area include houses with banqueting rooms, mosaic floors, and tiles from pitched roofs typical of Greek architecture. These contrast with the flat roofs of Egyptian architecture which also probably would have been used in the city.

The evidence for the cemeteries of the Ptolemaic city is archaeological. These included traditional Greek grave stelai, as well as larger rock-cut complexes whose layouts reflect both Greek and Egyptian influences. The more monumental examples are decorated with engaged Greek architectural orders providing a classical architectural setting, sometimes for features such as Egyptian sphinxes. The types of burials include cremation, inhumation and mummification, reflecting the diversity of ethnicity and cultural traditions amongst the city's population.

The growth and development of Alexandria was such that by the mid-second century BC, its wealth and size had exceeded all others. A century later it was described as the first city of the civilized world for its size, population, riches, elegance, and luxury, with three hundred thousand free inhabitants. As it grew, the Ptolemies further developed its palaces, as well as dockyards and harbours. This gradual development of the harbours is reflected in their organic shape, recently recorded.

Information about the city's topography and buildings during the reign of the last Ptolemaic monarch, Cleopatra VII, is provided by the classical written sources mentioning the settings for the Roman attacks on the city and related events. Poetic descriptions are given of two of the city's major buildings visited by Julius Caesar: the Sema complex and the interior of the palace. The descriptions of his attack on the city during the Alexandrian War of 48/47 BC provide important information about the locations of some buildings, indicating that part of the palace was on a promontory and that the Library was near the dockyards, as well as details about the Heptastadium and how the city's water supply functioned. These texts suggest that the Library caught fire at this time, although it is not completely clear if it was the whole Library or only part of it. The descriptions of the conquest of the city by Octavian (later called Augustus) in 30 BC provide further details, such as the fact that Cleopatra's tomb was located near the temple of Isis, and Octavian used the gymnasium as a public place to address the city. He spared it out of admiration for its size and beauty, and Egypt became a Roman province.

The style of the classical buildings in the Ptolemaic city had long been a mystery because no standing buildings survive and little information about this question is provided by the written sources and the *in situ* archaeological remains. However, evidence is provided by the classical architectural fragments dated to the Ptolemaic period in the storerooms of the Greco-Roman Museum. The examination of them shows a distinctive new style of classical architecture developed in the city. The forms of the Doric and Ionic orders used in Alexandria largely follow those at Greek sites in the Aegean

in the third century BC where these orders had become standardized. However, unlike them, the Corinthian order in this period was still evolving in Greece so that it had not reached a standardized form. This probably facilitated the development of new forms of the order in Alexandria. These include distinctive types of Corinthian capitals, and cornices with flat grooved or square hollow modillions. The sizes of these elements and the types of stone used for them indicate that they come from both large exterior orders and small brightly painted interior ones. Their find spots suggest that these were used in the palace area, as well as the Serapeum. In addition, the rigidity of the individual classical orders is broken down with the development of mixed orders, with Corinthian capitals supporting a Doric frieze – a combination not found in the Greek homeland.

At the same time, the earliest baroque architecture develops in the city catalysed by the structural forms used in Egyptian architecture. This results in new forms of pediments and entablatures, such as broken pediments, hollow pediments, segmental pediments, and entablatures which are broken forward or back, or curved upwards or inwards. The use of bent canes in local architecture apparently influenced the new curved forms, such as the segmental pediment, while the broken lintels on Egyptian stone temples may have led to the idea of the broken pediment and the hollow pediment (with broken entablature).

As standing buildings do not survive from Ptolemaic Alexandria, an indication of how the fragments of them might have looked when built into architectural compositions can be gleaned from other sites where complete schemes survive on monuments influenced by the architecture of Ptolemaic Alexandria, as indicated by the distinctive Alexandrian decorative details on them. These are the rock-cut facades of Petra in Jordan and the scenes of Alexandrian architecture depicted in Roman wall-paintings of the so-called Second Pompeian style. These schemes include the arrangement of a building facade crowned by a broken pediment with a colonnaded court behind it, as carved on the Tomb of the Broken Pediment at Petra and as depicted in the House of the Labyrinth in Pompeii. These have the combination of a broken pediment and tholos (circular building) also carved on the Khasneh at Petra.

Baroque architecture, using the structural features first developed in Ptolemaic Alexandria, spread throughout the Mediterranean during the late first and second centuries AD, especially in Turkey, Syro-Palestine and North Africa (but without the distinctive Alexandrian decorative details). Similarly, new building designs developed in Ptolemaic architecture continued in architecture beyond Egypt in the Roman period. These include: the use of an obelisk alone (rather than in a pair), the semi-circular fountain house with decorated facade, the peristyle with a clerestory (an 'Egyptian *oecus*'), the axially placed temple in a peristyle court, and lighthouses consisting of a series of diminishing tiers.

Both the local Egyptian and new imported Greek traditions were influenced by each other – with stimuli going in both directions. In the distinctive features of the classical architecture of Ptolemaic Alexandria we saw the influence of Egyptian architecture. At the same time, the temples of the native population which on the surface look Egyptian undergo considerable developments mostly as a result of subtle influence from the Greek architecture of the country's new rulers. Thus, the study of the Ptolemaic period is completed with the examination of the traditional architecture of the Egyptian temples. The vibrancy of the local Egyptian religion and culture in that period is observed in wall-reliefs, sculpture and architecture and also is reflected in the dramatic increase in the number of symbols used in Egyptian hieroglyphic writing.

To maintain their local legitimacy, in their role as pharaoh, it was essential for the Ptolemaic kings to support the native religion and its temples. Thus, under their rule considerable resources were expended on the construction of new temples which were still built in an Egyptian style but with forms which had evolved distinctively from their Dynastic predecessors. Some of these features are not new to Egyptian architecture, rather it is the frequency of their use as standard forms which characterizes the Ptolemaic temples. They include the temple with an outer hypostyle hall with screen walls, and the birth house with surrounding colonnade.

The Ptolemaic temples are also characterized by new forms of capitals whose developments can be traced from the surviving examples. Although the Egyptian composite capitals which are characteristic of the Ptolemaic period in fact begin before it, their developments during it show Greek influence, such as the addition of volutes (like on Corinthian capitals). Changes in these capitals are detected particularly in the reign of Ptolemy VIII Euergetes II. This is notable because the standardization of the organizing principles of the temple reliefs also occurred during his reign (but in what seems to be an Egyptian development independent of Greek influence).

After the Roman conquest of Egypt in 30 BC, its new rulers the Roman emperors also took on the role of pharaoh, but this was weakened by the fact that, unlike the Ptolemaic kings, they did not reside in Egypt. Under the first two emperors (Augustus and Tiberius) substantial additions were made to major Egyptian temple complexes and new temples were erected. However, from the mid-first century AD new building activity in the Egyptian style diminished, ceasing all together by the mid-third century AD (although this did not mark an immediate end to Egyptian religion).

After this, only the classical style was used for new monumental buildings, including all temples. The two architectural traditions, classical (Greco-Roman) and Egyptian, no longer evolved in tandem. This is the most notable change which distinguishes developments in the Ptolemaic period from those in the Roman period when the classical (Greek and Roman) tradition increased in dominance until it became the sole one, even if incorporating some local features. This trend is also observed in sculpture and the demise of the use of Egyptian writing, both in hieroglyphs and the cursive form, Demotic. The Egyptian temples remained standing as reminders of what had been lost since the Ptolemaic period, when the two cultures had not only coexisted, but also stimulated each other.

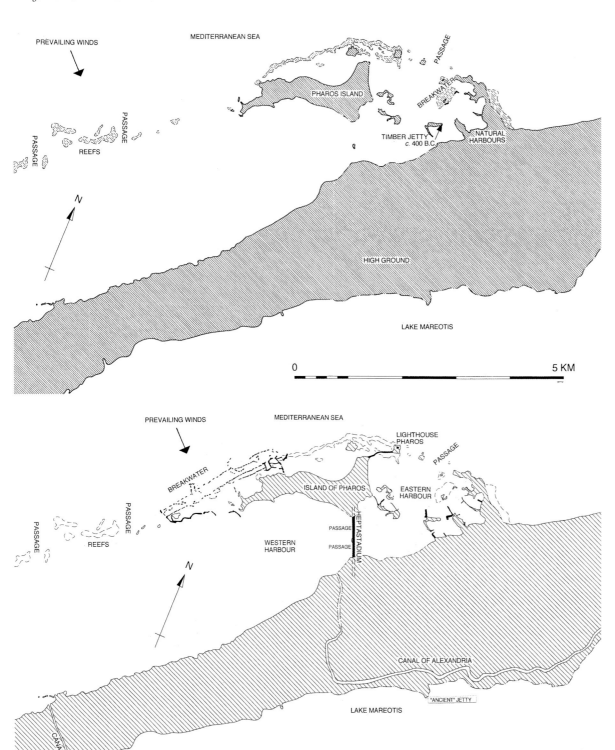

37. Alexandria, plan
with man made harbour
works marked in solid
black

Ptolemaic Alexandria:
Buildings Erected from the Late Fourth Century to the Mid-first Century BC

Most discussions of the buildings and layout of Alexandria begin with the geographer Strabo's famous description of the city based on his visit in *c.* 26–20 BC. They then either extrapolate back from it or consider there is little information about the Ptolemaic city and its development.[1] Nevertheless, whilst there is no single description as detailed as Strabo's for the earlier period, there are sufficient other written sources to provide an indication of the development of the city especially during the important century after its foundation in 331 BC. They indicate the dates by which various buildings have been constructed, even if they do not indicate their precise location.

Some of the writers are contemporary with the buildings they mention, such as the poets Callimachus, Theocritus, and Posidippus, in the third century BC. Others are later historians describing events sometime after they occurred. Some authors had a first hand knowledge of the city because they had visited it or lived there, such as Callimachus, Theocritus, Posidippus, Polybius, Diodorus Siculus, Plutarch, Lucian, and the author of the 'Letter of Aristeas'. Notably, when the contemporary references are combined with evidence from later sources, a credible picture appears of the development of the Ptolemaic city. Thus, it is worthwhile presenting this evidence, so that these texts speak for themselves, as much as possible. At the same time, their limitations need to be kept in mind due to the influence of their poetical, historical, or political contexts.

In the present chapter we will leave aside the topographical framework of Strabo's description, as it dates after the Ptolemaic period and is included with the Roman city in Chapter 8. Instead, this discussion will follow the chronological sequence of buildings suggested by the sources to glimpse the development of the city, especially in the late fourth and third centuries BC. This examination concentrates on the major monumental buildings, for many of which the only record is now in the written sources. The locations, designs and any archaeological remains of these buildings are included only when there is reliable evidence for them.

The picture which will emerge of the city's development is much as would be expected. The basic features of its layout go back to the original plan: the grid of streets (with water supply below them), the city walls, the agora, and palace. Ptolemy I Soter was responsible for their construction. The long reign of Ptolemy II Philadelphus saw the completion of facilities for its maritime trade (Lighthouse and Heptastadium), places for Greek cultural events (the Great Theatre and the Lageion or racecourse), for intellectual life (the Museum and Library) and some sanctuaries. Temples for the royal cult and the tomb of Alexander were built to confirm the legitimacy of the Ptolemaic kings. With the city's main facilities established, Ptolemy III Euergetes I was able to concentrate on further development of the sanctuaries to local gods, especially the major redevelopment of the temple of Serapis. Local influence can be detected in the city's layout and in some buildings, especially sanctuaries. Although the buildings are largely Greek, Egyptian influence leads to the development of new architectural forms. By the end of the third century BC the city had all the facilities of a Greek city, as well as a large palace area and the major monuments for which it became famous.

ALEXANDER THE GREAT AND THE FOUNDATION OF THE CITY

The island of Pharos off the coast of Alexandria, and the harbour there, were already known to the Greeks in the centuries before Alexander the Great, as Homer comments in the *Odyssey* when Odysseus was becalmed there: 'Now there is an island in the surging sea beside the Nile, and men call it Pharos . . . There is a harbour (*limen*) there with good anchorage, from which men launch the shapely ships into the sea, when they have drawn supplies of black [?Egyptian] water.'[2] Recent mapping and examination of the details of the harbour, which are now submerged, make it possible to ascertain the topography of the site before it was changed by man-made structures, especially the causeway the Heptastadium. This indicates that the reefs in front of what later became the eastern harbour were substantial enough to provide some protection to the natural harbours formed by the promontory el-Silsila (later called akra Lochias) and a smaller promontory (later called the Poseidium) and an island (later called Antirrhodos) ([36], later names marked on [299])

A Greek trading colony was founded further inland at Naukratis (el-Giʿeif) in the seventh century BC [35].[3] Some Greek pottery which can be reliably dated before Alexander the Great reportedly has been found in Alexandria. However, while doubt has been cast on whether this pottery reached the site before him, it would suggest a settlement there and trade or other contact with Greece.[4] The recent excavations under the eastern harbour have confirmed its use as a port by *c.* 400 BC with the discovery of a timber construction on the eastern tip of the island of Antirrhodos. This was apparently part of a jetty, and is dated by Carbon 14.[5]

Thus, the location on the Nile Delta on the strip of land north of Lake Mareotis [35] was known to the Greeks and already in use when Alexander the Great decided to found a city there in 331 BC. The Roman architect Vitruvius notes

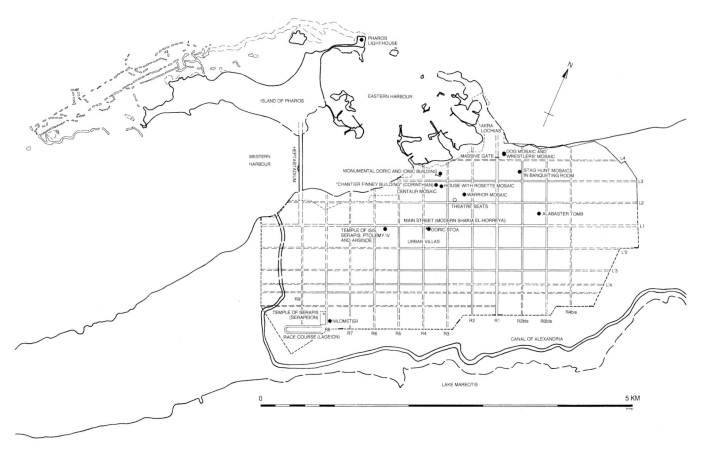

38. Alexandria, plan of Ptolemaic city, archaeological remains (For cemeteries, see fig. 28)

Alexander chose the site 'observing a harbour rendered safe by nature, an excellent centre for trade, cornfields throughout all Egypt, and the great usefulness of the mighty river Nile'.[6] The biographer Plutarch suggests Alexander's choice was influenced by its reputation, reflected in Homer's description of the site with its natural harbour.[7] Strabo notes that there was already an Egyptian defensive settlement there: 'Rhakotis, as it is called, which is now that part of the city of the Alexandrians which lies above the ship-sheds, but was at that time a village . . . But when Alexander visited the place and saw the advantages of the site he resolved to fortify the city on the harbour.'[8] Pliny the Elder mentions 'the site was previously named Rhacotes'.[9] The Egyptian name Raqote is used for the site as early as 311 BC in the Satrap Stele (discussed below).

The most detailed descriptions of laying out the city are given by the historians Diodorus Siculus and Arrian, with further details provided in the legendary *Romance of Alexander*. Although these sources attribute to Alexander himself responsibility for more details of the city layout than he possibly concerned himself with, they do provide an indication of the features which would have been part of the original plan.

Diodorus Siculus records that Alexander 'laid out the site and traced the streets skilfully and ordered that the city should be called after him Alexandria. It was conveniently situated near the harbour (*limen*) of Pharos, and by selecting the right angle of the streets, Alexander made the city breathe

with the etesian winds so that as these blow across a great expanse of sea, they cool the air of the town, and so he provided its inhabitants with a moderate climate and good health. Alexander also laid out the walls so that they were at once exceedingly large and marvellously strong. Lying between a great marsh, and the sea, it affords by land only two approaches, both narrow and very easily blocked . . . Alexander gave orders to build a palace marvellous for its size and the massiveness of its works.'[10]

This indicates the development of the city from the beginning with both local features and Greek ones. The choice of the site involved local knowledge of its suitability, as did the orientation of the streets to suit the local weather conditions. The archaeological evidence for the plan indicates it was oriented to catch the north-west winds of summer [38]. The Seleucid cities of Syria were similarly oriented to catch the wind.[11] The main east-west street, the *plateia*, which Diodorus Siculus and Strabo describe as a plethron (one hundred ancient feet, *c.* 30 m) or more wide,[12] appears to have been laid out as part of the original design of the city [22]. It has been suggested that such broad avenues derive from the Egyptian idea of the broad avenue (*dromos*) leading up to an Egyptian temple.[13]

If, as the historian Quintus Curtius records, Alexander 'embracing all the ground between the lake and the sea, planned a circuit of 80 stadia [*c.* 14.4 km] for the walls', then these walls probably followed the full extent of 5.2 km by 2.2 km, later reflected in the main Ptolemaic and early Roman

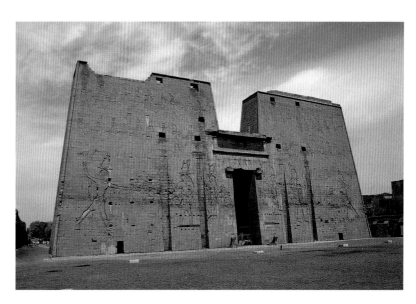

39. Pylon of Egyptian temple of Isis on Alexandrian coin of emperor Hadrian

40. Edfu, pylon of Ptolemaic temple of Horus

circuit [38]. This circuit of 14.4 km is not so surprising when compared with the 27 km to which the walls of Syracuse were enlarged in 402 BC to enclose high ground to prevent enemy use of it, even though that area was considerably larger than the occupied area of the city.[14]

The combination at this early stage of distinctively Greek features, such as the agora, juxtaposed with Egyptian ones is given by Arrian: Alexander 'himself marked out where the city's market place (*agora*) was to be built, how many temples (*hiera*) there were to be and the gods, some Greek, and Isis the Egyptian, for whom they were to be erected, and where the wall was to be built around it. With this in view he offered sacrifice, and the sacrifice proved favourable.'[15] Regardless of whether Alexander's trip to the temple of Ammon at the oasis of Siwa was before or after his foundation of the city, it was to ensure local divine support.[16] Similarly, his marking out the line of the city walls using barley meal was to give it Macedonian religious blessing.[17] Temples were to be built to the local gods, as well as Greek ones. The temple of the Egyptian goddess Isis[18] is later depicted as an Egyptian temple on Roman coins minted in Alexandria, which could suggest that it was built from the start in the local Egyptian style like the many temples outside the capital [39–40].

Thus, the principal features mentioned by the Roman architect Vitruvius involved in the design of a new classical city were marked out in the original design attributed to Alexander: the city walls, the street grid oriented to the local climatic conditions, the location of the agora and the main temples.[19] He is also credited with ordering the construction of its other key building. This was the palace, to which one fifth of the site was dedicated.[20] The allocation, in advance of their development, of areas of the city for specific purposes is a feature of classical city design.

In the adventures described in the *Romance of Alexander* one can find some details of local interest, such as establishing the relationship between Alexander and the last native pharaoh Nectanebo. Although the earliest surviving version is dated to the third century AD parts of it go back to the third century BC.[21] Whilst some episodes in it are fantastic, it includes topographical and other details which should not be ignored as they often accord with information in other sources. It credits Alexander with naming the areas of the city using the first five letters of the Greek alphabet, and relates that he built the Great Altar of Alexander.[22]

Alexander was also credited with the choice of some other key features which would have been part of the original plan and result from the nature of the site. Aphthonius, writing in the late fourth century AD, credits him with the choice of the location which was later used as the citadel (the *akra* which was the acropolis), on the only naturally occurring high ground where the temple of Serapis was erected [38].[23] The *Romance of Alexander* explains how the basic design of the city's water supply was part of the original layout of the city. The natural rivulets were diverted along channels under the main streets to fill cisterns with Nile water. These streets included cross-street R8 which was 'the *dromos* of the Great God Serapis'. Channels also ran under the Tycheion, the temple of Isis, 'the *plateia* of the agora', and other locations which it names. Drains were also built under the main streets.[24] The archaeological evidence for many of these water channels under the main streets was still visible in the nineteenth century, as well as the cisterns which were enlarged over the centuries [27].

Having determined the main features of the plan, 'Alexander charged certain of his friends with the construction of Alexandria, settled all the affairs of Egypt, and returned with his army to Syria.'[25] He made Kleomenes of Naukratis satrap of Egypt, in charge of its financial administration, with orders to develop Alexandria and establish a market there.[26] He was responsible for the temples, and ordered by Alexander to erect a large shrine on the island of Pharos to Alexander's friend Hephaestion.[27]

41. Satrap Stele, 311 BC. Cairo, Egyptian Museum

The *Romance of Alexander* mentions that Kleomenes of Naukratis and a Rhodian (Dinocrates or Nomocrates) advised Alexander on the design of the city. It adds, even if some of the names are legendary: 'Alexander took advice also from other builders, including Numenius the stone-mason, Kleomenes of Naukratis the engineer, and Karteros of Olynthus. Numenius had a brother by the name of Hyponomos. He advised Alexander to build the city on stone foundations, and to construct water channels and drains running to the sea. So such channels are called Hyponomos after him because of his advice.'[28] Vitruvius gives the main architect as Dinocrates of Macedonia, while Pliny the Elder spells the name Dinochares.[29]

These sources possibly have an element of truth, as the two Greek cities whose plans it is sometimes suggested bear the most relationship to Alexandria are Pella in Macedonia and Rhodes.[30] The involvement of Kleomenes of Naukratis in the design of the city and the description of him as an engineer (*mechanikos*) suggest that he had some involvement in organizing the details of the layout. As a local Greek, Kleomenes would have been acquainted with Egyptian ways and the use of local units of land measurement, indicated in the archaeological evidence of the grid plan, would have saved disputes, especially among the Egyptians who moved to the city from the surrounding area.

The *Romance of Alexander* explains how Alexander intended to populate the city, notably not just with Greeks, and fund the construction of it: 'Then Alexander ordered all those who lived within thirty miles of the city to leave their villages and move to the city; he presented them with parcels of land and called them Alexandrians.'[31] 'Then Alexander demanded of them the tribute they had formerly paid to [the Persian King] Darius . . . "so that I may spend it on your city of Alexandria".'[32]

PTOLEMY I SOTER (306–282 BC)

After the death of Alexander in 323 BC one of his generals, Ptolemy, killed Kleomenes[33] and became ruler of Egypt himself, as satrap for Alexander's half-brother Philip Arrhidaeus (323–316 BC) and then for his son Alexander IV (316–305 BC). Ptolemy assumed the title of king in 306 BC and was crowned pharaoh in 304 BC. As Ptolemy I Soter he reigned until 282 BC. He was responsible for constructing the main buildings which Alexander was credited with ordering.

In 321 BC the preserved body of Alexander was brought from Babylon to Alexandria in an ornate funeral wagon according to Diodorus Siculus who described it in detail.[34] Ptolemy decided 'to entomb it in the city that had been founded by Alexander himself, which lacked little of being the most renowned of cities of the inhabited world. There he prepared a precinct (*temenos*) worthy of the glory of Alexander in size and construction. Entombing him in this and honouring him with such sacrifices as were paid to demigods and with magnificent games, he won fair requital not only from men but also from the gods.'[35] Later sources suggest he was first buried at Memphis before being moved to Alexandria by Ptolemy I or II.

The hieroglyphic Satrap Stele of 311 BC records that Ptolemy 'made his Residence [the palace], whose name is the Fort of the King of Upper and Lower Egypt, son of Re [Alexander], on the shore of the Sea of the Ionians [the Mediterranean Sea], Raqote was its former name' [41]. This confirms the Egyptian name of the site, Raqote, which remained the name of Alexandria in Coptic even after the Arab conquest. It has been suggested that as Raqote can mean 'construction site' this was not the name of a village, but referred to the new city under construction and, by implication, that there might not have been an earlier Egyptian settlement there. However, the term, as used on the stele, goes back to the Dynastic period, even if the Egyptians of the early Ptolemaic period may have enjoyed the pun on a phrase that was current in administrative documents.[36]

Ptolemy I Soter is credited by the Roman historian Tacitus, writing in the first decade of the second century AD, with giving the city walls, temples and religious rites.[37] That the walls were already standing during the reign of Ptolemy II Philadelphus (285–246 BC) is shown by the reference to them

in the poetry of Callimachus (*c.* 310–240 BC).[38] It is possible that this first set of walls could have been constructed of mudbrick, like the substantial walls around Egyptian temple enclosures. Mudbrick fortification walls, which are apparently Ptolemaic, survive elsewhere in Egypt and mudbrick on a stone socle was sometimes used in Greek fortifications.[39]

Tacitus records that the temples erected by Ptolemy I included the temple of Serapis, the Serapeum: 'A temple befitting the size of the city, was erected in the place called Rhacotis; there had previously been on that spot an ancient shrine (*sacellum*) dedicated to Serapis and Isis.'[40] The Christian philosopher Clement, in *c.* AD 190, credits Ptolemy II Philadelphus with this and gives a detailed description of the statue of Serapis which he describes as dark in appearance. Later sources indicate the statue was moved to Alexandria in 286 or 278 BC (according to the church historian Eusebius) or 284–281 BC (according to Cyril of Alexandria), i.e. at the very end of the reign of Ptolemy I or, more probably, at the beginning of the reign of Ptolemy II (which began in 285 BC).[41] Obviously by this date, a building would have been required to house the cult statue. Archaeological evidence found at the site indicates its use as a sanctuary by the first quarter of the third century BC. This includes dedications to Isis and Serapis dated to the reign of Ptolemy I or early in that of Ptolemy II,[42] and an *in situ* altar mentioning Ptolemy II Philadelphus and Arsinoe (i.e. dated to 279–270 BC).[43] Detailed re-examination of the archaeological evidence indicates that there was a monumental building phase before the construction of Ptolemy III Euergetes I [61].[44]

Tacitus mentions that Ptolemy consulted 'Timotheus, an Athenian of the clan of Eumolpidae, whom he had called from Eleusis to preside over the sacred rites', concerning the god Serapis. A reference in a papyrus by the early second century BC indicates that Eleusis in Alexandria was related to the famous sanctuary near Athens for the cult of Demeter.[45] Eleusis, mentioned in an epigram of Posidippus (*c.* 285–246 BC) is apparently the one in Alexandria, rather than Attica in Greece as the poem asks to 'keep free from earthquakes Ptolemy's land and shores'.[46]

The remaining civic structures were built either during the reign of Ptolemy II or were finished by him, having been begun by Ptolemy I. These include the Lighthouse, the Heptastadium, and the racecourse, the Lageion. Although Ptolemy II was responsible for the main development of the Museum, it was begun under Ptolemy I, as was probably the Library.[47] The theatre could have been begun or finished during his reign.

PTOLEMY II PHILADELPHUS (285–246 BC)

During the reign of Ptolemy II Philadelphus the main facilities of the city required for both commerce and Greek culture were completed. The principal port facilities are attested as existing during his reign: the Lighthouse, the Heptastadium, and some harbour works. During his reign there are also references to the main buildings characteristic of a Greek way of life. These include the agora, places of

entertainment such as the stadium, hippodrome and theatre, as well as the places of learning for which the city was famous: the Museum and the Library. Royal cult temples, such as the Arsinoeion, also became a major feature of the cityscape. He was able to fund all this construction required for a Greek culture, with its buildings and festivities, because of the exceptional wealth of Egypt from its extensive territories during his reign. The amalgam of the traditions and influences of both Greece and Egypt will be found to be reflected in the built environment of his city.

Lighthouse

The lighthouse Pharos and a breakwater, apparently the Heptastadium, are mentioned in an epigram by Posidippus, who was active in Alexandria during the reign of Ptolemy II: 'As a saviour of Greeks, this watchman of Pharos, O Lord Proteus, was erected by Sostratus, son of Dexiphanes, from Cnidus. For in Egypt there are no lookout posts on a mountain, as in the islands, but low lies the breakwater (*chamai chele*) where ships take harbour. Therefore this tower, in a straight and upright line, appears to cleave the sky from countless stadia away, during the day, but throughout the night quickly a sailor on the waves will see a great fire blazing from its summit. And he may even run to the Bull's horn, and not miss Zeus the Saviour, O Proteus, whosoever sails this way.'[48] This poem survives on a papyrus, but was apparently also inscribed on the building.

Strabo gives a similar explanation of the need for the Lighthouse: which 'bears the name of the island. This was an offering made by Sostratus of Cnidus, a friend of the kings, for the safety of mariners, as the inscription says: for since the coast was harbourless and low on either side, and also had reefs and shallows, those who were sailing from the open sea thither needed some lofty and conspicuous sign to enable them to correct their course aright to the entrance of the harbour. And the western mouth is also not easy to enter, although it does not require so much caution as the other.'[49]

The Lighthouse was built on the eastern tip of the island of Pharos, either late in the reign of Ptolemy I Soter or early in the reign of Ptolemy II Philadelphus [38]. Obviously, it was built by the time Posidippus wrote the epigram.[50] Specific dates for its construction given by later sources are 283/2 BC by Eusebius,[51] writing in the fourth century AD, and 297 BC in *Souda*.[52]

A private individual, rather than the king, would not normally be expected to dedicate such a major monument. According to Pliny, Ptolemy allowed Sostratus as the architect to inscribe his name on it.[53] Lucian, writing in the second century AD, adds that the architect inscribed his own name under the coat of plaster on which he had inscribed the king's name, and gives the inscription as: 'Sostratus of Cnidus, the son of Dexiphanes, to the Divine Saviours, for the sake of them that sail the sea.'[54] There is some uncertainty as to whether Sostratus was the architect, as indicated by Pliny and Lucian, or only paid for it.[55] He is sometimes identified as the Sostratus who was an envoy of Ptolemy II Philadelphus at

Delos in *c.* 280–270 BC.[56] It is possible that the epigram inscribed on the tower commemorates only the dedication of the statue of Zeus the Saviour (Soter) at the top of it (discussed below) and not the tower itself.[57]

Pliny records that the Lighthouse cost 800 talents.[58] Some sense of the value of this amount, and that the country could afford it, is given by the fact that there were 8000 talents in the treasury when Ptolemy I Soter took over Egypt.[59] The Parthenon, the Greek temple which was built in Athens a century and a half earlier, is estimated to have cost 450–500 talents.[60] It is very unlikely that a private individual, rather than the king, could have afforded the construction cost of the Lighthouse of 800 talents.

Pliny mentions that Sostratus was the first to build a promenade supported on piers or arches (the *pensilis ambulatio*), which he did at Cnidus.[61] This raises the question as to whether Sostratus also built the Heptastadium. Lucian, who lived in Egypt late in life, comments 'we ought to admire those engineers (*mechanikoi*) who, though famous for their knowledge, have yet left to later generations reminders and proofs of their practical skill . . . Such we are told was Archimedes, and also Sostratus of Cnidus'.[62] This suggests Sostratus had sufficient skill to design a monument as complex and novel as the Lighthouse. While he is unlikely to have paid for it, he could have been a prominent courtier, 'a friend of the kings', as well as an engineer of exceptional skill.

For the tower to shine in the daylight, as described by Posidippus, it would probably have been white. The next indication of its appearance is given by Strabo, in *c.* 26–20 BC, who describes it as 'constructed of white stone (*leukos lithos*) with many storeys'.[63] This is the earliest evidence for the tower having a number of storeys. They also occur on depictions of it, none of which are dated to before the first century AD [42–45].[64] These, like Strabo's description, are all dated after Cleopatra may have repaired it, following the Alexandrian War of 48/47 BC.[65]

However, many Arab authors give descriptions of the Lighthouse from the ninth century until the fourteenth century, when it was destroyed by earthquakes [46].[66] They reliably indicate that Fort Qait Bey was built on its site in AD 1477–9 [2]. The Arab historian Ibn Iyas records that Qait Bey ordered the fort to be built on the foundations of Pharos.[67] The Arab sources also provide the key to the type of white stone used for the Lighthouse. According to al-Idrīsī it was built 'of excellent stones of the type called *caddzân* (*kadhdhān*)'. This seems to be limestone of the hard type (which is nearly marble) used when a durable stone is required, such as for door thresholds and street paving. Red granite was used for some features, such as lintels and door frames.[68]

The Arab descriptions of the Lighthouse are remarkably consistent, although it was repaired a number of times, especially after earthquake damage [46]. The height they give varies only fifteen per cent from *c.* 103 to 118 m, on a base *c.* 30 by 30 m square.[69] Like the depictions on coins and glass gems from the first century AD [43–44],[70] the Arab authors indicate a tower with three tapering tiers, which they describe as square, octagonal and circular, with a substantial ramp

leading to it. These features, size and proportions are reflected in Thiersch's famous reconstruction [48b, 49]. The Arab authors describe it as built of very large blocks of stone held together by lead clamps. It might also have had timber string courses to strengthen it against earthquakes. They explain that the openings or 'windows' are to prevent the wind blowing it over. The ashlar masonry, consisting of large blocks, and these openings are also indicated in some depictions [42, 44–45]. The Arabs describe a slowly ascending ramp inside it. They also describe the bronze statues at the top of it and mention a mirror. This is visible in the Qasr el-Lebia mosaic of *c.* AD 539, although it is not known how early a mirror was installed [45]. The fire was visible at night, like a star, while by day the smoke from it directed ships to the harbour. The fuel may have been naphtha (crude petroleum), which would have provided a much brighter flame than firewood.[71]

Although the shapes of the different tiers are not very clear on the first century AD depictions, the arrangement described by the Arab authors of a square, octagonal and circular tier is used on a smaller scale in the small stone tower (h. *c.* 20 m) west of Alexandria at Taposiris Magna (Abusir). This tower is built in a Ptolemaic cemetery, possibly as a funerary monument. Dated to the second or first century BC, it is the earliest surviving reflection of the Lighthouse structure [50].[72]

The lowest (square) tier remained largely intact when the Lighthouse was later repaired. Consequently, it would not have been structurally possible to make the height of the upper two tiers (which it supported) much greater than what they would have been originally. It is notable that the heights given by the Arab authors to the top of the second tier are also within a fifteen percent range. Most of the variation occurs in the details of the top tier, which make relatively little difference to the basic design. The total height which the Arab writers indicate of *c.* 110 m accords with that suggested by the historian Josephus' reference in the first century AD to it having been visible from 300 stadia (*c.* 54 km) away.[73] Its cost and the skill of Sostratus would indicate that the original building could have been this substantial. He would have been helped by local stone masons already skilled in monumental stone construction. Thus, the Arab sources may be accepted as giving a reasonable indication of the general size and structure of the original Ptolemaic Lighthouse of Sostratus.

The ancient depictions provide further details of its appearance, even if they lack a sense of scale. The simplified version on the coins and gems indicate tritons on the corners of the two lower levels although it is not known when, before the first century AD, these were added [43–44]. They also indicate that there was a statue on the top, but there is uncertainty as to its identity. The epigram of Posidippus is sometimes interpreted to suggest that it had a statue of Zeus Soter on it from the beginning, while the figure depicted holding an oar on the glass beaker from Begram has been identified as either Ptolemy I Soter or Poseidon [42].[74] Helios is depicted, centuries later on the Qasr el-Lebia mosaic, beside the mirror [45]. The earlier depictions do not clearly indicate where the fire was relative to the statue.

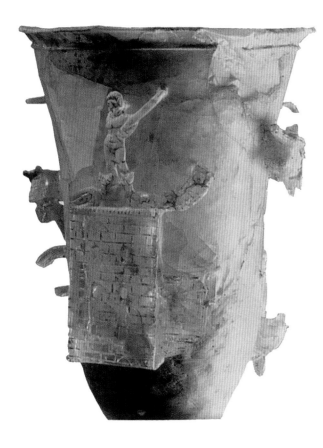

42. Glass beaker from Begram depicting lighthouse Pharos. Kabul Museum

43. Lighthouse Pharos with three storeys and entry ramp on Alexandrian coin of emperor Domitian

Recent underwater exploration near the Lighthouse site has revealed remains including five obelisks, thirty-two sphinxes, six papyriform columns of the Dynastic period, a Corinthian capital, and attic bases [54–55]. Of the 2655 architectural pieces recorded so far the majority are complete or fragmentary red granite smooth column shafts. Many of the Egyptian style remains date from the Dynastic period, and came from Heliopolis (Tell Hisn) near modern Cairo.

Six colossal statues of red granite were found of Ptolemaic rulers represented as Egyptian pharaohs and their queens.

44. Isis Pharia and lighthouse on seal impression of a glass gem. Vienna, Kunsthistorisches Museum, no. XI. 991

45. Qasr el-Lebia, Cyrenaica, mosaic, depicting lighthouse Pharos

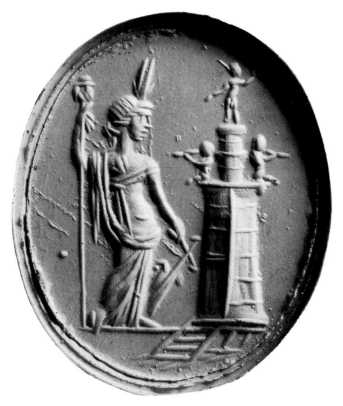

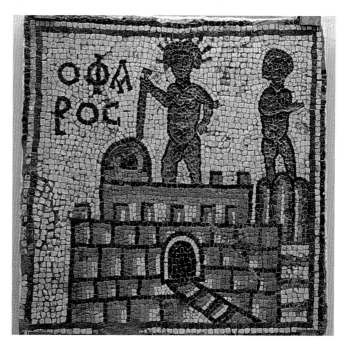

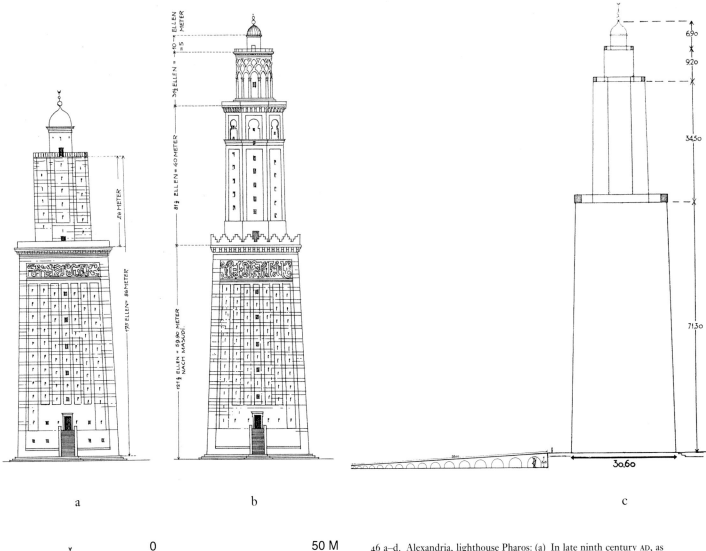

a

b

c

0 50 M

d

47. Alexandria, Fort Qait Bey, built in AD 1477–9 at Lighthouse site (before destruction of minaret by British bombardment of 1882)

46 a–d. Alexandria, lighthouse Pharos: (a) In late ninth century AD, as described by al-Yakubi; (b) Tulinid version, first half of tenth century, as described by al-Masudi; (c) In AD 1165, as described by Ibn al-Sayj (side view showing the approach ramp); (d) In early thirteenth century, after repairs to earthquake damage, as described by Yakut

These are of particular interest as they were apparently found near to where they were erected beside the Lighthouse, because the pieces of them were found together near their bases [52]. The two largest consist of the king, apparently Ptolemy VIII, (re-erected near the Bibliotheca Alexandrina) and his queen with an Isis crown, apparently Cleopatra III [51, 53].

Because the blocks include pieces which were dumped working out which of them came from the Lighthouse is a complex task. However, there are a few architectural pieces found possibly near to where they fell, which include red granite blocks from a monumental (11m high) door-frame [48a] and a white marble block with traces of a monumental inscription. Limestone and marble blocks which must have fallen from a building in this location include those which still contain clamps of iron encased in lead (because the metal would have been robbed if these blocks were dumped).[75]

a b

48 a–b. Alexandria, lighthouse Pharos: (a) Reconstruction by I. Hairy incorporating underwater discoveries of Centre d'Études Alexandrines, directed by J.-Y. Empereur (side view); (b) Reconstruction by H. Thiersch based on the Arab descriptions and the ancient depictions

Along the eastern harbour shoreline and on the island of Antirrhodos there are many other architectural pieces under water, at least some of which were certainly dumped as joining pieces were found in different locations. Both Egyptian and classical statues were also found in this area.[76]

Heptastadium and Harbours

The Heptastadium was the man-made causeway or breakwater, so-called because of its length of seven stadia (c. 1260 m), which joined the island of Pharos to the mainland forming the two main harbours [37–38].[77] It silted up so that the Ottoman town was built on it [5–6]. Posidippus appears to be mentioning it when he refers to the low-lying breakwater in the epigram quoted above.[78] The reefs in front of the natural harbours protected by the island of Antirrhodos and

the promontory to its east provided some protection [36]. The Heptastadium served to provide considerably more protection, by creating the two main harbours giving protection regardless of the seasonal direction of the prevailing winds and swell. More than half the time they came from the northwest, especially in summer, with the other main wind direction from the north-east [37].[79] The approach to the harbours was treacherous because of the reefs, as well as the seas which even today are frequently very rough.[80]

The 'Letter of Aristeas', which was written probably in about the mid-second century BC, describes the translation of the Hebrew scriptures into Greek (the Septuagint) during the reign of Ptolemy II Philadelphus. Although the description which it gives of the translation is considered partially mythical, the details it includes of the topography are probably reliable. It mentions that when Demetrius of Phalerum led the translators to the island of Pharos, he 'took the men with him and crossed the breakwater (anachoma), seven stadia long, to the island; then he crossed over the bridge and proceeded to the northerly parts'.[81] Strabo and Julius Caesar mention a bridge at either end of the Heptastadium,[82] which provided passage for ships from one harbour into the other, and for cleansing waters to decrease the rate of siltation which was always a problem with such structures.[83] It could also have had other smaller openings in it because of this.

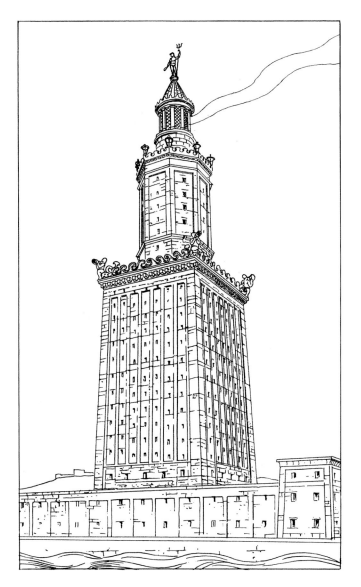

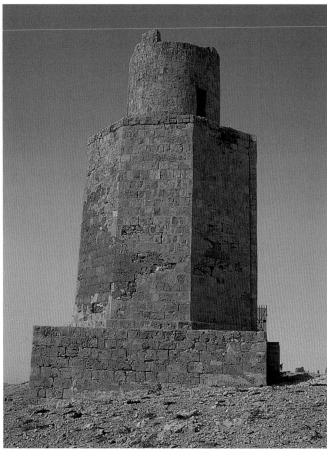

49. Alexandria, lighthouse Pharos, H. Thiersch's reconstruction

50. Taposiris Magna (Abusir), structure above a Ptolemaic tomb with square, octagonal and circular storeys

The recent underwater archaeological research has revealed evidence for substantial harbour constructions dating from *c.* 250 BC in the eastern harbour. These consist of timber planks from the bottom of the cribs or caissons which were the formwork for the lime mortar blocks cast in them. The lime mortar had to set in the air, above the water, before the caisson was sunk to form the foundations for a breakwater.[84] The Romans also used such caissons for harbour constructions, as described by Vitruvius.[85] Harbour construction in Italy was revolutionized by the invention of a concrete which set under water because it contained the local volcanic earth, pozzolana, as a hardening agent.[86] This concrete was used in caissons for the construction of Herod's harbour at Caesarea in 21–10 BC.[87] The pozzolana would have been shipped there as ballast on the journey out from Italy. Thus, if major harbour works were being built in Alexandria after the late first century BC they would be expected to have used concrete with pozzolana as it could have been shipped to it in the ships which transported grain back to Italy. Consequently, the construction of the other moles and jetties with blocks cast in lime mortar forming the smaller harbours within the eastern part of the eastern harbour of Alexandria[88] would date to the Ptolemaic rather than the Roman period [37].

Although further research is still required to ascertain the precise chronology of the development of these moles and jetties within the Ptolemaic period, they create the basis for the smaller harbours or basins within the Great (eastern) Harbour, which Strabo later mentions as being 'cut up into several harbours'.[89]

Ptolemy II Philadephus built up an extensive navy, with a core of 336 ships which are listed by Athenaeus of Naukratis, writing in the second century AD.[90] These would have required dockyards, as well as ship-sheds as the ships could not have been stored for lengthy periods in the water. It has been calculated that when this complete navy was ready for immediate action, it could fit in the three smaller harbours or basins in the eastern part of the eastern harbour,[91] although it is not known if they were all developed by then. The two basins to the east of Antirrhodos would have also been most suitable for commercial shipping as they were easier to enter.

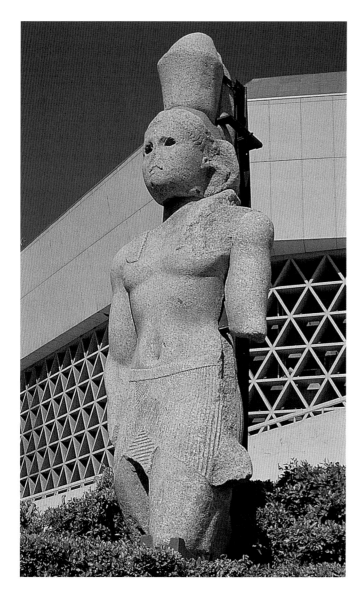

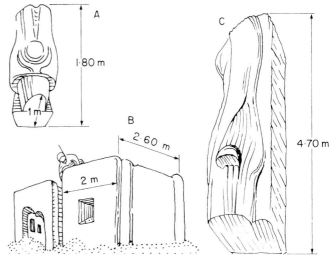

51. Alexandria, red granite statue, probably of Ptolemy VIII Euergetes II represented as an Egyptian pharaoh, found under water near the Lighthouse site, re-erected outside the Bibliotheca Alexandrina

52. Alexandria, tracings from photographs of blocks of monumental statues recorded near Lighthouse site in 1968, including Isis crown and bases of statues in fig. 51 and 53

53. Alexandria, granite statue of? Cleopatra III as Isis, found under water near the Lighthouse site

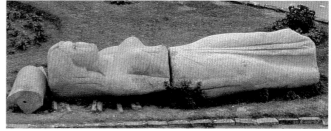

Extensive submerged harbour works running along the north and to the west of the island of Pharos were recorded in detail by Gaston Jondet, Chief Engineer of the Ports of Egypt in 1911–15 [30, 37].[92] The northernmost breakwater, which was 2.4 km long, had regular gaps in it to prevent silting, while also giving protection to a second breakwater parallel to it. Parallel to this is a third, southernmost, breakwater which Jondet thought formed a man-made harbour, 1.2 km long and 0.2–0.4 km wide, with the entrance on the southern side (from the western harbour). These structures, which include limestone blocks, also provided additional protection to the western harbour. Jondet made a detailed record with descriptions, sections, and plans of these features. Some of these structures were man-made, although often they include natural reefs, if available. Those along the northern shore of the island are marked here as reefs.

Jondet observed that as no pozzolana was used the man-made structures would antedate the Roman conquest. Because of their monumental size he suggested that perhaps they were built in the Dynastic period, possibly of Ramesses II (c. 1279–1213 BC), and some scholars have suggested they

might be Minoan (c. 2000–1470 BC).[93] However, monumental structures, such as the Lighthouse and eastern harbour works, were also built by the Ptolemies. Once the Heptastadium was built creating the western harbour, a breakwater to its north-west would have been needed to provide protection for that harbour. Thus, if these harbour works did not already exist by then, it would have been necessary to construct them, as also indicated by the construction of the modern breakwater on the same line.

Agora

Greek cities were distinguished by having an open space near the centre of them called the agora which was the focal point of their civic life, and also a market. A papyrus recording the city law of Alexandria in the mid-third century BC, includes the penalty for crimes committed while drunk in an agora, as double the normal penalty.[94] It also mentions the swearing of oaths in the agora, and indicates that there was only one main agora.[95] This was different from the commercial market, the

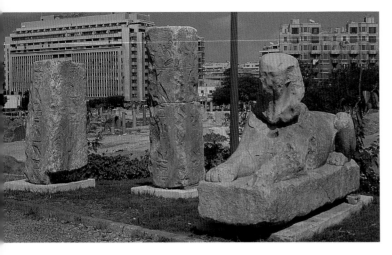

54. Alexandria, fragments of an obelisk and a sphinx, found under water near the Lighthouse site. Kom el-Dikka

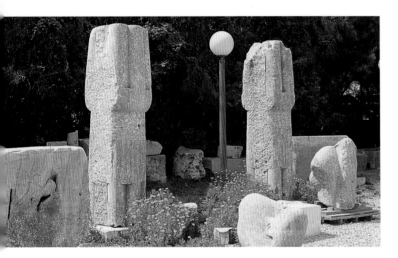

55. Alexandria, fragments of Dynastic period papyriform columns, found under water near the Lighthouse site. Kom el-Dikka

Emporium, later mentioned by Strabo as near the dockyards and harbours.[96] There is no indication in this early period of the location of the agora. The suggestions which have been made are dependent on the possible location of the Forum, its Roman successor, which was apparently south of the Caesareum, on the north side of the main east-west street [23]. It is assumed that it would have been unlikely to have moved in a city with a continuous life.

Places of Public Entertainment: Great Theatre, Hippodrome and Stadium

Besides the agora, other characteristic buildings of a Greek city include those for public entertainment reflecting Greek cultural life. These are attested as existing in Alexandria early in the reign of Ptolemy II, having been begun by him, or Ptolemy I.

In his poem in praise of Ptolemy II, Theocritus mentions Ptolemy presenting prizes for the 'sacred competitions of Dionysos', i.e. for the dramatic festivals.[97] As it was written in c. 276–271 BC, this suggests that there was a theatre in use by then. Athenaeus of Naukratis mentions that 'the comedian Hegesias acted the poems of Hesiod in the Great Theatre at Alexandria while Hermophantus acted those of Homer'. Hegesias was probably active in about the mid-third century BC.[98] There is no definite evidence for the location of the Great Theatre, unless it was the theatre later mentioned as near the palace. Because there were no hillsides into which to build it, it must have been at least partially supported by artificial terracing.[99]

Early in his reign, Ptolemy II Philadelphus instituted games in honour of his father described as 'a gymnastic, musical and equestrian contest to be equal in rank with the Olympic Games', and named the Ptolemaieia. The first celebration of them occurred in 279/8 BC[100] which means that by then the city had somewhere to use as a hippodrome (for horse racing) and a stadium (for athletic games). The track in a stadium was usually one stade, or 600 ancient feet (c. 180 m) long, while the one in a hippodrome was twice that length.[101]

Archaeological evidence for a racecourse survived in the nineteenth century south-west of the temple of Serapis [25].[102] That this had been a Roman circus for chariot racing was indicated by the remains of the divider (spina) separating the two sides of the track. However, as the track was nearly too narrow for Roman chariot racing, it was probably a Hellenistic structure which was remodelled.[103] As it is called the Lageion in later sources, which explained that it was named in honour of Lagos, father of Ptolemy I,[104] it is possible that it was laid out by Ptolemy I. In 267 BC horse races, as well as running races, occurred in a building called the stadium in a town in the Faiyum. The poet Posidippus uses the term stadium (rather than hippodrome) for the place in which chariot races occurred at Olympia and Isthmia, when he is celebrating the victories of queen Berenice, but this might be due to metrical considerations.[105] Horse races later occurred in Alexandria in the 'stadium', and athletic contests are recorded as taking place in the Lageion.[106] Consequently, it is possible that the Lageion was used from the early Ptolemaic period as both a stadium and a hippodrome.

The famous procession of Ptolemy II Philadelphus, which was described in considerable detail by Athenaeus, passed through the 'city stadium' in mid-winter, probably in 275/4 BC.[107] This procession was in honour of Dionysos who was equated with Serapis, and notably the Lageion was located beside the sanctuary of Serapis [56]. As Greek religious processions finished at the main temple of the god being

56. Alexandria, race-
course (Lageion) and
temple of Serapis,
axonometric recon-
struction

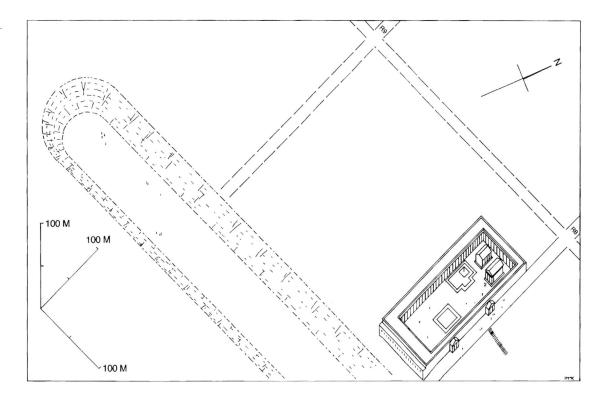

100 M

100 M

100 M

honoured,[108] the Lageion would have been an appropriate venue, and its large size would also have made it suitable for such a long procession.

Banqueting Tent of Ptolemy II Philadelphus

The pavilion or banqueting tent of Ptolemy II Philadelphus 'was set up inside the enclosure (*peribolos*) of the *akra* at a distance from the place where the soldiers, artisans, and tourists were entertained' apparently for a feast connected with the procession mentioned above.[109] The term *akra* can mean a projecting piece of land or a piece of high ground. Here it is apparently the promontory now called el-Silsila (ancient akra Lochias, mentioned by Strabo) near the palaces, rather than the hill on which the temple of Serapis stood and later identified as the *akra* or acropolis and citadel.[110]

The banqueting tent was described in detail by Athenaeus, from information recorded by Kallixeinos of Rhodes, probably from the second century BC.[111] It held couches for one hundred people to dine. The main hall was 50 cubits (*c.* 26 m) high, with a colonnade around the outside of it on three sides with a curved ceiling (*syrinx*).[112] It not only supported curtains, but was decorated with paintings, sculpture and many other items. As the description is not precise enough to make an exact reconstruction, various suggestions have been made for it.[113] Tents had long been used in the East, and Alexander also used one as an audience hall and for banquets, but they were not characteristic of Greece or Macedonia.[114] Very tall, large ornate tents are still used in Egypt for feasting and entertainment, in cities such as Cairo and Alexandria.

Palace

The palace complex was open to the public during the festival of the death of Adonis in *c.* 272 BC. Theocritus describes Praxinoa and Gorgo's day out to the palace where 'the Queen is giving a fine show'. They enter the palace (*aule*) where there is a tableau of Adonis and Aphrodite, and bowers were also erected. There were tapestries apparently with life-size figures.[115] Wall tapestries with life-size figures survive from later periods in Egypt, such as the Dionysos tapestry of the fourth century AD [419].

According to the 'Letter of Aristeas', after the translators of the scriptures were admitted to the palace (*aule*),[116] Ptolemy 'ordered the best lodgings (*katalumata*) to be assigned to them near the *akra*, and the banquet (*symposion*) to be made ready'.[117] The movable dining couches (*klisiai*) were arranged for the banquet.[118] The *akra* here probably refers to the promontory el-Silsila (akra Lochias) [38]. The impression is given later (in the time of Cleopatra VII) that the domestic part of the palace was on or near this promontory. The translation itself was done on Pharos 'in a house built by the seashore, magnificently appointed in a quiet place' on the north side of the island, presumably to catch the breeze like the promontory el-Silsila.[119]

Ptolemy II was interested in collecting animals from many countries, including wild ones ranging from elephants to snakes, and domestic ones for breeding.[120] This variety of animals is reflected in those in his procession. Birds were mentioned by Ptolemy VIII as being kept in the palace area.[121] Consequently, it is possible that Ptolemy II established a zoological garden there.[122] While there might have been some animals, such as birds, in the palace gardens, it is possible that there was also a royal game reserve elsewhere. Formally laid out parks and gardens occurred in palaces of the Egyptian pharaohs, as well as in Persia.[123]

Museum and Library

The palace complex was distinguished from its eastern coun-
terparts by the inclusion of institutions such as the Museum
and Library.[124] Ptolemy II was responsible for the main devel-
opment of the Museum and Library in a period of consider-
able intellectual activity in the city.

The Museum is mentioned as one of the main attractions
of Egypt by the poet Herodas, writing *c.* 270–250 BC.[125] It was
based on the Museum of the Lyceum, Aristotle's teaching
institution in Athens which had a garden, an altar, a prome-
nade (*peripatos*), and adjoining housing (*oikiai*).[126] The name,
Museum in Latin or Mouseion in Greek, indicates its dedi-
cation to the Muses, who provided inspiration to scholars.
Plutarch indicates that the Museum in Alexandria was estab-
lished by Ptolemy I Soter, whose advisor was Demetrius of
Phalerum who had ruled Athens.[127] No indication of its
design is given in this early period, although Posidippus pos-
sibly mentions the erection of a statue in it during the reign
of Ptolemy II.[128]

As Ptolemy I Soter was responsible for the initial estab-
lishment of the Museum, it is probable that he also began the
Library which would have been necessary for the intellectual
activity in it. However, Ptolemy II Philadelphus seems to have
been responsible for the main development of the Library
which focused on the methodological acquisition of all sci-
entific, historical and literary writings on a scale not previ-
ously attempted.[129] When mentioning his achievements,
Athenaeus of Naukratis in the second century AD, asks: 'And
about the books (*biblia*), the number [of them], the establish-
ment of libraries (*bibliothekai*) [for them], and the gathering
[of them] into the Museum, why need I even speak, since
they are in everyone's memory?'[130]

As the 'Letter of Aristeas' was written in the mid-second
century BC, it is the earliest surviving source for the number
of books in the royal library, even though it contains some
anachronisms. In relating events under Ptolemy II Philadel-
phus, leading up to the translation of the Hebrew scriptures
for the Library, it relates: 'When Demetrius of Phalerum was
put in charge of the library (*bibliotheke*) of the king he was
assigned large sums of money with a view to collecting, if
possible, all the books (*biblia*) in the world; and by arranging
purchases and transcriptions he carried the king's design to
completion as far as he was able. When he was asked, in my
presence, about how many thousands of books (*biblia*) were
already collected, he replied, "Above two hundred thousand
Your Majesty; and in a short while I shall exert every effort
for the remainder, to round out a number of half a
million".'[131] As indicated, Ptolemy II Philadelphus expended
considerable resources in compiling the collection.

Some of the confusion over the number of books in the
Library arises because the Greek term *biblia*, and Latin term
volumina refer to the papyrus scrolls, which often contained
only one 'book' each of an ancient work which was the equiv-
alent of a chapter or so of a modern book.[132] A single scroll
could also contain more than one short work. The active col-
lecting of books for the Library was continued by Ptolemy
III Euergetes I.[133] The poet Callimachus, who was still alive

57. Alexandria, red granite block (probably a statue base), inscribed
'Dioskourides three volumes,' found in 1847 beside the main east–west street.
Vienna, Kunsthistorisches Museum Reg. no. III 86 (L)

early in his reign, made a catalogue (called the *Pinakes*) of all
the works in the Library which itself filled 120 scrolls.[134] The
number of entries which would fit into these suggests that a
figure of over a hundred thousand might be within the realm
of possibility for the number of scrolls.[135]

No indication survives in the early sources for the design
of the Library building.[136] However, perhaps it consisted of a
large colonnaded court with rooms around it for reading,
copying and storing books. It could have had either stack
rooms for the books, or a series of rooms with niches in their
walls for storing books which could also have served as
reading rooms. The Roman libraries which survive elsewhere
often consisted of one or two rooms within a larger building,
with the scrolls stored in bookcases inserted into wall niches
in those rooms. The library of Celsus at Ephesus, built early
in the second century AD, was a separate building consisting
of a room *c.* 17 by 11 m with 10 niches on each of three
levels.[137] As this room possibly held about 6,000 scrolls, stack
rooms may have been necessary for the large number of
scrolls in the Alexandria library.

A red granite block was found in 1847 in Alexandria with
the inscription 'Dioskourides three volumes (*tomoi*)' [57].
Whilst the recess in the top of it is the correct size to have
held three scrolls, it is also the correct size for the tenon of a
small statue. Consequently, if it were not for the inscription,
it would be considered a statue base. Also as it was a loose
find, its findspot does not provide reliable evidence for the
location of the Library building.[138]

Royal Cult Temples

The reign of Ptolemy II Philadelphus saw the establishment of royal cult temples in Alexandria.[139] In his poem in praise of Ptolemy II, Theocritus included among his achievements: 'he has founded temples (naoi) filled with incense to his own mother and father, in them he has set up beautiful [statues of them] in gold and ivory'.[140] One of these, the shrine of Berenice, wife of Ptolemy I Soter, (the Berenikeion) is mentioned in the description of the procession of Ptolemy II.[141]

While she was still alive, Ptolemy II Philadelphus' wife Arsinoe was deified with him as the Sibling Gods (Theoi Adelphoi,) in 272/1 BC (year 14 of his reign), for veneration by the Greek population.[142] Herodas mentioned the 'enclosure (temenos) of the Theoi Adelphoi' as one of the attractions of Egypt.[143] After her death in 270 BC, Arsinoe was honoured as a goddess for whom statues were to be erected in all Egyptian temples throughout Egypt, as recorded in the Mendes Stele.[144]

In Alexandria the sanctuary of Arsinoe, known in Greek as the Arsinoeion, became a major monument in the city. Ptolemy II Philadelphus had begun in it her honour. Pliny records: 'The architect Timochares had begun to use lodestone to construct the vaulting (concamarare) in the temple (templum) of Arsinoe at Alexandria, so that the iron statue contained in it might have the appearance of being suspended in mid-air; but the project was interrupted by his own death and that of King Ptolemy who had ordered the work to be done',[145] although it was apparently later finished.[146] Pliny mentions another statue 4 cubits (c. 2.1 m) high that was made of peridot in honour of Arsinoe, and consecrated in the shrine (delubrum) which was named after her, the Arsinoeum.[147] The use of vaulting for an interior which is not underground is Egyptian, rather than Greek.

Pliny also relates that according to 'Callixenus' (Kallixeinos), Ptolemy II Philadelphus erected an obelisk in the Arsinoeion. As this obelisk was 80 cubits (c. 42 m) high, Pliny describes in detail the method devised to transport it.[148] It was one of the tallest obelisks ever successfully made, being about the same size as the unfinished one at Aswan which is 41.75 m long [58–59].[149] According to Pliny, it was carved in the reign of Necthebis (Nectanebo I or II, 380–341 BC). It is depicted on a late sixteenth-century map of Alexandria, but it is not known if it is included from the ancient written sources, or if it was still standing when the map was made, as the map includes both ancient and contemporary buildings [60]. The use of a single obelisk is distinctive, because obelisks were usually used in pairs on Dynastic Egyptian temples. The interest in that period in monumental size and the skills necessary for construction on such a scale can also be seen in the Lighthouse and the colossal statues of the Ptolemies.

In c. AD 12–14/15 this obelisk was moved to the Forum in Alexandria because it was in the way of the dockyards (navalia).[150] An ancient commentator on Callimachus' Apotheosis of Arsinoe indicates the altar and sacred enclosure (temenos) of the deified Arsinoe Philadelphus were situated in the neighbourhood of the commercial market, the

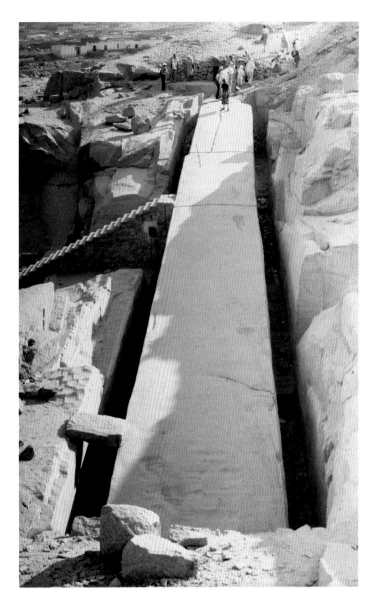

58. Aswan, unfinished obelisk in red granite quarry

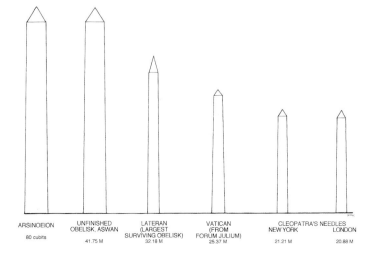

59. Diagram showing the relationship between the heights of some obelisks, all of red granite from the quarry at Aswan

ARSINOEION
80 cubits

UNFINISHED
OBELISK, ASWAN
41.75 M

LATERAN
(LARGEST
SURVIVING OBELISK)
32.18 M

VATICAN
(FROM
FORUM JULIUM)
25.37 M

CLEOPATRA'S NEEDLES
NEW YORK
21.21 M

LONDON
20.88 M

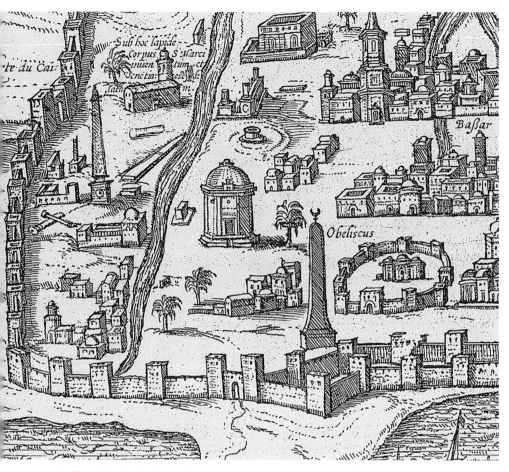

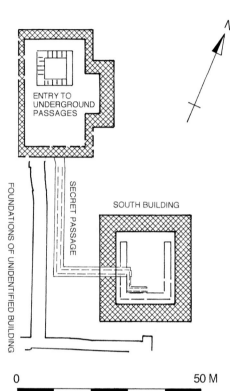

ALTAR (PTOLEMY II AND ARSINOE)➡▪

ENTRY TO UNDERGROUND PASSAGES

FOUNDATIONS OF UNIDENTIFIED BUILDING

SECRET PASSAGE

SOUTH BUILDING

N

0 50 M

60. Alexandria, detail of map of *c.* 1590 which apparently depicts the obelisk from the Arsinoeion. Cleopatra's Needles, with one fallen, are depicted on the left

61. Alexandria, temple of Serapis complex, plan of structures and foundations before main construction phase of Ptolemy III Euergetes I (246–221 BC)

Emporium.[151] As Strabo later mentions the Emporium near the dockyards, this would accord with the obelisk being in their way.[152]

East of Alexandria on the promontory Zephyrion, so-called after Zephyr the west wind, there was also a sanctuary (*hieron*) of Arsinoe where she was worshipped as the Greek goddess Aphrodite. It was apparently built while Arsinoe was still alive. Three epigrams of Posidippus indicate it was consecrated by Kallikrates of Samos, the admiral of the royal fleet,[153] who was the first priest of Alexander and the *Theoi Adelphoi* for the year 272/1 BC.[154] Posidippus indicates the sanctuary was mid-way between Alexandria and Canopus [35], but its exact location has not been identified.[155] Another poem indicates there was a mechanical drinking horn in the temple (*naos*) which made music and was invented by the engineer (*mechanopoios*) Ctesibius. It was fashioned in the shape of the Egyptian god Bes.[156] Thus, like the Arsinoeion in Alexandria, this sanctuary also had Egyptian features.

By the end of the reign of Ptolemy II Philadelphus, the basic cityscape of Alexandria was established, and details such as street names were reflected in legal documents. A papyrus contract of 252/1 BC gives addresses which include streets named after Queen Arsinoe, Arsinoe Our Lady of Mercy, Arsinoe who answers our prayers, and Arsinoe of the Brazen House.[157] The city law also specifies how far apart houses should be built and trees planted.[158]

PTOLEMY III EUERGETES I (246–221 BC)

As the city had all the basic structures for the city's commerce and culture by the time of his reign, Ptolemy III Euergetes I could direct his resources towards two of the most important sanctuaries and temples of the local gods. These are the second phase of the temple of Serapis (the Serapeum) and its enclosure (*temenos*) in Alexandria, and the temple of Osiris at Canopus. In addition, in Alexandria temenoi, altars, and adjoining land were also dedicated on behalf of Ptolemy III and his wife for both the royal cult and the Greek god Zeus mentioned in an inscription: 'to the *Theoi Adelphoi* and Zeus Olympios and Zeus Synomosios [in whose name oaths are made]'.[159]

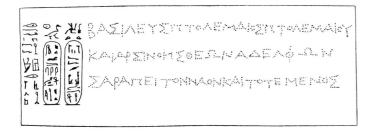

62. Alexandria, temple of Serapis, gold bilingual dedication plaque

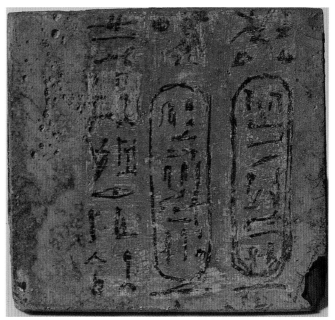

63. Alexandria, temple of Serapis, turquoise glazed terracotta foundation plaque. Greco-Roman Museum

Temple of Serapis

The exact location of the Serapeum is known because its main Ptolemaic phase is identified by its foundation plaques which were placed in the corners of the temenos and temple, and firmly date them to the reign of Ptolemy III Euergetes I. Made of materials such as gold and turquoise-green glazed terracotta, they bear the inscription: 'King Ptolemy, son of Ptolemy and Arsinoe, the Sibling Gods, [dedicated] to Serapis the temple and the sacred enclosure (*temenos*)' [62–63].[160] They are inscribed in Greek and Egyptian hieroglyphs, indicating that they were made taking into account both the Greek and Egyptian populations, although the custom of using such foundation plaques is Egyptian, not Greek.[161] The foundations of the temenos and the temple survive, as well as some architectural fragments.[162] The foundations dated by the plaques are of ashlar masonry set in rock-cut foundation trenches [64–65]. They indicate a colonnaded court forming a temenos with the temple placed in it parallel to, but not on, its axis [66–67]. There were rooms along the western side of this court, and on the level below along the south side [64, 67–68]. There appear to have been two entrances to the temenos on the long side (on the east)

65. Alexandria, temple of Serapis complex, blocks of Ptolemaic ashlar walls

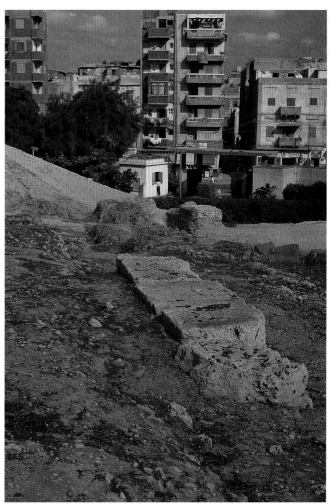

64. Alexandria, temple of Serapis complex, cuttings in bedrock for Ptolemaic ashlar walls of rooms of lower level, viewed from south-east

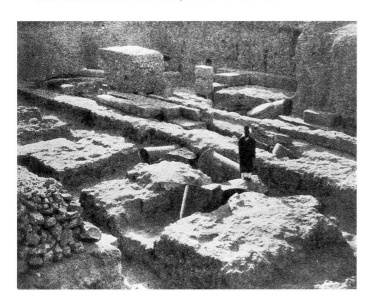

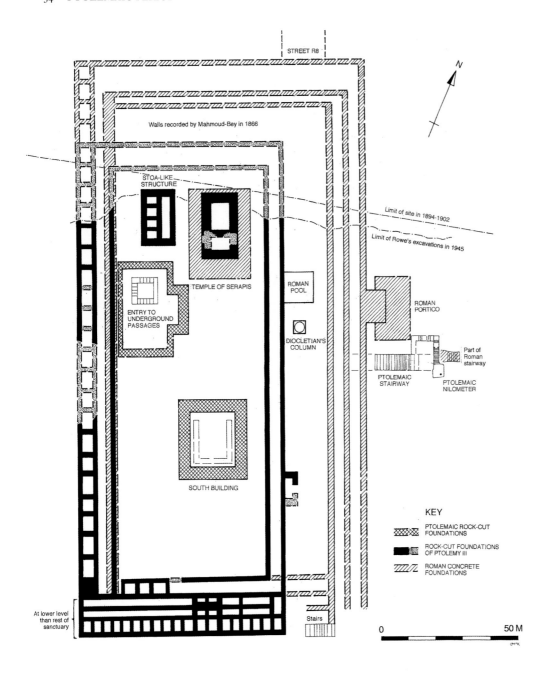

66. Alexandria, temple of Serapis complex, plan of building foundations of Ptolemaic and Roman phases

from street R8 which ran beside the temenos [67]. After passing through the northern one of these entrances the temple is approached at an angle, as in a Greek sanctuary [68]. This entrance is also approached by a staircase leading up the eastern slope of the hill. The Ptolemaic Nilometer, for measuring the height of the annual Nile flood waters, was located at the base of the hill beside this staircase.[163] The architectural fragments include Corinthian capitals [69], Alexandrian type modillion cornices, and Doric frieze pieces. The approximate size of the columns of the court can be established from the width of its foundations.

There is also a second set of foundations for the temple building and the colonnade around the temenos which are quite distinct [66] as they are the concrete foundations of the Roman replacement. The Ptolemaic structure appears to have survived until it was burnt down in AD 181 after which it was replaced by this Roman version (as explained in

Chapter 8). Thus, the temple depicted on Roman coins before AD 181 is the Ptolemaic one, which had four columns across the front with Corinthian capitals and a Doric frieze [68, 70–71].

The foundations also indicate other structures which are Ptolemaic, on account of their rock-cut foundations and remains of ashlar masonry in them. The stoa-like structure consisting of four rooms next to (west of) the temple is positioned symmetrically with the temple on either side of the axis of the temenos suggesting that they were built at the same time [67]. This stoa-like structure is set back apparently to take into account the pre-existence of the T-shaped building to its immediate south. Further south, the foundation trench survives of a large, nearly square, structure, the South Building, but insufficient survives to determine what type of building it was (or to reconstruct it).[164] A secret passage ran underground from this building to the T-shaped building to

67. Alexandria, Ptolemaic temple
of Serapis complex, restored plan

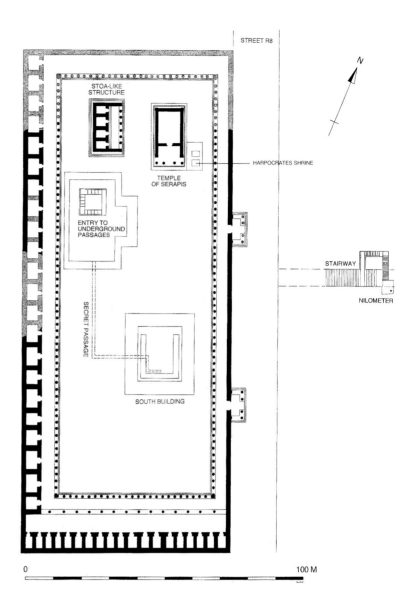

its north which surrounded the entrance to the underground passages. This extensive complex of underground passages was in use by the Ptolemaic period.[165] Thus, from their positions and connecting passage, the two southern structures (the T-shaped building and the South Building) appear to be earlier than the colonnaded court, temple and stoa-like structure [61].[166]

Epiphanius, bishop of Salamis in Cyprus writing in the fourth century AD, indicates that a second smaller library was established in the Serapeum after the Great Library. This could have been in one of these earlier structures, or later in the rooms along the side of the temenos.[167]

Many Egyptian statues, as well as classical style ones, were found in the Serapeum enclosure. The Egyptian style ones are dated to both the Dynastic and the Ptolemaic periods.[168] The Dynastic period statues include kneeling pharaohs with ritual objects, a Dynastic official [72], and sphinxes, of which at least six came from Heliopolis (Tell Hisn) near Cairo. The Ptolemaic examples include the pair of red granite sphinxes on the site today [73]. There is also a fragment of an Egyptian water clock (clepsydra) of the fourth or third century BC.

It is unlikely that the Egyptian style sculptures would have been placed in the sanctuary only in the Roman period to make it more Egyptian. Thus, it is highly likely that some Egyptian sculptures were placed in the precinct during the Ptolemaic period when other Egyptian features were also erected in sanctuaries in the city, such as the obelisk in the Arsinoeion.

The Serapeum had some Egyptian features, such as the foundation plaques, Nilometer, and Egyptian style sculpture, while its architectural decoration is classical, giving the impression of a Greek building.

The combination of classical architecture with Egyptian style sculptures was also seen on the very large building which was apparently a temple, east of the Canopic Gate, (marked 'temple' on Mahmoud-Bey's plan [20]). It had classical fluted columns of red granite as well as statues of sphinxes, and a colossal (c. 10m high) Egyptian style statue of a royal couple. The only evidence now surviving consists of fragments of the latter, which is dated to the second century or first half of the first century BC.[169]

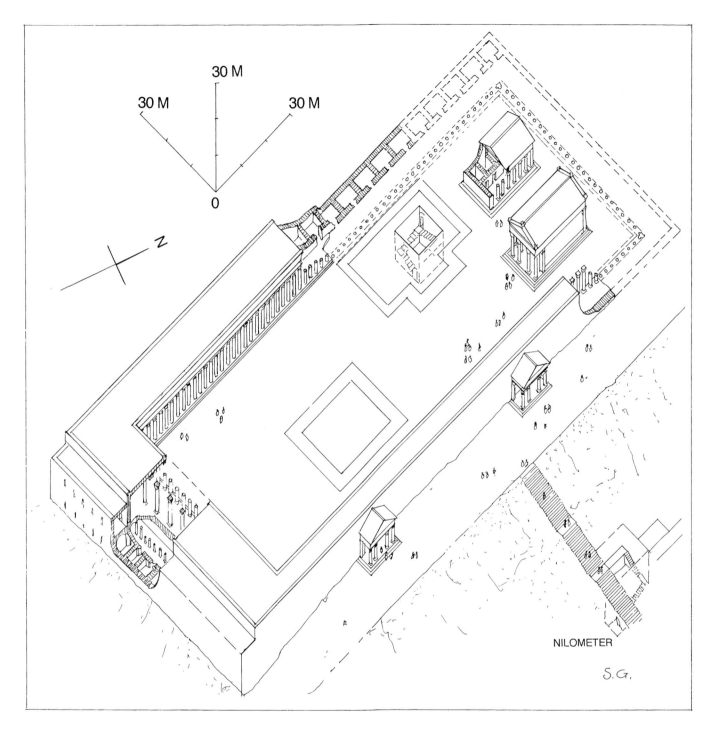

30 M

30 M 30 M

0

N

NILOMETER

S.G.

68. Alexandria, Ptolemaic temple of Serapis complex of Ptolemy III Euergetes I (246–221 BC), axonometric reconstruction. (Sheila Gibson)

Sanctuary of Ptolemy III Euergetes I and Berenice II at Hermopolis Magna (el-Ashmunein)

The impressive classical sanctuary which was built for the royal cult at Hermopolis Magna (modern el-Ashmunein), beside the Nile 450 km south of Alexandria, is included here as it is one of the few Ptolemaic classical style buildings surviving outside Alexandria. The Greek dedicatory inscription on a Doric architrave from it indicates that the Greek cavalry soldier settlers dedicated the statues, temple (*naos*), the other things in the enclosure (*temenos*) and the portico (*stoa*) in honour of the *Theoi Euergetai* (Ptolemy III and his wife Queen Berenice) and the Sibling Gods the *Theoi Adelphoi* (Ptolemy II Philadelphus and Arsinoe II) [74].[170] The foundations indicate a colonnaded court with the entrance in the centre of the short side [75]. Fragments survive of an Ionic,

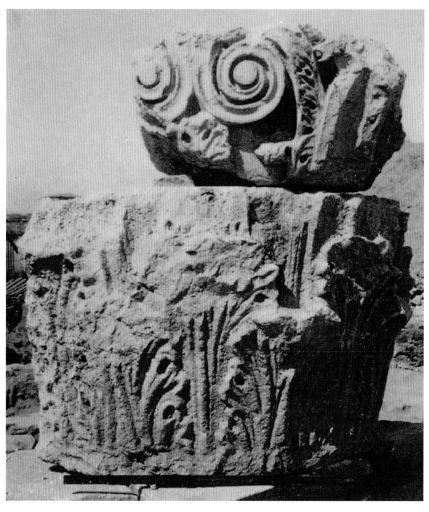

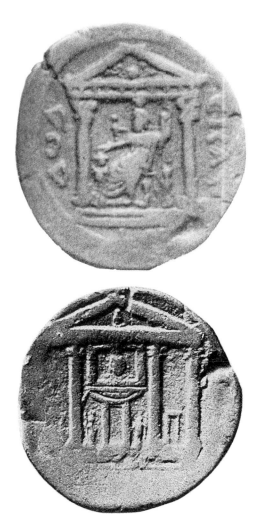

69. Alexandria, temple of Serapis complex, remains of Ptolemaic Corinthian capital in 1901

70. Ptolemaic temple of Serapis on Alexandrian coin of emperor Marcus Aurelius, year 11 or 12

71. Ptolemaic temple of Serapis on an Alexandrian coin of emperor Lucius Verus

72. Alexandria, temple of Serapis complex, upper part of statue of an official from the eighteenth Dynasty. Greco-Roman Museum

73. Alexandria, temple of Serapis complex, Egyptian statues

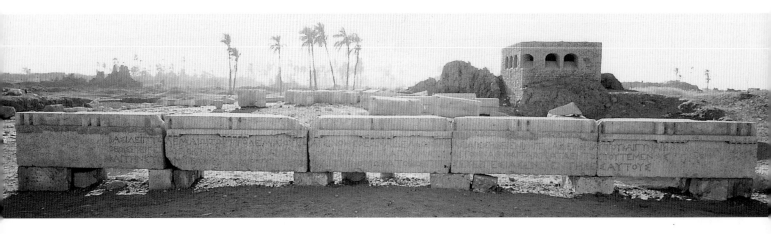

74. Hermopolis Magna (el-Ashmunein), Ptolemaic sanctuary, Doric architrave with Greek dedicatory inscription

75. Hermopolis Magna (el-Ashmunein), Ptolemaic sanctuary, sketch plan

a Corinthian and two Doric orders, which were carved from local limestone and brightly painted. They are important as they provide evidence for a 'classical' style of architectural decoration outside the capital in this period [76–78]. It is not clear which of these fragments belong to which set of foundations, except that the south colonnade was Doric. The foundations remain of a structure, apparently the temple, placed in this court, on the axis of the entrance [75]. The Doric architrave with the inscription is too long to have belonged to this structure [74]. It came from a building with six columns across the front, of traditional Greek appearance.

There was possibly Egyptian influence in the design of the layout. On entering their enclosure Greek temples were approached from an angle. Because Dynastic temples were axially approached and frontally viewed, like the Hermopolis Magna sanctuary, it has been suggested that its layout possibly resulted from Egyptian influence. It has also been suggested that this arrangement of a Greek temple approached along its axis developed in Alexandria, and that perhaps the idea of a sanctuary with a complete colonnaded court also developed in Egypt.[171] The Ptolemaic Serapeum in Alexandria had a colonnaded court, but the temple and entrance were not placed on the same axis. Consequently, the example from Hermopolis Magna is the earliest surviving example of the layout with the temple on the axis of the entrance and enclosed by a colonnaded court. This was later used in some temples in the Roman Near East, such as at the temple of Artemis at Jerash.

Sanctuary of Osiris and Other Buildings at Canopus (Abuqir)

Canopus (in the area of modern Abuqir) was located east of Alexandria on the Delta near the Canopic branch of the Nile which led to Naukratis [35]. In 238 BC the temple of the *Theoi Euergetai* was the venue for the meeting which resulted in the Canopus decree ratifying the introduction of the royal cult to the Egyptian temples. A gold foundation plaque was found in 1816 at Canopus for the sanctuary (*temenos*) of Osiris which was dedicated by Ptolemy III Euergetes I and Berenice. Although inscribed in Greek, this foundation plaque accords with the Egyptian custom [79]. No record was kept of the exact find spot, as the plaque was found *in situ* when the Mahmoudiyah Canal was being dug, but the site must still have

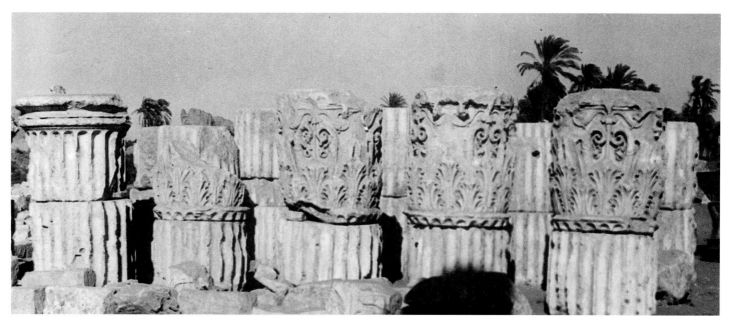

76. Hermopolis Magna (el-Ashmunein), Ptolemaic sanctuary, limestone Corinthian capitals, column drums and (upside down) base

been on dry land then.[172] Early in the twentieth century considerable archaeological remains survived at Canopus from a variety of buildings, none of which has been identified as the Osiris sanctuary. These remains of walls, mosaics, baths, and

pools, range in date from the Ptolemaic to Byzantine periods. There were also architectural fragments and sculptures in both classical and Egyptian styles. They include sphinxes, Egyptian statues, and architectural fragments showing

77. Hermopolis Magna (el-Ashmunein), Ptolemaic sanctuary, limestone Corinthian capital. Alexandria, Greco-Roman Museum

78. Hermopolis Magna (el-Ashmunein), Ptolemaic sanctuary, watercolour drawing of Corinthian capital in fig. 77 with traces of paint

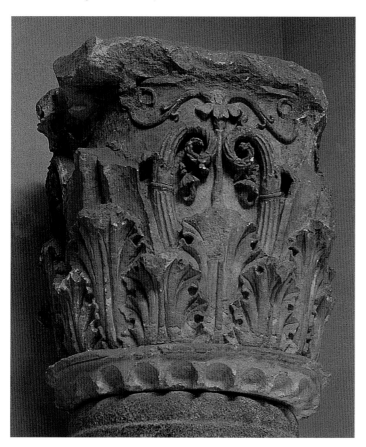

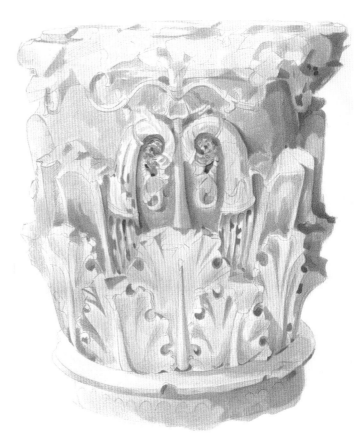

79. Canopus (Abuqir), gold foundation plaque of Ptolemy III Euergetes I (246–221 BC), from enclosure of Osiris. London, British Museum

80. Canopus (Abuqir), view of remains in the late eighteenth century

81. Canopus (Abuqir), upper part of red granite statue of the Egyptian pharaoh Ramasses II (c. 1279–1213 BC). Alexandria, Greco-Roman Museum

classical influence [80–81].[173] Some of the Egyptian, and classical Corinthian and Ionic architectural fragments are Ptolemaic in date, including red granite Doric column shafts. The poet Apollonius of Rhodes, in the third century BC, states that at Canopus 'the scheme of columns is Corinthian fashioned', but gives no indication of on which building or buildings.[174]

82. Praeneste (Palestrina) Nile mosaic, detail, possibly of the sanctuary of Osiris at Canopus

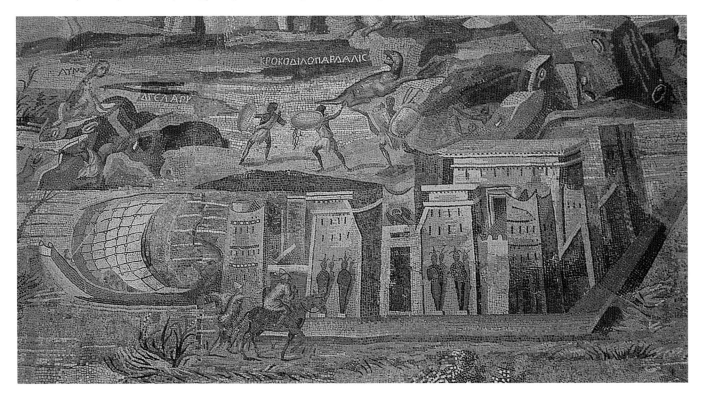

83. Sanctuary of Osiris at Canopus on an Alexandrian coin of emperor Marcus Aurelius

The sanctuary of Osiris at Canopus is possibly depicted on the Nile mosaic at Praeneste (Palestrina) of about the late second century BC [82]. It is possible to identify it on Roman coins minted in Alexandria [83] because it has similar features to the Egyptian temple on bone tokens which have 'Canopus' inscribed on the back [314].[175] Thus, the sanctuary of Osiris had an eclectic mix of Egyptian and Greek features, ranging from the foundation plaque in Greek to the Egyptian style temple, which are also reflected in the other remains in the area.

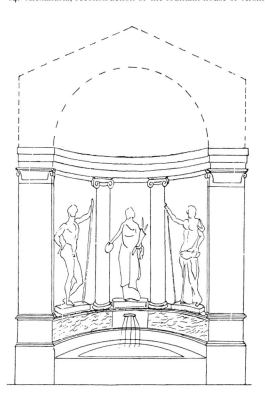

84. Alexandria, reconstruction of the fountain house of Arsinoe

PTOLEMY IV PHILOPATOR (221–205 BC)

In the reign of Ptolemy IV Philopator an increasingly complex combination of Greek and Egyptian features were used together, such as on the fountain house of Arsinoe and his floating palace. He also erected temples for the royal cult and to local gods, such as Isis, Serapis and Harpocrates, as well as to the Greek poet Homer. An impression is also given of the cityscape which provides the background to some events during the reign of Ptolemy IV and early in that of Ptolemy V.

Fountain House of Arsinoe

A fountain house dedicated to Arsinoe is described in an epigram which was copied onto a papyrus dating to the reign of Ptolemy IV. As the next epigram on this papyrus mentions the dedication of a Homereion by Ptolemy IV Philopator, it has generally been assumed that these poems are a pair, one for each of the reigning couple, and that the fountain house is dedicated to Arsinoe III the wife of Ptolemy IV, rather than Arsinoe II the wife of Ptolemy II Philadelphus. However, it has recently been suggested that the epigram about the fountain house is by Posidippus who was active during the reign of Ptolemy II. If this were the case, then it will have been dedicated to Arsinoe II wife of Ptolemy II. Either way, it means the comments concerning the fountain house and architectural innovation are applicable by the end of the third century BC, if not earlier.[176]

The description of this fountain house, which is difficult to translate, gives some indication of its appearance. It was a semi-circular ('hemispherical') structure of white Parian marble, with an Ionic entablature (?) of Parian marble, and a base of red granite from Syene (Aswan). It had running water gushing from the 'Hymettan stone', and was decorated with statues of Arsinoe and the nymphs in 'rich white marble' [84].

The idea of combining different coloured stones within one structure occurred in Dynastic Egypt; for example the colonnade of Hatshepsut I (1473–1458 BC) on the temple of Amun at Luxor has bases of black stone [85]. It was also used in the Greek homeland, on the Athenian Acropolis on the Propylaia and Erechtheion. The use of different coloured stones together became a characteristic feature of Alexandrian and also later Roman and Renaissance baroque architecture. The use of sculptural decoration in a semi-circular exedra occurs in Hellenistic exedrae. The semi-circular plan for the water basin on nymphaea was usually assumed to have been a Roman invention of the early second century AD. It occurs on the undated nymphaeum at Petra, and in the mid-second century AD in Greece.[177] However, an example from the fourth century BC from the island of Tenos has a semi-circular exedra, with water basins on either side of it which are rectangular in shape.[178] The fountain house of Arsinoe is the first example with all the characteristic features of later Roman nymphaea: semi-circular shape, marble statues of the nymphs, and running water in the framework of a colon-

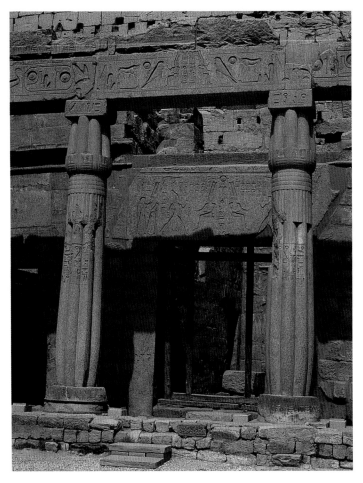

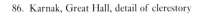
85. Luxor Temple, colonnade of Hatshepsut I (*c*. 1473–1458 BC)

86. Karnak, Great Hall, detail of clerestory

naded facade.[179] Thus, this is another distinctive building type in third century BC Ptolemaic Egypt, which results from the combination of Greek and Egyptian features, but which at first glance appears classical.

Houseboat or Floating Palace of Ptolemy IV Philopator

The houseboat (*thalamegos*) of Ptolemy IV Philopator was a floating palace with many banqueting rooms, as well as bedrooms. It is described in detail by Athenaeus based on Kallixeinos of Rhodes.[180] It was a catamaran three hundred feet long and forty-five feet wide. Its interesting architectural details reflect those used on more permanent structures. The description of the two storeys of the main peristyle around the boat, the top one with windows, has some similarities to Vitruvius' description of an 'Egyptian *oecus*' which he distinguishes as having an upper row of columns between which there are windows. He notes these 'Egyptian halls resemble basilicas'.[181] Clerestories beside a flat roof are earlier used on Dynastic Egyptian temples [86].

The main dining room (*megistos oikos*) which would hold twenty couches, had a row of columns around it. These had Corinthian capitals, covered with ivory and gold, supporting a gold entablature with a frieze of ivory figures. It also had a coffered ceiling of cypress wood decorated with sculptured ornament and gilt. On the upper deck, opposite the circular shrine of Aphrodite, there was a sumptuous dining room (*symposion*) surrounded by a row of columns of stone from India. The room of Dionysos which held thirteen couches was also surrounded by a row of columns, and on one side it had a recess in which there were statues of the royal family in Parian marble. Beyond this, there was the open space (*aithrion*), then another dining room (*symposion*) which 'was Egyptian in the style of its construction' with bulbous columns with alternate black and white drums (as in [87–88]). Its Egyptian capitals were 'circular in shape' and resembled slightly opened roses, 'with no volutes or acanthus leaves laid on, as on Greek capitals, but calyxes of water-lilies and the fruit of freshly-budded date palms, with several other kinds of flowers sculptured on some of them'.[182] Thus, Ptolemy IV was using both the Egyptian and classical styles, on the one

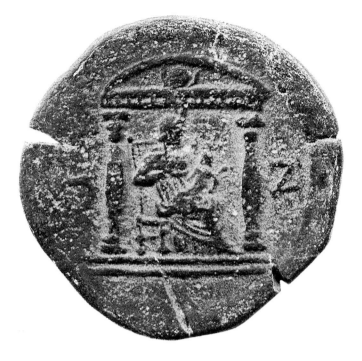

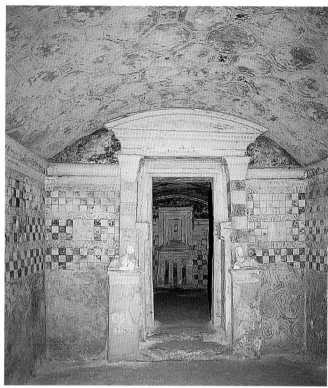

87. Temple of Isis in Greco-Egyptian style on Alexandrian coin of emperor Antoninus Pius, year 7. Oxford, Ashmolean Museum no. 1768

88. Alexandria, Anfoushy Tomb 2, chamber 1 (j)

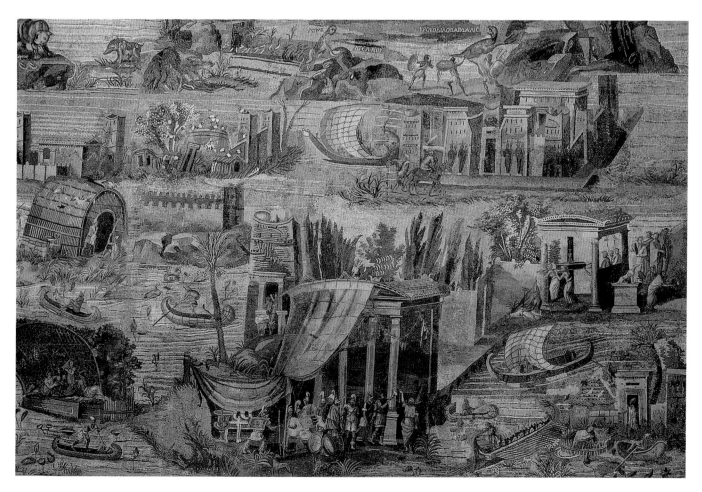

89. Praeneste (Palestrina) Nile mosaic, detail of structures with segmental pediments

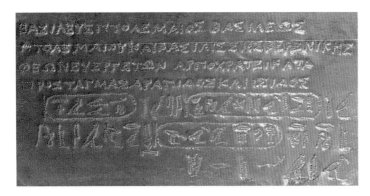

90. Alexandria, small temple of Harpocrates adjoining temple of Serapis, bilingual gold foundation plaque of Ptolemy IV Philopator (221–205 BC). Greco-Roman Museum

structure, but they were not mixed within a room or order.

There were also other ornately furnished boats, including the *Syracusia* which was built by Hieron II of Syracuse, under the supervision of Archimedes. It was renamed the *Alexandris* and given to Ptolemy IV in Alexandria because it would not easily fit into some other harbours. It was described in detail by Athenaeus who indicates that, although used for transport, it also included cabins with floors of multicoloured mosaics depicting the story of the *Iliad*, a gymnasium, a bathroom, promenades with pot plants, a reading room, a library, and a shrine to Aphrodite.[183] Archaeological remains of two houseboats built by the Roman emperor Gaius (Caligula) (AD 38–42) were uncovered in Lake Nemi in Italy, but since destroyed. One of these was 77m (234 feet) long and 21 m wide, and the other 70m by 25m. The remains which survived from these included mosaic pavements, marble wall veneer and sculptured bronze fittings.[184] This archaeological evidence, although later, gives veracity to Athenaeus' description with regard to both the size and ornateness of the houseboat of Ptolemy IV, and probably provides a reliable reflection of other more permanent Ptolemaic royal architecture.

Athenaeus also mentions the super galley built by Ptolemy IV, which was a 420 feet long forty-bank ship. He describes the slipway with skids later invented by a Phoenician, which could be used both for launching ships and as a dry dock. This gives some indication of the type and size of the structures which would have been built in the dockyards beside the harbour. The *Alexandris* docked in Alexandria, which indicates that it was able to accommodate much larger ships than many other harbours. There was a dock for unloading river craft near the Serapeum by the last quarter of the third century BC.[185]

Temple of Serapis, Isis, Ptolemy IV Philopator and Arsinoe III on the Main East-west Street

In the centre of the city, on the south side of the main east-west street foundation plaques were found *in situ* for a temple dedicated to Serapis (or Osiris-Apis in hieroglyphs), Isis, Ptolemy IV Philopator and Arsinoe III (location marked on [38]). In a purpose-made cavity in a corner stone of the foundations were found four plaques in gold, silver, bronze and greenish porcelain.[186] These plaques are bilingual in Greek and Egyptian hieroglyphs, like those for the Serapeum enclosure. The architectural fragments which had survived from it in 1885, from what seems to have been a substantial building, were described as from a 'Greco-Egyptian temple'.[187] If this means what might be supposed, it would be the earliest dated evidence for a mixed Greco-Egyptian style in the architectural decoration of a building rather than just in the overall design.

Other Temples and Sanctuaries

In the Serapeum enclosure, adjoining the temple of Serapis, Ptolemy IV Philopator dedicated the small temple of Harpokrates 'according to the direction of Serapis and Isis'. It is identified by its bilingual foundation plaques in Greek and Egyptian hieroglyphs [90]. There were two holes cut in each corner of the rock-cut foundations. The main corner hole of each pair contained ten plaques, each of a different material, including mud, bronze, opaque glass in six different colours, silver, and gold. The use of mud brick plaques and of pairs of holes goes back to the Dynastic period.[188]

Ptolemy IV Philopator is credited with dedicating a Homereion, a sanctuary in honour of the poet Homer, in an epigram on the same papyrus as the one mentioning the fountain house of Arsinoe.[189] The historian Polybius' description of the events of 203 BC mentions a sanctuary of Demeter and the Thesmophorion.[190] Thus, by the end of the third century BC, there is some record of specific Greek temples and sanctuaries, as well as those for the local gods and the royal cult.

The Sema, and the Tombs of Alexander and the Ptolemies

Ptolemy IV also attended to the architecture of the royal cult. According to the sophist Zenobius, writing under Hadrian (AD 117–38), Ptolemy IV Philopator 'having built a monument (*mnema*) in the middle of the city, which is now called the Sema, he put in there all the ancestors with her [his mother Berenice] and Alexander the Macedonian and on the shore they built a sanctuary (*hieron*) to her, as Berenice the Saviour (*Sozousa*)'.[191] This continued interest in the dynastic cult to stress the legitimacy of his rule going back to Alexander, was probably necessary given the political situation.

Strabo further explains that the Sema 'was an enclosure (*peribolos*) which contained the burial places (*taphai*) of the kings and that of Alexander'.[192] Thus, by the 'monument

91. Alexandria, palace area, entablature blocks from large Doric and Ionic building. Kom el-Dikka

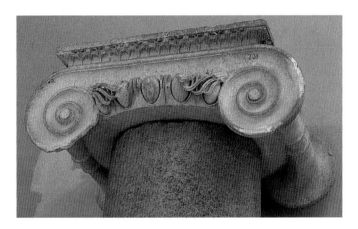

92. Alexandria, palace area, Ionic capital from large building. Greco-Roman Museum

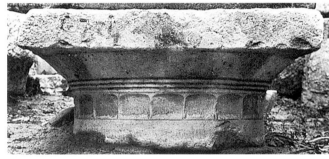

93. Alexandria, palace area, Doric capital from large building

. . . called the Sema' Zenobius is referring to the whole complex. Within it, the excavated vault which contained the shrine with the sarcophagus and body of Alexander was underground.[193] Suetonius indicates that the Ptolemaeum contained remains of the Ptolemies.[194] It seems to have been within the same complex as the tomb of Alexander. However, other sanctuaries of the royal cult which were temples in honour of specific members of the royal family seem to have been in other parts of the city, separate from their burial place, as indicated for Berenice II.

Besides Zenobius' reference to the Sema being in the middle of the city, the only additional information concerning its location is given by Strabo who mentions that it is in the palace area.[195] Despite much speculation, and various later traditions, the exact location of the Sema and the tomb of Alexander is not known.[196]

94a–b. Alexandria, palace area, reconstructions (elevations and sections) of (a) Ionic and (b) Doric orders of large building incorporating blocks in fig. 91–3

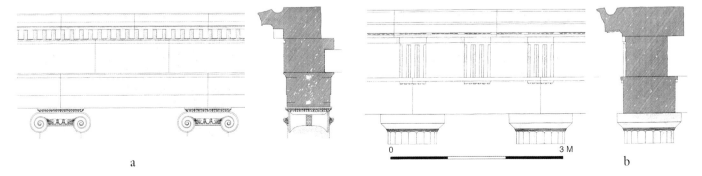

a b

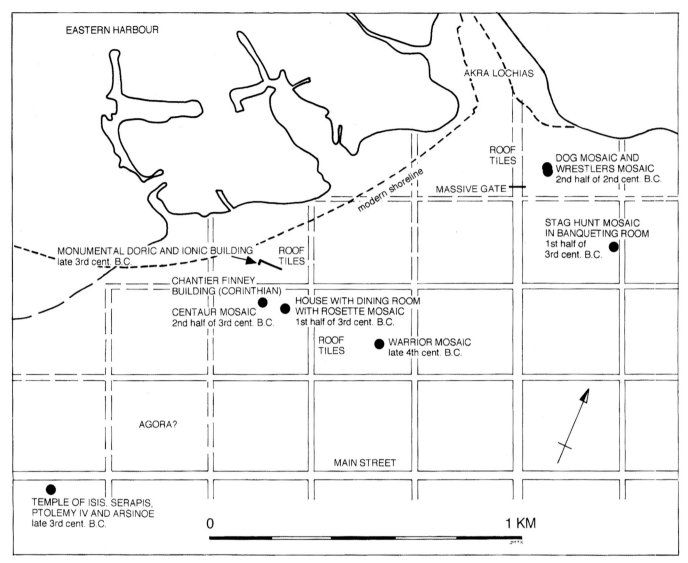

95. Alexandria, palace area, plan with Ptolemaic remains found *in situ*

THE CITYSCAPE IN THE LATE THIRD CENTURY BC

The descriptions of some historical events during the reign of Ptolemy IV Philopator, and early in the reign of Ptolemy V Epiphanes, mention the buildings in which the action occurred and so provide an impression of the cityscape. These give the impression which would be expected, with people gathering in the main street (the *plateia*), the great peristyle court of the palace, and other buildings, such as the hippodrome, stadium, theatre, palaestra and temples.

The uprising led by Cleomenes of Sparta in 219 BC was described by Polybius who was appointed envoy to Alexandria in 180 BC. Cleomenes was imprisoned in 'a huge house' (*oikia pammegethes*) from which he escaped and his supporters met in the *plateia*. When the populace did not join the uprising they 'retraced their steps and made for the citadel (*akra*) with the intention of forcing the gates and getting the prisoners to join them' but they were foiled by the guards and killed. Clearly, there was a prison with walls on an *akra*.[197] As there was no suitable high ground in the palace area, it is not

clear if this *akra* was the promontory near the palace (akra Lochias).

When Ptolemy IV decided to persecute the Jews, he erected 'a pillar on the tower (*pyrgos*) near the palace (*aule*)' with an inscription against them.[198] After bringing the Jews to Schedia, east of Alexandria [35], he ordered them 'to be imprisoned in the hippodrome that was before the city, a place of immense circuit and very suitable for making an example of them to all who entered the city'.[199] He intended to trample them with 500 elephants which were put 'in motion in the great colonnaded court (*megalon peristylon*)'.[200] Then the elephants and the crowd went out of the gate towards the hippodrome.[201] It is not known if this great peristyle was the one in the palace, or another building. Although it is clear that this hippodrome was outside the city walls, it is not clear whether it was the Lageion to the southwest of the city, or the hippodrome east of the Canopic Gate mentioned in the second half of the first century BC.[202] The Jewish presence at Schedia in the reign of Ptolemy III Euergetes I is indicated by the dedicatory inscription from a synagogue there, i.e. a 'prayer hall of the Jews' (*proseuche ton ioudaion*).[203]

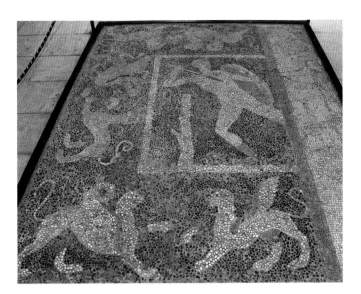

96. Alexandria, palace area, warrior mosaic. Greco-Roman Museum

97. Alexandria, palace area (garden of former British Consulate), reconstruction of dining room with mosaic floor

Polybius gives a lengthy description of the revolt against Agathocles under Ptolemy V Epiphanes in 203 BC. After the death of Ptolemy IV Philopator in 204 BC, a platform (*bema*) was set up in the largest colonnaded court (*megiston peristylon*) of the palace (*aule*),[204] and Agathocles and Sosibus presented the king's bones in a silver urn to the people.[205] The urn, and another one for Arsinoe, were placed 'in the royal chambers (*basilikoi oikoi*)'.[206] The great colonnaded court of the palace was thus large enough to be used for such public gatherings. In Macedonia, in northern Greece, archaeological remains of palaces indicate they were built around a large colonnaded court (peristyle).[207]

As Ptolemy V was a child, Agathocles tried to keep power. During the conflict some of the women unsuccessfully sought refuge in sanctuaries. Agathocles' supporters took Danae, the mother-in-law of his enemy Tlepolemus, from the sanctuary (*hieron*) of Demeter and dragged her through the middle of the city to the prison (*phylake*).[208] Later, Agathocles' mother, Oenanthe visited the Thesmophoreion (the sanctuary of Demeter and Kore) as the temple (*naos*) was open for an annual sacrifice, and then seated herself beside the altar.[209]

There was a garrison (*skene*) belonging to the Macedonian troops not far from the palace (*aule*).[210] When the people decided to revolt by night: 'The open spaces round the palace, the stadium, and the *plateia* were now filled by a mixed multitude, including the portico (*prostasis*) of the theatre of Dionysos'. On hearing this, Agathocles went to the boy king (presumably in the palace), then 'took him by the hand and went up into the vaulted passage (*syrinx*) between the Maeander and the exercise court (*palaestra*) leading to the entrance (*parodos*) to the theatre. After this, having made fast the first two doors', they retired to the third. 'The doors were of open lattice work' each secured by two bolts. The populace assembled 'from every part of the city, so that not only the ground floors, but also the roofs and steps were full of people'.[211] 'At first the Macedonians got up and seized the

gate of the audience [hall] (*chrematistikon pylon*)[212] of the palace (*basileia*), but shortly after, when they discovered in what part of the palace (*aule*) the king was, they went round and after taking the [first] door of the vaulted passage (*syrinx*) off its hinges approached the second,'[213] which they broke down.[214] Agathocles then let the Macedonians have the boy king and setting him on a horse they conducted him to the stadium and placed him in the royal seat.[215] It was filled with a cheering crowd[216] who killed Agathocles and his followers.

This passage suggests that the palaestra[217] was near the theatre, and that both of them were the near the palace and the stadium mentioned. The vaulted passage apparently led from the palace to the theatre. If this stadium was in or adjoining the main Gymnasium later mentioned by Strabo, it would have been near the main east-west street (the *plateia*).[218] The Maeander is thought to be an ornamental stream named after the one in Caria noted for its meandering course.[219]

THE CITY FROM THE SECOND CENTURY TO THE MID-FIRST CENTURY BC

It has been shown how all the main civic and religious buildings in Alexandria were established during the late fourth and third centuries BC. There are few additional references to these buildings during the second and early first centuries BC as detailed descriptions of events in that period have not survived in the classical sources.

There are small fragments of a papyrus copy of Satyrus' treatise *On the Demes of Alexandria* which was probably composed in 193–180 BC, during the reign of Ptolemy V Epiphanes. It explains why the tribes and demes (districts) of Alexandria were given their names, and mentions some sanctuaries.[220] In particular, it confirms that Eleusis in Alexandria, where there were annual festivals, was named after the famous sanctuary at Eleusis near Athens where the festival of

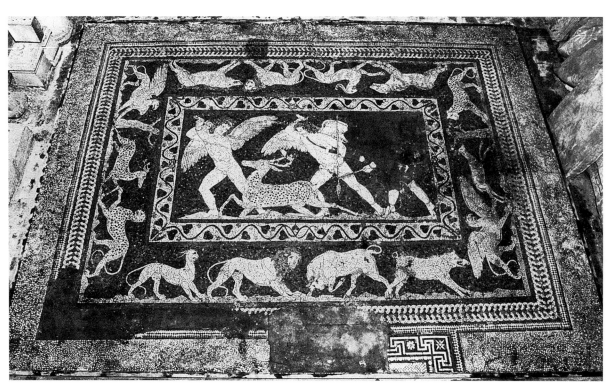

98. Alexandria, palace area, Shatby stag hunt mosaic. Greco-Roman Museum

Demeter was held.²²¹ It mentions a number of other sanctuaries, such as those of Leto, and of the Dioskouroi, and the Thesmophoreion.²²² These sanctuaries could have included temples. It also mentions the Ptolemaieion.²²³ Other religious buildings in the city included synagogues, as indicated by the dedication for one found in the eastern part of the city, at Hadra, and dated to *c.* 150–100 BC.²²⁴

The 'so-called quadrangular portico' is mentioned by Hipparchus as the location in which there was a bronze ring (an equatorial armillary) used for astronomical observations in 146 BC. This building is difficult to identify without further information, because of the imprecise term used.²²⁵ It has been suggested that quadrangular stoas were colonnaded courts.²²⁶ The main palaestra in Alexandria, which later had two of these bronze rings in it,²²⁷ would have included a large colonnaded court. The agora could have been surrounded on four sides by a continuous colonnade, like the one at Pella.²²⁸ Earlier Greek agoras usually had stoas at the edge of them, but were not closed inward looking courts.²²⁹ Thus, the structure mentioned by Hipparchus could have been the palaestra, the agora, or another building.

The growth and development of the city since its foundation was such that by the mid-second century BC the writer of the 'Letter of Aristeas', noted that Alexandria 'surpasses all other cities in size and wealth', and mentioned the problems caused by too much immigration from the countryside.²³⁰ Its role as a port, the source of this wealth, is reflected in the unloading place for cargo (*exairesis*) in the harbour mentioned in a papyrus concerning customs duties under Ptolemy VIII Euergetes II.²³¹ The strength of the city walls is indicated by the fact that when the Syrian ruler Antiochus IV Epiphanes attacked the city in 169 BC he was unable to breach them.²³²

When Scipio Africanus and his ambassadors visited it about twenty years later they also observed 'the situation and strength of the city, [and] the distinctive features of the Pharos'. They attended banquets in the palace (*basileia*), while appreciating their hosts' country as a land worth coveting for 'the quality of the land and the blessings brought to it by the Nile, the great number of Egyptian cities (*poleis*) and the untold myriads of their inhabitants, the strong defensive position of Egypt, and the general excellence of the country, in that it is well suited to provide for the security and greatness of an empire.'²³³

ARCHAEOLOGICAL EVIDENCE IN THE AREA OF THE PALACES

Although they mention the palace, written sources for the Ptolemaic period do not indicate where it was. This is only given later in the descriptions of the Alexandrian War in 48/47 BC (in Ch. 4 below), and in Strabo's description (Ch. 8).²³⁴ These indicate that the palace area was on the promontory el-Silsila (akra Lochias) and in the area to its south-west [38]. Archaeological remains survive in the area to the south and south-west of this promontory. They are dated to the Ptolemaic period from the late fourth century BC onwards, and indicate that this area had monumental structures, and buildings with expensive mosaic floors. Although the floor plan of none of these buildings is complete, this evidence suggests that in the Ptolemaic period this was the palace area, as the later written sources indicate. These buildings had Greek architectural decoration, mosaic floors, and tiled roofs.

Limestone and marble capitals, column drums and entablature blocks, and foundations were found near the eastern

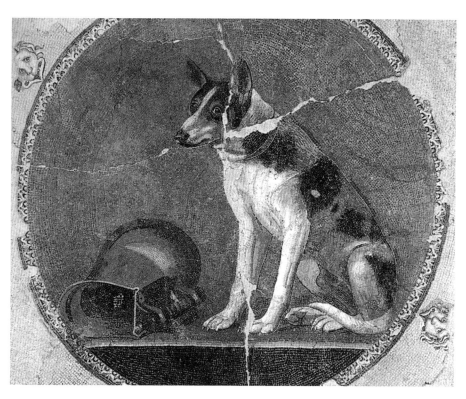

99. Alexandria, palace area (Chantier Finney), centaur floor mosaic. Greco-Roman Museum

100. Alexandria, dog mosaic from floor in palace area (site of Bibliotheca Alexandrina)

harbour from a large monumental building with Doric and Ionic colonnades [91–94]. As it is dated to the late third century BC,[235] it proves that by then the palace area of later writers had monumental buildings in it (location marked on [38]). Further south, a stoa was constructed, east of R4, on the southern side of the main east–west street at right angles to it.[236] It was built in the Doric order with monumental proportions, and reflects the Ptolemaic buildings on the main street.

South-east of the large Doric and Ionic building mentioned, apparently near east–west street L2, the curved marble seats of a 'Greek theatre' were found in 1892 when the fortifications on the Government Hospital hill were being demolished (location marked on [38]). However, excavations in this area have not uncovered the foundations for a theatre, but reveal that much of this area was occupied by other buildings in the Ptolemaic period, leaving insufficient space for a large theatre.[237] Thus, the location of the theatre which written sources indicate was near the palace is at present unknown.

A variety of Hellenistic mosaic floors have been found in the palace area of Alexandria [95]. These include one of a warrior dated to c. 320–300 BC found south-east of the large Doric and Ionic building [96]. It is made largely of black and white pebbles, with some yellow and red-brown ones for shading and lead strips marking outlines and details. It has squared tesserae used in a few places on it, exemplifying the earliest stage of the transition from pebble to tesserae floors.[238] It is not clear to what type of building it belonged. To its west, on the next city block, houses were recently found which included a dining room with a simple pebble mosaic floor with a rosette at its centre. The position of the dining couches was marked by an outline in terracotta and indicated by the off-centre doorway marked by a lozenge pattern [97]. It is dated to c. 300–250 BC.[239] The room had stuccoed walls.

Further east, beyond cross-street R1 and nearer to the promontory el-Silsila at Shatby, three mosaic floors were found which are dated to c. 290–260 BC, apparently from a large house. They include one depicting a stag hunt by three Erotes with a frieze of real and mythical animals around all four sides [98]. The scene reflects a direct development from pebble mosaics in northern Greece at Pella. However, its technique is much more developed. It is made primarily of tesserae, with the cubes coloured and graded for shading. Specially cut pieces are used for details and lead strips are extensively used. It was from a large room over 7.2 by 5.8 metres,[240] which was apparently a banqueting room, as the off-centre panel indicates the position of the doorway, and that it would have held nine dining couches. In the Chantier Finney, east of the later site of Cleopatra's Needles, fragments of mosaics dated to c. 250–225 BC were found including a centaur [99] and a stag, possibly from the one pavement. Their tesserae technique is more developed than that of the Shatby stag hunt mosaic.[241]

Closer to the promontory el-Silsila mosaics of a dog and wrestlers were found, one metre apart, in 1993 while digging the foundations for the Bibliotheca Alexandrina [100]. These are very expensive high quality floor mosaics made with *opus vermiculatum* (very small pieces) which provide the full variety of shading and colours of a painting. They are dated to the first half or middle of the second century BC. They are important as they reflect the role of Alexandrian workshops in the development of this art.[242] On the same insula as the centaur mosaic, parts of three plainish mosaic floors from the early first century BC were found *in situ* under the Cricket Ground.[243]

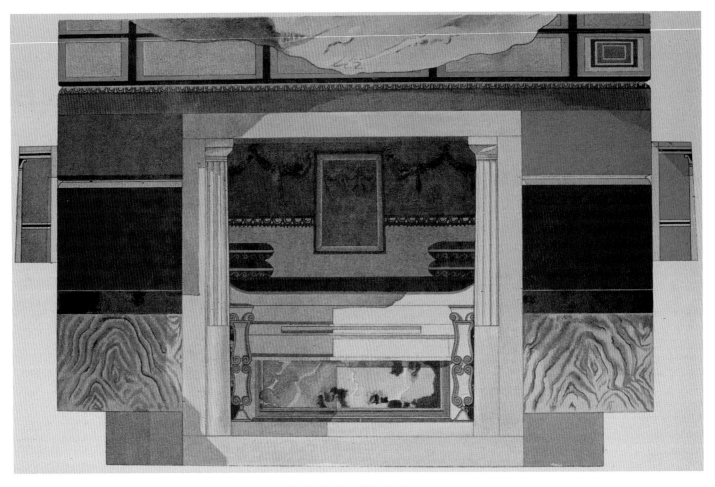

101. Alexandria, Sidi Gaber Tomb, section through main chamber looking into *kline* chamber

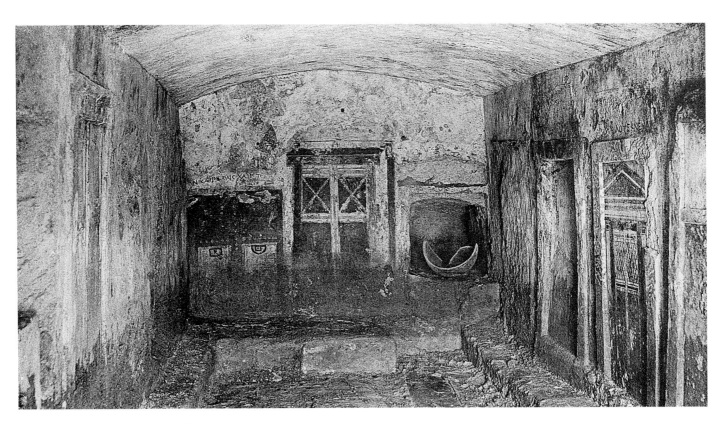

102. Alexandria, Shatby, Tomb A, chamber e

These floor mosaics all indicate high quality buildings in the area near the eastern harbour and the promontory el-Silsila (akra Lochias), indicated by Strabo as being the palace area. South of the main east-west street near cross-street R4 at Kom el-Dikka, remains of dwellings, including a plain pebble mosaic floor, were found from the third and second centuries BC indicating residential occupation in that area.[244]

As at other Hellenistic sites the walls of rooms in Alexandria would have been decorated with stucco which was painted to look like stone. These would have depicted ashlars, or panels of imitation veneer of marble or alabaster, also used in some of the tomb decoration [101]. The painted decoration of the tombs reflects perishable materials also used in houses but not otherwise preserved, such as wall-paintings, inlaid doors, couches, and the textiles on them [101–103]. Some of the more monumental houses would have had rooms arranged around a peristyle court,[245] as reflected in the tombs at Moustapha Pasha [106–107]. These include a newly discovered example which is even more monumental than Tombs 1 and 2 as it has six Doric columns along its court.[246] Some archaeological evidence in the palace area indicates gardens, with Nile mud brought in for the tree planting found between some Ptolemaic mosaics. These gardens could have been surrounded by peristyle courts.[247] The Greek arrangement of rooms around a court with the dining room floor decorated with mosaics is later reflected in the early Roman houses at Kom el-Dikka.[248]

An indication of the Corinthian order used on building interiors is given by the finely carved limestone architectural fragments which were found in the Chantier Finney at the same site as the centaur mosaic. Their size and the use of paint suggests they came from the interior of a building, on which they were used as an engaged order. They are of similar size and were painted similar colours to the Alexandrian architecture later depicted in Roman wall-paintings. They are dated to the (third or) second century BC and have the distinctive features of Alexandrian classical architecture of the Corinthian order which had developed by then, and will be discussed in Chapter 5.

Thus, not only did Ptolemaic buildings in the palace area have Greek style floor mosaics, dining rooms, and classical colonnades, but roof tiles found in the area also show that they had tiled pitched roofs which are typical of Greek, rather than Egyptian, architecture (locations marked on [95]).[249]

ARCHAEOLOGICAL EVIDENCE FOR CEMETERIES AND TOMBS

The Ptolemaic cemeteries were located to the east and west of the city.[250] About half a kilometre east of the building with the stag hunt mosaic [38], in sight of the sea, lies the cemetery of Shatby [28]. It had begun to be used by the late fourth century BC, as had those to the south of it at Hadra.[251] During the third and second centuries BC cemeteries were established further east of the city along the coast, extending from Ibrahimieh to Sidi Gaber and Moustapha Pasha.[252] Cemeteries also developed to the west of the city by the first half

of the third century, at Minet el-Bassal[253] and further west at Gabbari and Mafrousa [28].[254] The main period of use of the cemetery at Shatby was the third century BC,[255] while the one at Hadra continued to be used in the second century BC.[256] By the first century BC the cemeteries at Hadra and Shatby were covered by the expansion of the city so that they were not used in the Roman period [29]. Their location relative to the eastern wall, and the issue of whether or not they would have been inside the city walls were discussed in Chapter 2.

Stepped pedestals for gravestones or funerary stelai are still visible today at Shatby. These stelai were painted, or carved in relief, with traditional Greek funerary scenes.[257] Stele-shaped slabs were also used to close the narrow rock cuttings (loculi) for the body or the funerary urn containing ashes. More affluent underground tombs have rock-cut architecture, such as Tomb A at Shatby with Greek architectural orders consisting of Doric and Ionic engaged colonnades. It contained burial vases from c. 250 BC.[258] The loculi in it were closed with stone slabs decorated with painted doors, like the many examples at Shatby [102–103].[259] These sometimes have Greek scenes on them, including one of the underworld with elements of landscape painting [104]. The date suggested for the landscape painting of a waterwheel run by oxen and adjoining scenes from Hypogeum 3 at Wardian (Minet el-Bassal) is much debated [105].[260] At Ibrahimieh, to the east of the city, Jewish burials dating back to the first half of the third century BC were found with Aramaic inscriptions on loculus slabs.[261]

Tomb A at Shatby, like other affluent tombs, had funerary couches (klinai) in it,[262] following the Macedonian custom. Some smaller expensive tombs were built focused on a main burial in a chamber with a couch, with a larger chamber in front with benches, as in the example at Sidi Gaber to the east of the city which is dated to the early Ptolemaic period [101].[263] A tomb at Mafrousa, in the western cemetery, had an altar surviving in it.[264] While their decoration is Greek, the layout of some tombs also reflects Egyptian tomb designs of earlier periods.[265] These earlier Egyptian rock-cut tombs had columns cut free from the rock inside them. The same feature, but in Greek style, is seen in Tomb 2 at Moustapha Pasha.[266]

In Tomb 1 at Moustapha Pasha, dated to the third or second century BC, the combination of Greek and Egyptian features is apparent [106–107]. It has Greek painted decoration and architectural features, such as the Doric colonnade and Corinthian pillar capitals.[267] Its design with the chambers arranged around a colonnaded court reflects the design of a Greek peristyle house.[268]

Egyptian sphinxes guard the doorways of Tomb 1 at Moustapha Pasha [106]. They later occur on Tomb 2 at Anfoushy [88]. This tomb was initially decorated with Greek style decoration, including painted ashlars, in about the second century BC. It was later redecorated with a segmental pediment, and Egyptian features such as the cavetto cornice and some painted decoration, resulting in a mixture of Egyptian and classical decoration.[269] The combination of cavetto cornice and segmental pediment is also seen in the

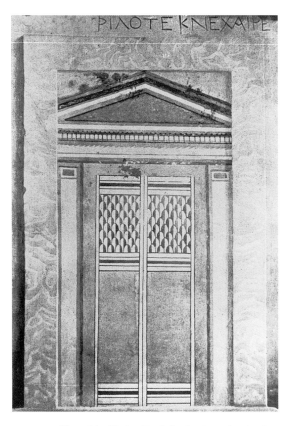

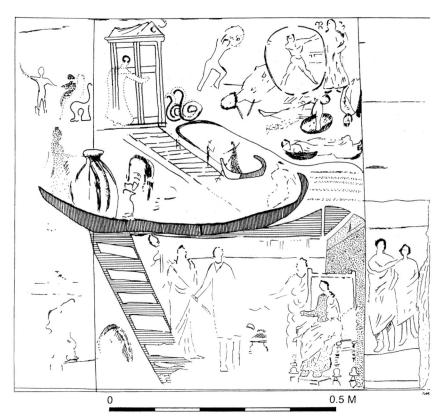

103. Alexandria, Shatby, Tomb A, chamber e, loculus door

104. Alexandria, Shatby, sketch of Hellenistic loculus slab with underworld scenes

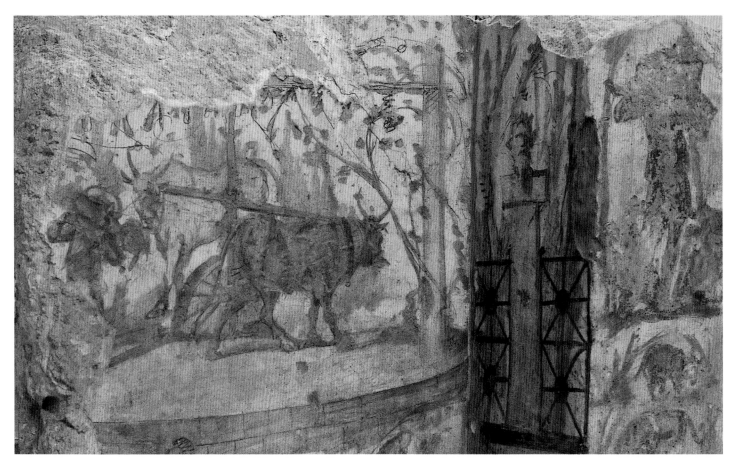

105. Alexandria, Wardian (Minet el-Bassal), Hypogeum 3, landscape paintings of water wheel, herm and shepherd. Greco-Roman Museum

106. Alexandria,
Moustapha Pasha, Tomb 1,
chamber 1

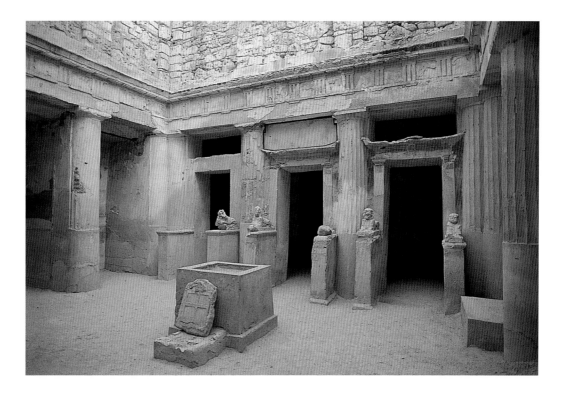

Praeneste (Palestrina) Nile mosaic of about the late second century BC [89].

The tombs at Shatby and Moustapha Pasha are the predecessors of the later, much larger, centrally organized tombs, such as the one at Wardian which begins in the second half of the first century BC.[270] The tombs at Fort Saleh in the Gabbari area uncovered by the construction of the new freeway show the intensity of development of the site for burials in centrally organized complexes with loculi on a number of levels in rows in relatively plain chambers, like those previously excavated in that area [108]. These contrast with the tombs at Shatby and Moustapha Pasha with more substantial architectural decoration of engaged orders. The latter would seem to be more up market. The recently

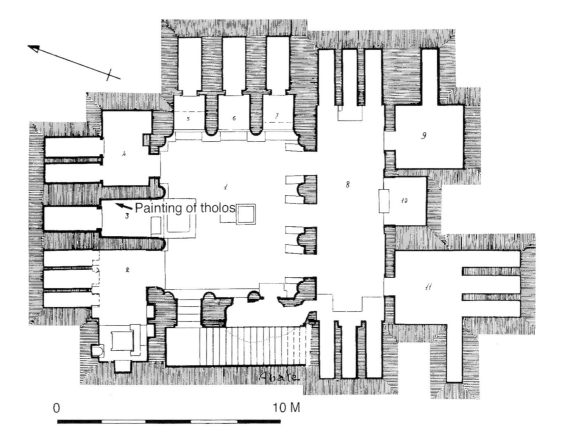

107. Alexandria,
Moustapha Pasha, Tomb 1,
plan

0 10 M

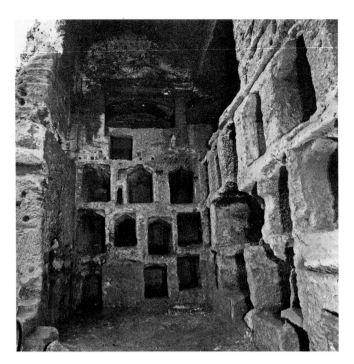

108. Alexandria, Gabbari (Fort Saleh), interior of Tomb IX, room 4, looking north

excavated tombs at Gabbari were in use from the mid-third century BC to at least the sixth century AD.

To the east of the city, the so-called Alabaster Tomb which is Ptolemaic in date, appears to have been a tumulus type tomb; i.e. it would have had a mound of earth over it, and apparently been entered at ground level in antiquity, not by going down to it.[271] It was apparently located inside the city walls, which would not be surprising for a major monument for the burial of an important person (location marked on [28]).

Thus, the same developments are observed in the tomb architecture of Alexandria as had been indicated by written sources during the third century. Greek and Egyptian features of design are combined in subtle ways which on the surface look Greek, while on other occasions Greek and Egyptian decorative elements are used together on one structure.

CONCLUSION

The written sources indicate that by the end of the third century BC Alexandria had all the features of a Greek city: a laid out grid plan surrounded by fortification walls, an agora (market place), temples, gymnasium, a racecourse (the Lageion) which functioned as both a hippodrome and stadium, the Great Theatre, fountain houses with running water, houses, and cemeteries. It also had a large palace area which was developed with the buildings for which the city was renowned: the Library, Museum and the tomb of Alexander. Their exact positions are not known, unlike that of its most famous temple, the Serapeum which can even be

reconstructed. The natural harbours were upgraded for extensive maritime trade with the construction of the Heptastadium, the lighthouse Pharos, breakwaters, and jetties. The palace had a large peristyle (colonnaded court) typical of those in Alexander's homeland, while the erection of the banqueting tent by Ptolemy II Philadelphus is an eastern, rather than a Greek, custom. The remains of *in situ* buildings in the palace area from the Ptolemaic period are typical of Greek architecture with tiled roofs, Doric, Ionic and Corinthian architectural orders, and Greek-style dining rooms with mosaic floors.

Although the city's plan and architecture were basically Greek, some Egyptian influence is also detected. Local influence is seen in the choice of site, the orientation of the street grid, and the broad main street. The interaction of the Greek and Egyptian traditions is initially most obvious in the city's sanctuaries. This is seen as early as the reign of Ptolemy II Philadelphus who embellished the Arsinoeion with a single Egyptian obelisk. By the second half of the third century BC Greek and Egyptian features had begun to be combined both in architectural decoration and design with the development of distinctive architectural layouts in which the mixture of Greek and Egyptian influence is subtle. Two sanctuaries erected in the reign of Ptolemy III Euergetes I look Greek on the surface with classical orders but incorporate some Egyptian features. One is the Serapeum in Alexandria. The other is the royal cult sanctuary at Hermopolis Magna (el-Ashmunein) which has a new layout with the temple axially placed in a peristyle court as a result of Egyptian influence.

Ptolemy IV's dedications included a sanctuary to the Greek poet Homer as well as temples to the royal cult and local gods (Harpocrates, Isis and Serapis). His interest in both traditions is seen in his houseboat with Greek and Egyptian orders used to decorate separate dining rooms. At the same time, the amalgamation of Egyptian and classical features results in the development of the 'Egyptian *oecus*' (peristyle with a clerestory). This is later used in Roman architecture, as is the new fountain house design with semi-circular plan and colonnaded facade.

The local Egyptian tradition is seen in some temples and statuary. Egyptian temples include the temple of Osiris at Canopus, to the city's east, and apparently the temple of Isis in the city. On the other hand, the Serapeum had Egyptian statuary but in a classical architectural setting (as did at least one other of the city's temples). The importance of the Ptolemies' Egyptian identity is seen in the monumental statues of them dressed as Egyptian pharaohs and of their queens erected in front of the Lighthouse to greet travellers entering the harbour.

Although the surviving evidence indicates the plan and buildings of Ptolemaic Alexandria were largely Greek, there was a notable amount of Egyptian influence acting as a subtle stimulus on the city's architecture resulting in new developments, as will also be observed in its distinctive style of classical architecture (Ch. 5).

Cleopatra's Alexandria, and The Roman Conquest

The growth of Alexandria continued throughout the first century BC, although there are few references to the city in the classical authors early in the century. Their interest in it increases later in the century especially during the reign of the last Ptolemaic monarch Cleopatra VII when the Romans attacked the city. Roman writers and historians mention major buildings and the topography of the areas which provide the background to the events they describe, especially when fighting occurred. This gives a glimpse of the city in the final decades of Ptolemaic rule, before the conquest of Egypt by the Romans in 30 BC.

This evidence is nearly all written rather than archaeological. The texts are presented here without the overlay of later discussion (which is often based on speculation) in order to see precisely what they say. This approach is essential for evaluating them, especially those concerning the controversial subject of whether or not the Library was burnt by Julius Caesar in 48/47 BC.

The historian Diodorus Siculus gives an impression of how the city had continued to grow through the Ptolemaic period. He describes it in the decade before Cleopatra VII came to the throne. He observed (in c. 60–56 BC): 'The city in general has grown so much in later times that many reckon it to be the first city of the civilized world, and it is certainly far ahead of all the rest in elegance and extent and riches and luxury. The number of its inhabitants surpasses that of those in other cities. At the present time when we were in Egypt, those who kept the census returns of the population said that its free residents were more than three hundred thousand'.[1] The city was embellished with buildings by Alexander's successors. He had given orders to build an impressive palace, and with few exceptions his successors 'augmented this with elaborate constructions'.[2] Some of them adorned the city 'with magnificent palaces, some with dockyards (*neoria*) and harbours, and others with further dedications and notable buildings, to such an extent that it is generally reckoned the first or second city of the inhabited world'.[3]

This reference to the development of the harbours and dockyards in stages during the Ptolemaic period accords with the recently recorded archaeological evidence revealing smaller harbours or bays within the Eastern Harbour [31, 37]. This complex design probably resulted from their gradual development. However, it must be remembered that further evidence for the chronology of the various parts of them is still required. The overall design of the harbours, based on additions to pre-existing islands, breakwaters and natural harbours, contrasts with the more symmetrical single Roman harbours which were later built elsewhere, such as the port of Ostia in the mid-first century AD.[4]

Diodorus Siculus noted that the hundred feet wide *plateia*, the main east-west street, was forty stadia (*c.* 7.2 km) long. This length presumably includes when it runs past the cemeteries outside the city. He observed it 'is bordered throughout its length with elaborate constructions consisting of houses and sanctuaries (*hiera*)'.[5] The evidence for the possible appearance of some of these buildings along the main east-west street and the colonnaded courts off it is provided by the architectural fragments considered in Chapter 5.

ALEXANDRIA IN THE TIME OF CLEOPATRA VII (51–30 BC)

A number of classical authors give an impression of the city in the period leading up to the Roman conquest. They mention buildings and the city's topography as settings for Cleopatra's activities, including her involvement with Julius Caesar and the battle for the city in 48–47 BC, and later with Mark Antony and the battle of 30 BC.

The poet Lucan, writing in AD 39–65, mentions Julius Caesar's visits to the city's major monuments in 48 BC. When he entered the city 'he visited the temples of the gods and the ancient shrines of divinity which attest the former might of Macedonia. No thing of beauty attracted him, neither the gold and ornaments of the gods, nor the city walls; but he eagerly went down into the excavated vault (*effossum . . . antrum*) of the burial mound (*tumulus*)' of Alexander the Great whose limbs 'they laid in a hallowed shrine (*adytum*)'.[6] According to Lucan, Alexander was preserved 'in a consecrated vault . . . pyramids and unworthy mausolea enclose the shades of the Ptolemies and their shameful dynasty'.[7] These comments of Lucan suggest that the tomb of Alexander was underground, and that there were separate structures for the Ptolemies, presumably within the same enclosure.

Lucan gives a detailed poetic description of the lavish interior of part of the palace, built by Cleopatra or an earlier Ptolemy, where she entertained Julius Caesar to dinner: 'The place itself was like a temple . . . the panelled ceiling displayed wealth, and the beams were hidden beneath a thick coating of gold. The walls shone with marble; nor were they merely overlaid with a thin surface of it; and agate stood there on its own account, no useless ornament, and purple stone [porphyry]. Alabaster was laid all over the hall to tread on; and the ebony of Meroe, no mere covering for the great doors, took the place of common wood – a support and no mere decoration of the dwelling. Ivory clothed the hall (*atrium*); and Indian tortoise-shell, artificially coloured, was

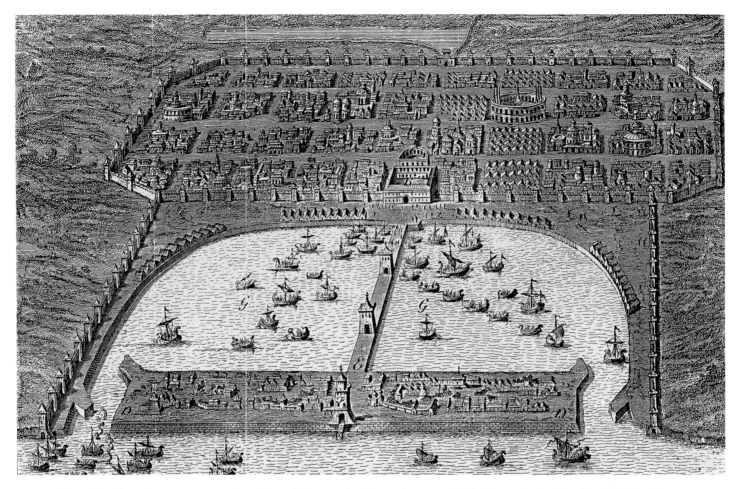

109. Alexandria, eighteenth-century reconstruction of Alexandria in 47 BC, based on passing topographical references in the *Alexandrian War* (rather than on Strabo's description)

inlaid upon the doors, and its spots were adorned with many an emerald (*smaragdus*).'[8] As Lucan was writing poetry not history, a century after the events, this description can only be used to give a general impression of the splendour of the palace and possible variety of materials used to decorate it.

The detailed accounts of the battles which were fought between the Egyptians and the troops of Julius Caesar given in his eyewitness account, and in the *Alexandrian War*,[9] provide further topographical and strategic information about the city [109]. Prior to the battles barricades were set up by both sides through the city, and the main streets (*plateae*) were broad and flat enough to move siege towers along them.[10]

Julius Caesar took refuge in part of the palace: 'Caesar, on his part, distrusted the city walls and defended himself by closing the gates of the palace (*aula*) . . . Hemmed in as he was, the whole palace (*regia*) was not at his disposal: he had gathered his forces in the innermost part of the palace (*domus*).'[11] As his opponents could not breach the gates of the palace without a battering ram, 'they assailed the palace (*regia*) also by means of ships at the point where the splendid dwelling projected with bold frontage into the middle of the sea'.[12] A further impression of the topography is given in Julius Caesar's description: 'In this region of the town there was a small part of the palace (*regia*) to which he

had first been conducted for his personal residence, and a theatre was attached to the house (*domus*) which took the place of a citadel (*arx*), and had approaches to the port and to the rest of the dockyards.'[13] It is possible that the residential part of the palace was on the promontory el-Silsila (akra Lochias). Remains of a substantial gate were found across R1, the main cross street leading to this promontory, in a location where it could have closed off the street [38, 95]. The archaeological evidence indicates that this gate went out of use in the late Ptolemaic period.[14] El-Silsila would have been supplied with water by the channel under street R1 [27]. The enemy deliberately pumped sea water into Caesar's water supply.

The descriptions of Caesar's attack provide the only indication we have of the location of the Library which seems to have been sufficiently close to the dockyards for the fire apparently to have spread to it from them. (Otherwise, the Library is assumed to have been near the Museum in the palace area, which adjoined the harbour front.) From his cornered position, cut off from his troops and fresh water, Julius Caesar set fire to the attacking ships and those in the dockyards (*navalia*).[15] According to Plutarch this fire 'spread from the dockyards (*neoria*) and destroyed the Great Library (*megale bibliotheke*)'.[16] The historian Dio Cassius later states, in the early third century AD, that 'many places were set on

fire with the result that among other buildings burnt were the dockyard (*neorion*) and the storehouses (*apothekai*) of grain and of books (*bibloi*), which it is said were of greatest number and excellence'.[17]

Some indication of the flammability of the building materials and construction techniques in the city are also given. The writer of the *Alexandrian War* observes: 'For Alexandria is well-nigh fire-proof, because its buildings contain no wooden joinery and are held together by arched constructions and are roofed with pavers (*pavimenta*).'[18] This seems to refer to the local method of construction, which was largely used for domestic architecture. However, some timber appears to have been used on public buildings because the writer later notes, when 'there was a shortage of oars: the roofs of colonnades, gymnasia and public buildings were dismantled, and their beams made to serve as oars.'[19] This would accord with the observation in Lucan's poetic account: 'Nor did the fire fall upon the vessels only: the roofs near the sea caught fire from the spreading heat, and the south winds fanned the conflagration till the flames, smitten by the eddying gales rushed over the roofs as fast as meteors . . . though they have nothing solid to feed on and burn by means of air alone.'[20] It is possible that the fire, like bush fires fanned by a strong wind, did not burn all of the buildings in its path if they were not very flammable.

The extent of the damage caused by the fire, especially to the Library, is unclear when the sources written up to two centuries or so after the event are considered. Although they mention the fire, neither Julius Caesar nor Lucan mention the burning of any books or the Library.[21] But Strabo's reference, from his visit only two decades after the event, to 'a library as large as Hipparchus himself says it was' suggests the whole collection, or much of it, was burnt.[22] Lucan's contemporary, the philosopher Seneca, writing after AD 49, comments 'forty thousand books were burned at Alexandria' from the Library which was a 'most beautiful monument'.[23] However, he does not say that this was the entire library, nor does he indicate when the fire occurred. Plutarch, writing more than a century after the event, is the earliest surviving author to state that the fire 'destroyed the Great Library'.[24] He also mentions that Antony bestowed on Cleopatra 'the libraries from Pergamum in which there were 200,000 rolls [each] containing a single author (*haploa biblia*)',[25] which suggests that perhaps the library was burnt. This would partially explain why scholarship was not 'lost' in Egypt at this date if, in fact, the main library had been burnt. Also, as in other classical cities, there would have been other libraries in temple complexes and in gymnasia.[26] The miscellanist Aulus Gellius writing over two centuries after these events, in *c*. AD 180, reports that 'an enormous quantity of books (*libri*), nearly seven hundred thousand rolls (*volumina*) . . . were all burned during the sack of the city in our first war in Alexandria, not intentionally or by anyone's order, but accidentally by the auxiliary soldiers'.[27] This apologetic tone would suggest that perhaps Caesar's silence on the subject is one of embarrassment.

Julius Caesar then moved the battle to the island of Pharos to gain control of the entry to the harbour. As he relates: 'On the island there is a tower called Pharos, of great height a

work of wonderful construction, . . . it is connected with the town by a narrow roadway like a bridge, moles nine hundred paces in length (*c*. 1.3 km) having been thrown out seawards by former kings. On this island there are dwelling-houses of Egyptians and a settlement the size of a town . . . On account of the narrowness of the passage there can be no entry for ships into the harbour without the consent of those who are in occupation of Pharos.'[28] According to Lucan the harbour was closed by a chain, like other ancient harbours.[29] This suggests that there was a breakwater, to which to attach the chain, built across the reefs running north-west from the promontory el-Silsila, as mentioned by the Jewish historian Josephus.[30] The island had 'a continuous line of lofty towers taking the place of a wall'.[31] Once Julius Caesar had taken the island he ordered the buildings on it to be demolished.

The battle moved to the Heptastadium which is described as having a bridge at either end for ships to pass from one harbour to the other. The bridge near the mainland was narrower, while the other one, near Pharos, had 'an opening for the passage of ships formed by an arch'. During the battle this was blocked with stones to prevent the passage of the ships.[32] The damage to the buildings on the island was so extensive that two decades later they still had not been rebuilt, nor had the aqueduct on the Heptastadium which supplied the island with fresh water.[33] Clearly the Heptastadium would have needed to be repaired. Consequently, the comment of the historian Ammianus Marcellinus in the late fourth century AD that Cleopatra built the Lighthouse and the Heptastadium presumably refers to her repairing them, rather than being a fable.[34]

As the supply of fresh water was essential for Julius Caesar's troops, there is a description explaining how the city's water supply functioned: 'Practically the whole of Alexandria is pierced underneath and has subterranean conduits stretching from the Nile, by which water is conducted into private houses; which water in the course of time gradually settles down and becomes clear. This is what is normally used by the owners of mansions and their households; for what the Nile brings down is so muddy and turbid that it gives rise to many different diseases. Yet the rank and file of the common sort are perforce content with the latter, inasmuch as there is not one spring in the whole city. The main stream in question, however, was in the part of the city which was held by the Alexandrians.'[35] This stream was the Canal of Alexandria (the Mahmudiya Canal) from which water was fed into the underground channels which filled the cisterns [27]. It is possible that water was pumped into them to control the flow, as later described at Arsinoe (Medinet el-Faiyum).[36] The pumping devices could have included water wheels like those which were so efficient for contaminating Julius Caesar's water supply with sea water.[37] The many large cisterns which survived from later periods are very deep, allowing for the Nile mud to settle so that the best water, which is clear, can be drawn from the top as described.

Although Julius Caesar was finally victorious, he gave Egypt to Cleopatra to rule with the young Ptolemy.[38] After his return from Egypt, Caesar is thought to have been

110. Rome, Vatican Obelisk in front of St Peter's basilica, originally erected in the Forum Julium of Alexandria (or nearby Nikopolis)

influenced by the Alexandrian library in his idea of beginning a public library in Rome, although he himself was unable to implement this project.[39] Meanwhile, there is some suggestion that Cleopatra began the construction of a building in Alexandria in honour of Julius Caesar or Mark Antony, later known as the Caesareum and dedicated to Augustus (discussed in Chapter 8). She was not responsible for the erection of the obelisks in front of it, which were later nicknamed Cleopatra's Needles.

ROMAN CONQUEST OF EGYPT IN 30 BC

In 30 BC the Roman ruler Octavian (who was later called Augustus) attacked Alexandria after his victory in the Battle of Actium in 31 BC. Much of the information about the city at that time is provided by Plutarch in his biography of Mark Antony, written more than a century after events. Octavian took up position against Mark Antony near the 'hippodrome'.[40] This is probably the area of the 'so-called hippodrome' east of the 'Canopic Gate' later mentioned by

Strabo.[41] There was an 'outer [city] gate which faced the enemy', apparently on the eastern side.[42] This suggests that there was an inner and outer set of walls on the eastern side of the city, with the second one possibly erected after the Alexandrian War.[43]

When Cleopatra heard that Antony had been defeated, Plutarch records she 'fled for refuge into her tomb (*taphos*) and let fall the drop doors, which were made strong with bolts and bars'.[44] When Antony believed she was dead he killed himself then, after some drama, Cleopatra died by the asp.[45] 'She had a tomb (*theke*) and monuments (*mnemata*) built surpassingly lofty and beautiful, which she had erected near the temple of Isis.'[46] The chamber in which she died looked out onto the sea.[47] Octavian 'allowed them both the honour of burial, in the same tomb, giving orders that the tomb (*tumulus*) which they had begun should be finished'.[48] The temple of Isis was probably the substantial Egyptian one later depicted on Roman coins minted in Alexandria [39]. The *domus* of Cleopatra, which could refer to either her tomb or the palace, is mentioned as one of the major tourist attractions of the city in *c.* AD 90/91.[49]

111. Rome, inscriptions at base of Vatican Obelisk. The original inscription recording its erection in the Forum Julium by Cornelius Gallus, Roman ruler of Egypt, in 30 BC was in bronze letters which can be reconstructed from the holes for them

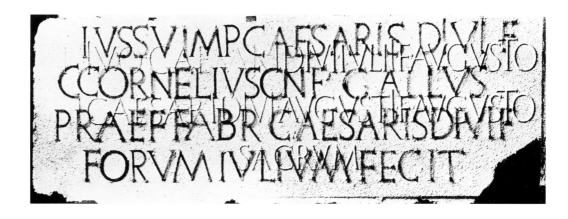

Octavian entered the Gymnasium and ascended a platform (*bema*) from which he pronounced, to the assembled crowd, on the fate of the city which he spared partly 'because he admired the great size and beauty of the city'.[50] According to the historian Suetonius, Octavian 'had the sarcophagus (*conditorium*) and body of Alexander the Great brought fourth from its shrine, and after gazing on it . . . and being then asked whether he wished to see the Ptolemaeum as well, he replied, "My wish was to see a king, not corpses".'[51] This suggests that this structure, already known as the Ptolemaieion in Greek, was the one in the complex within which the remains of the Ptolemies were kept, and that it was distinct from the tomb of Alexander. Octavian killed Cleopatra's son Caesarion[52] and gave control of Egypt to Cornelius Gallus, known for his poetry.[53] 'He reduced Egypt to the form of a province, and to make it more fruitful and better adapted to supply the city with grain, he set his soldiers at work clearing out all the canals into which the Nile overflows, which in the course of many years had become choked with mud.'[54] He founded a city which he called Nikopolis (Victory City), east of Alexandria at the site of the battle, to perpetuate the memory of his victory.[55]

The Obelisk in the Forum Julium (later the Vatican Obelisk)

The so-called Vatican Obelisk in the square in front of St Peter's basilica in Rome was apparently originally erected in Egypt in the year of the Roman conquest [110].[56] The holes for the letters of its original bronze inscription are visible between the letters of the later carved one. This original Latin inscription recorded that the Forum Julium was 'made'

by Cornelius Gallus, in 30 BC [111].[57] Regardless of whether this forum was in Alexandria or Nikopolis,[58] it involves the idea of a single obelisk being erected in the open space of a forum. This also occurred about four decades later when the obelisk from the Arsinoeion was moved to the Forum in Alexandria. The idea of the erection of a single obelisk, rather than a pair as was customary in Egyptian architecture, first occurred when Ptolemy II Philadelphus erected the one in the Arsinoeion. This Ptolemaic architectural arrangement of a single obelisk in an open area was also used in Rome in 10 BC, when Augustus used one for the gnomon of the sundial near the Ara Pacis.[59] The obelisk in the Forum Julium only remained in Egypt until AD 37 when it was moved to the Vatican Circus in Rome, by the emperor Caligula.[60]

CONCLUSION

By the time Cleopatra VII came to the throne in 51 BC, Alexandria was, besides Rome, the premier city of the 'civilized world' (the Mediterranean, Europe, and the Near East). It had continued to be developed by her ancestors who added to its harbours, palaces, and other monuments, while its population grew and it expanded. The accounts of Cleopatra's involvement with Julius Caesar and later with Mark Anthony, and of the Roman attacks on the city give further details about some buildings and their locations, especially the palace, the Library, Cleopatra's tomb, the Heptastadium, and the island of Pharos. For the details, lacking in the written sources, of the architectural style of the city of Cleopatra and her predecessors we need to turn to the archaeological evidence.

Classical Architectural Style of Ptolemaic Alexandria and Its Depiction

The style of architecture built in Alexandria under the Ptolemaic rulers in which the Greek tradition was predominant, but blended with older local features, has long been a mystery. No standing buildings or substantial fragments of buildings have survived to document it, and this type of detail is not provided by the historical sources. However, in the storerooms of the Greco-Roman Museum in Alexandria today there are many decorative architectural fragments from buildings in the Ptolemaic city that properly studied reveal far more than might be expected. Their value is enhanced when it is realized that this elusive local style is reflected in the later rock-cut architecture of Petra in Jordan and in wall-paintings at Pompeii in Italy.

These fragments in the Greco-Roman Museum include decorative details such as capitals and cornices which can be shown to be distinctive of Alexandria. They also include the earliest surviving examples of features of the 'baroque' architecture later to be found across the Roman world. In addition, the city had buildings with the traditional Greek Doric and Ionic orders. The focus here is on the new forms of classical architecture which developed in Alexandria, beginning with how they relate to earlier developments in Greece.

The influence of Alexandrian architecture is found at sites with strong political or commercial contacts with it, most notably Petra. As the architecture there has striking similarities with that depicted in Pompeian wall-paintings of the so-called Second Style, the evidence for Alexandrian architecture in them is examined. Distinctively Alexandrian architecture not only continues to be built, but also develops, through the Roman and Byzantine periods. At the same time, alongside this, there is a pictorial tradition involving the depiction of Alexandrian architecture the continuation of which is seen in the East in Byzantine and early Islamic art with architectural panoramas in wall-mosaics, and on a smaller scale in Gospel manuscripts (Ch. 14). Thus, the evidence for origins of this in Alexandrian wall-paintings of the Ptolemaic period depicting architecture with the illusion of a scene beyond the wall needs to be considered.

Because the architecture of Petra and that depicted in Pompeian wall-paintings survive as complete architectural compositions, they reveal how fragments in Alexandria would have fitted into major architectural schemes of decoration. This evidence when taken together reveals that far more may be discovered about the classical style of architecture in Ptolemaic Alexandria than had previously been appreciated. Thus, although the exact plans of many specific buildings in Alexandria, such as the palaces, gymnasium, most temples, the Museum and the Library are unknown, we have an indication of the probable appearance of these buildings at a general level of their architectural style.

CHRONOLOGY OF THE ARCHITECTURAL FRAGMENTS IN THE GRECO-ROMAN MUSEUM, ALEXANDRIA

There are over two hundred published architectural fragments in the Greco-Roman Museum, although most are no longer on display [112–113].[1] As most of these fragments were stray finds, it had generally been assumed that there was no reliable basis on which to date them. However, a detailed re-examination of them reveals that some came from specific buildings or tombs. It also reveals that, while it is not possible to date the tombs within a quarter of a century, it is generally clear whether they are Ptolemaic (third or second century BC), rather than Roman (first or second century AD). Some of the architectural fragments from buildings may then be dated by comparison with similar examples from tombs of known date.

112. Alexandria, Ptolemaic architectural fragments in Greco-Roman Museum in c. 1910

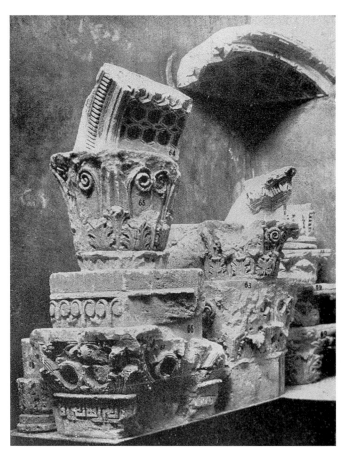

a. Entablature with Doric frieze, dentils, and modillion cornice

b. Cornice fragment

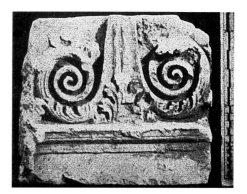

c. Frieze fragment

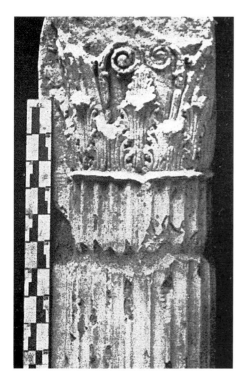

d. Type I Alexandrian capital

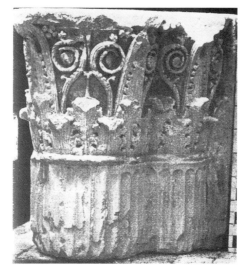

e. Type III Alexandrian capital

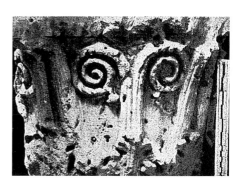

f. Type II Alexandrian capital

113a–f. Alexandria, Chantier Finney building in palace area, architectural fragments reproduced at about the same scale. Greco-Roman Museum

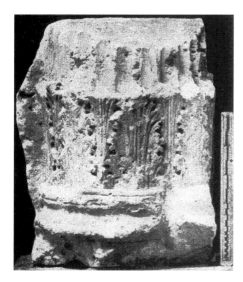

g. Acanthus column base

As this detailed re-examination of the chronology of the tombs in Alexandria and the architectural fragments from buildings has been presented elsewhere, it will not be repeated here at length.[2] Rather a couple of examples will be given. An important group of fragments from the 'Chantier Finney', in the palace area, were found together (location marked on [38]) and appear to have come from one building, based on their sizes and stylistic details [113].[3] These may be dated by comparison with the evidence provided by the tombs at Moustapha Pasha. Tomb 2 at Moustapha Pasha is dated to about the second century BC, on the evidence for the coins, pottery and epigraphy found in it. Tombs 1 and 3 at Moustapha Pasha are slightly earlier. Based on a comparison with these, the group of fragments from the Chantier Finney building may be dated to about the second century BC or slightly earlier.[4] A pediment and pilaster come from Tomb A at Shatby which was in use during the third century BC [114].[5]

Once it has been shown that a substantial number of the architectural fragments in the museum are dated to the

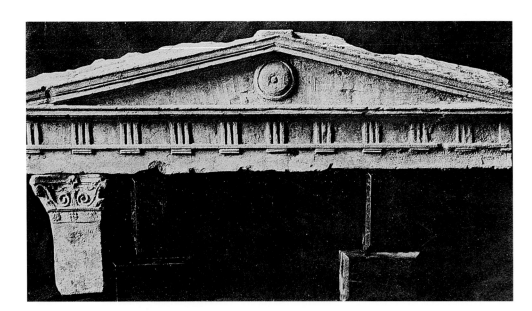

114. Alexandria, Shatby, Tomb A, pediment and pilaster

Ptolemaic period, it becomes clear that there is a remarkable consistency in their details and the resultant picture they present. Thus, it is possible from them to define specific capital and cornice types as distinctively Alexandrian. They also indicate that the earliest examples of new baroque structural features, such as half-pediments and curved entablatures, survive from Ptolemaic Alexandria.

Before discussing these distinctive features and their possible origins, consideration should be given to the use of the traditional Greek Doric and Ionic orders in Alexandria. It is

115. Doric order

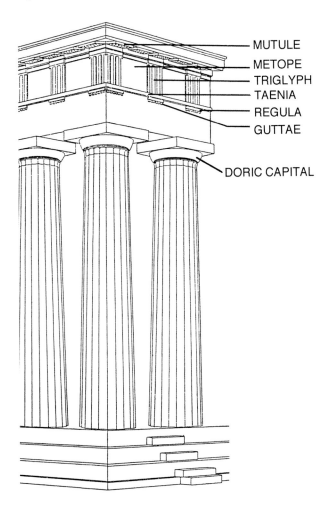

MUTULE
METOPE
TRIGLYPH
TAENIA
REGULA
GUTTAE

DORIC CAPITAL

116. Ionic order

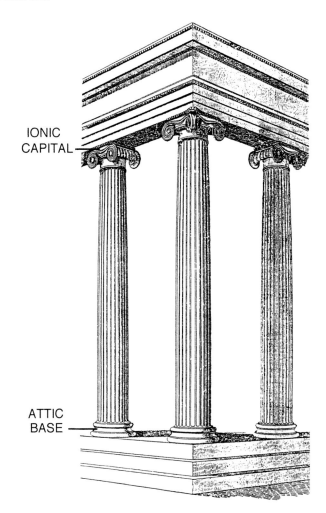

IONIC CAPITAL

ATTIC BASE

FLAT GROOVED MODILLION
SQUARE HOLLOW MODILLION

117. Alexandrian Corinthian order: underside of corona

fruitful to consider the Greek architecture in the fourth and third centuries BC elsewhere, in order to explore how the developments in Alexandria relate to it. For convenience the term Aegean Greece will be used to denote sites in mainland Greece, the Aegean islands and the west coast of Asia Minor in modern Turkey, marked on Maps 4–5. The architectural orders are illustrated in [115–118].

DORIC AND IONIC ORDERS

As at other Greek sites, some buildings in Alexandria were built with the traditional Doric and Ionic orders, as reflected by fragments in the Greco-Roman Museum and displayed at

118. Roman Corinthian order

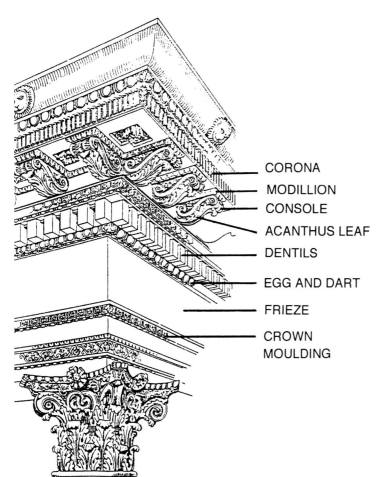

CORONA
MODILLION
CONSOLE
ACANTHUS LEAF
DENTILS
EGG AND DART
FRIEZE
CROWN MOULDING

Kom el-Dikka.[6] Some of these fragments came from buildings of which the foundations also survived. These include the large limestone and marble building in the palace area which had Doric and Ionic capitals and entablatures (location marked on [38]). These were on two major exterior colonnades each a single storey high [91–94].[7] The stonemasons' marks on them are in Greek, but use the Egyptian method for recording fractions.[8] These blocks are dated to the late third century BC[9] and the details of their Doric and Ionic capitals are close to those of contemporary architecture at other Greek sites such as Olympia, Delos and Didyma.[10] The orders of this building in the palace area also have details related to the sanctuary of the third quarter of the third century BC up the Nile at Hermopolis Magna (el-Ashmunein) [74].[11]

Another Doric building in Ptolemaic Alexandria with some foundations in situ was the stoa at right angles to the main east-west street (location marked on [38]). Like the building in the palace area it seems to have had a Doric frieze with two metopes between each pair of columns. This number of metopes results in a more monumental stoa with larger columns than normally achieved by the usual Hellenistic custom of placing three metopes between the columns.[12]

Doric and Ionic orders are also used as engaged orders carved in some of the Ptolemaic tombs in Alexandria, such as Tomb A at Shatby, the tomb at Sidi Gaber and Tombs 1 and 2 at Moustapha Pasha [101, 106]. The shape of the Doric capitals on these follows contemporary developments at other Greek sites.[13]

The Doric and Ionic orders in mainland Greece and Asia Minor were very standardized in the third century BC and so it is not surprising that the examples in Egypt are closely related to them. By contrast, in this period, the Corinthian order was only in the early stages of development in Aegean Greece. It had not yet evolved into a standardized form. Perhaps this facilitated the development of a distinctive form of it in Alexandria.

CORINTHIAN ORDER

It is first desirable to summarize the development of the Corinthian order in the fourth and third centuries BC in Aegean Greece to provide a context for the developments in Alexandria. This examination of the Corinthian order is necessary before arguing that Alexandria developed its own form of classical architecture, including distinctive capital and cornice types. From this it will be possible to see how an Alexandrian form of the Corinthian order emerged which was different from the later Roman one [118]. The evolution of this distinctive local form of classical order also makes the appearance of a precocious baroque architecture in Ptolemaic Alexandria less surprising.

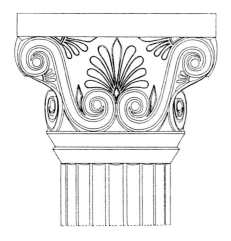

119. Olympia, 'Double volute' capital, fifth century BC

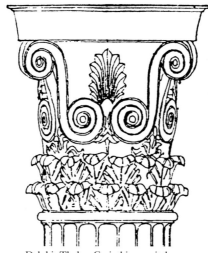

120. Delphi, Tholos, Corinthian capital, *c.* 375 BC

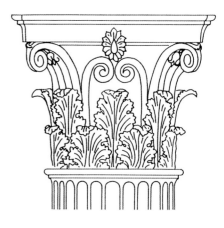

121. Epidaurus, Tholos, Corinthian Capital, *c.* 340 BC

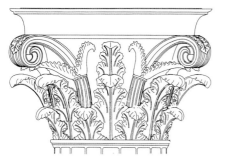

122. Tegea, temple of Athena Alea, Corinthian capital, *c.* 340 BC

123. Samothrace, Propylon of Ptolemy II (285–246 BC), Corinthian capital

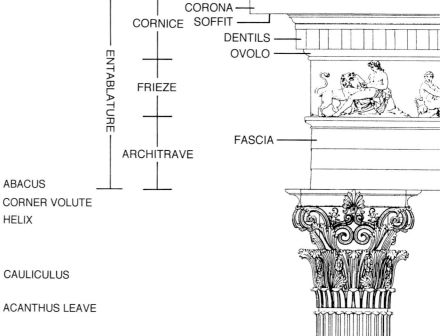

124. Athens, Monument of Lysikrates, Corinthian capital with Ionic entablature, with architectural terms, *c.* 334 BC

Corinthian Order in Greece
in the Fourth and Third Centuries BC

The main feature of the Corinthian order is its capitals which are characterised by a collar of acanthus leaves and volutes on the corners, usually with scrolls or helices between them [123]. The features which most distinguish between the different types of Corinthian capitals are the shape and treatment of the helices.

The Corinthian capitals which occur in Aegean Greece during the fifth to third centuries BC are of a variety of types

[119–124].[14] The earliest known Corinthian capital survived in the Greek mainland from the temple of Apollo at Bassai, *c.* 430–400 BC. It had a collar of acanthus leaves, and corner volutes with flat spirals between them.[15] The capitals on the circular building (tholos) at Delphi, of *c.* 375 BC, have the corner volutes continuing into back to back spirals [120].[16] The fifth-century 'double volute' capital from Olympia is similar, but without a collar of acanthus leaves [119].[17]

The so-called Epidauran type occurs on the tholos at Epidauros *c.* 340 BC and later on other buildings at Epidauros.[18] It is characterized by helices which spring directly from the

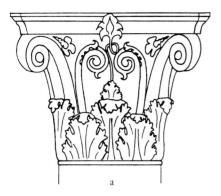 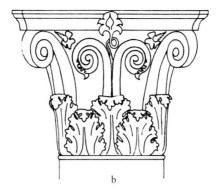 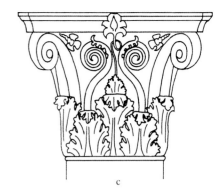

125a–c. Alexandrian Corinthian capitals: (a) Type I; (b) Type II; (c) Type III

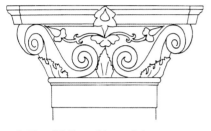

126. Type IV Alexandrian capital

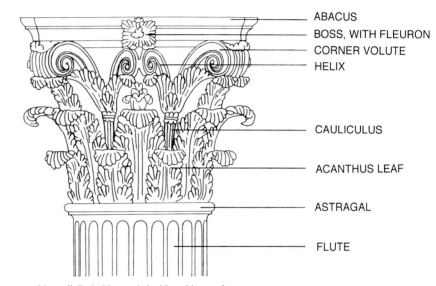

127. 'Normal' Corinthian capital with architectural terms

collar of acanthus leaves, as do the volutes [121]. Some examples of *c.* 340–330 BC, such as those on the temple of Athena Alea at Tegea [122], have the corner volutes covered by a ribbed sheath called a 'cauliculus' with a small acanthus leaf at the top of it, from which the corner volute curls, but these capitals lack helices.[19] In Athens, on the Monument of Lysikrates of *c.* 334 BC, the helices and corner volutes spring together from the one leaf which is wrapped around them [124].[20]

The earliest so-called Normal Corinthian capitals occur at Samothrace on the Rotunda of Arsinoe, *c.* 299–270 BC and the Propylon of Ptolemy II Philadelphus, the Ptolemaion, *c.* 285–246 BC.[21] These are characterized by the helices and corner volutes springing together from the one sheath, or cauliculus [123]. This contrasts with the Epidauran type on which the helices and corner volutes spring separately from the collar of acanthus leaves [121].[22] The 'Normal' Corinthian capital is the form which later is taken over and standardized by the Romans, hence its name [127].[23]

In this period of evolution of the Corinthian capital in Aegean Greece there was no distinctive Corinthian entablature. Consequently, when one was required, an Ionic entablature was used. These Ionic entablatures generally had dentils and they had a plain soffit on the underside of the corona, as seen on the Monument of Lysikrates in Athens [124] and the Propylon of Ptolemy II at Samothrace.[24]

The first dated brackets, called modillions, on the underside of the cornice do not appear in Greek architecture until the first half of the second century BC.[25] These are wide and flat with vertical sides. Their underside later becomes slightly curved. When used in the Roman empire modillions are much more ornate, being decorated with consoles with an acanthus leaf along them [118].

As the discussion indicates, in the late fourth and third centuries BC in Aegean Greece there was a great variety of Corinthian capitals, and the Corinthian entablature had not yet developed. Thus, in the period leading to the development of the distinctively Alexandrian form of Corinthian order, as there was not yet a standardized form in Greece or Asia Minor this could have contributed to the development of the new form in Alexandria. The Greek architects there might have felt less constrained by conventions for the form of the Corinthian order than with the use of the already standardized Doric and Ionic orders. The characteristic features of the Alexandrian version and their possible origins will now be considered.

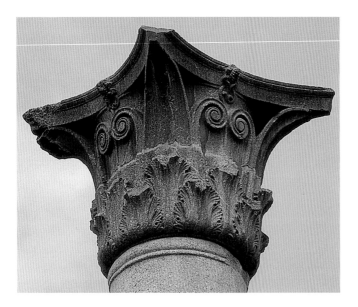

128. Alexandria 'Khartoum Monument', large basalt Type I capital carved on two blocks, third century BC. h. 1.38 m

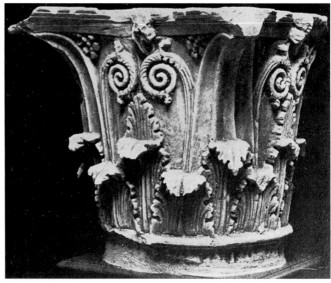

129. Alexandria, Hadra (Sharia Abukir), one of three almost identical large limestone Type I Alexandrian capitals. h. 0.59 m. Greco-Roman Museum

Alexandrian Corinthian Order

The Corinthian capitals surviving in Alexandria from the Ptolemaic period have been divided into a number of distinct types by Ronczewski.[26] Each of his Alexandrian Types I–III is distinguished by the arrangement of the helices [125]. Types I to III are related to the Epidauran type [121], because, like it, the Alexandrian ones have the helices springing directly from the collar of acanthus leaves. On the Type I capitals the helices are facing each other [125a]. On Type II the helices are back to back [125b]. On Type III the helices are also back to back but spring from further apart [125c]. The surface decoration of some of the helices on the Alexandrian capitals is distinctive with the spiral covered by a small leaf which curls back, and the spiral is twisted and terminates in a circular blob. Examples of Type I, II and III capitals survive from the 'Chantier Finney' building of c. second century BC [113d–f]. There are also many other examples in the Greco-Roman Museum collection from the third to first

centuries BC of which only a few are illustrated here [128–133]. Some are dated to the third century BC [128–130], like the example found at the Serapeum site [69], while the examples from Tomb 2 at Moustapha Pasha [131] are dated to the second century BC from their archaeological context.[27]

The Type IV Alexandrian capitals [126] are related to the earlier 'double volute' capitals in Greece, such as the example from Olympia [119]. Like it, they are characterized by the corner volutes continuing into spirals back to back in place of the helices, and do not have a collar of acanthus leaves. They frequently have a necking band, often decorated with rosettes. They are most commonly used on pilasters.[28] The earliest dated Type IV capital occurs on the small pilaster from Tomb A at Shatby of the third century BC [114, 134]. They are depicted in the tomb at Sidi Gaber of the third century BC [173]. Other Ptolemaic examples survive in Alexandria including two very finely carved examples of marble which both apparently came from the one building in the palace area [135].[29]

130. Alexandria, top drum of limestone Type I Alexandrian capital. h. 0.49 m. Greco-Roman Museum

131. Alexandria, Moustapha Pasha, Tomb 2, in fill, limestone small Type I Alexandrian capitals on pillar. h. 0.78 m. Greco-Roman Museum

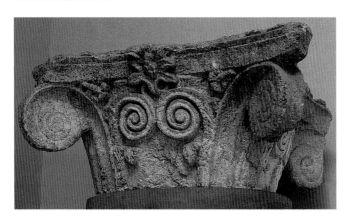

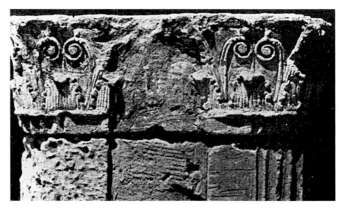

132. Alexandria, small limestone Type
II Alexandrian capitals. h. 0.22 and
0.38 m. Greco-Roman Museum

133. Alexandria, limestone small Type
III Alexandrian capital. h. 0.14 m.
Greco-Roman Museum

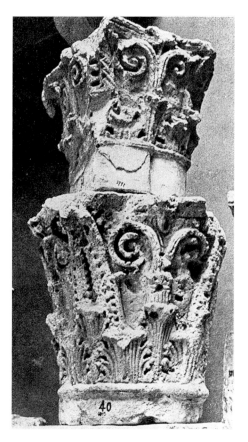
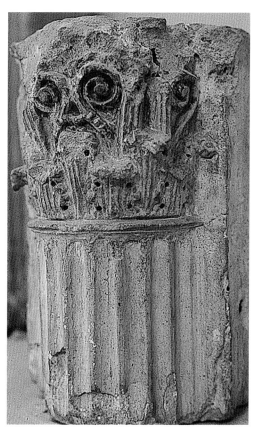

An acanthus column base above an attic base supported one of the Corinthian columns on the Chantier Finney building of *c.* second century BC [113g].[30] These acanthus bases were common in Alexandria [136–137] and are found later at other sites. The idea for them was probably influenced by Egyptian architecture, in which the lower leaves of plants, such as the papyrus, were depicted around the lower part of the column [201a–b, 202]. The base below the acanthus base is an attic base (consisting of a torus, cavetto and torus) [113g, 137]. This form, which goes back to the bases as used on the Ionic order in Athens in the late fifth century BC [116], is used as the standard form of base for the Corinthian order in Alexandria.

The modillion cornices in Alexandria are very distinctive because of the shape of their modillions. These are narrow

134. Alexandria, from Shatby Tomb A, Type IV Alexandrian capital

135. Alexandria, palace area, one of a pair of large marble Type IV Alexandrian capitals. h. 0.62 m. Greco-Roman Museum

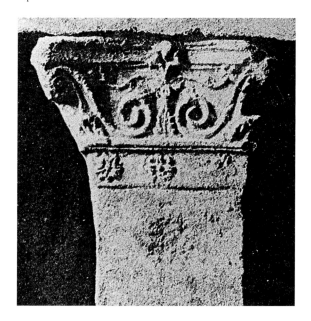
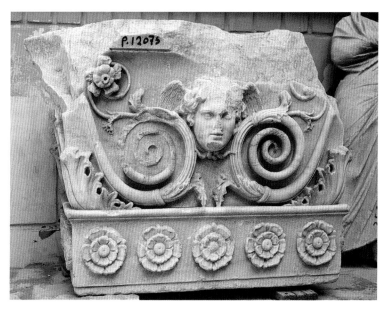

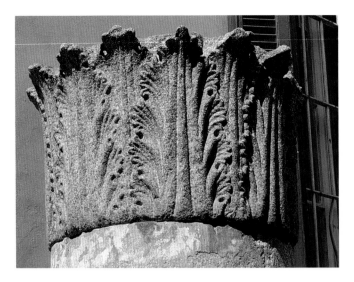

136. Alexandria, large granite acanthus base, third century BC. h. 0.55 m. Greco-Roman Museum

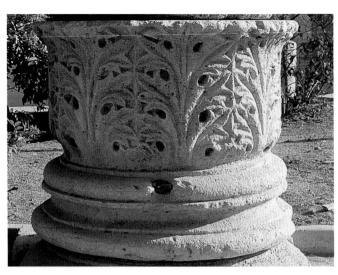

137. Alexandria, acanthus base with attic base

with a deep groove along them, and their lower surface is flat with splaying sides [117]. From their shape it is possible to see their origin influenced by the roof-beams of Egyptian tombs, as early as the twelfth dynasty in the rock-cut example at Deir Rifa [138].[31] Sometimes, rather than just the flat grooved modillions, there are square hollow modillions used

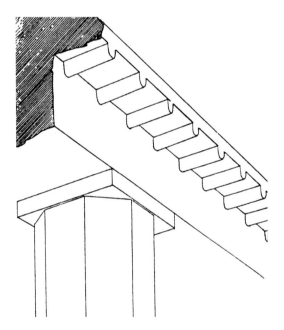

138. Deir Rifa, rock cut cornice, twelfth Dynasty

139. Alexandria, Gabbari (Fort Saleh) Trier Tomb 3, modillion cornice, and blocked out Type IV capital

140. Alexandria, cornice with narrow flat grooved and square hollow modillions

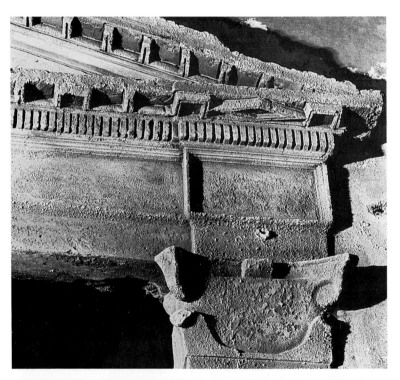

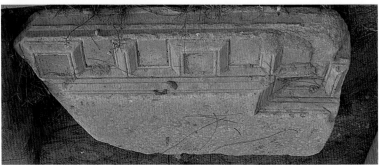

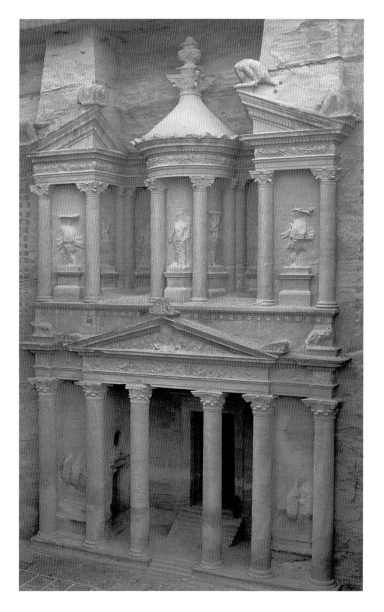

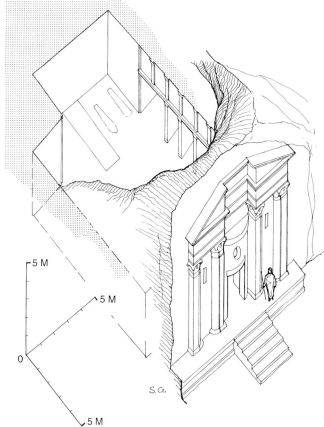

141. Petra, Khasneh

142. Petra, Tomb of the Broken Pediment. (Sheila Gibson)

alternately with them [139–140]. Modillion cornices occur by the second century BC, as on the Chantier Finney building [113b]. Many examples of narrow flat grooved and square hollow modillions survive in Alexandria. They are distinctive to the architecture of Alexandria and they are found only at sites influenced by it.[32]

These modillion cornices in Alexandria were often used above a Doric frieze,[33] sometimes with Ionic dentils between them and the frieze, as observed on the Chantier Finney building [113a]. On it, this entablature seems to have been used above Corinthian capitals. The combination of Corinthian capitals with a Doric frieze was not used in Aegean Greece.

A Doric frieze was also used with Corinthian capitals on the pediment from Tomb A at Shatby in Alexandria [114]. Depictions on coins show a Doric frieze above Corinthian capitals on the temple of Serapis, built by Ptolemy III Euergetes I, 246–222 BC [70]. The use of Corinthian capitals to support a Doric frieze, sometimes with dentils and a modillion cornice, became characteristic of the Alexandrian form of the Corinthian order. It remained common in the classical architecture of Egypt, occurring even in the Roman period.

The fragments from Corinthian orders in Alexandria have survived from a variety of structures, as indicated by their sizes and materials. The materials range from local limestone to marble, or hardstones, such as diorite and red and grey granite. The column capitals which survive are generally from free-standing buildings, not tombs. As the tombs were rock-cut, usually the architectural orders in them were engaged, being either pilasters or half-columns, not free-standing columns. The larger capitals and bases come from monumental buildings, such as the very large basalt capital and a grey granite acanthus base [128, 136], as well as large limestone and marble capitals [129–130, 135]. Many fragments are carved in local limestone which varied from very fine to coarse grained and was often painted, especially if it was used for orders which were employed for interiors. These are generally smaller, such as those from the Chantier Finney building in the palace area [113d–f]. The interior orders on it were of very fine limestone and brightly painted, as were

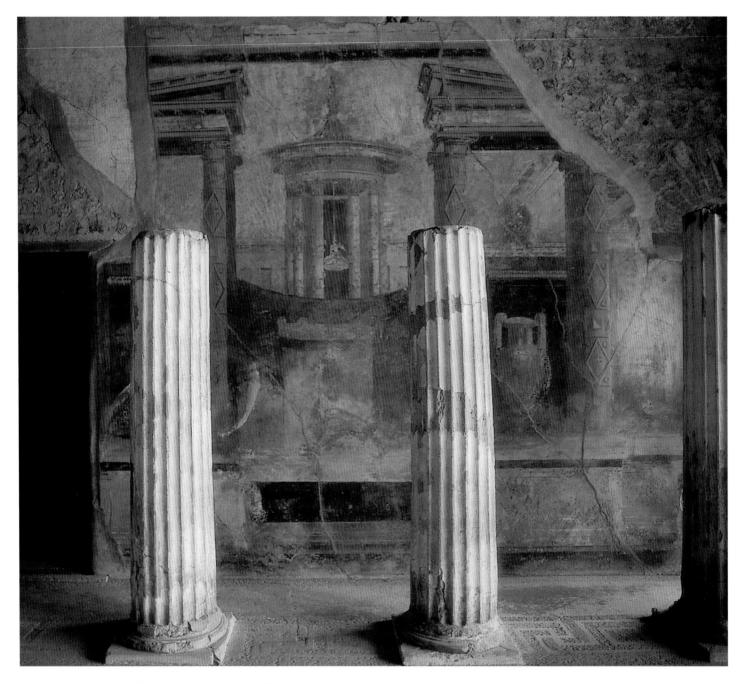

143. Pompeii, House of the Labyrinth, *oecus* 43, right side wall

other capitals in the Greco-Roman Museum on which traces of paint survive [133].[34]

The capitals are sometimes carved using two drums (of about equal height) rather than a single drum, as was also customary on the Egyptian style examples. Hellenistic and Roman Corinthian capitals outside Egypt are almost always carved from a single drum. This use of two drums most commonly occurs on larger capitals of limestone, as it is more appropriate to the material [130]. However, it is also sometimes used on local hardstone, such as basalt [128] and later observed at Philae on the temple of Augustus [288]. Some capitals carved in Egyptian hardstones, such as basalt, despite the hardness of the stone, have naturalistic acanthus leaves (more easily carved in marble or limestone) [128]. Similar high quality naturalistic carving was achieved in granite, as on the acanthus column base [136].[35] This capital and base, both dated to the third century BC, reflect the use of local Egyptian technology for high quality carving of hardstones already used for Egyptian sculpture, but achieving a result which is completely Greek in style. It is not known if these blocks were carved by Egyptian workmen giving a Greek result or by Greek workmen using Egyptian techniques.

Thus, just as the Doric and Ionic orders in Alexandria survived from free-standing monumental buildings, as well as tombs, fragments from the Corinthian order survived largely

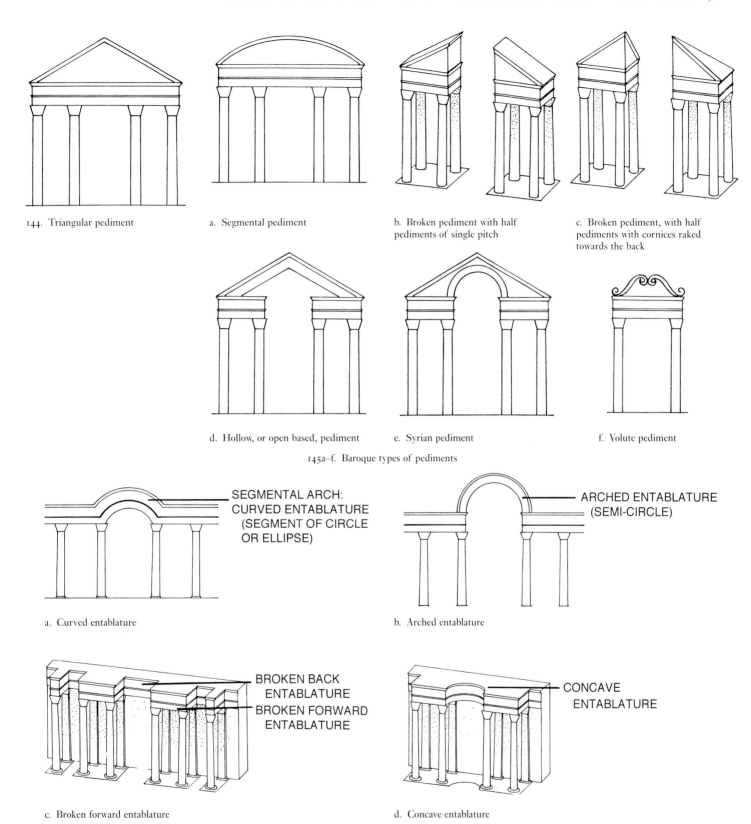

144. Triangular pediment

a. Segmental pediment

b. Broken pediment with half pediments of single pitch

c. Broken pediment, with half pediments with cornices raked towards the back

d. Hollow, or open based, pediment

e. Syrian pediment

f. Volute pediment

145a–f. Baroque types of pediments

a. Curved entablature

b. Arched entablature

c. Broken forward entablature

d. Concave entablature

146a–d. Baroque forms of entablatures

from buildings, not just tombs. The development of the distinctive form of Corinthian order reflects a period of innovation in classical architecture in Ptolemaic Alexandria which provides a background to the developments which also occurred there in baroque architecture. The evidence from the city itself for this baroque architecture will be considered before discussing the reflection of Alexandrian architecture at other sites. The examples at Petra and Pompeii in particular will provide an indication of how these architectural fragments might have looked when reconstructed into complete buildings [141–143].

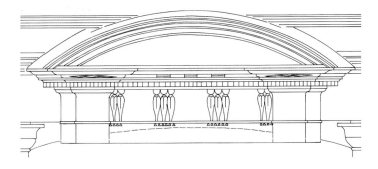

147. Alexandria, Gabbari, Thiersch's Hypogeum 2, segmental pediment

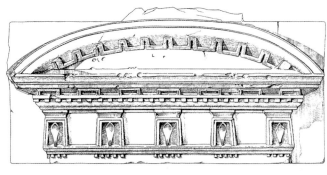

148. Marsa Matrouh, segmental pediment. Alexandria, Greco-Roman Museum

BAROQUE ARCHITECTURE OF PTOLEMAIC ALEXANDRIA

The fragments in the Greco-Roman Museum in Alexandria include the earliest surviving examples of baroque forms of pediments and entablatures, such as broken pediments, segmental pediments and arched entablatures. However, before considering these it should first be explained what is meant by the term 'baroque' in this context.

The tectonic nature of Greek architecture exemplified by the Doric temple, such as the Parthenon in Athens (*c.* 447–432 BC) involves the use of a post and lintel system in which each member has a specific, but inter-dependent, structural purpose. For example, a column is a free-standing vertical member which supports a horizontal member, an architrave or an entablature. If the columns were removed the entablature would collapse.

By contrast, baroque architecture of both antiquity and the sixteenth and seventeenth centuries, exemplified by the

149. Praeneste (Palestrina) Nile mosaic, detail of temple with segmental pediment and reed hut

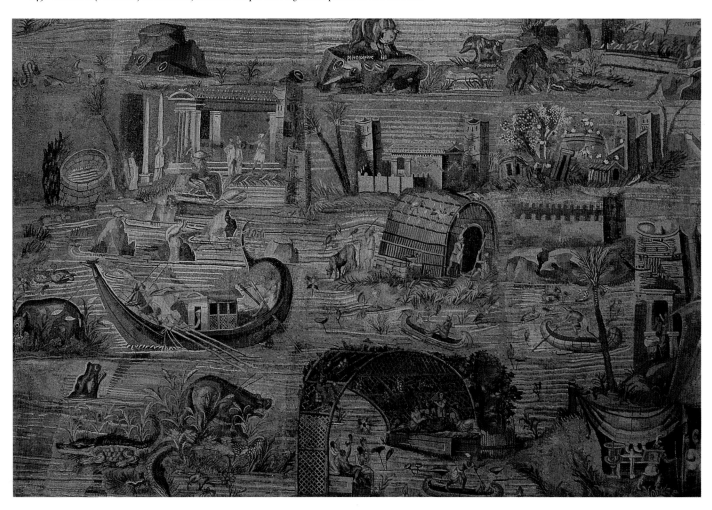

150a–b. Alexandria, fragment of a half pediment with flat grooved modillions. Greco-Roman Museum

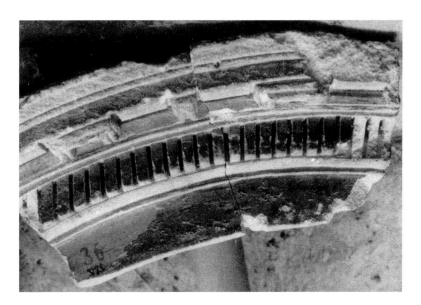

151. Alexandria, fragment of a curved entablature. Greco-Roman Museum

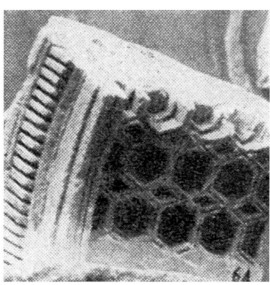

152. Alexandria, fragment of an arched entablature with a barrel vault behind. Greco-Roman Museum

Khasneh at Petra [141] and S. Carlo alle Quattro Fontane in Rome, involves two specific structural aspects: the use of structural members as surface decoration and the use of new forms of pediments and entablatures.

The use of structural members as surface decoration involves engaged columns, pilasters, and quarter columns. As they are only decoration, if they were removed the architrave would remain standing, being supported by the wall. This use of structural members as surface decoration occurs in Greek architecture by the fifth century BC.[36] In all the Greek examples, including those of the third century BC, if the wall between these engaged members were removed, it would be possible, using a post and lintel system, to build the columns and entablature which would be left. In this system, niches and doorways may be framed by their own entablature and pilasters.

The other structural aspect of baroque architecture is the use of new and more complex forms of pediments and entablatures [145–146]. It is the development of this aspect which seems to have occurred first in Alexandria, where the earliest examples of the baroque forms of pediments and entablatures survive, including the half-pediment and curved entablature [150–151]. In the post and lintel system of a conventional Greek temple the pediment takes the shape of a triangle reflecting the ridge roof formed by straight beams [144]. The baroque forms of pediments and entablatures break away from this system. The new forms of pediments include broken pediments, hollow pediments, segmental pediments, broken forward pediments and volute pediments [145].[37] The entablature is no longer always straight but may be broken forward or curved upwards or inwards [146]. These baroque forms are used not only in the principal orders but also for framing niches.

Local Egyptian architecture apparently provided the stimulus for the development of the segmental pediment, curved entablature, broken pediment, and hollow pediment. Once the traditional Greek system had been broken down further developments could occur.

Many examples of segmental pediments, formed by a curve in place of the triangle [145a], survive in Alexandria framing doorways or niches, as on Tomb 2 at Anfoushy, Thiersch's Hypogeum 2 at Gabbari, and an example from Marsa Matrouh [88, 147–148]. Segmental pediments are also

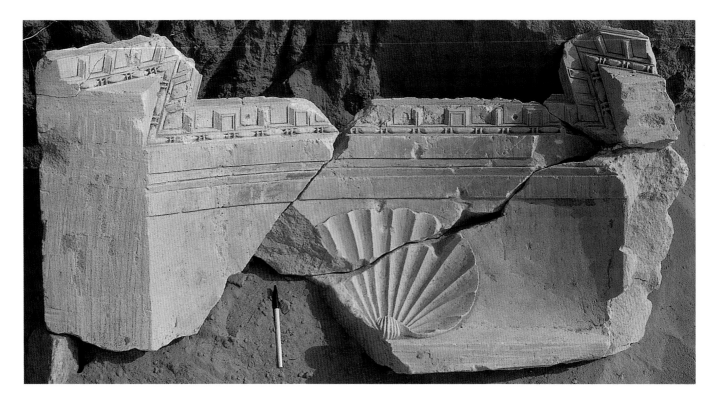

153. Marina el-Alamein, niche head with broken pediment

used for the principal pediment of temples depicted on the Praeneste (Palestrina) Nile mosaic of about the late second century BC [89] and on coins from Roman Alexandria, such as a temple of Isis on one of Antoninus Pius [87]. Timber roofs of this shape might have been used on the birth houses and kiosks built in the Egyptian style.[38] It has been suggested that the shape of the segmental pediment arose from the influence of local Egyptian building materials, like the bent canes on structures such as the reed hut depicted on the Praeneste mosaic [149].[39] Once the beams were no longer considered rigid, the entablature could also be curved inwards forming a concave entablature [146d], or upwards resulting in a curved entablature [146a] or an arched entablature [146b], as in the example illustrated with a vault behind it decorated with coffering [152]. Once the entablature no longer has always to be straight, new forms result. It may be broken forward over pilasters or columns [146c].

A broken pediment consists of two half-pediments [145b–c], while a hollow pediment is formed by the lack of a continuous entablature [145d]. The half-pediments are of two types. One is similar to a short section of roof of single pitch [145b, 150]. These can be free-standing or joined by horizontal cornices [142]. The second type has cornices raked in two directions with the pediment sloping down towards the back [145c, 141]. It has been argued that the idea for the broken entablature on the hollow pediment, and for the broken pediment, arose from the broken lintel on Egyptian temple entrances [200, 224].[40]

Examples of broken pediments, concave entablatures, curved entablatures, and arched entablatures survive in the Greco-Roman Museum [112, 150–152]. The Hellenistic date of these examples of new baroque forms is based on their long narrow dentils.[41] Note that they also have the distinctive Alexandrian square hollow and flat grooved modillions. Having seen the development of a distinctive form of the Corinthian order in Alexandria, the development of this new baroque architecture there should come as less of a surprise.

The features of distinctively Alexandrian architecture continued in Egypt not only into the first and second centuries AD but until as late as the sixth century (Ch. 9 and 11). For example, at Marina el-Alamein, near the site of the World War II battle about one hundred kilometres west of Alexandria, a niche head was uncovered which had a broken pediment framing a conch [153–154].[42] It is decorated with flat grooved and square hollow modillions. It has been suggested that it dates to the first century AD. There are flat grooved and square hollow modillions on second-century buildings [387], while there are many niche heads with broken pediments and flat grooved modillion cornices in Late Antique Egyptian architecture [432, 436].

As will be discussed below, broken pediments and other baroque forms are used in Roman architecture outside Egypt in the first and second centuries AD but, notably, without the distinctive Alexandrian types of capitals and cornices [186–187]. However, beyond the Roman period baroque forms of pediments continue only in Egypt, where broken pediment niche heads are carved as late as the fifth and sixth centuries AD [507]. The strength of continuity of the broken pediments in Egypt possibly relates to its local origin.

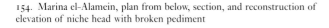

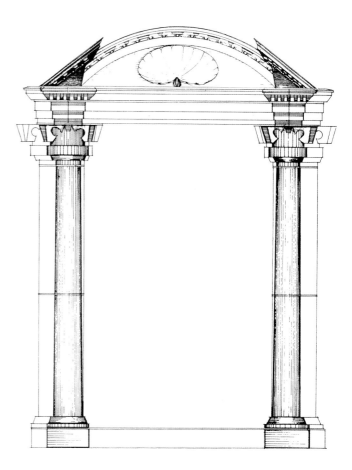

154. Marina el-Alamein, plan from below, section, and reconstruction of elevation of niche head with broken pediment

ALEXANDRIAN STYLE ARCHITECTURE BUILT AT SITES OUTSIDE EGYPT

The distinctively Alexandrian style of architecture was built at some sites outside Egypt which were, or had been, under Ptolemaic political control or influence. As these buildings are generally considerably better preserved than those in Alexandria they also provide additional information about them.

Of particular importance is Qasr il ʿAbd, the fortress Tyros at ʿIraq el-Amir in Jordan, because it is reliably dated to the early second century BC [155].[43] Much of it has survived still standing and it has been possible to rebuild it to nearly the top of the upper order.[44] It has Alexandrian decorative details, such as Type II and III Corinthian capitals and acanthus column bases [156–157]. Corinthian capitals support a Doric frieze,[45] following the Alexandrian custom of combining these two orders [156]. The basic unit of the building's design is the Egyptian (and Ptolemaic) cubit of 0.525 m.[46] Hyrcanus, who built Qasr il ʿAbd, had connections with Alexandria as he had visited the court there and received royal support.[47] As this building is securely dated, it confirms the existence by the early second century BC of features of distinctively Alexandrian architecture already suggested by sometimes less firmly dated evidence from the city itself.

At other sites under Alexandrian influence there is a strong continuity of its architecture, especially in two areas which remained under Ptolemaic control in the second century BC: Cyrenaica in modern Libya in North Africa, and on the island of Cyprus.

The Palazzo delle Colonne at Ptolemais in Cyrenaica has Alexandrian types of Corinthian capitals (Types I and IV) and cornices with square hollow and flat-grooved modillions.[48] It also has baroque structural features, such as broken pediments, decorated with Alexandrian narrow flat grooved modillions [160]. Sufficient fragments survive to reliably reconstruct the aedicule facade in which these features were used [158] on the interior upper storey of the palace's main colonnaded court [258]. This facade had Type I Alexandrian capitals [159]. The chronology of this building is complex because it was repaired in the first and second centuries AD. However, some of its features are reliably dated to before c. 80 BC, as possibly is the aedicule facade (based on its capitals).

At Apollonia in Cyrenaica a variety of Alexandrian Corinthian capital types are used together on the peristyle of the 'Roman Baths' in the first century AD.[49] The use of different Alexandrian capitals (Types I-III) together on the one colonnade also seems to occur in Alexandria on the Chantier Finney building [113d–f]. The idea of using a variety of capitals on the one colonnade is also found in Ptolemaic Egyptian style architecture [219], in contrast to Greek and Roman architecture elsewhere in which only a single capital type is used on the one colonnade.

On Cyprus Alexandrian Corinthian capital and cornice types are used from the third century BC until the late first century AD.[50] A local form of architecture develops with blocked out capitals derived from Alexandrian ones. This also occurs in the Nabataean architecture of Petra in Jordan. In

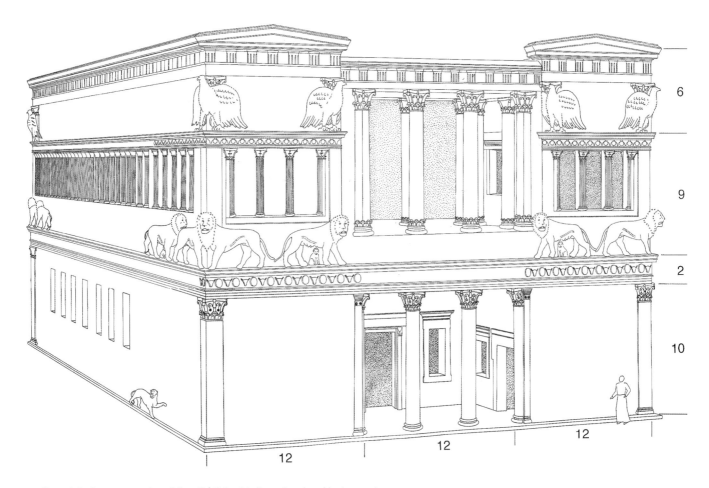

155. ʿIraq el-Amir, reconstruction of Qasr il-ʿAbd, with dimensions in cubits (0.525 m)

both Cyprus and Nabataea blocked out capitals are used as a finished form. However, in Alexandria and elsewhere in Egypt blocked out forms are also sometimes used as the finished form, such as the capitals on the niche from Marina el-Alamein [154]. As the details of the shape of these blocked out capitals are distinctive to each country those in Egypt and Cyprus cannot accurately be called Nabataean capitals.[51] However, Nabataean architecture in particular is characterized by the frequency of the use of blocked out capitals as the intended finished form.

Alexandrian Influence on the Architecture at Petra

The site where the most architecture survives with orders exhibiting Alexandrian influence is Petra. It was the capital of the Nabataean kingdom which encompassed part of modern Jordan and northern Saudi Arabia, until its annexation by the Romans in AD 106. Although never under Ptolemaic rule, Petra had extensive commercial contacts with Alexandria because of the Nabataean monopoly of the trade in frankincense and myrrh. This provided the wealth which funded its many free-standing buildings and rock-cut facades, most of which were built during the first century BC and first century AD. The clarification of the chronology of these monuments,[52] as well as the dating of the architectural fragments in Alexandria to the Ptolemaic period and the establishment of their characteristic features has made it possible to demonstrate convincingly that the architecture of Alexandria was the chief source of the classical aspects of the architecture at Petra.[53] This was suggested as early as 1932 by Ronczewski in his study of the capitals on the most famous monument at Petra, the Khasneh [141],[54] now known from

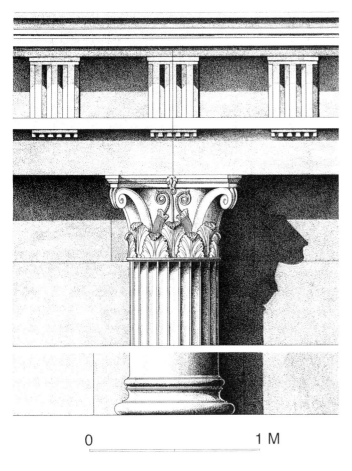

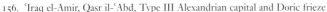

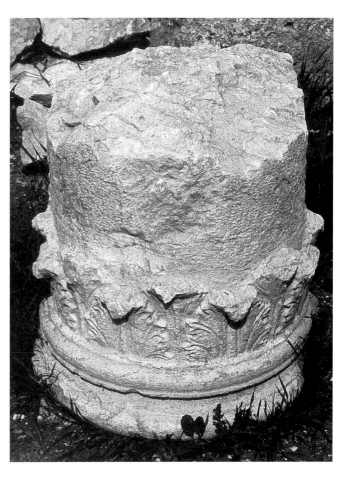

156. ʿIraq el-Amir, Qasr il-ʿAbd, Type III Alexandrian capital and Doric frieze

157. ʿIraq el-Amir, Qasr il-ʿAbd, acanthus column base

archaeological evidence to have been carved by the end of the first century BC (or very beginning of the first century AD).[55] As the Alexandrian influence at Petra is demonstrated in more detail elsewhere,[56] and as it is accepted by scholars of Nabataean architecture,[57] it will not be repeated at length here.

The mixed order, typical of Alexandrian architecture, is used at Petra (with Corinthian type capitals supporting a Doric frieze and an Ionic cornice).[58] Details of the orders at Petra are derived from Alexandria, seen in the examination of the capitals and cornices. The distinctive forms of floral capitals at Petra are based on Alexandrian prototypes (rather than the 'Normal' capitals typical of Roman architecture)[59] as, in turn, are the Nabataean capital types which are blocked-out versions of them. The cornice mouldings at Petra follow Alexandrian examples.[60] The discovery at Petra of Alexandrian Corinthian capitals (Types I, II and IV),[61] mouldings, and an acanthus column base[62] confirm the Alexandrian influence on its architecture, as does the use of the Egyptian cubit of 0.525 m.[63] This evidence also suggests the presence of Alexandrian architects at Petra when this ornate architecture began to be built, although Nabataean architects and stone masons were clearly also involved from an early stage as indicated by masons' marks in Nabataean letters.[64]

At Petra extensive use is made of the 'baroque' structural elements which appeared in Ptolemaic Alexandria. There are

rock-cut examples of both types of broken pediments: those raked towards the back, as on the Khasneh [141] and the Deir, as well as those with sections of roof of single pitch, as on the Tomb of the Broken Pediment [142].[65] There is also a half-pediment of this latter type from a free-standing building erected in Petra, in about the first century BC.[66] Other baroque structural elements of Alexandrian architecture at Petra include segmental pediments, concave entablatures, and curved entablatures.[67] The evidence from Petra is of particular significance because these structural elements on the rock-cut facades survive as part of complete architectural arrangements. Thus, they potentially provide an indication of how these features might have been used in Alexandrian buildings.

Broken pediments at Petra frame a circular structure (tholos) which has a distinctive form. Tholoi themselves are common, occurring as early as the fourth century BC at Delphi.[68] However, the tholoi at Petra are distinguished by a combination of features, seen on the Khasneh [141], the Corinthian Tomb, and the Deir.[69] They not only have tall narrow proportions and Corinthian capitals (as found on some other tholoi), but their most characteristic feature is a tent roof crowned by a Corinthian capital supporting a lidded urn.[70] The only other tholoi with this combination of features are those depicted in wall-paintings in Italy [143, 161–162] of

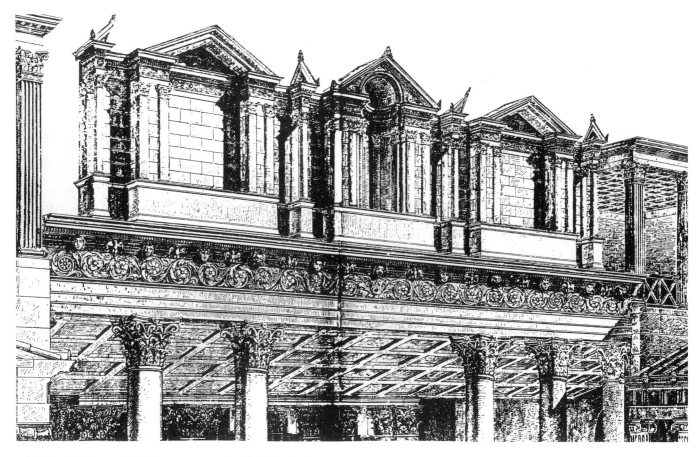

158. Ptolemais, Palazzo delle Colonne, reconstruction of aedicule facade

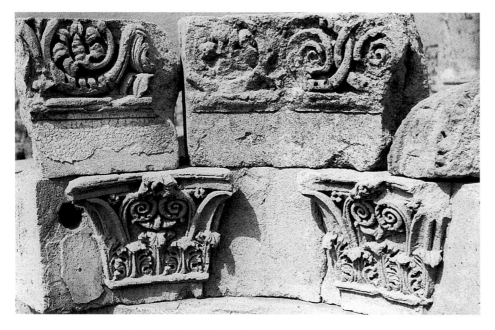

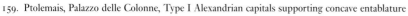

159. Ptolemais, Palazzo delle Colonne, Type I Alexandrian capitals supporting concave entablature

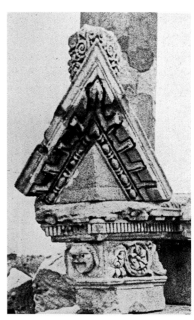

160. Ptolemais, Palazzo delle Colonne, broken pediment from aedicule facade

the so-called Second Style of the first century BC (specifically phase I, dated *c.* 90–50 BC)[71] in houses and villas in Pompeii and other sites on the Bay of Naples destroyed by the eruption of Mt Vesuvius in AD 79 (Map 4). The relationship between the architecture at Petra and that in the wall-paintings will be explored before coming to the styles of Roman wall-paintings and their chronology in more detail.

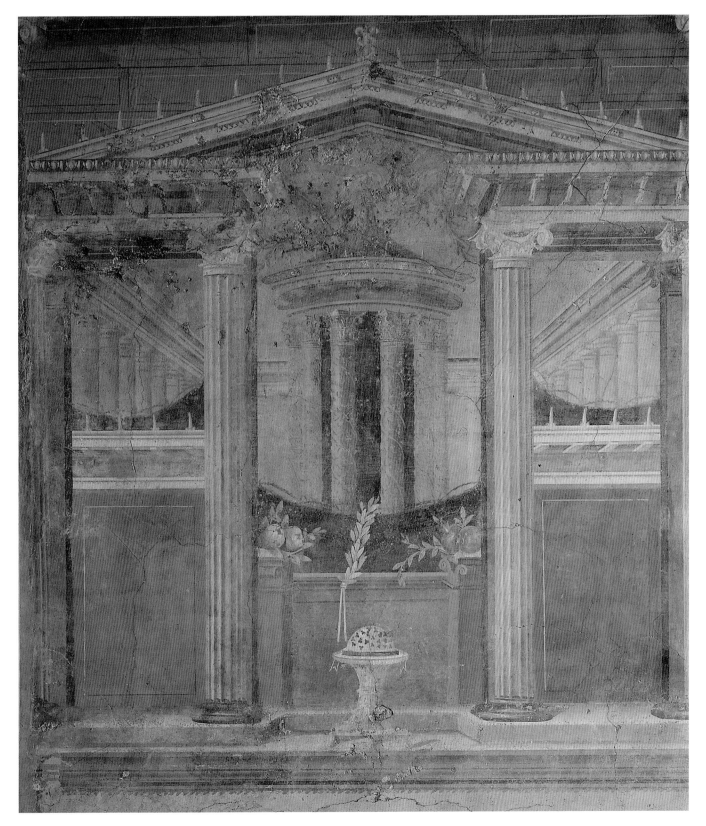

161. Boscoreale, Villa of P. Fannius Sinistor, cubiculum M. New York, Metropolitan Museum of Art

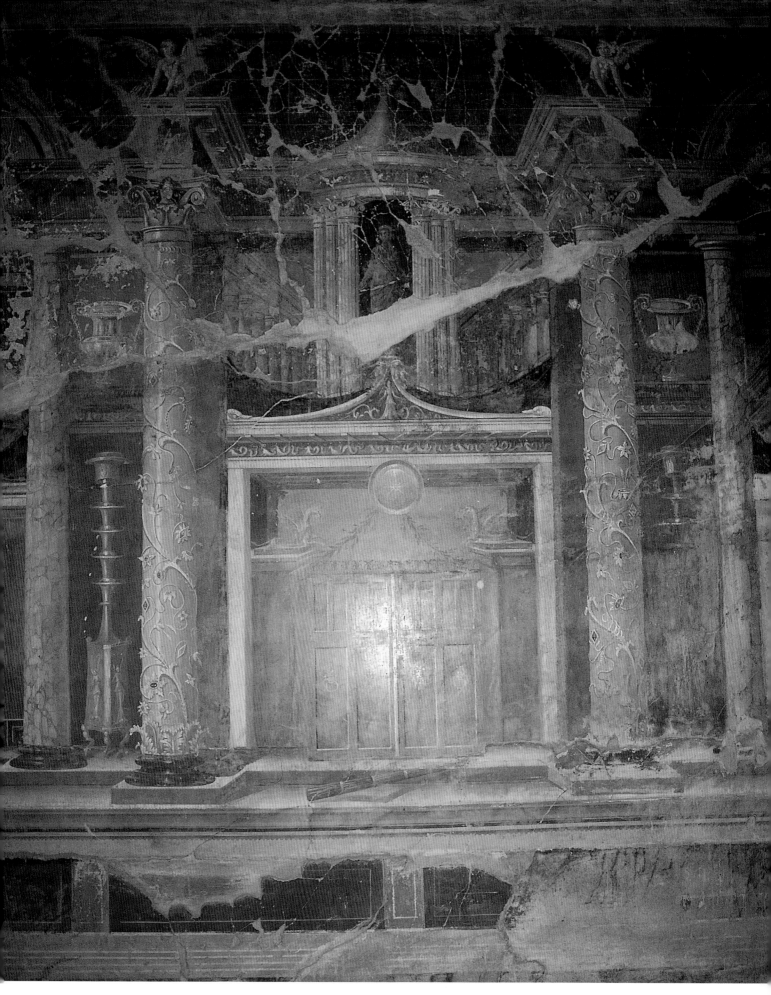

162. Torre Annunziata, Villa of Oplontis, triclinium 14

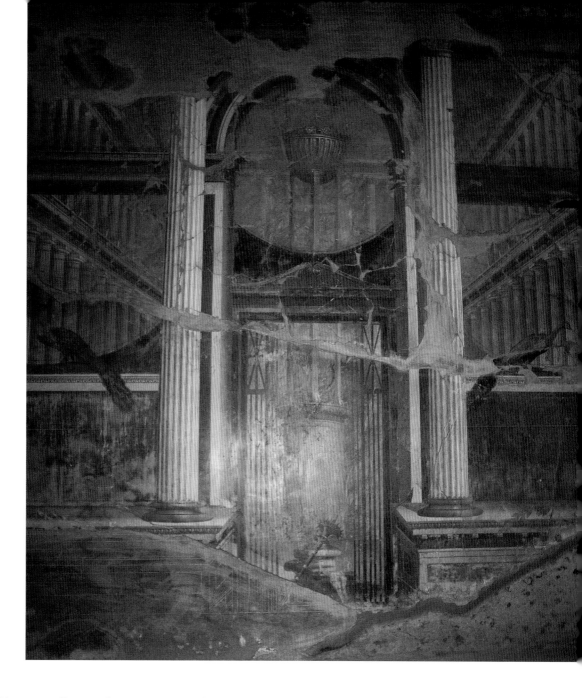

163. Torre Annunziata, Villa of Oplontis, room 15

Similarities between the Architecture at Petra and in Pompeian Wall-paintings

In addition to the distinctive form of the tholos at Petra and in the Pompeian wall-paintings, the architectural composition in which it occurs are strikingly similar. The similarity between the architecture depicted in *oecus* 43 of the House of the Labyrinth in Pompeii and the Khasneh at Petra [141, 143] was observed by the French architect Hittorff in 1862.[72] Ever since then, this relationship had been a mystery because they are the only surviving examples of a tholos framed by a broken pediment, although one is painted and the other rock-cut. A closely related composition to that in the House of the Labyrinth is depicted in cubiculum M of the Villa of P. Fannius Sinistor at Boscoreale, now in New York, with a hollow pediment (instead of a broken pediment) positioned in front of a colonnaded court containing a tholos [161]. An arrangement related to that depicted in the House of the Labyrinth [143] is preserved at Petra carved from the rock in three dimensions on the Tomb of the Broken Pediment [142],

but with some details observable in other wall-paintings. The tholos is indicated on the tomb facade, i.e., on the plane in front of the court.[73] The tomb chamber behind the facade was decorated with a two-storey colonnade carved in relief on its walls.[74] Similarly, the interior colonnade of the court-yard building depicted in room 15 of the Villa of Oplontis at Torre Annunziata has two storeys [163].

Other baroque structural elements in the Pompeian wall-paintings which are also found at Petra[75] include curved entablatures and arched entablatures, while wall-paintings there depict volute pediments. Various of these types of baroque entablatures and pediments are depicted in cubiculum 16 of the Villa of the Mysteries [171].

The origin of the baroque architecture in the Pompeian wall-paintings had been an enigma because they predate the building of complex baroque compositions in Roman architecture (in the late first and second centuries AD). The similarities noted between the tholoi and the architectural compositions in which they were used at Petra and those in the Pompeian wall-paintings suggest a common origin in a

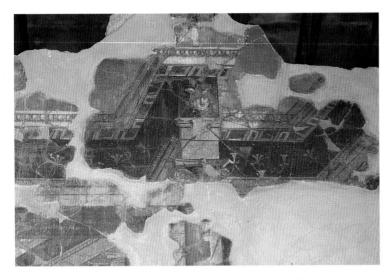

164. Pompeii, House of Obellius Firmus, room 3, detail of entablature with painted square hollow modillions

167. Pompeii, House of Ceres, cubiculum C, painted Corinthian capital

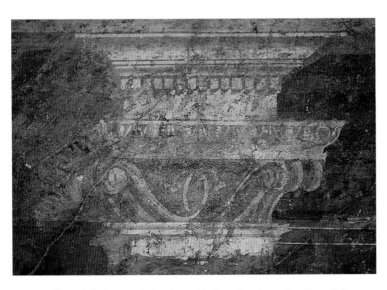

169. Pompeii, Villa of the Mysteries, cubiculum 16, painted Type IV capital

165. Boscoreale, Villa of P. Fannius Sinistor, large triclinium, detail of painted cornice

166. Pompeii, House of the Epigrams, triclinium m, detail of painted frieze

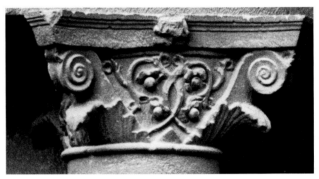

168. Petra, Khasneh, Type 2 floral capital on tholos

170. Pompeii, Villa of the Mysteries, cubiculum 16, painted Type IV capital

major centre with which both sites had contacts, as it is unlikely that Petra or Pompeii had a direct influence on each other. As the main source of the classical orders and baroque structural elements of the architecture of Petra is Alexandria (rather than Rome), the possibility arises of Alexandria being the common source of the distinctive type of tholos and its use in a colonnaded court with a broken pediment at the entrance. In light of this, the orders of the architecture in the wall-paintings will be examined to see if they include any details distinctive of the architecture of Alexandria. As this evidence has been presented by the writer in more detail elsewhere,[76] only selected examples will be given here.

A notable feature of Alexandrian architecture is cornices with square hollow and flat grooved modillions [139–140], which were not built in Roman architecture outside the Egyptian sphere. Square hollow modillions are depicted in Pompeii in room 3 of the House of Obellius Firmus [164] and in *oecus* 6 of the Villa of the Mysteries.[77] Modillions which are very narrow like Alexandrian examples [139] are depicted in wall-paintings, as in the large triclinium of the Villa of P. Fannius Sinistor at Boscoreale [165] and in room 4 of the House of the Griffins in Rome [176].[78] The 'block consoles' used in contemporary architecture in Italy are proportionately wider and shorter and do not have a central groove. Examples of wider flat modillions with a central groove, like Alexandrian examples,[79] are depicted in the House of Ceres [167] and the House of the Labyrinth.[80]

Friezes from Alexandrian entablatures are sometimes decorated with a distinctive pattern of spirals placed back to back in a row, as seen on the Chantier Finney building of *c.* second century BC [113c] and on a related, but simpler, example (upside down in [112]). Similar friezes are depicted in the wall-paintings, supporting face-standing brackets (possibly of metal) as in triclinium m of the House of the Epigrams in Pompeii [166], the Villa of the Mysteries, and in the villa at Boscoreale.[81]

The Corinthian capitals in the Pompeian wall-paintings are of a variety of types.[82] Notably, they do not include any of the Italic-Corinthian capitals (with a long narrow leaf between the helices and corner volutes) seen in contemporary architecture in Italy, such as those in the House of the Labyrinth.[83] Rather, the capitals in the wall-paintings include 'Normal' capitals (with the helices and corner volutes springing from a single sheath [127])[84] which are common in the Hellenistic architecture of Asia Minor and the nearby islands[85] and later became typical of Roman architecture, appearing in Rome by *c.* 100 BC.[86] They also include examples derived from the Epidauran type (in which the helices spring separately from the corner volutes [121]),[87] and from which the Type I Alexandrian capitals also developed. The capitals in the wall-paintings include some Alexandrian examples, such as the example in the House of Ceres depicted beside an Alexandrian type modillion cornice [167]. This capital has helices terminating in a circular blob like on the Type I Alexandrian examples [131].

The colour scheme used for the Corinthian capitals is also instructive. Those capitals in Alexandria on which traces of paint survive have a red background behind the helices and

yellow acanthus leaves, as on the capitals from the Chantier Finney building [113d–e][88] and observed on a capital on display in the Greco-Roman Museum [133], as well as on the sanctuary at Hermopolis Magna (el-Ashmunein) in the third century BC [78]. Capitals in the Pompeian wall-paintings frequently have this red and yellow colour scheme, as in the Villa of P. Fannius Sinistor at Boscoreale and the Villa of the Mysteries at Pompeii [161, 170].

The types of pilaster capitals in the wall-paintings are of particular interest because all the main houses with Second Style paintings have many examples depicted which are related to the Type IV Alexandrian capitals and the Type 2 floral capitals of Petra.[89] They are characterized by the volutes curling back against each other [175] as in the Alexandrian examples [126, 134–135],[90] and sometimes interlocking [169–170], like the examples at Petra [168].[91]

Acanthus column bases, which are typical of Alexandrian architecture going back to the third century BC [136], are depicted in the wall-paintings, as in triclinium 14 of the Villa of Oplontis at Torre Annunziata [162] and in the Villa of P. Fannius Sinistor at Boscoreale. The wall-paintings also include other features found in Alexandria, such as griffins [162] in place of sphinxes guarding entrances [106],[92] and wind towers used in Egyptian architecture until the nineteenth century.[93]

The occurrence of features of Alexandrian architectural orders in the Pompeian wall-paintings would tend to confirm the picture suggested by the baroque structural elements and architectural compositions seen also at Petra, i.e., that the common origin of the architecture at Petra and that in the wall-paintings is Alexandria. However, in addition to the uniquely Alexandrian details, the architecture in the wall-paintings also has features, both of layout and details, seen in contemporary architecture in Italy and the Hellenistic Aegean, as well as Alexandria.[94] This is to be expected because of the Hellenistic influences which they have in common.

These features range from the general to the specific. A layout with a colonnaded court (peristyle) was used for Greek houses and palaces, Pompeian houses and villas, and in Alexandria for houses, the palaces (the great peristyle), public buildings (the quadrangular portico) and temples (the Serapeum). The baroque treatment of walls in the paintings, with columns depicted in front of the walls on projecting pedestals also occurs in Hellenistic architecture.[95] The architecture in the wall-paintings also has details found in Italy, as well as the Hellenistic Aegean and Alexandria, such as attic column bases,[96] and Doric and Ionic capitals. Thus, because each of these features is not unique to a particular place in the Hellenistic period, they do not help to pinpoint the origin of the architecture in the wall-paintings.

Because of the similarities between the architecture in the wall-paintings, contemporary domestic architecture or villas in Italy, and Hellenistic architecture it is sometimes argued that the wall-paintings depict them.[97] The problem with these suggestions is that they do not account for those elements which only occur in Alexandrian architecture. On the other hand, a conscious attempt to depict Alexandrian architecture

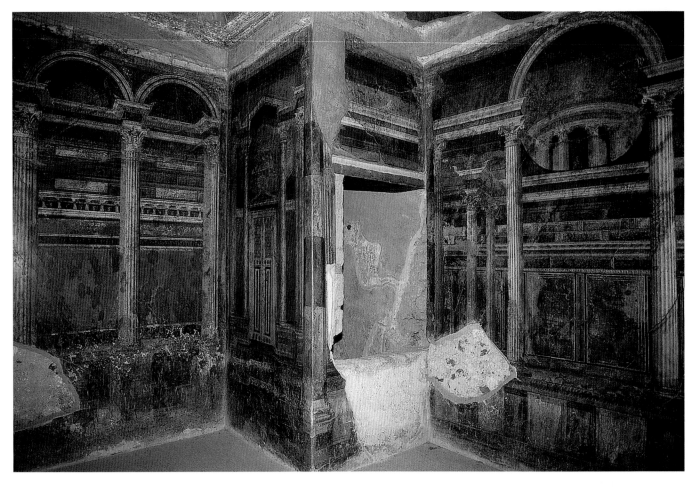

171. Pompeii, Villa of the Mysteries, cubiculum 16

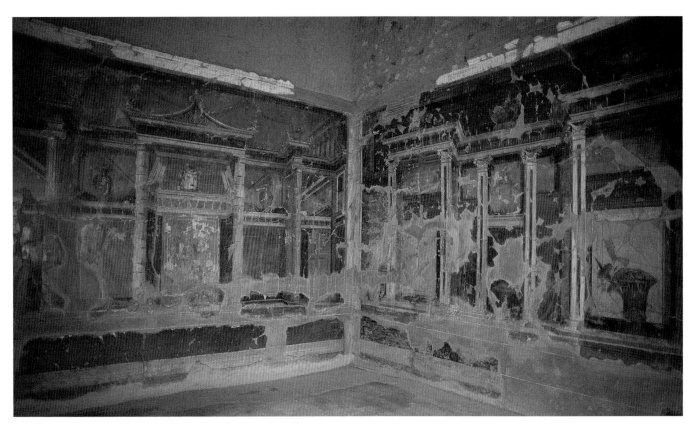

172. Torre Annunziata, Villa of Oplontis, room 23, back and right side walls

would explain both the Alexandrian features and those in common with contemporary Republican and Hellenistic architecture.

The identification of the architecture in the wall-paintings as that of Alexandria was suggested in the 1970s by the Swiss scholar Schefold, following on the work of Lauter who had attempted to define the characteristics of Alexandrian architecture using the evidence from the Palazzo delle Colonne at Ptolemais and concluded that the Second Style represented real rather than fantasy architecture.[98] However, this idea did not gain general acceptance because sufficient evidence from Ptolemaic Alexandria had not been published by then, nor by the time Tybout's study was published in 1989,[99] to show convincingly a distinctive architectural style. Rather, there has been general agreement that the wall-paintings were influenced by a variety of sources, including contemporary local and Hellenistic architecture and stage painting, and that they were a Roman invention resulting from the combination of these.[100]

Stage Painting

In 1938 and 1957, when there was insufficient knowledge of the architecture of the second and first centuries BC to demonstrate definitively that the paintings depict built architecture, Beyen argued that they were derived from Hellenistic stage painting.[101] Perspective painting was used in Greek stage sets in Athens in the fifth century BC, according to the Roman architect Vitruvius who was writing in about the 20s BC and explained the principle of how the eye perceives perspective.[102] Stage sets were probably used throughout the Greek world in the Hellenistic period. Vitruvius describes tragic, comic, and satyric theatre sets (flats) as decorated with royal buildings, private buildings, and landscape scenes respectively,[103] as in cubiculum M of the Villa of P. Fannius Sinistor [608]. Because the Second Style paintings would have made excellent stage sets these could have been similar. Stage painting is also suggested by some elements in the wall-paintings, such as masks [172, 608].

Vitruvius describes the painting of a stage set for the 'very small theatre' (which he specifies is an *ecclesiasterion*) by Apaturius of Alabanda at Tralles in western Asia Minor.[104] The events surrounding this are instructive because the set depicted baroque features such as half-pediments and tholoi. Licymnius, a mathematician, objected to the set because he considered that these were not representative of real architecture. Consequently, Apaturius had to remove them from the scene so as 'to resemble reality'. This incident suggests that this scene and the real version of it did not have a local origin in the Hellenistic cities of the western coast of Asia Minor. Rather, stage paintings depicting other architecture would have been used in them. Because the baroque features in it are not attested elsewhere in the Mediterranean, it could be suggested that Apaturius' stage set, like the architecture depicted in it, had its origin in Alexandria.[105]

The occurrence of distinctively Alexandrian architectural details in the Pompeian wall-paintings raises the question of whether Alexandrian painters played a role in the production of some Second Style wall-paintings. Whilst a Roman painter might depict the general structural features of Alexandrian architecture such as a broken pediment, he is unlikely to have noticed the minute details of the capitals and cornices. It is much more likely that he would depict only conventional Roman ones, as later occurred when baroque architectural compositions were built in Roman architecture in the late first and second centuries AD. A painter from Alexandria would unconsciously use the Alexandrian architectural details he knew. Thus, these details suggest that some paintings include the work of some Alexandrian artists. Equally, because 'Normal' Corinthian capitals are used in some paintings but were not used in Ptolemaic Egypt,[106] unlike Italy and Aegean Greece, they suggest local painters (or those from Asia Minor and the islands) were also involved.

As the Second Style has two aspects, not only the architecture it depicts but also the method of depicting it, the latter aspect also needs to be considered. It involves the depiction of architecture at life size combined with the use of blue paint to create a scene beyond the wall, shading, vanishing-point perspective, and particular colour schemes. Before considering the evidence for these in architectural wall-paintings in Alexandria in the third and second centuries BC and how these relate to the Second Style, we should pause briefly to explain the types of Roman wall-paintings and their chronology.

Typology and Chronology of Roman Wall-painting

The Pompeian wall-paintings mentioned so far belong to phase I of the Second Style (also called early Second Style). Roman wall-paintings are divided into four main typological styles which develop in chronological order,[107] as indicated by stratigraphical archaeological evidence[108] and the history of wall-painting styles given by the Roman architect Vitruvius in about the 20s BC.[109]

The First Style involves the decoration of the wall to imitate masonry using stucco in relief,[110] in a variation of the painted imitations of masonry found throughout the Hellenistic world.[111] The Second Style, which begins early in the first century BC, is characterized by the depiction of buildings with a 'realistic' appearance.[112] The Second Style has two phases. Phase I is stratigraphically earlier than phase II, which begins c. 50 BC.[113] Phase II is distinguished by the use of more pastel colours than phase I, especially turquoise and substantial amounts of white. It is used in the House of Augustus on the Palatine in Rome, c. 36–28 BC.[114] The architecture in phase II has thinner columns than phase I and includes two-storey high buildings.[115] The Third Style, which appears c. 30–20 BC,[116] has architectural features, but they are more 'fantastic', being too spindly to be built, and often include mythological scenes. These features are also found in the Fourth Style which begins in the middle of the first century AD.[117] Some of the scenes, despite their spindly

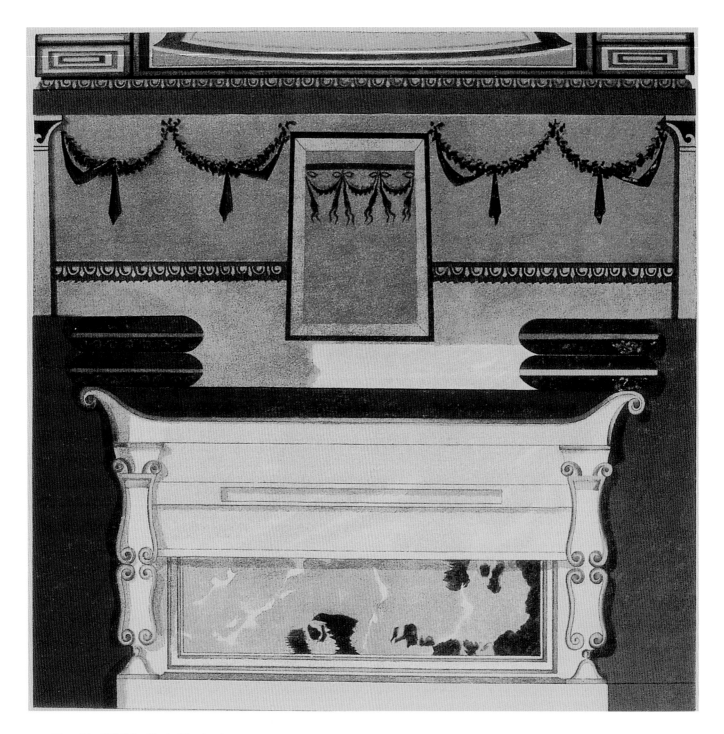

173. Alexandria, Sidi Gaber Tomb, *kline* chamber

architecture, are clearly of stage buildings, such as the painting in the Terme del Sarno which has been shown to be the Grand Theatre in Pompeii.[118]

The Dutch scholar Beyen made the most detailed analysis of the Second Style.[119] He divided phase I into three subphases, a, b and c, on the typological basis of the amount of wall-opening depicted: whether the wall is solid, partially open or fully open. In phase Ia three-dimensional columns and cornices are depicted in front of a solid wall. In phase Ib the top third or so of the wall is depicted open with blue sky

to create a vista beyond the wall. Architecture in this vista can include colonnaded courts or the full variety of baroque forms of pediments and entablatures, and tholoi [171]. In phase Ic the walls are open above the socle with more complex scenes, such as those with tholoi and colonnaded courts in the House of the Labyrinth, the villa at Boscoreale, and the Villa of Oplontis [143, 161–162].

It is a fluke of chance that so many wall-paintings have been preserved in houses in Pompeii and other sites on the Bay of Naples thanks to the eruption of Mt Vesuvius in AD

79. In Rome no examples survive of wall-paintings with blue sky and a scene beyond the wall showing realistic architecture with a broken pediment with a colonnaded court behind and a tholos (Second Style phases Ib–c). However, there are examples in Rome of the types of wall-paintings which were painted in the periods immediately before and after these phases, such as those in the House of the Griffins and in the House of Augustus (Second Style phases Ia and II, respectively). It would be expected that the wall-paintings surviving in the Bay of Naples copied fashions in Rome. Thus, it is highly likely that there were paintings of phases Ib–c in Rome, and that it is only a matter of chance that they have not survived.

Beyen considered that the sub-phases (a, b, and c) of the Second Style were introduced in chronological order. He dated phase Ia based on the House of the Griffins in Rome (now dated *c.* 90–80 BC).[120] Phase Ib is represented by the Villa of the Mysteries (now dated *c.* 80–50 BC).[121] Phase Ic is represented by the House of the Labyrinth (now dated *c.* 70–60 BC),[122] the Villa of P. Fannius Sinistor at Boscoreale and the Villa of Oplontis (now dated *c.* 60–50 BC).[123] Whilst this chronological sequence is probably correct for these houses based on archaeological evidence, all three sub-phases are used contemporaneously in the last three buildings, even on walls of the same room (e.g. room 23 of the Villa of Oplontis [172]).[124] Consequently, doubt has been cast on whether the three sub-phases are chronologically sequential.[125] Thus, it is probably methodologically more correct to use the term 'sub-types' (rather than 'sub-phases') for the sub-divisions of phase I, because their typology is valid but, even if they developed in chronological order, once introduced they were used contemporaneously.

There is a relationship between the amount of wall-opening depicted and the position of the wall in a room. For example, in room 23 of the Villa of Oplontis the most complex scene is on the wall one sees at the end (back wall) of the room on entering, with less complex scenes on the side walls [172] and the simplest scene on the wall through which the room is entered [174]. Similarly, the complexity of the scenes and the degree of wall opening depicted are related to the type and size of room. Architectural vistas with sky are rarely depicted in narrow spaces (*fauces*, corridors) or those with an open roof (atria and peristyles); rather they occur in rooms, such as dining rooms and bedrooms (triclinia and cubicula). Not surprisingly, there is also a similar relationship to the size of the residence.[126] All of this evidence reflects the judicious use of all three sub-types of phase I at the same time for integrated decorative schemes.

Vanishing Point Perspective in Pompeian Wall-painting

The effect of depth beyond the wall and the realistic appearance of the architecture in phase I of the Second Style is achieved by the use of central perspective in which lines recede to a single central vanishing point. It is used in all three sub-types of phase I in a very sophisticated way which is related to the position of the viewer in the room.[127] Thus,

174. Torre Annunziata, Villa of Oplontis, room 23, wall with entrance to room, detail showing sky and garlands depicted above a screen wall

allowance is made for the height of the viewer and their proximity to the wall by the upper parts of the walls having a central vanishing point, while features in the lowest parts, such as pedestals for columns, are rendered with parallel perspective. Alternatively, the vanishing point is placed off centre to allow for the position of the viewer along the wall. In phase II of the Second Style there is increasing use of a number of vanishing points on a central line.[128] This method, rather than central perspective, is used in the Third and Fourth styles.[129]

The use of vanishing point perspective in the Second Style in a consistent way in large scale compositions is a major innovation because earlier versions are lacking in the art of Italy or the Hellenistic Aegean, and the Second Style paintings are the only surviving examples of it until the Renaissance.

175. Rome, House of the Griffins, room 4, details of corner pilaster capitals

176. Rome, House of the Griffins, room 4, detail of cornice

Architectural Painting in Alexandria in the Third and Second Centuries BC

We now turn to the evidence for wall-paintings in Ptolemaic Alexandria to see if they suggest Alexandrian influence on the method of depiction of the architecture in Second Style wall-paintings, rather than only the architecture itself. As in most cities, in Alexandria there are no substantial remains of wall-paintings from free-standing buildings, such as houses, surviving from the Ptolemaic period. However, there are wall-paintings in tombs which are cut into the city's bedrock, including some from the third and second centuries BC. Importantly, these paintings are earlier than the Pompeian examples. They are remarkable because they include key technical details which are later used in the Pompeian wall-paintings.

Blue paint used as the means of creating the illusion of a scene beyond the wall first occurs in Alexandria, as seen in tombs of the third century BC. In the *kline* chamber of the tomb at Sidi Gaber[130] the lower part (about two-thirds) of the wall is depicted as a screen wall while the upper third of the wall is painted blue between the pilasters to create the effect of looking beyond the wall [173]. The garlands depicted in the upper part of the scene are on the plane of the wall. This increases the illusion of the blue paint representing space (sky) beyond the wall.[131] Blue paint is also used

on Tomb A at Shatby in the openings of rock-cut false doors.[132]

What is notable about these arrangements in Alexandria is that they involve a life-sized spatial illusion. By contrast, the Hellenistic grave stones called funerary stelai (from a variety of sites), with blue sky depicted above a screen wall, consist of only small pictures.[133] The Tomb of Lyson and Kallikles at Lefkadia in Macedonia, dated *c.* 200 BC, has simple life-size pillars depicted, but it lacks a blue background between them so that there is no illusion of looking beyond the wall.[134] The large scale use of blue paint on ceilings already occurred in Egyptian temples[135] and Dynastic period tombs, but with stars.[136] The ceiling of chamber g of Tomb A at Shatby in Alexandria was painted blue.[137] Thus, the use of blue paint on the upper parts of walls to create a spatial illusion may have developed in Alexandria by extending the Egyptian use of blue paint on ceilings to the upper part of walls, but with a conceptual change from the depiction of the night sky to the daytime one. The painting of substantial areas of walls blue would have been facilitated by the local availability of blue paint, which Vitruvius mentions was first made in Alexandria.[138]

One of the most distinctive features of the Second Style wall-paintings with architectural vistas (phases Ib–c) is the depiction of blue sky in the scenes depicted as beyond the wall. Similar compositions to the Alexandrian ones with screen walls, blue sky, and garlands are used later in Pompeian wall-paintings and, notably, at a similar scale. A version of the type of arrangement used at Sidi Gaber [173] is depicted later in room 23 of the Villa of Oplontis at Torre Annunziata [174]. In both scenes pilasters are depicted in the corners in front of the screen wall. Pilasters are divided lengthwise down the middle with one half of the pilaster (and of its Type IV capital) painted on each wall [173]. This method of depicting pilasters in the corners is also used in other examples in Italy, such as the House of the Griffins in Rome [175].[139]

There are also compositions on loculus slabs from Alexandria which are related to Second Style examples. Notably, the relevant examples of these slabs, used to close the loculus or elongated niche in which the dead were buried, are all from Alexandria, rather than other Hellenistic sites. The loculus slab of the tomb of Stephanos at Hadra, of the third century BC, has blue paint and a garland at the very top of the scene framed by pilasters [177].[140] It has a gate with spikes along the top. A closely related composition is painted in cubiculum 11 of the Villa of Oplontis at Torre Annunziata [178]. This same arrangement is used as part of a larger composition in triclinium 14 of the same villa [162], and in triclinium G of the Villa of P. Fannius Sinistor at Boscoreale.[141] A simpler version with garlands and blue sky above a spiked wall is depicted on the side walls of room 23 of the Villa of Oplontis [179].

Thus, the earliest examples of blue paint used in life size architectural depictions to create the illusion of a scene beyond the wall survive from Alexandria in the third century BC.[142] They are used in compositions which are similar to those later painted on Pompeian walls.

Depth is achieved in the depiction of architecture by means of cast shadow in addition to the use of perspective. Cast shadow is depicted below cornices in Alexandria to increase their depth using a distinctive method consisting of a row of sloping strokes, as observed below the painted ovolo moulding decorated with egg and tongue pattern along the top of the screen wall depicted in the tomb at Sidi Gaber [173]. On a third century BC loculus slab in Tomb A at Shatby, the shadows cast by the dentils on the cornice of the painted pediment are similarly rendered [183].[143] The cornice on a fragment of wall-painting from Tomb 2 at Moustapha Pasha,[144] of not later than the second century BC, has cast shadows depicted the same way [182]. Notably, this technique is not found in other Hellenistic wall-painting, but it is used in Pompeian wall-paintings, especially below the egg and tongue motif [161].[145] This suggests that its use there might be derived from the earlier Alexandrian practice.

Perspective rendered by means of (parallel or slightly converging) lines which recede towards a centre line (a vanishing axis, rather than a vanishing point),[146] was used in Alexandria in the third century BC. An example of that date occurs on a loculus slab, the 'stele of Helixo', from Hadra. The coffering on it is depicted by lines which converge towards a central vanishing line, so that the ceiling recedes, with blue sky beyond [181]. Similarly, the lines of the paving stones on it converge.[147] A vanishing axis is also used on a loculus slab from a late Hellenistic tomb at Wardian in Alexandria [180].[148] The depth of this scene is accentuated by the lines representing horizontal (presumably timber) beams supporting the pillars.[149] A vanishing axis is also observed on the wall-paintings in Italy. It is used in the central panels of the side walls of room 23 in the Villa of Oplontis [179], which also have horizontal beams depicted supporting pillars.

The Alexandrian examples with a vanishing axis, especially the third century BC one, are instructive because it is on the way to the development of central perspective (with a vanishing point). As no predecessors of this are found in Italy before the Second Style, this raises the possibility that vanishing point perspective was developed in Alexandria.[150] This would not be so surprising in the light of the observations on the optical theory of perspective made by the mathematician Euclid who taught in Alexandria in the early third century BC.[151]

The representation of doors opening into the room (with a figure coming through them) is used on the Wardian loculus slab to create the illusion of going through the wall [180]. The partially open doors carved in Tomb A at Shatby have been mentioned. The device of partially open doors to give the effect of moving through the wall is also used in the painting in room 32 of the House of Fabius Rufus in Pompeii[152] (in one of the few examples of the early Second Style with figures in the scene).

Architecture in a scene beyond the wall is depicted in an Alexandrian tomb painting of the third or second century BC which survived *in situ* in Tomb 1 at Moustapha Pasha on the east wall of chamber 3 [184–185] (location marked in [107]).[153] This scene includes a tholos of which the upper part survives, with blue sky depicted above it, and traces of a garden at its

177. Alexandria, Hadra, Tomb of Stephanos, loculus slab

178. Torre Annunziata, Villa of Oplontis, cubiculum 11

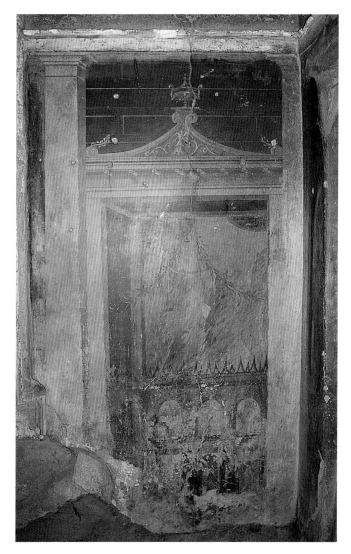

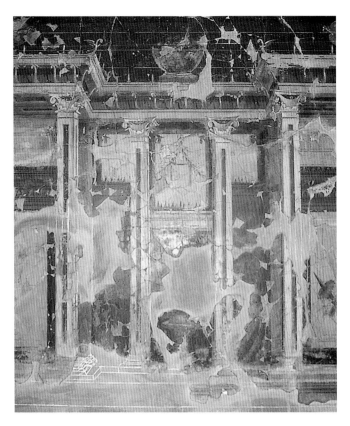

179. Torre Annunziata, Villa of Oplontis, room 23, detail of right side wall

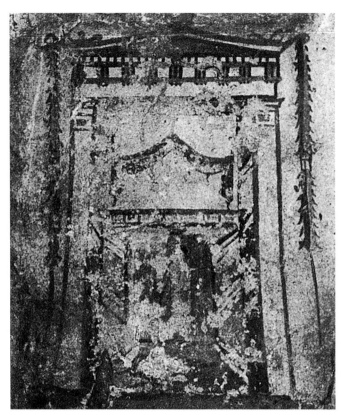

180. Alexandria, Wardian (Mex) cemetery, painted loculus slab

base. On the right hand edge of the scene there was a yellow band (possibly of a pilaster) framing the scene beyond the wall. The similarity of this scene to the Second Style (phase Ic) has been noted by other scholars.[154] Although the roof of this tholos does not seem to have had a tent shape, it is notable for other details. It has (red) garlands hanging from it, as sometimes observed on the Pompeian examples [171]. It also has them on its frieze (in white), as on the Khasneh at Petra [141]. Of particular note are the colours of this Alexandrian example with its yellow roof and a blue and yellow entablature, because this same colour scheme is one of those later used in the Second Style examples. The tholos depicted in triclinium 14 of the Villa of Oplontis has a yellow roof, a yellow cornice and architrave, and a blue frieze with a white pattern on it [162].

Similarly, the fragment of a painting from Tomb 2 at Moustapha Pasha is interesting because of the colour scheme of the cornice on it includes yellow and red or maroon [182]. These same colours are commonly used for cornices in the Pompeian wall-paintings [143, 161].[155] Red and yellow were also used on capitals there and in Alexandria, as noted above.

Thus, the depicted architecture in Alexandria has similar colour schemes to the real architecture there. These same colours are also used for examples of the same architectural elements in the Pompeian wall-paintings. In addition, both the Alexandrian and Pompeian painted examples involve similar compositions and techniques.

The problem still remains of the lack of evidence surviving from Ptolemaic wall-paintings in houses and other buildings in Alexandria and of more substantial examples of painted

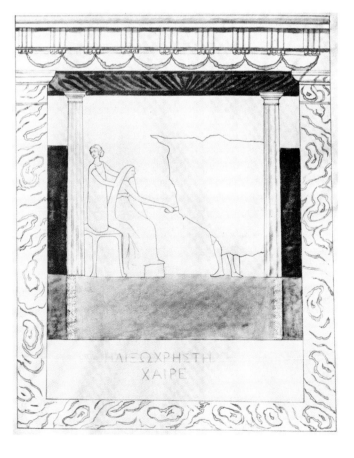

181. Alexandria, Hadra cemetery, loculus slab 'stele of Helixo' (watercolour)

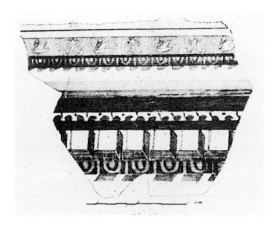

182. Alexandria, Moustapha Pasha, Tomb 2, painted cornice on stucco fragment (watercolour)

183. Alexandria, Shatby, Tomb A, chamber e, detail of loculus door in fig. 102–103

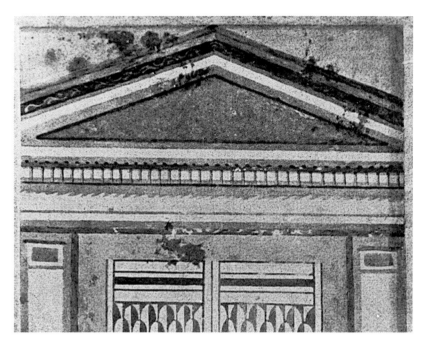

architectural scenes there, especially complex ones with vanishing point perspective. However, the fact remains that the types of scenes found in the Alexandrian tombs are closely related to examples and details of paintings in phases Ib–c of the Second Style. Similar scenes would have been used in houses in Alexandria because the designs of larger tombs there, such as those at Moustapha Pasha, are related to those of a Greek house. The palaces and villas in Ptolemaic Alexandria would have had larger scenes which would probably have been more expensive and also more complex than those surviving in the tombs.

The colour schemes of the architecture depicted in the Alexandrian wall-paintings are significant because centuries later the same colours are still used when tholoi of the distinctive type (which might perhaps be called Alexandrian) are depicted on Gospel manuscripts [610, 613–614, 616]. They have a yellow tent roof, as first observed in Alexandrian wall-painting in the third or second century BC, as well as a blue frieze. This is discussed in more detail when we come to the Byzantine and early Islamic periods (Ch. 14), when depictions of this architecture in the East derive from further developments in Alexandria. This suggests that there was an

184. Alexandria, Moustapha Pasha, Tomb 1, chamber 3, painting of tholos

185. Alexandria, watercolour of top of tholos in fig. 184

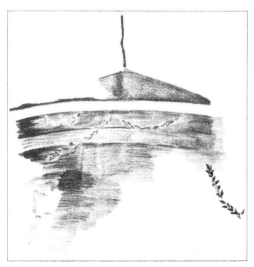

earlier version of these architectural scenes in Alexandria. The best evidence for both the predecessors of phases Ib–c of the Second Style and for its direct successors points to Alexandria. Later versions of wall-paintings related to the Second Style occurred in the East in the first to third centuries AD – at a time when this style does not continue in Italy. The recently discovered paintings at Petra and in Egypt (at Kellis, Ismant el-Kharab) are most closely related to each other because they result from continuity in the East from a version there of the Second Style.

Thus, it is not unreasonable to suggest that the Pompeian wall-paintings with architectural scenes with blue sky and garlands above a screen wall, as well as the more complex arrangements with the distinctive tholos sometimes framed by a broken pediment (or related features such as a hollow pediment), not only represent Alexandrian architecture but also that some influence of Alexandrian painting is involved in them. The evidence from Alexandria suggests that it had a version of wall-painting with these specific aspects prior to its appearance in Italy. It is the version in Alexandria from which the later pictorial tradition of the depiction of its architecture in the East is derived. This does not mean to say that there was not involvement of Roman painters in the examples on the Bay of Naples, as suggested by the 'Normal' capitals. There is no evidence to suggest that Roman painters were not responsible for the later development of the Second Style in Italy (phase II) and of the Third and Fourth styles.

Thus, the Pompeian wall-paintings of phase I of the Second Style and the architecture depicted in them are important for two reasons. Firstly, like the architecture at Petra, they provide an impression of how the architecture of Ptolemaic Alexandria might have looked in complete architectural compositions. Secondly, they preserve some sense of the lost pictorial tradition of the depiction of Alexandrian architecture of which there would have been a version in Alexandria prior to its appearance in Italy.

Why Alexandria?

Having acknowledged that the Roman wall-paintings of the Second Style phase I include Alexandrian architecture, the question arises of why Roman patrons would wish to have it depicted in their houses. A key to the meaning of the paintings is possibly provided by the general absence of figures in them.[156] This has led to the suggestion that they represent an idyllic, sacred, or paradisal world of the gods.[157]

Diodorus Siculus, writing c. 60–56 BC, describes Egypt as the country in which the gods first lived, the first two gods being Osiris and Isis.[158] It is also the country in which man first lived, surviving on the fruits of the Nile.[159] Athenaeus describes a flourishing garden as characteristic of Egypt.[160] It is equivalent to the Biblical garden of Eden. In the first century AD Josephus describes the Nile as one of the four rivers of paradise which flow from Eden.[161]

Thus, because the Romans viewed Egypt as a paradisal land in which the gods once dwelt, Alexandrian architecture could be used in their wall-paintings to represent a paradisal

world without this conflicting with the fact that real architecture is being depicted. The allusion to Egypt is subtle because the viewer needs to know that features such as the form of tholos and broken pediment are Alexandrian. However, because the scenes have a 'classical' form it is one with which the Roman viewer could have felt at home. It is also possible that the Romans simply wanted the latest fashion in interior decoration and the luxury that it conveyed.

There are other scenes in mosaics and paintings in Italy which more obviously depict Egypt, because they include distinctively Egyptian iconography.[162] The most famous example is the Nile mosaic at Praeneste (Palestrina), southeast of Rome, which was made in about the late second century BC.[163] It is a pictorial map of the Nile with obviously Egyptian features, such as Egyptian temples and animals [149]. Scholars agree that this scene is derived from Alexandrian examples.[164]

The frieze around the top of the atrium of the Villa of the Mysteries in Pompeii also contains Egyptian elements. It was originally up to 40 metres long. It was painted in c. 80–70 BC and retained when the room was redecorated in c. 60 BC.[165] As it is the earliest example of landscape painting in Roman art,[166] it demonstrates that new types of scenes with Egyptian elements were appearing in Roman wall-painting early in the first century BC, at about the time that the Second Style appears.

Landscape and topographical paintings could have been introduced by Alexandrian artists in Rome, such as the topographical painter (topographos) Demetrios. He lived in Rome and housed Ptolemy VI when he fled there in 164 BC.[167] The number of Egyptians in Rome seems to have sharply increased after c. 75 BC, reflecting increased cultural contact and trade. As well as slaves, they included musicians and actors[168] who could have brought the painters for their stage sets with them. The Alexandrian painters and those involved in theatre production in Rome could have introduced their painted stage sets and wall-paintings there and in Pompeii, painting them with the help of local artists.

Although most of the gardens depicted in wall-paintings in Pompeii are an extension of the garden area of the house and contain local fauna and flora,[169] deliberate allusions to Egypt are made in some Third Style garden scenes. In the House of the Orchard (I 9, 5) in Pompeii, c. AD 40–50,[170] the garden room with a blue background has a painting of a sacred bull and a statue of Osiris depicted, while in the room with a black background there is a distinctive long spouted vessel depicted which is associated with the cult of Isis and used to hold Nile water.[171]

When Alexandrian architectural scenes and gardens are later used in Byzantine and early Islamic art they seem to be used with a similar intent of representing paradise, so that there is continuity not only of the form but also of its meaning (Ch. 14).

ROMAN BAROQUE ARCHITECTURE

Baroque architecture was built elsewhere in the Roman world (outside Egypt) in the late first century and especially the second century AD, but without the Alexandrian decorative details of capital and cornice types. Rather, this later baroque architecture was decorated with the 'Normal' Corinthian capitals, ornate friezes and cornices ubiquitous throughout the Roman empire in this period. This architecture is found at sites ranging from Baalbek, Palmyra and Jerash in Syro-Palestine to Leptis Magna in North Africa.[172] Only a few examples will be given here.

Some of the finest examples have survived in Asia Minor, modern Turkey. The most notable example is the propylon of the recently reconstructed processional way of the Sebasteion at Aphrodisias, dated to the first century AD [186]. This propylon has a broken pediment in a similar position to that depicted in the wall-paintings, as in the House of the Labyrinth [143]. In both cases the broken pediment crowns an architectural arrangement which has a colonnaded open space visible behind it.[173] It is a free-standing version of the type of arrangement cut out of the rock on the Tomb of the Broken Pediment at Petra [142].

A broken pediment is also used on the Market Gate from Miletus of c. AD 120–30 with standard Roman capital and cornice types [187].[174] Like the propylon of the Sebasteion at Aphrodisias and the Khasneh at Petra [141], the Market Gate is two stories high. However, it is treated as a solid facade, unlike the propylon at Aphrodisias but like the Khasneh at Petra. The two-storey facade of the Market Gate serves as a decorative background to the outdoor space in front of it, like the Library of Celsus at Ephesus, built in the early second century AD [188].[175]

Baroque facades are similarly used on fountain houses, such as the one at Miletus with volute pediments.[176] They are also used for the stage buildings of theatres, such as the one at Aspendos with a central broken pediment. This facade also has alternating segmental and triangular pediments,[177] as does the Library of Celsus at Ephesus [188]. The breaking forward of the entablatures alternates on its upper and lower orders. Triangular and segmental pediments are also used together on other buildings reflecting Alexandrian influence, such as the Palace Tomb at Petra.[178]

Interior space is ornamented with baroque forms of niches. Alternating triangular and segmental pediments are used on the interior of the 'Temple of Diana' (which might have been a library) at Nîmes.[179] This building is unusual because, rather than the ornate Roman cornices and 'Normal' capitals, it has plain cornices, floral capitals and acanthus column bases. Complex baroque forms occur at Baalbek in modern Lebanon, especially on interiors. There, the sanctuary of Jupiter has alternating segmental and triangular pediments on its interior which are individually broken foward so that they are also broken pediment niche heads.[180] The 'Temple of Venus' at Baalbek has alternating segmental and triangular pediments on the niches decorating its interior, but their individual entablatures are broken back so

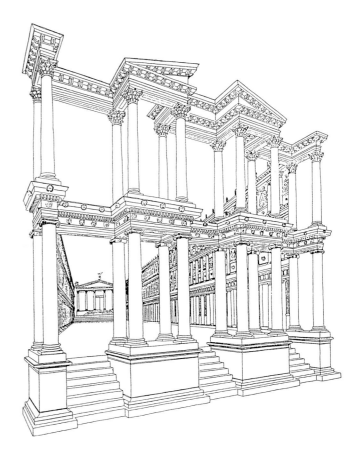

186. Aphrodisias, propylon of processional way to Sebasteion

that they are versions of hollow pediments and segmental entablatures.[181]

Baroque forms, especially arched and concave entablatures, were used on the main orders of other buildings, such as temples and arches. The recently rebuilt tetrapylon at Aphrodisias is crowned by a broken pediment combined with an arched entablature.[182] The temple of Hadrian at Ephesus, c. AD 118, had raking cornices above its arched entablature forming a so-called Syrian pediment [189, 145e].[183] The main order of the 'Temple of Venus' at Baalbek has a series of concave entablatures which curve inwards between each column.[184] The 'Canopus' of Hadrian's Villa at Tivoli near Rome has a series of vertically curved entablatures [190][185] on the colonnade surrounding the pool. This long pool was built to evoke the Canopic branch of the Nile at Canopus (Abuqir), site of the sanctuary of Osiris, east of Alexandria.

Thus, the full variety of baroque forms of pediments and entablatures, which first appear in Ptolemaic Alexandria, was used subsequently in the baroque architecture of the Roman empire.

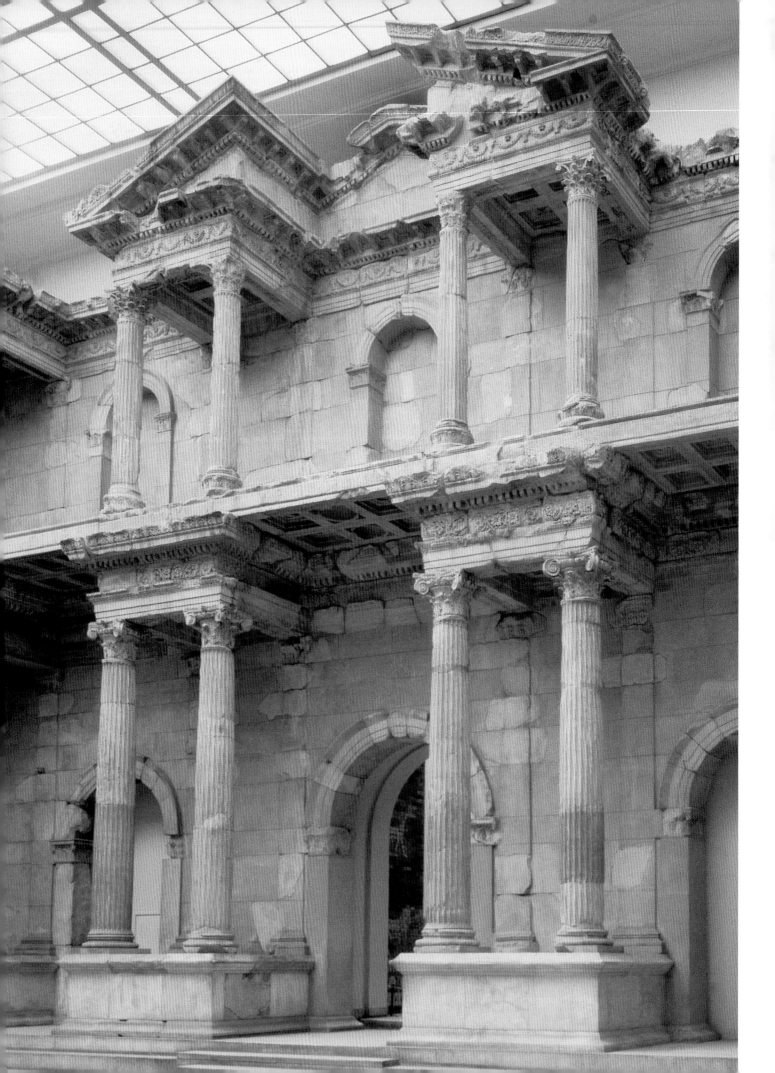

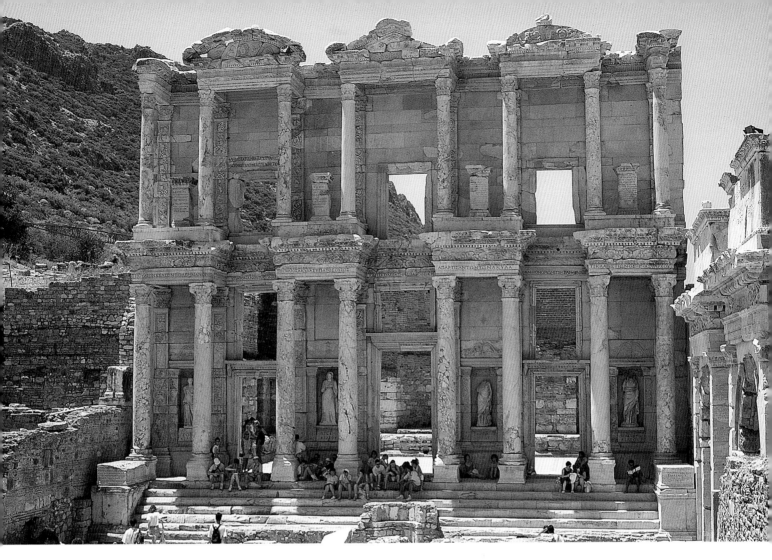

188. Ephesus, Library of Celsus

EGYPTIANIZING CLASSICAL ARCHITECTURE IN ALEXANDRIA

The new forms of classical architecture which developed in Alexandria look Greek on the surface, although they resulted from the inspiration and influence provided by the local Egyptian architecture. Thus, the effect of this influence is subtle. However, some Egyptian features are also more obviously mixed or combined with classical ones.

Classical capitals are given some Egyptian features, while conversely, some Egyptian examples are used like classical ones. A mixture of Greek and Egyptian details are used on some capitals of the new Alexandrian Types I–III.[186] On some examples acanthus leaves are replaced by papyrus [191–192]. Helices spring from papyrus fronds on both Type I and II capitals [192–193] and, in the Roman period, on Type III capitals [194]. These mixed capitals occur not only on freestanding columns, but also on types of engaged supports used in classical baroque architecture, like pilasters and half-columns [192–193]. Egyptian capitals are also used on

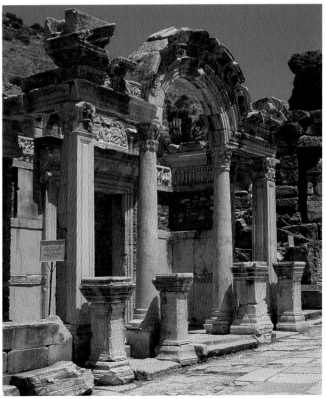

187. Miletus, Market Gate. Staatliche Museen zu Berlin, Antikensammlung

189. Ephesus, Temple of Hadrian

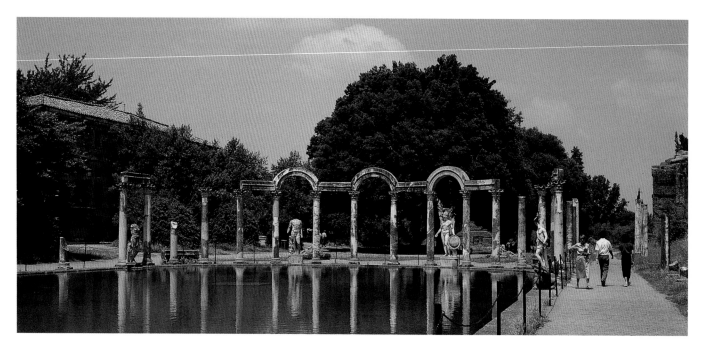

190. Tivoli, Canopus of Hadrian's Villa

baroque supports, such as papyrus ones on half-columns and quarter-columns [195–196].[187]

Sometimes Egyptian motifs are incorporated in Alexandrian architecture into other classical features, such as the Doric frieze. Groups of three cobras are used in place of the triglyphs of the Doric frieze on the segmental pediment in Thiersch's Hypogeum 2 at Gabbari [147]. Each triglyph is replaced by a single cobra in a shrine on the pediment from Marsa Matrouh [148]. On both pediments the guttae below them from a Doric frieze are retained (compare with [115]). In Tomb 2 at Anfoushy an Egyptian entablature with a cavetto cornice and other Egyptian features are combined with a segmental pediment which has the flat grooved modillions of Alexandrian classical architecture [88].

191. Alexandria, Type I Alexandrian capital with some Egyptian features and lower row of acanthus leaves replaced by papyrus

192. Alexandria, Type II Alexandrian pilaster capital with some papyrus features

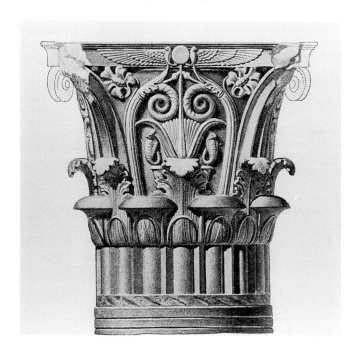

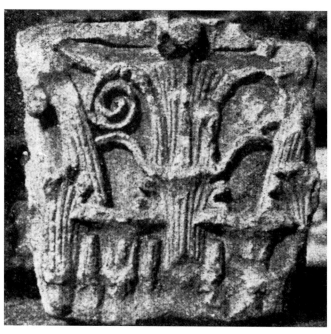

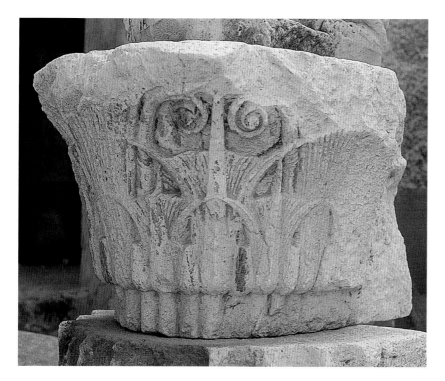

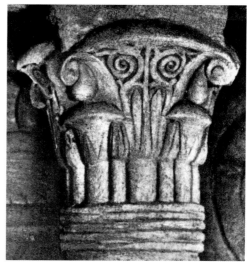

193. Alexandria, papyrus capital with helices from Type I Alexandrian capital, on half-column engaged to pillar. Greco-Roman Museum

194. Alexandria, Kom el-Shuqafa, Great Hypogeum, one of a pair of Type III Alexandrian capitals with papyrus in place of acanthus leaves

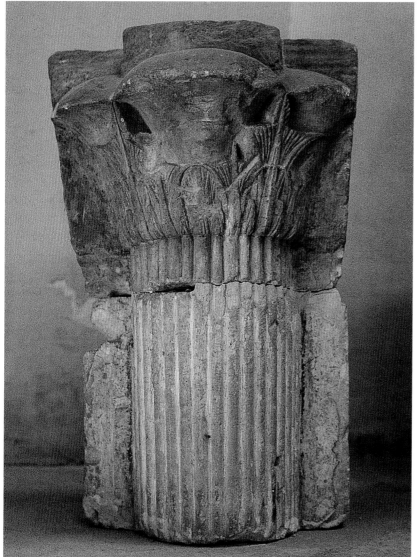

195. Alexandria, papyrus capital on engaged half-column. Greco-Roman Museum

196. Alexandria, papyrus capital on engaged quarter-columns. Greco-Roman Museum

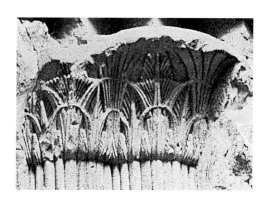

The subtle conceptual similarities which Alexandrian classical architecture has in common with contemporary traditional Egyptian architecture are considered in the next chapter.

CONCLUSION

Buildings in Ptolemaic Alexandria had Doric and Ionic orders which remain close to those in the Greek homeland where they had been standardized by the third century BC. By contrast, it was suggested that because the Corinthian order was still evolving in the Aegean at this time, this probably encouraged architects in Alexandria to develop a novel form of it with new varieties of capitals and distinctive cornices. At the same time, local Egyptian architecture influenced the development of the earliest baroque structural features which included new types of pediments and entablatures, such as broken pediments, segmental pediments, and curved entablatures.

The architectural fragments in the Greco-Roman Museum in Alexandria which illustrate the lost architecture of Ptolemaic Alexandria show it to be the ultimate source for the later baroque architecture in the Roman world. These fragments indicate most accurately, at a general level, decorative architectural details as would have been used on the city's major Ptolemaic buildings. An indication of how these elements might have looked when built in complete architectural compositions is provided by the rock-cut architecture of Petra and the architecture depicted in Second Style Pompeian wall-paintings.

Just as Alexandrian architecture produced new forms after the Ptolemaic period, we will also see how the pictorial tradition of architectural panoramas continued to evolve there (Ch. 14). That the monumental Byzantine versions of these scenes in Thessaloniki and Ravenna were developed in Alexandria will be seen from the new elements of Late Antique Egyptian architecture in them. The examples on major religious buildings of the Holy Land include those on the Great Mosque in Damascus and in the Crusader refurbishment of the Church of the Nativity at Bethlehem. At the same time, those on a miniature scale in Gospel manuscripts, largely of the eastern Churches, are painted using a similar palette to that used for the earlier painted examples in the Bay of Naples. This is not so surprisingly if they had a common Alexandria origin.

Traditional Egyptian Architecture

Having considered the architecture of Ptolemaic Alexandria, to complete the discussion of the monumental architecture of Ptolemaic Egypt the developments which occur elsewhere in Egypt should be considered. Egyptian temples are the main monumental buildings surviving in the cities and towns of the Nile valley and the oases (Maps 1–2). Administrative and other records indicate that these sites also had classical buildings although those from the Ptolemaic period are no longer visible, unlike some Roman examples as will be seen in the next chapter.

Support for the Egyptian temples by the Ptolemaic kings and first few Roman emperors was essential for fulfilling their local role as pharaoh and in order to maintain the loyalty of the native population. Just as the classical architecture of Alexandria undergoes lively innovations in the Ptolemaic period, so also do the Egyptian temples. Consequently, they become distinctive from those of the Dynastic period. These developments reflect the vibrancy of the traditional Egyptian religion and culture through the Ptolemaic period. After the Roman conquest of Egypt in 30 BC, these temples continued to be a major feature of the country's urban centres, which were increasingly embellished with classical buildings.

197. Memphis (Mit Rahina), classical structure for the lamplighters beside the Egyptian chapel for statue of the Apis bull

CLASSICAL STRUCTURES IN THE PTOLEMAIC PERIOD

Before considering the Egyptian temples, the classical religious structures from the Ptolemaic period outside Alexandria should be mentioned. Archaeological evidence for these survived *in situ* at only two sites: in the former Egyptian capital Memphis [197] and further south at Hermopolis Magna (el-Ashmunein).

Memphis (Mit Rahina) was the former capital of Egypt, and the place where Alexander was reportedly first buried in Egypt, hence the support of the new rulers for the cults there.[1] This included the building of temples under Ptolemy I Soter (323–285 BC) and Ptolemy II Philadelphus (285–246 BC).[2] The processional way (*dromos*) of the Egyptian Serapeum of Memphis was decorated with Greek sculptures pertaining to Dionysos, the Greek god with whom Serapis was equated. At about the same time, in the second half of the second century or the first century BC, a classical semicircular exedra was erected on this *dromos* immediately in front of the east temple and facing the avenue of the sphinxes. This exedra was decorated with statues of Greek poets and philosophers (Pindar, Hesiod, Homer, Protagoras, Thales, Heraclitus, and Plato), and possibly some Ptolemies [198].[3] Early in the reign of Ptolemy II, a small classical structure for the lamplighters (a *lychnaption*) had been erected on the *dromos* beside an Egyptian chapel which contained a statue of

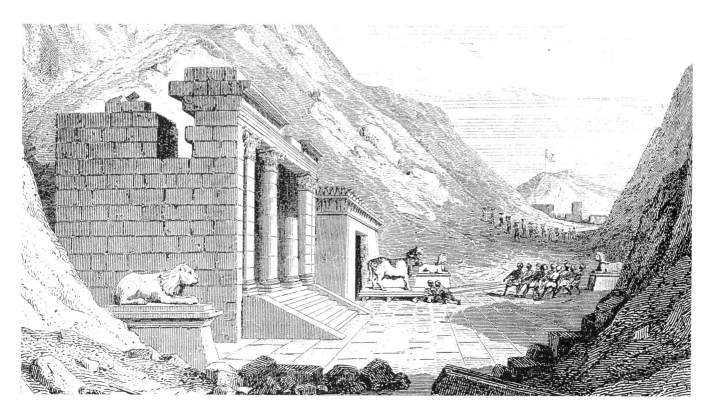

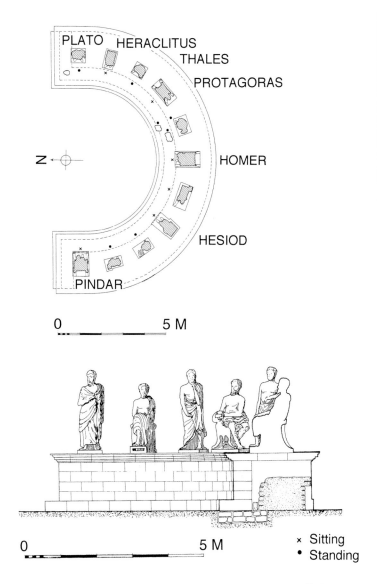

PLATO HERACLITUS
THALES
PROTAGORAS

HOMER

HESIOD

PINDAR

N

0 5 M

0 5 M × Sitting
 • Standing

198. Memphis (Mit Rahina), reconstruction of exedra with identified statues of Greek philosophers and poets, in front of East Temple

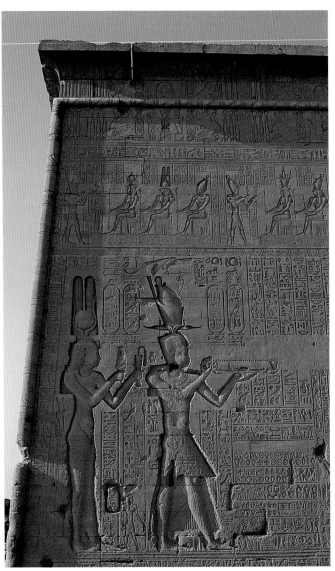

199. Dendara (Tentyris), temple of Hathor, detail of rear wall relief with Cleopatra VII and her son Ptolemy XV Caesar depicted as pharaoh

an Apis bull dating to the thirtieth dynasty [197].[4] Thus, the *dromos* of the most important temple in the former Egyptian capital had a mixed Greek and Egyptian character from the early Ptolemaic period onwards.

The only Ptolemaic classical temple of which foundations survive outside Alexandria is the temple at Hermopolis Magna (el-Ashmunein), in honour of Ptolemy III Euergetes I and Berenice (246–222 BC) [74–78]. It was built in front of the entrance to the enclosure of the Egyptian temple of Thoth [269]. As it was a private dedication by the Greek soldier settlers this probably explains its classical style, with Corinthian capitals and a Doric frieze. As at Memphis, the close proximity of the classical structure to the Egyptian temple reflects the continued importance of the religious complexes dedicated by the native Egyptians to their own gods.

SUPPORT OF THE PTOLEMAIC KINGS FOR THE EGYPTIAN TEMPLES

To appreciate the importance of the Egyptian temples some explanation of the relationship of the ruler to the native Egyptian religion is necessary. *Ma'at*, which could be translated as 'world order', 'justice' and 'harmony' was central to the Egyptians' view of kingship. *Ma'at* referred to the ideal state of the universe and society. It was the king's responsibility to maintain this by making offerings in the temples either in person or by proxy through the priesthood.[5] Pharaoh, the king, was regarded as a god, the incarnation of the god Horus: after he died he was identified with Osiris, god of the underworld. In order to be accepted as ruler by the Egyptian population and especially their priesthood, the Ptolemaic kings, and later the Roman emperors, had to take on the role of pharaoh [199].[6]

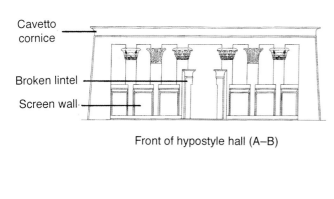

Cavetto cornice

Broken lintel

Screen wall

Front of hypostyle hall (A–B)

NAOS (Sanctuary)

INNER HYPOSTYLE HALL (Pronaos)

OUTER HYPOSTYLE HALL (Hypostyle hall)

A B

COURT

PYLON

OBELISKS

DROMOS

200. Typical Egyptian temple plan of Ptolemaic and Roman periods, with elevation of front of hypostyle hall: principal features and architectural terms

Thus, the Ptolemaic kings and the Roman emperors needed to support the Egyptian temples in order to maintain *ma'at*. This was essential to ensure the support of the Egyptian priesthood, who had considerable influence in the keeping of order among the native population. Consequently, both the Ptolemies and Romans paid for extensions to these temples. These continued to be built in an Egyptian style, but one which developed distinctive features. The most distinctive of these features were the screen wall across the front of the outer hypostyle hall [200] and the new forms of capitals and columns [202–205] which were more varied than earlier examples [201].

Egyptian temples were usually built in a number of phases with later additions being made around or in front of the earlier structure. This method continued to be used in the Ptolemaic and Roman periods. Thus, the small sanctuary (naos), which contained the statue of the god at the core of the building, has the main temple with rooms built around it, at the front of which was a columned hall called the inner hypostyle hall or pronaos [200]. In front of this a larger, usually taller, hall was added, called the outer hypostyle hall (sometimes also called the pronaos). A colonnaded court was often added in front of this. In front of the whole complex there was frequently a monumental gateway with tapering sides, called a pylon [40].

These temples were built in an enclosure which was surrounded by very substantial walls of mudbrick.[7] Within this enclosure wall other free-standing structures were also built. These included the birth house (in Arabic *mammisi*) in which the birth of the god was celebrated,[8] and the kiosk, which was a bark station, a processional resting place for the god's bark.[9] The major temples also had a Nilometer for measuring the height of the annual flood waters.[10]

The reliefs carved on the Egyptian temples were a central repository of religious beliefs, as well as presenting important elements of major rituals, festivals and mythology. These reliefs cover all surfaces of the temple walls, screen walls, ceilings and column shafts. Thus, the Egyptian temples were not

only buildings for worship, but also surfaces on which this religion was selectively presented.

Not only were the temples constructed in a number of phases, under a number of Ptolemies and even Roman emperors, but the walls were often decorated by these rulers over a period of time. This makes the reliable dating of their various parts difficult. Normally the decoration can be dated by the cartouches, but not the periods of construction prior to that decoration. An exception is the temple of Horus at Edfu (Apollinopolis Magna) for which there are building inscriptions.

There is also a problem of survival of evidence. The extent and speed of destruction of the temples along the Nile can be evidenced by the disappearance of many of them since they were recorded by the Napoleonic expedition in 1799. There is also an imbalance in the evidence, as most of the temples which have survived are in Upper Egypt with only a few from the Delta or the oases. These limitations need to be

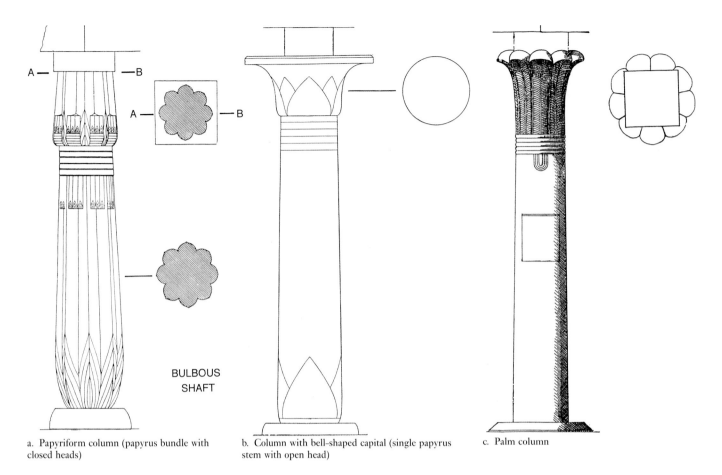

a. Papyriform column (papyrus bundle with closed heads)

b. Column with bell-shaped capital (single papyrus stem with open head)

c. Palm column

201a–c. Egyptian columns of Dynastic period

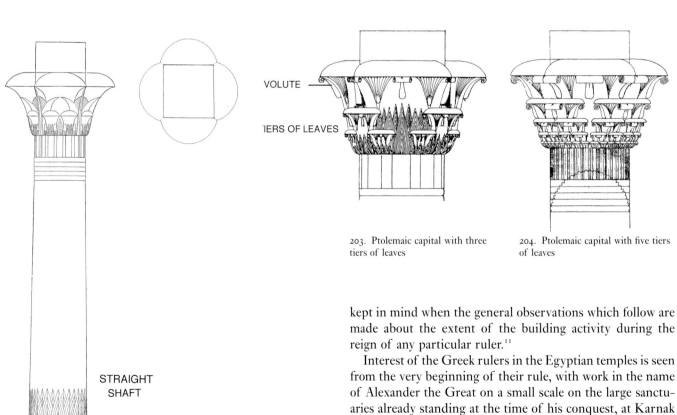

202. Ptolemaic column

203. Ptolemaic capital with three tiers of leaves

204. Ptolemaic capital with five tiers of leaves

kept in mind when the general observations which follow are made about the extent of the building activity during the reign of any particular ruler.[11]

Interest of the Greek rulers in the Egyptian temples is seen from the very beginning of their rule, with work in the name of Alexander the Great on a small scale on the large sanctuaries already standing at the time of his conquest, at Karnak and Luxor in Upper Egypt.[12] It is possible that the main resources for building during the reigns of Ptolemy I to III went into establishing the civic buildings in the new city

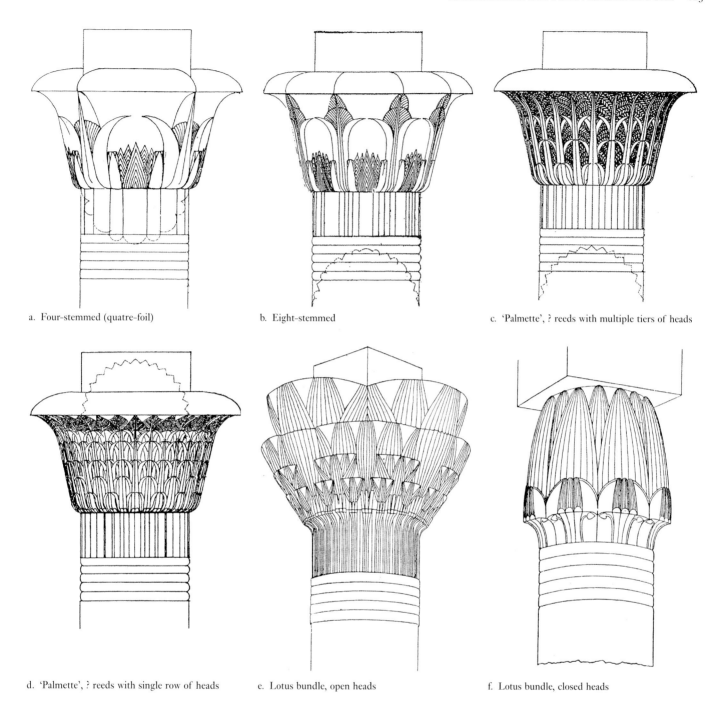

a. Four-stemmed (quatre-foil)

b. Eight-stemmed

c. 'Palmette', ? reeds with multiple tiers of heads

d. 'Palmette', ? reeds with single row of heads

e. Lotus bundle, open heads

f. Lotus bundle, closed heads

205a–f. Some Ptolemaic and Roman capital types

Alexandria. The island of Philae in Upper Egypt was important as the source of the Nile inundation, consequently Ptolemy II Philadelphus added to the work of the pharaoh Nectanebo I there by building the naos of the Isis temple, and Ptolemy III Euergetes I built a birth house.[13] Some constructions under Ptolemy III were extensions to pre-Ptolemaic ones, such as the Fifth Gate on the large sanctuary of the temple of Ptah at Karnak. The work of Ptolemy II and III is also observed at the other end of Egypt at Behbeit el-Hagara in the Delta where they completed the work of the

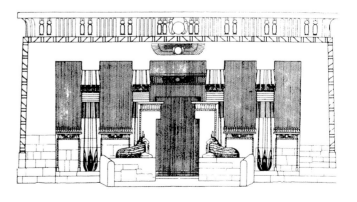

206. El-Hiba, temple of Sheshonq I (c. 945–925 BC), reconstruction of facade

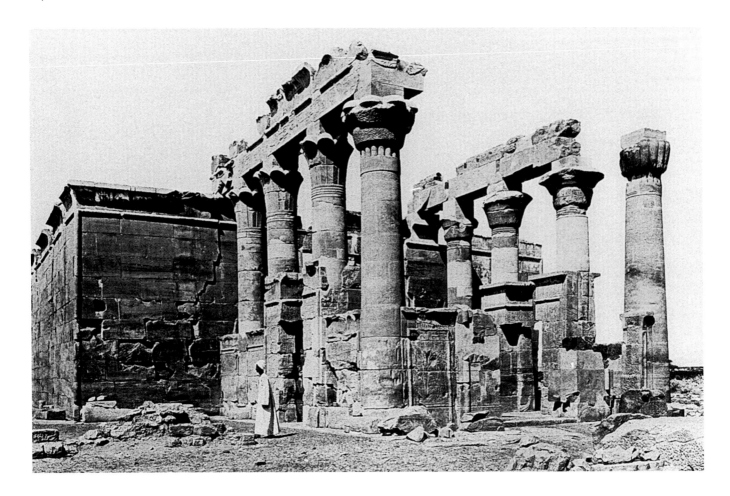

207. El-Kharga Oasis, Hibis Temple, portico of Nectanebo I, 380–362 BC, (with modern replacement for capital in fig. 208)

208. El-Kharga Oasis, Hibis Temple, portico of Nectanebo I, composite capital. New York, Metropolitan Museum of Art, inv. 10.177.2

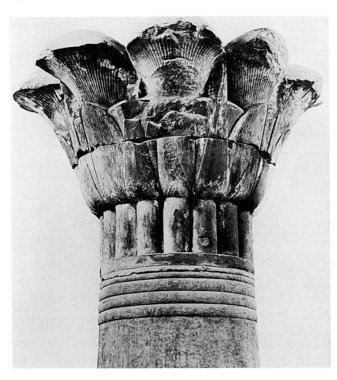

last native pharaoh Nectanebo II on the temple of Isis.[14]

Under Ptolemy III Euergetes I the meeting of priests in the temple at Canopus (Abuqir), east of Alexandria, in 238 BC ratified the Ptolemaic ruler cult in the Egyptian temples in return for royal benefactions.[15] This followed introduction of the royal cult by Ptolemy II Philadelphus for his wife Arsinoe II.[16] The king and queen were worshipped as the *Theoi Synnaoi* by putting them in the same temple with the already existing Egyptian gods.

After his victory at the battle of Raphia in 217 BC Ptolemy IV Philopator showed his gratitude to the Egyptian gods with generous gifts to the temples.[17] The victory at Raphia had come with the help of Egyptian troops. However, the arming of the Egyptians led to a major revolt in 207/6 BC, resulting in the loss of Upper Egypt at the end of his reign. As a result of these political problems in Upper Egypt the building activities of Ptolemy V Epiphanes were limited until after the revolt had been quelled.[18] In 196 BC he was crowned pharaoh of Upper and Lower Egypt in the old capital of Memphis by the high priest of Ptah.[19] In the decree of 196 BC, which is recorded in the Rosetta Stone, he freed the temples of their debts and gave them cult buildings and financial support.[20] Extensive building programmes were achieved later in the second century BC under Ptolemy VI Philometor and especially Ptolemy VIII Euergetes II.[21]

The revolts of Upper Egypt during the second century BC were finally crushed by Ptolemy IX Soter II in 88 BC[22] and followed by a building programme there to regain support.

The Romans conquered Egypt in 30 BC, and the extensive building programme of Octavian (later the emperor Augustus) after the revolt early in his reign[23] possibly also resulted from a similar need to gain local support in the south.

DISTINCTIVE DESIGN OF EGYPTIAN TEMPLES OF THE PTOLEMAIC PERIOD

The Egyptian temples of the Ptolemaic (and Roman) periods are quite distinct from those of the Dynastic period. They have a colonnaded court behind the first pylon, an outer hypostyle hall across the front of which is a screen wall, an inner hypostyle hall and a sanctuary (naos) [200]. The columns are decorated with new varieties of capitals, often no two alike [202–205]. These and the screen wall across the front of the outer hypostyle hall are probably their most distinctive features.

Although most of the features on them occur in the Dynastic period, it is the frequency of their use and the combination of them which gives the Ptolemaic temples their distinctive character. The screen wall occurs occasionally in Dynastic architecture, for example on the temple of Sheshonq I (Sesonchis) at el-Hiba, c. 945–925 BC, where the top half of the wall is open, between the columns, and is crowned by a row of snakes [206].[24] This temple also has a broken lintel on the entrance in its screen wall, as later seen on Ptolemaic temples [224]. The basic axial arrangement with a colonnaded court at the front of the temple approximates that used in the Dynastic period.[25] There were often two obelisks in front of the temple which was approached by a processional way, as occurred on the earlier Egyptian temples. This processional way, which was sometimes lined with sphinxes,[26] was called a *dromos* in Greek.

Although there seem to have been earlier birth houses, a distinctive design of them developed in the Ptolemaic period and continued into the Roman period. This is characterised by a colonnade around all four sides, with screen walls and L-shaped piers on the corners [228].

Egyptian 'Composite Capitals'

One of the most distinctive features of many of the Egyptian temples of the Ptolemaic and Roman periods is the column capital.[27] These are called 'composite capitals' by Egyptologists, because different plant forms are combined on a single capital. By contrast, in the Dynastic period a capital was decorated with only a single plant: papyrus (bundle or single stem) or palm. The Egyptian 'composite capitals' are not related to the Ionic-Corinthian combination called Composite in Greco-Roman architecture. While the column shafts in the Dynastic period are generally slightly bulbous in shape [201a–b], those in the Ptolemaic period are generally straight and unfluted [202].

The way the capitals are used on a building is also distinctive: in the Dynastic period the columns of one colonnade or courtyard would all have identical capitals [206], in the Ptolemaic (and Roman) periods each capital would frequently be different from the one beside it [219].

Before the date of introduction of the composite capitals is discussed some mention should be made of the difficulties of ascertaining their chronology. Because these temples often took a very long time to complete and had a number of construction phases, the reliefs were often carved long after the construction of the temple, as evidenced by the Edfu temple inscription. Consequently, the column shafts were often decorated a long time after they were erected. The capitals were carved *in situ*, but it is not always completely clear at which stage in construction they were carved, although they were generally carved before the wall reliefs.[28]

As the situation is exacerbated by the small number of buildings surviving, absence of evidence is a potential source of error. Thus, the generalizations made here are limited to the date by which particular features appear to have become common, rather than over-emphasizing their date of introduction, because the earliest surviving examples may not be as early as the first examples.

The Amun temple of Hibis in el-Kharga Oasis, the main part of which was built in the Saite period and renewed by the Persian king(s) Darius I (?and II), is one of the few monuments surviving with work from the Persian period. The earliest surviving composite capital occurred on the entrance kiosk or portico built in front of it under Nectanebo I, 380–362 BC [207]. This is a simple composite capital without volutes or multiple layers of leaves [208].[29] It is used in association with two other types of capital on the one colonnade.[30] This means that both the composite capitals and the idea of using a variety of capitals together already occurred by the fourth century BC, prior to Ptolemaic rule.

Under Ptolemaic rule the new capital types and usage overlap with those which are a continuation of the traditional Dynastic types and usage. The temple of Thoth at Hermopolis Magna (el-Ashmunein) built under Philip Arrhidaeus (323–316 BC) had papyriform capitals on its hypostyle hall reminiscent of Dynastic ones [209, 210a].[31] There are no standing monuments surviving with capitals from the reigns of Ptolemy I and II. The temple at Antaeopolis (Qaw el-Kebir) had palm capitals on the hypostyle hall related to Dynastic ones [210, 201c]. This temple, dedicated to Anty, was constructed under Ptolemy IV Philopator and its hypostyle hall has a dedicatory inscription in Greek from the reign of Ptolemy VI Philometor.[32] Only one type of capital was used on the one building, or part of it, as was the custom during the Dynastic period.

However, on the Fifth Gate of the temple of Ptah at Karnak, from the reign of Ptolemy III Euergetes I, a variety of capitals is used together [211].[33] These include simple composite capitals which are related to those on the Hibis temple in el-Kharga Oasis. Simple composite capitals are also used on the inner hypostyle hall of the temple of Horus at Edfu, built under Ptolemy IV Philopator.[34] On the portico of the Montu temple at Medamud, built under Ptolemy VIII Euergetes II, there is a combination of simple composite capitals used with papyriform capitals reminiscent of the Dynastic ones [212].[35] Thus, there is an overlap of the Dynastic

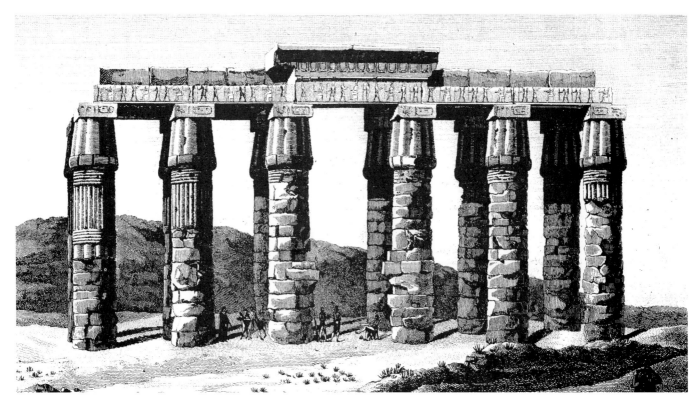

209. Hermopolis Magna (el-Ashmunein), temple of Thoth, built under Philip Arrhidaeus

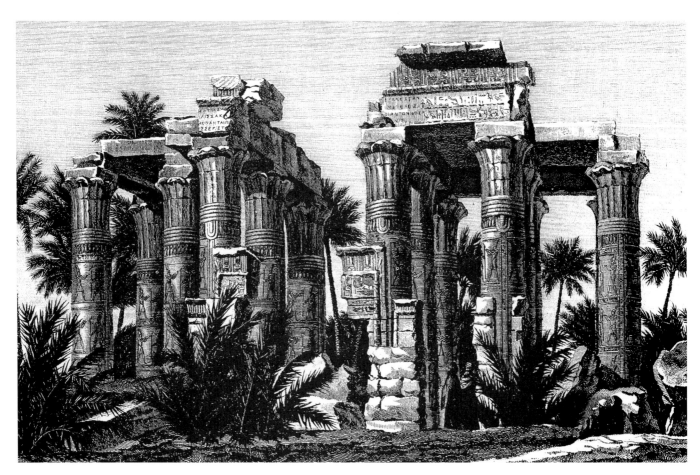

210. Antaeopolis (Qaw el-Kebir), temple of Ptolemy IV and Arsinoe, dedicated to Anty

211. Karnak, fifth gate of the
temple of Ptah, built under
Ptolemy III Euergetes I

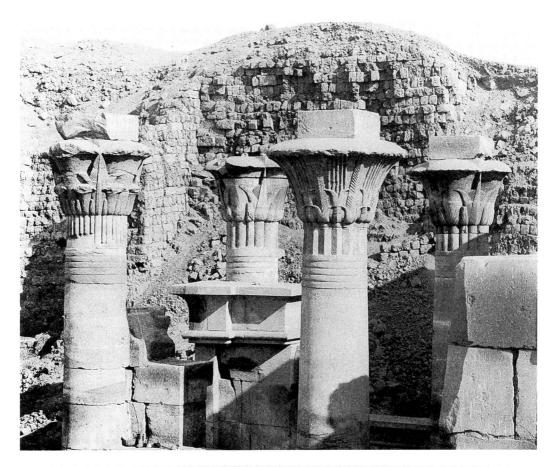

212. Medamud, portico of
Montu temple, built under
Ptolemy VIII Euergetes II

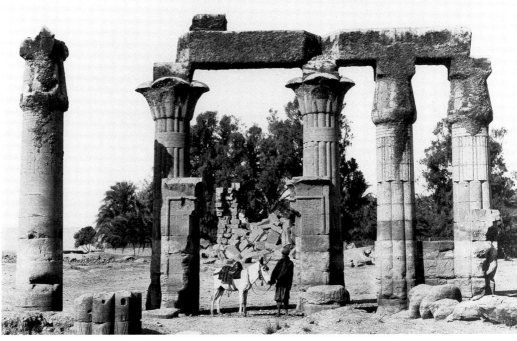

capital types with the introduction of the composite capitals
while the frequency of their use gradually increases.

Many of the composite capital types are further distin-
guished from the Dynastic ones by the fact that they have
four distinct sides or faces, rather than being the same all the
way round. This is a feature which also occurs on Corinthian
capitals. The composite capitals later develop two additional

features which seem to result from the influence of
Corinthian capitals: these are the small volutes and the two
lower layers of leaves [203] which are reminiscent of the
arrangement of the two rows of acanthus leaves on
Corinthian capitals [121].[36] Thus, while the idea of using a
variety of capitals together and the composite capitals began
prior to the Ptolemaic period, the capitals became more

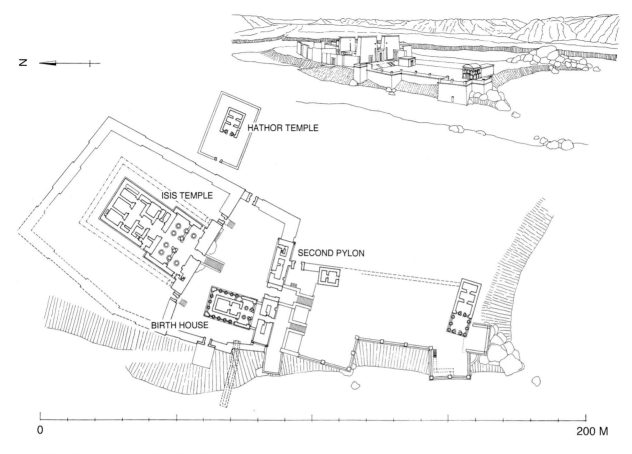

213. Philae, plan and reconstruction of temples, *c.* 150 BC

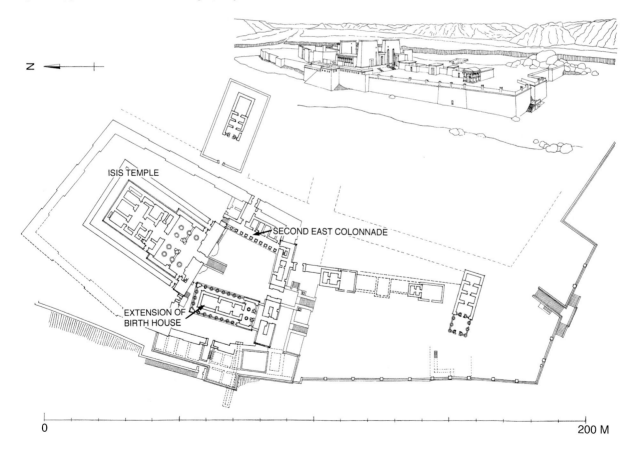

214. Philae, plan and reconstruction of temples, *c.* 100 BC

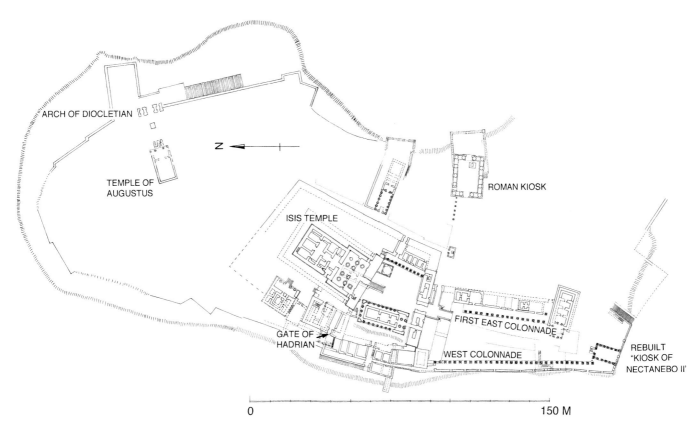

215. Philae in Roman period, plan

varied during that period as a result of the subtle inclusion of some Greek features.

The description of the Egyptian capitals on Ptolemy IV Philopator's river boat specifically states that they did not have volutes,[37] suggesting that at the end of the third century BC the Egyptian style ones still did not have them. The process of the development of the composite capitals with volutes may most easily be observed at Philae.

The most substantial series of structures built under the Ptolemies survives on the island of Philae, where the gradual architectural embellishment of the site can be traced [213–215].[38] The main part, or naos, of the Isis temple was built under Ptolemy II Philadelphus. The birth house was built nearby under Ptolemy III Euergetes I. During the reign of Ptolemy VI Philometor the pronaos was added to the front of the Isis temple and the Hathor temple was built [213]. Ptolemy VIII Euergetes II was responsible for the decoration of the pronaos of the Isis temple, along with the construction of the so-called Second East Colonnade and the extension to the back of the birth house [214].

On the pronaos of the Isis temple, simple composite capitals without volutes are used [216].[39] They are also used on the temple at Deir el-Medina completed under Ptolemy VI Philometor.[40] During his reign, the first reasonably well-dated examples of composite capitals with volutes also occur on the pronaos of the Hathor temple at Philae [217].[41] There are possibly earlier examples with volutes on the birth house at Philae if they date to Ptolemy III to V, before its extension under Ptolemy VIII [218].[42] Both of these sets of capitals have the capital subdivided two or three times, i.e. there are not more than three layers of leaves and volutes (as in [203]).

There was extensive building activity during the reign of Ptolemy VIII Euergetes II, principally 145–116 BC. During this period there seem to be further developments in the composite capitals. The first dated examples of composite capitals with more than three layers of 'leaves' or volutes [204] survive from his reign. Examples from his reign can be observed on the extension of the birth house at Philae[43] [219], the Second East Colonnade at Philae[44] [221], and on the facade on the outer hypostyle hall of the temple of Horus at Edfu (Apollinopolis Magna) [222, 224]. Also during his reign, on these buildings there is an increase in the variety of capital types used on one row of columns [221]. It is notable that these novel developments of the capitals occurred under Ptolemy VIII during whose reign there is also a marked development in the sophisticated and complex design of the temple reliefs.[45] These capitals are derived from by then existing types, but what is significant at this time is the development of their full diversity and the standardization of the variety of types which then continue for the remainder of the Ptolemaic period. With the temple reliefs, although there are earlier forerunners, it is the standardization of organizing principles which is notable. Furthermore, this does not seem to be the result of Greek influence, but a purely Egyptian development reflecting the strength of Egyptian religion, art and culture in this period.

The various parts of the temple of Horus at Edfu are reliably dated by its building inscriptions. These give a detailed

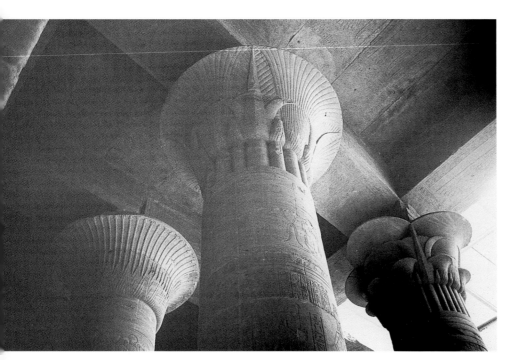

216. Philae, temple of Isis, capitals in pronaos

description of the exact layout of the building and its dimensions, and also of the phases of construction and decoration of each of its parts. The measurements given in the inscription may be compared with those of the chambers themselves. This gives a length of cubit of 0.522–0.542 m, which is an average of 0.531 m with a 2 per cent variation on either side. Notably the dimensions given in the inscription often include fractions of cubits, not just whole cubits.[46]

The temple was begun in 237 BC. The outer hypostyle hall was built under Ptolemy VIII Euergetes II in 140–124 BC, and the forecourt and pylon in 116–71 BC [223]. It provides evidence for the increased diversity of capitals introduced under

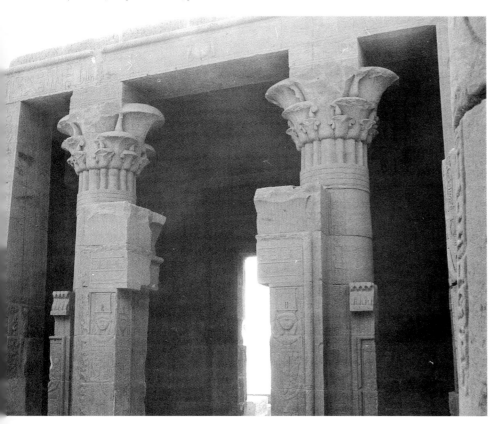

217. Philae, temple of Hathor, pronaos

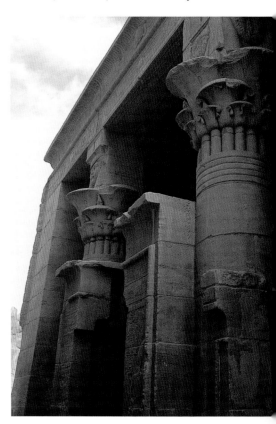

218. Philae, birth house, south entrance of pronaos

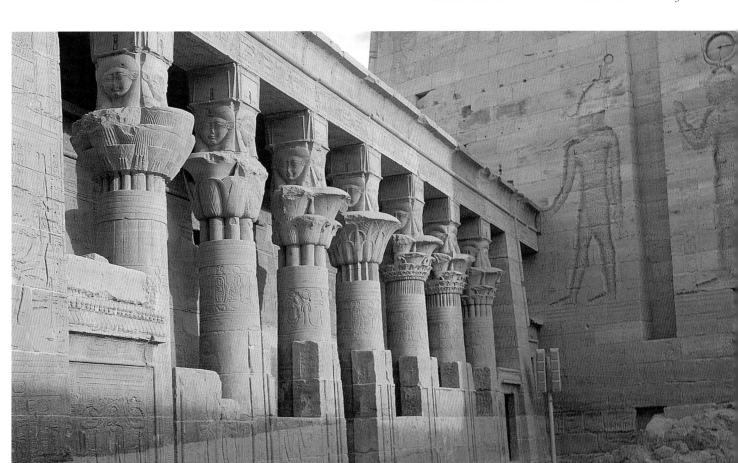

219. Philae, birth house, east side

Ptolemy VIII, including the composite capitals already men-
tioned on the outer hypostyle hall, with the different types
symmetrically arranged about the entrance [224]. This
variety of capitals continues under Ptolemy IX Soter II on
the forecourt [225–227]. It is also observed on the birth house
at Edfu, from his reign, 116–107 and 88–81 BC [228].[47]

This birth house has considerable traces of paint surviv-
ing, giving a glimpse of how the reliefs and capitals would
have been brightly painted [229–230]. The palette of colours
used in the Ptolemaic period is generally lighter than in the
Dynastic period.

The outer hypostyle of the temple of Horus and Sobek at
Kom Ombo (Ombos) was built under Ptolemy XII Neos
Dionysos (Auletes), 80–58 and 55–51 BC. This temple has
more ornate capital types on the facade, with older plainer
types used inside [231–232].[48] These simpler examples would
have been cheaper to carve, saving the most expensive deco-
ration for where it would be seen at the front of the build-
ing. Just as the complexity of the capitals is not related solely
to chronology, it is also related to other factors. The Kiosk,
or bark station, at Armant (Hermonthis) of Cleopatra VII
had the variety of capitals mentioned on the earlier monu-
ments, but as Ptolemaic rule came to an end, those at its front
were left unfinished.[49]

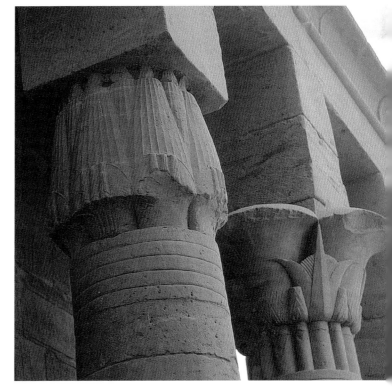

220. Philae, birth house, capitals on extension of Ptolemy VIII Euergetes II

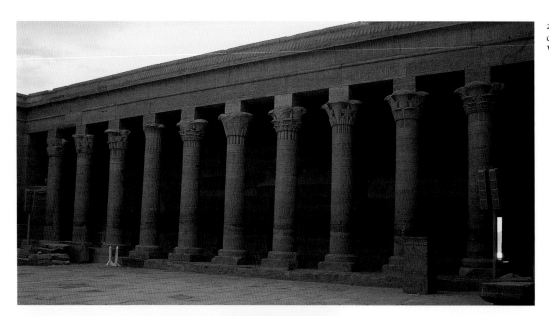

221. Philae, second east colonnade built under Ptolemy VIII Euergetes II

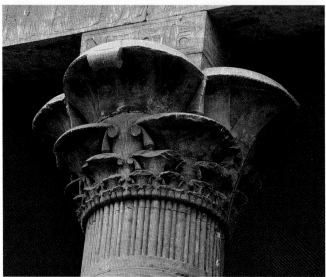

222. Edfu (Apollinopolis Magna), temple of Horus, capital on front of outer hypostyle hall, built under Ptolemy VIII Euergetes II in 140–124 BC

FEATURES COMMON TO EGYPTIAN AND CLASSICAL PTOLEMAIC ARCHITECTURE

Despite their apparently dissimilar appearances, there are some subtle and interesting conceptual similarities between the Egyptian and classical architecture in the Ptolemaic period. These seem largely to result from Egyptian influence on classical architecture. By contrast, the building techniques which become standard in Egyptian architecture of the Ptolemaic period, and are also used in classical architecture, do not necessarily result directly from Greek influence

223. Edfu (Apollinopolis Magna), temple of Horus, plan showing construction phases recorded in inscriptions

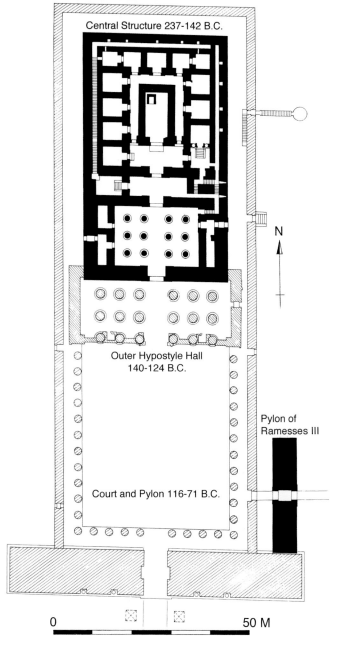

Central Structure 237-142 B.C.

N

Outer Hypostyle Hall 140-124 B.C.

Pylon of Ramesses III

Court and Pylon 116-71 B.C.

0 50 M

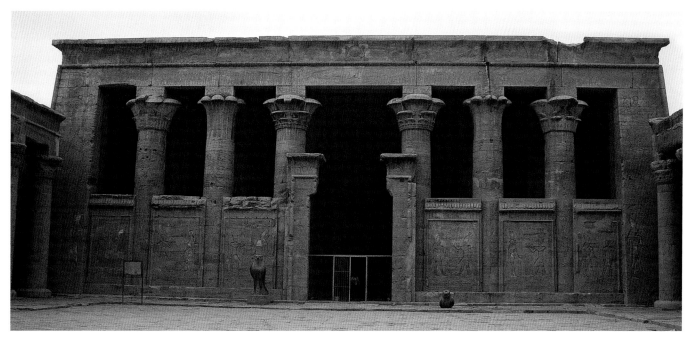

224. Edfu (Apollinopolis Magna), temple of Horus, outer hypostyle hall built under Ptolemy VIII in 140–124 BC

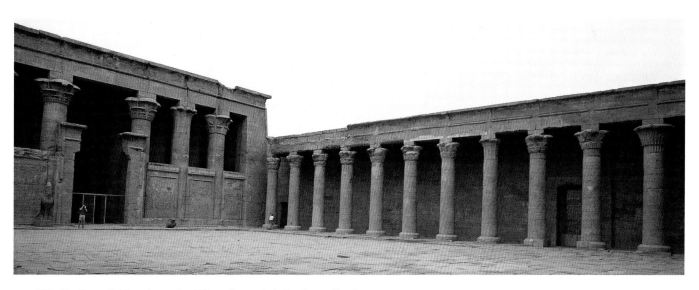

225. Edfu (Apollinopolis Magna), temple of Horus, hypostyle hall and east side of court

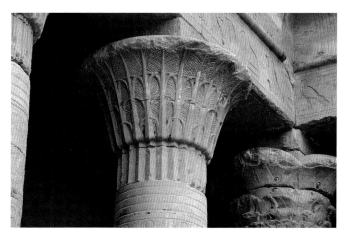

226. Edfu (Apollinopolis Magna), temple of Horus, capital on forecourt, 116–71 BC

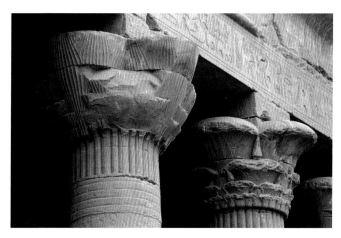

227. Edfu (Apollinopolis Magna), temple of Horus, capital on forecourt, 116–71 BC

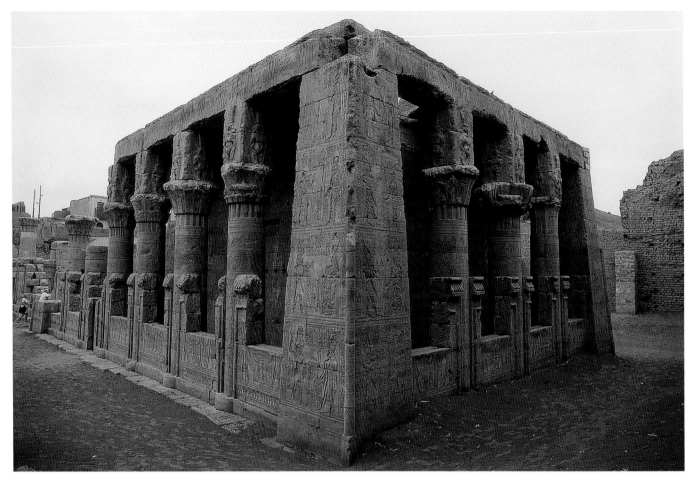

228. Edfu (Apollinopolis Magna), birth house

because they are used in Egyptian architecture of the Dynastic period, even if infrequently.

Conceptual similarities are seen in the details of the capitals. On both the Egyptian and classical architecture there is a creative variety of new capital types, and this variety is further increased by the use of different types on the one colonnade. This is seen on typical Egyptian examples at

Philae [219, 221], while classical examples occurred on the Chantier Finney building in Alexandria [113d–f], and on a building at Edfu (Apollinopolis Magna) [240–241, 377–378].

The development of this richness of design of the colonnades and their capitals resulted from the influence of Egyptian and Greek architecture on each other.[50] The idea of using a variety of capitals on one colonnade was Egyptian, but these

229. Edfu (Apollinopolis Magna), birth house, reliefs with traces of paint

230. Edfu (Apollinopolis Magna), birth house, capital with traces of paint

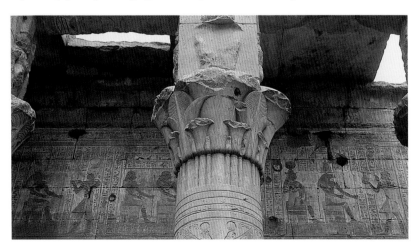

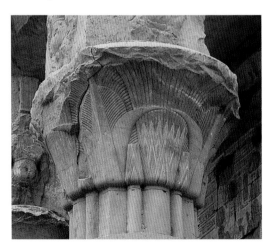

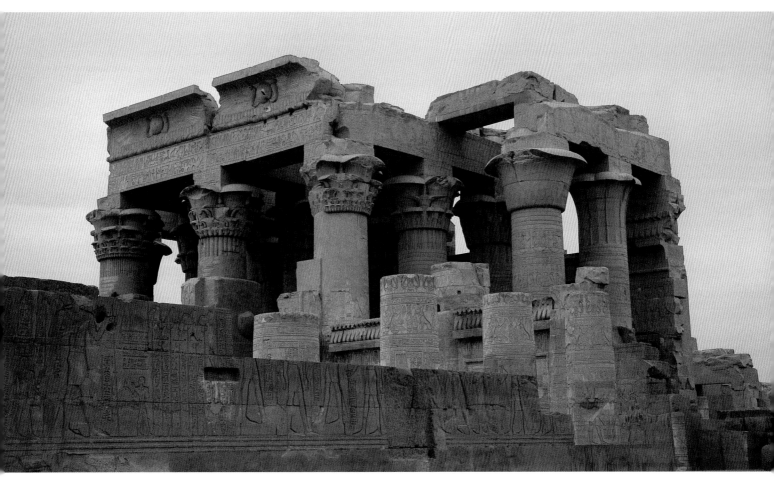

231. Kom Ombo (Ombos), temple of Horus and Sobek, outer hypostyle hall, built under Ptolemy XII Neos Dionysos (80–51 BC)

Egyptian capitals became more ornate with the addition of features from the Corinthian capitals [123]. These include the small volutes, the layers of leaves, and the dominance of four faces on the capital [203]. The attempt to make the capitals the same all the way round, like on the earlier Dynastic ones, then led to the next stage in their development with further subdivisions of each capital making its four faces less obvious. This made the capitals even more ornate [204].

On both the Egyptian temples and the classical architecture of Alexandria, depicted in the Pompeian wall-paintings, there is a screen wall across the front [161, 224]. The style differs but the content is the same. The top part of the wall between the columns is open. Whereas, in Hellenistic architecture outside of Egypt screen walls are only surface decoration with the top part of the wall between the columns solid and not open. The broken lintel, at the entrance in the screen wall to the hypostyle hall in the Egyptian temples [224], is in the equivalent position to the broken pediments or hollow pediments, with a broken entablature, depicted in the Pompeian wall-paintings [143, 161]. Both the broken lintel and screen wall occurred (although less frequently) in Dynastic architecture, suggesting that these features result from influence of Egyptian examples on the classical ones, rather than the reverse.

The design of both the Egyptian temples and of the architecture depicted in the Pompeian wall-paintings also exhibits

an interest in the frontality and axiality of the building design. The axial approach to the Egyptian temples is reflected in the design of the classical sanctuary at Hermopolis Magna (el-Ashmunein) [75]. It is sometimes suggested that this concentration on frontality and axiality

232. Kom Ombo (Ombos), capitals of outer hypostyle hall

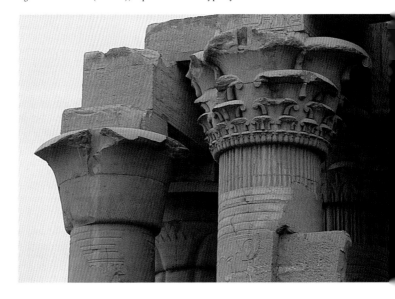

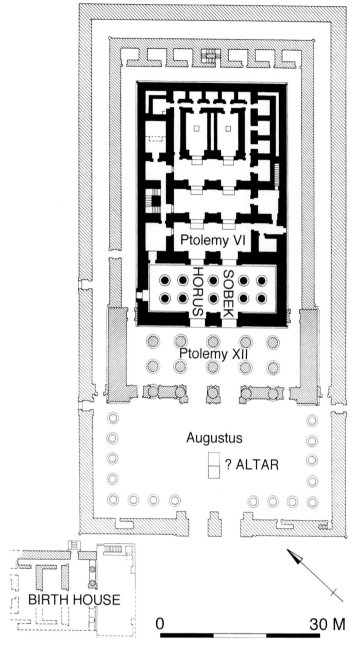

233. Kom Ombo (Ombos), temple of Horus and Sobek, plan of construction phases

like the walls of an Egyptian temple [228]. There are Dynastic examples of kiosks with a row of square pillars (not columns) around all four sides, so the Greek influence on the birth house design seems to be subtle causing an existing type to become more developed and more common.

The choice of paint colours used for wall reliefs is distinctive with a more pastel palette used in the Ptolemaic period, but it is not clear if this is the result of classical influence.

There are clear developments in the construction techniques of the Egyptian temples in the Ptolemaic period involving techniques which are the same as those used in classical architecture. Because examples of these techniques also occur, although much less frequently, in architecture in Egypt before the Ptolemaic period,[51] it is only the frequency of their use, rather than the techniques themselves, which can potentially have resulted from Greek influence in the Ptolemaic period.

Stone slabs remained the traditional roofing material for monumental stone Egyptian temple architecture. However, birth houses and related structures, such as kiosks, had timber roofs. As these occurred on such structures before the Ptolemaic period, they cannot be attributed to classical influence in the Ptolemaic period.

In the Dynastic period the foundations of monumental stone buildings were usually laid on a layer of sand, whereas in the later periods the use of solid masonry foundation platforms became standard, although there are some examples from the Old Kingdom. The temples in the Ptolemaic and Roman periods are built using isodomic masonry, in which the stones are rectangular and laid in courses of equal height [219]. This technique had become standard by the thirtieth dynasty in contrast to the earlier custom which involved the use of larger and irregular stone blocks. Although, isodomic masonry was used in Greek architecture by the sixth century BC, it was occasionally used prior to that in Egyptian architecture. In the Ptolemaic period the masonry is characterized by roughly recessed bands running lengthwise along the top surface of the blocks, and these recesses are more deeply cut in the Roman period. Although this technique is related to that used in Greek architecture, it was occasionally used in Egypt in the Middle and New Kingdoms, and became standard on early Ptolemaic buildings. Seeing these techniques used all the time on classical architecture, in cities such as Alexandria, might have led the Egyptians to appreciate their advantages, and thus their use became standard.

EGYPTIAN ARCHITECTURE IN THE ROMAN PERIOD

Construction under the first two Roman emperors, Augustus and Tiberius (from the Roman conquest of Egypt in 30 BC until AD 37) generally consists in the addition of an outer hypostyle hall, a colonnaded court, or colonnades to existing complexes. These emperors extended the Ptolemaic temples just as the Ptolemies had extended the Dynastic ones, as seen in the temple of Horus and Sobek at Kom Ombo (Ombos) which was enlarged by successive Ptolemies while the court in front was added under Roman rule [233].

may have influenced Roman architecture. The location of the colonnaded court (a temenos or forum) at the front of the temple, as in architecture in Rome, rather than around it as in Hellenistic architecture, follows the basic arrangement used in Egypt since the Dynastic period.

The development of a colonnade around the birth house has some similarity to Greek temple design with a colonnade around all four sides, a feature which also occurs on temples in the Roman East. Besides being Egyptian in style, the birth house colonnade also has other Egyptian features, such as the screen walls. Rather than the columns on the corners, as on a Greek temple, it has L-shaped piers which taper upward

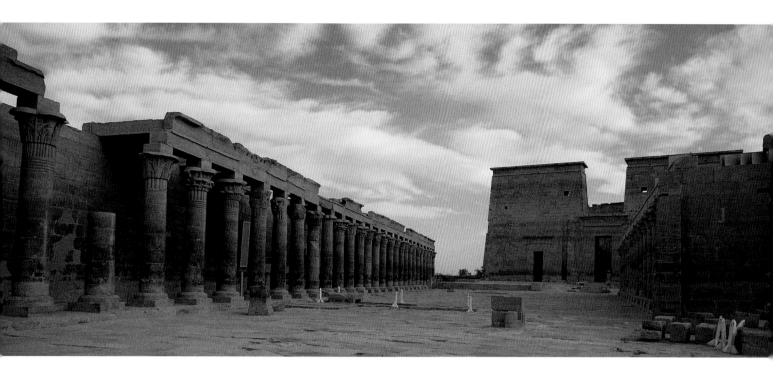

234. Philae, West Colonnade (on left) and First East Colonnade (on right) in front of the First Pylon of the temple of Isis

Generally after the mid-first century AD building activity consisted of wall decoration rather than new constructions, although some new buildings were erected under Antoninus Pius (AD 138–161). The surviving evidence suggests that during the later second and the third centuries AD in the towns and cities up the Nile the construction effort and resources went into classical public buildings, rather than Egyptian temples.

Strabo's Description

The Roman geographer Strabo, who visited Egypt in *c.* 26–20 BC, gave a more detailed account of the Egyptian temples, than of any individual building in his description of Alexandria: 'The plan of the construction of the temples is as follows: at the entrance into the sacred precinct there is a floor paved with stones, with a breadth of about a plethrum [100 ancient feet], or less, and a length either three or four times as great, or in some cases more; and this is called the *dromos* . . . Throughout its whole length are stone sphinxes placed in order on each of its two sides, at a distance from one another of twenty cubits or a little more, so that one row of sphinxes is on the right and one row on the left. And after the sphinxes one comes to a large *propylon*, and then, as one proceeds, another, and then another; but there is no prescribed number either of *propyla* or of sphinxes, and they are different in different temples, as were also the lengths and breadths of the *dromoi*. After the propylaia one comes to the naos [the temple proper], which has a large and noteworthy pronaos, and to a sanctuary (*sekos*) of commensurate size, though it has no statue, or rather no statue of human form, but only of some irrational animal. In front of the pronaos is

the pylon, *ptera*, as it is called . . . as one proceeds onward, [the walls] follow lines travelling upwards for fifty or sixty cubits, and these walls have figures of large images cut in low relief, like Tyrrhenian images and the very old works of art among the Greeks. There is also a kind of hall with numerous columns, as at Memphis, for example, which is constructed in the barbaric manner; for, except for the fact that the columns are large and numerous and form many rows, the hall has nothing pleasing or picturesque, but is rather a display of vain toil'.[52] This last sentiment would not be shared by most contemporary inhabitants of Egypt or by the present day visitor.

Egyptian Temples from Augustus to Nerva (30 BC–AD 98)

Like Alexander and the Ptolemies before him, Octavian (later Augustus) took on the role of pharaoh, after the Roman conquest of Egypt in 30 BC. Unlike the Ptolemies, the Roman emperors did not live in Egypt which made their relationship with the Egyptian people and their religion more distant.

The revolt in Upper Egypt early in Augustus's reign was followed by considerable building activity on temples in Upper Egypt, presumably to re-establish *ma'at* and the support of the native population and their priesthood. These included both the erection of new temples and extensions to existing ones, with this work being continued under his successor, Tiberius, AD 14–37. In the ninth year of Augustus the naos of the temple of Hathor at Dendara (Tentyris), which was begun under Ptolemy XII Neos Dionysos (Auletes) in 53 BC, was completed.[53]

The most substantial structures built under Augustus are the West Colonnade and the so-called First East Colonnade,

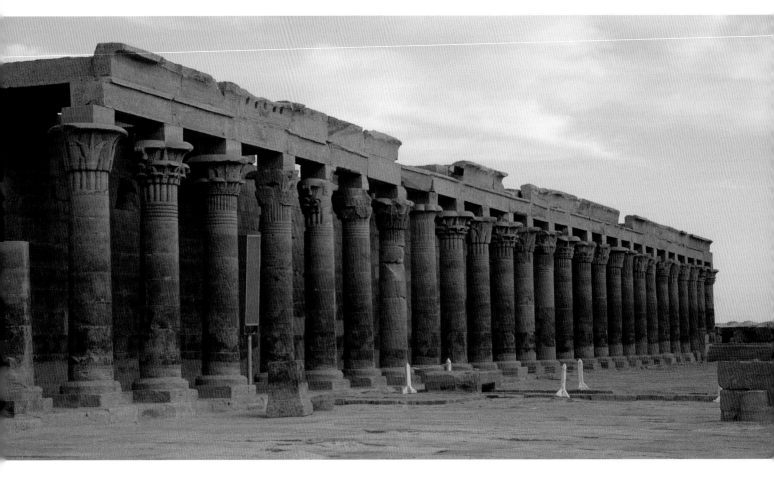

235. Philae, West Colonnade, Roman

opposite it, at Philae [215, 234].[54] The design of these long independent colonnades shows classical influence because they relate to the colonnades or stoas used at the edges of classical open space, such as an agora. The West Colonnade has lively new details on the capitals [235–239], while those on the north half of the First East Colonnade were not completed [242] although the decoration of both colonnades continued to be carved under Tiberius. The shapes of the unfinished blocked out capitals show the variety of capital types which were planned.

Further south, beyond the First Cataract, temples were also erected under Augustus at Tafa (Taphis),[55] Kalabsha (Talmis)[56] and Dendur (Tutzis).[57] During his reign and that of Tiberius, substantial additions were made to the Ptolemaic sanctuary at el-Dakka (Pselchis),[58] and the Ptolemaic sanctuary at Dabod was decorated.[59]

Other major constructions which were erected under Augustus and Tiberius include the forecourt of the Temple of Horus and Sobek at Kom Ombo (Ombos) [233].[60] At Dendara towards the end of Tiberius's reign, in AD 32–7, the large hypostyle hall at the front of the temple of Hathor was built onto the front of the Ptolemaic temple which Augustus had completed [243–244]. The decoration of its screen walls was completed under Nero, AD 54–68.[61]

Under Claudius, AD 41–54, the hypostyle hall was constructed in front of the Ptolemaic temple of Khnum at Esna (Latopolis) [245]. The work undertaken during the reigns of the next emperor, Nero, and his successors during the remainder of the first century AD seems to have been largely decorative. The decoration of the facade of the hypostyle hall on the temple of Khnum was continued under the emperors down to Hadrian [246], while the columns in its hall were decorated from the reign of Domitian until Antoninus Pius.[62] Nero's cartouche appears on the temple of Isis and Serapis at el-Maharraqa (Hierasykaminos) which was never completed.[63] The decoration of the temple at Kom Ombo (Ombos) was also continued through the first century AD and during the next century.[64]

Egyptian Capitals

The composite capital types which had developed during the Ptolemaic period are also used on the Egyptian architecture in the Roman period. Those from the reigns of Augustus to Claudius exhibit further lively developments with additional ornamentation on them.

Egyptian capitals on columns of the West Colonnade at Philae, which were decorated under Tiberius, have details from classical Corinthian capitals added to them. These details include a single row of acanthus leaves above bead and reel decoration [236], and two rows of acanthus leaves with

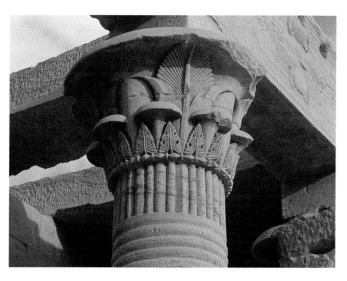

236. Philae, West Colonnade, Egyptian capital with acanthus leaves and bead and reel decoration

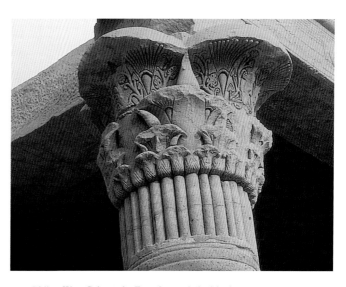

237. Philae, West Colonnade, Egyptian capital with vines

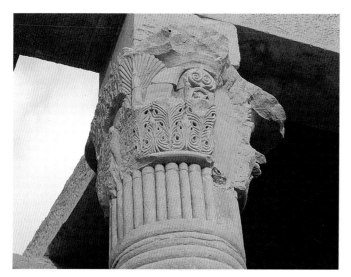

238. Philae, West Colonnade, Egyptian capital with acanthus leaves and helices

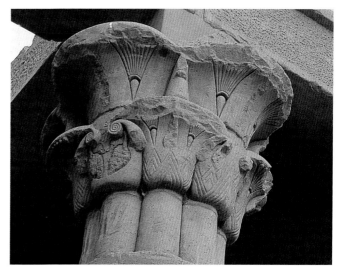

239. Philae, West Colonnade, Egyptian capital with bunches of grapes below volutes

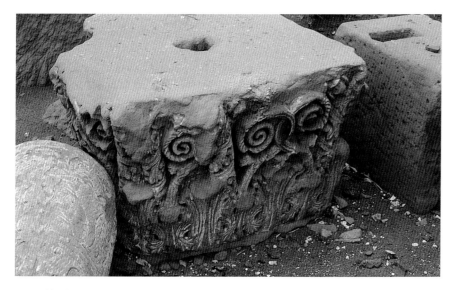

240. Edfu (Apollinopolis Magna), Alexandrian type Corinthian capital

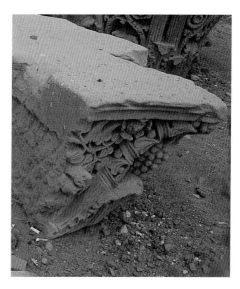

241. Edfu (Apollinopolis Magna), Corinthian capital with vines

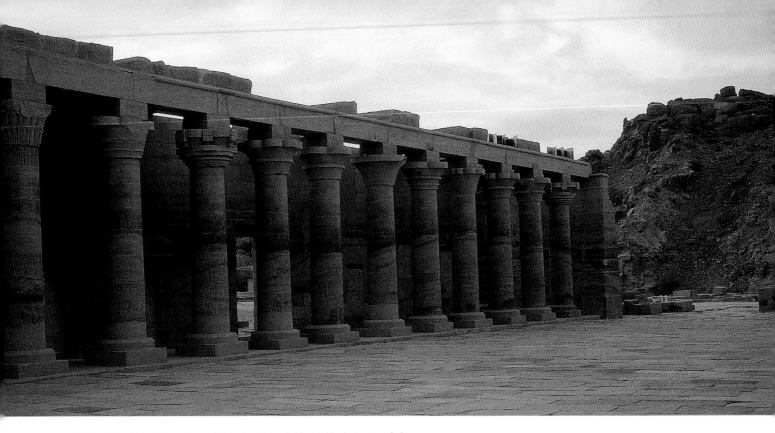

242. Philae, First East Colonnade, unfinished northern half with blocked out capitals

helices [238]. Some of these capitals have vines on them [237] or a bunch of grapes under the volutes [239], as also observed on some classical examples, such as those from a building at Edfu [241].

Some of the motifs added to these Egyptian capitals as surface decoration are of particular interest because they also are later used in the architecture of Late Antique Egypt. These occur on the hypostyle hall of the temple at Esna built under Claudius, and the Augustan temple at Kalabsha. These have vines running up some capitals and date palms depicted around the drum of the capital [250].[65] They also have a lotus motif decorating the front of the capital [247–248], of which related examples are also depicted at Philae on the Roman Kiosk [254] and on the West Colonnade.[66]

Egyptian Temples in the Second Century AD

Under the emperor Trajan, AD 98–117, as under his immediate predecessors, existing monuments seem to have been decorated in preference to new ones being built. The birth house at Dendara was decorated mostly under Trajan, although it is not clear when it was built.[67] The capitals and reliefs along its side screen wall were finished [251, 252]. However, the birth house was not completed at the back, where some capitals have been left blocked out and the whole screen wall below them has not been decorated [253]. Similarly, under Trajan the Roman Kiosk (or so-called Trajan's Kiosk) at Philae was decorated on the inside of its screen walls, but its exterior screen walls were left unfinished [255].[68] On the similar structure at Qertassi (Tzitzis) the capitals were also completed, but not the reliefs.[69]

During the reign of Hadrian, AD 117–38, the work on the Egyptian temples also seems to have been largely decorative. Instead, considerable construction work went into the new city of Antinoopolis (el-Sheikh ʿIbada) which Hadrian founded in AD 130, as well as temples in his honour. There was even one in the old Egyptian capital Memphis.[70]

However, some new Egyptian-style structures have survived from the period of the next emperor, Antoninus Pius, AD 138–61. During his reign the decoration of the Montu temple at Medamud, which had been extended under Ptolemy VIII Euergetes II, continued.[71] An entrance kiosk and forecourt were begun which were extensions to the eighteenth Dynasty temple of the primordial Amun at Medinet Habu, joining extensions of Ptolemy VIII.[72] During the reign of Antoninus Pius some small temples were also apparently constructed, such as those at Kom Mer 12 km south of Esna

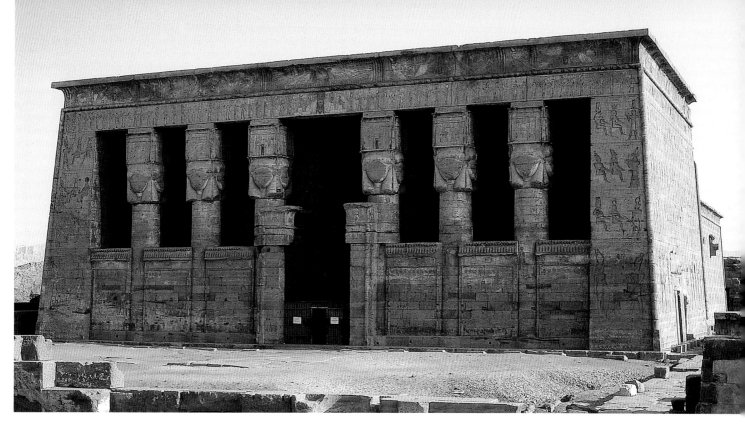

243. Dendara (Tentyris), temple of Hathor

and at Nadura in the el-Kharga Oasis.[73] He is also credited
with major building works in Alexandria, and in the cities and
towns elsewhere in Egypt. The papyrological and archaeo-
logical evidence indicate increased resources going into
classical public buildings and temples during the rest of the
second century AD.

After Antoninus Pius, new construction work in the
Egyptian style apparently ceases, and the amount of wall
decoration being carved rapidly decreases, based on the
cartouches.[74] Marcus Aurelius, AD 161–80, and Commodus,
AD 180–92, were responsible for some of the decoration on
the landing stage, the Gate of Hadrian, at Philae.[75] Septim-
ius Severus, AD 193–211, repaired the Colossi of Memnon at
Thebes.[76] There are cartouches on the temple at Kom Ombo
(Ombos) mentioning emperors, including Marcus Aurelius
and Commodus, down to Macrinus, AD 217–18.[77] The last
temple decoration occurs at Esna under Decius, AD 249–51.[78]

While the lack of cartouches might indicate no further
building activity or new decoration on the Egyptian temples,
this is not necessarily a reliable indicator of cessation of
worship.[79] Many temples continued in use through the third,
fourth and fifth centuries. Although the last dated cartouches
at Philae are of Septimius Severus and Caracalla,[80] AD
198–217, there are Demotic graffiti there from the third
century.[81] The last dated hieroglyphic inscription at Philae,
on Hadrian's Gate, is dated to AD 394, and the last Demotic
graffito to AD 452.[82] The temple of Isis at Philae continued in

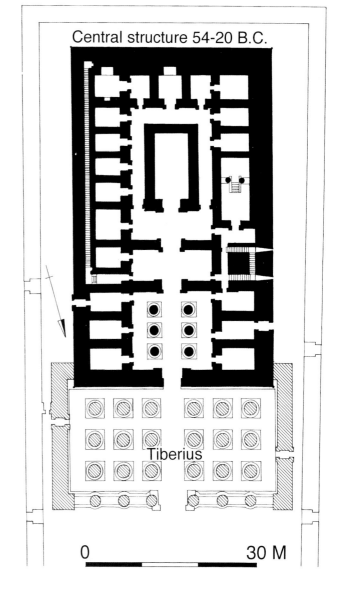

Central structure 54-20 B.C.

Tiberius

0 30 M

244. Dendara (Tentyris), temple of Hathor, plan of construction phases

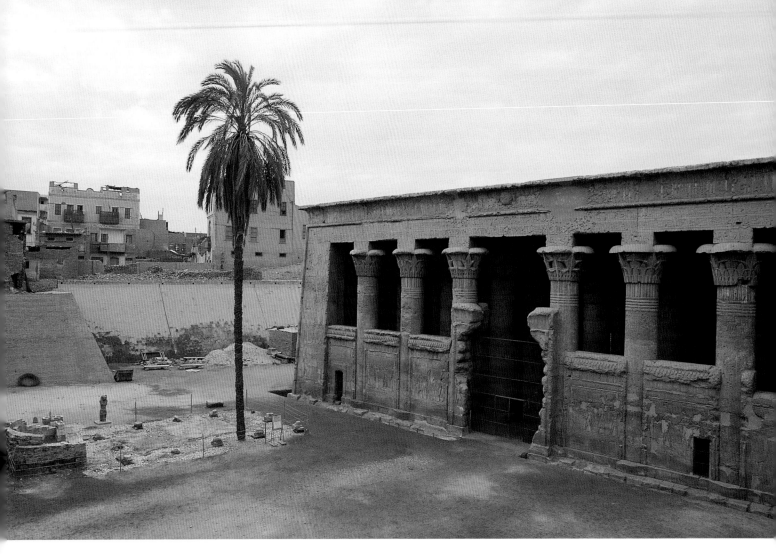

245. Esna (Latopolis), temple of Khnum, hypostyle hall

a. Claudius

b. Nero

c. Vespasian

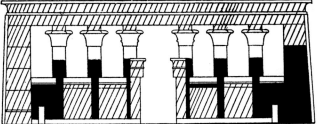

d. Domitian

246. Esna (Latopolis), temple of Khnum, facade of hypostyle hall, decorative phases of Roman emperors marked in black

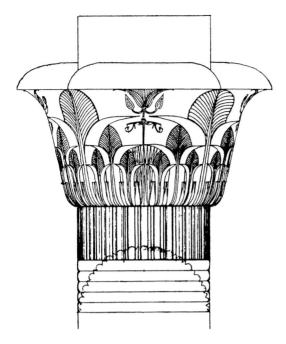

247. Esna (Latopolis), temple of Khnum, facade of hypostyle hall, capital with lotus motif

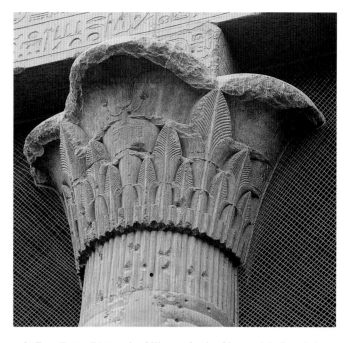

248. Esna (Latopolis), temple of Khnum, facade of hypostyle hall, capital with lotus motif

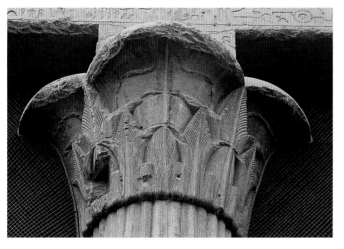

249. Esna (Latopolis), temple of Khnum, facade of hypostyle hall, capital

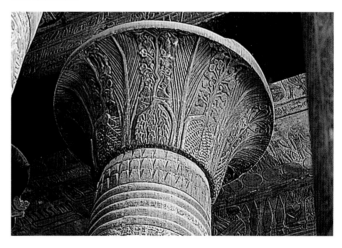

250. Esna (Latopolis), temple of Khnum, interior of hypostyle hall, capital with date palms and vines

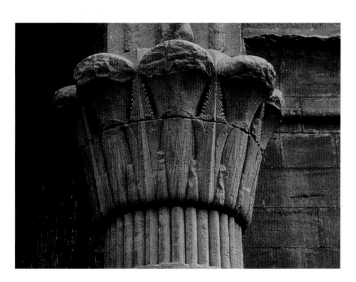

251. Dendara (Tentyris), birth house, capital

use until it was closed during the reign of Justinian in AD 535–8.[83] By contrast at Luxor (Thebes) in the late third century when the military camp was established around the temple, and an inner chamber of it was converted to the 'Imperial Chamber', [294, 297] the statues of the Egyptian gods were carefully buried.[84]

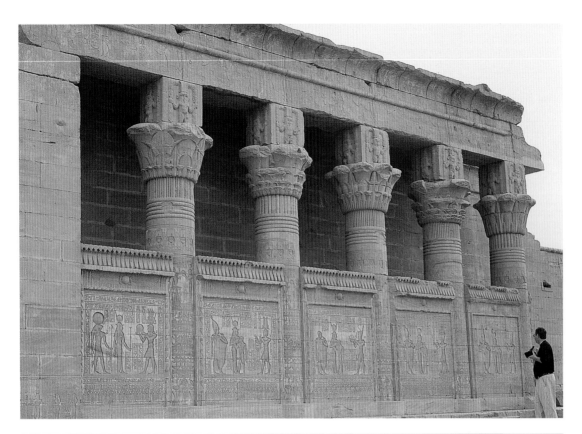

252. Dendara (Tentyris), side of birth house

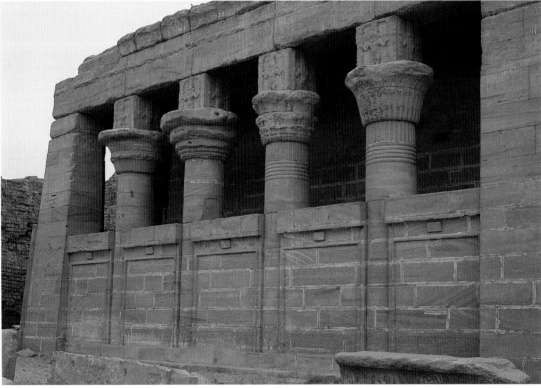

253. Dendara (Tentyris), back of birth house

CONCLUSION

The Egyptian temples were very much part of the monumental building programmes of both the Ptolemaic kings and the first few Roman emperors with their need to maintain power through their role as the god-king, pharaoh. The

strength and vibrancy of the native religion and culture in the Ptolemaic period and the importance of its temples are evidenced by the fact that they not only continued to be built in the Egyptian style, but also that this style evolved.

While many features of the Ptolemaic (and Roman) temples are derived from earlier Dynastic architecture, it is

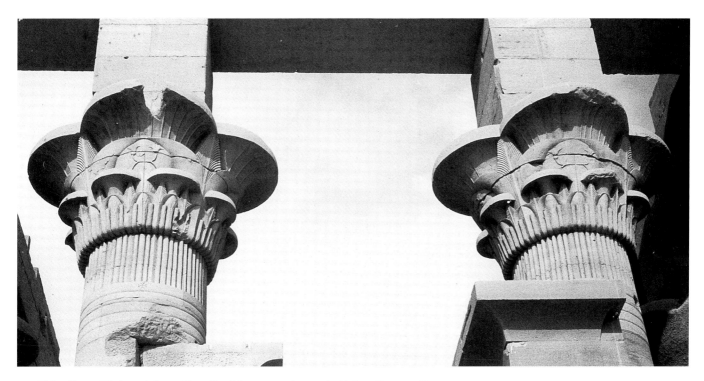

254. Philae, Roman Kiosk, capitals on either side of the entrance decorated with lotus flower motif

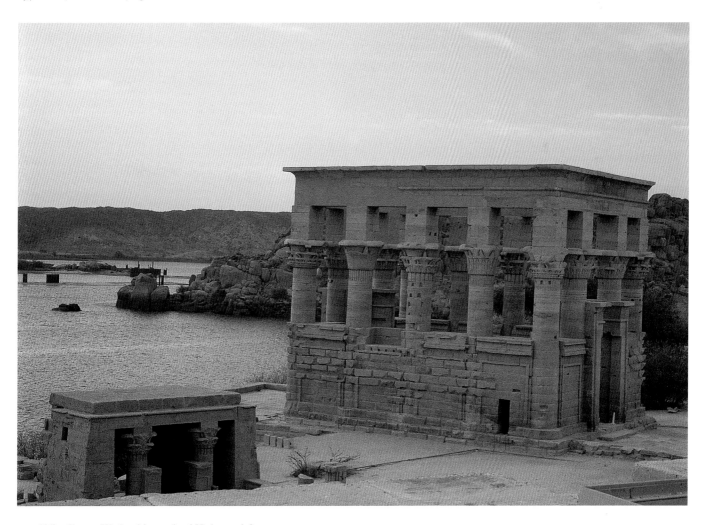

255. Philae, Roman Kiosk, with temple of Hathor on left

the combination of them and the frequency of their use as the standard form which gives these temples their distinctive character. In addition, the temples develop new features resulting from Greek influence, as seen for example in their capitals. They also acquire some features in common with the contemporary classical architecture of Ptolemaic Alexandria.

New construction in Egyptian style continued in the first half century or so of Roman rule, until ceasing completely just after the mid-second century AD. After this the carving of decoration on them rapidly decreases, ceasing completely after a century. Despite this, the Egyptian temples remained a major feature of the urban landscape, and worship of the Egyptian gods did not immediately stop. Resources for the construction of new buildings in the cities and towns of Roman Egypt were increasingly devoted to classical temples and public buildings, from the mid-first century AD and especially during the second and third centuries.

Roman Period

Introductory Summary

Roman rule in Egypt began in 30 BC when Octavian (later known as Augustus) made it a Roman province, having defeated Antony and Cleopatra at the battle of Actium in 31 BC. Alexandria became the second city, after Rome, of the Roman empire. It was important to the Roman economy because its location made it a gateway to trade with the East, while Egypt became the breadbasket of Rome, supplying it with grain. At the same time, Alexandria remained an academic centre for both research and education.

The Roman period is used here largely to mean the period from 30 BC to the beginning of the fourth century AD when the recognition of freedom of religion by the state marks the beginning of major changes to the cityscape with the erection of churches. That development is covered in Part IV on the Late Antique (or Byzantine) period, while buildings of the fourth to seventh centuries at Kom el-Dikka in the city centre are included in the discussion of the Roman city because they are public buildings and houses.

The main interest of the study of the Ptolemaic period was how the Greek and Egyptian cultures interacted because when Alexander the Great arrived in Egypt it was a land with a completely different civilization to his. By contrast, when the Romans conquered Egypt it was by then a country with a pre-existing Hellenistic culture – one not dissimilar to theirs – both in Alexandria, as well as in the other urban centres where it coexisted with Egyptian culture. Thus, the principal concerns for the study of the architecture of Egypt in the Roman period are: how it related to the pre-existing distinctive style of classical architecture; how the architecture of Alexandria related to that elsewhere in the country (where new construction in the Egyptian style eventually ceased), and what this architecture had in common with that of the wider Mediterranean world of the Roman empire. Consideration of the architecture of the Roman period begins with the cityscapes of the cities and towns of Egypt as these provide the local background to developments in Alexandria, to which the focus then moves. Finally, architectural style is considered.

The types of evidence for each of these aspects are different. For the cities and towns of Roman Egypt papyrological records and archaeological evidence indicate the types of buildings constructed and the city layouts. By contrast, there are hardly any papyrological records, and few archaeological remains of substantial parts of buildings in Alexandria before the fourth century AD. Information is provided by other evidence, such as classical literary and historical writings, inscriptions and depictions. Detailed information about the style of classical architecture is provided by architectural fragments.

The examination of this variety of evidence reveals that the cityscapes of the cities and towns of Roman Egypt have local features, and their classical buildings have distinctive designs which are also found in Alexandria. While this architecture has local features, it also has much in common with other major urban centres of the Roman East. Like the building designs, the architectural fragments show that there is no difference in the Roman period between the classical architecture built in Alexandria and in other urban centres of Egypt.

The developments in the classical architecture of the cities and towns of Roman Egypt were facilitated by the pre-existing tradition of classical architecture established in them during the Ptolemaic period. Few traces of their Ptolemaic classical buildings survive on the ground but they are recorded in papyri. These show that the facilities necessary for Greek city life were built as early as the third century BC in the old Egyptian towns beside the Egyptian temples which dominated them (although they lacked the formal status of Greek cities – unlike Naukratis and Ptolemais). These buildings included gymnasia and public-baths which were central to a Greek way of life. There were also purpose-built structures in which to hold Greek public entertainment, including theatres and racecourses (hippodromes and/or stadia). The central square, the agora, which was the traditional focus of Greek civic life also functioned as a market place.

A more detailed picture is provided of these urban centres in the Roman period as considerably more papyrological evidence survives from it, as well as substantial remains of some buildings. These combine to give an impression of town plans, as well as the types of buildings in them and their characteristics. New buildings embellished them creating cityscapes which were similar to other urban centres in the Roman East, except for the continued presence of an Egyptian temple enclosure in most of them. Their main street and cross-street were decorated with colonnades, porticoes, monumental arches and fountain houses, while major intersections were marked by sets of four columns (tetrastyla). Facilities included gymnasia, public-baths, racecourses and theatres. There were market buildings (*macella*) in addition to the agora. Classical temples were erected in honour of a variety of Greek and Roman gods, and for the imperial cult.

Most of the evidence for the distinctive local designs for these buildings comes from archaeological remains. Only tetrastyla found in Egypt have acanthus column bases. The theatre at Antinoopolis, although a new Roman construction, had a design which had continued from the Hellenistic period, as did the one at Oxyrhynchus. Like the Lageion in Ptolemaic Alexandria, racecourses elsewhere in Egypt were used both for horse racing (as circuses or hippodromes) and for athletic events (as stadia). The distinguishing features of the triumphal arch at Antinoopolis are also evidenced from Alexandria, but not outside Egypt. Papyri indicate other classical building designs attested only in Egypt include a circular gymnasium, and the procession house known as a *komasterion*.

Archaeological evidence reveals that construction techniques which are local to Egypt were used for classical buildings. These include the way stone is cut, with the division of parts of classical architectural orders between blocks not following Greek and Roman conventions. Stone was used in innovative ways to create classical structural shapes. Like local mudbrick vaults, stone arches were built without the use of centering. Structures using cheaper local materials, such as baked bricks or mudbricks, were sometimes covered with plaster to look like more expensive classical buildings of stone.

Thus, while the cities and towns of Roman Egypt resembled other urban centres of the Roman East, with similar types of buildings they also had features of their design and construction distinctive to Egypt. It is within this context that developments in Roman Alexandria should be considered.

Alexandria was distinguished from the other urban centres of Roman Egypt by its size, maritime harbours and lighthouse. While a prominent feature of the former capitals of the Egyptian administrative districts (nomes) continued to be the Egyptian temple enclosure, in Alexandria this function was served by its most important sanctuary, the Serapeum, built in classical style and standing on a hill above the city. The other distinctive feature of its cityscape was the large palace area with famous buildings, such as the Museum and the tomb of Alexander. However, despite these differences, in the Roman period types of buildings were erected in Alexandria similar to those observed at other sites in Egypt and elsewhere in the Roman East.

The geographer Strabo's famous description of Alexandria made soon after the Roman conquest of 30 BC gives an indication of its size, overall topography and the relative positions of some major buildings, although their precise locations are not known. His descriptions of the bays and promontories in the eastern harbour accord with recent underwater discoveries. The locations of the few *in situ* archaeological remains in the city from the first and second centuries AD, including houses with mosaic floors and cemeteries, suggest the area covered by the Roman city until the third century AD. The dimensions (5.2 by 2.2 km) of the main city grid plan established by the Arab astronomer and surveyor Mahmoud-Bey in 1866 are similar to those given by Strabo.

The streetscape of Roman Alexandria was adorned like other cities and towns of Egypt, as well as the Roman East, with colonnades, tetrastyla, fountain houses, city gates, and triumphal arches. Some of these are attested by numismatic evidence, while archaeological remains of others show the continuation of a trend observed in the Ptolemaic period with the combination of different coloured stones, especially the use of red granite column shafts with white marble bases and capitals. Some of these structures have features distinctive to Roman Egypt.

The lack of archaeological remains of public buildings in Alexandria from the first and second centuries AD means that our knowledge of them largely comes from written sources. These indicate that its main facilities for Greek (and Roman)

city life continued in use, including the Gymnasium, agora, Museum, theatre and the Lageion (racecourse), as well as famous landmarks, such as the Sema (containing the tomb of Alexander) and the lighthouse Pharos. Some of these buildings were modernised. The Lageion was given a central barrier (*spina*), a feature of Roman circuses, and the Museum was enlarged.

Roman rule was also reflected in some of the city's new buildings. Typical Roman public buildings constructed in the city in the first century AD (at the same time that they appear elsewhere) include an amphitheatre (which is a Roman, rather than Greek, building type) and imperial baths. The city's imperial dedications (buildings in honour of Roman emperors) included the Forum of Augustus, the Claudieum (an extension to the Museum named after the emperor Claudius), a Hadrianeion (a temple in honour of the emperor Hadrian), and the library of Hadrian (which was a depository for legal documents). The Caesareum, dedicated to the worship of the emperor Augustus, was the city's main temple for the imperial cult. This large sanctuary was located on the harbour side in the city centre one block north of the main east-west street in a prominent position still marked in the nineteenth century by Cleopatra's Needles. These were a pair (following Egyptian custom) of obelisks erected in front of it in the year in which Augustus became Pontifex Maximus, 13/12 BC.

Information about what the city's other temples looked like in the later first and second centuries AD is given by depictions of them on coins and bone tokens. These show three separate architectural styles: Egyptian, Greco-Egyptian and classical. As in the Ptolemaic period, the Egyptian tradition is most prominent in religious contexts. The temple of Osiris at Canopus and the temple of Isis are depicted with traditional Egyptian pylons. Archaeological evidence survives from some Egyptian style architecture created in Roman Alexandria, if not earlier, from reused architectural elements of the Dynastic period. Temples in Greco-Egyptian style (characterized by features such as bulbous columns and segmental pediments) are depicted with local gods. Classical temples (those with a triangular pediment) are depicted housing Greek and Roman gods, as well as some local ones such as Serapis.

The version of the city's most important temple, the temple of Serapis, on Roman coins is the Ptolemaic one which remained in use for the first two centuries of Roman rule, until it burnt down in AD 181. The Roman replacement (completed by *c.* AD 216) was larger, with the temple on the axis of the court. It had a more Roman design, although it continued to be visited by the Egyptian population from outside the city. Diocletian's Column was erected in the court in AD 298 on the highest point of the city. Sufficient archaeological remains survive of both phases of the sanctuary to determine their plans reliably and reconstruct them on paper.

The evidence for the funerary architecture of Roman Alexandria is archaeological. By the Roman period, the city had expanded east over some of the Ptolemaic cemeteries so that the main Roman burial grounds were to the west of the city, while there were also smaller ones to the city's east and

south-east, and on the island of Pharos. Many of these consist of large centrally organized tomb complexes. The feature of the Roman tombs in the late first and second centuries AD. which differs most from the Ptolemaic examples, is their decorative schemes because of the way they have classical (Greco-Roman) decorative motifs but Egyptian iconography for scenes involving the expression of religious beliefs. Notably, the body of the deceased is depicted as a mummy, in accordance with Egyptian burial custom. These scenes are found in tombs in each cemetery so that there is no evidence for the strong association of one cemetery with a particular part of the population (Egyptian, as opposed to Greek or Roman).

Kom el-Dikka in the ancient and modern city centre is the only area of Alexandria where sufficient evidence survives to reveal changes through time in urban planning and building designs, from the first century BC to the seventh century AD. This area had expensive houses during the first to the late third century AD when they were destroyed (by earthquakes and/or military action). These houses had a distinctive local design resulting from the combination of Greek and Egyptian features. They had a dining room with a mosaic floor as in a Greek house, while their courtyards had a pseudo-peristyle (with engaged columns on some sides) which was a cross between a Greek peristyle court (with free-standing columns) and an internal light well of an Egyptian house.

The eastern part of the site (beyond street R4) was levelled in the fourth century AD and the houses there replaced by cheaper ones incorporating shops and workshops for small industries. In the sixth and seventh centuries narrow shops were built along both sides of the street frontage in a very orderly encroachment keeping the street (R4) straight. This would explain the preservation of the city's regular grid plan described by the Arab authors.

The western part of the Kom el-Dikka site was completely redesigned in the first half of the fourth century AD for public buildings associated with a major educational establishment, including the so-called small theatre and an imperial baths-building. As these buildings were in use for so long – into the seventh century – they have more than one phase so that changes can be seen in their designs. As part of the same complex beside the large colonnaded green square there are at least eighteen lecture rooms. These long narrow rooms

with tiered stone seating have a unique design. They provide the setting for the education in the city from the late fourth to the late seventh century mentioned in the written sources and continuing the tradition established by the Ptolemaic Museum, but on a new site.

Consideration of the relationship between the architecture of Alexandria and other Egyptian sites in the Roman period is completed with an examination of architectural style which confirms the picture observed for urban planning and building designs. The Corinthian order surviving in Egypt in the late first century BC and the first century AD is a continuation of the distinctive form developed in Ptolemaic Alexandria. By contrast, in the second and third centuries AD, two styles of the Corinthian order are observed: one which is derived from the local Ptolemaic examples and the other which is similar to that in use elsewhere in the Roman empire. Rather than one style being observed in Alexandria and the other elsewhere in Egypt, both styles were used in Alexandria and at other Egyptian sites. Both the local and imported versions of classical architecture coexisted, just as in the Ptolemaic period two architectural styles had existed side by side (but Egyptian and classical).

After less than a century of Roman rule the amount of construction in the Egyptian style at sites outside Alexandria greatly decreased and it ceased completely just after the mid-second century AD. The papyri record many classical buildings of which no traces otherwise survive in these cities and towns. Analysis of them reveals that those with the largest numbers of classical public buildings are at or near those sites which later have the best quality Late Antique carved architectural decoration. This suggests continuity at a local level of expertise in classical architecture, rather than only skilled craftsmen coming from Alexandria. It also accords with the lack of distinction between the classical architecture of Roman Alexandria and other sites in Egypt in both the types of buildings and their designs, as well as in the style of their architectural decoration.

The continuity and consistency in classical architecture of Roman Egypt provide the background to the developments in architecture there in the following centuries. This has important implications for our understanding of the style commonly called 'Coptic' which had been assumed to be different to that of Alexandria in the Late Antique (or Byzantine) period.

Classical Architecture in the Cities and Towns of Roman Egypt

As the Egyptian temples are the only complete buildings still standing in the former cities and towns of Ptolemaic and Roman Egypt this can give the impression that the architecture of these sites was all Egyptian in style. Their classical public buildings and streetscapes have not survived so well. There are virtually no remains of these from the Ptolemaic period, while the Roman ones now consist of little more than a few foundations and fallen columns. Thus, it is not immediately obvious that the cities and towns of Roman Egypt had cityscapes with much in common with other urban centres of the Roman East. This also provides the local context for the developments which occur in Roman Alexandria.

The lack of archaeological evidence for the classical buildings at these Egyptian sites is made up for by the fact that the country's dry climate has preserved the papyrus (the equivalent of paper) on which administrative and other records were written. These mention many types of classical public buildings, their dates and locations, and other information such as who paid to build and maintain them. The papyrological evidence for lost Ptolemaic classical buildings is important as it provides the background to developments in the Roman period. There are considerably more papyri surviving from the Roman period. When the evidence from these is combined with the archaeological remains they give an indication of the layout of these urban centres and their buildings. There is also sufficient evidence for it to be possible to detect local design features and construction techniques.

The urban centres of Egypt (Maps 1–2) are referred to here as 'cities and towns' (not just cities). This is in order to avoid confusing ancient historians to whom the term 'city' in ancient Greek (*polis*) implies a formal city status which most of these Egyptian examples did not have.

PTOLEMAIC PERIOD

In the Dynastic period the towns up the Nile and in the oases[1] were capitals of the nomes, which were the Egyptian administrative districts. Architecturally they were dominated by the enclosure containing the large Egyptian stone temple dedicated to the local god, and related structures. The remainder of the architecture seems to have consisted of housing of mud brick, which was also used for the perimeter wall of the temple enclosure. The temple enclosure was the main official complex in which all state and religious functions were conducted.

In the Ptolemaic period, the forty or so nome capitals were called *metropoleis* (mother cities).[2] They continued to be dominated architecturally by the Egyptian temple, but their Greek cultural life, organized by the members of the gymnasium (responsible for physical training and intellectual education),[3] was reflected in the construction of classical buildings. Examples include, besides a gymnasium, baths, and sometimes a theatre and hippodrome. Some of the nome capitals also had other classical buildings, such as temples to Greek gods and procession houses (*komasteria*).

The only monumental classical building of which substantial remains, including foundations, survive from the Ptolemaic period is the temple and its enclosure at Hermopolis Magna (el-Ashmunein) dedicated by the Greek soldier settlers (*katoikoi*), under Ptolemy III Euergetes I (246–222 BC), from which a Doric frieze, and Doric and Corinthian capitals survive [74–78]. It was built facing the processional way (*dromos*) of the Egyptian Thoth temple [209], in front of the Egyptian temple enclosure which

256. Philadelphia (Kom el-Kharaba el-Kebir), sketch plan

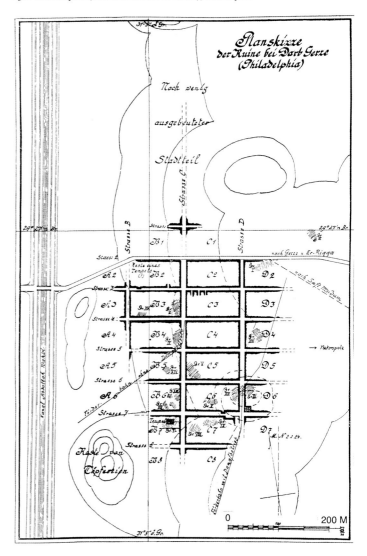

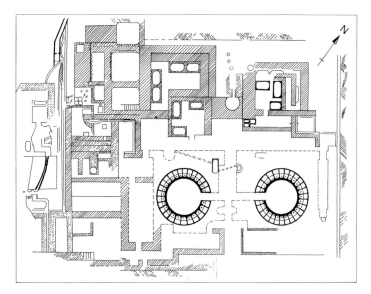

257. Arsinoe/Krokodilopolis (Medinet el-Faiyum), plan of baths-building with two circular chambers

dominated the site [269], so that both the new classical and old Egyptian style architecture were juxtaposed with each other.

Our knowledge of other classical buildings in the Ptolemaic period comes from passing references to them in papyri.[4] The old Egyptian capital, Memphis, was described by the geographer Strabo, who visited Egypt soon after the Roman conquest, as the second city of Egypt, indicating that it had remained a major centre through the Ptolemaic period.[5] It apparently had a temple to the Greek god Herakles as early as 256 BC which could possibly have been associated with the gymnasium.[6] Papyri also indicate that there was a hippodrome there by 63 BC.[7]

Gymnasia, which are essential for a Greek way of life, are attested in other old Egyptian towns by the late third century BC. In 221/220 BC the gymnasium building at Samaria in the Faiyum is mentioned in a papyrus which indicates that it was dedicated to the king.[8] In Upper Egypt an inscription, probably from Thebes (Luxor), refers to a gymnasium building and its members in c. 221–180 BC.[9] Public baths, which were also a feature of Greek life, occur at Arsinoe/Krokodilopolis (Medinet el-Faiyum) by the mid-third century BC.[10] There was a gymnasium at Herakleopolis Magna (Ihnasya el-Medina) which seems to have been used exclusively by the Greek soldier settlers in the first century BC.[11]

Other buildings reflect Greek cultural events. In 267 BC, an inscription indicates games were held in honour of the king (probably in Memphis or Herakleopolis) which were distinctively Greek with musical, gymnastic, and equestrian events. The horse races were held in a racecourse called a stadium.[12] This term, normally used for the venue for athletic competitions, seems to have been used in Egypt in the third century BC for a racecourse in which both chariot racing and athletics took place. Herakleopolis had a hippodrome which, in c. 45/44 BC, was one of the places to be illuminated by public donations.[13]

The agora at Herakleopolis is mentioned c. 160/159 BC as a place where sales were transacted.[14] A procession house (komasterion) at Krokodilopolis was also used as a location for government auction sales in 158 BC.[15] The Komasterion at Hermopolis Magna (el-Ashmunein) is mentioned in 89 BC.[16]

In addition to the old Egyptian towns there were some which were new Greek foundations. In central Egypt, Ptolemy I Soter founded Ptolemais Hermiou (el-Mansha) across the Nile from the old Egyptian centre Panopolis (Akhmim).[17] It was organized as a Greek city (polis) with democratic institutions. The popular assembly (demos) met in the theatre.[18] Thus, like the komasterion at Krokodilopolis, the theatre was used for more than one purpose. Ptolemais also had buildings specifically associated with its city status, with popular assemblies (both demos and ekklesia). As it had a town council (boule) it probably had a council chamber (bouleuterion) and a town hall (prytaneion) for the presiding officers (prytaneis) of the boule. It also had courts of justice (dikasteria).[19] According to Strabo, early in the Roman period Ptolemais was the largest city in Upper Egypt.[20]

Philadelphia (Kom el-Kharaba el-Kebir), in the Faiyum, was a smaller Greek foundation. Ptolemy II Philadelphus (285–246 BC) had it laid out like a typical Greek city with a regular grid of streets, preserved in the archaeological record [256].[21] There is more detailed information about some classical buildings in it than elsewhere in the mid-third century BC because of the papyri which constitute the archive of Zenon, who was the estate manager of the administrator (dioiketes) Apollonios. These mention the construction of the theatre and other buildings.[22] The gymnasium is mentioned in c. 242/1 BC and later, in discussions about the fees associated with it.[23] A letter to Zenon indicates that there was a small exercise court (palaestra) in which education also occurred.[24]

The specifications given in a papyrus for the floors of the baths in Philadelphia, c. 256–246 BC, indicate that they had mosaic floors in the two circular chambers (tholoi), one each for men and women, with entry halls (prostades). The details of this description accord with the archaeological remains at other sites. Circular chambers of Hellenistic baths are easily identifiable in the archaeological record. At Arsinoe/Krokodilopolis (Medinet el-Faiyum) a baths-building has two such chambers [257]. There also is a baths-building at Theadelphia (Batn Ihrit), apparently from the Ptolemaic period. A mosaic floor survived on the one at Diospolis Parva (Hiw).[25] These baths-buildings reflect a distinctively Greek lifestyle, while mosaic floors are characteristic of Greek architecture.

The Zenon papyri also provide detailed information about the villa or private palace in Philadelphia which belonged to the Ptolemaic court official Diotimos. It had an entrance portico (pylon) and a vestibule (prostas). The official area was arranged around two interior courts (aulai), off which there were two banqueting rooms for seven couches each. It also had an exedra with doors. The sleeping quarters and private dining area were centred around a light well (aithrion). The service area included a baths complex. Many of these features can be recognized as typical of the Greek house as described by the Roman architect Vitruvius. The design of the whole

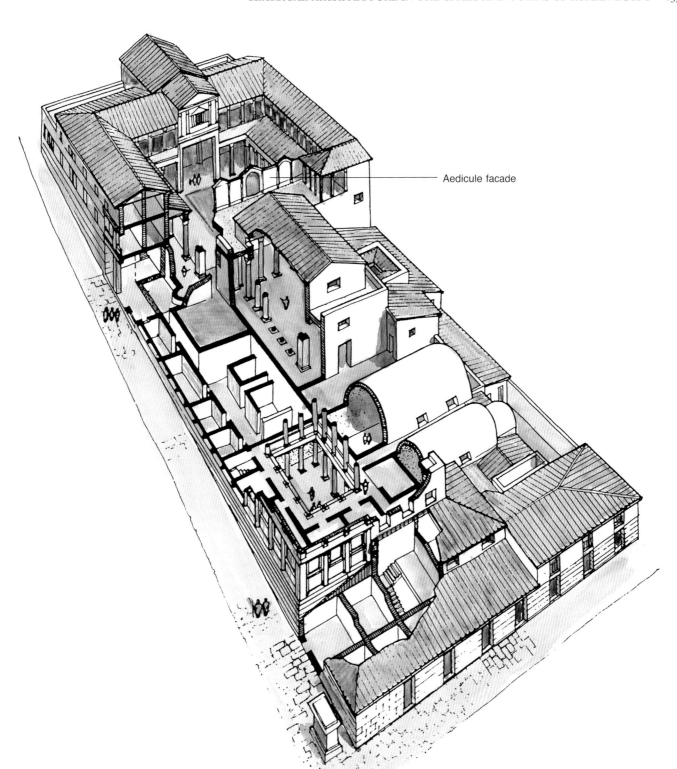

Aedicule facade

258. Ptolemais, Palazzo delle Colonne, axonometric reconstruction (Sheila Gibson)

building was very similar to the Palazzo delle Colonne at Ptolemais in Libya which can be used to provide an impression of it [258].[26] Diotimos' villa was built of local building materials such as brick, which were hidden behind Greek-style wall-paintings. The painters' specifications for it and similar buildings provide information about the patterns, colours and techniques they used.[27]

Whilst the main monumental buildings which survived from the Ptolemaic period in the towns up the Nile were Egyptian temples, the evidence provided by papyri indicates that these towns also had buildings reflecting a Greek cultural life. This provided the background which facilitated developments in the Roman period.

CITY STATUS

The record of the foundation of a new town in Upper Egypt in 132 BC, indicates that it was formally laid out like a Greek city, with specific measurements, around a market place (*agora*) which is described as rectangular. It also had distinctively Greek structures, such as colonnaded porticos called stoas. Like Philadelphia, this town (which has not been identified) is referred to as a *polis*, although neither had the formal institutions of a city like Ptolemais.[28] In the Ptolemaic period and the first century AD, the only cities which had the formal status of a Greek *polis* were some of those which were Greek foundations: Naukratis (which had been founded as a Greek colony by the seventh century BC), Alexandria, and Ptolemais. Later, Antinoopolis (el-Sheikh 'Ibada), which was founded by Hadrian in AD 130, was also a *polis*.[29]

However, the former nome capitals were equally urbanized, and during the Roman period in the first to third centuries AD, the streetscapes of these towns, as well as the cities, were ornamented with structures which were also built in this period in other cities of the Roman East: colonnaded streets, tetrastyla, monumental gates, triumphal arches, tetrapyla and fountain houses (*nymphaea*). Other buildings in them included the agora (which functioned as a market place), a market building (*macellum*), gymnasium, baths, palaestra, theatre, circus and temples of the imperial cult. These are all structures which were independent of formal city status.

The evidence in the papyri indicates the development of a corporate identity which took responsibility for city construction work, repairs, and maintenance.[30] These were funded by the wealthy élite, especially the town officals (gymnasiarchs, exegetes, cosmetes, archons).[31] In c. AD 201 they were given town councils (*boulai*)[32] and in theory this provided an administrative basis for later local building programmes. Even though the nome capitals lacked *boulai* until c. AD 201, the cities and towns in Egypt could be equated with other urban provincial centres of the Roman East.[33]

NATURE OF THE EVIDENCE

There is much more evidence surviving from the Roman period, than the Ptolemaic period, for the classical architecture of the cities and towns of Egypt. There are more archaeological remains, as well as many more papyri. Because of the survival of the papyri in Egypt there are many more references than from elsewhere, to buildings which are no longer visible in the archaeological evidence.[34] These give some indication of what has not survived. When examined, the papyri and the archaeological remains both give a similar picture of city layout and types of buildings.[35] However, the archaeological evidence also provides information about architectural decoration and style which is not provided by written sources.

Some of the classical buildings will be found to have designs in common with the rest of the Roman East, while others have particular local features. These two strands are also observed in the classical decorative details of capitals and cornices on these buildings. One strand is shown to be a continuation from the classical architectural style of Ptolemaic Alexandria, whilst at the same time details are also used which occur in other Roman architecture of the eastern Mediterranean. The evidence for city layout and building types will be discussed in this chapter. The architectural decoration and style, followed by the implications of the references to buildings in the papyri will be discussed in Chapter 9, after the evidence from Roman Alexandria has been considered.

CITY LAYOUT AND BUILDING TYPES

As indicated, the picture of the cities and town of Roman Egypt develops from the combination of the archaeological and the papyrological evidence. This picture is most easily created by considering firstly the site which had the most substantial archaeological remains, Antinoopolis (el-Sheikh 'Ibada), followed by one which has more information about its buildings and layout provided by papyri: Hermopolis Magna (el-Ashmunein). The papyrological and archaeological evidence from other sites will then briefly be related to these, as it provides confirmation of the picture which results.

The best visual impression of the classical architecture of these cities is provided by the archaeological remains of Antinoopolis (el-Sheikh 'Ibada) [259–260] which were recorded by the Napoleonic expedition in 1799–1800.[36] At that time, a similar range of buildings survived there to those which also survived in Alexandria at the beginning of the nineteenth century. Antinoopolis was founded in AD 130 by the emperor Hadrian in honour of his lover Antinoos, who was drowned in the Nile, and in whose honour he erected an obelisk, now in Rome.[37] Antinoopolis is located across the Nile from Hermopolis Magna (el-Ashmunien) (Map 1). It became a major city and, from the mid-fourth century AD, was the capital of much of Middle and Upper Egypt.[38]

The archaeological remains of Antinoopolis included the lengthwise street and principal cross-street. These were decorated with colonnades of a simplified Doric order of local limestone, and paved with basalt [261].[39] There was also a second cross street which was colonnaded. The intersections of the main street with these cross-streets were each marked by a set of four large columns (a tetrastylon). These had acanthus bases, which are common on tetrastyla in Egypt.[40] One of these tetrastyla is dated to Alexander Severus, AD 222–35, indicating that the city was still being embellished a century after its foundation [262].

At the south-west end of the principal cross-street there was a triumphal arch which was crowned by a Doric entablature with a pediment [263], with openings or panels above the side arches,[41] like the examples depicted on coins from Roman Alexandria [332].

Along the colonnaded streets some monumental porticoes survived which were generally twice the height of the street colonnades, and built in the Corinthian or Ionic order [264].[42] There were also the remains of a baths-building.[43] At the south-east end of the main lengthwise street there was a well-

259. Antinoopolis (el-Sheikh ʿIbada) in 1799

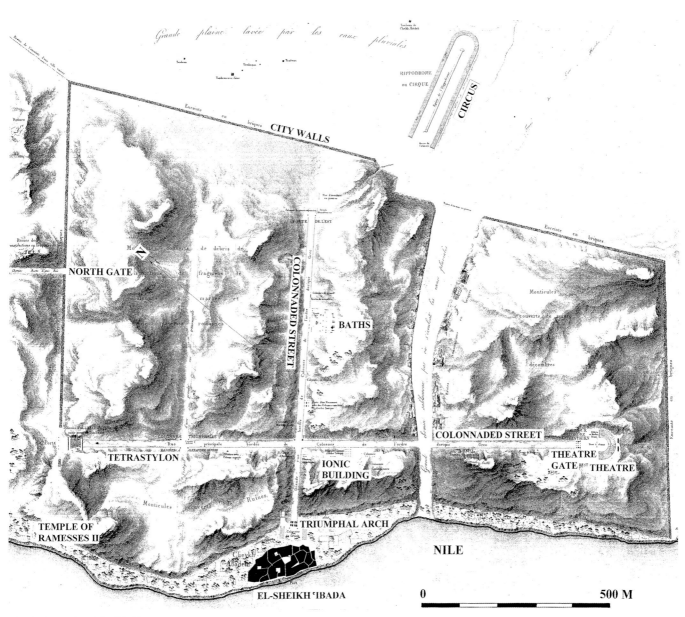

260. Antinoopolis (el-Sheikh ʿIbada), plan of remains in 1799

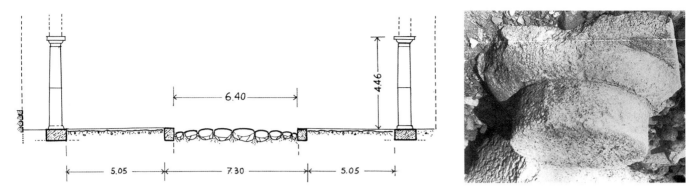

261a–b. Antinoopolis (el-Sheikh 'Ibada), colonnaded street section (with dimensions in metres), and simplified Doric capital from it

preserved monumental gate[44] which led into a colonnaded court[45] and to the theatre [265–266].

Roman theatres normally have a semi-circular seating area (*cavea*), but the one in the theatre at Antinoopolis was slightly more than semi-circular [266]. However, although this type of plan is a continuation from the Hellenistic period, it was used here on a new theatre as it was built after AD 130, probably in *c.* AD 138 according to a papyrus.[46] A more than semi-circular plan was also used on Roman theatres in Asia Minor (modern Turkey).

Although little remains of the structures mentioned, the outline of the circus for chariot racing still survives, with its central dividing barrier (*spina*) and starting gates visible from the air [260, 267–268].[47] It apparently had wide entrances halfway along the sides – a feature normally found on stadia.[48]

It is possible that, like the Lageion in Alexandria, it was used as a stadium as well as for chariot racing. This also occurs at Oxyrhynchus (el-Bahnasa) where a sixth-century AD papyrus programme has games and processions between races in the hippodrome.[49] Like some other circuses of the Roman East, the narrow track at Antinoopolis was only wide enough for ten chariots drawn by four horses (*quadrigae*) to race at once.[50]

Thus, the archaeological evidence from Antinoopolis reflects a similar picture to that which will be observed for Alexandria and other cities of the Roman East. It was ornamented with a main colonnaded street and cross-street, tetrastyla, porticoes and arches. It had buildings of types also found elsewhere, but with some local features in their designs. These are the tetrastyla, triumphal arch, theatre and circus. The papyrological sources provide evidence for a further

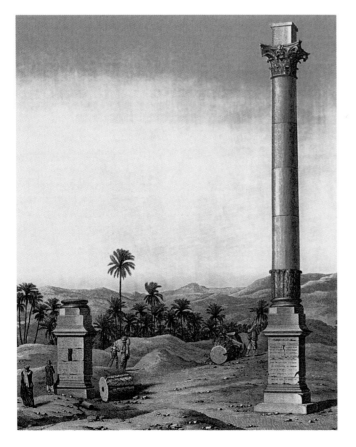

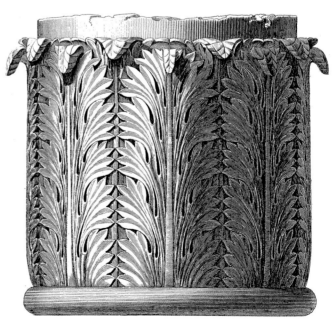

262a–b. Antinoopolis (el-Sheikh 'Ibada), tetrastylon of Alexander Severus (AD 222–35), and acanthus column base from it, in 1799

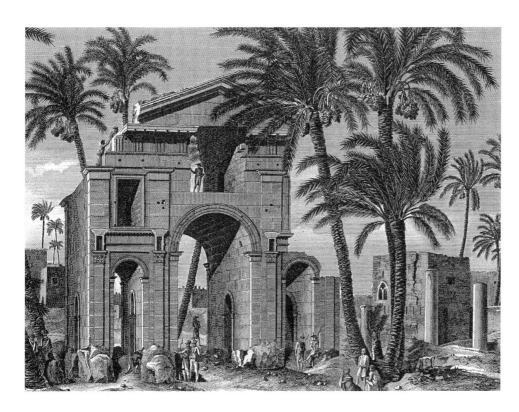

263a–b. Antinoopolis (el-Sheikh ʿIbada), Triumphal Arch and detail of its Doric entablature, in 1799

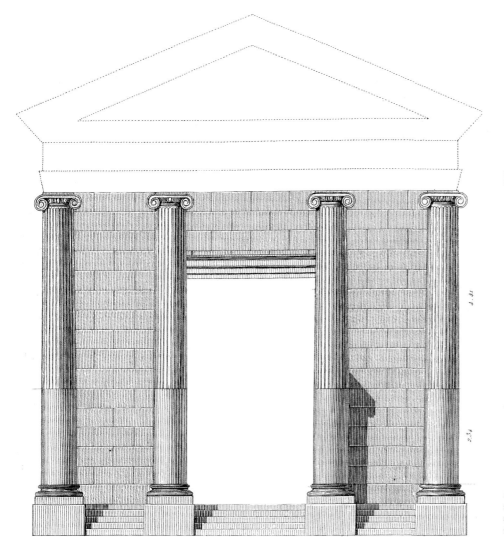

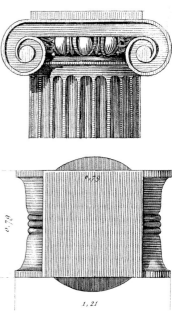

264a–b. Antinoopolis (el-Sheikh ʿIbada), small Ionic structure on main cross-street and one of its capitals (dimensions in metres), in 1799

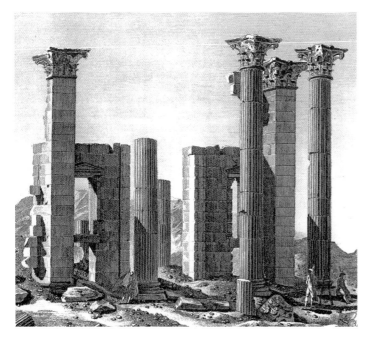

265. Antinoopolis (el-Sheikh ʿIbada), Theatre Gate in 1799

distinctive building design in Antinoopolis, which is so far unique. This is the circular gymnasium, which was built or repaired in AD 263 using expensive imported pine and fir timbers, and with gilded coffering on the ceilings of its colonnade (*stoa*) and entry halls.[51]

Across the Nile from Antinoopolis, in the old Egyptian town of Hermopolis Magna (el-Ashmunein) there was an equally developed Roman urban landscape [269] built beside the enclosure of the Egyptian temple [209]. This is indicated

by the references in papyri to many classical buildings most of which no longer survive.[52]

One of these papyri is a report to the city council in *c.* AD 267 on substantial repairs to public buildings.[53] The buildings mentioned include, in order: the temple of Antinoos; the temple of Hadrian, the south-west stoa, the market building (*macellum*) and the stoa outside it, the stoa near the agora; the temple of Serapis by the temple of the Nile; the procession house (*komasterion*); the west fountain house and the east fountain house, and the temple of Fortune (Tychaion). Along what would have been the main east-west street, Antinoe Street, it indicates in order, which would have been from east to west: the Sun Gate, the north stoas, the first tetrastylon, the arch (*apsis*), the gate (*pylon*) of the temple of Aphrodite, the temple of Fortune, the Great Tetrastylon, stoas on both sides, the tetrastylon of Athena, stoas on both sides, and the Moon Gate.

This vivid impression of the Roman urban landscape of Hermopolis Magna is further augmented by other papyri. These give the names of other temples including those of Apollo, Asklepios, Bastet, the Dioskouroi, and three temples of Serapis. Those mentioned for emperor-worship included a Sebasteion, a Kaisareion, one for the cult of Faustina and one to Alexander Severus and Julia Mamaea. The papyri also mention a triumphal arch, the council house (*bouleuterion*), town hall (*prytaneion*) and library. The main cross-street (which ran north-south) was called the '*dromos* of Hermes' as it led to the Egyptian temple of Thoth (who was called Hermes in Greek), also known as the Great Hermaion [269].[54] Papyri also indicate that the baths of Hadrian, the gymnasium, and Great Serapeum were all in one complex.[55] The combining of the baths with the teaching function occurs elsewhere in this period. The only structures not

266. Antinoopolis (el-Sheikh ʿIbada), theatre, plan in 1799

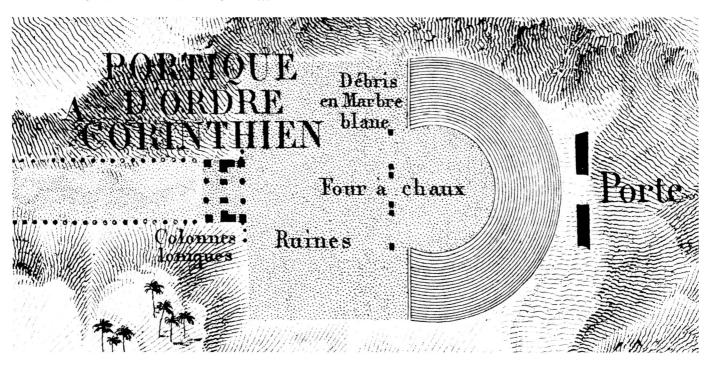

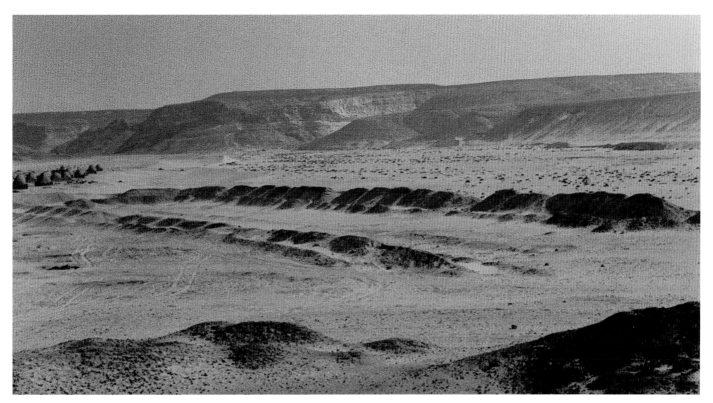

267. Antinoopolis (el-Sheikh 'Ibada), looking north to remains of circus in 1988

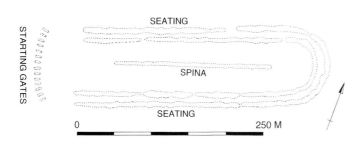

268. Antinoopolis (el-Sheikh 'Ibada), circus, plan

mentioned in papyri, but which might have been expected, are a theatre and a hippodrome.[56] Traces of only a few of these buildings at Hermopolis Magna (el-Ashmunein) have survived.

Remains of the procession house (the Komasterion) include the foundations, red granite columns, and limestone 'Normal' Corinthian capitals [270–273].[57] These capitals are dated to the Antonine period.[58] The construction techniques on this building include some local features, such as pitched brick vaulting in the foundations and the unique carved granite ridge beam (3.58 m long) which was used on the front portico [274].[59] It is possible to identify this structure as the Komasterion because of the references in papyri. It seems to

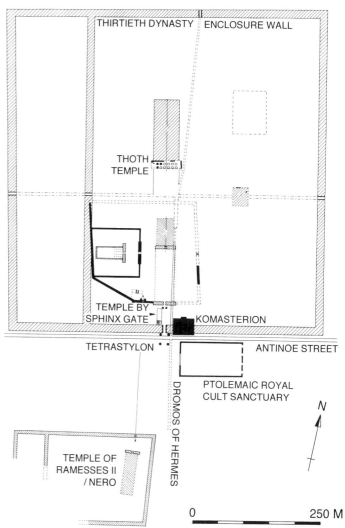

269. Hermopolis Magna (el-Ashmunein), plan of archaeological remains

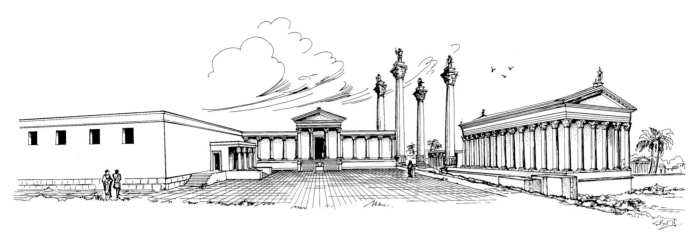

270. Hermopolis Magna (el-Ashmunein), hypothetical reconstruction of view looking south to bastion, Komasterion (procession house), Great Tetrastylon and 'temple by the Sphinx Gate' (Susan Bird)

have been used as a place of assembly for processions. This is a building type which seems to occur only in Egypt under that name.[60] On the surface it is classical, but it was built for the sanctuary which contained the large Egyptian temple of Thoth [209].

At the intersection of Antinoe Street and the *dromos* of the Great Hermaion (Thoth temple) column drums have been identified from the Great Tetrastylon mentioned in the papyrus.[61] There are also the remains of an Antonine temple (whose name is not known) with 'Normal' Corinthian capitals near the Sphinx Gate [270].[62] The water conduit indicates the possible location, on the *dromos* of the Great Hermaion, of the east fountain house, with the west fountain house presumably opposite it.[63]

Further south, at Tentyris (Dendara) the *dromos* of the Egyptian Hathor temple [243] was also decorated with classical structures, including colonnades, like a colonnaded street.[64] There is a fountain house at either side of it just before entering the Egyptian temple enclosure [275–276].[65]

As ablution was a requirement when entering an Egyptian temple this position of the fountain houses could have resulted from this local function rather than merely being part of the articulation of Roman urban space.[66] At Hermopolis Magna a classical colonnade was built alongside the south wall of the Egyptian temple precinct as an architectural backdrop for the Roman-style public space.[67]

The contrast between the number of buildings mentioned in papyri at Hermopolis Magna (el-Ashmunein) and the existing archaeological remains there, is a reflection of the amount of evidence which has not survived, not only there but also at other sites. The papyri indicate Hermopolis Magna had classical buildings similar to those observed at Antinoopolis. In addition, Hermopolis Magna still had the Ptolemaic classical temple precinct beside the large enclosure containing Egyptian temples.

Similarly, at Oxyrhynchus (el-Bahnasa) there were many classical public buildings in a town which was dominated by a large Egyptian temple. This temple no longer survives, but

271. Hermopolis Magna (el-Ashmunein), reconstruction of the Komasterion (procession house), looking south-east (Susan Bird)

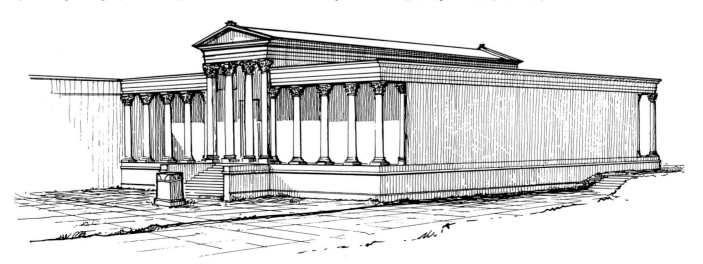

ANTINOE STREET

DROMOS OF HERMES

'BASTION'

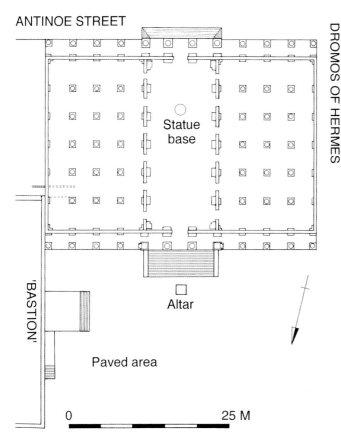

Statue base

Altar

Paved area

0 25 M

272. Hermopolis Magna (el-Ashmunein), Komasterion (procession house), restored plan

273. Hermopolis Magna (el-Ashmunein), Komasterion, fallen columns from north front

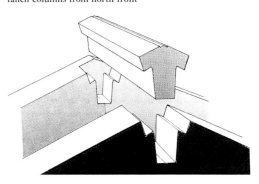

274. Hermopolis Magna (el-Ashmunein), Komasterion, 3.58 m long granite ridge beam from portico of north front

it was of similar size to the temple of Hathor at Tentyris (Dendara) [243–244].[68] The principal archaeological remains of classical buildings surviving at Oxyrhynchus consisted of the colonnaded street[69] [277] and the theatre. This exceptionally large theatre, which is no longer visible, held

c. 11,000 spectators [278–280]. It had a more than semi-circular *cavea* which seems to have resulted from it being rebuilt on an earlier one, in *c.* AD 169–73 according to the papyri.[70]

A great deal more information about the buildings in Oxyrhynchus can be found in papyri than in the meagre

275. Tentyris (Dendara), temple of Hathor, with fountain houses on either side of the entrance at the end of colonnaded *dromos*

276. Tentyris (Dendara), Roman fountain house on west side of *dromos* to precinct of temple of Hathor (with columns possibly not reconstructed to their full height)

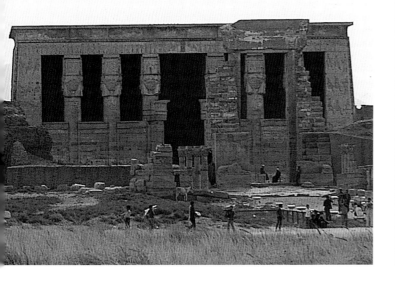

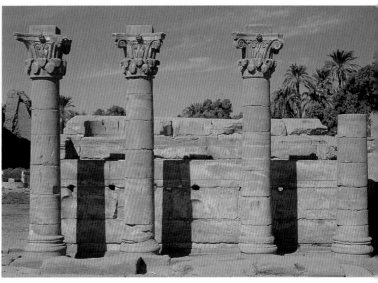

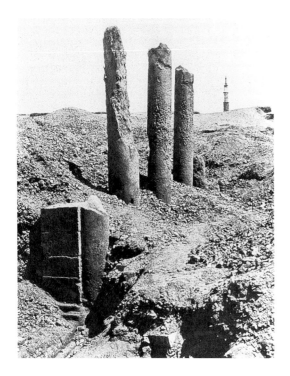

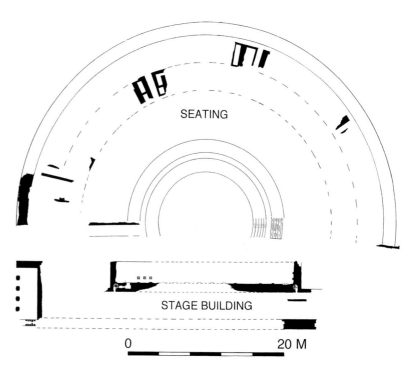

277. Oxyrhynchus (el-Bahnasa), remains of colonnaded street

278. Oxyrhynchus (el-Bahnasa), Roman theatre, plan

archaeological evidence. As occurred with Hermopolis Magna, the papyri provide information on the construction, maintenance and repair of buildings. These records reveal that although Oxyrhynchus, like the other former nome capitals such as Arsinoe, did not have the formal status of a Greek city (*polis*) in the first and second centuries AD, it did have a corporate identity which carried out similar func-

tions. A letter of AD 128 was sent from the prefect to the *polis* of the Oxyrhynchites granting permission to fit out the baths from the funds they had collected. This indicates the town had its own finances, derived essentially from the private wealth of the local élite.[71] There are also sufficient references in the papyri to reconstruct a hypothetical town plan.[72]

279. Oxyrhynchus (el-Bahnasa), frieze fragments from Roman theatre

280. Oxyrhynchus (el-Bahnasa), remains of stage building of Roman theatre

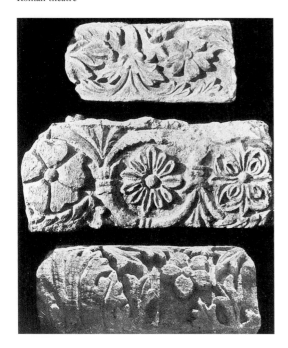

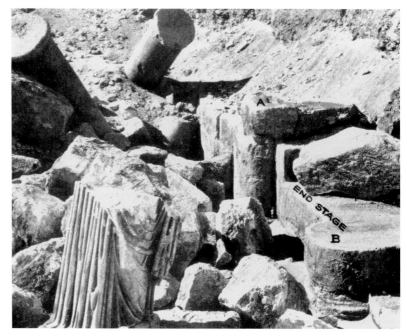

281. Marina el-Alamein,
reconstructed peristyle house
H10 with Ionic columns

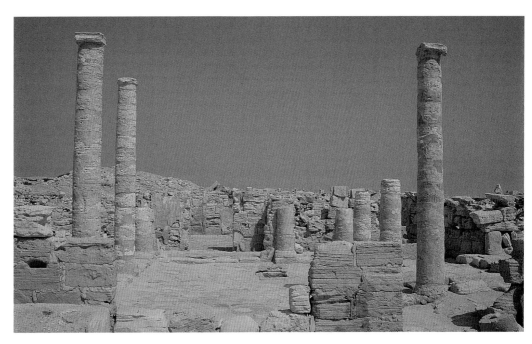

281. Marina el-Alamein,
reconstructed peristyle house
H10 with Ionic columns

282. Marina el-Alamein,
reconstructed towers above
tombs

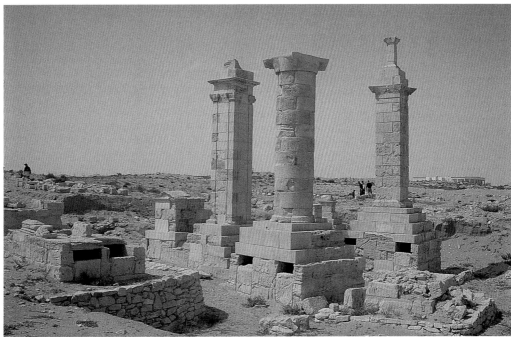

The extent and number of classical buildings in Oxyrhynchus at the end of the fourth century AD are conveyed by two papyri. A list of the watchmen there in *c.* AD 300 mentions buildings such as temples of Serapis, Isis, and Thoëris, the Caesareum, a tetrastylon, the theatre, the Capitolium, baths-buildings, a gymnasium, and monumental gates. It also mentions the north and south churches (*ekklesiai*) and the Nilometer. It includes street names which are frequently derived from a prominent building on them.[73] The report of AD 315/16 by the craftsmen listing the repairs necessary to the civic and other buildings 'broken down from hard usage' mentions buildings which seem to be located along each colonnade (*stoa*) of the city's main north-south and east-west colonnaded streets. Apparently, along the 'western stoa', there were a school, temple of Fortune, temple

of Achilles, record office or library (*bibliotheke*) and a market building (*makellos*). The eastern stoa had various food shops along it. The public baths are mentioned, and a colonnaded running track (*xystos*) which was apparently part of the baths-building. There were also temples of Demeter, Dionysus, and Hadrian, and an imperial 'residence' (*palation*).[74] Thus in the early fourth century AD, care was still taken to keep in repair the buildings and facilities which constituted a developed classical cityscape.

The Oxyrhynchus papyri also give an impression of housing arrangements and craftsmen's quarters in the Roman period. The archaeological remains at other sites indicate two main types of residential areas. At Marina el-Alamein there are houses based on the typical Greek arrangement with rooms off a courtyard with a colonnade along one or more

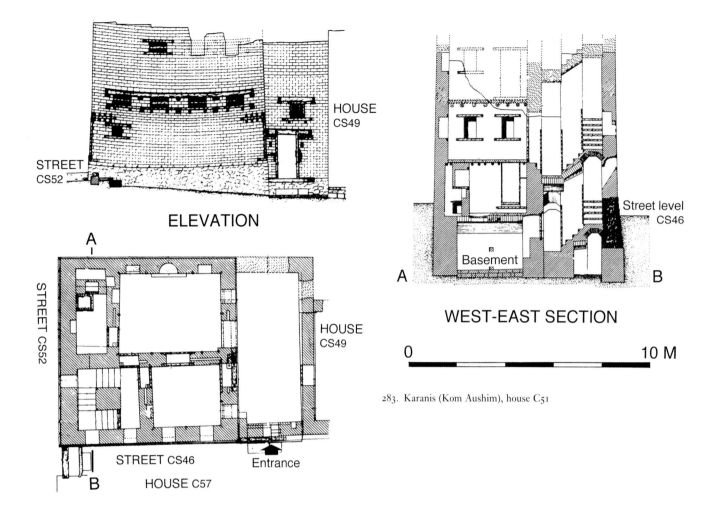

ELEVATION

WEST-EAST SECTION

0 10 M

283. Karanis (Kom Aushim), house C51

GROUND FLOOR PLAN

sides from the second to fourth centuries AD [281], as well as a cemetery [282].[75] The archaeological evidence from about the same period at Karanis (Kom Aushim) includes houses of mudbrick with timber trims [283]. These houses were three stories high, often with underground rooms. They were taller than they were wide and generally lacked a courtyard, in contrast to the Greek peristyle house design. A baths-building also survived at Karanis.[76]

At Arsinoe (Medinet el-Faiyum) details are provided about how the water system functioned, in AD 113. Most of the revenue for operating it was derived from those holding public offices. The water was pumped day and night into reservoirs by shaduf, water wheels (possibly *saqiya*), and screws of Archimedes. This highly organized and costly operation supplied water to the fountains, baths, two synagogues, and a brewery.[77]

Many classical buildings are mentioned in papyri in Arsinoe, as well as Panopolis, and other towns. Those in Arsinoe, in the Roman period, include: the agora, baths, library, gymnasium, theatre, *komasterion*, nymphaeum, stoa, and temples of Demeter, Hermes, Neptune and Nemesis, as well as a Thesmophoreion, Lageion, Hadraneion and Kaisareion.[78] As the *metropoleis* were not given town councils (*boulai*) until *c.* AD 201, it is only after this date that they would have had a council house (*bouleuterion*). It is not until

late in the third century AD that there are references to any of them having an imperial 'residence' (*palation*).[79]

Archaeological evidence also survived from some other towns, as at Herakleopolis Magna (Ihnasya el-Medina) where there is a building with Antonine Corinthian capitals and red granite column shafts [284–285].[80] At Athribis (Tell Atrib) in the Nile Delta, where the Napoleonic expedition recorded the colonnaded streets, there are the remains of a classical temple with columns, bases, and local simplified Corinthian capitals, all carved in granite. However, the marble cornice, frieze and 'Normal' Corinthian capitals from the tetrapylon of AD 374 are like those found elsewhere in the eastern Mediterranean. Thus, both the local classical style and the imported one were built side by side. East of the Delta at Pelusium (Tell el-Kana'is) a theatre has been excavated which had also been used as an 'arena' for gladiatorial contests. It was built in the third or early fourth century AD and notably had a semi-circular plan, unlike the earlier ones at Oxyrhynchus and Antinoopolis.[81]

As would be expected, some of these cities and towns, in particular the *metropolis* or main town of each nome, were larger than others. In the late fourth century AD, Ammianus Marcellinus mentions the 'most famous' cities in Upper Egypt (the Thebaid) as Hermopolis [Magna], Antinoopolis, Thebes [Luxor] and Coptos, and in Lower Egypt the 'greatest

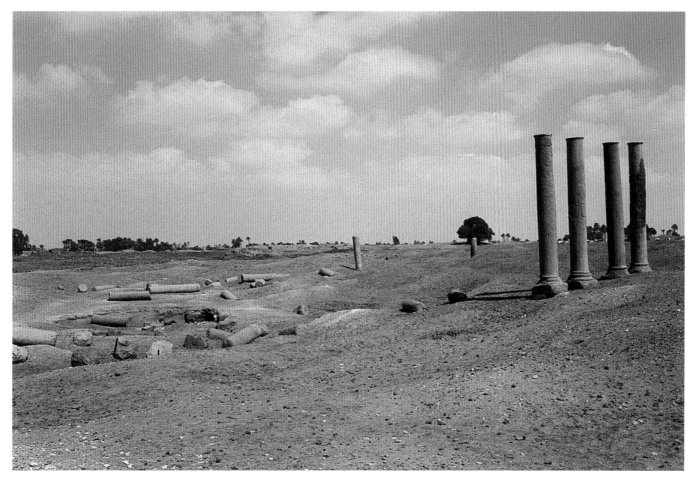

284. Herakleopolis Magna (Ihnasya el-Medina), red granite remains of Antonine building

cities' are Athribis, Oxyrhynchus, Thumuis, and Memphis, and many lesser towns.[82] In the light of the archaeological and papyrological evidence, Panopolis, Arsinoe, and Herakleopolis Magna could be added to this list, and possibly some others.[83]

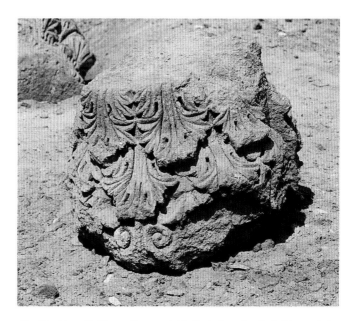

285. Herakleopolis Magna (Ihnasya el-Medina), Antonine Corinthian capital from building in fig. 284

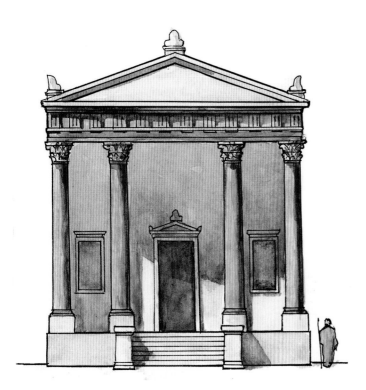

286. Philae, temple of Augustus, reconstruction of front showing different coloured stones: sandstone, red Aswan granite, black diorite, 13/12 BC

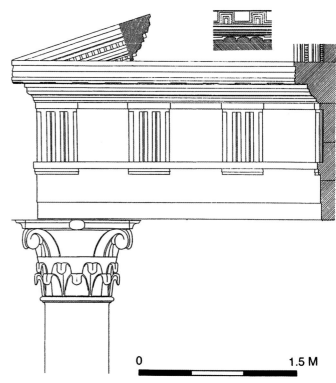

287. Philae, temple of Augustus, main order

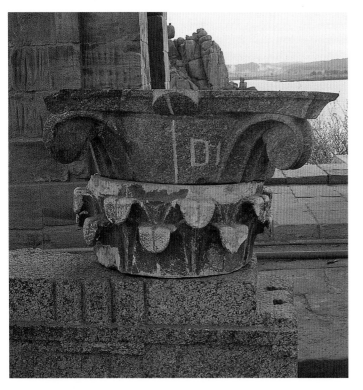

288. Philae, temple of Augustus, main order, top drum of capital (with a modern cast of the lower drum) and lower block of Doric frieze

SOME OTHER BUILDINGS AND CONSTRUCTION TECHNIQUES

In addition to the towns which had a fully developed Roman urban cityscape, there were also some buildings which survive at other sites which provide information about the use of local construction techniques on classical architecture.

On the island of Philae, where the Egyptian sanctuary was embellished under Augustus, a temple of Augustus was built and dedicated by Publius Rubrius Barbarus. He was prefect of Egypt when Cleopatra's Needles were erected in 13/12 BC, the year in which Augustus became Pontifex Maximus. The temple was built of local sandstone, but with red granite columns supporting black diorite capitals, and a red granite Doric entablature at the front [286]. These hard stone blocks were cut following local custom, not used elsewhere in the classical world. The capitals were carved using two blocks instead of one [288]. Similarly, the Doric entablature was not divided in the traditional Greek manner in which the triglyphs of the Doric frieze were carved on separate blocks to the architrave block with regulae and guttae. Rather, at Philae the Doric frieze was carved so that the lower part of the triglyphs were on the architrave block [288]. This same division was also used on the Ptolemaic sanctuary at Hermopolis Magna [74] and on the portico of the Roman theatre at Oxyrhynchus. The classical pediment above the doorway of the temple of Augustus at Philae was supported

289. Philae, temple of Augustus, axonometric reconstruction, with the altar in front obscured by the Arch of Diocletian (Sheila Gibson)

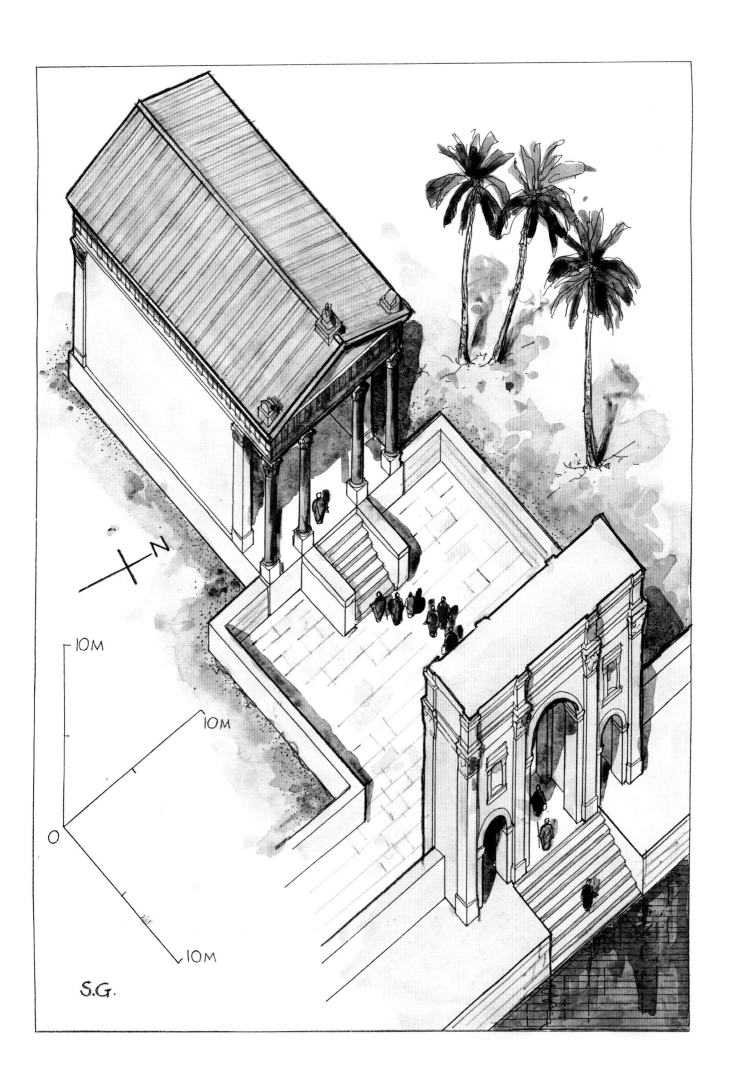

10M

10M

10M

O

N

S.G.

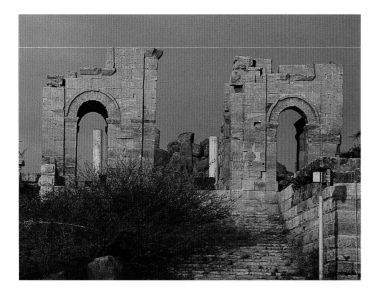

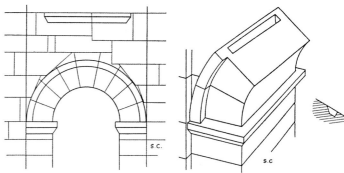

290. Philae, Arch of Diocletian, view from east with the temple of Augustus columns behind

291. Philae, Arch of Diocletian, details of method of construction of arch without centering

by an Egyptian cavetto cornice. The main order of this temple was a mixed order with local modified Corinthian type capitals, a Doric frieze, and Ionic raking cornices [286–287]. A mixed order was also used even further south on a Roman building at Syene (Aswan), which had similar use of coloured local stone. Its Doric frieze, column bases and shafts were of red granite and it had dark hardstone capitals of a local Corinthian type.[84]

An arch was built opposite the temple of Augustus at Philae under the emperor Diocletian [289–290].[85] It had small pendentive domes crowning each of the side arches. Although of stone, these arches were built using a technique which did not require the use of centering [291]. This technique might be a local invention because the traditional Egyptian method for the construction of mud brick vaults with pitched brick vaulting also does not involve the use of centering.

At Thebes (Luxor) a temple for Serapis and other gods was built under Hadrian in AD 127 inside the Egyptian temple

enclosure [294].[86] Baked brick, which would have been finished in stucco, was used for the whole building including the columns, like buildings at many other sites. These structures have often not survived or been recorded because archaeologists have been more interested in the remains of Egyptian stone temples. However, a more recently excavated example is West Tomb 1 at Kellis (Ismant el-Kharab) which provides a glimpse of the lost classical architecture of Roman Egypt which was built of more perishable materials than stone. Its peristyle had stuccoed columns of baked brick supporting Corinthian capitals made of baked brick, wood and plaster. Surprisingly, it was laid out with the precision normally associated with stone architecture. It had a unique design with a peristyle of the Corinthian order, but with a flat roof like the building depicted on Alexandrian coins [328].[87] This contrasts with the pitched roofs suggested by the triangular pediments at Philae and Mons Porphyrites (Gebel Dukhan) [289, 292].

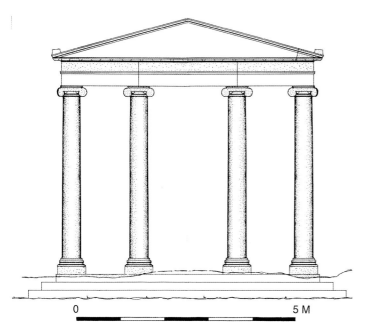

292. Mons Porphyrites (Gebel Dukhan), temple of Serapis, front elevation

293. Mons Porphyrites (Gebel Dukhan), temple of Serapis fragments

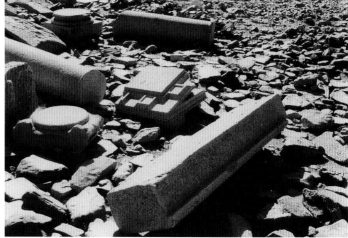

0 5 M

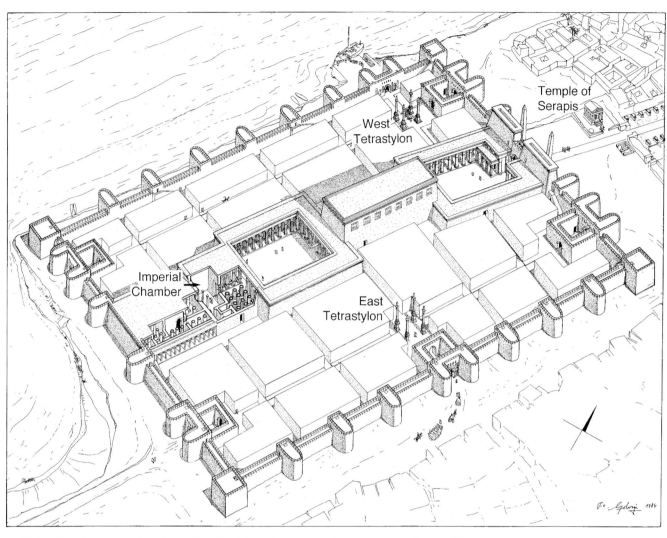

294. Thebes (Luxor), reconstruction of area of temple of Amun, in *c.* AD 310, after conversion to a Roman military camp

295. Thebes (Luxor), east tetrastylon, *c.* AD 308/9, beside Egyptian temple of Amun

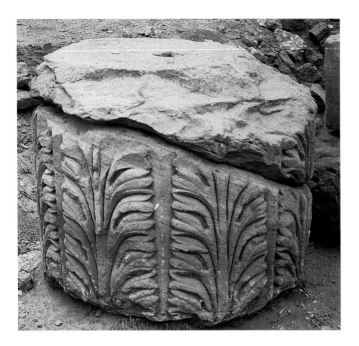

296. Thebes (Luxor), east tetrastylon, column base

ROMAN MILITARY CAMPS

The sites which served primarily as military camps had the normal layout of a legionary fortress.[88] Classical architectural decoration occurred in them on only a few specific structures, which are generally not very large and are fairly simple.

Mons Porphyrites (Gebel Dukhan) and Mons Claudianus were military camps in the eastern desert (Map 2) with basic utilitarian architecture constructed to oversee the quarrying of their respective stones: porphyry, and black and white speckled granodiorite.[89] They each had a small temple of Serapis with simplified local classical architectural decoration, illustrated here by the example at Mons Porphyrites, built in AD 117–19 [292–293].[90]

Remains of the late third-century version of the fortress of Babylon (Old Cairo), may still be seen near the Coptic Museum.[91] At Dionysias (Qasr Qarun) in the Faiyum the Diocletianic fort was built beside the existing Egyptian village. The fort had an unusual basilica-like structure at its centre which had local classical architectural decoration.[92]

At Thebes (Luxor) the Egyptian temple seems to have been out of use by the time the temple enclosure was converted to a Roman military camp in c. AD 300 [294].[93] This camp was ornamented with tetrastyla at the cross roads, to the east and west of the temple in AD 301/2 and 308, like other Roman towns of Egypt [295].[94] They have bases reminiscent of the acanthus column bases on other tetrastyla in Egypt [296]. Classical decoration was used inside the former Egyptian temple of Amun in the so-called Imperial Chamber [294]. Its Egyptian decoration was covered with stucco and wall-paintings of the Tetrarchs, and four columns with simplified Corinthian capitals were erected [297].[95]

CHANGES IN THE USE OF RESOURCES FOR BUILDING PROGRAMMES

Some general observations can be made on the changes in the use of resources for building programmes in the towns and cities of Roman Egypt. Substantial new structures were added to the Egyptian temple complexes under Augustus and Tiberius, as under the Ptolemies before them. By the reign of Hadrian, when the main resources for construction went into the new city of Antinoopolis, the additions to the Egyptian temples were largely only wall decoration.

Under Antoninus Pius, AD 138–61, it is notable that some new Egyptian style buildings were erected, coinciding with an apparent increase in classical building programmes. After his reign, construction in the Egyptian style in Egyptian temple complexes ceased, while new classical buildings continued to be constructed. It was during this period, for example, that the theatre at Oxyrhynchus, and the Komasterion and 'Sphinx Gate temple' at Hermopolis Magna were apparently erected.

Classical construction work continued during the third century AD. The tetrastylon of Alexander Severus at Antinoopolis is a dated example of city embellishment in 222–35, as is the gymnasium of 263. The papyri of 266–7 from Hermopolis Magna (el-Ashmunein) indicate substantial amounts of money were being spent on repairing and rebuilding the existing fabric of a city already fully adorned with classical structures. There is no doubt that a considerable amount was spent on building work during the mid- to later part of the third century, even if it was for repairs.[96] Clearly once a city has a colonnaded street it could only be repaired or rebuilt. There is also other evidence suggesting prosperity in the later third century in other major cities: Oxyrhynchus, Antinoopolis, and Panopolis.[97]

The movement of resources away from Egyptian temples to classical public buildings was possible because of the increase in private property. Papyri provide evidence for the role of gifts and bequests for buildings, and contributions to civic amenities, such as the gymnasium in the second and third centuries AD. As occurred in the western empire from the second and third centuries onwards, there appears to be an increase in Egypt in the proportion of buildings paid for by cities, rather than individuals.[98] In Egypt these were apparently funded by taxes levied locally. This might partially explain why the building programmes there did not necessarily reflect the decline which occurred elsewhere in the late third century.

It is important to note that the evidence indicates that there was sufficient building activity in Egypt during the third century to ensure continuity of workmanship to enable the continuation of the tradition of the Ptolemaic classical architecture through the Roman period. This made it possible for it then to be transmitted into the pagan and Christian architecture of the fourth century, during a period when the principal new building activity was the construction of churches.

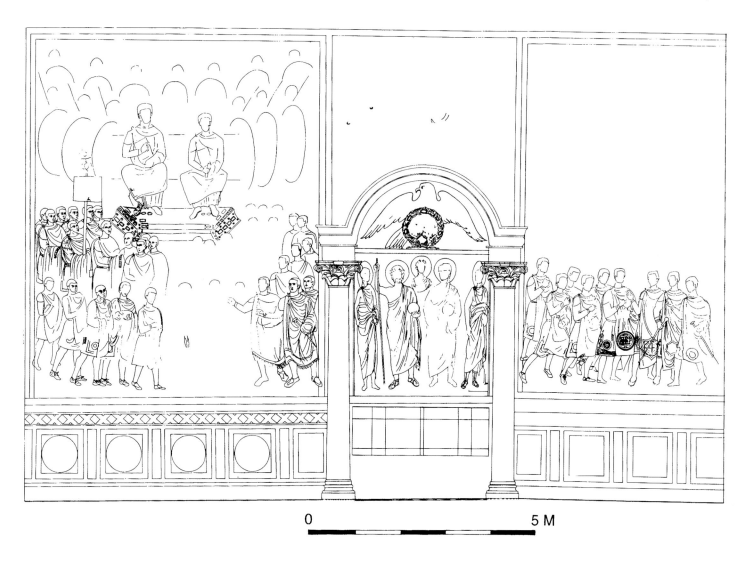

0 5 M

297. Thebes (Luxor), temple of Amun, Imperial Chamber, detail of wall-paintings and niche in south wall

CONCLUSION

The traditional Egyptian temple complex continued to be a dominant feature of the old Egyptian towns in the Ptolemaic and Roman periods, while they also developed a classical cityscape. In the Ptolemaic period, as early as the third century BC, these sites had buildings distinctive to a Greek way of life including baths and gymnasia, an agora, buildings in which to hold Greek cultural events, and temples to Greek gods. The fact that there were already classical buildings in these cities and towns in the Ptolemaic period facilitated the developments in classical architecture in them after the Roman conquest, as this represented the continuation of an existing trend and not a completely new development. Rather, the major change in the Roman period was the cessation (just after the mid-second century AD) of construction in the Egyptian style, while resources were devoted to classical public buildings.

Except for the presence of the Egyptian temples, the cityscapes and monumental buildings of these urban centres of Egypt were similar to those elsewhere in the Roman East. Like them, the cities and towns of Egypt had a main length-wise street and a main cross-street which were colonnaded, with tetrastyla at their intersections. These streets were ornamented with porticoes, stoas, monumental arches, gates and fountain houses. The agora functioned as a market, while there were also market buildings (*macella*). For public entertainment there was a theatre, and sometimes a hippodrome or circus (for chariot racing) which was also used as a stadium (for athletic events). Other facilities included gymnasia and baths-buildings. There were classical style temples to Greek and Roman gods and for the imperial cult. Sometimes they had a procession house (*komasterion*). To have all of these types of buildings it was not necessary for the urban centres in which they were built to have the formal status of a city. Those buildings which resulted from city status included the council house (*bouleuterion*) and town hall (*prytaneion*). Later, some cities had an imperial 'residence' (*palation*).

Whilst these are classical building types which also occur elsewhere, the designs of many of those in Egypt have

features which are specific to it. Archaeological remains show that these features include details of the tetrastylon, the designs of the triumphal arch, theatre, and circus, while *komasteria* occur only in Egypt. The idea of a circular (rather than rectangular) gymnasium is also unique. Local construction techniques were also used on some classical buildings.

The cities and towns of Egypt, with their cityscapes similar to other urban centres in the Roman East, thus, provide the context for Roman Alexandria as a city in Egypt.

Roman Alexandria

Alexandria was not only the capital of Roman Egypt – a country with urbanized cities and towns – but the principal city of the Roman empire after Rome. Its importance to the Romans came from the wealth it provided as a trading port because of its ideal location not only for trade with Egypt but as far east as India. As the geographer Strabo, who observed it shortly after the Roman conquest of Egypt in 30 BC, noted it 'is by nature well suited . . . both to commerce by sea, on account of the good harbours, and to commerce by land, because the river easily conveys and brings together everything into a place so situated – the greatest emporium in the inhabited world'.[1] Its role as a commercial centre and the source of Rome's grain supply, as well as a major centre of learning, continued in the following centuries.

Although Alexandria, obviously, was much larger than the other cities and towns of Roman Egypt, the contemporary developments observed in them in the previous chapter provide the local backgound to those in the capital. They had similar types of classical civic buildings to other urban centres of the Roman East but with some local features. Unlike most of these Egyptian sites, Alexandria was not dominated by an Egyptian temple complex. Instead, it had other sanctuaries (such as the Serapeum and the Caesareum), as well as an extensive palace area with buildings for which the city was renowned (including the Museum and the tomb of Alexander).

The evidence for the architecture of the other cities and towns of Egypt is provided by papyri and archaeological remains. However, the picture of Roman Alexandria comes from the combination of different evidence. For it, there are fewer papyri, but more historical sources. Although not many of its monumental buildings have survived from before the fourth century AD, there is also other evidence. The need to combine these different types of evidence makes presenting them more difficult. Thus, it is worthwhile giving a brief indication of the types of evidence and the order in which they will be presented. This follows approximately the historical development of the city.

Consideration of the Roman city begins with Strabo's description to provide a sense of its topography soon after the Roman conquest and the relative positions of some buildings, whose exact locations are not always known. For some aspects of the city during the late first century BC to the second century AD, there are both archaeological remains and written sources. These include its harbours, its main imperial cult temple the Caesareum, the approximate size and area of occupation of the city, and types of houses. On the other hand, information about other public buildings in the first and second centuries AD comes largely from the written testimony of Jewish authors and other historians. These mention the city's large arenas for public entertainment, and the major monuments which attracted the interest of the Roman emperors who visited them.

By contrast, for the styles of architecture of the city's sanctuaries, it is necessary to turn to the images on coins and tokens, combined with written and archaeological evidence. The monumental architecture along the colonnaded streets (such as triumphal arches and fountain houses) was largely classical, while the temples were apparently built in one of three distinct styles (classical, Egyptian, or Greco-Egyptian).

The evidence for the tombs of Roman Alexandria is archaeological. Many are centrally organized and have some classical architectural features. However, the decoration of individual tomb chambers or niches involves the use of classical (Greek or Roman) and Egyptian iconography together.

Sufficient architectural remains survive of the Roman city's most famous sanctuary, the Serapeum, to reconstruct it. Detailed analysis of the archaeological and written evidence reveals that its chronology can be clarified. The descriptions of the Roman phase, written in the fourth century AD, are more accurate than previously appreciated. The conversion of the adjoining racecourse, the Lageion, to a circus is indicated by the archaeological remains. For the city's other major buildings of the third century, it is necessary to return to the written sources.

However, for the fourth to seventh centuries, there is considerable archaeological evidence in the city centre at Kom el-Dikka. This is the one area of the city which is large enough and with sufficient remains to show changes in land usage and the evolution of buildings through a number of phases. These include an imperial baths-building complex (with cistern and latrines), a large teaching complex with lecture rooms, a 'small theatre' (a concert hall and/or large lecture theatre), workshops, shops, and houses.

Thus, the combination of different types of evidence will provide a glimpse of Roman Alexandria: its layout, major buildings, and distinctive local building designs. The facilities covered range from those for maritime trade and places of entertainment to those for worship of Greek, Roman and local gods, as well as places to live, study, shop and be buried.

STRABO'S TOPOGRAPHICAL DESCRIPTION, c. 26–20 BC

As evident in Chapter 3, more is known about the early development of Alexandria than has generally been assumed. Strabo's description of Alexandria is discussed by Peter Fraser in *Ptolemaic Alexandria* in great detail, relating all earlier and some later references to each of the structures mentioned (and not mentioned) in it. As many of these are covered in Chapters 3 and 4, that level of detail will not be repeated here. Those references are passing ones, whereas Strabo's is the earliest topographical description of the city as a whole which has survived. It is apparently based on first-

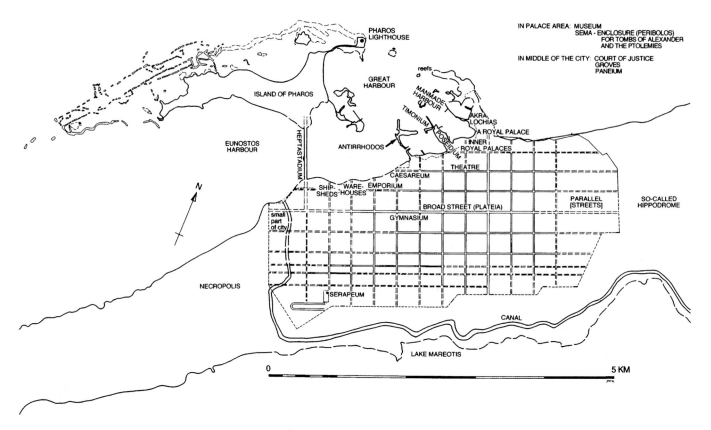

298 Alexandria, plan with locations and buildings mentioned in Strabo's description

hand observation in *c.* 26–20 BC when he visited the city after the Roman conquest of Egypt.[2] His description will be presented here on its own, so that it is possible to see exactly what information it provides. It is shortened and the order changed slightly to avoid repetition. It gives more indication, than the passing references, of the position of buildings relative to each other even if it does not always give their precise locations [298].

Like Diodorus Siculus, Strabo comments on the embellishment of the city by each of the kings with public buildings and palaces. The one feature which Strabo's description gives which is not conveyed by the earlier references is the impression of a very large area for the palaces and public buildings, with the palaces connecting with each other. Knowledge of the locations of the palaces and the theatre is also largely dependent on him. He indicates that the palace area included various structures, such as the Museum and the Sema which contained the tombs of Alexander and the Ptolemies. However, disappointingly, he does not give the locations of these buildings within it, which are also not indicated by the earlier references. He does not mention the Library, but perhaps it was located within the Museum complex[3] (unless it had been burnt by then).

Strabo first discusses the location of the city, and describes how its harbours are formed. He explains how the embankment, the Heptastadium, joins the mainland to the island of Pharos and separates the two main harbours. These are the western harbour called the Eunostos (Good Return) Harbour which 'lies in front of the closed harbour which was dug by

the hand of man', and the eastern Great Harbour which 'is not only so deep close to the shore that the largest ship can be moored at the steps, but also is cut up into several harbours'. The Heptastadium had two bridges which gave access between the two harbours [299], and it had carried an aqueduct to the island [27]. To the south is Lake Mareotis (modern Lake Mariut) which also has a harbour for the imports which come along the canals which fill it from the Nile.

The narrow entry to the eastern Great Harbour has the tower Pharos on the right and the promontory Lochias [modern el-Silsila] on the left. Strabo observes the Lighthouse was necessary because of the reefs: 'in addition to the narrowness of the intervening passage [to the eastern harbour] there are also rocks, some under water, and others projecting out of it, which at all hours roughen the waves that strike them from the open sea. And there is also this promontory (*akron*) of the island, a rock washed all round by the sea, having a tower (*pyrgos*) which is arranged marvellously of white stone (*leukos lithos*) of many stories.' He mentions that the island of Pharos, had been laid waste by Julius Caesar, and had not been reinhabited.[4]

Strabo describes the city layout: 'The city as a whole is intersected by streets practicable for horse-riding and chariot-driving, and by two that are very broad, extending to more than a plethrum [100 feet] in breadth, and which cut one another into two sections and at right angles. And the city contains the most beautiful public precincts (*koina temene*) and also the royal palaces (*basileia*), which consti-

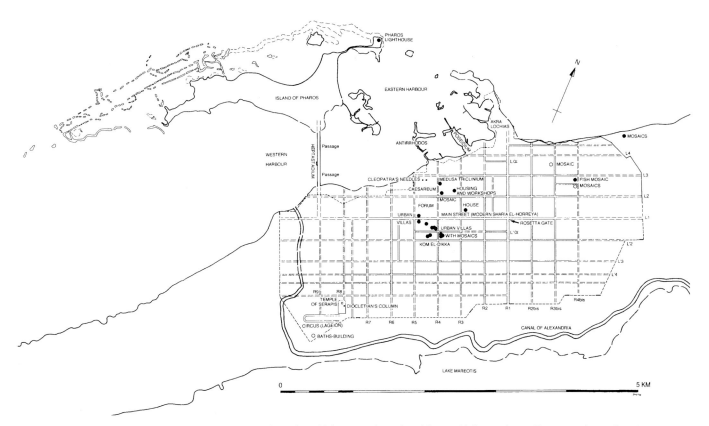

299. Alexandria, plan of Roman city *c.* AD 300, archaeological remains with houses and mosaics of first to third centuries AD (For cemeteries see fig. 29)

tute one-fourth or even one-third of the whole circuit of the city; for just as each of the kings, from love of splendour, was wont to add some adornment to the public monuments, so also he would invest himself at his own expense with a residence, in addition to those already built, so that now . . . "there is building upon building". All, however, are connected with one another and the harbour, even those that lie outside the harbour. The Museum is also a part of the royal palaces; it has a walk (*peripatos*), an exedra, and a large house in which is the common mess-hall (*syssition*) of the men of learning who share the Museum . . . The Soma [or Sema] also, as it is called, is a part of the royal palaces. This was the enclosure (*peribolos*) which contained the burial-places (*taphai*) of the kings and that of Alexander . . . the body of Alexander was carried off by Ptolemy and given sepulture in Alexandria, where it still now lies – not, however, in the same sarcophagus as before, for the present one is made of glass, whereas the one wherein Ptolemy laid it was made of gold. The latter was plundered by Ptolemy [XII]'.[5]

'The city is full of dedications and sanctuaries; but the most beautiful is the Gymnasium, which has porticoes (stoas) more than a stadium [600 ancient feet, *c.* 180m] in length. And in the middle are both the court of justice (*dikasterion*) and the groves (*alse*). Here too is the 'Paneum', which he describes as an artificial hill with a spiral ascent road. 'The *plateia* that runs lengthwise extends from the Nekropolis [the cemeteries to the west of the city] past the Gymnasium to the Canopic Gate'.[6]

The location of the palaces is clearly indicated by Strabo. There is one on the promontory Lochias (el-Silsila) next to the 'inner royal palaces, which are continuous with those on Lochias and have groves (*alse*) and many dwellings (*diaitai*) painted various colours. Below these lies the harbour which was dug out and is hidden from view, the private property of the kings, as also Antirrhodos, an island lying off the "dug out" harbour, which has both a palace and a small harbour.'

He continues by describing the buildings on the eastern or Great Harbour, from east to west: 'Above the artificial harbour lies the theatre; then the Poseidium – an elbow, as it were, projecting from the Emporium, as it is called, and containing a temple of Poseidon.' At the tip of the promontory (*akra*) which he added to this elbow Antony 'built a royal lodge (*diaita*), which he called the Timonium . . . Then one comes to the Caesareum and the Emporium and the warehouses; and after these to the ship-sheds, which extend as far as the Heptastadium.' Recent underwater exploration of the eastern harbour has uncovered three harbours within its eastern part, including the hidden harbour near Lochias [31]. It has also revealed the location of a large promontory, apparently the Poseidium [298]. Two man-made jetties protrude from this promontory, but it is not completely clear on which one the Timonium was built. The island of Antirrhodos appears to be the island to the west of the Poseidium, forming a harbour with it. Strabo's description gives the impression that Antirrhodos was east of the Poseidium, and consequently, Mahmoud-Bey had identified the remains of the

300. Alexandria, Cleopatra's Needles in 1785

promontory and the island the other way around (compare [20] with [298]).[7]

'Next, after the Heptastadium one comes to the Harbour of Eunostos, and beyond this, to the artificial harbour which they call the Chest (Kibotos); it too has ship-sheds.' In the light of the underwater archaeological research clarifying the shape of the harbours, there is no harbour on the mainland identifiable as the Kibotos (unless under part of the silted Heptastadium). As it was 'beyond' the Heptastadium and the western harbour, it is possible the Kibotos was the harbour to the north-west of Pharos recorded by Jondet [30, 298].

Strabo continues 'farther in there is a navigable canal, which extends to Lake Mareotis [Mariut]'. West of 'the canal there is, still left, only a small part of the city; and then one comes to the suburb Nekropolis in which there are many gardens (kepoi) and graves (taphai)'.[8]

Strabo does not mention the cemeteries to the east of the city, but this is not surprising as they seem to have been used less in this period, having been largely covered by the expansion of the city [29].[9] East of the Canopic Gate was 'the so-called hippodrome and the other [streets] that lie parallel'. One passes 'through the hippodrome' which suggests that it perhaps was not a substantial structure with seating; but rather was a flat area used for horse racing, possibly since Ptolemaic times, like the one at Jericho mentioned by Josephus.[10]

After 30 stadia [c. 5.3 km] one comes to Nikopolis which Strabo's comments suggest had been built fairly quickly in the four to ten years since its foundation by Octavian: 'the Serapeum and the other sacred precincts of ancient times, which are now almost abandoned on account of the construction of the new things in Nikopolis; for instance, there are an amphitheatre and a stadium and the quinquennial games are celebrated there; but the ancient things have fallen into neglect'. Suetonius mentions that Octavian also enlarged the ancient temple of Apollo there.[11] Strabo continues, near Alexandria and Nikopolis was the sanctuary of Eleusis on the canal to Canopus. The temple of Serapis at Canopus was visited in order to be cured by incubation, and to consult the oracle. Beyond Canopus was the promontory (akra) Zephyrion where there was the shrine (naiskos) of Arsinoe-Aphrodite.[12]

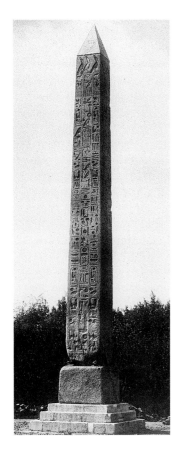

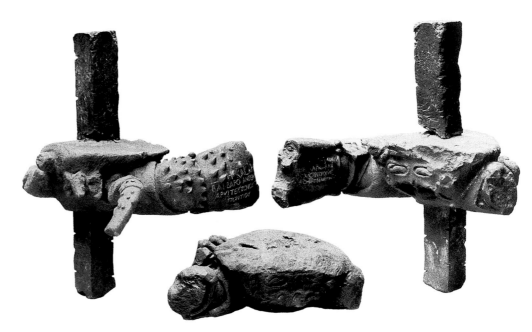

301. New York, Central Park, Cleopatra's Needle re-erected, with reproduction crabs

302. Inscribed crabs which supported Cleopatra's Needle

THE CAESAREUM AND THE FORUM

Strabo's reference to the Caesareum, which was the temple of the seafaring Caesar, indicates that it existed by *c.* 26–20 BC. Thus, by this date there was a substantial temple in the city dedicated to the cult of its new rulers. Whilst there is agreement that it was later a cult centre for the worship of the emperor Augustus, there is uncertainty about whether its construction was begun in honour of Julius Caesar or Mark Antony by Cleopatra.[13]

The position of the Caesareum mentioned by Strabo accords with the location of Cleopatra's Needles, which stood in front of it facing the harbour [299–300].[14] The inscription on the bronze crabs which supported them records their erection in year 18 of the emperor (13/12 BC) by the prefect Barbarus and the architect Pontius [301–302].[15] This is the same year in which Augustus became Pontifex Maximus, and the temple of Augustus at Philae was dedicated at the other end of Egypt. The hieroglyphic inscriptions on the obelisks indicate they were moved from Heliopolis, near modern Cairo.[16] The placement of two obelisks in front of the temple is an Egyptian custom, here copied by the Romans.

Pliny locates these obelisks at the entrance to the 'temple of Caesar'. He gives their height as 42 cubits, (22.05 m) which, notably, is close to their actual height of *c.* 21 m [59]. In the nineteenth century one obelisk was still standing with the other, fallen, beside it [300]. The orientation of the standing obelisk (now in Central Park in New York [301]) and the position of the fallen one (now on the Thames Embankment in London [303]) indicate that they were not oriented on the city grid plan, but at an angle to it. This suggests that (even if its enclosure was on the grid) the temple was also positioned at this angle to the grid,[17] to make it easier to view as ships came into the harbour, steering around Antirrhodos [304].

The philosopher Philo describes the enclosure (*temenos*) of the Caesareum in *c.* AD 38 which included a variety of structures: 'For there is elsewhere no precinct like that which is called the Sebasteum, a temple to Caesar on shipboard, situated on an eminence facing the harbours famed for their excellent moorage, huge and conspicuous fitted on a scale not found elsewhere with dedicated offerings, around it a girdle of pictures and statues in silver and gold, forming a precinct of vast breadth, embellished with porticoes (stoas), libraries, banqueting rooms (*androries*), chambers, groves, monumental gates and wide open spaces and unroofed structures and everything which lavish expenditure could produce to beautify it – the whole a hope of safety to the voyager either going into or out of the harbour.'[18] It is notable that this precinct included libraries.

By AD 94 the enclosure included subsidiary shrines and was also used as a public place for displaying notices, as a soldier reports a bronze copy of his certificate of discharge was 'lodged in the Great Caesareum, as you mount the second stairs, within the right-hand portico, near the temple of the Marble Venus, fastened on the wall'.[19]

The Forum should be mentioned before further considering the layout of the Caesareum. The Forum seems to

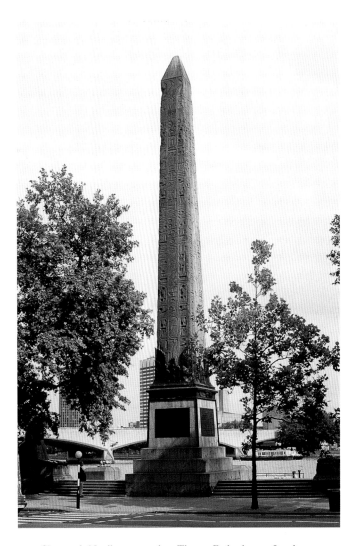

303. Cleopatra's Needle re-erected on Thames Embankment, London

have been located to the south of the Caesareum. Pliny the Elder mentions that the large obelisk from the temple of Arsinoe was moved to the forum by the prefect Maximus, *c.* AD 12–14/15 AD.[20] As Pliny does not specify which forum, this suggests that there was one main forum when he was writing in the mid-first century AD. The Sebaste Agora is mentioned in AD 41 and, as it is the Greek equivalent of the name, is presumed to be the Forum Augusti which was used in AD 110 and 128 for displaying notices, such as an Alexandrian birth certificate.[21] It is sometimes suggested that the Forum Julium, i.e. a forum in honour of Julius Caesar, was an earlier name for it,[22] and, on the basis of equivalent examples in Rome, that this forum directly adjoined the temple of the Caesareum, located to its north.[23] The Forum of Augustus could have been slightly further south, between the temenos mentioned by Philo, in which the temple stood, and the main east-west street [304].[24]

As mentioned, the temple (the building for the cult statue) of the Caesareum does not seem to have been oriented on the axis of its enclosure. As it faced the harbour with Cleopatra's Needles in front of it, it is not clear, contrary to what has often been suggested, that its design was similar to that of

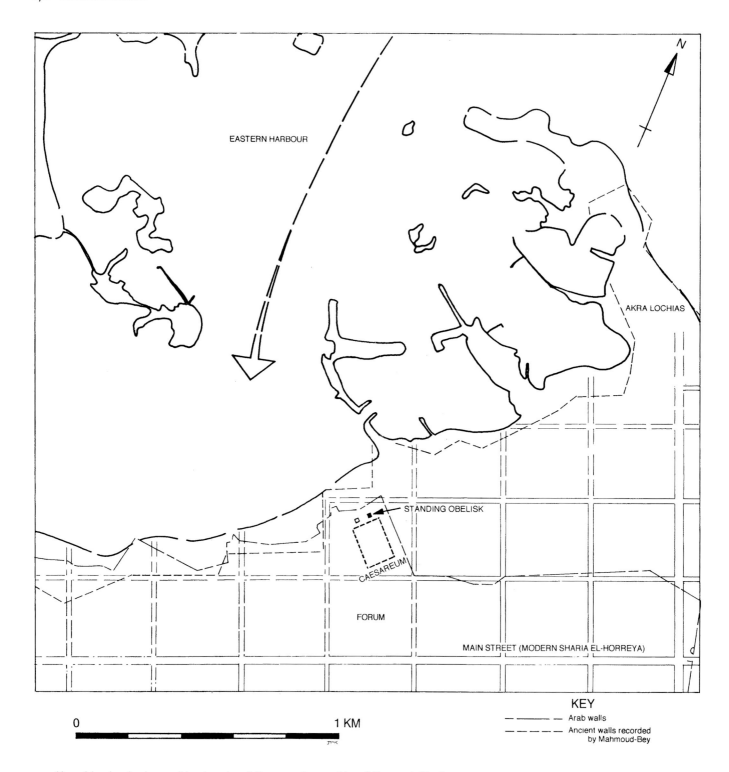

304. Alexandria, plan showing possible orientation of Caesareum from position of Cleopatra's Needles

related sanctuaries elsewhere consisting of a temple placed on the long axis of a colonnaded court and approached from the front along that axis.[25] However, although the Caesareum in Alexandria did not necessarily have this design, the Ptolemaic temple at Hermopolis Magna (el-Ashmunein) did [75]. It is, thus, possible that other sanctuaries in Egypt provided the inspiration for the axial approach to a temple in a colonnaded court used on later buildings, such as the Caesareum at Cyrene[26] and the Temple of Artemis at Jerash. The axial

approach to a temple had become common in classical architecture by the late Hellenistic period, so the inspiration for it elsewhere need not to have come directly from Egypt. In Rome this axial arrangement has the temple pushed back against the rear wall of the enclosure with the open space (a temenos or forum) in front of it, which is an arrangement with more similarity to Egyptian temples than the classical examples.

305. Alexandria, plan of Kom el-Dikka with locations of Roman houses with mosaics

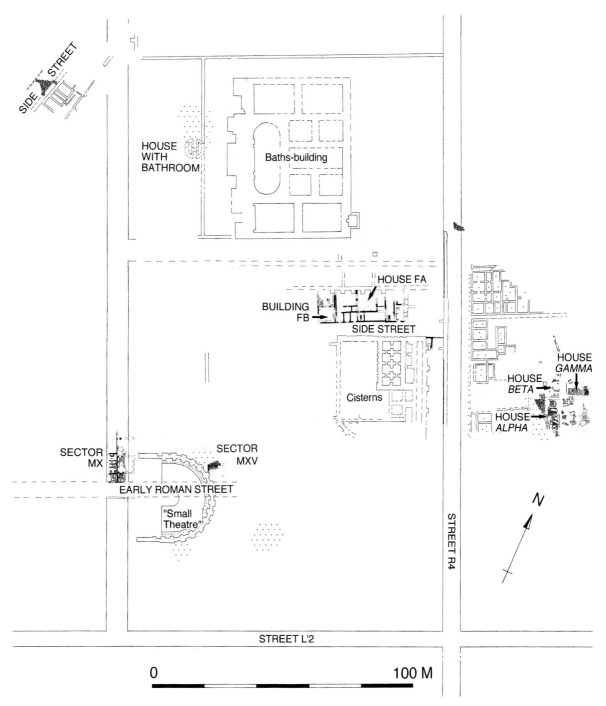

The written sources and archaeological evidence provide glimpses of the city's houses from the late first century BC to the second century AD and an indication of the areas of occupation during that period.

Strabo gives the size of the city as 30 by 7 or 8 stadia in c. 26–20 BC.[27] It continued to be about this size through the first century AD. The dimensions the Jewish historian Josephus gives of 30 stadia (c. 5.4 km) by at least 10 stadia (1.8 km) are close to those indicated by the archaeological evidence for the street grid and walls, with a length of 5.2 km and a width (at cross-street R4) of 2.2 km. These dimensions are notably the same as the circuit of 80 stadia (c. 14.4 km) described as originally laid out by Alexander the Great [299]. Estimates of the city's population have varied from 300,000 to 1,500,000.[28]

Development of municipal facilities would have been necessary as the population increased. Improvements were made to the city's water supply in AD 10/11 with the construction of, or major repairs to, the 'Canal of Augustus for 200 stadia [c. 36 km] from Schedia through the whole city' by the prefect Caius Iulius Aquila. These improvements were sufficiently important that they are recorded in two inscriptions.[29]

Alexandria had a sizeable Jewish population and two Jewish authors, Philo and Josephus, provide information about the city in the middle decades of the first century AD. Philo lived in Alexandria and his discussions of contemporary events also give an impression of their architectural setting.

Philo mentions the division of the city into five districts (*grammata*) named after the first five letters of the Greek alphabet. Although these districts or 'quarters' are also mentioned in other sources, including passing references in papyri, insufficient information is given to establish the exact location within the city of each of them, despite speculation. Philo indicates that the Jews lived in two locations in particular, but also mentions that they were scattered through the city, until after AD 38 when they were confined to one quarter. Josephus indicates that this was called Delta. By the second or third century AD the names of quarters in the city include those extending for some distance outside it, including: 'Hadrianos which is immense', 'Lochias which is outside of Pharos', Antirhodos, the 'Refuge of the Serapeum', the 'Isle of Anotinos pandotos', Zephyrion, Canopus, New Canal, Nikopolis, Camp of Manutius, and Bendideion. The Mercurium and Neaspoleos are mentioned in association with the grain supply and so have been assumed to have been districts with granaries, although their locations are not known.[30]

The houses of affluent members of the Jewish population, which Philo criticises for their splendour, were similar to those of the Greek population, and reflected in the archaeological remains. Philo describes these houses as having pavements and walls decorated with expensive marbles, and columns and architraves imported from Asia, Libya, and the islands. Their column capitals were adorned with Doric, Ionic, and Corinthian carvings. They had men's and women's apartments decorated with gilded ceilings. They were expensively furnished with beds with ivory legs, and sofas inlaid with mother of pearl and tortoiseshell, and bedcovers of gold brocade.[31] The use of a variety of stones and the Doric, Ionic, and Corinthian orders, mentioned by Philo, has already been observed in the archaeological evidence from the Ptolemaic period.

Remains of houses with ornate mosaic floors dated to the first and second centuries AD have been found in the central area of the city, in particular on the city blocks at Kom el-Dikka [305]. These include a house south of the main east-west street L1 discovered in the late nineteenth century, and those excavated by the Polish mission to the east of cross-street R4 under fourth-century housing and workshops. House *alpha* has a mosaic with panels depicting birds and some of the mosaics have geometrical patterns [306–308].[32]

The most recently excavated houses, which were later partly covered by the baths-building complex and the 'small theatre', provide more indication of the design of these expensive houses [309–310]. They were laid out following the Greek custom with a dining room (*andron*), which had expensive mosaic paving, off a courtyard. The rooms were arranged around this courtyard which had an engaged colonnade around it [309, 310a]. There were sometimes private baths attached to the house.[33]

The houses partly under the imperial baths complex, and between it and the cisterns [309], include House FA, built in the late first century AD with an *andron* containing a fine geometric mosaic and a courtyard with an engaged Doric colonnade. The architectural decoration of the house to its east, House FC, includes stucco and limestone capitals and cornices decorated with dentils and square hollow modillions. Both of these houses had a staircase to an upper floor, and House FC had a privy on both floors. To the west of House FA, there is a building (FB) with two large rooms, one with a black and white *opus tesselatum* mosaic.

Houses under the 'small theatre' and the new street in front of it include one in Sector MX, built in the late first century BC or early first century AD, with a pseudo-peristyle and mosaic floors [310a]. Another house with an *andron* mosaic was found under the edge of the *cavea* of the 'small theatre' in Sector MXV [310b].

Further north, the mosaic floor of a banqueting room was excavated in 1994, to the east of the Caesareum near cross-street R4 [299, 311]. It is dated to the first half of the second century AD. The design at its centre, with a Medusa head and a scale pattern, had continued from the Ptolemaic period.[34] This room was a triclinium with the location for the dining couches (*klinai*) for the guests, around three sides of the room and set back from the doorway, indicated by the panels in the mosaic. This arrangement is similar to the examples with rock-cut benches in the triclinium in the catacomb of Kom el-Shuqafa and at Petra.[35] It contrasts with the earlier Ptolemaic dining rooms in which the couches were arranged around all four sides of the room, with the door positioned off-centre to allow for the position of the couches, in the traditional Greek arrangement [97, 98]. The Medusa head panel at the centre of the mosaic was finer than the rest of the floor, and was made on a terracotta tray on which it was placed into the floor.[36] Written sources indicate that such panels, called *emblemata*, were exported from Alexandria.[37]

Other Roman remains of the first to third centuries AD were found throughout the city.[38] However, loose materials, such as architectural fragments, statues, inscriptions, or pottery, do not necessarily provide a reliable indication of a Roman structure or Roman occupation in a particular area. This is even more of a problem in Alexandria than is normally the case because the archaeological remains there have been so badly disturbed.

Consequently, the main *in situ* archaeological evidence for Roman buildings of the first and second centuries AD consists of intact mosaic floors, like those mentioned. Sometimes the walls around them have been robbed out so it was not always possible to ascertain the plan or function of the building to which these floors belonged. However, even mosaic floors found in excavations where few other details were recorded can still be dated approximately. Generally the patterns of these Roman mosaics are quite distinctive. They are usually geometric, often based on an overall arrangement of a panel consisting of a circle in a square, with the main colours being black and white. As in the Medusa triclinium, sometimes a more detailed coloured medallion is placed in the centre, and some of the patterns have developed from those used in the Ptolemaic period.

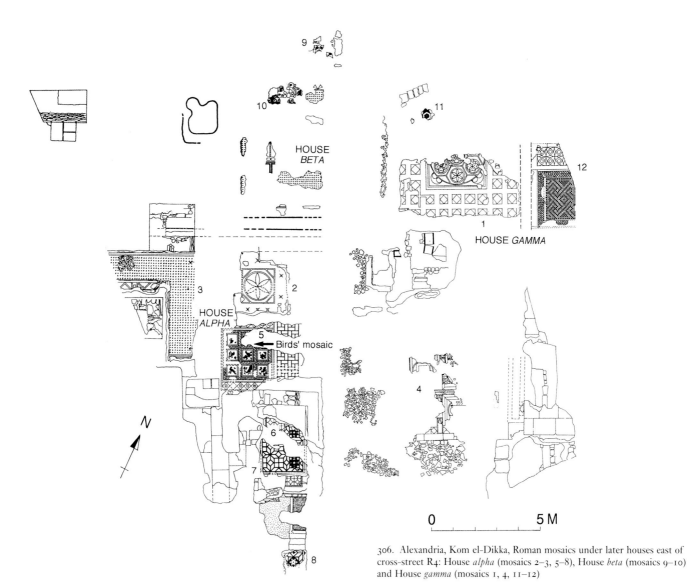

306. Alexandria, Kom el-Dikka, Roman mosaics under later houses east of cross-street R4: House *alpha* (mosaics 2–3, 5–8), House *beta* (mosaics 9–10) and House *gamma* (mosaics 1, 4, 11–12)

In addition to those in expensive houses of the first and second centuries AD already mentioned, Roman floor mosaics were also found in other parts of the city. On the city block to the east of the Caesareum, towards cross-street R3, remains of mosaics, housing and workshops of the first and second centuries AD were found.[39] In the eastern part of the city, remains of expensive houses, and mosaics dated to the second and third centuries AD, were found to the west of cross-street R4bis. One mosaic had a central medallion depicting sea fish, and other houses had mosaic floors with geometric patterns (locations marked on [299]).[40] Roman mosaics were also found further east outside the city walls, near the coast.[41]

Roman baths structures can also be reliably identified as being *in situ*. In the south-west corner of the city, to the south of the racecourse, the Lageion, Roman baths-buildings were uncovered, with one for men and one for women, dated possibly to the second century AD [299].[42]

Thus, the *in situ* remains of Roman occupation during the first and second centuries AD suggest that the Roman city could have extended the full length of the ancient plan indicated by the written sources.

PUBLIC BUILDINGS AND MONUMENTAL ARCHITECTURE IN THE FIRST AND SECOND CENTURIES AD

For public buildings in the city (besides the Caesareum and Forum discussed above) in the first and second centuries AD, it is necessary to return to the written sources. Some buildings are mentioned because of the conflicts with the Jews, and others when the Roman emperors visited the city's most famous monuments. The written sources also give further details about the harbour and the Lighthouse. Information about the architectural style of the city's sanctuaries is provided by the depictions of them on coins and some archaeological evidence. The buildings adorning the streetscape are indicated by a variety of types of evidence.

Philo gives some indication of the purposes for which various buildings were used by the populace. He mentions that the many meeting-houses of the Jews (*proseuchai*) used for prayer and teaching were in each part of the city, and there was also a main synagogue. Some of these meeting-houses were destroyed in AD 38, but those in the areas with a higher Jewish population to protect them were desecrated instead by

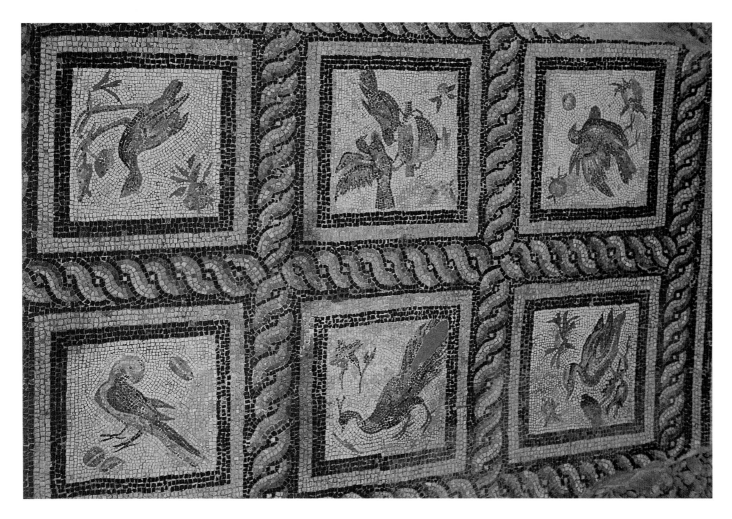

307. Alexandria, Kom el-Dikka, bird mosaic in house *alpha*, with birds facing different directions

308. Alexandria, Kom el-Dikka, mosaic in house *alpha*

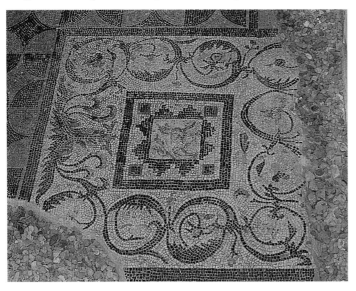

the erection of statues of the emperor Caligula (Gaius).[43] Philo mentions that the agora was a place of commerce which was also frequented by philosophers,[44] while both physical and intellectual education were gained in the gymnasium.[45]

A variety of performances were held in the theatre, including the plays of Euripides and concerts, and it was also used as a place for torturing the Jews.[46] The gymnasium and the theatre were also used for public meetings.[47]

In AD 63 the Great Atrium, which had a tribunal (*bema*), was used for court cases. This major building, which has not been otherwise identified, is also repeatedly mentioned in papyri as a place for displaying public notices, especially Alexandrian birth certificates.[48] It is not known if it was in the former palace complex.

In the next period of conflict with the Jews, in AD 66, Josephus describes the Alexandrians assembling for a public meeting in a building he calls an amphitheatre. This is a Roman building type, not a Greek one, which was a large public arena of elliptical plan used for gladiatorial and other contests. They were built in the Roman East in Syro-Palestine, as well as the western empire.[49] Another Roman building type which is also introduced to Alexandria at the same time as elsewhere are imperial baths, with one erected for the proposed visit of the emperor Nero.[50]

The main place of public assembly for entertainment continued to be the racecourse. Having attacked the Alexandrians' passion for the enjoyment of music, especially in the theatre, Dio Chrysostom criticizes their behaviour at the horse races. He calls the structure in which these occurred the stadium.[51] This suggests that the Lageion, near the

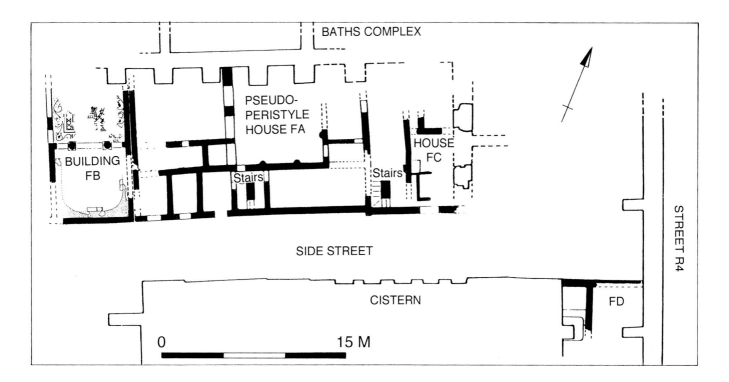

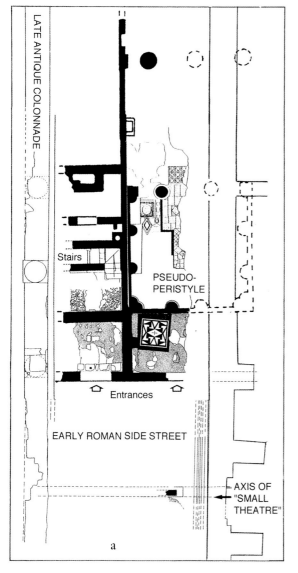

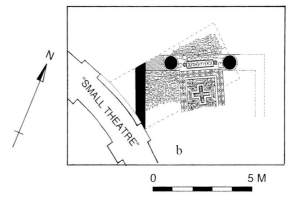

309. Alexandria, Kom el-Dikka, Roman houses north of cistern and partially under later baths complex

310a–b. Alexandria, Kom el-Dikka, Roman houses with mosaics partially under 'small theatre': (a) Under later portico in Sector MX; (b) Beside cavea in Sector MXV

temple of Serapis, continued its dual usage as the hippodrome (*circus* in Latin) for horse-racing while also being used for athletic games,[52] as also occurred at Antinoopolis and Oxyrhynchus.

The 'hippodrome' is mentioned when the emperor Vespasian visited it,[53] and consulted the oracle in the temple of Serapis in AD 69/70.[54] His son, the future emperor Titus, also visited the Serapeum and the hippodrome in AD 71.[55] The proximity of the Serapeum to the Lageion [56] suggests that on both occasions the hippodrome visited was the Lageion.

Monuments in the palace area were also subject to imperial visits and attention. Caligula (AD 37–41) removed the

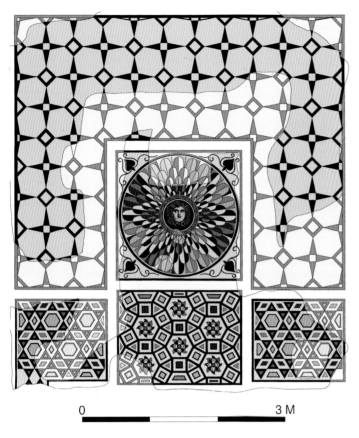

311. Alexandria, palace area (east of Caesareum), reconstruction of mosaic floor of a banqueting room (triclinium)

breast plate of Alexander from his tomb (*conditorium*).[56] A new museum was added to the 'old' one so that the historical works of the emperor Claudius (AD 41–54) could be read in it. It was named the Claudieum, after him.[57] Vespasian was very unpopular with the Alexandrians for selling 'the greater part of the palaces (*basileia*)'.[58] However, some major monuments in the palace area continued to be used for their previous purposes. These included the Museum.[59] The continued importance of the city as a centre of learning is also indicated by the decision of the emperor Domitian (AD 81–96) to have the texts in Alexandria copied for the libraries in Rome.[60] The tomb of Alexander remained one of the major attractions for visitors to the city in AD 90/91.[61]

Further information about the city's other famous landmark, the lighthouse Pharos, is provided by Josephus and Pliny. Josephus, *c.* AD 75–9, mentions that the island of Pharos had immense walls around it. He comments that the light from Pharos was visible from 300 stadia (*c.* 54 km) away to warn mariners at night to anchor some distance off.[62] That it could have been visible from this distance (allowing for the curvature of the earth) is possible as a height of *c.* 110 m is indicated by the Arab descriptions. Pliny the Elder (AD 23/24–79) explains: 'for owing to the treacherous shoals Alexandria can be reached only by three channels of the sea, those of Steganus, Posideum and Taurus'.[63] It is not clear whether these are the three passages marked on [37] (two for the western harbour and one for the eastern harbour) or if he

is only referring to access to the eastern harbour, for which Strabo gives the impression there was a single main passage. Pliny observes that the continuous burning of the beacon at night could be dangerous because it could be confused with a star. As today, a flashing beacon would have been safer. He comments 'similar beacons now burn brightly in several places, for instance at Ostia and Ravenna'.[64] The depictions of the lighthouse at Ostia, which was built by the emperor Claudius in *c.* AD 50, indicate a copy of the Alexandrian one which is depicted with a number of tiers on Roman coins and gems [43–44].[65]

There was a hauling-way for ships (*diolkos*) apparently near the Pharos, possibly across the northern end of the Heptastadium, enabling transfer of ships between the two harbours if the second bridge had silted up by then.[66] In the mid-second century AD, very large ships could still be docked in the harbour of Alexandria, as indicated by the description of the grain carrier, the Isis, which was 120 cubits (*c.* 63 m) long, over 30 cubits (*c.* 15.75 m) wide and 29 cubits (*c.* 15.23 m) from the deck to the bottom. The wooden hull of a smaller ship (over *c.* 30 m long) has been found on the sea bed in the harbour off Antirrhodos island, and dated by Carbon 14 to between 90 BC and AD 130.[67]

Dio Chrysostom explains how the city's beautiful harbours and its location give it a monopoly on trade, which makes it the market of the whole world. It surpasses all others in the abundance of all that man requires and the number of its inhabitants. He describes it as 'practically the centre of the civilized world'.[68] He mentions its beautiful buildings, noting it was adorned with monuments given by the emperor such as fountains (*krenai*) and monumental gates (*propyla*), despite the antipathy of the population to him and their restlessness.[69] These comments occur in a discourse which he delivered to the Alexandrians when he was in the city, under Vespasian (AD 69–79) or Trajan (AD 98–117).[70]

The unrest in AD 115–16 under the emperor Trajan resulted in the worst attacks on the Jews, during which the Great Synagogue, mentioned in the Talmud, was destroyed. It was a very large and impressive building which had a double colonnade (*diplostoon*). It 'was made like a great basilica, one colonnade within another'. It is not completely clear whether these colonnades were above or beside each other, i.e. whether there were two storeys or two rows of them on each side. It had expensive chairs for the elders, and there was a wooden platform (*bema*) in the middle for the cantor.[71] The temple of Nemesis is recorded as destroyed by the Jews in the same unrest.[72]

When the emperor Hadrian was in the city in AD 130 he visited the tomb of Pompey, whose monument he restored.[73] He debated in the Museum.[74] In the enclosure of the temple of Serapis a statue was found of a black Apis bull which Hadrian dedicated 'to Serapis and the other gods worshipped together in the same temple' [312].[75] A Hadrianeion, a temple in Hadrian's honour, was built in Alexandria, as in other cities of Egypt and the Roman East.[76] From AD 127 onwards, copies of legal documents, which had previously been placed in the Nanaeum, were to be deposited in the 'library of Hadrian' which had been built specifically for this purpose. The

'Hadrianon' is depicted and labelled on coins minted in Alexandria [313]. The city also had other libraries, such as the one in the Mercurium mentioned in a second-century AD papyrus.[77]

The tomb of Alexander, called the Sema, was described as being in the centre of the city by the sophist Zenobius, during the reign of Hadrian (AD 117–38).[78] Another public building mentioned at about this time is the main exercise court (*palaestra*), in which the geographer Ptolemy made astronomical observations using its two bronze rings.[79]

From the period of Augustus onwards, the visits of the Roman emperors to Alexandria resulted in an interest in Egyptian architecture in Rome. This was reflected in structures in that city with distinctively Egyptian characteristics, such as the pyramid of Cestius, obelisks and temples of Isis and Serapis, as well as in decorative arts such as wall-paintings.[80] The 'Egyptian *oecus*' is described by the Augustan architect Vitruvius as like a basilica with a clerestory,[81] which is a feature used earlier on Egyptian temples [86]. The obelisks taken to Rome from Egypt, include the two which Augustus took in 10 BC, one which he erected as a gnomon for the sundial near the Ara Pacis, and the other in the Circus Maximus. Caligula removed the one from the Forum Julium in Egypt to the Vatican Circus in AD 37 [110–111].[82] Segmental pediments were used on the Iseum Campense in Rome, which also had other architectural features and sculptures with deliberate allusion to Egypt.[83] Hadrian's interest in Egypt was reflected in the construction of the 'Canopus' of his villa at Tivoli [190], alluding to the sanctuary of Osiris at Canopus east of Alexandria.[84]

Sanctuaries Depicted on Coins and Tokens in Three Styles: Egyptian, Greco-Egyptian and Classical

Dio Chrysostom observed that Alexandria surpassed all other cities in the beauty of its sanctuaries.[85] The extent and number of these is reflected in the temples depicted on tokens and Roman coins. These coins minted in Alexandria from the reigns of Galba to Marcus Aurelius (AD 68–180) depict a greater variety of building types than the coins of any other provincial mint.[86] Some of these buildings, as well as others, are depicted and labelled on bone tokens, which are also called 'game counters' or tesserae. The temples depicted were built in three styles: Egyptian, Greco-Egyptian and classical.

The temple of Isis is depicted with a traditional Egyptian pylon on the coins [39]. This seems to suggest that the sanctuary of Isis was built in the Egyptian style, and was still standing in the Roman city in the early second century AD. As the written sources indicate the temple of Isis was one of the earliest in the city,[87] and as it was built for a local goddess, the use of the Egyptian style would not be surprising. The temple of Osiris at Canopus (Abuqir), is also depicted with a traditional Egyptian pylon on coins [83] as late as the mid-second century AD. Its identification on them is confirmed by the inscription on the back of bone tokens which, like the examples on the coins, have Osiris of Canopus in the doorway and an eagle framed by the top of the pylon [314].[88] There could have been other Egyptian temples built in the city in both the Ptolemaic and Roman periods.

Some Egyptian architecture in the city was created by the reuse of Egyptian elements from the Dynastic period. This

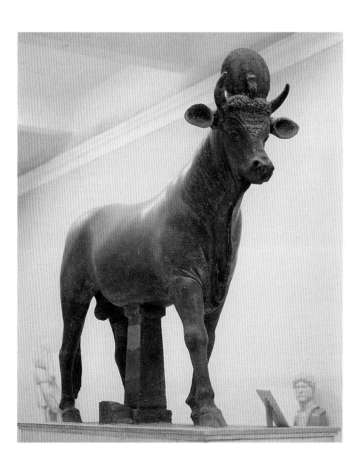

312. Alexandria, temple of Serapis complex, statue of the black Apis bull erected by the emperor Hadrian. Greco-Roman Museum

313. 'Hadrianon' on Alexandrian coin of emperor Hadrian, Year 17. Oxford, Ashmolean Museum no. 1378

314. Bone token depicting temple of Osiris at Canopus, identified by the inscription on the back. Milan, Scala

is indicated by some architectural fragments which were apparently reused for Egyptian style architecture.[89] These are amongst about four hundred architectural and sculptural blocks found in Alexandria but which came from Egyptian temples of the Dynastic period which had originally been built at other sites, especially Heliopolis. Some of these blocks show signs of reuse not in their original structural role and consequently not necessarily keeping their Egyptian appearance. Thus, those which were used for Egyptian style architecture are notable. These include three monolithic papyriform columns of red granite with cartouches of Thutmose IV (c. 1400–1390 BC), Merneptah (1213–1204 BC) and Sety II (1204–1198 BC) [315], which originally came from a building in Memphis. They were found in Alexandria and were sent to Vienna in 1869. As they show no sign of later recutting, when they were reused in Alexandria they must have been reused as columns and thus kept their original Egyptian appearance. A column was more recently found from the same colonnade but recut into a rectangular beam. It has cartouches of the Roman emperor Trajan added to those of Thutmose IV and Sety II.

Seven distinctive blocks of screenwalls of greywacke were also found in Alexandria, having originally come from a kiosk or similar building in Sais or Heliopolis (near modern Cairo), as indicated by their hieroglyphic inscriptions of the twenty-sixth and thirtieth dynasties [316]. They appear to have been reused on a structure (possibly a fountain) of Egyptian appearance. The Greek inscription on one of them has been dated to the Roman period. Both these screenwalls and the papyriform columns mentioned were clearly in use in the Roman period. It is also possible they were first reused in the Ptolemaic period, when Egyptian obelisks were erected as were sculptures of the Ptolemaic kings dressed as Egyptian pharaohs.

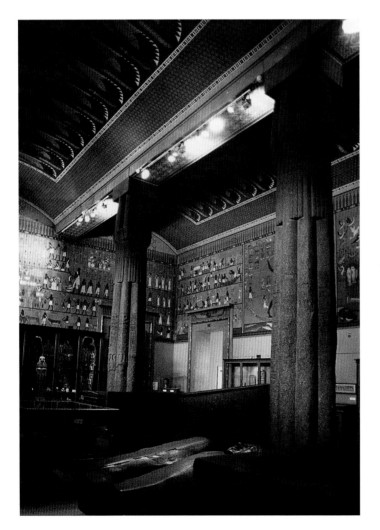

315. Papyriform columns of the Dynastic period from Memphis, re-used in Alexandria. Vienna, Kunsthistorisches Museum

316. Screen wall fragment from a building in Sais or Heliopolis, re-used in Alexandria. Vienna, Kunsthistoriches Museum

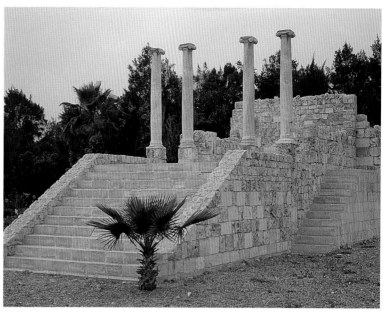

317. Canopi in Greco-Egyptian temple on Alexandrian coin of emperor Hadrian, Year 18. Oxford, Ashmolean Museum no. 1430

318. Alexandria, Ras el-Soda, small temple with marble Ionic capitals (re-erected near Bab el-Sharqi)

Temple buildings are depicted on coins for local gods in the Greco-Egyptian style [317]. These have bulbous Egyptian style columns and segmental pediments, like those in the Praeneste Nile mosaic [89]. The deities with temples in this style on coins include Isis Lactans (suckling Harpokrates), Harpokrates, the Canopi, and Hermanubis [87]. This style is also used for the temple of Nemesis on coins of Hadrian (AD 117–38).[90] As the temple of Nemesis outside the city was destroyed immediately before Hadrian's reign, in the Jewish uprising of AD 115–16, the date of these coins could suggest that this temple was rebuilt.

Classical architecture was also used on temples for local gods, such as the small temple with marble Ionic columns and capitals which survived at Ras el-Soda east of Alexandria [318]. It contained statues of the gods including Osiris-Canopus, Isis, Harpokrates and Hermanubis which are dated after *c*. AD 150 [319].[91] On coins classical architecture with a triangular pediment is also depicted for some local gods, as well as for Greek and Roman ones. These include Athena,[92] Fortune (Tyche),[93] the Nile River god,[94] Elpis[95] and Hermanubis[96] [320–321]. The Tycheion, the temple of Fortune (Tyche), is described in the fourth century AD as circular. Thus, it is possible that the pediment depicted the coins [322] was one on its vestibule, like that on the Pantheon in Rome.

The temple of the god Serapis [323] on coins has a triangular pediment, a Doric frieze, Corinthian capitals and up to four columns across its front [70–71].[97] This was the Ptolemaic temple building which was still standing [324], although part of the complex was redecorated in the first century AD.[98] There is no evidence that it was destroyed in the Jewish uprising of AD 115–16, as sometimes suggested.[99]

The images on bone tokens from Alexandria are identified by the inscriptions on their backs,[100] such as Nikopolis [325]. They depict a reed hut labelled 'Eurylochou' [326][101] which

is similar to one in the Praeneste mosaic [149]. They also include the sanctuary at Eleusis, which has a classical pediment and appears to have a colonnaded court [327],[102] and the Caesareum.[103] A building labelled 'hemicycle' appears to be a theatre.[104]

A distinctive, but unidentified, structure is also depicted on the coins. It has a Corinthian colonnade of at least six columns across the front, but lacks a pediment or pitched roof [328]. It has sphinxes on its corners, garlands on the entablature and screens between the columns. On some copies the goddess Eusebia is depicted inside the building. It is depicted in a number of versions, suggesting it was a well-known structure in the city, although it has not been identified. It appears to be a flat-roofed temple with a fire altar on top. None of the suggestions which have been made for its iden-

319. Ras el-Soda, statues of Canopi, Hermanubis, and Harpokrates, when excavated in the temple in fig. 318

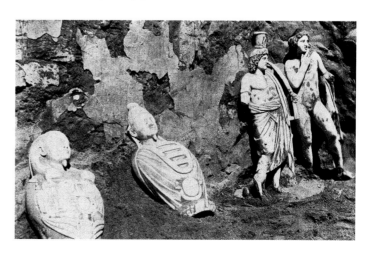

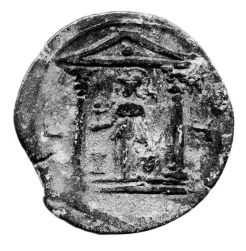
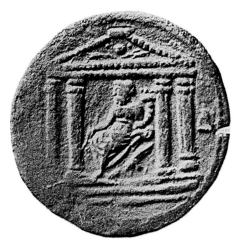
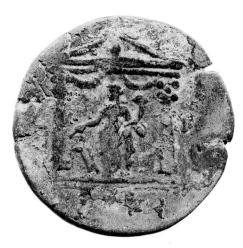

320. Temple of Athena on Alexandrian coin of Antoninus Pius, Year 8. Oxford, Ashmolean Museum no. 1840a

321. Temple of Nilus on Alexandrian coin of emperor Antoninus Pius

322. Temple of Tyche on Alexandrian coin of emperor Antoninus Pius, Year 8. Oxford, Ashmolean Museum no. 1836

323. Alexandria, bust of Serapis. Greco-Roman Museum

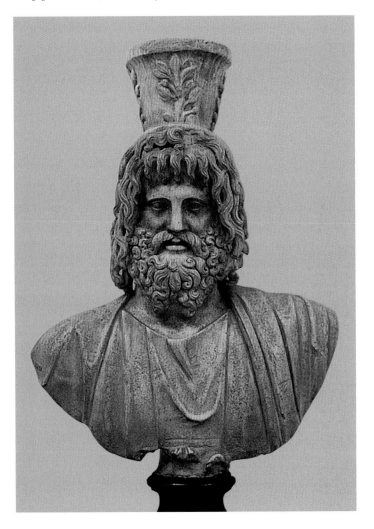

tification are satisfactory. They are mostly monumental altars, such as the one in the Caesareum, the altar of Agathos daimon, or the altar of Alexander.[105]

Although the buildings on the tokens and coins are represented in iconographic shorthand, they do convey a sense of the number and diversity of some of the city's lost major monuments, especially temples and sanctuaries. Further glimpses, especially of the streetscape, are provided by archaeological evidence.

Monumental Adornment of the Streetscape

Achilles Tatius, who was a native of Alexandria,[106] gives a vivid impression of the city in the second half of the second century AD in the romantic novel *Leucippe and Clitophon*. Further details of the splendid cityscape to which he alludes are provided by other evidence for the buildings decorating its streets. Tatius' character Clitophon describes his arrival in the city:[107] 'I entered it by the Sun Gate, as it is called, and was instantly struck by the splendid beauty of the city, which filled my eyes with delight. From the Sun Gate to the Moon Gate[108] . . . the street has a straight line of columns on either side. In the middle of the columns is the *pedion* of the city[109] with many streets leading into and out of it . . . Going a few stadia further into the city, I came to the place (*topos*) named after Alexander, from where I saw the rest of the city.' From here, he observed the cross-street which is colonnaded like the main one. 'I tried to cast my eyes down every street, but my gaze was still unsatisfied, and I could not grasp all the beauty of the spot at once . . . Two things struck me as especially strange and extraordinary – it was impossible to decide which was the greatest, the size of the place or its beauty, the city itself or its inhabitants.'

He also went to marvel at Serapis and his temple. He informs us that Serapis is the Egyptian equivalent to Zeus, for whom there was an impressive torch-bearing proces-

324. Alexandria, Ptolemaic temple of Serapis complex which stood until AD 181, axonometric reconstruction of northern part. (Sheila Gibson)

20M 20M 20M

0

N

S.G.

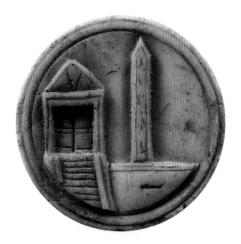

325. Bone token depicting a single obelisk, labelled 'Nikopolis' on the back. Vienna, Kunsthistorisches Museum, inv. AS 1033

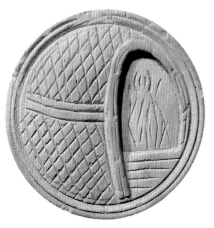

326. Bone token from Alexandria depicting reed hut, labelled 'Eurylochou' on the back. Paris, Bibliothèque Nationale, Froehner 309

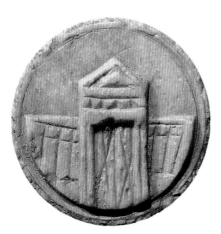

327. Bone token, labelled 'Eleusis' on the back. Paris, Bibliothèque Nationale, Froehner 308

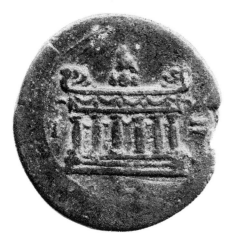

328. Unidentified structure on Alexandrian coin of emperor Antoninus Pius, Year 17. Oxford, Ashmolean Museum no. 2252

sion.[110] Before visiting a house on the island of Pharos, he went to see the Lighthouse (*pyrgos*) and 'showed us the arrangement from below something marvellous and beyond description. It was a hill lying in the middle of the sea touching the clouds, and the water was flowing below this structure; it stood hanging above the sea. The guide for the ships appeared above the horizon towards the top of the hill as another [sun].'[111]

The general impression Tatius gives of the Roman city accords with the archaeological evidence, although some of this could be from later versions of structures he mentions. Some of the red granite columns of the main east-west street colonnades survived *in situ* until the nineteenth century [13–14], as did columns on some cross-streets [21].

After quelling a rebellion by the Egyptians, while in Alexandria Antoninus Pius (AD 138–61) is credited by the chronicler John Malalas (*c.* AD 575) with building the Gates of the Sun and the Moon, and the *dromos*.[112] These gates were those at the east and west ends, respectively, of the main east-west street. It is possible that Antoninus Pius' work on the *dromos* relates to a rebuilding of the circus, but *dromos* in Egypt usually refers to an avenue leading to a temple, like the one (cross-street R8) to the Serapeum. In later sources *dromos* is used to refer to the main east-west street. Perhaps Malalas is referring to work on it, such as new paving or colonnades, because he does not distinguish between repairs and the erection of new buildings.[113]

As in other towns and cities of Egypt and the Roman East, in addition to colonnades, the streetscape of Alexandria was embellished with tetrastyla, triumphal arches, monumental gates, and fountain houses. Tetrastyla, consisting of a set of four columns, are more common in Egypt than elsewhere, and remains of one survived inside the Rosetta Gate, apparently at the intersection of the main east-west street with a cross-street [329].[114] It was decorated with acanthus column bases like all other tetrastyla surviving in Egypt. It had red granite columns with capitals of white stone, possibly marble. This combination of coloured stone is also used on the colonnades of the passages beside the baths-building at Kom el-Dikka, and survived on the Rosetta Gate [330–331]. It is very likely that white stone capitals were also used on the red granite shafts of the main east-west street.

One or more triumphal arches, whose locations are not known, are depicted on Roman coins from Alexandria. The main example, which first appears under Domitian, AD 81–96, is a triple arch with a single pediment above a Doric frieze, with 'windows' or panels above the archways [332].[115] These features later occurred on the arch at Antinoopolis [263]. The arch on the coins has a statue on top of it of an emperor in a horse-drawn chariot, and columns in front with statues on them.

A fountain house depicted on Alexandrian coins of Trajan has three bays, on a high podium, with statues in them [333].[116] The earliest known example of an apse-shaped fountain house decorated with colonnaded facade and statues was built in Alexandria in the third century BC [84], and they became common elsewhere in Roman architecture in the second century AD.

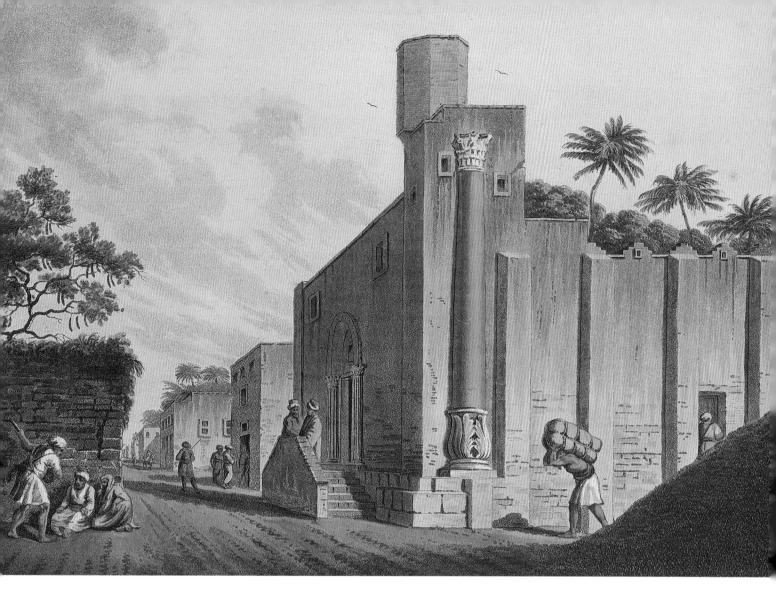

Many Corinthian capitals survive in Alexandria from the second and third centuries AD from classical buildings, like those depicted on the coins.[117] The fragment of an architrave and a frieze found near the Serapeum [335] would have been supported by capitals like some in the Greco-Roman Museum [334].[118] The capitals are generally loose finds with no related foundations, and also could have been reused in later buildings. Thus, while the buildings for which they were originally carved have not generally survived nor their locations, these fragments do provide an indication of their style.

329. Alexandria, column apparently from a tetrastylon near the Rosetta Gate in late eighteenth century

330. Alexandria, Kom el-Dikka, columns erected on north side of baths-building

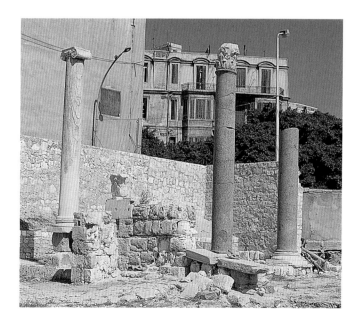

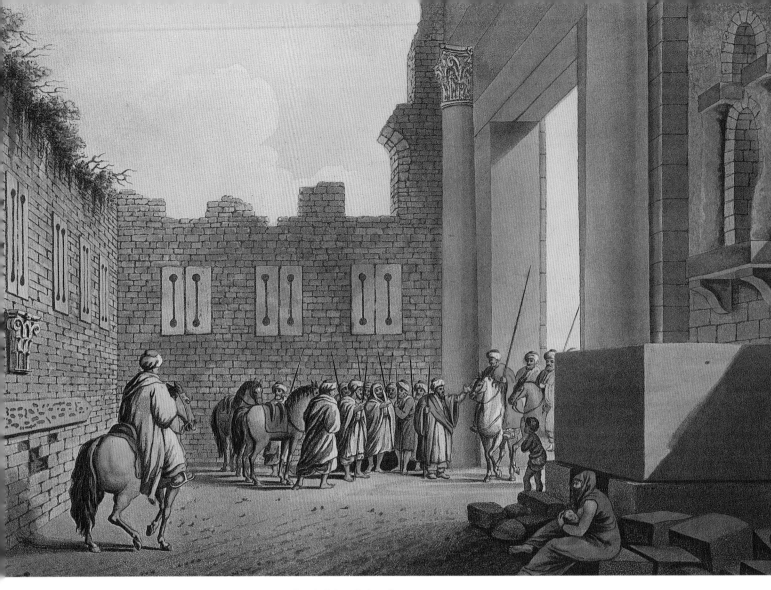

331. Alexandria, late eighteenth century view of Rosetta Gate built into Arab walls

ARCHAEOLOGICAL EVIDENCE FOR CEMETERIES AND TOMBS, FROM THE LATE FIRST CENTURY BC TO THE SECOND CENTURY AD

There were many tomb complexes for the city's inhabitants, of which only a few examples will be mentioned here.[119] The city had expanded over some of the former Ptolemaic cemeteries in the eastern part of the city so that the main Roman cemeteries were in the very large area to the west of the city, which is the Nekropolis mentioned by Strabo, in the areas known today as Minet el-Bassal, Gabbari, Mafrousa and Wardian [29]. There were also some to the east of the city in the area known today as Cleopatra and to the south-east of the city in Antoniadis Garden, as well as on the island of Pharos (at Anfoushy and Ras el-Tin).

332. Triumphal arch on Alexandrian coin of emperor Trajan, year 20. Oxford, Ashmolean Museum no. 816

333. Fountain house with statues between columns on Alexandrian coin of emperor Trajan

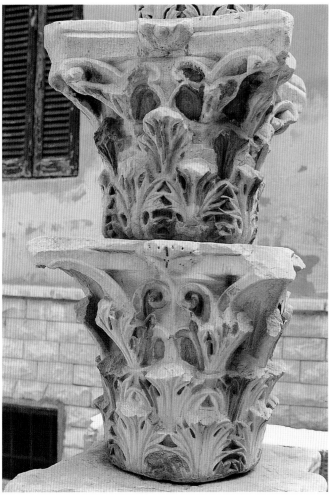

334. Alexandria, marble 'Normal' Corinthian capitals from monumental buildings, second and third centuries AD. Greco-Roman Museum

335. Alexandria, fragment of marble entablature found east of temple of Serapis complex. Greco-Roman Museum

336. Wardian, Hypogeum in late eighteenth century

The cemeteries include many large multi-occupancy tombs which continued to be used and expanded in the Roman period. Some complexes at Gabbari consisted of chambers with rows of loculi, one above the other, which were sold individually.[120] In 1997 more of these tomb complexes were rediscovered in this area, at Fort Saleh, showing an extremely densely developed cemetery.[121] Further west the Great Hypogeum (Grand Catacomb) at Wardian, which was used from the second half of the first century BC onwards, was less utilitarian in design with a more complex plan consisting of large chambers with carved classical architectural decoration [336].[122] The tomb in Antoniadis Garden, to the south-east of the city, has classical decoration and is dated to the end of the Ptolemaic or early Roman period.[123]

When figured and decorative schemes survive on tombs in Alexandria from the Roman period, they usually consist of a combination of classical and Egyptian features. The tombs to the west of the city at Gabbari and Mafrousa, and the cemeteries of Anfoushy and Ras el-Tin on the island of Pharos, have both Egyptian and Greek features.[124] These include an example at Fort Saleh in Gabbari (Room 3 of Tomb 1) with columns with Egyptian composite capitals supporting a

cavetto cornice and a broken lintel, in front of a classical couch. Egyptian gods were depicted on the walls and the ceiling was decorated to imitate rich textiles. To the south-east of this tomb another example (Habachi Tomb A) has scenes in the sarcophagus burial room depicting the mummy laid out on a lion bed and flanked by Egyptian deities. Mummified bodies have found in both the eastern cemeteries (at Hadra) and western cemeteries (at Gabbari), and at Kom el-Shuqafa.

A more recently discovered example of a tomb with classical and Egyptian decoration was excavated in Tigrane Pasha Street in Cleopatra in part of the area of the former eastern cemeteries (location marked on [29]).[125] Part of it may be seen today reconstructed in the grounds of Kom el-Shuqafa [337]. The domed ceiling of the burial chamber is decorated with classical decoration, including a Medusa head surrounded by garlands, florals and animals. By contrast, the walls of the burial alcoves are decorated with largely Egyptian content with the mummy attended by Isis and Nephthys.

The tombs at Kom el-Shuqafa are located south-west of Diocletian's Column and the Lageion [338]. They are notable for their Egyptian decoration, iconography and decorative motifs.

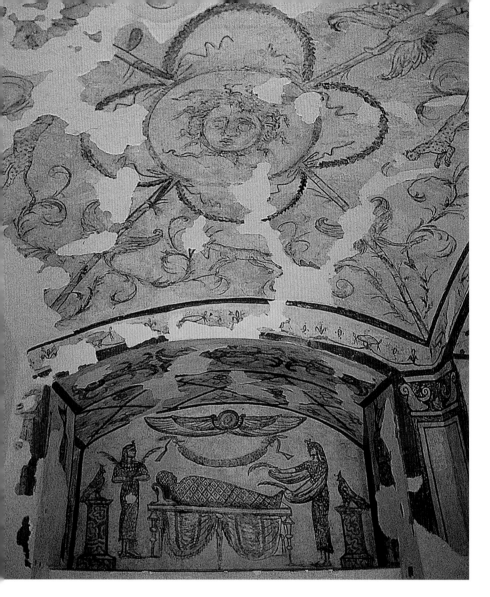

337. Alexandria, tomb from Tigrane Pasha Street (re-erected at Kom el-Shuqafa), with classical and Egyptian decoration

In the Large Hypogeum at Kom el-Shuqafa[126] the niches in the main burial chamber have Egyptian religious scenes carved in relief on their walls, while the rock-cut sarcophagi in these niches are decorated with conventional classical decoration of Medusa heads and garlands [339–340]. The central scene depicts a mummy attended by Anubis, flanked by Horus and Thoth. Hybridized architectural decoration is also used. The burial alcoves in the central chamber are framed by pillars, but they have Egyptian capitals and bases. The vestibule to this chamber has Type III Alexandrian capitals with papyrus in place of acanthus leaves [194], but classical octagonal column bases. This hypogeum is a large complex carved on three levels reached by a gradually spiralling staircase, perhaps reflecting the one in the Lighthouse. It has a large triclinium for funerary banquets, and burial chambers with rows of loculi [339, 341]. It was begun in the first century AD and continued to be enlarged through the third century. It was still in use at the beginning of the fourth century. It may be visited today, south-west of the Serapeum site.

In the next tomb complex to the east, the so-called Hall of Caracalla [342], there are tomb paintings with Egyptian scenes, probably from the late first century AD, in some burial alcoves. One alcove has a classical architectural form with a triangular pediment, but the painted decoration consists of figures of Egyptian deities appropriate to a funerary context, such as Isis and Nephthys, but it lacks the depiction of the mummy on a bier [343].[127] The paintings in two other alcoves (Tombs 1 and 2) have recently been revealed using ultraviolet light. They are particularly important because they consist of Egyptian and classical scenes used together, like parallel texts in two languages, with the equivalent scenes from both cultures, one above the other [344].[128] They depict life, death, and the return to life, with an Egyptian panel depicting the scene of mummification, the embalming of Osiris, placed above the Greek scene in which Persephone is abducted by Hades in his chariot. Classical birds, garlands and flowers are painted on the vaulted ceilings of both alcoves. These paintings are dated to the late first or early second century AD. In the other examples which have survived classical and Egyptian features are used together, but not duplicated to create a bilingual iconography.

Thus, as there are examples of classical and Egyptian decoration used together in each area of the city's cemeteries (to the east and west of the city, and on the island of Pharos), there is insufficient evidence to indicate a strong association of one cemetery in preference to another with the Egyptian population. Rather, by the Roman period, the use of mixed elements may have become the norm for burials of Egyptians, Greeks, and Romans.

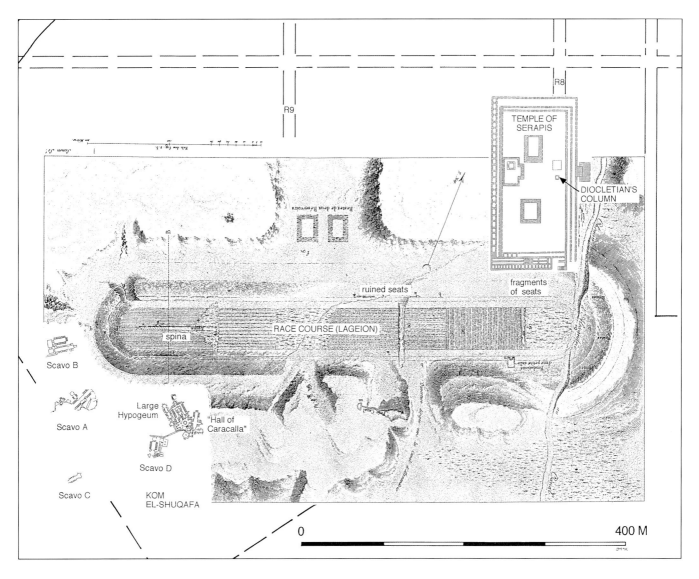

338. Alexandria, plan of Roman temple of Serapis, racecourse (Lageion), and tombs of Kom el-Shuqafa

ROMAN TEMPLE OF SERAPIS

North-east of the tombs of Kom el-Shuqafa is the hill on which the city's most important sanctuary, the Serapeum, stood with traces of it remaining near Diocletian's Column (location marked on [299] and [338]). The temple of Serapis is depicted on Roman coins [70–71] and there is no reason to believe that this was not still largely the Ptolemaic structure [324]. This is because the archaeological evidence indicates only two main building phases for the temple and its colonnaded court [66].[129] The Ptolemaic one of ashlar masonry, with foundation trenches cut into the bedrock [64–65], is clearly distinct from the Roman one with concrete foundations [345–346]. The Ptolemaic phase is dated by the foundation plaques of Ptolemy III Euergetes I (246–21 BC) found at the corners of the temple and enclosure [62–63]. This Ptolemaic version survived the first two centuries of Roman rule before burning down. The Christian philosopher Clement of Alexandria mentions in c. AD 190 that close to the

burial places is 'the *akra* which they now call Rhakotis, where stands the honoured sanctuary (*hieron*) of Serapis' which was burnt. The Christian scholar Jerome gives the date it was burnt as AD 181.[130]

It was replaced with the second main (or Roman) phase of the temple of Serapis [349–350], which was larger, and the colonnaded court was extended to the east and north [351]. In addition to concrete foundations, some granite fragments of columns and cornices survive [347–348].[131] The concrete is identical to that used for the floor of the pool,[132] in which foundation deposits of coins were found embedded in the corners, the latest of which are dated to AD 211.[133] This provides a date after which the pool was finished and an indication of the date of the temple and its enclosure. Before Caracalla's death in AD 217, the temple (*naos*) of Serapis is reported to have been filled with a great fire which did not damage it.[134] Even though this event was miraculous, it suggests that the temple had been rebuilt by then, if not by the time he made sacrifices there, in AD 215/16.

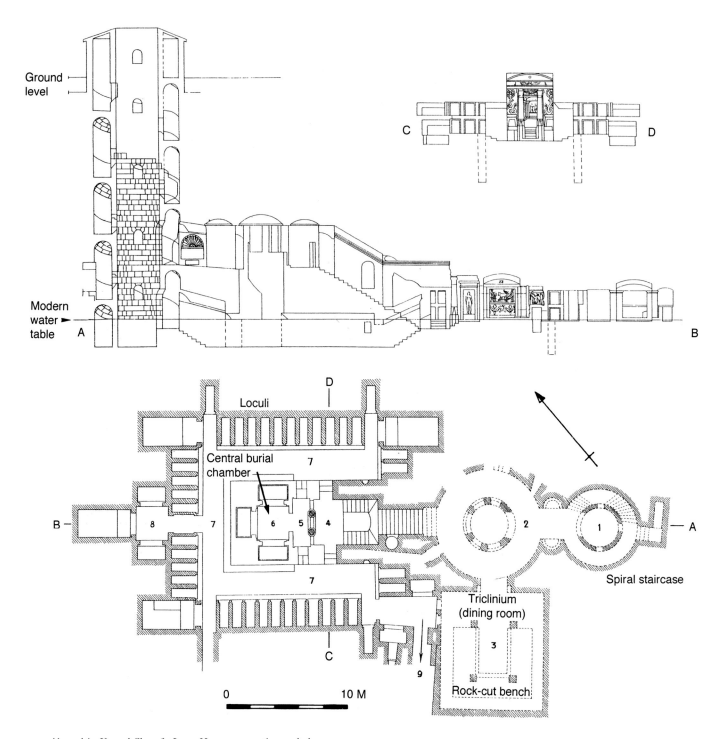

339. Alexandria, Kom el-Shuqafa, Large Hypogeum, sections and plan

Thus, the written and archaeological evidence indicate that the Serapeum was rebuilt between AD 181 and 215/16. The numismatic evidence from the pool suggests it was probably finished under Caracalla (AD 211–17), who is described as Philosarapis on some columns found in the harbour in 1997. It is not known if this phase was begun under Commodus (AD 180–92), rather than Septimius Severus (AD 193–211) during whose reign most of the work apparently would have been done. It is possible that it was the 'Pantheon' which was built by Septimius Severus in *c*. AD 205. This name could have been

an appropriate term for the Serapeum as other gods were worshipped there together with Serapis, although this could have referred to the Tychaion. The rebuilding also could have coincided with the identification of the dynasty with the Egyptian gods in AD 202.[135]

The foundations surviving from the Roman phase indicate that the colonnaded court was widened on its east side, being extended across street R8, so that the temple of Serapis was on the lengthwise axis of the court [349, 351]. The court was also apparently extended to the north. The concrete founda-

Placing content:

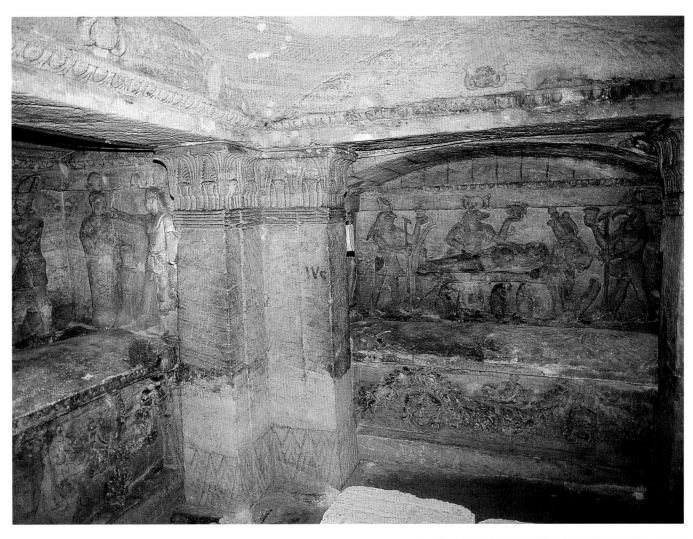

340. Alexandria, Kom el-Shuqafa, Large Hypogeum, niches in central burial chamber with Egyptian scenes above classical sarcophagi

341. Alexandria, Kom el-Shuqafa, Large Hypogeum, detail of rows of burial loculi, some with the slabs which would have closed them

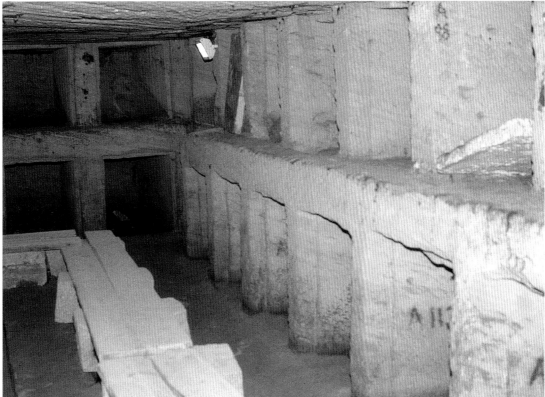

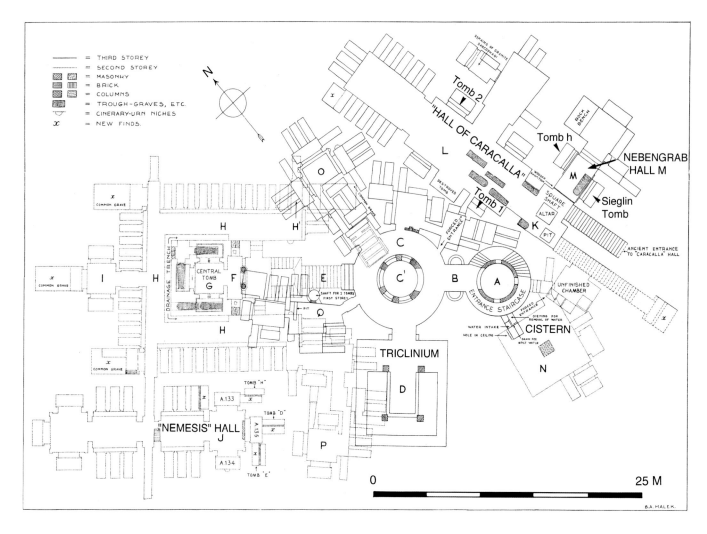

342. Alexandria, Kom el-Shuqafa, 'Hall of Caracalla' beside Large Hypogeum, plan

tions of the temple enclose the foundations cut for the ashlar walls of the earlier Ptolemaic one [66]. The sizes of the columns of both the temple and the colonnaded court are indicated by the granite column shafts and bases at the site.[136]

There was a staircase up to the temenos entrance on the east side, traces of which survive, along with fragments of the entrance portal [348].[137] The pool mentioned is to the right (north) of this entrance [349–350]. The staircase covered over the Ptolemaic Nilometer,[138] but the location of the Roman Nilometer has not been found. There were rooms along the west and south sides of the Roman enclosure, as in the Ptolemaic phase. The underground passages also continued to be used [352–353].[139] The continued importance of the T-shaped building above them is indicated by the positioning of the east entrance to the court on the axis of this building. There would have been a second entrance to the colonnaded court where street R8 met it on the north side [349–350].

Many Egyptian statues were found at the site [72–73], as well as fragments of two obelisks. Regardless of whether or not they were in the sanctuary since the Ptolemaic period, the Roman sanctuary should be visualized with Egyptian sculptures in a classical setting.[140] Diocletian's Column was not erected until AD 298 [345, 354].

Writing in c. AD 197 the Christian apologist Tertullian, who came from Carthage in North Africa, apparently referring to the Septuagint mentions that 'the libraries of Ptolemy are exhibited today in the Serapeum along with the Hebrew writings'.[141] They could have been housed in the rooms along the west side of the temenos which were retained in the rebuilt version [349–350]. In the southern rooms at the lower level the remains of two fireplaces dating to the Roman period were found with channels for conducting heated air. This suggests that these southern rooms were not used as a library because of the risk of fire.[142]

Two detailed written descriptions of the Serapeum survive. They were made in the late fourth century by the rhetorician Aphthonius and by Rufinus of Aquileia who describe its appearance before it was attacked by the Christians. Whilst the Roman complex probably continued to be embellished during the third and fourth centuries, the basic complex they describe is the Roman one built in the late second or early third century AD. Consequently, these descriptions will be included at this point. Now that the

archaeological evidence has been re-examined and recon-structions prepared it becomes apparent that these descrip-tions accord more closely with the archaeological evidence than had previously been appreciated. In view of this and the fact that it was the city's most famous sanctuary, it is worth giving new translations of these passages in full.

Aphthonius, a student of Libanius, describes the Ser-apeum in the second half of the fourth century AD.[143] He compares it with the acropolis in Athens in *A Description of the Temple of Alexandria in the Midst of the Acropolis*:

In general, the acropoleis of cities are set up for general security, since they are the citadels (*akrai*) of the cities, but they are not so much fortified by the buildings as they are themselves the fortifications for the cities. Accordingly, there is open-country around the Athenian acropolis in the midst of Athens, but in contrast, with regard to the citadel (*akra*) which Alexander established for his own city, this he built in a manner befitting the name he gave it, for he set it up toward the city-summit, and it is more legitimate to describe this as an acropolis than the one in which the Athenians have taken to priding themselves. Its arrangement is more or less as follows, as my description relates.

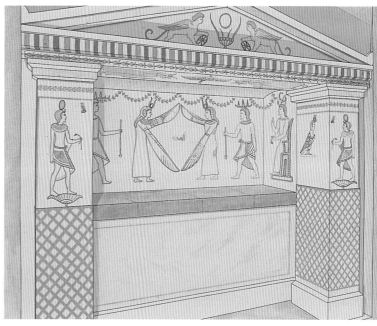

343. Alexandria, Kom el-Shuqafa, 'Hall of Caracalla', Nebengrab/Hall M, Tomb h

344. Alexandria, Kom el-Shuqafa, 'Hall of Caracalla', wall-painting on back wall of Tomb i

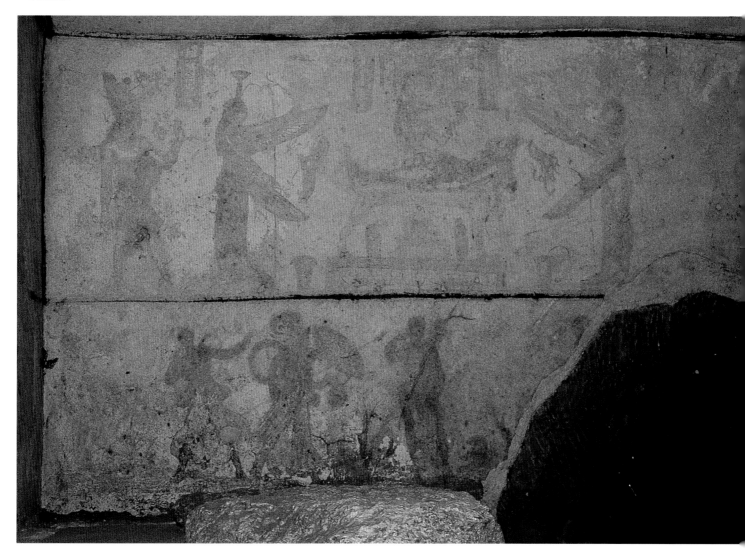

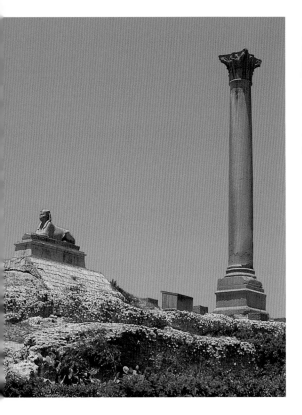

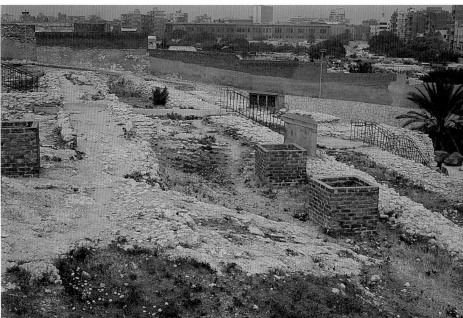

345. Alexandria, temple of Serapis hill, from east with Roman concrete foundations in foreground

346. Alexandria, temple of Serapis complex, view looking north-east with lines of concrete foundations of Roman colonnade

There is a citadel, jutting out of the land, rising until well into the heights and called an acropolis for two reasons: first, because it is exceedingly high, and second, because it has been built on the very peak of the city. The roads (*hodoi*) that lead up this citadel are not of the same sort, since in one area, there is just a road, but in another, an entranceway (*eisodos*). And these roads change their names and become called as their nature dictates, for on one, it is possible to approach on foot, and this road is shared with those who enter by cart [apparently entrance from street R8 in the north side of the court]. On another, staircases (*anabathmoi*) rise up, and there, passage is impossible for carts, since step (*klimax*) gives way to step, always such that the larger leads on from the smaller, and the steps go on higher without ceasing until they reach a hundred, when at last the termination of the number brings the length [of the staircase] to completion.

A propylaeum now takes over from the steps, surrounded by lattice-gates (*kigklides*) of average height, and then four very large columns rise up and bring the different types of paths toward the one entrance. Upon these columns rests a structure (*oikos*) with many columns of average height jutting forward. On the one hand, these have not just one colour, but, jutting forward in the building, have been fixed as decoration. The roof (*orophe*) of the structure came up to a vault (*kyklos*), and along the vault was affixed a large representation of the world (*ton onton hypomnema*).

But as one enters the acropolis itself from the side, the single area is divided by four similar sides, and the scheme of the arrangement happens to be rectangular (*plaision*), in the midst of which is a colonnaded court (*aule peristylos*).

So then, stoas follow the shape of the court, stoas divided by equal columns, and their size is such that it is not possible to accommodate anything more. Thus, each stoa comes to an end against another, and a double column [?heart-shaped pier] divides one stoa from the next, the one coming to an end, the other starting up in turn.

Precincts (*sekoi*) of the stoas have been built inside, some as storehouses (*tameia*) for the books, open to those eager

347. Alexandria, Roman temple of Serapis, fragments of granite column shafts and bases

to study, and they lift the entire city up to the possibility of acquiring wisdom; but others were erected to venerate the traditional gods. As for the roofing of the stoas: this is constructed of gold, whereas the column-capitals are worked in bronze, but plated by gold. The ornamentation of the courtyard, therefore, is not all uniform, for one was one way, while another was another way, especially the part with the 'Labours of Perseus'.

And in the centre, there rises a column of surpassing height that renders the location recognizable – someone leaving would not at all know where he was heading, were he not to use the column as a reference-point for his journey – and the acropolis visible to land and sea. The 'beginnings of the world' (*archai ton onton*) are positioned around the capital of the column.

Before one passes through to the middle of the court-yard, a building (*kataskeuasma*) has been erected, distin-guished by its gates, each named after the old gods [the South Building]. There stand also two stone obelisks and a spring having even better water than the one of the Peisistratids.

There is another thing to marvel at with regard to the number of builders. This has become a matter beyond belief, since, just as it would not be possible for one man to do all the construction, so only twelve craftsmen are identified and set forth as makers of the whole acropolis.

As one descends the acropolis, there comes a level area resembling a stadium, which was also the name of that place. But elsewhere is another designed for similar ends, though not having the same size.

348. Alexandria, Roman temple of Serapis, red granite fragment of cornice from monumental east entrance with Roman concrete foundations behind it

349. Alexandria, Roman temple of Serapis complex, restored plan

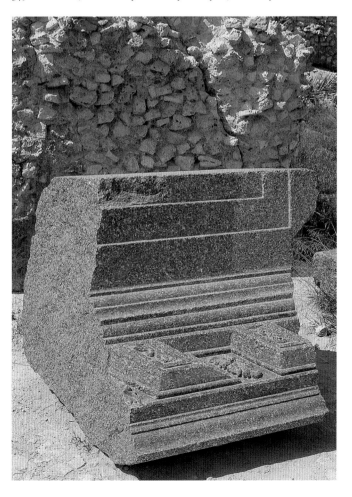

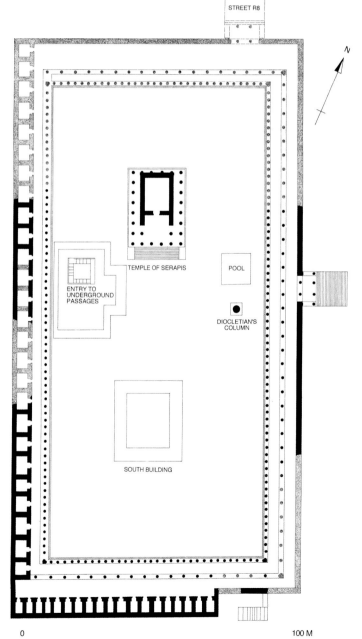

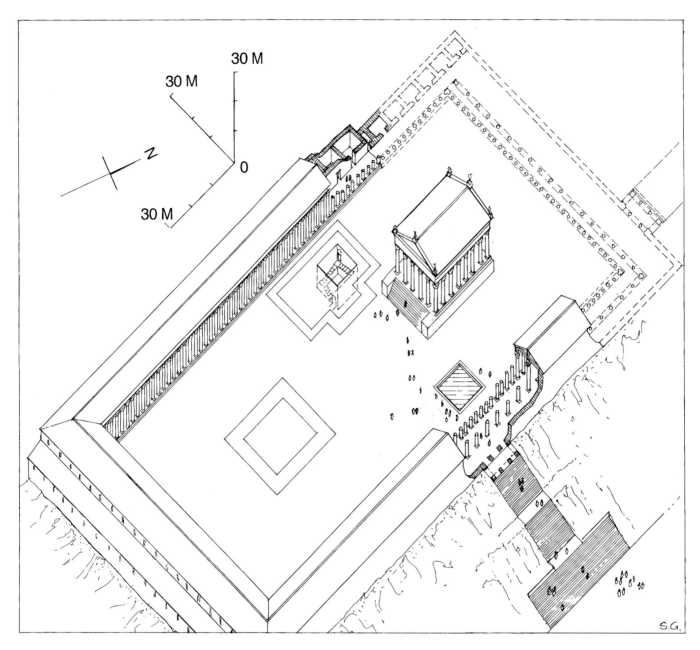

350. Alexandria, Roman temple of Serapis complex before the erection of Diocletian's Column, axonometric reconstruction. (Sheila Gibson)

For the rest, the beauty surpasses the telling, and if any-thing has been passed over, this may be taken as additional to what is amazing. What was simply impossible to describe has been omitted.[144]
Rufinus, who spent eight years in Alexandria, in c. AD 373–80, provides further details about the Serapeum writing in AD 402,[145] after its destruction:

Everyone, I think, has at least heard of the temple of Serapis at Alexandria, and to several, it is in fact well-known. The site is not a natural one, but rather one built by hand and constructed, situated as it is high above past a hundred or more steps and stretched open on every side with huge rectangular spaces. Until the highest part of the flooring is reached, in fact, everything is built with vaulted work, and with the lighting let in from above and with the shrines (*adyta*) hidden, each structure in turn has itself a use given over to distinct and particular rituals, in addition to secret functions.

Now then, in the upper areas, around the extreme edges of the whole periphery, there are exedrae and priests-quarters (*pastoforia*) and houses (*domus*) that reach a great height, in which temple-keepers or those whom they used to call *hagneuontes* (that is, the ones who make themselves pure) had been accustomed to gather. There were also por-ticoes beyond these that went round all this circumference on the inside, defined by a rectangular arrangement.

In the midst of the whole space was the temple (*aedes*), wrought with expensive columns and built impressively and magnificently with marble-stone on the outside. In this was an image of Serapis, so huge that its right hand was

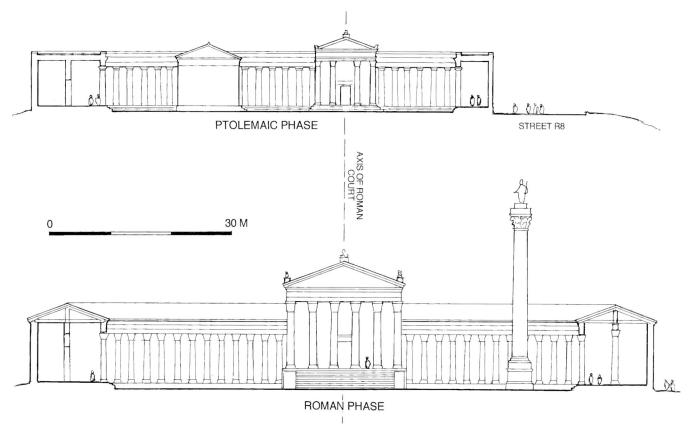

351. Alexandria, temple of Serapis enclosure, west-east sections of Ptolemaic and Roman phases. (Sheila Gibson)

touching one wall, while its left hand touched another – a monstrous object said to have been made from all sorts of metals and woods. The interior walls of the shrine (*delu-brum*) were covered at first by gold plates, then by silver plates above these, and finally by bronze plates to protect the more precious metals.

There were also certain devices designed by cunning and artistry for the astonishment and admiration of onlookers. A very small window had been so positioned with respect to the sunrise that, on the day on which it had been decreed that an image of the sun was to be carried inside to greet Serapis, the timing had to be observed carefully as the image entered, so that a sun-beam, passing straight through that very window would light up the mouth and lips of Serapis to give the effect, as people watched, that Serapis was apparently receiving a kiss from the sun in salutation.

There was also another trick of this sort. The magnet-stone has a property generally acknowledged to be of the following kind: it draws and attracts iron to itself. The sun-symbol had been designed by the hand of a craftsman from the finest iron to such an extent that the stone – whose nature it is, as we have said, to draw iron to itself – affixed above in the panelled ceilings would pull the iron toward itself, after the symbol had in due course been positioned at a level directly beneath. To the people, therefore, the image seemed to have risen and to hang in the air, and in order that

this deception should not be betrayed by a sudden slip, the perpetrators of the deceit kept affirming, 'The sun has risen to depart for its own realm, and in so doing, bids farewell to Serapis.' Several other devices also had been built into the site by the ancients for the sake of their trickery, but they are too many to number one by one.[146]

These descriptions can now be compared with the recon-structed complex [350]. Rufinus also describes the destruc-tion of the cult statue and the temple by the Christians in AD 391 (discussed in Ch. 10).

LAGEION, RACECOURSE

Aphthonius mentioned the area 'resembling a stadium' below the Serapeum. The remains of this racecourse, recorded by the Napoleonic expedition and Henry Salt, were completely covered over by the end of the nineteenth century. It has been identified as the Lageion which was originally built in the early Ptolemaic period [56] and apparently used for horse-racing (as a hippodrome) as well as for athletic events (as a stadium). The archaeological evidence recorded by the Napoleonic expedition indicated a structure with an overall length of 615m with a curve at both ends, rather than just at one end, and a track 560m long [338].[147] Remains of the central dividing barrier (*spina*) from the Roman phase were

found at the western end, indicating that it had been converted to a circus for chariot racing [355]. Traces of the starting gates were not recorded. Humphrey revised the plan to suggest a circus 450 m long (i.e. without the eastern curve).[148] Remains of seating were found on the south slope of the Serapeum enclosure (although not *in situ*) 140 m to the west of the *in situ* seating recorded by the Napoleonic expedition [338],[149] raising the possibility that the overall length of the Lageion was at least *c.* 530 m. The possibility also remains that it did have the curve at the east end recorded by the Napoleonic expedition. As a theatre was built at one end of the hippodrome at Jericho[150] and at one end of the stadium at Aezani in Turkey, it is possible that there was a similar arrangement in Alexandria, or that the Lageion was one very large racecourse with a curve at both ends.[151]

352. Alexandria, temple of Serapis complex, detail of underground passage

353. Alexandria, temple of Serapis complex, plan of underground passages

THE CITY IN THE THIRD CENTURY AD

The interest of the Roman emperors in the city, reflected in the rebuilding of the Serapeum, continues through the third century. In *c.* AD 201 Septimius Severus granted Alexandria

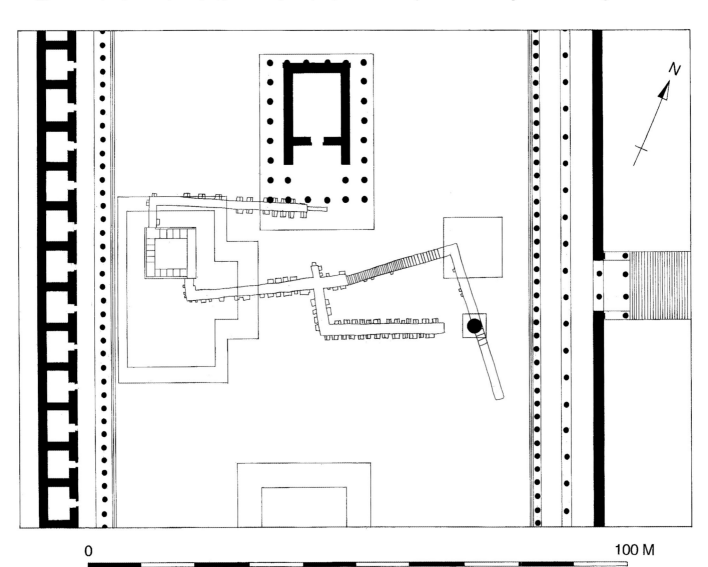

0 100 M

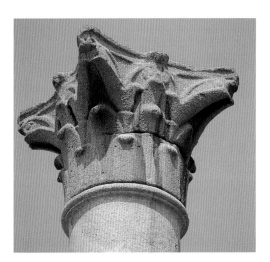

354. Diocletian's Column, capital, AD 298

355. Alexandria, Roman temple of Serapis complex and circus (Lageion), axonometric reconstruction

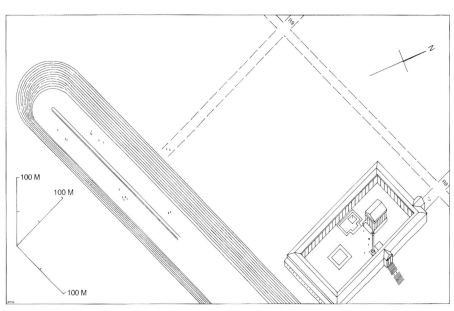

a city council (*boule*)[152] but the remains of the council house (*bouleuterion*) from this period have not been found. According to John Malalas, Septimius Severus built the public baths (*demosion loutron*) called the Severium, and the sanctuary (*hieron*) of Rhea.[153] The *Chronicon Pascale*, probably compiled in *c*. AD 630, records that Septimius Severus built 'in Alexandria the gymnasium called the Severianum and there also the great sanctuary called the Pantheon' in about AD 205.[154] The baths here are also called the gymnasium, as happened elsewhere in the Roman period, where the baths, which were always a feature of a Greek gymnasium, grew to replace the exercise court as its main element.[155] In *c*. AD 200 when Severus visited Egypt, Dio Cassius records that he 'took from nearly all the sanctuaries all the books (*biblia*) he could find

containing any secret lore and locked up the monument (*mnemeion*) of Alexander, so that his body could not be viewed. The Arab historian Maqrizi records that he slaughtered the Christians, destroyed their churches, and built in Alexandria a temple for his idols.[156]

When the emperor Caracalla arrived in the city in AD 215/16, the historian Herodian, who lived at the time of these events, informs us that the emperor 'went up to the temple [of Serapis], where he made a large number of sacrifices and laid large quantities of incense on the altars. Then he went to the monument (*mnemeion*) of Alexander and laid upon the grave (*soros*) the purple cloak he was wearing, and other valuables.[157] He ordered the youth of the city to assemble in the *pedion* where he massacred them.[158] A later source provides

356. Kom el-Dikka, view from north-east

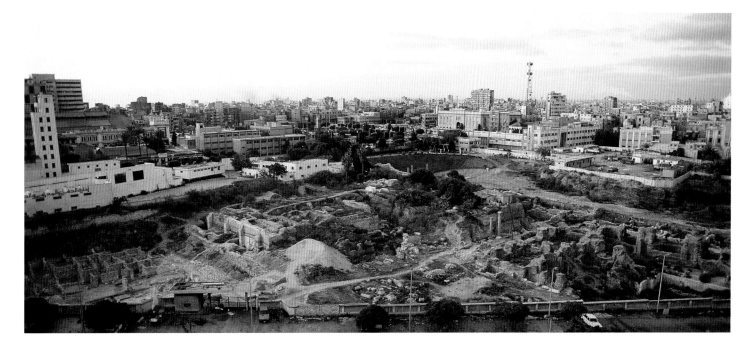

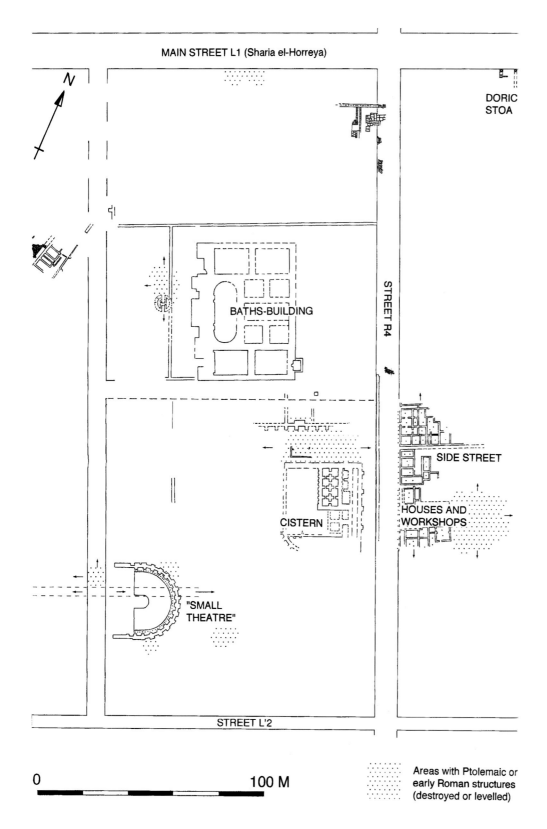

MAIN STREET L1 (Sharia el-Horreya)

DORIC STOA

N

BATHS-BUILDING

STREET R4

CISTERN

SIDE STREET

HOUSES AND WORKSHOPS

"SMALL THEATRE"

STREET L'2

0 100 M

357. Alexandria, Kom el-Dikka, plan of excavated area at beginning of the fourth century AD (with areas of destroyed late Ptolemaic or early Roman structures marked)

Areas with Ptolemaic or early Roman structures (destroyed or levelled)

further details, reporting that Caracalla remained in the precinct (*temenos*) of the Serapeum while the citizens of the city were massacred, and the city was pillaged over a number of days. Caracalla's use of the Serapeum site accords with Clement's reference to it as the *akra*. Caracalla wanted to burn the books of the Aristotelian philosophers. According to Dio Cassius: 'He abolished the spectacles and the common

mess-halls (*syssitia*) [of the Museum] and ordered that Alexandria should be divided by a cross-wall'. Inscriptions from the second half of the second century AD record the dedications of statues in *syssitia*.[159]

In 1997 on the island of Antirrhodos in Alexandria's eastern harbour [299] parts of eight column shafts, all exactly 2 cubits (1.05 m) in diameter, were found with inscriptions on

358. Alexandria, Kom el-Dikka, plan of excavated area, mid-sixth century AD

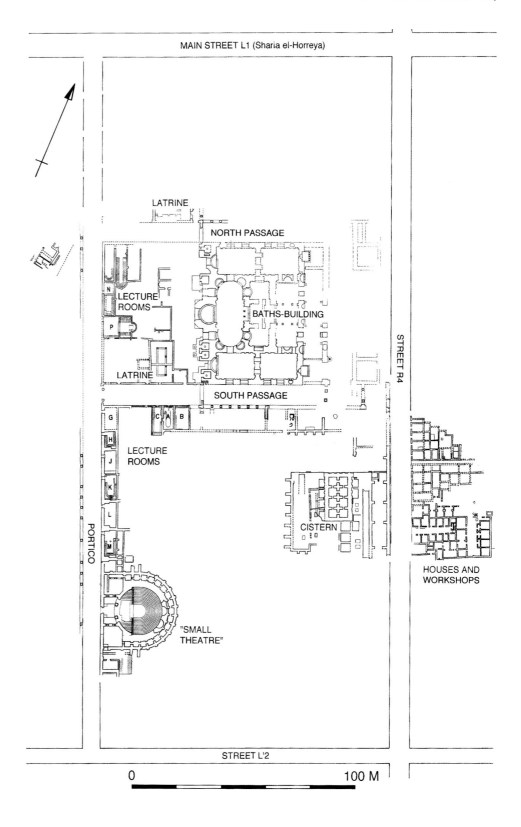

them.[160] One has an inscription dated to Commodus, and five mention Caracalla. He is described as adorer of Serapis (Philosarapis). Three were dedicated to him by the 'Romans and Alexandrians', and one gives the exact year as AD 213. Two of these inscriptions were carved by the same workman suggesting that these (and possibly some other shafts of the same diameter) were from the one architectural ensemble. It is not clear if they were erected on the island or deposited there from elsewhere, because they were not all found together. They could have been columns for statues, like those depicted beside other ports, or columns from a colonnade. They could even have come from the Serapeum (which had columns of the same diameter), from which columns were dumped on the harbour shore.

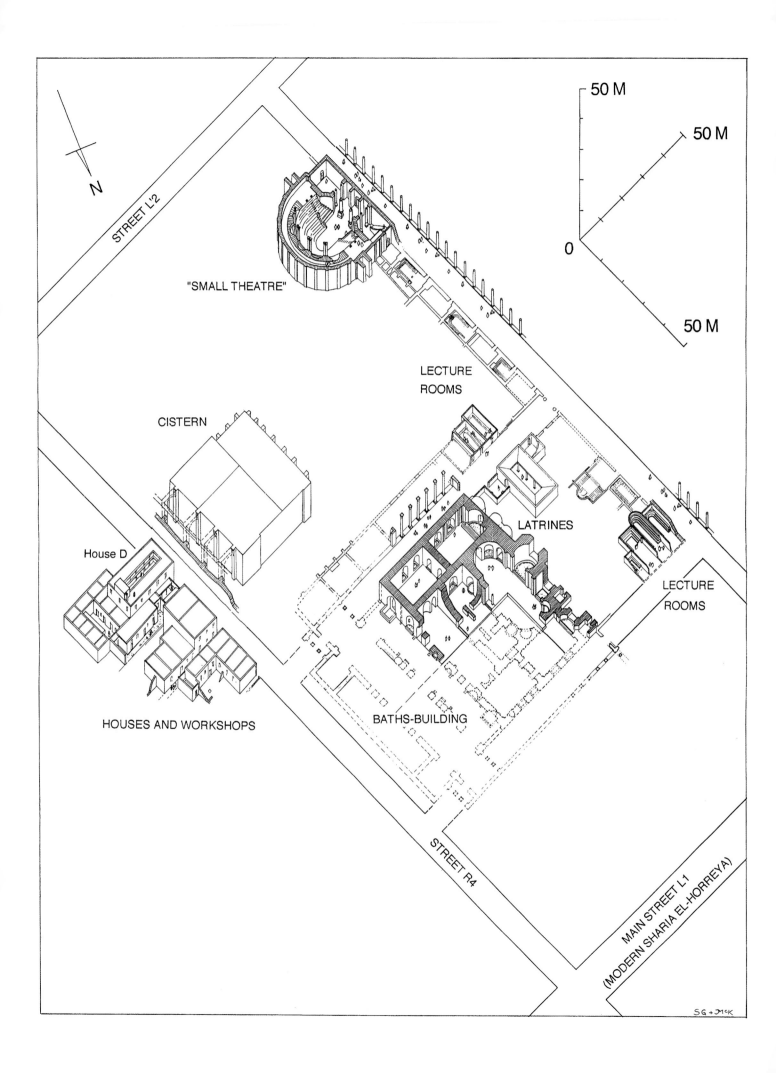

STREET L'2

N

50 M

50 M

50 M

0

"SMALL THEATRE"

LECTURE ROOMS

CISTERN

House D

LATRINES

LECTURE ROOMS

HOUSES AND WORKSHOPS

BATHS-BUILDING

STREET R4

MAIN STREET L1 (MODERN SHARIA EL-HORREYA)

SG + JMcK

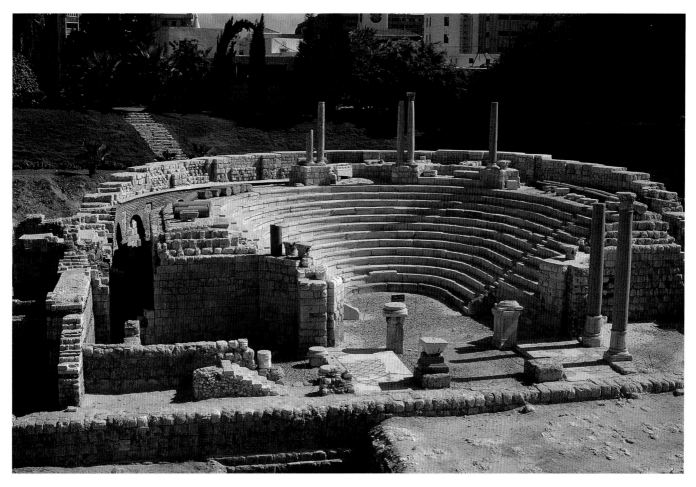

360. Alexandria, Kom el-Dikka, 'small theatre'

The city was invaded by the Palmyrenes under Queen Zenobia. However, when it was recaptured under the emperor Aurelian in AD 272 its extensive and beautiful city walls were destroyed along with 'the greater part of the district called Bruchion which had long been the abode of distinguished men.'[161] A century later this district was still deserted, according to Epiphanius, who lived in Alexandria in his youth.[162]

However, the city's substantial walls must have been repaired or rebuilt by AD 298 to withstand the eight month long siege of it by the emperor Diocletian, when the Egyptians rebelled. John Malalas describes these events: 'He besieged it, dug trenches and cut and destroyed the aqueduct which came from the place known as Canopus and supplied the city. He captured Alexandria and burnt it.'[163] Diocletian's Column was erected in AD 298 in honour of Diocletian by Publius, prefect of Egypt, in the colonnaded enclosure of the Roman Serapeum [345, 349].[164] It still stands today in its original position on the highest point of the hill, and on the line of the north-south street R8 [351] so that it would have been

visible looking along the street. Diocletian was in the city again in AD 302 before beginning the Great Persecution against the Christians.[165] The Egyptian bishop John of Nikiu, writing in the late seventh century, reports that Diocletian burnt the Christian books[166] and, according to Souda, he burnt the chemistry books of the Egyptians.[167]

Evidence for the destruction of parts of the city centre resulting from the attacks on the city in the later part of the third century survives in the archaeological record, especially at Kom el-Dikka.

BUILDINGS AT KOM EL-DIKKA IN THE FOURTH TO SEVENTH CENTURIES AD

The remainder of this chapter will concentrate on the archaeological evidence from the secular buildings which have survived in the area of Kom el-Dikka [356, 359] in the centre of the city on the city blocks on the southern side of the main east-west street and to the south of the Caesareum (location marked on [23]). During the fourth century there is an overlap of the construction of churches, with the conversion of temples into churches and the continued use of some pagan buildings. These aspects will be discussed in Chapter 10 which covers written sources for the developments in

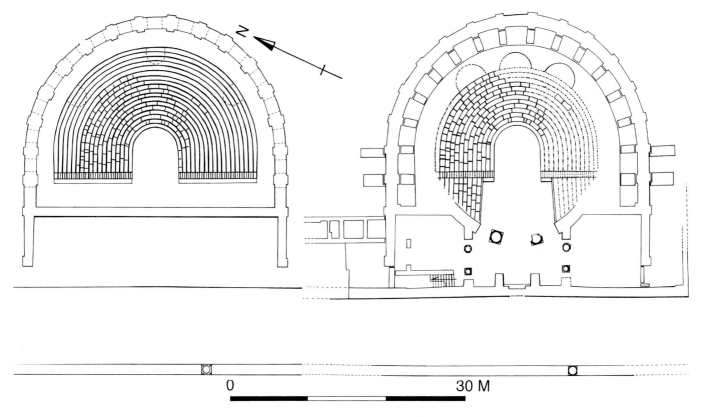

361a–b. Alexandria, Kom el-Dikka, 'small theatre,' phases I and II, plans. (a) Phase I; (b) Phase II

church architecture in Alexandria from the fourth to the seventh centuries AD.

The city block at Kom el-Dikka had expensive housing of the first and second centuries AD surviving in a number of areas of it [299], so that it could not have been an area of public buildings in that period. The later public buildings – the baths-building and the 'small theatre' – are built over the top of some of this housing, to the west of cross-street R4 [305]. Houses from the first and second century were destroyed in the late third century AD, possibly by earthquakes or during one of the invasions of the city.[168] After the area was left deserted for a period the houses were filled with earth and the whole city block was completely reorganized with the construction of public buildings in the first half of the fourth century [357]. This is particularly obvious where the new thoroughfare beside the 'small theatre' was built over some of these houses on the same orientation as the existing grid [305, 310].[169] These public buildings had a number of phases as they were further developed. Sufficient survives of them for the city block in the mid-sixth century to be reconstructed reliably [358–359]. They continued in use into the seventh century.

The 'small theatre' [360] had two phases. The first one consisted of an open air semi-circular building with 16 to 17 rows of seating of reused white marble, and a scene structure [361a].[170] Carved entablature blocks were reused for the seating, including the cornice block illustrated [362]. Some of these seats were numbered.[171] It has been suggested that this was the council house (bouleterion).[172] It is possible that it was used by the council (boule), as well as for entertainment.

However, as it was not built until the mid-fourth century, another location would have been used as the bouleterion for the first century and a half of the existence of the boule.

In c. AD 500 the 'small theatre' was considerably remodelled. The stage building was demolished and the building was extended on the west (street) side by the addition of a tripartite vestibule [361b]. The seating was extended on that side using blocks from the back of the first phase, reducing to 13 the number of rows of seats. Niches and columns of coloured marble and granite, with white marble capitals [364], were added around the top of the seating to help support a dome [363a–b]. The main room and vestibule had

362. Alexandria, Kom el-Dikka, 'small theatre,' marble cornice block

363a–b. Alexandria, Kom el-
Dikka, 'small theatre' phase II: (a)
section; (b) axonometric
reconstruction (Sheila Gibson)

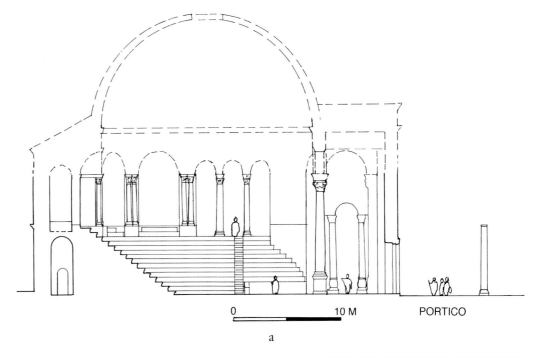

0 10 M PORTICO

a

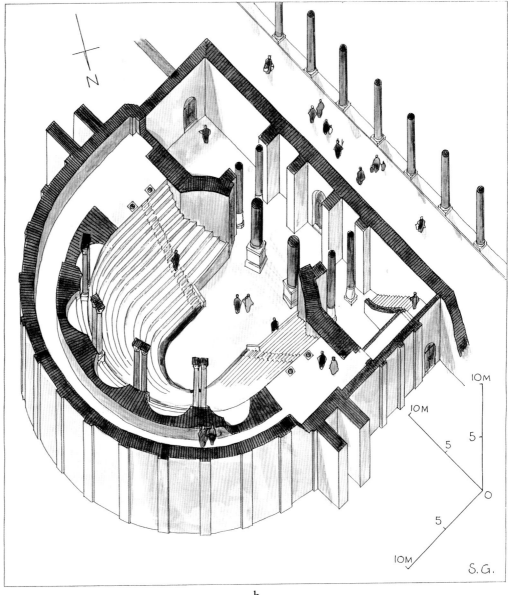

S.G.

b

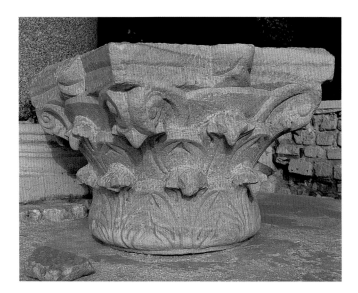

364. Alexandria, Kom el-Dikka, 'small theatre,' Corinthian capital of fifth century AD

365. Alexandria, Kom el-Dikka, 'small theatre,' acanthus column base

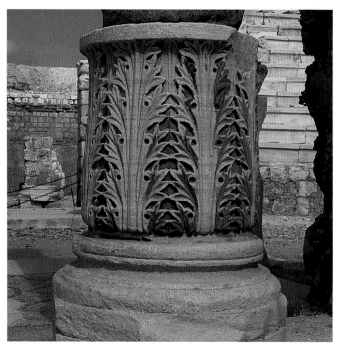

mosaic floors and wall-paintings with geometric patterns. The acanthus bases on the columns in the vestibule are reused [365].[173]

The function of this second phase of the 'small theatre' is not completely clear: one possibility which has been suggested is that it was a lecture theatre, as there are many lecture rooms further along the street and adjoining the baths-building. The consoles and some capitals on the 'small theatre' were decorated with crosses, and it has graffiti praising the faction called the Greens in the early seventh century. Perhaps it was used for poetry recitals and pantomime. Such a performance is depicted on a comb (probably from Anti-noopolis) of the late fifth or early sixth century AD mentioning the Blues.[174] The 'small theatre' went out of use by sometime in the second half of the seventh century.[175]

The imperial baths-building was constructed in the fourth century as part of the same major redevelopment as the 'small theatre' [357]. That this baths-building was imperial is suggested by its size and symmetrical design, as well as the authority needed for the reorganization of the site which involved building over houses. It had three main building phases,[176] during which the plan remained basically the same as in its final phase (III) [367–368]. It continued in use until the early seventh century. Its northern part was destroyed in 1866. It had a symmetrical rectangular plan of eastern Mediterranean type, with some local North African features.[177] The building faced street R4, from which a vestibule led into the cold bath (frigidarium). On either side a double sequence of chambers occurred with the usual warm room (tepidarium), room for rubbing down (destrictarium), steam bath (sudatorium), and hot room (caldarium) with a large pool.[178] West of the caldarium is the service area including the furnaces and stores.

The original plan of the baths-building was basically Roman, but significantly with the usual Roman dry steam

bath replaced by the wet steam bath preferred by the Greeks. It also had a small dry steam bath for those who preferred it. The first rebuilding occurred after the earthquake of AD 447 (phase II), when the main alterations were made to the frigidarium, with the large pools in it being replaced by numerous small pools.[179] The building seems to have been damaged in the earthquake of 535 after which it was redesigned with major alterations to the caldarium.[180] The caldarium was used for hot and cold baths, and the furnaces were adjusted to suit the local fuel of straw and reeds, as used elsewhere in North Africa.[181] This last phase (III) of use lasted until the beginning of the seventh century.

There are passage-ways along the northern and southern sides of the baths-building [367]. On the south side of the south passageway there were rooms which might have been changing rooms (apodypteria). Beyond this, the passage had a portico with monolithic granite columns with Corinthian capitals.[182] The passageways led to latrines built in the fourth century AD on the northern side of each of them. The southern latrine is the better preserved, consisting of a low peristyle building with the roof sloping into the centre [368]. The seats were along the walls, in the shade of the roof.[183] The latrines were flushed with water which had been previously flushed through the ashes of the furnace with the resultant high alkaline content acting as a disinfectant.[184]

Opposite the southern latrine there were two or three long narrow rooms with seating around the walls [368]. They were decorated with painted walls depicting imitation veneer of

366. Alexandria, Kom el-Dikka, baths-building (phase III), south–north section with roof restored

367. Alexandria, Kom el-Dikka, baths-building (phase III) and adjoining structures, plan

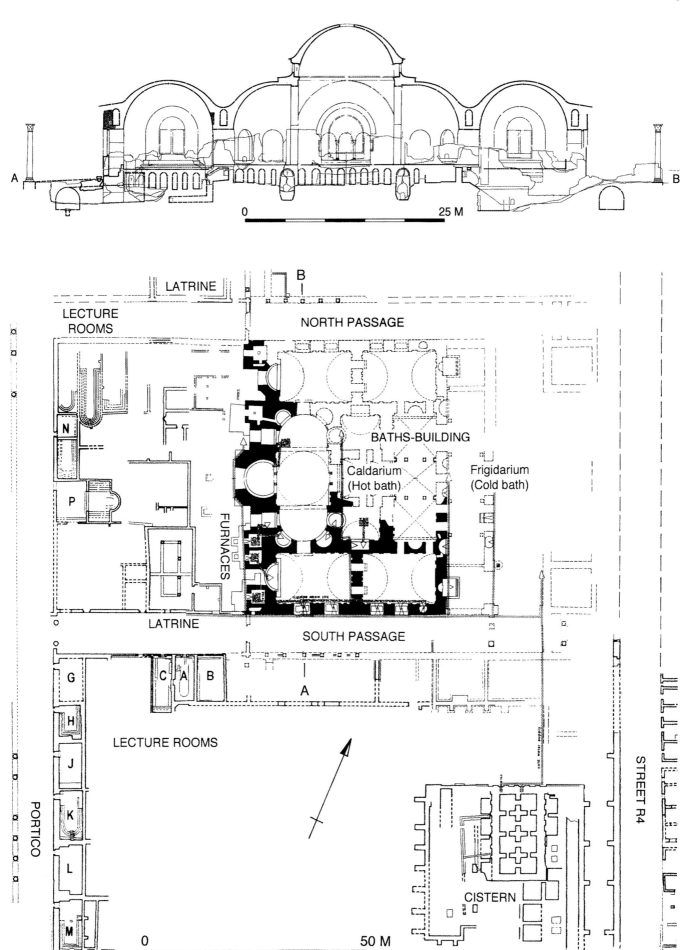

A ————————— B

0 25 M

LATRINE

B

LECTURE
ROOMS

NORTH PASSAGE

N

BATHS-BUILDING

P

Caldarium
(Hot bath)

Frigidarium
(Cold bath)

FURNACES

LATRINE

SOUTH PASSAGE

G C A B

A

H

LECTURE ROOMS

J

K

STREET R4

L

PORTICO

M

CISTERN

0 50 M

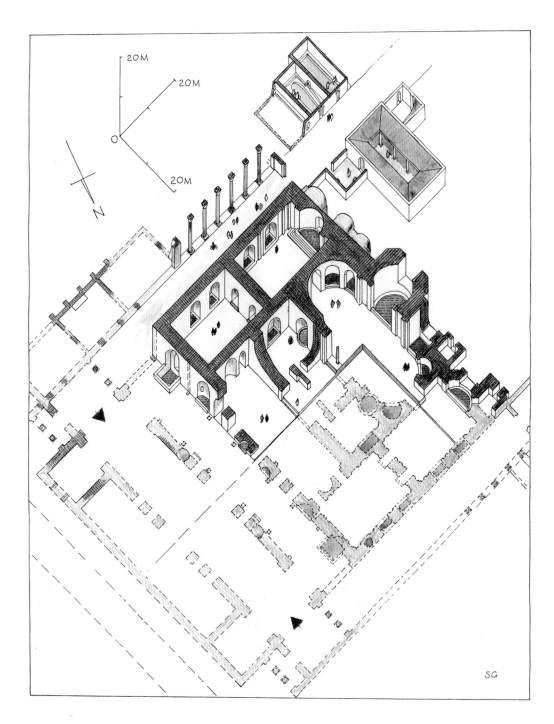

coloured stone, indicated by plaster fragments. These rooms had a number of phases from the fifth to first half of the seventh century AD. On the southern side of the north passageway there is a second set of long narrow rooms including one with a curved end [367]. These rooms with tiered seating on three sides were apparently lecture rooms [371]. Their proximity to the baths would also suggest this, as the teaching function of the gymnasium had moved to the baths-building, along with the name, and in the Roman period teaching occurred elsewhere in building complexes which had become predominantly baths-buildings. The recent discovery of further lecture rooms along the portico leading north from the 'small theatre' suggests a very large teaching institution in the

sixth century reflecting the city's continued role as a major academic centre [359, 367, 369]. The rooms are typically *c.* 5.5 by 11 m, with three rows of benches and have a semicircle and a stepped dais (cathedra) at the end furthest from the door [370].[185] The design of these Alexandrian lecture rooms with their stone seating, is unique. Yākūt (AD 1179–1229) describes the place 'where scholars and alchemists sit' for 'their sessions was like stairs'.[186] This educational complex adjoining a green square was apparently the 'Temenos of the Muses' mentioned in written sources from the second half of the fourth and early sixth century.

The baths-building was supplied with water from the cistern to its south [367]. This cistern was unusual when

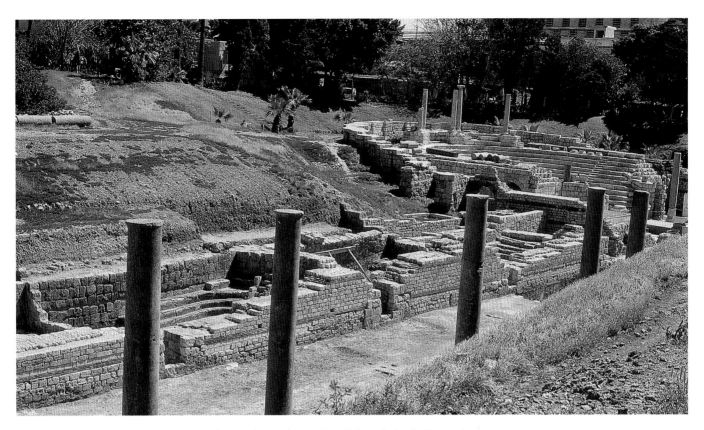

369. Alexandria, Kom el-Dikka, lecture rooms along portico north-east of 'small theatre', view looking south-east

370. Alexandria, Kom el-Dikka, lecture room with benches and cathedra

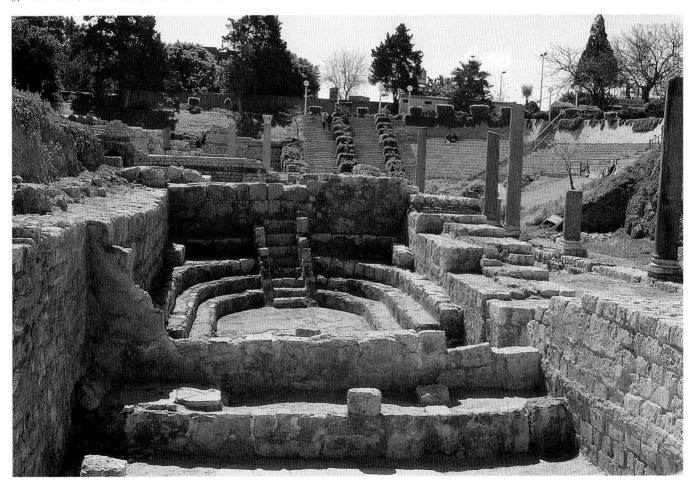

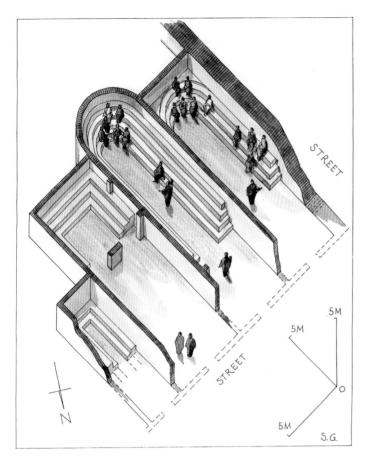

371. Alexandria, Kom el-Dikka, lecture rooms, on south side of north passage-way, axonometric reconstruction (Sheila Gibson)

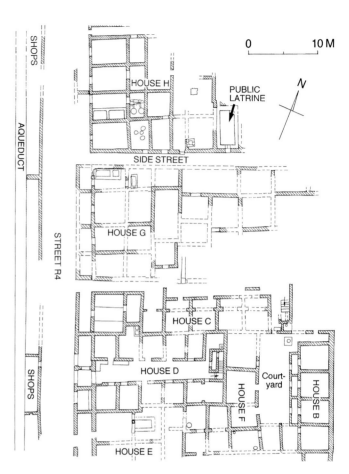

372. Alexandria, Kom el-Dikka, plan of houses and workshops, with sixth-seventh century shops encroaching onto street R4

compared with all other examples which survived in Alexandria as they are underground. By contrast, it was a reservoir (*kastellon*) built above ground to a height of almost 10 m to give sufficient water pressure to supply the baths-building [359].[187] It was built in the fourth century and was rebuilt and remodelled at least twice before it went out of use in the

373. Alexandria, Kom el-Dikka, houses, view from north

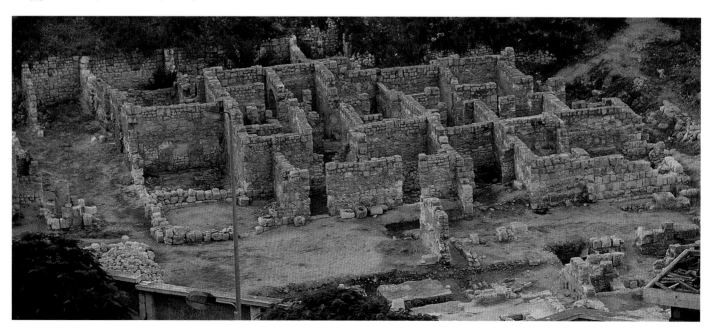

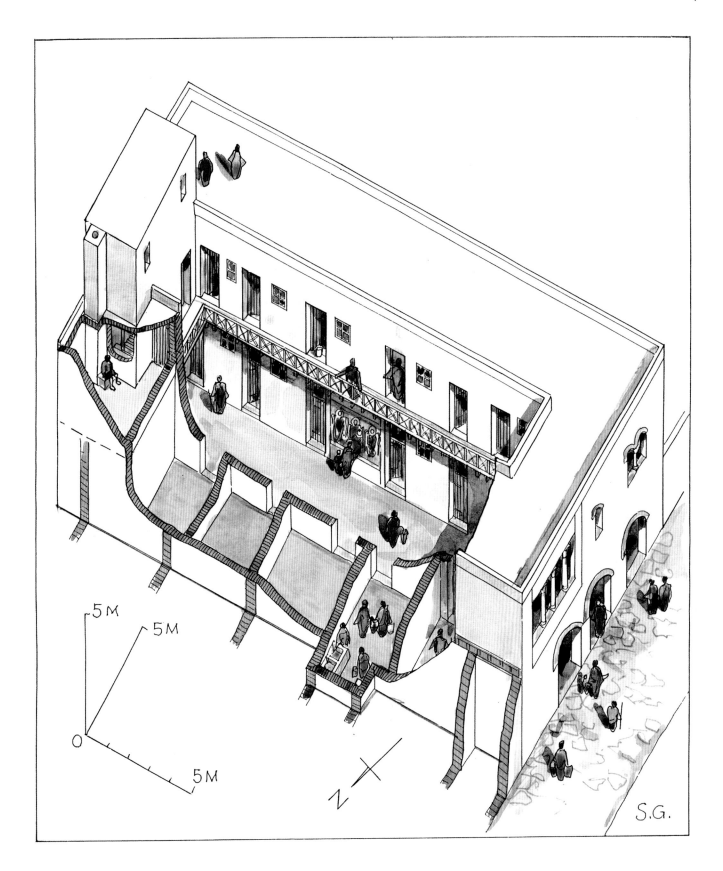

374. Alexandria, Kom el-Dikka, House D, axonometric reconstruction. (Sheila Gibson)

seventh century. It would have been filled by pumping water from some of the underground cisterns in the area, which were fed from the Nile by the raised aqueduct along street R4.

East of the cistern on the other (eastern) side of cross-street R4, the expensive houses, which were destroyed at the

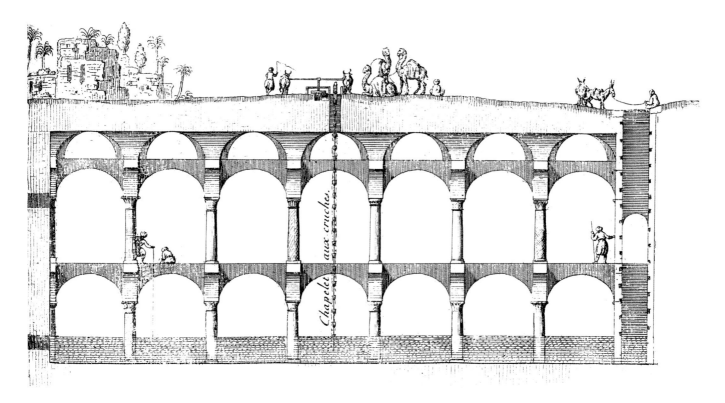

375. Alexandria, cistern beside the church of St Sabas in 1737, in use with *saqiya* and a pot-garland for pumping water

end of the third century,[188] were not replaced by public build-ings, unlike those to the west of this street. Instead, after a period of not being reoccupied these houses were levelled and replaced by cheaper housing and workshops at the beginning of the fourth century [357–359], almost directly on the level of the mosaic floors of the earlier houses [305–306].[189] Their walls were built in a technique derived from *opus africanum* with small limestone blocks set in mortar, and were stuccoed and painted [373]. They were occupied until the seventh century, with some slight modifications, and changes in room usage.

Most of these houses (C, D, E, G and H) were entered from cross-street R4 [372]. Houses A and B were small and only one-storey high. The rooms in Houses G and H which opened onto street R4 would have been shops. Those behind them were used as workshops and domestic areas. The narrow passageway between Houses G and H was built on the early Roman side street, indicated by the sewerage system under it. There was a public latrine off this street, beside House H. The whole area of houses (A to H) and workshops had a well-planned and executed sewage system.

House D was well preserved, so that its plan is quite clear. It was entered from street R4, into a long courtyard with workshops on either side [372, 374]. At the end of this court-yard there was a staircase which would have led to the domes-tic quarters on the next floor. At the end of the courtyard there was a private latrine. One of the ground floor rooms had a mosaic floor from an earlier phase. Fragments of Chris-tian paintings survived on the walls of the courtyard [406].

The workshops in Houses A, B, D, F, and H were used for working semi-precious stones and finishing glass. There was

a small glass kiln in House H. Fragments of rock crystal and unfinished glass, especially coloured glass beads, were found in many rooms of these houses, suggesting an area specializ-ing in these particular crafts. On the same city block, further east, evidence for other housing and workshops from the fifth to the seventh centuries was found.[190]

The design of the houses at Kom el-Dikka, in particular of House D, reflects a similar plan to the multi-storey tene-ments in Rome.[191] These houses are less affluent than those over which they were built. Although the southernmost house (E) was poorly preserved and only partly excavated, it reflects a more archaic plan with the rooms arranged around a peristyle court with a pool, and it is also possible that it was more affluent [372].

Affluent housing of the fifth and sixth centuries was found elsewhere in the city. On the north-east of this insula, beside the main east-west street, the remains of rich housing with private baths were found, dating to the fifth to sixth cen-turies.[192] South of the site of the 'small theatre' on the other (southern) side of street L'2, there were also private baths of the fifth century, such as would be part of a wealthy house.[193]

In the early sixth century narrow single shop units were built along the west side of the street against the aqueduct wall making street R4 narrower, so that it became *c.* 6.50–6.70 m wide. In the sixth to seventh centuries similar structures were also built along the east side of the street, further

376. Alexandria, el-Nabeh Cistern in Shallat Gardens

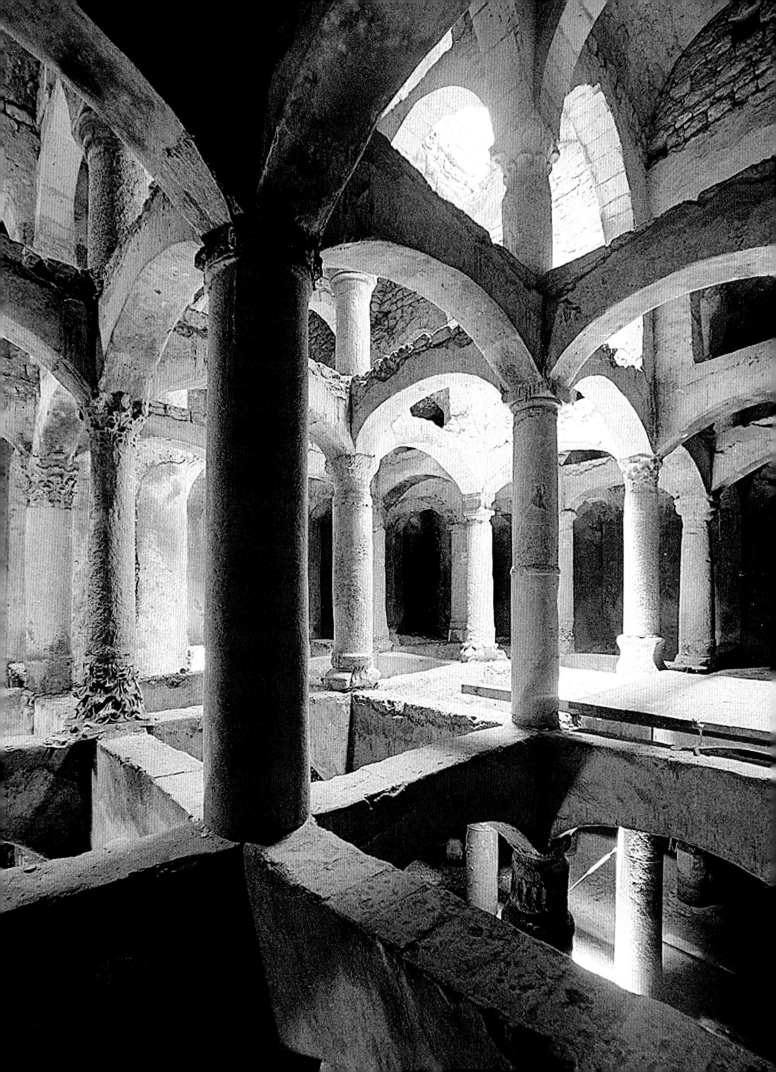

narrowing the street to *c.* 3.5 m wide [372]. It remained straight but lined with shops and workshops along either side, like in a mediaeval *suq.*

CISTERNS

Many of the cisterns which have survived from the Arab period in Alexandria seem to have existed in the late Roman and Byzantine periods. Some of these were Ptolemaic or early Roman ones which had been enlarged.[194] The late Roman and Byzantine cisterns are characterized by internal rows of columns of up to three tiers, supporting arches [375–376]. They included many reused late Roman and Byzantine columns and capitals. Similar cisterns were built in Constantinople in the same period. Some of those in Alexandria were rebuilt or repaired in the Islamic period, as indicated by pointed arches and other Islamic features.[195] There were hundreds of these cisterns surviving in Alexandria in the early nineteenth century.

The cisterns were filled by underground channels from the Canal of Alexandria. The considerable depth of the cisterns made it possible for the water to settle so that the best water, which could be used for drinking, was at the top. In antiquity the water was probably raised from the cisterns using a *saqiya* with a pot-garland, as depicted in use in the seventeenth century [375].

The evidence for conduits for water at Kom el-Dikka includes lead water pipes from the early Roman period, and late Roman pottery water pipes. Sewage channels also survive there from the late fourth to fifth centuries AD.[196]

CONCLUSION

Under the Romans, Alexandria continued to be renowned as a world market and place of learning, famous for its beautiful buildings. Its principal facilities and monuments continued in use from the Ptolemaic period, including its deep harbours and the lighthouse Pharos essential to maritime trade, and major buildings, such as the theatre, the tomb of Alexander, and many temples. Some Ptolemaic buildings were rebuilt or extended, such as the Museum which was enlarged under Claudius. The Serapeum was rebuilt at the end of the second or beginning of the third century AD, again with a unique design, but one reflecting some Roman influence. The racecourse, the Lageion, was modernized by being converted to a circus (for Roman chariot racing) while it also continued to be used as a stadium (for athletics). The change to Roman government was seen in some buildings, as in the Gymnasium which replaced the palace of the Ptolemaic kings as the location of political activity. From *c.* AD 201, the city would have had a council house (*bouleuterion*) for meetings of the city council (*boule*).

Roman rule was reflected in buildings in honour of the country's new rulers. The Caesareum was a major temple to the imperial cult of Augustus. Other imperial dedications include the Forum of Augustus, an extension to the Museum called the Claudeium, a library of Hadrian, a Hadrianeion (temple dedicated to Hadrian), and a public baths/gymnasium named the Severianum. New building-types, specific to Roman architecture, which appeared in the city included imperial baths and an amphitheatre. The streetscape was decorated with colonnades along the main thoroughfare and cross-streets, with the monuments along them including gates (the Gate of the Sun and Moon), triumphal arches, and fountain houses. Thus, in the Roman period Alexandria was embellished with similar types of buildings to other cities of the Roman East. It was distinguished from them by its size and famous monuments as well as its extensive maritime trade and academic facilities.

Some buildings in Alexandria had local features, also observed on examples from elsewhere in Roman Egypt, such as the tetrastylon with acanthus bases, triumphal arch and the circus (the Lageion). Examples of local designs in the fifth and sixth centuries AD are observed at Kom el-Dikka including the imperial baths-building with furnaces for local fuel. The shape of the long, narrow lecture rooms is not only unique, but their number indicates the successor to the city's famous Museum was a larger educational establishment than in any other city, even in the sixth century.

While the same types of classical buildings in Alexandria and elsewhere in Egypt were also built in other urban centres of the Roman empire, two additional observations can be made about the situation in Egypt. Firstly, there is no detectable difference between the types and the designs of classical buildings erected both in Alexandria and elsewhere in Egypt. Secondly, both have buildings with local features as well as aspects in common with those building types throughout the Roman Empire.

CHAPTER 9

Classical Architectural Style of Roman Alexandria and Egypt

For the details of the architectural style of the classical buildings of Alexandria and other sites in Roman Egypt, it is necessary to turn to the little-known architectural fragments of this period. These will be found to indicate two strands of development in the second and third centuries AD, like those observed in the building designs. One strand is a direct continuity from the Ptolemaic classical architectural style of Alexandria, which had continued through the first century AD. The other style is similar to Roman architecture elsewhere in the eastern Mediterranean. Furthermore, both styles are found to occur equally in Alexandria and elsewhere in Egypt. The evidence from the Roman period, although fragmentary, is important because it provides the missing link to show local continuity between the classical architectural decoration of the Ptolemaic period and Late Antique architecture in Egypt, as also revealed from analysis of the papyrological evidence.

CORINTHIAN ORDER IN THE LATE FIRST CENTURY BC AND THE FIRST CENTURY AD

The few Corinthian capitals surviving at sites in the Nile valley from the late first century BC and the first century AD are derived directly from the distinctive Alexandrian Corinthian capitals of the Ptolemaic period. On these the helices and corner volutes spring separately from the collar of acanthus leaves, and the helices are arranged in a variety of ways facing inwards or outwards [125]. By contrast, the Roman 'Normal' capitals (which were the standard form of the Corinthian order elsewhere in the Roman empire in the first century AD) have the helices and the corner volutes springing from a single sheath or cauliculus, and the helices always face each other ([127], which includes the architectural terms). Examples of the Alexandrian Corinthian capital types at sites up the Nile include Type I (with the helices facing each other and springing from the sides) and Type III

377. Edfu (Apollinopolis Magna), Type I capital

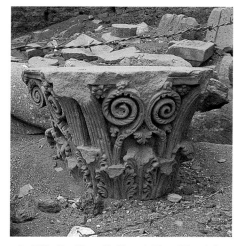

378. Edfu (Apollinopolis Magna), Type III capital

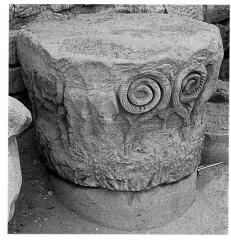

379. Kom Ombo (Ombos), Type III capital

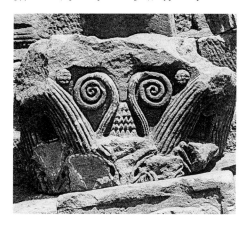

380. Philae, Type III capital

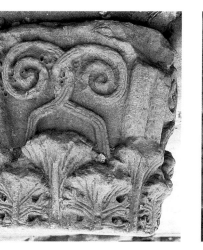

381. Dendara (Tentyris), *dromos*, Type III capital

382. Dendara (Tentyris), Type IV capital

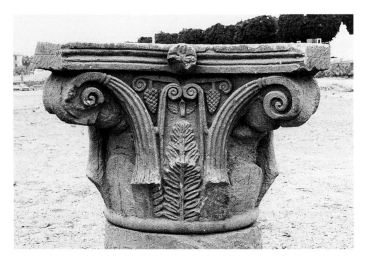

383. Thebes (Luxor), Corinthian capital

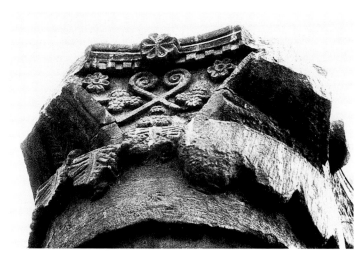

384. Kom Ombo (Ombos), detail of Corinthian capital with crossed helices

(with the helices back to back and springing from the sides). These survive at Apollinopolis Magna (Edfu)[1] and Ombos (Kom Ombo)[2] from the second or first century BC [377–379]. These have the distinctive decorative details on the helices observed in Ptolemaic examples [113e, 129], with ribbing, small leaves, and spiral decoration. Later examples of Type III also survive at Philae[3] and Tentyris (Dendara)[4] possibly from about the first century AD [380–381]. The decoration of the helices on these has been simplified. An example of Type IV (characterized by the lack of the collar of acanthus leaves, and continuity of the corner volutes into two spirals back to back in place of the helices [126]) survives at Dendara [382].[5] These sites – Tentyris (Dendara), Apollinopolis Magna (Edfu), Ombos (Kom Ombo), and Philae –

are all in Upper Egypt. Their considerable distance from Alexandria gives some indication of how far the Ptolemaic classical architectural tradition had spread in Egypt (Maps 1–2).[6]

One of the most characteristic features of the classical architectural orders of the Ptolemaic period in Alexandria is the cornice with flat grooved and square hollow modillions [117]. These continue into the Roman period, as on a broken pediment niche head from the first century AD at Marina el-Alamein c. 100 km west of Alexandria [153–154].[7]

Thus, during the first century BC and first century AD the distinctive capital and cornice types of Ptolemaic Alexandria continued at sites considerable distances from it, indicating the strength of this classical architectural tradition.

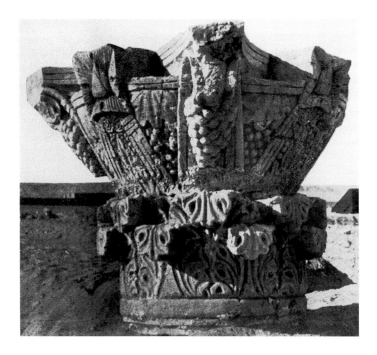

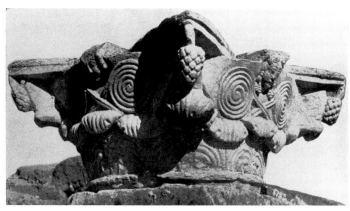

385. Dionysias (Qasr Qarun), 'Basilica', Corinthian capital

386. Dionysias (Qasr Qarun), 'Basilica', capital with crossed helices

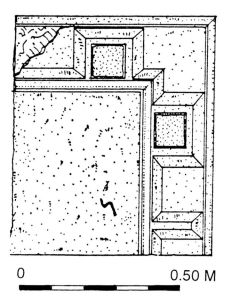

0 0.50 M

387. Mons Porphyrites, temple of Serapis, cornice with square hollow and flat grooved modillions

388a–b. Antinoopolis (el-Sheikh 'Ibada), Triumphal Arch, detail of entablature with flat grooved modillion cornice

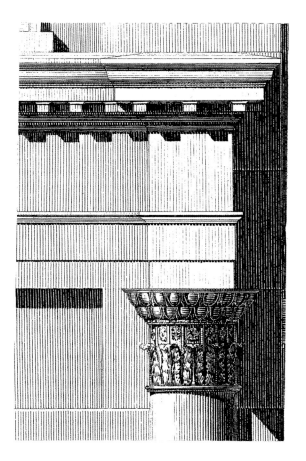

THE SECOND AND THE THIRD CENTURIES AD

In the second and third centuries AD the archaeological evidence from Roman Egypt, including Alexandria, indicates two strands of development of the decorative details of the Corinthian order. The first strand continues from the local classical architecture. The second strand is similar to that which is ubiquitous throughout much of the Roman Empire.

The first strand is a direct continuation of the Ptolemaic classical architecture observed above at sites in Roman Egypt in the late first century BC and the first century AD. The continuity of this strand may be observed in the Corinthian capitals at sites as far south as Thebes (Luxor) and Ombos (Kom Ombo) [383–384]. These capitals lack the sheath, called a cauliculus, which occurs on 'Normal' Corinthian

capitals. In addition, the arrangement of their helices varies.[8] The capitals surviving at Dionysias (Qasr Qarun) in the Faiyum from the late third or early fourth century AD are related to these,[9] but the original shape of the Corinthian capital has begun to break down. The helices have become surface decoration on the circular drum of one capital [386], and on another grapes completely fill the spaces between the helices [385].

The distinctive Alexandrian cornices also continue with square hollow and flat grooved modillions. They are used on the temple of Serapis at Mons Porphyrites (Gebel Dukhan), in AD 117–19 [387],[10] and on the Triumphal Arch at Antinoopolis (el-Sheikh 'Ibada), built after AD 130 [388].[11] Later examples of these cornices have also survived from the late third or early fourth century AD from the 'basilica' at

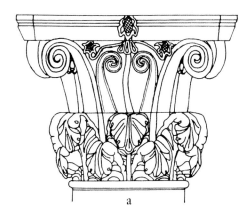

a

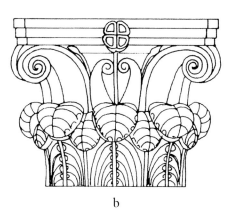

b

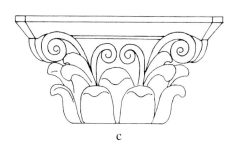

c

389a–c. Capital types distinctive to Egypt in Roman period

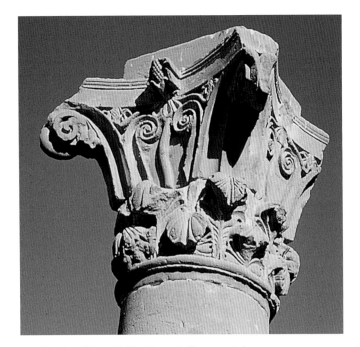

390. Dendara (Tentyris), East Fountain House, capital

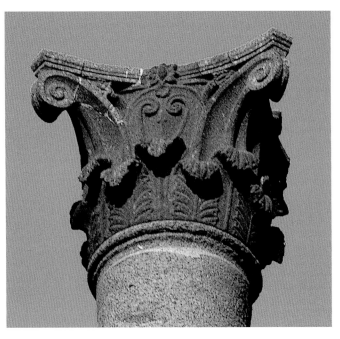

391. Alexandria, grey granite capital

392. At monastery of Apa Shenute (White Monastery) near Sohag, hardstone capital

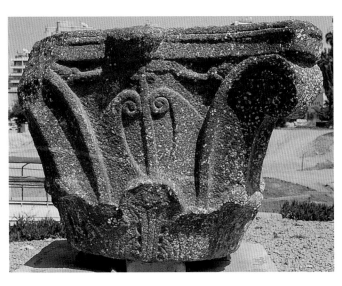

393. Alexandria, hardstone capital from a single column found underwater near the Lighthouse by Centre d'Études Alexandrines. Kom el-Dikka

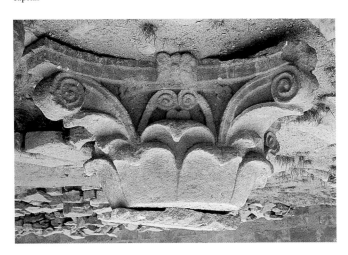

394. Temple of Amun at Luxor (Thebes), 'Imperial Chamber,' capital

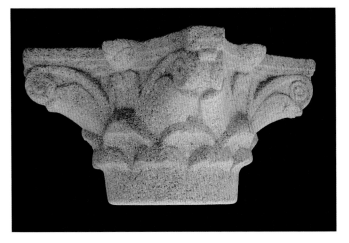

395. Alexandria, red granite capital found under water in eastern harbour by Institut Européen d'Archéologie Sous-Marine

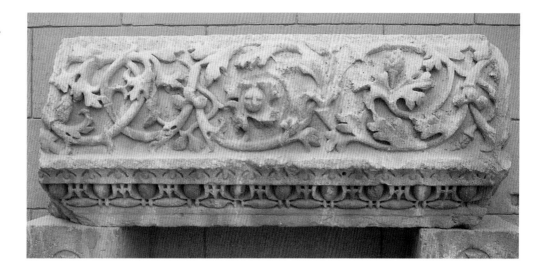

396. Akoris, frieze block apparently from the tetrapylon of AD 374. Cairo, Coptic Museum

Dionysias (Qasr Qarun)[12] and on the fortress of Babylon (Old Cairo).[13]

Continuity from Ptolemaic classical architecture is further illustrated by new Corinthian capital types which evolve and are characteristic of Egypt, including Alexandria. These are a direct development from the Ptolemaic ones because, like them, their helices and corner volutes spring separately from the collar of acanthus leaves. These new capital types are quite distinctive and occur at sites in Egypt very long distances apart. There are three types, which will be given here.

The first type [389a] occurs on the Fountain Houses at Tentyris (Dendara),[14] probably in the second or third century AD, whilst examples also survived in Alexandria[15] [390–391]. These capitals are characterized by plain helices with a raised outline, and a stem up the centre of the capital (between the helices) with a flower at the top and flowers on a long stem

on either side. This motif between the helices is reminiscent of details of the capitals from the Ptolemaic temple at Hermopolis Magna (el-Ashmunein) [77].

The second type [389b] can be illustrated by examples surviving at Hermopolis Magna, the monastery of Apa Shenute (White Monastery) near Sohag, and in Alexandria [392–393].[16] These are made of hard stone. They are characterized by the shape of their plain flat helices, which taper in sharply from a wide base, and the engraved surface decoration on the turnovers of their acanthus leaves. This treatment of the turnover on the acanthus leaves seems to be distinctive to Egypt.

The third type is often of hard stone [389c]. It is characterized by plain leaves pointing out at a sharp angle and simple narrow helices. This type is used in c. AD 300 in the 'Imperial Chamber' at Thebes (Luxor) [394].[17] There are

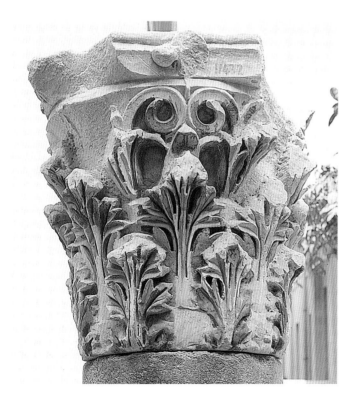

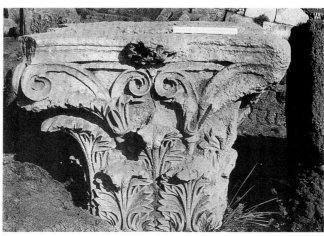

397. Alexandria, marble 'Normal' Corinthian capital. Greco-Roman Museum

398. Hermopolis Magna (el-Ashmunein), Komasterion, limestone 'Normal' Corinthian capital

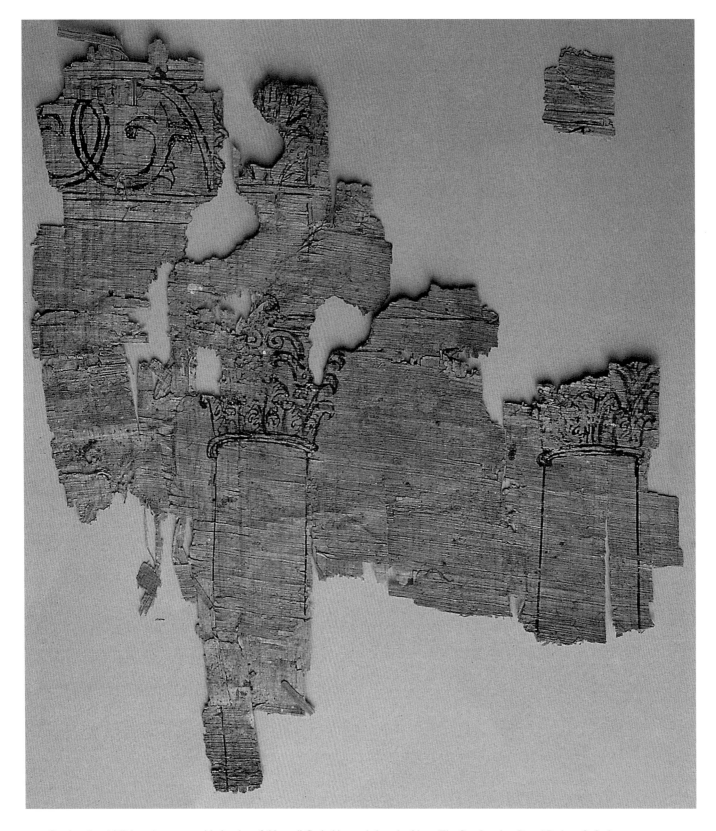

399. Oxyrhynchus (el-Bahnasa), papyrus with drawing of 'Normal' Corinthian capitals and a frieze. The Oxyrhynchus Papyri Project, Oxford

related examples in Alexandria [395].[18] An earlier example occurs on the temple of Serapis at Mons Claudianus, *c.* AD 118, where it is notable that the inscription to Trajan on the altar of AD 108/9 was dedicated by Apollonios who described himself as an Alexandrian architect.[19] The style of capital on Diocletian's Column in Alexandria is similar to this, but it has cauliculi like the Roman 'Normal' Corinthian capitals [354].

It should be noted that not only are each of these capital types remarkably consistent in style at sites very long distances apart, but also that each of them occurs at the sites up the Nile and in Alexandria itself. There is no distinction between the style of Alexandria and of the rest of Egypt. A similar situation will be observed with the 'Normal' Corinthian capitals which occur side by side with these capitals at sites along the Nile as well as in Alexandria.

The second strand of architectural decoration in Egypt in the second and third centuries AD [396–398] is similar to that which is ubiquitous throughout much of the Roman Empire, especially in the eastern Mediterranean, and continues into the fourth century. The 'Normal' Corinthian capitals which represent this strand are similar to those found at sites such as Ostia in Italy, Leptis Magna in North Africa, and Palestine.[20] They have the helix and corner volute springing together from a single sheath (cauliculus), observed on the typical Roman Corinthian capital type [127]. Examples in Egypt come from Antinoopolis (el-Sheikh 'Ibada) [262, 265], Akoris (Tihna el-Gebel),[21] Athribis (Tell Atrib),[22] Oxyrhynchus (el-Bahnasa),[23] Sohag, and Alexandria[24] [334, 397]. The examples from Hermopolis Magna (el-Ashmunein) occured on the Antonine Komasterion[25] [398], and the temple near the Sphinx Gate.[26] These examples from Hermopolis Magna are notable because they are carved of local limestone not imported marble, which means that they were made at the site itself. Their style is the same as the others, despite the different material.

A typical entablature for a Roman Corinthian order is more ornate than the Ptolemaic ones. It is decorated with rinceaux (floral scrolls) on the frieze, and acanthus leaves on the consoles on the cornice [118]. Generally few entablature blocks have survived in Egypt, perhaps because they were suitable for reuse as door lintels. However, when they have survived, they are similar to those used at other Roman sites in the eastern Mediterranean in combination with 'Normal' Corinthian capitals. A rinceaux frieze was supported by 'Normal' Corinthian capitals at Akoris, apparently on the tetrapylon [396].[27] Earlier examples of Roman rinceaux friezes in Egypt were found near the Serapeum site in Alexandria[28] [335], and on the theatre at Oxyrhynchus (el-Bahnasa) [279]. Typical Roman cornice blocks with acanthus leaves on the consoles were reused in the 'small theatre' in Alexandria [362]. An architectural drawing on a papyrus from Oxyrhynchus depicts a rinceaux frieze above 'Normal' capitals. It is dated to about the late first century AD [399].[29]

The fact that at Hermopolis Magna (el-Ashmunein) capitals are carved from limestone using a completely different technique to marble, which is harder, yet with an identical result, as well as the consistency of the style of the local capital types at sites very long distances apart, raises the question of how such quality control was achieved. Perhaps small model capitals were carried by workmen, as this consistency in three dimensions would not be possible merely from drawings. Examples of model capitals survive from the Ptolemaic period in the Egyptian style[30] which had similar uniformity of style and production quality at sites far from one another.

It is notable that while there are two strands of classical architecture in Egypt evidenced by the decorative details: one common in the rest of the Roman Empire, especially in the eastern Mediterranean, and the other continuing from the Ptolemaic classical architecture; buildings which were dedicated by Romans were built in both styles. Examples with local decorative features, such as capitals and cornices, include the temple of Augustus at Philae (13/12 BC) dedicated by the Roman prefect [286–288]. The quarries at Mons Porphyrites (Gebel Dukhan) and Mons Claudianus were operated by Roman troops, but the temple of Serapis at both sites is built in the local style of classical architecture. The Imperial Chamber in the former temple of Amun at Thebes (Luxor), which was decorated with wall-paintings of the Tetrarchs [297], was given local Corinthian capitals [394], rather than 'Normal' ones.

IMPLICATIONS OF THE ARCHAEOLOGICAL EVIDENCE

The fact that this local classical architectural decoration co-exists with the architectural style of the eastern Roman empire, rather than being replaced by it, indicates the strength of the local tradition. This continuity also explains why Ptolemaic features are later observed in the Late Antique architecture of Egypt.

Furthermore, both styles are observed at sites up the Nile as well as in Alexandria. The remarkable consistency of the architectural decoration at sites which are far apart is notable, as well as the lack of any archaeological evidence to indicate any distinction between the classical architecture of the rest of Egypt and that of Alexandria in the Roman period, from the first through to the fourth century AD. This conclusion is worth keeping in mind when the classical architecture in the fourth to sixth centuries AD in Egypt is considered (variously called Late Antique, Byzantine, or Coptic). It has generally been assumed that the classical architectural style of Alexandria of the fourth to sixth centuries, of which very little survives, was unlike that of the rest of Egypt as evidenced by the architecture surviving at sites along the Nile in the style commonly termed 'Coptic'.

PAPYROLOGICAL EVIDENCE FOR A TRADITION OF CLASSICAL ARCHITECTURE

The strong tradition of classical architecture at sites in the Nile valley is also confirmed by a detailed analysis of the references to buildings in papyri. The papyri provide some indication of city layout and building types and these have been confirmed by archaeological evidence (Ch. 7). Although the archaeological evidence suggests what public buildings in Roman Egypt looked like, the papyri give much more evidence for which specific buildings occurred in each city or town as they contain references to many buildings of which no other traces survive.

The papyri are the main written sources for the classical buildings of the sites up the Nile, rather than Alexandria for

which there are more historical sources. The Polish scholar Lukaszewicz has brought together the information in the papyri about classical public buildings in the cities and towns of Roman Egypt. He has collected references to: buildings concerned with administration, temples of the imperial cult, other public buildings such as gymnasia, theatres, hippodromes or circuses, *komasteria* or procession houses, *macella* and stoas, monumental structures such as fountain houses and tetrapyla, and baths.[31] He has deliberately excluded buildings such as Egyptian temples, propyla, and tombs. Thus, he has concentrated on the buildings which are characteristic of a Hellenized or Romanized society. At the end of his book Lukaszewicz has summarized this information arranged by building type, along with the date.[32]

If this information is rearranged by site, rather than building type, it becomes apparent that the sites, which in the Roman period had the greatest number of classical public buildings, are at or near the sites which later had the highest quality Late Antique carved architectural decoration (in the fourth to sixth centuries AD). These sites are:

First–third centuries	Fourth–sixth centuries
Memphis	Saqqara
Arsinoe/Krokodilopolis (Medinet el-Faiyum)	Herakleopolis Magna (Ihnasya el-Medina)
Oxyrhynchus (el-Bahnasa)	Oxyrhynchus (el-Bahnasa)
Antinoopolis (el-Sheikh 'Ibada) and Hermopolis Magna (el-Ashmunein)	Hermopolis Magna (el-Ashmunein) and Bawit
Panopolis (Akhmim)	White and Red Monasteries near Sohag

This evidence shows that because there was already local expertise in classical architecture in the Roman period conti-

nuity was possible at a local level of skilled workmen for carving architectural decoration on Late Antique buildings at nearby sites.

It is also notable that the numbers of classical buildings in towns along the Nile, recorded in the papyrological evidence, do not bear any relationship to their distance from Alexandria. The same picture has been observed in the consistency in the quality and details of architectural decoration of capitals and cornices.

CONCLUSION

The strength of the local classical architectural tradition of Ptolemaic Alexandria in the second and third centuries AD is shown by the fact that it was not replaced by the architectural style in use elsewhere in the Roman empire, but rather in Egypt coexisted with it. Both styles were used equally in Alexandria and the other urban centres in Egypt, reflecting a lack of division between them. Furthermore, the analysis of the evidence from papyri confirms the archaeological evidence of classical architecture throughout Roman Egypt.

This picture gives the background to explain how there were skilled local architects producing high quality architecture in the fourth to sixth centuries AD, as a continuation into the Late Antique period of the classical architectural tradition which goes, unbroken, directly back to that of Ptolemaic Alexandria. It had been assumed that the lost churches of Alexandria were different to those surviving in the Nile valley and the oases, and that any classical features on them were imported from Constantinople (rather than the result of local continuity). Thus, these new observations have serious implications for our perceptions about the development of ecclesiastical architecture in Egypt, considered in the following chapters.

Late Antique (Byzantine) Period

Introductory Summary

During the Roman period in Egypt, from its conquest in 30 BC through to the third century AD, Alexandria was the undisputed second city, after Rome, of the Roman empire. However, the situation becomes more complex after AD 330 when Constantinople (modern Istanbul) was made imperial capital of the East. Although not an imperial capital, Alexandria was equally important for other reasons. The Egyptian grain supply shipped from it provided the life blood of the new capital. Alexandria remained a trading port and a centre of learning. It also played a considerable ecclesiastical role with the city's wealth contributing to the power of its patriarch. Most importantly of all, for the consideration of its artistic legacy, is the fact that it was the only major city in the East with a continuous development of classical art and scholarship going back to the Hellenistic period.

This came gradually to an end after Byzantine rule in Egypt ceased with the Arab conquest of Alexandria in AD 642. The focus here is largely on the period, from the fourth to the seventh centuries, when Christianity flourished in Egypt and its aftermath.

The term Late Antique is used here in a general sense to cover this period as it creates fewer problems than the alternatives. The term 'Coptic' is often applied to the art and architecture of this period in Egypt. However, it can be misleading because it is often assumed to refer only to the period after the Church in Egypt became distanced from the Church in Constantinople in AD 451, even though the Coptic language dates from before then as does some of the material culture to which the term is applied. Another problem with this term is that it was used for the evidence from the rest of Egypt which was perceived as largely 'peasant' and different to that from Alexandria which was assumed to be more 'Byzantine'. However, the term Byzantine also has problems. Rather than merely referring to a period of rule (equivalent to the terms Ptolemaic and Roman as applied to Egypt), it is assumed to imply that a predominant influence was imported from the imperial capital Constantinople. The term 'Byzantine' is used here occasionally for convenience to refer to the period in Egypt from the establishment of the new imperial capital in the East (Constantinople) until the Arab conquest of Alexandria in 642. However, this term is chronologically imprecise because some scholars would not use it for such an early period of the history of the eastern Roman empire, but only for the period after the Arab conquest of parts of it.

Consideration of the Late Antique architecture of Egypt is concerned primarily with three aspects. The first two are interrelated: what the lost ecclesiastical architecture of Alexandria looked like, and how it related to architecture elsewhere in the Byzantine empire. The third and final aspect to be considered is the pictorial versions of Alexandrian architecture in large scale architectural panoramas. A brief outline of the main changes in the Roman empire from the fourth to seventh centuries provides the historical background. The changes in political power were largely in the West while, by contrast, the tensions in the East were more ecclesiastical.

During the third century, and especially under the emperor Diocletian (AD 284–305) and the 'Tetrarchy', Rome was abandoned as a major centre of government and the focus moved to the imperial residences of Trier and Milan in the West and Salonica (Thessaloniki), Nicomedia and Antioch in the East. Following the 'Great Persecution' of the Christians from AD 303–313, the greatest change occurred when they began to receive open support from Constantine, sole ruler of the West from 312. However, in the East the pagan Licinius remained emperor until 324 when he was defeated by Constantine who reunited the empire and became its sole ruler. In 325, the ecumenical council (meeting of bishops) at Nicaea (Iznik) confirmed officially the existing informal jurisdiction over their provinces of the bishops of Antioch, Alexandria, and Rome, with a special status for the bishop of Jerusalem. Constantine made Constantinople capital of the eastern empire in 330, and the Egyptian grain supply was sent there instead of Rome. The new role of Constantinople and its increasing importance led to the decision at the ecumenical council there in 381 to give primacy to the bishop of Constantinople after the bishop of Rome.

After Constantine's death in AD 337, and especially after the death of Julian 'the Apostate' the last pagan emperor in 363, the empire was largely ruled in two halves. In 395, the emperor Theodosius I gave his sons Arcadius and Honorius the eastern and western empires, respectively. During the following century and a half, the West was invaded repeatedly. In 402 Honorius had to move his capital from Milan to Ravenna, as it could be defended more easily. Rome was sacked in 410 by the Visigoths and in 455 by the Vandals. The Ostrogoth Theodoric ruled Italy from Ravenna from 497 to 526. Ravenna was the 'capital' of the West during the fifth and sixth centuries and its most prosperous city as it was the major trading port of western Europe for the eastern Mediterranean.

During the fifth and sixth centuries, the major changes affecting Egypt resulted from the tensions with Constantinople related to the Church. At the Council of Chalcedon, in AD 451, the Church in Egypt became distanced from the Church in Constantinople because of disagreements over Christology. The split became functionally final in 538 under the emperor Justinian when a separate Chalcedonian episcopate was established.

The Persians invaded Egypt in AD 619 and remained until 629. After Alexandria came under Arab rule in 642, the supply of grain to Constantinople ceased. By 654 Syria, Palestine, Cyprus, and Rhodes were also under Arab control. However, scholarship continued in Alexandria and it

remained a trading port because of its maritime location, while Cairo became increasingly important.

That Alexandria had many churches is indicated by written evidence. As virtually no archaeological remains survive of these churches, determining what they looked like is a problem. The keys to the solution might be expected to be provided by the extensive archaeological evidence for churches elsewhere in Egypt, but previous studies have rejected them as a reflection of those in Alexandria. Rather, because of the division between the Coptic Church and the one in Constantinople, it was thought that the churches elsewhere in Egypt would have been different to the lost Alexandrian ones and that these would have followed developments in Constantinople. Because Constantinople was the imperial capital, it was assumed that any artistic and architectural innovations would have come to Alexandria from it, rather than the reverse.

However, re-examination of the evidence, taking into account more recent discoveries, reveals a different picture. To undertake this, the written evidence for church building in Alexandria is presented first, followed by the extensive archaeological remains from the churches elsewhere in Egypt, from the fourth to seventh centuries. It was found that in the Roman period (in the first to third centuries AD) the classical architecture of Alexandria was indistinguishable from that elsewhere in Egypt in terms of types and designs of buildings and style of architectural decoration. There is no reason why this relationship could not have continued in the following centuries, and recent studies have discovered that the Church elsewhere in Egypt did not function in isolation from Alexandria. Thus, it is likely that the surviving church buildings in Egypt bear some relationship to the lost ones of Alexandria.

This evidence reveals architects with a considerable knowledge of church plans beyond Egypt, who erected churches which also have some distinctive local features. Architectural proficiency at a high level is indicated by the diversity of these designs, their size (often equal to major churches elsewhere), and the quality of their carved decoration. In addition, examination of the treatises and textbooks of mathematicians and *mechanikoi* (architects and engineers) related to building construction reveals a concentration of architectural scholarship and training in Alexandria.

Given the level of competence of architects in Egypt, attention then turns to examining whether they had any influence on architectural developments in Constantinople, in the light of these and other new discoveries. The earliest examples of some novel features are found to have survived in Egypt raising the possibility that they may have been invented there, before appearing in Constantinople in the first half of the sixth century. The evidence suggests that Alexandria may have played a major role in architectural innovation in the Byzantine period, as in the Ptolemaic period.

The final aspect to be considered concerns the pictorial manifestation of Alexandrian architecture in monumental architectural panoramas in both early Islamic and church wall-mosaics, and in Gospel manuscripts. The earliest of these scenes survive in Roman wall-paintings of the so-called Second Pompeian Style of the first century BC. Thus, the important issue, in the absence of pictorial evidence from Alexandria, is to determine whether the later versions evolved elsewhere, or if this pictorial tradition continued to develop in Alexandria (as is found to be the case).

Alexandrian Churches

Evidence for churches in Alexandria comes from a variety of ecclesiastical and historical sources. These provide information, such as when they were built, by whom, and to whom they were dedicated. From this data patterns in church construction can be detected. Papyri mention church buildings in Egypt as early as c. AD 300, and there is a distinct increase in the number of churches mentioned outside of Alexandria in c. 330–50. The rate of growth in Christianity in Egypt is also suggested from Christian names in documents with the main increase in them, notably, during the fourth rather than the fifth century.

According to tradition, Christianity was established in Alexandria by St Mark in the mid-first century AD. By the mid-fourth century his martyrium was a place of pilgrimage (located at Boukolou beside the sea in the eastern part of the city). The city's first cathedral, the church of Theonas built in AD 300–11 near the western edge of the city, was enlarged by Patriarch Alexander (312–28) to hold the expanding congregation. By c. 351 the cathedral was able to move to a prominent location in the city centre when it was erected in the enclosure of the city's main imperial cult temple, the Caesareum, under the emperor Constantius II. Tensions between the different Christian groups, as well as with the pagans, also led to the destruction and rebuilding of churches, such as this cathedral.

While Athanasius was patriarch (AD 328–73) many churches were erected in the city. It had at least twelve churches by c. 375 for which he or Epiphanius provide contemporary testimony. These included: the Caesareum, and/or the one in the former Hadrianon, the churches of Kyrinos, Theonas, Baukalis, St Mark, Pierios, Serapion, the Persaia, Dizya, and of Annianos. The church of Dionysius was a major church and apparently the episcopal residence, although its location is not known. The church at Mendesium (the church of Athanasius), on the coast in the eastern part of the city was completed in 371, and a church was built by Mother Theodora to the west of the city. The patriarch Timothy I (378–84) also built many churches and monuments.

At the same time as these churches were being erected some major temples continued to function, including the temple of Kore (Persephone), the Tychaion for the city goddess of fortune, and the city's most important pagan sanctuary the Serapeum. The final closure of the remaining temples occurred under the patriarch Theophilus (AD 385–412) with the support of the emperor Theodosius I (379–95), who banned the pagan practice of sacrifice elsewhere in 392. The end of pagan presence on the cityscape was marked in 391 by the destruction of the temple buildings of the Serapeum, located on the city's highest point.

On this hill Theophilus built the martyrium of St John the Baptist and the Arcadia church, named after Arcadius son of Theodosius I. Other churches were erected by Theophilus including a church in honour of Theodosius, one to Raphael on Pharos, the church of the Three Young Men (the Hebrews thrown into the furnace by Nebuchadnezzar), and one dedicated to Mary located to the east of the city. The temple of Dionysos was converted to a church in honour of Theodosius' son Honorius and also called the church of Cosmas and Damian. It is notable that, as these churches were built with strong imperial support, some of them were dedicated to the imperial family. Previously churches in Alexandria were dedicated to a patriarch or specific saints, usually as martyria. By the time Theophilus died, in 412, the city had at least twenty churches for which the names have survived.

Thus, a picture emerges of extensive church construction activity in the city during the fourth and early fifth centuries, especially under Athanasius and Theophilus. These churches were nearly all new buildings, not converted temples. Carving of new architectural decoration for Christian buildings in the city in this period is also indicated by locally-made capitals, including those reused in the mosques of Cairo.

By the time Cyril of Alexandria became patriarch in AD 412 the city was well-equipped with churches. He apparently built a great church in honour of the emperor Theodosius II. He took over the synagogues for use as churches, including one named after St George.

At the Council of Chalcedon in 451 the Church in Egypt, called the Coptic Church, became distanced from the Church in Constantinople. This led to a period of tension in Alexandria over whether its patriarch was a Copt (Monophysite) or a Chalcedonian (Melkite). During this time, resources were expended on the city's public baths and its water supply. Towards the end of the fifth century, when the Monophysites had the support of the emperor Zeno, churches were built by the patriarch Athanasius II.

The greatest change affecting the city's churches came in AD 538, under the emperor Justinian, when most of them came under sole Chalcedonian control. A separate Chalcedonian episcopate was established and the Coptic patriarch had to leave the city. The two main Coptic churches became the Angelion, built at the foot of the great staircase to the former Serapeum, and the Church of Cosmas and Damian. Other churches mentioned for the first time during the sixth century, without any indication of when or where they were built, include the churches of Saints Victor and Sarapammon, and those housing the bones of St Faustus, St Epimachus, and St Antony. The Chalcedonian patriarch Eulogius (581–608) rebuilt both the Church of Holy Theotokos (Mary), also called Dorothea, and the church of St Julian outside the city.

The Coptic patriarch Anastasius (AD 605–616) built more churches which led to the confiscation of the Church of Cosmas and Damian. Additional churches mentioned early in the seventh century before the Persian invasion of 619 include the Church of St Theodore in the east of the city, the Church of St Sophia near Pharos, and the Church of St Metra near the Sun Gate. Notably, the Theonas Church,

which was also the Church of the Virgin Mary, was still used by different groups – Copts as well as Gaianites – but not all at the same time.

After the Arab conquest of AD 642 the Angelion remained the Coptic cathedral. In 912 the Caesareum was burnt down, apparently for the final time, leaving Cleopatra's Needles marking the spot. St Mark's was destroyed in 1218. It is not clear when, after the Arab conquest, some of the city's other major churches went out of use, such as the churches of Theonas and of St John the Baptist. The current Chalcedonian cathedral church of St Sabas, located south of the site of the Caesareum, is the only church in the city today which could go back to the seventh century.

Church Buildings in Egypt

Having established that many churches were built in Alexandria, attention then turns to the remains of churches in Egypt which might give an impression of the appearance of these lost churches.

The continuity of classical architecture from the Ptolemaic and Roman periods is seen in major urban centres, such as Hermopolis Magna (el-Ashmunein) and Oxyrhynchus, where architectural sculpture was carved for both pagan and Christian buildings by the same, or closely related, sculptors, as illustrated by broken pediment niche heads. Because much of this decoration is dated to the third or fourth century AD it demonstrates continuity between the classical civic architecture of the cities of Roman Egypt of the first to third centuries AD and the churches of the fifth and sixth centuries.

Filling the previously assumed gap between these is helped also by recently excavated churches of the fourth and early fifth centuries. Notably, these have the characteristic elements of small and medium sized Egyptian basilical churches of the following centuries: a tripartite sanctuary with a straight east wall, and a transverse aisle. These features are found on fourth-century churches in the town of Kellis (Ismant el-Kharab). The two largest fourth-century Egyptian churches (56–60 m long) at Pbow (Faw Qibli, phase 2) and at Antinoopolis (el-Sheikh 'Ibada) are basilicas with a combination of local and imported features. They had five aisles like fourth-century examples in Rome (St Peter's Basilica and the Lateran Basilica). However, they are a local version with their outer side aisles narrower than the inner ones and a straight east wall, retaining the rectangular outer shape seen on Egyptian temples. By contrast, on the Roman examples the apse protrudes from the east wall.

In the fifth century a rectangular exterior was also used to enclose more complex and ornate interiors, creating distinctive plans. The churches of the monasteries of Apa Shenute and Apa Bishuy (the White and Red Monasteries) at Sohag near Panopolis (Akhmim) have a sophisticated triconch sanctuary with 'baroque' decorative niches. These have broken pediments and flat grooved modillions, showing continuity of the local classical architecture going back to the Ptolemaic period. At the same time, like Egyptian temples, these

churches have inward tapering exterior walls crowned by a cavetto cornice.

The size of the triconch on the Red Monastery is the same as those on the church near the Hathor temple at Dendara and on a church near Panopolis. This implies contact between their architects concerning their designs and knowledge of what size could be built reliably.

The White and Red Monasteries have a long narrow room along their south sides which is an unusual feature, but also found in Cyrenaica. This suggests that this might also have occurred in Alexandria – as the common centre between them. It raises the question of whether the overall plans of the triconch churches and rectangular exteriors were used for churches in Alexandria, especially as triconches are more common in Egyptian churches than elsewhere.

Architects in Egypt in the fifth and sixth centuries had a knowledge of church designs and features from a remarkably wide area of the empire, as reflected in the diversity of plans they built. Apses at either end of the narthex (the entry room along the west end), as in the Dendara church, are also found elsewhere, as in fourth-century churches in Cologne and Trier. The sixth-century tetraconch East Church at Abu Mina has a double shell design similar to S. Lorenzo in Milan, erected in the fourth century, while tetraconch churches particularly survive in Syria. The East Church at Abu Mina had an atrium (a colonnaded court) to its west. Although a feature more common in Europe, there was also one on the Church of Dionysius in Alexandria.

The proficiency of architects in Egypt is seen not only in their ability to erect churches to a wide variety of plans, but also is further indicated by their creation of local versions of them. Sometimes plans are made more complex by the incorporation of curved shapes, as in the triconch churches. This is also seen in the transept basilicas (cross-shaped basilicas with the long arm for the nave). These were built elsewhere, as in Greece and Asia Minor in the fifth and sixth centuries. Unlike them, those in Egypt have an apse at each end of the short arms of the cross, as on the large basilica at Hermopolis Magna (el-Ashmunein) and the basilica at Marea (Hauwariya). These two basilicas have some relationship to the Justinianic Church of the Nativity in Bethlehem, which is a similar size. Contacts between Egypt and Palestine are also suggested by the design of the circular church building and atrium at Pelusium (Tell el-Farama) (c. AD 450–550) which is related to that of the Constantinian Church of the Holy Sepulchre in Jerusalem.

The dimensions of the White Monastery, c. AD 440 (37 × 75 m), and of the basilical church at Pbow (Faw Qibli, phase 3), dedicated in 459, are very close to those of one of the cathedral halls at Trier, begun after 326, while their length approaches that of the Lateran Basilica in Rome (with its 75 m long nave). As these Egyptian churches are of similar scale to those of other major cities of the empire, it is not unreasonable to assume that churches of this size were found in Alexandria in the first half of the fifth century, as well as even larger ones, and with the rich variety of plans seen elsewhere in Egypt.

The question then arises of the architectural style of the Alexandrian churches. Carved decoration survives from some of the churches mentioned, and the well-preserved examples on the churches in the monasteries of Bawit and Saqqara are of particular interest. Although the South Church at Bawit is small, its limestone decoration is striking. Closely related pieces were also found at Saqqara, 270 km to its north, near the old Egyptian capital of Memphis (near modern Cairo). The decoration at Bawit and Saqqara is remarkable not only because of its similarity despite the distance between the two sites, but also its high quality. It includes new features which were thought to appear first in Constantinople under the emperor Justinian (AD 527–65), most notably some types of impost capitals such as fold- and leaf-capitals. However, details of these Egyptian examples suggest that they were perhaps developed there.

The carved limestone ornament was brightly painted, as was the timber. Interiors of Alexandrian churches could have been further embellished with wall-paintings and mosaics. This is suggested by more expensive churches, as at Abu Mina, which had glass wall-mosaics, marble wall-veneer and coloured stone ('marble') *opus sectile* floors. Glass mosaics decorated the apse of the Main Church at Saqqara, which also had coloured glass windows.

Thus, from the plans and decoration surviving from churches in Egypt an impression begins to form of how the churches of Alexandria might have looked.

Architectural Scholarship and Education in Alexandria

The evidence for architectural scholarship comes from the writings of *mechanikoi* (architects and engineers) and mathematicians giving calculations related to building design and construction. These indicate a concentration of architectural knowledge centred in Alexandria, where their authors taught or studied. This knowledge continues to be taught in the city into the sixth century AD and it is notable for mathematics related to curved structures (vaults, domes and semi-domes).

The earliest detailed work from Alexandria with calculations relevant to building is a manual recorded by Didymus of Alexandria in the first century BC for quantity surveying, which involves calculating the quantities of materials to be ordered for buildings. The famous manual of the Roman architect Vitruvius, written in c. the 20s BC, has much simpler mathematics than the later works because they involve more curved shapes.

Heron of Alexandria is the *mechanikos*, active c. AD 62, who was skilled in applied mathematics and mechanics. The breadth of his knowledge is seen from his works, ranging from mirrors to land surveying and mechanics, war machines and pneumatics, and miraculous devices in temples. The latter three follow in the tradition going back to Ctesibius in the third BC. Heron's competency in mathematics and its application to building, especially those involving curved shapes, is seen in his geometrical and mensurational books. These remained in use through the centuries with additional examples being added to them. His *Metrica* includes calculations for vaults and semi-domes. His *Stereometry* has calculations for quantity surveying for virtually any part of a

building in nearly any shape. It is particularly concerned with those for domes and semi-domes (i.e. parts of spheres), and even domes on pendentives. Although, it is not Heron's work in its present form, more of it may go back to Heron than has been appreciated because *Sphaerica* of the mathematician Menelaus of Alexandria, who was active *c.* AD 98, involves calculations for triangles on a sphere, indicating complex calculations for curved surfaces by this date.

Skill in mathematics continued in Alexandria through the third century AD with the work of Diophantus of Alexandria in problems involving unknown quantities in his *Arithmetic*, and Anatolius of Alexandria in arithmetic, geometry, physics, and astronomy. Early in the fourth century Pappus of Alexandria notes that *mechanikoi* were skilled in both the theoretical and applied sides of geometry, arithmetic, and construction, as well as other subjects. Mathematical scholarship and teaching were continued in the city later in the fourth and into the fifth century by Theon of Alexandria and his daughter Hypatia.

Early in the sixth century when Ammonius taught in Alexandria it was a more major educational centre than Athens. Eutocius, who dedicated one of his commentaries on geometry to Ammonius, taught mathematics and philosophy, apparently in Alexandria. He knew the two architects of H. Sophia who were his teacher (Isidorus of Miletus) and his friend (Anthemius of Tralles). Because the most novel feature of this building, erected in AD 532–7 by the emperor Justinian, was its large dome on pendentives it is notable that the traces of their written works indicate their competency in the geometry of curved shapes, mechanics, and their practical application. In addition, according to Procopius, Chryses of Alexandria, who was a contemporary of Anthemius and Isidorus and worked for Justinian, was at least their equal, if not greater, in skill as seen from his design of the dam at Dara using a horizontal arch.

Architectural Influence of Alexandria

The consideration of the architecture of Late Antique Egypt in a broader context especially involves how it relates to that of the imperial capital, Constantinople. This is especially pertinent in light of Alexandria's role as a centre of architectural scholarship and education into the sixth century AD, and of the contacts of mathematicians and *mechanikoi* there with those in Constantinople.

The little evidence which survives of buildings in Constantinople in the late fourth and fifth centuries indicates that these involved a continuity of the classical forms of Roman architecture seen in the Greek cities of the coast of Asia Minor. The only fifth-century church in the city which is largely still standing, St John Studios (*c.* AD 450), is a traditional basilica with a tiled timber pitched roof, while its marble decoration shows some developments from earlier classical orders.

By contrast, because H. Sophia (built in AD 532–7) has striking new features, seen in its marble decoration and monumental dome on pendentives, it was thought to represent a revolution in Byzantine architecture in Constantinople under the emperor Justinian (527–65). However, in the 1960s the remains were excavated there of the large church of St Polyeuktos, completed before 527 (i.e., shortly before the reign of Justinian). It has features which were thought previously to have been introduced into Constantinople only later, under Justinian, such as some types of impost capitals. These include lotus-panel capitals, which have elements found in Egypt. Because there are no predecessors in Constantinople for the unusual motifs in the exquisitely carved marble decoration on this church, their origin has remained a mystery, unlike their interpretation (alluding to Solomon's Temple). It is shown here that good parallels for them are found in the architecture of Late Antique Egypt and, most importantly, at an earlier date. The carved marble decoration on H. Sophia is less innovative than that on St Polyeuktos.

The church of Saints Sergios and Bakchos, which was built in Constantinople at the same time as H. Sophia or slightly before, has some features of both its plan and decoration which show local continuity while it also has other aspects which are new. These new features include melon- or fold-capitals, which have their closest parallels in earlier architecture in Egypt. This church adjoined the palace where Monophysite priests and monks resided for a time under the protection of Justinian's wife Theodora, who had connections with Alexandria. The developments in the churches of St Polyeuktos and of Saints Sergius and Bakchos suggest influence of the architecture (or architects) of Late Antique Alexandria and Egypt on architecture in Constantinople.

The most striking feature of H. Sophia is its monumental pendentive dome. This type of dome involves placing a dome on a square base. The resultant spherical triangles which run down into the corners of the sides of the cube are called pendentives. The mathematics associated with such shapes goes back to the treatises of Heron and Menelaus in Alexandria, in the first century AD. The earliest surviving masonry dome with continuous pendentives is the small one in the baths-building at Petra, dated to the first century BC.

It is the use of pendentives on a monumental scale which distinguishes the pitched brick dome of H. Sophia from earlier surviving examples. Large concrete domes were built in Roman architecture from the second century AD but on a circular plan, while pitched brick was used for them from the fourth century AD. Previously, pitched brick was used for vaulting in Asia Minor, Mesopotamia, and Egypt. Only concrete or pitched brick (unlike masonry or timber) was suitable for large pendentive domes. A dome with continuous pendentives (rather than one on a circular or polygonal base) is the best design to avoid the problem of radial cracking in large domes made of rigid material – knowledge of which was lost until modern times. Pictorial evidence in a mosaic in Jerash in Jordan suggests that there was a major building in Alexandria with a monumental dome with pendentives by AD 531, i.e. before the one on H. Sophia was constructed. This suggests that the one on H. Sophia, although the earliest surviving example, was not necessarily the first example to be built on a monumental scale.

The fact that some features of the architecture of Late Antique Egypt subsequently occur in Constantinople raises the possibility that Late Antique Alexandria may have been the source of some architectural innovations. Because St Polyeuktos incorporates details so similar to those found in the earlier limestone architecture of Late Antique Egypt it is not unreasonable to conclude that with its high quality marble decoration St Polyeuktos preserves an indication of the architecture of major churches of Alexandria which might have been more expensive (and sometimes larger) than those surviving elsewhere in Egypt. A wide variety of impost capitals are subsequently spread throughout the Byzantine Mediterranean from Constantinople, under Justinian. Monumental pendentive domes become one of the most impressive features of later Byzantine and Islamic architecture.

Artistic Influence of Alexandria

The depiction of Alexandrian architecture is seen on the walls of houses in first-century BC Italy in paintings of the so-called Second Pompeian Style. Related monumental schemes of decoration are found in the wall-mosaics of major Byzantine and early Islamic buildings.

Architectural compositions are depicted in the domes of Christian buildings in Salonica (Thessaloniki) and Ravenna in the fifth century. The architectural scenes in the Orthodox Baptistery at Ravenna in Italy appear to be derived from those in the Pompeian wall-paintings. By contrast, the scenes depicted in St George's in Salonica, in northern Greece, incorporate details not seen in the Pompeian wall-paintings but rather which are used in Late Antique architecture in Egypt. This means that the scenes in St George's are based apparently on versions which must have developed in Late Antique Alexandria.

Related scenes are also depicted in the Great Mosque in Damascus (AD 705–714/15) and in the Church of the Nativity in Bethlehem (1169). These mosaics have details in common with those in the Dome of the Rock in Jerusalem, which predated them (691).

Recently discovered archaeological evidence has revealed that churches in Syro-Palestine and Egypt were decorated with wall-mosaics in similar colours to the distinctive combination later used on the mosaics of the Dome of the Rock: a gold background with patterns in shades of blue and green with red highlights and much use of mother of pearl. The iconography of its mosaics shows local continuity of classical motifs combined with some Sassanian elements. Although its distinctive octagonal design, with a gilded wooden dome visible above it, and decoration incorporate features already used in Syro-Palestine and Egypt, the result is a distinctly Islamic building.

The mosaics in the Great Mosque in Damascus, built shortly after the Dome of the Rock, show continuity of the local mosaic technique already used in it. The scene in the Great Mosque of most relevance here is the landscape panorama in its courtyard consisting of scenes of cityscapes, trees, and monumental architecture. Its striking similarity to Pompeian wall-paintings has generally been accepted. However, what has not previously been noted is that these scenes include details which suggest that they are not directly descended from the versions in the Pompeian wall-paintings, but from more recent examples. As in St George's in Salonica (Thessaloniki), details of built architecture from Egypt are incorporated which are more recent than the Roman wall-paintings, such as a broken pediment framing a conch. In addition, details are included which are also found in other later pictorial versions, as in Gospel manuscripts.

Gospel manuscripts are illustrated with versions of the genre of architectural scenes depicted in Second Style Pompeian wall-paintings. This gives this iconography a long continuity in the East. The distinctive circular building (tholos) is most frequently depicted in Gospels of the eastern Churches, especially Armenian and Ethiopian examples (as late as AD 1401), although there are two Carolingian examples. These tholoi are notable for how close they are to those found in the Roman wall-paintings, with even the same colours used for the same parts of the tholos. At the same time, their details suggest the development of a number of intermediary examples (derived from those in the wall-paintings) at a central location prior to their dispersal. The most likely place is Alexandria.

The deliberate allusion to Alexandria by the use of particular architectural compositions is also suggested by the distinctive broken pediment framing a conch in scenes of saints associated with Egypt on both manuscripts and ivories.

The final example to be considered is the use of Alexandrian architectural scenes in the wall-mosaics of the Crusader redecoration of the Church of the Nativity in Bethlehem in AD 1169. The technique of these mosaics is a continuation of the local mosaic workmanship seen in the early Islamic monuments mentioned, and also indicated by the church's recently cleaned inscriptions. The iconography of its architectural scenes is partly derived from versions related to those in the Orthodox Baptistery in Ravenna, even if the details have evolved over more than half a millennium.

The architectural scenes in the Church of the Nativity, like those in the Orthodox Baptistery and in the Second Style Pompeian wall-paintings lack figures, but not because of an aversion to the figured form but rather for a deliberate iconographic reason – that they would appear to be representing paradise. This is possibly also the reason for the absence of figures in the scenes in the Great Mosque in Damascus. Thus, the continuity of the Alexandrian architectural panoramas is not just in the form but also in their meaning, which is retained even when they are used by different religions.

CHAPTER 10

The Churches of Late Antique Alexandria: the Written Sources

(Judith McKenzie and A.T. Reyes)

For the churches of Alexandria far more evidence survives from written sources than material remains. By contrast, there is considerable archaeological evidence for church architecture elsewhere in Egypt. Before it can be used to provide information, lacking in the written records, about what the Alexandrian churches looked like, the chronological relationship of these two types of evidence needs to be established. Hence, the dates and extent of church building activity in Alexandria need to be ascertained from the written sources, while the chronology of the archaeological evidence elsewhere in Egypt is re-examined in the next chapter. Only then, can it be used as a valuable indication of the distinctive designs and decorative details of the lost churches of Alexandria.

There are over fifty Roman, Byzantine and Coptic historical and ecclesiastical sources with passing references to buildings, especially churches, in Alexandria. These sources range from the testimony of contemporary Alexandrian ecclesiastical writers, such as Athanasius, to later historics based on earlier sources which have often been lost. The local Egyptian sources, sometimes preserved in Coptic, Syriac or

Arabic versions, often provide reliable topographical information, even when they include miraculous events. The relative reliability of the sources needs to be kept in mind when using them.

Although they do not include descriptions of the city's churches, and rarely their locations, these sources give a considerable amount of other information about these churches: whether they were converted from temples or new foundations, when they were built or rebuilt, who organized this, who paid for them, and to whom they were dedicated. Analysis of this information reveals patterns in these aspects and the main periods of church construction.

EARLY GROWTH OF CHRISTIANITY IN EGYPT

A brief indication should first be given of the evidence surviving for the early development of Christianity in Egypt to provide some background. St Mark is traditionally credited with evangelizing Alexandria during his visits there in the middle of the first century AD, when he converted Anianas

400. Alexandria, Late Antique city, plan of archaeological remains

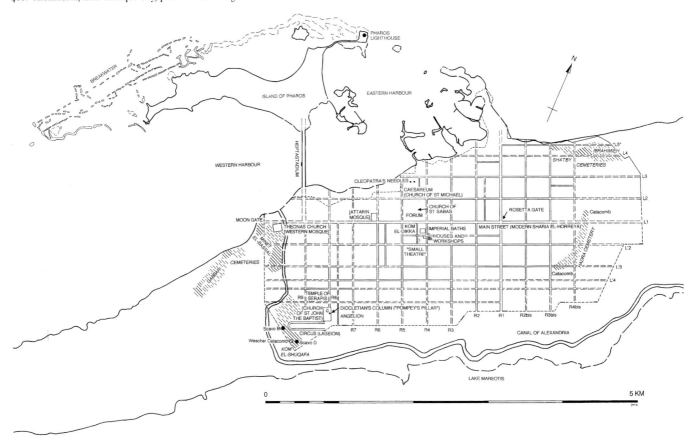

401. Ivory panel depicting St Mark with Anianas mending his sandal. Milan, Civiche Raccolte d'Arte Applicata, Castello Sforzesco

402. Ivory panel depicting St Mark baptizing Anianas who became the first bishop of Alexandria. Milan, Civiche Raccolte d'Arte Applicata, Castello Sforzesco

(Annianus) who became the first bishop in *c.* AD 62 [401–402]. This tradition is recorded by the church historian Eusebius of Caesarea writing in the early fourth century.[1]

There is a lack of reliable contemporary information on the development of Christianity in Alexandria until *c.* AD 175 when its famous Catechetical School emerged from obscurity. This increased prominence of Christianity led to its persecution by Septimius Severus in 202, when Clement fled and was succeeded by Origen as head of the school.[2] This assertion of paganism was reflected in the major rebuilding of the temple of Serapis (the Serapeum) by 217 [350]. The attacks on the Christians in Alexandria during the first half of the third century culminated in those by Decius in 250 (when Origen was persecuted at the Serapeum) and a few years later, in the last years of Valerian's reign.[3]

His son Gallienus issued an edict returning the 'places of worship' to Dionysius of Alexandria (d. AD 264), and giving his bishops freedom to practise their ministry.[4] The rest of the century was relatively peaceful for the Christians, although later in it Alexandria suffered repeated occupations. While Theonas was head of the Catechetical School (282–300) Christians held administrative posts, and were even considered potentially suitable for the post of palace librarian for which a knowledge of classical literature was specified.[5]

This period of increased freedom of worship led to the emperor Diocletian, in AD 303, 'commanding that the churches be levelled to the ground and the scriptures burnt', according to the church historian Eusebius, writing soon after. So great were these persecutions that the Coptic

Church later dated the Era of the Martyrs, and the beginning of its calendar, from the beginning of Diocletian's reign in 284. The persecutions were continued by Galerius (305–11) and Maximinus Daia.[6]

Our knowledge of the growth of Christianity elsewhere in Egypt in the second and third centuries AD comes mainly from the papyrological evidence. Some Christian manuscripts survive from the second century which reflect the spread of Christianity outside of Alexandria. They were found at sites such as Oxyrhynchus, and include fragments of the Gospels of Matthew, Luke and John from papyrus codices (with pages like modern books, rather than scrolls).[7] The earliest surviving official text mentioning a Christian is a papyrus from Arsinoe (Medinet el-Faiyum) which indicates that a Christian could stand for minor public office there in the early third century AD. Eusebius indicates there were Christians at Antinoopolis (el-Sheikh 'Ibada) at about this time, and that a conference was later held at Arsinoe by Dionysius for the presbyters and teachers from the surrounding villages. Papyri mention two church buildings (*ekklesiai*) by *c.* AD 300 at Oxyrhynchus, and one by 304 in the nearby village of Chysis. During the period *c.* 330–50 there was a very noticeable increase in the number of papyri indicating churches in the rest of Egypt.[8] During the fourth century, the monasteries were instrumental in the spread of Christianity in rural areas and came to play a major economic role in these areas by the fifth century.[9]

The increase in the number of identifiably Christian names used in documents has been used as a basis for attempting to estimate the rate of Christianization of the population. Although the sample is limited by the selection of documents which have survived, these possibly provide a rough indication of the minimum percentage of the population who were Christian. These figures indicate that by *c.* AD 312 the percentage of Christian personal names would have been about eighteen percent, and this number at least doubled by *c.* 334. By *c.* 428 it reached sixty-six per cent. Thus, the main increase was during the fourth and early fifth centuries, with the greatest speed of change in the first half of the fourth century. There has been debate about the extent to which these figures can be increased to reflect Christians without Christian names (especially converts), and thereby to give a more accurate reflection of the rate of Christianization. In the early eighth century only sixty-nine per cent of Christians had Christian names, so that by the time the two-thirds of the population had Christian names (*c.* 428) it could have been nearly completely Christian.[10]

CHRISTIAN TOMBS IN ALEXANDRIA

Although churches have not survived in Alexandria from the fourth to sixth centuries, other archaeological evidence for Christianity there has survived, consisting mainly of paintings and inscriptions in tomb complexes in the ancient city's main cemeteries [400]. The most impressive of these was the painting in the so-called Wescher (or Karmouz) Catacomb, found in 1857 south-west of the Serapeum hill, in an area

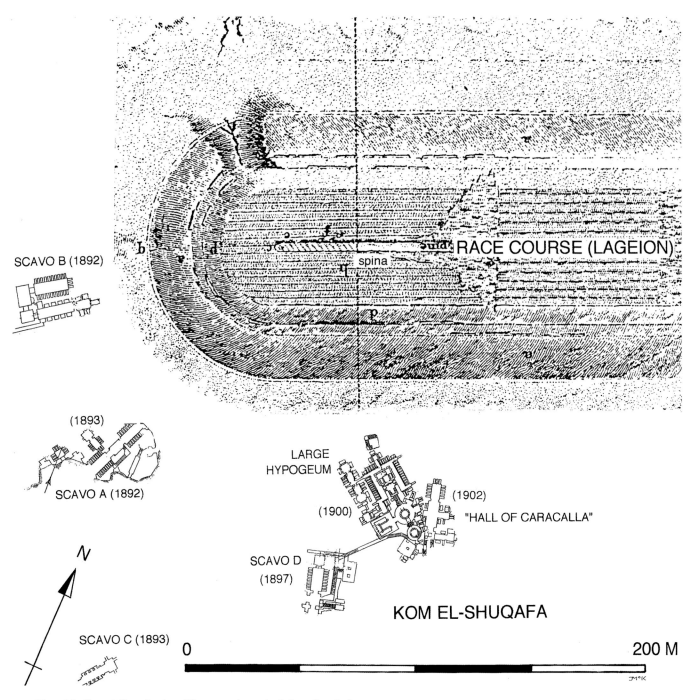

403. Alexandria, Kom el-Shugafa, plan of Roman tombs south of circus (Lageion)

with other hypogea reused by the Christians, such as Scavo B and Scavo D [403]. This painting depicted three scenes forming a eucharistic cycle [404].[11] On the left was the wedding at Cana, in the centre the multiplication of the loaves and fishes, with Peter and Andrew on either side of Christ, and on the right reclining figures described in the inscription above them as 'eating the gifts of Christ'. The painting included partially clad women, who would usually be associated with pagan art. It is possibly dated as early as the third or fourth century AD, while its sketchy naturalistic style is reminiscent of the earlier tomb paintings of Persephone's abduction by Hades [344]. The Wescher Catacomb also had other depictions of Christ and the saints.

Simpler paintings and inscriptions have also been found in tombs which were reused by Christians to the west of the city near the site of the Western Mosque, and further west at Gabbari [405] and Mafrousa,[12] as well as to the east of the city at Hadra and Shatby.[13] Christian wall-paintings of the Madonna and Child, dated to the first half of the sixth century [406], were found in the courtyard of House D at Kom el-Dikka [374], which had Christian graffiti in its upper floors.[14]

404a–b. Alexandria, Wescher Catacomb, watercolour of painting in apse depicting the wedding at Cana, the multiplication of loaves and fishes, and eating the gifts of Christ; and plan and sections of tomb

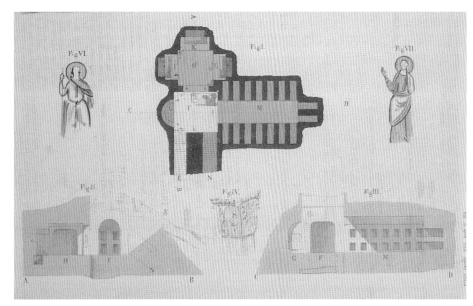

405. Alexandria, Gabbari (Fort Saleh), Tomb VII, painted niche in east wall

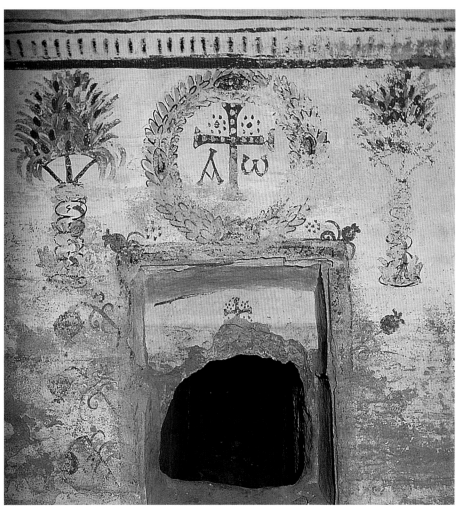

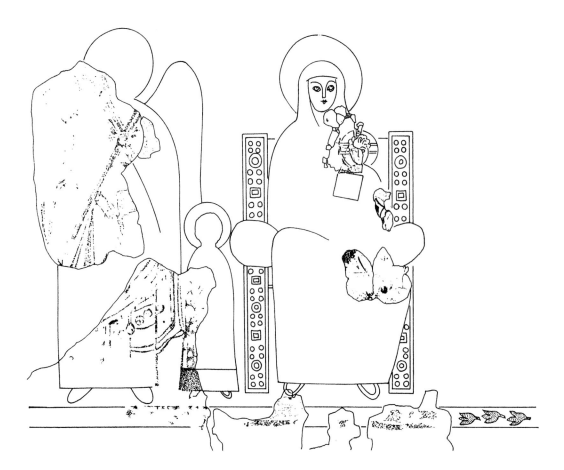

406. Alexandria, Kom el-Dikka, reconstruction of wall-painting in courtyard of House D

EARLIEST CHURCHES IN ALEXANDRIA, BEFORE AD 328

The earliest churches mentioned in Alexandria by name are the martyrium of St Mark to the east of the city and its first cathedral, the Church of Theonas, to the city's west. The *Acts of St Mark* describe the martyrdom of St Mark. Although these were recorded much later, and their reliability is still uncertain, they provide some topographical information worth mentioning.[15] According to them 'a church (*ekklesia*) was built in the area beside the sea under crags called Boukolou',[16] and after St Mark was killed by the pagans his remains were deposited 'in a place (*topos*) hewn out of rock and held in esteem' which was 'located in the eastern part [of the city]'.[17] The *Acts of St Peter* also provide useful information, although later additions were made to the original fourth-century version. These indicate that the commemorative chapel (*martyrion*) and underground tomb (*taphos*) of St Mark were at Boukolou and that the Church of Theonas functioned as the cathedral, when the patriarch Peter I was martyred in AD 311.[18]

The Church (*ekklesia*) of Theonas was built by the patriarch Peter I (AD 300–11) and named in honour of his predecessor. It is described as constructed in the west of the city, near the cemeteries,[19] where there would have been space for a new building. Like the first Constantinian churches in Rome[20] it was a new structure, rather than one created by converting a temple. The written sources indicate it was built on the site where the Western Mosque (Gama el-Gharbi), also called the Mosque of One Thousand Columns, later

stood until the nineteenth century [407].[21] This mosque was in the area at the western edge of the city where there were some Christian cemeteries (inside the walls of the Ptolemaic and Islamic city) [400]. It had many Christian column capitals and shafts reused in it [408–409].

An agreement allowing freedom of worship for all religions was made in Milan in AD 313 between Constantine and Licinius. However, Licinius who was anti-Christian remained emperor in the East until 324, when Constantine overthrew him and became sole emperor, ruling until 337.[22] The Church in Egypt and Libya was sufficiently well established for its hierarchy to be formally recognised at the Council of Nicaea in 325. Authority over the provincial bishops was given to the bishop of Alexandria, who will be referred to here as the patriarch to avoid confusion.[23]

Constantine I sent Eulogius with twenty thousand soldiers to Alexandria, and up the Nile, burning and destroying the temples, and building a number of churches, according to the account of the Coptic martyrdom of Eulogius' brother Macarius of Antioch. However, the extent of the destruction of temples is exaggerated, as some continued in use. In AD 319/20 buildings in Alexandria were also damaged by the 'most violent earthquake [which] shook Alexandria, with many houses collapsing and considerable loss of life'.[24]

According to John of Nikiu, an Egyptian bishop in the late seventh century, it was with Constantine's support that the first conversion of a major temple to a church occurred in Alexandria, when its main imperial cult temple, the Caesareum, was converted to a church. It was called the Church

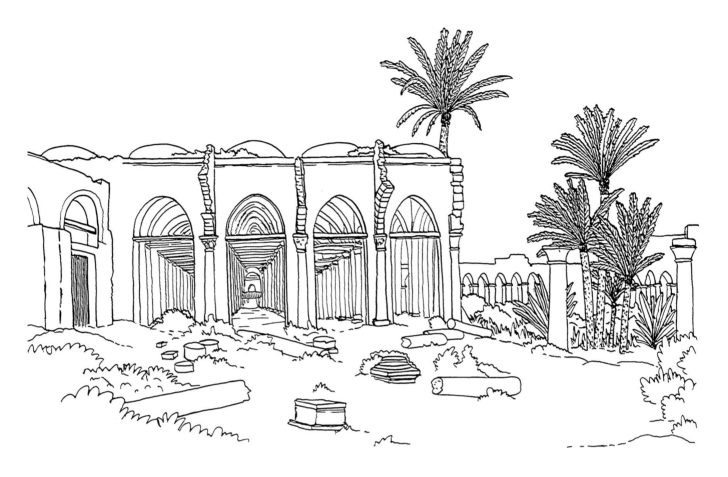

407. Alexandria, Western Mosque on site of Theonas Church in 1785

408. Alexandria, Western Mosque, one of two Christian grey granite columns re-erected in front of the Faculty of Arts of Alexandria University

409a–b. Alexandria, Western Mosque, sketch of relief decoration on the columns in fig. 408, with Christ's monogram and cross

of St Michael while also retaining its old name, the Cae-
sareum. Eutychius of Alexandria later specifies that this
occurred while Alexander was patriarch (i.e. by AD 328), but
some modern scholars prefer to attribute the first church in
the Caesareum to Constantius II (337–61).[25]

The patriarch Alexander (AD 312–28) built a larger version
of the Theonas Church 'which was then considered very
large' because the other places were too small, according to
his successor Athanasius.[26] This was possibly Constantine's
main contribution to church building in Alexandria. The
'Church (ekklesia) of Baukalis', which is also mentioned in
the time of patriarch Alexander, was the church at which
Arius was presbyter.[27] It is sometimes suggested that this was
the church associated with the martyrium of St Mark at
Boukolou, based on the assumption that the two terms,
'Baukalis' and 'Boukolou', are the same, but there is no philo-
logical basis for this.[28]

ATHANASIUS, AD 328–73

Patriarch Alexander was followed in 328 by Athanasius. The
growth of Christianity by the time he became patriarch is
reflected in the number of bishops. Egypt had at least about
fifty, with the total for Egypt and Libya possibly one
hundred.[29] The need for church buildings for expanding con-
gregations in Alexandria is seen in the writings of Athana-
sius which include many references to churches in the city.
His testimony is important as it provides contemporary proof
of the existence of the churches he mentions, as well as often
giving information about the circumstances of their con-
struction and/or rebuilding.

Friction between Athanasius and the followers of Arius,
the Arians (who sometimes had imperial support), led to
attacks on church buildings, as well as Athanasius being
exiled five times.[30] He conducted many baptisms in the
Church of Theonas before he fled in 339.[31] Two churches are
first mentioned at this time because of damage to them – the
Church of Kyrinos (or Cyrinus in Latin) which was attacked
by the Arians led by Gregory,[32] and the Church (ekklesia) of
Dionysius to which their opponents, the followers of Athana-
sius, set fire. This was apparently a major church, and it was
not permanently destroyed because it is mentioned again
later by Athanasius. If, as its name might suggest, it was built
by Dionysius, 247–64, it would have been the oldest church
in Alexandria,[33] although the possibility remains that St
Mark's might have been older.

According to Epiphanius who was describing events within
his lifetime, Gregory (AD 341–4), with the support of the
Arian emperor Constantius II, had 'that which was once the
Hadrianon, which was later the Licinian Gymnasium and
then a palace (basileion) . . . built as a church'. Some scholars
consider that this is referring to the Caesareum, which
Epiphanius mentions just before it.[34] The 'Hadrianon' (sic) is
known from coins of Roman Alexandria on which it is
labelled and depicted [313].

In AD 346 Athanasius returned to Alexandria. The Great
Church, in the enclosure of the Caesareum, was built by

Constantius II for use as the cathedral. It was not completely
finished in c. 351, when it was used at Easter by Athanasius,
because the other churches were too small to hold the large
number of Christians. Consequently, as it had not been ded-
icated, he incurred the wrath of Constantius II.[35] The size
and construction time indicate that it was a new construction,
not just part of the old temple complex converted. It was
completed by 356 when it was pillaged by the pagans at the
instigation of the Arians. They seized 'the benches and the
throne, and the altar which was of wood, and the curtains'
and 'burnt them in front of the porch (pylon) in the Great
Plateia'. This suggests that the precinct in front of the church
extended to the main east-west street, the plateia [400].[36]
Notably, Cleopatra's Needles remained standing to the north
of the church. They are possibly the two obelisks visible in
the ivory in [401].

The city's two main older churches continued in use. The
martyrium of St Mark is mentioned as a place of pilgrimage
in the mid-fourth century, along with that of St Peter in
Rome, and the Church of the Holy Sepulchre in Jerusalem.
Later in the century the narthex of the Church of St Mark
was used as a place for visitors to sleep.[37] The Church of
Theonas is also mentioned, when it is referred to in Latin as
a basilica.[38]

When the Arian George became patriarch in AD 357, the
Church of Dionysius was apparently the site of the episco-
pal residence, as was also the case later when, in 366, it was
occupied by Athanasius and had an atrium and upper floors.
There is no indication of where in the city it was located.[39]
Constantius II gave the deserted Mithraeum to the Church
of the Alexandrians, and as George wished 'to erect a church
on the site of it' he attempted to clear it out, including the
innermost sanctuary, the adytum, in 361. This provoked the
pagans so badly that the Christians had to desist, and George
was killed.[40] After his death, the pagan emperor Julian the
Apostate (361–3) demanded all the books from George's
library, which was 'very large and complete'.[41] This indicates
that there were important private libraries during this period,
and that there was a common body of classical scholarship
valued by both pagans and Christians.

In AD 362 Julian the Apostate attempted to restore pagan-
ism. He paid for the reopening and repair of the temples. He
transferred the Nilometer back to the Serapeum as Constan-
tine had previously ordered it moved to a church.[42] Under
Julian the church in the former 'Hadrianon' was burnt down,
but it was rebuilt by Athanasius. Conflict with the pagans led
to the Caesareum being burnt down, in 366. It was rebuilt
two years later, in 368, once imperial permission had been
obtained.[43]

In AD 369 Athanasius began a church in 'Mendesium'
which was finished in 371, having taken three years to build,
and which afterwards was called the Church of Athanasius.[44]
According to John of Nikiu, it was beside the sea and in the

410. Alexandria, Roman temple of Serapis complex after erection of
Diocletian's Column in AD 298, axonometric reconstruction (Sheila Gibson)

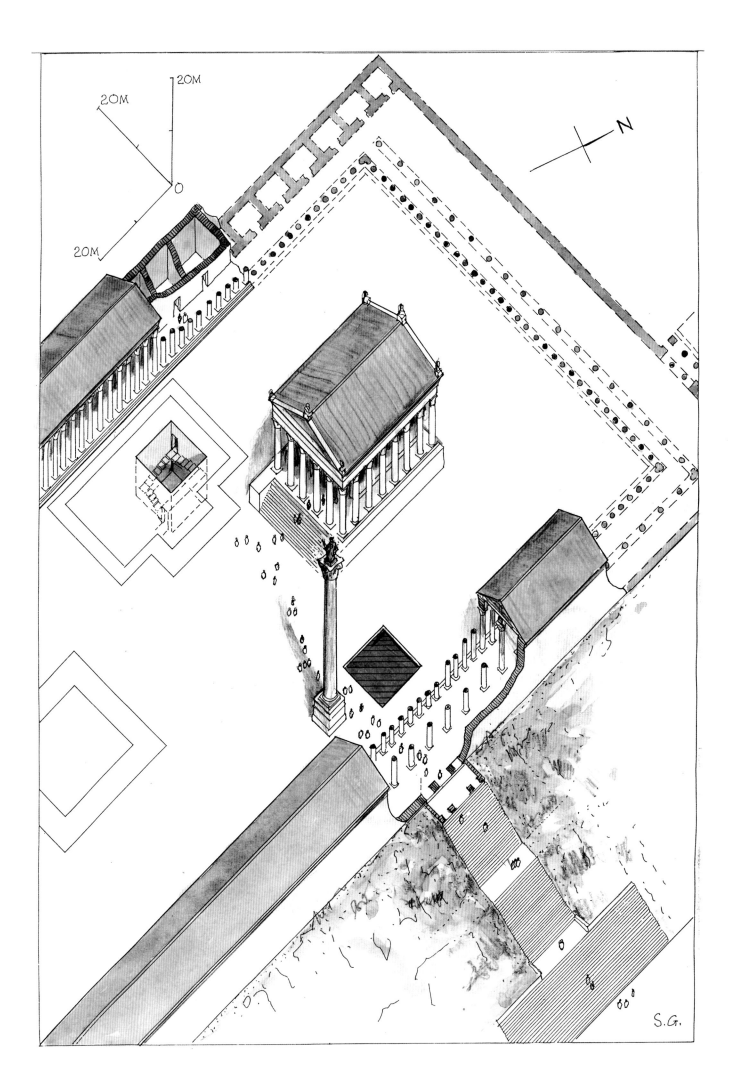

20M

20M

20M

0

N

S.G.

eastern part of the city.[45] There does not seem to be any evidence for it having been on the site of the Attarin Mosque (named after the spice market) at the intersection of the main east-west street with street R5, as has sometimes been assumed [400].[46]

Individual efforts also led to the construction of other churches, such as one built to the west of the city by Mother Theodora who had wealthy parents and became a follower of Athanasius, according to the Coptic tradition.[47]

An indication of the number of churches in Alexandria by the time Athanasius died, in AD 373, is given by Epiphanius, writing sometime in the following three years. He observes that 'there are many churches in number in Alexandria'. Major ones discussed above which he mentions are: the Caesareum and/or the one in the former 'Hadrianon', and those named after Dionysius, Theonas, 'Mendidion', and 'Baukalis'. In addition, he gives the names of a further five: the churches of Pierios and Serapion, of the Persaia, of Dizya, and of Annianos; 'and others'.[48] The Church of 'Pierios and his brother Isidore' is described soon after this as 'very large'.[49] It is called a *naos*, rather than *ekklesia* (church). The Greek term *naos* (which was used for a temple or its inmost part housing the cult statue of the god) seems to be used when the church was also a martyrium (for the remains of a saint).

Thus, the contemporary testimonies of Athanasius and Epiphanius mention the existence of at least twelve churches in Alexandria, by *c.* AD 374–7, for which they give the names, with a further two indicated by other sources, making a total of at least fourteen, as well as the 'others' mentioned by Epiphanius. The only church by this date for which there is evidence for it having been built at a former temple site is the one in the enclosure of the Caesareum, which was a new construction in order to hold the large congregation.

Church construction continued in the following years, with the patriarch Timothy I (AD 378–84) credited by later sources with building many 'churches and monuments', although their names are not given.[50]

TEMPLES AND OTHER MONUMENTAL BUILDINGS
IN THE FOURTH CENTURY AD

While churches were being built, rebuilt and enlarged in Alexandria during the fourth century, many temples in the city remained in use, until the last major assault on them towards the end of the century. In the same work in which he lists the churches, Epiphanius describes the festival then practised 'in the Koreion as it is called, which is a very large temple (*naos*), namely the enclosure (*temenos*) of Kore' (Persephone), with an underground shrine.[51] There are other writers, who are contemporaries of Epiphanius, who also give an impression of the temples and other buildings in the city, in this period.

In the second half of the fourth century the Tychaion, the sanctuary of Tyche who was the city goddess of fortune is described. It was 'an enclosure (*temenos*) in the middle of the city'. It had a circular temple with exedras which were 'dec-

orated with columns of every kind jutting forward' and framing statues. There were statues of Alexander with Ptolemy I Soter, and Tyche with Gaia (Earth) and Nikes (winged victories). There were chairs on a stone platform from which to philosophize, and an arm chair (cathedra). Apparently there was a circular hole in the top of the dome. Standing in the middle of the floor there were bronze stelai with the laws (*nomima*) of the city engraved on them. And towards the middle there were the gates (*pylai*) leading to the 'Temenos of the Muses'.[52] The Theodosian Code mentions that an imperial law of AD 392 concerning Alexandria had to be posted up in the Eutycheum, as the Tychaion was also called.[53]

The city's famous academic institution, the Museum, is described in *c.* AD 359 as seeming to reach the Serapeum.[54] Epiphanius observed that the 'Broucheion' (the palace area) in which the Library had been located, was still deserted in his time,[55] after most of it had been destroyed a century earlier. This has sometimes been interpreted as indicating that all the buildings which had formerly been in the palace area, such as the Museum and Tomb of Alexander, no longer existed. It suggests that in the fourth century the Museum, of which the mathematician Theon was the latest recorded member,[56] had been relocated to another part of the city, or that the part of the palace area which included it had survived or been rebuilt. The Temenos of the Muses seems to be the city's main educational complex in the fifth to seventh centuries, recently excavated at Kom el-Dikka in the city centre [359, 369].

The tomb of Alexander is another building which had been described as in the palace area, and in the middle of the city. Libanius mentions that the body (*nekros*) of Alexander was to be seen in Alexandria in *c.* AD 388–92,[57] although a comment by his student, John Chrysostom, implies that the tomb (Sema) had been destroyed.[58]

Other classical public buildings mentioned in Alexandria as the location of events during the fourth century include places of public entertainment: the theatre,[59] and apparently the amphitheatre (*kynegion*) where St Dorotheos was thrown to the wild beasts by the Arians.[60] The market place (*agora*) is also mentioned, as well as the 'tetrapylon which is in the middle of the city', and the Sun Gate.[61]

An unknown author, 'Hegesippus', wrote interpolations into an edition of Josephus' *Jewish War*, in *c.* AD 370, which includes a description of the harbour. The Lighthouse flame was kept alight at night by attendants who stoked it with wood.[62] He also observed that the city had a 'divided fortification' (*dividuum munimentum*) along the north, harbour, side.[63] Two parallel walls are depicted on the map of *c.* 1590 [3]. The fortifications mentioned by Hegesippus predate the famous double Theodosian land walls of Constantinople (Istanbul), which were completed in 413.[64] The double walls along the harbour of Alexandria would have also provided some protection against tidal waves (tsunami), such as the one associated with the earthquake of 365 which destroyed some buildings.[65] This could have led to the construction of the walls.

Ammianus Marcellinus, a pagan, gives a description, completed in the mid- to late-380s, of the city which he probably

411. Destruction of the temple of Serapis in AD 391 with Bishop Theophilus standing on the temple with the statue of Serapis is depicted on a papyrus page of the *Alexandrian World Chronicle* of the fifth century

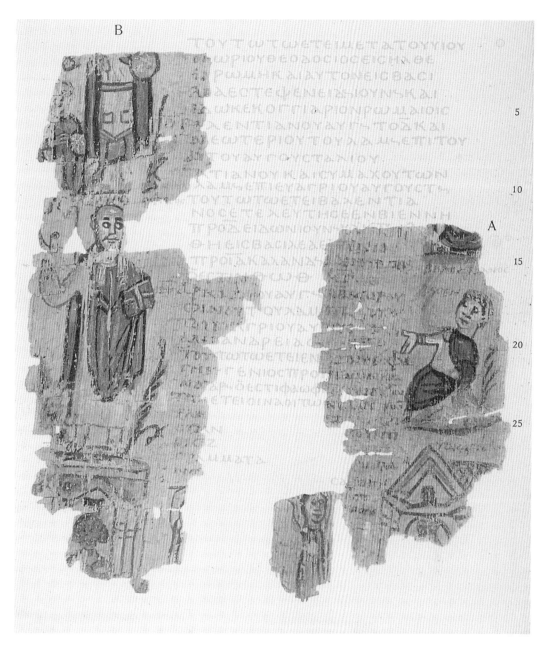

visited on his trip to Egypt. Although the main library might have been destroyed by then, he elaborates how learning even at that date was still alive in the city.[66] He also indicates that the city still had many impressive temples, including the temple of Serapis [410]: 'There were besides in the city, temples pompous with lofty roofs, conspicuous among them the Serapeum which . . . is so adorned with extensive columned halls (*atria*), with almost breathing statues, and a great number of other works of art, that next to the Capitolium, with which revered Rome elevates herself to eternity, the whole world beholds nothing more magnificent.'[67]

PATRIARCH THEOPHILUS (AD 385–412)

At the request of the patriarch Theophilus, the emperor Theodosius I issued an edict allowing him to demolish all the pagan temples in Alexandria.[68] This was the last major assault on the pagan temples, resulting in the closure of even those major ones which had survived until then, including the temple of Osiris at Canopus.[69] Theophilus also succeeded in clearing out the Mithraeum.[70] As this had provoked sufficient popular resistance to prevent it when George had attempted it, it suggests that the process of Christianization of the populace had reached the point when there was now sufficient popular support, compared with three decades earlier, to facilitate the closure of temples. Theophilus also removed the statues from the temple (*hieron*) of Dionysos and converted it to a church (*ekklesia*).[71]

It is sometimes suggested that the Tychaion was closed because four epigrams of Palladas, who was a schoolmaster in Alexandria in the second half of the fourth century and a contemporary of Hypatia, refer to Tyche as now serving in a wineshop.[72] It is more likely that these poems are metaphorical, indicating only that Tyche was no longer worshipped as a goddess. Her temple does not seem to have

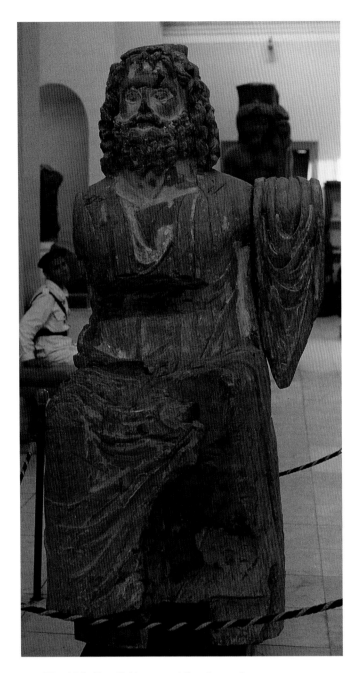

412. Theadelpia (Batn Ihrit), statue of Serapis, *c*. 2nd century AD, sycamore wood covered in painted plaster. h. 1.9 m. Alexandria, Greco-Roman Museum

been attacked, as it was apparently still standing as late as AD 602 when its statues are mentioned, and it was described as a 'famous place' of Alexandria.[73]

In AD 391 the city's most important pagan sanctuary, the Serapeum [410], was finally closed.[74] In the illustration of this in the papyrus codex of *The Alexandrian World Chronicle* [411] the cult statue has a black face, as in Clement's description of it two centuries earlier.[75] The descriptions of the temple by Rufinus of Aquileia and Aphthonius, prior to its destruction, were given in Chapter 8. Rufinus, writing in AD 402, describes the destruction of the cult statue of the god Serapis, which was mainly of wood[76] like the one surviving from Theadelphia (Batn Ihrit) in the Faiyum [412]. He adds

that 'the profane temples (*aedes*) were razed to the ground, a martyrium rose up on one side, a church (*ecclesia*) on the other'.[77] Writing about the same time the pagan Eunapius, who noted pagan prophesies of the temple's destruction (also mentioned by St Augustine), observed that they did not remove the floor because of the weight of the stones.[78] The church historians Sozomen and Socrates, writing about half a century after the event, relate how blocks with hieroglyphs (including symbols interpreted as crosses) were uncovered when the temple (*naos*) was being dismantled.[79] This is possible as blocks with hieroglyphs were reused in the Roman complex, such as those found in the base of Diocletian's Column.[80] There is no reason to believe that the colonnaded court [350], which is later described in the Arab sources, was destroyed at this date. The inside of the temple building itself would have been about nine metres wide [349], so that it would not have made a particularly large church if they had decided to convert it, rather than pull it down.[81] As temples were originally built to house only the cult statue, and not the congregation, only the largest ones were generally suitable for conversion. Smaller ones, such as those the size of the one at Ras el-Soda [318], would only have been suitable as small chapels (if they were converted – which it wasn't).

The martyrium, mentioned by Rufinus, was built by Theophilus to house the bones of St John the Baptist, and (possibly later) Elisha, which had been sent to Athanasius from Sebaste under the emperor Julian.[82] This building 'was massive, its dimensions lofty, and it was very much decorated'.[83] It is later described as octagonal, like martyria elsewhere.[84] According to Sozomen, the church (*ekklesia*) built beside it by Theophilus was named after the emperor Arcadius.[85] These two structures seem to have been new buildings, rather than conversions. It is possible that this was a similar arrangement to the Constantinian Church of the Holy Sepulchre in Jerusalem, where there was a rotunda over the tomb and a basilica church beside it, and the Constantinian Church of the Nativity in Bethlehem, which had an octagonal structure over the grotto adjoining a basilica. Some archaeological remains of Christian structures were found to the west of the former court of the Serapeum, including part of a late fourth century structure, cisterns with inscribed crosses, baptismal fonts, and a fragment of a chancel screen.[86] There are no wall foundations inside the former temple enclosure later than the Roman ones which suggests that these churches were built to the west of the colonnaded court and not inside it, i.e. that the church was not erected directly on top of the site of the former temple.

It is notable that in this period when the churches are built with such strong imperial support, they are dedicated in honour of the imperial family, rather than patriarchs. John of Nikiu indicates Theophilus built 'a magnificent church' which he named after the emperor Theodosius I (AD 379–95), as well as the one already mentioned named 'Arcadia after his son' Arcadius (who became eastern emperor, 395–408). Theophilus converted a temple 'into a church which he consecrated in the name of his [Theodosius'] younger son Honorius [who became western emperor 395–423]. This church was also called the Church of Cosmas and Damian. It was

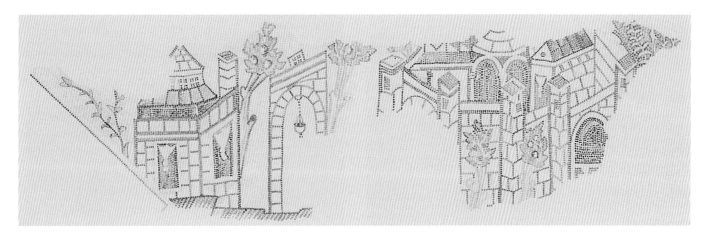

413. Jerash, Church of St John the Baptist, AD 531, watercolour detail of floor mosaic, apparently with the shrine on the left that of Saints Cyrus and John at Menouthis

situated facing the church of patriarch St Peter I [possibly the Church of Theonas]'.[87]

The later sources indicate Theophilus also built other churches including one to Raphael on Pharos,[88] the Church of the Three Young Men (the three Hebrews who were thrown into the furnace by Nebuchadnezzar),[89] and one dedicated to Mary to the east of the city.[90] In addition, he built hostels for visitors.[91] His successor, his nephew Cyril, attributes to Theophilus the construction of the 'Great church of St Menas'.[92] Theophilus built a shrine (*sekos*) consecrated to the evangelists at Menouthis, about 3km east of Canopus [35],[93] to which Cyril moved the bones of St Cyrus and St John from the Church (*naos*) of St Mark. The shrine at Menouthis apparently is depicted on a mosaic church floor at Jerash, over a century later [413]. The Arabic name of St Cyrus, Abuqir, came to be used for Canopus after Menouthis was submerged under water, in about the eighth century.

The written sources indicate that Theophilus was responsible for the creation of eight churches for which we have the names, as well as the two major pilgrimage shrines outside the city, at Menouthis and Abu Mina. Two of these churches are described as converted temples (the one in the temple of Dionysos and the Church of Cosmas and Damian or Honorius) but the other six were apparently new constructions as were the two major shrines outside the city. Because Theophilus built so many churches the Coptic sources discuss from where he obtained the money to pay for them. His successor Cyril and the Coptic Synaxarium indicate that he used the treasure of the Egyptian temples, with Theodosius' agreement.[94]

By the time Theophilus died, in AD 412, Alexandria had at least twenty churches for which we have the names. The question arises as to what they looked like, as well as others such as the domed church of St Athenog[enes] depicted on an ampula of the fifth or sixth century [414].

The conversion of a classical temple (rather than the erection of a church in its enclosure) would have involved the reuse of the whole building. The first rebuilding might have involved reuse of marble or granite columns and marble capitals, especially in the nave. These were made of hardstone and suitable for recycling, while small details of carved limestone decoration, such as friezes, pilasters and niche heads, were not normally reused as they were more fragile. Following the local Egyptian tradition of the reuse of building stone, stone was also recarved, such as the block found at the Serapeum site with an inscription mentioning Serapis which was recut as a support for a chancel screen or related structure.[95] Some new churches could also have included reused columns and capitals.

Given the fact that most of the churches erected by Theophilus were new buildings, as were those of his predecessors, it would be reasonable to expect that a distinctive local architectural style for them would have developed during the fourth century.

414. Alexandria, pottery fragment of a flask, depicting St Athenog[enes] with a domed church in a garden. Berlin, Museum für Spätantike und Byzantinische Kunst, inv. 4503 and 6019

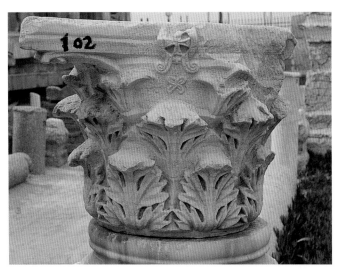

415. Alexandria, marble Corinthian capital from a Christian building, second half of fourth century AD

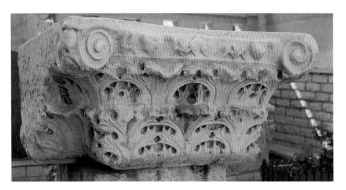

416. Alexandria, pilaster capital, fifth century AD. Greco-Roman Museum

417. Alexandria, marble Corinthian capitals from a Christian building, top: fifth century, bottom: late fourth century AD. Greco-Roman Museum

Evidence for construction work with new purpose-made architectural members is also provided by the marble Corinthian capitals found in Alexandria which are reliably dated to the fourth and the fifth centuries AD [415–417]. Some have wreathed crosses carved on them (as do Ionic impost and impost capitals [418]), showing that they were originally made for churches or other Christian buildings. The ribbons hanging below the wreaths around these crosses are distinctive to Alexandria, indicating that they were locally made.[96]

Although the written sources have not shown what the lost churches of Alexandria looked like in any detail, they have provided information about why they were built and named. These reasons included the desire to make the point by converting specific temples or their enclosures to Christian use (such as the Caesareum, the temple of Dionysos, and the Serapeum), as well as to dedicate them as martyria (such as those for St Mark and St John the Baptist), and to honour specific patriarchs (Dionysius, Theonas, and Athanasius) and the imperial family (Honorius, Arcadius, and Theodosius). They were also enlarged to accommodate the increasing congregation.

Thus, analysis of the written evidence for church building in Alexandria during the fourth century indicates that, rather than an abrupt change occurring under Constantine, there was a gradual change through the century so that by the period of Theophilus Christianity was strongly in favour. The conflicts resulting in the destruction of religious buildings were not just between the pagans and Christians, but also amongst the Christians themselves and with the Jews. Through most of the fourth century the risk of popular unrest meant that there was a point at which all sides had to tolerate the others, with it being possible for them only to destroy minor, but not necessarily major, monuments of the other side. The written reports are prone to exaggerate the extent of destruction of the buildings of the opposition. Also, churches recorded as having been burnt down were usually rebuilt. This is not always stated, but rather becomes apparent when they are mentioned again later.

CYRIL OF ALEXANDRIA (AD 412–44)

The intolerance of Cyril of Alexandria of any alternative beliefs was shown early in his period as patriarch. He began by closing the churches of the schismatic Novatians. As a result of communal tensions arising from the Jews' enthusiasm for attending theatrical performances on Sundays, their synagogues were recorded as being converted to churches,

418. Alexandria, impost capital and Ionic impost capital carved in Alexandria, with wreathed crosses with ribbons below

including one which was named after St George.[97] As synagogues, like churches, were designed to hold a congregation they were eminently suitable for use as churches.

Further intolerance in AD 415 led to Theon's daughter Hypatia, the pagan scholar, philosopher and mathematician, being taken to the Caesareum and cruelly killed by the Christians.[98] The destruction of pagan books is mentioned by Orosius, writing *c.* 418, who saw empty book chests which 'were emptied by our own men in our own day when these temples were plundered'.[99] Just as this and Hypatia's death, did not mark the end of scholarship in Alexandria, it also did not mark the complete end of paganism. The 'all night festival of the Nile' was still held in 435/6 in the theatre of Alexandria, when it collapsed killing 572 men.[100] It is notable that it fell down unaided by an earthquake, as archaeologists are prone to date the collapse of such major buildings to earthquakes. A baths-building (*balaneion*), the Kantharos, is mentioned as being completed a few years later, in AD 440/1.[101]

Having destroyed the pagan idols, Cyril apparently erected Christian images as, according to the Arab historian Maqrizi, he 'was the first to set up figures [statues or images] in the churches of Alexandria and the land of Egypt'.[102] John Malalas (writing *c.* 530–570s) records that, as he supported Cyril, Theodosius II (eastern emperor AD 408–450) 'built the great church (*megale ekklesia*) of Alexandria, which is known to the present day as the Church of Theodosius'.[103] Malalas compiled his work from a variety of sources, some of which were not very reliable. If this reference is correct, it is the only record of any new churches constructed by Cyril. His apparent lack of expenditure on new church buildings is at first surprising, given the intensity of his beliefs and that the see of Alexandria was enormously wealthy. This is reflected in the size of his bribes to the imperial court to ensure the desired result at the Council of Ephesus in 431.[104] Possibly, he was able to keep the money for these purposes if he did not need to spend it on new churches. It is possible that by then the city was already well-equipped with them, especially if the main growth in Christianity occurred during the fourth and early fifth century. Additional churches were supplied

by the converted synagogues, and possibly those of the Novatians which he had closed.

Cyril moved the bones of Saints Cyrus and John to the shrine (*sekos*) of the Evangelists, which Theophilus had built at Menouthis [413]. This was located opposite the temple of Isis which continued in use, according to the Coptic tradition. The traditional healing function associated with this temple of Isis was transferred to the sanctuary of Saints Cyrus and John. The walls of the temple are described as decorated with hieroglyphs. The worship of the Egyptian gods and along with their statues survived there until *c.* AD 488/9, when these statues and those of classical gods were finally destroyed. Some were destroyed at Menouthis, and the rest were taken to Alexandria where a bonfire was made of them 'in the middle of the city' in front of the place 'called Tychaion'.[105]

Paganism was still strong in Upper Egypt in the mid-fifth century, as reflected in the intensity of the attacks by Apa Shenute, the abbot of the White Monastery near Sohag, across the Nile from Panopolis (Akhmim), on local pagans.[106] The continuation of paganism is also indicated by works by pagan poets during the fifth century, such as the long epic poem *Dionysiaca* by Nonnos of Panopolis, and the *Hieroglyphica* by Horapollo, and the work of his father Asclepiades from the Panopolite nome who made a detailed study of paganism. There were also Christian poets who wrote poems with pagan themes: Cyrus of Panopolis in the fifth century, and Dioscorus of Aphrodito (Kom Ishqaw) in the mid-sixth century. This creative literature evoked the gods and heroes of classical myth and legend, without necessarily being a reflection of religious belief.[107] These subjects also continued to appear in artistic representations. The fourth-century Dionysos tapestry has a pagan subject matter [419], even though it apparently came from the tomb of a Christian. Some workshops carved both pagan and Christian architectural decoration in places such as Herakleopolis Magna (Ihnasya el-Medina). Similarly, in Alexandria the lamp workshop near the Serapeum manufactured pagan, Christian, and Jewish lamps in the second half of the fourth century.[108]

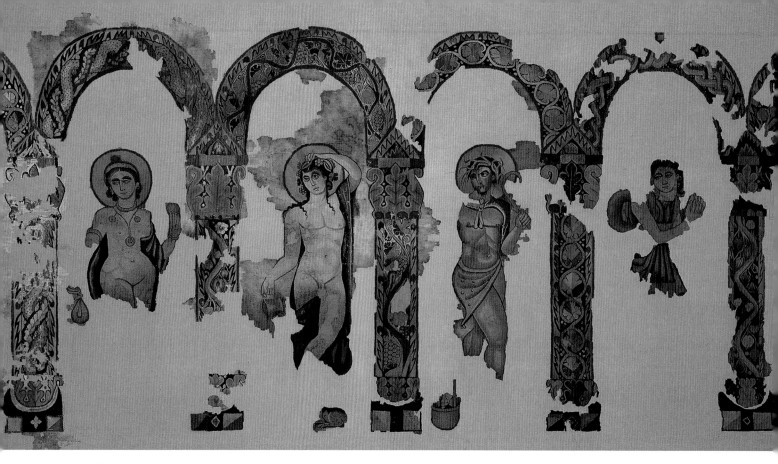

419. Detail of Dionysos tapestry, Late Antique Egyptian wool and linen hanging. h. 2.20 m. Riggisberg, Abegg Stiftung, inv. 3100a

THE CENTURY AFTER AD 451, AND THE EMERGENCE OF THE COPTIC CHURCH

The Council of Chalcedon, in AD 451, resulted in the Church in Egypt being distanced from the Church in Constantinople.[109] Whilst western scholars treat the Coptic Church (which was Monophysite) as beginning at this time, the Copts themselves view it as having existed continuously in Egypt with their patriarchs, according to tradition, going back to Anianas who was converted by St Mark.

Following the Council of Chalcedon, during the third quarter of the fifth century when there was uncertainty and tension over whether the patriarch in Alexandria was a Copt or a Chalcedonian, resources were apparently spent on baths-buildings and the water supply, rather than churches. Although this was continuing a pattern observed under Cyril, it was also a period when imperial resources were focused on the construction of churches in Constantinople itself. The first rebuilding of the baths-building at Kom el-Dikka occurred at this time, although we do not know its name.[110] Theophanes' *Chronicle* mentions the restoration of major public baths in this period, including: the bath of Diocletian, the bath of Trajan, the Koreion bath, and one called Heptabizos.[111] It is always possible that although these references to baths-buildings survived for this period references to churches did not, but the absence of records of church construction is notable. Theophanes also notes that in AD 464/5 'the four [-sided] colonnade (*tetrastoa*) of St John and the sanctuary (*hagiasterion*)' were built.[112] It is possible he is referring to a repair of the large colonnaded court of the former Serapeum.

Theophanes mentions that in AD 466/7 'Alexandria enlisted 3,000 men and the great cistern (*lakkos*) was built in the district of John, together with two baths (*balaneia*) named Health (Hygeia) and Cure (Iasis).' This cistern is possibly one of the two cisterns marked on the Napoleonic plan to the north of the Lageion and to the west of the sites of the former Serapeum and the Church of St John the Baptist [25]. Theophanes continues, in the same year, 'the canal (*potamos*) at Alexandria was dug from Chersaion to Kopreon', which is confirmed by an inscription which has survived commemorating this work on the canal.[113] Improvements to the city's water supply would have been necessary for the baths-buildings. In 528 the aqueduct of Alexandria was reconstructed by the emperor Justinian.[114] He also had to build a wall around the quarter of the city called the Bowl (Phiale), which the grain ships reached by the canal, to protect the grain from the rebellious population.[115]

The Caesareum was still used by the Copts as the Cathedral after AD 451. In 457 the Coptic patriarch Timothy Aelurus (the Weasel) was ordained in the 'Cathedral (Great Church) which was called the Caesareum'.

Another of the city's famous buildings which continued in use was the racecourse, the Lageion. The Chalcedonian patriarch Proterius was killed in the Church of Cyrinus, and his body was cremated in 'the Great Hippodrome which Ptolemy Lagus built.'[116] It continued in use after the reign of the emperor Zeno (AD 474–91) when the 'Great Hippodrome of Alexandria for horse races perished by fire'. It must have been repaired, as chariot races were held in the city under Justinian.[117]

Zeno supported the Monophysites and, according to Maqrizi, Athanasius II (AD 489–96) who became patriarch

towards the end of Zeno's reign built many churches. After Athanasius II, there continued to be a sole patriarch of Alexandria and he was a Copt, until 538.[118] The churches in which the patriarch preached are sometimes indicated. Those of St Victor and St Sarapammon are mentioned in the time of the patriarch Timothy III (517–35), who preached in the latter. His successor, the Coptic patriarch Theodosius (535–66) preached in the 'Great Church',[119] presumably before he went into exile in 538.

By AD 530 the first Coptic priests had been ordained, followed in 536 by the consecration of the first bishops, and in 538 a separate Chalcedonian (Melkite) episcopate was established. Thus, although the Coptic Church was distanced from the Church in Constantinople in 451, it was not functionally separate until 538, under the emperor Justinian. In 576 the Coptic patriarch Peter IV consecrated about seventy bishops, completing the creation of a separate Coptic (Monophysite) hierarchy.[120]

Sharp exclusion of one group or the other from all the churches in Alexandria does not seem to have occurred until AD 538. Severus, bishop of el-Ashmunein (Hermopolis Magna) in the tenth century, describes how, when the inhabitants of Alexandria would not recognize the Chalcedonian patriarch Paul (537–40), the churches in the city were kept closed by the emperor Justinian for a whole year. As a result the Copts built (or restored) two churches for their own use: one at the steps to the former Serapeum, called the Angelion, and another 'in the name of Cosmas and Damian, to the east of *al-mal'ab*, and a little to the west of the colonnade'. The approximate location of the Angelion is clear [400]. However, the location of the Church of Cosmas and Damian depends on to what the Arabic term *al-mal'ab* is referring and whether this church was a repair of the one of that name facing the church of patriarch St Peter I. As *al-mal'ab* means 'place in which to have a play or game' it could be the racecourse (the Lageion), the theatre, or a related building. Severus continues that when Justinian heard what the Copts had done, he 'opened all the churches, but put them under the authority of the Chalcedonians', leaving the Copts with only these two and their patriarch Theodosius went into exile, initially to Constantinople[121] where he was protected by the wife of Justinian, the empress Theodora who was sympathetic to the Monophysites.

The fact that the Coptic Church did not become functionally separate until the reign of Justinian has important implications for our perceptions of the development of the art and architecture of Late Antique Egypt, because it is often suggested that the archaeological remains of churches up the Nile embody the style of the local Egyptian church, and do not also reflect that of Alexandria which is assumed to be closer to Constantinople. However, as there was no clear functional division of the church before AD 538, there is no reason to suggest a distinct architectural style of these churches of the rest of Egypt dating from the Council of Chalcedon in 451.

Similarly, there was no clear division based on language. Before the detailed study of the papyri, church historians assumed that the churches, and monasteries, of the rest of Egypt were Coptic speaking and antagonistic to the one in Alexandria, which was perceived as Greek speaking. However, even for some time after the Council of Chalcedon, works were produced for the Church in Egypt concurrently in Greek as well as Coptic, and many monks were apparently bilingual. This is not surprising, as Coptic writing was based on letters of the Greek alphabet with many Greek loan words, including common ones and not merely learned terms. Although the use of Greek gradually decreased, bilingual lectionary manuscripts continued to be produced even after the Arab conquest. The lack of ecclesiastical administrative division was also reflected in a lack of religious or linguistic division.[122]

Thus, there is no reason based on the history of the church in Egypt for suggesting that the church architecture of the rest of Egypt would be different from that of Alexandria. With no evidence for two separate worlds, there is no basis to apply a model of two separate worlds to the study of the architecture of Late Antique Egypt in the style commonly termed 'Coptic'. Consequently in the light of the lack of archaeological evidence for the many churches in Alexandria so far mentioned, the archaeological evidence of the churches elsewhere in Egypt considered in Chapter 11 might be hoped to provide details of the appearance of the city's lost churches.

DEPICTIONS OF ALEXANDRIA IN THE SIXTH CENTURY

We will now pause in our narrative of the written sources to consider the depictions of the city of Alexandria in sixth-century Byzantine mosaics. The most important example possibly reflects some contemporary buildings in the city, including some of its larger churches. This depiction survives in the floor mosaics of the Church of St John the Baptist at Jerash, in Jordan, which are dated by their inscription to AD 531. Alexandria [420] and Memphis are labelled, and the shrine at Menouthis [413] has been identified between them.[123] There is also a simpler, slightly later, version which is assumed to be a copy of *c.* AD 533–40, in the floor of the nearby Church of Saints Peter and Paul [421].[124] The earlier version will be considered here [420]. It depicts the colonnades of a number of streets, and at least four principal buildings inside the city walls. Two of these buildings are rectangular with pitched roofs. The domed building on the left is circular, with windows below the dome. By contrast, the domed building on the right apparently has a substantial pendentive dome, i.e. a circular dome supported by an arch on each of four sides of a cube. This image is of particular importance, because it predates the earliest known large pendentive dome which survives on Hagia Sophia in Constantinople (Istanbul), built in 532–7. This also suggests that the mosaic was a reasonably up-to-date representation of the city. The lighthouse Pharos is depicted to the right of the city, with a square lower level and part of the next level. Above this the mosaic is damaged.

The Lighthouse, the Nilometer and the city are also depicted in other mosaics. The lighthouse Pharos on a panel

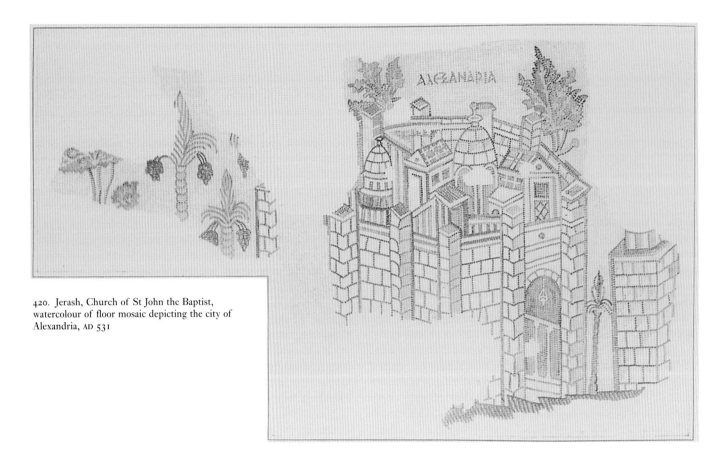

420. Jerash, Church of St John the Baptist, watercolour of floor mosaic depicting the city of Alexandria, AD 531

of the mosaic from the East Church at Qasr el-Lebia, Cyrenaica, dated to AD 539/40, is identified by the label beside it [45]. It has an arched door approached by steps, and a statue and mirror on top.[125] The arched door and steps are also depicted in the version in S. Marco in Venice in *c.* 1270 [422].[126] It lacks the statue and mirror but instead includes some later alterations to the Lighthouse – with a small

mosque at the top.[127] In this mosaic, to the right of the Lighthouse, the walled city of Alexandria is depicted in a version which, although much later, is based on a mirror image of the one in the Jerash mosaics [420–421]. The city and the Nilometer are much more simplified in other Late Antique mosaics.[128] A house at Sepphoris, dated to the fifth or sixth century, has a very simple representation of the city,

421. Jerash, Church of Saints Peter and Paul, watercolour of floor mosaic depicting the city of Alexandria, *c.* AD 535–50

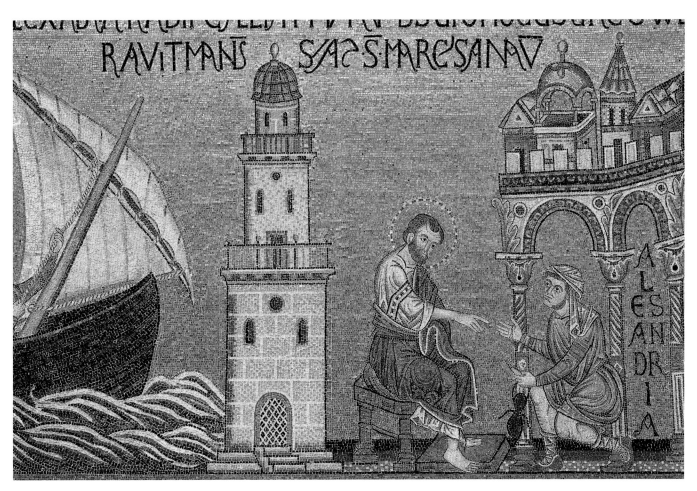

422. Venice, S. Marco, vault of Capella Zen, ceiling mosaic depicting St Mark converting Anianas in front of Alexandria and the Lighthouse

although a complex figured scene. The Lighthouse is simpli-fied so that its tiers are not depicted, but unlike other depic-tions of Pharos it includes the flame for the light [423].[129]

The Nilometer in the Sepphoris mosaic is supported by an arched structure in an arrangement similar to that in a Late Antique Egyptian textile, dated to *c.* sixth century [424].[130] Although dating to the period when Christianity was well-established, these two scenes depict the personification of the Nile. The letters on the Nilometer marked the height of the annual Nile flood, which remained just as important under Christianity, with the continuity of the annual flood being one of the most important tests of the power of the new religion, especially after the destruction of the statue of the god Serapis from the Serapeum.

THE CENTURY BEFORE THE ARAB CONQUEST, *c.* AD 540–640

We return to the written sources for the century before the Arab conquest of Alexandria in AD 642. Visitors to the city provide first-hand information about it in the second half of the sixth and early seventh century. These include Agathias who studied law there and described the severe earthquake of 554 in the 'great metropolis of Alexandria', although it was less damaged than some other places.[131] The Piacenza pilgrim observed in *c.* 570: 'Alexandria is a renowned city . . . full of sects. St Athanasius lies buried there, and also St Faustus, St Epimachus, St Antony, St Mark and many other saints.'[132] An impression of the city in the years immediately before the Persian invasion of AD 619 is given by John Moschus, who wrote *The Spiritual Meadow*, and Sophronius of Jerusalem, who wrote the *Miracles of Saints Cyrus and John*. John Moschus and Sophronius both visited Alexandria while John the Almsgiver was patriarch. They wrote biographies of him, of which only a summary has survived, while Leontius of Neapolis wrote a version in 641–2, which has survived.[133]

During the last quarter of the sixth century, the Coptic patriarch Peter IV, and his successor Damian, had to reside nine miles outside Alexandria in the monastery at Ennaton.[134] Meanwhile, according to John Moschus, the Chalcedonian

423. Sepphoris, floor mosaic of house, depicting Nilometer, simplified city of Alexandria, and the lighthouse Pharos

patriarch Eulogius (AD 581–608) built [or rebuilt] the Church of 'holy Theotokos' [Mary] also called Dorothea.[135] He also rebuilt from its foundations and ornately decorated the

424. Late Antique Egyptian textile depicting a Nilometer. 0.125 × 0.135 m. Paris, Louvre Museum, inv. AF 5448

Church (*naos*) of St Julian, which was apparently his martyrium, located nine miles outside the city.[136] The Coptic patriarch Anastasius (605–616), who had been presiding priest of the Angelion and Church of Saints Cosmas and Damian, was bolder than his predecessor and 'began to build church after church'. This inevitably led to trouble, and after Anastasius preached in the Church of St John the Baptist, Eulogius persuaded the emperor Phocas (602–610) to allow him to confiscate the Church of Cosmas and Damian.[137]

An indication of the defensive barriers of the city, before the Persian invasion, is given by John of Nikiu in his description of the battles at the time of the overthrow of the emperor Phocas. These included the canal 'on the south side of the city'.[138] 'The river, named the Pîdrâkôn, that is the Dragon, which flows close to the great city of Alexandria on the west',[139] could possibly be the canal to the west of the city recorded by the Napoleonic Expedition (marked on [37]). Ships were brought into the 'canal of Alexandria'[140] reflecting its role as a navigable waterway, not merely an aqueduct. To the east of the city there was 'the second gate which was close to the Church of St Mark'. This suggests that, although the whole of the former area of the Roman city might not have been occupied at this stage, the city still had two sets of defensive walls on its eastern side, as also seems to have been the case at the time of the Roman conquest in 30 BC.[141] The Rosetta Gate which survived in the nineteenth century was incorporated into the Arab walls [6], of which a section sur-

425. Alexandria, section of Arab walls in Shallat Gardens

vives to its north in the Shallat Gardens [425]. The capitals on the Rosetta Gate possibly date to the second century AD, but as they could have been reused it is probably later than that [331]. It possibly marked the line of the inner set of city walls.

John of Nikiu also gives the approximate locations of some churches: the 'Church of St Theodore on the east of the city' and the Church of St Athanasius, mentioned as in the eastern part of the city, is 'on the sea coast'.[142] After the victory of Heraclius, John Eleemon, known as John the Almsgiver, was appointed Chalcedonian patriarch in AD 610 and he increased the number of churches in the hands of the Chalcedonians.[143] The churches John Moschus mentions include the Church of St John behind which there were sepulchres.[144] He visited the Church (ekklesia) of Theodosius,[145] and the Church of St Sophia which was near Pharos. There was a hostel between the Church of St Sophia and the Church of St Faustus.[146] The Church (ekklesia) of St Metra was near the Sun Gate.[147]

John Moschus indicates that the Tetrapylon was still a major landmark in the city, and the place of it held in great regard by the Alexandrians because of a legend that Alexander the Great deposited the remains of the prophet Jeremiah there.[148]

Sophronius attended the Christmas festivities at the Church of Theonas, 'of Holy Virgin Mary and mother of God (Theometor)'.[149] He indicates that it was used for worship by the different Christian groups taking turns, in a similar way to the Church of the Holy Sepulchre in Jerusalem today. At the Christmas festival attended by Julian, as soon as the Chalcedonian liturgy was finished, about a hundred clergy of the Gaianite sect came in, according to custom, to venerate Mary (Theotokos).[150] The Copts used holy oil which was taken from the lamps burning in front of the reserved sacrament.[151]

After Sophronius came out of the Church of Theonas, he went out of its enclosure (temenos) onto the famous dromos (the main east-west street) 'which has the scheme of an avenue with two porticoes (emboloi), and was adorned with columns and marbles'. It had crowded markets along it,[152] as found elsewhere along main colonnaded streets in the East in this period. The Heptastadium had apparently become considerably silted up by this time, with Pharos 'now part of Alexandria, the island being considered part of the city'.[153]

The church was still very wealthy, with a fleet of trading vessels when John the Almsgiver was patriarch.[154] He spent much of this on the needy. Visitors would hang around the market-place (agora) destitute.[155] He built hostels for visitors, inns for monks, maternity hospitals, asylums for the old, and poor houses.[156] These included a series of long buildings, which were apparently vaulted, in the vicinity of the Caesareum.[157] The wealth of the church is reflected in the resources, and a workforce of one thousand, which he sent to restore the churches in Jerusalem, after they were damaged by the Persians, in AD 614.[158] This also suggests that Alexandria still had skilled craftsmen for building work.

By the time of the Persian conquest in AD 619, there are at least ten additional churches in the city whose names are not mentioned during the fourth century. Five of these were recorded as built during the fifth and sixth centuries: the Church of St George, the Church of Theodosius II, the Angelion, the Church of Cosmas and Damian, and the Church of Holy Theotokos also called Dorothea. Those which could have been built then, or earlier, include those of St Theodore, St Sophia, St Faustus, St Metra, and the Churches of Saints Victor and Sarapammon. At the same time, the major churches continued in use, including the Caesareum

Church, St Mark's Church, the Church of St John the Baptist, the Theonas Church, and the Church of Athanasius.

Although the Persians allowed the Coptic patriarch to reside at the Angelion, they did much damage to the monasteries. The many monasteries destroyed included those at Ennaton, although they spared the one at Canopus.[159] Archaeological evidence was found of a Christian establishment, founded *c.* AD 400 at Miami-Sidi Bishr (on the way to Canopus), which did not continue into the Islamic period. Marble remains of a church and Christian epitaphs survived from a sixth-century establishment located to the west of the city.[160]

THE ARAB CONQUEST AND ITS AFTERMATH

In AD 642 Alexandria was conquered by the Arabs.[161] The later Arab sources report how impressed the Arab general 'Amr and his troops were by the city. The source nearest in date to the event, the Egyptian bishop John of Nikiu writing half a century after it, claimed that 'Amr 'took none of the property of the churches and committed no act of spoliation or plunder', but the Christians were oppressed by excessive taxes.[162] However, there were clearly some problems earlier, as he also reports that one of the conditions of the treaty of Alexandria was that 'the Moslems were to desist from seizing Christian churches'.[163]

The suggestion that the books from the Library were burnt by the Arabs as fuel for the baths is a sensitive subject. The Library (or part of it) may have been burnt by accident by Julius Caesar's troops during the Alexandrian War of 48 BC, and books were burnt deliberately at other times later in the city's history. The baths-building which survives at Kom el-Dikka [367–368], like other baths-buildings in North Africa, had furnaces designed for the local fuel of rushes. Consequently, it is possible that it was already the local custom to use old papyrus archives as a fuel for the baths-building, just as old papyri were previously recycled as cartonage (the equivalent of papier mâché) for mummies.[164]

The church of St Mark might have suffered damage at the time of the Arab conquest or in the following four decades. According to the Coptic tradition the Arab conquerers 'burnt most of the churches, including the Church of St Mark'.[165] Its destruction seems to be confirmed by a contemporary source, Mena of Nikiu, who reports that it was [re]built by the Coptic patriarch John III (AD 680–9) who was buried in it. According to Severus of el-Ashmunein this building work was done 'in three years with every kind of decoration'.[166] Arculf, a bishop from Gaul, visited it at about this time, and his travels were recorded by Adamnan, a monk on the island of Iona. He observed: 'coming in from the Egyptian side one enters the city of Alexandria and reaches on the north a church of great size. The Evangelist Mark lies buried in it, and one sees his tomb there. It stands in front of the altar at

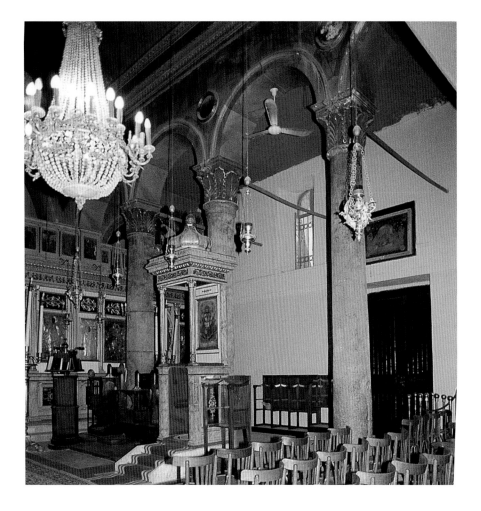

426. Alexandria, Church of St Sabas, interior with reused red granite columns

427. Alexandria, Church of St Sabas, plan

0 15 M

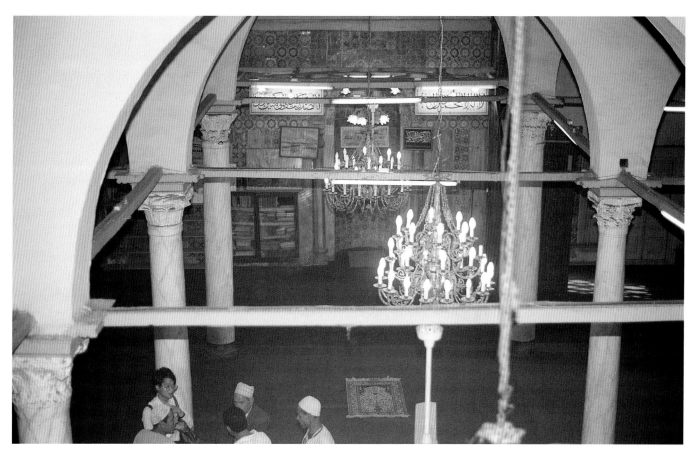

428. Alexandria, Mosque of Ibrahim at-Tarbana

the east end of this rectangular church, and has above it a monument made of marble slabs.'[167]

As the 'Evangelium . . . was ready to fall down on account of its great age', the Coptic patriarch Isaac (AD 690–3) 'rebuilt it and adorned it with great beauty',[168] as well as the episcopal residence.[169] His successor Simon (693–700) 'was enthroned on the apostolic throne in the Great Church called the Angelion'.[170] Thus, the Angelion remained the Coptic cathedral, even though there was no Chalcedonian patriarch during this period (AD 652–729)[171] for the Caesareum, which had been the Chalcedonian cathedral at the time of the Arab conquest.[172] The Caesareum Church was apparently burnt down for the final time in AD 912,[173] but Cleopatra's Needles remained standing.

Alexandria continued as a trading emporium, although Cairo became increasingly important.[174] In AD 828/9 the body of St Mark was stolen and taken to Venice (and returned to Egypt in 1968).[175] The first serious looting of the city's churches for architectural material for reuse elsewhere occurred a few years later, in 836, when pieces were taken for al-Mu'tasim's new capital of Samarra, in Iraq. Severus of el-Ashmunein, who was a Copt, partially blamed the Chalcedonians for this: 'the prince Ibrahim sent men to Egypt with orders that the columns and the marble should be taken from the churches in every place . . . the Chalcedonian heretics dwelling in Alexandria . . . persuaded Lazarus to demolish the churches of Alexandria. And they guided him to the

places where there were columns and pavements; and so he carried them off by force and violence.'[176]

The middle of the ninth century was marked by considerable persecution of the Christians with some of their churches being pulled down.[177] By early in the eleventh century the level of persecution of the Christians had greatly increased.[178] Under Saladin in AD 1167 the columns at the Serapeum site, where the Church of St John the Baptist had stood, were broken up and moved to the edge of the sea shore, to deaden the force of the waves undermining the city walls, and make the approach of the Crusader ships more difficult [8].[179] St Mark's Church was destroyed in 1218 to prevent the Crusaders launching an attack from it.[180]

Abu l-Makarim lists the churches (both Chalcedonian and Coptic) standing in the city at the end of the twelfth century.[181] The only one of these which has survived to the present day is the Chalcedonian (Greek Orthodox) cathedral Church of St Sabas, which might go back to the early seventh century[182] and was mentioned in the early eighth century.[183] The floor level of its nave is two metres below the present street level, and six large red granite columns support the nave, although they do not have ancient capitals [426]. As it contains the so-called altar of St Catherine,[184] it was called the Church of St Catherine by some travellers, after the city's most famous saint in the West. She is sometimes confused with Hypatia who died nearby, in the Caesareum.[185] It is

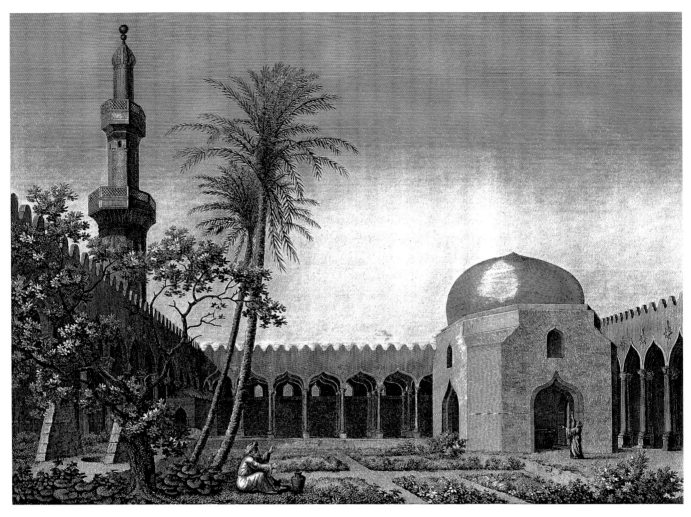

429. Alexandria, courtyard of Attarin Mosque

interesting to note the continuity seen in the fact that the Church of St Sabas is located on a part of the former Forum, in front of the enclosure of the Caesareum where the former Chalcedonian cathedral had stood [400]. The only other building which may be visited in the city today with many reused Roman and Byzantine columns and capitals, is the Mosque of Ibrahim at-Tarbana built in 1685 in the Ottoman town on the former Heptastadium [428].[186]

The Church of Theonas is not mentioned after the Arab conquest. The Western Mosque (the Mosque of One Thousand Columns) was built on its site and was still standing in 1800, although apparently derelict by the end of the seventeenth century [407]. It had many reused columns and capitals from churches. These columns were of a variety of types of stone including white, grey veined and green (cipollino) marble, as well as red granite, grey granite, and black basalt.[187] Only two grey granite columns, probably from the church, survive today, one with a cross and the other with Christ's monogram carved in relief [408–409].[188]

The Attarin Mosque on the main east-west street contained many reused columns and capitals from churches, prior to its destruction in 1830 [429]. These were recorded by the Napoleonic expedition as nearly all of green (cipollino)

marble, with some of granite.[189] Ibn Hawkal, writing in the tenth century, observed that the columns in the churches of Alexandria are beautiful on account of their perfect polish and the colour of their stones: green, yellow, and red.[190]

In the courtyard of the Attarin Mosque there was a small octagonal structure [429], in which stood an Egyptian sarcophagus of green breccia, known to the Arabs as the tomb of Alexander the Great. To the great distress of the Egyptians at the time, this sarcophagus was removed by the French but, as a result of the British victory over Napoleon, is now in the British Museum [430]. Later, when it was possible to translate the hieroglyphs on it, it was found to be the sarcophagus made for the last native pharaoh Nectanebo II.[191] Again the continuity is fascinating, as this is the one sarcophagus Ptolemy might have placed in Alexander's tomb complex to give him local credibility as Nectanebo's legendary son – at a time when people could still read the hieroglyphs on it. This legendary relationship is mentioned in the *Romance of Alexander* which concludes the discussion of it: 'It is a remarkable proof of divine Providence, that Nectanebo the Egyptian was laid to rest in Macedonia in a Greek grave, while Alexander the Macedonian was laid to rest in an Egyptian one.'[192] Perhaps the local Arab tradition was not so far from the truth.

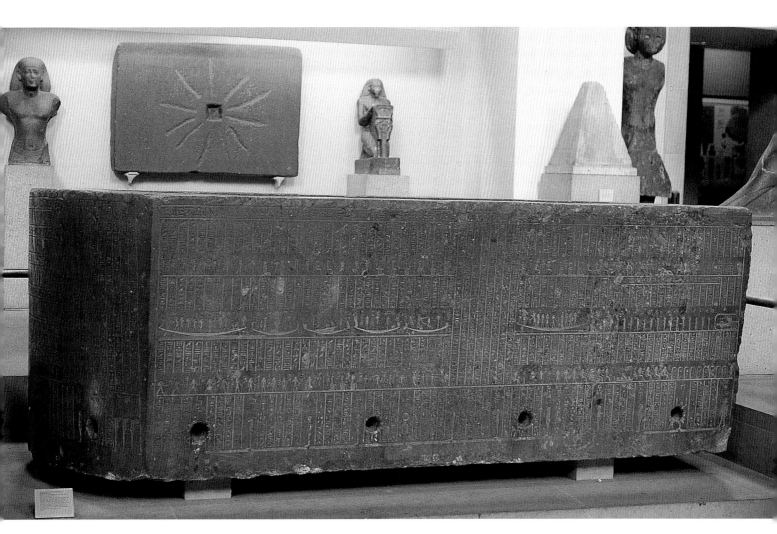

430 Alexandria, sarcophagus of Nectanebo II from fountain in courtyard of Attarin Mosque. London, British Museum

CONCLUSION

The written sources provide more information than has generally been appreciated about the construction of churches in Alexandria, even if they do not indicate what they looked like and rarely give their locations.

During the fourth century paganism and Christianity coexisted in Alexandria with the balance shifting from one to the other through the century as reflected in the major places of worship. The cathedral was the Theonas Church located at the edge of the city early in the fourth century. By the middle of the century it was possible to move the cathedral to the city centre with a new building in the former the Caesareum enclosure. The destruction towards the end of the century, under Theodosius, of the city's last major temple, the Serapeum, on a hill overlooking the city and the erection of two churches there completed the Christian dominance of the cityscape.

The sources give the names of many churches and often an indication of who sponsored them. The early churches were named in honour of the local patriarchs and saints whose bones they often contained (such as Theonas, St Mark, and Athanasius). By contrast, those churches built later and with stronger imperial support, especially towards the end of the fourth and early in the fifth century, were sometimes named in honour of the imperial family (such as Theodosius, and his sons Arcadius and Honorius).

There are twenty or so churches built in the city by AD 412 of sufficient importance for us to be given their names. Nearly all of these were new buildings. Only two churches are described as created by the direct conversion of temples (rather than involving a new building in a former temple enclosure). These are the church in honour of Honorius (the Church of Cosmas and Damian) and the church in the temple of Dionysos, both converted by Theophilus. The churches at the sites of the city's two major temples were new buildings, beside the Serapeum and in the Caesareum enclosure.

Thus, given the number of churches which were new buildings (rather than converted temples) erected in the city during the fourth and early fifth centuries, it would not be unreasonable to suggest their architectural style and designs evolved during this period. The marble capitals carved in Alexandria in the fourth and fifth centuries for Christian buildings are also evidence of new construction work during this period.

Although the Church in Egypt was distanced from the Church in Constantinople after the Council of Chalcedon in AD 451, the allocation of the churches of Alexandria between the Copts and Chalcedonians did not occur until 538. However, during the period of tensions in the city immediately after 451 resources are not mentioned as being expended on churches but rather on baths-buildings and the water supply. Towards the end of the century, when the emperor Zeno was sympathetic to the Monophysites, many churches were built. Additional churches are mentioned in the sixth and early seventh centuries so that, by the time of the Persian invasion of 619, the city had over thirty churches for which we know the names.

Thus, the written sources provide a picture of many churches being erected in Alexandria from the fourth to early seventh century, and especially during the fourth and early fifth centuries. As almost no traces of them survive in the city we need to turn, in the next chapter, to the archaeological evidence of the churches elsewhere in Egypt to gain a glimpse of the possible appearance of those of Alexandria.

The analysis of the evidence for the Roman period in the previous chapters indicates that the classical architecture of the cities and towns of the Nile valley and the oases was similar to that of Alexandria. Recent work on the history of the Church in Egypt in the fourth to sixth centuries shows that during this period the Church in Alexandria and the rest of Egypt functioned as a single world, rather than as parts of two separate worlds as had previously been assumed. Thus, there is no reason why the church architecture of the Nile valley and the oases should not provide a reliable indication of the lost churches of Alexandria mentioned in the written sources.

Church Building in Late Antique Egypt: the Archaeological Evidence

The written evidence discussed in the previous chapter demonstrated that there was considerable church-building activity in Alexandria, especially in the fourth and early fifth centuries. Although there is little archaeological evidence in Alexandria of these churches, there is extensive evidence surviving for churches elsewhere in Egypt. These have two main aspects which can be examined: the design of the buildings and their carved architectural decoration. The extent to which these reflect local continuity of both classical and Egyptian features, as well as contact outside Egypt, needs to be considered.

The date of this evidence also needs to be taken into account. The chronology of these churches is important because they provide evidence for how well-established Christianity was outside Alexandria at what date, especially in the light of the written evidence for church building in Alexandria which has shown the process of Christianization of its cityscape. As some of the churches (including some large ones) in this chapter date to the fourth century and first half of the fifth century (rather than there only being examples dated to the early sixth century as had been thought previously) there is no longer a gap of two centuries in the construction of monumental architecture – between the erection of classical civic architecture in the third century and churches in the following century. This confirms the contribution to the picture given by papyri for continuity of expertise at a local level in the construction of classical architecture of a high quality.

The other aspect of the chronology which needs to be taken into account is how it relates to the establishment of the Coptic Church. Although in AD 451 it was distanced from the Church in Constantinople by the disagreements over Christology at the Council of Chalcedon, the Coptic Church did not become functionally separate until 538. As many of the churches to be examined in this chapter date before then, the term 'Coptic architecture' is possibly inappropriate, other than to convey the sense of the architecture of the Church in Egypt which later became the Coptic Church, which is how the modern Copts view it. The term 'Coptic' is generally used for the art and architecture of the Byzantine period in Egypt in French and German scholarship, while the term 'Late Antique' has become more common in English language scholarship, especially that published in the United States.

There is another problem with the use of the term 'Coptic' here. For many years it was applied to the Christian art and architecture of Egypt, except for Alexandria. This material was assumed to be different to, and of poorer quality than, the lost evidence from Alexandria. However, recent scholarship on Church history has revealed that there is no evidence that the Church in the rest of Egypt in the fourth to sixth centuries functioned as a separate world from that in Alexandria. This means there is no longer any reason to think that the churches in Egypt would not reflect those in Alexandria.

This is supported by the archaeological evidence from the Roman period, about which three important new observations were made. Firstly, in the first to third centuries AD two styles of classical architecture were built in Egypt. One was found to have developed from the distinctive classical architectural style of Ptolemaic Alexandria, while the other was similar to architecture elsewhere in the Roman empire. Secondly, both of these styles were used equally in Alexandria and in the cities and towns of the rest of Egypt, i.e. there was no discernible difference between the classical architecture of Alexandria and that of the rest of Egypt in the Roman period. Finally, there was continuity into the late Antique (Byzantine) period of expertise in the carving of classical architectural decoration at a local level. Thus, there is no reason to assume a division in the Byzantine period between the church architecture of Alexandria and that of the rest of Egypt. This means that it is valid to use the church architecture from elsewhere in Egypt as a reflection of the otherwise lost churches of Alexandria, even if some of these might have been larger and had more expensive decoration.

As there is an enormous amount of material to be considered, making this chapter rather lengthy, a brief indication will be given here of the order in which this material will be covered and its significance. This evidence includes a diversity of church plans, while the carved decoration is notable not only for its enormous quantity but also its quality. This wealth of material, while enabling both of these aspects to be considered in detail, also complicates the presentation of the analysis of the evidence.

Firstly, the evidence from Herakleopolis Magna (Ihnasya el-Medina) and Oxyrhynchus (el-Bahnasa) is considered as it reflects the changeover from paganism to Christianity, as well as their coexistence. Both pagan and Christian architectural decoration was carved at both sites in the third and fourth centuries. Consideration is also given to the issue of the types of buildings on which such decoration was used.

As a result of modern archaeological excavation, foundations of some churches have now been uncovered which are dated reliably to the fourth century, from a time when it had been thought there were no churches surviving in Egypt. These provide an indication of early church plans there in a period from which it is relatively rare for churches to have survived.

The discussion then moves onto the triconch churches which have more substantial remains and are notable for their distinctive local design. These include the monasteries of Apa Shenute and of Apa Bishuy (the White and Red Monasteries) near Sohag which are still in use, and are also important for their architectural decoration which survives *in situ*.

431a–b. Herakleopolis Magna (Ihnasya el-Medina), Burnt House L, architectural fragments from wall niches: (a) broken pediment; and (b) pilaster capital

The monumental churches with features reflecting contact with the wider Mediterranean world and developments in ecclesiastical architecture outside Egypt are considered next. These are the transept basilicas at Hermopolis Magna (el-Ashmunein) and Marea (Hauwariya), and the circular church complex at Pelusium (Tell el-Farama). The Great Basilica and the tetraconch churches at the pilgrimage centre Abu Mina are also considered in this context. Excavation there has provided extensive evidence for the townscape in which they were built.

The study then returns to architectural decoration in more detail, focusing on the churches of the monasteries at Bawit and Saqqara. They are important because of the high quality of their decoration and its almost identical style, despite their distance apart.

Examination of the other types of archaeological evidence for churches completes the study. Brief mention is made of the use of temples or their enclosures for church buildings, and the various ways in which this conversion of sacred space occurred. Finally, consideration is given to the few marble capitals of the fourth to sixth century in Alexandria and the innumerable examples from there reused in the mosques of Cairo.

This wealth of material evidence in Egypt outside Alexandria provides an approximate indication of the plans and architectural decoration of the city's lost churches.

PAGAN AND CHRISTIAN ARCHITECTURAL DECORATION AT HERAKLEOPOLIS MAGNA (IHNASYA EL-MEDINA) AND OXYRHYNCHUS (EL-BAHNASA)

Most discussions of the carved architectural decoration of Late Antique Egypt (so-called Coptic sculpture) begin with the pieces from Herakleopolis Magna (modern Ihnasya el-Medina often called Ahnas) and Oxyrhynchus (el-Bahnasa), which were major urban centres in the Roman period. Only the site where they were found was recorded for most of these architectural and sculptural fragments, without the archaeological context of their exact find-spot or the building to which they had belonged. Consequently, confusion has arisen over the types of buildings from which they came and their functions.[1] The lack of archaeological context for many of them has resulted in style and typology being used as the basis for arranging them into groups and chronological order.[2] In order to attempt as rigorous a study as the evidence permits, the examination of the carved architectural decoration presented here focuses on the fragments which were recorded as found in specific buildings.

At Herakleopolis Magna (Ihnasya el-Medina), c. 120 km south of modern Cairo (Map 1), the Egyptologist Flinders Petrie excavated a number of burnt houses including House L. It 'was a large and important mansion, with many pilasters and capitals of stone', which was possibly constructed in the late third or early fourth century AD.[3] The architectural blocks from it included remains of two niche heads with broken pediments,[4] and the pilaster capitals which would have supported them [431],[5] as well as larger pilaster capitals, and cornice mouldings.[6] This evidence indicates that carved niche heads and pilasters were used as decoration in expensive houses. The use of niches with ornate relief decoration in houses occurs elsewhere in Egypt in the first to third centuries AD, as at Karanis (Kom Aushim) where they were found in situ in brick houses, and in houses at Marina el-Alamein, west of Alexandria [153–154].[7]

At Herakleopolis Magna other broken pediment niche heads were also found with similar flat grooved modillion

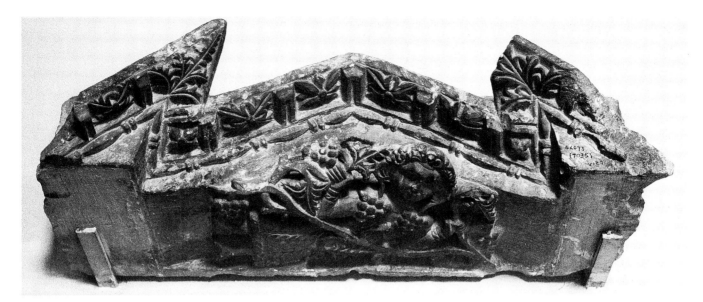

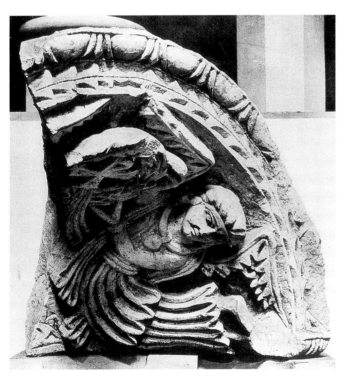

432. Herakleopolis Magna (Ihnasya el-Medina), broken pediment niche head from rectangular niche with Dionysos in vines. Cairo, Coptic Museum

433. Semi-dome niche head with angel supporting wreathed monogram of Christ. Cairo, Coptic Museum

434. Detail of head of Dionysos in fig. 432

cornices and bead and reel decoration to House L. These include one with a pediment of low pitch with Dionysos with vines framed by half-pediments [432].[8] Broken pediment niche heads with flat grooved modillions go back to the Ptolemaic period in Egypt [150]. The examples from Herakleopolis Magna and the earlier ones from Marina el-Alamein have a large bead and reel motif below the modillions [153, 431a, 432]. This continuity of the flat grooved modillion cornices provides the proof, previously lacking,[9] that Late Antique broken pediments in Egypt are the result of a local survival, as this type of cornice does not occur in Roman baroque architecture outside Egypt.

Pagan and Christian subjects were carved by the same schools of sculptors at Herakleopolis Magna. This is suggested by details in the carving of the eyes, which are one of the most distinctive features reflecting the work of an individual sculptor, his school, or workshop. For example, the treatment of the eyes of the pagan Dionysos on the half-pediment from Herakleopolis Magna [434] is identical to those of the angel holding a wreath surrounding Christ's monogram, on a Christian semi-dome [433].[10] Similar semi-domes, which crowned small apse-shaped niches (w. c. 0.8–0.9 m) were also used for pagan subjects, such as Daphne turning into a laurel tree, and the birth of Aphrodite (Venus) [435].[11] Equally, broken pediment niche heads with flat grooved modillions were carved with Christian subjects, such as an unprovenanced one with Daniel standing between two lions [436].[12]

The Small Church at Herakleopolis Magna was another building in that town in which carved architectural fragments

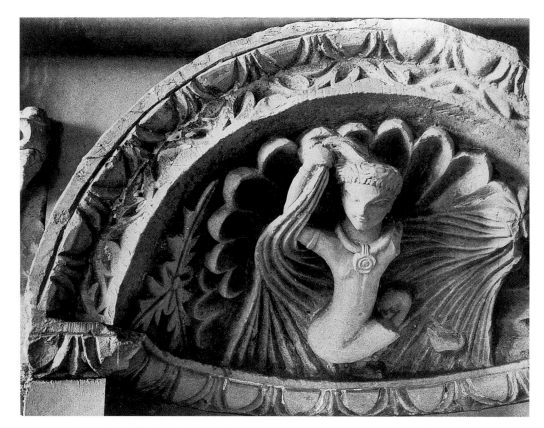

435. Herakleopolis Magna (Ihnasya el-Medina), semi-dome niche head with birth of Aphrodite (Venus). Cairo, Coptic Museum

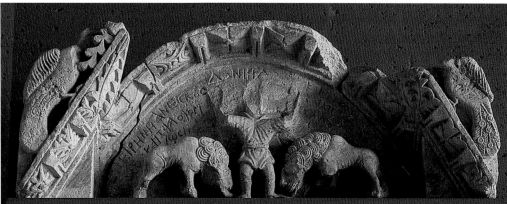

436. Broken pediment niche head with Daniel between two lions. Brussels, Royal Museums of Art and History

were found fallen along with its foundations. The excavator, Naville, observed in 1890: 'We dug also near the two huge granite bases, which looked like Roman work. The excavations showed that they had supported two large columns at the entrance of a Coptic church, now entirely destroyed, but of which nearly all the materials were left. They consisted of columns in grey marble with Corinthian capitals, some of which had, instead of astragalus, a Coptic cross, also architraves, and friezes well sculptured with flowers, arabesques, and animals, and even with mythological subjects.'[13] Photographs of some of the blocks were published [437–438], along with a sketch plan of the structure. This was about 20 × 25 feet (c. 6.1 × 7.6 m) with an apse on a platform of baked bricks, approached by steps, and oriented slightly east of north.[14]

Limestone blocks from it were brought back to Cairo, along with one marble capital (of ?Proconnesian marble).

These were published by the Byzantine scholar Strzygowski who gives their dimensions. He found five more marble capitals left at the site along with their columns and bases.[15] It is possible to reconstruct the Small Church from the sketch plan and the pieces recorded as being found in it because they are the correct size to fit the plan [439]. The limestone fragments included parts of the main friezes and their crown mouldings, pilaster capitals from either end of the row of columns in the nave, and a corner capital of the apse. The broken pediment niche heads would have fitted along the side walls. Six is the correct number of marble columns for the size of the nave. Stylistic details on the limestone pieces indicate that they were all carved at the same time.[16] The limestone capitals [437] have been dated to the early to mid-fourth, or mid-fifth, century,[17] while the marble column capitals [438] are reliably dated to the second half of the fourth or early fifth century.[18] The partial overlap of these

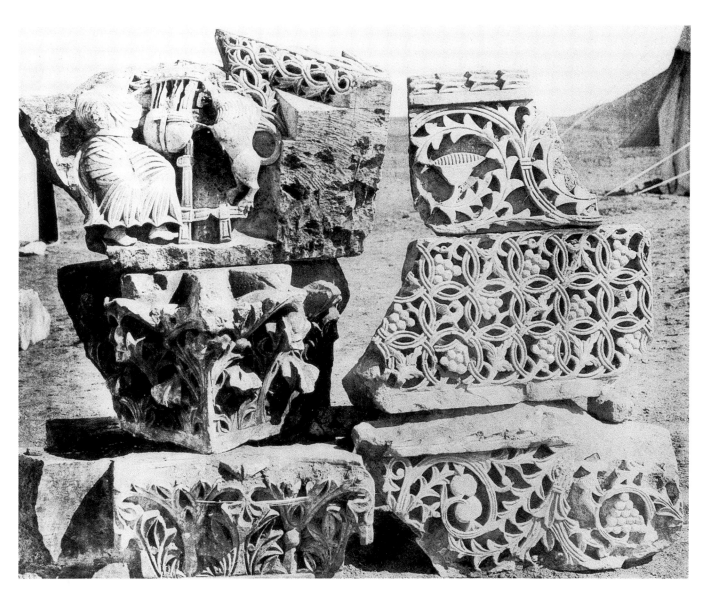

437. Herakleopolis Magna (Ihnasya el-Medina), Small Church, some of the limestone architectural fragments found in it in 1890

438. Herakleopolis Magna (Ihnasya el-Medina), Small Church, marble capital found in it in 1890

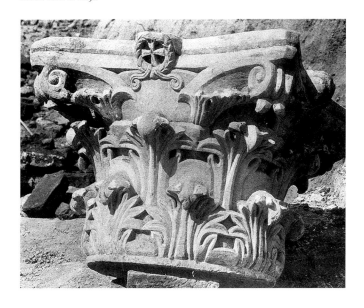

possible dates means that the limestone capitals (which were all from engaged orders) could have been contemporary with the marble ones (from the free-standing columns). This would suggest a construction date for the Small Church of *c.* AD 350–425.

A male figure playing the lyre to a rampant lion is depicted on one of the niche heads found in the Small Church [437, 440].[19] The classical iconography of Orpheus playing to the lion is used in the mosaic floor of the synagogue at Gaza (AD 508/9) to depict king David who is labelled 'David' in Hebrew,[20] indicating that the classical image has been taken over with a different meaning without the need to be allegorical. Thus, the niche head from the Small Church could represent David playing his lyre, rather than Orpheus. An enigmatic figure of a partially clad woman has survived on a fragment of another niche head from the church. Whilst she has not yet been identified,[21] partial nudity was also depicted in Alexandria in the Christian painting in the Wescher Cata-comb, which includes partially clad figures more usually asso-ciated with pagan than with early Christian art [404a].

A niche head found at Sidmant, the main Roman cemetery of Herakleopolis Magna (Ihnasya el-Medina), has a pagan

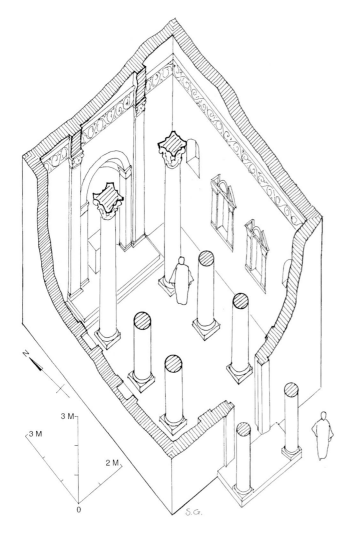

439. Herakleopolis Magna (Ihnasya el-Medina), Small Church, axonometric reconstruction (Sheila Gibson)

subject on it consisting of an ecstatic follower of Bacchus and a maenad [441].[22] This maenad has similar carving on the hem of her drapery to that on the figure on the niche head from the Small Church [440]. A similar niche head has a Christian subject with two naked boys (instead of angels) holding up a wreathed cross [442].[23] These three broken pediment niche heads are distinguished by the shape of their steeply pitched half-pediments and the details of the carving on their cornices. Thus, both Christian and pagan subjects were carved on these niche heads, at about the same time when the limestone carving was being done for the Small Church.[24] The stylistic details suggest that carving for both pagan and Christian monuments was being done by the same, or closely related, sculptors and workshops.

Other pagan subjects carved on the architectural fragments from Herakleopolis Magna and elsewhere include Gaia and the personification of the Nile, as well as Nilotic and maritime scenes, such as nymphs riding sea creatures and the birth of Aphrodite (Venus). Incidents from classical literature which are depicted include Daphne turning into a laurel tree, the labours of Herakles, the rape of Europa, Leda

and the swan, and Dionysiac scenes.[25] Beside the Nilotic scenes, some other sculptures reflect local influences in their details, such as a bust which has a hairstyle characteristic of the Egyptian goddess Hathor.[26] Most of these classical subjects also survive on 'Coptic' textiles, together with other scenes from classical literature, such as Thetis in Hephaestos's forge, Iphigeneia in Tauris, and Meleager and Atalanta, and some biblical scenes. Many of these textiles were found in Christian tombs.[27]

The use of elements of pagan iconography in a Christian context, and the contemporaneity of both Christian and pagan subjects, accords with the evidence for continuity of pagan culture in Egypt along with Christianity in the fourth to sixth centuries also noted in recent studies of contemporary literature.[28] It is also indicated by other evidence, such as the recently discovered Dionysos tapestry [419] which was apparently found in the tomb of a Christian with a textile depicting the Virgin Mary and Nilotic scenes with the personification of the Nile.[29]

The fact that the same workshops of sculptors clearly worked on both pagan and Christian scenes led to the assumption by some scholars that the pagan scenes were carved for churches where they were given an allegorical meaning, rather than being made for both pagan and Christian contexts which coexisted.[30] This, in turn, led to a reaction by some later scholars who suggested that all the pagan niche heads were carved for pagan tombs. This began with the suggestion that the limestone carvings found in the Small Church at Herakleopolis Magna were the remains of an earlier pagan tomb, over which a Christian structure (which was possibly a tomb, rather than a church) with marble capitals was built in the late fourth or early fifth century.[31]

The archaeological context of the niche heads provides the key to the types of buildings in which they were used and their possible function and meaning. Although, none of the niche heads are recorded as being found in tombs, the fact that carved limestone decoration was also sometimes used on the interiors of tombs is indicated by its use in Christian funerary chapel Tomb 42 at Oxyrhynchus (el-Bahnasa) [443]. Dated to the late fifth or sixth century, it was one of a series of tombs based on the design of an Egyptian church [444].[32] The niche head mentioned with an ecstatic follower of Bacchus and a maenad was found in a cemetery, Sidmant, even if not recorded as excavated from a tomb [441]. Niche heads survive in Alexandria in tombs from the Ptolemaic and Roman periods.[33] As has been mentioned, carved niche heads (including some with broken pediments) were found in houses. Broken pediment niche heads were very common in churches, with over sixty surviving in situ in the monastery of Apa Shenute (White Monastery) near Sohag (c. AD 440) [458]. Thus, there are excavated examples of ornate carved decoration from houses and tombs, while carved niche heads were found in houses and survive in situ in churches. Carved limestone decoration was clearly used in all three types of structures: houses, tombs, and churches; and in both pagan and Christian contexts.

There are about six hundred carved architectural fragments from Oxyrhynchus (el-Bahnasa) in the storerooms of

440. Herakleopolis Magna (Ihnasya el-Medina), Small Church, fragment of broken pediment niche head with a figure playing his lyre to a lion. Cairo, Coptic Museum

441. Sidmant, broken pediment niche head with an ecstatic follower of Bacchus and a maenad. Cairo, Coptic Museum

442. Herakleopolis Magna (Ihnasya el-Medina), broken pediment niche head with two small boys holding a wreathed cross. Berlin, Museum für Spätantike und Byzantinische Kunst

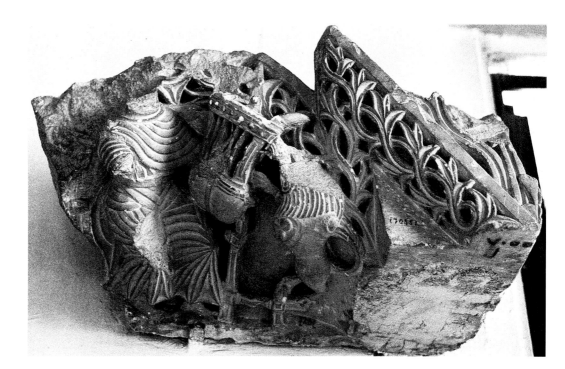

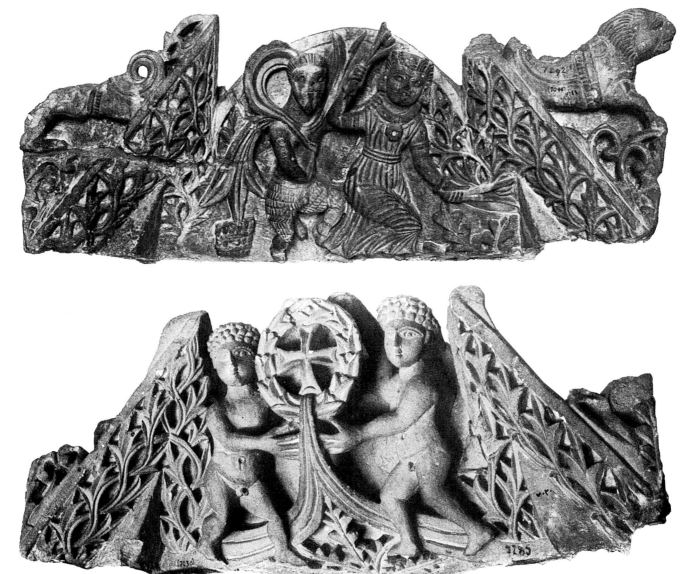

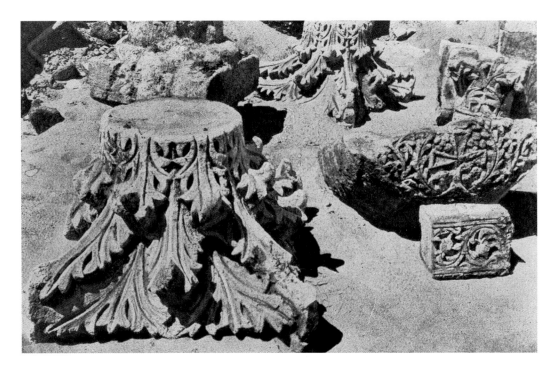

443. Oxyrhynchus (el-Bahnasa), Tomb 42, fragments of capitals and cornices

444. Oxyrhynchus (el-Bahnasa), Tomb 42, plan

445. Oxyrhynchus (el-Bahnasa), architectural fragments in Greco-Roman Museum, Alexandria in *c.* 1920s

the Greco-Roman Museum in Alexandria [445]. These include those found *in situ* in the domed Christian structure excavated to the north of the town by the Italian archaeologist Evaristo Breccia, then director of the museum. This was a *c.* 5 m squared room of ashlar masonry with an apse in the east wall decorated with *alpha* and *omega* and an ansate cross (the Egyptian cross with a circle at the top based on the Egyptian hieroglyphic symbol *ankh* representing life). The niche was decorated with a cornice with plain flat grooved

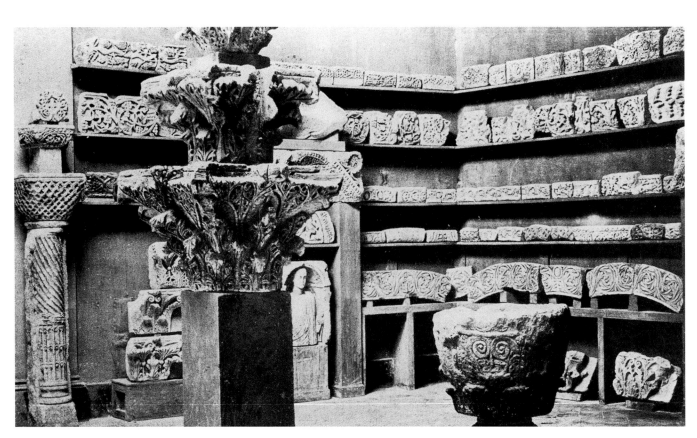

446. Oxyrhynchus (el-Bahnasa), Christian structure, niche in east wall decorated with a plain flat grooved modillion cornice

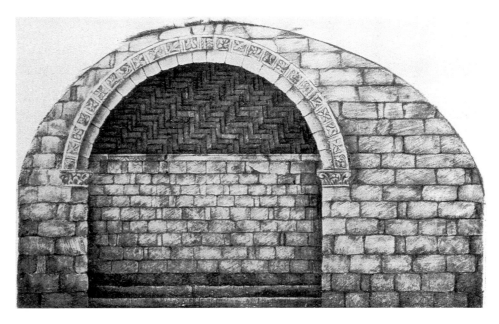

447. Oxyrhynchus (el-Bahnasa), fragment of broken pediment niche head

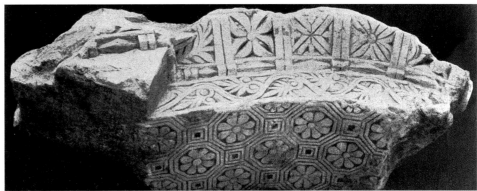

modillions [446]. The room had been altered three or four times.[34] Many architectural fragments were found both in it and reused in Arab housing above it which was in use in the late eighth to early ninth centuries.[35]

These, and other pieces published by Breccia, divide into two main groups.[36] Pieces in the first group are characterized by their plainness, as on the broken pediment niche head illustrated here [447]. They have some similar details to the *in situ* pieces in the Christian structure [446].[37] The pieces in the second group are more ornate and finely carved. They are characterised by cornices with decorative panels both on and between wide modillions [560].[38] Some pieces in this second group are of particular importance because of their relationship to the decoration from the church of St Polyeuktos in Istanbul, to be discussed in the next chapter.

At Herakleopolis Magna, the subjects on the broken pediment niche heads found at Oxyrhynchus are pagan, such as a nereid riding a sea creature,[39] as well as Christian.[40] The niche heads were once brightly painted with sophisticated shading. This was seen on the nereid on a flat semi-circular

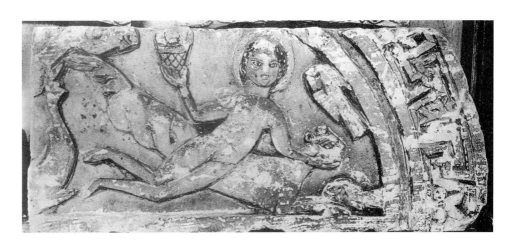

448. Oxyrhynchus (el-Bahnasa), semi-circular panel of nereid with remains of paint. Alexandria, Greco-Roman Museum

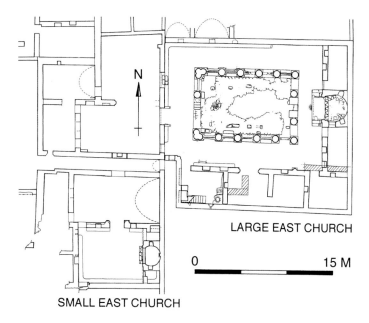

LARGE EAST CHURCH

0 15 M

SMALL EAST CHURCH

449. Kellis (Ismant el-Kharab), east churches, plan

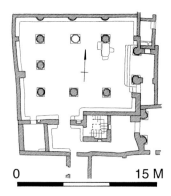

0 15 M

450. Shams al-Din (Munisis), church, plan

panel which had sufficient traces of paint on her when discovered to show how added depth was achieved by painted shading and outlines, since lost [448].[41]

Two capitals with monograms on them have been attributed to Oxyrhynchus. The form of monogram on them is dated to *c.* AD 600.[42]

Before considering the churches of the fifth century which are still standing and the carved stone decoration used in them, remains of some of the earliest churches surviving in Egypt, dated by archaeological evidence to the fourth century, have to be considered.

FOURTH-CENTURY CHURCHES

Small Early Churches

In el-Dakhla Oasis, at least two churches were excavated at ancient Kellis (Ismant el-Kharab) [449]. As the site ceased to be occupied by the end of the fourth century AD,[43] this provides an important date before which they would have been in use. The Small East Church (6.5 × 9.5 m) was created by the conversion of a pre-existing room with the extension of the benches around the walls of the nave which lacked an inner colonnade, and the addition of an apse to form the sanctuary, together with lateral chambers which were storage rooms. The apse was decorated with painted decoration including fake columns and cupboard doors, and an ansate cross. Coins indicate this small church was in use in the first half of the fourth century.

Immediately to the north-east, as part of the same complex, the Large East Church (13.5 × 20 m) was a purpose-built structure of plastered mudbrick and apparently with a flat roof. It had an apse and lateral chambers at its east end, a series of rooms along the south side, and entrance rooms

on the west end. An interior colonnade ran around all four sides of the nave. There were one metre high wood screen walls between the side columns. The nave was equipped with benches running east-west. The apse and north wall were decorated with niches. The painted decoration included ansate crosses. Numismatic evidence indicates this church was in use during the fourth century, possibly having been built early in the century.

Both of these churches at Kellis have an apse with rectangular rooms on either side, set against a straight east wall. This feature, which is very common in Egyptian churches, is also found in churches in Jordan and Syria where it is thought to derive from the tripartite sanctuaries of Syrian temples.[44] However, as there are three rooms across the back wall in some Egyptian temples, such as the temple of Isis at Philae [213], the development of this church design would appear to be common to both areas. Elsewhere, on churches in Italy, Greece and North Africa, and on some Syrian examples, the apse normally protrudes from the eastern wall. This feature is rare in Egypt occurring on only a few small examples.[45]

At Munisis (modern Shams al-Din), south of el-Kharga near Baris, a courtyard building was converted into what was apparently a small church (11 × 15.5 m) of stuccoed brick [450]. It is dated to the beginning of the fourth century based on numismatic evidence.[46] It has a vestibule on the south side leading to the entrance and a staircase. It has a rectangular sanctuary approached by three steps. A bench runs around the walls of the nave, which has a colonnade around three sides forming a transverse (or return) aisle across the west end. Although not very common in Egyptian churches, rectangular sanctuaries are also found in the small fifth- century churches near the hermitages of the Kellia, near the road from Alexandria to Cairo, and in the funerary chapel at al-Bagawat, a necropolis of Hibis (near el-Kharga), famous for its painted mudbrick tomb-chapels dating back to the fourth century. A transverse aisle across the west end is standard in basilical churches in Egypt, but does not normally occur elsewhere in churches. It is used in the synagogue (or church?) from the seventh or eighth century at Hammath-Tiberias in Galilee. A transverse aisle across the other (opposite) end of the building is common on synagogues in Palestine.[47]

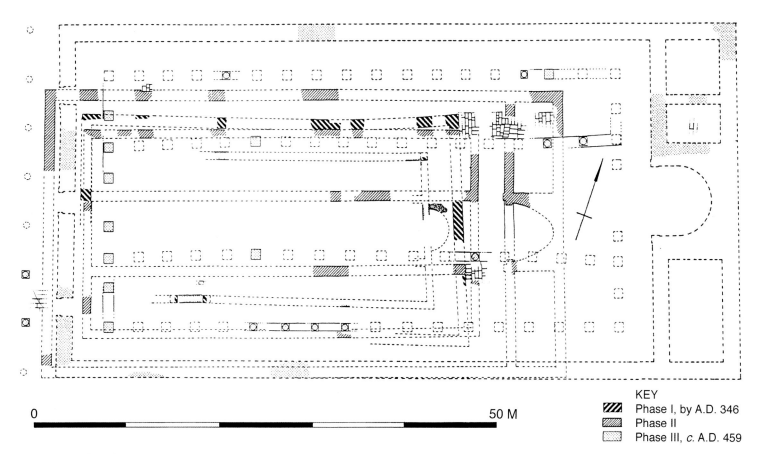

KEY
▨ Phase I, by A.D. 346
▨ Phase II
▦ Phase III, c. A.D. 459

0 50 M

451. Faw Qibi (Pbow), church, plan of phases

These small early churches indicate that by the fourth century Egyptian churches already had the most characteristic features observed in small and medium sized basilical churches in Egypt in the fifth century and later: a transverse aisle and a tripartite sanctuary against a straight east wall.

Five-Aisled Churches

Larger churches dated to the fourth century have also been found in Egypt. At Antinoopolis (el-Sheikh 'Ibada), the 22 × 60m church in the south cemetery is dated by the excavators to the fourth century. It apparently had five aisles. The outermost aisles and transverse aisle on it are narrower than its inner lateral aisles which are almost twice as wide.[48]

At the Pachomian monastery of Pbow (modern Faw Qibli), 18 km north-east of Nag 'Hammadi, archaeological remains of three phases of the church survive [451].[49] The first version was c. 24 × 41 m. Based on the date of the pottery, this was the church mentioned in the written sources as built in AD 337/8 by Pachomius, who died in AD 346. The second version, which was larger (30 × 56m), was built at the end of the fourth or beginning of the fifth century. The final version was even larger (36 × 74 m, excluding the columns across the west side). It was probably built in the first half of the fifth century and dedicated in 459. This last phase was of stone

and baked brick, with granite columns which are still visible fallen in the village today.

The second and third phases of the church at Pbow had a similar arrangement of five aisles to that of the church in the south cemetery at Antinoopolis, with the outer side aisles narrower than the inner ones. The Constantinian St Peter's Basilica and the Lateran Basilica in Rome also had five aisles but their side aisles were of equal width.[50] These five-aisled churches in Rome have an apse protruding from the east wall, while those mentioned in Egypt have a straight east wall, giving them a solid rectangular exterior reminiscent of Egyptian temples. Thus, these five-aisled churches in Upper Egypt reflect local features alongside developments in church designs which are also seen in Italy early in the fourth century.

TRICONCH CHURCHES IN UPPER EGYPT

As the White and Red Monasteries near Sohag have remained in continuous use since they were built in the fifth century, they have survived in relatively good condition giving a reliable impression of their original appearance. Along with the church at Dendara, they have a distinctive plan with a triconch sanctuary built into their rectangular shape. They are also significant because of their decoration which survives *in situ*, especially niche heads.

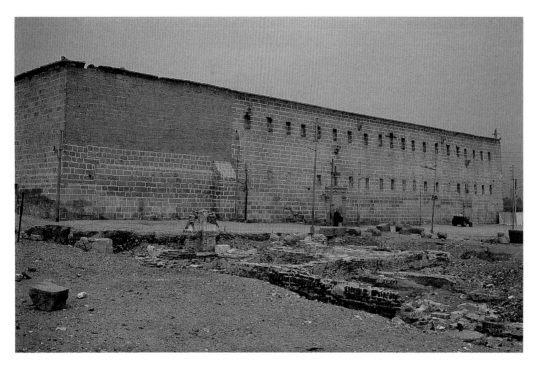

452. Monastery of Apa Shenute (White Monastery) near Sohag, view from south

453. Monastery of Apa Shenute (White Monastery) near Sohag, nave looking east with modern wall across the east end enclosing ancient chancel

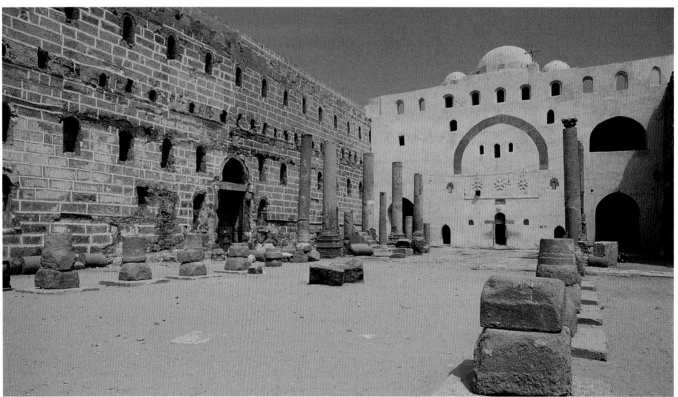

Monastery of Apa Shenute (White Monastery)

The monastery of Apa Shenute (the White Monastery) is 8 km north-west of Sohag, on the west bank of the Nile opposite the city of Panopolis (modern Akhmim) which was noted for its lively literary community during the fifth century producing both pagan and Christian poetry. The importance of this monastery lies in its well-preserved state, combined with the fact that it provides a chronological fixed point for its carved limestone decoration and floor plan [452–455].

Its common name, the White Monastery, Deir el-Abiad in Arabic, comes from the colour of the local limestone from which it was built. It is the main church of the monastery of the abbot Shenute.[51] This monastery also had a well, eleven bread ovens and storerooms.[52] The monastery was founded in the mid-fourth century.[53] Petrie found what he considered to be traces of an earlier church, as well as other buildings.

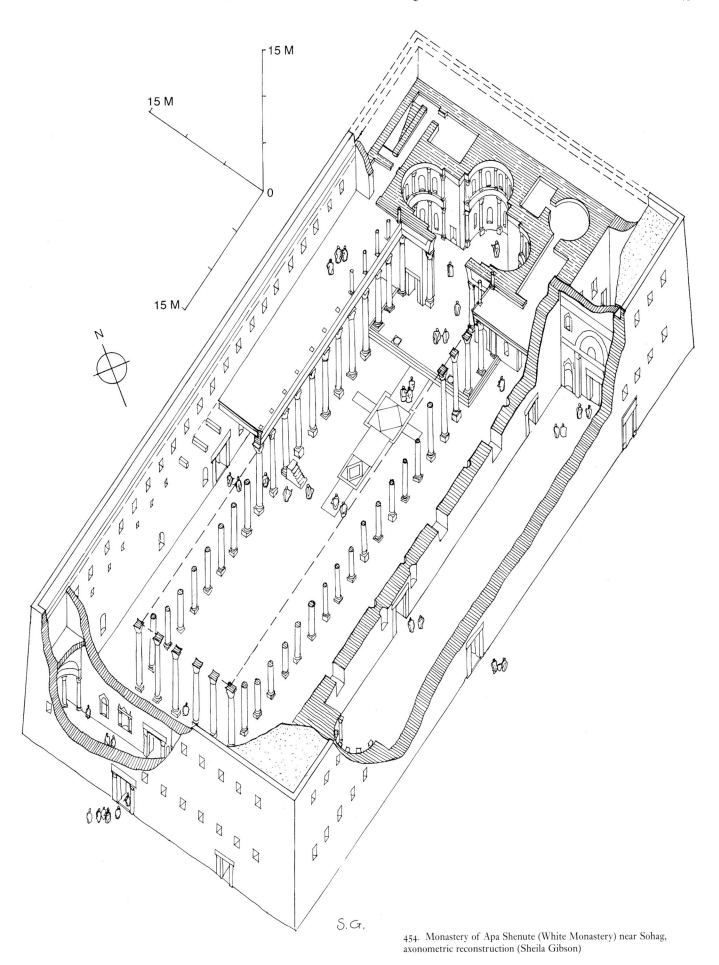

15 M

15 M

0

15 M

N

S.G.

454. Monastery of Apa Shenute (White Monastery) near Sohag,
axonometric reconstruction (Sheila Gibson)

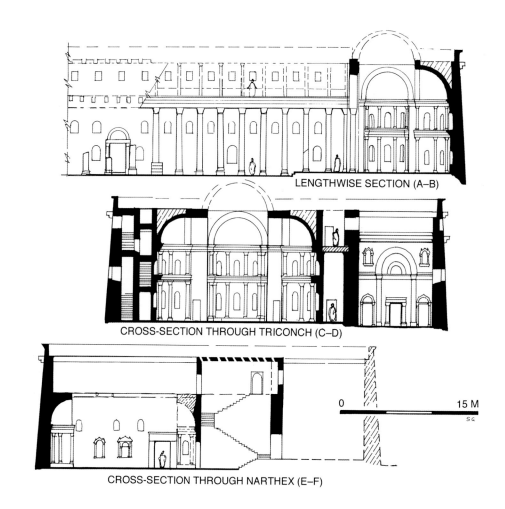

LENGTHWISE SECTION (A–B)

CROSS-SECTION THROUGH TRICONCH (C–D)

0 15 M

CROSS-SECTION THROUGH NARTHEX (E–F)

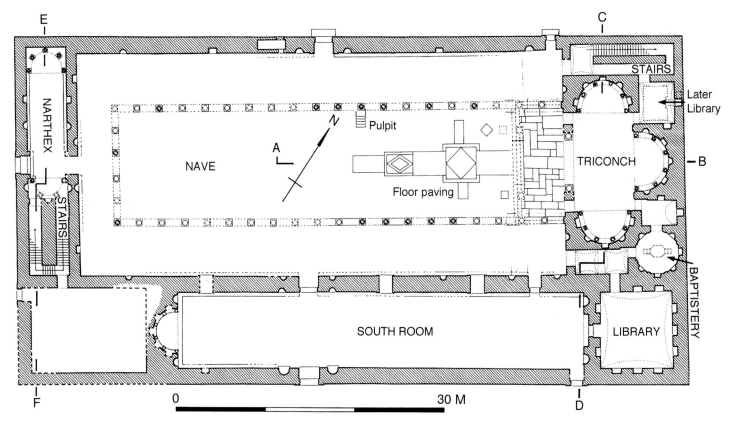

E

C

STAIRS

Later
Library

NARTHEX

Pulpit

N

A

NAVE

TRICONCH

B

STAIRS

Floor paving

BAPTISTERY

SOUTH ROOM

LIBRARY

F

0 30 M

D

456. Monastery of Apa Shenute (White Monastery) near Sohag, main south door with inscribed lintel

457. Monastery of Apa Shenute (White Monastery) near Sohag, detail of *in situ* modillion cornice

Some buildings of the monastery have recently been excavated, including one with long rooms for accommodation and a refectory.[54]

The date of construction of the main church by Shenute is provided by an *in situ* inscription, combined with written sources. This inscription on the lintel of the inner side of the main south doorway [456] states: 'To the eternal memory of the very illustrious count Kaisarios, son of Kandidianos, the founder.'[55] Count Kaisarios was a contemporary of Shenute[56] who attended the Council of Ephesus in AD 431 with Cyril of Alexandria.[57] The construction of this church which replaced an earlier smaller one, to hold an increased number of monks, is described by Besa. He was involved in its construction,[58] which took place in *c.* 420–50 and most probably *c.* 440.[59] According to Besa, the chief mason spent his earnings on a beautiful crown which was hung in the cupola of the altar, and his brother made a cross ornamented with gold and silver which hung in the middle of the [wooden] roof.[60]

It was a large church with outer dimensions (37 × 75 m) very close to those of the largest phase of the church at Pbow (Faw Qibli), as may be seen by comparing their plans which are reproduced here nearly at the same scale [451, 455]. They also had a similar axial width between the nave columns of *c.* 12 metres. The size of their plans is close to that (38 × 73 m) of one of the two halls of the cathedral, begun after AD 326, at Trier[61] where Athanasius lived in exile in 335–7. Trier

was the principal residence of Constantinus, one of Constantine's sons, so that these Egyptian churches are of comparable size to major churches elsewhere.

The ashlar masonry walls of the White Monastery were decorated with over sixty carved niche heads. Their details indicate they were made at the same time, as part of the original construction, as was the modillion cornice which runs around the top of the long south room and of the nave [457]. However, the building also incorporated some reused stone. The columns in the nave had reused capitals, as well as reused shafts of red granite which was stronger than limestone for long load bearing blocks [453]. Similarly, long blocks from classical and Dynastic buildings, including some from Abydos (42 km to the south), were reused for other structural purposes, such as door jambs and lintels. Large granite blocks from there with hieroglyphs on them were also used as flagstones in the nave.[62] As a paved floor is a surface which would not normally have been stuccoed, these inscribed hieroglyphs would have remained visible when the church was in use. According to Besa, the masons objected to one of the stones used in the construction.[63] This could suggest the monks had to be convinced that the pagan carvings did not have a power of their own.

Repairs to the church have complicated the determining of its chronology. It was badly damaged by fire, possibly in the Persian invasion of AD 619, after which the collapsed parts were rebuilt following the original design. Baked bricks were used for some of this, including the repair of some columns in the nave [453].[64] The apses of the triconch were also repaired, with reused columns placed between the niches, some of which had capitals carved for the original construction

455. Monastery of Apa Shenute (White Monastery) near Sohag, sections and plan

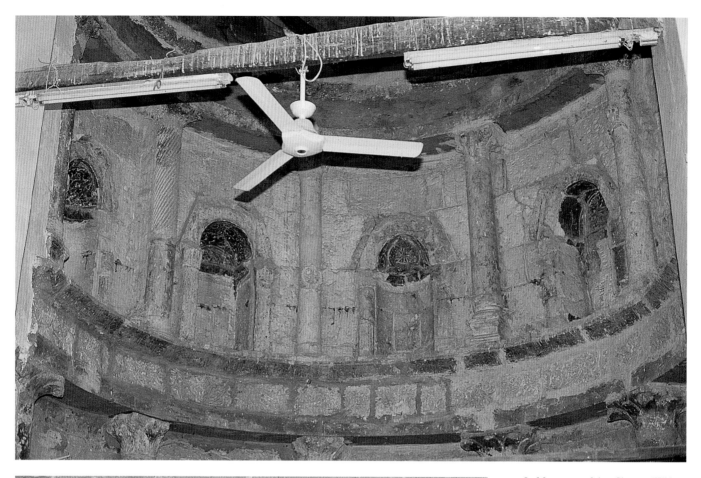

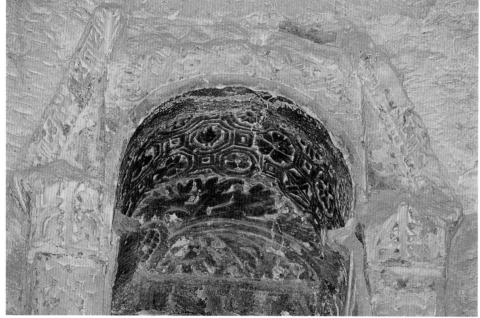

458. Monastery of Apa Shenute (White Monastery) near Sohag, upper order of east apse

459. Monastery of Apa Shenute (White Monastery) near Sohag, east apse, broken pediment niche head

[458–459].[65] The frieze of the lower order of the east apse was repaired with blocks placed out of sequence [458].[66] This led some scholars to assume that the rest of the limestone sculpture, including the niche heads, was reused and consequently that the inscribed lintel did not provide a reliable date for the carved decoration.[67] However, this lintel is in its original position. This is indicated by the fact that the modillion cornice which runs above it around the top of the long south

room, as well as around the top of the nave, is part of the original construction and still *in situ* [456–457].[68] The present dome over the centre of the sanctuary was built in the thirteenth century,[69] and the apse fresco was painted in the twelfth century.[70]

The part of the building currently in use as a church occupies the triconch and the *khurus* (the mediaeval room in front of it across the nave). The original nave, which is now open

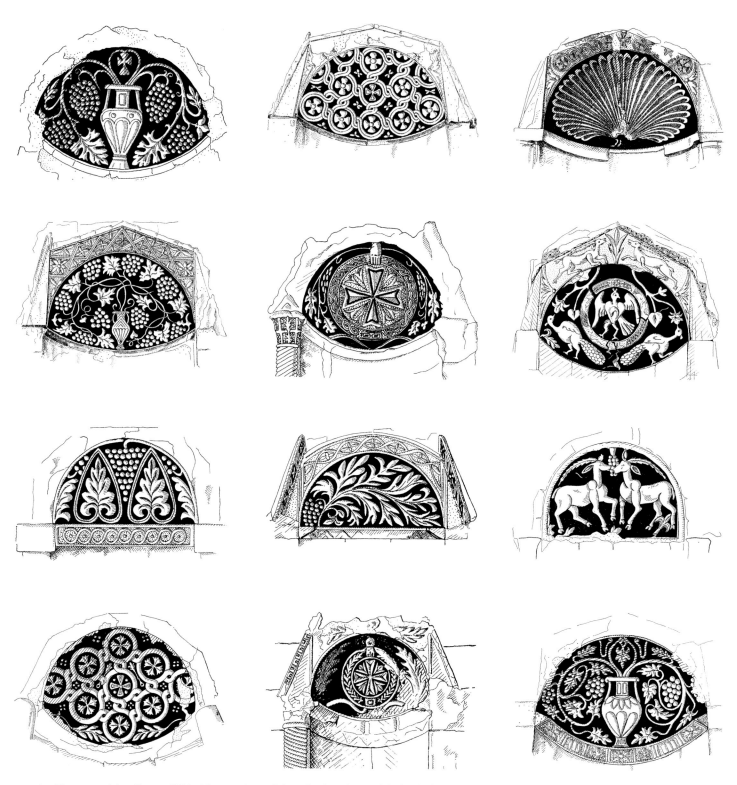

460. Monastery of Apa Shenute (White Monastery) near Sohag, sketches of some niche heads showing the variety of motifs used

to the air, had a gallery with a transverse aisle [454]. The beam holes for the gallery floor and roof are still visible in the walls, in alignment with the columns [453].[71] The gallery was approached by a staircase in the north-east corner of the building and by one on the south side of the narthex [455]. Along the south side of the building there is a long room, the function of which is uncertain. The narthex which runs across the west end of the nave, had an apse in its north end with capitals which were carved for it.[72] At the other end of the church, the octagonal room south-east of the triconch was the baptistery.[73] Beside it, at the east end of the long south room, there is a room which housed books whose subjects were indicated by the labels near the niches for them.[74]

The only copies of many of the writings of Shenute survived from this famous library. Despite his notoriety for his hostility to paganism, they indicate that he knew Greek and

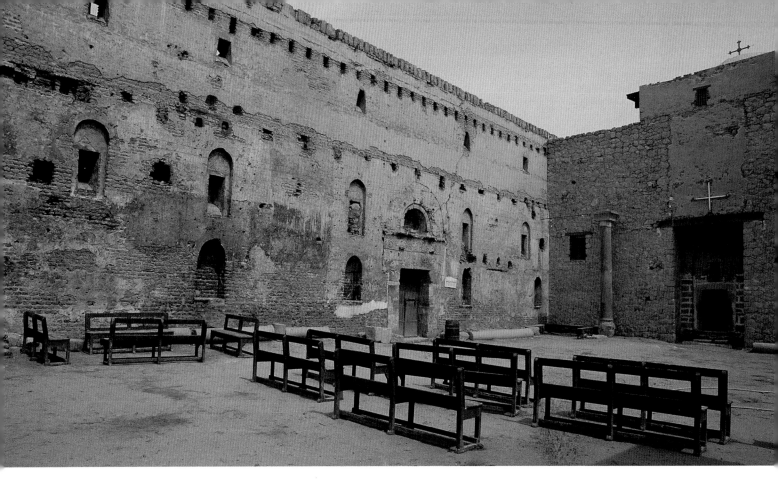

461. Monastery of Apa Bishuy (Red Monastery) near Sohag, nave looking north-east with modern wall across east enclosing ancient chancel

was acquainted with Greek rhetoric and philosophy.[75] The intensity of his opposition to the pagans and their religious worship can be taken as a reflection of the strength of conti-nuity of paganism in the area at the time, while his attendance at the Council of Ephesus with Cyril of Alexandria reflects his contacts further afield.

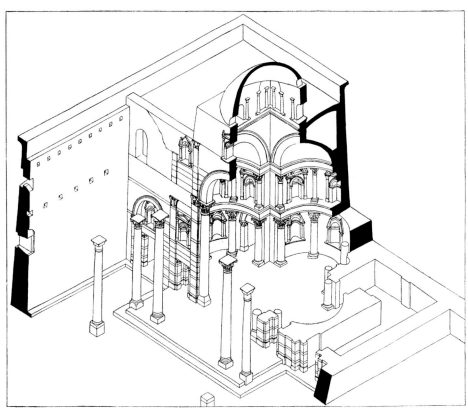

462. Monastery of Apa Bishuy (Red Monastery) near Sohag, detail of chancel

463. Monastery of Apa Bishuy (Red Monastery) near
Sohag, plan

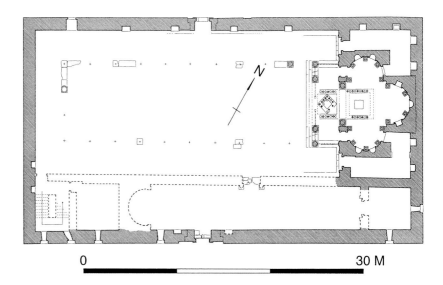

0 30 M

The niche heads were carved for the original construction of the church, in *c.* AD 440. They were symmetrically arranged to fit with the plan. None of them were decorated with human figures [458–459]. Rather their decoration includes goats or gazelles and peacocks sometimes arranged symmetrically in pairs, as well as grapevines, amphorae with grapevines springing from them, wreathed crosses, shells, and intertwined and geometric patterns [460].[76] These geometric patterns do not interlock [459], like those from the simpler group at Oxyrhynchus (el-Bahnasa) [447]. The pagan Dionysiac imagery of the vine was taken over as a Christian motif associated with the Eucharist, as also seen on Christian lintels in Syria.

These carved niche heads have very steeply pitched half-pediments with a cornice of lower pitch (or curved) between them across the top [459]. This arrangement frames either a semi-dome crowning apse-shaped niches, or a short barrel vault with a flat end crowning rectangular niches. In the triconch these two types of niche heads alternate [458]. They are supported by pilasters and placed in bays between columns. The baroque effect created is increased by the use of two superimposed orders. The cornices of the niche heads have flat grooved modillions [459], which are also used on the mouldings around the top of the nave and the long south room [457].[77]

These flat grooved modillion cornices and the broken pediment niche heads reflect a continuation of classical architecture in Egypt from the Ptolemaic and Roman periods. The design of the White Monastery also has some features which are obviously local Egyptian ones, such as the rectangular shape of its exterior [454–455] with inward tapering walls and a cavetto cornice (but no torus) along the top, like an Egyptian temple [243]. Similarly, it has rooms in the area behind the sanctuary which is also a feature of Egyptian temples [455, 244].[78] The parabolic curve used on the large relieving arch in the east wall of the south room[79] reflects the shape of bent rushes used locally for less permanent structures.

Monastery of Apa Bishuy (Red Monastery)

The monastery of Apa Bishuy,[80] which is located a few kilometres north-west of the monastery of Apa Shenute (White Monastery), was apparently founded by monks from there.[81] It is the only remaining building of the monastery [461–463], with the colour of its baked brick walls reflected in its common name, the Red Monastery (Deir el-Ahmar in Arabic). It is important because the original walls of its triconch are still standing [464],[82] and its purpose-made column capitals are *in situ* [465–467]. It is about two-thirds (23 × 43.5 m) the size of the White Monastery, as may be seen by comparison of their plans which are both reproduced here at nearly the same scale [455–463]. Like it, the Red Monastery has a shape reminiscent of an Egyptian temple with walls with inward sloping sides and a cavetto cornice along the top [462].

In the Red Monastery, as in the White Monastery, only the triconch and area in front of it have remained in use as a church, while the original nave is now open to the sky [461].[83] There are L-shaped rooms on either side of the triconch [463]. The nave had a transverse aisle, and a gallery approached by steps in the south-west corner of the building.[84] Along the south side there was a long room which has not survived, but is indicated by traces of the wall dividing it from the nave.[85] It did not have a narthex.

The capitals in the Red Monastery were all carved for it at the same time [464–467].[86] Those on the largest columns have an impressive variety of motifs incorporated into the leaves above their cauliculi, sometimes with different motifs on different sides of the same capital, including a pattern of interlocking circles [465–467]. The leaves on the capitals have been enlarged to fill the space of the helices, which are lacking (architectural terms [127]). Some of the capitals have very small corner volutes, while these are absent on others. The abacus is sometimes so diminished in height that it has nearly disappeared. Some capitals have a torus around their base decorated with a wreath pattern [466]. The red granite column shafts which support these capitals are reused. The stone carvings on the north and south doorways of the nave

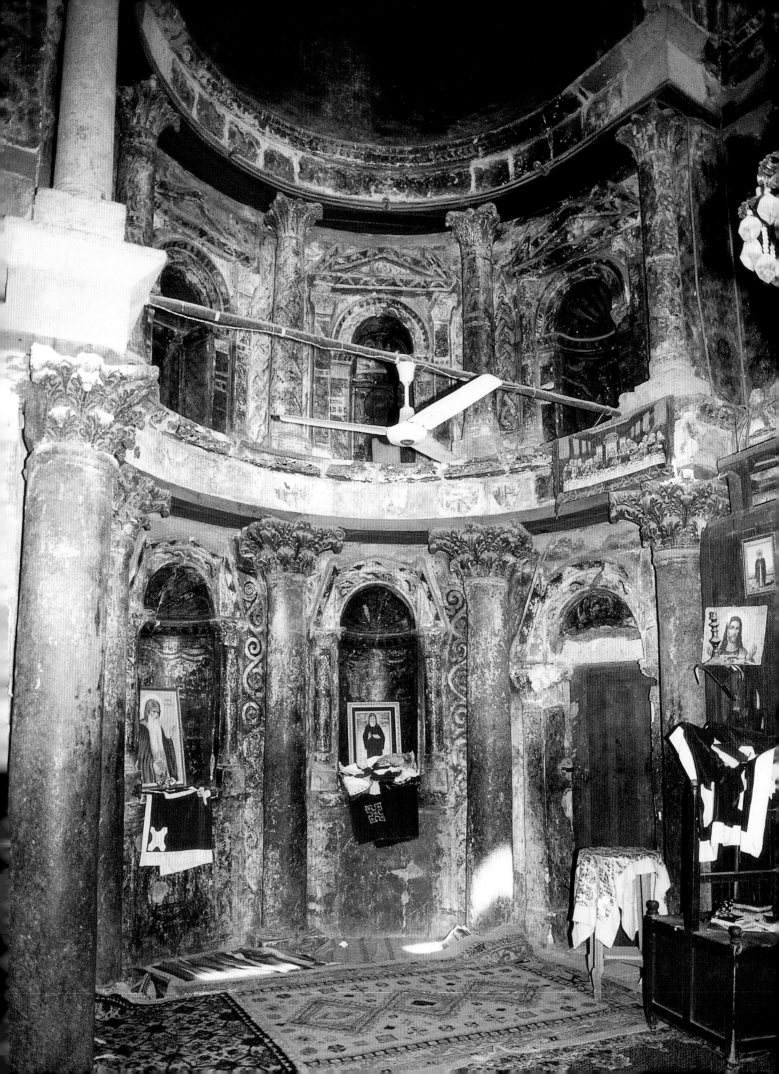

are reused also, although they probably date to the original construction of the church.[87]

Because it is more economically constructed than the White Monastery, the broken pediment niche heads in the triconch of the Red Monastery have painted, not carved, cornices on them [464], although those over the doorways in the triconch apses have carved modillions.[88] The walls and semi-domes of the triconch were stuccoed, as were those of the nave on which traces of paintings survive, including draped crosses still visible on the west wall [468].[89]

Details of the capitals and carved modillion cornices on the monastery of Apa Bishuy (Red Monastery) are close to those made for the monastery of Apa Shenute (White Monastery), indicating that the monastery of Apa Bishuy was built at a similar date, or slightly later, in the second half of the fifth century.[90]

The niche heads on the lower order of the triconch [464] are of a similar shape to those on the monastery of Apa Shenute (White Monastery), with steeply pitched half-pediments framing a semi-dome or short barrel vault [458–459]. Those on the upper order of the Red Monastery have half-pediments with a lower pitch on either side of a tri-angular tympanum and supported by pilasters [464]. Both of these arrangements of niche decorations, involving broken pediments of both high and low pitches, are also used in the narthex of the monastery of Apa Shenute,[91] reflecting the fact that both types of broken pediments were contemporary.

The use of niches within a larger order on these two monasteries is like that observed elsewhere in Roman architecture of the second century AD [187–188]. The alternation of semi-circular and rectangular niches decorating their apses is also seen in Roman architecture. However, the use of niches in this manner does not continue outside Egypt into the period of church construction, except in North Africa in Algeria and Tunisia.[92] Decorative niches are distinctive of the church architecture of Egypt.[93] As the broken pediments originated in the classical architecture of Ptolemaic Alexandria, like the flat grooved modillion cornices on them, this might explain the strength of their local continuity.

The long room on the south side of the monasteries of Apa Bishuy and Apa Shenute is very unusual [455, 463]. However, a long room in this position also occurs on a church in Cyrenaica,[94] which was under the authority of the patriarch of Alexandria.[95] As the major centre between Sohag and Cyrenaica is Alexandria and both are related by having been under its influence, this might suggest that this feature also occurred at Alexandria, rather than being unique to Upper Egypt.

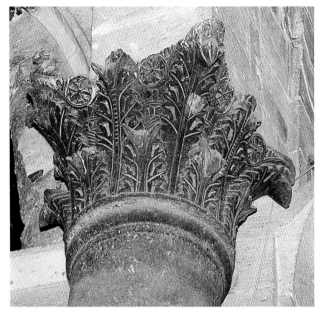

465. Monastery of Apa Bishuy (Red Monastery) near Sohag, capital

466. Monastery of Apa Bishuy (Red Monastery) near Sohag, capital

467. Monastery of Apa Bishuy (Red Monastery) near Sohag, capital

464. Monastery of Apa Bishuy (Red Monastery) near Sohag, north apse of triconch

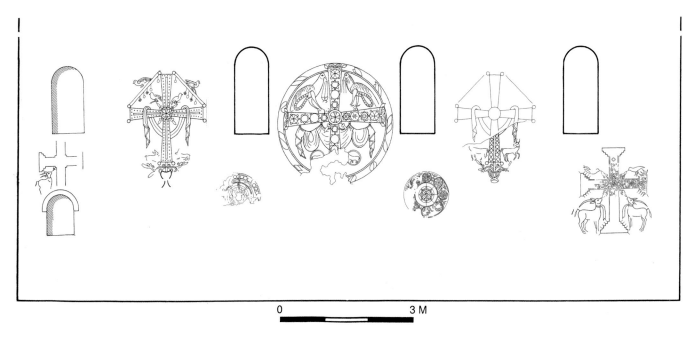

468. Monastery of Apa Bishuy (Red Monastery) near Sohag, painted crosses on back wall

Dendara: Church near the Birth House of the Hathor Temple

At Dendara, *c.* 130 km south of Sohag, there is a church inside the perimeter wall of the Hathor temple enclosure [469]. Dendara had a bishop by the first quarter of the fourth century AD. Egyptian churches generally face east-north-east, as seen on the monasteries of Apa Bishuy and Apa Shenute (Red and White Monasteries) [455, 463], whereas the orientation of the church at Dendara (slightly south of east) was influenced by pre-existing buildings, such as the nearby birth house to which it is parallel [469–470].

The walls of the Dendara church (*c.* 18 × 36 m) survived to a height of up to *c.* 5 metres. It had a triconch with traces of paintings in it,[96] and its east apse was decorated with small apse-shaped niches. There was a L-shaped room on either side of the triconch, as in the monastery of Apa Bishuy (Red Monastery) and some other Egyptian churches.[97] The nave had a transverse aisle. There were pilasters on the walls of the nave aligned with its columns [470].

On the side walls, between alternate pilasters, there were apse-shaped niches with small columns which supported niche heads consisting of semi-domes. These lacked half-pediments. Rather the arch on one of them has the parabolic shape [471] associated with bent rushes [149]. Both entry rooms to the narthex have a niche crowned by a semi-dome in the wall facing their entrance [472]. In addition, there were large apses at either end of the narthex, as found in some examples elsewhere, as in the church of St Gereon in Cologne (*c.* AD 340) and apparently in the cathedral at Trier.

The semi-domes of the niche heads on the Dendara church are decorated with conch shells, and often additional motifs, such as an eagle or a wreathed cross [472].[98] Flat grooved modillions are carved in outline on the mouldings on the niche heads from the nave [471]. They also survive from

the main cornice[99] and *in situ* high up on the exterior of the western wall. Vine leaves decorate the *in situ* door lintel,[100] and fragments of the main frieze of the nave.

The details of the style of the carving of these architectural fragments indicates that they were all made at the same time.[101] This carving is very close to that on fragments from the church at Luxor in front of the pylon of the former Amun temple [523, 525],[102] and across the Nile at Deir el-Medina.[103] This similarity seems to be regional, not just chronological. The generally suggested dates for the Dendara church, in the second half of the fifth or the sixth century, are based on its plan and style of carving.[104] Blocks from temple structures were reused on the church. Its construction technique with dovetail dowels of wood follows that used on the adjacent temple.

The outline of the triconch of the Dendara church was drawn on the paved floor at the front of the birth house to provide the shape for cutting the blocks for the walls of the apses [473a–b].[105] The diagram has a circle in the central square formed by the apses suggesting a dome. This would seem also to suggest it was supported by pendentives. Even though the apses were of masonry, the dome was probably of baked brick. This triconch is the same size as the one on the monastery of Apa Bishuy (Red Monastery) [473c], as well as the one on the church of Deir anba Bakhum (the monastery of St Pachomius), 8 km north of Panopolis (Akhmim) [473d], which was also decorated with broken pediment niche heads.[106] The consistency of the size of these triconches indicates not only architects who were in contact with each other, but also that they knew that a design of this size and proportions was reliable. This is also possibly reflected by how long the White and Red Monasteries have remained standing.

The triconch in churches is more common in Egypt than elsewhere, although predecessors of these triconches were

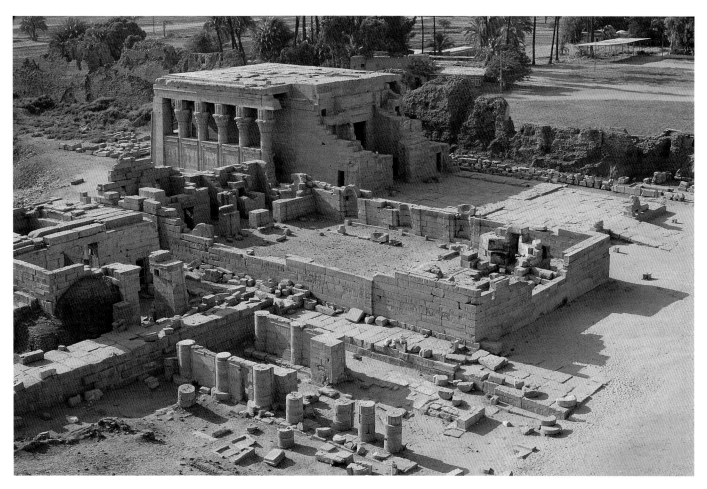

469. Dendara (Tentyris), church beside birth house in temple enclosure, view looking north

used in Roman architecture.[107] A triconch-shaped sanctuary in a solid block was built in the fourth century for the memorial church of Moses at Mt Nebo, in Byzantine Palestine (in modern Jordan). Triconches also occur in Lycia (in southern Turkey) carved from the rock in the church at Alacahisar and built at Karabel.[108] However, these examples lack the rooms behind the sanctuary found on the Egyptian examples and typical of Egyptian temples. The triconch on the churches in Upper Egypt is clearly a classical design, but built into the distinctive rectangular shape of an Egyptian temple. As the triconch built into a solid block is common in Upper Egypt, while also occurring in Palestine, it is reasonable to suggest it was also sometimes used in churches in Alexandria. Whether the church design with a rectangular exterior with inward sloping walls like an Egyptian temple was local to Upper Egypt or also occurred in Alexandria is still unknown.

An apparently late legacy of the broken pediment niche heads survives on the small church (12 × 21.5 m) of St Athanasius at Deir ez-Zawiah, c. 16 km south-east of modern Asyut, where they are used on its small east apse, which is not curved but formed by three flat surfaces forming a less than semi-circular apse. These niches appear to be in their original position as some of them match the frieze below them which is continuous and shows no sign of being reused.

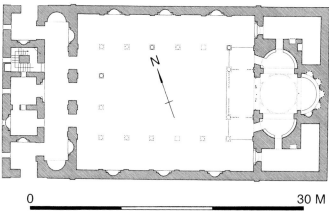

0 30 M

470. Dendara (Tentyris), church beside birth house, plan

They have flat grooved modillions carved in outline on them. However, unlike on other broken pediment niche heads in Egypt the cornice of each of these half-pediments is bent in the middle. Thus, it is possible that they are much later than the examples so far studied.[109]

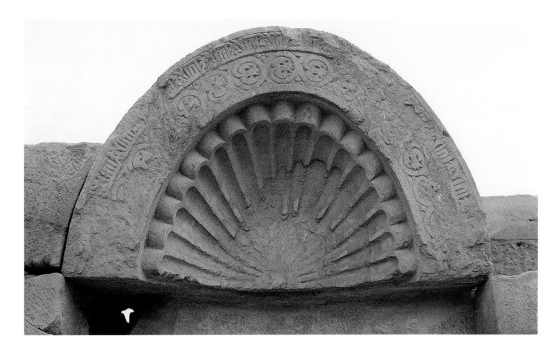

471. Dendara (Tentyris), church beside birth house, nave, niche head with parabolic shape

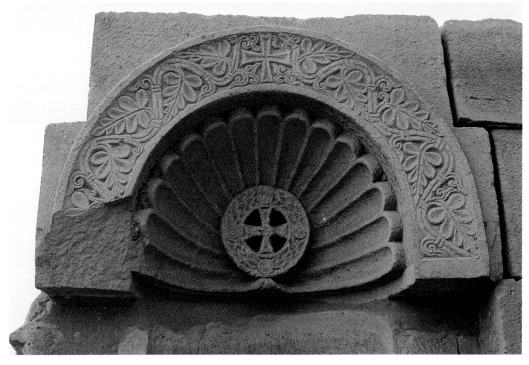

472. Dendara (Tentyris), church beside birth house, north entry room, semi-dome niche head

TRANSEPT BASILICAS WITH APSES AT HERMOPOLIS MAGNA (EL-ASHMUNEIN) AND MAREA (HAUWARIYA)

At Hermopolis Magna (el-Ashmunein) the large transept basilica, which was probably the cathedral [474], was built on the site of the sanctuary of the royal cult of Ptolemy III Euergetes I and Berenice [269].[110] The blocks from capitals of this Ptolemaic temple which were reused in the church foundations had traces of paint on them in such good condition [78] as to suggest that the temple was still standing until shortly before the church was erected directly over the temple foundations, not before the end of the fifth century. It is notable that this church is of monumental proportions without a smaller predecessor.

The plan of this large transept basilica had a curved end on each of the three short arms of the cross with each of these apses built into a solid block. As in the triconch churches, the east apse has rooms on either side of it and is bounded by a straight east wall ([475] reproduced here at a smaller scale than the plans of the churches discussed so far). The nave had a transverse aisle and galleries. The Great Synagogue in Alexandria (destroyed in AD 115–16) which is described as like a very large basilica possibly had two levels of columns,[111] suggesting that large basilical structures with galleries might already have been built in Alexandria.

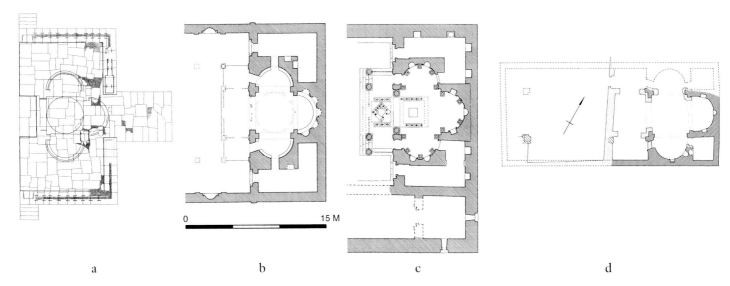

a b c d

473. Plans of triconches of Upper Egyptian churches, all at same scale: (a) Dendara (Tentyris), outline of church triconch on paving of birth house; (b) Dendara (Tentyris), church beside birth house, triconch; (c) Monastery of Apa Bishuy (Red Monastery) near Sohag, triconch; (d) Deir Anba Bakhum near Akhmin

The plan of the church and adjoining buildings at Hermopolis Magna takes into account the structures of the pre-existing pagan sanctuary, with the altar and sanctuary of the church located approximately over the Ptolemaic temple [475]. The court in front of the church reflects the Ptolemaic enclosure, although atria are rare in front of churches in Egypt. The off-centre entrance door of the narthex is in alignment with the west entrance to the forecourt which is built above that of the Ptolemaic enclosure [75], while the narthex is shorter than the nave on the south side to allow for access from outside to a well. The monumental entrance on Antinoe Street provides access directly to the nave from the north.

The red granite columns and limestone Corinthian capitals from the second or third century in the nave were reused from earlier Roman buildings [474].[112] Other architectural

474. Hermopolis Magna (el-Ashmunein), basilica

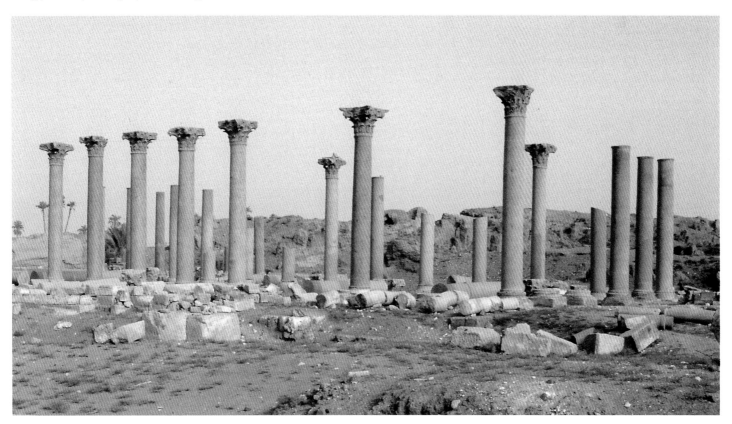

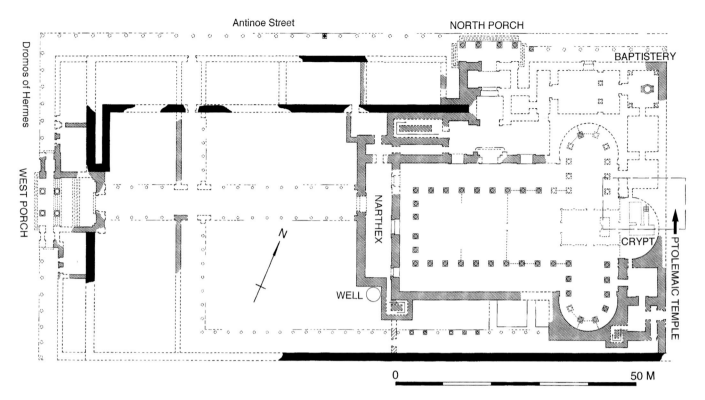

475. Hermopolis Magna (el-Ashmunein), basilica, plan

decoration was carved of local stone specifically for the church, including some capitals, friezes, and niche heads [476–477]. These niche heads are for both rectangular and apse-shaped niches which might have alternated on the walls of the east apse, nave and/or transept.[113] The purpose-carved capitals have been dated to the second third of the fifth century.[114] Recent excavations have uncovered pottery from the mid-fourth to at least the fifth century while coins of the

end of the fifth century were found in the well which was closed when the north transept was constructed.[115]

At Marea (Hauwariya), c. 33 km south-west of Alexandria, a large transept basilica (l. c. 50.4 m, w. of nave 25 m) recently has been partially excavated. It is provisionally dated to the fifth or sixth century.[116] At both ends of the wide transept it has a semi-circular wall with its curved shape visible from the outside [478]. It has an apse protruding from the east wall

476. Hermopolis Magna (el-Ashmunein), capital carved for basilica

477. Hermopolis Magna (el-Ashmunein), basilica, fragment of broken pediment niche head with flat grooved and square hollow modillions

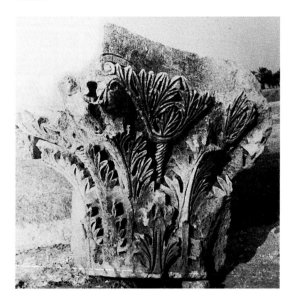

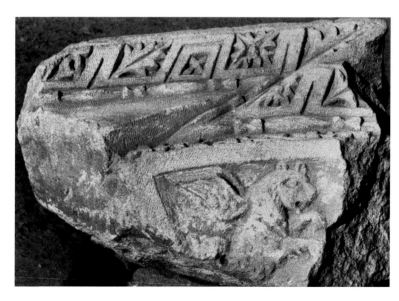

478. Marea (Hauwariya),
basilica, plan

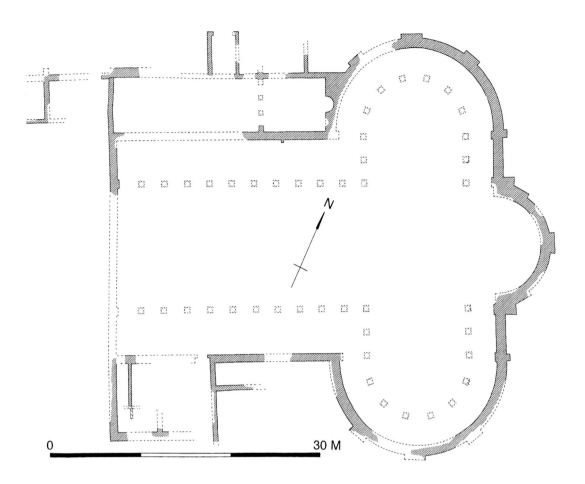

0 30 M

which is rare in Egypt but more common outside Egypt. The design of this church is also related to the transept basilica at Hermopolis Magna (el-Ashmunein) except on it the apses are built into solid blocks [475].

The sizes of these transept basilicas are comparable with other churches. The internal width of the nave at Marea (c. 23 m) is about the same as on the monastery of Apa Shenute (White Monastery) (c. 24 m), as can be seen by comparison of their plans which are reproduced here at nearly the same scale [455, 478]. The lengths of the transepts at Marea and Hermopolis Magna are similar (c. 42 m), but the Marea transept is wider. The axial width (c. 11.4 m) between the transept columns there is about the same as the width of the transept at Hermopolis Magna (c. 12 m). The internal width of the nave and the axial width of the centre aisle (c. 23 m, c. 13.7 m) at Marea are slightly smaller than at Hermopolis Magna (c. 27.5 m, c. 14.7 m, respectively).

The basic design of these churches at Marea and Hermopolis Magna seems to be based on their lengths being twice the width of their naves: at Marea, c. 25 × 50.4 m; at Hermopolis Magna, c. 29.5 × 59 m (excluding the narthex). These latter dimensions are notably close to those of the (five-aisled) Justinianic Church of the Nativity in Bethlehem, built over the Constantinian one, which is 30 × 59 m (excluding the narthex). Transept churches with curved ends are unique to Egypt,[117] but the design of the church at Marea is also partly related to the Justinianic version of the Church of the Nativity in Bethlehem, which has an inter-nal transept with a large apse protruding from the side wall at either end of it and an apse protruding from the east wall.[118]

CIRCULAR CHURCH BUILDING AT PELUSIUM (TELL EL-FARAMA)

The recently excavated church complex at Pelusium (Tell el-Farama) is the only surviving church building in Egypt which includes a circular structure [479]. It has a crypt in its western end and a large rotunda (internal diameter c. 30 m) with an ambulatory around its interior and an atrium to its east. To the east of this everything is destroyed.[119]

The circular design, based on imperial mausolea, was also used at Rome in the fourth and fifth centuries AD, as well as in Palestine.[120] However, the arrangement of a centrally designed building with an adjoining atrium and/or basilica is more common in Palestine than elsewhere.[121] The Constantinian Church of the Holy Sepulchre in Jerusalem, like the church complex at Pelusium, has a circular building at its west end with an atrium (and a basilica) to its east.[122] As Pelusium is located on the eastern tip of the Nile delta, before entering Palestine (Map 1), these connections with churches there are not surprising. The church complex in the former Serapeum in Alexandria possibly consisted of a similar arrangement with an octagonal martyrium for St John the Baptist and an adjoining basilica, which is the

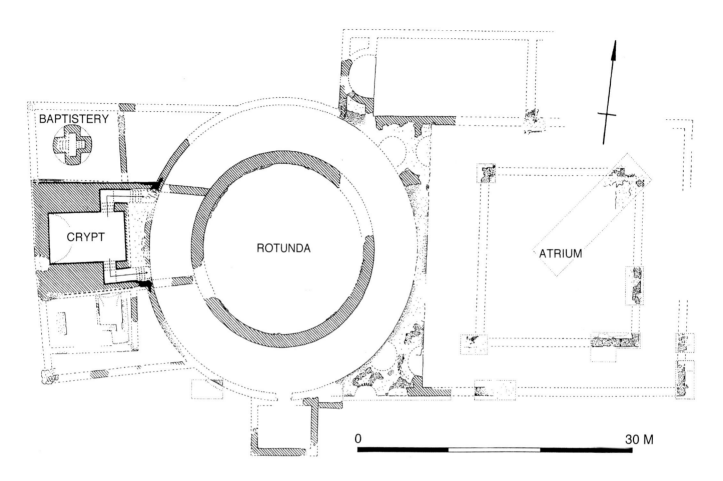

BAPTISTERY

CRYPT

ROTUNDA

ATRIUM

0 30 M

479. Pelusium (Tell el-Farama), circular church building, plan

480. Pelusium (Tell el-Farama), circular building, composite capital

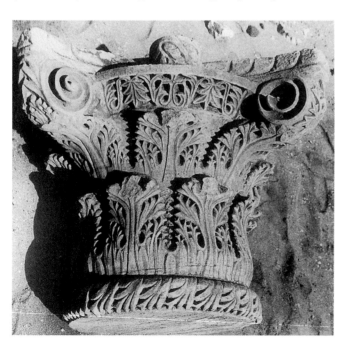

arrangement used for the Constantinian version of the Church of the Nativity in Bethlehem.[123]

Other features of the complex at Pelusium reflect contacts possibly further afield. It has a cruciform-shaped baptismal font, which is more common outside Egypt, in Palestine, Syria, and Greece.[124] The complex had classical composite capitals of Proconnesian marble with distinctive serrated or 'fine-toothed' cutting on their acanthus leaves [480], as also seen in examples in Salonica (Thessaloniki), Corinth, Ravenna, Jerusalem and Constantinople.[125] Dated to *c.* AD 450–550, these provide the most reliable basis for dating the complex. It also had Ionic impost capitals which indicate an upper floor around the rotunda.[126] Other examples of Ionic impost capitals in Egypt have only been found in Alexandria, dated to the late fifth or early sixth century [418].[127]

ABU MINA

Abu Mina was a pilgrimage town, *c.* 65 km south-west of Alexandria. It developed around the tomb of St Menas which was renowned for its healing power.[128] St Menas is the saint traditionally depicted between two camels, as on the distinctive flasks which pilgrims from round the Mediterranean took home from Abu Mina, *c.* AD 400 (or 480) to 650.[129] The initial development of the site began in the late fourth century AD. It was a pilgrimage centre until the ninth century. The extensive archaeological remains there are important because they provide an indication of its townscape, especially in the sixth

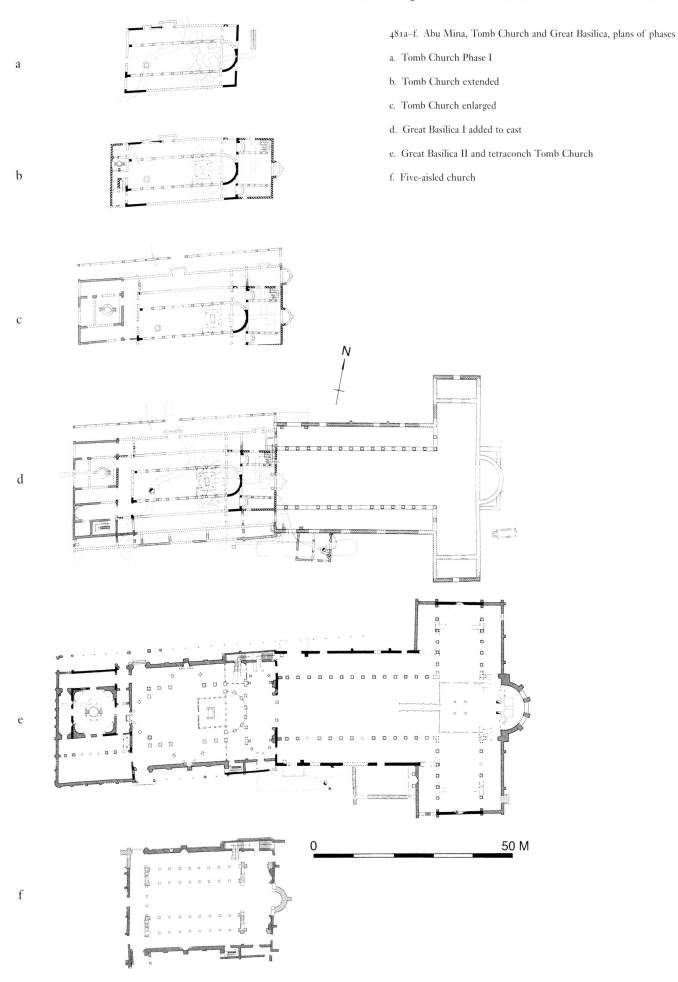

481a–f. Abu Mina, Tomb Church and Great Basilica, plans of phases

a. Tomb Church Phase I

b. Tomb Church extended

c. Tomb Church enlarged

d. Great Basilica I added to east

e. Great Basilica II and tetraconch Tomb Church

f. Five-aisled church

N

0 50 M

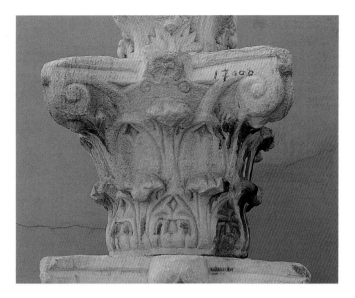

482. Abu Mina, marble capital, late fourth or first half of fifth century AD. Alexandria, Greco-Roman Museum

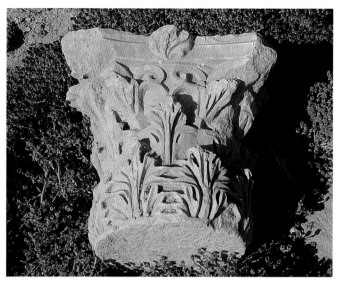

483. Abu Mina, marble capital, late third century AD, re-used in main church complex

century. The main church complex (the Tomb Church and Great Basilica) was extended and rebuilt a number of times during its lengthy period of use. There were also two other churches near the town: the North Basilica and the East Church.

Main Church Complex: Tomb Church and Great Basilica

The main church complex of St Menas consisted of the Tomb Church (also called the Martyr Church) over the tomb, with the Great Basilica added to its east, and a baptistery at its western end. Each of these parts of the complex was built in a number of phases [481]. The written sources and the archaeological evidence indicate the same relative sequence of construction. However, the written sources date the earliest phases about fifty years earlier than the excavators have dated them based on the pottery associated with them.[130] This pottery has still not been published, so it is not yet possible to check its chronological range.

Before examining the archaeological evidence, the written sources for construction at Abu Mina will be summarised. Notably, the main periods of building there coincide with those for churches in Alexandria indicated by contemporary sources, although the written records for Abu Mina are sometimes disregarded for being biased towards a Coptic (Monophysite) perspective and failing to mention Chalcedonian activity. The most reliable source is the Encomium in praise of St Menas, which was compiled after the Arab conquest and survives in a Coptic manuscript dated to AD 893.[131] It describes the first structure over the grave as 'a small oratory like a tetrapylon'. Then, under patriarch Athanasius, 'a wondrous memorial church' was built with financial help from the emperor Jovian (363–4): 'He brought it to completion in all beauty, adorning it with precious marbles glistening like gold.' In 375 the remains of St Menas were moved to the

crypt and the church was consecrated.[132] However, the increased congregation under the patriarch Theophilus (385–412) led the emperor Arcadius (395–408) to order 'the building of a spacious memorial church . . . And he made it one with the memorial church which the holy Athanasius had already built.' Its completion was celebrated with a synod when it was consecrated.[133] A sermon of Cyril of Alexandria, Theophilus' successor, also credits Theophilus with the construction of the 'Great Church of St Menas'.[134] Severus of el-Ashmunein indicates further construction was completed by the Coptic patriarch Timothy Aelurus (457–60, 475–7).[135] According to the Encomium, his contemporary the pro-Monophysite emperor Zeno (474–91) provided the shrine with financial support and military protection, and also built hospices there. Further facilities for pilgrims on the road were built under Zeno's successor Anastasius (491–518) who also had Monophysite sympathies.[136]

The ceramic evidence from the excavations indicates the site was occupied from the late fourth century AD, and the earliest structure above the underground tomb or hypogeum was a sepulchral monument, dated to the last quarter of the fourth century.[137] A small mudbrick structure was built around this at about the beginning of the fifth century, based on the pottery.[138]

The first version of the Tomb Church was erected over this. It consisted of a small stone basilica (15 × 28 m) with an apse flanked by rectangular side chambers in the east end, and the altar placed over the sepulchral monument [481a]. The first entrance with steps down to the hypogeum was carved in the natural rock at the same time. The construction of this first church is dated to the first half of the fifth century, based on the pottery.[139] An annex was added to the eastern end to cover the entrance to the crypt,[140] and at about the same time a small baptistery was added to the western end [481b].[141] Later the baptistery was enlarged and the whole complex widened by one aisle on each side.[142] A colonnaded porch was

484. Abu Mina, Tomb Church, panel of *opus sectile* marble paving preserved under altar, with monogram of Christ

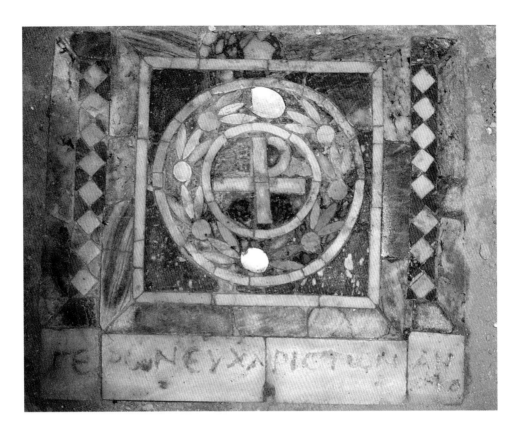

added along the north side of the Tomb Church [481c], before the Great Basilica was added, to its east.[143]

The Great Basilica had two phases. The first phase (Great Basilica I), which more than doubled the length of the whole complex (from *c.* 51 to *c.* 109 m), was built over late fourth-century mudbrick buildings which were pulled down to make space for it.[144] It had a three-aisled nave without a gallery, and a transept with a single aisle and a room across either end [481d]. The apse, which protruded from the east wall,[145] later had to be strengthened with corner buttresses.[146] In the second phase (Great Basilica II) the transept was widened all round by one aisle (from *c.* 10.4 to *c.* 20.8 m), with the foundations of the walls of the old transept being used as a stylobate (the course of masonry at ground level for columns) [481e]. Subsequently, a new apse was built in the new east wall (which was further east) with rooms on either side running the full length of the transept.[147] The construction of the new walls of the north transept resulted in a cistern being closed off. As it contained types of pottery developed by *c.* AD 475,[148] this provides a date after which the second phase of the Great Basilica was built. This evidence accords with its construction late in the period when Timothy was patriarch or in the reign of Zeno (474–91),[149] one of the periods of construction indicated by the written sources.

The Great Basilica was of similar size to the basilica at Hermopolis Magna (el-Ashmunein). The internal width of the nave and the axial width of the centre aisle of the Great Basilica (*c.* 26.5 m, 14.8 m) are close to those of the basilica at Hermopolis Magna (*c.* 27.5 m, 14.7 m, respectively) [475]. The internal length of the Phase II Great Basilica at Abu Mina (62 m) is about the same as that of the basilica at Hermopolis Magna (61 m, including the narthex).

The design of the Great Basilica also relates to plans further afield. Its first phase, with an apse protruding from the east wall and a single aisled transept with rooms at either end, is similar to the Constantinian St Peter's Basilica in Rome with an area divided off by columns, and also related to the Lateran Basilica there.[150] Like them, the Great Basilica at Abu Mina did not have a gallery. It had three aisles, whereas they had five, like some fourth-century basilicas in Egypt, as at Antinoopolis (el-Sheikh 'Ibada) and Pbow (Faw Qibli) [451]. The transept became a more prominent feature of the Great Basilica when it was widened in the second phase. Transept churches (although not identical in design) were also built elsewhere, especially in Greece in the fifth and sixth centuries. Examples include the church of St Demetrios at Salonica (Thessaloniki) (over 55 m long), which was built in the last quarter of the fifth century, and St John's church at Ephesus, completed by AD 565.[151]

At Abu Mina, the major remodelling of the Tomb (Martyr) Church included the final version of the crypt, which is stratigraphically later than the Great Basilica.[152] A second entrance corridor to the crypt was constructed to enable the circular flow of pilgrims. Fragments of gold mosaic with figured decoration were found in the crypt, apparently from its dome.[153] The old eastern wall of the Tomb Church was demolished when four semi-circular colonnades were erected in it to form a tetraconch, and a semi-circular colonnade was erected at either end of the old eastern annex [481e].[154] The baptistery was enlarged and rebuilt with semi-circular niches in the corners, and a dome.[155] These constructions are all dated to the second quarter of the sixth century, based on the pottery.[156]

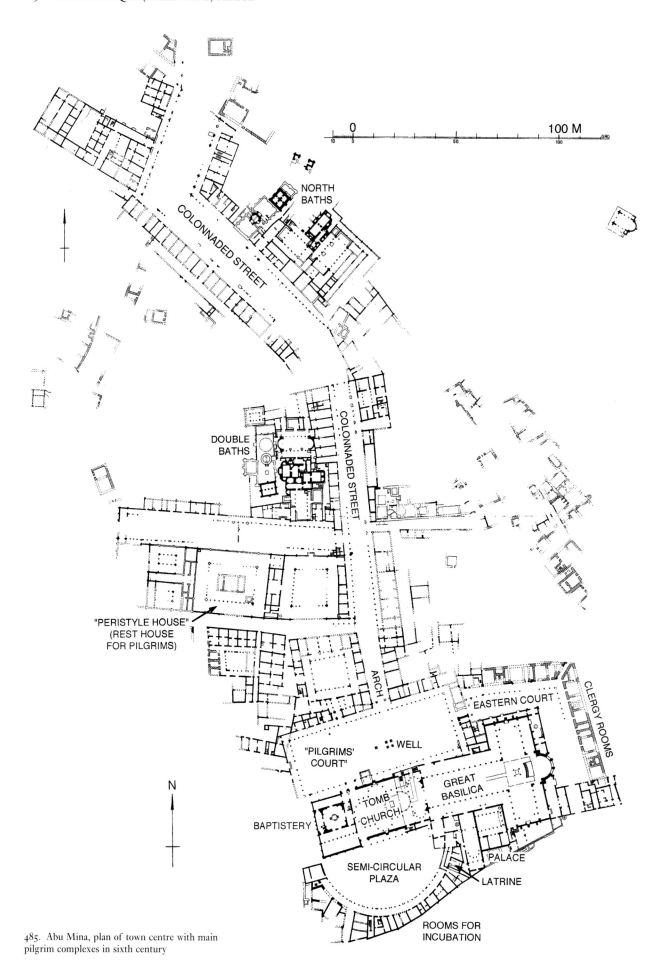

NORTH
BATHS

COLONNADED STREET

0 100 M

DOUBLE
BATHS

COLONNADED STREET

"PERISTYLE HOUSE"
(REST HOUSE
FOR PILGRIMS)

ARCH

EASTERN COURT

CLERGY ROOMS

WELL

"PILGRIMS'
COURT"

GREAT
BASILICA

N

TOMB
CHURCH

BAPTISTERY

PALACE

SEMI-CIRCULAR
PLAZA

LATRINE

ROOMS FOR
INCUBATION

485. Abu Mina, plan of town centre with main
pilgrim complexes in sixth century

The tetraconch version of the Tomb (Martyr) Church was damaged early in the seventh century, presumably during the Persian invasion when much of the town was apparently damaged. The Tomb Church was repaired later in the century.[157] Under the Coptic patriarch Michael I (AD 744–68), the Tomb Church was rebuilt within its old walls in its final form as a basilica (c. 25 × 41 m), with five aisles, a transverse aisle, and a *khurus* [481f].[158] While he was patriarch a dispute arose with the Chalcedonians who wanted control of the shrine,[159] but it remained in Coptic hands.

Early in the ninth century when pilgrimage to the site was disrupted by the fighting between the Egyptians and the Madlajites and Spaniards in Alexandria, the Coptic Church lost an important source of its revenue.[160] In AD 836 the church was robbed for al-Muʿtasim's new capital of Samarra in Iraq. When Lazarus 'looked at the building and its ornaments, and saw the beauty of the columns and coloured marbles which it contained, he marvelled and was amazed, and said "This is what the prince needs" . . . [He] robbed the church of its coloured marbles and its unequalled pavement, which was composed of all colours and had no match'. Although this report is possibly exaggerated, the marble floor paving and wall veneer of the parts of the Great Basilica which were no longer in use by then were taken. According to Severus of el-Ashmunein, the patriarch Joseph (830–49) repaired the church by obtaining more marble from Alexandria and elsewhere in Egypt.[161] However, because of the wars, reaching it became increasingly difficult. Later in the ninth century the bedouin pillaged it and laid waste to it. Archaeological evidence indicates occupation at the site until at least the eleventh century. It is mentioned in the written sources at the end of the twelfth century.[162]

Besides the basic design and phases of the main church complex, its architectural decoration also needs to be considered. Most of the pedestals with column bases, which were made for the nave of the first phase of the Great Basilica, were found still *in situ*.[163] The octagonal pedestals which were carved for later structures, including the tetraconch phase of the Tomb (Martyr) Church, had a plainer profile.[164]

It has not been possible to ascertain which capitals were originally carved for which phase of the main church complex. The surviving capitals were not found still standing on columns and their find-spots were not adequately recorded before most of them were removed from the site.[165] They are dated from the late fourth to mid-fifth century AD [482],[166] and are similar to locally made capitals from this period found in Alexandria.[167] It is worthwhile noting that the surviving capitals fall within the main periods of construction indicated by the written sources: under Athanasius in c. AD 363–75, by Theophilus under Arcadius, 395–408, and by Timothy Aelurus (457–77). There are also some earlier capitals which were apparently imported to the site, possibly from Alexandria, and reused [483].[168] The surviving column capitals, pilaster capitals, column bases, a piece of moulded decoration, and the remains of chancel screens are all of marble. They do not include frieze fragments. Nor do they include carved limestone decoration, although it might have been used for details such as engaged friezes.

The capitals are largely Corinthian, with a few Ionic ones. Notably, they do not include the new impost capital types which occur elsewhere in the Justinianic period,[169] although the tetraconch version of the Tomb (Martyr) Church was built then.[170] It is not clear if such capitals were used, but robbed in the ninth century, or if earlier capitals were reused in the tetraconch phase. In addition, it is not clear whether some of the capitals found at the site were those brought there from Alexandria and elsewhere after the site was robbed in the ninth century.

An indication of the quality of the marble paving and veneer which was stolen can be seen in the panel of *opus sectile* which was found preserved under the altar of the Tomb (Martyr) Church [484].[171]

Townscape

The considerable remains of other structures at Abu Mina provide a valuable indication of the streetscape in which the main church complex was built, with adjoining buildings, colonnaded courts and facilities for pilgrims [485]. The Great Basilica had a mudbrick multi-storied building (apparently with cells for clergy) forming an L-shaped colonnaded court (the Eastern Court) to the north and east of the north transept.[172] South of the Tomb Church there was a two-storey high semi-circular building enclosing a plaza. It had rooms apparently for accommodation (possibly for healing the sick by incubation in proximity to the tomb), and it was equipped with lavatories.[173] The rectangular colonnaded court (the 'Pilgrims' Court') on the north side of the church complex led to the main entrances to both the Tomb Church and the Great Basilica. Towards the centre of this court there was a small well-house with four columns. A gate on the east side of this court led to the Eastern Court.[174] The 'Pilgrim's Court' was approached from the north along the wide colonnaded street and through a triple arch.[175] On either side of this street there were extensive structures surviving from the sixth century, which provided facilities for pilgrims. These included buildings with peristyle courts with roofs with a wide overhang possibly for accomodating pilgrims, and two public baths-buildings.[176] These remains give us some sense of the townscape in which the church complex functioned. The fortification wall which was built around the town in the late sixth or early seventh century provides some indication of its extensive area.[177]

North Basilica Complex and East Church

Abu Mina had two churches located outside it. The North Basilica complex was built outside the town fortification wall. The church has the basic Egyptian basilical design with an apse with a room on either side, against a straight east wall, and a transverse aisle [486]. Its size (c. 15.6 × 27.6 m) is similar to the first Tomb Church (c. 15 × 28 m). The North Basilica is dated by ceramic evidence to the first half of the sixth century AD.[178] Its apse once had a *synthron* with a bishop's

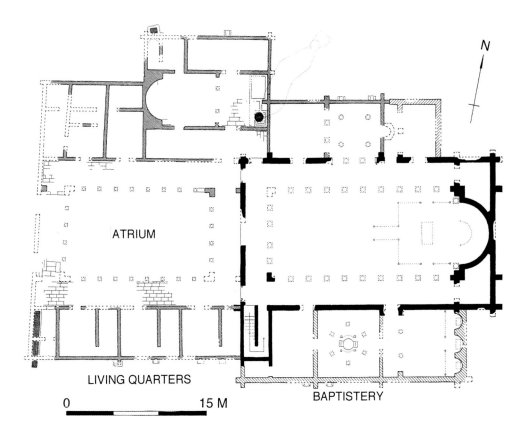

486. Abu Mina, North Basilica, plan

ATRIUM

LIVING QUARTERS

BAPTISTERY

0 15 M

throne. There was an atrium in front (to the west) of the church with residential rooms and a latrine. Various other rooms were built on either side of the church. These rooms included a baptistery, with its font crowned by a canopied shrine (ciborium) supported by six columns, as well as one of the earliest examples of a chapel with three altar niches.

The East Church, which is about 1.6 km east of Abu Mina, is thought to have been the church for the nearby hermitages.

Apparently the first version was a three-aisled basilica with a transverse aisle and an apse protruding from the east wall, beyond which a room with a baptistery was added. This church was of similar size to the Large East Church at Kellis (Ismant el-Kharab) [449].

The second version of the East Church was a centrally designed tetraconch or quatrefoil church (internal length 24 m) consisting of four large apses built around a square, with

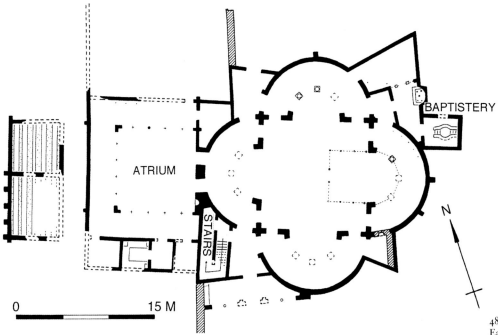

ATRIUM

STAIRS

BAPTISTERY

0 15 M

487. Abu Mina, tetraconch phase of East Church, plan

their curved walls visible from the outside [487], like the apses on the basilica at Marea (Hauwariya) [478]. The East Church also had an atrium with rooms and latrines adjoining it. It is dated to the mid-sixth century, slightly after the tetraconch version of the Tomb (Martyr) Church.[179] The diameters (c. 11.4m) of the apses of the East Church are the same as the axial width of the transept on the basilica at Marea and the Phase II Great Basilica at Abu Mina. Presumably, this is a width which the architects knew they could roof above the central square on the East Church, as it is in the equivalent position to where the transept and nave intersect in these two basilicas.

As tetraconch churches are rare in Egypt, it has been suggested that the two examples at Abu Mina may reflect influence from Syria where the most examples survive, such as the late fifth-century church at Seleucia-Pieria (Samandag). However, S. Lorenzo in Milan, built shortly before AD 378 when Milan was capital of the western empire, has a similar double shell design to the East Church at Abu Mina which is half the size.[180]

The East Church and North Basilica each have an atrium which is normal in Europe in front (on the west side) of early churches, but is rare on Egyptian churches. The church of Dionysius in Alexandria had an atrium in the mid-fourth century, mentioned by Athanasius.[181] As the design of the nave with transverse aisle in Egyptian basilical churches is reminiscent of the courtyards of Egyptian temples, with columns on their long sides and inside the entrance [223], this precursor may perhaps explain the lack of a separate atrium in most Egyptian churches.

Other buildings provide an indication of the interior decoration of buildings, not only churches, at Abu Mina. The 'house with the portico' beside the North Baths had painted floors and walls which show the high quality of painted decoration even in a mudbrick building, dated by the excavator to the sixth century [488].[182]

CHURCHES IN CAIRO

The arrangement seen in the North Basilica at Abu Mina [486], of an apse with lateral rooms set into an eastern wall which is straight on the outside, is characteristic of simpler churches in Egypt of the fourth to eighth centuries, which also usually have a transverse aisle. This arrangement survives in a few churches which are still in use and apparently date back to that period. In Cairo these include the churches of St Sergius (17 × 27m) and St Barbara (15 × 26m) in the former Roman fortress at Babylon (Old Cairo), and the church of St Mercurius (21 × 32m) to its north. These churches have three western doors, like the North Basilica at Abu Mina. They underwent repeated major destructions and rebuilding since their original construction, as did the church of the Virgin Mary called al-Muʿallaqa (the Suspended) built over the south gate of the fortress at Old Cairo.[183] Consequently, because they have more recent upper structures, these churches give little idea of their original appearance. The other churches in Cairo reflect more recent designs,

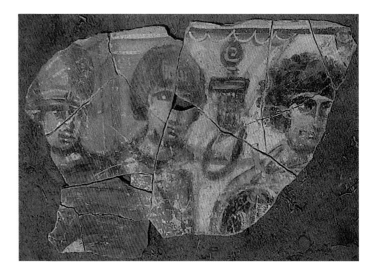

488. Abu Mina, fragment of a wall-painting from the 'house with the portico' beside the North Baths

beyond the chronological limits of this chapter. A basilical design is preserved in the church of St Sabas in Alexandria which might go back to the early seventh century [427].

Carved wood from the fourth to eighth centuries was found in the churches of St Sergius, St Barbara and al-Muʿallaqa. The famous wooden lintel from the latter in the Coptic Museum depicting Christ's entry into Jerusalem and the Ascension has an inscription which is used as the basis for its date, sometimes considered to be as early as the fourth century, but more recently thought to date to AD 735. If this date is correct, the lintel would provide important evidence for the style of carved decoration in churches, nearly a century after the Islamic conquest.[184]

CHURCHES OF MONASTERIES AT BAWIT AND SAQQARA

Having covered the churches notable for their plans, and often their decoration, and the influences which can be detected in them, our attention now turns to a detailed examination of the limestone architectural decoration of the churches in the monasteries at Bawit and Saqqara. They are important, not only because their decoration is remarkable for its high quality, but also, despite the distance between them, its remarkable consistency. These two monasteries also have well preserved wall-paintings.

Monastery of Apa Apollo at Bawit

The monastery of Apa Apollo (Deir Apa Apollo) at Bawit is 2km west of the modern village and 28km south of Hermopolis Magna (el-Ashmunein) (Map 1). The monastery was probably founded at the end of the fourth century. The latest inscription there is dated to AD 961, but the site continued to be occupied until about the second half of the twelfth century.[185] When uncovered early in the twentieth century,

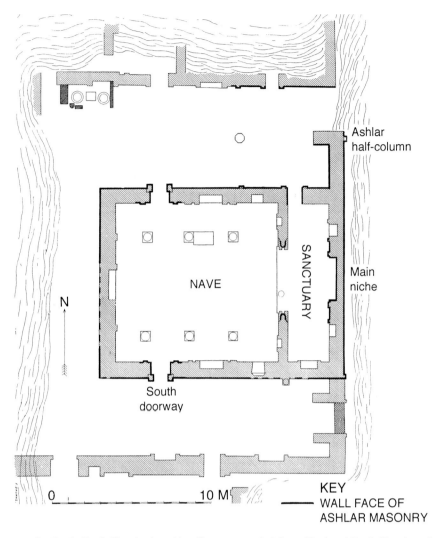

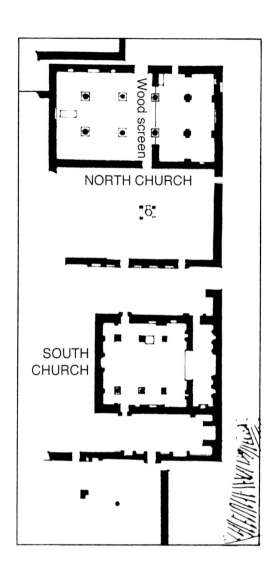

489. Bawit, South Church, plan with wall masonry marked. Inset: North and South Churches, plan

the walls were still standing to a considerable height. The buildings included the South Church noted for its carved limestone decoration, as well as the nearby North Church which also had carved timber and painted limestone decoration [489]. The other chapels and rooms are famous for their wall-paintings.

The South Church is important because of the high quality carved limestone architectural decoration found *in situ* in its walls, which were preserved to a height of *c.* 3 m. Detached pieces were also found in it [490]. These walls were photographed with their carved decoration still *in situ*. Unfortunately, before these photographs were taken, the detached pieces which had fallen to the ground were removed without their find-spots being recorded. The walls were dismantled and some of the carved fragments were taken to the Coptic Museum in Cairo, while most of the remainder went to the Louvre Museum in Paris where the church was re-erected [491].[186] This was possible because it was relatively small (11.8 × 15.5 m), of similar size and design to the small fourth-century church at Shams al-Din (Munisis), with three columns along each side of the nave and lacking an apse against the east wall [450, 489].

The published record of the South Church consists of photographs of it and the fragments from it, without a detailed accompanying text.[187] A brief description of the church was given later by Clédat, one of the excavators.[188] He describes the walls as faced with ashlar masonry on both sides of a baked brick core, and with timber string courses.[189] He notes that the building was paved with dressed granite blocks which, like the Roman granite columns in the nave, had been reused from a pagan temple.[190]

Clédat dated the South Church to not before the fifth century and considered that it 'and above all the sculptures are of the period of Justinian, sixth century'.[191] As it was thought to be a homogeneous (i.e., a single phase) building and as the impost capitals in the nave were related to distinctive types which appeared in Constantinople under the emperor Justinian (AD 527–63), it was accepted by scholars for over half a century as a fixed point in the chronology of 'Coptic' architecture dated to the mid-sixth century (and with its Corinthian capitals dated by the impost capitals).[192]

Then, in 1977, after examining the photographs of the church when it was excavated, the architectural historian Severin suggested that the two different construction

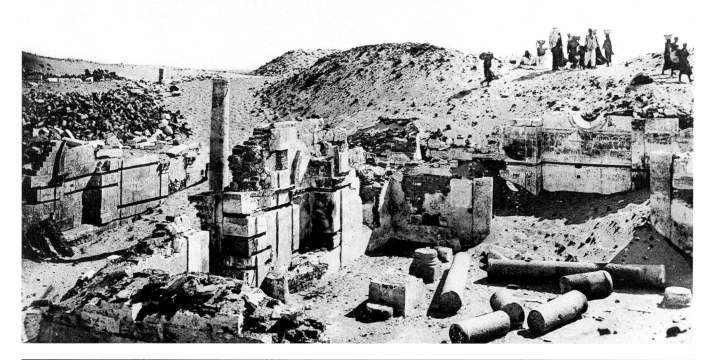

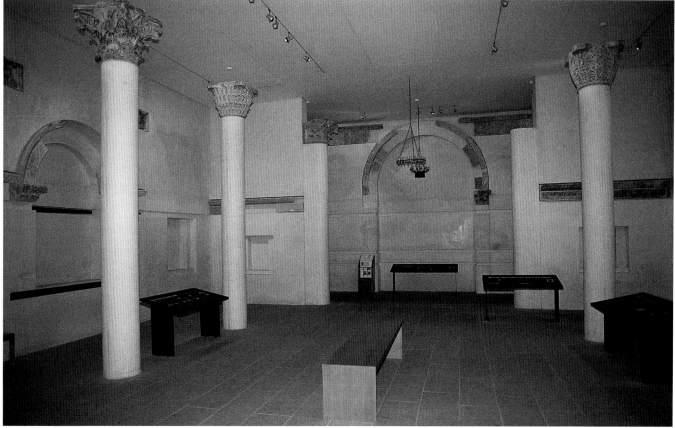

techniques used on the walls (ashlar and brick) indicated that the building had two main phases. He also considered that its limestone decoration was not all carved at the same time, but rather that some was reused from other buildings. This, in turn, meant that the date for the Corinthian capitals was not

490. Bawit, South Church, interior looking north-east during excavation

491. Bawit, South Church, re-erected in Paris, Louvre Museum

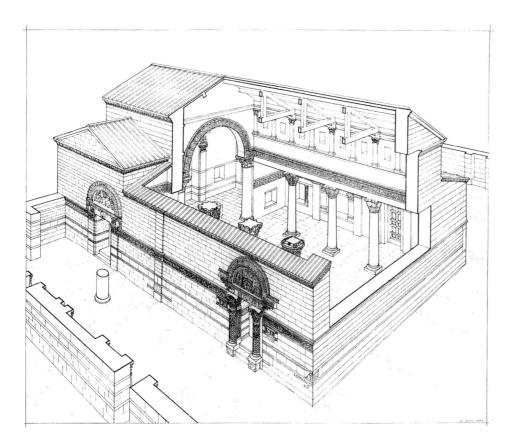

492. Bawit, South Church, hypothetical reconstruction (J.-C. Golvin)

dependent on that for the impost capitals. He later dated the first phase of the building to the fifth century and the second one, when it was rebuilt, to the late sixth or seventh century.[193] Severin rejected stylistic analysis as a basis for grouping the carved decoration. His theory, which destroyed the importance of the building as largely a single phase monument, received general acceptance, although notably not by Torp who had examined the carved fragments in detail.[194]

In the light of the reinstallation of the chapel in the Louvre Museum in 1997 [491], the phases of its construction merited re-examination. This new display incorporates in their original position many of the pieces which were found fallen in the church [492]. These include pilaster capitals, archivolt friezes, the frieze of the main interior order, and tympana.[195] As these pieces were found in the church and because, for most of them, there is a unique position into which they fit, this reconstruction is reliable. Taking into account these newly repositioned blocks, as well as a detailed analysis of the carving of the fragments starting with those found *in situ*, there is sufficient evidence to reconsider the possibility that the church was built, and most of its carving done, in one main phase, with some later repairs. Because of the significance of the implications of this it is necessary to present the evidence in detail.

The construction techniques of the walls are marked on [489]. The outside faces of the external walls of the church were of limestone ashlar masonry.[196] Major features on the interior faces of these walls were also made of ashlars, such as the main niche in the east wall and the pilasters of the main order of the nave, even if above a brick sockle.[197] The rest of

the inside faces of the exterior walls were largely of baked brick which was stuccoed.[198] Baked brick was used for the internal wall dividing the nave from the sanctuary.[199] Carved limestone decoration was used on both the ashlar and brick faces of the walls, which also had timber string courses to strengthen them against earthquakes.

Severin considers that the brick and ashlar walls on the South Church reflect two separate phases of the building, with the first phase of ashlars, while the brick parts represent the rebuilding.[200] However, there is a relationship between the prioritization of the use of stone and the importance of its decorative function within the building. This was also observed in the construction of the monastery of Apa Bishuy (Red Monastery) near Sohag where carved limestone was used for the most important features, while painted stuccoed brick was used for others making the economies taken in the use of materials less obvious. Thus, it is possible that the ashlars and bricks on the South Church could have been used together in a single construction phase – if detailed study of the limestone architectural decoration on both the ashlar and brick walls reveals that it all was carved at the same time. It is essential to pause to examine this possibility, before considering its implications.

The details of carving on the Corinthian capitals on the South Church indicates their contemporaneity. The complexity of their design relates to their size and structural function (whether they are for pilasters, half-columns, or columns) rather than suggesting a chronological sequence. The capitals on the pilasters, the simplest of these supports (i.e. flat engaged supports), have the least detail: they have a

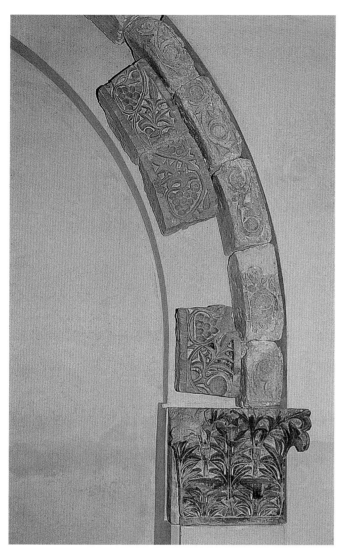

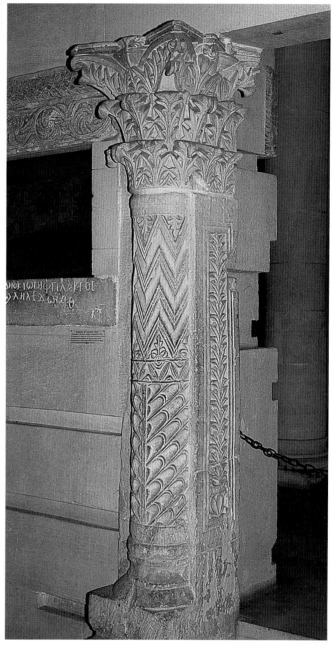

493. Bawit, South Church, detail of arch of main niche in east wall. Paris, Louvre Museum

494. Bawit, South Church, half-column and jamb of north doorway of nave. Paris, Louvre Museum

495. Bawit, South Church, frieze from centre of outside of east wall. Cairo, Coptic Museum

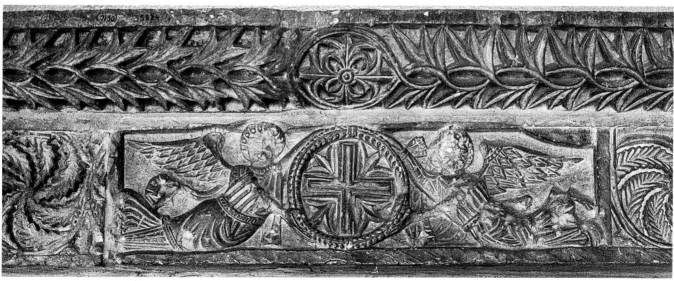

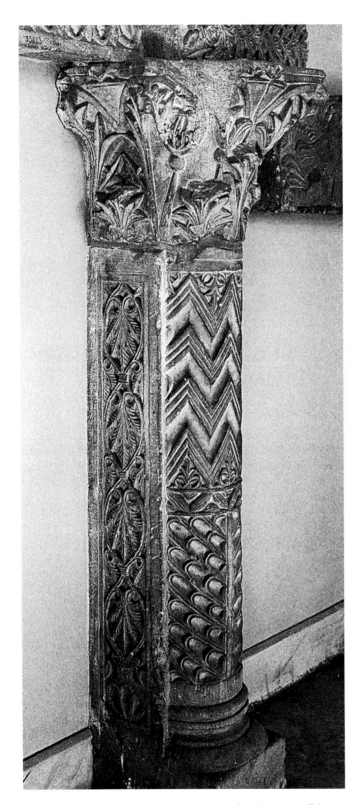

496. Bawit, South Church, half-column and jamb of south doorway. Cairo, Coptic Museum

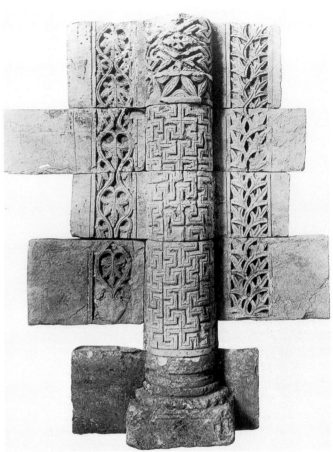

497. Bawit, South Church, carved ashlar half-column from exterior of east wall. Paris, Louvre Museum

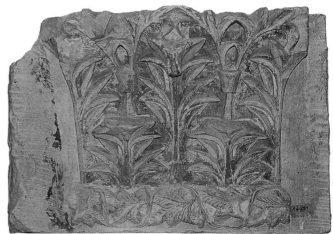

498. Bawit, South Church, pilaster capital. Paris, Louvre Museum

cauliculus, but lack helices or volutes (architectural terms in [127]). One was found *in situ* on the main niche of the sanctuary [493], while others are from the main order of the nave.[201] They may now be observed, reconstructed in their original positions, in the Louvre Museum. The capitals of the engaged half columns have a more complex design with corner volutes. Those on the north and south doorways of the nave were supported by ornate shafts [494, 496] and they were also used on the antae of the internal walls [499].[202] A closely related capital was also used on one of the free-standing columns in the nave.[203] The carving of the acanthus leaves and other details on the half-column capitals is identical to

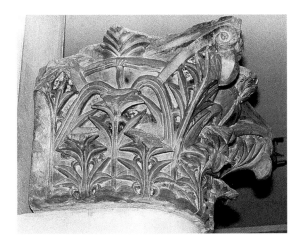

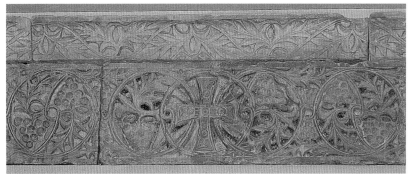

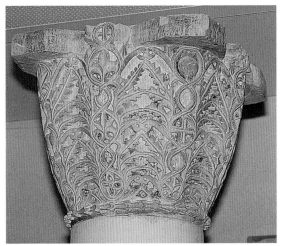

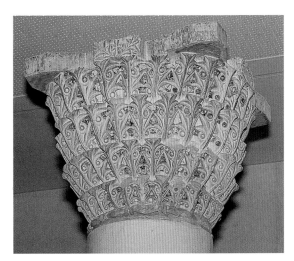

499. Bawit, South Church, anta capital of wall between nave and sanctuary. Paris, Louvre Museum

500. Bawit, South Church, fold-capital. Paris, Louvre Museum

501. Bawit, South Church, leaf-capital. Paris, Louvre Museum

502. Bawit, South Church, frieze

503. Bawit, South Church, vine frieze with cross and crown moulding. Paris, Louvre Museum

504. Bawit, South Church, frieze with narrow serrated leaves. Paris, Louvre Museum

505. Bawit, South Church, frieze. Paris, Louvre Museum

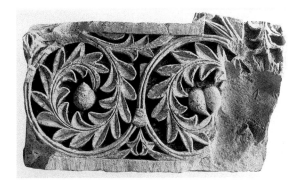

that on the pilaster capitals,[204] suggesting they are contemporary.

The ornately decorated half-column shaft on the east side of the south doorway had vine leaves with a finely cut texture on their surface [496].[205] Similar leaves are carved on the ashlars joining a half-column which were part of the original construction of the east wall [497].[206] This treatment of the vine leaves is also used on the necking band of a pilaster capital found in the church, which otherwise matches those mentioned above [498].[207] The occurrence of the same treatment of the vine leaves on them suggests the contemporaneity of

506a–b. Bawit, South Church, modillion cornices. Paris, Louvre Museum

the half-columns and the pilaster capitals with the original ashlar wall construction.

The friezes of the main niche, main engaged orders and the friezes along the outside walls and their crown mouldings also have details indicating they were contemporary with the Corinthian capitals. The carving of leaves of the vine scrolls on the archivolt of the main niche in the east wall [493][208] and of the frieze of the main interior order [503][209] is the same as that on the capitals of the half-columns of the north doorway of the nave [494], suggesting that these friezes were also contemporary with the original construction. Other pieces of the main frieze have narrow serrated leaves with a raised centre rib [504].[210] The acanthus frieze to the right of the ashlar half-column [497] is identical to that cut in the quarter circle crown moulding above some of the *in situ* friezes,[211] suggesting that these frieze crowns were also carved for the original construction.[212]

In the centre of the frieze on the outside of the east wall there is a panel with angels supporting a wreath containing a cross [495],[213] which indicates that the original building was Christian. This wreath is similar to one on the south wall[214] and to those around busts on the north wall.[215]

There is, in addition, some evidence for repairs to the building. The remains of the main north niche of the nave which were found *in situ* [490] indicate some repairs,[216] as do other archivolt frieze fragments found in the church, some modillion cornice blocks, and possibly a couple of main order pilaster capitals.[217] A photograph of the outside of the south wall also indicates that it had been repaired.[218] The evidence discussed so far suggests that the friezes and capitals belonging to the walls, except for these repairs, were contemporary and carved for the original structure.

The column capitals in the nave include types of impost capitals (a fold-capital and a leaf-capital) and a two-zone capital which appear in Constantinople and elsewhere under the emperor Justinian (AD 527–65). Consequently, whether or not those in the nave were contemporary with the original structure and its Corinthian capitals matters because of the chronological implications. To determine this the details of these capitals need to be compared with those on the carving already found to be part of the original buiding. The fold-capital [500] has the same narrow serrated leaves with raised ribs as a section of the main frieze [504].[219] The motifs in the

interlocked circles on the fold-capital also occur on a section of the main frieze, such as the shape of the cross, the flower with four hollow petals, and the three-lobed leaf [505].[220] The carving of the leaves on the leaf-capital [501][221] is identical to that on the jamb of the west pilaster of the south doorway.[222] That these two capitals were originally carved for a Christian building is indicated by the cross on a boss of the abacus on each of them [500–501]. The other capitals from the nave are an archaizing Corinthian capital and a two-zone capital,[223] which have a similar bead and reel pattern, along their bases, to that on the leaf-capital. Thus, the capitals in the nave seem to be contemporary with the carved decoration on the walls, and so with the original structure and its Corinthian capitals. If this is so, then, if both the Corinthian and impost capital types have the same date, the problem arises as to whether they are all dated to the fifth century which the Corinthian capitals would suggest (making the impost capitals earlier than examples in Constantinople and raising the possibility that they developed in Egypt); or whether they are dated to the sixth century (with the Corinthian capital types continuing until then).[224]

The South Church had modillion cornices and a broken pediment, like other Egyptian churches, reflecting continuity from the classical architecture of the Ptolemaic and Roman period in Egypt. Fragments from two flat-grooved modillion cornices were found in the church. One ran along the exterior of the north wall,[225] in a similar position to the one *in situ* on the outside back (west) wall of the church at Dendara. Another apparently ran around the inside [506],[226] as on the monastery of Apa Shenute (White Monastery) near Sohag. A broken pediment niche head [507], found in the South Church, has been restored above the niche in the south wall of the sanctuary in the Louvre.[227] Its contemporaneity with the original church construction is indicated by the acanthus leaf pattern on the mouldings of the half-pediments which is identical to that on the pilaster of the north doorway of the nave [494].

The nave column capitals have features reflecting influence from Egyptian architecture. The idea of covering the whole bell of a capital with a pattern of leaves of diminishing size used on the leaf-capital [501] was previously used on Egyptian capitals [219]. The acanthus leaves on the leaf-capital [501] are also related to those with a pronounced circle on

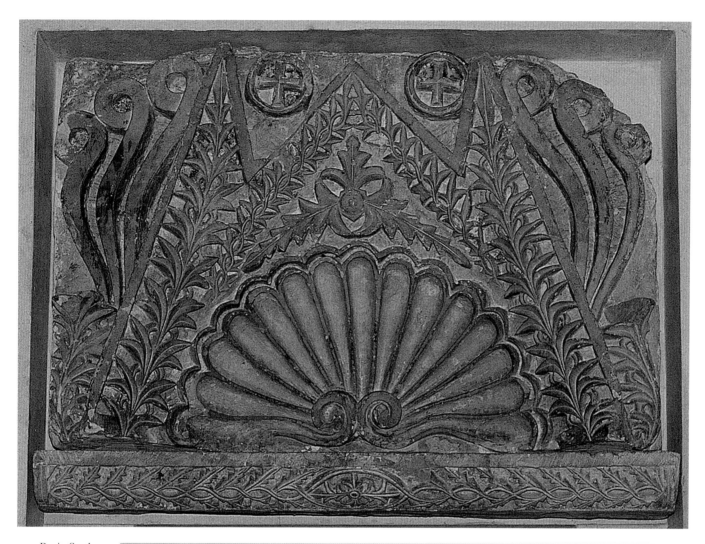

507. Bawit, South Church, broken pediment niche head. Paris, Louvre Museum

508. Bawit, North Church, capital with painted veins on leaves. Cairo, Coptic Museum

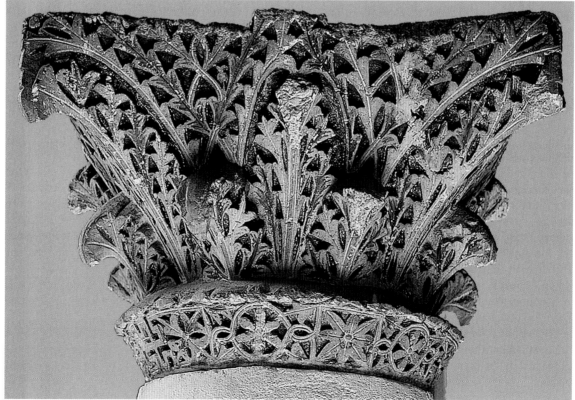

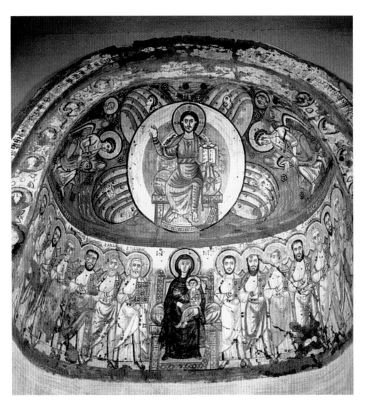

509. Bawit, Monastery of Apa Apollo, room 6, painting of Christ in Majesty, the Virgin and Child with Apostles. Cairo, Coptic Museum

their lowest lobe, on columns on the West Colonnade at Philae, carved under Tiberius (AD 14–37) [236, 238].[228] One of these also has a bead and reel pattern along the base of its capital [236]. The leaf-capital on the South Church has a simplified abacus, reminiscent of those used on a Corinthian capital, as does the fold-capital [500]. This fold-capital has a pattern of circles running up it, as occurs above the cauliculus on a Corinthian capital in the monastery of Apa Bishuy (Red Monastery), dated to the mid- to late fifth century [467]. The lobed or undulating cross-section of the fold-capital is related to that of some traditional Egyptian examples [220, 251], as is the fanning out of the leaves up the capital [226]. These similarities add weight to the possibility that these new capital types at Bawit first developed in Egypt, as precursors of these details do not occur in Constantinople, nor does the way they are used. The nave of the South Church had at least five different types of capitals used on its six columns. This idea of carving a variety of capitals for one part of a building was very common in the Egyptian style architecture of the Ptolemaic and Roman periods [219], in contrast to Greek and Roman architecture outside Egypt in which a single capital type was used for a whole colonnade.

Mention should also be made of the North Church at Bawit, which was separated from the South Church by two courtyards or rooms [489]. Like it, the North Church had a flat east wall without an apse. The North Church was not published by the excavators, except for some observations by Clédat,[229] but the photographs from the excavation survived.[230] It was built of stuccoed baked brick. A capital with

serrated leaves with considerable remains of paint was found in it [508].[231] Identical leaves were carved on the blocks of an archivolt which were found reused in the North Church, along with blocks of the tympanum which it framed. In the Louvre this is reconstructed above the north door of the South Church.[232] This tympanum had a saint on horseback killing a serpent with a lance.[233] It shows the apotropaic use of a mounted saint on a doorway, as also occurs on the north doorway of the monastery of Apa Bishuy (Red Monastery),[234] and on a tympanum reused over the entrance of the mosque at Duschlut.[235] Another fragment of a tympanum from the South Church depicts Jonah and the whale.[236]

Although damaged, the carving of the figures on the two tympana re-erected in the South Church in the Louvre appears to be fairly simple. This contrasts with the high quality, naturalistic carving of the vines and figures on the so-called Paris pilaster, reportedly from Bawit.[237] On the South Church leaves are carved with deep V-cuts, at the same time that a more naturalistic, softer treatment is used [496–498].

Considerable remains of timber fittings were found in the North Church, including a *haikal* screen and a panelled door. Timber in the South Church included carved string courses, and timber panels containing figures on either side of the nave doorways. It also survived from other buildings in Bawit.[238] The carved timber decoration would have been brightly painted, as indicated by examples surviving from other sites.[239] The timber friezes are often carved with similar patterns to the limestone ones and in a sufficiently similar style to suggest the possibility of the same workmen sometimes did carving in both materials.

The insides of both the North and South Churches were decorated with wall-paintings. The main niches of the South Church had scenes painted in them, such as the Last Supper in the main east niche.[240] The columns of the North Church were decorated with religious figures, such as the Virgin and Child, St George, and King David. These columns were repainted in the twelfth century, indicating that the North Church continued in use until not long before the monastery was abandoned.[241] The North Church had painted imitation marble veneer, while the South Church had painted geometric friezes in place of some carved ones, but with similar patterns.

There were also many smaller chapels and rooms of the monastery with extremely well-preserved paintings depicting a variety of religious subjects ranging from Christ enthroned [509] to scenes from the life of Christ, the lives of saints, and the Old Testament with particular concentration on the life of David. Clédat had considered that these were tomb chapels, but Maspero later identified them as living quarters based on the household goods found in them, their building designs, inscriptions and the iconography of their paintings.[242]

These paintings reflect the richness and diversity of the art of Christian Egypt. The ornateness and high quality of the carved stone decoration in the South Church is remarkable given the building's relatively small size. Fewer wall-paintings survive from the churches elsewhere in Egypt than

on these small chapels at Bawit so that their decoration pro-
vides a hint of what larger and more complex decorative
schemes on these churches might have been like. Unfortu-
nately, little architectural decoration survives from the largest
Egyptian churches. Hence the South Church at Bawit is
important as it shows how ornate and how high quality this
decoration was on a relatively small chapel in a monastery.
From this the lost decoration on larger churches may be visu-
alized. Further evidence is provided by the strikingly similar
carved decoration found further north at Saqqara.

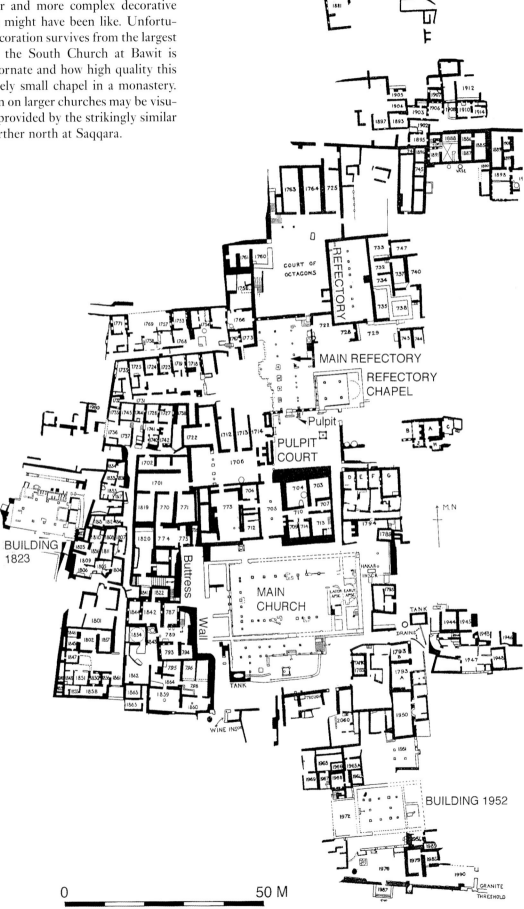

510. Saqqara, site plan

0 50 M

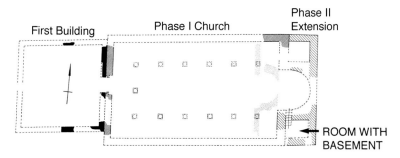

511. Saqqara, Main Church, plans of phases I–III

First Building Phase I Church Phase II Extension

← ROOM WITH BASEMENT

PHASES I AND II

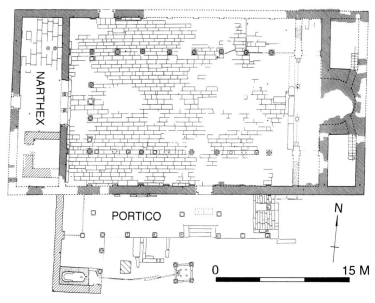

NARTHEX

PORTICO

N

0 15 M

PHASE III CHURCH

Monastery of Apa Jeremiah at Saqqara

Deir Apa Jeremiah (the monastery of father Jeremiah) is located at the western edge of Saqqara, the necropolis of Memphis which was the capital of Egypt before the foundation of Alexandria and remained a major urban centre into the Roman period. It is situated in the vicinity of modern Cairo (Map 1). Apa Jeremiah, after whom the monastery was named, was active in the late fifth century, although it is not known if he was its founder. It was obviously founded by the time he was visited there by Anastasius (who later became emperor) when he was exiled by his predecessor Zeno (AD 474–91), according to John of Nikiu. Archaeological and written evidence survive from the site as early as the first half of the sixth century. Epigraphic evidence suggests it was probably abandoned by the mid-tenth century, or perhaps a century earlier.[243]

It is one of the few surviving examples of a monastery of cenobitic monks. They did not live as hermits, but shared communal buildings [510]. Their cells were generally approximately square, often with a decorated apse in the east wall and rectangular cavities for storage. These cells were entered off a common entrance-hall. Buildings which survive at the site for communal use include refectories, a kitchen, a bakery,

an oil-press, store-rooms, and workshops. The whole complex was protected by a surrounding wall. Many of these buildings were decorated with wall-paintings, dated to about the sixth to eighth centuries. Their subjects, such as Christ enthroned, the Virgin and Child, and pictures of saints, are generally less biblical than those in the monastery of Apa Apollo at Bawit.[244]

The monastery at Saqqara had a Main Church and a chapel adjoining the main refectory. Two other structures thought to be churches have since been re-identified: the so-called Tomb Church (Building 1823) and so-called South Church (Building 1952).

The importance of the carved architectural decoration from Saqqara has been dismissed in recent years, because the buildings had a number of phases involving the reuse of carved decoration, not all of which was found *in situ*. For seventy years since their publication by the excavator Quibell in 1909–12, the architectural decorative blocks had been considered as original elements of the monastic architecture, and dated to the sixth century when the monastery was thought to be at its peak. Then, in 1982 Severin argued that, on the contrary, they were reused blocks not originally produced for church or monastic architecture, but carved for the necropolis during the fifth to mid-sixth century.[245] Thus, examina-

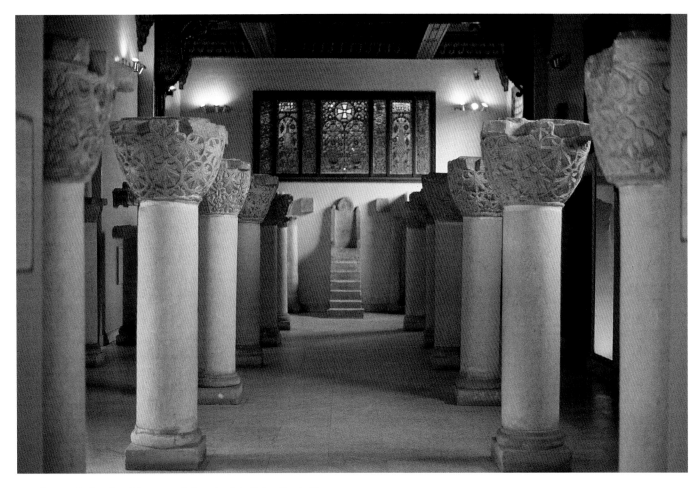

512. Saqqara, basket-shaped impost capitals and pulpit. Cairo, Coptic Museum

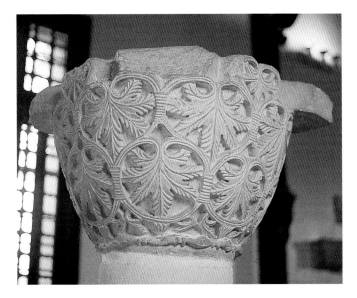

513. Saqqara, Main Church, fine basket-shaped impost capital. Cairo, Coptic Museum

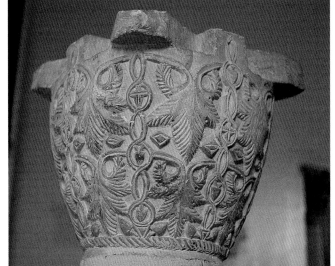

514. Saqqara, Main Church, coarse basket-shaped impost capital. Cairo, Coptic Museum

tion of these individual buildings is necessary for a rigorous appraisal of this architectural evidence, to see if perhaps a different picture emerges, halfway between these two.

Such an examination should begin with the Main Church. The foundations of an earlier, smaller version of it were found in excavations by Grossmann, under the one excavated by Quibell [511].[246] A small square chapel of mudbricks became the narthex when the small (Phase I) church was added to its east. This church was a basilica (c. 12 × 21 m) with five pairs of columns in the nave and an apse in the

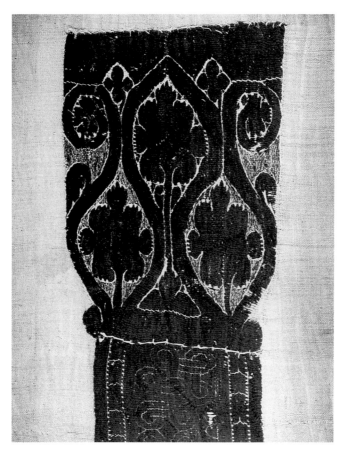

515. Sheikh Shata near Damietta, detail of Late Antique wool and linen hanging. New York, Metropolitan Museum of Art, 22.124.3

sanctuary with rectangular chambers on either side. It is dated by the excavators to the second half of the sixth century. It was extended toward the east with one pair of

columns and a new sanctuary with an apse and lateral rooms on either side. The south lateral room was constructed as a basement and a painted pot was found built into its stairs. This pot has been dated to *c.* AD 600, but might belong to the early sixth century. It provides a date after which this extension occurred, possibly a quarter of a century later.[247] It also gives a *terminus post quem* for the construction of the larger version of the Main Church over it, which Grossmann suggests occurred after the Arab Conquest to accommodate the increased population of the monastery.

The foundations of this larger version (Phase III), excavated by Quibell, may still be seen at the site. It was wider than its predecessor, with the nave columns erected above the foundations of the side-walls of the earlier version [511]. It is of similar proportions (the length about twice the width) to the monastery of Apa Bishuy (Red Monastery), which is slightly larger than it. It is a little larger (20 × 40 m) than the basilicas at Dendara and Luxor. It has a basilical plan with transverse aisle and a narthex.[248] There were pilasters along the nave walls in alignment with the columns. It had a central apse in the sanctuary, but the chambers on either side were at a lower level approached by steps from the apse. The main entrance was in the west end, through the narthex, and there was also a doorway in either side of the nave.

The doorway in the south side led to a porch which was later extended to an L-shaped portico, which was repaired with tomb stones dated to the mid-eighth century.[249] This indicates that the church was apparently still in use sometime after that date. The narthex was later divided into three rooms. Roughly built piers were added to the nave in its last period of use in an attempt to support the roof, for which additional columns had been added.[250] The repairs to the building, the reuse of blocks, and the later robbing of many blocks make difficult the interpretation of the blocks found

516. Saqqara, Main Church, capital with palm leaves above acanthus leaves, with traces of paint. Cairo, Coptic Museum

517. Saqqara, palm capital with painted leaves. Cairo, Coptic Museum

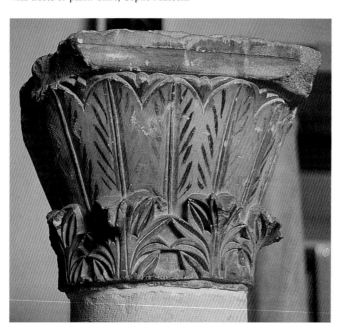

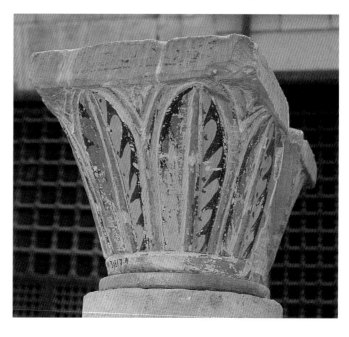

518. Saqqara, friezes found re-built in mudbrick buttress-wall immediately to west of the Main Church, after excavation

519. Saqqara, a frieze from fig. 518

520. Saqqara, detail of vine frieze from fig. 518

521. Saqqara, broken pediment niche head

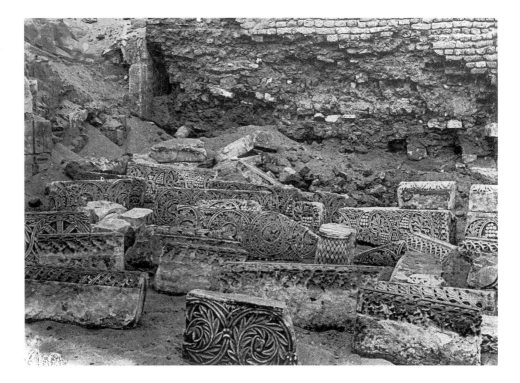

at the site and photographed at the time by Quibell.[251]

A sense of the building materials and structure of the Main Church is given by the evidence found in it. Blocks which are obviously reused architectural elements include three pedestal bases and three column shafts of grey-streaked white marble, and blocks from Egyptian temples. The two granite pedestals in the west entrance of the nave supported granite shafts. The remainder of the surviving column-shafts and all of the surviving capitals are of local limestone with traces of painted decoration. Many mouldings of the arches which the

nave columns would have supported were found by Quibell, who suggested they had timber tie-beams between them.[252] Fragments of carved timber screens survived. There were also pieces of lattice windows with coloured glass (colourless, purple or blue) set in plaster, like those later used in mosques. Mosaic cubes (tesserae) were found from the mosaic of the semi-dome, including some of glass encasing gold leaf.[253]

A variety of capitals were found in the church.[254] The sizes of some suggest that they were specifically carved for reused bases and columns in the nave. The capitals found along its

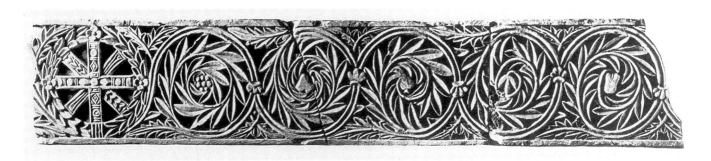

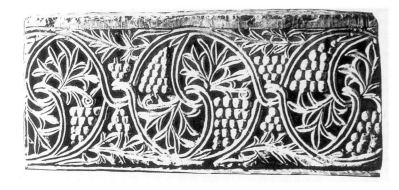

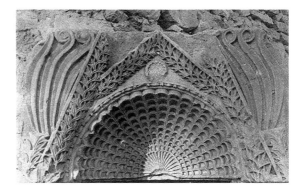

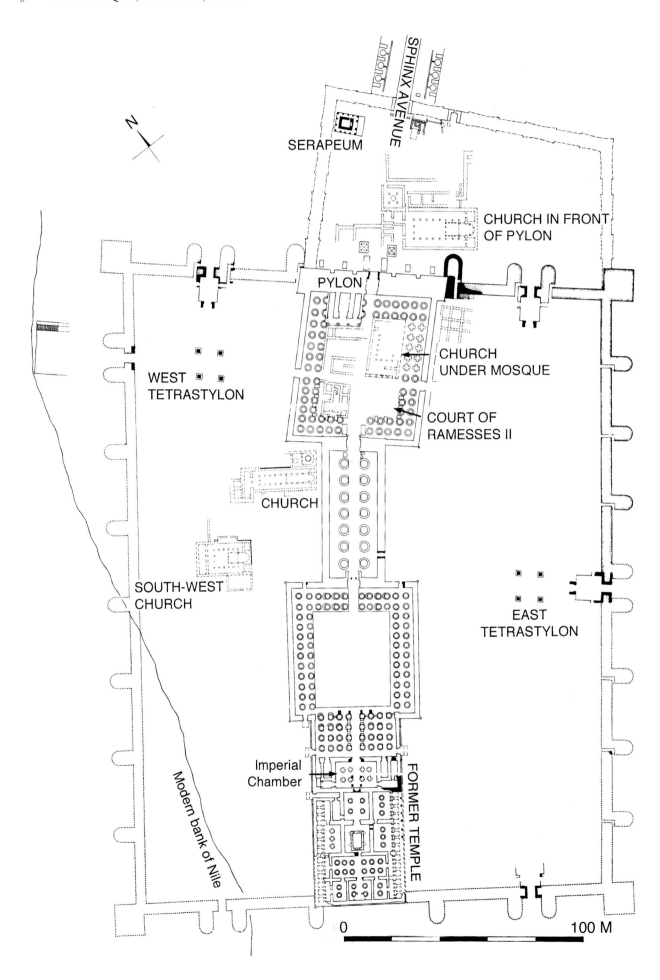

SPHINX AVENUE

SERAPEUM

CHURCH IN FRONT
OF PYLON

PYLON

CHURCH
UNDER MOSQUE

WEST
TETRASTYLON

COURT OF
RAMESSES II

CHURCH

SOUTH-WEST
CHURCH

EAST
TETRASTYLON

Modern bank of Nile

Imperial
Chamber

FORMER TEMPLE

0 100 M

north side are simplified Corinthian ones, with a single acanthus leaf under each corner volute and no helices. The variations in their proportions suggest that they were possibly carved to accommodate the differences in heights and widths of reused column shafts and bases which, if made of harder stone, would have been more difficult to cut down to size.[255] At one time, there seems to have been a main order of basket-shaped impost capitals, seven of which survive [512]. They have an interlocking pattern of hanging vine-leaves on their convex bodies, and a plain abacus. Two of the three finely carved, high quality examples were found in the south aisle [513]. They presumably came from the main order of the church which seems to have been repaired as four more coarsely cut examples were found in a variety of heights and widths, suggesting they were made to fit reused columns and bases [514].[256] The design on the finer examples is notably similar to that of the capitals in a Late Antique textile from near Damietta in the Nile Delta [515] further suggesting that this is an Egyptian capital type.

Other capitals found in the Main Church included capitals with an ornate interlocking overall decoration used on some for engaged columns and fold-capitals for columns (with slots for a screen).[257] Four palm capitals with a collar of acanthus leaves and considerable traces of paint were also found in the church [516],[258] together with two unrelated Corinthian capitals.[259] The paint surviving on another palm capital gives a further indication of how apparently plain capitals would have appeared when the ribs and lobes of their leaves were added in paint [517].

Severin dates the simplified Corinthian capitals, mentioned above, to the fifth century. He considers that the basket-shaped capitals, fold-capitals, and other impost capitals could not date before the second quarter of the sixth century. He concludes that the architectural decoration of the Main Church may all have been reused. This is the only way his date for the carved decoration would fit with Grossmann's seventh century date for the construction of the church.[260] However, both types of capitals (Corinthian and impost) may be contemporary. Also, there is no reason why they need to have been made originally for a necropolis.

Fragments of the friezes which the capitals would have supported were largely absent from the church when excavated. However, they seem to have been reused in a nearby buttress-wall. They can be related to the church based on the frieze crowns found in it.

The pieces of frieze crowns found in the church are of two types. Most have the common motif of acanthus leaves sprouting from entwined central stalks.[261] The other pattern has serrated leaves with the same twined spiral along the centre.[262] A fragment of a main frieze with serrated leaves was also found in the church.[263] A large number of frieze blocks (height c. 0.35 m) and frieze crowns were found immediately to the west of the church reused in a buttress-wall of mud-brick [510, 518].[264] These include vine frieze blocks, one of

which has a vertical band with an entwined acanthus leaf motif on it, indicating the contemporaneity of the vine friezes with the frieze crowns from the church with entwined acanthus leaves. The pieces from the buttress-wall also included a frieze crown with the serrated leaf-pattern, like on the frieze fragment found in the church.

The frieze blocks from the buttress-wall are of three main types. Those with grape vines [520] have a very similar arrangement to that observed at Bawit [503], but with slightly less well-cut acanthus leaves. A second type has swirls of leaves with busts and lions at the centre of each swirl, defaced by iconoclasts. A third type has swirls of larger leaves with fruit, such as pomegranates, at the centre of each swirl, and a wreathed cross [519]. These friezes were clearly carved for a major Christian building. The most likely possibility would seem to be the main phase of the larger version of the Main Church in which pilasters along the interior walls could have supported the main engaged entablature from which the friezes might have come. However, this is not certain, especially as it is not completely clear which capitals originally belonged to this phase.

Other buildings at Saqqara with carved decoration include the chapel adjoining the main Refectory (locations in [510]). It had four reused marble pedestals which supported basket-shaped impost capitals, of which three were found. They have hanging vine-leaf decoration with fine cutting identical to those on the Main Church.[265] The chapel was square, with an apse and lateral chambers on the east side. In the so-called Pulpit Court, plainer capitals, like a blocked out version of the simplified Corinthian capitals, were used,[266] possibly because this was a less important area. The pulpit [512] bears a striking similarity to the Arab *mimbar*, which served the equivalent function in mosques.

Building 1823, which Quibell called the Tomb (or West) Church, turns out not to be a church, but rather a structure with a central colonnade.[267] Building 1952 in the southern part of the monastery, previously called the South Church, is also not a church.[268]

Other pieces of carved architectural decoration were published from the excavation and, although Quibell usually recorded where they were found, their original location is often not known as some were reused. They include a variety of capitals, including different Corinthian ones, basket-shaped impost and fold-capitals with hanging vine-leaf decoration, a basket-capital, and one with wind-blown leaves and a cross on it.[269] There are also small columns, door jambs, and niche-pillars with decoration over their whole shaft,[270] and frieze fragments.[271]

Of particular note is a broken pediment niche head with the cornices framing a shell [521].[272] It is strikingly similar to the one from Bawit [507]. Both are notable for their reduced half-pediments indicated by only a single cornice, compared with those from Herakleopolis Magna (Ihnasya el-Medina) [442].

Most of the figured decoration at Saqqara was damaged by iconoclasm, including the figures of the apostles framed by a series of small arches.[273] Two defaced frieze blocks had apparently pagan motifs on them. One had floating figures holding

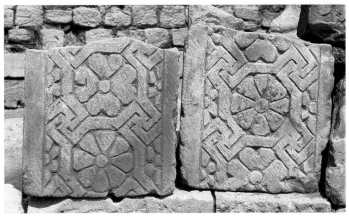

523. Luxor (Thebes), church in front of pylon of temple of Amun, modillion cornice

524. Luxor (Thebes), church in front of pylon of temple of Amun, fragments of frieze

525. Dendara (Tentyris), church beside birth house, detail of conch

garlands above their heads on either side of a rosette.[274] The other had a figure (?Aphrodite/Venus) in a shell, apparently with a sea-monster on either side.[275]

Despite the problems with their original locations, the architectural fragments from Saqqara remain important because of the striking similarity of many of them to those from Bawit.[276] This is seen not only in the broken pediment niche heads mentioned, but also in the various types of friezes, such as the vine-friezes [503, 520] and those in [505] and [519],[277] as well as the decorated door jambs [496].[278] The similarity of this decoration and its high quality, despite being carved at two sites 270 km apart, suggests a common source of inspiration for which Alexandria would be the obvious suggestion. It raises the possiblity that this decoration reflects that on the lost churches of Alexandria.

FRAGMENTS REUSED IN THE NILOMETER AT RODAH IN CAIRO

A group of carved limestone fragments of friezes and capitals was found reused in the Nilometer at Rodah, in modern Cairo, which was built at the beginning of the eighth century and rebuilt in the ninth century AD. Because reused Egyptian pieces from Heliopolis (near Cairo) were also built into it, it

has generally been assumed that the other fragments also came from there.[279] These include three small niches which had crosses on them as did a flat semi-circular pediment, indicating that they were made for Christian structures. Judging by their sizes and consistency in style, they could have come from a single structure. The friezes, small column capitals, and pilaster-capitals are strikingly similar to some of those found at Saqqara, while the Corinthian capitals are closer to the later examples from there. If the pieces did come from Heliopolis, they provide further evidence for the type of carving in the Delta region as seen at Saqqara, as well as further south at Bawit.

CHURCHES BUILT IN TEMPLE ENCLOSURES IN UPPER EGYPT

The churches discussed so far were all new constructions. The final category of churches which needs to be considered are those in former Egyptian temples. In this context churches which were new buildings erected in temple enclosures are included as they show the variations in the patterns of Christianization of earlier sacred space.

Churches were sometimes erected over demolished temples. The basilica at Hermopolis Magna was built over the site of a demolished classical temple, while retaining the

526. Luxor (Thebes), mosque of Abu al-Hajjaj built on a church in the Great Court of Ramasses II of the temple of Amun

layout of the design of its colonnaded court. This temple was still standing in good repair (suggesting it was still in use) prior to being demolished to make way for the basilica. As this was a much larger building, it would have held a larger congregation than the temple could have, if it had been converted [475]. By contrast, in Alexandria, when the temple of the Serapeum was demolished in AD 391, its colonnaded court was retained as an atrium while the new churches were built to its west, rather than over the demolished temple buildings. The temple of Ramesses II at Hermopolis Magna (el-Ash-munein) had been out of use for half a century before the South Church was built across the front in c. 450–60.[280]

Sometimes churches were erected inside a temple enclosure while the temple was not demolished but continued to stand beside them. At Dendara, the church in the enclosure of the Egyptian temple of Hathor is a new building built beside the birth house [469] while it and the temple of Hathor

remained standing [243]. Similarly, a church was erected in front of the temple of Khnum at Esna, which continued to stand (the church remains are visible to the left of the palm tree in [245]).

In the first half of the fifth century, Shenute, the abbott of the White Monastery at Sohag describes the conversion of some Egyptian temples: 'there is nothing else portrayed [on the Egyptian temples] except the likeness of snakes and scorpions, the dogs and cats, the crocodiles and frogs, the foxes, the other reptiles, the beasts and birds, the cattle, etc.; furthermore, the likeness of the sun and the moon and all the rest, all their things being nonsense and humbug – and – where these are, it is the soul-saving scriptures of life that will henceforth come to be there in, fulfilling the word of God, with His name inscribed for them and His son Jesus Christ and all His angels, righteous men and saints [will be portrayed on the walls of the converted shrine]'.[281]

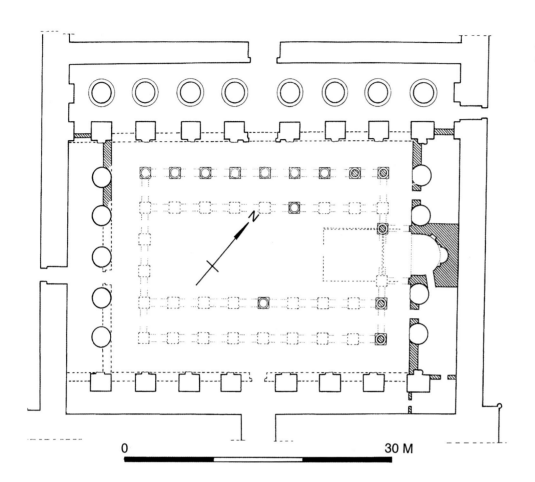

527. Medinet Habu, church in second court of the Great Mortuary Temple of Ramesses III

0 30 M

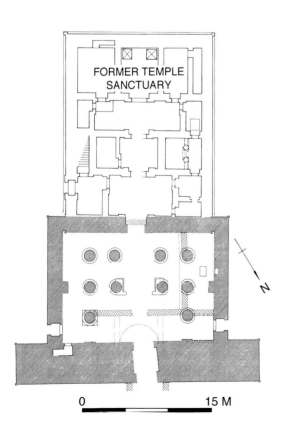

FORMER TEMPLE SANCTUARY

0 15 M

528. Philae, Isis temple with church in pronaos

At Luxor, the temple of Amun was no longer used for the Egyptian religion for two or three centuries prior to the construction of the churches in its enclosure. In *c.* AD 302 when its enclosure was converted to a Roman military camp, the entrance to the inner temple was converted to the so-called Imperial Chamber [294, 297],[282] and the statues of the Egyptian gods were carefully buried.[283] Two or three centuries later a church was built in front of the pylon of the former Egyptian temple enclosure, but inside the extension to the enclosure encompassing the Roman temple of Serapis [522].

The remains of this church were largely dismantled (except for the sanctuary) when the area was cleared as a tourist site.[284] It was of similar size to the church at Dendara, but with a less ornate plan than it. Its original plan was a conventional Egyptian one with a transverse aisle, and an apse and lateral chambers in the sanctuary. The apse was decorated with columns, like the one in the eighth-century mudbrick church at Tod (Tuphium), 19 km south of Luxor, and the sixth-century church at Deir Abu Fana.[285] The walls of the church in front of the pylon at Luxor include many reused blocks with Egyptian temple relief carvings which would have been covered by stucco. New decoration was also carved for it. This included the conch which crowned the single niche in the apse. It had a parabolic shape and a frieze[286] which are similar to examples on the church at Dendara [471]. The frieze blocks and modillion cornices from the Luxor church have the same distinctive four-petal flowers on them [523–524],[287] and modillions on the cornice carved in outline [523] as on the church at Dendara [525]. This church

at Luxor was substantially remodelled in about the thirteenth century.[288]

Other churches in the former enclosure of the temple of Amun at Luxor were built after the Persian occupation [522]. These include two to the west of the Great Court of Ramesses II, one of which had an unusual circular baptismal font.[289] The only church surviving in the temple of Amun itself was built in the east corner of the first court of the temple, the Great Court of Ramesses II. Its walls, which survive to a height (4.80 m) above the top of its windows (0.80 × 0.50 m), are built into the mediaeval Mosque of Abu al-Hajjaj [526].[290]

Karnak, north of Luxor, was also a major Egyptian religious site. Traces of three sets of monastery buildings were found in the enclosure of the temple of Amun, and temple buildings were converted to churches. Remains of saints painted on columns are still visible in the church in the Festival Hall of Tuthmose III. The hypostyle hall of the temple of Khons was converted to a small church, oriented east-west across the temple axis.[291] At Medamud, 8 km north-east of Luxor, a church was erected in the Egyptian temple incorporating one side of its south court, possibly in the sixth century at the earliest.[292]

Across the Nile, at Medinet Habu, a substantial church filled the second court of the Great Mortuary Temple of Ramesses III. It was large enough to incorporate five aisles and was oriented across the temple axis, with one temple column removed to accommodate an apse [527].[293] It was built in the fifth to seventh century. It had new capitals, which are plain, carved from reused temple blocks. The column shafts were roughly cut – at a time when knowledge of how to carve high quality (i.e. completely circular) column shafts was apparently lost.[294] The columns were removed in modern times and now lie outside the temple wall.

At Philae the cult of Isis seems to have coexisted with Christianity, especially the cult of the Virgin Mary,[295] much as occurred at Menouthis where the Isis temple coexisted with the shrine of the evangelists and Saints Cyrus and John during the fifth century, until c. AD 488/9.[296] The temple of Isis at Philae was closed on the orders of the emperor Justinian in 535–8, and its pronaos or hypostyle hall was converted to a small church [528], with crosses carved on the walls to negate the power of the hieroglyphs. It is notable that the archaeological evidence makes clear it was converted, rather than destroyed, contrary to Procopius' report that the sanctuaries at Philae were 'torn down' on the orders of Justinian and their statues sent to Byzantium.[297] Four other churches were also built in the temples at Philae. Two new churches were constructed with reused stone from Egyptian temple structures for their lower courses and brick above. They include the five-aisled East Church of about the first half of the sixth century, which was possibly the church of the Virgin Mary and apparently the cathedral.[298]

The new capitals and other decoration carved for these churches at Philae have some details in common with those further south, at Dongola and Qasr Ibrim in Nubia, and dated to about the eighth century.[299] At Faras in Nubia, five small capitals were also found of imported greyish-white (?Pro-

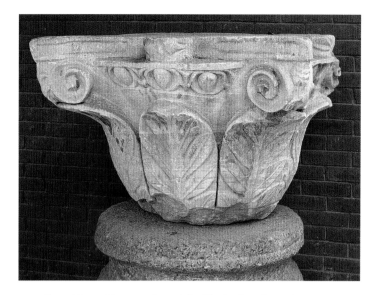

529. Alexandria, marble composite capital, with olive branches on large undivided leaves

connesian) marble, reused in the cathedral long after they were originally carved.[300] They are similar to some of the small capitals at Abu Mina, south-west of Alexandria, which were carved in Egypt. The discovery of these marble capitals at sites so far apart shows similar features in use despite the distances between them (Maps 1–2).

There is no consistent pattern in the conversion of temples to churches, once the written and archaeological evidence are considered. Rather there are examples of nearly every possibility regardless of the date.[301] There are some examples of the direct conversion of temples to churches to put an end to pagan practise. This is recorded in the written sources in Alexandria under the patriarch Theophilus (AD 385–412), with the conversion of the classical temple of Dionysos to a church. The conversion of Egyptian temples is mentioned by Apa Shenute in the first half of the fifth century, and observed about a century later at Philae. Destruction of the temple followed quickly by construction of a new church over it is attested by the archaeological evidence at Hermopolis Magna (el-Ashmunein). The use of a former temple location for a church building after it had been out of use for a time is seen for the South Church at Hermopolis Magna. Construction of new churches in former Egyptian temple enclosures without pulling down their main temple buildings was also observed at Dendara and Luxor. In a notable compromise, the Tychaion in Alexandria, with its pagan statues, was preserved by the apparent secularization of the building.

Stone from temples was reused in churches. These included large blocks with a structural function such as column shafts (from classical buldings), as well as door jambs and lintels, as on the monastery of Apa Shenute (White Monastery). Blocks from temples were also recut for use in ashlar walls of churches and their hieroglyphs were stuccoed over, as at Luxor, Dendara and Philae. There is a long tradition in Egypt of stone being reused, especially for

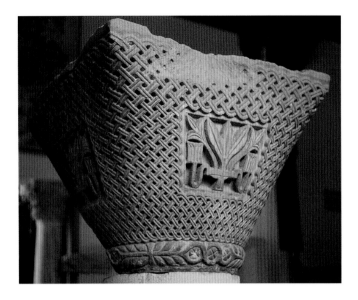

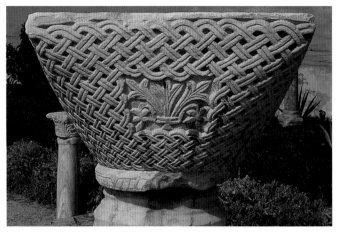

530. Alexandria, lotus-panel impost capital. Cairo, Coptic Museum

531. Alexandria, lotus-panel impost capital

features such as columns, for example the red granite palm columns on the temple of Ramesses II at Herakleopolis Magna (Ihnasya el-Medina).[302] Following this tradition, many marble capitals from churches and other buildings were used on mosques, especially in Cairo. As these provide our best indication of the marble capitals from the lost churches of Alexandria, and elsewhere in Egypt, they will be considered briefly after mention of those surviving in Alexandria itself.

CAPITALS IN ALEXANDRIA

Although there is almost no archaeological evidence for church buildings surviving in Alexandria, unlike the considerable written evidence for them, capitals have survived there from the fourth to mid-sixth centuries. Some of these are Corinthian capitals with crosses on them indicating they were made for churches or other Christian buildings [415, 417]. These Corinthian capitals include full-sized column capitals of the fourth and fifth centuries (and especially before the mid-fifth century), as well as smaller ones for structures such as chancel screens. Although their details indicate that they were carved locally, these capitals are of marble, some of which appears to be imported from the Greek island of Proconnesus.[303] Crosses are also carved on Ionic impost capitals and imposts [418].[304]

There are examples of types of capitals, usually of marble, with features which also occur outside Egypt. These include a two-zone capital (with beasts in the corners coming out of a basket) with 'fine-toothed' acanthus leaves of the second half of the fifth or first half of the sixth century.[305] There are also examples of a distinctive type of marble composite capital with, instead of acanthus leaves, a collar of olive branches carved in relief on large undivided leaves [529]. This type seems to be more common in Egypt than elsewhere and is generally dated to the early sixth century.[306] There is an impost capital with leaf-masks on the corners.[307] The most common of these non-Corinthian capital types surviving

in Alexandria are impost capitals with lotus-panels [530–531].[308] The origins of these and other impost capital types are considered in the next chapter.

The marble capitals in Alexandria, and those reused in the mosques of Cairo, could have been used with limestone cornices, friezes, pilasters, and niches which would have been brightly painted, as was carved timber. Equally the marble capitals could have been used with more expensive marble friezes and niches, while marble and granite were used for column shafts and bases. At the same time, high quality architecture was also achieved in local building materials, as evidenced by the carved limestone decoration, most notably that from Bawit and Saqqara. At Abu Mina marble paving and veneer suggest these could have been used in Alexandria, just as the glass mosaic cubes from there and in the Main Church at Saqqara suggest there could have been wall mosaics in Alexandrian churches.

CAPITALS REUSED IN MOSQUES

In the mosques of Cairo, over two hundred marble capitals have been re-used from the Late Antique buildings of Alexandria and elsewhere in Egypt. The earliest of these mosques, the Mosque of 'Amr ibn al-'As which was founded in AD 641–2, was in the centre of al-Fustat (Old Cairo). The mosque's present dimensions date to 827 when its size was doubled, although it underwent later alterations a number of times.[309] It is notable that the capitals reused in it seem to include more early examples from temples and other public buildings, rather than from churches [532]. This tends to suggest that the first capitals to be reused were those from buildings no longer in use or whose removal would not upset the Christians.

The Mosque of Ibn Tulun, built in Cairo in AD 876–9, has pillars instead of columns. The use of these rectangular supports was so novel that attempts were made to explain their origin. According to Maqrizi's version, a Christian architect offered to build Ibn Tulun a mosque with piers so that its

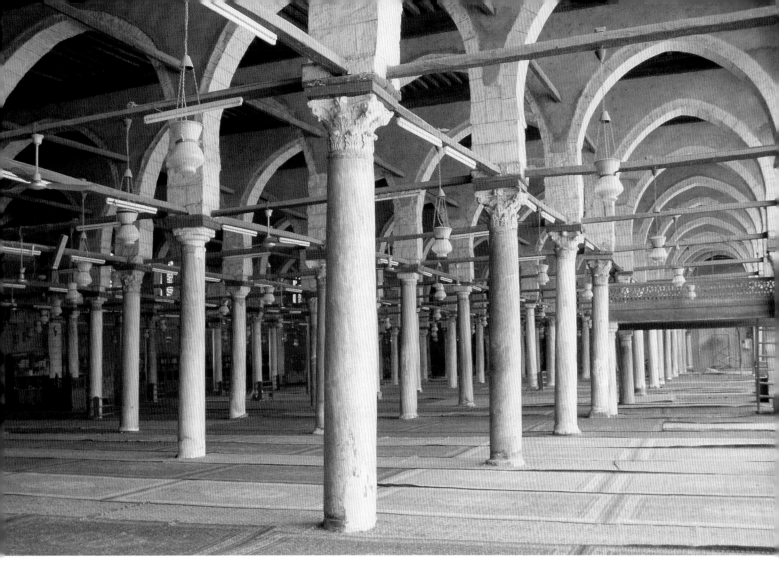

532. Cairo, Mosque of ʿAmir ibn al-ʿAs

construction would not involve wrecking churches for their columns, because over three hundred were needed and they could be obtained only from churches.[310] Even if this tale is legendary (as it is possible the idea of using such piers for mosques came from Samarra), it indicates an awareness of sensitivity over the reuse of church columns and capitals.

The Fatimid mosques with reused capitals include the al-Azhar Mosque which was founded in AD 970 by the Fatimid conquerer Gawhar as the congregational mosque of al-Qahira (Cairo),[311] the small el-Aqmar Mosque built in 1125 [533–534],[312] and the slightly larger Mosque of es-Salih Talaʾiʿ built in 1160 and restored after the earthquake of 1303. It was the last Fatimid mosque in Cairo [535–536].[313] The Mamluk mausoleum of Sultan al-Mansur Qalawun, built in 1284–5 also has reused capitals.[314] The early fourteenth century Mamluk mosques with reused capitals include the al-Nasir Mosque,[315] finished in 1334–5 by Sultan al-Nasir Muhammad as the principal mosque on the citadel in Cairo where it was the only structure not demolished by Muhammad Ali, and the Mosque of Amir Ilmas (Ulmās)[316] built in 1329–30. The older Coptic churches in Cairo also have reused marble capitals in them, probably added in their later repairs as these capitals are often more poorly preserved than those in the mosques.

Although most of the reused capitals in Cairo probably came from Alexandria, it was not the only place from which they might have been taken. Ibn al-Dawadari describes how 'great columns' were brought from Hermopolis Magna (el-Ashmunein) for the construction of the al-Nasir Mosque in AD 1334–5.[317]

Capitals were also reused in mosques elsewhere, including Alexandria: in the Western Mosque (the Mosque of One Thousand Columns), the Attarin Mosque, and the Mosque of Ibrahim at-Tarbana [407, 428]. They were also reused in mosques near sites which provided a ready source of capitals. The main mosque of Hermopolis Magna (el-Ashmunein), the Fatimid mosque of ʿAmr ibn al-ʿAs, seems to have been built on the site of a church, judging by the marble columns, capitals, and bases reused in it and lying outside. Examples can be seen also in the al-Yusufi Mosque (AD 1401–4) at Mellawi near Hermopolis Magna which incorporates some Egyptian style capitals.[318] They were also reused on the now destroyed Mosque of Sudun Min Zada of Suq al-Silah in Cairo (1623).[319] The small modern mosque at Oxyrhynchus (el-Bahnasa) has reused capitals including marble impost capitals with a lattice pattern, and Corinthian capitals.[320]

The Italian scholar Pensabene, who recently made a detailed study of the capitals in Alexandria, notes that 'the

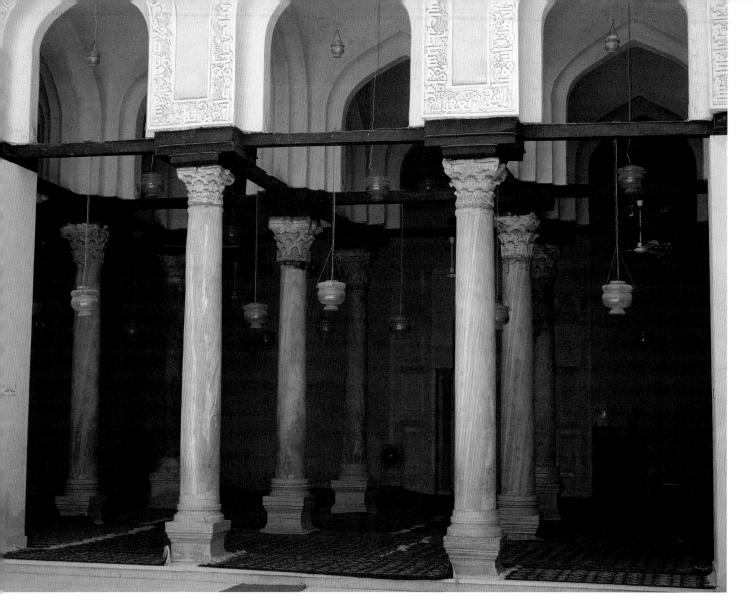

533. Cairo, el-Aqmar Mosque

extraordinarily high number of Corinthian capitals of the late
fourth and first half of the fifth century reused in the
mosques of Cairo probably were nearly all from Alexan-
dria'.[321] These then would reflect the building activity in
Alexandria in this period.

The majority of Late Antique capitals found in Alexandria
are Corinthian, with the next most common being compos-
ite capitals, with 'fine-toothed' or ordinary acanthus leaves, or
olive leaves. The capitals re–used in the mosques there and
in Cairo[322] include these types as well as others: two-zone cap-
itals, impost capitals of the basic type, fold-capitals, capitals
with leaf-masks in the corners, impost capitals with interlaced
olive branches, and capitals with wind-blown leaves. This
means that they include virtually every type of capital found
elsewhere in the Mediterranean world in the Byzantine
period, in both imported and locally made versions.

CONCLUSION

The ecclesiastical architecture surviving in the Nile valley
and the oases can provide an indication of the lost churches
of Alexandria mentioned in the written sources. The diver-
sity of plans of these churches suggests that those in Alexan-
dria also would have ranged from small ones of simple local
design, to larger more complex examples with both local and
imported features. Given this variety, it is instructive to sum-
marize them and consider their implications.

The smaller and medium sized churches are standard
throughout Egypt, consisting of a basilica with a transverse
aisle and a sanctuary with an apse and lateral rooms set
against a straight east wall. It is notable that the small fourth-
century churches already have these features. The transverse
aisle (across the west end of the church) is characteristic of
Egyptian churches. Sanctuaries with an apse with lateral
rooms are also found on some churches in Syria and Jordan,
where they are thought to have derived from Syrian temples.
Consequently, it is sometimes suggested that this feature of
Egyptian churches was derived from Syria. However,

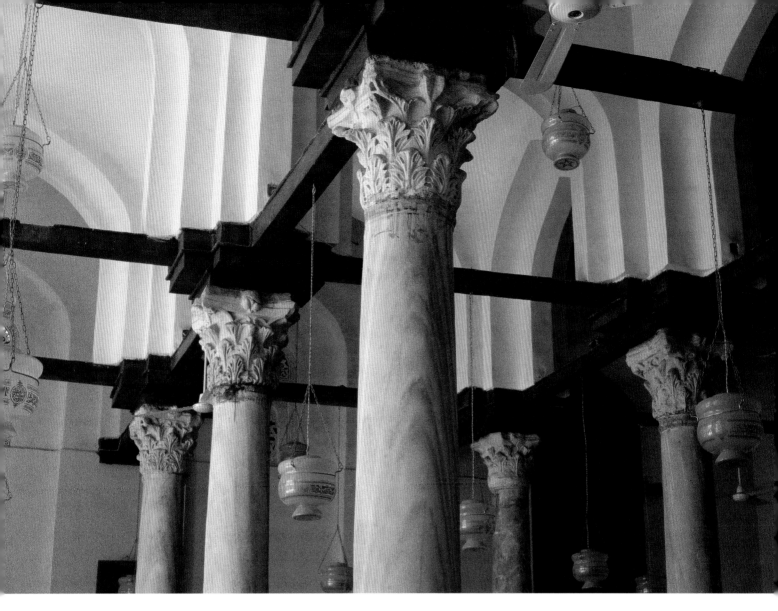

534. Cairo, el-Aqmar Mosque, detail of re-used capitals

tripartite sanctuaries are also found on some Egyptian temples. Thus, this feature, although common to churches of both areas, does not necessarily reflect the influence of the one on the other.

Similarly, a Syrian origin has been suggested for the tetra-conch church design in Egypt. Examples related to the East Church at Abu Mina are common in Syria, but the closest parallel for its double shell design is the fourth century S. Lorenzo in Milan. As this design ultimately goes back to earlier Roman architecture, it seems to be a shape used throughout the Mediterranean area, not one necessarily indicating specifically Syrian influence. Its use in Egypt, however, is a reflection of the contacts of the architects there with the wider world and their receptiveness to new designs in use elsewhere.

Five-aisled and transept basilicas are used for large churches in Egypt. These are also used elsewhere, but they have some local features in Egypt. Five aisles are used on the large Constantinian basilicas in Rome, St Peter's Basilica and the Lateran Basilica. However, these have an apse in their east wall, whereas the Egyptian examples have the local feature of

a straight east wall, as observed on the church at Pbow (Faw Qibli). There are transept basilicas elsewhere in the Mediter-ranean world, for example in Greece. However, the Egyptian version is distinctive with an apse at each end of the transept and in the east wall, as at Hermopolis Magna (el-Ashmunein) and Marea (Hauwariya).

The rare indications of designs for churches in Alexandria in written sources are confirmed by examples which have sur-vived elsewhere in Egypt. These include centrally designed churches adjoining a rectangular structure. The written sources seem to suggest that the complex of St John the Baptist on the Serapeum hill in Alexandria consisted of an octagonal martyrium with an adjoining basilica. A related design was used previously for the Constantinian Church of the Nativity at Bethlehem, while the foundations were exca-vated at Pelusium (Tell el-Farama) of a circular church with an adjoining rectangular structure. This type of design is best known in Palestine, where it was used for the Church of the Holy Sepulchre in Jerusalem.

Atria (colonnaded courts) are rare in front of churches in Egypt, in contrast to Europe where they are more common.

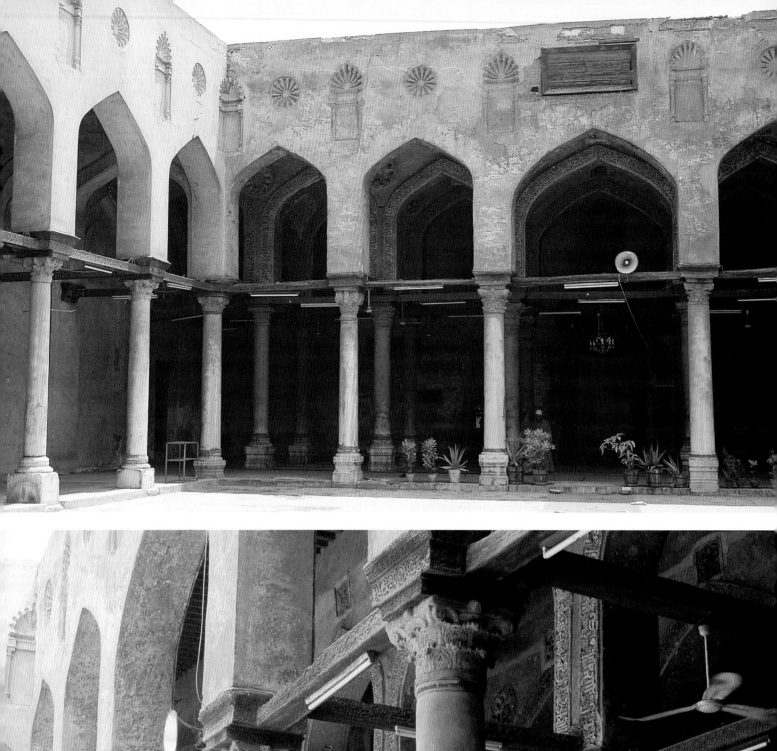
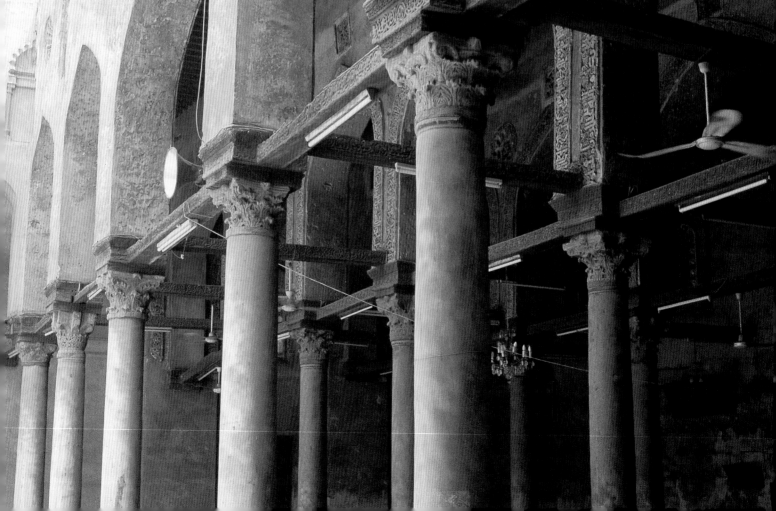

The written sources mention that the Church of Dionysius in Alexandria had an atrium in the fourth century. Archaeological evidence for them survives from the East Church and North Basilica at Abu Mina.

The triconch churches of Upper Egypt have a design which is unique to Egypt, as a result of the combination of local Egyptian and classical features. This involves a triconch, with baroque decorative niches, built into a rectangular structure which has an exterior reminiscent of an Egyptian style temple. Like Egyptian temples the triconch churches of the monasteries of Apa Bishuy and Apa Shenute near Sohag (the Red and White Monasteries) have tapering walls and a cavetto cornice. The long side room of these two churches is an unusual feature. However, as it is also found in Cyrenaica it possibly could have been a feature of some Alexandrian churches.

The sizes of Egyptian transept basilicas are comparable with major churches elsewhere, such as the Justinianic Church of the Nativity in Bethlehem. The five-aisled church at Pbow (Faw Qibli, phase 3) and the monastic church of Apa Shenute near Sohag (the White Monastery) are both of similar size to one of the halls of the cathedral at Trier. This demonstrates that, even in Upper Egypt, churches were constructed at a similar scale to those in major centres. Thus, Alexandria would have had churches at least of this size, and probably some which were larger.

The Egyptian churches also provide an indication of the minumum level of variety and complexity of the designs which might have been used for the lost Alexandrian churches. The diversity of these designs reflects the contacts of the Church in Egypt and its architects with those throughout the Mediterranean area, ranging from Milan and Rome to Greece and Palestine. The ability of these architects to build large churches in a variety of designs which are often complex because of the use of curved shapes shows the high level of their skill.

Similar developments and level of competency are seen in the architectural decoration of these churches. This carved limestone decoration involves continuity of features of local classical architecture from the Ptolemaic and Roman periods, as seen in the broken pediment niche heads and flat-grooved modillions. New developments are also observed, such as leaf- and fold-capitals which have elements derived from Egyptian style architecture. Of particular note is the carved decoration found at Bawit and Saqqara because it is of such high quality, and because, despite the 270 km distance between them, the style at both sites is remarkably close.

The fact that this decoration occurs so far north, at Saqqara (near Cairo), means that it is reasonable to suggest that similar decoration was carved in Alexandria and that it was at least of this calibre. Other traces of decoration in the Egyptian churches also give further glimpses of how the Alexandrian ones might have been furbished. The carved limestone decoration, and wood, would have been brightly painted. There would have been white marble column capitals, and marble columns in a variety of colours, including grey, red, yellow or green. In addition, there would have been marble wall veneer, with glass mosaics higher up the walls and on semi-domes.

The implications of the rich ecclesiastical architecture of Egypt to our understanding of Byzantine architecture elsewhere will be discussed in Chapter 13, after architectural training and scholarship in Alexandria are considered.

535. Cairo, Mosque of es-Salih Tala'i'

536. Cairo, Mosque of es-Salih Tala'i', detail of re-used capitals

Architectural Scholarship and Education in Alexandria

The written evidence which indicates considerable church building activity in Alexandria is complimented by the archaeological evidence for the rest of Egypt. These revealed that its major churches were built by architects with a knowledge of architectural design in major cities elsewhere in the Mediterranean area and Europe, although at the same time they exhibit features which reflect continuity of the local classical architectural tradition in Egypt. Both the diversity of the plans of these churches and the quality of their architectural decoration reflect skill at a high level in both architectural design and construction.

Another source of evidence for the proficiency of Alexandrian architects continuing into the Late Antique period comes from the texts concerned with the mathematics relevant to construction. These little-known texts provide much information about architectural practice and design. They range from quantity surveying to the geometry relevant to more complex structures, especially those involving curved surfaces, such as domes and semi-domes. These indicate the considerable mathematical competence of the architects designing and building such structures.

As domes and vaults did not become common in Roman architecture until the second half of the first century AD, these texts contrast markedly with the simpler mathematics in the treatise by the Roman architect Vitruvius, *On Architecture*, written in about the 20s BC.[1] Consequently, his work does not give an adequate indication of the mathematical and other skills of later architects.

As will be shown, the other surviving mathematical texts pertinent to building largely come from mathematicians and *mechanikoi* (architects, engineers, and master builders) working, studying, and teaching in Alexandria. They indicate a concentration of skill in and knowledge of the mathematics relevant to design and construction centred in that city.

SIMPLE QUANTITY SURVEYING

Quantity surveying is an essential part of the construction of buildings as it involves working out the quantities of materials which need to be ordered. The earliest surviving manual for quantity surveying is *The Measurement of Different Types of Timber*, generally attributed to Didymus of Alexandria, a first century BC scholar who collected and edited earlier knowledge in many disciplines.[2] This manual begins by defining the relationships between the units of length: one cubit equals 6 palms, 24 digits, $1\frac{1}{2}$ 'Ptolemaic' feet or $1\frac{4}{5}$ 'Roman' feet. He specifically calls them Ptolemaic feet. It follows that if a Ptolemaic foot ($\frac{2}{3}$ of a cubit, 0.525 m) is 0.35 m, and a Roman foot is defined as $\frac{5}{6}$ of a Ptolemaic foot, then a Roman foot would be 0.292 m. The length of a Roman foot on surviving buildings in Italy varies, but averages 0.296 m. Thus,

this simple conversion is slightly imprecise, but used for convenience. The text gives the relationships between these units when used for length, area and volume.[3] These relationships are then applied to the conversion, from one unit to another, of lengths, areas and volumes, by giving the rule for each conversion (i.e. what to multiply or divide by), then illustrating its use with an example.[4] Examples are also given for calculating the diagonal of dressed timber beams (with a square or rectangular cross-section),[5] presumably to work out what diameter logs to order. Finally, examples are given of calculating the volumes of solids (with measurements in different units) while changing the units at the same time.[6] These include the volumes (using $\pi = 3$) of undressed logs (i.e. cylinders) and logs split lengthwise, as well as the volumes of dressed timber beams and an elongated pyramid [537].

Whilst these calculations are largely given for timber, they are equally applicable to stone.[7] The cubit of $1\frac{1}{2}$ Ptolemaic

537. Page with diagrams for calculation of volumes in eleventh-or twelfth-century manuscript copy of *The Measurement of Different Types of Timber* 40–42, composed in the first century BC. Istanbul, Topkapi Library MS 1 fol. 65v

feet equals the 'lithic cubit', for use by stone masons and in quarries, which is the same as a 'wood-cutter's cubit'.[8] The calculations recorded by Didymus, and those of Heron which will be discussed below, are of particular note as Roman quantity surveying is sometimes thought to have been more concerned with areas (such as of marble veneer) rather than volumes.[9] Although Didymus' text is written in Greek and uses Greek letters as numerals, the fractions in it are written using the submultiple method developed by the Egyptians: for example, $1\frac{4}{5}$ Roman feet is written as $1\frac{1}{2}$ [+] $\frac{1}{5}$ [+] $\frac{1}{10}$ Roman feet. This system was already used (in Greek letters) on a column shaft by stone masons in Alexandria in *c*. 230–220 BC.[10]

HERON OF ALEXANDRIA, *MECHANIKOS*

Perhaps the best known figure in the Alexandrian tradition was Heron (Hero) of Alexandria, who was known as a *mechanikos* in Greek and skilled in applied mathematics and mechanics. He was active in Alexandria around AD 62, when he used an eclipse of the sun to measure the distance from Rome to Alexandria.[11] As Heron is the only *mechanikos* whose works are substantially preserved they give an indication of the areas of applied mathematics and mechanics he covered. Before discussing them it is worth defining mechanics which is the modern science of dynamics, with two main divisions: statics and kinetics. Statics deals with forces on bodies at rest and includes levers, pulleys, and other similar machines. Kinetics (for which the older term was dynamics) deals with moving bodies. One branch of kinetics deals with moving bodies such as projectiles, rams, and moving machinery. Another branch, hydrodynamics, deals with moving fluids and their interaction on solids, such as resistance of water to a vessel moving in it.

Many of Heron's works have survived, including Greek texts of: *On the Construction of Automata* especially miraculous devices in temples, *Pneumatica* which includes devices involving siphons and fountains and his renowned steam turbine (Ch. 64), and *Belopoeïca* on the construction of war-catapults. *Catoptrica* on plane and curved mirrors, survives in Latin translations. Heron's works in pneumatics and war machines follow in the tradition of Alexandrian *mechanikoi* established, under Ptolemaic rule in the third century BC, by Ctesibius and his pupil Philon.[12]

Because they were so useful Heron's manuals, like Euclid's *Elements*, remained in use through the centuries, with the geometrical and mensurational books being augmented with further examples.[13] This has created difficulties in working out what Heron originally wrote, and what has been added since. This is seen in the eleventh- or twelfth-century codex which includes Didymus' *The Measurement of Different Types of Timber*, between Heron's *Stereometry* and *Geometry*, and his *Metrica*. The diagrams illustrated here come from that manuscript.

Heron's *Metrica* in three books seems to have been preserved in its original form. It is concerned with calculating areas (in Book 1), volumes of geometrical figures (in Book 2),

538. Diagram for calculating the size of an amphitheatre in eleventh- or twelfth-century manuscript copy of Heron, *Stereometry* 1.44, composed in the first century AD. Detail of Istanbul, Topkapi Library MS1 fol. 17r

and their division (in Book 3). It gives examples of specific calculations along with geometrical proofs for them.[14] Heron often reminds the reader of the object being measured in these practical applications, such as a bathtub, vault, or conch (semi-dome). The calculations in it are independent of units, and the method of writing fractions with a single numerator and denominator is used (such as $\frac{4}{5}$).

A large number of numerical examples of the figures treated in *Metrica* Book 1 are also given in the *Geometry (Geometrica)*,[15] which is based on Heron's work, but is not his in its present form.[16] It is of direct use for quantity surveying as the lengths and areas are given in specific units of measure, and conversions from one unit of measure to another are also given. The submultiple method of writing fractions is used in it.

Stereometry (Stereometrica)[17] was probably compiled in the Byzantine period so it is not Heron's work in its present form, although it includes much which is earlier. It is his most interesting surviving work for architectural studies because it gives calculations connected with building.[18] Book 1 begins by calculating the volume of a variety of geometric shapes by giving worked examples with the same units of measurement throughout them, generally feet (Ch. 1–41). These are Greek (or Ptolemaic), not Roman, feet as a foot is defined as equal to 16 digits.[19] Practical examples are then given for using these calculations for specific applications on buildings. These include determining the seating capacity of a theatre with one foot allowed per person (Ch. 42–43),[20] which accords with the foot being the Ptolemaic foot (0.35 m) rather than slightly smaller. Calculations are given for the size (area and perimeter) of an amphitheatre (Ch. 44) [538].[21] The work also includes examples relevant to quantity surveying, such as calculating the volume of the walls of a triclinium (Ch. 45),[22] and the cubic capacity of a cistern (Ch. 48).[23] The area of the sides and bottom of the cistern are also calculated for ordering marble facing for it (Ch. 49)[24] and, similarly, the volume [of stone needed] to line a well (Ch. 50).[25]

Much of Book 1 is concerned with calculations for the surface areas and volumes of domes (hemispheres) and conches (semi-domes or quarter spheres), and fractions of them. They include examples taking into account wall thickness [539].[26] The calculations include the surface areas of these curved surfaces, giving applied examples using formulae proven by Archimedes, in the third century BC, in his *On the Sphere and Cylinder* Book 1. For example (Ch. 73), the

539. Diagram for calculating size of a conch taking into account wall thickness, in Heron, *Stereometry* 1.60. Detail of Istanbul, Topkapi Library MS1 fol. 13v

surface area of a dome is calculated based on Archimedes' proof that the surface area of a sphere is four times the area of a circle of the same radius.[27] *Stereometry* Book 1 concludes with calculations involving triangles on a spherical surface (Ch. 96–97).[28]

Stereometry Book 2 begins with calculations for relating a dome and a sphere to a cube where the diameter of the sphere is the same as the diagonal of the faces of the cube (Ch. 1–2) [540].[29] These are relevant to the application of a dome to a square base (specifically a dome with continuous pendentives). There are two types of so-called pendentive dome. A 'dome with continuous pendentives' results when a section of a sphere is placed over a square base whose diagonal is the same length as the diameter of the sphere [541]. The resultant triangles on a spherical surface which are squeezed down into the corners are called pendentives. Pendentives are also used to fill the corners when a dome is placed on a square

base on a circle or ring with the same diameter as the lengths of the sides of the cube, to form a 'dome on pendentives' [542]. The calculations for the surface area of a spherical triangle given at the end of Book 1 could be used for a pendentive.

It has been thought that pendentive domes were not built until the early third century AD, but the dome with continuous pendentives in the baths-building at Petra is now dated to the first century BC.[30] So there is no reason why these parts of *Stereometry* could not be part of Heron's original work in the first century AD. This also accords with the evidence from the *Sphaerica* of the mathematician Menelaus of Alexandria, who was active around AD 98. This textbook on spherical geometry, which is preserved in Arabic, contains the earliest known theories of spherical trigonometry, and Books 1 and 3 are concerned with triangles on a sphere.[31]

Much of *Stereometry* Book 2 is concerned with calculations for quantity surveying. These include practical examples of calculating the volumes of odd shapes. These consist of circular containers, such as those with sloping sides (i.e. bucket-shaped) (Ch. 7–8),[32] a keg (Ch. 9),[33] and pottery vessels (Ch. 21–24).[34] They include parts of buildings, such as tapering column shafts (Ch. 10–12),[35] tapering pillars (Ch. 20),[36] and stone blocks with an irregular shape (Ch. 17)[37] [543–544]. Examples are also given for curved shapes in buildings, including conches, arches, and barrel vaults, of specified thicknesses, and include the calculations for the volume of bricks required for them (Ch. 28–34) [545].[38] The calculations given for the surface area of mosaic needed for a conch (semi-dome) (Ch. 35)[39] are based on Archimedes' method for calculating the surface area of a sphere used in Book 1. Practical use is suggested by the calculation of the

540. Diagram for calculations concerning a sphere on a cube (a dome with continuous pendentives), where the diameter of the sphere is the same as the diagonal of the cube, in Heron, *Stereometry* 2.1. Detail of Istanbul, Topkapi Library MS1 fol. 46r

541. Dome with continuous pendentives which is formed by placing a sphere on a cube, where the diameter of a sphere is equals the length of the diagonal of the cube

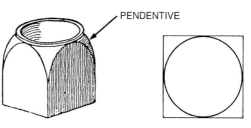

542. Dome on pendentives which is formed when a dome is placed on a ring supported by pendentives, and the diameter of the dome equals the length of the sides of the cube

543. Diagram for calculating volume of a column shaft taking into account tapering, in Heron, *Stereometry* 2.11. Detail of Istanbul, Topkapi Library MS1 fol. 44v

544. Diagram for calculating volume of a stone block with an irregular shape, in Heron, *Stereometry* 2.17. Detail of Istanbul, Topkapi Library MS1 fol. 45v

amount of paving to be ordered for a portico (stoa), which includes an allowance of an additional ten percent for wastage (Ch. 41),[40] still used by tilers. Calculations are also given for the number of roof tiles needed for a house (Ch. 43–44).[41] Other quantities calculated include the capacity of a ship (Ch. 50–52),[42] and the amount of canvas needed for a sail of specified size (Ch. 48).[43]

The examples in *Stereometry* always use a single unit, usually feet. As mentioned the foot used is a Greek (Ptolemaic) foot. How to convert these to digits in each dimension is given at the end of Book 2 (Ch. 69).[44] The submultiple method of writing fractions is used in *Stereometry*. In the Roman period this method was widely used by the Greeks and Romans. However, as it was used by builders in Alexandria by the late third century BC and in papyri, as well as elsewhere in the Greek world, as at Didyma in the inscriptions relating to the temple of Apollo,[45] there is no longer any reason to consider the use of submultiple fractions in Heron's texts as indicative of later editing.

Heron's *Dioptra*, which is the only surviving Greek treatise on land surveying, is named after the sighting instrument of that name, used for a similar purpose to that of a modern theodolite.[46] This text covers distance and height problems, such as the distance between two inaccessible points and the difference in their heights. It also includes practical problems relating to the construction of an underground water supply system, with how to site correctly the conduits and the vertical shafts to them. It includes mensuration problems, such as calculating irregular land areas and the replacement of lost boundary stones.

Heron's *Mechanics*, which survives in Arabic, is concerned with how to move weights with the least effort.[47] It covers the foundations of statics in Book 1, which begins with a machine for lifting huge weights using gears. Cranes and other lifting devices are described, including pulleys and lewises, along with diagrams of them. Lewises are the devices inserted into a stone to be lifted from above, such as by a crane. Archaeological evidence for examples from the Roman period survives in Egypt in the form of lewis holes in column drums and capitals. Those on the Great Tetrastylon (set of four columns) at Hermopolis Magna (el-Ashmunein) [270] would have been raised up to 27 m suggesting the possibility of a crane jib of 30–35 metres, unless scaffolding was used round the columns instead as on Trajan's Column in Rome. This is considerably taller than the cranes usually used in Roman architecture.[48]

As none of these surviving texts discusses the properties of materials and shapes when subjected to the forces and stresses operating in buildings, it is usually assumed that ancient architects lacked a knowledge of the mathematics of defining stresses and forces, and so could not calculate them before construction.[49] However, as two lost works of Heron, *Vaults (Camarica)* and *Balances (Zygia)*,[50] might have included discussion of these matters, their loss is unfortunate.

MECHANIKOI AND MATHEMATICIANS OF THE THIRD TO FIFTH CENTURIES AD

In Heron's work use of the numerical solution of problems involving unknown quantities was already established. However, Diophantus of Alexandria, who was active in the second or third quarter of the third century AD, is famous as he is often described as the first Greek to attempt to use algebraic notation, although this description is anachronistic. In his *Arithmetic* he established and used a system of symbols to present solutions to a wide variety of problems involving unknown quantities.[51] He dedicated *Arithmetic* to someone called Dionysius, who may have been the famous bishop of Alexandria who died in AD 264.[52] Since the geometrical *Definitions*, usually attributed to Heron of Alexandria, is dedicated to a Dionysius it has been suggested recently that is also by Diophantus. If it is, then, this would indicate Diophantus' involvement in the teaching of Euclidean geometry.[53]

As mentioned, Heron of Alexandria was called a *mechanikos* in Greek. His writings indicate that he had competency at a high level in mathematics including geometry, and was interested in its application to specific purposes for building and surveying. He also was skilled in applied mathematics and mechanics, reflected in the diversity of machines and inventions he describes. The relationship between the theoretical and practical parts of these disciplines is elucidated by two later Alexandrians: Anatolius and Pappus.

545a–c. Diagrams for calculations involving curved shapes in buildings, in Heron *Stereometry* 2.28, 2.30, 2.33. Details of Istanbul, Topkapi Library MS1 fol. 48r, 48v, 49v

Anatolius of Alexandria was professor of Aristotelian philosophy there before he became bishop of Laodicea in Syria. During the siege of the Brucheion area of Alexandria (the palace area which had contained the Museum) by the Roman emperor Aurelian in AD 272, Anatolius was an important leader concerned for the fate of both the Christian and non-Christian populace. The church historian Eusebius also mentions that Anatolius was 'an Alexandrian, who for his learning, secular education and philosophy had attained the first place among our most illustrious contemporaries; inasmuch as in arithmetic and geometry, in astronomy and other sciences, whether of logic or of physics, and in the arts of rhetoric as well, he had reached the pinnacle.'[54] Anatolius dedicated his treatise on the Egyptian method of reckoning to Diophantus.[55] In Anatolius' *Arithmetical Introductions*, while discussing the history of mathematics and what it is, he considers: 'There are two main parts of the esteemed subject primary mathematics: arithmetic and geometry. There are six parts of the mathematics concerning concrete things: they are calculation, surveying, optics, musical theory, mechanics and astronomy. But neither the art called tactics, nor architecture, nor popular music, nor physics, nor the other art called mechanics are parts of mathematics, as some people think.'[56]

By this definition Heron of Alexandria was proficient in mathematics, i.e. the language of the physical sciences which came under the general name of mathematics, as well as its practical application. The proficiency of *mechanikoi* at these sciences as well as their applied use is also indicated by Pappus of Alexandria, who was active *c.* AD 320: 'The *mechanikoi* of Heron's school say that mechanics (*mechanike*) can be divided into a theoretical and a manual part, the theoretical part is composed of geometry, arithmetic, astronomy, and physics; the manual part of work in metals, construction work, carpentering and the art of painting, and the manual execution of these things. The man who has been trained from his youth in the aforesaid sciences as well as practised in the aforesaid arts, and in addition has a versatile mind, will be, they say, the best inventor of mechanical devices and architect (*architekton*).'[57]

This passage is important as it shows that *mechanikoi* who were skilled in both the theoretical and practical aspects of

their discipline could act as architects. A *mechanikos* was the equivalent of a modern structural engineer, while also being an architect.

This proficiency at a high level in geometry, arithmetic, applied mathematics, and mechanics continues to be the case for the *mechanikoi* in the first half of the sixth century. However, some mention should first be made of the evidence for continuity of competence in mathematics by scholars in Alexandria because, although architectural mathematical texts have not survived from the fourth and the fifth centuries, the city's fame as a centre for scientific learning and mathematics continued.

Pappus of Alexandria (*c.* AD 320) in his *Mathematical Collection*, quoted above, covers arithmetic and mechanics, as well as advanced geometry and astronomy. In it he refers to an immense range of works by earlier mathematicians, and preserves some ancient mathematics which would be otherwise lost, such as linear curves and 'analytical' geometry. Some of the mathematical problems he discusses are useful for architecture.[58]

Theon of Alexandria, who taught in the city *c.* AD 360–80, and was the last recorded member of the Museum,[59] is best known for his astronomical writings, such as a commentary on Ptolemy's *Almagest*. These may also have included a lost work on the astrolabe.[60] His mathematical works include versions of Euclid's *Elements* (to which he made improvements, especially for students), *Data* and geometrical *Optics*. These became the versions most familiar to the Byzantine world, and so subsequently were used for the first modern editions of Euclid's texts. These continued the Alexandrian tradition of applied mathematics. In the mid-to-late 380s Ammianus Marcellinus, who visited Egypt, mentions 'not even today is learning of various kinds silent' in Alexandria, with the subjects still studied including geometry, music, astronomy, and medicine.[61]

The tradition of astronomical and mathematical scholarship in Alexandria was continued into the fifth century by Theon's daughter Hypatia,[62] who wrote commentaries, none of which have survived, on Diophantus of Alexandria, the *Astronomical Canon* of Ptolemy, and the *Conics* of Apollonius of Perge. She became the city's most celebrated teacher of

mathematics and philosophy until her death at the hands of the Christians in AD 415. However, her death did not bring mathematical scholarship to an end in Alexandria.

MECHANIKOI OF THE SIXTH CENTURY AD

Ammonius of Alexandria taught in the city early in the sixth century AD with his pupils including both pagans, such as Damascius, and Christians, such as John Philoponos.[63] As Eutocius (who was born in Ascalon in *c.* 480) dedicated his commentary on Book 1 of Archimedes' *On the Sphere and Cylinder* to Ammonius, this suggests that Eutocius spent at least part of his life in Alexandria.[64] His main works were his commentaries on Archimedes' *On the Measurement of a Circle* and *On Plane Equilibria*, and the *Conics* of Apollonius of Perge, continuing the tradition of Hypatia and her predecessors. He took care to consider the authenticity of the manuscripts he was using and the problems of scribal transmission.[65] Besides teaching mathematics, Eutocius also lectured on philosophy, apparently in Alexandria.

Eutocius was a student of Isidorus of Miletus and a friend of Anthemius of Tralles,[66] the two *mechanikoi* who are well known because in AD 532–7 they built the famous church of Hagia Sophia (Holy Wisdom) in Istanbul [580]. The traces which remain of their academic work reflect their own competence at a high level in geometry and mechanics, and suggest connections with Alexandria as well as Constantinople.

Eutocius notes that the text he used for his commentary on Books 1 and 2 of Archimedes' *On the Sphere and Cylinder* 'was revised by the Milesian *mechanikos* Isidorus our teacher'.[67] Isidorus seems to have been a professor of geometry and mechanics, possibly teaching in Alexandria before Constantinople.[68] He also wrote commentaries on Archimedes' *On the Measurement of a Circle* and on Heron's *Vaults*, neither of which has survived. Isidorus was responsible for rules in Book 15 of Euclid, written by a pupil of his.[69] Isidorus was clearly very proficient in the mathematics of the geometry of curved shapes and surfaces. The fact that he wrote a commentary on Heron's *Vaults*[70] is of particular importance, given his involvement in the design of H. Sophia with its large dome on pendentives, and supports a connection with the Alexandrian tradition.

Eutocius dedicated to his 'dear friend' Anthemius his commentary on Books 1–4 of the *Conics* of Apollonius of Perge, which suggests they may have studied together.[71] Anthemius' work *On Remarkable Mechanical Devices* includes the method for drawing an ellipse by means of a string looped around two fixed points. The whole of this work was translated into Arabic and it is frequently mentioned approvingly in Islamic sources, as the Arabs considered him a peer of Archimedes in the study of mirrors. The surviving Greek fragment of this work of Anthemius includes a complex arrangement of mirrors to cause the sun's rays to be reflected to a fixed point at any time of the day or year. Although the idea of using a parabolic mirror to reflect parallel rays to one point was described by Diocles in the early second century BC, this work shows Anthemius' acquaintance with the properties of more complex curved shapes, such as parabolas and ellipses.[72] Anthemius was also able to apply this knowledge to inventions similar to those of Heron of Alexandria, using mirrors and steam.[73] John Tzetzes, in the twelfth century, implies that Anthemius also wrote on mechanical and hydraulic subjects.[74]

Thus, the academic work of Isidorus and Anthemius indicates that they had the combined range of knowledge from geometry to mechanics and practical interests required of *mechanikoi* from the time Heron of Alexandria onwards. They are described as *mechankoi* in the context of their role as the designers and builders of H. Sophia.

The church of H. Sophia is the major surviving achievement of Byzantine architecture, with a large dome on pendentives extended by an apse at either end to create a nave with a free span of 31 × 67 m, in a building 72 × 78 m [580–581].[75] This design aimed not to use wood in the roof because its predecessor was burnt down in AD 532. A lengthy description of the church and its construction, in 532–7, is given by the contemporary historian Procopius of Caesarea in his work on the buildings of the emperor Justinian (527–65).[76] Procopius begins his account by mentioning the skill of Anthemius and Isidorus: 'The Emperor, disregarding all considerations of expense, hastened to begin construction and raised craftsmen from the whole world. It was Anthemius of Tralles, the most learned man in the discipline called mechanics (*mechanike*), not only of all his contemporaries, but also as compared to those who had lived long before him, that ministered to the Emperor's zeal by regulating the work of the builders and preparing in advance designs of what was going to be built. He had as partner another *mechanopoios* called Isidorus, a native of Miletus, who was intelligent in all respects . . . So the church has been made a spectacle of great beauty, stupendous to those who see it and altogether incredible to those who hear of it . . .'[77]

The construction was so daring that the dome fell down in AD 558, after earlier earthquake damage, and was reconstructed by 562. Agathias, who continued Procopius' history, records: 'Since Anthemius had long been dead, Isidorus the Younger and the other engineers (*mechanopoioi*) reviewed among themselves the former design', and built a new higher and steeper dome.[78]

The Greek term *mechanike* used by Procopius, in the passage above, is sometimes translated as 'mechanics', but it more accurately means both 'building and engineering'. Elsewhere, Procopius uses the term *mechanopoios* for Anthemius and 'eminent *mechanikoi*' for both him and Isidorus suggesting the two terms are interchangeable. These should probably be translated as 'architect and engineer', rather than just one or the other.[79]

Following in the tradition of Heron of Alexandria, Anthemius and Isidorus would have been skilled in the theory and practice of geometry and mechanics, as well as the design and construction of buildings in which they tested the boundaries of this knowledge. These skills, much wider than those of most modern architects, are comparable with those of the architect of St Paul's cathedral in London, Christopher Wren, who distinguished himself in astronomy, geometry, and applied mathematics, while also being a structural

engineer and supervising the day to day construction of the cathedral.[80] Similarly, at the same time that H. Sophia was being built, the architect of a palace was reminded by Cassiodorus, who was prefect of Italy AD 533–7, to study Euclid and Archimedes, prepare a design on paper, and deal with the day to day supervision of craftsmen.[81]

On the ceiling of the Sheldonian Theatre in Oxford, which Wren built covering a 22 m span with timber without intermediate supports, 'Architecture' is depicted as one of the Mathematical Sciences. Modern scholars have been prone to treat Anthemius and Isidorus as primarily either scientists[82] or architects,[83] rather than, like Wren, equally skilled as both.[84]

The continuation of the Alexandrian tradition in the sixth century is embodied in Chryses of Alexandria, a contemporary of Anthemius and Isidorus. Dara, an important fortress in Mesopotamia for the defence of the Byzantine empire against the Persians, was flooded, probably in the 520s.[85] Because of this, the emperor Justinian consulted not only Anthemius and Isidorus about flood abatement works, but also Chryses of Alexandria whom Procopius describes as 'a skilful *mechanopoios*, who served the emperor in his building operations, and built most of the structures erected in the city of Dara and in the rest of the country'.[86] Justinian chose to use Chryses' solution rather than that of Anthemius and Isidorus, who also were impressed by it. This proposal was a crescent-shaped dam with sluice gates to relieve the pressure.[87] Procopius specifies it 'was not built in a straight line, but was bent into the shape of a crescent, so that the curve, by lying against the current of the river, might be able to offer still more resistance to the force of the stream'. This description of the design of a dam, positioned against the current and using the fact that the force is greatest in the middle of the stream, indicates a knowledge of hydrodynamics. This type of structure, known as the horizontal arch dam, was largely forgotten until it was reinvented in modern times.[88] Although parts of three dams have been identified at Dara, none of them seems to be from this dam as none was apparently crescent-shaped.[89] However, at least one horizontal arch dam survives elsewhere in Syria from before the Islamic conquest.[90] The understanding of the principle behind the design and its novelty, indicated by Procopius, is instructive. Thus, the skill of Chryses, an Alexandrian *mechanopoios* who worked for the emperor Justinian, was at least equal to, and in some respects greater than, that of Anthemius and Isidorus.

CONCLUSION

The surviving works on the mathematics applied to the design and construction of buildings indicate a concentration (not evidenced elsewhere) of the study and teaching of it in Alexandria from the first century BC through to at least the sixth century AD.

The tradition which in Alexandria goes back to Ctesibius in the third century BC was continued by the *mechanikos* (architect and engineer) Heron of Alexandria, who was active there in *c.* AD 62. His skill in geometry and its application to quantity surveying is seen in his works involving calculations for nearly every shape used in a building, including curved surfaces (domes, semi-domes, and even domes on continuous pendentives). Following on the work by Menelaus of Alexandria on spherical geometry at the end of the first century AD, new mathematical work was continued in the city in the third century by Diophantus of Alexandria.

Pappus of Alexandria, early in the fourth century AD, pointed out that *mechanikoi* following in the tradition of Heron were skilled in both the theoretical side of geometry and arithmetic as well as the practical aspects of construction. A high level of mathematical scholarship and training was continued in Alexandria later in the fourth century and into the fifth century by Theon of Alexandria and his famous daughter Hypatia with their work on astronomy and geometry.

Eutocius of Ascalon, who wrote on geometry and taught mathematics and philosophy, dedicated one of his works to Ammonius who taught in Alexandria early in the sixth century. Eutocius was a student of Isidorus of Miletus and a friend of Anthemius of Tralles, the two *mechanikoi* responsible for the design and construction of H. Sophia in Constantinople under the emperor Justinian. The traces of their written work indicate their proficiency in geometry (especially of curved shapes) and mechanics, as well as their practical applications. At the same time Chryses of Alexandria who was at least their equal, if not superior, in skill was also working for Justinian.

As the *mechanikoi* in Constantinople were in close contact with those from Alexandria with whom they shared education and scholarship, it now remains to be considered if these contacts and influences were also reflected in the churches of Constantinople in the first half of the sixth century.

Influence of Alexandria on Byzantine Architecture Outside Egypt

We have seen that the mathematical texts relevant to construction show a concentration of architectural knowledge and education in Alexandria which had an established tradition of expertise in this field. These texts also show connections between architects and *mechanikoi* in Alexandria and those in Constantinople (modern Istanbul). The archaeological evidence of churches in Egypt demonstrates that their architects were aware of architectural developments elsewhere in the Mediterranean area and Europe, while also exhibiting continuity of local architectural knowledge and skills at a high level. Much of this archaeological evidence in Egypt was found to date from a period (the fourth and fifth centuries) prior to the main churches which survive in Constantinople (from the first half of the sixth century).

In the view of these discoveries, the focus now turns to ascertaining how the churches of the imperial capital relate to this picture. This evaluation is particularly pertinent because of the discovery there in the 1960s of the church of St Polyeuktos. It changes our understanding of architectural

developments in the city immediately before the emperor Justinian embellished it with the most famous Byzantine church, H. Sophia (AD 532–7), revealing that this building is not quite as revolutionary as had been thought.

ARCHITECTURE OF FIFTH-CENTURY CONSTANTINOPLE

Before looking at the revolutionary developments in church architecture in Constantinople during the first half of the sixth century, the evidence of the local architecture from the late fourth and the fifth century needs to be briefly considered. Although not much evidence survives in the city from churches of this period, the little evidence there is consistently shows architecture which has continuity with the classical forms of the Roman architecture seen in the Greek cities of the coast of Asia Minor.

This evidence includes blocks of carved architectural decoration. The first version of H. Sophia (the church of Holy

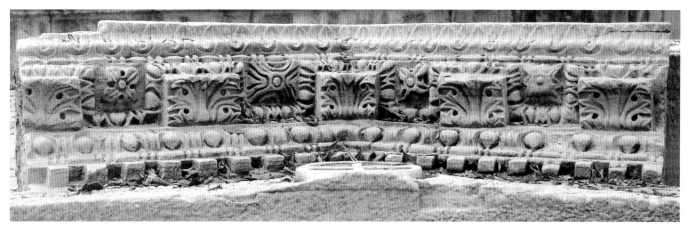

546. Constantinople (Istanbul), porch of Theodosius II to atrium of H. Sophia, cornice of pediment

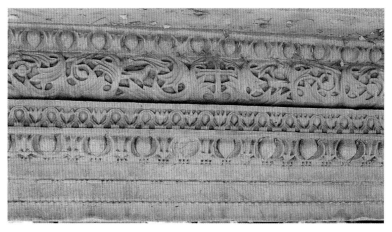

547. Constantinople (Istanbul), porch of Theodosius II to atrium of H. Sophia, architrave and frieze block

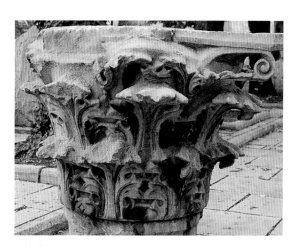

548. Constantinople (Istanbul), porch of Theodosius II to atrium of H. Sophia, capital

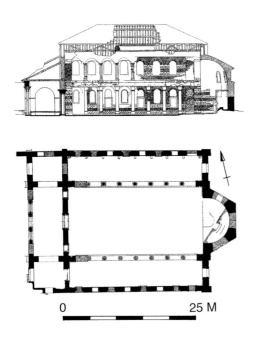

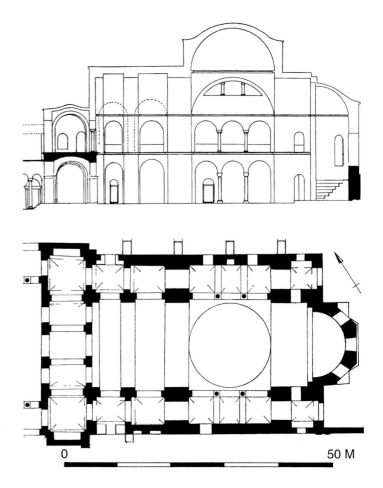

549. Constantinople (Istanbul), church of St John Studios, lengthwise section, and plan

550. Constantinople (Istanbul), H. Irene, reconstruction of Justinianic phase, lengthwise section and plan

551a–b. Constantinople (Istanbul), church of St John Studios, entablature and capital of narthex

Wisdom) in Constantinople burnt down in AD 404. It was rebuilt, and re-dedicated in 415. Marble architectural blocks from the portico leading to the atrium of this second version, built by Theodosius II, have survived, including capitals and entablature fragments [546–548], as well as coffering.[1] These reflect traditional Roman Corinthian architectural forms ([118] with architectural terms). They have conventional carved decoration, such as cornices with dentils, egg and dart motif, and modillions decorated with acanthus leaves [546]. Their date is reflected in the relative sizes of these features, such as the enlarged crown moulding on the architrave and diminished frieze above [547]. Similarly, on the Corinthian capitals the corner volutes are reduced and the helices absent or turned into a leaf motif [548], while the cutting of the acanthus leaves is sharper and more stylised than previously ([127] with architectural terms). Comparable evidence

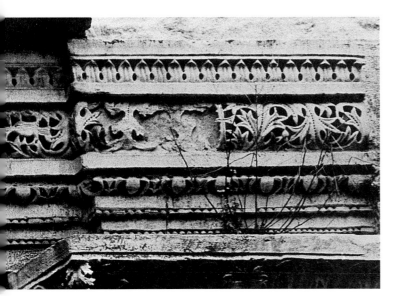

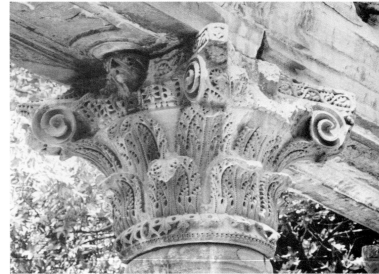

552. Constantinople (Istanbul), St
Polyeuktos, west-east section and plan of
foundations and partially reconstructed
ground level

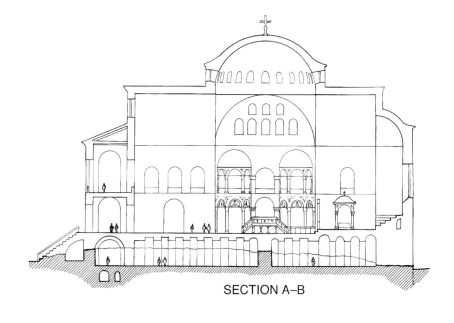

SECTION A–B

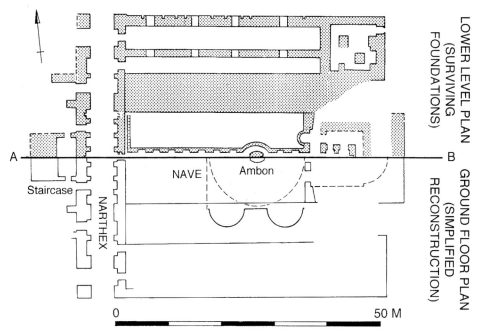

survives from other buildings, such as the 'triumphal arch' which was an entrance to the forum of Theodosius I (c. 393)[2] and, from the middle of the century, the capital on the column of the emperor Marcian (c. 450–2).[3]

The only church in Constantinople which remains substantially still standing since the fifth century is the church of St John Studios which was built in c. AD 450.[4] It has the traditional plan of a basilica with galleries, an apse at the east end, and a narthex [549]. The marble decoration of the entablature of the lower order follows the conventions of the Roman Corinthian order observed on the Theodosian porch of H. Sophia, except that the frieze decoration is hollowed out underneath to increase the effect of light and shade, using a method called undercutting [551a]. However, the capitals are not Corinthian but of another standard, less common, type called composite capitals because they have a ring of

acanthus leaves from Corinthian capitals combined with diagonal corner volutes from Ionic capitals [551b]. These examples on St John Studios have some undercutting, and their acanthus leaves are carved in the distinctive serrated or 'fine-toothed' style which first appears at about this time. The upper order has the earliest examples of Ionic impost capitals surviving in Constantinople. Thus, the church of St John Studios is fairly traditional in its plan, but has some new developments in its marble architectural decoration.[5]

The surviving examples of fifth century architecture of Constantinople contrast markedly with those of the following century which will now be considered.

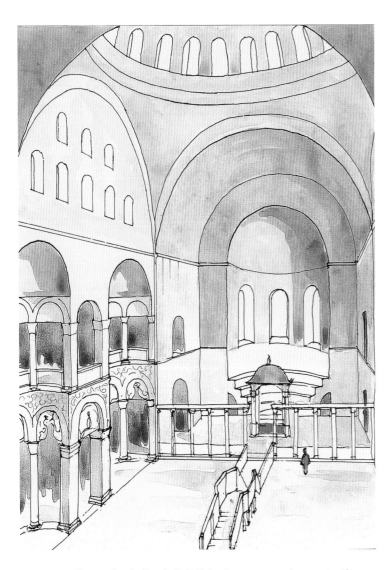

553. Constantinople (Istanbul), St Polyeuktos, axonometric reconstruction (Sheila Gibson)

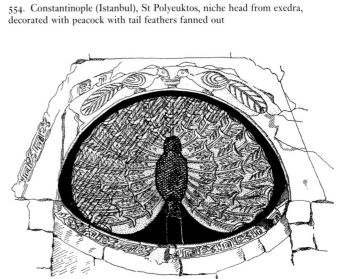

554. Constantinople (Istanbul), St Polyeuktos, niche head from exedra, decorated with peacock with tail feathers fanned out

555. Monastery of Apa Shenute (White Monastery) near Sohag, niche head decorated with peacock with tail feathers fanned out

CHURCH OF ST POLYEUKTOS, CONSTANTINOPLE

The church of St Polyeuktos at Saraçhane in Istanbul was discovered in the 1960s when its foundations and some marble architectural fragments were excavated by the English archaeologist Martin Harrison. Until then it was only known from written sources as it could still be visited in the tenth century and apparently remained standing until at least the end of the twelfth century.[6] It was very large, being two-thirds the size of the emperor Justinian's H. Sophia [552, 581]. St Polyeuktos has high quality carved marble decoration with very unusual patterns, and apparently had a vaulted roof. It is of particular importance because it was built immediately prior to H. Sophia (AD 532–7) which had been thought to be revolutionary in the history of Byzantine architecture for its monumental dome on pendentives and marble carving [580, 582].

St Polyeuktos had a dedicatory epigram which was inscribed around the nave and continued on four plaques at the entrance, outside the narthex (vestibule). The complete version of this poem (or two poems), which is preserved in the *Palatine Anthology*,[7] states that the church was built by [Anicia] Juliana. She was the daughter of Anicius Olybrius, western emperor in AD 472, and thus descended from the emperor Theodosius II and Eudocia. In 518 the Balkan peasant and soldier Justin I became emperor, despite his lack of aristocratic connections. As this church is unusual in being commissioned by a member of the traditional aristocracy, rather than the emperor, it has been suggested Anicia Juliana erected it to make a political statement, especially as she reportedly gilded the roof to prevent Justin's nephew and successor, Justinian, from taking the rest of her wealth.[8] This building, replacing an earlier smaller one of Eudocia, next to Anicia Juliana's palace not only reflected her enormous wealth but, according to the poem, was erected as a monument to her and the glory of her family.

The exact date of erection of St Polyeuktos is determined by the combination of the historical record with the archaeological evidence of its brickstamps. The church must have been completed by the time Anicia Juliana gilded the roof,

556a–b. Panopolis (Akhmin), two fragments of a Late Antique wall-hanging (or carpet) with pile. Riggisberg, Abegg-Stiftung, inv. 8a and b

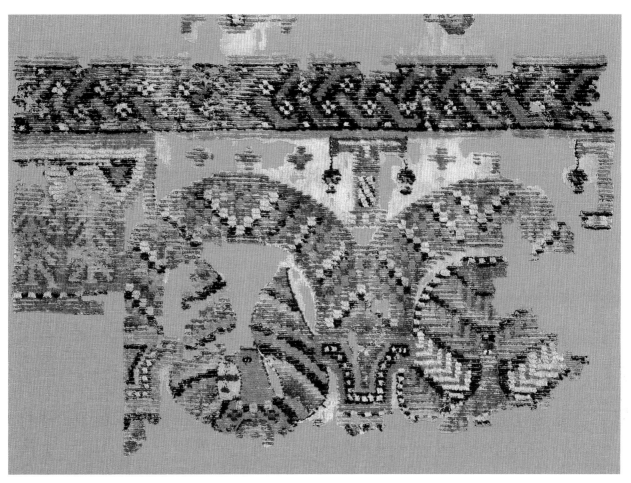

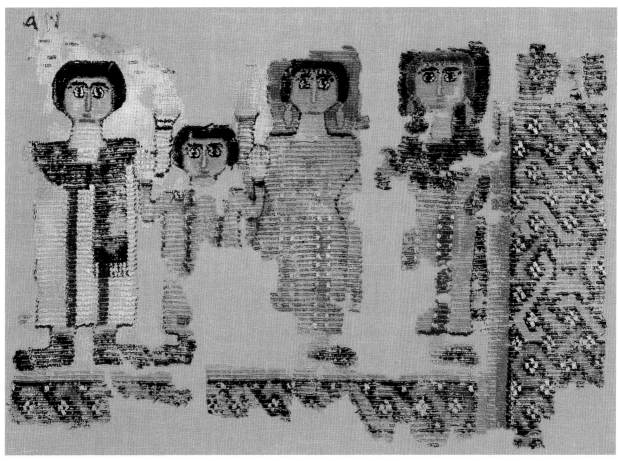

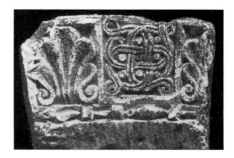

557. Constantinople (Istanbul), St Polyeuktos, cornice with shell motif on modillions

558. Oxyrhynchus (el-Bahnasa), cornice fragment with shell motif on modillions. Alexandria, Greco-Roman Museum

which written sources indicate occurred at the beginning of Justinian's reign (which began in AD 527) and before she died (in 527 or 528).[9] As a marginal note in a manuscript copy of the epigram indicates that the church took three or so years to build,[10] the date of its construction had generally been accepted as 524–7.[11] The stamps on the bricks of which it was built were considered by the excavators to confirm this,[12] but they have recently been re-examined. Brickstamps often include the indiction year. This is the number of the year of the fifteen year fiscal cycle when they were made, but it does not specify which cycle. The cycle has to be identified on the basis of other evidence. As bricks largely found *in situ* belonging to lower parts of the structure date to 508/19 to 511/12, it could have been begun by 508 (if these bricks were not stored before use).[13] Those found both loose and *in situ* from the walls and piers belong to 517/8 to 520/1, indicating that these parts of the building were probably under construction during those years.[14] The building is unlikely to have been completed before 522.

The church was built in a square (51.45 × 51.90 m) to an apparently unique design [552]. It had an internal basilical arrangement with a nave, and side aisles with galleries. There was an pulpit (ambon), indicated by the foundations, at the centre of the church. At its west end it had a vestibule (narthex) and a courtyard (atrium). The eight-metre-wide foundations, which run lengthwise along either side of the nave [552], are so impressive that they are mentioned in the poem.[15] They indicate that the nave had a brick vaulted roof rather than a timber one, unlike earlier basilicas such as St John Studios [549], because such substantial foundations and walls would only have been necessary to support a vaulted structure. A vaulted roof is also suggested by fragments of thinner and lighter bricks which have been found,[16] and by the positions of the drainpipes and drains which apparently indicate that there was not a single pitched timber roof across the width of the whole structure.[17]

The gilded 'covering' (*kaluptra*) mentioned in the poem, inscribed outside the narthex,[18] has generally been thought to refer to a dome. When Gregory of Tours, (AD *c.* 540–593/4), who became bishop of Tours in 573, related the story of Juliana gilding the roof he is more specific. He refers to the roof at least four times using the word *camera* which specif-

ically means 'vaulted roof', although he mentions that she ordered plates to fit the measurements of the beams.[19] It needs to be remembered that he was writing in France half a century after the event. It is also possible that the gold was not used in the form of hammered gold plaques, but rather in gold mosaic.[20]

This vaulted roof (covering the nave with a free span of 18 m and length of 34 m) could have consisted of a dome at the centre above the ambon, with one barrel vault running from the dome to the east apse, and a second barrel vault to the west [552–553]. This arrangement, proposed by Martin Harrison and Sheila Gibson, is similar to that originally used on H. Irene (the church of Holy Peace) (with a dome 15.38 m diam.) in Constantinople in AD 532 [550]. The details of the reconstruction of St Polyeuktos may require refinements in order to accommodate most satisfactorily the spacing of the poem's lettering, as indicated by the surviving fragments of it [554]. Earlier examples of a dome placed over the centre of a rectangular nave may survive in southern Asia Minor (Turkey) at the monastery at Alahan, dating from the late fifth century.[21]

Harrison concluded: 'With hindsight, neither the methods of construction nor the general form of the church of St Polyeuktos was at all surprising. What was indeed remarkable was the decorative programme, both in its exuberance and variety; and the dimensions were quite astonishing.'[22] The finely carved marble decoration of St Polyeuktos is much more lively and varied than that surviving either from before or after it in Constantinople. This decoration includes motifs which are unique in the city's architectural history.

The poem outside the narthex states that Anicia Juliana's building surpassed Solomon's Temple.[23] The decorative programme of the carved marble decoration has been interpreted as reflecting Solomon's Temple, with which it so strikingly accords.[24] The biblical descriptions of Solomon's Temple in Jerusalem indicate it was decorated with cherubim, palm trees [564], open flowers, capitals with network [569, 572] and pomegranates, and capitals like lilies [569].[25] Harrison suggested that the cherubim were represented as peacocks [554][26] because their feathers are sometimes depicted on the wings of angels.[27] Cherubim could also be represented in non-figured form by the split palmette motif framing an egg[28] and

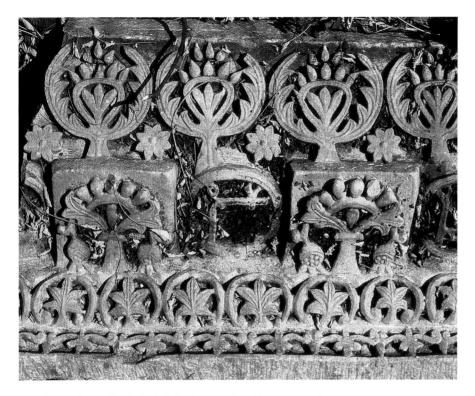

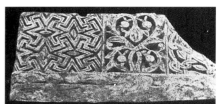

559. Constantinople (Istanbul), St Polyeuktos, cornice with palmette and pomegranate motif on modillions

560. Oxyrhynchus (el-Bahnasa), cornice fragment with palmette and pomegranate motif. Alexandria, Greco-Roman Museum

561. Late Antique Egyptian textile with palmette and pomegranate motif. 0.22 × 0.26 m. Washington DC, Textile Museum, inv. 71.23

as whirling wheels [568].[29] The Herodian version of the Temple was decorated with vines, which are also used on St Polyeuktos [554].[30] The connection with the Temple is also indicated by the external dimensions of St Polyeuktos of 100 × 100 cubits (of 0.5145–0.519 m), since Ezekiel's heavenly temple is described as 100 × 100 cubits.[31]

While the meaning of the decorative motifs on St Polyeuktos has generally been accepted as alluding to Solomon's Temple, their artistic origin has remained a mystery. Martin Harrison originally suggested that they were Sassanian,[32] but later modified his conclusion as the parallels were unconvincing.[33] However, whilst some details may have a Sassanian origin, good parallels for these decorative motifs are to be found in Late Antique Egypt. As will be seen, not only are the same motifs used in its architecture, but the equivalent motif is often used in the same position on the same architectural member as on St Polyeuktos: niche head, cornice, or capital. If the examples in Egypt are generally earlier than those on St Polyeuktos, it may be suggested that the influence came from Egypt rather than the other way round. Obviously, as this would have considerable implications each of these examples needs to be presented in turn.

The nave of St Polyeuktos had pillars and columns arranged in a series of exedras along either side. Each of these exedras was decorated with a semi-dome (or niche head) with

a marble vault (or arch) on either side. A peacock with its tail fanned out fills each semi-dome [554], and a pair of them is carved on the soffit (underside) of each vault [553].[34] Along the front face of the top of these vaults and semi-domes, following their curved shapes, runs the band with the poem (carved in relief).[35] The vertical surface in each exedra above and between these vaults and semi-domes is covered with vines,[36] while the flat surfaces on the sides are decorated with a lattice pattern with vine leaves.[37] This traditional motif of the vine is rendered in very high quality naturalistic carving [554].

These vaults and semi-domes are unlike other decoration in Constantinople, but related examples survive from earlier churches in Egypt. On the monastery of Apa Shenute (the White Monastery) near Sohag the *in situ* niche heads, carved in *c*. AD 440, include one with a peacock with its tail feathers fanned out [555]. Other niche heads on the monastery contain vines [460], and they were also used on niches on the fifth-century basilica at Hermopolis Magna (el-Ashmunein). These carved niche heads in Egypt are earlier than those on St Polyeuktos.

Series of niche heads are depicted on Egyptian textiles not only with similar decoration to St Polyeuktos, such as the peacock with an erect tail, but also as part of similar architectural compositions: with the niche heads (or semi-domes) placed in a row in a group of three or four, supported by

562. Constantinople (Istanbul), St Polyeuktos, fragments of screen with lotus pattern with hearts

563. Antinoopolis, silk textile with lotus pattern with hearts

564. Constantinople (Istanbul), St Polyeuktos, pillar capital with palm trees

565. Luxor (Thebes), column capital decorated with date palm

columns between large pillars as on an example from Panopolis (Akhmim) [556].[38] A single band runs along the top in the same position as the band with the inscription on St Polyeuktos [554]. On another Late Antique Egyptian textile, dated to about the late fourth or early fifth century, the surface between the niches is decorated with florals in a similar way to the vines on St Polyeuktos.[39]

The cornices on St Polyeuktos have unusual decoration on them. Traditional Roman Corinthian cornices have acanthus leaves carved on their modillions as observed in the fifth-century examples from Constantinople [546]. By contrast, in place of these traditional acanthus leaves, the cornices from St Polyeuktos have very unusual motifs on their modillions. These include shells [557][40] which are also found on cornices

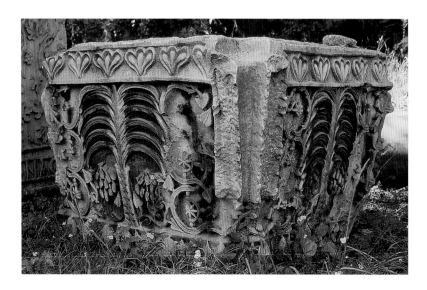

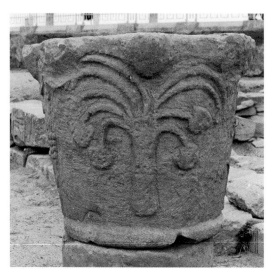

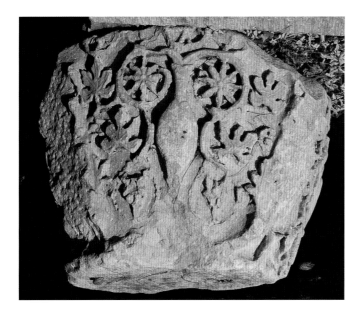

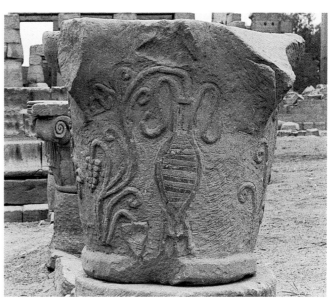

566. Constantinople (Istanbul), St Polyeuktos, column capital with vines rising out of tall vase with pointed base

567. Luxor (Thebes), column capital with vines rising out of tall vase with pointed base

from Oxyrhynchus (el-Bahnasa) in Egypt [558 The modillions on St Polyeuktos are also decorated with a split palmette motif with a pomegranate on either side [559].[42] Related motifs are used on some cornices from Oxyrhynchus [560],[43] while the closest parallel survives on a Late Antique Egyptian textile [561].[44] A fragmentary screen from St Polyeuktos has a lotus motif with hearts running up its centre [562], in a distinctive pattern also found on a silk from Antinoopolis [563].[45]

The capitals on St Polyeuktos are of particular note as they include the earliest examples in Constantinople of a number

of capital types, as well as the only examples of some types in the city.

Some pillar capitals of St Polyeuktos are decorated with a complete date palm [564].[46] Although in Egypt a whole column is sometimes carved to represent a palm tree, with the shaft forming the trunk and the palm fronds covering the capital [201c, 210], the use of complete date palm trees (rather than just their palm fronds) as decoration only on the capital is rare. An example survives at Luxor on a Late Antique column capital, although simply rendered [565]. Earlier examples from the Roman period occur on Egyptian style architecture on the

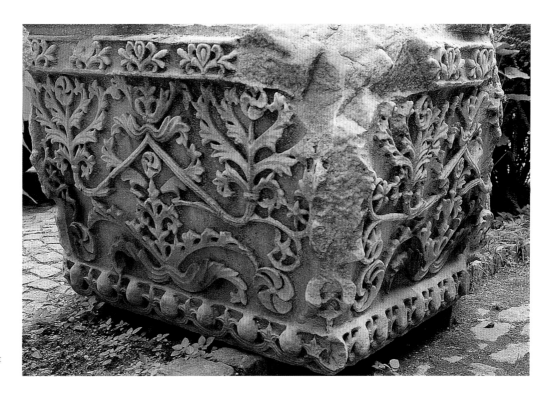

568. Constantinople (Istanbul), St Polyeuktos, pillar capital

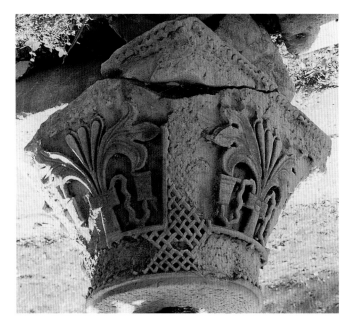

569. Constantinople (Istanbul), St Polyeuktos, lotus-panel impost capital

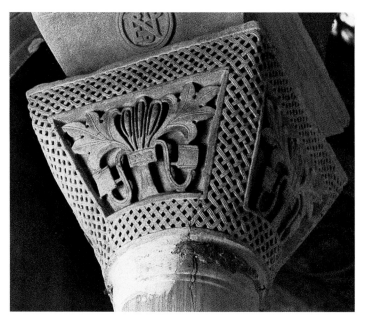

570. Ravenna, S. Vitale, lotus-panel impost capital

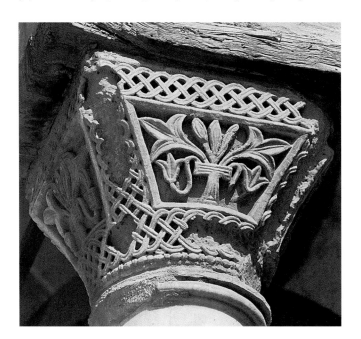

571. En-Nasir Mosque, Cairo, lotus-panel impost capital

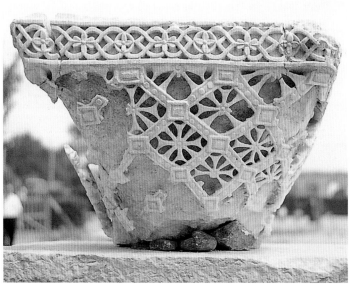

572. Constantinople (Istanbul), St Polyeuktos, impost capital with a pattern imitating jewelling

temple of Mandulus at Kalabsha, on the First East Colonnade and the West Colonnade at Philae,[47] and on the temple of Khnum at Esna. On some of these examples the palm trees have vines with heart-shaped leaves beside them [250],[48] as also seen on the example on St Polyeuktos [564].

One of the St Polyeuktos column capitals is decorated on each side with vines coming out of a tall narrow vase [566].[49] This motif also occurs on a column capital at Luxor from the same structure as the capital with the palm tree, mentioned above [567]. Vines springing from amphorae are also used as decoration in many of the niche heads on the monastery of Apa Shenute (the White Monastery) near Sohag, c. AD 440 [460].

The so-called *pilastri acritani* are two pillars with capitals, outside the church of S. Marco in Venice. They are now thought to have been taken there from St Polyeuktos presumably in, or soon after, 1204 in the Fourth Crusade, rather than from Akko (Acre) in the Holy Land which their traditional name implies,[50] because capitals with the same unusual decoration were also found in the excavations of St Polyeuktos from free-standing and engaged pillars [568].[51] This decoration consists of a complex symmetrical pattern with narrow acanthus leaves. Other details on the pillar capitals include whirling wheels which are an unusual motif, but also found on some Late Antique Corinthian capitals from Oxyrhynchus and Saqqara in Egypt.[52]

The capitals on St Polyeuktos include impost capitals of what will be called here the basic type, to distinguish them from other types of impost capitals. These basic impost capitals are characterized by their shape, which tapers from a square at the top to a circle at the bottom.

They include a type called lotus-panel impost capitals. They are distinguished by their decoration of carved basket-weaving and have a lotus-panel on each side [569].[53] A number of these capitals survive from Alexandria [530–531],[54] and one was reused on the al-Nasir Mosque in Cairo [571].[55] On these examples in Egypt the details of the motif in the panel on each side of a single capital can vary, for example with buds sometimes in place of the rectangular vessel on either side of the lotus motif [531]. The basket work on all the examples from Alexandria (which appear to be locally made) is rendered as a double strand, indicated by an incised centre line. Examples of basketry (matting) with strands woven in pairs also survive from Egypt.[56] This suggests that the finely carved marble example in the al-Nasir Mosque with double strand weaving, as well as undercutting, was also locally made [571]. Another feature of these capitals, the lotus motif, is used in Egypt in the Roman period in the same position on the front of some traditional Egyptian capitals, as on the temple of Mandulus at Kalabsha, the temple of Khnum at Esna, and on the Roman Kiosk at Philae [247–248, 254].[57] Thus, although none of the lotus-panel capitals in Egypt are reliably dated, the evidence tends to suggest Egyptian influence in their origin.[58]

Lotus-panel impost capitals also occur elsewhere on buildings which were erected after St Polyeuktos. However, the original date of these capitals is uncertain as they were usually either reused on these buildings or not originally carved for them.[59] The only building which has lotus-panel impost capitals in the original positions for which they were made is the church of S. Vitale in Ravenna where, in AD 538–45, fourteen of them were erected on the lower order of the ambulatory [570]. This church was commissioned by Bishop Ecclesius (522–32), and consecrated in 547. Because of their fragility the lotus-panel capitals in it were probably carved at the site, rather than imported in their finished form. On St Polyeuktos the final stage of the marble work was carved at the site, rather than at the quarry, because remains of marble chips were found there.[60] This contrasts with less fragile Corinthian capitals which were sometimes finished at the quarry and so exported in their finished form.[61] Thus, the question arises as to whether the capitals on S. Vitale were carved by local workmen, or workmen from Constantinople or Egypt.[62] The question of whether they worked from drawings also arises.

On S. Vitale the lotus motifs on each side of the capitals are almost identical.[63] The only variation in this motif from one capital to another is in the T-shape and in the lines which spring from it to join the rectangular motifs on either side of it which are sometimes slightly tapered to look like buckets or other vessels [570]. The carved basketry covering the capitals is not rendered in two strands with an incised line (as always occurs on the examples in Egypt), rather it has a fine raised line along the centre of each strand. This detail, along

with the lack of variation in the lotus panels, may suggest that the examples in S. Vitale were copied from a drawing,[64] like those surviving from papyrus pattern books for Late Antique Egyptian textiles,[65] and for architectural elevations from the Roman period [399].

One of the basic impost capitals from St Polyeuktos has a deeply undercut mesh pattern covering it and a lattice with carved jewelling [572]. Carved jewels are used on a cornice from the South Church at Bawit in Egypt [506b].[66] However, the design of this capital also has some striking similarities with Sassanian capitals. One from Isfahan is decorated with a lattice pattern and, like the one from St Polyeuktos, has a decorated band along its broad square abacus.[67] The (unbroken) side-profile of this capital from St Polyeuktos has a slight outward curve [572] which is also observed on some Sassanian capitals[68] (and some Byzantine basic impost capitals). It is sometimes suggested that the basic impost capitals (i.e. those with a square top and circular bottom) have a Sassanian origin, but at present none of the Sassanian examples are dated firmly before those from St Polyeuktos and the other Byzantine examples.[69] There is clearly a relationship between these capitals, but the problem of the direction in which the influence went remains unsolved. Another possible predecessor for the impost capital is the Ionic impost capital which is conceptually related, but less similar.[70]

As mentioned, the closest parallels for the split palmette motif with a pomegranate on either side on the St Polyeuktos cornices are in architecture as well as textiles in Egypt [560–561]. The distinctive lotus pattern with hearts running up its centre on a screen from St Polyeuktos and on a silk from Antinoopolis [562–563] is also found in Sassanian stucco.[71] Other textiles from Antinoopolis also have Sassanian motifs on them. Like the examples mentioned, they were woven in Egypt.[72] As these textiles are dated to the fifth and sixth centuries, the question arises as to whether the Sassanian motifs reached St Polyeuktos direct, or via Egypt.[73]

Thus, whilst the decoration on St Polyeuktos has some Sassanian features, possibly chosen for iconographic reasons, the strongest indications of the artistic origin of most of its decoration focus on Late Antique Egypt. It has already been suggested in Chapter 11 that the Late Antique architecture of the rest of Egypt can provide an indication of the lost church architecture of Alexandria. As the fine marble decoration on St Polyeuktos is of notably higher quality than the finest limestone decoration surviving at smaller sites in Egypt, the decoration of St Polyeuktos possibly gives an indication of that on the most expensive churches in Alexandria.

Since the evidence suggests influence from Egypt in the decoration of St Polyeuktos, the architect of it might have employed stone masons from Egypt, producing decoration from there and incorporating some Sassanian motifs as required for the iconography of the Temple of Solomon. This could also explain the use of cubits for its layout. This possibly Alexandrian influence on St Polyeuktos is not as surprising as might have been thought, given that shortly after this the *mechanopoios* (architect and engineer) Chryses of Alexandria is recorded working for the emperor Justinian.[74]

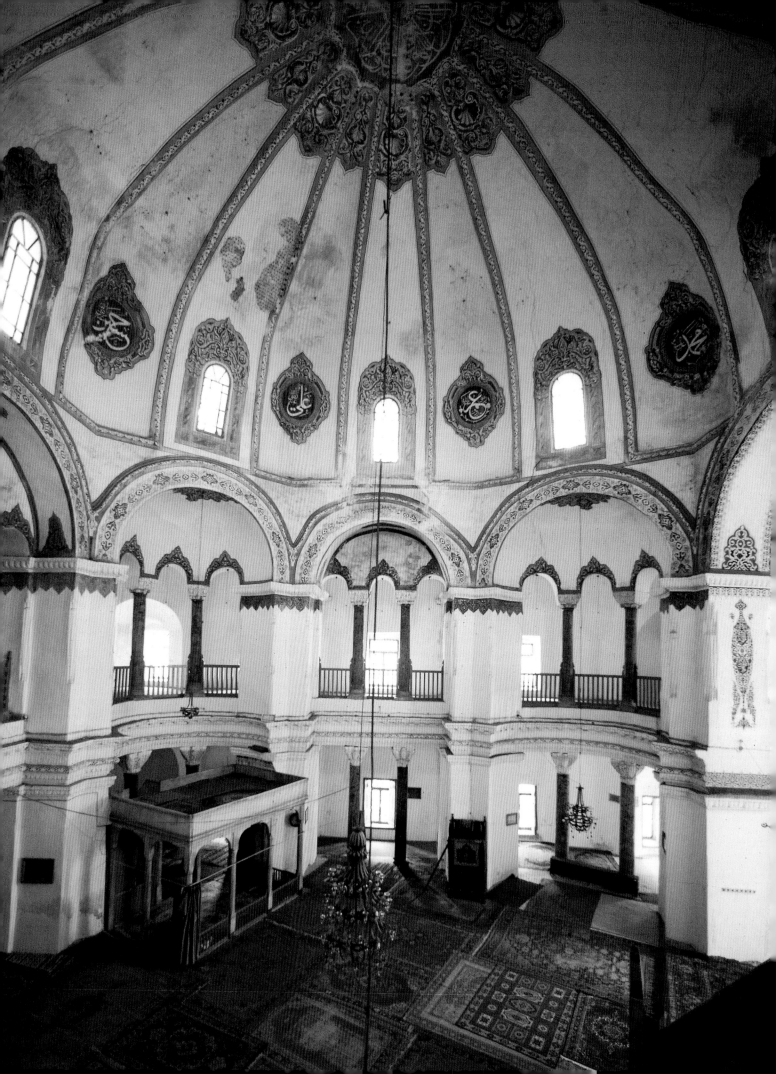

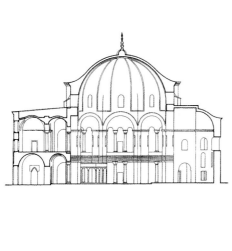

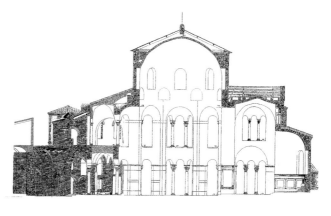

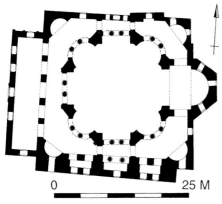

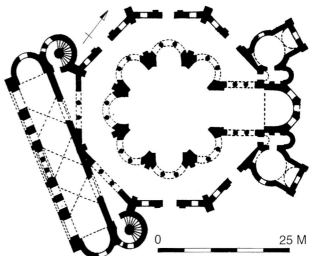

574. Constantinople (Istanbul), church of Saints Sergios and Bakchos, west-east section and plan

575. Ravenna, S. Vitale, lengthwise section and plan

CHURCH OF SAINTS SERGIOS AND BAKCHOS, CONSTANTINOPLE, *c.* AD 527–36

The church of Saints Sergios and Bakchos in Constantinople [573] was built in honour of St Sergios by the emperor Justinian and his wife Theodora, according to the inscription around its nave[75] and the imperial monograms on some of its capitals.[76] The written sources indicate it existed by AD 536, and may have been begun by 527.[77] Thus, it was built after St Polyeuktos and slightly before, or at the same time as, H. Sophia.[78] It was built adjoining the basilical church of Saints Peter and Paul in the Hormisdas palace,[79] which was the palace where Justinian resided while he was heir to the throne (518–27). His wife Theodora (formerly an actress in Alexandria), whom he married in 523, was pro-Monophysite.[80] Consequently, Monophysite priests and monks were allowed to reside in the Hormisdas palace, where there were up to five

hundred of them from 535 or 537 until 548, when Theodora died.[81] As St Sergios was a popular eastern saint, not otherwise well-known in Constantinople,[82] it has been suggested that the church was erected for these Monophysite monks.[83]

The most striking feature of this church is its shape [574].[84] It is based on an octagon (diam. *c.* 15.75 m, *c.* 50 Byzantine feet) in a square, with an exedra in each corner of the ambulatory, so that alternating semi-domes and arches support the dome which is made of sixteen alternating flat and curved panels [573]. There is an apse protruding from the east wall and a narthex on the west side. The fact that the plan is noticeably asymmetrical may result partly from it being built up against the church of Saints Peter and Paul.

The interior design of Saints Sergius and Bakchos has some similarity with that of S. Vitale in Ravenna, completed slightly later, which also has a centralized octagonal plan with a double shell and exedras in its ambulatory [575–576]. S. Vitale's construction shows some influence from Constantinople in the long thin, locally made, bricks used in it. The Byzantine architectural historian Richard Krautheimer compared the architect of S. Vitale with the famous architects of H. Sophia, and observed that as he was 'equal to Anthemios and Isidorus, or

573. Constantinople (Istanbul), church of Saints Sergios and Bakchos, view of interior, *c.* AD 527–36

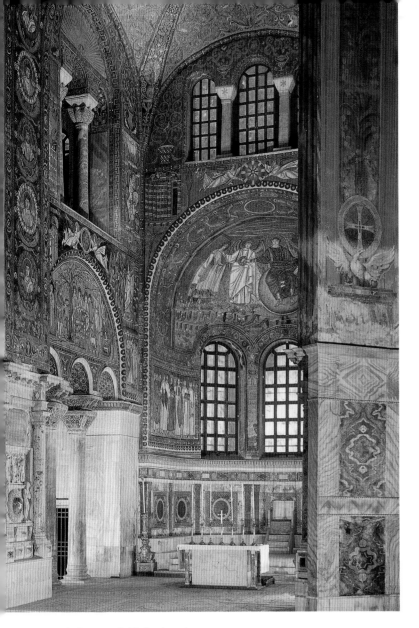

577. Pitched brick vault, Ramasseum, Luxor (Thebes)

576. Ravenna, S. Vitale, chancel

578. Construction of pitched brick dome, as used in early twentieth-century Egypt, with string used to measure radii of diminishing circles for the bricks

nearly their equal, he designed the one truly great building of the west in the sixth century'.[85] The dome of S. Vitale is made using the western construction method of interlocking, hollow, earthenware tubes. It is not visible from the outside as it is covered by a tiled timber roof [575].

By contrast, the shape of the dome of the church of Saints Sergios and Bakchos is visible from the outside [574]. It is made of a single layer of bricks pitched on their sides, and embedded in thick mortar.[86] Pitched-brick vaulting has a long history of use in Egypt and Mesopotamia, continuing through the Roman period to the present day,[87] and it was in use in Asia Minor by the third century AD at Salonica (Thessaloniki) on the Rotunda of Galerius c. AD 300, as well as in fifth-century Constantinople.[88] In pitched-brick vaulting bricks are set on edge with their long axis running across the vault, not lengthwise along it, so that each successive 'arch' is completed quite quickly [577]. Since these 'arches' lean back against the already completed part of the vault, the mortar can hold the bricks as they are laid and no wooden framework, called centering, is needed.[89] Previously used on vaults of a smaller span, this technique was transferred to use

on domes of more monumental size by the bricks being placed round the dome, pitched on their sides, in a spiral of ever decreasing radius [578], although it is not clear where this specific development occurred. In the West vaulting tubes, due to their lightness, were also used for domes of similar span, as observed on S. Vitale. Thus, whilst the design of the church of Saints Sergios and Bakchos is strikingly innovative, its construction technique has some features of local continuity as well as innovation.

Similarly, the marble decoration of the church of Saints Sergios and Bakchos shows the continuity of local traditional forms at the same time as dramatic new developments. Its main lower order has a horizontal entablature (rather than a series of arches) [573]. This has carved decoration [579] related to that on the church of St John Studios [551a] but with some developments away from conventional classical forms.[90] The modillions have a split palmette motif on them in place of the traditional acanthus leaves [579], as on St Polyeuktos and at Oxyrhynchus [559–560], but, unlike them, they have a conventional egg and dart motif around the modillions.

The church of Saints Sergios and Bakchos has basic impost capitals with vegetal decoration on them, including heart-shaped leaves,[91] with a liveliness reminiscent of the decoration on St Polyeuktos. The upper order of Saints Sergios and Bakchos has Ionic impost capitals with decoration including some elements, such as split palmettes,[92] related to those on St Polyeuktos.

The capitals on the lower order of the church of Saints Sergios and Bakchos are strikingly innovative. They are the earliest dated examples in Constantinople of impost capitals of the type known as fold-capitals or 'melon capitals' [579].[93] Their distinctive shape, with a horizontal section with eight lobes, has no predecessors in Constantinople. One cannot help noticing that the only other capitals with an eight-lobe horizontal section occur on traditional Egyptian temple architecture, such as the Roman birth house at Dendara [251]. The surface decoration on the fold-capitals consists of sprigs of leaves spraying out symmetrically from a centre vein of circles, as one moves up the capital [579]. Related surface decoration occurs in Egypt where vegetation sprays out symmetrically up the capital on some traditional Egyptian capitals [226, 249], and a twist of circles runs up a capital on the monastery of Apa Shenute (the White Monastery) near Sohag, c. AD 440 [467]. The pattern on the necking band of the fold-capitals on the church of Saints Sergios and Bakchos, derived from an egg and dart motif [579], is the same as that used on the pillar capitals of St Polyeuktos [568].

The fold-capitals of local limestone in Egypt, such as those from Bawit and Saqqara, have a clearly defined plain abacus on them characterized by its shape being independent of that of the main drum of the capital below it [500].[94] By contrast, the marble fold-capitals in both Constantinople and Egypt have the outward fold of the capital below the corners of the abacus stretched out to follow the shape of the abacus [579].[95] A clearly defined plain abacus is also observed on the basket-shaped impost capitals from Saqqara [513–514]. It is sometimes suggested that, because of this treatment of the abacus, the limestone examples in Egypt are derived from those in Constantinople, but a local misunderstanding of them.[96] A clearly defined abacus also occurs on the leaf capital from the South Church at Bawit, which is Egyptian in conception with its overall leaf decoration like those on traditional Egyptian capitals [501]. However, the separation of the shape of the drum of the capital from its abacus is seen prior to these examples at Dionysias (Qasr Qarun) in Egypt on the 'basilica' capitals, dated to the late third or early fourth century AD [385–386]. These tapering drums have features, such as the helices, following the drum's shape because they have become mere surface decoration. This shows that the separation of the shape of the abacus from the rest of the capital, as well as the use of surface decoration following the shape of the drum, already occurred in Egypt by the early fourth century AD.

Fold-capitals are also used on S. Vitale in Ravenna which has two, erected in AD 538–45, in the upper order of its chancel [576].[97] These and other types of impost capitals which were manufactured of Proconnesian marble (from Pro-

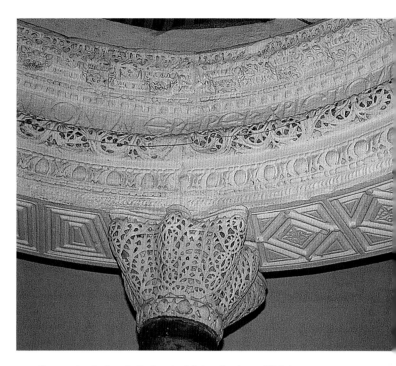

579. Constantinople (Istanbul), church of Saints Sergios and Bakchos, entablature and fold-capital of lower order

connesus on the island of Marmara, Map 4) were also used on other churches, such as the basilica of bishop Euphrasius in Poreč (built c. AD 554).[98] These types of impost capitals were only manufactured during the first half of the sixth century AD, but reused examples survive on many later structures. These include churches, mosques, and cisterns, throughout the eastern Mediterranean, and in North Africa and Italy.[99] They range from the Dome of the Rock in Jerusalem to S. Marco in Venice.

Before St Polyeuktos was discovered, the earliest dated impost capitals were thought to be those in Constantinople on Justinianic buildings and, consequently, it had been generally assumed that the impost capital types were invented there under the emperor Justinian.[100] However, as St Polyeuktos has impost capitals dated before Justinian, this is no longer a possibility. There is no doubt that impost capitals later became a feature of Justinianic architecture in Constantinople, where more versions and types survive than in Egypt. These were made of Proconnesian marble and were dispersed to the rest of the eastern Mediterranean where they provide a continuing legacy in Italy, Greece, the Balkans, Tunisia, and Syro-Palestine.

The similarities with features of earlier Egyptian examples of the characteristics of the fold-, leaf and basket-shaped impost capitals are striking, as are the Egyptian parallels for features of the lotus-panel capitals. The composite capitals with a collar of olive branches on large undivided leaves are more common in Egypt[101] than elsewhere, raising the possibility that they were invented there [529]. The question also arises whether the development of some of the other new capital types was strongly influenced by developments in Late Antique Egypt, or even occurred there.[102]

HAGIA SOPHIA, CONSTANTINOPLE, AD 532–7

H. Sophia (the church of Holy Wisdom) which was built by the emperor Justinian in AD 532–7 is the most impressive surviving Byzantine building in Constantinople [580]. Until St Polyeuktos was excavated in the 1960s, the plan of H. Sophia with the largest surviving dome on pendentives was considered original and unprecedented by scholars of Byzantine architectural history, as was its marble decoration [582]. H. Sophia contrasts with the traditional fifth-century basilica of St John Studios with its wooden roof and conventional classical marble architectural decoration [549, 551]. As found above, the evidence from St Polyeuktos exhibits influence of the architectural decoration of Late Antique Egypt, which is possibly also to be detected in the church of Saints Sergios and Bakchos. In addition, the written testimony shows close contact of the *mechanikoi* of Alexandria with those at Constantinople, with whom they shared scholarship and education in the mathematics relevant to construction. In the light of these observations and the new evidence a re-examination of H. Sophia is justified.

The marble carving in H. Sophia, while of high quality and very distinctive, is much less innovative than that in St Polyeuktos. There is much less variation in the types of capitals used on H. Sophia and the patterns on them are more repetitive. The swirling leaf pattern on the vertical surfaces between the arches in H. Sophia is related to that also used on their friezes [582].[103] Along the top of the marble decoration above these arches, on both the lower and upper orders of the nave, there is no frieze or architrave but only a fairly deep straight cornice with modillions decorated with traditional acanthus leaves and framed with an egg and dart pattern.[104]

On H. Sophia there is much repetitious use of acanthus leaves and they are elongated to fill the full height of the capital. These capitals include impost capitals of the basic type (on both columns and pilasters),[105] and a new type which is used on the lower order of the nave. These new ones, sometimes called 'kettle capitals', are impost capitals but with an Ionic volute along their tops on either side [582].[106] They are different from the so-called Ionic impost capitals which have Ionic volutes below their impost ([418] right hand capital). Although these examples (with the volutes along the top) are the earliest dated examples of this type in Constantinople, related plain examples in Syria are apparently dated to the late fourth and the early sixth centuries AD.[107] The Ionic impost capitals (with volutes below the impost) on H. Sophia also have their imposts decorated with both of its main types of leaf patterns (acanthus and swirling).[108] Some of these imposts and basic impost capitals on H. Sophia have an overall decoration on them of a mesh of circles or interlocking diamonds with leaves in them.[109] A pattern of a twist of circles running up the capital with leaves springing out on either side is used on the sides of the capitals on the lower order of the nave [582].[110] This pattern is related to the decoration on the fold-capitals on the church of Saints Sergios and Bakchos [579].

The use of acanthus leaves and Ionic volutes on H. Sophia makes its decoration more traditional than that of St Polyeuktos, and it is notably devoid of the Sassanian and other unusual motifs used on St Polyeuktos. H. Sophia appears to have had more local involvement in its design and its execution reflects more continuity. The lack of variation in the patterns carved in the marble on it would have greatly increased the speed of carving, enabling the building to be completed more quickly.

Just as the new features of the marble decoration on H. Sophia can no longer be viewed as appearing without immediate predecessors in Constantinople, so too its design. It has the earliest surviving dome of substantial dimensions on pendentives (31.2 m or 100 Byzantine feet in diameter).[111]

Before discussing the details of this dome, it is worth mentioning again that there are two types of dome which result when a dome is placed on a square base, when spherical triangles or pendentives fill the corners of the cube to bridge the change from the square to a circle. A 'dome with continuous pendentives' results when the diameter of the dome is the same length as the diagonal of the square base on which it is placed, so that the dome is continuous with the pendentives [541]. A 'dome on pendentives' results when a dome is placed on a square base on a circle or ring with the same diameter as the length of the sides of the square [542]. In this case the dome has a smaller diameter than the pendentives which support the ring, as the diameter of these pendentives is the same length as the diagonal (rather than side) of the square.

According to the written sources the original dome on H. Sophia, built when the church was erected in AD 532–7, was 20 Byzantine feet (*c.* 6.25 m) lower than the current one which replaced it. The first version may have been more or less equivalent to a dome with continuous pendentives [583a].[112] This first version fell down in 558 as the result of earlier earthquake damage. The second dome, which was completed in 562, is taller [583b]. It is ribbed and is supported by a ring above the pendentives, and has windows around the base to make it lighter.[113] This dome, with repairs, has survived to the present day [580–581].[114]

The most distinguishing feature of the dome of H. Sophia (beside its construction material) is its shape and size. Earlier domes with pendentives occur, just as equally large domes occur. It is the combination of shape and size which is innovative on H. Sophia.

Although, before it, there were small (*c.* 2–6 m diameter) domes either on pendentives or with continuous pendentives, the one on H. Sophia is the earliest surviving monumental example. The earliest surviving dome with continuous pendentives is constructed of ashlar masonry on the baths-building at Petra, dated to the first century BC by its capitals and cornices which show strong Alexandrian influence.[115] Domes with continuous pendentives become more common

580. Constantinople (Istanbul), H. Sophia, interior

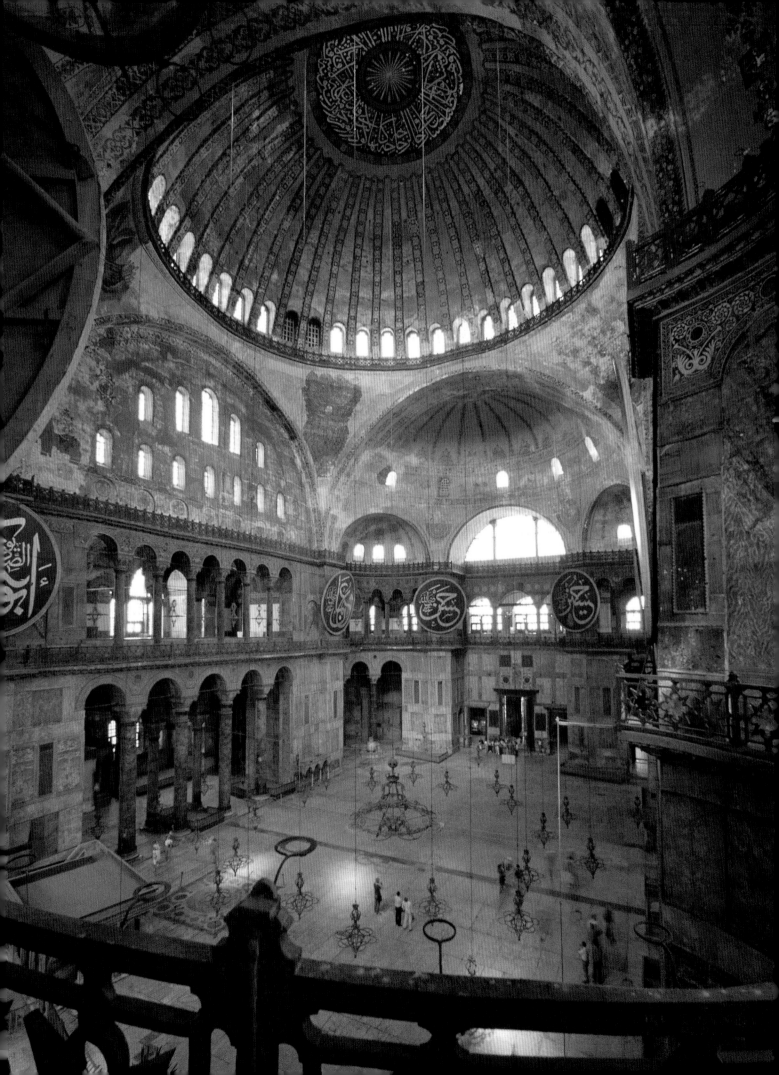

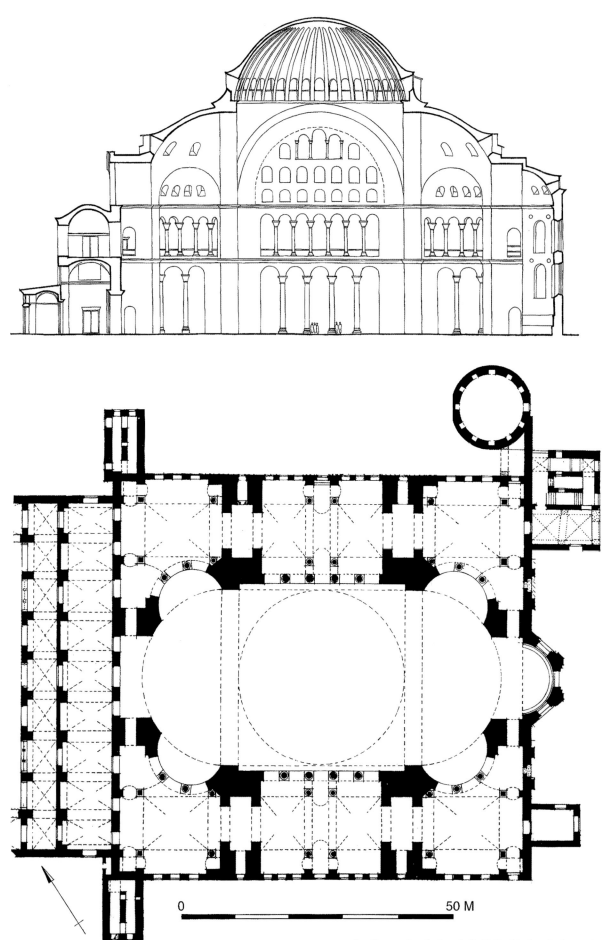

581. Constantinople (Istanbul), H. Sophia, lengthwise section and plan

0 50 M

in Roman architecture from the late second century AD, especially examples of ashlar masonry in Syro-Palestine,[116] and Egypt where Tomb 3 at Ezbet Bashendi has one *c.* 5.65 m in diameter dated to not later than end of second century AD.[117] These examples are only up to 6 m diameter because ashlar masonry is not as suitable as concrete or pitched-brick vaulting for very large domes since it has less tensile strength and is heavier. Brick vaulting supported by stone arches was used in Late Antique Egypt, as on the square crypt of the South Church at Hermopolis Magna (el-Ashmunein) which was built in *c.* AD 450–60.[118]

The design of H. Sophia was new, with a central dome and a semi-dome at either end to create a nave with a free span of 31 by 67 m. The dome has an arch and a semi-dome on its east and west ends, and is supported by an arch on either side [580–581]. Below the semi-domes there is a further semi-dome in each corner, in an arrangement not dissimilar to that of the church of Saints Sergios and Bakchos [573] which, however, has a centralized plan.[119] Notably, the baths-building at Kom el-Dikka in Alexandria was rebuilt after the earthquake of AD 535 with a plan which could have supported a semi-dome on either side of a dome, in an arrangement [366] related to that used on H. Sophia.[120]

Although, the dome on H. Sophia is the earliest surviving example of substantial dimensions of a circular dome on a square base, large domes were constructed in imperial Roman architecture on circular or polygonal plans.[121] These include the largest still surviving dome which was built before it on a circular plan on the Pantheon in Rome, AD 118–28. This was made of concrete with an internal diameter of 43.3 m [584]. Later examples of large domes on circular plans include that on the Rotunda of Galerius' palace in Salonica (Thessaloniki) built in *c.* AD 300 (later church of St George) which is made of pitched-brick and had an internal diameter of 24.5 m [589–590]. In Constantinople the fifth century 'Myrelaion Rotunda', with a 29.6 m internal diameter, would have had a dome.[122] Later Roman concrete domes over polygonal rooms had the corners bridged with shapes which are nearly pendentives, such as those with brick courses on the octagonal rooms of the Baths of Caracalla (AD 211–16).[123]

In contrast to the large Roman domes, the dome of H. Sophia is not built of concrete, but uses pitched bricks and mortar, like the one on the church of Saints Sergios and Bakchos, which is half the diameter (but built on an octagonal plan) [574].[124] The thickness of mortar used between the bricks gradually increased from the first century AD. By the time H. Sophia was built the combination of bricks and mortar was so strong it behaved like concrete.[125]

As pitched-brick vaulting was used in Asia Minor, Mesopotamia, and Egypt, the gradual developments leading to its use on large domes might have occurred in a combination of these places, rather than being specific to one place, especially as other features of church design in Egypt, Greece, Asia Minor, and Europe reflect considerable contact between their architects. Unlike St George's in Salonica, the surviving churches in Syria with centralized plans apparently did not have pitched-brick domes, as they do not have sufficiently strong supports, except the Tetraconch at Apameia.

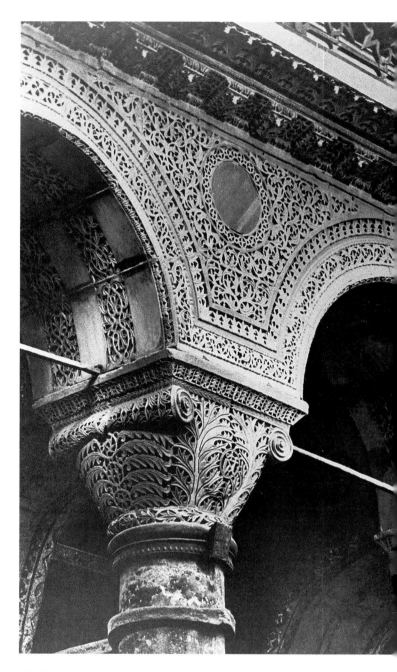

582. Constantinople (Istanbul), H. Sophia, detail of lower order

The written sources indicate that the dome on the Golden Church the octagonal Great Church in Antioch (AD 327–41) was made of timber, as were some later domes in Syro-Palestine and Egypt.[126] Timber was suitable for roofs on a circular base, i.e. circular domes and conical roofs, but not for domes with continuous pendentives. As the use of domes with continuous pendentives on a small scale occurred in Asia Minor, Syro-Palestine, and Egypt by the fifth century AD it is possible that the first use of a dome on pendentives for a large span might have occurred in any of these places.

It is only recently that modern scholars have noticed that a dome with continuous pendentives has an important structural advantage over a hemispherical dome on a circular base.

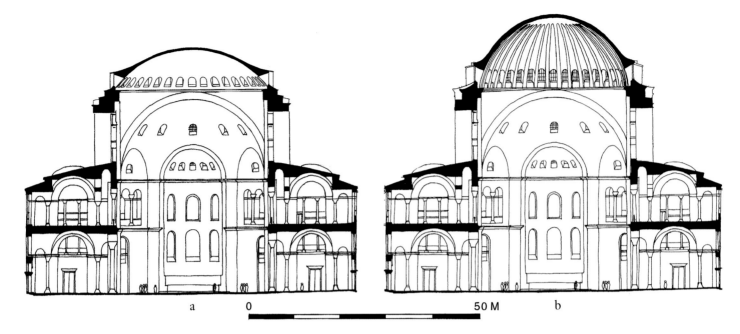

583a–b. Constantinople (Istanbul), H. Sophia, cross-sections of first and second domes

Computer analyses of the dome of the Pantheon in Rome (on a circular base) and related examples have explained the radial cracks in their lower parts. The structural reason for this is that the lower two-thirds of a hemispherical dome is subject to tensile forces, whereas the upper third is subject to compressive forces.[127] Computer modelling reveals 'that the hypothetical parallel separating the portion in tension from that in compression lies at approximately 54 degrees from the base of the dome', that is at the line where radii at 54 degrees to the horizontal base of the dome would meet the surface of the hemispherical dome. This is close to the average figure of 57 degrees for this parallel on the Pantheon up to which radial cracking has occurred [584].[128]

The monolithic dome on the Mausoleum of Theodoric in Ravenna, built in *c.* AD 526, is an 11 m diameter stone block consisting of the top part of the sphere above the parallel 54 degrees from the hypothetical horizontal base of the dome (if a complete one had been constructed rather than just the top part used). Consequently, because of its shape this large monolithic block is not subject to radial cracking [586–587].[129] This suggests that its architects knew of the problem of radial cracking, even if from observation rather than calculation.

A dome on a square base with continuous pendentives is the most effective solution to avoiding the problem of radial cracking, as its fully curved part [541, 585b] begins at the parallel 45 degrees from its horizontal base (of the hypothetical complete dome), and is more effective than those on an octagonal or hexagonal base which are more likely to be affected by radial cracking because of their shape [585a].[130] This might explain the original reason for the failure of the design of the first dome of H. Sophia. It is also possible it fell down due to poor workmanship (because of its hasty construction) rather than a flawed design, contrary to what was apparently assumed at the time – when its design was altered for the replacement.

Knowledge of these details of the behaviour of domes made of rigid materials has been lost until recent years, despite being known early in the sixth century AD. Similarly, knowledge of the horizontal arch dam (designed by Chryses of Alexandria who worked for the emperor Justinian)[131] and the understanding of the basis of its design were lost until it was re-invented in modern times.[132]

Pictorial evidence suggests that there was a dome of monumental proportions with pendentives on a building in Alexandria before the one on H. Sophia. This was found in the church of St John the Baptist at Jerash, a major Roman city in Jordan, in a floor mosaic which is firmly dated by its inscription to AD 531. It depicts the walled city of Alexandria with a major monument with a dome with pendentives between two basilicas [420, 588].[133] The name of this domed building is not known, but its importance is suggested by its location at the centre of the image. The way this dome is depicted (with pendentives) cannot be the result of the misrepresentation of a circular building as one is depicted (with a roof on a drum) on the far left, indicating how the artist of this mosaic represented circular buildings. Although the dome is clearly one with pendentives, it is not clear which type is indicated, i.e., if it is one on separate pendentives (suggested by its tall shape), or one with continuous pendentives (indicated by the lack of change in its outer curve). However, this evidence does suggest that there was a building in Alexandria with a dome both of substantial proportions and with pendentives by 531, i.e. before the one on H. Sophia was erected (in 532–7). Because timber would have been used for a conical roof or a dome on a circular base, but not a dome with pendentives it would have been of pitched brick or concrete.

584. Rome, Pantheon, AD 118–28, section

585a–b. Sections and plans of domes on polygonal bases: on an octagon and on a square (a dome on continuous pendentives)

a b

As pitched brick was already used in Egypt, it is more likely than concrete.

The marvel of H. Sophia is not only the size and shape of its dome, but also the fact that it has remained standing for so long. It left an important legacy in the design of Byzantine churches (both basilicas and cross-shaped) with a central dome,[134] which was repeated throughout the Mediterranean area in later periods on churches and, on a grander scale, on Ottoman mosques.[135]

CONCLUSION

In the late fourth and fifth centuries AD the architecture of the imperial capital Constantinople largely involved a continuation of the classical forms of Roman architecture, as used in the Greek cities of Asia Minor.

By contrast, the earliest major sixth-century church in the city of which substantial remains survive, St Polyeuktos (completed in AD 522–7), has features without precedent in Constantinople. Ever since it was excavated in the 1960s, the origins of the unusual motifs in its fine marble decoration have perplexed scholars. However, earlier reliably dated examples are found in Egypt, notably even used on the same

586. Ravenna, Mausoleum of Theodoric, section

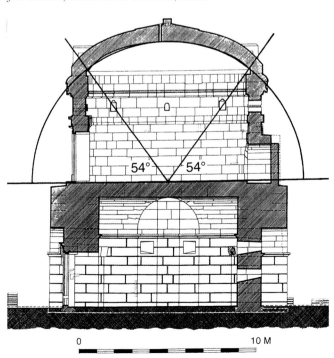

587. Ravenna, Mausoleum of Theodoric, c. AD 526

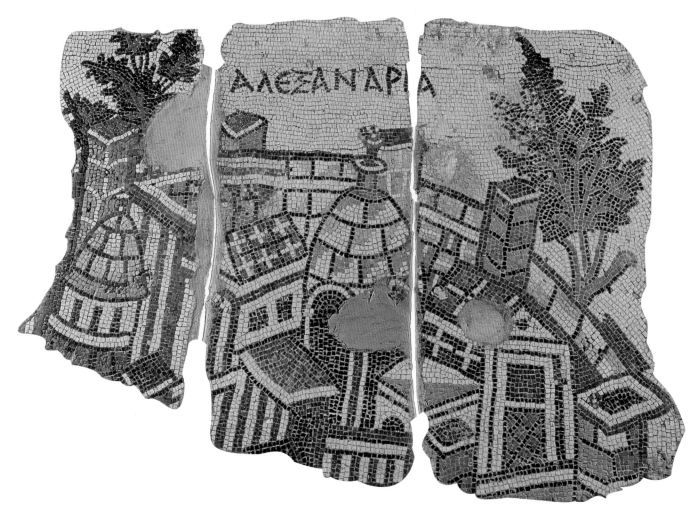

588. Jerash, church of St John the Baptist, detail of mosaic depicting Alexandria, AD 531

architectural members. This suggests some influence from Egypt on St Polyeuktos and that it possibly provides a glimpse of the decoration of the highest quality churches in Alexandria, which would have been marble, rather than limestone as survives on the churches of the Nile valley.

The church of Saints Sergios and Bakchos (c. AD 527–36) in Constantinople exhibits some features also found on St Polyeuktos as well as others of local continuity and new ones, notably fold-capitals. These capitals lack predecessors in Constantinople but the closest parallels for them are found in Egyptian architecture, raising the possibility that they were developed in Egypt.

Other information about construction in the first half of the sixth century comes from pictorial evidence. This reveals that there was a major building in Alexandria with a monumental dome with pendentives by AD 531. This is important because it predates the one on H. Sophia (532–7) which had been though to be the earliest, and has best survived the ravages of time.

Thus, the reconsideration of the history of Byzantine architecture in Constantinople in the light of the discovery of St Polyeuktos and of a detailed re-examination of the evidence from Egypt, suggests the architecture of Alexandria and Egypt was a major source of inspiration in Constantinople in the first half of the sixth century. The earliest examples of decorative and structural features which had been thought to develop there under the emperor Justinian (AD 527–65) are found in Egypt. Rather, under him, they were further developed in Constantinople, as seen in the pre-eminent surviving Byzantine church H. Sophia, and whence they were dispersed throughout the eastern Mediterranean.

This picture accords with what might be expected as a result of the concentration of architectural scholarship and training which has been found in Alexandria, and the close contacts of *mechanikoi* there with those working in Constantinople – while the skill of the Alexandrian *mechanikos* Chryses, who worked for the emperor Justinian, rivalled that of Anthemius and Isidorus who erected H. Sophia.

Pictorial Tradition of Alexandrian Architecture
in Byzantine and Early Islamic Art

No study of Alexandrian architecture would be complete without a concluding examination of its pictorial legacy in both the Byzantine and the Islamic worlds. In the Byzantine world, at Salonica (Thessaloniki) and Ravenna, wall-mosaics have monumental architectural scenes related to those in the first-century BC Roman wall-paintings in the Bay of Naples in the so-called Second Pompeian Style. In the East these scenes were also used on the Great Mosque in Damascus. Their relationship with those in the wall-paintings seven hundred years earlier is most striking.

On a smaller scale, the distinctively Alexandrian architectural scenes are used in illustrations in Gospel manuscripts especially from Syria, Armenia, and Ethiopia, as well as western Europe. The analysis of these presented here reveals a number of intermediate examples which are now lost but which must have been developed in Alexandria from the pictorial architectural tradition going back to the third and second centuries BC.

The final monumental example to be considered is seen in the refurbishment of the Church of the Nativity at Bethlehem, under Crusader rule in the twelfth century, with mosaics by local craftsmen still using the Alexandrian architectural settings for wall decoration.

All of these buildings are major monuments, especially of Syro-Palestine, while the manuscripts include many of the earliest surviving illuminated Gospel books of the eastern churches. The occurrence in them of Alexandrian architectural scenes suggests a wide diffusion of this iconography in the East.

BYZANTINE MOSAICS

Architectural compositions related to those depicted in Roman wall-paintings of the Second Pompeian Style (phase Ic) survive in fifth-century mosaics of Christian buildings at Salonica in northern Greece and at Ravenna in northern Italy, both having maritime connections with the eastern Mediterranean world. These architectural compositions are used in zones which are part of larger schemes of decoration on the domes of these buildings, so it is also worthwhile to provide some sense of their physical context as well as their possible meanings. At the same time, the relationship of these mosaics to both the wall-paintings and to later Alexandrian architecture needs to be considered.

Church of St George, Salonica (Thessaloniki)

The Rotunda of the palace of the emperor Galerius in Salonica, which was built in c. AD 300, was converted to the church of St George, Hagios Georgios, in the fifth century.[1] It was decorated with mosaics in a decorative scheme related to these structural alterations [589–590].[2] At the top of the 24 m diameter dome, at the centre of the mosaic Christ was depicted standing in a medallion carried by four angels. The lowest zone, which is 8 m high and 77 m long, is one of the most impressive and highest quality mosaics of the period [589]. It is divided into eight panels which depict four different architectural compositions [591–592].[3] These provide the backdrop for figures of saints, largely obscure ones martyred in the East.[4] Because the inscriptions beside each saint also give the month in which his feast is celebrated, it is sometimes suggested that the architectural zone represents some kind of calendar.[5] The meaning of the overall theme of the whole decorative scheme is difficult to interpret because the middle zone, below the angels, is now missing [589]. The Ascension of Christ or his Second Coming are amongst suggestions for the original design.

The architectural compositions depicted in the mosaic have some features in common with earlier built examples. They are two stories high [591–592], like earlier examples which also functioned as a facade or an architectural backdrop, such as the rock-cut Khasneh at Petra [141][6] and later on Roman theatres and other buildings [187]. As on them, the broken pediment is on the upper storey. The architecture in the Pompeian wall-paintings is usually a single storey high, with the scene given depth by the depiction of a courtyard beyond the facade [143]. Its background of blue sky creates the illusion of looking through the wall. By contrast, the architectural scenes in St George's have a gold background [591–592].[7]

The scenes in the mosaic include structural elements of the baroque architecture invented in Ptolemaic Alexandria. Although some of those which were later used in Roman architecture are depicted, such as the segmental and volute pediments, others in the mosaic have some features which are distinctively Alexandrian. For example, the half-pediments of the broken pediment have a conch between them [591] in an arrangement used in Egypt in the first-century AD niche head from Marina el-Alamein [154]. This type of pediment, with an arched cornice and/or conch between half-pediments, continued to be used in Late Antique Egypt [436, 460].

Decorative details depicted in the mosaics in St George's are seen in Late Antique buildings in Egypt. For example, fanned out peacock feathers used to decorate semi-domes in two of the mosaic panels [592] are also used on a niche-head in the

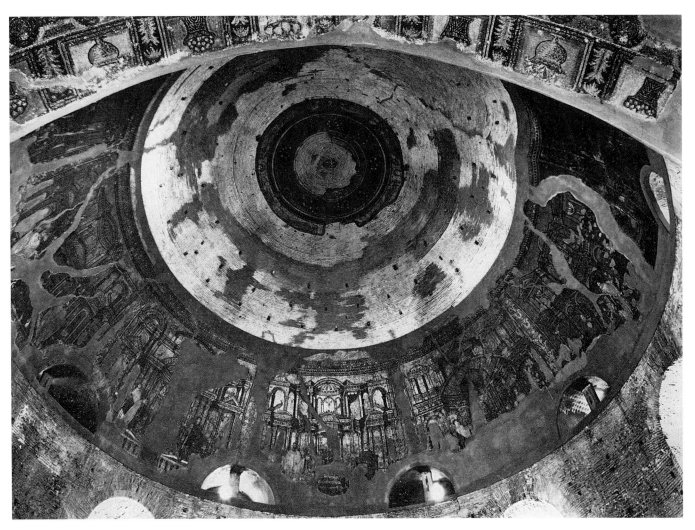

589. Salonica (Thessaloniki), church of St George, view into dome with mosaics

monastery of Apa Shenute (the White Monastery) near Sohag in Egypt, *c.* AD 440 [555]. Semi-domes decorated with a peacock with its feathers fanned out are also depicted in Egyptian textiles [556], and later carved in the church of St Polyeuktos in Constantinople [554]. The mosaic panels in St George's have

jewelling depicted on some columns and arches [591–592]. Jewelling is also represented on columns in Second Style Pompeian wall-painting, as in the House of the Labyrinth at Pompeii [143]. Jewels are carved on Late Antique cornices at Bawit in Egypt [506b] and on a capital from St Polyeuktos [572].

590. Salonica (Thessaloniki), church of St George, lengthwise section and plan

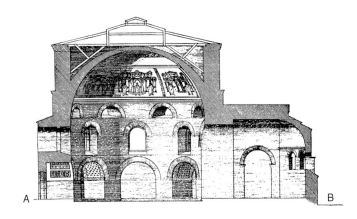

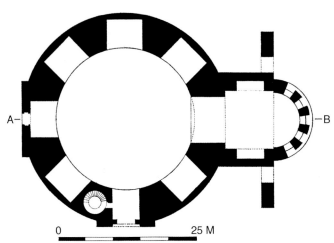

0 25 M

591. Salonica (Thessaloniki), church of
St George, detail of mosaic in dome
with broken pediment

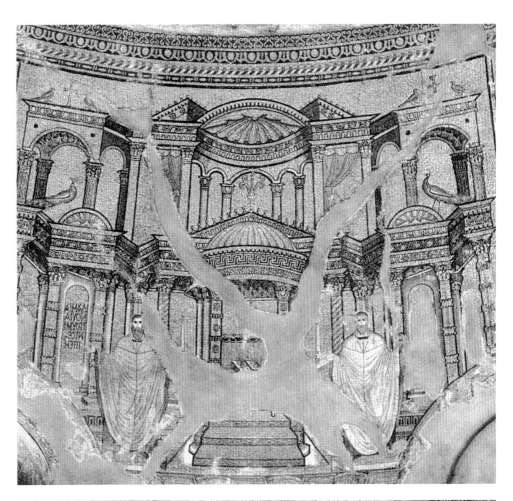

592. Salonica (Thessaloniki), church of
St George, detail of mosaics in dome
with peacock niche head

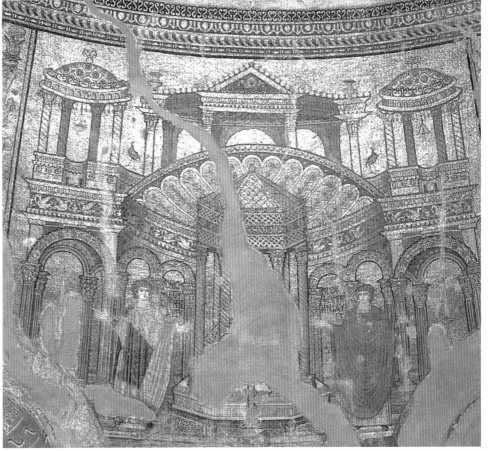

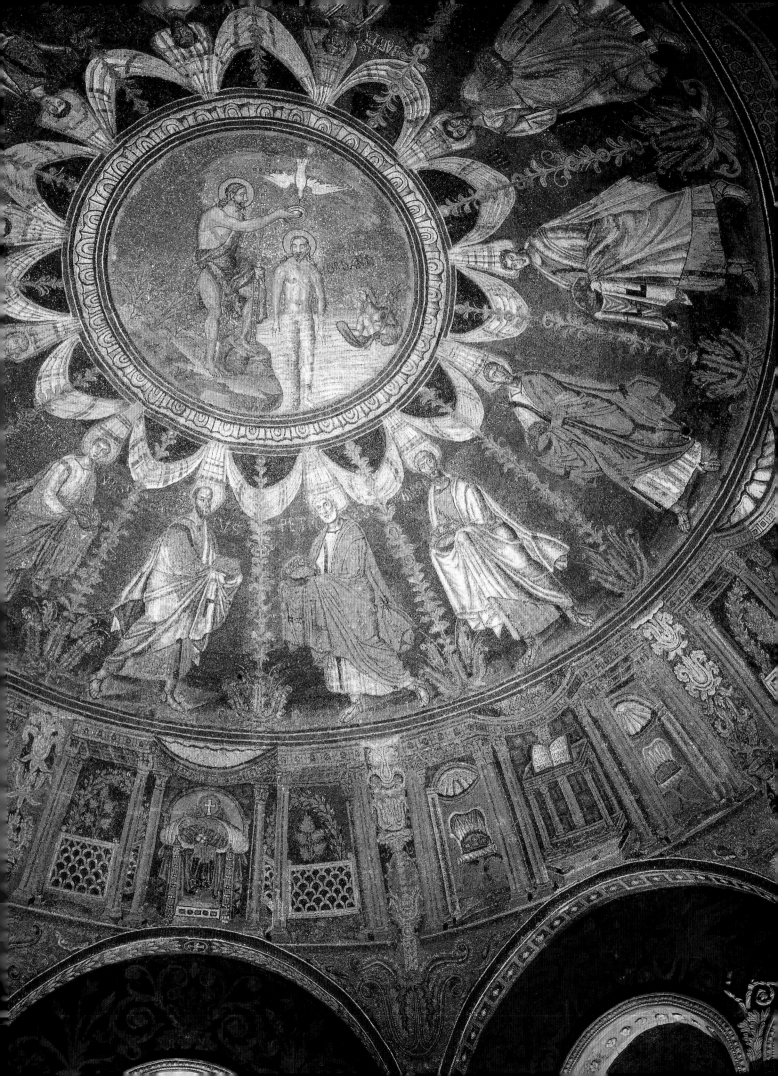

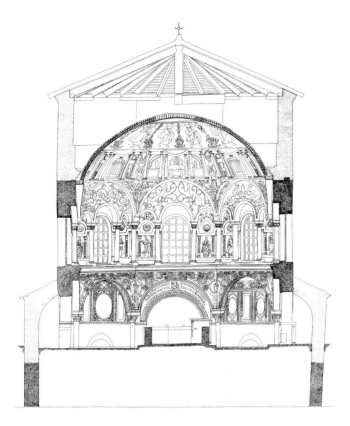

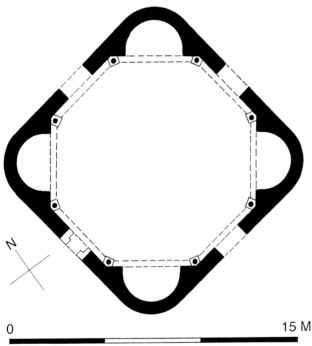

594. Ravenna, Orthodox Baptistry, section and plan, before the floor level was raised

593. Ravenna, Orthodox Baptistry, view into dome

Thus, the architectural scenes in St George's are not directly descended from those depicted in the Second Style Pompeian wall-paintings. Rather, they include features surviving in built architecture reflecting Alexandrian influence. They also include distinctive decorative details which appear in the architecture of Late Antique Egypt. This suggests that the architectural scenes in St George's may have been derived from contemporary examples in Alexandria.

On the dome of St George's between the architectural panels there are narrow vertical bands of vegetal decoration called plant-candelabra [592].[8] These also separate related architectural scenes in some mosaics discussed below, such as those in the Orthodox Baptistery at Ravenna [593] and in the Church of the Nativity at Bethlehem [623]. They were used between scenes in the lost fourth-century mosaics in Santa Constanza in Rome.[9]

Baptistery of the Orthodox, Ravenna

Ravenna was the western capital of the Byzantine empire from AD 402 to 751, and during the fifth and sixth centuries it was the most prosperous city in the West.[10] The Orthodox Bapistery was built for the Cathedral. The lower part was first erected in the late fourth century with a wooden roof. It was remodelled in c. 458, under bishop Neon, and given a new roof and a dome which was decorated with mosaics [593–594].[11]

Because this dome (diam. 9.6m) was placed on the existing octagonal walls which were only 0.6m thick,[12] it had to be extremely light [594]. Consequently, it was constructed of interlocking vaulting tubes held with fast-drying mortar and arranged in a way which would not have required wooden supports during construction. Rough blocks of pumice were used for the very top of the dome. The ground floor plan is square, with an apse in each corner [594] to support the octagonal walls on which the dome for the mosaics was placed directly. The curve of the dome runs down, across each angle of the octagon, forming shapes which are nearly pendentives [593].[13] Above the dome, there was a tiled timber roof so that the shape of the dome is not visible on the outside of the building [594]. The idea of moving from a square, via an octagon, to a circular shape is the same as that used on the Lighthouse at Alexandria.

The mosaic decoration of this dome, which survives virtually intact, has three main zones [593]. In the medallion at the top Christ is being baptized. In the zone below there is a procession of the apostles carrying crowns, with plant-candelabra between them.[14] In the lowest zone eight architectural panels are depicted separated by plant-candelabra.[15] The windows in the walls of the octagon are flanked by stucco figures in niches with stucco frames, which are contemporary with the mosaics above.[16] Below this, between blind arches, there are mosaics with vine scrolls enclosing figures holding books or scrolls.

Each architectural panel consists of a tripartite arrangement of three bays. They divide into two designs. One design has an altar table at its centre with one of the four Gospel books open

 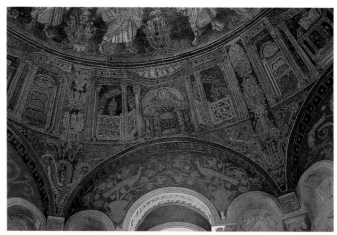

595a–b. Ravenna, Orthodox Baptistery, dome, details of mosaics with architectural panels with: (a) altar; and (b) throne

on it (identified by the inscriptions on them) and an empty chair in an apse on either side of it [595a]. The other design has an otherwise empty throne at the centre with a cross on it and a low fence on either side with trees behind [595b].

These architectural compositions with four columns across the front are simpler than those at St George's in Salonica [591–592]. Unlike them, but in common with the architecture in the Pompeian wall-paintings [143], they are only a single storey high and have only three architectural bays. In addition, the blue background in the mosaics further strengthens their relationship to the examples in Second Style Pompeian wall-paintings in which it is a characteristic feature. The architectural zone in the mosaics, notably, does not have figures in it. Similarly, they are absent from Second Style Pompeian wall-paintings although, while humans might not necessarily be expected in a garden or landscape scene, they would normally be expected in a setting of buildings.

This lack of figures has the effect of suggesting another world. Various interpretations have been suggested for the scenes in the Orthodox Baptistery, ranging from the earthly to the heavenly church.[17] The top scene of Christ's baptism clearly relates to the function of the building [593]. The throne occupied by a cross in the architectural scenes probably represents Christ enthroned. This is indicated by the fact that in the Arian Baptistery at Ravenna, half a century later, there is a similar decorative scheme but without the architectural zone. Instead the Apostles process with crowns towards a throne which is empty except for the cross on it.[18] This identification also tends to suggest that the architectural zone in the Orthodox Baptistery is alluding to a heavenly rather than to an earthly context.

In contrast to the examples in St George's which include later features indicating that its architectural scenes derive from more recent versions in Egypt, those in the Orthodox Baptistery are closer to the examples in the Pompeian wall-paintings. This suggests continuity of the pictorial versions seen in the wall-paintings, alongside depictions with elements from more recent architecture in Egypt.

These descendants of the genre of depiction of Alexandrian architecture in the Byzantine period are found at sites

to the north and west of Alexandria. They also occur to its north-east with the examples in early Islamic mosaics.

UMAYYAD MOSAICS

Surprisingly, the Great Mosque in Damascus (AD 705–714/15) contains mosaics with scenes related to those in Pompeian wall-paintings, which are also reflected in those used to decorate the Church of the Nativity at Bethlehem in 1169. As the mosaics in both of these buildings have some features in common with those which preceded them in the Dome of the Rock in Jerusalem (691), it should be included in the discussion. It and the Great Mosque in Damascus are still in use having survived largely unchanged since they were built, under Umayyad rule of the first Islamic empire.

The prophet Muhammad died in AD 632. By 661 the Umayyad court and administration were established in Damascus, which became the capital of the empire. ʿAbd al-Malik, who became caliph in 685, was responsible for making Arabic the official language and creating Arabic coinage.[19] As a result of the Arab conquests the Islamic state had immense financial resources from taxation which were used to fund the Umayyad building programme. ʿAbd al-Malik (685–705) set aside the tax revenues of Egypt for seven years to pay for the Dome of the Rock in Jerusalem, and his son al-Walid I (705–15) used the land tax revenue of Syria for seven years to pay for the construction and decoration of the Great Mosque in Damascus.[20]

Dome of the Rock, Jerusalem, AD 691

The Dome of the Rock, the earliest surviving Islamic monument [596], was built by ʿAbd al-Malik in AD 691, according to the inscription on it.[21] It is constructed in the prime location in Jerusalem on the Temple Mount, known as al-Haram al-Sharif. This was the site of Solomon's Temple which had not been built on since the destruction of the Herodian Temple by the Roman emperor Titus in AD 70. The

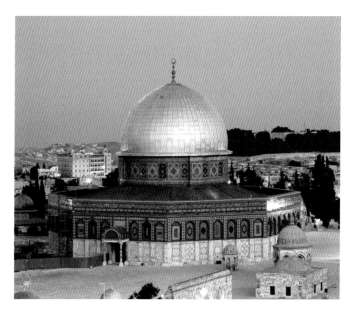

596. Jerusalem (al-Quds), Dome of the Rock (Qubbat al-Sakhra), AD 691, view from Ghawanima minaret

597. Jerusalem, Dome of the Rock, plan and axonometric reconstruction, AD 691

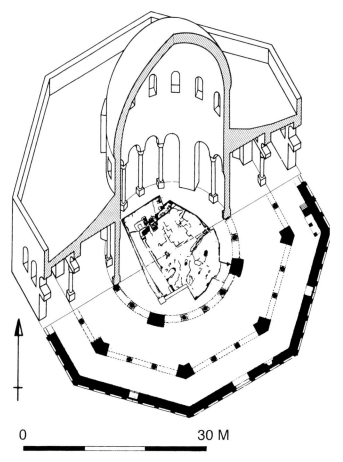

0 30 M

Dome of the Rock is a *c.* 60 m diameter octagonal structure enclosing an ambulatory around a rock out-crop at the centre, above which rises a 20.44 m diameter drum at the centre supporting a wooden dome [597].[22]

It is an important Islamic religious site because the rock out-crop which the building covers became associated in Muslim tradition as the place from which the prophet Muhammad began his night journey to heaven. Some Arab sources consider ʿAbd al-Malik erected it to replace Mekka as a pilgrimage site. This is doubted by some scholars, despite the inclusion of an ambulatory in its design. The Jerusalemite geographer al-Muqaddasi (AD 985) related that it was built to rival the Church of the Holy Sepulchre in Jerusalem.[23] It has monumental Arabic inscriptions which are largely Koranic quotations chosen to serve as a declaration of faith and summary of the fundamental principles of Islam, making clear how these beliefs differ from those of Christianity.[24] These inscriptions are the earliest surviving examples of the monumental Arabic inscriptions later frequently used on Islamic monuments.

The origin of the design of the Dome of the Rock is instructive and should be considered before attention is turned to its mosaic decoration. The octagonal design of the building is sometimes called a centralized plan [597] – a term also applied to circular buildings. The centralized plans used for some buildings in classical architecture and some churches in Rome are generally circular, whereas, an octagonal plan is usually used in the West for baptisteries. Whilst

circular churches occur in Egypt [479] and Syro-Palestine,[25] those with an octagonal plan are more common in the latter than in the West. The fifth-century Kathisma church in Jerusalem has a similar design to that later used on the Dome of the Rock as it consists of an octagonal structure with an internal colonnade built around a rock.[26] Fourth-century examples of octagonal churches, such as those at Nazianzus and Antioch, are also mentioned in the written sources. The Church of St John the Baptist in Alexandria and the Church of Theotokos in Tyre also seem to have been octagonal.[27] The octagonal shape of the Dome of the Rock would thus appear to be following a local tradition in religious buildings.

Another distinctive feature of the design of the Dome of the Rock is the way its dome rises above the centre part of the octagon [596–597]. The original dome was described in the early tenth century as made of two wooden shells covered with sheets of lead with plates over them of 'copper gilt' or 'brass gilt'.[28] The present outer dome, dating from the 1960s, replaced earlier replacements.[29] With its gold-coloured aluminium covering it gives an impression of how the original dome would have looked, dominating the skyline with the full shape of the dome visible above the rest of the building. This contrasts with the domes on S. Vitale and the Orthodox Baptistry in Ravenna, and on St George's in Salonica, which are hidden on the outside by tiled roofs [575, 594, 590].

However, there were earlier gilded wooden domes in Syro-Palestine and Egypt. The written sources mention that the

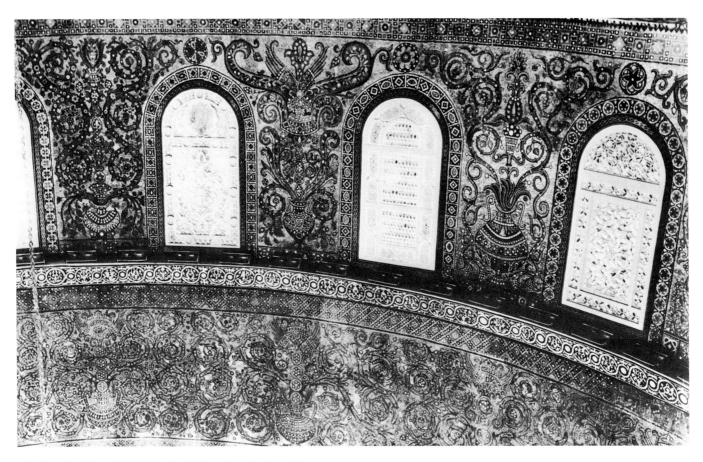

598. Jerusalem, Dome of the Rock, detail of mosaics in interior of drum

dome above the Golden Church (the octagonal Great Church) in Antioch, built AD 327–41, was hemispherical and rose to a great height. This dome had a gilded covering and was apparently made of wood.[30] Cedar would still have been available prior to the deforestation of Lebanon, and pine was also used for such purposes.[31] According to written sources a monumental gilded dome, apparently with a wooden frame, was built at al-Fustat (Old Cairo) in AD 686/7 for his palace by 'Abd al-Aziz, the brother of 'Abd al-Malik.[32] The Arab historians mention 'one of the marvels of Alexandria' was the 'Hadra dome' (apparently the Tychaion) which was 'wondrous, faced with copper – like pure gold, which nothing can destroy'.[33] Gilded bronze made by depletion gilding is resistant to corrosion. This method of manufacture, which is described in a metallurgical text on a papyrus of the early fourth century AD,[34] involves burnishing. Depletion gilding would have been particularly suited as a method for gilding metal sheets used on roofs.

Thus, the basic design of the Dome of the Rock, with an octagonal plan and a wooden dome covered with gilded bronze, is the result of local continuity of architectural features already in use in Syro-Palestine and Egypt.

The Dome of the Rock was decorated with mosaics inside and out. Those on the outside were replaced by tiles by 1552, which have since been replaced more than once to some extent.[35] Before considering the designs of these mosaics, mention should first be made of the earlier use of wall-

mosaics in the region. As most early churches there have not survived in continuous use, wall-mosaics have not generally survived *in situ* in them (except in St Catherine's at Mt Sinai), so it is only in more recent years that sufficient evidence has accumulated from excavations in Egypt and Syro-Palestine to indicate that wall-mosaics were already in use in the area prior to the construction of the Dome of the Rock.

In Egypt, very high quality, finely shaded and coloured floor mosaics from as early as the second century BC survive in Alexandria [100].[36] In the Late Antique period wall-mosaics were used in some churches in Egypt. The excavators of the Main Church at Saqqara, near Cairo, collected five and a half kilograms of mosaic cubes from the semi-dome. The relative quantities of each colour indicate that it had a gold background, while the main colours of its patterns were opaque grass green and light blue, reddish tones, and transparent dark blue.[37] These mosaics would have been made in the sixth to eighth century, depending on to which phase of the church or its rebuilding they belong.

There was also a strong tradition of mosaic work in Syro-Palestine, like elsewhere in the Roman empire. There is much more evidence for the floors, rather than the walls, of excavated buildings because these have survived more easily. At Antioch and at Apameia in Syria considerable evidence survives for floor mosaics, some of high quality, from the second through to the sixth century AD showing a continuity of development.[38] In Palestine and Jordan many floor mosaics

have been uncovered in churches and synagogues, especially from the fourth century through to the sixth century AD, with some as late as the eighth century.[39] Sufficient evidence has now been collected to show that there also were wall-mosaics in churches in Syro-Palestine. The upper parts of their walls, above the arcades and apses, as well as the semi-domes, might have been decorated with mosaics like those in S. Vitale at Ravenna [576]. Glass cubes from wall-mosaics, which have not survived intact, have been found in the excavations of churches at sites such as Apameia and Bosra in Syria, Bethany near Jerusalem,[40] and at Pella and Petra in Jordan.[41] These mosaic cubes include gold, many shades of blue and green glass, red, and other colours. Thus, in addition to the better preserved floor mosaics, churches in Syro-Palestine and Egypt were decorated with glass wall mosaics in the period before the construction of the Dome of the Rock.

The surviving mosaics on the Dome of the Rock are in its interior: around the inside face of the drum, on the arches of the circular colonnade which supports it, and on the octagonal colonnade which surrounds this.[42] Despite some repairs, the surviving mosaics accurately reflect the original decorative scheme.[43] Their patterns consist of vegetal scrolls [598–600], stylized plants [601–602], plant-candelabra [603], and trees [604]. These motifs have some features which indicate local continuity of the classical tradition, and others which show Sassanian influence. However, the unique result of this combination of influences is distinctly Islamic, especially because of the lack of figures, animals or buildings depicted in them. This is also emphasized by the Arabic

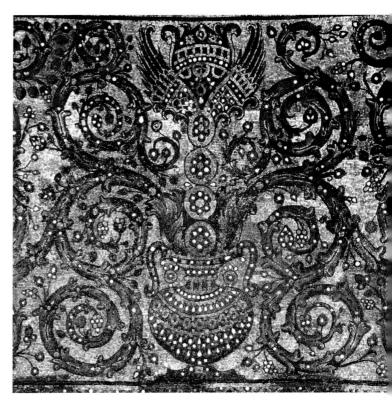

599. Jerusalem (al-Quds), Dome of the Rock (Qubbat al-Sakhra), detail of mosaics in south-west panel of lower register of drum

600. Jerusalem (al-Quds), Dome of the Rock (Qubbat al-Sakhra), mosaics on outer face of circular arcade, with vegetal scrolls springing from baskets of acanthus leave

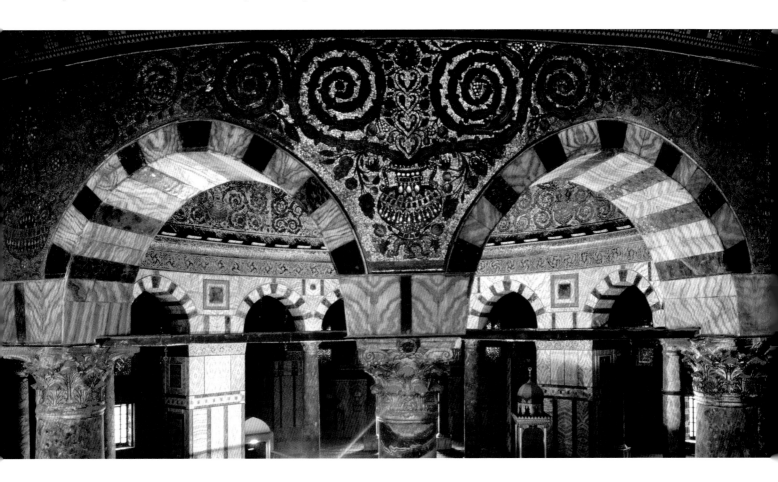

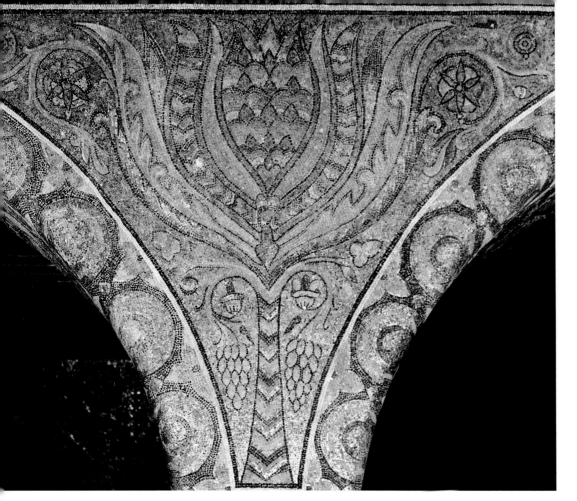

601. Jerusalem (al-Quds), Dome of the Rock (Qubbat al-Sakhra), mosaic on outer face of octagonal arcade depicting stylised trees

inscriptions. The mosaics on each part of the building and their origin will be considered in turn.

Between the arches on the outer face of the circular colonnade, there are vegetal scroll patterns springing from acanthus leaves [600]. Similar vegetal scroll patterns are depicted on the inner side of the drum, especially in the lower zone [598–599].[44] These vegetal scrolls or rinceaux are obviously derived from classical examples, which were carved in relief. They are also used in Christian mosaics in both the East and the West.[45]

On the surfaces, between the arches on the outer face of the octagonal colonnade, there are stylized trees with a lotus- or tulip-shaped flower [601].[46] These flowers have long petals or leaves without serrations. Some of the petals of the main flower have on them a pattern of chevrons or overlapping hearts. The trunk has a bud on either side, as does the main flower. This motif is similar to Sassanian examples which are earlier, and to related motifs in Sassanian stucco. A Sassanian capital also has a tulip-shaped flower with buds in similar positions, and it has a similar pattern on the petals.[47]

On the inner side of the octagon stylized plants spring from vases. At their centre they have a lotus- or tulip-shaped flower. These have a pointed egg-shape at their apex and are decorated with jewellery, such as necklaces and crowns [602].[48] On the mosaics in the lower zone of the drum (springing from the same vases as the vegetal scrolls) there are similar pointed egg-shapes with crowns, but they have a wing on either side of them [599].[49] In the register above (which has suffered repairs), between the windows there are related patterns, also springing from vases [598].[50] As the jewelled crowns are of both Byzantine and Persian designs,

various interpretations have been suggested for them.[51] The winged motif by itself is well known in Sassanian art.[52] It has been suggested that the winged motifs and crowns in these mosaics represent 'an abstraction of the angels'.[53]

Naturalistic palm and olive trees are depicted on some of the side faces of the piers of the octagon [604].[54] As some of these have jewelled trunks they may allude to Paradise where the Emerald Tree was studded with precious stones, in the Islamic tradition.[55]

Just as the iconography of the mosaics on the Dome of the Rock is very distinctive, so too are their colours. They are characterized by the use of a gold background with the main colours of the motifs being shades of blue (ranging from dark indigo to turquoise), green and gold, with highlights in red. There are also some silver cubes [601]. There is much use of mother of pearl in the surfaces which do not face the light, creating a distinctive iridescent glitter [599].[56] After her detailed analysis of the mosaic decoration and technique of the Dome of the Rock Margurite Gautier-van Berchem came to the conclusion that they were the result of local, rather than imported, Byzantine workmanship.[57] This possibility is now more likely in the light of the more recently uncovered archaeological evidence, mentioned above, which indicates wall-mosaics were produced in Syro-Palestine and Egypt prior to the Dome of the Rock, sometimes with cubes of similar coloured glass. This local workmanship also accords with the local content in the building's design, with its octagonal plan and golden dome rising above the skyline. However, it is also very much an Islamic building as proclaimed by its inscriptions, with its unique purpose and the decorative scheme of its wall-mosaics.

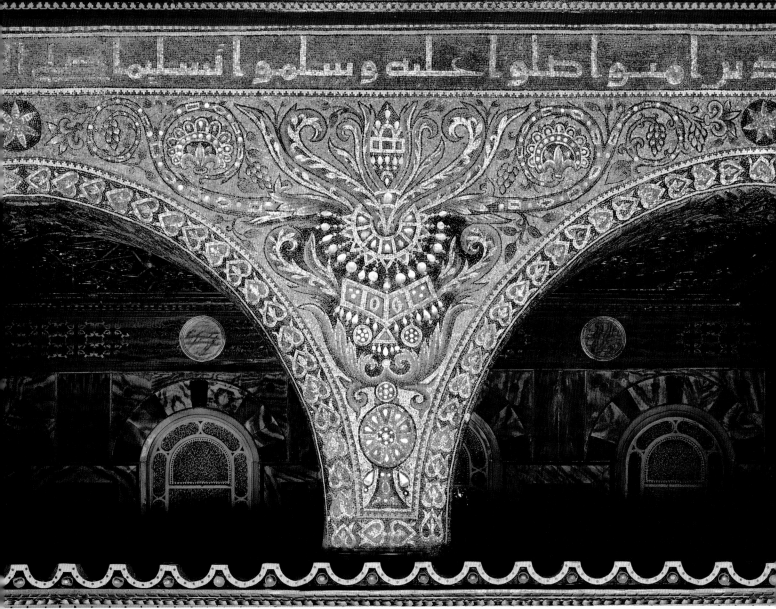

عـذرا بـمـوا اصـلـوا عـلـيـه و سـلـمـوا تـسـلـيـمـا ...

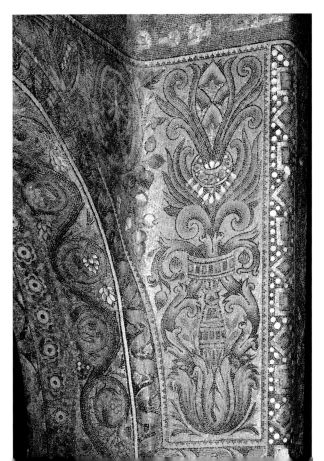

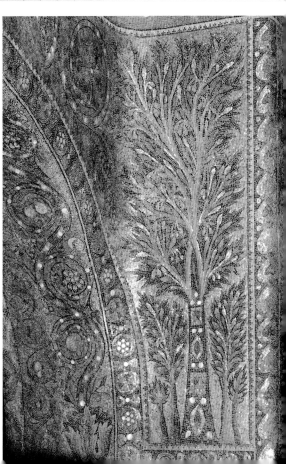

602. Jerusalem (al-Quds), Dome of the Rock (Qubbat al-Sakhra), mosaics on interior face of octagonal arcade, with stylized plants springing from vases

603. Jerusalem (al-Quds), Dome of the Rock (Qubbat al-Sakhra), mosaic on side face of pier of octagonal arcade, with plant candelabra

604. Jerusalem (al-Quds), Dome of the Rock (Qubbat al-Sakhra), mosaic on side face of pier of octagonal arcade, with trees

There are few references in Arab sources mentioning whence came the workmen employed on building the Dome of the Rock. The archaeological evidence for the origins of the design of the structure and its mosaics would tend to accord with the Jerusalemite preacher al-Wasiti (writing before AD 1019) who, when describing the construction of the Dome of the Rock, relates that 'Abd al-Malik 'gathered craftsmen from all his dominions and asked them to provide him with the description and form of the planned dome before he engaged in its construction'. At that time these dominions embraced Egypt and Bilad al-Sham (modern Syria, Lebanon, Palestine, Jordan, and western Iraq). When its construction was complete the supervisors of this, Raja' ibn Hayweh and Yazid ibn Salam, reported that they had also completed the construction of the al-Aqsa Mosque, which stands nearby.[58]

Skilled workmen from Egypt were employed on the al-Aqsa Mosque by 'Abd al-Malik's son al-Walid, from AD 706 to 715.[59] This is recorded in official correspondence, in Greek (the so-called Aphrodito papyri), which survives from the time in the form of letters on papyrus found at that site (Kom Ishqaw), 50 km north of Sohag in Upper Egypt. A letter between the Governor of Egypt in 709–14 and the Prefect of the district of Aphrodito refers to the provision of 'the maintenance of labourers and skilled workmen for the mosque in Jerusalem'.[60] This was part of the tax revenue and is also mentioned in 706.[61] A letter of 715, which mentions the sending of labourers and their maintenance, names 'ibn Yazid the superintendent'.[62] Sending craftsmen from Egypt to Jerusalem was not unprecedented, as a thousand Egyptian artisans and supplies were sent to help rebuild the churches there after they had been damaged by the Persians in 614.[63]

The Aphrodito papyri also mention skilled workmen and their maintenance being sent from Egypt to work on the Great Mosque in Damascus in 706/7 and 709.[64] One letter dated 710 which mentions materials being sent gives the names of those in charge of its construction: 'Abd ar-Rahman ibn . . . and 'Ubayd ibn Hormuz.[65] Notably, like the supervisors of the Dome of the Rock, they had Arabic names. We will now turn our attention to the Great Mosque in Damascus and the issue of local involvement in its construction versus the use of imported Byzantine craftsmen.

The Great Mosque in Damascus, AD 705–714/15

The Great Mosque in Damascus was begun by 'Abd al-Malik's son al-Walid in 706 and finished by 714/15.[66] It was built on the city's most important religious site replacing the cathedral, the church of St John the Baptist, which had been erected in the former enclosure (temenos) of the temple of Jupiter Damascenus.[67] The colonnades along three sides of the court relate to the earlier layout of that temenos, while the prayer hall design of the mosque is influenced by Byzantine basilical buildings [605].[68] However, the overall plan of the complex with the large columned prayer hall along one side is specific to its function as a congregational mosque.[69] Thus, whilst maintaining some features ultimately derived

from the Byzantine tradition, its design was a new one for the new religion.

Before a consideration of later Arab sources concerning the construction of the Great Mosque the evidence for its mosaics, which survive on the surfaces facing the courtyard,[70] is instructive. They include some traditional vegetal scrolls and plant-candelabra based on classical prototypes,[71] as were those in the Dome of the Rock. However, the most important mosaic is a landscape panorama (34.34 m long and 7.30 m high) on the west wall of the courtyard inside the colonnade [606–607].[72]

The mosaic was uncovered in the 1920s by the scholar Eustache de Lorey, who noted the similarities of its scenes to those in Pompeian wall-paintings.[73] These similarities have generally been accepted, as Robert Hillenbrand notes: 'the link with Roman wall-paintings of the type found at Pompeii is unmistakable; but here the idea is put to new and unexpected use, for it strikes the dominant note in a huge monument of religious architecture'.[74] As it has already been demonstrated that the monumental architecture depicted in these wall-paintings is that of Ptolemaic Alexandria, the scenes in this landscape panorama mosaic are very relevant here.

They are of the same types as those in the Roman wall-paintings: garden scenes, monumental architecture, and cityscapes [607]. This same combination of scenes is to be observed in cubiculum M of the Villa of P. Fannius Sinistor at Boscoreale, near Pompeii, now in the Metropolitan

605. Damascus, Great Mosque, axonometric drawing, AD 705–714/15

Landscape mosaic

Museum of Art in New York [608]. In its cityscapes and the Damascus mosaic the houses are piled up the hill in a similar manner.[75]

The monumental architecture depicted in the mosaic also has some striking similarities with that in Pompeian wall-paintings.[76] The most notable is the building with a broken pediment framing a conch [607]. Broken pediments are depicted in Pompeian wall-paintings framing a circular structure (tholos), as in the House of the Labyrinth in Pompeii [143]. The architecture in the wall-paintings is a single storey high and has broken pediments of single pitch. However, the Khasneh, which was carved out of the rock-face at Petra by about the end of the first century BC, has other features in common with this mosaic version [141]. Both are two stories high and their broken pediments have half-pediments on which the cornices are raked towards the back. The mosaic has a conch in place of the tholos between the half-pediments [607]. This was also to be observed in built examples in Egypt, such as the one from Marina el-Alamein [153–154], and later in the mosaic in St George's at Salonica [591].

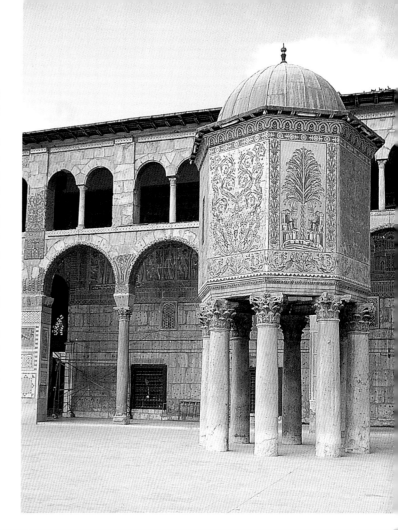

606. Damascus, Great Mosque, view of courtyard showing position of landscape panorama behind the colonnade

607. Damascus, Great Mosque, detail of wall-mosaic of landscape panorama depicting monumental architecture with tholoi, broken pediment, cityscape, and garden scenes

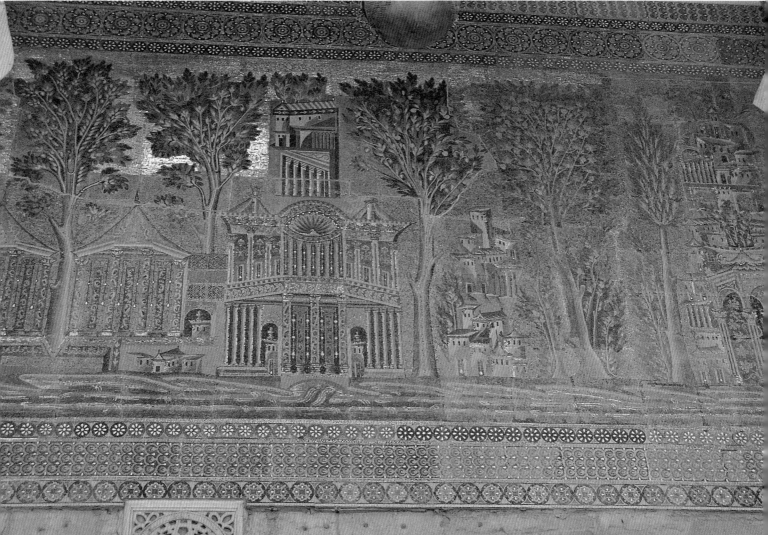

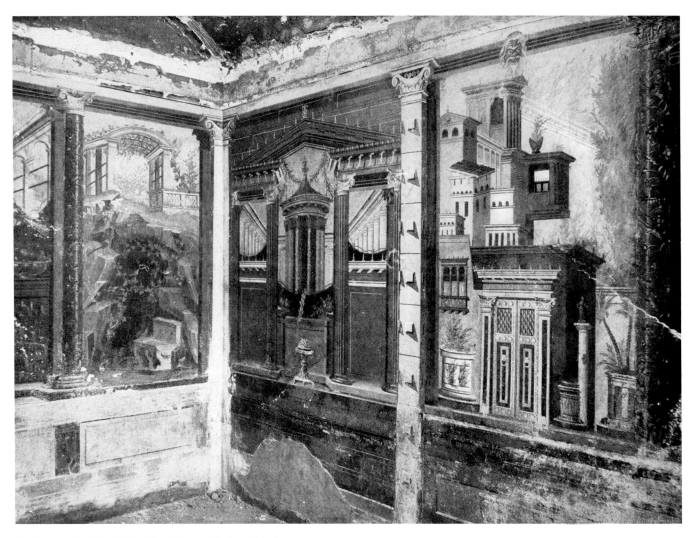

608. Boscoreale, Villa of P. Fannius Sinistor, cubiculum M *in situ*

The Great Mosque mosaic has tholoi depicted with a tent roof and Corinthian columns [607 far left], related to the distinctive examples in the Pompeian wall-paintings [143, 162].[77] The depictions in the mosaics also have decorated columns reminiscent of tholoi in Pompeian wall-paintings with vines winding up them [161].[78] However, the tholoi in the mosaic are proportionately wider, as are most of the examples in the Gospel manuscripts especially those from the eastern churches which will be discussed below [613–614, 616]. They indicate the wide diffusion in Late Antiquity of these motifs in the East.[79]

Like the depictions in St George's, the Great Mosque mosaics have details of Alexandrian architecture which are more recent than those in the Roman wall-paintings. This suggests that the mosaics in Damascus were also derived from versions of these scenes in Late Antique Alexandria.

The colour scheme of the Great Mosque mosaic, largely blues and greens on a gold background, is strikingly different from that used in the mosaics in St George's, where gold with black outlines is used for both the architectural constructions themselves and the background [591–592]. These different colour schemes suggest that both of these mosaics,

whilst sharing a common origin with the depictions in the wall-paintings, were also directly derived from more recent versions of these scenes.

The question arises as to why Alexandrian architecture is being depicted, i.e. its meaning. It is sometimes suggested that the architectural scenes in the mosaics in the Great Mosque refer to specific towns in the real world, as in the comment of the Jerusalemite al-Muqaddasi in *c.* AD 985: 'There is hardly a tree or a notable town that has not been pictured on these walls'. It has also been suggested that they depict the Barada River and Damascus.[80] A number of church floor mosaics in Jordan have towns depicted in them, but these towns are walled and identified by the labels beside them. They lack the ornate, slightly fanciful, details of the architecture depicted in the Great Mosque mosaics.[81] Consequently, it is possible that by alluding to Egypt, as the Roman wall-paintings had done, the images in the mosque panorama are alluding to another world: a paradisial one. This is also implied by Samhudi (1506) who relates that the mosaicists of the mosque at Medina, in Arabia, said: 'We have made it [the mosaic] according to what were known of the forms of the trees and mansions of Paradise.'[82]

The third main component of the panorama in the Great Mosque is the naturalistic trees which are disproportionately large in scale compared with the cityscapes and monumental architecture between which they are depicted. These trees also appear elsewhere in the mosque,[83] as do further examples of fanciful architecture.[84] These trees are related not only to the garden scenes in the Roman wall-paintings, but also to later Egyptian examples. The Roman example with which they are most frequently compared is painted in Livia's Garden Room in Rome.[85] Two rooms in the House of the Orchard (I 9, 5) in Pompeii have related scenes which include figures and motifs with direct allusions to Egypt. These include a seated Osiris, the Apis bull, and the long spouted pitcher[86] associated with the cult of Isis and used to hold the life-giving waters of the Nile.[87] A garden with similar trees is painted on an Egyptian textile of the first or second century AD with Euthenia, the Greek personification of Abundance.[88] Rows of trees are depicted in Egyptian textiles of the Late Antique period of which many examples survive [609].[89] These trees are on large curtains which might have been hung between columns in a colonnade – used in an architectural setting on a similar monumental scale to the examples in the mosaics.

As will be seen below, trees related to those in the Great Mosque are depicted in the Church of the Nativity at Bethlehem behind a jewelled cross which possibly represents the Fountain of Life in Paradise [624]. Thus, the trees in the Great Mosque, like the jewelled ones in the mosaics of the Dome of the Rock, discussed above, seem to suggest that the mosaics are indeed alluding to Paradise. This is also suggested by the lack of figures in these architectural settings, like the scenes in Second Style Roman wall-paintings and the architectural zone in the Orthodox Baptistery at Ravenna [593].

Further keys to the interpretation of the Great Mosque mosaics are provided by the written sources, rather than the archaeological evidence discussed above of mosaic cubes excavated in churches, at sites such as Petra, because these come from only small pieces of mosaic compositions.[90] Although complete decorative schemes have not survived *in situ* on walls, the sixth-century rhetorician Choricius of Gaza describes two churches in Gaza with wall-mosaics. The church of St Sergios at Gaza, built *c.* AD 527–36, had in its central apse a mosaic of the Virgin and Child with figures on either side. In the lateral apses 'there grew ever-burgeoning trees full of extraordinary enchantment' with a vine growing from a vase and below the main dome 'pear trees, pomegranate trees and apple trees bearing splendid fruit blossoming in all seasons alike'. The rest of the church was decorated with wall-paintings of incidents from the life of Christ.[91] Choricius describes the walls of the nave of the church of St Stephen at Gaza, between 536 and 548, as having a landscape alluding to the Nile River: 'The [Nile] river itself is nowhere portrayed in the way painters portray rivers [i.e. as a personification], but is suggested by means of distinctive currents and symbols, as well as by the meadows along its banks. Various kinds of birds that often wash in that river's streams dwell in the meadows.'[92] This demonstrates the use of land-

609. Egypt, Late Antique hanging of wool and linen. 1.96 × 2.25 m. St Petersburg, State Hermitage Museum, inv. 11660

scape or garden scenes to allude to Egypt, where the Nile was one of the four rivers of Paradise. Thus, the basic meaning conveyed by the use of this type of scene seems to continue along with the iconography of the scenes themselves, even if put to different uses in a mosque rather than in a church or a Roman residence.

The remaining problem is the method of transmission of these scenes. Depictions in Gospel manuscripts throw further light on this. However, brief mention should first be made of the technique of the mosaics in the Great Mosque and of the Arab sources relating to them.

The choice of colours in the mosaics in the Great Mosque is very distinctive. They have a gold background with the pattern largely in shades of blue and green, with highlights in white, mother of pearl, reddish tones, and black [607]. This unusual combination of colours is also observed in the Dome of the Rock in Jerusalem [601–604], built immediately before the Great Mosque.[93] It has already been discussed how

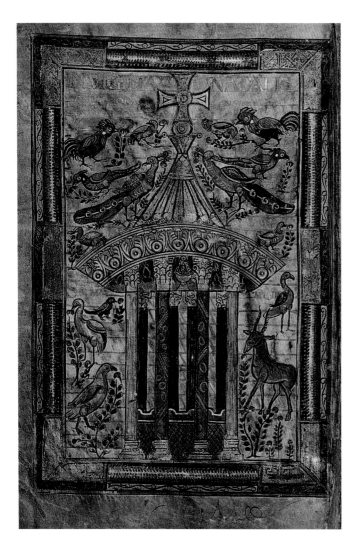

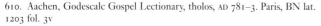

610. Aachen, Godescalc Gospel Lectionary, tholos, AD 781–3. Paris, BN lat. 1203 fol. 3v

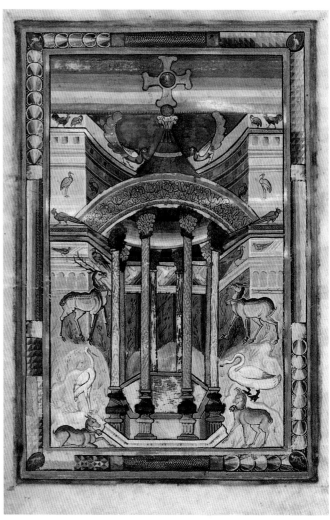

611. Gospels of St Médard of Soissons, tholos. Paris, BN lat. 8850 fol. 6v

the evidence indicates that the mosaics of the Dome of the Rock were a local product. The mosaic technique in the Great Mosque, like its iconography, similarly demonstrates continuity of local Syro-Palestinian and/or Egyptian workmanship. Marguerite Gautier-van Berchem, who examined the mosaics of both buildings as well as the comparative examples, thought that those in the Great Mosque were very likely the product of the same school of mosaicists who had worked on the Dome of the Rock. She considered them to have been Syrian. Because of the iconography of the Great Mosque mosaics, Van Lohuizen-Mulder suggests they were the product of Alexandrian mosaicists with the help of Syrian workmen.[94]

Based on the mosaics themselves there would probably be a consensus among scholars concerning the role of local workmen in the production of the mosaics in the Great Mosque, if it were not for the comments by later Arab writers concerning them and those in the mosque at Medina. These sources have led some scholars to suggest that the mosaics in the Great Mosque were the work of craftsmen imported from Constantinople.[95]

The Umayyad version of the mosque at Medina, which no longer survives, was built in AD 707–9 and decorated with mosaics.[96] The Arab historian Baladhuri (868) records that al-Walid wrote to the Governor of Medina ordering him to reconstruct the mosque and 'had money, mosaics, and marble sent to him and eighty Rumi [Greek] and Coptic craftsmen, inhabitants of Syria and Egypt'.[97] According to Yaʿqubi (874), the Arab historian and geographer, al-Walid wrote to the Byzantine emperor asking him to send 40 loads of mosaic and 100 workmen. This is also related by later writers,[98] while Dinawari (d. 895) only mentions that al-Walid asked the emperor for mosaic cubes.[99] Al-Muqaddasi (c. 985) observed that the craftsmen signed their work: 'The walls of the porticoes are covered on the outside with mosaic. Craftsmen of Syria and Egypt were brought thither for the purpose. Their names are to be seen there.' He also mentions elsewhere that the emperor sent workmen and mosaic cubes.[100] This evidence indicates that Coptic and Syrian artisans worked on the mosque at Medina, including its mosaics, and it is possible that in addition some workmen and mosaic cubes were sent from Constantinople or elsewhere in the Byzantine empire.

The written sources are even less clear for the Great Mosque in Damascus.[101] Ibn Qutayba (d. 889) relates that the Byzantine emperor complained to al-Walid about the demolition of the church for the construction of the mosque.[102] Al-Muqaddasi (*c.* 985) reports: 'al-Walid, they say, gathered together for its construction skilful [artisans] of Persia, India, the Maghreb and Rum'.[103] It is not until nearly five hundred years after the construction of the mosque that the historian of Damascus Ibn ʿAsakir (*c.* 1160) relates that the Byzantine emperor sent two hundred Rumi [Greek] workmen after al-Walid threatened to destroy the remaining churches. This tale is repeated by later writers.[104] Al-ʿUmari (*c.* 1340) mentions that mosaic cubes were brought from Constantinople to Damascus.[105] Whether the mosaic cubes were imported from Constantinople or manufactured in Egypt or Syro-Palestine is something which it should now be possible to ascertain by chemical analysis.

The archaeological evidence uncovered in recent years, which indicates the manufacture of wall-mosaics of similar colours in churches in Syro-Palestine and Egypt before the Great Mosque and the Dome of the Rock, would accord with craftsmen from both Syria and Egypt working on the mosaics in the mosque at Medina. Thus, there are no strong reasons to suggest that the mosaics in the Great Mosque are the product of designers and workmen from Constantinople, rather than a project on which some of them might have worked under local supervision.

GOSPEL MANUSCRIPTS

The genre of architectural scenes depicted in Second Style Pompeian wall-paintings has a long continuity in Late Antiquity in illustrations in manuscripts of the Gospels, which notably include tholoi and broken pediments. The extent of the use of the distinctive form of circular building or tholos[106] in these manuscripts indicates how widespread this genre was in Late Antiquity and later, largely in the East. The details of these tholoi indicate a number of different intermediate examples.

A tholos is depicted in the Godescalc Gospel Lectionary which was written in AD 781–3 by the scribe Godescalc and commissioned by the emperor Charlemagne, who resided in Aachen (now in modern Germany) [610].[107] The details of this tholos are strikingly similar to those in Pompeian wall-paintings. The strongest evidence of continuity is seen in the colour scheme, with blue on the cornice, yellow capitals, and red columns with yellow decoration, as in the Boscoreale Cubiculum [161]. As in the wall-painting, the two centre columns in the manuscript are darkest at the front. The columns at the back are black, in place of the black background in the wall-painting. The inside of the roof of the Godescalc tholos is red, as in the example in the House of the Labyrinth in Pompeii [612]. The lidded urn supported by a Corinthian capital at the apex of the roof in the wall-paintings has been replaced with a simplified capital and an orb and cross in the manuscript. The tholos in the manuscript has a yellow roof as observed in the Villa of Oplontis example [162].

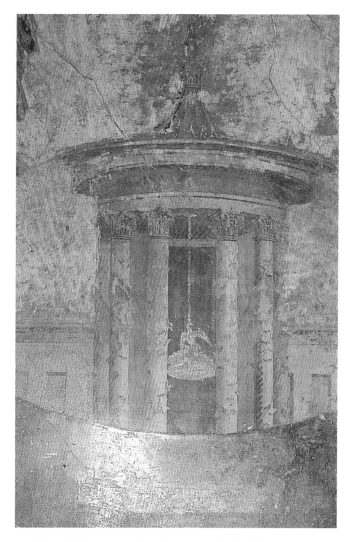

612. Pompeii, House of the Labyrinth, *oecus* 43, detail of tholos

The key to the meaning of the tholos in the Godescalc manuscript is provided by another, later, Carolingian example which is more detailed. This is in the Gospels of St Médart of Soissons [611].[108] In it the tholos is filled with water and represents the Fountain of Life, while the garden of Eden in which it stands is indicated by a park filled with animals. In the Godescalc example the water is hidden by the screen wall of the tholos, while the park is indicated by sprigs of plants [610].

While some of the tholoi in the Gospel manuscripts of the eastern churches, which will be discussed below, also have birds on the roof and trees on either side, it is not clear that they necessarily represent the Fountain of Life. It is possible that they are alluding to the tholos (of related shape) over the tomb of Christ.

The shape of the tholoi in Armenian and Ethiopian Gospel manuscripts [613–614, 616–617], like those in the Great Mosque [607], is proportionately wider than those in the wall-paintings and the Carolingian examples [610–611]. However, unlike those in the mosaics, the choice of colours in the examples in the Gospels is still closely related to that in the wall-paintings.

613. Etchmiadzin Gospels, tholos. Erevan, Matenadaran, inv. 2374 fol. 5v

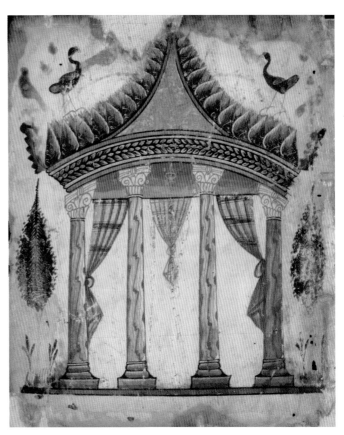

614. Tholos on loose page from an Armenian Gospel book. Erevan, Matenadaran, inv. 9430

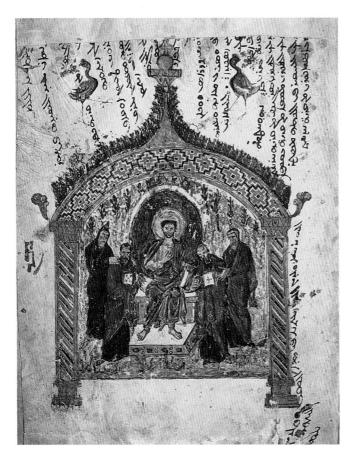

615. Rabbula Gospels, AD 586. Florence, Biblioteca Medicea Laurenziana, Plut. 1.56 fol. 14r

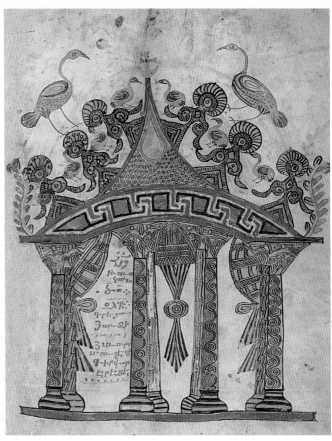

616. Second Etchmiadzin Gospels, tholos. Jerusalem, Armenian Patriarchate, Calouste Gulbenkian Library, Church of St Toros, inv. 2555 fol. 7r

A number of these tholoi are depicted in Armenian manuscripts.[109] There is one on a page at the front of the Etchmiadzin [Ējmiacin] Gospels [613].[110] The text of these Gospels was written in eastern Armenia in AD 989. However, the pages at the front (which include the Gospel tables, the tholos, and some figured scenes) were dated to the sixth century when they were published in 1891, but have more recently been thought to be contemporary with the text.[111] Despite the floral decoration on its roof, this tholos has striking similarities to those in Pompeian wall-paintings. The colour scheme used in the wall-paintings is retained: the entablature has a blue band with a red band above and below, as in the Boscoreale Cubiculum paintings [161] – even if the thicknesses of the bands have changed – and the capitals on both are yellow [161, 613]. The shading inside the roof behind them is red, as also observed in the Godescalc lectionary [610]. The Etchmiadzin Gospels columns are red and yellow, as in the Godescalc manuscript and in the Boscoreale Cubiculum, although yellow, rather than red, predominates on the manuscript columns and they are painted to look like marble. The column bases in the manuscript are blue, while the red and yellow columns in the Boscoreale Cubiculum have grey bases. The two central columns in the manuscripts are furthest apart, like those in the wall-paintings. The wall-paintings have much use of shading, and it is still used in the Etchmiadzin Gospels on the cornice, the inside of the roof, the columns, the trees, and on the curtains [613]. The roof has an orb and cross on a simplified capital at the top of it. There is no sign of this tholos containing anything (besides a tiny lantern). Its interpretation will be considered after an examination of other examples.

A closely related example is depicted on a loose page from an Armenian Gospel book [614].[112] This has the same colours in each part of it as in the Etchmiadzin Gospels example discussed [613]. The main difference is the pattern on the roof which, although having a similar colour scheme, is much more schematized than in the Etchmiadzin example.

A similar pattern is used on the roof of a structure depicted in the Rabbula Gospels [615],[113] which also include two other variations on the tholos motif framing scenes.[114] They were written in Syriac, north of Apameia in Syria, in AD 586 when they were also illustrated.[115] The shape used to frame the scene with Christ enthroned, is derived from a tholos by using only the two outer columns, and increasing the upward curve of the entablature (which had been given a curve for perspective) so that it nearly becomes an arch [615]. At the same time, it still has a tent roof with a simplified capital, orb and cross at the top, like the tholoi in the other manuscripts. The colour scheme seen in the Armenian manuscripts mentioned above is used: yellow capitals, yellow roof, red and yellow columns (although spirally decorated), and a blue cornice. The Rabbula Gospels are reliably dated, so this raises questions about the tenth-century date sometimes suggested for the Armenian example on the loose page discussed above [614], and likewise of the pages at the front of the Etchmiadzin Gospels which include the tholos, especially when compared with another Armenian example dated to the tenth century [616].

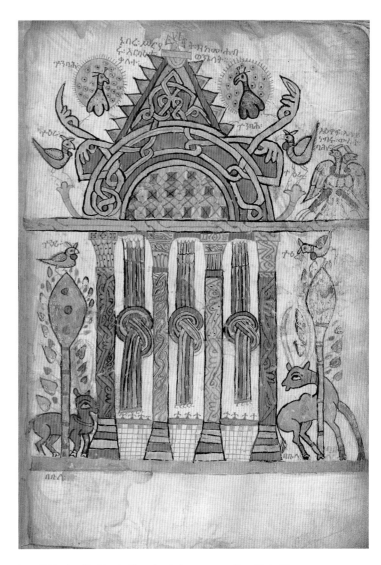

617. Ethiopian Zir Ganela Gospels, tholos, AD 1401. New York, Pierpont Morgan Library, MS M.828 fol. 6r

This tholos in the so-called Second Etchmiadzin Gospels, now in Jerusalem [616],[116] is much more clumsily rendered than the examples at the front of the Etchmiadzin Gospels and on the loose page [613–614]. However, it still retains much of the same colour scheme, with the yellow roof, blue frieze with a band of red above and below, yellow capitals, and blue bases. The depiction of the columns of the back half of this tholos and the highlighting of the centre two are details in common with the Carolingian examples [610–611]. This suggests it is based on a different intermediate example from the loose page and the example in the Etchmiadzin Gospels.[117] This intermediate example must have developed in a centre between western Europe and Armenia.

Tholoi are also depicted in Ethiopian Gospel books.[118] The example illustrated here, the Zir Ganela Gospels, was written in 1401 [617].[119] The curve for the perspective of the entablature of the tholos has been misunderstood so that it has become an arch combined with a horizontal straight line. This tholos has some features to be seen in the two more ornate Armenian examples illustrated here, from the

Etchmiadzin Gospels and the loose page: the knotted curtains, a single row of columns (without those at the back depicted), and a tree on either side [613–614]. However, the Ethiopian example also has features observed in the Godescalc manuscript: the screen wall between the columns, and animals and birds on either side [610]. This suggests the existence of yet another intermediate type somewhere between western Europe and Ethiopia. The variety of versions suggests that the tholos motif was fairly common.

The number of intermediate examples in manuscripts from locations so far apart shows the continued evolution of the tholos motif in a central location, prior to its dispersal. Alexandria is the obvious major centre between Ethiopia in the South, a long way up the Nile, Aachen in the West, and Armenia and Syria in the East. This is also supported by the fact that the scenes in the pages which accompany the tholos at the front of the Etchmiadzin Gospels have iconographic details which are closest to examples in Egypt.[120]

Having considered the continuity of the Alexandrian tholos motif, brief mention should be made of its meaning when used in the Gospel manuscripts. The tholos over the tomb of Christ, the Holy Sepulchre, is depicted on pilgrim flasks. It sometimes has a screen wall, and it has a straight (not sagging) roof and in some examples the columns support a series of arches.[121] A tholos in a Georgian manuscript of AD 897 with these features has been identified as the Holy Sepulchre.[122] It is sometimes suggested that the tholoi in the Armenian examples also represent the Holy Sepulchre.[123] On the other hand, a more complex interpretation suggests that the Holy Sepulchre could be employed as the Fountain of Life, and also as a symbol of the Church (Ecclesia) because the four rivers of Paradise which flow from the Fountain of Life can represent the four streams of the Gospels issuing from the Church.[124] Equally, as the four rivers of Paradise flowed from Jerusalem, which was the centre of the world, it could be represented by the Holy Sepulchre. The location of the tholos in the Gospel manuscripts, normally next to the Canon Tables, suggests it has taken on a specific meaning and function in this context.

Another distinctive motif of Alexandrian architecture which is depicted in some Gospel manuscripts consists of half-pediments framing a conch. It is used as a decorative frame for St Mark in the Rossano Gospels [618].[125] This is the oldest surviving illustrated Greek Gospel book. Its place of origin is not certain, but the suggestions are all in the East: Syria, Asia Minor or Palestine. It is generally agreed to date to the sixth century, but it has recently been suggested that the page with the depiction of St Mark was added in Italy in the eleventh or twelfth century.[126] The half-pediments on it are depicted raked towards the back like those built on the first-century AD niche head from Marina el-Alamein in Egypt [153] and on the Khasneh at Petra [141]. Half pediments of this type (i.e. raked towards the back) are also apparently depicted in an ivory panel with St Menas, dated to about the seventh or eighth century [619].[127] Thus, these depictions do not seem to be misinterpretations by the copyists of half-pediments of single pitch. Blue sky is depicted behind the screen wall in the manuscript to give an illusion of depth

[618], as in the Pompeian wall-paintings. The saints in both the manuscript and the ivory, St Mark and St Menas, are associated with Egypt suggesting that this architectural composition characterized by half-pediments was used as a deliberate allusion to Egypt.

This discussion of architectural scenes in Gospel manuscripts will conclude by returning to the Etchmiadzin Gospel book. There are two folios (pages) inserted at the end of it from another manuscript. They have been dated to the sixth or early seventh century, although they could be later.[128] On two of them a building with a Syrian pediment provides an architectural setting for the Annunciation of Mary and of Zacharias.[129] On another the Adoration of the Magi is depicted in front of a building with a broken pediment [620].[130] Like the example in the House of the Labyrinth in Pompeii [143] this building is a single storey high with colonnades behind it and blue sky. Shading is still used on the columns, as in Pompeian wall-paintings. The colour scheme in the manuscript is the same as that used in the wall-paintings. This is most obvious if it is compared with the scene in the House of the Labyrinth in which the main colours are also yellow, blue, and red. Yellow is used on the cornices and the columns, and red for the curtains [143]. On both this wall-painting and the manuscript the columns are decorated with jewelling [620]. As the jewelling on the arch above the conch in the manuscript is also related to that on the cornices in the mosaics of St George's at Salonica [591–592], this suggests later intermediate examples between the version in the wall-paintings and the one in the manuscript, as also observed in the tholoi. The half-pediments in the manuscript have been misunderstood and turned into gables at the ends of a pitched roof [620]. Despite this, there is little doubt as to the origin of this architectural scene.

An architectural setting with half-pediments is also represented in the mosaics in the Church of the Nativity at Bethlehem. On these, too, the artist has had trouble with understanding the half-pediments and depicted roof tiles on their front faces [623]. This, the most recent surviving example of the genre of architectural scenes on mosaics in monumental architecture, merits special consideration.

MOSAICS IN THE CHURCH OF THE NATIVITY, BETHLEHEM, AD 1169

The Church of the Nativity at Bethlehem has mosaics with Alexandrian architectural panels in arrangements related to those depicted centuries earlier in Second Style Pompeian wall-paintings, as well as other features in common with the Umayyad examples discussed above.

The present Church of the Nativity, replacing Constantine's building, was begun after c. AD 529 under the emperor Justinian [621].[131] It was built over the grotto traditionally identified as the place of Christ's birth. It is a basilical church with an apse at the east end, and an internal transept with an apse at either end. The church was decorated with mosaics, some of which have survived [622–624].[132] Recent cleaning has revealed that the present interior mosaics all were

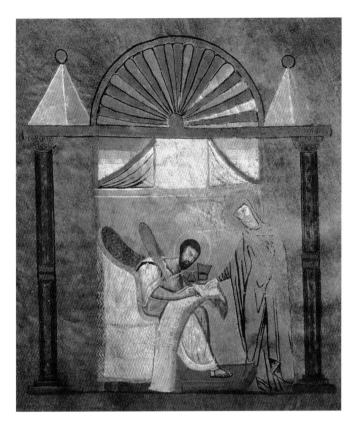

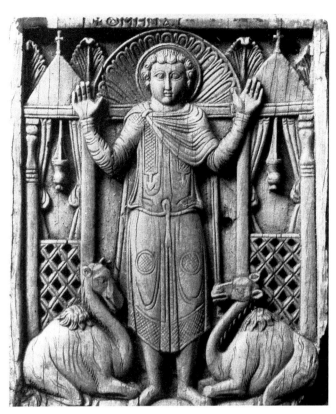

618. Rossano Cathedral Gospels, fol. 121r, St Mark with Sophia framed by a broken pediment and conch

619. Ivory panel depicting St Menas. Milan, Civiche Raccolte d'Arte Applicata, Castello Sforzesco

620. Etchmiadzin Gospels, page at the end of book with Adoration of the Magi framed by a misunderstood broken pediment with a colonnade on either side. Erevan, Matenadaran, inv. 2374, fol. 229r

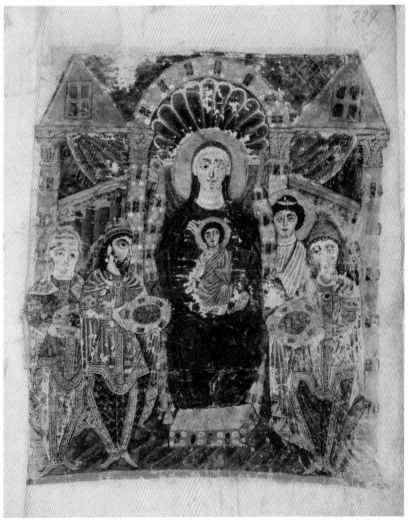

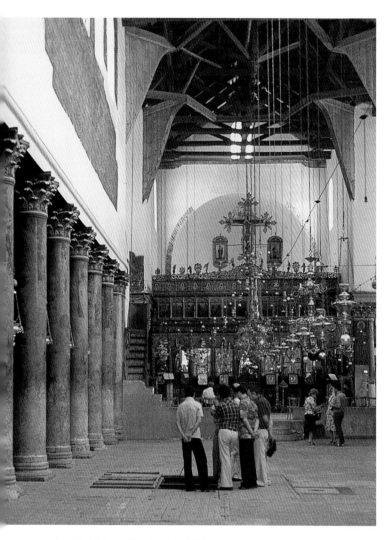

621. Bethlehem, Church of the Nativity, view of nave showing position of
wall-mosaics

completed in 1169 as part of the Crusader redecoration of
the church, as indicated by the inscription in them.[133] This,
notably, is the same date by which the Crusader rebuilding of
the Church of the Holy Sepulchre in Jerusalem was com-
pleted.[134]

The external facade of the church was decorated with
mosaics whose subjects included the adoration of the Magi.
These mosaics, which no longer survive, might have been
part of the original decoration of Justinian's church. The
mosaics in the bema and the transept include scenes from the
life of Christ.[135] They are now partially missing, as are the
mosaics on both sides of the nave which covered the
clerestory walls, supported by the inner row of columns
[621]. The nave mosaics have three registers. The top regis-
ter consists of an angel between each window, with a tradi-
tional classical acanthus scroll along the top and bottom
[623].[136] The lowest register on both sides consists of a row
of busts of the ancestors of Christ [622].[137]

In the main, or middle, register on each side are listed res-
olutions of Church councils in architectural settings.[138] Those
along the south side of the nave are the resolutions of the

seven general or ecumenical councils from Nicaea in AD 323
to Nicaea in 787. Each of these resolutions is framed by a pair
of arches, separated by a wide plant-candelabrum [622].
Opposite, on the north side of the nave, six provincial Church
councils are listed. Each of these is framed by its own archi-
tectural setting, separated by narrow plant-candelabra on
either side of a wide plant-candelabrum [623], except for the
centre candelabrum which is replaced by a cross with trees
behind it [624].

These architectural settings on the north side of the nave,
with one exception, have a single-storey tripartite structure.
The architectural zones on both sides of the nave lack figures.
Both of these features are characteristic of the related scenes
in Pompeian wall-paintings, and those in the Orthodox Bap-
tistery at Ravenna [595]. Like half of the panels in the Ortho-
dox Baptistery, the architectural settings in the Church of the
Nativity frame an altar with a book on it.[139]

The architectural setting for the Council of Sardica [623]
has a dome between two half-pediments in an arrangement
related to that in the wall-paintings, with a circular struc-
ture between two half-pediments of a broken pediment
[143]. However, the half-pediments on the mosaic have tiles
on their front faces and the circular structure (tholos) or
conch between them has become a tiled dome.[140]

In the architectural setting for the Council of Gangres,
which now only partly survives but was recorded in 1693,
there was half of a volute pediment on either side of a dome
(far left of [624]).[141] The volute pediment is a baroque archi-
tectural form [145f] which is depicted in Pompeian wall-
paintings, and later in the mosaics in St George's, Salonica.[142]
Some of the architectural compositions in the Church of the
Nativity are even more mediaeval in appearance, such as the
one for the Council of Antioch (right hand one in [623]),[143]
although it has screen walls and spirally decorated columns
as depicted in Pompeian wall-paintings [143, 161]. The level
of degeneration of the architectural compositions in the
Church of the Nativity, compared with earlier examples,
accords with the completion of the mosaics in 1169. It also
suggests that they were copied from earlier paintings or
mosaics. As the church was refurbished, it is not clear if they
are a renewal of its previous decoration or a scheme copied
from elsewhere.

Thus, despite their date, a basic inspiration from wall-
paintings and earlier mosaics for the architectural settings in
the Church of the Nativity can be detected. As early as 1910
William Harvey, who made the first detailed publication of
its mosaics, observed: 'The whole arrangement, however, has
a general resemblance to that seen in the architectural zones
of ornament in the domes of St George at Salonica and of
the Catholic [Orthodox] Baptistery at Ravenna, and these in
their turn may depend on Alexandrian prototypes.'[144] The
extent to which they might be reflecting continuity of local
Syro-Palestinian workmanship incorporating these designs is
clearer on further examination.

On the north side of the nave in the Church of the
Nativity on either side of each architectural composition
there are plant-candelabra [623].[145] They are narrow and
have the motifs springing from acanthus leaves not just at

622. Bethlehem, Church of the Nativity, watercolour of mosaics on south wall of nave

the bottom but also repeatedly higher up the central stem. Similarly, in St George's at Salonica and in the Orthodox Baptistery at Ravenna the architectural compositions are each separated by a single narrow plant-candelabrum [592–593].

The plant-candelabra in the Church of the Nativity are more stylized than these fifth-century examples. Rather, those in Bethlehem have some details in common with the nearby Umayyad examples which preceded them. Some of the narrow plant-candelabra in the Church of the Nativity have wings near their tops,[146] and what appear to be wings also occur on some of the wide examples [623].[147] These wings are clearly related to those in the Dome of the Rock at the top of plant-candelabra [599],[148] although those in the Church of the Nativity lack the pointed egg-shape between them observed there. The leaves of the plant-candelabra in the Church of the Nativity [622–623][149] retain the serrations of classical acanthus leaves, whereas those in the Dome of the Rock generally lack serrations, being more tulip-like [603]. However, some leaves in the Church of the Nativity[150] have a feature which occurs not only in the Dome of the Rock,[151] but also later in the al-Aqsa Mosque.[152] This is the use of fine

decoration on some of the leaves themselves. Thus, while there is clearly continuity of classical features in the plant-candelabra in the Church of the Nativity, they also include later features.

Similarly, the naturalistic trees behind the cross at the centre of the mosaic on the north side of the nave in the Church of the Nativity [624] may be compared with those in the Dome of the Rock and the Great Mosque in Damascus [604, 607].[153] The jewelled cross in front of trees is positioned at the mid-point of the frieze on the north wall of the nave of the Church of the Nativity. Just as the jewelled trees in the Dome of the Rock [604] could be associated with Paradise, the jewelled cross is also used to represent the Tree of Life in Paradise.[154]

Unlike the Islamic examples, the architectural zones in the Church of the Nativity do not lack figures as a result of an aversion to the figured form. Rather, because they are used in the other scenes in these mosaics, they are deliberately not depicted, as was also the case in the scenes in Second Style Pompeian wall-paintings (phase I, unlike phase II and Third and Fourth Style wall-paintings which include figures) and those in the Orthodox Baptistery at Ravenna.

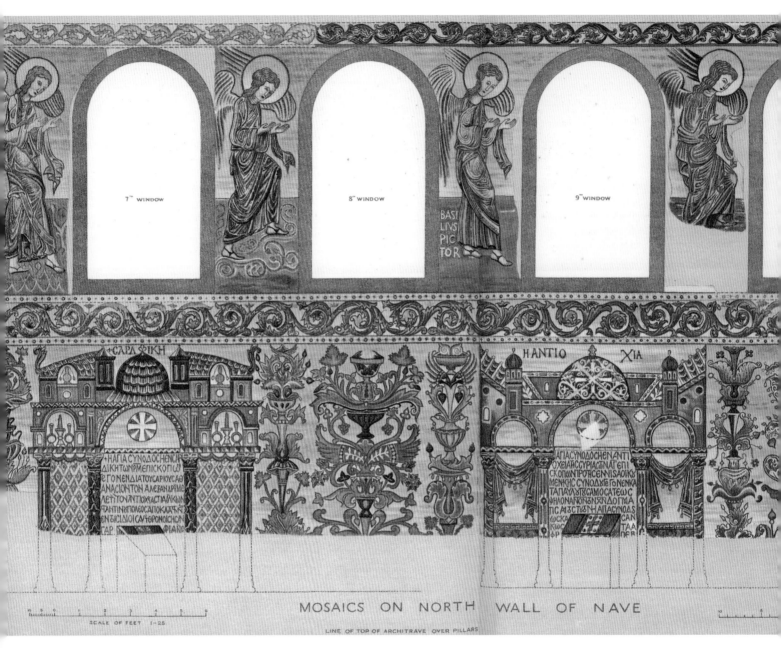

MOSAICS ON NORTH WALL OF NAVE

SCALE OF FEET 1·25

LINE OF TOP OF ARCHITRAVE OVER PILLARS

623. Bethlehem, Church of the Nativity, watercolour of mosaics on north wall of nave, with architectural settings for Council of Sardica and Council of Antioch

624. Bethlehem, Church of the Nativity, wall-mosaics at centre of north side of nave with jewelled cross and trees, to left of Council of Sardica

The technique used in the mosaics of the Church of the Nativity is distinctive. Their unusual iridescence is achieved by the use of gold and silver cubes with mother of pearl, among predominantly green and red mosaic. This technique is also specific to mosaics in the Dome of the Rock and the Great Mosque in Damascus.[155] Besides the gold background, the main colours at Bethlehem and in the Great Mosque are blue, red, and green. Green is the main colour followed by blue at Damascus and red at Bethlehem. The size of the cubes, *c.* 1 cm² is the same for both mosaics. These similar details of the technique strongly suggest continuity of local workmanship in Syro-Palestine.

The role of local craftsmen is also suggested by the inscriptions in the Church of the Nativity. The mosaics were part of the refurbishment of the church under Crusader rule in the Latin Kingdom of Jerusalem. This refurbishment started by AD 1130 with the painting of saints on the nave columns.[156] According to the inscription in the apse, in Greek and Latin, the mosaics, completed in 1169, were a collaborative effort made with the sponsorship of the Byzantine emperor Manuel Komnenos under King Amalric of Jerusalem, during the episcopy of Ralph, Bishop of Jerusalem.[157]

The use of Greek, Latin, and Syriac in the inscriptions in these mosaics acknowledges each of the communities represented in the Church of the Nativity: Orthodox, Latin, and 'Monophysite', so that the decorative programme of the mosaics functioned as an ecumenical statement.[158]

The texts recording the Church councils, which are largely in Greek, with one in Latin, include details which follow the Syrian Orthodox, rather than the Byzantine, tradition; as well as other features which indicate a lack of Latin interference in their content.[159] The inscription in the apse mentions Ephraim 'monk, artist and mosaicist'.[160] Another artist, mentioned in Latin as 'Basilius pictor' [623], also has a Syriac inscription which was uncovered by the recent cleaning on the north side of the nave: 'Basil the deacon depicted [this]'.[161] Initials on the south side, if they are his, could indicate perhaps he only supervised that side which is different in style.[162] Lucy-Anne Hunt, who made a detailed study of the mosaics after cleaning, considers that this Syriac inscription 'is arguably the tip of the iceberg of an unbroken indigenous Christian artistic tradition'.[163]

Thus, the inscriptions indicate the mosaics were the product of local workmen, and not of imported craftsmen from either Constantinople or the West.[164] This accords with the evidence for the iconography of the architectural compositions, and the Umayyad features in them.

The inscriptions for the Church councils serve a similar function to those in the Dome of the Rock encapsulating the fundamental principles of belief. As this was at a time when the Dome of the Rock was temporarily converted to a church[165] Christians would have had access to it, and they could have been aware of its decorative scheme.

CONCLUSION

The genre of Alexandrian architectural scenes goes back to architectural painting in the city in the third and second centuries BC and in Second Style Pompeian wall-paintings of the first century BC which depicted Ptolemaic architecture. Related scenes are observed on a monumental scale in fifth-century mosaics in the domes of church buildings in Salonica and Ravenna, on the walls of the Great Mosque in Damascus at the beginning of the eighth century, and as late as the twelfth century in the refurbishment of the Church of the Nativity in Bethlehem. The mosaics on the latter two, along with those in the Dome of the Rock, show local continuity of workmanship, also evidenced by its building design.

Although these architectural scenes all have features seen in the earlier wall-paintings, the mosaics in Salonica and Damascus include elements which have now been identified as distinctive of the architecture of Late Antique Egypt. This suggests that the iconography of Alexandrian architectural scenes continued to evolve in Egypt, rather than being derived directly from the Roman wall-paintings. This is also indicated by the tholoi in the Gospel manuscripts which reveal that a number of intermediate examples developed prior to their dispersal, apparently from Alexandria.

As seen from the use of these architectural scenes, the long shadow cast by the Alexandrian tradition covered a diverse range of religious traditions, since all were drawing on imagery which in itself did not carry an explicit ideological message. The continuity was not only in the form of these scenes and their lack of figures, but also their allusion to Paradise. These shadows of the depiction of Alexandrian architecture continued over a long period and wide area in the eastern Mediterranean where they are found on a noticeable number of major monuments and in illustrated manuscripts. This suggests that this iconography had a strong tradition and was relatively widespread.

It also shows that, just as Alexandria had a distinctive architectural style which continued to develop through the Late Antique period, it also had a pictorial tradition which equally had a major influence in the Mediterranean area. Given the city's importance as a centre of scholarship and education in other fields, such as science, philosophy, medicine and literature, it is not surprising to discover that it was also a major artistic centre with an equal role in the areas of architecture and art. Even if little trace of this survives in the city itself, we can still see its legacy today on a monumental scale in Salonica and Ravenna, and throughout Syro-Palestine in the Dome of the Rock in Jerusalem, the Great Mosque of Damascus, and the Church of the Nativity in Bethlehem.

List of Abbreviations

AA	*Archäologischer Anzeiger*
ActaArchHung	*Acta archaeologica Academiae scientiarum hungaricae*
AD	anno Domini
ADAJ	*Annual of the Department of Antiquities of Jordan*
Adriani *Annuario* (1932–3)	A. Adriani, *Annuario del Museo greco-romano*, vol. 1 (1932–3)
Adriani *Repertorio*	A. Adriani, *Repertorio d'arte dell'Egitto greco-romano*, Series C, vol. 1–2 (Palermo 1966)
AegTrev	*Aegyptiaca Treverensia*
AH	in the year of the Hijra
AJA	*American Journal of Archaeology*
Alston *City*	R. Alston, *The City in Roman and Byzantine Egypt* (London 2002)
al-Syriany and Habib *Coptic Churches*	S. al-Syriany and B. Habib, *Guide to Ancient Churches and Monasteries in Upper Egypt* (Egypt 1990)
AM	*Mitteilungen des Deutschen Archäologischen Instituts, Athenische Abteilung*
Amélineau *Géographie*	E. Amélineau, *La Géographie de l'Égypte à l'époque copte* (Paris 1893)
AnalBolland	*Analecta bollandiana*
Annuaire	*Annuaire du Musée greco-romain*
ANRW	*Aufstieg und Niedergang der römischen Welt*
AntJ	*The Antiquaries Journal*
Archeologia	*Archeologia. Rocznik instytutu historii kultury materialnej polskiej akademii nauk*
Arnold *Lexikon*	D. Arnold, *Lexikon der ägyptischen Baukunst* (Zurich 1994) [Eng. edn with different page numbers: D. Arnold, *The Encyclopedia of Ancient Egyptian Architecture*, London 2003]
Arnold *Temples*	D. Arnold, *Temples of the Last Pharaohs* (Oxford 1999)
ASAE	*Annales du Service des antiquités de l'Égypte*
Ashton *Ptol. Sculpture*	S.-A. Ashton, *Ptolemaic Royal Sculpture from Egypt, The Interaction between Greek and Egyptian Traditions, BAR International Ser.* 923 (Oxford 2001)
Athanasius, *Historia Arianorum*, ed. Opitz	*Athanasius Werke*, vol. 2.1, ed. H.G. Opitz (Berlin 1940)
Athanasius, *Apologia ad Constantium*, ed. tr. Szymusiak	*Athanase d'Alexandrie, Apologie à l'empereur Constance, Apologie pour sa fuite*, ed. and tr. J.-M. Szymusiak (Paris 1958)
Athanasius, *Historia acephala*, ed. Fr. tr. Martin and Albert	*Histoire 'Acéphale' et Index syriaque des lettres festales d'Athanase d'Alexandrie*, ed. and Fr. tr. A. Martin and M. Albert (Paris 1985)
AW	*Antike Welt*
b.	born
BABesch	*Bulletin antieke beschaving. Annual Papers on Classical Archaeology*
Bagatti *Betlemme*	B. Bagatti, *Gli antichi edifici sacri di Betlemme* (Jerusalem 1952)
Bailey *Hermopolis*	D.M. Bailey et al., *Hermopolis Magna: Buildings of the Roman Period, Excavations at el-Ashmunein*, vol. 4 (London 1991)
BAR	*British Archaeological Reports*
Barbet *Peinture*	A. Barbet, *La peinture murale romaine* (Paris 1985)
BC	before Christ

BCH	*Bulletin de correspondance hellénique*
Bd'É	*Bulletin de l'Institut égyptien 1859–1918*, continued as *Bulletin de l'Institut d'Égypte*, Cairo 1919 etc.
Besa, *Life of Shenute*, tr. Bell	*Besa, Life of Shenute*, tr. D.N. Bell (Kalamazoo 1983)
Betsch *Late Antique Capital*	W.E. Betsch, *The History, Production and Distribution of the Late Antique Capital*, PhD University of Pennsylvania 1977 (UMI Ann Arbor 1991)
BGU	*Berliner griechische Urkunden* (Berlin 1895–) *Ägyptische Urkunden aus den Staatlichen Museen Berlin, Griechische Urkunden*
BiblA	*Biblical Archaeologist*
BIFAO	*Bulletin de l'Institut français d'archéologie orientale*
BJb	*Bonner Jahrbücher des Rheinischen Landesmuseums in Bonn und des Vereins von Altertumsfreunden im Rheinlande*
BN	Bibliothèque Nationale
Botti *Fouilles à la colonne*	G. Botti, *Fouilles à la colonne Théodosienne (1896)* (Alexandria 1897)
Breccia *Alex. ad Aeg.*	E. Breccia, *Alexandrea ad Aegyptum* (Bergamo 1922) [Eng. edn]
Breccia *Musée gréco-romain 1925–31*	E. Breccia, *Le Musée gréco-romain 1925–31* (Bergamo 1932)
Breccia *Musée gréco-romain 1931–2*	E. Breccia, *Le Musée gréco-romain 1931–2* (Bergamo 1933)
BSA	*The Annual of the British School of Athens*
BSAA	*Bulletin de la Société d'archéologie d'Alexandrie*
BSAC	*Bulletin de la Société d'archéologie copte*
BullJRylandsLib	*Bulletin of the John Rylands Library Manchester*
ByzZ	*Byzantinische Zeitschrift*
c.	*circa*, about
Calderini *Dizionario*	A. Calderini ed., *Dizionario dei nomi geografici e topografici dell'Egitto greco-romano* (Cairo and Milan 1935–87); Suppl. 1 (1935–86) ed. S. Daris (Milan 1988)
Capuani *L'Égypte copte*	M. Capuani, *L'Égypte copte* (Paris 1999)
CE	A.S. Atiya ed., *Coptic Encyclopedia* (New York 1991)
cf.	compare
ch., Ch.	chapter(s)
Chassinat *Baouît*	E. Chassinat, *Fouilles à Baouît, MIFAO* 13 (1911)
cm	centimeter(s)
col.	column(s)
CorsiRav	*Corsi di cultura sull'arte ravennate e bizantina* [Title varies]
CRAI	*Comptes rendus des séances de l'Académie des inscriptions et belles-lettres*
Creswell rev. Allan *Short Account*	K.A.C. Creswell, *A Short Account of Early Muslim Architecture*, rev. edn, ed. J.W. Allan (London 1989)
Creswell *Early Muslim Archit.* 1.1	K.A.C. Creswell, *Early Muslim Architecture*, 2nd rev. edn, vol. 1 part 1 (Oxford 1969)
Cuomo *Ancient Maths*	S. Cuomo, *Ancient Mathematics* (London 2001)
Cuomo *Pappus*	S. Cuomo, *Pappus of Alexandria and the Mathematics of Late Antiquity* (Cambridge 2000)
d.	died
DaM	*Damaszener Mitteilungen*

Daszewski *Mosaics*	W.A. Daszewski, *Corpus of Mosaics from Egypt I: Hellenistic and Early Roman Period, AegTrev* 3 (Mainz 1985)
Dattari *Monete*	G. Dattari, *Monete imperiali greche; Numi Augg. Alexandrini* (Cairo 1901)
Description de l'Égypte	*Description de l'Égypte; ou Recueil des observations et des recherches qui ont été faites en Égypte pendant l'expédition de l'armée française* (2nd edn, C.L.F. Panckoucke, Paris 1821–9)
diam.	diameter
Didymus, ed. Ger. tr. Heiberg	Didymus of Alexandria, *The Measurement of Timber* in *Mathematici Graeci Minores*, ed. and Ger. tr. J.L. Heiberg (Copenhagen 1927) p. 4–22
Didymus, Fr. tr. ver Eecke	*Les Opuscules mathématiques de Didyme, Diophane, et Anthémius suivis du fragment mathématique de Bobbio*, Fr. tr. P. ver Eecke (Paris 1940) p. 3–16.
DOP	*Dumbarton Oaks Papers*
Drescher *Apa Mena*	*Apa Mena, a Selection of Coptic Texts Relating to St Menas*, ed. J. Drescher (Cairo 1946)
Duthuit *Sculpture*	G. Duthuit, *La Sculpture copte* (Paris 1931)
E	east
Ebersolt and Thiers *Églises*	J. Ebersolt and A. Thiers, *Les Églises de Constantinople* (Paris 1913, repr. London 1979)
ed.; eds.	edited by
edn	edition
e.g.	for example
Empereur *Alexandrie*	J.-Y. Empereur, *Alexandrie redécouverte* (Paris 1998)
Eng.	English
Epiphanius, *Panarion*, ed. Holl and Dummer	*Epiphanius III Panarion haer. 65–80*, ed. K. Holl and J. Dummer (Berlin 1985)
Epiphanius, *Panarion*, tr. Williams	*The Panarion of Epiphanius of Salamis Books II and III (Sects 47–80, de Fide)*, tr. F. Williams (Leiden 1994)
Ergh.	Ergänzungsheft
et al.	*et alii* (and others)
ÉtAlex	*Études alexandrines*
ÉtTrav	*Études et travaux. Studia i prace. Travaux du Centre d'archéologie méditerranéenne de l'Académie des sciences polonaise*
Eusebius, *Ecclesiastical History*, ed. tr. Lake and Oulten	*Eusebius the Ecclesiastical History*, ed. and tr. K. Lake and J.E.L. Oulten (London 1926–32)
Evagrius Scholasticus, *Ecclesiastical History*, ed. tr. Bidez and Parmentier	*The Ecclesiastical History of Evagrius*, ed. and tr. J. Bidez and L. Parmentier (London 1898)
fasc.	fascicule
FelRav	*Felix Ravenna*
Fig., fig.	figure(s)
fol.	folio
Folda *Art of Crusaders*	J. Folda, *The Art of the Crusaders in the Holy Land 1098–1187* (Cambridge 1995)
Fr.	French
frag.	fragment
Fraser *Ptol. Alex.*	P.M. Fraser, *Ptolemaic Alexandria* (Oxford 1973)
Goddio *et al. Alexandria*	F. Goddio *et al.*, *Alexandria. The Submerged Royal Quarters* (London 1998)
GöttMisz	*Göttinger Miszellen. Beiträge zur ägyptologischen Diskussion*
Grimm *Alexandria*	G. Grimm, *Alexandria, Die erste Königsstadt der hellenistischen Welt* (Mainz 1998)
Grossmann *Abu Mina* I	P. Grossmann, *Abū Mīnā* I. *Die Gruftkirche und die Gruft* (Mainz 1989)
Grossmann *Architektur*	P. Grossmann, *Christliche Architektur in Ägypten* (Leiden 2002)
h.	height
H.	Hagia, Hagios
Harrison *Saraçhane*	R.M. Harrison, *Excavations at Saraçhane in Istanbul*, vol. 1 (Princeton 1986)
Harrison *Temple*	[R.] M. Harrison, *A Temple for Byzantium* (London 1989)
Harvey *Ch. of Nativity*	W. Harvey *et al.*, *The Church of the Nativity in Bethlehem* (London 1910)
Heath *Hist. Greek Math.*	T. Heath, *A History of Greek Mathematics* (Oxford 1921, repr. New York 1981)
Heron, *On Measures*, ed. Ger. tr. Heiberg	Heron of Alexandria, *On Measures* in *Heronis Alexandrini opera quae supersunt omnia*, vol. 5, ed. and Ger. tr. J.L. Heiberg (1914, repr. Stuttgart 1976 [Teubner]) p. 163–219
Heron, *Stereometry*, ed. Ger. tr. Heiberg	Heron of Alexandria, *Stereometry* in *Heronis Alexandrini opera quae supersunt omnia*, vol. 5, ed. and Ger. tr. J.L. Heiberg (1914, repr. Stuttgart 1976 [Teubner])
Heron, *Stereometry*, ed. tr. Bruins	Heron of Alexandria, *Stereometry* in *Codex Constantinopolis Palatii Veteris No. 1*, ed. and tr. E.M. Bruins (Leiden 1964)
Hölbl *Geschichte*	G. Hölbl, *Geschichte des Ptolemäerreiches* (Darmstadt 1994) (Darmstadt 1994) [Eng. edn, with different page numbers: G. Hölbl, *A History of the Ptolemaic Empire*, London 2001]
Hoepfner and Brands *Basileia*	W. Hoepfner and G. Brands eds., *Basileia: die Paläste der hellenistischen Könige* (Mainz 1996)
Hoepfner and Schwandner *Stadt*	W. Hoepfner and E.-L. Schwandner, *Haus und Stadt im klassischen Griechenland* (Munich 1994)
Humphrey *Roman Circuses*	J.H. Humphrey, *Roman Circuses* (London 1986)
ibid.	*ibidem*, in the same place
idem	the same (author)
i.e.	that is
IEJ	*Israel Exploration Journal*
IGRom	*Inscriptiones Graecae ad res Romanas pertinentes*, ed. R. Cagnet *et al.*, vol. 1–4 (Paris 1911–27)
IJNA	*The International Journal of Nautical Archaeology*
ill.	illustration(s)
ILN	*The Illustrated London News*
inv.	inventory number
JARCE	*Journal of the American Research Centre in Egypt*
JdI	*Jahrbuch des Deutschen Archäologischen Instituts*
JEA	*The Journal of Egyptian Archaeology*
JGS	*Journal of Glass Studies*
JHS	*The Journal of Hellenic Studies*
John Malalas, ed. Dindorf	*Ioannis Malalae Chronographia*, ed. L. Dindorf (Bonn 1831)
John Malalas, ed. Thurn	*Ioannis Malalae Chronographia*, ed. J. Thurn (Berlin 2000)
John Malalas, tr. Jeffreys *et al.*	*The Chronicle of John Malalas*, tr. E. Jeffreys *et al.* (Melbourne 1986)
John Moschus, *Pratum Spirituale*, Fr. tr. Rouët de Journel	*Le Pré spirituel*, Fr. tr. M.J. Rouët de Journel (Paris 1946)
John of Nikiu, tr. Charles	*The Chronicle of John, Bishop of Nikiu translated from Zotenberg's Ethiopian Text*, tr. R.H. Charles (Oxford 1916)
JRA	*Journal of Roman Archaeology*
JRS	*The Journal of Roman Studies*
JThSt	*Journal of Theological Studies*
JWaltersArtGal	*The Journal of the Walters Art Gallery*
Kautzsch *Kapitellstudien*	R. Kautzsch, *Kapitellstudien, Beiträge zu einer Geschichte des spätantiken Kapitells im Osten vom vierten bis ins siebente Jahrhundert* (Berlin 1936)
km	kilometre(s)
Kostof *Orthodox Bapt.*	S.K. Kostof, *The Orthodox Baptistry in Ravenna* (London 1965)
Krautheimer *Byz. Archit.*	R. Krautheimer, *Early Christian and Byzantine Architecture* (3rd edn, Harmondsworth 1981)

l.	length
LÄ	W. Helck and E. Otto eds., *Lexikon der Ägyptologie* (Wiesbaden 1975–92)
Late Ant.	G.W. Bowersock, P. Brown, and O. Grabar eds., *Late Antiquity* (Cambridge Mass. 1999)
Leach *Painting*	E.W. Leach, *The Social Life of Painting in Ancient Rome and on the Bay of Naples* (Cambridge 2004)
Leontius of Neapolis, *Life of St John the Almsgiver*, ed. Fr. tr. Festugière and Rydén	*Léontios de Néapolis, Vie de Symeon le Fou et Vie de Jean de Chypre*, ed. and Fr. tr. A.-J. Festugière and L. Rydén (Paris 1974)
Ling *Painting*	R. Ling, *Roman Painting* (Cambridge 1991)
loc. cit.	place cited (for articles)
LSJ	H.G. Liddell and R. Scott, rev. H.S. Jones, *A Greek English Lexicon* (9th edn with suppl., Oxford 1996)
Lukaszewicz *Les Édifices publics*	A. Lukaszewicz, *Les Édifices publics dans les villes de l'Égypte romaine* (Warsaw 1986)
m	metre(s)
Mahmoud-Bey *Mémoire*	Mahmoud-Bey [Mahmoud el-Falaki], *Mémoire sur l'antique Alexandrie* (Copenhagen 1872)
Mainstone *H. Sophia*	R.J. Mainstone, *Hagia Sophia, Architecture, Structure and Liturgy of Justinian's Great Church* (London 1988)
Maqrizi, tr. Malan	*A Short History of the Copts and their Church. Translated from the Arabic of Taqi-ed-Din el-Maqrizi*, tr. S.C. Malan (London 1873)
Martin *Athanase*	A. Martin, *Athanase d'Alexandrie et l'église d'Égypte au IVe siècle (328–373)* (Rome 1996)
Mathews *Early Churches*	T.F. Mathews, *The Early Churches of Constantinople: Architecture and Liturgy* (London 1971)
Mathews *Byz. Churches*	T.F. Mathews, *The Byzantine Churches of Istanbul, A Photographic Survey* (London 1976)
McKenzie *Petra*	J. McKenzie, *The Architecture of Petra* (Oxford 1990, repr. 2005)
max.	maximum
MDIK	*Mitteilungen des Deutschen Archäologischen Instituts, Abteilung Kairo*
MEFRA	*Mélanges de l'École française de Rome. Antiquité*
MIFAO	*Mémoires publiés par les membres de l'Institut français d'archéologie orientale au Caire*
min.	minimum
Monneret de Villard *Ahnâs*	U. Monneret de Villard, *La scultura ad Ahnâs. Note sull'origine dell'arte copta* (Milan 1923)
Monneret de Villard *Sohâg*	U. Monneret de Villard, *Les Couvents près de Sohâg* (Milan 1925–6)
Müller-Wiener *Bildlexikon*	W. Müller-Wiener, *Bildlexikon zur Topographie Istanbuls* (Tübingen 1977)
n.	note(s)
N	north
n.d.	no date (of publication)
Néroutsos *Alexandrie*	Néroutsos-Bey, *L'Ancienne Alexandrie, étude archéologique et topographique* (Paris 1888)
Nielsen *Palaces*	I. Nielsen, *Hellenistic Palaces, Tradition and Renewal* (Aarhus 1994)
No.; no.; nos.	number(s)
NPNF	*A Select Library of Nicene and Post-Nicene Fathers of the Christian Church*, Second Series 1890– (repr. Edinburgh and Grand Rapids, Michigan 1991)
n.s.	new series
OCD[3]	S. Hornblower and A. Spawforth, ed., *Oxford Classical Dictionary* (3rd edn, Oxford 1996)
ODB	A.P. Kazhdan ed., *The Oxford Dictionary of Byzantium* (Oxford 1991)
OGIS	*Orientis Graeci Inscriptiones Selectae*, ed. W. Dittenberger (Leipzig 1903–5)
OLD	P.G.W. Glare, *Oxford Latin Dictionary* (Oxford 1982)
OpAth	*Opuscula atheniensia*
op. cit.	place cited (for books)
opp.	opposite
p.	page(s)
Palatine Anthology ed. tr. Paton	*The Greek Anthology*, ed. and tr. W.R. Paton (London 1916)
PAM	*Polish Archaeology in the Mediterranean*
Parker *et al. Islamic Monuments*	R. Parker, R. Sabin, and C. Williams, *Islamic Monuments in Cairo. A Practical Guide* (3rd edn, Cairo 1985)
PBSR	*Papers of the British School at Rome*
P.Cair.Zen.	*Zenon Papyri, Catalogue général des antiquités égyptiennes du Musée du Caire*, ed. C.C. Edgar, vol. 1–4 (Cairo 1925–31)
Pensabene *Elementi Aless.*	P. Pensabene, *Elementi architettonici di Alessandria e di altri siti egiziani, Repertorio d'arte dell'Egitto greco-romano*, Series C, vol. 3 (Rome 1993)
pers. com.	personal communication
PEQ	*Palestine Exploration Quarterly*
P.Fouad	*Les Papyrus Fouad* I, ed. A. Bataille *et al.* (Cairo 1939)
PG	*Patrologia Graeca*, ed. J.-P. Migne (Paris 1857–)
P.Halle 1	*Dikaiomata, Auszüge aus alexandrinischen Gesetzen und Verordnungen in einem Papyrus des philologischen Seminars der Universität Halle (Pap Hal.1)* (Berlin 1913)
P.Hibeh II	*The Hibeh Papyri*, Part 2, ed. E.G. Turner (London 1955)
Pl.; pl.	plate(s)
PM	B. Porter and R. Moss, *Topographical Bibliography of Ancient Egyptian Hieroglyphic Texts, Reliefs and Paintings*, 2nd edn ed. J. Malek (Oxford 1927–81)
P.Mil.Vogl. VIII 309	*Papyri dell'Università degli Studi di Milano – VIII Posidippo di Pella Epigrammi (P.Mil.Vogl. VIII 309)*, ed. and tr. G. Bastianini and C. Gallazzi (Milan 2001)
PO	*Patrologia Orientalis*
Poole *BMC*	R.S. Poole, *Catalogue of the Coins of Alexandria and the Nomes, Catalogue of Greek Coins in the British Museum* (London 1892)
Posidippus, ed. tr. Austin and Bastianini	*Posidippi Pellaei Quae Supersunt Omnia*, ed. and tr. C. Austin and G. Bastianini (Milan 2002)
P.Oxy.	*The Oxyrhynchus Papyri*, ed. B.P. Grenfell, A.S. Hunt *et al.* (London 1898–)
Procopius *Buildings*, ed. tr. Dewing and Downey	*Procopius vol. 7 Buildings*, ed. and tr. H.B. Dewing and G. Downey (London 1940 [1971])
PSI	*Papiri greci e latini, Pubblicazioni della Società italiana per la ricerca dei papiri greci e latini in Egitto* (Florence 1912–)
QDAP	*Quarterly of the Department of Antiquities of Palestine*
Quibell *Saqqara* III	J.E. Quibell, *Excavations at Saqqara (1907–1908)* (Cairo 1909)
Quibell *Saqqara* IV	J.E. Quibell, *Excavations at Saqqara (1908–9, 1909–10)* (Cairo 1912)
r	recto
RA	*Revue archéologique*
RE	*Paulys Real-Encyclopädie der klassischen Altertumswissenschaft*
repr.	reprinted
rev.	revised
RhM	*Rheinisches Museum für Philologie*
RIA	*Rivista dell'Instituto nazionale d'archeologia e storia dell'arte*
RM	*Mitteilungen des Deutschen Archäologischen Instituts, Römische Abteilung*
Rodziewicz *Les Habitations*	M. Rodziewicz, *Les Habitations romaines tardives d'Alexandrie, Alexandrie* III (Warsaw 1984)
Rosen-Ayalon *Early Isl. Monuments*	M. Rosen-Ayalon, *The Early Islamic Monuments of al-Ḥaram al-Sharīf, Qedem* 13 (Jerusalem 1989)

Rowe *Encl. Serapis*	A. Rowe, *Discovery of the Famous Temple and Enclosure of Serapis at Alexandria, Supplément aux ASAE*, cahier no. 2 (Cairo 1946)	th.	thickness
RStorAnt	*Rivista storica dell'antichità*	Theophanes, *Chronographia*, ed. de Boor	*Theophanis Chronographia*, ed. C. de Boor (Leipzig 1883)
Rufinus, *Ecclesiastical History*, ed. Mommsen	*Die lateinische Übersetzung des Rufinus*, ed. T. Mommsen, in *Eusebius Werke*, vol. 2, ed. E. Schwartz (Leipzig 1908)	Theophanes, *Chronographia*, tr. Mango and Scott	*The Chronicle of Theophanes the Confessor*, tr. C. Mango and R. Scott (Oxford 1997)
S	south	Thomas *Niche Decorations*	T.K. Thomas, *Niche Decorations from the Tombs of Byzantine Egypt (Heracleopolis Magna and Oxyrhynchus, AD 300–500)* PhD New York University 1990 (UMI, Ann Arbor 1991)
S.	San, Santa		
Sabottka *Serapeum*	M. Sabottka, *Das Serapeum in Alexandria*, diss. Technische Universität Berlin 1985 (Microfiche Berlin 1989)	Thomas *Sculpture*	T.K. Thomas, *Late Antique Egyptian Funerary Sculpture* (Princeton 2000)
Sammelbuch	F. Preisigke *et al.* eds., *Sammelbuch griechischer Urkunden aus Ägypten* (1915–)	Tkaczow *Topography*	B. Tkaczow, *Topography of Ancient Ancient Alexandria* (Warsaw 1993)
SEG	P. Roussel *et al.* eds., *Supplementum Epigraphicum Graecum* (1923–)	tr.	translated by, translation
ser.	series	Tybout *Aedificorum figurae*	R.A. Tybout, *Aedificorum figurae. Untersuchungen zu den Architekturdarstellungen des frühen zweiten Stils* (Amsterdam 1989)
Socrates, *Ecclesiastical History*, ed. Hansen	*Sokrates Kirchengeschichte*, ed. G.C. Hansen (Berlin 1995)	*UMI*	*University Microfilms International*
Sozomen, *Ecclesiastical History*, ed. Bidez and Hansen	*Sozomenus Kirchengeschichte*, ed. J. Bidez and G.C. Hansen (Berlin 1995)	v	verso
		van Millingen *Byz. Churches*	A. van Millingen, *Byzantine Churches in Constantinople* (London 1912)
St	Saint	Venit *Tombs*	M.S. Venit, *Monumental Tombs of Ancient Alexandria* (Cambridge 2002)
Strube *Polyeuktoskirche*	C. Strube, *Polyeuktoskirche und Hagia Sophia: Umbildung und Auflösung antiker Formen, Entstehen des Kämpferkapitells* (Munich 1984)	vol.	volume
Strzygowski *Koptische Kunst*	J. Strzygowski, *Catalogue général des antiquités égyptiennes du Musée du Caire, Koptische Kunst* (Vienna 1904)	w.	width
suppl.	supplement	W	west
TAPA	*Transactions of the American Philosophical Society*	*ZPE*	*Zeitschrift für Papyrologie und Epigraphik*

Notes

CHAPTER 1: HOW ANCIENT ALEXANDRIA WAS LOST

1. Severus ibn el-Muqaffa, *PO* X, 512–15.

2. S.K. Hamarneh, 'The Ancient Monuments of Alexandria According to Accounts by Medieval Arab Authors (IX–XV century)', *Folia Orientalia* 13 (1971) 82–3.

3. Abd al-Latif p. 112–13, *Relation de l'Égypte par Abd al-Latif*, tr. S. de Sacy (Paris 1810) 182–3; A.J. Butler, *The Arab Conquest of Egypt and the Last Thirty Years of Roman Dominion*, ed. P.M. Fraser (2nd edn Oxford 1978) 388. Columns on the eastern harbour shore: J. Yoyotte in Goddio *et al. Alexandria* 208.

4. A. Lacroix and G. Daressy, eds., *Dolomieu en Égypte (30 Juin 1798–10 Mars 1799) Mémoires présentés à l'Institut d'Égypte* 3 (Cairo 1922) 17. Examples in the walls near the Government Hospital: G. Botti, 'Additions au "plan de la ville d'Alexandrie etc." ', *BSAA* 1 (1898) 56–7.

5. Some examples: L.A. Ibrahim, 'The Islamic Monuments of Alexandria', *BSAA* 45 (1993) 145–52. Baths-building: *Description de l'Égypte* État modern plates vol. 2, pl. 94.10–11.

6. J.M. Rogers, 'The State and the Arts in Ottoman Turkey, 1: The Stones of the Süleymaniye', *International Journal of Middle East Studies* 14 (1982) 75–9.

7. S. Runciman, *A History of the Crusades*, vol. 3 (Cambridge 1954) 444–9; P.W. Edbury, 'Cyprus, Commerce and Crusade: King Peter I and the Background to the Sack of Alexandria in 1365', *BSAA* 44 (1991) 206–14.

8. Fraser *Ptol. Alex.* vol. 1, 8, vol. 2, 18–20 n. 32–3; D.G. Hogarth and E.F. Benson, *Report on Prospects of Research in Alexandria*, reprinted from *Archaeological Report of the Egypt Exploration Fund 1894–5* (London 1895) 5. Examples of submerged structures east of el-Silsila: Adriani *Repertorio* pl. 21 fig. 75–6. Subsidence of 5.5 m ± 1 in the seventh to tenth centuries AD: J.-P. Goiran *et al.*, 'Évolution géomorphologique de la façade maritime d'Alexandrie (Égypte)', *Méditerranée* 104, 1.2 (2005) 61–4. 'Change in sea level': A. de Graauw in Goddio *et al. Alexandria* 58. Stanley Bay beach in 1951: E. Spencer, personal communication 24 August 2000.

9. For example: C. Le Bruyn, *A Voyage to the Levant* (London 1702) 172–3, pl. 96–104; L.-F. Cassas, *Voyage pittoresque de la Syrie, de la Phénicie, de la Palestine et de la Basse-Égypte* (Paris 1799) vol. 3, pl. 47, 52–8 reproduced in E. Combe, 'Notes de topographie et d'histoire alexandrine', *BSAA* 36 (1943–4) 125–36, fig. 1–5; C.S. Sonnini, *Travels in Upper and Lower Egypt* (London 1800) 74–86; L. Mayer, *Views in Egypt* (London 1805); G. Valentia, *Voyages and Travels to India, Ceylon, the Red Sea, Abyssinia and Egypt in the Years 1802–1806* (London 1811) vol. 3, 395, 443–55, vol. 4, map; *Description de l'Égypte* vol. 5, 181–530, vol. 10, 509–30, vol. 15, 365–85, vol. 18, 383–496, plates vol. 5, pl. 31–43.

10. Mahmoud-Bey *Mémoire* 23–4.

11. *Description de l'Égypte* vol. 5, 325–6.

12. *Description de l'Égypte* vol. 5, 266. Later identified in more detail in: H. de Vaujany, *Recherches sur les anciens monuments situés sur le grand-port d'Alexandrie* (Paris 1888) 11–13.

13. *Description de l'Égypte* vol. 5, 215, 229–31. Still visible later in the century: de Vaujany *op. cit.* (n. 12) 5–7; Tkaczow *Topography* 48 site 1A.

14. *Description de l'Égypte* vol. 5, 352–4, plates vol. 5, pl. 37.1–3.

15. *Description de l'Égypte* vol. 5, 369–76, plates vol. 5, pl. 38–9.1.

16. This resulted in the mistaken identification of the Kom el-Dikka mound as the man-made hill, the sanctuary of Pan (Paneum), mentioned by Strabo, *Geography* 17. 1. 10: Fraser *Ptol. Alex.* vol. 1, 29. M. Rodziewicz, 'La Stratigraphie de l'antique Alexandrie à la lumière des fouilles de Kôm el-Dikka', *ÉtTrav* 14 (1990) 145–51, fig. 2. Earlier excavations (by A.J.B. Wace): A. Lane, 'Archaeological Excavation at Kom-el-Dik, a Preliminary Report on the Medieval Pottery', *Bulletin of the Faculty of Arts, Farouk I University Alexandria* 5 (1949) 143–9. Name and fort: Combe *loc. cit.* (n. 9) 142–4. The excavation records of A.J.B. Wace are in the archive of the British School at Athens.

17. History of the Arab walls in written sources: S. Labib, 'al-Iskandariyya', in E. van Donzel *et al.*, *Encyclopedia of Islam*, vol. 4 (London 1978) 132; D. Behrens-Abouseif, 'Notes sur l'architecture musulmane d'Alexandrie', in C. Décobert and J.-Y. Empereur, eds., *Alexandrie médiévale* 1, *ÉtAlex* 3 (1998) 102–4. Archaeological evidence: *Description de l'Égypte* vol. 5, 343–52, vol. 18, 415–18, État modern plates vol. 2, pl. 84, 86, 89–90, 91.2–4; Lacroix and Daressy eds. *op. cit.* (n. 4) 17–26; M. Herz, 'Deux tours des fortifications d'Alexandrie', *Comité de conservation des monuments de l'art arabe* 29 (1912) 123–4, pl. 17–22; M. Meinecke, 'Zur Topographie von Alexandria nach Ewliyā Celebī', *Zeitschrift der Deutschen Morgenländischen Gesellschaft*, suppl. III.1 (Weisbaden 1977) 524–7; M. Rodziewicz, 'Graeco-Islamic Elements at Kom el-Dikka in the Light of New Discoveries: Remarks on Early Mediaeval Alexandria', *Graeco-Arabica* 1 (1982) 42, fig. 3 (with later Arab walls and Moslem cemeteries marked); M. Hussam al-Din Isma'il, 'The Fortifications of Alexandria during the Islamic Period', *BSAA* 45 (1993) 153–61; M. Abd el Aziz Negm, 'Recent Activities around the Ancient Walls of Alexandria', in *Alessandria e il mondo ellenistico-romano, Congresso Alessandria 1992* (Rome 1995) 124–7.

18. Néroutsos *Alexandrie* 62; Tkaczow *Topography* 59.

19. Combe *loc. cit.* (n. 9) 138–42. Development of the city: P.M. Fraser, 'Alexandria from Mohammed Ali to Gamal Abdal Nasser', in N. Hinske ed., *Alexandrien, AegTrev* 1 (Mainz 1981) 63–74; M.F. Awad, 'Le Modèle européen: l'évolution urbaine de 1807 à 1958', *Alexandrie entre deux mondes, Revue de l'occident musulman et de la Méditerranée* 46 (1987.4) 93–109; *idem*, 'The Metamorphoses of Mansheyah', *Mediterraneans* 8/9 (1996) 42–57; A. Abou Zahra, 'Les Différentes Phases du développement d'Alexandrie', *Mediterraneans* 8/9 (1996) 23–30; R. Ilbert, *Alexandrie 1830–1930* (Paris 1996); R. Ilbert and I. Yannakakis, eds., *Alexandria 1860–1960* (Alexandria 1997). Some of these volumes have fascinating recollections of the city, including its Greek versus Egyptian identity.

20. H. Salt in 1816, in J.J. Halls, *The Life and Correspondence of Henry Salt*, vol. 1 (London 1834) 452–4.

21. H. de Vaujany, *Alexandrie et la Basse-Égypte* (Paris 1885) 125–38; G. Jondet, *Atlas historique de la ville et des ports d'Alexandrie, Mémoires présentés à la Société Sultanieh de géographie* 2 (Cairo 1921) pl. 44–6; Fraser *loc. cit.* (n. 19) 70; R. Ilbert, 'Bombardement et incendie: juillet 1882. Un témoignage', *Alexandrie entre deux mondes, Revue de l'occident musulman et de la Méditerranée* 46 (1987.4) 156–67.

22. Hogarth and Benson *op. cit.* (n. 8) 9.

23. Combe *loc. cit.* (n. 9) 135.

24. E. Sieglin, *Expedition Ernst Sieglin: Die Nekropole von Kôm-esch-Schukâfa*, vol. 1 (Leipzig 1908) 19–20, pl. X.

25. Hogarth and Benson *op. cit.* (n. 8) 5. Also observed by Lord Valentia nearly a century earlier: Valentia *op. cit.* (n. 9) 448–9.

26. Admiralty Chart no. 243, for the years 1825 (with additions to 1833, and includes ruins near Fort Qait Bey), 1857, and 1898. Recent recording of blocks not covered by the Corniche, of classical and Egyptian sculpture and architecture: Goddio *et al. Alexandria* 24–25, 31, 37–50, 168–98, 201, 220–44, fig. opp. p. 14, opp. p. 21, opp. p. 29; L. Foreman, *Cleopatra's Palace In Search of a Legend* (New York 1999) pls. on p. 78, 154, 160–1, 171, 175, 179–82, 188–95, 199, 204–6.

27. Breccia *Alex. ad Aeg.* 72; Fraser *Ptol. Alex.* vol. 1, 9, vol. 2, 20 n. 34.

28. This is most clearly seen by comparing the following plans reproduced in Jondet *op. cit.* (n. 21) pl. 36 (Mahmoud-Bey's plan of the modern city in 1865), pl. 47 (General Tanzim's plan of 1887), pl. 50 (the municipal plan of 1902, by which time most of the Arab walls have been dismantled), and pl. 53 (the plan by the survey of Egypt in 1917 showing the Arab walls completely dismantled and settlement as far as Ramleh).

29. Tkaczow *Topography* 58–9 no. 7, 78–9 no. 25.

30. Tkaczow *Topography* 97.

31. Detailed references are given in the present work as they are relevant to the discussion. For a detailed history of excavations up to the 1960s, with bibliography, see: Fraser *Ptol. Alex.* vol. 2, 13–17 n. 31; summary in Tkaczow *Topography* 15–19. Recent work is summarized, with bibliographies, in: Y. el-Gheriani, 'Brief Account of the Different Excavations in Alexandria 1950–1990', in *Alessandria e il mondo ellenistico-romano, Congresso Alessandria 1992* (Rome 1995) 156–68; M. Rodziewicz, 'Ptolemaic Street Directions in Basilea (Alexandria)', *ibid.* 227–35; J.-Y. Empereur, 'Fouilles et découvertes récentes', *Les Dossiers d'archéologie* 201 (1995) 82–7; Empereur *Alexandrie* 18–33; B. Tkaczow, 'Topographie et architecture de l'ancienne Alexandrie. Nouvelles recherches et découvertes', *ÉtTrav* 19 (2001) 329–36; *idem* 'Remarques sur la topographie et l'architecture de l'ancienne alexandrie à la lumière des récentes découvertes archéologiques', *Archeologia* 53 (2002) 21–37; J.S. McKenzie, 'Glimpsing Alexandria from Archaeological Evidence', *JRA* 16 (2003) 35–61.

32. Mahmoud-Bey *Mémoire*.

33. Hogarth and Benson *op. cit.* (n. 8) 3.

CHAPTER 2: THE PLAN OF ANCIENT ALEXANDRIA

1. Mahmoud-Bey [Mahmoud el-Falaki] *Mémoire*. The map is often missing from the copies of this text. A copy of the map is reproduced in G. Jondet, *Atlas historique de la ville et des ports d'Alexandrie, Mémoires présentés à la Société Sultanieh de géographie* 2 (Cairo 1921) pl. 37. The original map is reproduced in colour in: W. La Riche, *Alexandria the Sunken City* (London 1996) fig. on p. 54; Empereur *Alexandrie* pl. on p. 22–3; Grimm *Alexandria* fig. 8.

2. D.G. Hogarth and E.F. Benson, *Report on Prospects of Research in Alexandria*, reprinted from *Archaeological Report of the Egypt Exploration Fund 1894–5* (London 1895) 17–18 n. 1; Fraser *Ptol. Alex.* vol. 1, 10, 13, 14, vol. 2, 28–9 n. 68. Hogarth may not have made his judgement based on Mahmoud-Bey's French text but only on the English translation provided to him by Admiral Bloomfield. Perhaps this was a summary rather than a direct translation: Hogarth and Benson *op. cit.* 17 n. 1.

3. Mahmoud-Bey *Mémoire* 18–24, 27.

4. Mahmoud-Bey *Mémoire* 12–15, 18.

5. Plan of W. Sieglin (Greco-Museum reg. no. 20391) reproduced in: Rodziewicz *Les Habitations* pl. 2 opp. p. 365. Smaller copies in which the details are less visible: Breccia *Alex. ad Aeg.* fig. 25; Tkaczow *Topography* 15 n. 4, fig. 11a.

6. H. Kiepert, 'Zur Topographie des alten Alexandria. Nach Mahmûd Beg's Entdeckungen', *Zeitschrift der Gesellschaft für Erdkunde zu Berlin* 7 (1872) pl. 5 opp. p. 384. The paving is marked on the copy of Erdmann who explains the origin of these copies: M. Erdmann, *Zur Kunde der hellenistischen Städtegründungen* (Strassburg 1883) 11–12.

7. The two columns nearest the Rosetta Gate had white marble capitals: G. Valentia, *Voyages and Travels to India, Ceylon, the Red Sea, Abyssinia and Egypt in the Years 1802–1806* (London 1811) vol. 3, 451. The columns opposite the Attarin Mosque were of red granite, *c.* 12–13 m high, diam. 1.4 m. There were more of them surviving in 1692: *Description de l'Égypte* vol. 18, 423. A. Lacroix and G. Daressy eds., *Dolomieu en Égypte (30 Juin 1798–10 Mars 1799) Mémoires présentés à l'Institut d'Égypte* 3 (Cairo 1922) 16–17.

8. Valentia *op. cit.* (n. 7) vol. 3, 445, foldout map in vol. 4 = map reproduced in Jondet *op. cit.* (n. 1) pl. 28. Similar remains of the city grid of Rhodes were visible in aerial photographs in the mid-twentieth century: J. Bradford, 'Fieldwork on Aerial Discoveries in Attica and Rhodes', *AntJ* 36 (1956) 57–69, fig. 1, pl. 6.

9. Mahmoud-Bey *Mémoire* 18.
 Soundings of Noack: F. Noack, 'Neue Untersuchungen in Alexandrien', *AM* 25 (1900) 215–79, esp. 231–2, fig. 2–4, 8, pl. 9–11; Adriani *Annuario* (1932–3) 59–61 nos. 8–12 and 16–17, 63 nos. 23–5, 77–8 nos. 51–2, 80–1 nos. 60–1; Adriani *Repertorio* 70–4 nos. 25–8, fig. A on p. 71, pl. 12–13; Tkaczow *Topography* 127–8 site 80 (L5), 151–2 site 111 (R3), 157–8 site 119A–B (L2), 159–60 site 122A–C (L*alpha*, R2), 160 site 123B (L*alpha*, R1), fig. VII, 60–1, 64a–b.
 Street R2[bis]: Adriani *Annuario* (1932–3) 93–4 no. 116; Adriani *Repertorio* 80–1 no. 40, pl. 20.71; Tkaczow *Topography* 162–3 site 128.
 Street R4, south of L1 (for 52 m along modern Sharia el-Ibrahimieh): A. Adriani, 'Scavi e scoperte alessandrine (1949–1952)', *BSAA* 41 (1956) 6–7, fig. 1 no. 53, fig. 6; Adriani *Repertorio* 87–8 no. 48, pl. 26 fig. 93, pl. 27 fig. 96; Tkaczow *Topography* 106–7 site 53, fig. 39, no. 53 marked on plan IIIb. Street R4 further south: Rodziewicz *Les Habitations* 17–33, plan 1, fig. 7–11; Tkaczow *Topography* site 55 marked on plan IIIb; G. Majcherek, 'Kom el-Dikka Excavations, 1998/99', *PAM* 11 (1999) 37, fig. 8.
 Street R5 (beside modern Sharia Nebi Daniel): Breccia *Musée gréco-romain 1925–31*, 51–2, pl. 61; Adriani *Annuario* (1932–3) 19–27, pl. 4–9; Rodziewicz *Les Habitations* 18, pl. 6–7; Tkaczow *Topography* 93–4 site 40, plan 3b; possibly fourth-century remains of paving, and colonnade B. Tkaczow, 'The Historical Topography of Kom el-Dikka', in Z. Kiss *et al.*, *Fouilles polonaises à Kôm el-Dikka, Alexandrie* VII (Warsaw 2000) 134, 135 site 40, plan 12–13. A long row of fallen granite columns were discovered along Sharia Nebi Daniel in 1874: Néroutsos-Bey, *Notice sur les fouilles récentes exécutées à Alexandrie 1874–5* (Alexandria 1875) 6.
 Street L'2 (under Sharia Amir el-Munim): A. Adriani *Annuario* (1935–9) 57–64, fig. 27, pl. 24, 25.2; Rodziewicz *Les Habitations* pl. 8.3; Tkaczow *Topography* 83–4 site 31, plan 3b; Tkaczow *loc. cit.* 2000, 134 site 31, plan 12–13.
 Analysis: Rodziewicz *Les Habitations* 17–33; *idem* 'Le Débat sur la topographie de la ville antique', in R. Ilbert, ed., *Alexandrie entre deux mondes, Revue de l'occident musulman et de la Méditerranée* 46 (1987.4) 43–7.
 Mahmoud-Bey's paving and columns, and more recent discoveries of paving, are marked in Tkaczow *Topography* plan 1, which also gives a full list of sites with evidence of streets on p. 333 which can then be found in her text under those numbers, with detailed analysis and bibliography. Updated: B. Tkaczow, 'Topographie et architecture de l'ancienne Alexandrie. Nouvelles recherches et découvertes', *ÉtTrav* 19 (2001) 329–36, plan opp. p. 336; *idem* 'Remarques sur la topographie et l'architecture de l'ancienne Alexandrie à la lumière des récentes découvertes archéologiques', *Archeologia* 53 (2002) 26–35.

10. Street R1: M. Rodziewicz, 'Ptolemaic Street Directions in Basilea (Alexandria)', in *Alessandria e il mondo ellenistico-romano, Congresso Alessandria 1992* (Rome 1995) 230. Ptolemaic phases identified in Noack's excavations of streets R3, R2, and L2: Tkaczow *Topography* 151–2 site 111, 159–60 site 122C, 157–8 site 119A. Hoepfner has also identified the Ptolemaic street level in Noack's section of street R3: Hoepfner and Schwandner *Stadt* 238, fig. 226. The edge of street R4 in the Ptolemaic period was uncovered in 1992: Tkaczow *Topography* 110 n. 127. Rodziewicz, *loc. cit.* (n. 9) 45, mentions L1, L4 and L*alpha* continuing from the Ptolemaic period. For street R5 there is a drain probably going back to the Ptolemaic period which was found north of L'2: Tkaczow *loc. cit.* (n. 9) 132 site 40.

11. *Description de l'Égypte*, vol. 5, 328–37, vol. 10, 524–5, plates vol. 5, pl. 39.2–3; Valentia *op. cit.* (n. 7) vol. 3, 455, vol. 4 foldout plan. The racecourse (Lageion) has the same orientation in both plans.

12. *Description de l'Égypte*, plates vol. 5, pl. 39.2; A. Rowe and B.R. Rees, 'A Contribution to the Archaeology of the Western Desert IV: The Great Serapeum of Alexandria', *BullJRylandsLib* 39.2 (1957) plan opp. p. 492. Botti has the race course incorrectly marked at an angle, following its position on Sieglin's plan, even though Botti has north correctly marked on the copy of the Napoleonic plan which he reproduces: G. Botti, *Plan du quartier 'Rhacotis'* (Alexandria 1897); Tkaczow *Topography* fig. 12, 15c (details of plans).

13. H. Riad, 'Vestiges d'un édifice ptolémaïque en bordure de la voie canopique à Alexandrie', *BSAA* 42 (1967) 85–8; J.J. Coulton, *The Architectural Development of the Greek Stoa* (Oxford 1976) 116, 214; Tkaczow *Topography* 107–8 site 54, fig. 40, 54 on plan IIIb. As it was built on bedrock it is probably Ptolemaic, not early Roman, contra Rodziewicz *Les Habitations* 55–7.

14. Néroutsos *Alexandrie* 22; Tkaczow *Topography* 80 site 27, map B.

15. The Ptolemaic walls are distinctive, being of ashlar masonry often built directly on bedrock. Chantier Finney: A. Adriani *Annuaire* (1935–9) 25–32, pl. 5–11; Tkaczow *Topography* 138 site 95, fig. 53. Examples in Cricket Ground: S. Shenouda, 'Alexandria University Excavations on the Cricket Playgrounds of Alexandria', *Opuscula Romana* 9 (1973) 193–205; W.A. Daszewski, 'Notes on Topography of Ptolemaic Alexandria', in *Alessandria e il mondo ellenistico-romano, studi in onore di A. Adriani*, vol. 1 (Rome 1983) 55–9, 65, 67–9, fig. 2. Examples at Kom el-Dikka east of street R4, along side street L'*alpha*: G. Majcherek, 'Kom el-Dikka Excavations 1997', *PAM* 9 (1997) 33. Other examples: Tkaczow *Topography* 138–9 site 96 A–C; Rodziewicz *loc. cit.* (n. 10) 228–30.

16. H. de Vaujany, *Recherches sur les anciens monuments situés sur le Grand-Port d'Alexandrie* (Paris 1888) 23–31, 35–45; Breccia *Alex. ad Aeg.* 89–92, 95, 101–2; Noack *loc. cit.* (n. 9) 216–22. The finds whose locations were recorded are marked on W. Hoepfner, *Zwei Ptolemaïerbauten, AM* 1 (Berlin 1971) Beilage 22; Hoepfner and Schwandner *Stadt* fig. 232. This is based on the detailed catalogue and plan in Adriani *Annuario* (1932–3) 55–96, plan in pocket at back. Noack *loc. cit.* (n. 9), Hoepfner 1971 *op. cit.*, and Adriani *Annuario* (1932–3) can be cross-referenced to Tkaczow's site numbers in Tkaczow *Topography* 336–7.

17. Detailed discussion: Rodziewicz *loc. cit.* (n. 10) 227–8, 230, fig. 1–3; Tkaczow 2001 *loc. cit.* (n. 9) 336. Walls and street in palace area: M. Rodziewicz and A. Abdel Fatah, 'Recent Discoveries in the Royal Quarter of Alexandria', *BSAA* 44 (1991) 131–5, 140–4 fig. 1–5; Tkaczow *Topography* 121 site 72A, fig. 47a–b, plan 1 site E; Tkaczow 2002 *loc. cit.* (n. 9) 29–34. Walls and street at Kom el-Dikka: M. Rodziewicz, 'Report on the Activities of the Archaeological Mission at Kom-el-Dikka, Alexandria', *BSAA* 44 (1991) 84–5, 94–6 fig. 1–3; G. Majcherek, 'Excavations at Alexandria in 1990–91', *PAM* 3 (1991) 8–10, fig. 1; Tkaczow *Topography* 100–1 site 45, plan 1 site B.

18. Mahmoud-Bey *Mémoire* 22, 23. He also measured the distance from street R1 to Diocletian's Column (which is aligned almost on the axis of street R8) as 2310 m, which also gives 330 m. Inter-axial measurement of 330 m confirmed by excavations in n. 9. Use of 27.5 m on Serapeum layout: J. McKenzie, 'Alexandria and the Origins of Baroque Architecture', K. Hamma, ed., *Alexandria and Alexandrianism* (Malibu, California 1996) 113, fig. 4 (using old plan of Serapeum).

19. Néroutsos-Bey *op. cit.* (n. 9) 6–7; Néroutsos *Alexandrie* 10–11; de Vaujany *op. cit.* (n. 16) frontispiece plan, reproduced in Tkaczow *Topography* fig. XIb; G. Botti, *Plan de la ville d'Alexandrie* (Alexandria 1898) 67; Adriani *Annuario* (1932–3) 89–90 no. 104; Fraser *Ptol. Alex.* vol. 2, 70–1 n. 162 cites plan in G. Arvanitakis, Το Καισαρειον (Cairo 1899) fig. 2; Rodziewicz *loc. cit.* (n. 10) 228–9, fig. 1 nos. 10 and 11.

20. Z. Kiss, 'Remarques sur la datation et les fonctions de l'édifice théatral à Kom el-Dikka', in *50 Years of Polish Excavations in Egypt and the Near East, Symposium Warsaw University 1986* (Warsaw 1992) 173–4.

21. The side streets are clearly marked on Tkaczow *Topography* plan 1. They include the north-south ones recorded in Mahmoud-Bey *Mémoire* 23, 25: those located 110 m on either side of R8, the one *c.* 96 m east of R6, the street between R4 and R3 (north of L1), and the street 110 m east of R2.
 More recently discovered north-south side streets include the one east of Cleopatra's Needles, between R5 and R4 north of L2, on a different alignment to the one on the Kom el-Dikka block: Adriani *Annuario* (1932–3) 92 no. 111, marked on plan in back pocket; Tkaczow *Topography* 132–3 site 88, plan 1 site D.
 An east-west side street, 7 m wide, was uncovered for 250 m, between L2 and L3 west of R4[bis]: A. Adriani *Annuario* (1935–9) 150, fig. 63; Adriani *Repertorio* 82–3 no. 44, pl. 14 fig. 46; Tkaczow *Topography* 170 site 138, fig. 67, plan 1 northern street at site G. The other section of street found in this area was cleared for 50 m and photographed, but its precise location was not recorded. Adriani considered it was part of L2. Breccia *Musée gréco-romain 1925–31*, 27, pl. 33.117; Adriani *Repertorio* 83 no. 44; Tkaczow *Topography* 171 site 138A, fig. 68d.
 An additional east-west street L'*alpha* is marked on Adriani's plan in Adriani *Repertorio* vol. 1 (text) Tav. d'agg. A on p. 269. It was first marked on Breccia's sketch plan, reproduced in Tkaczow *Topography* 95 n. 93, 96 n. 96, 119 site 71, fig. XIIIa, 45. The continuation of it has recently been discovered east of R4 at Kom el-Dikka, *c.* 5 m wide: Majcherek *loc. cit.* (n. 15) 33–4. (R8 is incorrectly labelled on Adriani's plan, resulting in it also being incorrectly labelled on some later plans.)

22. Recent excavations of L'*alpha* at Kom el-Dikka: Majcherek *loc. cit.* (n. 15) 33–4. Hoepfner suggests a theoretical internal division of the large blocks, although there is no archaeological evidence for it: Hoepfner and Schwandner *Stadt* 238–40, fig. 227–8, 295; R. Tomlinson, 'Alexandria: the Hellenistic arrangement', *Numismatica e antichità classiche* 25 (1996) 155–6. It is based on 277 m for the block length and 310 m for the block width, with streets 50 feet wide. However, any such calculation should begin with the known distances between the street axes of 278 and 330 m respectively. The dimensions of the blocks of the contemporary cities of Seleucid Syria averaged *c.* 110 × 55 m: F.E. Peters, 'City Planning in Greco-Roman Syria', *DaM* 1 (1983) 269. The large Alexandrian blocks could be divided into lengthwise blocks of approximately this size.

23. Mahmoud-Bey *Mémoire* 21, 23; Noack *loc. cit.* (n. 9) 234–7, fig. 2–4, pl. 11. Paving of R2[bis] observed by Breccia: Tkaczow *Topography* 163. Narrowing of street R4: Majcherek 1999 *loc. cit.* (n. 9) 37 fig. 8. Earlier results: G. Majcherek, 'Notes on Alexandrian Habitat Roman and Byzantine Houses from Kom el-Dikka', *Topoi* 5 (1995) 144, fig. 4.

24. Mahmoud-Bey *Mémoire* 22; Noack *loc. cit.* (n. 9) 232–3; Tkaczow *Topography* 162 site 128, 171 site 138A. An indication of the appearance of the paving is given by the photograph of the Roman street: Breccia *Musée gréco-romain 1925–31*, pl. 33.117 = Tkaczow *Topography* site 138A fig. 68d.

25. Hoepfner and Schwandner *Stadt* fig. 226.

26. Diodorus Siculus, 17. 52. 3; Strabo, *Geography* 17. 1. 8. The length of a Greek foot varied from 0.27 to 0.35 m, with a Roman foot of *c.* 0.296 m: O.A.W. Dilke, *Mathematics and Measurement* (London 1987) 26.

27. Earlier metrological calculations, based on the assumption that the city was laid out in multiples of Greek feet: Mahmoud-Bey *Mémoire* 24–6; Erdmann *op. cit.* (n. 6) 12–17: Noack *loc. cit.* (n. 9) 237; A. von Gerkan, *Griechische Städteanlagen* (Berlin 1924) 68–70.

The Egyptian units of land measure are summarised in: F.L. Griffith, *Notes on Egyptian Weights and Measures*, reprinted from the *Proceedings of the Society of Biblical Archaeology* (June 1892) 1–18 [403–20], (May 1893) 1–6 [301–6]; Dilke *op. cit.* (n. 26) 23–4.

28. Mahmoud-Bey *Mémoire* 21.

29. Measured between the axes, the area of three of these 'blocks' is a total of 275,220 square metres. This is 99.9 percent of the area of 1000 × 1000 cubits of 0.525 m (or 100 percent of the area calculated using a cubit of 0.5246 m) which is also 100 *arourai*. The average length of a cubit measured by Petrie on Egyptian measuring rods was 0.5245 m: Griffith *loc. cit.* 1892 (n. 27) 4 [406].

30. From the plan [256] the blocks appear to be 200 × 100 cubits.

31. S.K. Hamarneh, 'The Ancient Monuments of Alexandria According to Accounts by Medieval Arab Authors (IX–XV century)', *Folia Orientalia* 13 (1971) 79. For the relationship of ancient streets to modern ones see also: G. Caruso, 'Alcuni aspetti dell'urbanistica di Alessandria in età ellenistica: il piano di progettazione', in *Alessandria e il mondo ellenistico-romano, studi in onore di A. Adriani*, vol. 1 (Rome 1983) 44, fig. 2, 3.

32. *Description de l'Égypte*, vol. 5, 355–61, vol. 10, 518–22, vol. 18, 424–9, plates vol. 5, pl 36.1–8, 37.4–23; Mahmoud-Bey *Mémoire* 31–2. Of the 129 cisterns listed by Botti, 119 were inspected in 1896: G. Botti, 'Les Citernes d'Alexandrie', *BSAA* 2 (1899) 15–26. The records of these, including plans and sections, are in the Greco-Roman Museum: Empereur *Alexandrie* 143. Other first hand investigations: M. Herz, 'Les Citernes d'Alexandrie', *Comité de conservation des monuments de l'art arabe* 15 (1898) 81–6; E. Combe, *Rapport sur la marche du service du Musée* (1917–18) 6–13, pl. 1–2; Breccia *Alex. ad Aeg.* 80–2, fig. 28–30; Adriani *Annuario* (1932–3) 24–5, fig. 3; L. Dabrowski, 'La Citerne à eau sous la mosquée de Nébi Daniel', *Bulletin of Faculty of Arts, University of Alexandria* 12 (1958) 40–8; W.A. Daszewski, 'Les Citernes et les chapiteaux', in *Alexandriaca I, Mélanges Gamal eddin Mokhtar, Bd'É* 97.1 (1985) 177–85; J.-Y. Empereur, 'Fouilles et découvertes récentes', *Les Dossiers d'archéologie* 201 (1995) 86–7; Empereur *Alexandrie* 124–43; A. Abd el-Fattah, 'Une Fouille récente au Sarapéion d'Alexandrie', in J.-Y. Empereur, ed., *Alexandrina 2, ÉtAlex 6* (Cairo 2002) 25–7; I. Hairy, 'Une Nouvelle Citerne sur le site du Sarapéion', in J.-Y. Empereur, ed., *Alexandrina 2, ÉtAlex 6* (Cairo 2002) 29–37. Discussion: G. Brands in Hoepfner and Schwandner *Stadt* 247–54; Tkaczow *Topography* list of sites on p. 333 under cisterns, fig. 28, 38, 55a–b, 56, 62.

Canal of Alexandria: *Description de l'Égypte*, vol. 15, 365–85; Mahmoud-Bey *Mémoire* 69–71; Breccia *Alex. ad Aeg.* 78–9; G. Brands in Hoepfner and Schwandner *Stadt* 248–52.

33. Botti *loc. cit.* (n. 32) 23–6, pl. A–B; Combe *loc. cit.* (n. 32); Tkaczow *Topography* 112 site 58, 142 site 101, fig. 55. Example south of Serapeum constructed in second century AD and abandoned in second half of the fourth or first half of the fifth century AD: Hairy *loc. cit.* (n. 32) 33.

34. *Description de l'Égypte*, vol. 5, 302–5, 307, 315, 355, 359, plates vol. 2, pl. 84; Mahmoud-Bey *Mémoire* 29–32; Botti *loc. cit.* (n. 32) 21, 26. The channels are most clearly marked on Sieglin's copy of Mahmoud-Bey's plan, in accordance with his description: Rodziewicz *Les Habitations* pl. 2 opposite p. 365. Botti reported that of the 700 cisterns noted by Mahmoud-Bey 143 were filled by the underground channels: Botti *op. cit.* (n. 19) 84–5.

35. Water channels were found under the streets excavated by Noack, including one under the Ptolemaic level of street R3, and a related rock-cut one under street L2: Noack *loc. cit.* (n. 9) 248–51, 253–60, pl. 11; Hoepfner and Schwandner *Stadt* fig. 226; Tkaczow *Topography* 158, fig. 60b, 61b. Water channel of masonry under street L1, west of street R4: Adriani 1956 *loc. cit.* (n. 9) 4–5, fig. 1, 4; Adriani *Repertorio* 87–8 no. 48, pl. 26 fig. 93–4; Tkaczow *Topography* 106–7 site 53. Ptolemaic water supply channel along R1 found in excavations for the Bibliotheca Alexandrina: M. Rodziewicz, 'Eco-archaeology of ancient Alexandria and Mareotis', in A.A.A. Hussein *et al.*, eds., *Proceedings of the Egyptian-Italian Seminar on Geosciences and Archaeology in the Mediterranean Countries, Cairo November 1993* (Cairo 1995) 135–6, fig. 6. A water channel was found by Breccia under street R2bis, north of street L3: Adriani *Annuario* (1932–3) 93–4 no. 116; Adriani *Repertorio* 162–3 site 128. Water channel parallel to street R5: Néroutsos-Bey *op. cit.* (n. 9) 8. A channel was found east of and parallel to street R4, south of street L3: Adriani 1956 *loc. cit.* (n. 9) 14, fig. 9 no. 44, fig. 15; Adriani *Repertorio* 77 no. 33, pl. 22 fig. 78–9; Tkaczow *Topography* 137 site 94, fig. 52 no. 44. Those which are considered the earliest examples were cut through bedrock. A series of rock-cut examples, lined with pink plaster, were found by Breccia between streets R4 and R3, north of street L2: E. Breccia, 'Cronaca del museo e degli scavi e ritrovamenti', *BSAA* 9 (1907) 107; Tkaczow *Topography* 141 site 100. The intersection of two rock-cut channels, lined with pinky-brown mortar containing crushed pottery, was found between R3 and R2, south of L3, although the street above them apparently did not survive: W.A. Daszewski, 'Nouvelles découvertes dans le quartier des Basileia en Alexandrie', *ÉtTrav* 11 (1979) 98–102, 105, fig. 4–5; Tkaczow *Topography* 148–9 site 108, fig. 58a. List of channels: Tkaczow *Topography* 333 under canals. Discussion: G. Brands in Hoepfner and Schwandner *Stadt* 252–4; Rodziewicz *loc. cit.* 135.

Similar pink mortar is used for waterproofing rock-cut cisterns at other sites, such as Petra. The shapes of the channels, which were possibly Ptolemaic and Roman, are similar to those surviving at Rhodes: Hoepfner and Schwandner *Stadt* 59–62, fig. 45. Water supply channels and drains under the streets were also included in the design of Rhodes and Akragas: Diodorus Siculus 11.25.3; Bradford *loc. cit.* (n. 8) 68; E.J. Owens, *The City in the Greek and Roman World* (London 1992) 46–7, 61.

36. So also Botti *loc. cit.* (n. 32) 25.

37. G. Brands in Hoepfner and Schwandner *Stadt* 254. Sewer under street R4: Majcherek *loc. cit.* (n. 23) 143. Sewer along L*alpha*: Rodziewicz *loc. cit.* (n. 35) 136, fig. 7.

38. Breccia's plan (reproduced in Tkaczow *Topography* fig. XIIIb) has an eastern branch of the canal marked as do some later plans, such as those in Tkaczow *Topography* maps B–D, plan I. But not in her most recent plans: Tkaczow *loc. cit.* 2002 (n. 9) fig. 1, 4–5.

39. Mahmoud-Bey *Mémoire* 31, 37–40; Strabo, *Geography* 17.1.6. This line was parallel to one of the main streets of the Ottoman town.

40. A. Hesse in *La Gloire d'Alexandrie* (Paris 1998) 88–9; *idem* 'Arguments pour une nouvelle hypothèse de localisation de l'Heptastade d'Alexandrie', in J.-Y. Empereur, ed., *Alexandrina* 1, *ÉtAlex* 1 (Cairo 1998) 21–33; A. Hesse *et al.*, 'L'Heptastade d'Alexandrie', in J.-Y. Empereur, ed., *Alexandrina* 2, *ÉtAlex* 6 (Cairo 2002) 191–273. Confirmed by geomorphology: J.-P. Goiran *et al.*, 'Évolution géomorphologique de la façade maritime d'Alexandrie (Égypte),' *Méditerranée* 104, 1.2 (2005) 61–4, pl. 3–4 esp. fig. 3.

41. Mahmoud-Bey *Mémoire* 12–18. The letters he mentions in this description can be seen in the copy of his plan in: Empereur *Alexandrie* 22–3. Discussion: Botti *op. cit.* (n. 19) 22–30; Tkaczow *Topography* 126–7 site 79A–B.

42. Mahmoud-Bey *Mémoire* 12, 14–15; de Vaujany *op. cit.* (n. 16) 43–5, 88–9; Tkaczow *Topography* 126–7 site 79A–B.

43. De Vaujany *op. cit.* (n. 16) 84–96; M. Herz, 'La Tour de missallah, dite "des Romains", à Alexandrie près de la gare de Ramleh', *Comité de conservation des monuments de l'art arabe* 19 (1902) 158–60, pl. 8; Adriani *Repertorio* 66–8 no. 15 (detailed bibliography), pl. 7–8; Tkaczow *Topography* 129–30 site 82, fig. 51.

44. Rodziewicz *loc. cit.* (n. 10) 230 fig. 1 no. 8.

45. Valentia *op. cit.* (n. 7) 450; Mahmoud-Bey *Mémoire* 15.

46. Tkaczow *Topography* 58 site 6, fig. 9.

47. Mahmoud-Bey *Mémoire* 14, 15.

48. Mahmoud-Bey *Mémoire* 12–13, 28.

49. Valentia *op. cit.* (n. 7) 450. G. Parthey, *Das Alexandrinische Museum* (Berlin 1838) 20, foldout plan; reproduced in Tkaczow *Topography* fig. 1. Although Parthey's plan includes features known only from the written sources he has used real topography for the plan on which he has marked them.

50. S. Cormack, 'Funerary Monuments and Mortuary Practice in Roman Asia Minor', in S.A. Alcock, ed., *The Early Roman Empire in the East* (Oxford 1997) 139–40.

51. Tkaczow *Topography* 60–1 site 8, map A.

52. Eastern wall further to the west suggested by Breccia *Alex. ad Aeg.* 68–70; plan reproduced in Tkaczow *Topography* fig. XIIIa. Breccia's wall was marked on other plans which also include Mahmoud-Bey's wall further east: Adriani *Repertorio* vol. 1 (text) Tav. d'agg. A on p. 269; Tkaczow *Topography* plan 1, map A; Hoepfner and Schwandner *Stadt* fig. 225. Wall further west: G. Grimm, 'City Planning?', in K. Hamma, ed., *Alexandria and Alexandrianism* (Malibu 1996) 56–63, foldout plan opp. p. 302; Grimm *Alexandria* fig. 9; Botti *op. cit.* (n. 19) foldout plan; reproduced in Tkaczow *Topography* fig. Xa. Contra, R. Tomlinson, *From Mycenae to Constantinople* (London 1992) 98.

CHAPTER 3: PTOLEMAIC ALEXANDRIA

1. The definitive work for a comprehensive discussion, with references, for the written sources on the topography of Ptolemaic Alexandria remains: Fraser *Ptol. Alex.* vol. 1, 3–37. Overview of written sources and how they relate to the archaeological evidence: B. Tkaczow, 'Remarques sur la topographie et l'architecture de l'ancienne Alexandrie dans les textes antiques', *Archeologia* 35 (1984) 1–25.

2. Homer, *Odyssey* 4. 354–9.

3. Herodotus, 2. 178–9; J. Boardman, *The Greeks Overseas* (3rd edn London 1980) 117–33.

4. Fraser *Ptol. Alex.* vol. 2, 9 n. 22; P. Green, 'Alexander's Alexandria', in K. Hamma, ed., *Alexandria and Alexandrianism* (Malibu 1996) 11. Two Corinthian vases of second half of seventh century BC: M.S. Venit, 'Two Early Corinthian Alabastra in Alexandria', *JEA* 71 (1985) 183–9, pl. 21. Athenian black figure sherds: E. von Sieglin, ed., *Die griechisch-ägyptische Sammlung Ernst von Sieglin, Expedition Ernst von Sieglin*, vol. 2, part 3, (Leipzig 1913) 6–8. List of Greek vases found in Alexandria dated before Alexander's foundation: Venit *loc. cit.* 186–7 n. 10. But see Venit *Tombs* 224 n. 60. Human presence prior to Alexander is also indicated by cereals before the fourth century BC, and metallurgical activity (indicated by lead): J.-P. Goiran, *Recherches géomorphologiques dans la region littorale d'Alexandrie en Égypte*, PhD thesis 2001, Aix-Marseille 1.

5. Carbon 14 on elm 410 ± 40 BC; Carbon 14 on pine 395 ± 40 BC Goddio *et al. Alexandria* 29–31, 56, 57 fig. 11 on p. 57, photo. 26, plan opp. p. 29, plan on p. 30.

6. Vitruvius, *On Architecture* 2. introduction. 4.

7. Plutarch, *Lives, Alexander* 26. 5–7. Plutarch lived *c.* AD 50–120.

8. Strabo, *Geography* 17. 1. 6. Rhakotis is given as the main one of a number of villages in Pseudo-Kallisthenes, *Romance of Alexander* 1. 31. Other references to Egyptian garrisons: Herodotus, 2. 30; Thucydides, 1. 104. 1; A.J.B. Wace, 'The Sarcophagus of Alexander the Great', *Bulletin of the Faculty of Arts, Farouk I University Alexandria* 4 (1948) 2–3; A. Rowe, 'A Contribution to the Archaeology of the Western Desert: II', *BullJRylandsLib* 36 (1954) 484–500; Fraser *Ptol. Alex.* vol. 1, 6, vol. 2, 9 n. 22; Green *loc. cit.* (n. 4) 11. See also n. 36 below.

9. Pliny, *Natural History* 5. 11. 62.

10. Diodorus Siculus, 17. 52. 1–4. He visited Alexandria *c.* 60–56 BC.

11. For example, Dura Europos: Hoepfner and Schwandner *Stadt* fig. 246.

12. A plethron wide: Diodorus Siculus, 17. 52. 3. 'More than a plethron in breadth': Strabo, *Geography* 17. 1. 8.

13. J.J. Coulton, *The Architectural Development of the Greek Stoa* (Oxford 1976) 178.

14. Quintus Curtius, *History of Alexander* 4. 8. 2. He lived *c*. AD 86–160. Walls of Syracuse, with references: A.W. Lawrence, *Greek Aims in Fortifications* (Oxford 1979) 117. On the plan of Alexandria being like a cloak: Strabo, *Geography* 17. 1. 8; Plutarch *Lives, Alexander* 26. 5; Pliny, *Natural History* 5. 11. 62.

15. Arrian, *Anabasis of Alexander* 3. 1. 5.

16. Diodorus Siculus, 17. 49. 2–17. 51; Plutarch, *Lives, Alexander* 26. 10–11; Arrian, *Anabasis of Alexander* 3. 3–3. 4; Pseudo-Kallisthenes, *Romance of Alexander* 1. 30. Macedonian custom: Quintus Curtius, *History of Alexander* 4. 8. 6; Green *loc. cit.* (n. 4) 8–9, 12–14. Siwa: S. Aufrère *et al.*, *L'Égypte restituée, Sites et temples des déserts* (Paris 1994) 143–57.

17. Strabo, *Geography* 17. 1. 6; Plutarch, *Lives, Alexander* 26. 8–10; Arrian, *Anabasis of Alexander* 3. 2. 1–2; Pseudo-Kallisthenes, *Romance of Alexander* 1. 32. On religious blessing: Fraser *Ptol. Alex.* vol. 1, 3, vol. 2, 1–2 n. 4; Green *loc. cit.* (n. 4) 12.

18. The temple of Isis of Nepheros is mentioned as the first temple founded in Alexandria in Pseudo-Kallisthenes, *Romance of Alexander* 1. 31. The Armenian version states that it was built 'before Alexandria': *The Romance of Alexander the Great by Pseudo-Callisthenes*, tr. A.M. Wolohojian (New York 1969) 79 on p. 49.

19. Vitruvius, *On Architecture* 1. 6. 1 and 1. 7. 1.

20. Pliny, *Natural History* 5. 11. 62. He lived *c*. AD 23/24–79.

21. The *Romance of Alexander* by an unknown author 'Pseudo-Kallisthenes' occurs in a number of versions. The earliest surviving version is in Greek from the third century AD: Pseudo-Kallisthenes, *Historia Alexandri Magni (Pseudo-Callisthenes)*, ed. G. Kroll (Berlin 1926); *The Greek Alexander Romance*, tr. R. Stoneman (Harmondsworth 1991). In theory it was composed some time between the death of Alexander in 323 BC and the third century AD, although Stoneman, *op. cit.* 8–17, suggests that it may date substantially to the third century BC with later additions. Fraser also acknowledges some elements as going back to the early Hellenistic period: *Ptol. Alex.* vol. 1, 677; P. Fraser, *Cities of Alexander the Great* (Oxford 1996) 214. See also: *ODB* vol. 1, 58–9. There are also versions in Syriac: *The History of Alexander the Great*, ed. tr. E.A.W. Budge (Cambridge 1889); Ethiopian: *The Life and Exploits of Alexander the Great*, ed. tr. E.A.W. Budge (London 1896); and Armenian: Wolohojian *op. cit.* (n. 18).

22. Pseudo-Kallisthenes, *Romance of Alexander* 1. 32–3. The Armenian version gives the impression that the Great Altar of Alexander was built opposite the temple of Serapis: Wolohojian *op. cit.* (n. 18) 88–9 on p. 52.

23. *Aphthonii Progymnasmata* 12, ed. H. Rabe (Leipzig 1926) p. 38.

24. Pseudo-Kallisthenes, *Romance of Alexander* 1. 31.

25. Diodorus Siculus, 17. 52. 7.

26. [Aristotle], *Oeconomica*, tr. E.S. Forster (Oxford 1920) 2. 2, 1352ᵃ 17 and 29–31; Quintus Curtius, *History of Alexander* 4. 8. 5; Pausanias, *Description of Greece* 1. 6. 3. For Kleomenes of Naukratis, with references, see: H. Berve, *Das Alexanderreich auf Prosopographischer Grundlage*, vol. 2 (Munich 1926) 210–11 no. 431; Green *loc. cit.* (n. 4) 14–16; G. Le Rider, 'Cléomène de Naucratis', *BCH* 121 (1997) 71–93.

27. Arrian, *Anabasis of Alexander* 7. 23. 7–8.

28. Pseudo-Kallisthenes, *Romance of Alexander* 1. 31.

29. Vitruvius, *On Architecture* 2. introduction. 1–4; Pliny, *Natural History* 5. 11. 62. On the name of the architect in various sources: G.A. Mansuelli, 'Contributo a Deinokrates', in *Alessandria e il mondo ellenistico-romano, studi in onore di A. Adriani*, vol. 1 (Rome 1983) 78–90, summarized on 87–8.

30. The city plan as it relates to Rhodes is discussed in: R.A. Tomlinson, 'Alexandria: the Hellenistic Arrangement', *Numismatica e antichità classiche* 25 (1996) 155–6. As it relates to Pella: *idem*, *From Mycenae to Constantinople* (London 1992) 98–102; *idem*, 'The Town Plan of Hellenistic Alexandria', in *Alessandria e il mondo ellenistico-romano, Congresso Alessandria 1992* (Rome 1995) 238–9.

31. Pseudo-Kallisthenes, *Romance of Alexander* 1. 31. So also: Quintus Curtius, *History of Alexander* 4. 8. 5.

32. Pseudo-Kallisthenes, *Romance of Alexander* 1. 34.

33. Pausanias, *Description of Greece* 1. 6. 3.

34. Diodorus Siculus, 18. 26. 1–18. 28. 2; Strabo, *Geography* 17. 1. 8. K.F. Müller, *Der Leichenwagen Alexanders des Grossen* (Leipzig 1905); H. Bulle, 'Der Leichenwagen Alexanders', *JdI* 21 (1906) 52–73.

35. Diodorus Siculus, 18. 28. 4. So also: Strabo, *Geography* 17. 1. 8. According to Pseudo-Kallisthenes, *Romance of Alexander* 3. 34, Ptolemy I Soter first took the body to Memphis, then to Alexandria where he 'built a tomb (*taphos*) in the sanctuary (*hieron*), which is now called the Sema of Alexander'. According to Pausanias, *Description of Greece* 1. 6. 3–1. 7. 1, Ptolemy I buried Alexander's body at Memphis and Ptolemy II Philadelphus moved it to Alexandria.

36. Cairo, Egyptian Museum no. 22182. Trans. of this passage: A. Rowe, 'A Contribution to the Archaeology of the Western Desert III', *BullJRylandsLib* 38 (1955) 156–8. Text in: *Hieroglyphische Urkunden der griechisch-römischen Zeit*, ed. K. Sethe (Leipzig 1904) (*Urkunden des ägyptischen Altertums*, ed. G. Steindorff, Part II) 14. Discussion of the translation of this passage: D. Lorton, 'The Names of Alexandria in the Text of the Satrap Stela', *GöttMisz* 96 (1987) 65–70. Eng. tr. of stele: E. Bevan, *A History of Egypt under the Ptolemaic Dynasty* (London 1927) 28–32. Date: Fraser *Ptol. Alex.* vol. 2, 11–12 n. 28; Hölbl *Geschichte* 75. Rhakotis, 'building site' not its former name: M. Chauveau, 'Alexandrie et Rhakôtis: Le point de vue des Égyptiens', in J. Leclant, ed., *Alexandrie: une mégapole cosmopolite, Cahiers de la Villa "Kérylos"*, No. 9 (Paris 1999) 1–10; M. Depauw, 'Alexandria, the Building Yard', *Chronique d'Égypte* 75 (2000) 64–5. Hölbl points out this meaning does not necessarily mean that the site was empty at the time of Alexander the Great: G. Hölbl, *A History of the Ptolemaic Empire*

(London 2001) 29 n. 2a. On word Rhaqote going back before to the Dynastic period: J. Baines, 'Possible Implications of the Egyptian Word for Alexandria', *JRA* 16 (2003) 61–3.

37. Tacitus, *Histories* 4. 83.

38. Callimachus, *Iambus* 1, line 9 (Fr. 191); Fraser *Ptol. Alex.* vol. 1, 12, 292, vol. 2, 453 n. 824.

39. Apparently Ptolemaic, mudbrick fortification walls elsewhere in Egypt: Lawrence *op. cit.* (n. 14) 171–2. The city walls of Antinoopolis (el-Sheikh 'Ibada) built in or after AD 130 were brick. Mudbrick on a stone sockle in Greek fortifications: F.E. Winter, *Greek Fortifications* (London 1971) 69–73.

40. Tacitus, *Histories* 4. 84. He is aware of the controversy surrounding the origin of the god Serapis. On the origin of Serapis, with refereces: *LÄ* V, 870–4.

41. Clement, *Exhortation to the Greeks (Protrepticus)* 4. 42–3. According to Jerome's version of Eusebius' *Chronicle* the move took place in 286 BC: *Eusebius Werke siebenter Band die Chronik des Hieronymus*, ed. R. Helm (Berlin 1956) 129 lines 3–4. According to the Armenian version of Eusebius in 278 BC: *Eusebi Chronicorum Libri duo*, ed. A. Schoene, vol. 2 (Berlin 1866) 120 in *Eusebi Chronicorum Canonum quae supersunt*, ed. A. Schoene. According to Cyril of Alexandria, in 284–1 BC: Cyril, *Adversus Iulianum* 1. 13. For versions of the statue, with illustrations, see: W. Hornbostel, *Sarapis* (Leiden 1973) 33–130; V. Tran Tam Tinh, *Sérapis debout, Corpus des monuments de Sérapis debout et étude iconographique* (Leiden 1983). Summary: J.J. Pollit, *Art in the Hellenistic Age* (Cambridge 1986) 279–80.

42. A.J.B. Wace, 'Greek Inscriptions from the Serapeum', *Farouk I University, Bulletin of the Faculty of Arts* 2 (1944) 18–19 no. 1, 21–3 no. 2; P.M. Fraser, 'Current Problems Concerning the Early History of the Cult of Sarapis', *OpAth* 7 (1967) 36–7, 42, pl. 2.3–4, 3.6; *SEG* 24. 1166 and 1167–8; Fraser *Ptol. Alex.* vol. 1, 268, vol. 2, 422 n. 644; E. Bernand, *Inscriptions grecques d'Alexandrie ptolémaïque* (Cairo 2001) 19–20 no. 2, 27–8 no. 4, pl. 1.2–4.

43. Inscribed altar *in situ* on pebble mosaic of the first quarter of the third century BC: *OGIS* II 725; *Sammelbuch* V 8921; Fraser *Ptol. Alex.* vol. 1, 236, vol. 2, 385–6 n. 367; G. Grimm, 'Zur Ptolemäeralter aus dem alexandrinischen Sarapeion', in *Alessandria e il mondo ellenistico-romano, Studi in onore di A. Adriani*, vol. 1 (Rome 1983) 70–3, pl. 8; Daszewski *Mosaics* 114 no. 8, pl. 16; Sabottka *Serapeum* vol. 1, 37–53, vol. 3, fig. 6–7, vol. 4, pl. 13–19; Grimm *Alexandria* 82 fig. 83; Bernand *op. cit.* (n. 42) 34–6 no. 8, pl. 3.

44. J.S. McKenzie, S. Gibson and A.T. Reyes, 'Reconstructing the Serapeum in Alexandria from the Archaeological Evidence', *JRS* 94 (2004) 83–4. I thank S.R.F. Price for drawing my attention to this earlier phase. See also: Sabottka *Serapeum* vol. 1, 30–55, vol. 3, fig. 4–7, vol. 4, pl. 8–13; G. Grimm, 'City Planning?', in K. Hamma, ed., *Alexandria and Alexandrianism* (Malibu 1996) 63, 72 n. 49.

45. Tacitus, *Histories* 4. 83; Fraser *Ptol. Alex.* vol. 1, 200. *P.Oxy.* XXVII 2465 Frag. 3 col. ii.

46. P.Mil.Vogl. VIII 309 col. IV 1–6 p. 45; Posidippus ed. tr. Austin and Bastianini p. 42–3 no. 20. Date of Posidippus: Bastianini and Gallazzi in introducion to P.Mil.Vogl. VIII 309 p. 17, 27. Earlier discussion of date of Posidippus: Fraser *Ptol. Alex.* vol. 1, 557–8.

47. R. Pfeiffer, *History of Classical Scholarship from the Beginning to the End of the Hellenistic Age* (Oxford 1968) 96; Fraser *Ptol. Alex.* vol. 1, 314–15, 321–2, vol. 2, 469 n. 69.

48. It is preserved on a papyrus of not later than 161 BC: P.Louvre 7172 = Posidippus ed. tr. Austin and Bastianini p. 142–3 no. 115; *The Greek Anthology, Hellenistic Epigrams*, ed. tr. A.S.F. Gow and D.L. Page (Cambridge 1965) vol. 1, p. 169 no. 11, vol. 2, 489–91; *Select Papyri, Literary Papyri*, ed. tr. D.L. Page (London 1941) vol.1, p. 444–7 no. 104a; Fraser *Ptol. Alex.* vol. 1, 18–19, vol. 2, 810 n. 129; F. Chamoux, 'L'épigramme de Poseidippos sur le phare d'Alexandrie', in J. Bingen *et al.*, eds., *Le Monde grec. Hommages à C. Préaux* (Brussels 1975) 214–22; D. Thompson, 'Ptolemaios and the "Lighthouse": Greek Culture in the Memphite Serapeum', *Proceedings of the Cambridge Philological Society* 213 (1987) 105–21; A. Bernand, 'Les Veilleurs du Phare', *ZPE* 113 (1996) 85–90; *La Gloire d'Alexandrie* (Paris 1998) 101 no. 62; Bernand *op. cit.* (n. 42) 23–6.

49. Strabo, *Geography* 1. 17. 6. Bing suggests Strabo's passage is sufficiently similar to the content of Posidippus' epigram that Strabo must have known it: P. Bing, 'Between Literature and the Monuments', in M.A. Harder *et al.*, eds., *Genre in Hellenistic Poetry* (Groningen 1998) 27–8.

50. Date of Posidippus: see n. 46.

51. *Eusebi Chronicorum Canonum quae supersunt*, ed. A. Schoene (*Eusebi Chronicorum Libri Duo*, ed. A. Schoene, vol. 2) (Berlin 1866) p. 118 Hl; Fraser *Ptol. Alex.* vol. 1, 20, vol. 2, 52 n. 120.

52. *Suidae Lexicon*, ed. A. Adler, part 4 (Leipzig 1935) p. 701, 114; Fraser *Ptol. Alex.* vol. 1, 20, vol. 2, 52 n. 117–18.

53. Pliny, *Natural History* 36. 18 (83).

54. Lucian, *How to Write History* 62. Lucian was born in *c*. AD 120.

55. Suggestion that the Lighthouse was a gift from Sostratus: Fraser *Ptol. Alex.* vol. 1, 20. References for Sostratus as an architect: Fraser *Ptol. Alex.* vol. 1, 19–20, vol. 2, 48–9 n. 104–5, 50–1 n. 111, 52 n. 115–16. Sostratus not an architect: Bing *loc. cit.*(n. 49) 22–3.

56. Fraser *Ptol. Alex.* vol. 1, 20, vol. 2, 52–4 n. 121.

57. Bing *loc. cit.* (n. 49) 21–9.

58. Pliny, *Natural History* 36. 18 (83).

59. Diodorus Siculus, 18. 14. 1.

60. R.S. Stanier, 'The Cost of the Parthenon', *JHS* 73 (1953) 68–76. Other examples of building costs, with references: J.J. Coulton, *Ancient Greek Architects at Work* (repr. Oxford 1995) 20–3.

61. Pliny, *Natural History* 36. 18 (83). Pseudo-Lucian, *Affairs of the Heart* 11, mentions the porticoes (stoas) of Sostratus at Cnidus.

62. Lucian, *Hippias, or the Bath* 2. Lucian in Egypt: C.P. Jones, *Culture and Society in Lucian* (Cambridge, Mass. 1986) 20–1.

63. Strabo, *Geography* 17. 1. 6.

64. F. Adler, *Der Pharos von Alexandria* (Berlin 1901). The most detailed study, leading to the famous reconstruction on which the model in Alexandria is based: H. Thiersch, *Pharos* (Leipzig 1909). Other more recent discussions of the ancient evidence: Calderini *Dizionario* vol. 1, 158–60; C. Picard, 'Sur quelques représentations nouvelles du phare d'Alexandrie et sur l'origine alexandrine des paysages portuaires', *BCH* 76 (1952) 61–95; Adriani *Repertorio* 103–6, 234–5, pl. 33; Fraser *Ptol. Alex.* vol. 1, 18, vol. 2, 44–7 n. 97, 99, 102; M. Reddé, 'La Représentation des phares à l'époque romaine', *MEFRA* 91 (1979) 845–72; M.-H. Quet, 'Pharus', *MEFRA* 96 (1984) 789–845; P. Clayton and M. Price, eds., *The Seven Wonders of the Ancient World* (London 1988) 138–57; W. Ekschmitt, *Die sieben Weltwunder. Ihre Erbauung, Zerstörung und Wiederentdeckung* (Mainz rev. edn 1991) 188–97; K. Brodersen, 'Ein Weltwunder auf "gläsernen Füssen", der Pharos von Alexandria in neuem Licht', *Antike Welt* 24 (1993) 207–11; Tkaczow *Topography* 47–8 site 1; J.-P. Adam, 'Le Phare d'Alexandrie', *Les Dossiers d'archéologie* 201 (1995) 26–31; M. Reddé, 'Le Phare d'Alexandrie', *Les Dossiers d'archéologie* 202 (1995) 60–5; J.-Y. Empereur, *Le Phare d'Alexandrie* (Paris 1998); Empereur *Alexandria* 82–7; Grimm *Alexandria* 43–6.

65. Ammianus Marcellinus, 22. 16. 9–11.

66. Detailed analysis of Arabic texts: Adler *op. cit.* (n. 64); Thiersch *op. cit.* (n. 64) 37–74; A.J. Butler, *The Arab Conquest of Egypt and the Last Thirty Years of Roman Dominion*, ed. P.M. Fraser (2nd edn Oxford 1978) 390–8. More recently discovered manuscripts: U. Monneret de Villard, 'Il Faro di Alessandria secondo un testo e disegni arabi inediti da codici milanesi Ambrosiani', *BSAA* 18 (1921) 13–35; M. de Asin and M. Lopez Otero, 'The Pharos of Alexandria', *Proceedings of the British Academy* (1933) 277–92; É. Lévi-Provençal, 'Une description arabe inédite du phare d'Alexandrie', in *Mélanges Maspero*, vol. 3 (*MIFAO* vol. 68) (Cairo 1939–40) 161–71; S.K. Hamarneh, 'The Ancient Monuments of Alexandria According to Accounts by Medieval Arab Authors (IX-XV Century)', *Folia Orientalia* 13 (1971) 85–91, 106–8. Dates of earthquakes and other discussion: Fraser *Ptol. Alex.* vol. 2, 46; Empereur *op. cit.* (n. 64) 56–63, 104–7; M.A. Taher, 'Les Séismes à Alexandrie et la destruction du phare', *Alexandrie médiévale* 1, *ÉtAlex* 3 (1998) 51–6.

67. Correct identification of site: M. van Berchem, 'Note sur les fondations du Phare d'Alexandrie', *CRAI* 4.26 (1898) 339–45; Thiersch *op. cit.* (n. 64) 51, 64; Fraser *Ptol. Alex.* vol. 2, 44–5 n. 98. Contra: Goddio *et al. Alexandria* 16. Even in the nineteenth century the promontory leading to the Lighthouse was much narrower than it is now.

68. Al-Idrīsī 139, *Abou-'Abdallah Moh. Edrisi, Description de l'Afrique de l'Espagne*, tr. R.P.A. Dozy and M.J. Goeje (Leiden 1866, repr. Amsterdam 1969) p. 166. Butler *op. cit.* (n. 66) 391 translates this as 'It is built of the hardest Tiburtine stone'. On *caddzân* (*kadhdhān*): R. Dozy, *Supplement aux dictionnaires arabes*, vol. 2 (Leiden 1881) 450 which cites Ibn-Ilyâs (d. *c.*1523) 'the stone *caddzân* is a stone which one uses to pave houses and for stairs'. I thank Marcus Milwright for help with the correct translation of *kadhdhān*.

Use of granite: van Berchem *loc. cit.* (n. 68); Tkaczow *Topography* 47–8.

69. Table of heights: Thiersch *op. cit.* (n. 64) 66. Up to fifteen percent is also about the amount of variation in the modern estimations of the lengths of units the Arab historians use, e.g. de Asin and Lopez Otero *loc. cit.* (n. 66) 282 no. 7. They use a larger cubit than Thiersch for their reconstruction.

70. Coins: Dattari *Monete* pl. 28.553, 1111, 1933, 3216, 3903; Poole *BMC* xciv, pl. 16.1119, 29.884, 1205–6, 1439; Thiersch *op. cit.* (n. 64) 6–13; S. Handler, 'Architecture on the Coins of Roman Alexandria', *AJA* 75 (1971) 58–61, pl. 11.1–3; Clayton and Price *op. cit.* (n. 64) 148–55, fig. 74–6, 78. Gems: F. Daumas and B. Matthieu, 'Le Phare d'Alexandrie et ses dieux: un document inédit', *Academiae Analecta, Medelingen van de Koninklijke Academie voor Wetenschappen, letteren en Schone Kunsten van België, Klasse der Letteren* 49.1 (1987) 41–55 (*non vidi*); *La Gloire d'Alexandrie* (Paris 1998) 100 no. 59; Empereur *op. cit.* (n. 64) fig. on p. 50; Grimm *Alexandria* fig. 44.

71. I thank John Bartlett for this suggestion. Naphtha was observed by Alexander in Babylonia. It was sometimes used in lamps instead of oil. II Maccabees 1. 20–2 and 31–6; Strabo, *Geography* 16. 1. 15; Pliny, *Natural History* 2. 109 (235); Plutarch, *Lives, Alexander* 35. 1–6. See also: D.J. Blackman, 'Ancient Harbours 2', *IJNA* 11 (1982) 207–8.

72. Thiersch *op. cit.* (n. 64) 26–31, fig. 41, 42–7, 49; A. Adriani, *Annuaire* (1940–50) 133–9, fig. 63–7, pl. D, L-LI; Fraser *Ptol. Alex.* vol. 2, 46–7 n. 100. If the graffito of the third or second century BC in a tomb near by (Thiersch, *op. cit.* n. 64, fig. 48; Quet, *loc. cit.* n. 64, 817 fig. 13) refers to this tower, rather than the Lighthouse in Alexandria, then the tower would have to date to the third or second century BC. On the other hand, if the graffito were referring to the Lighthouse in Alexandria then it would be the earliest surviving depiction of it. Before and after modern repairs (in which the doorway and window were moved): G. Vörös, *Taposiris Magna, Port of Isis Hungarian Excavations at Alexandria (1998–2001)* (Budapest 2001) pl. on p. 46–53.

73. Josephus, *Jewish War* 4. 10. 5 (613–14). Mahmoud-Bey *Mémoire* 36.

74. Fraser *Ptol. Alex.* vol. 1, 18–19, vol. 2, 47–50 n. 103, 108–9; Quet *loc. cit.* (n. 64) 807–13; Bernand *loc. cit.* (n. 48) 85–90; Bing *loc. cit.* (n. 49) 23–5.

Begram beaker: Picard *loc. cit.* (n. 64) 68–80, 94–5; S. Auth, 'Luxury Glasses with Alexandrian Motifs', *Journal of Glass Studies* 25 (1983) 42–4. The hoard in which it was found has been redated to *c.* AD 100: D. Whitehouse, 'Begram, the *Periplus* and Gandharan Art', *JRA* 2 (1989) 98–9. Empereur 1998 *op. cit.* (n. 64) 50–1, accepts the date in the second century BC suggested for the vase by Picard, *loc. cit.* (n. 64) 95. This date is dependent on a fragile vessel surviving for over two centuries until the hoard was deposited. Such an early date for the vase has serious implications as it would obviously then be a depiction surviving from before the first century AD.

75. The remains near Fort Qait Bey were well known due to the work of Kamel Abu al-Saadat and Honor Frost: H. Frost, 'The Pharos Site, Alexandria, Egypt', *IJNA* 4

(1975) 126–30; Clayton and Price *op. cit.* (n. 64) fig. 77; S.A. Morcos, 'Submarine Archaeology and its Future Potential: Alexandria Casebook', *BSAA* 45 (1993) 203–8; W. La Riche, *Alexandria the Sunken City* (London 1996); J.-Y. Empereur, 'Alexandrie (Égypte)', *BCH* 119 (1995) 756–60 and *BCH* 120 (1996) 963–70; *idem*, 'Alexandria: the Underwater Site near Qaitbey Fort', *Egyptian Archaeology* 8 (1996) 7–10; *idem*, 'The Discovery of the Pharos of Alexandria', *Minerva* 7.1 (1996) 5–6; *idem*, 'Les Fouilles sous-marines du Phare d'Alexandrie', *Égypte, Afrique et Orient* 6 (1997) 2–8; *idem op. cit.* (n. 64) 41, 78–96, 114–15; Empereur *Alexandria* 62–81; *La Gloire d'Alexandrie* (Paris 1998) 102–4, 307; J.-Y. Empereur, 'Diving on a Sunken City', *Archaeology* 52.2 (1999) 36–43; *idem*, *Le Phare d'Alexandrie, La Merveille retrouvée* (rev. edn, Paris 2004) 64–80, 98–103; *idem* ed., *Pharos* 1, *ÉtAlex* 9 (in press). Number of fragments updated by J.-Y. Empereur pers. com. 2003. Comments on Egyptian style fragments: N. Grimal, 'Fouilles sous-marines à l'est du fort Qaitbey', *BIFAO* 96 (1996) 563–70; J. Yoyotte in Goddio *et al. Alexandria* 203–4, 214, 217 n. 85, 242; N. Grimal, 'Le Site architectural immergé au pied du Fort Qaitbay', *BIFAO* 99 (1999) 507–12. Reconstruction drawings of statues of Ptolemies: Empereur *op. cit.* 2004, fig. on p. 72, fig. on p. 102. Comments on statues of Ptolemies with bibliography: Ashton *Ptol. Sculpture* 90 no. 19, 92 nos. 20–1, 110 nos. 56–7, fig. 19–21, 56–7 (Ptolemy IX or X and ?Cleopatra III for the pair); S.-A. Ashton in S. Walker and P. Higgs, eds., *Cleopatra of Egypt from History to Myth* (London 2001) 58, fig. 24a–b; P.E. Stanwick, *Portraits of the Ptolemies, Greek Kings as Egyptian Pharaohs* (Austin, Texas 2002) 115–16 no. C22 and C27, fig. 111–12, 115 (Ptolemy VIII and Cleopatra III); S. Albersmeier, *Untersuchungen zu den Frauenstatuen des Ptolemaïschen Ägypten, AegTrev* 10 (Mainz 2002) 292–4 no. 24–7, pl.39d–41 (two females, including largest with Isis crown: second half of second century to first half of first century BC). Block with 30 cm high inlaid letters from a Greek inscription API which might have come from the Lighthouse: Empereur 1995 *loc. cit.* (n. 75) 757; *idem op. cit.* (n. 64) 94–5, pl. on p. 94; P. Bing *loc. cit.* (n. 49) 28. Granite pieces from a doorframe: Empereur 1998 *op. cit.* (n. 64) fig. on p. 92, 95; B. Mathieu, 'Les Fouilles sous-marines sur le site de Qaitbey en 2000–2001', *BIFAO* 101 (2001) 524–5. Blocks with metal clamps: J.-Y. Empereur, 'Alexandrie (Égypte)', *BCH* 124 (2000) 598; *idem*, 'Alexandrie (Égypte)', *BCH* 125 (2001) 682–3, fig. 3.

76. The dumping of columns on the eastern harbour shore line: Ch. 1 n. 3. Examples of other pieces dumped there include five fragments from the same Egyptian style monument of Apries (589–570 BC) from Heliopolis dropped on the shore line and on the island of Antirrhodos: J. Yoyotte in Goddio *et al. Alexandria* 234–44, findspots on plan on p. 220. These include two blocks (505 and 890) which are joining halves of one block (one on the mainland shore and the other opposite on the island of Antirrhodos) which had been reused as a beam before it had broken and was dumped. Statuary: Z. Kiss, F. Dunand, J. Yoyotte in Goddio *et al. Alexandria* 168–98, findspots marked on plan on p. 168; Z. Kiss, 'Un portrait d'Antonia Minor dans les eaux du port d'Alexandrie', in *Studia Archeologica, Liber amicorum I.A. Ostrowski ab Amicis et discipulis oblatus* (Cracow 2001) 173–6; *idem*, 'Les cheveaux du prêtre', *Swiatowit. Rocznik Instytutu Archeologii Uniwersytetu Warszawskiego*, vol. 3 (44) fasc. A (Warsaw 2001) 77–9.

77. Calderini *Dizionario* vol. 1, 111–12; Adriani *Repertorio* 220–1; Fraser, *Ptol. Alex.* vol. 1, 21–2.

78. On 'low-lying breakwater' for *chamai chele* in line 4 of the epigram from papyrus see: Chamoux *loc. cit.* (n. 48) 214, 216; Posidippus ed. tr. Austin and Bastianini p. 143 no. 115 line 4. On the terms used for the Heptastadium in other sources see: P.M. Fraser, 'The διόλκος of Alexandria', *JEA* 47 (1961) 135–6.

79. More than half the time the prevailing winds and swell come from the northwest, reaching 70 to 90 per cent of the time in the summer (from June to September). The other main wind direction is from the north-east, 20 to 30 per cent of the time in the winter, from October to May. Details: A. de Graauw in Goddio *et al. Alexandria* 53, 57–8, fig. 9 on p. 54.

80. So also Fraser *Ptol. Alex.* vol. 2, 59 n. 138.

81. Letter of Aristeas, 301, *Aristeas to Philocrates (Letter of Aristeas)*, ed. tr. M. Hadas (New York 1951) 216–19. Date: J.R. Bartlett, *Jews in the Hellenistic World* (Cambridge 1985) 16–17. Brief summary of background and possible dates: E. Schürer, *The History of the Jewish People in the Age of Jesus Christ (175 BC–AD 135)*, eds. G. Vermes *et al.*, vol. 3 part 1 (rev. edn Edinburgh 1986) 677–87.

82. Caesar, *Civil Wars* 3. 112; Strabo, *Geography* 17. 1. 6.

83. Blackman *loc. cit.* (n. 71) 198–202; A. de Graauw in Goddio *et al. Alexandria* 58; J.-P. Goiran *et al.*, 'Évolution géomorphologique de la façade maritime d'Alexandria (Égypte),' *Mediterranée* 104, 1.2 (2005) 61–4.

84. Goddio *et al. Alexandria* 35–7, 55–6, photo 32, fig. 10 on p. 56, plan on p. 34. The planks are of pine with a Carbon 14 date of 250 ± 45 BC.

85. Vitruvius, *On Architecture* 5. 12. 2–6.

86. Blackman *loc. cit.* (n. 71) 197, 210 n. 85; J.P. Oleson, 'Technology of Roman Harbours', *IJNA* 17 (1988) 147–57. The earliest dated example of pozzolana-mortar concrete set under water is at Cosa from the mid-first century BC or slightly later: J.P. Oleson *et al.*, 'The ROMACONS Project: a Contribution to the Historical and Engineering Analysis of Hydraulic Concrete in Roman Maritime Structures', *IJNA* 33.2 (2004) 202, 225–6. Previously thought to be late second or early first century BC: Oleson *loc. cit.* 149.

87. Oleson *loc. cit.* (n. 86) 152–5; C. Brandon, 'The Concrete-filled Barges of King Herod's Harbour at Sebastos', in S. Swiny *et al.*, eds., *Res Maritimae* (Atlanta 1997) 45–57; C. Brandon, S. Kemp and M. Groove, 'Pozzolana, Lime and Single-mission Barges (area K)', in K.G. Horum, A. Raban and J. Patrich, eds., *Caesarea Papers 2, JRA* suppl. 35 (Portsmouth RI 1999) 173–5.

88. Goddio *et al. Alexandria* 18–52. The rough outline of the harbour formed by Antirrhodos and the large promontory to the east of it in also indicated by the water depths in G. Jondet, *Les Ports submergés de l'ancienne île de Pharos* (Cairo 1916) pl. 3.

The structures recorded in the western side of the harbour have not yet been published in detail: F. Goddio and A. Bernard, *Sunken Egypt: Alexandria* (London 2004) 146–65. That they are man-made was indicated by the labels on some of them on Mahmoud-Bey's plan. Plan of Goddio in S. Kingsley, 'Anatomy of the Port of Alexandria', *Minerva* 12.4 (July/Aug. 2001) fig. 1 on p. 41.

89. Strabo, *Geography* 17. 1. 6.

90. Athenaeus, *Deipnosophistae* 5. 203d: 'The largest ships owned by him were: two with thirty banks of oars, one with twenty, four with thirteen, two with twelve, fourteen with eleven, thirty with nine, thirty-seven with seven, five with six, and seventeen with five. But the number of ships with rowers ranging from four banks to one and a half was double the others.' The types of ships are explained in: L. Casson, *Ships and Seafaring in Ancient Times* (London 1994) 81–9.

91. A. de Graauw in Goddio *et al. Alexandria* 53–5. He gives the total number of ships as *c.* 265 rather than 336, but as he has space for 100 more 'fives' the latter total would still fit.

92. Jondet *op. cit.* (n. 88); *idem*, 'Les Ports antiques de Pharos' *BSAA* 14 (1912) 252–66; E. Breccia, Review of G. Jondet, *Les Ports submergés de l'ancienne île de Pharos*, *BSAA* 16 (1918) 137–43; Adriani *Repertorio* 58–9; Tkaczow *Topography* 49–50 site 1C. On G. Jondet: S. Marcos and N. Tongring, 'Gaston Jondet, The Discoveror of the Ancient Harbour of Alexandria, A Sketch of his Public Life', *BSAA* 46 (2000) 179–82.

Harbour works were also recorded for the quarry at el-Dekhela, west of Alexandria: B. Malaval, 'Un ancien port à Dékhéla', *BSAA* 11 (1909) 371–4. These were of very large ashlars, without mortar, which Malaval assumes are Ptolemaic. Their line followed that also used by the modern breakwater.

93. Jondet *op. cit.* (n. 88) 5, 71–3. Later comments: *idem*, 'Les Ports antéhelléniques de la côte d'Alexandrie et l'empire crétois par M. Raymond Weill', *BSAA* 17 (1919) 167–78; A. Breccia, 'Il porto d'Alessandria d'Egitto studio di geografia commerciale', *Mémoires de la Société royale de geographie d'Égypte* 14 (1927) 1–6. Blackman, *loc. cit.* (n. 71) 196, when discussing other breakwaters notes that the 'dating of such structures is exceptionally difficult'. Summary of discussion of dates: Fraser *Ptol. Alex.* vol. 2, 8 n. 21. Fraser did not consider these harbour works to be Ptolemaic. Petrie observed that the 'submerged harbour may well be *all* Ptolemaic' in E. Bevan, *A History of Egypt under the Ptolemaic Dynasty* (London 1927) 7 n. 1. So also: D. Clarke, 'Alexandrea ad Aegyptum. A Survey', *Farouk I University Bulletin of the Faculty of Arts* 5 (1949) 101. Suggestion of a Minoan date (*c.* 2000–1470 BC): R. Weill, 'Les Ports antéhelléniques de la côte d'Alexandrie et l'empire crétois', *BIFAO* 16 (1919) 1–37. Whilst acknowledging that they are not conclusively dated, Grimm suggests that they might be Minoan and represents them on his map schematically, as on Fraser's map: Grimm *Alexandria* 17, fig. 9; Fraser *Ptol. Alex.* vol. 1, 6, map opp. p. 8. Some modern scholars have dismissed them as never having existed, on the grounds that those at the eastern end of the island are natural land forms. Given the detail with which Jondet recorded them there can be little doubt that these ruins existed. He was also careful to note their man-made character as well as when they included natural reefs. It should be noted that none of the earlier scholars, who were alive when they were still visible, doubted the existence or man-made nature of these harbour works. Prof. M. el-Abaddi who grew up on Pharos confirms their existence (pers. com. 2002).

94. *P.Halle* 1. 215.

95. *P.Halle* 1. 194–5. Calderini *Dizionario* vol. 1, 88–9; R. Martin, *Recherches sur l'agora grecque* (Paris 1951) 412–15; Adriani *Repertorio* 203–4; Fraser *Ptol. Alex.* vol. 1, 30, vol. 2, 96 n. 215–16.

96. Strabo, *Geography* 17. 1. 9.

97. Theocritus, *Idyll* 17 line 112–14; *Theocritus*, tr. A.S.F. Gow (2nd edn Cambridge 1952) vol. 1, p. 136–7.

98. Athenaeus, *Deipnosophistae* 14. 620d. Date of Hegesias: M. Bonaria, 'Hegesias', *RE* suppl. 10 (1965) 244. Athenaeus gives his source as Jason's *On the Divine Honours to Alexander*. Possible date of Jason: Fraser *Ptol. Alex.* vol. 2, 65–6 n. 151. Written sources for the theatre: Calderini *Dizionario* vol. 1, 114–15.

99. Tomlinson *op. cit.* (n. 30) 103.

100. *Sylloge Inscriptionum Graecarum*, ed. W. Dittenberger, vol. 1 (Leipzig 1915) no. 390; tr. in M.M. Austin, *The Hellenistic World from Alexander to the Roman Conquest, A Selection of Ancient Sources in Translation* (Cambridge 1981) 359–61 no. 218. Date: Fraser *Ptol. Alex.* vol. 1, 224, 231, vol. 2, 372–3 n. 279; E. Rice, *The Grand Procession of Ptolemy Philadelphus* (Oxford 1983) 182.

101. Before the Hellenistic period a level area with slopes on either side for spectators was usually used, without necessarily stone seating. For stadium at Olympia, with a track 194 m long: L. Drees, *Olympia, Gods, Artists and Athletes* (London 1968) 87, 91–4. For hippodrome at Olympia see *ibid.* 97–100.

102. For archaeological evidence: *Description de l'Égypte*, vol. 5, 328–37, 477–82, vol. 10, 524–5, plates vol. 5, pl. 39.2–3; A. Lacroix and G. Daressy, eds., *Dolomieu en Égypte (30 Juin 1798–10 Mars 1799) Mémoires présentés à l'Institut d'Égypte* 3 (Cairo 1922) 30; G. Valentia, *Voyages and Travels to India, Ceylon, the Red Sea, Abyssinia and Egypt in the Years 1802–1806* (London 1811) vol. 3, 455, vol. 4, plan; G. Botti, *Plan du quartier 'Rhacotis' dans l'Alexandrie romaine* (Alexandria 1897) 2; Botti *Fouilles à la colonne* 50–9; E. von Sieglin and T. Schreiber, *Die Nekropole von Kôm-esch-Schukâfa, Expedition Ernst von Sieglin*, vol. 1 (Leipzig 1908) 19–20, pl. 10; Humphrey *Roman Circuses* 505–12.

103. Humphrey *Roman Circuses* 506, 508–9.

104. *Herodiani Technici Reliquiae*, ed. A. Lentz (Leipzig 1867–8) vol. 1, p. 371 line 1–2, vol. 2, p. 458 line 37 to p. 459 line 3. Epiphanius, *On Weights and Measures PG* 43, col. 257A; *Epiphanius' Treatise on Weights and Measures, The Syriac Version*, ed. tr. J.E. Dean (Chicago 1935) 12 p. 28. Lageion: Botti *Fouilles à la colonne* 50–9; Calderini *Dizionario* vol. 1, 124–5; A. Maricq, 'Une influence alexandrine sur l'art augustéen? Le Lageion et le Circus Maximus', *RA* 37 (1951) 26–46; Adriani *Repertorio* 225–6; Fraser *Ptol. Alex.* vol. 2, 100–1; Humphrey *Roman Circuses* 509–10.

105. Stadium in Faiyum: *SEG* XXVII 1114 and add. 1305; L. Koenen, *Eine agonistische Inschrift aus Ägypten und frühptolemäische Königsfeste* (Meisenheim 1977); Austin *op. cit.* (n. 100) 393–5 no. 234. Stadia at Olympia and Isthmia: P.Mil.Vogl. VIII 309 col. XII 23 p. 91 and col. XIII 10 p. 95; Posidippus ed. tr. Austin and Bastianini p. 102–3 no. 78 line 4 and p. 106–7 no. 82 line 2.

106. Dio Chrysostom, *Discourse* 32. 41–3 and 74: *Sammelbuch* III 6222.32; Humphrey *Roman Circuses* 510–11.

107. Athenaeus, *Deipnosophistae* 5. 197c–203b. His source is Kallixeinos of Rhodes, probably from the second century BC. Date of procession, on the occasion of the second Ptolemaieia in 275/4 BC: V. Foertmeyer, 'The Dating of the Pompe of Ptolemy II Philadelphus', *Historia* 37 (1988) 90–104. Previous discussion of date of procession: *c.* 280–270 BC, Fraser *Ptol. Alex.* vol. 1, 202, 557; *c.* 280–275 BC, Rice *op. cit.* (n. 100) 182–5. Discussion of procession: Fraser *Ptol. Alex.* vol. 1, 202–7; Rice *op. cit.* (n. 100). This is the only time a stadium was so described (personal communication from A. Segal). It also suggests that there was possibly more than one stadium in the city by this date.

108. Rice *op. cit.* (n. 100) 29–31, 34–5, assumes that the stadium in which the procession occurred was near the *akra* and near the palace area. However, she notes that Greek religious processions finished at the main temple of the honoured god. The route from the promontory el-Silsila (akra Lochias) to the Serapeum would provide a suitable lengthy route through the city.

109. Both were in the middle of winter: Athenaeus, *Deipnosophistae* 5. 196d and 197d.

110. Rice, *op. cit.* (n. 100) 32–4, assumes that the *akra* was an elevated citadel in the palace area, following Fraser, *Ptol. Alex.* vol. 1, 31, vol. 2, 99 n. 228. Tomlinson, *op. cit.* (n. 30) 102, notes the lack of suitable high ground, but that the *akra* was adjacent to the palace, without identifying it with the akra Lochias.

111. Athenaeus, *Deipnosophistae* 5. 196a–197c.

112. On *syringes*: Nielsen *Palaces* 232 n. 247.

113. The most famous reconstruction is that of: F. Studniczka, *Das Symposion Ptolemaios II* (Leipzig 1914). Other alternatives: F.E. Winter and A. Christie, 'The Symposium-Tent of Ptolemy II: a New Proposal', *Échos du monde classique* 29 (1985) 289–308; E.S. Prina Ricotti, 'Le tende conviviali e la tenda di Tolomeo Filadelfo', in R.I. Curtis, ed., *Studia Pompeiana & classica in Honor of W.F. Jashemski*, vol. 2 (New York 1989) 199–239; Grimm *Alexandria* fig. 53. See also: R.A. Tomlinson, 'The Ceiling of Anfushy II.2', in *Alessandria e il mondo ellenistico-romano, Studi in onore di A. Adriani*, vol. 2 (Rome 1984) 260–4; H. von Hesberg, 'Temporäre Bilder oder die Grenzen der Kunst. Zur Legitimation frühhellenistischer Königsherrschaft im Fest', *JdI* 104 (1989) 61–82. Like Studniczka, Winter and Christie, *loc. cit.* 306–7, suggest that it was the predecessor of the Roman basilica, i.e. 'of large covered spaces with an internal peristyle supporting a clerestory roofed with the aid of long-span wooden beams'. Athenaeus describes the main set of columns as being 50 cubits high. He then describes a peristyle as occurring around three sides of this. However, as he gives no indication of the height of the columns of this peristyle, both of these reconstructions are dependent on the assumption that the columns of it are shorter than the main set in order to create a clerestory.

114. Nielsen *Palaces* 21–2, 133–6, 221 n. 58 with references. Rock-cut examples of a colonnade with a curved ceiling survive in the Tombs of the Kings at Paphos in Cyprus, built under Ptolemaic influence: J. Mlynarczyk, 'Palaces of Strategoi and the Ptolemies in Nea Paphos', in Hoepfner and Brands *Basileia* 201 fig. 7.

115. Theocritus, *Idyll* 15, especially lines 22–4, 60, 65, 78–86, 119–22; *Theocritus*, tr. A.S.F. Gow (2nd edn Cambridge 1952) vol. 1, p. 108–21; Fraser *Ptol. Alex.* vol. 1, 197. See also von Hesberg *loc. cit.* (n. 113). Date: Gow *op. cit.* vol. 2, 264–5.

116. Letter of Aristeas, 173.

117. Letter of Aristeas, 181; Nielsen *Palaces* 23.

118. Letter of Aristeas, 183; Nielsen *Palaces* 22. Nielsen assumes that the banquet took place in the audience hall.

119. Letter of Aristeas, 301.

120. Snakes and elephants: Diodorus Siculus, 3. 36. 3–3. 37. 8; Fraser *Ptol. Alex.* vol. 2, 782 n. 200. In 257 BC a variety of domestic animals for breeding were sent to Ptolemy II from Tobias in Transjordan: *P.Cair.Zen.* I 59075.

121. Athenaeus, *Deipnosophistae* 14. 654c; Nielsen *Palaces* 133.

122. J.W. White, *The Scholia on the Aves of Aristophanes* (Boston 1914) xii; Fraser *Ptol. Alex.* vol. 1, 15, 515.

123. Nielsen *Palaces* 31, 49–51, 224 n. 112.

124. I. Nielsen, 'Oriental Models for Hellenistic Palaces?', in Hoepfner and Brands *Basileia* 211. The evidence for the Museum being part of the royal palaces comes from Strabo, *Geography* 17. 1. 8.

125. Herodas, *Mime* 1, line 31. Fraser *Ptol. Alex.* vol. 1, 315, vol. 2, 469 n. 73, 876–8 n. 30.

126. Origin and organization of the Museum in Alexandria: Fraser *Ptol. Alex.* vol. 1, 312–19; Pfeiffer *op. cit.* (n. 47) 96–8; M. el-Abbadi, *The Life and Fate of the Ancient Library of Alexandria* (Paris 1990) 84–90. Texts mentioning the Museum: Calderini *Dizionario* vol. 1, 128–30. Description of Museum in Athens: Fraser, *Ptol. Alex.* vol. 1, 314, vol. 2, 468 n. 63.

127. Plutarch, *Non posse suaviter vivi secundum Epicurum* 13, p. 1095D; Pfeiffer *op. cit* (n. 47) 96; Fraser *Ptol. Alex.* vol. 1, 314–15.

128. P.Mil.Vogl. VIII 309 col. X 16–25 p. 75; Posidippus ed. tr. Austin and Bastianini p. 86–7 no. 63.

129. For the Library and its history see: G. Parthey, *Das Alexandrinische Museum* (Berlin 1838) 64–84; F. Schmidt, *Die Pinakes des Kallimachos (Klassisch-philologische Studien* vol. 1) (Berlin 1922); Calderini *Dizionario* vol. 1, 102–4; E.A. Parsons, *The Alexandrian Library* (London 1952); Butler *op. cit.* (n. 66) 401–26; Pfeiffer *op. cit.* (n.

47) 98–104, 126, 236–7; Fraser *Ptol. Alex.* vol. 1, 320–35; E. Makowiecka, *The Origin and Evolution of Architectural Form of Roman Library* (Warsaw 1978) 11–21; el-Abbadi *op. cit.* (n. 126); L. Canfora, *The Vanished Library* (London 1991); 'From Romance to Rhetoric: The Alexandrian Library in Classical and Islamic Traditions', *The American Historical Review* 97 (1992) 1449–67; H. Blanck, *Das Buch in der Antike* (Munich 1992) 137–48, 185; R. Blum, *Kallimachos, The Alexandrian Library and the Origins of Bibliography* (Madison 1991) 99–113. On later translation of works from it: M. el-Abbadi, 'The Alexandria Library in History', in A. Hirst and M. Silk, eds., *Alexandria, Real and Imagined* (London 2004) 167–83. On the collection of texts for the library of the Assyrian king Ashurbanipal in Nineveh, *c.* 648 BC: G.B. Lanfranchi, 'The Library at Nineveh', in J.G. Westenholz, ed., *Capital Cities* (Jerusalem 1998) 147–56; D.T. Potts, 'Before Alexandria: Libraries in the Ancient Near East', in R. MacLeod, ed., *The Library of Alexandria, Centre of Learning in the Ancient World* (London 2000) 19–33.

130. Athenaeus, *Deipnosophistae* 5. 203e. It is sometimes suggested that the term 'the gathering' (*synagogon*) when used by Plutarch refers to the scholars in the Museum: Pfeiffer *op. cit.* (n. 47) 96, 97 n. 4; Fraser *Ptol. Alex.* vol. 2, 469 n. 69.

131. Letter of Aristeas, 9–10. The mention of Demetrius of Phalerum, who was active under Ptolemy I, is probably erroneous, as he was banished by Ptolemy II early in his reign. Similarly, Aristeas cannot have been present if he was writing in the mid-second century BC. Hadas *op. cit.* (n. 81) p. 96–7 n. 9–10; Fraser *Ptol. Alex.* vol. 1, 690.

132. Blanck *op. cit.* (n. 129) 85–6, 140; *OCD*³ 250.

133. Fraser *Ptol. Alex.* vol. 1, 325; Blanck *op. cit.* (n. 129) 139; Delia *loc. cit.* (n. 129) 1457.

134. *Suidae Lexicon*, ed. A. Adler, part 3 (Leipzig 1933) 19, 227 line 28–9; tr. in A. Cameron, *Callimachus and His Critics* (Princeton 1995) 220. Discussion: Schmidt *op. cit.* (n. 129) 21–7, 34–42, 46–106; Pfeiffer *op. cit.* (n. 47) 128–34; el-Abbadi *op. cit.* (n. 126) 101–2; Delia *loc. cit.* (n. 129) 1458 n. 36; Blum *op. cit.* (n. 129) 124–37, 150–60, 182, 226–39. Fragments of the catalogue (the Pinakes): *Callimachus* vol. 1 *Fragmenta*, ed. R. Pfeiffer (Oxford 1949) 344–9 nos. 429–53; tr. Blum *op. cit.* (n. 129) 152–3, 158.

135. If the scrolls in which Callimachus was writing were 8 m long, written on one side, in columns 10 cm wide, with 40 lines per column and three lines average per entry, and it is assumed each entry represented approximately one scroll, this would give a figure of 128,000 scrolls. An average of two lines per entry would give 192,000. These figures would decrease if the number of lines per column were less, and increase if the columns were narrower. John Tzetzes, writing in the twelfth century AD, gives the number as 490,000 in the time of Callimachus: *Comicorum Graecorum Fragmenta*, ed. G. Kaibel, vol. 1 (Berlin 1899) p. 19 20, p. 31 25; tr. of earliest version: Blum *op. cit.* (n. 129) 104–5. Discussion: White *op. cit.* (n. 122) xiii; Fraser *Ptol. Alex.* vol. 1, 328–9; Blanck *op. cit.* (n. 129) 140; Blum *op. cit.* (n. 129) 104–13. As Pfeiffer, *op. cit.* (n. 47) 102, had concluded, despite the differences between Aristeas and Tzetzes: 'They agree, however, in one point, that hundreds of thousands of papyrus rolls were stored there during the first half of the third century BC'. One hundred thousand scrolls would be the equivalent of five hundred or so Greek authors writing an average of 200 rolls each, i.e., ten works with twenty 'books' (chapters) each (or twenty works of ten books each). Figures for size of scrolls: *OCD*³ 250; Blum *op. cit.*, n. 129, 107. Bagnall has independently done very similar types of calculations, but with some different results: R.S. Bagnall, 'Alexandria: Library of Dreams', *Proceedings of the American Philosophical Society* 146 (2002) 348–62. He points out (p. 352–3) that 450 known Greek authors go back to the late fourth century and 625 to the end of the third century BC, and as he allows 50 rolls per author this gives a total of 31,250 rolls. His other (lower) figures (10,000–15,000 rolls) are dependent on what percentage of all ancient Greek writings have survived, being reached if this was only one fortieth of the original total (p. 353). He calculates 142,560 lines in the *Pinakes* of Callimachus by allowing 44 lines per column and 27 columns per roll (p. 356 n. 36). Allowing his suggestion of two-thirds of the lines for titles (at one title per line) would give a total of 94,945 rolls. The difference between the possible totals estimated above illustrates the limits of such calculations.

136. For the architecture of other ancient libraries: C. Wendel, 'Die bauliche Entwicklung der antiken Bibliothek', *Zentralblatt für Bibliothekswesen* 11/12 (1949) 407–28; Makowiecka *op. cit.* (n. 129); Blanck *op. cit.* (n. 129) 179–214; P. Gros, *L'Architecture romaine*, vol. 1 (Paris 1996) 362–75; L. Casson, *Libraries in the Ancient World* (London 2001); W. Hoepfner, ed., *Antike Bibliotheken* (Mainz 2002).

137. The Library of Celsus: J.B. Ward-Perkins, *Roman Imperial Architecture* (London 1981) fig. 187–8; Blanck *op. cit.* (n. 129) fig. 87, 113.

138. Vienna Kunsthistorisches Museum Reg. no. III 86 (L); A.J. Reinach, 'ΔΙΟΣΚ–ΟΥΡΙΔΗΣ Γ ΤΟΜΟΓ', *BSAA* 11 (1909) 362–70; R. Noll, *Die griechischen und lateinischen Inschriften der Wiener Antikensammlung* (Vienna 1986) 41 no. 108; Adriani *Repertorio* 211; Delia, *loc. cit.* (n. 129) 1454–6; Tkaczow *Topography* 201 object 38; Bernand *op. cit.*(n. 42) 167–9 no. 65; Bagnall *loc. cit.* (n. 135) 354 fig. 2. The block is 0.44 m long, 0.40 m wide, and 0.26 m high. The recess in the top of it is 0.225 by 0.195 m and 0.08 m deep. The block does not have holes in the end of it. The drawings, based on descriptions, are not accurate in: Reinach *loc. cit.* fig. 96, 100 and Delia *loc. cit.* (n. 129) 1454 fig. 2. Its whereabouts was not known to scholars of Alexandria for many years: Clarke *loc. cit.* (n. 93) 101. However, its location in Vienna was mentioned in: A. Wilhelm, *Neue Beiträge zur griechischen Inschriftenkunde*, Teil. 4, = *Kaiserliche Akademie der Wissenschaften in Wien philosophisch-historische Klasse* Sitzungsberichte 179. Band, 6. Abhandlung (Vienna 1915) 34. It was found in the garden of the Austrian consul, de Laurin, later the site of the Bourse Toussoun, on the southern side of the main east-west street (Sharia el-Horreya) between cross streets R5 and R6: G. Botti, *Plan de la ville d'Alexandrie à l'époque ptolémaïque* (Alexandrie 1898) 64–6; R.M. Bloomfield, 'The Sites of the Ptolemaic Museum and Library', *BSAA* 6 (1904) 32–6. The library is marked on Hoepfner's map as possibly on this city block, as suggested by Mahmoud-Bey *Mémoire* 53 and Noll, *op. cit.* 41; Hoepfner and Schwandner *Stadt* fig. 225. Example of a block of related size (0.47 × 0.37 m, h. 0.25 m with recess 0.24 × 0.27 m,

depth 0.075 m) which is identified as a statue base by its inscription: Bernand *op. cit.* (n. 42) 73–5 no. 27, pl. 12.27. I thank Amanda Claridge for her observations on the Dioskourides block.

139. Background: A.E. Samuel, *The Shifting Sands of History: Interpretations of Ptolemaic Egypt* (London 1989) 68–72; L. Koenen, 'The Ptolemaic King as a Religious Figure', in A. Bulloch *et al.*, eds., *Images and Ideologies* (Berkeley 1993) 38–81; Hölbl *Geschichte* 69–107.

140. Theocritus, *Idyll* 17 line 123–5; Austin *op. cit.* (n. 100) 358–9 no. 217; Gow *op. cit.* (n. 115) vol. 1, p. 138–9.

141. Athenaeus, *Deipnosophistae* 5. 202d; Fraser *Ptol. Alex.* vol. 1, 228.

142. *P.Hibeh* II 199; Hölbl *Geschichte* 88, 301 n. 96 with references.

143. Herodas, *Mime* 1, line 30. Fraser *Ptol. Alex.* vol. 1, 228, vol. 2, 386 n. 369, 876–8 n. 30.

144. Cairo Egyptian Museum no. 22181; H. De Meulenaere and P. MacKay, *Mendes II* (Warminster 1976) 173–7; Hölbl *Geschichte* 94–8. Background: J. Quaegebeur, 'Documents égyptiens anciens et nouveaux relatifs à Arsinoé Philadelphe', in H. Melaerts, ed., *Le Culte du souverain dans l'Égypte ptolémaïque au III* siècle avant notre ère (*Studia Hellenistica* 34) (Leuven 1998) 73–108. Date of death of Arsinoe II: H. Cadell, 'À quelle date Arsinoé II Philadelphe est-elle décédée?', in Melaerts *op. cit.* 1–3; M. Minas, 'Die Kanephoros. Aspekte des ptolemäischen Dynastiekults', in Melaerts *op. cit.* 43.

145. Pliny, *Natural History* 34. 42 (148). So also: Ausonius, *Moselle* 311–15. Writing in the fourth century AD, he confuses Dinochares with Timochares.

146. Fraser *Ptol. Alex.* vol. 1, 25, vol. 2, 72–3 n. 168.

147. Pliny, *Natural History* 37. 32 (108). Identification of the stone as peridot: G.F.H. Smith and F.C. Phillips, *Gemstones* (London 1958) 348, 350; A. Lucas, *Ancient Egyptian Materials and Industries*, rev. J.R. Harris (4th edn London 1962, repr. 1989) 402; *Pliny, Natural History*, tr. D.E. Eichholz (London 1962) vol. 10, p. 250 note c. The size makes it unlikely to have been carved from a single stone. I thank P.R.S. Moorey for his comments on this. Fraser, *Ptol. Alex.* vol. 2, 74–5 n. 170, identifies the stone as topaz.

148. Pliny, *Natural History* 36. 14 (67–9); Ricc *op. cit.* (n. 100) 154–5.

149. R. Engelbach, *The Aswân Obelisk* (Cairo 1922) 3, 9, pl. 1.

150. Pliny, *Natural History* 36. 14 (69). For date the obelisk was moved: see Ch. 8 n. 20.

151. *Callimachus*, ed. R. Pfeiffer, vol. 1 (Oxford 1959) p. 218; Fraser *Ptol. Alex.* vol. 1, 25, vol. 2, 72–3 n. 167. Another commentator (quoted by Fraser) notes that Ptolemy sent black cows into the temenos of Arsinoe described as 1000 *arourai* in size. Clearly 1000 *arourai* is too large, however, it could have come from confusion of the Egyptian hieroglyphic term 'a thousand' which was 10 square *khet* or 10 *arourai*. This would be a logical size of *c.* 1/3 of a large city block of *c.* 30 *arourai* in area. The area of 10 *arourai* is the equivalent of 200 × 500 cubits or *c.* 105 × 263 metres.

152. Strabo, *Geography* 17. 1. 9.

153. One epigram was preserved on the same papyrus, of not later than 161 BC, as the one about the Lighthouse: P.Louvre 7172 = Posidippus ed. tr. Austin and Bastianini p. 144–5 no. 116; ed. tr. Gow and Page *op. cit.* (n. 48) vol. 1, p. 169–70 no. 12, vol. 2, 491–2; Page *op. cit.* (n. 48) 447–9 no. 104b; Fraser *Ptol. Alex.* vol. 1, 239, 568–9, vol. 2, 389 n. 393. A second epigram is preserved in P.Mil.Vogl. VIII 309 col. VI 30–7 p. 57; Posidippus ed. tr. Austin and Bastianini p. 62–3 no. 39. Another epigram is preserved in Athenaeus, *Deipnosophistae* 7. 318d; Fraser *Ptol. Alex.* vol. 1, 239, 569, vol. 2, 812 n. 140; Posidippus ed. tr. Austin and Bastianini p. 152–3 no. 119. Arsinoe-Aphrodite of Zephyrion is also mentioned in the epigram of Callimachus about the dedication of a shell, preserved in Athenaeus, *Deipnososphistae* 7. 318b–c; Fraser *Ptol. Alex.* vol. 1, 587, vol. 2, 834–5 n. 263.

154. *P.Hibeh* II 199 lines 11–17; Fraser *Ptol. Alex.* vol. 1, 222, vol. 2, 364 n. 208; Hölbl *Geschichte* 97, 301 n. 96 with references.

155. Posidippus ed. tr. Austin and Bastianini p. 144–5 no. 116 line 1; Adriani *Repertorio* 249. Suggestion that Zephyrion was on the modern headland of el-Montazah, as the most conspicuous headland between Alexandria and Abuqir: Fraser *Ptol. Alex.* vol. 2 n. 388–9 n. 390. Identification of Zephyrion with Canopus and the promontory at Abuqir: J. Faivre, *Canopus, Menouthis, Aboukir* (Alexandria 1918) 11–18, pl. 2; E. Breccia, *Monuments de l'Égypte gréco-romaine* (Alexandria 1926) 12, pl. 2. So also: J. Yoyotte *et al.*, *Strabon, le voyage en Égypte* (Paris 1997) 106 n. 195. Zephyrion and Canopus cannot be the same place because they are mentioned as separate quarters of the city in the Syriac *Notitia Urbis*: P.M. Fraser, 'A Syriac *Notitia Urbis Alexandrinae*', *JEA* 37 (1951) 104.

156. Epigram of Hedylus preserved in Athenaeus, *Deipnosophistae* 11. 497d–e; Fraser *Ptol. Alex.* vol. 1, 239, 571, vol. 2, 815 n. 153–4; J. Yoyotte in Goddio *et al.* *Alexandria* 218. Date of Ktesibios: Fraser *Ptol. Alex.* vol. 2, 622–3 n. 445–6.

157. *P.Lond.* 2243 = H.I. Bell, 'Notes on Early Ptolemaic Papyri', *Archiv für Papyrusforschung*, ed. U. Wilcken (Berlin 1920) vol. 7, 19–21; *Sammelbuch* X 10251; Fraser *Ptol. Alex.* vol. 1, 35, vol. 2, 110 n. 276.

158. *P.Halle* I. 91–7.

159. The inscription was found in the eastern suburbs. Greco-Roman Museum no. 36; Fraser *Ptol. Alex.* vol. 1, 194, vol. 2, 326 n. 18; Tkaczow *Topography* 206 no. 49; Bernand *op. cit.* (n. 42) 37, 44–7 no. 14, pl. 6.14.

160. Rowe *Encl. Serapis* 1–10, 51–3, 59 fig. 1–3, 12, pl. 1–2, 7, 9–11; Fraser *Ptol. Alex.* vol. 1, 27–8; J.M. Weinstein, *Foundation Deposits in Ancient Egypt*, PhD University of Pennsylvania 1973 (*UMI* Ann Arbor) 368–9, 379–81 no. 162; Grimm *Alexandria* 83, fig. 84a–b,d,f–g; *La Gloire d'Alexandrie* (Paris 1998) 95 no. 51; Bernand *op. cit.* (n. 42) 42–3 no. 13, pl. 6.13.

161. Rowe *Encl. Serapis* 13–19, 65; Weinstein *op. cit.* (n. 160) 351–93.

162. Analysis of Ptolemaic archaeological evidence, especially for temple and temenos: Rowe *Encl. Serapis* 19–33, pl. 3, 6–9, 17; A. Rowe and B.R. Rees, 'A

Contribution of the Archaeology of the Western Desert: IV. The Great Serapeum of Alexandria', *BullJRylandsLib* 39.2 (1957) 487–95, plan opp. p. 492; Adriani *Repertorio* 93–4, fig. F on p. 91, pl. 29–31; Fraser *Ptol. Alex.* vol. 1, 266–70; R.A. Wild, *Water in the Cultic Worship of Isis and Sarapis* (Leiden 1981) 167–8; Sabottka *Serapeum* vol. 1, 56–177, 183–248, with many drawings and photographs from Thiersch's expedition of 1900/1; Pensabene *Elementi Aless.* 195–203; Tkaczow *Topography* 68–70. Detailed discussion and basis for reconstruction: McKenzie *et al. loc. cit.* (n. 44) 73–90. Other fragments of entablatures, cornices and capitals found at the site: G. Grimm and J.S. McKenzie, 'Architectural Fragments found in the Excavations of the Serapeum in Alexandria in *c.* 1901', *JRS* 94 (2004) 115–21.

163. Rowe *Encl. Serapis* 31–2, pl. 7, 12; Rowe and Rees *loc. cit.* (n. 162) 492–3; Wild *op. cit.* (n. 162) 29–31, fig. 12–13; Sabottka *Serapeum* vol. 1, 56–251, vol. 3, fig. 54–5, vol. 4, pl. 112–14.

164. As the plan does not indicate a classical temple, suggestions have included a monumental altar, a mausoleum, library or a Dynastic period temple: A. Rowe, 'New Excavations at "Pompey's Pillar" Site', *BSAA* 35 (1941–2) 144–52, pl. 29.2, 30–2, 34.1; Rowe *Encl. Serapis* 31; Adriani *Repertorio* 95, pl. 30 fig. 106; Fraser *Ptol. Alex.* vol. 1, 269; Sabottka *Serapeum* vol. 1, 231–46, vol. 3, fig. 47–53, vol. 4, pl. 1, 5, 27, 100–11.

165. G. Botti, *L'Acropole d'Alexandrie et le Sérapeum d'après Aphthonius et les fouilles* (Alexandria 1895) 24–7 with plan; Botti *Fouilles à la colonne* 112–21; Rowe *loc. cit.* (n. 164) 140 fig. 7, pl. 32, 35.3; Rowe *Encl. Serapis* 34–6; Rowe and Rees *loc. cit.* (n. 162) 498–9; Adriani *Repertorio* 95–6, pl. 31 fig. 110–11; Fraser *Ptol. Alex.* vol. 1, 269, vol. 2, 425 n. 660; Sabottka *Serapeum* vol. 1, 213–23, vol. 3, fig. 39–44, vol. 4, pl. 77–99.

166. McKenzie *et al. loc. cit.* (n. 44) 83–4.

167. Epiphanius, *On Weights and Measures* 11, *PG* 43, col. 255. John Tzetzes, in the twelfth century AD, mentions that under Ptolemy II there was a second library outside the palace with 42,800 scrolls: Blum *op. cit.* (n. 129) 104–5. It should be remembered that the lateness of this source does not necessarily make it particularly reliable. However, the archaeological evidence does not indicate that this library could not have been begun by Ptolemy II Philadelphus (contra: Pfeiffer *op. cit.* n. 47, 102). It is unlikely the underground passages were used when suitable buildings could have been available above ground (contra: Delia *loc. cit.* n. 129, 1458–9). Fraser *Ptol. Alex.* vol. 1, 323–4, assumes the library was established by Ptolemy III Euergetes I possibly in the rooms on the southern side of the temenos.

168. E. Breccia, 'Les Fouilles dans le Sérapéum d'Alexandrie en 1905–1906', *ASAE* 8 (1907) 62–76; PM IV, 3; Rowe *loc. cit.* (n. 164) 133–4, 139, 154–9; Rowe *Encl. Serapis* 40–1, 50, 59–60; Rowe and Rees *loc. cit.* (n. 162) 507–10; Fraser *Ptol. Alex.* vol. 1, 265–6; Tkaczow *Topography* p. 187–8 nos. 7–11, p. 233–7 nos. 122, 123, 125, 127–33, 136, p. 311–13 nos. 334–9; Ashton *Ptol. Sculpture* 82 nos. 1–2, 118 no. 69, fig. 1–2, 69; S. Walker and P. Higgs, eds., *Cleopatra of Egypt from History to Myth* (London 2001) 73–5 nos. 52–4, fig. 52–4; McKenzie *et al. loc. cit.* (n. 44) 100–1. Updating of lists of Egyptian style sculptures in Serapeum: J. Yoyotte in Goddio *et al. Alexandria* 212 n. 59. Large block of Ramesses II now at Serapeum site, but not found there: A. Abd el-Fattah and P. Gallo, 'Aegyptiaca Alexandrina. Monuments pharaoniques découverts récemment à Alexandrie', in J.-Y. Empereur, ed., *Alexandrina* 1, *ÉtAlex* 1 (1998) 7–8 no. 1, 15 fig. 2–3.

169. Mahmoud-Bey *Mémoire* 66–7; Adriani *Repertorio* 254–5 with bibliography; Tkaczow *Topography* 177–8 site 148 with bibliography, 196–7 object 29, photographs of obj. 29. The fragments include the head of dark grey granite in the garden of the Greco-Roman Museum, Alexandria, labelled 'Mark Antony' (inv. 11275) and the queen's head in Mariemont, Belgium (inv. E 49). Summary of arguments for date of sculpture and suggested reconstruction of it, with bibliography: M.C. Bruwier, 'Deux fragments d'une statue colossale de reine ptolémaïque à Mariemont', *Chronique d'Égypte* 64 (1989) 25–43; Ashton *Ptol. Sculpture* 98 no. 34, 102 no. 42, fig. 34, 42. This building is sometimes identified as the Thesmophoreion, although there is no reason for this other than the fact that both it and Eleusis were to the east of the city.

170. Archaeological evidence: A.J.B. Wace *et al.*, *Hermopolis Magna, Ashmunein, The Ptolemaic Sanctuary and the Basilica* (Alexandria 1959) 4–11, pl. 1–3, 10–17, 19; M. Baranski, 'The Archaeological Setting of the Great Basilica Church at el-Ashmunein', in D.M. Bailey, ed., *Archaeological Research in Roman Egypt*, *JRA* suppl. 19 (Ann Arbor 1996) 103–4, fig. 8.

Inscription and date: Wace *et al. op. cit.* 4–5; Fraser *Ptol. Alex.* vol. 1, 234–5, vol. 2, 384 n. 356; F. Rumscheid, *Untersuchungen zur kleinasiatischen Bauornamentik des Hellenismus* (Mainz 1994) vol. 1, 53–4. Wace suggests it was built with the benefits of the Third Syrian War, and so not much later than *c.* 240 BC.

Discussion of architectural order: W. Hoepfner, *Zwei Ptolemaierbauten*, *AM* Beiheft 1 (Berlin 1971) 78–83, fig. 9, pl. 24; Pensabene *Elementi Aless.* 248–53, 324–8, pl. 8–11, 12 no. 73, 19 nos. 121–2; Rumscheid *op. cit.* vol. 1, 53–4, vol. 2, 91–2 no. 370, pl. 196 nos. 3–8, 197 nos. 1–3.

171. Coulton *op. cit.* (n. 13) 171.

172. The plaque is now in the British Museum. *OGIS* I 60; Faivre *op. cit.* (n. 155) 14; Breccia *op. cit.* (n. 155) 52 no. 3, pl. 18.3; Fraser *Ptol. Alex.* vol. 2, 401 n. 486. Written sources for Canopus, with references: Calderini *Dizionario* vol. 3, 66–7; A. Bernand, *Le Delta égyptien d'après les textes grecs* 1.1 (Cairo 1970) 153–257.

173. C.S. Sonnini, *Voyage dans la Haute et Basse Égypte*, vol. 1 (Paris 1799) 390–5, pl. 5–7; Breccia *op. cit.* (n. 155) 9–82, pl. 1–47; Breccia *Musée gréco-romain 1925–31*, p. 2–9; O. Toussoun, 'Les Ruines sous-marines de la Baie d'Aboukir', *BSAA* 29 (1934) 342–54, pl. 8–9; Bernand *op. cit.* (n. 172) 259–90; Daszewski *Mosaics* 135–42 nos. 26–37, 176–7 no. 51, pl. 21b, 26–31b; Pensabene *Elementi Aless.* 60, 62, 217–18 with list of over one hundred architectural fragments which can be found in his catalogue and plates; Ashton *Ptol. Sculpture* 88 no. 15, 94 no. 27, 112 no. 59, 114 no. 62, 116 no. 66, fig. 15, 27, 59, 62, 66; P. Gallo, 'Aegyptiaca Alexandrina IV. Une nouvelle statue du pharaon Hakoris retrouvée à Abouqir', in J.-Y. Empereur, ed., *Alexandrina* 2, *ÉtAlex* 6

(Cairo 2002) 7–11; Stanwick *op. cit.* (n. 75) 20–1 types of sculptures. Recent discoveries at Herakleion (Thonis) east of Canopus, including pre-Ptolemaic remains, Egyptian temple and statues of a Ptolemaic king and queen, and Hapy: *The Times* 5–6 June, 2000; *The Sunday Times* Magazine, 20 August 2000; J. Yoyotte, 'Guardian of the Nile: Thonis Rediscovered', *Minerva* 13.3 (May/June 2002) 32–4. Subsidence below sea level of Herakleion (Thonis): J.-D. Stanley *et al.*, 'Submergence of Ancient Greek Cities Off Egypt's Nile Delta – a Cautionary Tale', *GSA Today* 14.1 (2004) 4–10. Catalogue of recent Herakleion and Canopus finds: F. Goddio and M. Clauss, eds., *Egypt's Sunken Treasures* (Berlin 2006).

174. Apollonius of Rhodes frag. 1 in *Collectanea Alexandrina*, ed. J.U. Powell (Oxford 1925) p. 4; Fraser *Ptol. Alex.* vol. 2, 421 n. 634. He was active during the reigns of Ptolemy II and III: Fraser *Ptol. Alex.* vol. 1, 331–2.

175. Date of Praeneste (Palestrina) Nile mosaic: P.G.P. Meyboom, *The Nile Mosaic of Palestrina* (Leiden 1995) 16–19. Identification of sanctuary at Canopus from tokens: Meyboom *op. cit.* 53–5, pl. 41–2.

176. Text and translations: P.Cair. 65445 line 140–54 = *Un livre d'écolier du IIIe siècle avant J.C.*, ed. O. Guéraud and P. Jouguet (Cairo 1938) 20–4, pl. 5; Page *op. cit.* (n. 48) 448–53 no. 105a; Fraser *Ptol. Alex.* vol. 1, 609, vol. 2, 860 n. 412; U.-W. Gans, 'Hellenistische Architekturteile aus Hartgestein in Alexandria', *AA* (1994) 448–9; Posidippus ed. tr. Austin and Bastianini p. 136–7 no. 113.

Assumption that it referred to the wife of Ptolemy IV Philopator, rather than of Ptolemy II Philadelphus, as Ptolemy IV is referred to in the next epigram on the papyrus concerning the dedication of the Homereion: Fraser *Ptol. Alex.* vol. 2, 861 n. 412. This was also suggested by an inscription (if it refers to the same building) 'To King Ptolemy Philopator and to Queen Arsinoe, the water reservoir (*hydreuma*) and the nymphaeum, Lucius the son of Gaius a Roman commandant (*phrourarch*) [dedicated]': *ILS* 9458 = *Inscriptiones Latinae Selectae*, ed. H. Dessau, vol. 3, part 2 (Berlin 1916) p. cli no. 9458; H. Lavagne, *Operosa Antra, Recherches sur la Grotte à Rome de Sylla à Hadrien* (Rome 1988) 133–4.

Identification of Arsinoe as wife of Ptolemy II: Grimm *Alexandria* 70, 72. Epigram possibly attributed to Posidippus: Austin and Bastianini p. 136 commentary. I thank Peter Parsons for clarifying this.

Reconstructions: B. Schweitzer, 'Ein Nymphäum des frühen Hellenismus', *Festgabe zur Winckelmannsfeier des Archäologischen Seminars der Universität Leipzig* (Leipzig 1938); D.S. Robertson in Page *op. cit.* (n. 48) 449–50; S. Settis, 'Descrizione di un ninfeo ellenistico', *Studi classici e orientali* 14 (1965) 247–57; A. Barigazzi, 'Due epigrammi ellenistici', *Atti dell'XI congresso internazionale di papirologia, Milano 1965* (Milan 1966) 69–85; G. Ronchi, 'Il papiro Cairense 65445 (vv. 140–54) e l'obelisco di Arsinoe II', *Studi classici e orientali* 17 (1968) 56–75; Grimm *Alexandria* fig. 72. The various possibilities are summarized, and alternatives suggested in: Lavagne *op. cit.* 127–35; D. Berg, *Fountains and Artistic Water Displays in Classical Antiquity. Origins and Development from 700 to 30 BC*, University of Texas at Austin PhD 1994 (*UMI*, Ann Arbor 1994) 95–104, 221 fig. 34. See also: F. Glaser, *Antike Brunnenbauten (krenai) in Griechenland* (Vienna 1983) 139–40, 163; *idem*, 'Brunnen und Nymphäen', in *Die Wasserversorgung antiker Städte*, vol. 2 (Mainz 1987) 117–18.

177. Petra: W. Bachmann *et al.*, *Petra* (Berlin 1921) 34–5, fig. 27–8; McKenzie *Petra* 132. Examples of later semi-circular nymphaea are given in: T. Aupert, *Le Nymphée de Tipasa* (Rome 1974) 104–11; Gros *op. cit.* (n. 136) 425–7, fig. 476–8, 481, 493–4. I thank Susan Walker for her observations concerning this.

178. Gros *op. cit.* (n. 136) 421, fig. 472.

179. Lavagne *op. cit.* (n. 176) 134–5.

180. Athenaeus, *Deipnosophistae* 5. 204d–206c; Nielsen *Palaces* 136, 232–3 n. 251–3, fig. 71; Casson *op. cit.* (n. 90) 134–7. Detailed reconstruction: F. Caspari, 'Das Nilschiff Ptolemaios IV', *JdI* 31 (1916) 1–74. Alternative reconstruction: M. Pfrommer in Grimm *Alexandria* 59–63, fig. 54a–d, 70. See also: M. Nowicka, *La Maison privée dans l'Égypte ptolémaïque* (Warsaw 1969) 154–6; A. Schmidt-Colinet, 'Exedra duplex. Überlegungen zum Augustusforum', in *Hefte des Archäologischen Seminars der Universität Bern* 14 (1991) 47–51.

181. Athenaeus, *Deipnosophistae* 5. 205a. Vitruvius, *On Architecture* 6. 3. 9. See also: Coulton *op. cit.* (n. 13) 182; Gans *op. cit.* (n. 176) 450.

182. Athenaeus, *Deipnosophistae* 5. 206a–c.

183. Athenaeus, *Deipnosophistae* 5. 206d–209b quoting 'a certain Moschion'. Rev. tr.: L. Casson, *Ships and Seamanship in the Ancient World* (Princeton 1971) 191–9. Discussion: Nielsen *Palaces* 173, 232–3 n. 251; Casson *op. cit.* (n. 90) 121–2.

184. G.F. Bass, ed., *A History of Seafaring Based on Underwater Archaeology* (London 1972) 69 fig. 5, pl. 6; Casson *op. cit.* (n. 90) 137–40, fig. 91, 103–4. It was destroyed during the Second World War.

185. Athenaeus, *Deipnosophistae* 5. 203e–204d; Casson *op. cit.* (n. 183) 108–12, fig. 112–13; Casson *op. cit.* (n. 90) 86–8. Other ancient slipways: Blackman *loc. cit.* (n. 71) 204–6. Unloading near Serapeum of Rhakotis: Fraser *Ptol. Alex.* Vol. 1, 144, vol. 2, 78 n. 182.

186. Found in the excavations for the then new Bourse, only the gold plaque was preserved. G. Maspero, 'Sur une plaque d'or portant la dédicace d'un temple', *Recueil de travaux* 7 (1886) 140–1; Néroutsos *Alexandrie* 21–2; J.P. Mahaffy, *The Empire of the Ptolemies* (London 1895) 73–4; *Sammelbuch* I 2136; Breccia *Alex. ad Aeg.* 12, 26, 75, 94; M.N. Tod, 'A Bilingual Dedication from Alexandria', *JEA* 28 (1942) 53–6 with earlier bibliography, pl. 6.1; Rowe *Encl. Serapis* 12–13, fig. 5; Rowe and Rees *loc. cit.* (n. 162) 509 n. 2; Adriani *Repertorio* 253; Weinstein *op. cit.* (n. 160) 385–6 no. 166; Tkaczow *Topography* 80 site 27, map B; Bernand *op. cit.* (n. 42) 53–6 no. 18.

187. Maspero *loc. cit.* (n. 186) 140.

188. Rowe *Encl. Serapis* 54–8, pl. 16; Rowe and Rees *loc. cit.* (n. 162) 509; Weinstein *op. cit.* (n. 160) 383–5 no. 165; Fraser *Ptol. Alex.* vol. 1, 261, 269, vol. 2, 412 n. 569; Sabottka *Serapeum* vol. 1, 178–82, vol. 3, fig. 2, 5, 35, vol. 4, pl. 64–7; Grimm

Alexandria 83, pl. 84c, e; *La Gloire d'Alexandrie* (Paris 1998) 95 nos. 50 and 52 (illustration incorrectly labelled); Bernand *op. cit.*(n. 42) 60–1 no. 21, pl. 9.21. Use of mud brick plaques or of pairs of holes going back to Dynastic period: Weinstein *op. cit.* (n. 160) 365–6, 368–9, 383–5. He suggests there were actually nine plaques in each hole, based on Egyptian custom.

189. Guéraud and Jouguet *op. cit.* (n. 176) 25–6; Page *op. cit.* (n. 48) 452–3 no. 105b; Barigazzi *loc. cit.* (n. 176) 70–5; Fraser *Ptol. Alex.* vol. 1, 611, vol. 2, 862–3 n. 423.

190. Polybius, 15. 27. 2 and 15. 29. 8. A circular altar found in Alexandria is dedicated to Ptolemy IV, Arsinoe III, Demeter, Kore and Dikaiosyne (the personification of Justice): Bernand *op. cit.*(n. 42) 62–3 no. 22, pl. 9.22.

191. Zenobius, *Proverbia* 3. 94 in *Paroemiographi Graeci*, ed. E.L. a Leutsch and F.G. Schneidewin, vol. 1 (Göttingen 1839) p. 81.

192. Strabo, *Geography* 17. 1. 8.

193. Julius Caesar 'went down (*descendit*) eagerly into the excavated vault of the burial mound' of Alexander the Great: Lucan, *Civil War (Pharsalia)* 10. 19.

194. Suetonius, *Lives, Deified Augustus* 18. 1.

195. Strabo, *Geography* 17. 1. 8.

196. Discussion of the Sema and possible locations of the tomb of Alexander: H. Thiersch, 'Die alexandrinische Königsnecropole', *JdI* 25 (1910) 55–97; Breccia *Alex. ad Aeg.* 96–100; E. Breccia, *Le Musée gréco-romain 1925–31*, 37–52; Calderini *Dizionario* vol. 1, 149–51; A. Rowe, 'A Contribution to the Archaeology of the Western Desert III', *BullJRylandsLib* 38 (1955) 139–61; Adriani *Repertorio* 242–5; Fraser *Ptol. Alex.* vol. 1, 15–17, 225, vol. 2, 32–3 n. 79, 34–41 n. 82–8 with references and summary of later legends; N. Bonacasa, 'Un inedito di Achille Adriani sulla tomba di Alessandro', *Studi Miscellanei* 28 (1984–5 [1991]) 5–19; Tomlinson *loc. cit.* 1996 (n. 30) 158–9; Green *loc. cit.* (n. 4) 18; G. Grimm in *La Gloire d'Alexandrie* (Paris 1998) 92–3; Grimm *Alexandria* 66–9, suggested location marked on fig. 22; Empereur *Alexandrie* 144–53; A. Adriani, *La Tomba di Alessandro. Realtà, ipotesi e fantasie*, ed. N. Bonacasa and P. Minà (Rome 2000); B. Tkaczow, 'Remarques sur la topographie et l'architecture de l'ancienne Alexandrie à la lumière des récentes découvertes archéologiques', *Archeologia* 53 (2002) 35–7.

197. Polybius, 5. 38–9. So also Plutarch, *Agis and Cleomenes* 37. Polybius appointed envoy: *OCD³* 1209. Date of uprising: Hölbl *Geschichte* 112.

198. III Maccabees, 2. 27–8. Greek text: *Maccabaeorum liber III*, ed. R. Hanhart (*Septuaginta Vetus Testamentum Graecum* vol. 9) (Göttingen 1980) 47. Date of this incident: *The Apocrypha and Pseudepigrapha of the Old Testament in English*, tr. R.H. Charles, vol. 1 (Oxford 1913) 155, 159–61; J.M. Modrzejewski, *The Jews of Egypt from Rameses II to Emperor Hadrian* (Princeton 1997) 142–52; Humphrey *Roman Circuses* 509.

199. III Maccabees, 4. 11, ed. Hanhart 54.

200. III Maccabees, 5. 23–4, ed. Hanhart 58.

201. III Maccabees, 5. 46 and 48–9, ed. Hanhart 61.

202. Plutarch, *Lives, Antony* 74. 3; Strabo, *Geography* 17. 1. 10. Identification with the Lageion: F.W. Walbank, *A Historical Commentary on Polybius*, vol. 2 (Oxford 1967) 490; Humphrey *Roman Circuses* 509–10. Humphrey points out that shutting the Jews up in it suggests a monumental structure which was enclosed.

203. *OGIS* II 726 With other examples from Egypt: Fraser *Ptol. Alex.* vol. 1, 282–3, vol. 2, 441 n. 766 no. (iii).

204. Polybius, 15. 25. 3. The term *megiston* implies 'very large' or 'largest'. If it were the latter it would mean that the palace had at least three colonnaded courts. However, it could just mean there was one very large court.

205. Polybius, 15. 25. 6–7. G. Grimm, 'Verbrannte Pharaonen?', *Antike Welt* 28 (1997) 233–49.

206. Polybius, 15. 25. 11.

207. Nielsen *Palaces* 81–99; W. Hoepfner, 'Zum Typus der Basileia und der königlichen Andro21es', in Hoepfner and Brands *Basileia* 8 fig. 5, 16 fig. 12, 28 fig. 22–3, 30 fig. 24–5.

208. Polybius, 15. 27. 2.

209. Polybius, 15. 29. 8–9; Fraser *Ptol. Alex.* vol. 1, 199. There is no basis for the identification, which is sometimes suggested, of the Thesmorphorion with the archaeological remains of the temple to the east of the city in n. 169 above.

210. Polybius, 15. 28. 4–5 and 15. 29. 1–2. For *skene* being the garrison: Walbank *op. cit.* (n. 202) vol. 2, 489.

211. Polybius, 15. 30. 3–9.

212. Nielsen *Palaces* 18–20, 130. She suggests this was a monumental portal.

213. Polybius, 15. 31. 2–4.

214. Polybius, 15. 31. 12.

215. Polybius, 15. 32. 2–4.

216. Polybius, 15. 32. 9.

217. For palaestra and gymnasia see: J. Delorme, *Gymnasion, étude sur les monuments consacrés à l'éducation en Grèce* (Paris 1960) 137–9. For gymnasia in Greece: F. Yegül, *Baths and Bathing in Classical Antiquity* (Cambridge, Mass. 1992) 7–21.

218. Strabo, *Geography* 17. 1. 10.

219. Walbank *op. cit.* (n. 202) vol. 2, 491; Nielsen *Palaces* 131.

220. *P.Oxy.* XXVII 2465 = *Oxyrhynchus Papyrii*, ed. G. Turner *et al.*, Part 27 (London 1962) p. 118–33. Date: *ibid.* 119.

221. *P.Oxy.* XXVII 2465 Frag. 3, col. ii; Fraser *Ptol. Alex.* vol. 1, 199–201; S. Skowronek and B. Tkaczow, 'Le Culte de la déesse Déméter à Alexandrie', in L. Kahil and C. Augé, eds., *Mythologie gréco-romaine, mythologies périphériques* (Paris 1981) 131–7.

222. Letoion: *P.Oxy.* XXVII 2465 Frag. 11, col. ii, line 6; Fraser *Ptol. Alex.* vol. 1, 196, vol. 2, 331 n. 43. Dioskoureion: *P.Oxy.* 2465 Frag. 11, col. ii, line 5; Fraser *Ptol. Alex.* vol. 1, 207. Thesmorphoreion: *P.Oxy.* 2465 Frag. 2, col. i, line 5.

223. *P.Oxy.* XXVII 2465 Frag. 2, col. i, line 6; Fraser *Ptol. Alex.* vol. 1, 228.

224. Greco-Roman Museum no. 17481; *Sammelbuch* I 589; Fraser *Ptol. Alex.* vol. 2, 441 n. 766 no. (ii); Tkaczow *Topography* 205–6 no. 48.

225. In Greek it is called a 'so-called four-cornered stoa' (*tetragonos kaloumene stoa*), which is sometimes colloquially translated as a 'square stoa'. Ptolemy is quoting Hipparchus and gives no indication that it is the palaestra. Claudius Ptolemy, *Syntaxis Mathematica [Amalgest]* in *Claudii Ptolemaei Opera quae exstant omnia*, vol. 1, ed. J.L. Heiberg (Leipzig 1898) 195–6. Discussion: *Ptolemy's Almagest*, tr. G.J. Toomer (London 1984) 133–4 H195–6; Fraser *Ptol. Alex.* vol. 1, 423, vol. 2, 98 n. 221, 609 n. 373. For the equatorial armillary see: C. Singer *et al.*, *A History of Technology*, vol. 3 (Oxford 1957) 587, fig. 343c on p. 589.

226. Coulton *op. cit.* (n. 13) 179. He does not specifically mention the Alexandrian examples.

227. *c.* AD 127–50. Toomer *op. cit.* (n. 225) p. 134 H197.

228. I. Akamantes, 'Η Αγορα της Πελλας κατα το 1991–1992', *Το Αρχαιολογικο Εργο στη Μακεδονια και Θρακη* 6 (1992) 112 fig. 1, 121; *idem*, 'Η Αγορα της Πελλας κατα το 1993', *Το Αρχαιολογικο Εργο στη Μακεδονια και Θρακη* 7 (1993) 185 fig. 1, 190; Tomlinson *op. cit.* (n. 30) 99; *idem loc. cit.* 1995 (n. 30) 238.

229. Coulton *op. cit.* (n. 13) 173–4.

230. Letter of Aristeas, 109–10; Bartlett *op. cit.* (n. 81) 25, 27.

231. F. Preisigke, 'Die Friedenskundgebung des Königs Euergetes II', *Archiv für Papyrusforschung*, ed. U. Wilcken, vol. 5 (Berlin 1913) 306–7 Abschnitt 5a.

232. Livy, 44. 19. 9–11; 45. 11. 1; Fraser *Ptol. Alex.* vol. 1, 12.

233. Diodorus Siculus, 33. 28b. 1–3.

234. Strabo, *Geography* 17. 1. 9.

235. Botti considered the blocks belonged to the theatre: G. Botti, 'L'Ancien Théâtre d'Alexandrie', *BSAA* 4 (1902) 119–21. The fragments found include Ionic and Doric capitals and some blocks of their entablatures: L. Borchardt, 'Von einer alexandrinischen Baustelle', *BSAA* 8 (1905) 1–6; Hoepfner *op. cit.* (n. 170) 55–91, pl. 13–23c, Beil. 23–31; E. Breccia, *Le Musée gréco-romain 1922–3*, 6, pl. 2–5.1; Adriani *Annuario* (1932–3) 67–9 nos. 29, 31, 33, 73 nos. 36–8, fig. 16–18, 21; W.A. Daszewski, 'Nouvelles découvertes dans le quartier des Basileia en Alexandrie', *ÉtTrav* 11 (1979) 104; W.A. Daszewski, 'Notes on Topography of Ptolemaic Alexandria', in *Alessandria e il Mondo ellenistico-romano, studi in onore di A. Adriani*, vol. 1 (Rome 1983) 60; Pensabene *Elementi Aless.* 213–14, 311–17, pl. 1–3, 4.20–1; Tkaczow *Topography* 145–8 sites 105–7B, 215–16 object 73, 218–20 objects 79–88. Date: Hoepfner *op. cit.* (n. 170) 87. Some of the entablature fragments were unfinished, but there is no reason to believe that the building was not 'finished' even if the carving of all the architectural decoration on it was not completed. Lower drum of Corinthian capital found with them: Tkaczow *Topography* 220–1 object 90.

The monumental foundations (possibly of it) which have been rediscovered recently are not on the orientation of the street grid, but are nearly parallel to the section of ancient city wall along the harbour: M. Rodziewicz and A. Abdel-Fatah, 'Recent Discoveries in the Royal Quarter of Alexandria', *BSAA* 44 (1991) 131–50. They are near the site identified as the location of the temple of Poseidon mentioned by Strabo two hundred years later. This possible identification had previously been suggested by Hoepfner in Hoepfner and Schwandner *Stadt* fig. 232.

236. Bibliography: Ch. 2 n. 13.

237. Marble seats: Botti *op. cit.* (n. 138) 136–7; Adriani *Repertorio* (1932–3) 78–9 no. 53 location marked on plan in pocket at back; Fraser *Ptol. Alex.* vol. 2, 64–5 n. 149; Tkaczow *Topography* 153–4 site 114. Comments on location as a result of excavations: A.J.B. Wace, 'Excavations on the Government Hospital Site, Alexandria', *Farouk I University, Bulletin Faculty of Arts Alexandria* 5 (1949) 154–5; Adriani *Repertorio* 247–8; Daszewski *loc. cit.* 1979. (n. 235) 99, 102; *idem loc. cit.* 1983 (n. 235) 62–3, 69. Other remains in this area: Adriani *Annuario* (1932–3) 55–69 and plan in back pocket; Wace *loc. cit.* 151–6; S. Shenouda, 'Alexandria University Excavations on the Cricket Playgrounds in Alexandria', *Opuscula romana* 9 (1973) 193–205; Daszewski *loc. cit.* 1979 and 1983 (n. 235); Pensabene *Elementi Aless.* 214–15; J.-Y. Empereur, 'Alexandrie', *BCH* 119 (1995) 744 fig. 1, 747–56. Adriani's 1932–3 plan is reproduced with additions in Hoepfner and Schwandner *Stadt* fig. 232.

238. Greco-Roman Museum no. 11125; 2.2 × 1.6 m. It was found in 1906. Adriani *Annuario* (1932–3) 69 no. 30, site marked on plan at back; W.A. Daszewski, 'Some Problems of Early Mosaics from Egypt', in H. Maehler, and V.M. Strocka, ed., *Das ptolemäische Ägypten* (Mainz 1978) 134–5; Daszewski *Mosaics* 101–3 no. 1, pl. 1–3 (detailed discussion with bibliography); Tkaczow *Topography* 156 site 116, map A; K.M.D. Dunbabin, *Mosaics of the Greek and Roman World* (Cambridge 1999) 23, 24.

239. *La Gloire d'Alexandrie* (Paris 1998) 227, fig. 5 on p. 229; J.-Y. Empereur, 'Sous le sol d'Alexandrie', *Archéologia* 345 (May 1998) 33, plan on p. 29; Empereur *Alexandrie* 60, pl. on p. 61; N. Grimal, 'Les Fouilles terrestres', *BIFAO* 98 (1998) 545–6.

240. Greco-Roman Museum no. 21643; present size: 5.3 × 4.0 m. E. Breccia, *Rapport sur la marche du service du musée 1921–2*, 3–10, pl.1; Adriani *Annuario* (1932–3) 93–4 no. 116, site marked on plan at back; Daszewski *loc. cit.* (n. 238) 128–35; Daszewski *Mosaics* 103–11 nos. 2–4, pl. C, 4–7a, 10–11, 12b–c (detailed discussion with bibliography); Tkaczow *Topography* 162–3 site 128; Grimm *Alexandria* fig. 38a–c; Dunbabin *op. cit.* (n. 238) 23–4, fig. 22–4.

241. Greco-Roman Museum nos. 25659 and 25660; A. Adriani, *Annuaire* (1935–9) 32, 43–4, fig. 13, pl. 13–14; Daszewski *loc. cit.* (n. 238) 134–5; Daszewski *Mosaics* 111–14, nos. 5–7, fig. 1, pl. 13–15; Tkaczow *Topography* 138 site 95, map A; Grimm *Alexandria* fig. 41a–b.

242. D. Saïd, 'Deux mosaïques hellénistiques récemment découvertes à Alexandrie', *BIFAO* 94 (1994) 377–80, 487–9 pl. A–D; Grimm *Alexandria* 105, fig. 102a–f; *La Gloire d'Alexandrie* (Paris 1998) 229–31; A.-M. Guimier-Sorbets, 'Alexandrie: les mosaïques hellénistiques découvertes sur le terrain de la nouvelle Bibliotheca

Alexandrina', *RA* (1998) 263–90. Date: *ibid.* 289.

243. Detailed discussion, with references: Daszewski *Mosaics* 115–18 nos. 12, 13, 14, 15; Tkaczow *Topography* 149–50 site 109.

244. It was found under room B3 of a late Roman building. The houses were abandoned by the end of the second century BC: M. Rodziewicz, 'Un quartier d'habitation gréco-romain à Kôm el-Dikka', *ÉtTrav* 9 (1976) 174–5; Daszewski *Mosaics* 177–8 no. 53.

245. M. Rodziewicz, 'Remarks to the Peristyle House in Alexandria and Mareotis', Πρακτικα του xii Διεθνους Συνεδριου Κλασικης Αρχαιολογιας (Twelfth International Congress of Classical Archaeology 1983) (Athens 1988) 175–8; Nowicka *op. cit.* (n. 180) 147–54.

246. M. Rodziewicz, 'Ptolemaic Street Directions in Basilea (Alexandria)', in *Alessandria e il mondo ellenistico-romano, Congresso Alessandria 1992* (Rome 1995) 229; Adriani *op. cit.* (n. 196) pl. XXV–XXVI.

247. These were found in the area south-east of the (later) site of the Caesareum at the Billardo Palace, and further east dating no later than the early Roman period, in the garden of the American Cultural Centre on Pharaohs Street: Rodziewicz *loc. cit.* (n. 246) 229; M. Rodziewicz and D. Abdo-Daoud, 'Investigation of a Trench near the Via Canopica in Alexandria', *BSAA* 44 (1991) 151–68.

248. Chapter 8 n. 33.

249. Roof tiles have been found at the site of the Bibliotheca Alexandrina, the WHO building, and the Government Hospital: Rodziewicz *loc. cit.* (n. 246) 230; and the British Consulate.

250. Detailed analysis of basis of chronology of Ptolemaic tombs: McKenzie *Petra* 63–9, 78 table 16, pl. 174–95, 197–8; Venit *Tombs, passim.*

251. S. Rotroff, 'Athenian Hellenistic Pottery: Toward a Firmer Chronology', in *Akten des XII. internationalen Kongresses für klassische Archäologie, Berlin 1988* (Mainz 1990) 177–8; Tkaczow *Topography* 168–9 site 135, 176–7 site 145; Grimm *loc. cit.* (n. 44) 58, fig. 1–3; Grimm *Alexandria* 33, fig. 29–31; Venit *Tombs* 23.

252. Tkaczow *Topography* 171–4 sites 139 and 142 with references.

253. Earliest burials at Minet el-Bassal, 300–250 BC: Grimm *loc. cit.* (n. 44) 61–2, fig. 9. Hadra vase sherds were found in the soil of Hypogeum 3 which has Ionic capitals and entablature: Adriani *Repertorio* 158 no. 110, pl. 81 fig. 265, pl. 82 fig. 271, 274, pl. 83 fig. 276; McKenzie *Petra* 65, pl. 185b–c; Venit *Tombs* 97–8, fig. 78–9. Some of the tombs at Minet el-Bassal were apparently located inside the ancient city walls: B. Tkaczow, 'La topographie des nécropoles occidentales d'Alexandrie', *Eos* 70 (1982) 345, plan on p. 347; Tkaczow *Topography* 60–1 site 8, map A. For more recent details of chronology of Hadra vases (than earlier summary in McKenzie *Petra* 80 n. 61) see A. Enklaar, *The Hadra Vases*, 1992 dissertation of University of Amsterdam (*non vidi*) cited in Venit *Tombs.*

254. Earliest burials at Mafrousa: Grimm *loc. cit.* (n. 44) 61–2, fig. 10. The new discoveries at Fort Saleh in the Gabbari area include Hadra vases: Empereur *Alexandrie* 200; J.-Y. Empereur, 'City of the Dead', *Archaeology* 52.5 (1999) 42. Fort Saleh, Gabbari, tombs of second century or first half of first century BC: M. Sabottka, 'Ausgrabungen in der West-Nekropole Alexandrias (Gabbari)', in G. Grimm, H. Heinen, and E. Winter, eds., *Das römisch-byzantinische Ägypten, AegTrev* 2 (Mainz 1983) 195–203; McKenzie *Petra* 66, pl. 188–9. Wardian, Mafrousa, and Gabbari cemeteries, with references: Tkaczow *Topography* 52 site 2, 54–6 sites 3–4. Detailed publication of cemeteries at Fort Saleh, Gabbari, excavated in 1996–7: J.-Y. Empereur and M.-D. Nenna, eds., *Nécropolis* 1, *Ét Alex* 5 (Cairo 2001); J.-Y. Empereur and M.-D. Nenna, eds., *Nécropolis* 2, *Ét Alex* 7 (Cairo 2003).

255. W. D. Coulson, 'Chatby Reconsidered', *JEA* 73 (1987) 234–6; Rotroff *loc. cit.* (n. 251) 174, 178.

256. Tkaczow *Topography* 177 site 145. It was used again in the third century AD.

257. Pedestals *in situ*: E. Breccia, *La necropoli di Sciatbi* (Cairo 1912) pl. 6–7, 16.13–15, 17. Painted examples: Breccia *op. cit.* 3–25, pl. 22–3, 25–33; R. Pagenstecher, *Nekropolis, Untersuchungen über Gestalt und Entwicklung der alexandrinischen Grabanlagen und ihrer Malereien* (Leipzig 1919) 32–85, fig. 19–54; A. Adriani, 'Scavi e scoperte alessandrine', *BSAA* 41 (1956) 25, 28, 43, fig. 27, 29, 47; B. Brown, *Ptolemaic Painting and Mosaics and the Alexandrian Style* (Cambridge, Mass. 1957) 13–33, 39–52 pl. 1–8, 9.1, 10–12, 13.1, 14–15, 16.1, 17, 19.1–2, 20.1, 21; G.L. Steen, ed., *Alexandria the Site and its History* (New York 1993) pl. on p. 46–8; Venit *Tombs* 24–5, fig. 7. Examples of reliefs: Breccia *op. cit.* pl. 20–1; Pagenstecher *op. cit.* fig. 3; Adriani *loc. cit.* 43, fig. 46; Brown *op. cit.* pl. 2.2; Grimm *Alexandria* fig. 85d, 91a–b.

258. Breccia *op. cit.* (n. 257) pl. 2–7; Adriani *Repertorio* 124–6 no. 79, pl. 44–6; McKenzie *Petra* pl. 175 a–b. Detailed basis of chronology: McKenzie *Petra* 63–4; Venit *Tombs* 30–3.

259. Breccia *op. cit.* (n. 257) pl. 13–14, 14, 16.16; Pagenstecher *op. cit.* (n. 257) 85–93, fig. 57–61; Brown *op. cit.* (n. 257) 33–52, pl. 22–3; McKenzie *Petra* 68, pl. 175c, 197–8; Adriani *Repertorio* 112–17 nos. 65–8, pl. 36–8; Venit *Tombs* 34–6, fig. 19.

260. The loculus slab was found *in situ* in 1981 east of the site of the cemetery of Shatby, and the archaeological evidence indicates that a date in the second century BC or slightly earlier is most likely: W.A. Daszewski and A. Abd-el-Fattah, 'A Hellenistic Painting from Alexandria with Landscape Elements', in *Akten des XII. internationalen Kongresses für klassische Archäologie, Berlin 1988* (Mainz 1990) 441–2, pl. 65.1–2; Venit *Tombs* 112–13, fig. 96. An early Roman date is suggested in M. Rodziewicz, 'On Alexandrian Landscape Paintings', in *Roma e l'Egitto nell'antichità classica, Cairo 1989* (Rome 1992) 330–1, 332 fig. 1, 3.

The landscape painting from Hypogeum 3 at Wardian (more specifically Mafrousa), preserved in the Greco-Roman Museum, depicts an Egyptian compartmented water wheel, rather than a wheel with a pot garland (a *saqiya*), run by oxen, water birds, a herm, and a man reclining under a bower, and on a wall opposite an Egyptian soul bird. Some of the iconography and the sketchy style have suggested dates ranging from the second century BC to early second century AD, while the reclining figure has also some-

times been identified as Jonah, resulting in suggestions of a date in the third century AD or later. Discussion and illustrations: H. Riad, 'Quatre tombeaux de la nécropole ouest d'Alexandrie', *BSAA* 42 (1967) 93–6, plan, pl. 3–4; J. Oleson, *Greek and Roman Mechanical Water-lifting Devices* (Toronto 1984) 184–5, 289, 340–1, 382–3, fig. 40; Rodziewicz *loc. cit.* 331, fig. 2, 4–6; *idem*, 'Painted Narrative Cycle from Hypogeum No. 3 in Wardian, Alexandria', *BSAA* 45 (1993) 281–90; S. Venit, 'The Painted Tomb from Wardian and the Decoration of Alexandrian Tombs', *JARCE* 25 (1988) 71–91; *idem*, 'The Painted Tomb from Wardian and the Antiquity of the *Saqiya* in Egypt', *JARCE* 26 (1989) 219–22; T. Schioler, *Roman and Islamic Water-lifting Wheels* (Odense 1973) 36, 152–3, fig. 108; Steen *op. cit.* (n. 257) pl. on p. 86, 96–7; Empereur *Alexandrie* 186; A.-M. Guimier-Sorbets and M. Seif el-Din, 'Les Deux Tombes de Perséphone dans la nécropole de Kom el-Chougafa à Alexandrie', *BCH* 121 (1997) 406, fig. 23–5; I. Kaplan, *Grabmalerei und Grabreliefs der Römerzeit* (Vienna 1999) 150–1, pl. 67–8; J. Oleson, 'Water-Lifting', in O.V. Wikander, ed., *Handbook of Ancient Water Technology* (Leiden 2000) 234, 269–70; Venit *Tombs* 101–18, fig. 83–93 (*c.* 150–100 BC).

261. Tkaczow *Topography* 171–2 site 139. Jewish ossuary of mid-first century AD: Sieglin and Schreiber *op. cit.* (n. 102) vol. 1, 188 fig. 120; A. Kerkeslager, 'Jewish Pilgrimage and Jewish Identity in Hellenistic and Early Roman Egypt', in D. Frankfurter, ed., *Pilgrimage and Holy Space in Late Antique Egypt* (Leiden 1998) 127–8. Loculi: E. Breccia, 'La necropoli de l'Ibrahimieh', *BSAA* 9 (1907) 38–42, 53–6, 65–8, fig. 9–10, 15. Jewish tombs, with references: Venit *Tombs* 20–1.

262. Breccia *op. cit.* (n. 257) pl. 8–9; Adriani *Repertorio* pl. 43 fig. 166, pl. 45 fig. 169; Venit *Tombs* fig. 15.

263. H. Thiersch, *Zwei antike Grabanlagen bei Alexandria* (Berlin 1904) 1–6, fig. 1–4, pl. 1–3; Adriani *Repertorio* 138–40 no. 88, pl. 59 fig. 206; McKenzie *Petra* 65, pl. 183–185a; Venit *Tombs* 38–41, fig. 20–4.

264. It was contemporary with, or slightly later than, the one at Sidi Gaber. Adriani *Repertorio* 146–8 no. 93, pl. 68 fig. 228, 230–1, pl. 69, pl. 70 fig. 234; McKenzie *Petra* 65–6, pl. 185b–187; Grimm *Alexandria* fig. 92.

265. On the Alexandrian tombs, like the Egyptian examples, the chamber in front of the *kline* chamber is larger than it. By contrast, on the Macedonian tombs the *kline* chamber is the larger of the two. Macedonian examples: D.C. Kurtz and J. Boardman, *Greek Burial Customs* (London 1971) 273–7, fig. 60–1. Detailed analysis: W.A. Daszewski, 'The Origins of Hellenistic Hypogea in Alexandria', in M. Minas and J. Zeidler, eds., *Aspekte spätägyptischer Kultur. Festschrift für E. Winter, AegTrev* 7 (Mainz 1994) 51–68.

266. Tomb 2 at Moustapha Pasha, *c.* second century BC: Adriani *Repertorio* 134–5 no. 85, pl. 52–3; McKenzie *Petra* 64–5, pl. 180; Venit *Tombs* 47, fig. 30–1. Egyptian examples: Daszewski *loc. cit.* (n. 265) 67 fig. 5.

267. Adriani *Repertorio* 130–4 no. 84, pl. 48–51; McKenzie *Petra* 64–5, pl. 176–9; Grimm *Alexandria* fig. 93; Venit *Tombs* 50–61, fig. 35–45.

268. So also: Hoepfner and Schwandner *Stadt* 240, fig. 229; Grimm *Alexandria* fig. 39.

269. Adriani *Repertorio* 192–4 no. 142, pl. 108 fig. 370, 372, 374, pl. 109 fig. 375–6, pl. 111 fig. 382–3, 385, pl. 113 fig. 392; McKenzie *Petra* 67–8, pl. 191–2; Venit *Tombs* 77–85, fig. 60–9. Hypogeum 5 at Anfoushy also had painted ashlar masonry and a segmental pediment: Ch. 8 n. 124f.

270. Bibliography: Ch. 8 n. 122.

271. A. Adriani, *Annuaire 1935–9*, 15–23, fig. 1–3; Adriani *Repertorio* 140–3 no. 189, pl. 61–3; Fraser *Ptol. Alex.* vol. 1, 34, vol. 2, 108 n. 263; McKenzie *Petra* 65; Tkaczow *Topography* 164–5 site 130; Venit *Tombs* 8–9, fig. 3; Adriani *op. cit.* (n. 196) 51–115, fig. 5–15, 19–22, pl. 1–5, A–F, I–XVII. Outside the city walls: Grimm *loc. cit.* (n. 44) 60. Suggestion that it was the tomb of Alexander: Bonacasa *loc. cit.* (n. 196); Empereur *Alexandrie* 152–3; Adriani *op. cit.* (n. 196) 39–50. Contra, Grimm *Alexandria* 69. Summary of arguments, including problems caused by discovery of Late Antique water channels near it suggesting that the Alabaster Tomb had been abandoned for a long time by then: Tkaczow *loc. cit.* (n. 196) 35–7.

CHAPTER 4: CLEOPATRA'S ALEXANDRIA

1. Diodorus Siculus, 17. 52. 5–6. For size of population: D. Delia, 'The Population of Roman Alexandria', *TAPA* 118 (1988) 275–92 with references; D. Sly, *Philo's Alexandria* (London 1996) 44–7.

2. Diodorus Siculus, 17. 52. 4.

3. Diodorus Siculus, 1. 50. 7.

4. The port at Ostia: M. Wheeler, *Roman Art and Architecture* (London 1971) 40–2, pl. 20; C. Scarre, *Chronicle of the Roman Emperors* (London 1995) fig. on p. 47 and 96.

5. Diodorus Siculus, 17. 52. 3.

6. Lucan, *Civil War (Pharsalia)* 10. 15–19 and 23.

7. Lucan, *Civil War (Pharsalia)* 8. 694–7.

8. Lucan, *Civil War (Pharsalia)* 10. 111–21. M. Nowicka, *La Maison privée dans l'Égypte ptolémaique* (Warsaw 1969) 32–3; U.W. Gans, 'Hellenistische Architekturteile aus Hartgestein in Alexandria', *AA* (1994) 450–1; Nielsen *Palaces* 20, 25, 130.

9. The *Alexandrian War*, which is a continuation of *Civil Wars* book 3, traditionally had been attributed to Julius Caesar, but it is now thought possibly to be by Aulus Hirtius who was an officer of Julius Caesar. The complex sequence of events, which included divisions on the Egyptian side is summarized in: *Caesar, Alexandrian, African and Spanish Wars*, tr. A.G. Way (London 1955) p. xiii–xiv, 6–7; Hölbl *Geschichte* 205–14.

10. [Caesar], *Alexandrian War* 2.

11. Lucan, *Civil War (Pharsalia)* 10. 439–43.

12. Lucan, *Civil War (Pharsalia)* 10. 486–8.

13. Caesar, *Civil Wars* 3. 112. A later example of the use of a theatre as a citadel or fort may be seen at Bosra in Syria.

14. M. Rodziewicz, 'Ptolemaic Street Directions in Basilea (Alexandria)', in *Alessandria e il mondo ellenistico-romano, Congresso Alessandria 1992* (Rome 1995) 230, fig. 1 no. 8, fig. 5 no. 1.

15. Caesar, *Civil Wars* 3. 111.

16. Plutarch, *Lives, Caesar* 49. 5–7.

17. Dio Cassius, *Roman History* 42. 38. 2. It is sometimes suggested that the storehouse (*apotheke*) for the books was the accession room of the Library as Galen uses the same term when describing the accessioning process: Fraser *Ptol. Alex.* vol. 1, 326, vol. 2, 480 n. 147 (text); M. el-Abbadi, *The Life and Fate of the Ancient Library of Alexandria* (Paris 1990) 100, 152; D. Delia, 'From Romance to Rhetoric: The Alexandrian Library in Classical and Islamic Traditions', *The American Historical Review* 97 (1992) 1462.

18. [Caesar], *Alexandrian War* 1.

19. [Caesar], *Alexandrian War* 13.

20. Lucan, *Civil War (Pharsalia)* 10. 498–503.

21. On whether or not the fire damaged the Library: A.J. Butler, *The Arab Conquest of Egypt and the Last Thirty Years of the Roman Dominion*, ed. P.M. Fraser (2nd edn Oxford 1978) 406–12; Fraser *Ptol. Alex.* vol. 1, 334–5, vol. 2, 493–4 n. 224–9; el-Abbadi *op. cit.* (n. 17) 146–54; L. Canfora, *The Vanished Library* (London 1991) 139–44; Delia *loc. cit.* (n. 17) 1460–2.

22. Strabo, *Geography* 2. 1. 5. Noted by el-Abbadi *op. cit.* (n. 17) 154.

23. Seneca, *Moral Essays, On Tranquility of Mind* 9. 5. Orosius, *History* 6. 15. 31–2, writing in *c.* AD 417, gives the number of volumes burnt as 400,000. Consequently, discussion has arisen concerning the figure given by Seneca: Fraser *Ptol. Alex.* vol. 2, 493 n. 224; Delia *loc. cit.* (n. 17) 1458 n. 38.

24. Plutarch, *Lives, Caesar* 49. 5–7. A friend of Plutarch's grandfather had first hand knowledge of the royal household of Cleopatra: Plutarch, *Lives, Antony* 28. 2. On Plutarch's reliability as a source for Alexandria: Fraser *Ptol. Alex.* vol. 1, 372, vol. 2, 494 n. 224; contra Delia *loc. cit.* (n. 17) 1461 n. 55.

25. Plutarch, *Lives, Antony* 58. 5.

26. Examples in temple sanctuaries and gymnasia: E. Makowiecka, *The Origin and Evolution of Architectural Form of Roman Library* (Warsaw 1978) 7–21. In gymnasia: e.g. J. Delorme, *Gymnasion* (Paris 1960) 121–2, 331–2.

27. Aulus Gellius, *Attic Nights* 7. 17. 3. His figure of 700,000 rolls is repeated in the late fourth century AD by Ammianus Marcellinus, 22. 16. 13.

28. Caesar, *Civil Wars* 3. 112. One pace (*passus*) is 5 Roman feet (5 × 0.296 m = 1.48 m). Thus, 900 paces equals 1,332 m, which compares with 7 stadia, *c.* 1,260 m.

29. Lucan, *Civil War (Pharsalia)* 10. 57; Vitruvius *On Architecture* 5. 12. 1.

30. Josephus, *Jewish War* 4. 613.

31. [Caesar], *Alexandrian War* 18.

32. [Caesar], *Alexandrian War* 19.

33. Strabo, *Geography* 17. 1. 6.

34. Ammianus Marcellinus, 22. 16. 9–11.

35. [Caesar], *Alexandrian War* 5.

36. P.Lond. 1177 = *Greek Papyri in the British Museum*, vol. 3, ed. F.G. Kenyon and H.I. Bell (London 1907) 180–90 no. 1177; A.C. Johnson, *Roman Egypt to the Reign of Diocletian* (Baltimore 1936) 685–91 no. 417.

37. [Caesar], *Alexandrian War* 6.

38. Suetonius, *Lives, Deified Julius* 35. It was written in the early second century AD.

39. Suetonius, *Lives, Deified Julius* 44; Makowiecka *op. cit.* (n. 26) 27.

40. Plutarch, *Lives, Antony* 74. 3.

41. Strabo, *Geography* 17. 1. 10. Humphrey *Roman Circuses* 509, considers Plutarch was referring to the Lageion. However, as there was space for Antony to rout Octavian's cavalry back to their camp, it would be unlikely that this occurred to the south of the city with the Canal of Alexandria (Mahmudiya Canal) and Lake Mareotis in the way.

42. Plutarch, *Lives, Antony* 75. 4.

43. The original Ptolemaic wall could have become known as the outer wall, with a new inner one possibly east of street R1. The lower parts of the standing remains of the surviving Arab walls, east of R1 today in the Shallat Gardens, have masonry which appears to be not later than Augustus: M. Herz, 'Deux tours des fortifications d'Alexandrie', *Comité de conservation des monuments de l'art arabe* 29 (1912) 123–4, pl. 17–19; Adriani *Repertorio* 68 no. 16, 228, pl. 9; Tkaczow *Topography* 119 site 70, fig. 44, site 70 on map A; A. Bernand, 'Alexandrie capitale des Ptolémées', *Les Dossiers d'archéologie*, 201 (1995) pl. on p. 13; Empereur *Alexandrie* 53, pl. on p. 51. The original Ptolemaic walls could not have been in this position further to the north, as the third- and second-century BC houses with high quality mosaics would have been just outside them. The most likely time for the erection of this inner wall is probably after the Alexandrian War. I thank J.J. Coulton for his observations on this.

44. Plutarch, *Lives, Antony* 76.

45. Plutarch, *Lives, Antony* 76. 2–86. 4; Dio Cassius, *Roman History* 51. 10. 4–51. 15. 1.

46. Plutarch, *Lives, Antony* 74. 1–2.

47. Plutarch, *Lives, Antony* 86. 3.

48. Suetonius, *Lives, Deified Augustus* 17. 4.

49. Statius, *Silvae* 3. 2. 117–20. It is not completely clear whether by *domus* Statius means the palace or the tomb of Cleopatra, because the reference by Martial (Epigram 4. 59. 5–6) suggests the tomb, but Lucan and Caesar also use *domus* for part of the palace (n. 11 and 13 above). On the tomb of Cleopatra: E. Bickel, 'Das Mausoleum der Kleopatra und des Antonius in lateinischer Dichtung', *RhM* 93 (1950) 191–2; I. Becher, *Das Bild der Kleopatra in der griechischen und lateinischen Literatur* (Berlin 1966) 168–71. Date of *Silvae* 3: A. Hardie, *Statius and the Silvae* (Liverpool 1983) 66–9. I thank P. and L. Watson for these references.

50. Plutarch, *Lives, Antony* 80. 1. So also: Plutarch, *Moralia, Sayings of the Romans* 207; Dio Cassius, *Roman History* 51. 16. 3–4.

51. Suetonius, *Lives, Deified Augustus* 18. 1. It was written in the early second century AD. So also: Dio Cassius, *Roman History* 51. 16. 5.

52. Plutarch, *Lives, Antony* 82. 1.

53. Dio Cassius, *Roman History* 51. 17.

54. Suetonius, *Lives, Deified Augustus* 18. 2. So also: Dio Cassius, *Roman History* 51. 18. 1.

55. Suetonius, *Lives, Deified Augustus* 18. 2; Dio Cassius, *Roman History* 51. 18. 1.

56. Obelisk: E. Iversen, *Obelisks in Exile*, vol. 1 *The Obelisks of Rome* (Copenhagen 1968) 19–22; A. Roullet, *The Egyptian and Egyptianizing Monuments of Imperial Rome* (Leiden 1972) 67–9.

57. F. Magi, 'Le Iscrizioni recentemente scoperte sull'Obelisco Vaticano', *Studi Romani* 11 (1963) 50–6; Fraser *Ptol. Alex.* vol. 2, 96–7 n. 218; E. Iversen, 'The Date of the So-called Inscription of Caligula on the Vatican Obelisk', *JEA* 51 (1965) 149–54; G. Alföldy, *Der Obelisk auf dem Petersplatz in Rom* (Heidelberg 1990) 15–27; F. Kayser, *Recueil des inscriptions grecques et latines (non funéraires) d'Alexandrie impériale* (Cairo 1994) 3–7 no. 1, pl. 1. Date of inscription: Fraser *Ptol. Alex.* vol. 2, 97 n. 218 (2); Alföldy *op. cit.* 33–7.

58. In Alexandria: Fraser *Ptol. Alex.* vol. 2, 97 n. 218 (3); H. Hänlein-Schäfer, *Veneratio Augusti* (Rome 1985) 211–16; Alföldy *op. cit.* (n. 57) 38–49, fig. 12; R.G.M. Nisbet, *Collected Papers on Latin Literature*, ed. S.J. Harrison (Oxford 1995) 128–9. In Nikopolis: H. Volkmann, 'Kritische Bemerkungen zu den Inschriften des Vatikanischen Obelisken', *Gymnasium* 74 (1967) 502. It has been suggested that, as some bone tokens or 'game counters' from Alexandria with 'Nikopolis' written on the back of them have an obelisk depicted, this provides proof of this obelisk (and the Forum Julium by implication) having been erected in Nikopolis rather than Alexandria: E. Alföldi-Rosenbaum, 'Alexandriaca. Studies on Roman Game Counters III', *Chiron* 6 (1976) 220–1, 234, pl. 26.61–3. On one example a sphinx is depicted beside the obelisk, on another an entrance-way or temple is depicted. It has been suggested that the obelisk depicted with the sphinx was the obelisk on the central barrier or spina of the circus at Nikopolis: J.-A. Blanchet, 'Tessères antiques théâtrales et autres', *RA* 14 (1889) 77. The Vatican Obelisk is not decorated with hieroglyphs, unlike one of the examples on the tokens. If this Forum Julium were in Nikopolis (founded in 30 BC) it must have been a complex established by Octavian (Augustus) in honour of Julius Caesar. Whereas, if it were in Alexandria, it would probably have been a project begun by Julius Caesar and completed by Octavian.

59. Sundial of Augustus: Pliny, *Natural History* 36. 15. 72–3; Iversen *op. cit.* (n. 56) 142–60, fig. 115–33; E. Buchner, *Die Sonnenuhr des Augustus* (Mainz 1982); L. Richardson, *A New Topographical Dictionary of Ancient Rome* (Baltimore 1992) 190–1, fig. 42; A. Claridge, *Rome, An Oxford Archaeological Guide* (Oxford 1998) 190–2, fig. 85–6. The design of such a sundial with an obelisk as the gnomon might be Egyptian: Roullet *op. cit.* (n. 56) 44–5.

60. Pliny, *Natural History* 36. 15. 74. Date of removal: Iversen *op. cit.* (n. 56) 21.

CHAPTER 5: PTOLEMAIC CLASSICAL ARCHITECTURAL STYLE AND ITS DEPICTION

1. McKenzie *Petra* 69–75, pl. 199–218; Pensabene *Elementi Aless.* An excellent summary of the latter large volume is given in P. Pensabene, 'Elementi di architettura alessandrina', *Studi Miscellanei* 28 (1984–5 [1991]) 29–85.

2. McKenzie *Petra* 63–9, with bibliography. Just as the discussion on the chronology of the Alexandrian tombs and architectural fragments has not been duplicated here, the developments in Greece which are presented here, along with the types of buildings on which this architecture was used in Alexandria, were not presented in *Petra*.

3. A. Adriani, *Annuaire* (1935–9) 45–53 fig. 14–21, pl. 15–19; McKenzie *Petra* 69, 71 nos. 14–15, 72 nos. 29–31, 39, 73 acanthus base no. 1, console no. 1, entablature fragments nos. 1, 3, 6, 74 nos. 7–13, pl. 201a–c, 203e–f, 204a, 205a–b, 208a, 209d–e, 210b, d, 211, 212a–d, 213a–d.

4. For more detail see: McKenzie *Petra* 69.

5. McKenzie *Petra* 63–4. The date of the Hadra vase in chamber h of Tomb A at Shatby is central to its chronology. This vase has most recently been dated to *c.* 240 BC in: A. Enklaar, *The Hadra Vases*, 1992 dissertation University of Amsterdam (*non vidi*) cited in Venit *Tombs* 32, 232 n. 304. Recent discussion concluding Tomb A could have been constructed *c.* 290/280 BC and in use for about one hundred years: Venit *Tombs* 26–34 (esp. p. 33).

6. W. Hoepfner, *Zwei Ptolemaierbauten*, AM Beiheft 1 (Berlin 1971) 55–62, pl. 13–19, 23a–d, Beil. 23–30; Pensabene *Elementi Aless.* 311–19, 335–40, 493–9, 514–18, pl. 1–4 no. 21, 16 nos. 96 and 98, 17–18, 89–91, 99 nos. 945–7.

7. Bibliography see Ch. 3 n. 234. The entablatures were the same height indicating that one order was not placed on the other, but that they were on the same level. The gutter for rain water carved in the top of the cornice indicates that they were for exterior colonnades; illustrated in Hoepfner *op. cit.* (n. 6) Beil. 25 Block G386, Beil. 28 Block G182, Beil. 30–1.

8. One of the unfluted column drums has the diameter and height engraved on it in Greek letters with the Egyptian system of submultiple fractions. Coulton interprets the inscribed letters as: diameter $1\frac{1}{2}\frac{1}{4}$ (?) $\frac{1}{8}\frac{1}{16}$ foot; and height $4\frac{1}{2}\frac{1}{16}$ foot. With a Ptolemaic foot of 0.35 m., this gives a diameter of 0.678 m (the actual diameter of the block is 0.68 m) and a height of 1.497 m (the actual height of the block is 1.51 m): J.J. Coulton, 'Towards Understanding Greek Temple Design: General Considerations', *BSA* 70 (1975) 77 n. 73; L. Haselberger, 'Bericht über die Arbeit am jüngeren Apollontempel von Didyma', *Istanbuler Mitteilungen* 33 (1983) 115–16 n. 96; G. Botti, 'L'Ancien

Théâtre d'Alexandrie', *BSAA* 4 (1902) 121 block no. 2 in fold out; L. Borchardt, 'Von einer alexandrinischen Baustelle', *BSAA* 8 (1905) 4, fig. 14; Hoepfner *op. cit.* (n. 6) 69–70, pl. 23b.

9. Hoepfner *op. cit.* (n. 6) 87.

10. A. Adriani, *Annuaire* (1935–9) 54 fig. 23; Hoepfner *op. cit.* (n. 6) 85–91, fig. 4; Pensabene *Elementi Aless.* 79–91.

11. Hoepfner *op. cit.* (n. 6) 78–83. Bibliography for sanctuary at Hermopolis Magna see Ch. 3 n. 170.

12. Bibliography: Ch. 2 n. 13.

13. Doric: A. Adriani, *Annuaire* (1933–5) 79–85; McKenzie *Petra* pl. 175b, 176b, 178, 180b, 181, 182b–c, 183b, 184a. Ionic: *ibid.* pl. 175a, 185b–c.

14. Developments discussed in detail with illustrations in: G. Roux, *L'Architecture de l'Argolide aux IV* et III* siècles avant J.-C.* (Paris 1961) Text 362–81; H. Bauer, *Korinthische Kapitelle des 4. und 3. Jahrhunderts v. Chr.*, AM Beiheft 3 (Berlin 1973) 81–123; A. Frazer, *Samothrace* 10, *The Propylon of Ptolemy II* (Princeton 1990) 171–9, 218–25; J.R. McCredie *et al.*, *Samothrace* 7, *The Rotunda of Arsinoe* (Princeton 1992) 125–41; Pensabene *Elementi Aless.* 115–20.

15. Bauer *op. cit.* (n. 14) pl. 16–17.

16. J. Charbonneaux and K. Gottlob, *Le Sanctuaire d'Athéna Pronaia, Fouilles de Delphes* II.4 (Paris 1925) Text vol. 20–2, Plates vol. pl. 23–6; Roux *op. cit.* (n. 14) pl. 95.1; Bauer *op. cit.* (n. 14) 84–6.

17. A. Mallwitz, 'Ein Kapitell aus gebranntem Ton oder zur Genesis des korinthischen Kapitells', in A. Mallwitz, ed., *X. Bericht über die Ausgrabungen in Olympia* (Berlin 1981) 318–52, fig. 107–9.

18. Roux *op. cit.* (n. 14) pl. 47–50, 70.1, 71, 77–8; Frazer *op. cit.* (n. 14) Text fig. 99, 121–2.

19. Temple of Athena Alea at Tegea, *c.* 340 BC, Temple of Zeus at Nemea, *c.* 330 BC, Philippeion at Olympia, *c.* 335 BC. Tegea fragments: Bauer *op. cit.* (n. 14) pl. 21–3, Beil. 9–11. Date: N.J. Norman, 'The Temple of Athena Alea at Tegea', *AJA* 88 (1984) 191–4. Nemea fragment and Philippeion capital: Roux *op. cit.* (n. 14) pl. 96; Bauer *op. cit.* (n. 14) Beil. 17–18.

20. Bauer *op. cit.* (n. 14) pl. 24–9, Beil. 13–14. See also the capitals of the Asklepeion in Athens: *ibid.* pl. 20.2–4, Beil. 16.

21. Rotunda of Arsinoe: McCredie *et al. op. cit.* (n. 14) fig. 90, 93–4; Frazer *op. cit.* (n. 14) fig. 67, 117–18. Propylon of Ptolemy II: McCredie *et al. op. cit.* (n. 14) fig. 91; Frazer *op. cit.* (n. 14) fig. 54, 66, 68, pl. 53; H. Lauter, *Die Architektur des Hellenismus* (Darmstadt 1986) 268, pl. 33a.

22. It is notable that the Corinthian capitals of Hellenistic Asia Minor and the islands nearby are more consistently generally 'Normal' capitals. In F. Rumscheid, *Untersuchungen zur kleinasiatischen Bauornamentik des Hellenismus* (Mainz 1994) for 'Normal' capitals see, for example, pl. 41.4, 45.1–4, 55.5, 69.1–3, 75.1, 99.1–3, 128.4–5, 170.3; for examples which are not 'Normal' capitals see pl. 25.2–4, 62.3–4, 106.3, 111.3–4, 6–7.

23. W.-D. Heilmeyer, *Korinthische Normalkapitelle*, RM Ergh. 16 (Heidelberg 1970); M. Wilson Jones, *Principles of Roman Architecture* (London 2000) 140–1. Detailed discussion of Roman developments with examples: P. Gros, *L'Architecture romaine du début du III* siècle av. J.-C. à la fin du Haut-Empire: 2. Maisons, palais, villas et tombeaux* (Paris 2001) 472–91.

24. Frazer *op. cit.* (n. 14) Text fig. 46, Plates pl. 84.

25. H. von Hesberg, *Konsolengeisa des Hellenismus und der frühen Kaiserzeit*, RM Ergh. 24 (Mainz 1980) 21, 227–9, pl. 2–3. On development of Roman Corinthian cornice: Wilson Jones *op. cit.* (n. 23) 141–2; Gros *op. cit.* (n. 23) 491–5.

26. K. Ronczewski, 'Les Chapiteaux corinthiens et variés du Musée gréco-romain d'Alexandrie', *BSAA* suppl. du fasc. 22 (1927). A slightly different system of classification is used in Pensabene *Elementi Aless.* 109–14.

27. Type I: McKenzie *Petra* 70–2, pl. 199–203d; Pensabene *Elementi Aless.* 352–60, pl. 26, 27, 28 excluding no. 196, pl. 29, 30 no. 209; G. Grimm and J.S. McKenzie, 'Architectural Fragments found in the Excavations of the Serapeum in Alexandria in *c.* 1901', *JRS* 94 (2004) 116–18, pl. 9.2, 10.1. Type II: McKenzie *Petra* 72, pl. 203e–204; Pensabene *Elementi Aless.* 374–6, pl. 37 excluding nos. 274–5 and 277; Grimm and McKenzie *loc. cit.* 116, 118–19, pl. 8. Type III: McKenzie *Petra* 72, pl. 205–206b; Pensabene *Elementi Aless.* 370–2, pl. 35 excluding no. 257, pl. 36 nos. 263–8.

Date of fragments from Chantier Finney building: McKenzie *Petra* 69. Third century BC date of capitals in [69, 128–130]: Grimm and McKenzie *loc. cit.* 117–18 with references. Date of capitals from fill of Tomb 2 at Moustapha Pasha: McKenzie *Petra* 65.

28. McKenzie *Petra* 72–3, pl. 207; Pensabene *Elementi Aless.* 380–3, pl. 39 except no. 302, 40, 41 except no. 318.

29. Pensabene *Elementi Aless.* 382–3 nos. 316–17, pl. 40, 41 no. 317.

30. Acanthus column bases: McKenzie *Petra* 73, 96–7, pl. 208–9c; Pensabene *Elementi Aless.* 121–2, 488–93, pl. 87, 88 nos. 790–1, 798–9. Including examples at other sites: R. Naumann, *Der Quellbezirk von Nîmes* (Leipzig 1937) 42–53, fig. 30–55, pl. 39; E. Makowiecka, 'Acanthus-base Alexandrian Form of Architectural Decoration at Ptolemaic and Roman Period', *ÉtTrav* 3 (1969) 115–31; H. Lauter, 'Ptolemais in Libyen, Ein Beitrag zur Baukunst Alexandrias', *JdI* 86 (1971) 153–4; M. Lyttelton, *Baroque Architecture in Classical Antiquity* (London 1974) 19, 51.

Attic bases: A.W. Lawrence, *Greek Architecture*, rev. R.A. Tomlinson (5th edn London 1996) fig. 186, 189.

31. M. Pillet, 'Structure et décoration architectonique de la nécropole antique de Deïr-Rifeh', in *Mélanges Maspero I*, *MIFAO* 66 (Cairo 1935–8) 65 fig. 3, 69–70 fig. 5–9.

32. von Hesberg *op. cit.* (n. 25) 68–86; McKenzie *Petra* 73–5, 93–4, pl. 211d, f, 212a–b, 213–215b, 216, 217a, e–f; Pensabene *Elementi Aless.* 94–104, 499–513, pl. 92–8. Date of Chantier Finney building: McKenzie *Petra* 69. A fragment with square hollow

and flat grooved modillions was found in Tomb 3 at Moustapha Pasha, which is dated to the third or second century BC: McKenzie *Petra* 64–5, 74 no. 14, 79, pl. 213e.

33. McKenzie *Petra* pl. 211d, f, 212a–b; Pensabene *Elementi Aless.* 518–19, pl. 101 nos. 960–5. On mixed orders formed by other combinations elsewhere: Wilson Jones *op. cit.* (n. 23) 111–12.

34. Capitals with traces of paint, including those from the Chantier Finney building: McKenzie *Petra* 71–3 nos. 3, 6, 15, 20–1, 39–40, 44, 52; Pensabene *Elementi Aless.* p. 354–60 nos. 189, 190, 197–8, 201, 210, 216, p. 370–2 nos. 256, 260–2, 265–8, p. 375–6 nos. 281–3, 287, p. 381 no. 306.

35. Discussion of dates of various examples, with cross references to Pensabene *Elementi Aless.*: U.-W. Gans, 'Hellenistische Architekturteile aus Hartgestein in Alexandria', *AA* 1994, 433–53; Grimm and McKenzie *loc. cit.* (n. 27) 118. The variety of stones used in Egypt for both sculpture and architecture from the Dynastic period onwards are described in: T. de Putter and C. Karlshausen, *Les Pierres utilisées dans la sculpture et l'architecture de l'Égypte pharaonique – guide pratique illustré* (Brussels 1992); E. Barre, *Choix et rôle de la pierre dans la construction des temples égyptiens* (Paris 1993).

36. Lyttelton *op. cit.* (n. 30) 38–9; McKenzie *Petra* 88, 91. Fifth-century examples include the engaged columns on the Temple of Zeus at Akragas, and pilasters on the temple of the Athenians on Delos. Hellenistic examples and further development of this aspect: Lauter *op. cit.* (n. 21) 253–65.

37. Further discussion of definition of ancient baroque: Lyttelton *op. cit.* (n. 30) 9–16. Each baroque form discussed in greater detail, with references, in McKenzie *Petra* 87–92.

38. Segmental pediments: McKenzie *Petra* 75 nos. 31–7, pl. 216b–d.

Coins with segmental pediments: Ch. 8 n. 90. Timber roofs on Egyptian birth houses and kiosks: Arnold *Temples* fig. 69–70, 179–80, 194, 244.

39. Lauter *loc. cit.* (n. 30) 171; Pensabene *Elementi Aless.* 133–5.

40. Lyttelton *op. cit.* (n. 30) 52.

41. McKenzie *Petra* 74–5; P. Pensabene, 'Lastre di chiusura di loculi con naiskoi egiziani e stele funerarie con ritratto del Museo di Alessandria', in *Alessandria e il mondo ellenistico-romano, Studi in onore di Achille Adriani*, vol. 1 (Rome 1983) 112–13. Half-pediments: McKenzie *Petra* 75 nos. 41–2, pl. 217d–f; Pensabene *Elementi Aless.* 504–5, 509–10, pl. 94 no. 888, 96 nos. 919–20, pl. 115.5, 132 no. 888. Concave entablature: Pensabene *Elementi Aless.* 510, pl. 97 no. 923. Curved entablature: McKenzie *Petra* 74–5 no. 30, pl. 216a; Pensabene *Elementi Aless.* 509, pl. 96 no. 916, pl. 131. Arched entablature: McKenzie *Petra* 75 no. 40 (incorrectly identified as a conch), pl. 217b; Pensabene *Elementi Aless.* 522, pl. 103 nos. 974–5, pl. 134.

42. W. Daszewski *et al.*, in L. Krzyzanowski, ed., *Marina el-Alamein: Archaeological Background and Conservation Problems*, vol. 1 (Warsaw 1991) 23, 26–7, fig. 11–13.

43. Date: E. Will *et al.*, *'Iraq al Amir: le château du tobiade Hyrcan* (Paris 1991) 17. It is the fortress Tyros built by the Tobiad Hyrcanus, which was described by Josephus, *Jewish Antiquities* 12. 4. 11 (230–3). Hyrcanus' building was begun by *c.* 177/6 BC and perhaps as early as 210/209 BC. It also has striking parallels with the slightly later fortress temple of Onias IV in Egypt which was described in Josephus, *Jewish War* 7. 10. 3 (426–32); J.M. Modrzejewski, *The Jews of Egypt from Rameses II to Emperor Hadrian* (Princeton 1997) 121–9.

44. Will *et al. op. cit.* (n. 43) Text pl. A3–A4, A16, Album pl. 11–39.

45. Detailed discussion of all aspects of its architectural decoration, including Alexandrian influence: J. Dentzer-Feydy in Will *et al. op. cit.* (n. 43) Text 140–208. Type II and III capitals: Text pl. B1.5–6, B9.6, B10, B11.3, B13, B15, Album pl. 58, 61–4, 66, 70–3, 94. Acanthus column bases: Text pl. B8, Album pl. 64, 69. Discussion of design: Nielsen *Palaces* 138–46.

46. J. Dentzer-Feydy in Will *et al. op. cit.* (n. 43) Text 135–40, Album pl. 36–7, 39.

47. Visit described in Josephus, *Jewish Antiquities* 12. 4. 7–9 (196–220).

48. G. Pesce, *Il 'Palazzo delle Colonne' in Tolemaide di Cirenaica* (Rome 1940) fig. 13–17, 48–9, 51, pl. 6, 8, 9, 10, 13a; McKenzie *Petra* 219–223a. Discussion of date: Lauter *loc. cit.* (n. 30) 149–58; McKenzie *Petra* 75–7; Barbet *Peinture* 51.

49. Capitals: G.R.H. Wright, 'Architectural Fragments from the Peristyle', in J.H. Humphrey, ed., *Apollonia, the Port of Cyrene* (Tripoli 1976) 192–5, fig. 9–12, pl. 39a–d, 40d. Examples of narrow flat grooved modillions in Cyrenaica: von Hesberg *op. cit.* (n. 25) 73–6, pl. 7.3.

50. H. von Hesberg, 'Zur Entwicklung der griechischen Architektur im ptolemäischen Reich', in H. Maehler and V.M. Strocka, eds., *Das ptolemäische Ägypten* (Mainz 1978) 137–45, pl. 132–3, 140–3; von Hesberg *op. cit.* (n. 25) 76–8, pl. 7.4; Will *et al. op. cit.* (n. 43) Text pl. B21.1–4; P. Vanderstar, *The Classical Orders in Hellenistic and Roman Cyprus*, D.Phil. thesis, Oxford University 1997.

51. J. McKenzie, 'Keys from Egypt and the East: Observations on Nabataean Culture in the Light of Recent Discoveries', *Bulletin of the American Schools of Oriental Research*, 324 (2001) 97–9.

52. McKenzie *Petra* 33–56.

53. McKenzie *Petra*.

54. K. Ronczewski, 'Kapitelle des El Hasne in Petra', *AA* 1932, 37–90.

55. J.S. McKenzie, 'Temples, Tombs, and Other Discoveries from the Rose Red City', *JRA* 17 (2004) 559. During the course of the twentieth century a variety of dates were suggested for it, ranging from the early first century BC to the second century AD: McKenzie *Petra* 7 Table 2, 51. In 1923 Ronczewski considered it was 'probably constructed towards the end of the first century BC': K. Ronczewski, 'Variantes des chapiteaux romains', *Latvijas Universitates Raksti, Acta Universitatis Latviensis* 8 (1923) 123.

56. McKenzie *Petra* 86–104, with earlier bibliography.

57. Lyttelton *op. cit.* (n. 30) 82–3; Z.S. Ismaïl, 'Les Chapiteaux de Pétra', *Le Monde de la Bible* 14 (1980) 27–9; A. Schmidt-Colinet, 'Nabatäische Felsarchitektur', *BJb* 180 (1980) 90–101; *idem* in A. Schmidt-Colinet *et al.*, ' "Arabischer Barock" Sepulkrale Kultur in Petra', in T. Weber and R. Wenning, eds., *Petra. Antike Felsstadt zwischen ara-*

bischer Tradition und griechischer Norm (Mainz 1997) 92–3; S.G. Schmid, 'The Nabataeans: Travellers between Lifestyles', in B. MacDonald *et al.*, eds., *The Archaeology of Jordan* (Sheffield 2001) 379, 386–7, 396; J. Dentzer-Feydy in F. Zayadine *et al.*, *Le Qasr al-Bint de Pétra* (Paris 2003) 50, 52–3, 58, 114; R. Wenning, 'The Rock-cut Architecture of Petra', in G. Markoe, ed., *Petra Rediscovered* (New York 2003) 141. This does not mean to say that it did not also include other influences, as mentioned by these scholars and McKenzie *loc. cit.* (n. 51) 102–9. The main examples of Roman influence in the architecture at Petra appear only towards the end of the first century AD, and especially after the Roman annexation of Arabia in AD 106. This contrasts with Herodian architecture which exhibits more Roman influence.

58. e.g. Kasr el-Bint, Corinthian Tomb, Deir: McKenzie *Petra* pl. 71b, 119a, 138.

59. McKenzie *Petra* 95–6; McKenzie *loc. cit.* (n. 51) 97–100.

60. McKenzie *Petra* 93.

61. McKenzie *Petra* 95, pl. 46d, 48.

62. Will *et al. op. cit.* (n. 43) Text pl. B20.2.

63. Demonstrated on the Kasr el-Bint: J. Dentzer-Feydy in Zayadine *et al. op. cit.* (n. 57) 77–9, 116–17.

64. There are Nabataean masons' marks on the Temple of the Winged Lions and the lower forecourt ('Temenos') of the 'Great Temple'.

65. Other examples: Corinthian Tomb, Bab el-Siq Triclinium, and Deir. McKenzie *Petra* pl. 116, 121, 138. Tybout considers broken pediments are not typically Alexandrian because of a simple example depicted on a grave relief from Samos of the second half of the second century BC: Tybout *Aedificorum figurae* 244, 246–7, pl. 108.1. The example he mentions of relief decoration on the Doric Nymphaeum at Lake Albano (246, pl. 104–5), which has also been noted by other scholars, is not necessarily earlier than the Alexandrian examples.

66. McKenzie *Petra* 41, 51, pl. 64–65a.

67. McKenzie *Petra* 89. Segmental pediments: McKenzie *Petra* pl. 74a, 109, 116, 126, 138, 145. Curved entablatures: McKenzie *Petra* pl. 150c, 154. Concave entablature: McKenzie *Petra* pl. 141d.

68. F. Seiler, *Das griechische Tholos* (Mainz 1986); Lawrence *op. cit.* (n. 30) 137–41, with references p. 233; Tybout *Aedificorum figurae* 316–19; Leach *Painting* 87.

69. On the Khasneh the roof does not sag as much as on the Corinthian Tomb and the Deir: McKenzie *Petra* pl. 116, 138–9. Absolom's Tomb in Jerusalem (Y. Yadine, *Jerusalem Revealed*, Jerusalem 1975, fig. on p. 17) also has a tent roof, but the Monument of Lysikrates in Athens has a straight roof. A capital supporting a lidded urn does not occur on either of them.

70. These features also appear on the cylindrical containers (*cistae*) in the wall-paintings in the atrium of the Villa of Oplontis: Tybout *Aedificorum figurae* 37, pl. 37.1–4.

71. Chronology of Second Style wall-painting: Tybout *Aedificorum figurae* 41–54, summarized in table on p. 48.

72. J. Hittorff, 'Pompéi et Pétra', *RA* 6 (1862) 1–18; R. Pagenstecher, *Alexandrinische Studien* (Heidelberg 1917) 34–40; W. Bachmann, C. Watzinger and T. Wiegand, *Petra*, Wissenschaftliche Veröffentlichung des deutsch-türkischen Denkmalschutz-Kommandos, Heft 3 (Berlin 1921) 18–28; Schmidt-Colinet *loc. cit.* 1980 (n. 57) 93–5; Barbet *Peinture* 49; Tybout *Aedificorum figurae* 245 n. 874 with earlier references. Detailed description of *oecus* 43 paintings in the House of the Labyrinth: V.M. Strocka, *Casa del Labirinto (VI 11, 8–10)*, *Häuser in Pompeji* vol. 4 (Munich 1991) 46–8, 119, pl. 287–8, 290–7, 305–12.

73. In a related arrangement in triclinium 14 of the Villa of Oplontis the tholos is depicted in front of the entablature [162], and on the Tomb of the Broken Pediment the half pediments are joined by an entablature.

74. Now surviving on only one side of the tomb, due to later re-cutting.

75. McKenzie *Petra* 88–92.

76. Detailed examination, with many more illustrations: McKenzie *Petra* 85–101. See also: Barbet *Peinture* 49–51; Leach *Painting* 78. Tybout *Aedificorum figurae* 234–60 methodically examined the same material (both built and painted) at the same time as McKenzie (but with the exception of the extra evidence from Alexandria itself published by herself and Pensabene). Tybout reached different conclusions, i.e. that the architecture depicted in the wall-paintings included real architecture but Alexandrian architecture was not a distinctive or major component of it (326–39, 355–7, especially 327–8). There is not space to re-argue this in detail here.

77. Lauter *loc. cit.* (n. 30) 174, fig. 20; Tybout *Aedificorum figurae* pl. 9; McKenzie *Petra* 93–4, pl. 227a.

78. Like the Alexandrian ones, these modillions are proportionately narrower, longer and further apart than the 'block consoles' on contemporary architecture in Italy. Contra, Tybout *Aedificorum figurae* 337–9. Examples of 'block consoles' in architecture of first century BC in Italy: von Hesberg *op. cit.* (n. 25) fig. 3–11, pl. 10.1, 11–14. Von Hesberg (99) discusses the examples depicted in the House of the Griffins under 'block consoles' but their proportions are closer to the Alexandrian examples. The wall-paintings also include some wide flat and some slightly curved modillions which can be compared with Greek examples: compare those in cubicula 8 and 4 of the Villa of the Mysteries (J. Engemann, *Architekturdarstellungen des frühen Zweiten Stils*, RM Ergh. 12, 1976, pl. 11.1 and 14) with von Hesberg *op. cit.*, n. 25, pl. 2, 4.1.

79. McKenzie *Petra* pl. 211d, 214f; Pensabene *Elementi Aless.* 499–502, pl. 92 nos. 848, 853, 860A, 93 nos. 871–7. Pensabene dates them to the second and first centuries BC.

80. In cubiculum c of the House of Ceres: M. de Vos, 'Scavi Nuovi sconosciuti (I 9, 13): pitture e pavimenti della Casa di Cerere a Pompei', *Mededelingen van het Nederlands Instituut te Rome* 38 (1976) pl. 40 no. 10 (photograph upside down and back to front), 41; Barbet *Peinture* fig. 33 top. In cubiculum 46 and alcove of the House of the Labyrinth: Strocka *op. cit.* (n. 72) pl. 347–8, 357, 360–1.

81. In cubiculum 3 of the Villa of the Mysteries, and exedra L of the Villa of P. Fannius Sinistor at Boscoreale: McKenzie *Petra* 94, pl. 227d–e.

82. H. Lauter-Bufe, *Die Geschichte des sikeliotisch-korinthischen Kapitells* (Mainz 1987) 93–8; Tybout *Aedificorum figurae* 329–31; McKenzie *Petra* 94–6.

83. K. Fittschen, 'Zur Herkunft und Entstehung des 2. Stils', in P. Zanker, ed., *Hellenismus in Mittelitalien* (Göttingen 1976) 549. Examples of Italic-Corinthian capitals (McKenzie *Petra* 189 diagram 13d): Gros *op. cit.* (n. 23) fig. 574–6; Examples on buildings in Pompeii: Lauter-Bufe *op. cit.* (n. 82) pl. 27–31; Strocka *op. cit.* (n. 72) pl. 141–8 in the House of the Labyrinth.

84. Engemann *op. cit.* (n. 78) 21; Fittschen *loc. cit.* (n. 83) 549. Cubicula 8 and 16 of the Villa of the Mysteries, the back wall of room 4 of the House of the Griffins, and cubiculum M of the Villa of P. Fannius Sinistor at Boscoreale: McKenzie *Petra* 95–6, pl. 224a–d. The Villa of Oplontis paintings have no examples of 'Normal' capitals.

85. See n. 22 above.

86. 'Normal' capitals in the late second or early first century BC on the Round Temple of the Forum Boarium beside the Tiber in Rome: P. Gros, *L'architecture romain du début du III^e siècle av. J.-C. à la fin du Haut-Empire: 1. Les monuments publics* (Paris 1996) 135, fig. 147.

87. Room H of the Villa of P. Fannius Sinistor at Boscoreale, and the left side wall of room 4 of the House of the Griffins: McKenzie *Petra*, 96, pl. 224e–f.

88. McKenzie *Petra* 71 no. 15, 72 no. 39.

89. *Oecus* 6 and cubicula 8 and 16 of the Villa of the Mysteries, rooms 2 and 4 of the House of the Griffins, the atrium of the Villa of Oplontis, triclinium 14, room 23 and cubiculum M of the Villa of P. Fannius Sinistor at Boscoreale and room 45/46 of the House of the Labyrinth: McKenzie *Petra* 96, pl. 225b–c, g–h, 226a–h. Cubiculum h of the House of Ceres: de Vos *loc. cit.* (n. 80) pl. 42.15, 44. Later examples of floral capitals in Italy: Ronczewski *loc. cit.* (n. 55) 121–32, 135–46, pl. 5–7.

As the Type IV Alexandrian capitals are ultimately derived from the double volute (or S-volute) capitals of fifth and fourth centuries BC in Greece [119–120] as are the late Republican examples (e.g. Ronczewski *loc. cit.*, n. 55, 119 fig. 2) some similarity between them is inevitable (mentioned by Engemann *op. cit.*, n. 78, 21; Tybout *Aedificorum figurae* 148, 329–30). Lauter-Bufe also points out the similarities between the capitals in the wall-paintings and the Alexandrian examples as well as the Italian ones: Lauter-Bufe *op. cit.* (n. 82) 96–7.

90. McKenzie *Petra* pl. 207a–i.

91. McKenzie *Petra* pl. 44–7.

92. McKenzie *Petra* 96–8.

93. E.R. Knauer, 'Wind Towers in Roman Wall Paintings?', *Metropolitan Museum Journal* 25 (1990) 5–20.

94. Elements of Hellenistic influence in architecture of Pompeii and in Republican Italy: R. Delbrück, *Hellenistische Bauten in Latium*, vol. 2 (Strassburg 1912) 169–73; R. Vallois, *L'architecture hellénique et hellénistique à Délos*, vol. 1 (Paris 1944) 281–364; Lyttelton *op. cit.* (n. 30) 17–25. Delbrück observed in the painted architecture various aspects of late Republican architecture, as well as Alexandrian elements. Vallois and Lyttelton observed the similarity between some of the architectural features in the wall-paintings and Hellenistic architecture, including some remains in Alexandria.

95. McKenzie *Petra* 91; Tybout *Aedificorum figurae* 216–28, 355.

96. Contra, Tybout *Aedificorum figurae* 148, 332.

97. Similarity to contemporary domestic architecture because of the view of the colonnaded court (behind a high wall) in cubiculum 8 of the Villa of the Mysteries and room 45/46 of the House of the Labyrinth: Engemann *op. cit.* (n. 78) compare pl. 11.1, 42 with pl. 50.2; McKenzie *Petra* pl. 240a, 242b; Barbet *Peinture* 45. Depicting contemporary Roman or Hellenistic villas: P.W. Lehmann, *Roman Wall Paintings from Boscoreale in the Metropolitan Museum of Art in New York* (Cambridge, Mass. 1953) 157–63. Leach argued that the paintings are a reflection of contemporary architecture based on literary descriptions with the choice of scenes also influenced by the taste of the owner: E. Leach, 'Patrons, Painters, and Patterns: The Anonymity of Romano-Campanian Painting and the Transition from the Second to the Third Style', in B. Gold, ed., *Literary and Artistic Patronage in Ancient Rome* (Austin, Texas 1982) 139–67; Leach *Painting* 86–92. Because the wall-paintings also have details, such as the use of varied and expensive construction materials, in common with Hellenistic palace architecture, especially that of Alexandria, Fittschen suggested that they depict these. Fittschen *loc. cit.* (n. 83) 553–6; Barbet *Peinture* 45; Leach *Painting* 298 n. 140.

98. K. Schefold, 'Der Zweite Stil als Zeugnis alexandrinischer Architektur', in B. Andreae and H. Kyrieleis, eds., *Neue Forschungen in Pompeji* (Recklinghausen 1975) 53–9; Lauter *loc. cit.* (n. 30) 149–78.

99. Tybout *Aedificorum figurae* 327–8. See n. 76 above.

100. Barbet acknowledges that the architecture of the Hellenistic East, especially Alexandria, was a probable source of inspiration for the paintings, but not the only source: Barbet *Peinture* 49–52. Ling also considers there was more than one source, with elements of Hellenistic palaces, local architecture and stage decoration: Ling *Painting* 30. Roman invention: Ling *Painting* 31; Leach *Painting* 85. Summaries of theories concerning origins and meaning of phase 1 of the Second Style: Barbet *Peinture* 44–52; Tybout *Aedificorum figurae* 18–22; McKenzie *Petra* 62–3, 100; Ling *Painting* 30–1; Leach *Painting* 298 n. 140. H. Fragaki, 'Représentations architecturales de la peinture pompéienne, Évolution de la pensée archéologique', *MEFRA* 115 (2003) 231–94.

101. H.G. Beyen, *Die pompejanische Wanddekoration vom Zweiten bis zum Vierten Stil* (The Hague 1938–60) vol. 1–2; *idem*, 'The Wall Decoration of the Cubiculum of the Villa of P. Fannius Synistor near Boscoreale in its Relations to Ancient Stage-painting', *Mnemosyne* 10 (1957) 147–53; T.B.L. Webster, *Hellenistic Art* (London 1967) 132–6; A.M.G. Little, *Roman Perspective Painting and the Ancient Stage* (Kennebunk 1971); *idem*, *Decor, Drama and Design in Roman Painting* (Kennebunk 1977). Discussion: C.-G. Picard, 'Origine et signification des fresques architectoniques romano-campaniennes dites de second style', *RA* (1977) 231–52; Barbet *Peinture* 44–5; Leach *Painting* 98–100, 298 n. 140; Tybout *Aedificorum figurae* 187–213.

102. Vitruvius, *On Architecture* 7. pref. 11. This is thought by R. Ling (pers. com.) to be 'describing some form of central perspective (*certo loco centro constituto*), and thus that the principle was understood in the fifth century, even if it was not yet consistently applied by painters'. Contra Tybout who considers this is not central perspective: R.A. Tybout, 'Die Perspektive bei Vitruv: Zwei Überlieferungen von *scaenographia*', in H. Geertman and J.J. de Jong eds., *Munus non ingratum, Proceedings of the International Symposium on Vitruvius' De Architectura and the Hellenistic and Republican Architecture, 1987* (Leiden 1989) 55–68. Examples of 'parallel perspective' but with orthogonals converging to a single (but not central) vanishing point, on fourth-century BC South Italian vases: J. Christensen, 'Vindicating Vitruvius on the Subject of Perspective', *JHS* 119 (1999) 162–4, pl. 12–13.

103. Vitruvius, *On Architecture* 5. 6. 9: 'The tragic sets are designed with columns, pediments and statues and other royal surroundings; the comic have the appearance of private buildings and balconies and projections with windows, made to imitate reality after the fashion of ordinary buildings; the satyric settings are painted with trees, caves, mountains and other country features, designed to imitate landscape.'

104. Vitruvius, *On Architecture* 7. 5. 5–7.

105. As also suggested in *Vitruvius, Ten Books on Architecture*, tr. I.D. Rowland and T.N. Howe (Cambridge 1999) 268: 'This kind of fantasy architecture (i.e. the basis of the second and third Pompeiian styles) was developed in real and painted architecture in Alexandria'.

106. 'Normal' capitals are not used in Egypt until the late first century AD when they appear as the result of Roman influence.

107. Concordance of the four styles, their chronology, and subdivisions suggested by different scholars: Barbet *Peinture* 182 Table 5.

108. First Style is replaced by Second Style in the House of Gavius Rufus (VII 2, 16) in the room to the right of the *fauces* on entering. Second Style is replaced by Third Style in cubiculum 12/13 of the Villa of the Mysteries: W. Ehrhardt, *Stilgeschichtliche Untersuchungen an römischen Wandmalereien von der späten Republik bis zur Zeit Neros* (Mainz 1987) pl. 98 fig. 383; Tybout *Aedificorum figurae* pl. 14.2; Leach *Painting* fig. 62.

109. Vitruvius, *On Architecture* 7. 5. 1–3: 'The ancients who first used polished stucco, began by imitating the variety and arrangement of marble inlay; then the varied distribution of festoons, ferns, coloured strips. Then they proceeded to imitate the contours of buildings, the outstanding projections of columns and gables; in open spaces, like exedrae, they designed scenery on a large scale in tragic, comic or satyric style [royal buildings, private buildings, and landscape scenes]; in covered promenades, because of the length of the walls, they used for ornament the varieties of landscape gardening, finding subjects in the characteristics of particular places; for they paint harbours, headlands, shores, rivers, springs, straits, temples, groves, hills, cattle, shepherds. In places, some have also the anatomy of statues, the images of the gods, or the representations of legends; further, the battles of Troy and the wanderings of Ulysses over the countryside with other subjects taken in like manner form Nature. But these which were imitations based upon reality are now distained by the improper taste of the present. On the stucco are monsters rather than definite representations taken from definite things. Instead of columns there rise up stalks: instead of gables, striped panels with curled leaves and volutes. Candelabra uphold pictured shrines . . .' Discussion, with earlier bibliography: Tybout *Aedificorum figurae* 55–107.

110. Barbet *Peinture* 25–6; Ling *Painting* 12–22 (he conveniently divides his discussion into phases I and II); Leach *Painting* 60–4. Detailed discussion: A. Laidlaw, *The First Style in Pompeii: Painting and Architecture* (Rome 1985).

111. Barbet *Peinture* 12–25.

112. Barbet *Peinture* 36–77; A. Rouveret, *Histoire et imaginaire de la peinture ancienne (Ve siècle av. J.-C. – Ier siècle ap. J.-C.)* (Rome 1989) 212–19; Ling *Painting* 25–31; Leach *Painting* 70–85.

113. Phase I is replaced by phase II in room 32 of the House of Fabius Rufus: Barbet *Peinture* pl. 2a; McKenzie *Petra* pl. 244b. Date of phase IIa (Odyssey frieze): R.A. Tybout, 'Roman Wall-painting and Social Significance', *JRA* 14 (2001) 55–6.

114. e.g., in the frigidarium of the House of the Cryptoporticus, Pompeii (I 6, 2): Ling *Painting* 33–4, fig. 31.

115. G. Carettoni, *Das Haus des Augustus auf dem Palatin* (Mainz 1983) 7–9 with colour illustrations; Tybout *Aedificorum figurae* 47–8.

116. Vitruvius's comment in n. 109 above is interpreted as meaning the Third Style which was introduced by the time (in the 20s BC) he was writing. Archaeological evidence indicates it appeared by *c.* 20–10 BC: McKenzie *Petra* 86. Third Style: Barbet *Peinture* 96–136; Ling *Painting* 52–71; Leach *Painting* 146–53; F.L. Bastet and M. de Vos, *Proposta per una classificazione del terzo stile pompeiano* (The Hague 1979).

117. Barbet *Peinture* 180–214; Ling *Painting* 71–100; Leach *Painting* 156–264.

118. Demonstrated by the computer reconstructions of Drew Baker for the Skenographia Project directed by Richard Beacham and Hugh Denard. Examples with actors on stage, House of Pinarius Cerealis and House of Apollo: Leach *Painting* fig. 79–80.

119. Beyen *op. cit.* (n. 101). Updating of his absolute chronology: Tybout *Aedificorum figurae* 41–54; Strocka *op. cit.* (n. 72) 107–15; Tybout *loc. cit.* (n. 113) 53–6.

120. Barbet *Peinture* 29–31, 37, fig. 18; Ling *Painting* 23–4; Leach *Painting* 64; Date: Tybout *Aedificorum figurae* 51–2, 373–5; F. Coarelli, 'Public Buildings in Rome between the Second Punic War and Sulla', *PBSR* 45 (1977) 14, 23; Lauter-Bufe *op. cit.* (n. 82) 93 n. 221.

121. Barbet *Peinture* 40, fig. 21; Ling *Painting* 24–5 (*c.* late 60s–50s BC); Leach *Painting* 74–5 (*c.* 50 BC); Strocka *op. cit.* (n. 72) 111 (*c.* 80–70 BC).

122. Strocka *op. cit.* (n. 72) 113, pl. 48.

123. Barbet *Peinture* 40, fig. 27, 32; Tybout *Aedificorum figurae* 52; Ling *Painting* 26–9; Leach *Painting* 75–85, 90; Tybout *loc. cit.* (n. 113) 53–6.
Because of the similarities between the scenes with the tholoi Leach considers the scenes in the House of the Labyrinth, the Villa of Oplontis, and the Villa of P. Fannius

Sinistor as the 'common products of one group of painters working in all three houses': Leach *Painting* 76–7.

124. Examples are given in McKenzie *Petra* 86–7. Barbet independently made observations some of which are almost identical to those made there, which tends to confirm their validity: Barbet *Peinture* 36–44.

125. Leach *loc. cit.* (n. 97) 158. Barbet refutes Beyen's subdivisions of Phase I but accepts that the House of the Griffins is earlier than the Villa of the Mysteries and the Villa of P. Fannius Sinistor: Barbet *Peinture* 37, 40, 43.

126. Examples given in McKenzie *Petra* 86–7. Barbet *Peinture* 57–77 also examines the Second Style paintings by room type, making different observations. Diagrams of houses with locations of wall-paintings indicated: Barbet *Peinture* fig. 21, 27, 32. Other observations: A. Wallace-Hadrill, *Houses and Society in Pompeii and Herculaneum* (Princeton 1994) 28–9; R.A. Tybout, 'Malerei und Raumfunktion im zweiten Stil', in E.M. Moormann, ed., *Functional and Spatial Analysis of Wall Painting* (Leiden 1993) 38–50.

127. H.G. Beyen, 'Die antike Zentralperspektive', *AA* 54 (1939) 47–72; Engemann *op. cit.* (n. 78) 44, 62–82, 90–5 (with ancient sources), pl. 6, 9, 14–15, 19–20, 22, 36–7; B. Wesenberg, 'Zur asymmetrischen Perspektive in der Wanddekoration des zweiten pompejanischen Stils', *Marburger Winckelmann-Programm* (1968) 102–9; Barbet *Peinture* 64; J. White, *The Birth and Rebirth of Pictorial Space* (3rd edn London 1987) 258–66; Tybout *loc. cit.* (n. 102); T. Mikocki, *La Perspective dans l'art romain* (Warsaw 1990) 30–45, 78–83, fig. 18–20, 22, 24–5.

128. Mikocki *op. cit.* (n. 127) fig. 29 (House of the Cryptoporticus) (Phase I examples: fig. 45–7). Detailed analysis, concentrating on Phase II walls, using computer reconstructions by Drew Baker and Martin Blazeby for the Skenographia Project directed by Richard Beacham and Hugh Denard.

129. Mikocki *op. cit.* (n. 127) 83–4.

130. H. Thiersch, *Zwei antike Grabanlagen bei Alexandria* (Berlin 1904) 13–16, pl. 2–3; A. Adriani, *Annuaire* 1933–5, 129–30; Tybout *Aedificorum figurae* 129–32; McKenzie *Petra* 98–9. Date of Sidi Gaber tomb: McKenzie *Petra* 65, 78.

131. The open court (f) of Tomb A at Shatby possibly had birds as well as garlands between the half-columns: R. Pagenstecher, *Nekropolis. Untersuchungen über Gestalt und Entwicklung der alexandrinischen Grabanlagen und ihrer Malereien* (Leipzig 1919) 109; Adriani *Repertorio* 125. Venit *Tombs* 29, 34 also notes the similarity of this to the Second Style.

132. In chamber d: E. Breccia, *La necropoli di Sciatbi* (Cairo 1912) xxxiv, pl. 2, 10–11; Adriani *Repertorio* 124, pl. 45 fig. 171, 46 fig. 174; Lyttelton *op. cit.* (n. 30) 41–2; Tybout *Aedificorum figurae* 282–5; McKenzie *Petra* 98–9, pl. 175a; Venit *Tombs* 29, 34–5, fig. 12.

133. Grave stelai from Macedonia, Thessaly, and Alexandria: Tybout *Aedificorum figurae* 121–4, 130–3, 143, 150–1, pl. 88–9, 91.1–2. He does not draw a distinction between these pictures and the life-size examples, although only giving examples of the latter from Alexandria.

134. It is sometimes suggested that the Second Style was derived from Macedonian tomb painting: C.I. Makaronas and S.G. Miller, 'The Tomb of Lyson and Kallikles', *Archaeology* 27 (1974) 258–9; P.W. Lehmann, 'Lefkadia and the Second Style', in G. Kopcke and M. Moore, eds., *Studies in Classical Archaeology, A Tribute to P.H. von Blanckenhagen* (1979) 225–9. Miller acknowledges the limits of the similarities and differences in: S.G. Miller, *The Tomb of Lyson and Kallikles: A Painted Macedonian Tomb* (Mainz 1993) 98–100, pl. II, IV. Contra: Tybout *Aedificorum figurae* 116–22, 146, 148. Earlier work quoted, with bibliography, in Tybout *Aedificorum figurae* 146 n. 501, 148 n. 510. Date, first half of second century BC: Tybout *Aedificorum figurae* 117, 377–80. Date, *c.* 200 BC: Miller *op. cit.* 92.

135. P. Clayton, *The Rediscovery of Ancient Egypt* (London 1982) pl. 10 (Dendara), 15 (Deir el-Medina), 25 (Philae); R.H. Wilkinson, *The Complete Temples of Ancient Egypt* (London 2000) pl. on p. 76, 160.

136. e.g. Tomb of Nefertari in the Valley of the Queens at Thebes, *c.* 1250 BC: R. Schulz and M. Seidel, eds., *Egypt The World of the Pharaohs* (Cologne 1988) 245 fig. 190.

137. Pagenstecher, *op. cit.* (n. 131) 108, 111; Breccia *op. cit.* (n. 132) pl. 8; Adriani *Repertorio* pl. 46 fig. 175.

138. Vitruvius, *On Architecture* 7. 11. 1.

139. On the Tomb of Lyson and Kallikles the pillars depicted are not divided in half across the corners but are wider than those along the main parts of the walls: Miller *op. cit.* (n. 134) pl. IIb, IVb.

140. A. Adriani, 'Osservazioni sulla Stele di Helixo e sui precedenti alessandrini del II stile pompeiano', *BSAA* 32–3 (1938–9) 120–3, fig. 3. Date: McKenzie *Petra* 68, 78.

141. McKenzie *Petra* pl. 235b. Also noted by Tybout *Aedificorum figurae* 133.

142. So also Adriani *loc. cit.* (n. 140) 128.

143. Notably, this pediment also has blue (sky) depicted in the corners above it: Breccia *op. cit.* (n. 132) xxxviii; Adriani *loc. cit.* (n. 140) 123–5; Adriani *Repertorio* 115. The cornice is dark red, bright red, black, grey, and white: Breccia *op. cit.* (n. 132) xxxvii–xxxviii.

144. It is on a loose fragment. A. Adriani, *Annuaire* (1933–5) 157–8, fig. 82. He notes the relationship to the Second Style.

145. McKenzie *Petra* pl. 227e; Beyen *op. cit.* (n. 101) vol. 1, Plates fig. 87, 180, 182, 184–6; Strocka *op. cit.* (n. 72) pl. 305.

146. Description of this type of perspective (used by Giotto *c.* AD 1300): White *op. cit.* (n. 127) 74–5.

147. Adriani *loc. cit.* (n. 140) 112–20, pl. 13–14. Adriani notes that the lines marking the flagstones of the paving in the painting did not come out in the reproduction of the water colour. Mervat Seif el-Din examined the panel itself in January 2006 and confirms that these lines converge also. Christensen (*loc. cit.* n. 102, 165) notes the development of the role of the use of spatial depth on ceilings and tiled floors in paintings in late mediaeval Italy.

148. Date, based on the pottery found in the *loculus*: A. Adriani, 'Scavi e scoperte alessandrine (1949–1952)', *BSAA* 41 (1956) 43, fig. 48; Adriani *Repertorio* 115; McKenzie *Petra* 68, 78. Tybout suggests it could date to the third or second century BC: Tybout *Aedificorum figurae* 134.

149. Timber cross beams supporting pillars are also depicted on the pergola in the garden scene of the Boscoreale Cubiculum [608].

150. White, *op. cit.* (n. 127) 260–2, considers there is no evidence of an increasingly accurate vanishing point perspective in Pompeii and that it must have developed elsewhere, existing at a slightly earlier date 'in at least one of the cultural centres that influenced Pompeii'.

151. e.g. Euclid, *Optics* Definition 2. Texts with discussion: Mikocki *op. cit.* (n. 127) 28–32. Central perspective is described in the first century BC by Lucretius (*De rerum natura* 4. 426–31) and Vitruvius (*On Architecture* 1. 2. 2): Mikocki *op. cit.* (n. 127) 32–7.

152. McKenzie *Petra* pl. 244. In colour: Barbet *Peinture* pl. 2a.

153. A. Adriani, *Annuaire* (1933–5) 27–8, fig. 12, pl. 10.2. Date of Tomb 1 at Moustapha Pasha: McKenzie *Petra* 64–5, 78; Venit *Tombs* 51. A. Adriani (*Annuaire* 1933–5, 30) raised the possibility that the tholos painting was part of a later alteration, partly because of the type of wall-painting, but Venit *Tombs* 60 casts doubt on this. Tybout acknowledges the relationship of the tholos painting to the Second Style and considers the painting could date to the first century BC on the grounds that other tombs in the necropolis were in use in the second half of the first century BC: Tybout *Aedificorum figurae* 163–4. However, as the painting was found *in situ* it should be dated by its own archaeological context, i.e. the tomb in which it occurs.

154. A. Adriani, *Annuaire* (1933–5) 131; Tybout *Aedificorum figurae* 163–4, pl. 78.1; Venit *Tombs* 60.

155. Unfortunately, the fragments of Second and Third Style wall-paintings found in Alexandria in the Serapeum enclosure lack a dated archaeological context, i.e., as they can only be dated on stylistic grounds it would create a circular argument if they were used to suggest the origin of the Second Style in Alexandria: Botti *Fouilles à la colonne* 79–81, pl. on p. 81; Pagenstecher *op. cit.* (n. 131) 187–9, fig. 113–17; Rowe *Encl. Serapis* 60 n. 3; Tybout *Aedificorum figurae* 161–3, pl. 77.2. Photographs of other fragments of paintings from the Serapeum site: Grimm and McKenzie *loc. cit.* (n. 27) 116, pl. 8.

156. Barbet *Peinture* 45–7 discusses the rare examples with figures, arguing that they imply the paintings represented the world of daily life.

157. Schefold considered because he detected elements of Alexandrian theology in the wall-paintings that they represent a sacred world: K. Schefold, 'Spuren alexandrinischer Theologie in römischen Wandmalereien', in E. Berger and H.C. Ackermann, eds., *Wort und Bild* (Basel 1975) 111–19. It was also suggested that they depicted the idyllic world of the gods visible when the city walls of the world descend, as described by Lucretius (*De rerum natura* 3. 16–24) in his presentation of Epicurean philosophy: A. Borbein, 'Zur Deutung von Scherwand und Durchblick auf den Wandgemälden', in B. Andreae and H. Kyrieleis, eds., *Neue Forschungen in Pompeji* (Recklinghausen 1975) 61–70.

158. Diodorus Siculus, 1. 9. 6; 1. 11. 1.

159. Diodorus Siculus, 1. 10. 1.

160. Athenaeus, *Deipnosophistae* 5. 196d.

161. Josephus, *Jewish Antiquities* 1. 1. 3.

162. For a complete list of examples, and detailed discussion: M.J. Versluys, *Aegyptiaca Romana. Nilotic Scenes and the Roman Views of Egypt* (Leiden 2002).

163. Date, 120–110 BC: P.G.P. Meyboom, *The Nile Mosaic of Palestrina* (Leiden 1995) 16–19; Versluys *op. cit.* (n. 162) 52.

164. Ling *Painting* 8.

165. Versluys *op. cit.* (n. 162) 155–8. Nilotic frieze, *c.* 60 BC: R. Ling, 'Studius and the Beginnings of Roman Landscape Painting', *JRS* 67 (1977) 7.
The monochrome examples from the Villa of P. Fannius Sinistor at Boscoreale and in the Villa of Oplontis have less obviously Egyptian elements: Ling *loc. cit.* 7–8; Versluys *op. cit.* (n. 162) 287, 460 n. 13, 462 no. 15. It is sometimes suggested that the small so-called sacral-idyllic landscapes were derived from Alexandria because they contain Egyptian elements and have a sketchy style associated with the fourth-century BC painter Antiphilus who was from Egypt: Pliny, *Natural History* 35. 37. 114; Quintilian *Institutio Oratoria* 12. 10. 6; S.R. Silberberg, *A Corpus of the Sacral-Idyllic Landscape Paintings in Roman Art*, PhD UCLA 1980 (*UMI* Ann Arbor 1981) 16–22.

166. Leach *Painting* 79.

167. Polybius 29. 27; Diodorus Siculus 31. 18. 2; Fraser *Ptol. Alex.* Vol. 2, 212–13 n. 220–1; Meyboom *op. cit.* (n. 163) 164; Versluys *op. cit.* (n. 162) 287, 421. Ling (*loc. cit.* n. 165, 14) suggests Demetrios might have painted stage-scenery.

168. Versluys *op. cit.* (n. 162) 13–14.

169. W.F. Jashemski, *The Gardens of Pompeii, Herculaneum and the Villas Destroyed by Vesuvius* (New York 1979) 87.

170. Jashemski *op. cit.* (n. 169) fig. 117, 123–4; Barbet *Peinture* 138–9, fig. 87, pl. 4b; Ling *Painting* fig. 159, pl. 13a; Leach *Painting* 126–7, fig. 81–2. More detailed discussion in: F. le Corsu, 'Un oratoire pompéien consacré à Dionysos-Osiris', *RA* 1967, 239–54, fig. 1–9; M. de Vos, *L'egittomania in pitture e mosaici romano-campani della prima età imperiale* (Leiden 1980) 15–21, fig. 12–19.

171. Jashemski *op. cit.* (n. 169) fig. 124; de Vos *op. cit.* (n. 170) pl. 19; G.E. Rizzo, *Le pitture dell'Aula Isiaca di Caligola*, Monumenti della pittura antica scoperti in Italia III, *Roma* 2 (Rome 1936) 34–7. This vessel is only used in contexts associated with the after life: R.A. Wild, *Water in the Cultic Worship of Isis and Serapis* (Leiden 1981) 2–3.

172. Further examples with illustrations in Lyttelton *op. cit.* (n. 30) 229–97.

173. U. Outschar, 'Betrachtungen zur kunstgeschichtlichen Stellung des Sebasteions in Aphrodisias', in J. de la Genière and K. Erim, eds., *Aphrodisias de Carie* (Paris 1987) 111, fig. 2.

174. Detailed illustrations and date: V.M. Strocka, *Das Markttor von Milet* (Berlin 1981).

175. V.M. Strocka, 'Zur Datierung der Celsusbibliothek', in *Proceedings of the Tenth International Congress of Classical Archaeology 1973*, vol. 2 (Ankara 1978) 893–900.

176. Gros *op. cit.* (n. 86) fig. 484.

177. Lyttelton *op. cit.* (n. 30) pl. 186; Gros *op. cit.* (n. 86) fig. 363.

178. McKenzie *Petra* pl. 145.

179. R. Naumann, *Der Quellbezirk von Nîmes* (Leipzig 1937); Gros *op. cit.* (n. 86) fig. 428.

180. Lyttelton *op. cit.* (n. 30) pl. 127.

181. Lyttelton *op. cit.* (n. 30) pl. 129.

182. G. Paul, 'Die Anastylose des Tetrapylons in Aphrodisias', and U. Outschar, 'Zur Baudekoration und typologischen Stellung des Tetrapylons', in C. Roueché and R.R.R. Smith, eds., *Aphrodisias Papers* 3, *JRA* Suppl. 20 (Ann Arbor 1996) 201–14 and 215–24.

183. M. Wörrle, 'Zur Datierung des Hadrianstempels an der "Kuretenstrasse" in Ephesos', *AA* (1973) 470–7.

184. Lyttelton *op. cit.* (n. 30) pl. 4.

185. *Scriptores Historiae Augustae*, Hadrian 26. 5. A. Roullet, *The Egyptian and Egyptianizing Monuments of Imperial Rome* (Leiden 1972) 49–51. The brick stamps indicate that it was built *c.* AD 125–8: M.T. Boatwright, *Hadrian and the City of Rome* (Princeton 1987) 148. This would mean that it was begun after Hadrian's earlier visit to Egypt, apparently mentioned in Dio Cassius, *Roman History Epitome* 69. 9. 4. Doubt has been cast on the identification of this structure as the Canopus in W.L. MacDonald and J.A. Pinto, *Hadrian's Villa and its Legacy* (New Haven 1995) 7–8, 108–11, fig. 133–4.

186. Pensabene *Elementi Aless.* 114, 144, 383–5, fig. 97, pl. 42.

187. Lauter *op. cit.* (n. 21) pl. 41a; Pensabene *Elementi Aless.* 348–51, pl. 23 nos. 160 and 163, 24, 25 no. 174.

CHAPTER 6: EGYPTIAN ARCHITECTURE

1. D. Thompson, *Memphis under the Ptolemies* (Princeton 1988). Topography: D. Crawford, 'Hellenistic Memphis: City and Necropolis', in *Alessandria e il mondo ellenistico-romano, Studi in onore di A. Adriani*, vol. 1 (Rome 1983) 16–24.

2. Under Ptolemy II Memphis was given a Hathor shrine (99 × 66 cubits) and a temple sanctuary (132 × 69 cubits): Thompson *op. cit.* (n. 1) 116–17.

3. Sculpture: G. Maspero, *Le Sérapeum de Memphis par A. Mariette-Pacha*, Atlas (Paris 1882); U. Wilcken, 'Die griechischen Denkmäler vom Dromos des Serapeums von Memphis', *JdI* 32 (1917) 149–203; J.P. Lauer and C. Picard, *Les Statues ptolémaïques du Sarapieion de Memphis* (Paris 1955); Hölbl *Geschichte* 256–8, fig. 24. Thompson *op. cit.* (n. 1) 116 n. 60 gives references for suggested dates for the sculptures.

4. These buildings have not survived since their rediscovery in the nineteenth century. A. Mariette, *Choix de monuments et de dessins découverts ou exécutés pendant le déblaiement du Sérapéum de Memphis* (Paris 1856) 7–8, pl. 4; Wilcken *loc. cit.* (n. 3) 156–60; Lauer and Picard *op. cit.* (n. 3) 176–80; Thompson *op. cit.* (n. 1) 28–9. Inscription: Lauer and Picard *op. cit.* (n. 3) 177–8, fig. 90.

5. J.H. Johnson, 'The Demotic Chronicle as a Statement of a Theory of Kingship', *The SSEA Journal (Journal for the Society for the Study of Egyptian Antiquities)* 13 (1983) 67–9.

6. Summary of this process during Ptolemaic period: Thompson *op. cit.* (n. 1) 125–38.

7. For example: S. Aufrère, J.-C. Golvin and J.-C. Goyon, *L'Égypte restituée, sites et temples de Haute Égypte* (Paris 1991) pl. on p. 154, 226–7, 230–1.

8. Arnold *Lexikon* 90–1 Geburtshaus with references; *LÄ* II, 462–75 Geburtshaus (detailed discussion in French); Arnold *Temples* 285–8, 288 Table 2.

9. Arnold *Lexikon* 35–6 Barkenstation.

10. Diodorus Siculus, 1. 36. 11–12; Strabo, *Geography* 17. 1. 48. Types of Nilometers, with references: *LÄ* IV, 496–8 Nilmesser; P.G.P. Meyboom, *The Nile Mosaic of Palestrina* (Leiden 1995) 51–3, 244–5 n. 77–8.

11. Most conveniently given in more detail and summarized in a very useful table in Hölbl *Geschichte* table after p. 341; and list in Arnold *Temples* 322–4. There is not space to go into the detailed basis of the chronology of the temples discussed here, suffice to say that the following observations are made after an examination of the basis of the chronology of the relevant monuments. The study has focused on those still standing, rather than those destroyed since the Napoleonic expedition. Summary of Greco-Roman period temples, their importance, characteristics and wall decoration: J. Baines, 'Temples as Symbols, Guarantors, and Participants in Egyptian Civilization', in S. Quirke, ed., *The Temple in Ancient Egypt* (London 1997) 226–35. See also: R.B. Finnestad, 'Temples of the Ptolemaic and Roman Periods: Ancient Traditions in New Contexts', in B.E. Shafer, ed., *Temples in Ancient Egypt* (London 1998) 185–237; D. Kurth, 'A World Order in Stone – The Late Temples', in R. Schulz and M. Seidel, eds., *Egypt the World of the Pharaohs* (Cologne 1998) 296–311.

12. Arnold *Temples* 138. Luxor: M. abd el-Raziq, *Die Darstellungen und Texte des Sanctuars Alexanders des Grossen im Tempel von Luxor* (Mainz 1984); Arnold *Temples* fig. 93. Karnak: PM II, 119–20.

13. Meyboom *op. cit.* (n. 10) 61; G. Haeny, 'A Short Architectural History of Philae', *BIFAO* 85 (1985) 206–7, 211; E. Vassilika, *Ptolemaic Philae* (Leuven 1989) 27, 38.

14. C. Favard-Meeks, *Le Temple de Behbeit el-Hagara* (Hamburg 1991) plan pl. 1; Arnold *Lexikon* 114–15 with references.

15. Thompson *op. cit.* (n. 1) 133; Johnson *loc. cit.* (n. 5) 70; Hölbl *Geschichte* 99–105. Decree of Canopus inscription: *OGIS* I 56; with Fr. tr. A. Bernand, *La Prose sur pierre dans l'Égypte hellénistique et romaine* (Paris 1992) vol. 1, 22–4 nos. 8–9, vol. 2, 30–5. Eng. tr.: M.M. Austin, *The Hellenistic World from Alexander to the Roman Conquest: a Selection of Ancient Sources in Translation* (Cambridge 1981) 366–8 no. 222.

16. Thompson *op. cit.* (n. 1) 126–7. Following the decree of Ptolemy II recorded in the Mendes Stele: H. De Meulenaere and P. MacKay, *Mendes* II (Warminster 1976) 173–7. On the tax for the cult of Arsinoe Philadelphus: W. Clarysse and K. Vandorpe, 'The Ptolemaic Apomoira', in H. Melaerts, ed., *Le Culte du souverain dans l'Égypte ptolémaïque au III* siècle avant notre ère, Studia Hellenistica 34 (Leuven 1998) 5–42.

17. Thompson *op. cit.* (n. 1) 117–18 with references; Johnson *loc. cit.* (n. 5) 70–1; Hölbl *Geschichte* 144.

18. For building programmes of Ptolemy V: E. Lanciers, 'Die ägyptischen Tempelbauten zur Zeit des Ptolemaios V Epiphanes (204–180 v. Chr.)', *MDIK* 42 (1986) 81–98 and 43 (1987) 173–82; Arnold *Temples* 179–83.

19. Thompson *op. cit.* (n. 1) 118; Hölbl *Geschichte* 145.

20. Thompson *op. cit.* (n. 1) 119; Hölbl *Geschichte* 146. Rosetta Stone inscription: *OGIS* I 90; *Sammelbuch* V 8299; with Fr. tr. Bernand *op. cit.* (n. 15) vol. 1, 44–9 no. 16, vol. 2, 46–54; Eng. tr.: Austin *op. cit.* (n. 15) 374–8 no. 227; S. Quirke and C. Andrews, *The Rosetta Stone* (London 1988); R. Parkinson, *The Rosetta Stone* (London 2005).

21. For building programmes of Ptolemy VI and VIII: M. Minas, 'Die Dekorationstätigkeit von Ptolemaios VI Philometer und Ptolemaios VIII Euergetes II an ägyptischen Tempeln', *Orientalia Lovaniensia Periodica* 27 (1996) 51–78 and 28 (1997) 87–121 esp. tables on p. 111 and 114. These are also obvious at a glance in Hölbl *Geschichte* table after p. 341, discussed 228–44; Arnold *Temples* 183–205.

22. Thompson *op. cit.* (n. 1) 108, 153–4. Revolts: K. Vandorpe, 'City of Many a Gate, Harbour for Many a Rebel', in S.P. Vleeming, ed., *Hundred-Gated Thebes* (Leiden 1995) 232–5. Textual sources for revolts: Austin *op. cit.* (n. 15) 378–88 nos. 228–31.

23. Revolt suppressed by Cornelius Gallus: Strabo, *Geography* 17. 1. 53. Detailed discussion of the temples in the Roman period: Arnold *Temples* 225–73; G. Hölbl, *Altägypten im Römischen Reich. Der römische Pharao und seine Tempel* I (Mainz 2000). Tables of occurrences of imperial titles on temples (which only indicate decoration of walls not new building activity, or lack of it): Alston *City* 204–6 tables 5.2.1–3.

24. Arnold *Lexikon* 229 Schrankenwand; Arnold *Temples* 302–3. Example from 29th dynasty (c. 404–380 BC) on the Hibis Temple in el-Kharga Oasis: D. Arnold, *Die Tempel Ägyptens* (Zurich 1992) fig. on p. 27.

25. For example, Medinet Habu: Aufrère *et al. op. cit.* (n. 7) pl. on p. 172–3, 175.

26. Arnold *Lexikon* 243–4 Sphinxallee, with references, pl. on p. 243.

27. M. Haneborg-Lühr, 'Les Chapiteaux composites. Étude typologique, stylistique et statistique', in C. Obsomer, and A.-L. Oosthoek, ed., *Amosiadès, mélanges offerts au Professeur Claude Vandersleyen par ses anciens étudiants* (Louvain-la-Neuve 1992) 125–52, reproduces and gives some chronological analysis of the types classified by G. Jéquier, *Manuel d'archéologie égyptienne, les éléments de l'architecture* (Paris 1924) 230–74. Dynastic period: Jéquier *op. cit.* 197–230; G. Foucart, *Histoire de l'ordre lotiforme* (Paris 1897); L. Borchardt, *Die ägyptischen Pflanzensäule* (Berlin 1897).

28. Vassilika *op. cit.* (n. 13) 184–6.

29. H.E. Winlock, *The Temple of Hibis in el Khargeh Oasis* (New York 1941) 26–7, 31, pl. 4–8, 35, 41, 46; Arnold *Lexikon* fig. on p. 49; Arnold *Temples* 113, 115, fig. 68. When the portico was reconstructed a roughly blocked out capital was erected in place of the composite capital which is now in the Sackler Gallery of the Metropolitan Museum of Art, New York. Date: E. Cruz-Uribe, 'Hibis Temple Project: Preliminary Report 1985–1986', *Varia Aegyptiaca* 3 (1987) 230. Another composite capital was erected on a single column in chamber L: Winlock *op. cit.* 13, pl. 19b, 32; Haneborg-Lühr *loc. cit.* (n. 27) fig. 5.

30. Two capital types were earlier used together on the outer hypostyle hall N, which was built in the reign of Hakoris, 393–380 BC: Winlock *op. cit.* (n. 29) 20, 23, pl. 12–13, 32, 34–5. Date: Cruz-Uribe *loc. cit.* (n. 29) 230.

31. Recorded by the Napoleonic expedition, destroyed c. 1826. *Description de l'Égypte*, vol. 4, pl. 51–2; PM III, 165–7; *LÄ* II, 1142; Arnold *Lexikon* 105–6.

32. Recorded by the Napoleonic expedition, destroyed in 1821. *Description de l'Égypte* vol. 4, pl. 38–42; Arnold *op. cit.* (n. 24) 177–8; PM V, 15–16. Date: Arnold *Lexikon* 25; *OGIS* I 109; Arnold *Temples* 174, 184, fig. 132–5.

33. G. Jéquier, *Les Temples ptolémaïques et romains* (Paris 1924) pl. 4.3, 5.1–3; M.A. Murray, *Egyptian Temples* (London 1931) 92, pl. 18.2; Arnold *Temples* 167, fig. 113. Date: PM II, 198. See also the pronaos of the temple at Qasr el-Ghueida in el-Kharga Oasis built by Ptolemy III: Arnold *op. cit.* (n. 24) pl. on p. 156; PM VII, 293.

34. Jéquier *op. cit.* (n. 33) pl. 31, 32.2; S. Sauneron and H. Stierlin, *Die letzten Tempel Ägyptens, Edfu und Philae* (Zürich 1978) pl. on p. 89. Date: PM VI, 135–8.

35. Jéquier *op. cit.* (n. 33) pl. 9; Murray *op. cit.* (n. 33) pl. 21; Arnold *Lexikon* pl. 31; Arnold *op. cit.* (n. 24) 160–2; Arnold *Temples* 195–6, fig. 145–6. Date: PM V, 140; Arnold *Lexikon* 151.

36. It had been thought that the earliest example of a composite capital with volutes survived on the Kiosk of Nectanebo I at Philae, which meant they would have been introduced before the Ptolemaic period (but still as a result of Greek influence). However, when the monuments were moved from Philae with the construction of the Aswan Dam it was discovered that the kiosk had been altered by Ptolemy II Philadelphus and re-erected by Ptolemy XII Neos Dionysos (Auletes). Thus, it can no longer be used as a fixed point for the introduction of volutes on composite capitals. Vassilika *op. cit.* (n. 13) 23–4; Haeny *loc. cit.* (n. 13) 204–6, 224, 228; H.G. Lyons, *A Report on the Island and Temples of Philae* (London 1896) pl. 4 capital second from right.

37. Athenaeus, *Deipnosophistae* 5. 206b.

38. The building sequence is described in Haeny *loc. cit.* (n. 13) utilizing the information gleaned when the buildings were pulled down for re-building as a result of the

flooding of the island by the Aswan Dam. See also Vassilika *op. cit.* (n. 13) with detailed analysis and Lyons *op. cit.* (n. 36); *LÄ* IV, 1022–7.

39. Capitals: Vassilika *op. cit.* (n. 13) pl. 43d, 44; Sauneron and Stierlin *op. cit.* (n. 34) pl. on p. 157, 165–6. Date: Construction by Ptolemy VI possibly by 157 BC and earliest decoration in later years of Ptolemy VIII: Haeny *loc. cit.* (n. 13) 208; Vassilika *op. cit.* (n. 13) 62–3.

40. Jéquier *op. cit.* (n. 33) pl. 13; Murray *op. cit.* (n. 33) 140, pl. 33. The temple was begun under Ptolemy IV Philopator: Arnold *Lexikon* 63. Date of pronaos: PM II, 402.

41. Lyons *op. cit.* (n. 36) pl. 12, 14; Vassilika *op. cit.* (n. 13) pl. 41c. Date: PM VI, 251–252; Haeny *loc. cit.* (n. 13) 230–1; Vassilika *op. cit.* (n. 13) 167, 184.

42. Capitals: Sauneron and Stierlin *op. cit.* (n. 34) pl. on p. 164 third capital from left, Vassilika *op. cit.* (n. 13) pl. 42c-d, 43a. Date: Haeny *loc. cit.* (n. 13) 211; Vassilika *op. cit.* (n. 13) 38–40, 184–5.

43. Vassilika *op. cit.* (n. 13) 57–62, 70, 184–5, pl. 43c.

44. Built by Ptolemy VIII including capitals, other decoration by Ptolemy XII: Haeny *loc. cit.* (n. 13) 212; Vassilika *op. cit.* (n. 13) 69–71, 76–8, pl. 42b; PM VI, 219.

45. E. Winter, *Untersuchungen zu den ägyptischen Tempelreliefs der griechisch-römischen Zeit* (Vienna 1968) Part 1, 45, 58. Earlier prototypes: J. Baines, 'King, Temple and Cosmos: an Earlier Model for Framing Columns in Temple Scenes of the Greco-Roman Period', in M. Minas and J. Zeidler, eds., *Aspekte spätägyptischer Kultur, Festschrift für E.Winter zum 65. Geburtstag, AegTrev* 7 (Mainz 1994) 23–33.

46. Inscription: C. de Wit, 'Inscriptions dédicatoires du temple d'Edfou', *Chronique d'Égypte* 71 (1961) 56–97 and 277–320; explained in S. Cauville and D. Devauchelle, 'Le Temple d'Edfou: étapes de la construction, nouvelles données historiques', *Revue d'égyptologie* 35 (1984) 31–55. Analysis of measurements: S. Cauville and D. Devauchelle, 'Les Mesures réelles du temple d'Edfou', *BIFAO* 84 (1984) 23–34; Arnold *Temples* 152. Length of cubit calculated by writer from Cauville and Devauchelle *loc. cit.* table on p. 24 excluding staircase (room 20). Building: *Description de l'Égypte*, vol. 1, pl. 48–60; Jéquier *op. cit.* (n. 33) pl. 15–32; Arnold *Lexikon* 71–2 with references; Aufrère *et al. op. cit.* (n. 7) 248–56; Sauneron and Stierlin *op. cit.* (n. 34) pl. on p. 12–13, 24–47, 50–2, 59–61, 65, 72, 89, 97–109, 114–121, 124. Date: *LÄ* VI, 323; Arnold *Lexikon* 71–2; Cauville and Devauchelle *loc. cit.*

47. *Description de l'Égypte*, vol. 1, pl. 62–65; Jéquier *op. cit.* (n. 33) pl. 33–5. Date: 'Outer vestibule' Ptolemy IX Soter II; PM VI, 170 plan, 172; *LÄ* VI, 323.

48. *Description de l'Égypte*, vol. 1, pl. 39–46; Jéquier *op. cit.* (n. 33) pl. 36–53; Aufrère *et al. op. cit.* (n. 7) 259–61; Arnold *Lexikon* 126–7 with references. Date: PM VI, 182; *LÄ* III, 679.

49. Destroyed in 1861/2. *Description de l'Égypte*, vol. 1, pl. 91–4; Arnold *Lexikon* 28 Armant; Arnold *Temples* 223. Date: PM V, 151–7; *LÄ* I, 438.

50. Contra: A.E. Samuel, *From Athens to Alexandria: Hellenism and Social Goals in Ptolemaic Egypt* (Louvain 1983) 54–6. The similar problem of the combination of Greek and Egyptian features in the traditional Egyptian style portrait sculpture is discussed in: R.R.R. Smith, 'Ptolemaic Portraits: Alexandrian Types, Egyptian Versions', and B.V. Bothmer, 'Hellenistic Elements in Egyptian Sculpture of the Ptolemaic Period', in K. Hamma, ed., *Alexandria and Alexandrianism* (Malibu 1996) 203–13 and 215–30.

51. Wooden roofs: D. Arnold, 'Holzdächer spätzeitlicher ägyptischer Tempel', in M. Bietak, ed., *Archaische griechische Tempel und Altägypten* (Vienna 2001) 107–15; Arnold *Temples* 115, fig. 69–70. Foundations: Arnold *Lexikon* 86–7. Masonry techniques: Arnold *Temples* 96, 144–5, 153, fig. 96. Paint colours: Baines *loc. cit.* (n. 11) 233; Arnold *Temples* 148–9.

52. Strabo, *Geography* 17. 1. 28; Fraser *Ptol. Alex.* vol. 2, 414–15 n. 582. On the bone tokens *ptera*, usually translated 'wings', refers to the pylon of a traditional Egyptian temple: E. Alföldi-Rosenbaum, 'Alexandriaca. Studies on Roman Game Counters III', *Chiron* 6 (1976) 222–3, pl. 27.70–3.

53. *Description de l'Égypte*, vol. 4, pl. 2–31.1; Jéquier *op. cit.* (n. 33) pl. 55–64; Sauneron and Stierlin *op. cit.* (n. 34) pl. on p. 20–1, 48, 55–7, 66–9, 76–9, 91–5; Aufrère *et al. op. cit.* (n. 7) figs on p. 223–8; Arnold *Lexikon* 65–6 with references. Date: E. Winter, 'A Reconsideration of the Newly Discovered Building Inscription on the Temple of Denderah', *GöttMisz* 108 (1989) 75, 78–80.

54. Colonnades: *Description de l'Égypte*, vol. 1 pl. 5, 8; Lyons *op. cit.* (n. 36) pl. 32–5 First East Colonnade, pl. 36–41 West Colonnade, pl. 42–5. West Colonnade: Sauneron and Stierlin *op. cit.* (n. 34) 150–3. Date: Both colonnades are decorated with reliefs of Augustus and Tiberius. The *terminus post quem* for their construction comes from reused blocks inscribed in Greek from the early Roman period. Other reused blocks indicate that they cannot date before the reign of Ptolemy XII. Haeny *loc. cit.* (n. 13) 226–8; PM VI, 208–9. It is possible that the Roman Kiosk was also constructed at the same time, under Augustus, see n. 68 below. Examples of columns decorated under Tiberius: E. Drioton, 'De Philae à Baouît', *Coptic Studies in Honour of W.E. Crum* (Boston 1950) 444 fig. 1.

55. North Temple, now in the Rijksmuseum van Oudheden in Leiden. Murray *op. cit.* (n. 33) 194–6, pl. 50.3, 51; G. Roeder, *Debod bis Bab Kalabsche*, vol. 2 *Les Temples immergés de la Nubie* (Cairo 1911) pl. 82–8; H.D. Schneider, *Taffeh Rond de wederopbouw van een Nubische tempel* ('s-Gravenhage 1979) 20–3, 83–122; F.C. Gau, *Antiquités de la Nubie, ou monuments inédits des bords du Nil, situés entre la première et la seconde cataracte* (Paris 1822) pl. 10–11. Date: Arnold *Lexikon* 255.

56. Great Temple of Mandulis: Gau *op. cit.* (n. 55) pl. 17–22; K.G. Siegler, *Kalabsha, Architektur und Baugeschichte des Tempels* (Berlin 1970); G.R.H. Wright, *Kalabsha, The Preserving of the Temple* (Berlin 1972); Arnold *Lexikon* 119; Arnold *Temples* 240, 243, fig. 201–43. Date: PM VII, 10; *LÄ* III, 295.

57. Now in Metropolitan Museum of Art, New York: Gau *op. cit.* (n. 55) pl. 23–6; A.M. Blackman, *The Temple of Dendûr, Les Temples immergés de la Nubie* (Cairo 1911) pl. 1, 31–32; H. el-Achirie *et al.*, *Le Temple de Dandour*, 3 vols (Cairo 1972–9) Centre

de documentation et d'études sur l'ancienne Égypte; C. Aldred, *The Temple of Dendur* (New York 1978) [= *Metropolitan Museum of Art Bulletin* 36.1, 1978]; Arnold *Temples* 244, fig. 204–46. Date: PM VII, 27; *LÄ* I, 1063; Arnold *Lexikon* 66. 23–10 BC: Aldred *op. cit.* 37.

58. Gau *op. cit.* (n. 55) pl. 33–8; G. Roeder, *Der Tempel von Dakke, Les Temples immergés de la Nubie* (Cairo 1913) pl. 1–10. Date: *LÄ* I, 988; Arnold *Lexikon* 58.

59. Under Augustus and Tiberius the forecourt of the Ptolemaic temple of Isis was decorated. Temple, now in Madrid: Gau *op. cit.* (n. 55) pl. 2–6; Roeder *op. cit.* (n. 55) pl. 2–41; PM VII, 2. Date: PM VII, 3–5; *LÄ* I, 997; J.-C. Grenier, *Les Titulatures des empereurs romains dans les documents en langue égyptienne* (Brussels 1989) 11 A5, 17 B4.

60. The walls of the forecourt were decorated under Augustus and the columns under Tiberius. For building see n. 48 above. Forecourt: Arnold *Temples* 232, 235, fig. 188–91. Date: PM VI, 197; *LÄ* III, 679.

61. For building see n. 53 above. Date: Winter *loc. cit.* (n. 53) 76 n. 2, 80.

62. This is the only one of three temples at Esna which survived. Temple: *Description de l'Égypte*, vol. 1, pl. 72–8, 83; Jéquier *op. cit.* (n. 33) pl. 72–7; Arnold *Lexikon* 75–6 with references. The date of the hypostyle hall is based on the earliest cartouches which are those of Claudius: *LÄ* II, 30–3; S. Sauneron, *Le Temple d'Esna* (Cairo 1959–82) vol. 2, p. XLI–XLII. Date of decoration: PM VI, 111–16; Sauneron *op. cit.* vol. 2, p. XXXIX–XLIV, 320–1, fig. on p. XLIII, vol. 3, p. XXII–XXIII and 392, fig. on p. XXII, includes diagrams of the sequence of decoration.

63. Gau *op. cit.* (n. 55) pl. 40–1; Murray *op. cit.* (n. 33) 216–18, pl. 57.3; G. Maspero, *Rapports relatifs à la consolidation des temples, Les Temples immergés de la Nubie* (Cairo 1911) pl. 99–109, D–F; Arnold *Temples* 244, fig. 207. Date: PM VII, 51; Arnold *Lexikon* 145.

64. *LÄ* III, 679; Grenier *op. cit.* (n. 59) 103·

65. Examples from Kalabsha: Siegler *op. cit.* (n. 56) fig. 60, 62, pl. 5, 17, 30.I–II, IV, B, C. Qertassi: Siegler *op. cit.* (n. 56) fig. 116.

66. Examples from Kalabsha: Siegler *op. cit.* (n. 56) fig. 63, pl. 5, 30.III.

67. Building: *Description de l'Égypte*, vol. 4, pl. 32; Jéquier *op. cit.* (n. 33) pl. 68–9; F. Daumas, *Les Mammisis de Dendara* (Cairo 1959) pl. 34–53. The earliest cartouches on it are of Trajan. PM VI, 103; Daumas *op. cit.* p. XX–XXI; Grenier *op. cit.* (n. 59) 102. Nero is depicted on the pronaos of the Hathor temple offering a model birth house: Arnold *Temples* 257.

68. Building: Lyons *op. cit.* (n. 36) pl. 17–19; Sauneron and Stierlin *op. cit.* (n. 34) pl. on p. 132, 160–1. The decoration on it was done under Trajan: Grenier *op. cit.* (n. 59) 104. But it is not clear when it was built. Haeny observes that from its architectural form it could be late Ptolemaic, although he suggests it was most likely Augustan: Haeny *loc. cit.* (n. 13) 228–30.

69. Building, re-erected south of Sadd el-'Ali: Roeder *op. cit.* (n. 55) 146–79, pl. 50a, 51–9a; Murray *op. cit.* (n. 33) 192–3, pl. 49; Arnold *Lexikon* pl. 38; Gau *op. cit.* (n. 55) pl. 7–8; Siegler *op. cit.* (n. 56) fig. 116–117. From its form it could be Ptolemaic or early Roman and has obvious similarities with the Roman Kiosk ('Trajan's Kiosk') at Philae: Arnold *Lexikon* 209; *LÄ* V, 48–9.

70. A. Lukaszewicz, *Les Édifices publics dans les villes de l'Égypte romaine* (Warsaw 1986) 162. Memphis: Thompson *op. cit.* (n. 1) 274.

71. PM V, 138 plan; Aufrère *et al. op. cit.* (n. 7) fig. on p. 147; Arnold *Lexikon* 151–2 with references. Previous date: PM V, 140; Arnold *Lexikon* 151. Revised date: Arnold *Temples* 194–6, fig. 145, 147, 12 plan VII.

72. Jéquier *op. cit.* (n. 33) pl. 12; M.V. Seton-Williams, *Ptolemaic Temples* (London 1978) fig. 5 plan; Arnold *op. cit.* (n. 24) pl. on p. 149; Aufrère *et al. op. cit.* (n. 7) pl. on p. 174; Arnold *Temples* 265, fig. 230–1, 15 plan X. Date: PM II, 461–2; *LÄ* III, 1257.

73. Kom Mer: M. es-Saghir and D. Valbelle, 'The Discovery of the Komir Temple: preliminary report', *BIFAO* 83 (1983) 150, 153, pl. 30B, 31B; Arnold *Temples* 267. Nadura: PM VII, 290–1; S. Aufrère, J.-C. Golvin and J.-C. Goyon, *L'Égypte restituée* 2, *Sites et temples des déserts* (Paris 1994) 96–7; Arnold *Temples* 267, fig. 234. Other examples hypothetically attributed to Antoninus Pius: Arnold *Temples* 267–70.

74. R.S. Bagnall, *Egypt in Late Antiquity* (Princeton 1993) 262. As evidence he cites: Grenier *op. cit.* (n. 59) and J.-L. Fournet, Review of J.-C. Grenier, *Les Titulatures des empereurs romains dans les documents en langue égyptienne*, *Revue des études grecques* 104 (1991) 616–19 with graph.

75. Meyboom *op. cit.* (n. 10) 307 n. 114; Grenier *op. cit.* (n. 59) 104.

76. Arnold *Lexikon* 158 with references; Arnold *op. cit.* (n. 24) pl. on 145.

77. *LÄ* III, 679; Grenier *op. cit.* (n. 59) 103.

78. PM VI, 114; S. Sauneron, 'Les Querelles impériales vues à travers les scènes du temple d'Esné', *BIFAO* 51 (1952) 111–21 with diagrams; *LÄ* II 30; Grenier *op. cit.* (n. 59) 103; Seton-Williams *op. cit.* (n. 72) fig. 7.

79. Detailed discussion of the strength of continuity of Egyptian religion through the Roman period: D. Frankfurter, *Religion in Roman Egypt: Assimilation and Resistance* (Princeton 1998).

80. Grenier *op. cit.* (n. 59) 75 C1; Bagnall *op. cit.* (n. 74) 262.

81. Grenier *op. cit.* (n. 59) 77–85.

82. E. Winter, 'Die Tempel von Philae und das Problem ihrer Rettung', *AW* 7.3 (1976) 6 fig. 7; J.-C. Grenier, 'La Stèle funéraire du dernier taureau Bouchis', *BIFAO* 83 (1983) 204–5.

83. *LÄ* IV, 1026; P. Nautin, 'La Conversion du temple de Philae en église chrétienne', *Cahiers archéologiques* 17 (1967) 8; P. Grossmann, 'Die Kirche des Bischofs Theodoros im Isistempel von Philae. Versuch einer Rekonstruktion', *Rivista degli studi orientali* 58 (1984 [1987]) 108; Procopius, *Persian Wars* 1. 19. 36–7.

84. Bagnall *op. cit.* (n. 74) 263; M. el-Saghir, *Das Statuenversteck im Luxortempel* (Mainz 1992).

CHAPTER 7: CITIES AND TOWNS OF ROMAN EGYPT

1. B.J. Kemp, 'Temple and Town in Ancient Egypt', in P.J. Ucko, R. Tringham and G. Dimbleby, eds., *Man, Settlement and Urbanism* (London 1972) 657–80; H.S. Smith, 'Society and Settlement in Ancient Egypt', in P.J. Ucko *et al. op. cit.* 705–19.

2. J. Bingen, 'Le Milieu urbain dans la chôra égyptienne à l'époque ptolémaïque', *Proceedings of the XIV International Congress of Papyrologists, Oxford 1974* (London 1975) 367–73; Lukaszewicz *Les Édifices publics* 21–2; G. Husson and D. Valbelle, *L'État et les institutions en Égypte des premiers pharaons aux empereurs romains* (Paris 1992) 231–46; A.K. Bowman and D. Rathbone, 'Cities and Administration in Roman Egypt', *JRS* 82 (1992) 109.

3. Husson and Valbelle *op. cit.* (n. 2) 242–3; A. Bowman, 'Public Buildings in Roman Egypt', *JRA* 5 (1992) 498–9. The gymnasia in the villages (not the *metropoleis*) were closed under the Romans: Bingen *loc. cit.* (n. 2) 371.

4. On the survival of papyri from the Ptolemaic period, compared with the more plentiful finds from the Roman period after Augustus: R.S. Bagnall, *Reading Papyri, Writing Ancient History* (London 1995) 26–7.

5. Strabo, *Geography* 17. 1. 32.

6. D. Thompson, *Memphis under the Ptolemies* (Princeton 1988) 19 cites *P.Corn.* 1. 84–85 = *Greek Papyri in the Library of Cornell University*, ed. W.L. Westermann and C. J. Kraemer (New York 1926) p. 5, 11, 18, no. 1 lines 84–5.

7. *BGU* VIII 1741–3; XIV 2368; Humphrey *Roman Circuses* 520; Thompson *op. cit.* (n. 6) 19.

8. *Sammelbuch* III 7245; J. Delorme, *Gymnasion, étude sur les monuments consacrés à l'éducation en Grèce* (Paris 1960) 139–40. Tr.: M.M. Austin, *The Hellenistic World from Alexander to the Roman Conquest* (Cambridge 1981) 428–9 no. 255.

9. *Sammelbuch* III 7246; with Fr. tr. A. Bernand, *La Prose sur pierre dans l'Égypte hellénistique et romaine* (Paris 1992) vol. 1, 42–3 no. 15, vol. 2, 44–5. It was bought in Luxor in 1922. H. Henne, 'Inscriptions grecques, décret des membres d'un gymnase d'époque ptolémaïque', *BIFAO* 22 (1923) 191–202; Delorme *op. cit.* (n. 8) 139.

10. *PSI* VI 584. Also for Hypsele/Lykopolites: *BGU* IV 1130. 9; Lukaszewicz *Les Édifices publics* 166. On costs of running baths in mid-third century BC based on papyrological references: C. Préaux, *Les Grecs en Égypte d'après les archives de Zénon* (Brussels 1947) 44.

11. *BGU* VIII 1767–8; Bowman *loc. cit.* (n. 3) 499.

12. *SEG* XXVII 1114 and add. 1305; Fraser *Ptol. Alex.* vol. 2, 382 n. 341; *La Gloire d'Alexandrie* (Paris 1998) 267 no. 210. Ger. tr. L. Koenen, *Eine agonistische Inschrift aus Ägypten und frühptolemäische Königsfeste* (Meisenheim 1977); Eng. tr. Austin *op. cit.* (n. 8) 393–5 no. 234; S. Walker and P. Higgs, eds., *Cleopatra of Egypt from History to Myth* (London 2001) 116.

13. *BGU* VIII 1854; Humphrey *Roman Circuses* 519–520; Bowman *loc. cit.* (n. 3) 499.

14. *BGU* XIV 2390. 34. Bowman *loc. cit.* (n. 3) 499. Auctions in agora in Herakleopolis, c. 36/35 BC: *BGU* XIV 2376. 13.

15. *P.Tebt.* III.2 871. 3, 13, 20 = *The Tebtunis Papyri*, ed. A.S. Hunt *et al.*, vol. 3.2 (London 1938) 120–2 no. 871. Lukaszewicz *Les Édifices publics* 63; Bailey *Hermopolis* 22; Bowman *loc. cit.* (n. 3) 499.

16. *P.Ryl.* II 68.7 = *Catalogue of the Greek Papyri in the John Rylands Library Manchester*, ed. J. de M. Johnson *et al.*, vol. 2 (Manchester 1915) 9–10 no. 68; Calderini *Dizionario*, vol. 2, 173; Lukaszewicz *Les Édifices publics* 61; Bailey *Hermopolis* 22.

17. Husson and Valbelle *op. cit.* (n. 2) 224–5.

18. *OGIS* I 49; C. Plaumann, *Ptolemais in Oberägypten. Ein Beitrag zur Geschichte des Hellenismus in Ägypten* (Leipzig 1910) 59; Bowman *loc. cit.* (n. 3) 499.

19. *Boule*: *OGIS* I 48 and 49; *dikasteria*: *OGIS* I 48; *prytaneis*: *OGIS* I 49; *demos*: *OGIS* I 49; *ekklesiai*: *OGIS* I 48. Bowman *loc. cit.* (n. 3) 499.

20. Strabo, *Geography* 17. 1. 42 (c. 26–20 BC).

21. *BGU* VII pt. 1; M. Nowicka, *La Maison privée dans l'Égypte ptolémaïque* (Warsaw 1969) 105–7; Bowman and Rathbone *loc. cit.* (n. 2) 109; P. Davoli, *L'archeologia urbana nel Fayyum di età ellenistica e romana* (Naples 1998) 140–1, fig. 60–1.

22. Préaux *op. cit.* (n. 10) 40–4 with references in papyri. Theatre, c. 253 BC: *P.Cair.Zen.* 59823; S. Daris, 'Lo spettacolo nei papiri greci', *Aevum Antiquum* 1 (1988) 78.

23. c. 242/1 BC: *PSI* IV 391a. First half of second century BC: *BGU* VI 1256; Delorme *op. cit.* (n. 8) 139.

24. *PSI* IV 418; Delorme *op. cit.* (n. 8) 139.

25. *P.Cair.Zen.* 59665. Detailed discussion, with archaeological examples: W.A. Daszewski, 'Some Problems of Early Mosaics from Egypt', in H. Maehler and V.M. Strocka, eds., *Das ptolemäische Ägypten* (Mainz 1978) 123–36. Diospolis Parva (Hiw): Daszewski *Mosaics* 170–1 no. 46, fig. 11, pl. 38–9. Arsinoe: Davoli *op. cit.* (n. 21) 152, fig. 70. Euhemeria (Qasr el-Banat): Davoli *op. cit.* (n. 21) 295, fig. 141. Small private bath of early Ptolemaic period and public bath of mid-Ptolemaic period at Athribis: K. Mysliwiec, 'L'habitat d'Athribis à la lumière des fouilles récentes', *Topoi* 5 (1995) 125–8, fig. 1–3; K. Mysliwiec and M. Bakr Said, 'Polish-Egyptian Excavations at Tell Atrib in 1994–1995', *ÉtTrav* 18 (1999) 180, 189–90, 205, 209–10, 217–18, fig. 1–4, 19–21. Bath with circular building (tholos) at Marina el-Alamein, first century AD: W.A. Daszewski, 'Témoignage de l'urbanisation de la côte méditerranéenne de l'Égypte à l'époque hellénistique et romaine à la lumière des fouilles de Marina el Alamein', *Bulletin de la Société française d'Égyptologie* 132 (April 1995) 18–19, fig. 3–4.

26. *P.Cair.Zen.* 59763–4. E. Vanderborght, 'La Maison de Diotimos, à Philadelphie', *Chronique d'Égypte* 33 (1942) 117–26; Préaux *op. cit.* (n. 10) 42–3; Nowicka *op. cit.* (n. 21) 139–47 with references. Discussion of terms used: G. Husson, *Oikia, le vocabulaire de la maison privée en Égypte d'après les papyrus grecs* (Paris 1983) 29–30, 49, 105–7, 111, 152–3, 219, 223–4, 239–40, 243–4, 283, 302–6. Comparison with the Palazzo delle Colonne at Ptolemais in Libya: J. Raeder, 'Vitruv, de architectura VI 7 (*aedificia*

Graecorum) und die hellenistische Wohnhaus- und Palastarchitektur', *Gymnasium* 95 (1988) 365–8; Nielsen *Palaces* 138, 151.

27. *P.Cair.Zen.* 59445, 59767, 59847. Detailed discussion on painting: Vanderborght *loc. cit.* (n. 26) 120–3; Nowicka *op. cit.* (n. 21) 44, 101–3; *idem*, 'Théophilos, peintre alexandrin, et son activité', in *Alessandria e il mondo ellenistico-romano, studi in onore di A. Adriani*, vol. 2 (Rome 1984) 256–9; Husson *op. cit.* (n. 26) 110–11, 153, 224, 240, 283–304.

28. A. Bowman, 'Urbanisation in Roman Egypt', in E. Fentress, ed., *Romanization and the City*, *JRA* suppl. 38 (Portsmouth, RI 2000) 174, 185; B. Kramer, 'Der κτίστης Boethius und die Einrichtung einer neuen Stadt. Teil I. P.UB Trier S 135–3 und S 135–1', *Archiv für Papyrusforschung* 43.2 (1997) 315–39; H. Heinen, 'Der κτίστης Boethius und die Einrichtung einer neuen Stadt. Teil II', *Archiv für Papyrusforschung* 43.2 (1997) 340–63.

29. Lukaszewicz *Les Édifices publics* 20. Antinoopolis: E. Kühn, *Antinoopolis* (Göttingen 1913) 90; Husson and Valbelle *op. cit.* (n. 2) 225–6.

30. This also included running civic cults and amenities including the baths, markets and gymnasium. A.C. Johnson, *Roman Egypt to the Reign of Diocletian* (Baltimore 1936) 691 no. 418, 693 nos. 422–3; Lukaszewicz *Les Édifices publics* 89–119; Bowman *loc. cit.* (n. 3) 495, 498; Bowman and Rathbone *loc. cit.* (n. 2) 123–5.

31. Cf. R.P. Duncan-Jones, 'Who paid for public buildings in Roman Cities', in F. Grew and B. Hobley, eds., *Roman Urban Topography in Britain and the Western Empire* (London 1985) 28–33.

32. Bowman and Rathbone *loc. cit.* (n. 2) 108; R. Bagnall, *Egypt in Late Antiquity* (Princeton 1993) 55; A.K. Bowman, *The Town Councils of Roman Egypt*, American Studies in Papyrology 11 (Toronto 1971).

33. Lukaszewicz *Les Édifices publics* 22–3, 61; Pensabene *Elementi Aless.* 288.

34. Lukaszewicz *Les Édifices publics*. Lukaszewicz gives a detailed analysis of the buildings and their functions based only on the papyrological references, with a useful list of them at the end. Papyrological references are also given in Calderini *Dizionario* under the name of each town.

35. Archaeological evidence summarized by building type in: D.M. Bailey, 'Classical Architecture in Roman Egypt', in M. Henig, ed., *Architecture and Architectural Sculpture in the Roman Empire* (Oxford 1990) 121–37. General analysis: Bowman *loc. cit.* (n. 3) 495–503; Bagnall *op. cit.* (n. 32) 45–54.

36. Most of these remains had been destroyed by 1819. *Description de l'Égypte*, vol. 4, 197–283, vol. 10, 413–28, plates vol. 4, pl. 53–61. Kühn *op. cit.* (n. 29) 20–80; Pensabene *Elementi Aless.* 273–88, fig. 178–93; Alston *City* 242–4.

37. Foundation: H. Halfmann, *Itinera principum, Geschichte und Typologie der Kaiserreisen im römischen Reich* (Stuttgart 1986) 193. There was an earlier temple of Ramesses II to the west of the town: A. Gayet, *L'Exploration des ruines d'Antinoë et la découverte d'un temple de Ramsès II enclos dans l'enceinte de la ville d'Hadrien* (Paris 1897); *idem, Antinoë et les sépultures Thaïs et Sérapion* (Paris 1902) fig. on p. 3, 7; H.I. Bell, 'Antinoopolis: a Hadrianic Foundation in Egypt', *JRS* 30 (1940) 135; PM IV, 175–6 with references. Notably, Dio Cassius, *Roman History Epitome* 69. 11. 2–4, states that Hadrian rebuilt (rather than built) the city.

It has been suggested that the obelisk of Antinoos was originally erected in Antinoopolis: M.T. Boatwright, *Hadrian and the City of Rome* (Princeton 1987) 239–60, fig. 58. Translation of inscriptions on obelisk: A. Grimm, D. Kessler and H. Meyer, *Der Obelisk des Antinoos* (Munich 1994).

38. Kühn *op. cit.* (n. 29) 163–75; Bagnall *op. cit.* (n. 32) 66.

39. *Description de l'Égypte*, vol. 4, 247–53, vol. 10, 428, plates vol. 4, pl. 53, 60.18, 61.25–8; S. Donadoni *et al.*, *Antinoe (1965–1968)* (Rome 1974) 61; E. Mitchell, 'Osservazioni topografiche preliminari sull'impianto urbanistico di Antinoe', *Vicino Oriente* 5 (1982) 174–6, fig. 1, 3, pl. 2.1–2; Bailey *loc. cit.* (n. 35) 124; Pensabene *Elementi Aless.* fig. 178, 180. For a large scale construction such as this, with 772 columns on the main lengthwise street, the *Cardo* (w. 6.40 m), and 572 on the main cross-street, the *Decumanus maior* (w. 5.8 m), they would have provided the cheapest solution as the capitals are simplified and the columns not fluted. The Doric order was also used in Cyrene in the second century AD when the Corinthian order might have been expected: A.J. Spawforth and S. Walker, 'The World of the Panhellenion II. Three Dorian Cities', *JRS* 76 (1986) 100–1.

40. Tetrastylon at the main crossroad: Bailey *loc. cit.* (n. 35) 130; Bailey *Hermopolis* 30. Northern Tetrastylon inscribed to Alexander Severus and his mother Julia Mamaea: *Description de l'Égypte*, vol. 4, 237–42, 262, vol. 10, 423–6, plates vol. 4, pl. 59.1–2, 60.1–9, 18; Bailey *loc. cit.* (n. 35) 129–30; Bailey *Hermopolis* 30; Pensabene *Elementi Aless.* 190, 287, fig. 123–5; D.M. Bailey, 'Honorific Columns, Cranes, and the Tuna Epitaph', in D.M. Bailey, ed., *Archaeological Research in Roman Egypt*, *JRA* suppl. 19 (Ann Arbor 1996) 163, fig. 8. Inscription: *Description de l'Égypte* vol. 4, 240–1.

41. *Description de l'Égypte*, vol. 4, 228–34, 261–2, vol. 10, 420–2, plates vol. 4, pl. 57–8; Pensabene *Elementi Aless.* 281–4, fig. 187–7.

42. Corinthian structure on main lengthwise street: *Description de l'Égypte*, vol. 4, 256, vol. 10, 426–7, plates vol. 4, pl. 61.1–6. Corinthian structure 'in the middle of the city': *Description de l'Égypte*, vol. 4, 259–60, vol. 10, 427, plates vol. 4, pl. 61.15–20; Pensabene *Elementi Aless.* fig. 193. Small Ionic structure on main cross-street: *Description de l'Égypte*, vol. 4, 257, vol. 10, 427, plates vol. 4, pl. 61.7–14; Pensabene *Elementi Aless.* 285, fig. 192. Possible triumphal arch at east end of main cross-street with red granite bases, columns and architraves, previously identified as temple of Isis: Gayet *op. cit.* (n. 37) 28, figs on p. 9, 11, 13; Donadoni *et al. op. cit.* (n. 39) 52, 61, 63–4, fig. 1, pl. 24.2; Bailey *loc. cit.* (n. 35) 125, 128; Bailey *loc. cit.* (n. 40) 159 fig. 2. An inscription of AD 282–3 possibly came from it: Donadoni *et al. op. cit.* (n. 39) 52 n. 9 = *IGRom* I 1144; *Sammelbuch* V 8803.

43. *Description de l'Égypte*, vol. 4, 253–5, vol. 10, 427, plates vol. 4, pl. 61.21–2; Bailey *loc. cit.* (n. 35) 122.

44. 'Theatre Gate': *Description de l'Égypte*, vol. 4, 222–8, vol. 10, 417–20, plates vol. 4, pl. 55–6; Bailey *loc. cit.* (n. 35) 128; Pensabene *Elementi Aless.* 284–5, fig. 188–91. The Napoleonic expedition made the measurements of it twice for accuracy.

45. *Description de l'Égypte*, vol. 4, 228.

46. *Description de l'Égypte*, vol. 4, 226–8, plates vol. 4, pl. 53; Kühn *op. cit.* (n. 29) 68–71, fig. 7; Mitchell *loc. cit.* (n. 39) 176–7, fig. 1 c, 1; Bailey *loc. cit.* (n. 35) 122; P.C. Rossetto and G.P. Sartorio, eds., *Teatri greci e romani*, vol. 1 (Rome 1994) 322. Diameter of *cavea c.* 86 m; length of *scena c.* 85 m. Mentioned under construction in a papyrus: *P.Bad.* IV 74 = *Veröffentlichungen aus den Badischen Papyrus-Sammlungen*, vol. 4, *Griechische Papyri*, ed. F. Bilabel (Heidelberg 1924) no. 74; Bell *loc. cit.* (n. 37) 135; Daris *loc. cit.* (n. 22) 80.

47. *Description de l'Égypte* vol. 4, 242–7, vol. 10, 425–6, plates vol. 4, pl. 53, 60.16–17; Bailey *loc. cit.* (n. 35) 123, fig. 8.3. Humphrey *Roman Circuses* 513–16 detailed analysis, since updated by Mitchell's plan [268]. On it the total length is *c.* 395 m. The Napoleonic expedition recorded the width as 77 m.

48. Humphrey *Roman Circuses* 514. One entrance is visible in Mitchell's plan [268], suggesting the accuracy of the Napoleonic expedition's description.

49. *P.Oxy.* XXXIV 2707. Humphrey *Roman Circuses* 518–9.

50. Humphrey *Roman Circuses* 514. Mitchell's plan [268], shows that the barrier was oblique.

51. *Kölner Papyri*, ed. B. Kramer and R. Hübner, vol. 1 (Opladen 1976) 128–56 nos. 52–3; J.R. Rea, 'Cologne Papyri', *Classical Review* 94, n.s. 30 (1980) 260–2; Lukaszewicz *Les Édifices publics* 59; Bowman *loc. cit.* (n. 3) 500.

The recently identified 'palaestra' is apparently a nineteenth-century saltpetre factory: D.M. Bailey, 'A Ghost Palaestra at Antinoopolis', *JEA* 85 (1999) 235–9.

52. Analysis relating papyri to archaeological remains, with references: Bailey *Hermopolis* 21–2, 56–9. Summarized in Bailey *loc. cit.* (n. 35) 124–7, 130, 133–4; Alston *City* 238–42, 260–2.

53. *P.Vindob. gr.* 12565 = *Sammelbuch* X 10299. H. Schmitz, 'Die Bau-Urkunde in P.Vindob. gr. 12565 im Lichte der Ergebnisse der deutschen Hermopolis Expedition', in *Papyri und Altertumswissenschaft*, ed. W. Otto and L. Wenger, *Münchener Beiträge zur Papyrusforschung und antiken Rechtsgeschichte* 19 (1934) 406–28; Johnson *op. cit.* (n. 30) 700–1 no. 435; H. Schmitz in G. Roeder, ed., *Hermopolis 1929–1939* (Hildesheim 1959) 101–5, 107–10, 114–7, pl. 9; Lukaszewicz *Les Édifices publics* 141; Pensabene *Elementi Aless.* 244–8, fig. 146, 150. The earlier plans have been updated as a result of the British Museum excavations: Bailey *Hermopolis* 21–2, 57–8.

54. G. Meautis, *Hermoupolis-la-Grande* (Lausanne 1918); Schmitz *loc. cit.* (n. 53); Schmitz in Roeder *op. cit.* (n. 53) 104–5, 112–7; Calderini *Dizionario* 2, 171–3 with papyrological references; Bailey *loc. cit.* (n. 35) 124; Bailey *Hermopolis* 58–9 with references; P. Pensabene, 'Il tempio di tradizione faraonica e il dromos nell'urbanistica dell'Egitto greco-romano', in *Alessandria e il mondo ellenistico-romano, Alessandria 1992* (Rome 1995) 213–14.

55. Johnson *op. cit.* (n. 30) 698–700 nos. 431–4; Schmitz in Roeder *op. cit.* (n. 53) 126–8; Lukaszewicz *Les Édifices publics* 59; Bailey *Hermopolis* 59.

56. Bailey *loc. cit.* (n. 35) 124; Bailey *Hermopolis* 59.

57. D.M. Bailey, 'The Procession-house of the Great Hermaion at Hermopolis Magna', in M. Henig and A. King, eds., *Pagan Gods and Shrines of the Roman Empire* (Oxford 1986) 231–7; *idem loc. cit.* (n. 35) 125–7, fig. 8.6; Bailey *Hermopolis* 13–24, pl. 2–6, 13–17, 19a–c, f, 20–3; Pensabene *Elementi Aless.* 255–7, fig. 155–7, pl. 46 nos. 381–95 and 1, pl. 47 nos. 384 and 1.

58. Bailey *Hermopolis* 16, pl. 13–17. He compares them with examples from the arch of Marcus Aurelius at Leptis Magna, *c.* AD 161–80, and the Forum Baths at Ostia, *c.* AD 160: W.-D. Heilmeyer, *Korinthische Normalkapitelle*, RM Ergh. 16 (Heidelberg 1970) pl. 1.5, 31.4. However, related examples are also found from the Severan period, such as the Severan Forum at Leptis Magna, *c.* AD 200–215: J.B. Ward-Perkins, 'Nicomedia and the marble trade', *PBSR* 48 (1980) pl. 17c.

59. Pitched brick vaulting: Bailey *Hermopolis* pl. 9b. Ridge beam: Bailey *Hermopolis* 19, pl. 19b–c.

60. Discussion of function, with references: Lukaszewicz *Les Édifices publics* 61–4; Bailey *Hermopolis* 20–2.

61. These include a very large capital drum and a column drum (diam. 1.91 m). There was also an inscribed base of AD 176–9 which might have come from it: Bailey *loc. cit.* (n. 35) 130, fig. 8.12; Bailey *Hermopolis* 29–32, pl. 2, 35c–d, 36–7, 39; Bailey *loc. cit.* (n. 40) 162–5, fig. 11–12. Inscription: *IGRom* I 1145; *Sammelbuch* V 8311; Bailey *Hermopolis* 29.

62. 'Temple by the Sphinx Gate' from which granite columns and limestone Corinthian capitals survived, dated to the Antonine period: Bailey *Hermopolis* 33, 37–43, pl. 39b, 40, 46–8, 55–8. A number of Ionic capitals were also found, possibly of Hadrianic or early Antonine date: Bailey *Hermopolis* 41–2, pl. 64, 66 c–d.

63. Bailey *Hermopolis* 58.

64. With Type III Alexandrian Corinthian capitals: E. Chassinat, *Le Temple de Dendara*, vol. 1 (Cairo 1934) pl. 1–5; G. Castel, F. Daumas and J.-C. Golvin, *Les Fontaines de la Porte Nord* (Cairo 1984) pl. 9a; Pensabene *Elementi Aless.* 373–4, pl. 37 nos. 274–5. Pensabene dates the capitals to the first century AD. Reconstruction drawing of street and fountain houses: S. Aufrère, J.-C. Golvin and J.-C. Goyon, *L'Égypte restituée*, *Sites et temples de Haute Égypte* (Paris 1991) fig. on p. 226.

65. Castel *et al. op. cit.* (n. 64); Bailey *loc. cit.* (n. 35) 133, fig. 8.13; Pensabene *Elementi Aless.* 361–3, pl. 30.1–2, 31. Date: second or third century AD when related fountain houses largely built elsewhere: Castel *et al. op. cit.* (n. 64) 12–14. Pensabene dates the Corinthian capitals to the second century AD

66. Contra Castel *et al. op. cit.* (n. 64) 1–3.

67. Bagnall *op. cit.* (n. 32) 48.

68. B.P. Grenfell, *Egypt Exploration Fund Archaeological Report* 1896–7, 6; E.G. Turner, 'Roman Oxyrhynchus', *JEA* 38 (1952) 82; Bagnall *op. cit.* (n. 32) 48. R. Alston, 'Ritual and Power in the Romano-Egyptian city', in H.M. Parkins, ed., *Roman Urbanism* (London 1997) 151.

69. Colonnaded street: W.M.F. Petrie *et al.*, *Tombs of the Courtiers and Oxyrhynkhos* (London 1925) 13, pl. 35.1, 3–5, pl. 39. Columns of numilitic limestone with Corinthian capitals carved using two drums: diam. *c.* 0.83 m, height of columns 5.64 m, inter-columniation 3.18 m, width of street 6.58 m. Blocked out acanthus column base from honorific column or tetrastylon, with later inscription: Petrie *et al. op. cit.* 13, pl. 35.2; Bailey *loc. cit.* (n. 35) 130–3, fig. 8.11. Recent archaeological work at Oxyrhynchus: Equipo de la Misión Catalano-egipcia en Oxirrinco, 'Excavaciones arqueologicas en Oxirrinco Egipto', *Revista de arqueologia* 146 (June 1993) 14–19; J. Padró *et al.*, 'Fouilles archéologiques à Oxyrhynchos, 1992–1994', in C. J. Eyre, ed., *Proceedings of the Seventh International Congress of Egyptologists* (Leuven 1998) 823–8.

70. Petrie *et al. op. cit.* (n. 69) 14–16, pl. 36, 37.3–8, 38–9; Bailey *loc. cit.* (n. 35) 122; Rossetto and Sartorio *op. cit.* (n. 46) vol. 1, 320–1. Diameter of *cavea* 121.80 m, length of stage 61.1 m, diameter of orchestra 30.48 m. Possibly 35 rows of seats. Pilasters along stage front with red granite columns (diam. 0.69 m, h. 4.06 m) in front with marble Corinthian capitals and bases, and marble figures between the columns. There seems to have been a colonnade around the top of the *cavea* with red granite columns (diam. 0.56 m) and a limestone frieze with rosettes. The portico at the east end had composite capitals supporting a Doric frieze. There was a spiral staircase at either end of the stage building. The rebuilding of the *cavea* on earlier foundations is indicated by the relationship of it and the orchestra to the stage building (J.R. Green pers. com.). The architectural decorative fragments all appear to be of one date, indicating a major re-building: Petrie *et al. op. cit.* (n. 69) pl. 36.3–5, 37.6–8, 38. Their date would accord with the reference in the papyrus: *P.Coll.Youtie* I 28 I 10, 13 = *Collectanea Papyrologica, Texts Published in Honour of H.C. Youtie*, Part I, ed. A.E. Hanson (Bonn 1976) 249–53 no. 28 col. I lines 10 and 13. Lukaszewicz *Les Édifices publics* 105–6; Bailey *loc. cit.* (n. 35) 122. See also: D. Bailey, 'Architectural Blocks from the Great Theatre at Oxyrhynchus', in A.K. Bowman *et al.*, eds., *Oxyrhynchus, a City and its Texts* (in press). Types of performances in the theatre indicated by the papyri, with references: Turner *loc. cit.* (n. 68) 83; at other sites as well: Daris *loc. cit.* (n. 22) 77–93.

71. *P.Oxy.* XLIII 3088; E.G. Turner, 'Oxyrhynchus and Rome', *Harvard Studies in Classical Philology* 79 (1975) 15–16; Bowman *loc. cit.* (n. 3) 495; Bowman and Rathbone *loc. cit.* (n. 2) 123–4; Alston *loc. cit.* (n. 68) 154–7. Philadelphia is often called a *polis* in the Zenon archive: Bowman and Rathbone *loc. cit.* (n. 2) 109. The names, including the term *polis*, such as Krokodilopolis (for Arsinoe) and Nikopolis, also suggest that they were thought of as cities, even if they lacked formal city status.

72. The papyri give the relative positions of buildings even if their exact locations are not known: H. Rink, *Strassen und Viertelnamen von Oxyrhynchos* (Giessen 1924); Turner *loc. cit.* (n. 68) 81–3, 90; A. Bowman, *Egypt After the Pharaohs* (London 1986) 143–8; J. Krüger, *Oxyrhynchos in der Kaiserzeit, Studien zur Topographie und Literaturrezeption* (Frankfurt 1990) plan on p. 372; Bagnall *op. cit.* (n. 32) 46; Alston *City* 262–8, tables 5.3–4, fig. 5.11.

73. *P.Oxy.* I 43.

74. *P.Oxy.* LXIV 4441 col. iii–xiv, with additional references for some of the building types mentioned; Bowman *loc. cit.* (n. 28) 182.

75. Turner *loc. cit.* (n. 68) 82, 85; Bowman *op. cit.* (n. 72) 146–50; Bagnall *op. cit.* (n. 32) 49–53. Information about houses from papyrological sources: F. Luckhard, *Das Privathaus im ptolemäischen und römischen Ägypten* (Giessen 1914); Husson *op. cit.* (n. 26); R. and R. D. Alston, 'Urbanism and Urban Community in Roman Egypt', *JEA* 83 (1997) 199–216; R. Alston, 'Houses and Households in Roman Egypt', in R. Lawrence and A. Wallace-Hadrill, eds., *Domestic Space in the Roman World: Pompeii and Beyond* (Portsmouth, RI 1997) 25–39; Alston *City* 58–87, 110–12. Houses on sale documents from Egypt: Johnson *op. cit.* (n. 30) 256–77. Archaeological evidence from other sites: O. Rubensohn, 'Aus griechisch-römischen Häusern des Fayum', *JdI* 20 (1905) 1–25; Nowicka *op. cit.* (n. 21); H. Maehler, 'Häuser und ihre Bewohner im Fayûm in der Kaiserzeit', in G. Grimm, H. Heinen and E. Winter, eds., *Das römisch-byzantinische Ägypten*, *AegTrev* 2 (Mainz 1983) 119–37. Marina el-Alamein peristyle houses, first century AD in use until at least fourth century: W.A. Daszewski *et al.*, *Marina el Alamein, Archaeological Background and Conservation Problems* vol. 1 (Warsaw 1991) 23–9, 33–42; Daszewski *loc. cit.* (n. 25) 19–24, fig. 8–14; S. Medeksza, 'Marina el-Alamein, Restoration Work 1997', *PAM* 9 (1997) 72–6; *idem*, 'Marina el-Alamein, Conservation Work 1998', *PAM* 10 (1998) 51–62; *idem*, 'Marina el-Alamein, Conservation Work, 1999', *PAM* 11 (1999) 47–57; *idem*, 'Marina el-Alamein, Conservation Work 2001', *PAM* 13 (2001) 87–104; S. Medeksza and R. Czerner, 'Rescuing Marina el-Alamein: a Graeco-Roman Town in Egypt', *Minerva* 14.3 (2003) 20–3. Marina el-Alamein cemetery, with references: W.A. Daszewski, 'La nécropole de Marina el-Alamein', in S. Marchegay *et al.*, eds., *Nécropoles et pouvoir. Idéologies, pratiques et interprétations* (Paris 1998) 229–41.

76. Karanis: S. el-Nassery, G. Wagner, and G. Castel, 'Un Grand Bain gréco-romain à Karanis', *BIFAO* 76 (1976) 231–75; E.M. Husselman, *Karanis, Topography and Architecture* (Michigan 1979); Davoli *op. cit.* (n. 21) 73–116; Alston *City* 52–8. Baths-buildings in Egypt, with references: I. Nielsen, *Thermae et Balnea* (Aarhus 1990) vol. 1, 99–101, 112–16, vol. 2, 35; Bailey *loc. cit.* (n. 35) 122; Pensabene *Elementi Aless.* 19–25, fig. 17–27; F. Yegül, *Baths and Bathing in Classical Antiquity* (Cambridge, Mass. 1992) 237, 404, 470 n. 123.

77. P.Lond. 1177 = *Greek Papyri in the British Museum*, vol. 3, ed. F.G. Kenyon and H.I. Bell (London 1907) 180–90, no. 1177, pl. 31–5; Johnson *op. cit.* (n. 30) 685–91 no. 417; T. Schiøler, *Roman and Islamic Water-lifting Wheels* (Odense 1973) 123–4, *saqiya* and *shaduf* illustrated in fig. 87–8; J.P. Oleson, *Greek and Roman Mechanical Water-lifting Devices* (Toronto 1984) 289, 293, 295, 302, 304, 332, 353, 371.

78. Arsinoe: C. Wessely, *Die Stadt Arsinoë (Krokodilopolis) in griechischer Zeit* (Vienna 1902; repr. Milan 1975); Lukaszewicz *Les Édifices publics* 162–83. Panopolis: Lukaszewicz *Les Édifices publics* 162–83; Calderini *Dizionario* vol. 4, 43. Other towns: Lukaszewicz *Les Édifices publics* 161–83.

79. Bowman *loc. cit.* (n. 3) 502.

80. Davoli *op. cit.* (n. 21). Akoris (Tihna), propylon of Serapis sanctuary with 'Normal' Corinthian capitals: P. Grossmann, 'Ein kaiserzeitliches Sarapis-Heiligtum in Akoris', *MDIK* 37 (1981) 199–202, pl. 31–5; Pensabene *Elementi Aless.* fig. 15. Classical architectural fragments from some other sites: Bailey *loc. cit.* (n. 35) 133. Ptolemaic Doric frieze at Tebtunis: Nowicka *op. cit.* (n. 21) fig. 65. Information on Herakleopolis Magna provided by D. Bailey (pers. com.).

81. The remains at Athribis include a very wide main street and cross-street with colonnades (w. 42 m), and baths. Marble Corinthian capitals, cornice and frieze fragments survive apparently from the tetrapylon which had a dedicatory inscription of AD 374 to Valentinian, Valens and Gratian. *Description de l'Égypte*, vol. 9, 341–52, vol. 10, 494, plates vol. 5, pl. 27.3 (plan at 1:10,000 nn 1:5000); A. Rowe, 'Preliminary Report on Excavations of the Institute of Archaeology, Liverpool, at Athribis', *Annals of Archaeology and Anthropology* 25 (1938) 129–31, pl. 36–7; L. Dabrowski, 'La Topographie d'Athribis à l'époque romaine', *ASAE* 57 (1962) 19–31; Bailey *loc. cit.* (n. 35) 127; Pensabene *Elementi Aless.* 46, fig. 57; Alston *City* 236–8. Inscription from tetrapylon: *OGIS* II 722; *Sammelbuch* X 10697; Rowe *loc. cit.* pl. 36. Remains of city from Ptolemaic and early Roman periods: M. Mysliwiec and S. Abu Senna, 'Polish-Egyptian Excavations at Tell Atrib in 1991–1993', *ÉtTrav* 17 (1995) 205–40; Mysliwiec *loc. cit.* (n. 25) 119–31; Mysliwiec and Bakr Said *loc. cit.* (n. 25) 179–219. 'Arena Theatre' at Pelusium: H. Jaritz *et al.*, *Pelusium Prospection archéologique et topographique de la region de Tell el-Kana'is 1993 et 1994* (Stuttgart 1996) 98–153, fig. 31, plan 2. Date: *ibid.* 121–2, 134.

82. Ammianus Marcellinus, 22. 16. 2 and 6.

83. The areas of most of the larger towns and cities are calculated at *c.* 100–230 hectares, listed with discussion and bibliography in: Bowman *loc. cit.* (n. 28) 178 Table 1. From these, attempts have been made to calculate the number of houses and population. See also: Bagnall *op. cit.* (n. 32) 52–3; R. and R. D. Alston *loc. cit.* (n. 75) 200–5, Table 1.

84. Temple of Augustus at Philae: H.G. Lyons, *A Report on the Island and Temples of Philae* (London 1896) 29–30, 65–8, pl. 20–1, 47; L. Borchardt, 'Der Augustustempel auf Philae', *JdI* 18 (1903) 73–90, pl. 3–5; H. Hänlein-Schäfer, *Veneratio Augusti, eine Studie zu den Tempeln des ersten römischen Kaisers* (Rome 1985) 219–22, pl. 53–5; Bailey *loc. cit.* (n. 35) 127; Pensabene *Elementi Aless.* 6–8, 387, 515, 554, fig. 1–7, pl. 43 no. 354, 99 no. 949. Inscription: *OGIS* II 657; *Sammelbuch* V 8897; *IGRom* I 1294; E. Bernand, *Les Inscriptions grecques et latines de Philae* II (Paris 1969) 72–6 no. 140; *idem*, 'Épigraphie grecque et architecture égyptienne à l'époque impériale', in H. Walter, ed., *Hommages à Lucien Lerat* (Paris 1984) 74 no. 1.

Roman building at Syene (Aswan): H. Jaritz, 'Ein Bau der römischen Kaiserzeit in Syene', in M. Krause and S. Schaten, eds., *ΘΕΜΕΛΙΑ, Spätantike und koptologische Studien Peter Grossmann zum 65. Geburtstag* (Wiesbaden 1998) 155–65.

85. An inscription found near the arch mentioning Diocletian is dated to AD 293–305. Lyons *op. cit.* (n. 84) 33, pl. 25, 47–8; S. Clarke and R. Engelbach, *Ancient Egyptian Construction and Architecture* (= *Ancient Egyptian Masonry* Oxford 1930; repr. New York 1990) 188–9, fig. 225–7; U. Monneret de Villard, *La Nubia romana* (Rome 1941) 5–6, fig. 4–8; Bernand *op. cit.* (n. 84) pl. 91–3, 113; Bailey *loc. cit.* (n. 35) 128–9, fig. 8.10; Pensabene *Elementi Aless.* 33, 66, fig. 40–1, pl. 127.3. Inscription: British Museum Department no. 1359; *OGIS* II 719; *Sammelbuch* V 8833 and 8918; *IGRom* I 1298; Bernand *op. cit.* (n. 84) 209–12 no. 185, pl. 93a. Dome: P. Grossmann, *Mittelalterliche Langhaus-kuppelkirchen und verwandte Typen in Oberägypten* (Glückstadt 1982) 237, 252, pl. 55a, 58a.

86. J.-C. Golvin *et al.*, 'Le Petit Sarapieion romain de Louqsor', *BIFAO* 81 (1981) 115–48, fig. 1, 2; Bailey *loc. cit.* (n. 35) 125; Pensabene *Elementi Aless.* 8, 11, fig. 9–10, pl. 127.1–2. Inscription: Golvin *et al. loc. cit.* 130–1; Bernand *loc. cit.* (n. 84) 78 no. 18.

87. C. Hope and J. McKenzie, 'Interim Report on the West Tombs', in C. A. Hope and A.J. Mills, eds., *Dakhleh Oasis Project: Preliminary Reports on the 1992–1993 and 1993–1994 Field Seasons* (Oxford 1999) 62–8, fig. 1, pl. 1, 10–13.

88. Pensabene *Elementi Aless.* 25–34, fig. 28–39.

89. S. Aufrère, J.-C. Golvin and J.-C. Goyon, *L'Égypte restituée, sites et temples des déserts*, vol. 2 (Paris 1994) 216–27.

90. Mons Porphyrites, temple of Serapis of local grey granite: T. Kraus, J. Röder and W. Müller-Wiener, 'Mons Claudianus-Mons Porphyrites', *MDIK* 22 (1967) 172–81, pl. 55–7, fig. 17–19; R. Wild *ANRW* II 17.4, 1799–1801; Bailey *loc. cit.* (n. 35) 125; Pensabene *Elementi Aless.* 14, 180, 328–31, fig. 11–13, pl. 12 nos. 74–80, pl. 13–15. Inscription: *Sammelbuch* V 8320; *IGRom* I 1256; Bernand *loc. cit.* (n. 84) 77 no. 16. Mons Claudianus, temple of Serapis, AD 118: T. Kraus and J. Röder, 'Mons Claudianus', *MDIK* 18 (1962) 91–7, fig. 2, pl. 12b, 13–17; Wild *loc. cit.* 1793–7, fig. 23–4; Bailey *loc. cit.* (n. 35) 133; Pensabene *Elementi Aless.* 15, fig. 14. Inscription: *OGIS* II 678; *Sammelbuch* V 8324; *IGRom* I 1255; Bernand *loc. cit.* (n. 84) 77–8 no. 17.

91. *Description de l'Égypte*, vol. 10, 485–6, plates vol. 5, pl. 20; Bailey *loc. cit.* (n. 35) 121, fig. 8.1; Pensabene *Elementi Aless.* 25–7, fig. 28–9, pl. 128; P. Sheehan, 'The Roman fortress of Babylon in Old Cairo', in D.M. Bailey, ed., *Archaeological Research in Roman Egypt*, *JRA* suppl. 19 (Ann Arbor 1996) 95–7; P. Grossmann, C. Le Quesne, and P. Sheehan, 'Zur römischen Festung von Babylon – Alt-Kairo', *AA* (1994) 271–87; K. Spence *et al.*, 'Archaeological Survey Drawings of the Fortress of Babylon', and P. Sheehan, 'The Roman Fortification', in P. Lambert, ed., *Fortifications and the Synagogue: the Fortress of Babylon and the Ben Ezra Synagogue, Cairo* (London 1994) 40–7 and 49–63.

92. J. Schwartz *et al.*, *Fouilles franco-suisses rapports II Qasr-Qârûn/Dionysias 1950* (Cairo 1969); J.-M. Carrié, 'Les *Castra Dionysiados* et l'évolution de l'architecture mil-

itaire romaine tardive', *MEFRA* 86 (1974) 819–50; Bailey *loc. cit.* (n. 35) 121; Pensabene *Elementi Aless.* 223–37, fig. 135, 139–45. Sufficient lengths of the modillion cornice of the basilica survive to belong to the construction of the late third or early fourth century AD. The Corinthian capitals and one Ionic capital were also probably carved at the same time: A. Badawy, 'Greco-Roman Figure Capitals from Dionysias in Egypt', *Gazette des beaux-arts* 72 (1968) 249–54; Schwartz *et al. op. cit.* 52–61, fig. 38–43, pl. 9–13, 24, 25b, 26. Some of the Ionic capitals were reused: Schwartz *et al. op. cit.* pl. 6–8. Date: Schwartz *et al. op. cit.* 1–2; Carrié *loc. cit.* 838–9, 850.

93. M. el-Saghir *et al.*, *Le Camp romain de Louqsor*, *MIFAO* 83 (Cairo 1986) 20–1, pl. 1, 20; Pensabene *Elementi Aless.* 27, fig. 30–1.

94. Western tetrastylon (1) dedicated to the Tetrarchs in AD 301–2: el-Saghir *et al. op. cit.* (n. 93) 20, 122, fig. 1–22, pl. 17a, 18a; Bailey *loc. cit.* (n. 35) 130. Inscription: P. Lacau, 'Inscriptions latines du Temple de Louxor', *ASAE* 34 (1934) 29–33; el-Saghir *et al. op. cit.* (n. 93) 122. Eastern tetrastylon (2) has names of Galerius, Maximianus, Licinius and Constantine, erected *c.* AD 308/9: el- Saghir *et al. op. cit.* (n. 93) 21, 122, fig. 23, pl. 16, 17b, 19b; Bailey *loc. cit.* (n. 35) 130 fig. 8.12; Pensabene *Elementi Aless.* 491, pl. 88 no. 793. Inscription: Lacau *loc. cit.* 20–9; el-Saghir *et al. op. cit.* (n. 93) 122.

95. El-Saghir *et al. op. cit.* (n. 93) 27–31, fig. 29–32, pl. 22; Bailey *loc. cit.* (n. 35) 127, fig. 8.7; Pensabene *Elementi Aless.* 67, 369–70, pl. 34 nos. 252–4. Function: as Diocletian's throne room or audience hall, I. Kalavrezou-Maxeiner, 'The Imperial Chamber at Luxor', *DOP* 29 (1975) 225–51; as a shrine (*sacellum*) to hold imperial standards and for imperial cult, U. Monneret de Villard, 'The Temple of the Imperial Cult at Luxor', *Archaeologia* 95 (1953) 85–105; J.G. Deckers, 'Die Wandmalerei im Kaiserkultraum von Luxor', *JdI* 94 (1979) 600–652.

96. Lukaszewicz *Les Édifices publics* 139–50, 159–60 notes the amount of building activity in the mid-third century AD. Bailey *loc. cit.* (n. 35) 124, doubts that there was a rush of construction of new buildings in the third century as the archaeological evidence from Hermopolis Magna (el-Ashmunein) is from the second century and those recorded for the third century were repairs. See also Bowman *loc. cit.* (n. 3) 495–8. On the enormous cost of the repairs and improvements at Hermopolis Magna see Bagnall *op. cit.* (n. 32) 47. For the suggestion that Egypt was not affected by the decline elsewhere in the third century see: A.C. Johnson, 'Roman Egypt in the Third Century', *Journal of Juristic Papyrology* 4 (1950) 151–8. Cf. J.A. Lloyd, 'The Cities of Cyrenaica in the Third Century AD', *Atti dei Convegni Lincei* 87 (1990) 41–53.

97. P. J. Parsons, 'Petitions and a Letter: the Grammarian's Complaint, 253–60 A.D.', in A.E. Hanson, ed., *Collectanea Papyrologica. Texts Published in Honor of H.C. Youtie*, Part 2 (Bonn 1976) 438–40.

98. Bowman *loc. cit.* (n. 28) 184.

CHAPTER 8: ROMAN ALEXANDRIA

1. Strabo, *Geography* 17. 1. 13.

2. Detailed discussion: Fraser *Ptol. Alex.* vol. 1, 7–37. Date of Strabo in Egypt: *Strabon, le Voyage en Égypte*, tr. P. Carvet (Paris 1997) 18, 76.

3. Fraser *Ptol. Alex.* vol. 1, 321, 334.

4. Strabo, *Geography* 17. 1. 6–7. Lake Mareotis: E. Combe, 'Alexandrie musulmane. Le lac Mariout', *Bulletin de la Société royale de géographie d'Égypte* 16 (1928–9) 269–92; Empereur *Alexandrie* 214–17.

5. Strabo, *Geography* 17. 1. 8.

6. Strabo, *Geography* 17. 1. 10.

7. Strabo, *Geography* 17. 1. 9. The new identifications of the Poseidium and Antirrhodos are made in Goddio *et al. Alexandria* plan opp. p. 249, on which the red outline 'contour as per ancient texts' seems to be based on an inaccurate drawing of Mahmoud Bey's plan. It is not possible to ascertain if the location marked 'palace' on Antirrhodos in that plan is based on sufficient archaeological evidence as the architectural remains have not yet been published in enough detail. Earlier reports: *Der Spiegel* 46 (1996) 234–50; *Weekly Telegraph* (6 Nov. 1996) 18; *The Times* (1 Nov. 1997) 9. Grimm suggests Antirrhodos is the island discovered by Goddio to the north of the promontory newly identified as the Poseidium: G. Grimm, 'Alexandria in the Time of Cleopatra', in S. Walker and S.-A. Ashton, eds., *Cleopatra Reassessed* (London 2003) 48, 46 fig. 1.

8. Strabo, *Geography* 17. 1. 10. In Procopius, *On Buildings* 1. 11. 19–20, the term *kibotos* is used for the caissons or cribs which were sunken in the construction of the breakwater of a harbour in Constantinople. Caissons filled with lime mortar were used on the eastern harbour. Alternatively, it had been suggested that the Kibotos harbour had a rectangular shape which was derived from earlier Egyptian harbours: E. el-Fakharani, 'The *Kibotos* of Alexandria', *Studi Miscellanei* 28 (1984–5 [1991]) 22–8. See n. 30 below, however, for other references to the Kibotos and its possible location.

9. In the areas of Hadra, Shatby and Ibrahimieh. Tkaczow *Topography* 168–9 site 135, 171–2 site 139, 176–7 sites 145–6.

10. Strabo, *Geography* 17. 1. 10. Josephus, *Jewish War* 1. 33. 6 (659); Humphrey *Roman Circuses* 509, 530–1, fig. 258. If it were not a substantial structure, since Ptolemaic times, then it is unlikely it was the one into which Ptolemy IV herded the Jews, making it more likely that this occurred in Lageion: see Ch. 3 n. 202. For the suggestion that this 'so-called hippodrome' was a hippodrome garden: A. Maricq, 'Une influence Alexandrine sur l'art augustéen? Le Lageion et le Circus Maximus', *RA* (1951) 36.

11. Strabo, *Geography* 17. 1. 10; Suetonius, *Lives, Deified Augustus* 18. 3.

12. Strabo, *Geography* 17. 1. 16–17. Contra, Posidippus who indicates Zephyrion was mid-way between Alexandria and Canopus: Ch. 3 n. 155.

13. Ancient sources: H. Hänlein-Schäfer, *Veneratio Augusti, eine Studie zu den Tempeln des ersten römischen Kaisers* (Rome 1985) 203–4. Discussion: A.C. Merriam,

'The Caesareum and the Worship of Augustus at Alexandria', *TAPA* 14 (1883) 5–35; E. Sjöqvist, 'Kaisareion, A Study in Architectural Iconography', *Opuscula romana* 1 (1954) 86–9; Adriani *Repertorio* 64–6, 214–6; Fraser *Ptol. Alex.* vol. 2, 68–9 n. 156; D. Fishwick, 'The Temple of Caesar at Alexandria', *American Journal of Ancient History* 9 (1984) 131–4; Hänlein-Schäfer *op. cit.* 10–11, 203–19; G. Alföldy, *Der Obelisk auf dem Petersplatz in Rom* (Heidelberg 1990) 43–7; D. Fishwick, 'The Caesareum at Alexandria Again', *American Journal of Ancient History* 12 (1987) [1995] 62–72.

14. Obelisks: H.H. Gorringe, *Egyptian Obelisks* (London 1885); E. Iversen, *Obelisks in Exile*, vol. 2 *The Obelisks of Istanbul and England* (Copenhagen 1972) 90–6; Fraser *Ptol. Alex.* vol. 1, 24, vol. 2, 68 n. 155, 69 n. 158; L. Habachi, *The Obelisks of Egypt* (London 1977) 152–82; R. Haywood, *Cleopatra's Needles* (London 1978); M. D'Alton, *The New York Obelisk* (New York 1993) = *Metropolitan Museum of Art Bulletin* 50.4 (Spring 1993); Tkaczow *Topography* 128–9 site 81. Archaeological remains in area of Caesareum, including many reused from a temple of Ramesses II (*c.* 1279–1213 BC): Mahmoud-Bey *Mémoire* 43–4; G. Botti, *Rapport sur les fouilles pratiquées et à pratiquer à Alexandrie* (Alexandria 1894) 3–4, plan; *idem*, *Plan de la ville d'Alexandrie* (Alexandria 1898) 67–8; D.G. Hogarth and E.F. Benson, *Report on Prospects of Research in Alexandria* (London 1895) 10; Adriani *Repertorio* 65–6; Fraser *Ptol. Alex.* vol. 2, 70–1 n. 162; Tkaczow *Topography* 130–6 sites 83–92; M. Rodziewicz, 'Ptolemaic Street Directions in Alexandria', in *Alexandria e il mondo ellenistico-romano, Congresso Alessandria 1992* (Rome 1995) 228–9, 235 fig. 1 nos. 10 and 11. For wall lines see Ch. 2 n. 19.

15. Bilingual inscription in Greek and Latin: *OGIS* II 656; *IGRom* I 1072; A.C. Merriam, *The Greek and Latin Inscriptions on the Obelisk-Crab in the Metropolitan Museum, New York* (New York 1883); Gorringe *op. cit.* (n. 14) pl. IV, V, XI; Iversen *op. cit.* (n. 14) 91; Fraser *Ptol. Alex.* vol. 2, 69–70 n. 160; F. Kayser, *Recueil des inscriptions grecques et latines (non funéraires) d'Alexandrie impériale* (Cairo 1994) 8–12 no. 2, pl. 2–3. The crabs are now in the Sackler Gallery of the Metropolitan Museum of Art, New York. Augustus became *Pontifex Maximus* on 6 March 12 BC: A.K. Bowman *et al.*, eds., *Cambridge Ancient History* vol. 10, *The Augustan Empire 43 BC–AD 69* (Cambridge 1997) 998.

16. The obelisks were erected at Heliopolis by Thutmose III, *c.* 1479–1425 BC; Iversen *op. cit.* (n. 14) 90. Translation of hieroglyphic inscriptions: Gorringe *op. cit.* (n. 14) 61–8; E.A.W. Budge, *Cleopatra's Needles and Other Egyptian Obelisks* (London 1926) 166–75. The bronze crabs are mentioned by the ninth-century Arab author Yaqubi, but some later Arab authors are confused and describe the Lighthouse as supported by such crabs: A.J. Butler, *The Arab Conquest of Egypt*, ed. P.M. Fraser (2nd edn Oxford 1978) 376.

17. Pliny, *Natural History* 36. 14. 69. 42 cubits of 0.525 m gives a height of 22.05 m. The obelisk in New York is 21.21 m high, and the one on the Thames Embankment in London is 20.88 m high. Thus, Pliny's height is accurate to within 5 per cent. Comparative heights of obelisks: Habachi *op. cit.* (n. 14) fig. 33. Attempt to re-establish exact location and orientation of Cleopatra's Needles: J.L. Arnaud, 'Sources et méthodes de restitution les obélisques et le Césaréum d'Alexandrie', in J.-Y. Empereur, ed., *Alexandrina 2*, *ÉtAlex* 6 (Cairo 2002) 177–90. The line of the Arab walls between east-west streets L2 and L3 notably followed this orientation.

18. Philo, *Embassy to Gaius* 151.

19. *Inscriptiones Latinae Selectae*, ed. H. Dessau (1916) vol. 3 part 3, no. 9059; J.B. Ward-Perkins and M.H. Ballance, 'The Caesareum at Cyrene and the Basilica at Cremna', *PBSR* 26 (1958) 176; Adriani *Repertorio* 64; Hänlein-Schäfer *op. cit.* (n. 13) 205 no. 13.

20. Pliny, *Natural History* 36. 14. 69. Date of prefect M. Magius Maximus: Fraser *Ptol. Alex.* vol. 2, 73–4 n. 169; P.A. Brunt, 'The Administrators of Roman Egypt', *JRS* 65 (1975) 143; G. Bastianini, 'Lista dei Prefetti d'Egitto dal 30ᵃ al 299ᵖ', *ZPE* 17 (1975) 269 with references, 326; *idem*, 'Aggiunto e correzioni', *ZPE* 38 (1980) 76.

21. Sebaste Agora: *BGU* IV 1079; Fraser *Ptol. Alex.* vol. 2, 96 n. 218. Forum Augusti: J.G. Winter, ed., *Papyri in the University of Michigan Collection, Miscellaneous Papyri, Michigan Papyri* vol. 3 (Ann Arbor 1936) 149–50 no. 166; H.A. Sanders, ed., *Latin Papyri in the University of Michigan Collection, Michigan Papyri* vol. 7 (Ann Arbor 1947) 19–21 no. 433; Ward-Perkins and Ballance *loc. cit.* (n. 19) 176 n. 52.

22. Fraser *Ptol. Alex.* vol. 2, 97 n. 218 (3); Alföldy *op. cit.* (n. 13) 38–45. It has been observed that this is more likely if the temple was first built in honour of Julius Caesar: Fishwick 1995 *loc. cit.* (n. 13) 66–8. The evidence for a Forum Julium comes only from the inscription on the Vatican Obelisk, references Ch. 4 n. 57.

23. Alföldy *op. cit.* (n. 13) fig. 12; Fishwick 1995 *loc. cit.* (n. 13) 66–8; Hänlein-Schäfer *op. cit.* (n. 13) 213.

24. So also, agora in: Hoepfner and Schwandner *Stadt* fig. 225, 232.

25. Sjöqvist *loc. cit.* (n. 13) 95–105, 108; Ward-Perkins and Ballance *loc. cit.* (n. 19) 176, 183–6.

26. Ward-Perkins and Ballance *loc. cit.* (n. 19) fig. 1.

27. Strabo, *Geography* 17. 1. 8.

28. Josephus, *Jewish War* 2. 386. Circuit laid out by Alexander the Great: Quintus Curtius, *History of Alexander* 4. 8. 2. City size: M. Letronne, *Recherches critiques, historiques et géographiques sur les fragments d'Héron d'Alexandrie, ou du système métrique égyptien* (Paris 1851) 220–3; Adriani *Repertorio* 18–19; Fraser *Ptol. Alex.* vol. 2, 26–7 n. 64; Calderini *Dizionario* vol. 1, 77; C. Préaux, 'Alexandrie et la Chlamyde', *Chronique d'Égypte* 85 (1968) 180. Estimates of population summarized in: D. Delia, 'The Population of Roman Alexandria', *TAPA* 118 (1988) 275–92; D. Sly, *Philo's Alexandria* (London 1996) 44–7.

29. Bilingual inscriptions in Greek and Latin: one on a column found at Minet el-Bassal (still in Alexandria) and a plaque found near the Rosetta Gate (now in Vienna): Greco-Roman Museum inv. 18 = *Sammelbuch* I 401; R. Noll, *Die griechischen und lateinischen Inschriften der Wiener Antikensammlung* (Vienna 1986) 41 no. 109; Tkaczow

Topography 261–2 no. 207, 269 no. 225a; Kayser *op. cit.* (n. 15) 12–19 nos. 3, 3bis, pl. 3–4.

30. Philo, *Against Flaccus* 55; Josephus, *Jewish War* 2. 488 and 495. Josephus' later reference, *Against Apion* 2. 34. and 36, to the Jewish quarter being by the seaside and near the palaces has led to the placing of the Jewish quarter, Delta, to the east of the palace area on some maps of the city: Fraser *Ptol. Alex.* vol. 1, 35. However, a papyrus of 13 BC refers to the 'Keibotos' as being located in Delta, and in Strabo's description (17. 1. 10) the Kibotos Harbour is 'beyond' [to the west of] the Heptastadium: *BGU* IV 1151iv col. 2 line 40; Adriani *Repertorio* 239; Calderini *Dizionario* vol. 1, 80; B.A. Pearson, 'Earliest Christianity in Egypt: Some Observations', in B.A. Pearson and J.E. Goehring, eds., *The Roots of Egyptian Christianity* (Philadelphia 1986) 146–7, 152–3; C.J. Haas, *Alexandria in Late Antiquity: Topography and Social Conflict* (Baltimore 1997) 95, 400–1 n. 9.

Alpha was mentioned in 221 BC: *P.Ent.* 8. 7 = O. Guéraud, *ΕΝΤΕΥΧΕΙΣ, Requêtes et plaintes adressées au roi d'Égypte au III'siècle av. J.-C.* (Cairo 1931) p. 22 no. 8 line 7; Fraser *Ptol. Alex.* vol. 1, 34, vol. 2, 109 n. 266. A quadrangular [stoa] is mentioned in Beta quarter in 18 BC in the Augustan period: *BGU* IV 1127 lines 8–9; Calderini *Dizionario* vol. 1, 79; Fraser *Ptol. Alex.* vol. 1, 30, 34–5, vol. 2, 98 n. 222. A house in Gamma quarter is mentioned in a papyrus of *c.* AD 47–54 without indication of its location: *P.Oxy.* XLVI 3271; Haas *op. cit.* 142. Epsilon quarter is mentioned in a papyrus of AD 325: *P.Oxy.* LIV 3756; Haas *op. cit.* 142, 377 n. 8.

Quarters A to E are also given in Pseudo-Kallisthenes, *Romance of Alexander* 1. 32; *The Greek Alexander Romance*, tr. R. Stoneman (Harmondsworth 1991) 65.

The names of other quarters in the second or third century AD, probably *c.* AD 117–270/2, are mentioned in the work of Michael bar Elias, Jacobite patriarch of Antioch from 1166 to 1199, in Syriac: P.M. Fraser, 'A Syriac *Notitia Urbis Alexandrinae*', *JEA* 37 (1951) 103–8; Haas *op. cit.* 141–2, 377 n. 8–9, 408 n. 32, 425–6 n. 17–21. For quarters from A to E it lists the numbers of temples, courts, houses, baths, taverns, and porticoes.

Mercurium, Neaspoleos and grain supply: C. Rickman, *Roman Granaries and Store Buildings* (Cambridge 1971) 298–306.

Summary of all evidence for names of quarters until the seventh century AD: B. Tkaczow, 'Remarques sur la topographie et l'architecture de l'ancienne Alexandrie dans les textes antiques', *Archeologia* 35 (1984) 10–12.

31. Philo, *On Dreams* 2. 54–7; Sly *op. cit.* (n. 28) 48.

32. a) House discovered by Hogarth, with mosaic of early second century AD south of the main east-west street, at north-west of insula: Tkaczow *Topography* 102–3 site 47 with references, fig. 37b; W.A. Daszewski, 'From Hellenistic Polychromy of Sculptures to Roman Mosaics', in K. Hamma, ed., *Alexandria and Alexandrianism* (Malibu 1996) 151.

b) House *alpha* with bird mosaics under the later workshops and houses east of street R4: Rodziewicz *Les Habitations* 41–50, fig. 28–32, mosaics 2–3, 5–8 on plan IX; Daszewski *loc. cit.* 150–1, fig. 9; Tkaczow *Topography* 109 site 55, under 55 on plan IIIb.

c) House *gamma* with *opus sectile* mosaic under the later workshops and houses east of street R4: Rodziewicz *Les Habitations* 45, fig. 34–40, mosaics 1, 4, 11, 12 on plan IX; Daszewski *loc. cit.* 151–2, fig. 10; Tkaczow *Topography* 109 site 55, under 55 on plan IIIb.

d) Earlier version of house H: G. Majcherek, 'Excavation at Kom el-Dikka in Alexandria in the 1989 Season', *PAM* 1 (1988–9) 77–8; *idem*, 'Excavations in Alexandria in 1991–1992', *PAM* 4 (1992) 18–20; *idem*, 'Excavations in Alexandria, 1992–93', *PAM* 5 (1993) 14–15. The alley beside house H (between later houses G and H) was in use in the early Roman period when it was a *c.* 5 m wide side street: G. Majcherek, 'Excavations in Alexandria in 1989–90', *PAM* 2 (1989–90) 24.

e) House with evidence of a garden on next city block, east of street R3, built in first century AD (in garden of American Cultural Institute): M. Rodziewicz and D.A. Daoud, 'Investigation of a Trench near the Via Canopica in Alexandria', *BSAA* 44 (1991) 151–68; Tkaczow *Topography* 113–14 site 61A.

33. a) House FA built on earlier structures: Tkaczow *Topography* 95–7 site 43, plan IIIb; G. Majcherek, 'Alexandria 1994', *PAM* 6 (1994) 14–20, fig. 2; *idem*, 'Excavations at Kom el-Dikka 1995', *PAM* 7 (1995) 13–19, fig. 1; *idem*, 'Kom el-Dikka Excavations 1995–1996', *PAM* 8 (1996) 19–30, photo 1, fig. 1; *idem*, 'Kom el-Dikka Excavations 1997', *PAM* 9 (1997) 25–30, fig. 1–2; *idem*, "Kom el-Dikka Excavatons, 1997/98", *PAM* 10 (1998) 35–7, fig. 4. Building FB: *ibid.* 37–9, fig. 4, 7. House FC: *ibid.* fig. 4; Majcherek *loc. cit.* 1997, 29–30, fig. 1.

b) House A in test pit MX under the new street and the 'small theatre': Rodziewicz *Les Habitations* 33–41, fig. 16–17, 19–24; Tkaczow *Topography* 87–8 site 34, fig. 26, plan IIIb; Majcherek *loc. cit.* 1994, 13–14, fig. 1; G. Majcherek, 'Kom el-Dikka Excavations, 1998/99', *PAM* 11 (1999) 32–4, fig. 5–6.

c) In trench MXV under the edge of the *cavea* of the 'small theatre', *andron* mosaic with Greek inscription: Majcherek *loc. cit.* 1993 (n. 32d) 18–20, fig. 1; J. Lis, 'Mosaic Conservation at Kom el-Dikka in Alexandria in 2002', *PAM* 15 (2003) 39–42. *Emblemata* of *opus vermiculatum* found at far end of it: G. Majcherek, 'Kom el-Dikka Excavations and Preservation Work, 2002/2003', *PAM* 15 (2003) 33–4, fig. 7.

d) East of 'small theatre' in test pit ME part of a late Ptolemaic or early Roman ? house/villa: Tkaczow *Topography* 85 site 32, plan IIIb.

e) Remains of a private baths-building of the second century AD which would have belonged to a house like those mentioned above, were found under the western side of the imperial baths-building: K. Kolodziejczyk, 'Private Roman Bath at Kom el-Dikka in Alexandria', *ÉtTrav* 2 (1968) 143–54; Rodziewicz *Les Habitations* 53, fig. 41, plan II site 3; K. Kolodziejczyk, 'Remarques sur les thermes privés à Kôm el-Dikka', *ÉtTrav* 16 (1992) 57–65; Tkaczow *Topography* 99–100 site 44A. Fragments of figured wall-paintings: K. Kolodziejczyk, 'Fragments d'enduits peints des fouilles polonaises', *ÉtTrav* 15 (1990) 193–202.

34. On the western side of cross-street R4, found when the modern Theatre of Diana was demolished: J.-Y. Empereur, 'Fouilles et découvertes récentes', *Les Dossiers d'archéologie* 201 (1995) pl. on p. 83, 86; *idem*, 'Alexandrie (Égypte)', *BCH* 120 (1996) 959, 962–3, fig. 1; N. Grimal, 'Fouilles du Diana', *BIFAO* 96 (1996) 544–50, 561–2; A.-M. Guimier-Sorbets in *La Gloire d'Alexandrie 1998* (Paris 1998) 291–3; *idem*, 'Le Pavement du triclinium à la Méduse dans une maison d'époque impériale à Alexandrie', *ÉtAlex* 1 (1998) 115–39. Date: *ibid.* 130. Ptolemaic example from Gabbari, Greco-Roman Museum no. 3696: Daszewski *Mosaics* 120–8 no. 20, fig. 6, pl. 22–3; Tkaczow *Topography* 56–7 site 5, fig. 8a–b.

35. E. Sieglin and T. Schreiber, *Die Nekropole von Kôm-esch-Schukâfa* Plates (Leipzig 1908) pl. 36; McKenzie *Petra* pl. 128–9.

36. Empereur *loc. cit.* 1995 (n. 34) pl. on p. 87.

37. W.A. Daszewski, 'An Old Question in the Light of New Evidence Ἐμβλήματα Ἀλεξανδρεινὰ Ψηφωτά', in G. Grimm, H. Heinen, and E. Winter, eds., *Das römisch-byzantinische Ägypten*, AegTrev 2 (Mainz 1983) 161–5.

38. Tkaczow *Topography* listed on p. 334–5, sites marked on Map C.

39. a) Early Roman habitation and workshop complex in Cricket Grounds: S. Shenouda, 'Alexandria University Excavations, on the Cricket Playgrounds in Alexandria,' *Opuscula romana* 9 (1973) 193–205; W.A. Daszewski, 'Notes on Topography of Ptolemaic Alexandria,' in *Alessandria e il mondo ellenistico-romano, Studi in onore di A. Adriani*, vol. 1 (Rome 1983) 54–69; Tkaczow *Topography* 149–50 site 109, fig. 59a–c.

b) Mosaic in grounds of Scottish School, now el-Manaar School: Tkaczow *Topography* 142 site 101 with references, fig. 55d mosaic.

40. a) Mosaic of *c.* second century AD at Shatby, Greco-Roman Musuem inv. 10200: Adriani *Repertorio* 109; Daszewski *loc. cit.* (n. 32a) 146, fig. 4; Tkaczow *Topography* 169 site 136.

b) Mosaic floor of *c.* AD 200 with central medallion depicting sea fish, found near an octagonal pool, Greco-Roman Museum inv. 25093: A. Adriani *Annuaire* (1935–9) 149–50, pl. 61; Adriani *Repertorio* 83 no. 44; Daszewski *Mosaics* 20 n. 56, 50 n. 182; *idem loc. cit.* (n. 32a) 147 fig. 5; Tkaczow *Topography* 170 site 138 with references, fig. 67.

c) Mosaic floors with geometric patterns and Greek inscription (*epagatho*) of *c.* third century AD: Tkaczow *Topography* 170–1 site 138A with references, fig. 68a–c; Adriani *Annuario* (1932–3) 35–6, pl. 19–20; Adriani *Repertorio* 83 no. 44, pl. 14 fig. 46–7.

41. E. Breccia, *Le Musée gréco-romain 1922–23* (Alexandria 1924) 6–7, pl. 6; Tkaczow *Topography* 173 site 141.

42. H. Riad, 'Anciens Bains d'Alexandrie', *BSAA* 43 (1975) 117–22; Tkaczow *Topography* 66–7 site 13, fig. 14 plan.

43. Philo, *Embassy to Gaius* 132–4, *Moses* 2. 216; E.R. Goodenough, *Jewish Symbols in the Greco-Roman Period*, vol. 2 (New York 1953) 86–8; Sly *op. cit.* (n. 28) 67, 95, 173–4.

44. Philo, *On the Special Laws* 3. 51; *On the Giants* 39. Other references to agora: Philo, *On the Special Laws* 3. 105 and 171; *On Dreams* 2. 91; Sly *op. cit.* (n. 28) 86–97.

45. Philo, *On the Special Laws* 2. 229–30, *On Providence* 2. 44; Sly *op. cit.* (n. 28) 150–2.

46. Euripides: Philo, *Every Good Man is Free* 141. Concerts: Philo, *Against Flaccus* 85. Sly *op. cit.* (n. 28) 85–6.

47. Gymnasium: Philo, *Against Flaccus* 139; A.K. Bowman and D. Rathbone, 'Cities and Administration in Roman Egypt', *JRS* 82 (1992) 118. On the use of the Gymnasium as the seat of government in the Roman period: F. Burkhalter, 'Le Gymnase d'Alexandrie: centre administratif de la province romaine d'Égypte', *BCH* 116 (1992) 345–73. Theatre: Philo, *Against Flaccus* 41.

48. Court case in *mega atrion*: *P. Fouad* I 21. 4; Burkhalter *loc. cit.* (n. 47) 350. Birth certificates in the Atrium Magnum in AD 62, 109, 144, 145, 149 and 163: O. Guéraud, 'A propos des certificates de naissance du Musée du Caire', *Études de papyrologie* 4 (1938) 14–31; Burkhalter *loc. cit.* (n. 47) 350–1.

49. Josephus, *Jewish War* 2. 490–2. Strabo (17. 1. 10) mentions an amphitheatre at Nikopolis by *c.* 26–20 BC which was clearly a new structure. Thus, it is possible that Josephus does mean an amphitheatre and is not confusing it with the hippodrome or the theatre: J.-C. Golvin, *L'Ampithéâtre romain*, vol. 1 (Paris 1988) 151, 153, 263; D.M. Bailey, 'Classical Architecture in Roman Egypt', in M. Henig, ed., *Architecture and Architectural Sculpture in the Roman Empire* (Oxford 1990) 123. Those later built in Syro-Palestine in the second century AD were often associated with the presence of Roman troops: A. Kloner and A. Hübsch, 'The Roman Amphitheater of Bet Guvrin', *'Atiqot* 30 (1996) 104–5.

50. Suetonius, *Lives, Nero* 35. 5; Dio Cassius, *Roman History, Epitome* 62. 18. 1. Suetonius was born in *c.* AD 70 and died possibly *c.* AD 130.

51. Dio Chrysostom, *Discourse* 32. 41–3 and 74.

52. Humphrey *Roman Circuses* 510.

53. *P. Fouad* I 8; Humphrey *Roman Circuses* 510; O. Montevecchi, 'Vespasiano acclamato dagli Alessandrini ancora su P. Fouad 8', *Aegyptus* 61 (1981) 155–70.

54. Tacitus, *Histories* 4. 82; Suetonius, *Vespasian* 7. 1; A. Henrichs, 'Vespasian's Visit to Alexandria', *ZPE* 3 (1968) 51–80.

55. *P.Oxy.* XXXIV 2725; Humphrey *Roman Circuses* 510 n. 92.

56. Suetonius, *Lives, Gaius Caligula* 52.

57. Suetonius, *Lives, Deified Claudius* 42. 2.

58. Dio Cassius, *Roman History, Epitome* 65. 8. 4.

59. Dio Chrysostom, *Discourse* 32. 100.

60. Suetonius, *Lives, Domitian* 20.

61. Statius, *Silvae* 3. 2. 117–18. Date of *Silvae* 3: A. Hardie, *Statius and the Silvae* (Liverpool 1983) 66–9.

62. Josephus, *Jewish War* 4. 10. 5 (613–4); Mahmoud-Bey *Mémoire* 36.

63. Pliny, *Natural History* 5. 43. 128; Fraser *Ptol. Alex.* vol. 1, 22, vol. 2, 58 n. 136; Goddio *et al. Alexandria* 14.

64. Pliny, *Natural History* 36. 18. 83.

65. C. Picard, 'Sur quelques représentations nouvelles du phare d'Alexandrie et sur l'origine alexandrine des paysages portuaires', *BCH* 76 (1952) 61–95; M. Reddé, 'La représentation des phares à l'époque romaine', *MEFRA* 91 (1979) 845–72. Ostia: M. Wheeler, *Roman Art and Architecture* (London 1964) fig. 17, 19. Other examples: R.L. Vann, 'The Drusion: a Candidate for Herod's Lighthouse at Caesarea Maritima', *IJNA* 20 (1991) 123–39. Coins: Dattari *Monete* pl. 28.553, 1111, 1933, 3216, 3903; Poole *BMC* xciv, pl. 16.1119, 29.884, 1205–6, 1439; H. Thiersch, *Pharos* (Leipzig 1909) 6–13; S. Handler, 'Architecture on the Roman Coins of Alexandria', *AJA* 75 (1971) 58–61, pl. 11.1–3; J.G. Milne, *Catalogue of Alexandrian Coins* (Oxford 1971) pl. 3.2001; M.J. Price and B.L. Trell, *Coins and their Cities* (London 1977) 181, fig. 313; P. Clayton and M. Price, eds., *The Seven Wonders of the Ancient World* (London 1988) 148–55, fig. 74–6, 78; P. Clayton, 'The Pharos of Alexandria: The Numismatic Evidence', *Minerva* 7.1 (1996) 7–9. Gems: E. Zwierlein-Diehl, ed., *Die antiken Gemmen des Kunsthistorischen Museums in Wien* vol. 2 (Munich 1979) 91 no. 973, pl. 58; *La Gloire d'Alexandrie* (Paris 1998) 100 no. 59; J.-Y. Empereur, *Le Phare d'Alexandrie* (Paris 1998) fig. on p. 50; Grimm *Alexandria* fig. 44.

66. Mentioned by Xenocrates of Aphrodisias, a doctor of the first century AD: P.M. Fraser, 'The διολκος of Alexandria', *JEA* 47 (1961) 134–8.

67. Description of the Isis: Lucian, *Navigium* 5–6; L. Casson, *Ships and Seafaring in Ancient Times* (London 1994) 123–4. Remains of a shipwrecked wooden hull: L. Foreman, *Cleopatra's Palace In Search of a Legend* (New York 1999) pls. on p. 62, 195–8, 200 top, 202–3, location marked on plan on p. 163.

68. Dio Chrysostom, *Discourse* 32. 36, 41 and 47.

69. Dio Chrysostom, *Discourse* 32. 95–6.

70. Dio Chrysostom, *Discourse* 32. 1–2. Date: Vespasianic, c. AD 71–5, C.P. Jones, *The Roman World of Dio Chrysostom* (Cambridge Mass. 1978) 36–44, 134; Trajanic, H. Sidebottom, 'The Date of Dio of Prusa's Rhodian and Alexandrian Orations', *Historia* 41 (1992) 407–19; Vespasianic, W.D. Barry, 'Aristocrats, Orators, and the "Mob": Dio Chrysostom and the World of the Alexandrians', *Historia* 42 (1993) 82–103; either date, G. Bowersock, 'Late Antique Alexandria', in K. Hamma, ed., *Alexandria and Alexandrianism* (Malibu 1996) 264.

71. *The Tosefta, Second Division Moed*, tr. J. Neusner (New York 1981) Sukkah 4:6 p. 224; *The Babylonian Talmud*, ed. tr. I. Epstein (*Sukkah* tr. I.W. Slotki) (London 1938) 51b p. 244–5. Tr., with discussion: Goodenough *op. cit.* (n. 43) 84–6; J.M. Modrzejewski, *The Jews of Egypt from Rameses II to Emperor Hadrian* (Princeton 1995) 91–3; Sly *op. cit.* (n. 28) 43–4. See also: Z. Ma'oz, 'The Judean Synagogues – As a Reflection of Alexandrian Architecture', *Alessandria e il mondo ellenistico-romano* C (Rome 1995) 192–201.

72. Appian, *Civil Wars* 2. 90. Relations between Jews and Greeks in Alexandria under Trajan: M. Beard *et al.*, *Religions of Rome* vol. 2 (Cambridge 1998) 327–8.

73. Dio Cassius, *Roman History*, *Epitome* 69. 11. 1.

74. *Scriptores Historiae Augustae* Hadrian 20. 2. It was probably written at the end of fourth century AD: *OCD*³ 713.

75. G. Botti, 'L'Apis de l'empereur Adrien trouvé dans le Sérapeum d'Alexandrie', *BSAA* 2 (1899) 30, 34–6. Find spot and inscription: A. Rowe, 'A Short Report on Excavations of the Greco-Roman Museum made during the Season 1942 at "Pompey's Pillar" ', *BSAA* 35 (1941–2) pl. 32 and 37; A. Rowe and B.R. Rees, 'A Contribution to the Archaeology of the Western Desert IV. The Great Serapeum of Alexandria', *BullJRylandsLib* 39.2 (1957) 496; Kayser *op. cit.* (n. 15) 176–9 no. 48, pl. 27.

76. An inscription of AD 170 mentions the chief priest (*archiereus*) of the Hadrianeion and the Sebasteion: *Archiv für Papyrusforschung* 2 (1903) 444 no. 66 line 20; Calderini *Dizionario* vol. 1, 89–90; Adriani *Repertorio* 222–3.

77. 'Library of Hadrian': *P.Oxy.* I 34; Handler *loc. cit.* (n. 65) 67. 'Hadrianon' on coins: Poole *BMC* xcii–xciii, pl. 29.876; Dattari *Monete* pl. 29.1944, 1947; Adriani *Repertorio* 222–3; Handler *loc. cit.* (n. 65) 66–7, pl. 11.16; Milne *op. cit.* (n. 65) pl. 4.1380. Library in Mercurium: *P.Oxy.* XI 1382 lines 19–20.

78. Zenobius, 3. 94 in *Paroemiographi Graeci*, ed. E. L. a Leutsch and F. G. Schneidewin, vol. 1 (Göttingen 1839) p. 81.

79. c. AD 127–50. *Ptolemy's Almagest*, tr. G.J. Toomer (London 1984) p. 1, p. 134 H197; J. Delorme, *Gymnasion, étude sur les monuments consacrés à l'éducation en Grèce* (Paris 1960) 139.

80. Detailed examples with distinctively Egyptian features, including the temple of Isis in the Campus Martius, obelisks, Augustus' 'Aula Isiaca', and the Egyptian pavillion in the Gardens of Sallust: A. Roullet, *The Egyptian and Egyptianizing Monuments of Imperial Rome* (Leiden 1972) 23–51. It is sometimes suggested that the design of the tomb of Augustus in Rome was influenced by the tomb of Alexander: M.-L. Bernhard, 'Topographie d'Alexandrie: le tombeau d'Alexandre et le mausolée d'Auguste', *RA* 47 (1956) 129–56; Grimm *Alexandria* 160, fig. 146, 147c; A. Claridge, *Rome, an Oxford Archaeological Guide* (Oxford 1998) 183, fig. 78–9. However, there is insufficient evidence from Alexandria to provide proof. Similar problems occur with the suggestion that the design of Nero's Golden house was influenced by palaces in Alexandria: D. Hemsoll, 'The Architecture of Nero's Golden House', in M. Henig, ed., *Architecture and Architectural Sculpture in the Roman Empire* (Oxford 1990) 26–8. Summary of visits of Roman emperors: *CE* 2061–4.

81. Vitruvius, *On Architecture* 6. 3. 9.

82. Pliny, *Natural History* 36. 14. 70, 36. 15. 75. Sundial of Augustus, see Ch. 4 n. 59. Inscription on Vatican Obelisk: E. Iversen, 'The Date of the So-called Inscription of Caligula on the Vatican Obelisk', *JEA* 51 (1965) 149–54; *idem, Obelisks in Exile*, vol. 1, *The Obelisks of Rome* (Copenhagen 1968) 20–1; Alföldy *op. cit.* (n. 13) 82–7, pl. 2–3; Kayser *op. cit.* (n. 15) 23–5 no. 4.

83. A segmental pediment is depicted on a coin of Vespasian, and small segmental pediments survive from it: Roullet *op. cit.* (n. 80) 57–9 nos. 16–23, pl. 15, 25–34, 36. Detailed description of the complex rebuilt by Domitian: K. Lembke, *Das Iseum Campense in Rom* (Heidelberg 1994); Beard *et al. op. cit.* (n. 72) vol. 1, 264–5, fig. 6.2.

84. *Scriptores Historiae Augustae* Hadrian 26. 5.

85. Dio Chrysostom, *Discourse* 32. 41.

86. Handler *loc. cit.* (n. 65) 57.

87. Coins with temple of Isis, issued under Trajan and Hadrian: Handler *loc. cit.* (n. 65) 61, pl. 11.4; Poole *BMC* xci, pl. 28.542, 879; Dattari *Monete* pl. 30.1161, 1972; Price and Trell *op. cit.* (n. 65) fig. 509. Temple of Isis going back to Alexander's city layout: Arrian, *Anabasis of Alexander* 3. 1. 5.

88. Dattari *Monete* pl. 30.3569, 1167, 3568; Handler *loc. cit.* (n. 65) 63–4, pl. 11.8, 9; E. Alföldi-Rosenbaum, 'Alexandriaca. Studies on Roman Game Counters III', *Chiron* 6 (1976) 218, 233, pl. 24 nos. 51–2; P.G.P. Meyboom, *The Nile Mosaic of Palestrina* (Leiden 1995) 53–5, pl. 41–2. It has been suggested that the sanctuary at Taposiris Magna (Abusir) is depicted on the Praeneste (Palestrina) mosaic, rather than the temple of Osiris at Canopus, but there is no basis for such a specific identification, contra: G. Vörös, *Taposiris Magna Port of Isis, Hungarian Excavations at Alexandria (1998–2001)* (Budapest 2001) 120–4, 182–3; *idem Taposiris Magna 1998–2004* (Budapest 2004) 50–1.

89. Papyriform columns taken to Vienna in 1869; two columns h. 6.30 m, circumference 3.40 m; one column h. 5.96 m, circumference 3.25 m: E. von Bergmann, 'Inschriftliche Denkmäler der Sammlung ägyptischer Alterthümer des Österr. Kaiserhauses', *Recueil de travaux relatifs à la philologie et à l'archéologie égyptiennes et assyriennes* 9 (1887) 177–8; G. Foucart, *Histoire de l'ordre lotiforme* (Paris 1897) 160–1, fig. 53; H. Sourouzian, *Les Monuments du roi Merenptah* (Mainz 1989) 49 no. 11a; B. Kriller and G. Kugler, *Das Kunsthistorische Museum. Die Architektur und Ausstattung Idee und Wirklichkeit des Gesamtkunstwerkes* (Vienna 1991) fig. 92, 94–5; H. Satzinger, *Das Kunsthistorische Museum in Wien, die ägyptisch-orientalische Sammlung* (Mainz 1994) fig. 31; J. Yoyotte in Goddio *et al. Alexandria* 214–15.

Screen wall blocks, list with bibliography: J. Yoyotte in Goddio *et al. Alexandria* 215–17, fig. 19, photo 102–3. See also: M. Eaton-Krauss, 'A Falsely Attributed Monument', *JEA* 78 (1992) 285–7; Satzinger *op. cit.* 46–7, fig. 30a, b. The dating of the original monument is complicated by the combination of cartouches on the blocks. Date of Greek inscription 'uncertain, perhaps Roman': E. Bernand, *Inscriptions grecques d'Alexandrie ptolémaïque* (Cairo 2001) 179–80, no. 79, pl. 35.79.

90. Poole *BMC* xci–xcii, pl. 28.1194, 877, 1197; Dattari *Monete* pl. 29.1134, 1949, 3798, 3045; Handler *loc. cit.* (n. 65) 61–4, pl. 11.5–7, 10; Price and Trell *op. cit.* (n. 65) fig. 493; Milne *op. cit.* (n. 65) pl. 4.2018–9. Temple of Nemesis: Dattari *Monete* pl. 30.1968; AD 137: Price and Trell *op. cit.* (n. 65) fig. 494.

91. A. Adriani, *Annuaire* (1935–9) 136–48, fig. 61, pl. 50–9; Adriani *Repertorio* 100–1, pl. 32.113–15; R.A. Wild, *Water in the Cultic Worship of Isis and Sarapis* (Leiden 1981) 11–12, 181, fig. 1; *idem*, 'The Known Isis-Serapis Sanctuaries of the Roman Period', *ANRW* II 17.4, 1810–11; Bailey *loc. cit.* (n. 49) 125; Pensabene *Elementi Aless.* 17, fig. 16. Date: sculpture not before second half of second century AD, Adriani *loc. cit.* 147.

92. Poole *BMC* xc, pl. 28.1191; Dattari *Monete* pl. 29.1131, 3029.

93. Poole *BMC* xc, pl. 28.1198; Dattari *Monete* pl. 30.3061, 3062.

94. Poole *BMC* xcii, pl. 28.881; Dattari *Monete* pl. 29.3801, 3051.

95. Dattari *Monete* pl. 29.3030; Price and Trell *op. cit.* (n. 65) 287 no. 848.

96. Dattari *Monete* pl. 29.3036; Milne *op. cit.* (n. 65) pl. 4.1840.

97. The Serapeum coins continue until at least year 16 of Marcus Aurelius (AD 175/6): Bern 80.586 in B. Karpossy, 'Alexandrinische Münzen, Neuerwerbungen des Bernischen Historischen Museums 1971–4', *Jahrbuch des Bernischen Historischen Museums* 63–4 (1983–4) 178 no. 25. I thank Chris Howego for this reference. Poole *BMC* xc–xci, pl. 28.872 and 1252, 29.537; Dattari *Monete* pl. 30.1142, 1150, 1152, 1154, 1967, 3060 bis, 3803; Handler *loc. cit.* (n. 65) 65–8, pl. 11.13–15, 17; Milne *op. cit.* (n. 65) pl. 4.672; Price and Trell *op. cit.* (n. 65) 183–5, fig. 318.

98. Remains of painted stucco of the first century AD: Botti *Fouilles à la colonne* 79–82, pl. on p. 81; R. Pagenstecher, *Necropolis* (Leipzig 1919) 187–99, fig. 113–17; Rowe *Encl. Serapis* 60 n. 3.

99. So also: F. Thelamon, *Païens et chrétiens au IV* siècle. L'apport de l' 'Histoire ecclésiastique' de Rufin d'Aquilée* (Paris 1981) 169. Contra: Wace in Rowe *Encl. Serapis* 63–4; Rowe and Rees *loc. cit.* (n. 75) 496, 506; Haas *op. cit.* (n. 30) 101 despite 406–7 n. 28.

100. Alföldi-Rosenbaum *op. cit.* (n. 88) 205–39; J.-A. Blanchet, 'Tessères antiques, théâtrales et autres', *RA* 14 (1889) 64–80; M. Rostovtzew, 'Interprétation des tessères en os avec figures, chiffres et légendes', *RA* 5 (1905) 110–24. Alföldi-Rosenbaum, *loc. cit.* (n. 88) 206, considers they were made c. 45 BC to AD 68. Names on them include Adelphoi, Agathodaimon, Aischylou, Alsos, Bomoi, Ibion, Hiera, Kyamon, Pamyles, Ptera and Pyle (gate).

101. Alföldi-Rosenbaum *loc. cit.* (n. 88) 215–16, 231–2, pl. 21.33–6.

102. Eleusineion: Rostovtzew *loc. cit.* (n. 100) 119, fig. 3; Alföldi-Rosenbaum *loc. cit.* (n. 88) 215, 231, pl. 21.28–31.

103. Kaisareion: Alföldi-Rosenbaum *loc. cit.* (n. 88) 217–18, 233, pl. 23.49.

104. Hemikyklia: Blanchet *loc. cit.* (n. 100) 67–8, 64 fig. no. 54; Alföldi-Rosenbaum *loc. cit.* (n. 88) 216–17, 232, pl. 22.37.

105. Altar of Caesareum?: Poole *BMC* xciii, pl. 29.882, 1200, 1204, 1255; Milne *op. cit.* (n. 65) pl. 1.2158, 2160. Altar: Dattari *Monete* pl. 27.3003, 3009. Agathos daimon altar: Handler *loc. cit.* (n. 65) 68–9, pl. 12.18–21. Gate and altar combined: Price and Trell *op. cit.* (n. 65) 21 fig. 10. Another possibility is the altar of Alexander mentioned in: Pseudo-Kallisthenes, *Romance of Alexander* 1. 33; tr. Stoneman 20. p. 65; *The Romance of Alexander the Great by Pseudo-Callisthenes translated from the Armenian Version*, tr. A.M. Wolohojian (New York 1969) 89, p. 52. I thank Chris Howego for the indentification of Eusebia.

106. *Suidae Lexicon*, ed. A. Adler (Leipzig 1928) part I p. 439, 4695 l. 22–7. E. Vilborg, *Achilles Tatius' Leucippe and Clitophon, A Commentary* (Göteborg 1962) 8; *Achille Tatius d'Alexandrie, Le roman de Leucippé et Clitophon*, ed. Fr. tr. J.-P. Garnaud (Paris 1991) vii.

107. Achilles Tatius, 5. 1. 16. The discovery of papyri have now shown this novel to date to the second half of the second century AD, not the early fifth century AD as had previously been thought: Vilborg *op. cit.* (n. 106) 9; Garnaud *op. cit.* (n. 106) viii–ix. Discussion of passage, with old date: Botti 1898 *op. cit.* (n. 14) 17–22.

108. Sun Gate and Moon Gate: Calderini *Dizionario* vol. 1, 113–14, 147; Adriani *Repertorio* 236.

109. The term *pedion* seems to have been equivalent of the Latin *campus*, for a flat expanse of land, as used for the Field of Mars (Campus Martius) in Rome and in Strabo, *Geography* 5. 3. 8: Burkhalter *loc. cit.* (n. 47) 352 n. 23. Mesopedion: Calderini *Dizionario* vol. 1, 137 *pedion* (*meson*); R. Martin, *Recherches sur l'agora grecque* (Paris 1951) 415; Adriani *Repertorio* 227. Pseudo-Kallisthenes, *Romance of Alexander* 1. 32. 5: *Scriptores Rerum Alexandri Magni*, ed. C. Müller (Paris 1846, repr. Chicago 1979) p. 35; *Historia Alexandri Magni (Pseudo-Callisthenes)*, ed. G. Kroll (Berlin 1926) p. 32.

Posidippus (P.Mil.Vogl. VIII 309, col. X l. 12 p. 73; Posidippus ed. tr. Austin and Bastianini p. 84–5 no. 62 line 5) mentions the erection of statues in the *pedon*. This is possibly the *pedion* in Alexandria, as this epigram comes in the papyrus manuscript immediately before the poem mentioning the erection of a statue possibly in the Museum in Alexandria.

110. Achilles Tatius, 5. 2. 1–2. Zeus is also depicted on the Roman coins: Poole *BMC* xc, pl. 28.533; Dattari *Monete* pl. 30.1157; Price and Trell *op. cit.* (n. 65) 286 no. 835.

111. Achilles Tatius, 5. 6. 1–3.

112. John Malalas, 11. 23 (280), *PG* 97, col. 424B (280), ed. Thurn p. 212. So also: John of Nikiu 74. 6–7, *The Chronicle of John, Bishop of Nikiu*, tr. R.H. Charles (Oxford 1916) 56.

113. Malalas does not distinguish between repairs and building for many of the buildings in other cities to which he refers: G. Downey, 'Imperial Building Records in Malalas', *ByzZ* 38 (1938) 1–15, 299–311. *Dromos* is translated as racecourse in *The Chronicle of John Malalas*, tr. E. Jeffreys *et al.* (Melbourne 1986) p. 149, following *Die römische Kaisergeschichte bei Malalas Griechischer Text der Bücher IX–XII und Untersuchungen*, ed. A. Schenk and G. von Stauffenberg (Stuttgart 1931) 495. *Dromos* for the avenue leading up to a temple: Strabo, *Geography* 17. 1. 28. *Dromos* is also used for other streets at Oxyrhynchus and Hermopolis Magna (el-Ashmunein), as indicated by the examples in papyri. Inscription in Alexandria mentioning *dromos* and Serapis, dated to the first or second century AD: A.J.B. Wace, 'Greek Inscriptions from the Serapeum', *Farouk I University, Bulletin of Faculty of Arts, Alexandria* 2 (1944) 23–5 no. 3; Kayser *op. cit.* (n. 15) 181 no. 50, pl. 27.

114. Mayer's caption identifies it as 'A mosque with an antique fragment in Old Alexandria near the Gate of Rosetta': L. Mayer, *Views in Egypt* (London 1805) pl. 18 opp. p. 37.

115. Dattari *Monete* pl. 27.449, 541, 1083, 1088; Poole *BMC* xciii, pl. 29.285, 341–2; Handler *loc. cit.* (n. 65) 70–1, pl. 11.22–5; Price and Trell *op. cit.* (n. 65) fig. 89. The distinctiveness of the design is obvious when compared with examples at other sites outside Egypt in the Roman period illustrated in: P. Gros, *L'Architecture romaine* I (Paris 1996) 56–92, fig. 43–94.

116. Poole *BMC* xciii–xciv; Dattari *Monete* pl. 28. 1101; Price and Trell *op. cit.* (n. 65) 287 no. 850, fig. 488.

117. Pensabene *Elementi Aless.* 397–410, pl. 49–52.

118. It was found in the area to the east of the Serapeum enclosure. Height of block: 0.60 m. Pensabene *Elementi Aless.* 322–4, pl. 7 no. 38; Tkaczow *Topography* 276–7 no. 243 with references, photo obj. 243; Kayser *op. cit.* (n. 15) 362–3 no. 117, pl. 57.

119. Detailed examples, with bibliography: Adriani *Repertorio* 146–88, pl. 68–104 western cemeteries (including Ptolemaic examples) and those of Kom el-Shuqafa, 188–97, pl. 105–13 cemeteries on Pharos (including Ptolemaic examples); Tkaczow *Topography* 52–6 sites 2–4, 60–1 site 8, 65–6 site 12; Venit *Tombs, passim*.

120. Tkaczow *Topography* 55 site 4.

121. J.-Y. Empereur, 'Sous le sol d'Alexandrie', *Archéologia* 345 (1998) 34–7; Empereur *Alexandrie* 174–83, 188–211; J.-Y. Empereur and M.-D. Nenna, eds., *Nécropolis* 1 and 2, *ÉtAlex* 5 and 7 (Cairo 2001 and 2003).

122. Adriani *Repertorio* 162–71 no. 118 with references, pl. 86–95; Daszewski *Mosaics* 128–9 no. 21; Tkaczow *Topography* 52–3 site 2A; Grimm *Alexandria* 126–8, fig. 122a–d; Venit *Tombs* 131–2, fig. 112.

123. Tomb in Antoniadis Garden: H. Thiersch, *Zwei antike Grabanlagen bei Alexandria* (Berlin 1904) 6–10, 16, fig. 5–7, pl. 4–6; Adriani *Repertorio* 143–4 no. 90, pl. 64–5; McKenzie *Petra* 68, pl. 195; Venit *Tombs* 41–4, fig. 25–7.

124. a) Gabbari, Fort Saleh, Room 3 of Tomb 1: Breccia *Musée gréco-romain 1925–1931*, 36–7, pl. 25; Adriani *Repertorio* 151 no. 99, pl. 75 fig. 249; M. Sabottka, 'Ausgrabungen in der West-Nekropole Alexandrias (Gabbari)', in G. Grimm, H. Heinen and E. Winter, eds., *Das römisch-byzantinische Ägypten*, *AegTrev* 2 (Mainz 1983) 197, 202, pl. 42; I. Kaplan, *Grabmalerei und Grabreliefs der Römerzeit* (Vienna 1999) 155, pl. 69b–70a; Venit *Tombs* 93–4, fig. 77.

b) Mafrousa, segmental pediment: G. Botti, 'Études topographiques dans la nécropole de Gabbari', *BSAA* 2 (1899) 53, pl. K.

c) Mafrousa, Egyptian style palm capitals: Adriani *Repertorio* 148 no. 95, pl. 70 fig. 235.

d) 'Sieglin Tomb' with painted Egyptian religious scenes and classical decoration: Sieglin and Schreiber *op. cit.* (n. 36) Text p. vii fig. 1; Adriani *Repertorio* 180, pl. 101 fig. 339; Kaplan *op. cit.* 147–8, pl. 62a; Venit *Tombs* 124, fig. 102.

dd) South-east Gabbari, in area of Gabbari Goods' Station, Habachi Tomb A: B. Habachi, 'Two Tombs of the Roman Epoch Recently Discovered at Gabbary', *BSAA* 31 (1937) 270–82, fig. 1–5; Adriani *Repertorio* 159–60 no. 113; Kaplan *op. cit.* 145–7, pl. 60–1; Venit *Tombs* 120–2, fig. 99–100.

e) Wardian (Stagni) Hypogeum II chamber IIe, classical triangular pediment and a segmental pediment: A. Abd el-Fattah and S. Ali Choukri, 'Un nouveau groupe de

tombeaux de la nécropole ouest d'Alexandrie', *ÉtAlex* 1 (1998) 39–41, fig. 1, 22–31; Empereur *Alexandrie* pl. on p. 187; Kaplan *op. cit.* 148–9, pl. 62b–66; Venit *Tombs* 159–65, fig. 136–42.

f) Anfoushy, Hypogeum 5, segmental pediment, classical decoration on ceiling: Adriani *Repertorio* 195–7 no. 145, pl. 107 fig. 365–6, pl. 113 fig. 395; A. Adriani *Annuaire* (1940–50) 125, pl. 38.2; McKenzie *Petra* 68, pl. 193; Venit *Tombs* 85–90, fig. 70–5.

g) Ras el-Tin Tomb 8, segmental pediment with classical decoration and couch: Adriani *Repertorio* 190 no. 138, pl. 107 fig. 368; A. Adriani *Annuaire* (1940–50) 125, pl. 32.2; McKenzie *Petra* 68, pl. 194c; Venit *Tombs* 72–3, fig. 55.

Mummified bodies: J.-Y. Empereur, 'Alexandrie (Égypte)', *BCH* 124 (2000) 609, fig. 18.

125. A. Adriani, 'Ipogeo dipinto della Via Tigrane Pascià', *BSAA* 41 (1956) 63–86; Adriani *Repertorio* 145–6 no. 91, pl. 66–7, pl. 72 fig. 239; G.L. Steen, ed., *Alexandria the Site and its History* (New York 1993) colour pl. on p. 99. Detailed photographs of paintings: S. Venit, 'The Tomb from Tigrane Pasha Street and the Iconography of Death in Roman Alexandria', *AJA* 101 (1997) 701–29; Kaplan *op. cit.* (n. 124a) 142–4, pl. 50–9; Venit *Tombs* 146–59, fig. 127–33, 135. Chamber IIe of Hypogeum II at Wardian (Stagni) has Anubis depicted dressed as a Roman legionary, as well as classical Erotes: n. 124e above.

126. Sieglin and Schreiber *op. cit.* (n. 36) 77–120, 133–49, 213–17, 252–62, pl. 1–2, 4–7, 18–35; A. Rowe, 'Excavations of the Greco-Roman Museum at Kôm el-Shukafa during the Season 1941–1942', *BSAA* 35 (1942) 10–45; Adriani *Repertorio* 173–8 no. 122, pl. 97–8, pl. 99 fig. 332–4, 336, pl. 100, pl. 101 fig. 340; Tkaczow *Topography* 65–6 site 12; Kaplan *op. cit.* (n. 123a) 129–33, pl. 30–7 'Hypogeum I'; Venit *Tombs* 124–45, fig. 103–4, 106–11, 113–23, 125–45. Drawings of religious scenes: Société archéologique d'Alexandrie, *Les Bas-reliefs de Kom el Chougafa* (Munich n.d.). Date: Kaplan *op. cit.* (n. 124a) 133.

D. Bailey (pers. com.) notes that the *saqiya* at Tuna el-Gebel has a similar encircling spiral staircase: A. Badawy, 'Au grand temple d'Hermoupolis-Ouest: l'installation hydraulique', *RA* 6th ser. 48 (1956) 140–54; T. Schrioler, *Roman and Islamic Water-lifting Wheels* (Odense 1973) 143, fig. 102–3.

127. Niche h of 'Saal EF' of Nebengrab of 1902: Sieglin and Schreiber *op. cit.* (n. 36) 128–32, 150–3, pl. 4, 60–2; Rowe *loc. cit.* (n. 126) 36, pl. 4 Hall M 'left painted tomb', pl. 15; Adriani *Repertorio* 179–80, pl. 101 fig. 342; Kaplan *op. cit.* (n. 124a) Hypogeum II. 1 Grab 134–5, pl. 38–40; Venit *Tombs* 122–3, fig. 101.

128. Rowe *loc. cit.* (n. 126) 32–3, pl. 4 Hall L; Empereur *Alexandrie* pl. on p. 170–2. Detailed description, analysis, illustrations and bibliography: A.-M. Guimier-Sorbets and M. Seif el-Din, 'Les Deux Tombes de Perséphone dans la nécropole de Kom el-Chougafa à Alexandrie', *BCH* 121 (1997) 355–410. Date: *ibid.* 405–6; Kaplan *op. cit.* (n. 124a) Hypogeum II. 3 Grab 135–7, pl. 42–7; Venit *Tombs* 145–6, fig. 126. English summary: A.-M. Guimier-Sorbets, 'The Function of Funerary Iconography in Roman Alexandria. An original form of Bilingual Iconography in the Necropolis of Kom el Shogafa', in R.F. Docter and E.M. Moormann, eds., *Proceedings of the XVth International Conference of Classical Archaeology, Amsterdam 1998* (Amsterdam 1999) 180–2.

129. Main references: Mahmoud-Bey *Mémoire* 53–6; G. Botti, *L'Acropole d'Alexandrie et le Sérapeum* (Alexandria 1895); Botti *Fouilles à la colonne*; G. Botti, 'Additions au "Plan de la ville d'Alexandrie etc." ', *BSAA* 1 (1898) 49–51; idem, *Plan du quartier 'Rhacotis' dans l'Alexandrie romaine* (Alexandria 1897); E. Breccia, 'Les Fouilles dans le Sérapéum d'Alexandrie en 1905–1906', *ASAE* 8 (1907) 62–76; Rowe *loc. cit.* (n. 75) 124–61; Rowe *Encl. Serapis*; Rowe and Rees *loc. cit.* (n. 75) 485–520; Adriani *Repertorio* 90–100 nos. 54–5, pl. 28–31; Fraser *Ptol. Alex.* vol. 1, 27–8, 265–70, vol. 2, 83–92 n. 190–203, 419–26 n. 621–64; Thelamon *op. cit.* (n. 99) 167–73; Sabottka *Serapeum* 252–306; Pensabene *Elementi Aless.* 195–203; Tkaczow *Topography* 68–70 site 15. Colour aerial view of site: A. Charron, 'Sarapis, dieu tutélaire d'Alexandrie', *Archéologia* 345 (1998) pl. on p. 26. Detailed analysis and summary of all evidence and basis for reconstructions: J.S. McKenzie, S. Gibson and A.T. Reyes, 'Reconstructing the Serapeum in Alexandria from the Archaeological Evidence', *JRS* 94 (2004) 73–114.

130. Clement of Alexandria, *Exhortation to the Greeks (Protrepticus)* 4. 42 and 47. Jerome: *Eusebius Werke, Siebenter Band: die Chronik des Hieronymus*, ed. R. Helm (Berlin 1956) p. 208 l. 19 and p. 423g; T. Hopfner, *Fontes historiae religionis aegyptiacae* (Bonn 1922–25) 487; J. Schwartz, 'La Fin du Serapeum d'Alexandrie', in A.E. Samuel, ed., *Essays in Honor of C. Bradford Welles* (New Haven 1966) 97 n. 1; Thelamon *op. cit.* (n. 99) 169. Jerome refers to the *templum* not the *aedes*, suggesting he possibly means the whole complex.

131. Principal analysis of Roman remains as a result of excavations: Rowe *Encl. Serapis* 33–40, 60–4, pl. 4–5, 7, 9, 17; Rowe and Rees *loc. cit.* (n. 75) 496–502; Sabottka *Serapeum* 252–301. Two sizes of granite columns were found: Botti *Fouilles à la colonne* 96, 111; Rowe *loc. cit.* (n. 75) 157; Rowe *Encl. Serapis* 3 n. 3, 23–4; Pensabene *Elementi Aless.* 202 nos. 2–3, 321 no. 31, pl. 5.31. Larger ones, only: I. Hairy, 'Analyse de pièces architecturales d'une colonnade sur le site du Sarapéion', in J.-Y. Empereur, ed., *Alexandrina* 2, *ÉtAlex* 6 (Cairo 2002) 85–98.

132. Rowe *Encl. Serapis* 61.

133. The coins were dated from Trajan to Julia Domna, wife of Septimius Severus (AD 193–211) and Augusta (AD 193–217), and Geta (AD 211): Rowe *Encl. Serapis* 61–2. Coins were also used for foundation deposits in the Roman period at Kom Ombo: M. Jones, 'An Unusual Foundation Deposit at Kom Ombo', *BSAC* 31 (1992) 102–7. Despite dating the pool to *c.* AD 215, Rowe dated the temple to Hadrian.

134. Dio Cassius, *Roman History Epitome* 79. 7. 3.

135. Roullet *op. cit.* (n. 80) 4. The coins issued in AD 202 reflect the acceptance of the Egyptian cults and the identification of the dynasty with the Egyptian gods: C. Foss, *Roman Historical Coins* (London 1990) 174. Caracalla: *Scriptores Historiae Augustae, Antoninus Caracalla* 9. 10. The remains of the large temple on the Quirinale in Rome are not necessarily those of the Serapeum of Caracalla: R. Santangeli Valenzani, 'ΝΕΩΣ

ΥΠΕΡΜΕΓΕΘΗΣ, Osservazioni sul tempio di Piazza del Quirinale', *Bullettino della Commissione archeologica comunale di Roma* 94.1 (1991–2) 7–16; Beard et al. op. cit. (n. 72) vol. 1, 254 n. 33. Columns found in harbour in 1997: references in n. 160 below. Pantheon built *c.* AD 205: n. 154 below.

136. Rowe *Encl. Serapis* 60–61, plan pl. 17; Rowe and Rees loc. cit. (n. 75) 496–8, with plan. Column shafts measured by Rowe: Botti *Fouilles à la colonne* 96, 111; Rowe loc. cit. (n. 75) 157; Rowe *Encl. Serapis* 3 n. 2, 23–4; Pensabene *Elementi Aless.* 202 nos. 2–3, 321 no. 31, pl. 5 no. 31.

137. Fragments of entrance porch: Botti *Fouilles à la colonne* 78, fig. on p. 140; Rowe loc. cit. (n. 75) fig. 8; Botti *Fouilles à la colonne* 34, 61; Pensabene *Elementi Aless.* 64, 199, 202 no. 6, 321–2 nos. 33–7, fig. 221, pl. 6; Tkaczow *Topography* 276 object 242.

138. Rowe *Encl. Serapis* 32, 34, pl. 7; Wild op. cit. (n. 91) 32.

139. Botti 1895 op. cit. (n. 129) 24–6 with plan; Botti *Fouilles à la colonne* 112–21; Rowe loc. cit. (n. 75) 140 fig. 7, 152, pl. 32, 34.3, 35.3; Rowe *Encl. Serapis* 34–6; Rowe and Rees loc. cit. (n. 75) 498–9; Adriani *Repertorio* 95–6, pl. 30 fig. 107, pl. 31 fig. 110.

140. Obelisks: N.L. Norden, *Voyage d'Égypte et de Nubie* vol. 1 (Copenhagen 1755) pl. 12; Botti *Fouilles à la colonne* 47–8. Bibliography for complete list of Egyptian statues: J. Yoyotte in Goddio et al. *Alexandria* 212 n. 59. See also: Rowe loc. cit. (n. 75) 133–4, 139, 154–7, pl. 27.1–2, 28.3, 36, 42.4; Rowe and Rees loc. cit. (n. 75) 507–8.

141. Tertullian, *Apologeticum* 18. 8, *Tertullien Apologétique*, ed. tr. J.-P. Waltzing and A. Severyns (Paris 1961) p. 42. Date: *OCD³* 1487.

142. Rowe *Encl. Serapis* 24, pl. 5.2, 8.

143. Aphthonius a student of Libanius (b. AD 314): G.A. Kennedy, *Greek Rhetoric under Christian Emperors* (Princeton 1983) 59–60. This means Aphthonius would have been too young to visit the city as early as AD 315. Contra: Butler op. cit. (n. 16) 382 n. 2; Thelamon op. cit. (n. 99) 166.

144. Tr. by A.T. Reyes in McKenzie et al. (n. 129) 104–5 with more detailed notes, from: *Aphthonii Progymnasmata* 12, ed. H. Rabe (Leipzig 1926) 38–41. Text with Latin tr. Botti *Fouilles à la colonne* 23–6; text with Ger. tr. Sabottka *Serapeum* 320–4; Fr. tr. K. Macaire, 'Nouvelle étude sur le Sérapéum d'Alexandrie', *Bulletin de la Société Khédievale de géographie* 7 ser., no. 7 (1910) 396–8. Discussion of text: Botti op. cit. 1895 (n. 129) 5–12; Botti *Fouilles à la colonne* 26–9, 82–5; Sabottka *Serapeum* 324–9, 336–7. The obelisks are also mentioned in Pseudo-Kallisthenes, *The Romance of Alexander* 1. 33; tr. Stoneman op. cit. (n. 30) 66. References for sculpture in Serapeum: Ch. 3 n. 168.

145. Date: F.X. Murphy, *Rufinus of Aquileia (345–411), His Life and Works*, The Catholic University of America, Washington, Studies in Medieval History n.s. 6 (Diss. 1945) 47, 232, 235.

146. Tr. by A.T. Reyes (originally prepared in 1993 concentrating on the architectural terms) in McKenzie et al. (n. 129) 106, from: Rufinus, *Historiae ecclesiasticae* 11. 23, *Die lateinische Übersetzung des Rufinus*, ed. E. Schwartz, in *Eusebius Werke*, ed. T. Mommsen, vol. 2 (Leipzig 1908) 1026–7. Alternative tr.: *The Church History of Rufinus Aquileia Books 10 and 11*, tr. P.R. Amidon (Oxford 1997) 80–1; text with Fr. tr. Thelamon op. cit. (n. 99) 166–7; text with Ger. tr. Sabottka *Serapeum* 329–32. Discussion of text: Botti *Fouilles à la colonne* 35–40; Macaire loc. cit. (n. 144) 398–402; Sabottka *Serapeum* 333–7. Other examples of *pastophoria*: G. Husson, *Oikia, le vocabulaire de la maison privée en Égypte d'après les papyrus grecs* (Paris 1983) 221–3.

147. G. Valentia, *Voyages and Travels to India, Ceylon, the Red Sea, Abyssinia and Egypt in the Years 1802–1806* (London 1811) vol. 3, 455, vol. 4 plan by H. Salt; *Description de l'Égypte* vol. 5, 328–37, 477–82, vol. 10, 524–5, plates vol. 5, pl. 39.2–3; G. Botti, *Plan du quartier 'Rhakotis' dans l'Alexandrie romaine* (Alexandria 1897) 2; Humphrey *Roman Circuses* 505–12.

148. *Spina*: *Description de l'Égypte* vol. 5, 328, 330, 478, plates vol. 5, pl. 39.2–3. Humphrey *Roman Circuses* 507–8, fig. 254, analysed the evidence recorded by the Napoleonic expedition and redrew the plan of it as a circus based on this. It was similar in size to the Circus Maximus in Rome.

149. Seats found on south slope of Serapeum enclosure: drawings by A. Thiersch, reproduced in Sabottka *Serapeum* vol. 1, 96–7, vol. 3, fig. 17–19. These were found on the southern side of the Serapeum hill beyond (east of) where Humphrey *Roman Circuses* fig. 254, ended the circus. Seating further west: *Description de l'Égypte* vol. 5, 329, vol. 10, 524, plates vol. 5, pl. 39.2 seats at 'k'; Humphrey *Roman Circuses* fig. 254.

150. Nielsen *Palaces* fig. 110.

151. Aezani: R.L. Vann, *The Unexcavated Buildings of Sardis*, BAR International 538 (Oxford 1989) fig. 117. Other combinations of theatre and stadium in Asia Minor, and stadia with both ends rounded: Vann op. cit. 62–5, fig. 116, 118–21. The Napoleonic expedition suggested the structure they recorded was a stadium, rather than a circus: see n. 147.

152. *Scriptores Historiae Augustae*, Severus 17. 2; Dio Cassius, *Roman History* 51. 17. 3. F. Millar, *A Study of Cassius Dio* (Oxford 1964) 144, 209–10; D. Delia, *Alexandrian Citizenship During the Roman Principate* (Atlanta 1991) 120–3.

153. John Malalas, 12. 21 (293), ed. Thurn p. 222; tr. Jeffreys et al. 156. Haas op. cit. (n. 30) 143 apparently assumes that Rhea is to be equated here with Kybele (based on Fraser *Ptol. Alex.* vol. 1, 277–8), although Isis equally could be equated with her (Fraser *Ptol. Alex.* vol. 1, 671–2).

154. *Chronicon Pascale*, PG 92, col. 652C–653A (266).

155. Lukaszewski *Les Édifices publics* 59; A. Farrington, *The Roman Baths of Lycia* (London 1995) 135.

156. Dio Cassius, *Roman History Epitome* 76. 13. 2. Maqrizi (AD 1364–1442), *A Short History of the Copts*, tr. S.C. Malan (London 1873) p. 33–4. Slaughter of Christians: *Chronicon Pascale*, PG 92, col. 652C (266).

157. Herodian, 4. 8. 9.

158. Herodian, 4. 9. 4–8. The massacre of the youth is located in the gymnasium in *Scriptores Historiae Augustae*, Antoninus Caracalla 6. 2–3. Discussion of different versions of events: Millar op. cit. (n. 152) 156–8; E. Bernand in Goddio et al. *Alexandria* 161–5.

159. Dio Cassius, *Roman History Epitome* 78. 7 and 22–3. A. Favuzzi, 'Ancora su Caracalla e i *syssitia* degli Alessandrini', *ZPE* 121 (1998) 251–6; K. Buraselis, 'Zu Caracallas Strafmassnahmen in Alexandrien (215/6). Die Frage der Leinenweber in P.Giss. 40 II und der *syssitia* in Cass. Dio 77 (78). 23.3', *ZPE* 108 (1995) 173–84. *Syssitia* mentioned in inscriptions: (i) the erection of a statue by the philosophers in the common mess hall, second half of second century AD: Kayser op. cit. (n. 15) 287 no. 98 line 5, pl. 47; (ii) dedication of statues of the emperors in it, third quarter of second century AD, discovered in 1993 at site of Billardo Palace, south-east of site of Cleopatra's Needles: A. and E. Bernand, 'Un procurateur des effigies impériales en Alexandrie', *ZPE* 122 (1998) p. 98 lines 4–5, 8.

160. Column shafts: E. Bernand in Goddio et al. *Alexandria* plan and table of find-spots on p. 144, 147–55. Painting from Stabiae of a port with statues on columns: J. Kolendo, 'Le port d'Alexandrie sur une peinture de Gragnano?', *Latomus* 41 (1982) 305–11, pl. 3–5 fig. 1–3. Kolendo (p. 310–11) suggests the painting depicts Alexandria based on the depictions of a port on some lamps. Bailey suggests these lamps (except those which he points out are fake) do not depict Alexandria but possibly Carthage and Ostia: D. Bailey, 'Alexandria, Carthage and Ostia (Not to mention Naples)', in *Alessandria e il mondo ellenistico-romano*, vol. 2 (Rome 1984) 265–72. The possibility that the painting depicts Alexandria is now more likely in the light of the new evidence for the positions of jetties etc. in its eastern harbour.

161. Ammianus Marcellinus, 22. 16. 15 (written mid-late AD 380s); A. Bowman, *Egypt after the Pharaohs* (London 1986) 44; A. Martin, 'Alexandrie à l'époque romaine tardive: l'impact du christianisme sur la topographie et ses institutions', C. Décobert and J.-Y. Empereur eds., *Alexandrie médiévale* 1, *ÉtAlex* 3 (1998) 11. Seige of Bruchion (spelt variously, including 'Pirouchion'): Eusebius, *Ecclesiastical History* 7. 32. 7–12 (written in early fourth century). The 'Proucheion' is mentioned as near the *dromos* in the late second century AD: *Apollonii Dyscoli*, ed. R. Schneider and G. Uhlig (Leipzig 1910) *Grammatici Graeci* vol. 3 part 2, p. xi. Identification of Broucheion with palace area: Fraser *Ptol. Alex.* vol. 2, 24 n. 47.

162. Epiphanius, *Weights and Measures* 52b; *PG* 43, col. 249C; *S. Epiphanius of Salamis, Treatise on Weights and Measures, The Syriac Version*, ed. tr. J.E. Dean, *Studies in Ancient Oriental Civilisation* 11 (Chicago 1935) p. 25. Written in AD 392.

163. John Malalas, 12. 41 (309), ed. Dindorf 309, ed. Thurn p. 237–8. Eutropius, 9. 23 (written in AD 370). Bowman op. cit. (n. 161) 44–5; Haas op. cit. (n. 30) 364 n.1. Date of event: A.K. Bowman, 'Papyri and Roman Imperial History', *JRS* 66 (1976) 159.

164. Prefect, and date from papyrological evidence: C. Vandersleyen, *Chronologie des préfets d'Égypte de 284 à 395* (Brussels 1962) 66–70. Inscription: idem, 'Le Préfet d'Égypte de la colonne de Pompée à Alexandrie', *Chronique d'Égypte* 33 (1958) 113–34; Kayser op. cit. (n. 15) 52–7 no. 15, pl. 10. Column: *Description de l'Égypte* vol. 5, 315–28, 470–7, plates vol. 5, pl. 34; Adriani *Repertorio* 97, pl. 28.102; Pensabene *Elementi Aless.* 200, 323–4 nos. 39–40, fig. 127–9, pl. 7.1, 2, 39, 40. The mention of only one large column by Aphthonius suggests that there was only ever one column, that it was not one of a pair. Contra: Rowe and Rees loc. cit. (n. 75) 498 and plan.

165. Bowman op. cit. (n. 161) 45.

166. John of Nikiu 77. 10, tr. Charles 58.

167. *Suidae Lexikon*, ed. A. Adler (Leipzig 1931) Part 2 p. 104, 1156 Diocletianos, and Part 4 (1935) p. 804, 280 Chemeia.

168. I thank Z. Kiss for his comments on this complicated subject: pers. com. 24 November 2003.

a) House A in test pit MX under new (later) thoroughfare and 'small theatre' final abandonment dated tentatively to end of third century AD, the ruins were levelled in the fourth century: Majcherek loc. cit. 1999 (n. 33b), 14.

b) House in trench MXV partially under cavea of 'small theatre', ruined by a sudden catastrophe such as an earthquake, with a fire in late third or early fourth century: Majcherek loc. cit. 1993 (n. 33a), 20.

c) House FA partially under the baths and between them and the cistern, abandoned in the first half of the fourth century: Majcherek loc. cit. 1996 (n. 33a), 29–30.

cc) Building FB ruined late third or early fourth century AD: Majcherek loc. cit. 1998 (n. 33a) 39.

d) House discovered by Hogarth near the main east-west street, demolished at end of third century: Rodziewicz *Les Habitations* 50; Tkaczow *Topography* 103 site 47.

e) On the city block further east, house with garden east of street R3 abandoned in third/fourth century AD: Rodziewicz and Daoud loc. cit. (n. 32e) 154; Tkaczow *Topography* 114 site 61A.

169. Z. Kiss, 'Les Auditoria romains tardifs de Kôm el-Dikka (Alexandrie)', *Acta antiqua academiae scientiarum Hungaricae* 33 (1990–2) 332; idem, 'Remarques sur la datation et les fonctions de l'édifice théâtral à Kôm el-Dikka', in *50 Years of Polish Excavations in Egypt and the Near East, Symposium Warsaw University 1986* (Warsaw 1992) 173–4, 177; idem, 'L'Évolution de la structure urbaine d'Alexandrie romaine à la lumière des fouilles récentes', *XIVᵉ congreso internacional de Arqueología clásica* (Taragona 1994) 3.

170. It had two entrance corridors (*parodoi*) at the sides. W. and T. Kolataj, 'Polish Excavations at Kom el Dikka in Alexandria, 1967', *BSAA* 43 (1975) 84–5, pl. 4 (stage building foundations); Kiss loc. cit. 1990–2 (n. 169) 332; idem loc. cit. 1992 (n. 169), 171, fig. 1; Tkaczow *Topography* 85–7 site 33, 279–80 no. 251 with photographs obj. 251.

171. E. Makowiecka, 'The Numbering of the Seating Places at the Roman Theatre of Kom el-Dikka in Alexandria', *Acta Conventus XI 'Eirene'* (Warsaw 1971) 479–83; W. and T. Kolataj loc. cit. (n. 170) 86.

172. J.-C. Balty, 'Le "Bouleuterion" de l'Alexandrie sévérienne', *ÉtTrav* 13 (1983) 7–12; idem, *Curia Ordinis* (Brussels 1991 [1983]) 534–8; Kiss loc. cit. 1990–2 (n. 169) 332–4; Kiss loc. cit. 1992 (n. 169) 174–8.

173. W. Kubiak, 'Les Fouilles polonaises à Kôm el-Dik en 1963 et 1964', *BSAA* 42 (1967) 79–80, pl. 4b, 8–9; W. and T. Kolataj loc. cit. (n. 170) 79–97; Kiss loc. cit. 1990–2

(n. 169), 334; Kiss *loc. cit.* 1992 (n. 169) 171, 173, 177, fig. 2; B. Tkaczow, 'Observations préliminaires sur les fragments de décoration architectonique à Kôm el-Dikka', *ÉtTrav* 16 (1992) 229–33; W. Kolataj, 'The Kom el-Dikka Archaeological Site', in *Alessandria e il mondo ellenistico-romano, Congresso Alessandria 1992* (Rome 1995) 189–90. Concerning the dome (but chronology superseded by recent excavations results): W. Kolataj, 'Recherches architectoniques dans les thermes et le théâtre de Kôm el-Dikka à Alexandrie', in G. Grimm, H. Heinen and E. Winter, eds., *Das römisch-byzantinische Ägypten*, *AegTrev* 2 (1983) 190–4, fig. 3, 5, 7. Revised reconstruction of dome: W. Kolataj, 'Theoretical Reconstruction of the Late Roman Theatre at Kom el-Dikka in Alexandria', in C.J. Eyre, ed., *Proceedings of the Seventh International Congress of Egyptologists* (Leuven 1998) 631–8.

174. Suggestion the 'small theatre' was a lecture theatre: E. Rodziewicz, 'Late Roman Auditoria in Alexandria in the Light of Ivory Carvings', *BSAA* 45 (1993) 269–79. Graffiti: Z. Borkowski, *Inscriptions des factions à Alexandrie*, *Alexandrie* II (Warsaw 1981); Kiss *loc. cit.* 1990–2 (n. 169), 334–5; Kiss *loc. cit.* 1992 (n. 169), 177; Z. Kiss, 'Les Auriges de Kom el-Dikka', *Centenary of Mediterranean Archaeology at the Jagiellonian University 1897–1997* (Cracow 1999) 135–42. Developing role of factions in the theatre from late fifth century and transfer of theatre partisans to Blues and Greens: A. Cameron, *Circus Factions Blues and Greens at Rome and Byzantium* (Oxford 1976) 194–6, 214–21, 226–9. Ivory comb: Louvre Museum E 11874: N. Bosson and S.H. Aufrère, eds., *Égyptes... L'Égyptien et le copte* (Lattes 1999) 274–5 no. 92, fig. 92a–b on p. 280; *L'Art copte en Égypte, exposition présentée à l'Institut du monde arabe* (Paris 2000) 222. Because of the Christian symbols Kiss suggested it was used for meetings of clergy: Z. Kiss, 'Czy "budowla teatralna" na Kôm el-Dikka (Aleksandria) sluzyla do kultu?', *Sympozja Kazimierskie* 3 (Lubin 2002) 215–23.

175. Tkaczow *Topography* 86; Kiss 1992 *loc. cit.* (n. 169) 172, 178.

176. Chronology summarised in: W. Kolataj, 'Late Roman Baths at Kôm el-Dikka in Alexandria', in *50 Years of Polish Excavations in Egypt and the Near East* (Warsaw 1992) 179–83; largely based on numismatic evidence: W. Kolataj, *Imperial Baths at Kom el-Dikka*, *Alexandrie* VI (Warsaw 1992) 43–56, 198–9; *idem loc. cit.* 1983 (n. 173), 189. The block with an inscription mentioning an architect (*architekton*) was reused: A. Lukaszewicz, 'Fragmenta Alexandrina I', *ZPE* 82 (1990) 135, pl. IIb; Kolataj *op. cit.* phot. 9. Public baths mentioned in written sources: Calderini *Dizionario* vol. 1, 96–7.

177. Kolataj *loc. cit.* (n. 176) 181.

178. Kolataj *op. cit.* (n. 176) 62–82, fig. 34–5, 45, plan VII, XI; Tkaczow *Topography* 97 site 44. On Roman baths-buildings in general: F. Yegül, *Baths and Bathing in Classical Antiquity* (Cambridge, Mass. 1992).

179. Phase I: Kolataj *op. cit.* (n. 176) fig. 15, plan IX. Phase II, when the arrangement of two steam baths was discarded: Kolataj *loc. cit.* (n. 176) 181; *idem op. cit.* (n. 176) 50, 168, plan X; *idem loc. cit.* 1995 (n. 173), 189.

180. Kolataj *loc. cit.* (n. 176) 181–3, plan III; *idem op. cit.* (n. 176) 163–6, 170–1, fig. 51, 53, plan XI, section C–C and D–D.

181. Kolataj *loc. cit.* (n. 176) 183; *idem op. cit.* (n. 176) 176, 180–1, 199.

182. Kolataj *op. cit.* (n. 176) 169–70, fig. 36–7, phot. 15.

183. E. and M. Rodziewicz, 'Alexandrie 1977', *ÉtTrav* 12 (1983) 269–75, fig. 10–12; Kolataj *op. cit.* (n. 176) 170; M. Rodziewicz, 'A Brief Record of the Excavations at Kom el-Dikka in Alexandria from 1960 to 1980', *BSAA* 44 (1991) 9, 12, 27–9 fig. 12–14; Tkaczow *Topography* 99.

184. Kolataj *loc. cit.* (n. 176) 185.

185. The two sets of lecture rooms excavated in 1980–7 near the baths-building are dated by the pottery to the fifth to seventh centuries AD: M. Rodziewicz, 'Excavations at Kom-el-Dikka in 1980–1981', *BSAA* 44 (1991) 73–5, 83 fig. 5; *idem*, 'Report on the Activities of the Archaeological Mission at Kom el Dikka, Alexandria in 1982', *BSAA* 44 (1991) 86, 98 fig. 5, 102 fig. 11–13; *idem*, 'Report on the Excavations at Kom-el-Dikka in Alexandria in 1983–1984', *BSAA* 44 (1991) 115 pl. III, 118 fig. 6; Kiss *loc. cit.* 1990–2 (n. 169), 336–8, fig. 2–4; Z. Kiss, 'Alexandrie 1987', *ÉtTrav* 16 (1992) 346–51, fig. 1–4; B. Tkaczow, 'An Imitation of *opus alexandrinum* in Wall Painting ?', *ÉtTrav* 17 (1995) 320–1; Rodziewicz *loc. cit.* (n. 174) 271, 273, pl. 49; Z. Kiss, 'Les Auditoria romains tardifs', in Z. Kiss *et al.*, *Fouilles polonaises à Kôm el-Dikka (1986–1987)*, *Alexandrie* VII (Warsaw 2000) 8–33, fig. 1–11. Lecture rooms excavated in 2002–3 include auditorium K, abandoned mid- to late seventh century AD, and auditorium P, remodelled in the late sixth to early seventh century AD: Majcherek *loc. cit.* (n. 33c) 29–33, fig. 4–6.

186. S.K. Hamarneh, 'The Ancient Monuments of Alexandria according to Accounts by Medieval Arab Authors (IX–XV Century)', *Folia Orientalia* 13 (1971) 80. J. McKenzie, 'The Place in Late Antique Alexandria "where Alchemists and Scholars Sit . . . was like Stairs"', in T. Derda *et al.*, eds., *Alexandria: Auditoria of Kom el-Dikka and Late Antique Education*, *Journal of Juristic Papyrology* suppl. 8 (Warsaw in press 2007).

187. Not fully excavated or studied. Summary: Rodziewicz *Les Habitations* 263–70. Later preliminary reports: E. and M. Rodziewicz, 'Alexandrie 1978–1979', *ÉtTrav* 14 (1990) 301–10; Kolataj *op. cit.* (n. 176) 79–82; G. Majcherek, 'Excavations in Alexandria 1990–91', *PAM* 3 (1991) 5–7; *idem loc. cit.* 1992 (n. 32d), 11–14; W. Kolataj, 'Alexandria 1993–94', *PAM* 6 (1994) 5–7, fig. 2.

188. Houses *alpha* to *gamma* were destroyed by fire at the end of third century AD: Rodziewicz *Les Habitations* 50–3; Tkaczow *Topography* 110 site 55.

189. Overview: G. Majcherek, 'Notes on Alexandrian Habitat: Roman and Byzantine Houses from Kom el-Dikka', *Topoi* 5 (1995) 133–50.

Houses A–H: Rodziewicz *Les Habitations* 59–194, plan III; Rodziewicz *loc. cit.* 1991 (n. 183) 54 fig. 40; Tkaczow *Topography* 109–10.

House A: Rodziewicz *Les Habitations* 127–8.

House B: Rodziewicz *Les Habitations* 128–46, fig. 143, 155; Rodziewicz *loc. cit.* 1991 (n. 183) 47–50 fig. 33–6.

House C: Rodziewicz *Les Habitations* 159–73; Rodziewicz *loc. cit.* 1991 (n. 183) 15, 52 fig. 38, 58 fig. 45.

House D: Rodziewicz *Les Habitations* 66–127, 194–234, 333–4 fig. 338–9; Rodziewicz *loc. cit.* 1991 (n. 183), 15, 55 fig. 41–2, 58–63 fig. 45–52, 64–6 fig. 55–8, 67–8 fig. 60–5.

House E: Rodziewicz *Les Habitations* 177–94; Rodziewicz *loc. cit.* 1991 (n. 183) 15, 56 fig. 43, 58 fig. 45, 64 fig. 53–4.

House F: Rodziewicz *Les Habitations* 146–59; Rodziewicz *loc. cit.* 1991 (n. 183) 53 fig. 39, 66 fig. 59.

House G: Rodziewicz *Les Habitations* 173–7; Majcherek *loc. cit.* 1988–9 (n. 32d), 82–83; *idem loc. cit.* 1989–90 (n. 32d) 19–22, fig. 1; *idem loc. cit.* 1992 (n. 32d) 15–18, fig. 2 plan; *idem loc. cit.* 1993 (n. 32d) 11–14; *idem loc. cit.* 1995 141–5.

House H: Majcherek *loc. cit.* 1988–9 (n. 32d) 80–2; *idem loc. cit.* 1989–90 (n. 32d) 23–4, fig. 1; *idem loc. cit.* 1991 (n. 187) 11–14, fig. 2 plan; *idem loc. cit.* 1995 135–45.

Narrow shop units along street: Rodziewicz *Les Habitations* 246–51, fig. 271–2; Majchereck *loc. cit.* (n. 33b) 37–8, fig. 8.

Evidence for bone workshops: E. Rodziewicz, 'Bone Carvings Discovered at Kom el-Dikka, Alexandria, in 1967', *ÉtTrav* 3 (1969) 147–52; *idem*, 'Reliefs figurés en os des fouilles à Kôm el-Dikka', *ÉtTrav* 10 (1978) 317–36; *idem*, 'Archaeological Evidence of Bone and Ivory Carvings in Alexandria', in J.-Y. Empereur, ed., *Commerce et artisanat dans l'Alexandrie hellénistique et romaine, Actes du Colloque d'Athènes, 1988, BCH* suppl. 33 (Athens 1998) 135–58.

190. M. Rodziewicz, 'Nouvelles données sur le quartier de Kopron à Alexandrie', *ÉtTrav* 11 (1979) 79–89; Rodziewicz *Les Habitations* 252–6; Tkaczow *Topography* 111 site 56, marked on plan IIIb.

191. Rodziewicz *Les Habitations* pl. 18 nos. 2–3.

192. Rodziewicz *Les Habitations* 317–29, fig. 329 plan; Tkaczow *Topography* 111 sites 57–8. The detailed report has not been published.

193. M. Rodziewicz, 'Thermes romains près de la Gare centrale d'Alexandrie', *ÉtTrav* 11 (1979) 107–38; Rodziewicz *Les Habitations* 313–16, fig. 328 plan; Tkaczow *Topography* 82–3 site 30.

194. Full bibliography for cisterns: Ch. 2 n. 32.

195. For example: (i) el-Nabeh cistern in the Shallat Gardens, which survives today: Breccia *Alex. ad Aeg.* 81, fig. 28–30; Adriani *Annuario* (1932–3) 81 no. 62, marked on plan at back; Tkaczow *Topography* 158–9 site 120, fig. 62; M. Sartre, 'Alexandrie romaine', *Les Dossiers d'archéologie* 201 (1995) pl. on p. 51; Empereur *Alexandrie* pl. on p. 130–1, 135–9. (ii) cistern near church of St Sabas: Norden *op. cit.* (n. 140) vol. 1, pl. 10; Tkaczow *Topography* 105 site 51A, fig. 38. (iii) under Nebi Daniel Mosque: L. Dabrowski, 'La Citerne à l'eau sous la Mosquée de Nébi Daniel', *Bulletin of Faculty of Arts, University of Alexandria*, 12 (1958) 40–8; Tkaczow *Topography* 90 site 37, fig. 28.

196. Marked on section of trench MXVI: Rodziewicz *loc. cit.* 1991 (n. 183) 14, 41–2, fig. 27–8.

CHAPTER 9: ROMAN CLASSICAL ARCHITECTURAL STYLE

1. Type I: P. Pensabene, 'Elementi di architettura Alessandrina', *Studi Miscellanei* 28 (1984–5 [1991]) 38, fig. 12; Pensabene *Elementi Aless.* 356, pl. 28 no. 196. Type II. Pensabene *Elementi Aless.* 374, pl. 37 no. 277. Type III: K. Ronczewski, 'Les Chapiteaux corinthiens et variés du Musée gréco-romain d'Alexandrie', *BSAA* suppl. du fasc. 22 (1927) pl. 7.2; C. Börker, 'Die Datierung des Zeus-Tempels von Olba-Diokaisareia in Kilikien', *AA* (1971) 54, fig. 8; Pensabene *Elementi Aless.* 38, fig. 11, 13–15; Pensabene *Elementi Aless.* 371, 373, 378, pl. 35 no. 257, 36 no. 271, 38 nos. 296–7.

2. Pensabene *Elementi Aless.* 373, pl. 36 no. 272 (not at Edfu). There is also an unprovenanced Type III capital from Egypt in the storeroom of the Louvre Museum, Paris, stored with the architectural fragments from Bawit.

3. H.G. Lyons, *A Report on the Island and Temples of Philae* (London 1896) pl. 64; E. Sieglin and T. Schreiber, *Die Nekropole von Kôm-esch-Schukâfa*, vol. 1 text (Leipzig 1908) 283–4, fig. 212; Pensabene *Elementi Aless.* 120, fig. 99.

4. G. Castel, F. Daumas and J.-C. Golvin, *Les Fontaines de la Porte Nord* (Cairo 1984) pl. 9a; Pensabene *Elementi Aless.* 372–4, pl. 36 no. 269, 37 nos. 274–5.

5. Castel *et al. op. cit.* (n. 4) pl. 15f; Pensabene *Elementi Aless.* 383, pl. 41 no. 318.

6. Simplified Type III capitals occur as far south as Naqa in the Sudan on temple B, probably dated to the first century AD: Sieglin and Schreiber *op. cit.* (n. 3) 283–4, fig. 213; T. Kraus, 'Der Kiosk von Naga', *AA* 1964, 834–68; L. Török, 'Zur Datierung des sogenannten römischen Kiosks in Naqa/Sudan', *AA* 1984, 153–9, fig. 4, 7, 11; L. Török, 'Meroitic Architecture: Contributions to Problems of Chronology and Style', *Meroitische Forschungen 1980 = Meroitica* 7 (1984) 363–5.

7. W. Daszewski *et al.* in L. Krzyzanowski, ed., *Marina el Alamein: Archaeological Background and Conservation Problems*, vol. 1 (Warsaw 1991) cover, 23, 26–7, fig. 11–13.

8. Thebes (Luxor): G. Roeder, ed., *Hermopolis 1929–1939* (Hildesheim 1959) pl. 55g. Ombos (Kom Ombo): Pensabene *Elementi Aless.* 67, 376–7, pl. 38 no. 293; M. Jones, 'An Unusual Foundation Deposit at Kom Ombo', *BSAC* 31 (1992) pl. XIb. At Kom Ombo the column and bases have been re-erected with only one base in its original position: Jones *loc. cit.* 97. Type III capital from Hermonthis (Armant) in Cairo Museum: Sieglin and Schreiber *op. cit.* (n. 3) fig. 211; Pensabene *Elementi Aless.* 110, fig. 96.

9. See Ch. 7 n. 89 above. J. Schwartz *et al.*, *Fouilles franco-suisses rapports II, Qasr-Qârûn/Dionysias 1950* (Cairo 1969) pl. 10–13, 24, 26; Pensabene *Elementi Aless.* 111.

10. T. Kraus, J. Röder and W. Müller-Wiener, 'Mons Claudianus-Mons Porphyrites', *MDIK* 22 (1967) 177 fig. 19, pl. 57a; Pensabene *Elementi Aless.* 329–30, fig. 13, pl. 14 nos. 86–9.

11. *Description de l'Égypte*, vol. 4, pl. 58.4, 5, 13. Another example occurs at Theadelphia (Batn Ihrit) which is Roman based on the dentils: E. Breccia, 'Teadelfia

e il Tempio di Pneferôs', *Monuments de l'Égypte gréco-romaine*, vol. 1 (Bergamo 1926) 128, pl. 67.5; Pensabene *Elementi Aless.* 512, pl. 98 no. 937.

12. Schwartz *et al. op. cit.* (n. 9) fig. 9, pl. 3.

13. Pensabene *Elementi Aless.* 100, pl. 128.1–2. Date: see Ch. 7 n. 88 above.

14. Ronczewski *op. cit.* (n. 1) 8–9, fig. 5a–b; Castel *et al. op. cit.* (n. 4) 24–6, fig. 3–4, pl. 9b–c; Pensabene *Elementi Aless.* 361–3, pl. 31 nos. 220–6. Date: see Ch. 7 n. 65 above.

15. L. F. Cassas, *Voyage pittoresque de la Syrie, de la Phénicie, de la Palestine et de la Basse Égypte*, vol. 3 (Paris 1799) pl. 54 capital in foreground. Grey granite example: Ronczewski *op. cit.* (n. 1) 7–8, fig. 3–4; Pensabene *loc. cit.* (n. 1) fig. 78; Pensabene *Elementi Aless.* 360, pl. 30 no. 217; U.-W. Gans, 'Hellenistische Architekturteile aus Hartgestein in Alexandria', *AA* (1994) 439–40, fig. 7, 9.

16. Red granite example from Hermopolis Magna (el-Ashmunein): K. Ronczewski, 'Kapitellfragmente aus Hermopolis', *MDIK* 6 (1936) 90–2, fig. 4; Roeder *op. cit.* (n. 8) 274 § 23, 281 § 50, pl. 51h; Pensabene *Elementi Aless.* 172, 364, fig. 98, pl. 32 no. 231. Example of black basalt-like stone at Hermopolis Magna: J. McKenzie, 'The Architectural Style of Roman and Byzantine Alexandria and Egypt', in D.M. Bailey, ed., *Archaeological Research in Roman Egypt*, *JRA* suppl. 19 (Ann Arbor 1996) 132 fig. 3c. Red granite example in Apollinopolis Magna (Edfu): Pensabene *Elementi Aless.* 363–4, pl. 32 no. 229. Red granite example in Cairo Museum: Strzygowski *Koptische Kunst* 80 no. 7355, fig. 108. Grey granite example in Rome: Ronczewski *loc. cit.* 91, pl. 22a; Roeder *op. cit.* (n. 8) 281, pl. 55i. Alexandria: J.-Y. Empereur, 'Alexandria: the Underwater Site near Qaitbay Fort', *Egyptian Archaeology* 8 (1996) pl. on p. 8.

17. M. el Saghir *et al.*, *Le Camp romain de Louqsor*, *MIFAO* 83 (Cairo 1986) fig. 29–32; Gans *loc. cit.* (n. 15) 444; Pensabene *Elementi Aless.* 369–70, pl. 34 nos. 252–4.

18. Green granite: Ronczewski *op. cit.* (n. 1) fig. 14; Pensabene *loc. cit.* (n. 1) fig. 77; Pensabene *Elementi Aless.* 172, 369, pl. 34 no. 249; Gans *loc. cit.* (n. 15) 443–4, fig. 12. Granite example from temple at Athribis (Tell Atrib): A. Rowe, 'Preliminary Report on Excavations of the Institute of Archaeology, Liverpool, at Athribis', *Annals of Archaeology and Anthropology* 25 (1938) pl. 37c.

19. *IGRom* I 1254; E. Bernand, 'A propos de l'autel dédié à Zeus Soleil, Grand Sarapis, par l'architecte Alexandrin Apollônios fils d'Ammônios, au Mons Claudianus', *ZPE* 91 (1992) 221–5.

20. See Ch. 7 n. 58 above. Examples in Palestine: M. Fischer, *Das korinthische Kapitell im alten Israel in der hellenistischen und römischen Periode* (Mainz 1990) pl. 9–37.

21. P. Grossmann, 'Ein kaiserzeitliches Sarapis-Heiligtum in Akoris', *MDIK* 37 (1981) pl. 35b.

22. Apparently from the tetrapylon of the inscription of AD 374; marble: Rowe *loc. cit.* (n. 18) pl. 37a.

23. W.M.F. Petrie *et al.*, *Tombs of the Courtiers and Oxyrhynkhos* (London 1925) pl. 36.3.

24. Many examples: Pensabene *Elementi Aless.* 397–410, pl. 49–52.

25. Bailey *Hermopolis* 16, pl. 13–17.

26. Bailey *Hermopolis* 33, 37, pl. 55–6.

27. Apparently from the tetrapylon of the inscription of AD 374; marble or limestone: Rowe *loc. cit.* (n. 18) pl. 37d; Pensabene *Elementi Aless.* 529, pl. 105 no. 993.

28. See Ch. 8 n. 109 above.

29. T. Borkowska-Kolotaj, 'Wstepna interpretacja niektorych elementow dekoracji architektonicznej odkrytych w widowni teatru na Kom el-Dikka' [Preliminary interpretation of some elements of architectural decoration found in the auditorium of the theatre at Kom el-Dikka], in M.L. Bernhard, ed., *Starozytna Aleksandria w badaniach polskich* (Warsaw 1977) 41, 44, fig. 8a, 10; McKenzie *Petra* 74 no. 28, pl. 215d–e; Pensabene *Elementi Aless.* 527–8, pl. 105 nos. 989–90.

30. e.g. E. Young, 'Sculptors' Models or Votives?', *The Metropolitan Museum of Art Bulletin* 22 (1964) 256, fig. 14; D. Arnold, *Building in Egypt, Pharaonic Stone Masonry* (Oxford 1991) fig. 2.27; A.M. Donadoni Roveri, ed., *Egyptian Civilization, Monumental Art* (Milan 1989) pl. 144, 147; G. Jéquier, *Les Temples ptolémaïques et romains* (Paris 1924) pl. 80. Oxyrhynchus Papyri Project, Oxford interim no.: P.Oxy 8 1B.199/H (1–2) c [i]: H. Whitehouse and J.J. Coulton, 'Drawing a Fine Line in Oxyrhynchus: Egyptian ad Graeco-Roman Draughtsmanship on Papyrus', in A.K. Bowman *et al.* eds., *Oxyrhynchus: A City and its Texts* (in press).

31. Lukaszewicz *Les Édifices publics* 32–3.

32. Lukaszewicz *Les Édifices publics* 161–83.

CHAPTER 10: CHURCHES OF LATE ANTIQUE ALEXANDRIA

1. Eusebius, *Ecclesiastical History* 2. 16 and 24; ed. tr. K. Lake and J.E.L. Oulton (London 1926–32) vol. 1, 144–5 and 178–9; B.A. Pearson, 'Earliest Christianity in Egypt: Some Observations', in B.A. Pearson and J.E. Goehring, eds., *The Roots of Egyptian Christianity* (Philadelphia 1986) 138; C.W. Griggs, *Early Egyptian Christianity from its Origins to 451 C.E.* (2nd edn Leiden 1991) 20–1. Date of Eusebius' *Ecclesiastical History* (c. AD 300 or 311): Late Ant. 438. On forgery of letter published by M. Smith: P. Jeffrey, *The Secret Gospel of Mark Unveiled* (London, 2007)

2. Eusebius, *Ecclesiastical History* 5. 10. 1–5. 11. 2, 6. 1–3, 6. 6, 6. 18. 2–4, ed. tr. Lake and Oulton vol. 1, 462–5, vol. 2, 8–11, 26–9, 54–5; A. Martin, 'Aux Origines de l'église copte: l'implantation et le développement du christianisme en Égypte (Iᵉ–IVᵉ siècles)', *Revue des études anciennes* 83 (1981) 35–6; W.H.C. Frend, *The Rise of Christianity* (Philadelphia 1984) 243, 253, 286–9.

3. Eusebius, *Ecclesiastical History* 6. 41, 7. 10–11, ed. tr. Lake and Oulton vol. 2, 98–111, 148–67; J. Faivre in A. Baudrillart *et al.* eds., *Dictionnaire d'histoire et de géographie ecclésiastiques*, vol. 2 (Paris 1914) col. 298–302; Martin *loc. cit.* (n. 2) 37; Frend *op. cit.* (n. 2) 321–2, 325–7; W. Clarysse, 'The Coptic Martyr Cult', in M. Lamberigts

and P. van Deun, eds., *Martyrium in Multidisciplinary Perspective, Memorial Louis Reekmans* (Leuven 1995) 377–9. Persecution of Origen at Serapeum: Epiphanius, *Panarion* 64. 1. 4–5; *Epiphanius II Panarion haer. 34–64*, ed. K. Holl and J. Dummer (Berlin 1980) 403; *The Panarion of Epiphanius of Salamis. Books II and III (Sects 47–80, de Fide)*, tr. F. Williams (Leiden 1994) 132. Origen was tortured under Decius: Williams *op. cit.* 132 n. 6.

4. Eusebius, *Ecclesiastical History* 7. 10 and 13, ed. tr. Lake and Oulton vol. 2, 150–5 and 168–171. He is quoting contemporary sources: Dionysius of Alexandria and Valerian. Faivre *loc. cit.* (n. 3) 338; A. Martin, 'Les Premiers Siècles du christianisme à Alexandrie, Essai de topographie religieuse (IIIᵉ–IVᵉ siècles)', *Revue des études Augustiniennes* 30 (1984) 211.

5. E.L. Butcher, *The Story of the Church of Egypt*, vol. 1 (London 1897) 111–20; *CE* 2244–7.

6. Eusebius, *Ecclesiastical History* 8. 1–2, 8. 6, 8. 8–10, 8. 13. 7, ed. tr. Lake and Oulton vol. 2, 252–9, 268–71, 272–85, 296–7; Frend *op. cit.* (n. 2) 474, 481; Pearson *loc. cit.* (n. 1) 151; Clarysse *loc. cit.* (n. 3) 379–82.

7. Pearson *loc. cit.* (n. 1) 133; C.H. Roberts, *Manuscript, Society and Belief in Early Christian Egypt* (London 1979) 12–14.

8. Eusebius, *Ecclesiastical History* 6. 11. 3 and 7. 24. 6, ed. tr. Lake and Oulton vol. 2, 36–7 and 194–5; Martin *loc. cit.* (n. 2) 37. Antonius Dioskoros whose father came from Alexandria is described as a Christian in a list of candidates for liturgical offices in Arsinoe: P. van Minnen, 'The Roots of Egyptian Christianity,' *Archiv für Papyrusforschung* 40 (1994) 74–7. Church buildings at Oxyrhynchus and Chysis: *P.Oxy.* I 43; J. van Haelst, 'Les Sources papyrologiques concernant l'église en Égypte à l'époque de Constantin', *Proceedings of 12th International Congress of Papyrology* (Toronto 1970) 498 nos. 13 and 17; E.A. Judge and S.R. Pickering, 'Papyrus Documentation of Church and Community in Egypt to the Mid-Fourth Century', *Jahrbuch für Antike und Christentum* 20 (1977) 59–61, 69; Pearson *loc. cit.* (n. 1) 151; R. Bagnall, *Egypt in Late Antiquity* (Princeton 1993) 53–4, 264, 278. Churches in papyri c. AD 330–50: van Haelst *loc. cit.* 499–500.

9. Early development of monasticism, with references: B.A. Pearson and J.E. Goehring, eds., *The Roots of Egyptian Christianity* (Philadelphia 1986) 235–306; Bagnall *op. cit.* (n. 8) 293–303; van Minnen *loc. cit.* (n. 8) 78–85. Economic role: E. Wipszycka, *Les Ressources et les activités économiques des églises en Égypte du IVᵉ au VIIIᵉ siècle* (Brussels 1972).

10. R. Bagnall, 'Religious Conversion and Onomastic Change in Early Byzantine Egypt', *Bulletin of the American Society of Papyrologists* 19 (1982) 105–24, with graph on p. 124 summarizing results with extrapolations. The generalizations here are based on Bagnall's revised figures in: R. Bagnall, 'Conversion and Onomastics: a Reply', *ZPE* 69 (1987) 243–50 especially table on p. 249; and Bagnall *op. cit.* (n. 8) 280–1. Wipszycka disagrees with Bagnall's extrapolations of the rate of conversion: E. Wipszycka, 'La Valeur de l'onomastique pour l'histoire de la christianisation de l'Égypte', *ZPE* 62 (1986) 173–81; *idem*, 'La Christianisation de l'Égypte aux IVᵉ–VIᵉ siècles. Aspects sociaux et ethniques', *Aegyptus* 68 (1988) 164–5. See also van Minnen *loc. cit.* (n. 8) 73–4.

11. a) Wescher Catacomb: C. Wescher, 'Un ipogeo cristiano antichissimo di Alessandria in Egitto', *Bullettino di archeologia cristiana* III No. 8 (1865) 57–61; G.B. de Rossi, 'Commento sulla precedente relazione del ch. sig. Wescher', *Bullettino di archeologia cristiana* III No. 8 (1865) 61–4; *idem*, 'I simboli dell'Eucaristia nelle pitture dell'ipogeo scoperto in Alessandria d'Egitto', *Bullettino di archeologia cristiana* III No. 10 (1865) 73–7; Néroutsos-Bey, *Notice sur les fouilles récentes exécutées à Alexandrie* (Alexandria 1875) 29–40 (= Néroutsos-Bey in *Bulletin de l'Institut égyptien* 13, 1874–5, 211–21); Néroutsos *Alexandrie* 41–54; T. Schreiber, ed., *Die Nekropole von Kom-esch-Schukafa* (Leipzig 1908) vol. 1 text 20–6, 30–8, Beiblatt I, fig. 13–20, 22–4 (on Wescher Catacomb in 1876: J.P. Richter *ibid.* 30–8); H. Leclercq in F. Cabrol and H. Leclercq, eds., *Dictionnaire d'archéologie chrétienne et de liturgie*, vol. 1 (Paris 1924) 1125–45, fig. 277–9, 281–4, 287; M. Krause in K. Wessel, ed., *Reallexikon zur Byzantinischen Kunst*, vol. 1 (Stuttgart 1966) 105–7; Adriani *Repertorio* 184–6 no. 128 (with bibliography), pl. 103–4 fig. 348–51; M. Rassart-Debergh, 'La Peinture copte avant le XIIIᵉ siècle: Une approche', *Acta ad archaeologiam et artium historiam pertinentia* 9 (1981) 231–2, fig. 1; Tkaczow *Topography* 65–6 site 12. Date, end of third century AD: M.-H. Rutschowscaya, 'Les Arts de la couleur', *Dossiers d'archéologie* 226 (Sept. 1997) 32, pl. on p. 33; Venit *Tombs* 183–6 fig. 158.

It had completely disappeared by 1888. The main painting was in the apse of vestibule F. In chamber H there are more paintings of saints and inscriptions. At the back of burial niche K there was a faded figure of Christ crushing two serpents (Wescher *loc. cit.* 60). Néroutsos-Bey depicted a similar scene from an ivory: Néroutsos *Alexandrie* 49–50, fig. on p. 49; Richter in Schreiber *op. cit.* 38, 39 n. 7. This ivory is incorrectly labelled as the tomb painting in: Leclercq, *loc. cit.* 1138 fig. 286; Rassart-Debergh *loc. cit.* fig. 2. On the side wall of burial niche L there were three figures of saints, including one which was indentified as St John the Baptist because of the painted scroll quoting Matthew 3. 3 (= Mark 1. 3). The long gallery with thirty-two loculi had no wall paintings or inscriptions visible. The sketchy naturalistic style of the Eucharistic cycle again raises the question as to whether the paintings from Hypogeum 3 at Wardian (in the Greco-Roman Museum) with the bucolic scenes, and one possibly of Jonah are Christian, Ptolemaic or Roman. References: Ch. 3 n. 260.

b) Scavo B at Kom el-Shuqafa has a cross on one of the pediments above the niches of room B (of first to second centuries AD), indicating Christian reuse: Schreiber *op. cit.* (n. 11a) 57, 60, 62, plates pl. 1, 2, 8, 9 lower; Adriani *Repertorio* 182–3 no. 125, pl. 99 fig. 335, pl. 102 fig. 346.

c) Scavo D at Kom el-Shuqafa (= tomb at Borg Abou-el-Achem), tomb of first half of first century AD reused by Christians, possibly as a chapel: G. Botti, 'Fouilles dans le céramique d'Alexandrie en 1898 [7]', *BSAA* 1 (1898) 18–21, plan in pl. A–B; Schreiber

op. cit. (n. 11a) 68–73, plates pl. 3D1–5; Leclerq *loc. cit.* (n. 11a) 1145–7, fig. 290–1; A. Rowe, 'Excavations of the Graeco-Roman Museum at Kôm el-Shukafa during the Season 1941–1942', *BSAA* 35 (1942) 6–9, pl. 2; Adriani *Repertorio* 183–4 no. 127, fig. Za, pl. 102 fig. 344.

d) Rufini Chapel, found in 1876 near Wescher Catacomb: Schreiber *op. cit.* (n. 11a) 26; Adriani *Repertorio* 186 no. 128; Leclerq *loc. cit.* (n. 11a) 1149–50; Tkaczow *Topography* 66 site 12.

12. a) Catacombs of Minet el-Bassal, behind Western Mosque (between it and Bourse of Minet el-Bassal) hypogea of Christian cemetery (Constantinian) with loculi with painted inscriptions and inscribed loculus slabs, found in 1879 when digging foundations for cotton mill near Arab wall: Néroutsos *Alexandrie* 61, 95 nos. 6–7; G. Botti, 'Le iscrizioni cristiane di Alessandria d'Egitto', *Bessarione* 4 vol. 7 (1899–1900) 273 nos. 6–7, 275; Leclerq *loc. cit.* (n. 11a) 1150–1; Tkaczow *Topography* 61 site 9. Hypogeum discovered in 1899 during work on the railway to Gabbari: Botti *loc. cit.* 273–4 nos. 8–9. Christian inscription in tomb at Gabbari: G. Botti, 'Bulletin épigraphique', *BSAA* 4 (1902) 99 no. LXXVI.

b) Gabbari, Ptolemaic tombs reused in the Christian period with painted Christian symbols including wreathed crosses and candelabra (Tomb IX and VII): M. Sabottka, 'Ausgrabungen in der West-Nekropole Alexandrias (Gabbari)', in G. Grimm *et al.*, eds., *Das römisch-byzantinische Ägypten*, *AegTrev* 2 (Mainz 1983) 202–3, pl. 43; Tkaczow *Topography* 56 site 4; Venit *Tombs* 183. Christian epitaphs and crosses (Tomb B2 and B3): M.-F. Boussac and J.-Y. Empereur, 'Les Inscriptions', in J.-Y. Empereur and M.-D. Nenna, eds., *Necropolis* 1, *ÉtAlex* 5 (Cairo 2001) 236 nos. 19–22, fig. 5.29–36.

c) Hypogeum of Gabbari, to the north-west beside the sea, found in 1876, with eucharistic symbols of fishes and loaves, and an inscription found nearby from the Christian tomb of Theodota (*?c.* AD 240): Néroutsos *Alexandrie* 93–4 no. 3; Botti 1899–1900 *loc. cit.* (n. 12a) 272–3 no. 5; Leclerq *loc. cit.* (n. 11a) 1151.

d) Mafrousa, Ptolemaic hypogea reused by Christians, one apparently in AD 148–9: G. Botti, 'Études topographiques dans la nécropole de Gabbari', *BSAA* 2 (1899) 39–40 nos. 1–2; Leclerq *loc. cit.* (n. 11a) 1159–60; Tkaczow *Topography* 55 site 3.

e) Agnew Catacomb found in 1836 to west of the city (twenty minutes walk from the west gate between the Mahmudiya Canal on the east, Lake Mariut on the south, and on the west the new palace and gardens of Ibrahim Pasha) is a reused Ptolemaic hypogeum with red painted inscriptions on the plaster, farewelling the dead and dated to AD 305–346: H.C. Agnew, 'Remarks on Some Remains of Ancient Greek Writings, on the Walls of a Family Catacomb in Alexandria', *Archaeologia* 28 (1840) 152–67; Leclerq *loc. cit.* (n. 11a) 1147–8; Tkaczow *Topography* 56 site 4. It is unclear from the painted inscriptions whether they are Christian. There is no record of the Christian inscription on a marble slab which was published with them having been found in this hypogeum: Agnew *loc. cit.* 170 no. F, pl. 14F; contra Leclerq *loc. cit.* (n. 11a) 1148, fig. 292.

f) Inscription found near Fort Kom el-Guilleh, recording the repair of a ?church by architects Theodoros and Ser[apionos] (in ? AD 488): Botti 1899–1900 *loc. cit.* (n. 12a) 271 no. 2; Leclerq *loc. cit.* (n. 11a) 1118–9.

13. a) East of Shatby station (half way between Alexandria and Moustapha Pasha stations on the Ramleh line), Christian burials in reused tombs with galleries of loculi: *AJA* 3 (1887) 145–6; *AJA* 3 (1887) 411–12; Néroutsos *Alexandrie* 110 no. 31; Leclerq *loc. cit.* (n. 11a) 1149; Tkaczow *Topography* 171–2 site 139.

b) Shatby, Hypogeum of Zonéina, with lengthy inscription of AD 409 on her loculus slab: Néroutsos-Bey in *Bulletin de l'Institut égyptien* 12 (1872–3) 111–6; Néroutsos-Bey 1875 *op. cit.* (n. 11a) 47–8; Botti *loc. cit.* 1899–1900 (n. 12a), 278–9 no. 15; Leclerq *loc. cit.* (n. 11a) 1152–4.

c) Ibrahimieh (east of Shatby), inscription from Christian cemetery, discovered in 1892: G. Botti, 'Additions au "Plan de la Ville d'Alexandrie etc." ', *BSAA* 1 (1898) 53; Leclerq *loc. cit.* (n. 11a) 1140.

d) On site of then new Polytechnical Faculty on Sharia el-Horreya (i.e. north of the main east-west stret and east of ancient cross-street R4bis), a Christian rock-cut hypogeum with a curved roof and eight loculi. The walls were painted with epitaphs above the loculi, and an ornate painting (possibly of the fourth or fifth century) of a cross with *alpha* and *omega* on either side and surrounded by a wreath, with candelabra on either side, similar to the paintings surviving at Gabbari (n. 12b above): A. Adriani, 'Scavi e scoperte alessandrine (1949–1952)', *BSAA* 41 (1956) 37–9, fig. 37–41.

e) Hadra, site of then new Deaconess Hospital on hill of Hadra to left of Alexandria–Cairo railway (i.e. in the southern part of Hadra), reused Ptolemaic hypogeum with rock-cut columns with capitals with crosses carved into them, with Christian inscriptions and symbols painted in red: E. Breccia, 'Un ipogeo cristiano di Hadra', *BSAA* 9 (1907) 278–88; Faivre *loc. cit.* (n. 3) 339; Leclerq *loc. cit.* (n. 11a) 1125; Adriani *Repertorio* 122–3 no. 74, pl. 41 fig. 158–9; Venit *Tombs* 181–2, fig. 157.

f) Hadra, Christian structure (third or fourth century), on line of railroad, possibly associated with Christian tombs found in area: Tkaczow *Topography* 177 site 147, 177 n. 245.

14. Rodziewicz *Les Habitations* 194–227, fig. 226–54. Date of painting of Archangel, Madonna and child in courtyard of House D: *ibid.* 203–4.

15. Symeon Metaphrastes (late tenth century AD), *Acts of St Mark*, *PG* 115, col. 163A–170D; M. Krause, 'Das christliche Alexandrien und seine Beziehungen zum koptischen Ägypten', in N. Hinske, ed., *Alexandrien*, *AegTrev* 1 (Mainz 1981) 53. Detailed analysis of sources, including summary of *Acts of St Mark*: Pearson *loc. cit.* (n. 1) 137–45. References for versions of *Acts of St Mark*: *ibid.* 140 n. 37. Date of St Mark's arrival in Alexandria: *ibid.* 139 n. 30, 142. See also: B.A. Pearson, 'The *Acts of St Mark* and the Topography of Ancient Alexandria', *BSAA* 45 (1993) 239–46.

16. *Acts of St Mark* 5, *PG* 115, col. 168A. References for *Boukolou topoi*: Calderini *Dizionario* vol. 1, 105, 173; Adriani *Repertorio* 211; Martin *Athanase* 147; J. Gascou, 'Les Églises d'Alexandrie: questions de méthode', in C. Décobert and J.-Y. Empereur, eds., *Alexandrie médiévale* 1, *ÉtAlex* 3 (1998) 37–9, 43–4. *Boukolou* is often translated as

'cow pastures', but it also has other possible meanings: Pearson *loc. cit.* (n. 1) 141, 153 n. 122; Pearson *loc. cit.* (n. 15) 242; C. Haas, *Alexandria in Late Antiquity* (Baltimore, Maryland 1997) 213, 270–1; J. Gascou, review of C. Haas *Alexandria in Late Antiquity*, in *Topoi* 8.1 (1998) 391; A. Martin, 'Alexandrie à l'époque romaine tardive: l'impact du christianisme sur la topographie et les institutions', in C. Décobert and J.-Y. Empereur, eds., *Alexandrie médiévale* 1, *ÉtAlex* 3 (1998) 12.

17. *Acts of St Mark* 10, *PG* 115, col. 169C; Severus ibn el-Muqaffa, ed. tr. B. Evetts, *PO* I 145–8 [47–50]. References for church (*naos*) of St Mark: J. Faivre, 'Le Martyrium de Saint-Marc', *Bulletin de l'Association des amis de l'art copte* 3 (1937) 67–74; Calderini *Dizionario* vol. 1, 173–4; Martin *loc. cit.* (n. 4) 216; Martin *Athanase* 153.

18. Eusebius, *Ecclesiastical History* 7. 32. 31, 8. 13. 7, 9. 6. 2; ed. tr. Lake and Oulton vol. 2, 244–5, 296–7, 340–1. The detailed description of the martyrdom of Peter I is in the *Acts of St Peter*. Reconstructed fourth-century version (in Latin): W. Telfer, 'St Peter of Alexandria and Arius,' *AnalBolland* 67 (1949) 126–30; tr. T. Vivian, *Saint Peter of Alexandria: Bishop and Martyr* (Philadelphia 1988) 68–70. Longer Greek version: P. Devos, 'Une passion grecque inédite de S. Pierre d'Alexandrie', *AnalBolland* 83 (1965) 157–87; tr. Vivian *op. cit.* 70–8. Coptic version: *Les Actes des martyrs de l'Égypte tirés des manuscrits coptes de la Bibliothèque vaticane et du Musée Borgia*, ed. tr. H. Hyvernat, vol. 1 (Paris 1886) 263–83; Amélineau *Géographie* 27–8, 31–2. On later additions to original fourth-century account: Telfer *loc. cit.* 117–30; Pearson *loc. cit.* (n. 1) 143; Vivian *op. cit.* 44–8, 64–7; Gascou *ÉtAlex loc. cit.* (n. 16) 36–7.

The longer Greek version, although much later, includes useful topographical details, even if the events described were added later (Pearson *loc. cit.*, n. 1, 143; Vivian *op. cit.* 65–6). Peter is described as 'going down' to the tomb of St Mark (*Acts of St Peter* 11–14, ed. Devos *loc. cit.* 171–3, tr. Vivian *op. cit.* 75–6), which also suggests that it was rock-cut. The role of the church [of Theonas] as the cathedral is indicated by Peter's successor Achillas being ordained patriarch in it. It was in the western part of the city in the suburbs, and had a sanctuary (*thysiasterion*) in which there was a bishop's throne (*Acts of St Peter* 16–18, ed. Devos *loc. cit.* 175–177; tr. Vivian *op. cit.* 77–8). The Coptic version indicates that this was the Church of Theonas (Hyvernat *op. cit.* 280).

19. Coptic *Acts of St Peter*, Hyvernat *op. cit.* (n. 18) 279–80. Pearson considers this area was also the Jewish quarter Delta: Pearson *loc. cit.* (n. 1) 152.

20. On location of early churches in Rome: B. Ward-Perkins, in A. Cameron and P. Garnsey, eds., *Cambridge Ancient History*, vol. 13 *The Late Empire, AD 337–425* (Cambridge 1998) 396–8.

21. Church of Theonas: Leclerq *loc. cit.* (n. 11a) 1110–11; Calderini *Dizionario* vol. 1, 169–70; Martin *loc. cit.* (n. 4) 214; Martin *Athanase* 144–5; Gascou *ÉtAlex loc. cit.* (n. 16) 26, 37 42. (Gascou considers the Church of Theonas was to the east of the city, and so obviously rejects the suggestion that it was on the later site of the Mosque of One Thousand Columns.)

The identification of the Church of Theonas with Gama el-Gharbi was made in: Néroutsos *Alexandrie* 62. According to the Coptic Synaxarium (1 Amchir, 26 January, ed. tr. R. Basset, *PO* XI [724–5] 758–9): 'During the reign of Constantine, when the temples were destroyed and the churches constructed, the faithful built one to the west of the city, to remember St Peter. It lasted until the Arabs entered the country . . . and was known as el-Gharbyah'. (On the various versions of the Coptic Synaxarium, with references see: O.F.A. Meinardus, *Christian Egypt Ancient and Modern*, Cairo 1965, 36–80; *CE* 2172–90. These also give equivalent dates for the Coptic calendar dates.)

The long Latin version of the *Acts of St Peter* refers to the church [of Theonas] as 'the church of the most beautiful Mother of God and always Virgin Mary' which Peter I built near 'the cemetery of the martyrs in the western part of the city' (*PG* 18, col. 464B). The church of St Peter was apparently possibly also the Church of Theonas, although Martin suggests it was a different cemetery church. Church of St Peter (and Virgin Mary): Calderini *Dizionario* vol. 1, 176; Martin *loc. cit.* (n. 4) 219–20; Martin *Athanase* 152; Gascou *ÉtAlex loc. cit.* (n. 16) 38 n. 94, 39–40.

22. Frend *op. cit.* (n. 2) 482–8, 495–6; Eusebius, *Life of Constantine* 1. 49–2. 60, tr. A. Cameron and S.G. Hall (Oxford 1999) 89–114, 224–48; H. Chadwick, *The Church in Ancient Society* (Oxford 2001) 187–8.

23. Frend *op. cit.* (n. 2) 500; B. Watterson, *Coptic Egypt* (Edinburgh 1988) 36–8; *CE* 1998; Bagnall *op. cit.* (n. 8) 285–6.

24. Coptic *Martyrdom of St Macarius of Antioch*, Hyvernat *op. cit.* (n. 18) vol. 1, 73–6; Amélineau *Géographie* 26. On St Macarius and his life: *CE* vol. 5, 1489.

The major attacks on the temples in Egypt seem to have occurred, as elsewhere in the empire, at the end of the fourth century, rather than at the beginning of the century. Detailed discussion, with references for whole empire: H. Saradi-Mendelovici, 'Christian Attitudes toward Pagan Monuments in Late Antiquity and their Legacy in Later Byzantine Centuries', *DOP* 44 (1990) 47–61.

Earthquake: Theophanes, *Chronographia* AM 5812; *Theophanis Chronographia*, ed. C. de Boor, vol. 1 (Leipzig 1883) 17; *The Chronicle of Theophanes Confessor*, tr. C. Mango and R. Scott (Oxford 1997) 29. It is based on a compilation of earlier sources. On Theophanes' Alexandrian sources: *ibid.* lxxviii–lxxx. Theophanes died in AD 818.

25. John of Nikiu, 64. 9–10, Ethiopian text Fr. tr. M.H. Zotenberg, 'Chronique de Jean évêque de Nikiou. Text éthiopien', in *Notices et extraits des manuscrits de la Bibliothèque nationale* vol. 24 (Paris 1883) 125–608; Eng. tr. *The Chronicle of John, Bishop of Nikiu translated from Zotenberg's Ethiopic Text*, tr. R.H. Charles (Oxford 1916) 49. The Ethiopian text of John of Nikiu was translated from the Arabic version in 1602. On John of Nikiu and his sources: A. Carile, 'Giovanni di Nikius, cronista bizantino-copto del VII secolo', *FelRav* 121–2 (1981) 103–55.

Eutychius of Alexandria, *Annales* 300 and 433–5, *PG* 111, col. 975C and 1005A–B. So also: Coptic Synaxarium 12 Baounah (6 June), ed. tr. R. Basset, *PO* XVII, 559–60 [1101–2]. Eutychius (Sa'īd ibn al-Biṭrīq in *CE* vol. 4, 1265–6) was the Chalcedonian patriarch of Alexandria, AD 933–40, whose annals were translated from Arabic into Latin in 1654 by Edward Pococke (reproduced in *PG* 111); Arabic text: *Eutychii*

Patriarchae Alexandrini Annales. CSCO *Scriptores Arabici*, series 3, 6, and 7, ed. L. Cheikho, B. Carra de Vaux and H. Zayyat (Beirut and Paris 1905–9).

All three sources state that the Caesareum was also the Church of St Michael. John of Nikiu mentions Constantine. Eutychius mentions that the Caesareum was dedicated by Cleopatra to Saturn, and describes the destruction of the large bronze idol in it, by the patriarch Alexander. The Coptic Synaxarium mentions Constantine, and the role of Alexander in the destruction of the statue of Saturn. The Forum Romanum in Rome had a temple of Saturn in it, so there could have been one in Alexandria in the Forum in front of the Caesareum. Some scholars (mentioned below) have suggested that Eutychius and the Coptic Synaxarium are referring to the destruction of the temple of Kronos. As Kronos (Latin Cronus) was 'predominantly a mythical god', Greek cult places for him are rare (*OCD*[3] 411). However, a temple (*hieron*) of Kronos in Alexandria is mentioned in the first century BC, recorded in Athenaeus, *Deipnosophistae* 3. 110b. A festival of Kronos is also mentioned in the late third century AD in the Faiyum: *P.Oxy.* VII 1025; D. Frankfurter, *Religion in Roman Egypt* (Princeton 1998) 56–7. The worship of Saturn in Egypt is mentioned by Macrobius, *The Saturnalia* 1. 7. 14–16, tr. P.G. Davies (London 1969) 57.

Equally, as these references to the destruction of the statue of Saturn are very late, it is possible that they are symbolic of the destruction of paganism in a general sense, rather than specifically referring to the actual temple of Kronos. Frankfurter indicates that Kronos is representative of Satan in the sermons of Apa Shenute, the abbot of the White Monstery at Sohag near Panopolis, in the first half of the fifth century: Frankfurter *op. cit.* 117 with quotations and references. Kronos was also equated with the Egyptian crocodile god Sobek, and also Petbe (Greek Nemesis): Frankfurter *op. cit.* 57 n. 59, 117 n. 69. The Egyptian god Horus is depicted mounted on a horse spearing a crocodile in a similar way to later representations of St George killing the dragon: Musées de Marseille, *Égypte romaine* (Marseilles 1997) 232–3.

The reference to the temple and statue of Saturn have also resulted in the suggestion that the 'temple of Kronos or Saturn' was converted into a church of St Michael by patriarch Alexander: Haas *op. cit.* (n. 16) 209–10; *CE* 1617; Martin *Athanase* 149–51. Contra: Gascou *Topoi loc. cit.* (n. 16) 390; *idem ÉtAlex. loc. cit.* (n. 16) 31. Calderini (*Dizionario* vol. 1, 175; following Néroutsos *Alexandrie* 71) assumed that the temple of Saturn was the temple of Kronos mentioned by Athenaeus, and that it was the Church of St Michael and was the 'church of Alexander' mentioned in n. 97 below.

Martin (*loc. cit.* n. 4, 219 n. 51; Martin *Athanase* 149 n. 146) considers John of Nikiu and Eutychius had confused the Caesareum with the temple of Saturn. She concludes that no churches or other buildings in Alexandria were built with the generosity of Constantine (Martin *loc. cit.* n. 16, 20). She also considers that the conversion of the Caesareum occurred under Constantius II (see n. 34 below).

Martin (*Athanase* 150 n. 152) considers the reference to the temple of Mercury [Hermes], rather than Saturn, (Amélineau *Géographie* 43) is erroneous, but Hermes [Egyptian Thoth] is mentioned in a tenth-century chronicle, and sometimes Michael is considered his successor: *CE* 1617.

References for Caesareum Church (*Kaisareia ekklesia*): Calderini *Dizionario* vol. 1, 171–2. See also: Amélineau *Géographie* 28–9; Martin *loc. cit.* (n. 4) 214, 217–8, 221; Martin *Athanase* 148–9. Christian archaeological remains on site of Caesareum: Néroutsos *Alexandrie* 13–14; Kyrillos II, 'Le Temple du Césareum et l'église patriarchale d'Alexandrie', *Bulletin de la Société royale de géographie d'Égypte* 6 (1900) 349–53; B. Tkaczow, 'Archaeological Sources for the Earliest Churches in Alexandria', in W. Godlewski, ed., *Coptic Studies* (Warsaw 1990) 434 site 16; Tkaczow *Topography* 135 site 90.

26. Athanasius, *Defence Against Constantius* 15, *Athanase d'Alexandrie, Apologie à l'empereur Constance, Apologie pour sa fuite*, ed. Fr. tr. J.-M. Szymusiak (Paris 1958) 104, tr. *NPNF* 4, 243–4; Haas *op. cit.* (n. 16) 209.

27. Epiphanius, *Panarion* 68. 4. 1–2 and 69. 1. 1–2, *Epiphanius III Panarion haer. 65–80*, ed. K. Holl and J. Dummer (Berlin 1985) 144 and 152, tr. Williams 318 and 325.

28. For possible meanings and origin of 'Baukalis' see: Faivre *loc. cit.* (n. 17) 70; Calderini *Dizionario* vol. 1, 105, 174; G.W.H. Lampe, *A Patristic Greek Lexicon* (Oxford 1961) 294; Gascou *Topoi loc. cit.* (n. 16) 391; Martin *loc. cit.* (n. 16) 12; Martin *Athanase* 147–8. Martin suggests the Baukalis Church was located near the emporium as Arius sang to mariners, dockers and millers. However, it could have equally been located elsewhere in the city. Assumption that 'Baukalis' was the same as 'Boukolou', and that therefore the Baukalis Church was located next to the martyrium of St Mark, and so to the east of the city: Pearson *loc. cit.* (n. 1) 153; Haas *op. cit.* (n. 16) 213, 269–71. For Boukolou see n. 16 above.

29. Sozomen, *Ecclesiastical History* 2. 17. 4; *Sozomenus Kirchengeschichte*, ed. J. Bidez and G.C. Hansen (Berlin 1995) 72; tr. *NPNF* 2, 269. It was written by c. AD 443. Detailed tables of evidence: Martin *Athanase* 94–112. Under patriarch Alexander there were nearly one hundred bishops for Egypt and Libya: Socrates, *Ecclesiastical History* 1. 6. 13; *Sokrates Kirchengeschichte*, ed. G.C. Hansen (Berlin 1995) 8; tr. *NPNF* 2, 4; Krause *loc. cit.* (n. 15) 54. Socrates' *Ecclesiastical History* was written c. AD 439–50. Ninety-four Egyptian bishops at the Council of Sardica in AD 346: Martin *Athanase* 28 n. 49, 75.

30. Athanasius' periods of exile (AD 335–7, 339–46, 356–62, 362–4, 365–6) are tabulated in: Frend *op. cit.* (n. 2) 940–50; T.D. Barnes, *Athanasius and Constantine* (Cambridge, Mass. 1993) xi–xii (which also gives more background to the relevant events).

31. Athanasius, *Chronicon Praevium* 5, *PG* 26, col. 1353D.

32. Athanasius, *History of the Arians* 10. 1–2; *Athanasius Werke*, ed. H.G. Opitz, vol. 2.1 (Berlin 1940) 188; tr. *NPNF* 4, 273; Calderini *Dizionario* vol. 1, 173; Martin *Athanase* 149.

33. Socrates, *Ecclesiastical History* 2. 11. 6, ed. Hansen 103, tr. *NPNF* 2, 40; Martin *Athanase* 144; *idem loc. cit.* (n. 16) 12. A mediaeval marginal note in an eleventh-century copy of Gregory of Nazianzus' description of the church at Nazianzus in the fourth

century indicates that the Church of Dionysius in Alexandria had three-storeyed colonnades (*stoai*): A. Birnbaum, 'Die Oktogone von Antiocha, Nazianz und Nyssa', *Repertorium für Kunstwissenschaft* 36 (1913) 192; C. Mango, *The Art of the Byzantine Empire* (Toronto 1986) 27 n. 21. This suggests it was a fairly large and important structure but, of course, gives no indication as to the date when it had this feature.

34. Epiphanius, *Panarion* 69. 2. 2–3, ed. Holl and Dummer 153, tr. Williams 326; Calderini *Dizionario* vol. 1, 89–90; Adriani *Repertorio* 216–17, 222–3. It is sometimes suggested that Epiphanius was referring to the Caesareum, which he mentioned in the previous sentence or clause, and thus that the initial conversion of it was under Constantius II. This is dependent on the phrase being a relative clause (as in Holl and Dummer, and Williams), rather than a separate sentence (as in the Greek, but not the Latin, text in *PG* 42, col. 204B–205A). Initial conversion under Constantius II: Faivre *loc. cit.* (n. 3) col. 340; Martin *loc. cit.* (n. 4) 217 n. 39, 221; Martin *Athanase* 148–9; Martin *loc. cit.* (n. 16) 12; Gascou *ÉtAlex loc. cit.* (n. 16) 25. Gascou considers that this reference to a gymnasium, and other evidence, indicates that the Caesareum in which the church was built was an imperial baths-building, not the imperial cult temple, and he also suggests it was located to the south of the city: Gascou *ÉtAlex loc. cit.* (n. 16) 32–3.

There is a difference in the dates when the former church 'Hadrianon' and the one in the Caesareum were burnt down, as recorded in contemporary sources. The one in the former 'Hadrianon' was burnt down under Julian, i.e. in AD 362: Epiphanius, *Panarion* 69. 2. 3, ed. Holl and Dummer 153, tr. Williams 326. The one in the Caesareum was burnt down in AD 366, the year after the major earthquake (Athanasius, *Chronicon Praevium* 15–16, *PG* 26, col. 1358C–1359B; *Festal Index* 38, ed. Fr. tr. Martin and Albert 269, tr. *NPNF* 4, 505). If it were the same building, there was little time for it to have been rebuilt after being burnt down in AD 362, before being burnt down again in AD 366. Epiphanius and Athanasius are both describing events in their lifetimes.

35. Athanasius, *Defence Against Constantius* 14–18, ed. Fr. tr. Szymusiak 102–9, tr. *NPNF* 4, 243–5; Faivre *loc. cit.* (n. 3) col. 312–3; Leclerq *loc. cit.* (n. 11a) 1109; Martin *loc. cit.* (n. 4) 217–18; A. Martin, 'Topographie et liturgie: le problème des "paroisses" d'Alexandrie', in *Actes du XIᵉ Congrès international d'archéologie chrétienne, 1986*, vol. 2 (Rome 1989) 1137–8. Date of use: Barnes *op. cit.* (n. 30) 302 n. 4. Date of composition of *Defence Against Constantius*: Barnes *op. cit.* (n. 30) 196–7. Athanasius refers to it as the 'Great Church in the Caesareum' indicating it occupied part of the precinct of the old Caesareum: *History of the Arians* 74.2, ed. Opitz vol. 2.1, 224, tr. *NPNF* 4, 298.

36. Athanasius, *History of the Arians* 56, ed. Opitz vol. 2.1, 214–15, tr. *NPNF* 4, 290–1. The *plateia* is the main east-west street, as discussed in Chapter 3. It is possible that 'Great Plateia' here refers to the former Forum in front of the Caesareum.

37. Place of pilgrimage: Palladius, *Historia Lausiaca* 45. 4 (written c. AD 419); *Palladio, La Storia Lausiaca*, ed. tr. G.J.M. Bartelink and M. Barchiesi (Verona 1974) 220–1. Use of narthex: Martin *loc. cit.* (n. 4) 216 n. 32; Martin *Athanase* 153.

38. Athanasius, *Chronicon Praevium* 11, *PG* 26, col. 1356D.

39. AD 356: Athanasius, *Historia acephala* 2. 2–3; *Histoire 'Acéphale' et Index syriaque des lettres festales d'Athanase d'Alexandrie*, ed. tr. A. Martin and M. Albert (Paris 1985) 144–7, 185 n. 49; tr. *NPNF* 4, 497 (V. 6). AD 366: Athanasius, *Historia acephala* 5. 4, ed. tr. Martin and Albert 162–3, tr. *NPNF* 4, 499 (XI. 16); Calderini *Dizionario* vol. 1, 167–8; Martin *loc. cit.* (n. 4) 213; Martin *Athanase* 144. Haas's discussion of its location is completely speculative: Haas *op. cit.* (n. 16) 208.

40. Attempt at clearing Mithraeum: Socrates, *Ecclesiastical History* 3. 2, ed. Hansen 193–4; tr. *NPNF* 2, 78–9. It is possible that this was the abandoned 'public basilica' which, according to Rufinus (who was in Alexandria c. 373–80), Constantius gave to the bishops: Rufinus, *Ecclesiastical History* 11. 22; *Die lateinische Übersetzung des Rufinus*, ed. T. Mommsen, in *Eusebius Werke*, ed. E. Schwartz, vol. 2 (Leipzig 1908) 1025; *The Church History of Rufinus of Aquileia, Books 10 and 11*, tr. P.R. Amidon (Oxford 1997) 79, 104 n. 80, text with Fr. tr. F. Thelamon, *Paiens et chrétiens au IVᵉ siècle. L'Apport de l' 'Histoire ecclésiastique' de Rufin d'Aquilée* (Paris 1981) 247–8. The incident is not mentioned in Athanasius, *Historia acephala* 2. 9–10 (8), ed. tr. Martin and Albert 148–9, 188–9 n. 63.

41. *The Works of the Emperor Julian*, ed. tr. W.C. Wright (London 1923) vol. 3, no. 23 (377–8) p. 72–5, and no. 38 (411C) p. 122–5.

42. Socrates, *Ecclesiastical History* 1. 18. 2, ed. Hansen 58, tr. *NPNF* 2, 22; Sozomen, *Ecclesiastical History* 5. 3. 3, ed. Bidez and Hansen 195, tr. *NPNF* 2, 328; Thelamon *op. cit.* (n. 40) 171 n. 14, 273–7.

43. 'Hadrianon': see n. 34 above. Caesareum: Athanasius, *Chronicon Praevium* 15–16, *PG* 26, col. 1358C–9B; *Festal Index* 38 and 40, ed. Fr. tr. Martin and Albert 269 and 271–3, tr. *NPNF* 4, 505; Barnes *op. cit.* (n. 30) 164; Martin *Athanase* 597.

44. Athanasius, *Chronicon Praevium* 17, *PG* 26, col. 1359B–C; Calderini *Dizionario* vol. 1, 101, 166; Adriani *Repertorio* 210, 216; Martin *loc. cit.* (n. 4) 215; Martin *Athanase* 146–7; Martin *loc. cit.* (n. 16) 14. 'Mendesion' or 'Bendideion' is to the north near the sea in: Pseudo-Kallisthenes, *Romance of Alexander* 1. 31. 7; *Historia Alexandri Magni*, ed. G. Kroll (Berlin 1926) p. 30 line 14; *The Greek Alexander Romance*, tr. R. Stoneman (Harmondsworth 1991) 64. The Armenian version has 'Mendidos': *The Romance of Alexander the Great by Pseudo-Callisthenes translated from the Armenian*, tr. A.M. Wolohojian (New York 1969) 81 p. 49. 'Mendion' or 'Bennidion' is mentioned in the *Acts of St Mark*: Pearson *loc. cit.* (n. 1) 140, 152; Pearson *loc. cit.* (n. 15) 240–1. Suggestion this was the former temple of Bendis: H. Heinen, 'Alexandria in Late Antiquity', in *CE* vol. 1, 101. Bendideion (possibly in the second or third century AD) is mentioned by Michael bar Elias, writing in the second half of the twelfth century: P.M. Fraser, 'A Syriac *Notitia Urbis Alexandrinae*', *JEA* 37 (1951) 104.

45. It was either near or in 'a place called Arûtîjû': John of Nikiu, 91. 2 and 107. 17, tr. Charles 144, 169; Amélineau *Géographie* 30, 32, 43. Pearson locates it to the northwest of the city, in the area he considers was the Jewish quarter Delta, in accordance with his view that the earliest churches in Alexandria would have been prone to be in Jewish neighbourhoods: Pearson *loc. cit.* (n. 1) 152–3.

46. Identification of Church of Athanasius with Attarin Mosque, i.e., the Mosque of Suq el-Attarin (the Spice Market): Néroutsos *Alexandrie* 66 following *Description de l'Égypte* vol. 5, 369. Prof. Mostafa El-Abbadi also checked the Arabic sources for me and could find no evidence in them for this. In the *Acts of St Mark* after St Mark arrived by boat from Cyrene, he went to a place called 'Mendion' (or Bennidion) and after he entered the gate of the city he went to Anianas the cobler whom he converted. One Coptic version has St Mark visiting Anianas in the agora instead (Pearson *loc. cit.* n. 1, 152 n. 118), which could possibly explain the identification of the Attarin Mosque with the Church of Athanasius.

47. Coptic Synaxarium 11 Barmoudah (6 April), ed. tr. R. Basset, *PO* XVI, 301 [943].

48. Epiphanius, *Panarion* 69. 2. 2–4, ed. Holl and Dummer 153, tr. Williams 326; Calderini *Dizionario* vol. 1, 167, 176–7. Date of *Panarion*: Martin *loc. cit.* (n. 4) 215 n. 29. The churches mentioned by Epiphanius are discussed together in: Martin *loc. cit.* (n. 4) 212–21; Martin *Athanase* 142–9. Persaia possibly from name of an Egyptian fruit tree: Martin *Athanase* 146 n. 131, with references. Church of Pierios: Martin *loc. cit.* (n. 4) 214–15; Martin *Athanase* 145–6, 151 n. 156; Martin *loc. cit.* (n. 16) 12. There was also a church of Pereos or Peraios: Martin *Athanase* 151.

49. Philip of Side (first half of fifth century AD): Faivre *loc. cit.* (n. 3) col. 339; H. Delehaye, 'Les Martyrs d'Égypte', *AnalBolland* 40 (1922) 34–5; Calderini *Dizionario* vol. 1, 177.

50. Eutychius of Alexandria, *Annales* 491, *PG* 111, col. 1018A; Maqrizi, *A Short History of the Copts and of their Church. Translated from the Arabic of Tāqi-ed-Dīn el-Maqrīzī*, tr. S.C. Malan (London 1873) 52. Maqrizi was an early fifteenth-century Arab historian.

51. Epiphanius, *Panarion* 51. 22. 8–10; *Epiphanius II Panarion haer. 34–64*, ed. K. Holl and J. Dummer (Berlin 1980) 285, tr. Williams 50–1. It was a pagan festival, but with some features reflecting Christian influence: G.W. Bowersock, *Hellenism in Late Antiquity* (Ann Arbor, Michigan 1990) 22–8; Haas *op. cit.* (n. 16) 137–8.

52. [Libanius], *Progymnasmata, Descriptiones* 25 in *Libanii Opera*, ed. R. Foerster (Leipzig 1925) vol. 8, p. 529–31; Fraser *Ptol. Alex.* vol. 2, 392–3 n. 417; Calderini *Dizionario* vol. 1, 155; Adriani *Repertorio* 258–9; H. Lauter, *Die Architektur des Hellenismus* (Darmstadt 1986) 179; Grimm *Alexandria* 70. The author makes the comment: 'It is a marvel to see, a prophet to learn from, and an injustice to be concealed in silence.' The Tychaion is earlier mentioned in pseudo-Kallisthenes, *Romance of Alexander* 1. 31, ed. Kroll *op. cit.*(n. 44) p. 29 line 7, tr. Stoneman *op. cit.* (n. 44) 63.

53. Theodosian Code 14. 27. 1; *The Theodosian Code and Novels and the Sirmondian Constitution*, tr. C. Pharr (Princeton 1952, repr. New York 1969) 422; Néroutsos *Alexandrie* 96.

54. 'The temple of Serapis is there, the one and only strange sight in all the world. For nowhere in the world is found such a building or such an arrangement of a temple or such an arrangement of a religion, and from it, moreover, the Museum seems to reach to it': *Expositio totius mundi et gentium* 35, ed. Fr. tr. J. Rougé (Paris 1966) 170–1.

55. Epiphanius, *Weights and Measures* 52b; *PG* 43, col. 249C; S. *Epiphanius of Salamis, Treatise on Weights and Measures, the Syriac Version*, ed. tr. J.E. Dean, *Studies in Ancient Oriental Civilization* 11 (Chicago 1935) 25. It was written in AD 392: Dean *op. cit.* 2.

56. Theon: *ODB* vol. 3, 2060–1.

57. Libanius, *Oration* 49. 12 in *Libanius, Selected Works*, ed. tr. A.F. Norman (London 1977) vol. 2, 471. The date is based on it being written when Tatianus was the praetorian prefect. Date and reference to Tatianus: Norman *op. cit.* vol. 2, 460 note b, 487, 486 note b. Date of Tatianus: A.H.M. Jones *et al.*, *The Prosopography of the Later Roman Empire*, vol. 1 *AD 260–395* (Cambridge 1971) 877. Libanius died in *c.* AD 393.

58. P. Green assumes the tomb of Alexander was destroyed along with the Broucheion in AD 272: 'Alexander's Alexandria', in K. Hamma, ed., *Alexandria and Alexandrianism* (Malibu 1996) 18. So also Haas *op. cit.* (n. 16) 28, 340–1. John Chrysostom, *Oration* 26. 12 cited in Green *loc. cit.* 18, 24 n. 135 (with Greek): 'Tell me, where is Alexander's tomb (Sema)? Show me, tell me the day on which it ceased to exist!' Rowe considers that the tomb was destroyed in AD 391: A. Rowe, 'A Contribution to the Archaeology of the Western Desert III', *BullJRylandsLib* 38 (1955) 155 n. 5.

59. Libanius, *Oration* 19. 14 in Norman *op. cit.* (n. 57) vol. 2, 277. Date: AD 387–c. 393. It is dated after AD 387, because it mentions the destroyed temple of Nemesis at Daphne: Norman *op. cit.* (n. 57) vol. 2, 271–2 note f.

60. St Dorotheos was martyred in AD 377/8 under the emperor Valens (AD 364–78): Theophanes AM 5870, ed. de Boor 66, tr. Mango and Scott 100–1; Faivre *loc. cit.* (n. 3) col. 317. The role of the wild beasts suggests *kynegion* is referring to the amphitheatre, rather than the circus.

61. Coptic *Life of Macarius of Alexandria*, Fr. tr. in E. Amélineau, *Histoire des monastères de la Basse-Égypte* (Paris 1914) 258–9; Amélineau *Géographie* 29–30. Macarius of Alexandria was active in the fourth century: *CE* 1489–90. The *agora* is also mentioned in Athanasius, *History of the Arians* 58.2, ed. Opitz vol. 2.1, 215, tr. *NPNF* 4, 292 (written in AD 357).

62. *Hegesippi Qui Dicitur Historiae Libri V*, ed. V. Ussani, *Corpus Scriptorum Ecclesiasticorum Latinorum* 66 Part 1 (Paris 1932) 4. 27. 1, p. 285 line 2–11. Not included in Josephus, *Jewish War* 4. 614. Date of Hegesippus: A.A. Bell, 'Josephus and Pseudo-Hegesippus', in L.H. Feldman and G. Hata, eds., *Josephus, Judaism and Christianity* (Detroit 1987) 350. The function of the Lighthouse at night is also mentioned in Ammianus Marcellinus, 22. 16. 9, ed. tr. J.C. Rolfe, vol. 2 (London 1940) 300–1.

63. Hegesippus, 4. 27. 1 in Ussani *op. cit.* (n. 62) p. 283 line 20–2; not included in Josephus, *Jewish War* 4. 611.

64. Theodosian land walls: R. Krautheimer, *Early Christian and Byzantine Architecture* (4th edn rev., Harmondsworth 1986) 73.

65. John of Nikiu, 82. 22–3, tr. Charles 84. Discussion, with earlier references: F. Jacques and B. Bousquet, 'Le Raz de marée du 21 Juillet 365', *MEFRA* 96 (1984) 440–1, 453, fig. 1 on 442.

66. Ammianus Marcellinus, 22. 16. 17–19, ed. tr. Rolfe, vol. 2, 304–7. Bowersock considers this has an 'elegaic tone': G. Bowersock, 'Late Antique Alexandria', in K. Hamma, ed., *Alexandria and Alexandrianism* (Malibu 1996) 265–6. Date: J. Matthews, *The Roman Empire of Ammianus* (London 1989) 23–4, 26. Ammianus' visit to Egypt/Alexandria: *ibid.* 14.

67. Ammianus Marcellinus, 22. 16. 12, ed. tr. Rolfe, vol. 2, 300–3.

68. Socrates, *Ecclesiastical History* 5. 16. 1, ed. Hansen 289, tr. *NPNF* 2, 126. Theodosius' ban on sacrifices elsewhere in AD 392: M. Beard *et al.*, *Religions of Rome* vol. 2 *A Sourcebook* (Cambridge 1998) 286–7; S. Price, *Religions of the Ancient Greeks* (Cambridge 1999) 164–5. Attacks on churches elsewhere under Theodosius I, with references: Saradi-Mendelovici *loc. cit.* (n. 24) 47–8.

69. Rufinus, *Ecclesiastical History* 11. 26, ed. Mommsen 1033, tr. Amidon 85; Eunapius, *Lives of the Philosophers* 472, in *Philostratus and Eunapius, Lives of the Sophists*, ed. tr. W.C. Wright (London 1921) 418–19 (written *c.* AD 399–414); Thelamon *op. cit.* (n. 40) 225–6, 258; Martin *loc. cit.* (n. 16) 19. A monastery was established there, which remained Chalcedonian after AD 451: J. Faivre, *Canopus, Menouthis, Aboukir* (Alexandria 1918) 23–30. Written sources for Canopus collected in: A. Bernand, *Le Delta égyptien d'après les textes grecs* 1.1 (Cairo 1970) 153–257. Archaeological evidence: *ibid.* 259–90.

70. Socrates, *Ecclesiastical History* 5. 16. 2–3, ed. Hansen 289–90, tr. *NPNF* 2, 126; Thelamon *op. cit.* (n. 40) 248, 250; Gascou *Topoi loc. cit.* (n. 16) 31–2.

71. Sozomen, *Ecclesiastical History* 7. 15. 2, ed. Bidez and Hansen 319–20, tr. *NPNF* 2, 385; Adriani *Repertorio* 250.

72. The epigrams survived in the *Palatine Anthology*, 9. 180–3: *The Greek Anthology*, ed. tr. W.R. Paton, vol. 3 (London 1917) 94–7; C.M. Bowra, 'Palladas on Tyche', *Classical Quarterly* 54 (1960) 122–8.

73. Theophylact Simocatta, *Historiae* 8. 13. 10; *Theophylacti Simocattae Historiae*, ed. C. de Boor (with additions by P. Wirth, Stuttgart 1972) p. 310 line 10–12; *The History of Theophylact Simocatta*, tr. L.M. and M. Whitby (Oxford 1986) 231; Fraser *Ptol. Alex.* vol. 2, 393 n. 417. It was written in the early seventh century: Whitby *op. cit.* xiii. On preservation of pagan statues elsewhere for their aesthetic value: Saradi-Mendelovici *loc. cit.* (n. 24) 51, 57.

74. Rufinus, *Ecclesiastical History* 11. 22–3, ed. Mommsen 1025–6, 1028, tr. Amidon 79–82; Sozomen, *Ecclesiastical History* 7. 15. 3–10, ed. Bidez and Hansen 320–1, tr. *NPNF* 2, 385–6; Haas *op. cit.* (n. 16) 161–3; J.S. McKenzie, S. Gibson, and A.T. Reyes, 'Reconstructing the Serapeum in Alexandria from the Archaeological Evidence', *JRS* 94 (2004) 107–10. Extensive bibliography in: J. Schwartz, 'La Fin du Serapéum d'Alexandrie', in A.E. Samuel, ed., *Essays in Honour of C. Bradford Welles* (New Haven 1966) 97–111; A. Baldini, 'Problemi della tradizione sulla 'disruzione' del Serapeo di Alessandria', *RStorAnt* 15 (1985) 97–152. Date of destruction, A.D 391: Bowersock *loc. cit.* (n. 66) 266, 271 n. 14.

75. A. Bauer and J. Strzygowski, *Eine alexandrinische Weltchronik* (Vienna 1905) 71–3, pl. 6v. Fifth-century date: U. Horak, *Illuminierte Papyri, Pergamente und Papiere* I (Vienna 1992) 97. Eighth-century (?) date: S. Hodjash in *L'Art copte en Égypte, 2000 ans de christianisme* (Paris 2000) 42, fig. 10. Description of cult statue: Clement, *Exhortation to the Greeks (Protrepticus)* 4. 43.

76. Rufinus, *Ecclesiastical History* 11. 23, ed. Mommsen 1028–9, tr. Amidon 81–2. Date of Rufinus: see Ch. 8 n. 145. Theodoret, *Ecclesiastical History* 5. 22. 3–6; *Theodoret Kirchengeschichte*, ed. L. Parmentier (Berlin 1998) 321; tr. *NPNF* 3, 148. Theodoret's *Ecclesiastical History* was written in AD 444–50: *ODB* vol. 3, 2049. The statue of Serapis is also described at the beginning of the fifth century by Macrobius, *The Saturnalia* 1. 20. 13, tr. P.G. Davies (London 1969) 140. Statue of Serapis from Theadelphia: A. Rowe, 'New Excavations at "Pompey's Pillar Site"', *BSAA* 35 (1941–2) 137 no. 6, pl. 40.

77. Rufinus, *Ecclesiastical History* 11. 27, ed. Mommsen 1033 line 14–18, tr. Amidon 85.

78. Eunapius, *Lives of the Philosophers* 471–2, in Wright *op. cit.* (n. 69) 417–23; Schwartz *loc. cit.* (n. 74) 100. St Augustine, *The Divination of Demons* 1 in *Bibliothèque augustinienne, Oeuvres de saint Augustin* vol. 10, *Mélanges doctrinaux*, ed. Fr. tr. G. Bardy *et al.* (Paris 1952) 654–5; Eng. tr. R.W. Brown in R.J. Deferrari, ed., *Saint Augustine, Treatise on Marriage and Other Subjects, Fathers of the Church*, vol. 27 (New York 1955) 421–2.

79. Socrates, *Ecclesiastical History* 5. 17. 1, ed. Hansen 290–1, tr. *NPNF* 2, 126–7; Sozomen, *Ecclesiastical History* 7. 15. 10, ed. Bidez and Hansen 321, tr. *NPNF* 2, 386; Nicephorus Callistus (*c.* AD 1256–1335), *Ecclesiastical History* 12. 26, *PG* 146, col. 825D–828A; Thelamon *op. cit.* (n. 40) 268–73.

Although the Serapeum was 'demolished', it is also described as being 'converted' to a church in: Sozomen, *Ecclesiastical History* 7. 15. 10, ed. Bidez and Hansen 321, tr. *NPNF* 2, 386; John of Nikiu, 78. 45, tr. Charles 79. When describing events in AD 451 Evagrius (writing at the end of the sixth century) mentions imperial troops taking refuge 'in the old sanctuary (*hieron*) of Serapis': Evagrius Scholasticus, *Ecclesiastical History* 2. 5; *The Ecclesiastical History of Evagrius*, ed. J. Bidez and L. Parmentier (London 1898) 51 line 11; Gascou *loc. cit. ÉtAlex* (n. 16) 34.

80. Pharaonic blocks reused in the base of Diocletian's Column: Tkaczow *Topography* 237–8 object 137; PM IV, 3. Two blocks remain *in situ*, and one is in the British Museum.

81. Colonnaded court in Arab descriptions: S.K. Hamarneh, 'The Ancient Monuments of Alexandria According to Accounts by Medieval Arab Authors', *Folia Orientalia* 13 (1971) 82–3. The Hephaisteion, a Greek temple in Athens, with an interior slightly over 6 m wide, was converted to a church, although Price suggests such conversions were relatively rare: Price *op. cit.* (n. 68) 166, fig. 8.4.

82. Martyrium of St John the Baptist: Rufinus, *Ecclesiastical History* 11. 28, ed. Mommsen 1033–4, tr. Amidon 85; John of Nikiu, 78. 44–6, tr. Charles 74–5. Bones of St John the Baptist and Elisha: *The Story of the Church of Alexandria*, ed. tr. T. Orlandi, *Storia della Chiesa di Alessandria* (Milan 1967–70) vol. 1, 66–7 line 304–48, vol. 2, p. 62, 100–2; Severus ibn el-Muqaffa, ed. tr. B. Evetts, *PO* I, 419 [155], 426 [162]. Severus ibn el-Muqaffa (i.e. Severus son of the Hunchback), also called Severus of Ashmunein, was the Coptic bishop of el-Ashmunein in the tenth century who recorded the *History of the Patriarchs of the Coptic Church of Alexandria* in Arabic using Greek and Coptic sources, and was an opponent of the Chalcedonian patriarch Eutychius of Alexandria: F.R. Farag, 'The Technique of Research of a Tenth-Century Christian Arab Writer: Severus ibn al-Muqaffa', *Muséon* 86 (1973) 37–66; J. den Heijer, 'Réflexions sur la composition de l'*Histoire des patriarches d'Alexandrie*: les auteurs et des sources coptes', in W. Godlewski, ed., *Coptic Studies* (Warsaw 1990) 107–13; *CE* 1238–42 History of the Patriarchs, 2100–2 Sawirus ibn al-Muqaffa.

The Coptic Synaxarium (18 Babeh, 15 October, ed. tr. R. Basset, *PO* I, 347 [133]) mentions that the Church of St John the Baptist and Elisha is 'known today as ed-Daimâs'. It is sometimes suggested that this refers to Kom el-Dikka because there were tombs there. However, there was also a cemetery to the south-west of the hill on which the Serapeum and later the Church of St John the Baptist stood. Contra: Amélineau *Géographie* 41; Adriani *Repertorio* 216, 225.

The date Theophanes gives for the relics of John the Baptist being moved to Alexandria, AD 397/8, is after the death of Athanasius, and perhaps refers to placing them in the newly constructed martyrium: Theophanes AM 5890, ed. de Boor 75, tr. Mango and Scott 114. According to Theophanes (AM 5956, ed. de Boor 114, tr. Mango and Scott 176) the remains of Elisha were not moved to Alexandria until AD 463/4 when they were 'placed in the monastery of Paul the Leper'.

The bones of St Antony were deposited in the Church of St John the Baptist in AD 561: Calderini *Dizionario* vol. 1, 171; Martin *loc. cit.* (n. 4) 222 n. 72.

83. John of Nikiu, 78. 46, tr. Charles 75.

84. By the scholiast mentioned in n. 33 above. Birnbaum *loc. cit.* (n. 33) 192; Mango *op. cit.* (n. 33) 27 n. 21; Gascou *loc. cit. ÉtAlex* (n. 16) 34.

85. Sozomen, *Ecclesiastical History* 7. 15. 10, ed. Bidez and Hansen 321, tr. *NPNF* 2, 386; Nicephorus Callistus, *Ecclesiastical History* 12. 26, *PG* 146, col. 828B; Calderini *Dizionario* vol. 1, 167; Schwartz *loc. cit.* (n. 74) 99 n. 13; Martin *loc. cit.* (n. 4) 222; *idem loc. cit.* (n. 16) 16.

86. Archaeological remains of Christian structures at the south-west of Rowe's excavations: Rowe *Encl. Serapis* 47–9, fig. 14 on p. 67, pl. 13–14, 18; A. Rowe and B.R. Rees, 'A Contribution to the Archaeology of the Western Desert IV. The Great Serapeum of Alexandria', *BullJRylandsLib* 39.2 (1957) 503–4. Fragment of chancel screen: see n. 95 below. Detailed discussion: McKenzie *et al. loc. cit.* (n. 74) 108.

87. John of Nikiu, 83. 37–8, ed. Fr. tr. Zotenberg *loc. cit.* (n. 25) 450, tr. Charles 88. There are some important differences between the translation of this passage by Zotenberg and that by Charles, leading to confusion. Zotenberg has Theophilus responsible for these constructions, but Charles has Timothy. 'A temple in the city of Serapis' of Zotenberg is restored by Charles as 'there was a temple of Serapis in the city' (Charles 88 n. 1). Consequently, this passage is sometimes erroneously used to suggest that there was a church of Honorius at the former Serapeum site. See also: Amélineau *Géographie* 41; Martin *loc. cit.* (n. 4) 223.

Church of Theodosius: Severus ibn el-Muqaffa, ed. tr. B. Evetts, *PO* V 122 [376]; Eutychius of Alexandria, *Annales* 528, *PG* 111, col. 1026A; Amélineau *Géographie* 39, 41; Calderini *Dizionario* vol. 1, 168; Martin *loc. cit.* (n. 4) 223–4; *idem loc. cit.* (n. 16) 16. According to Eutychius it was covered in gold.

The church of St Peter 'the patriarch' which it faced was possibly the Church of Theonas (see n. 21 above). Contra: Martin *loc. cit.* (n. 4) 223. Martin (*loc. cit.* n. 16, 16) considers there was a church of St Peter at the former Serapeum site.

88. Severus ibn el-Muqaffa, ed. tr. B. Evetts, *PO* I 430 [166]; Coptic Synaxarium 18 Babeh (15 October), ed. tr. R. Basset, *PO* I 347 [133]; Orlandi *op. cit.* (n. 82) vol. 2, p. 105; Martin *loc. cit.* (n. 4) 224.

89. Theophilus unsuccessfully attempted to obtain their remains from Babylon as he wanted to make this church a martyrium. Coptic Synaxarium 20 Babeh (17 October), ed. tr. R. Basset, *PO* I, 353 [139]; Amélineau *Géographie* 35–6; Calderini *Dizionario* vol. 1, 177; Orlandi *op. cit.* (n. 82) vol. 2, 102–4. The Chalcedonian patriarch Apollinarius (AD 551–5) is also credited with establishing this martyrium: Sophronius, *Laudes in Ss Cyrum et Joannem* 2–4; *PG* 87.3, col. 3677C–3680C; Gascou *loc. cit. ÉtAlex* (n. 16) 24–6. Summary of various versions, with references: *CE* 2257–9.

90. Eutychius of Alexandria, *Annales* 528, *PG* 111, col. 1026A; Coptic Synaxarium 18 Babeh (15 October), ed. tr. R. Basset, *PO* I 347 [133]. According to the latter, this was later 'in the possession of the Melkites'.

91. Coptic Synaxarium 18 Babeh (15 October), ed. tr. R. Basset, *PO* I, 347 [133].

92. Fragment of a sermon of Cyril of Alexandria in G. Zoega, *Catalogus codicum copticorum* (Rome 1810) Cod. xxix, p. 50–1.

93. Built by Theophilus: Sophronius, *Laudes in SS Cyrum et Joannem* 27, *PG* 87.3, col. 3413A. (Written c. AD 610–14). Location of Menouthis: Faivre *op. cit.* (n. 69) 36–7 n. 3; O. Toussoun, 'Les Ruines sous-marines de la Baie d'Aboukir', *BSAA* 29 (1934) 348; F. Goddio, *Sunday Times* Magazine August 20, 2000, map on p. 29. Marble capitals from Abuqir, fifth century AD: Pensabene *Elementi Aless.* 422–4 no. 498–9, pl. 59.498–9, p. 432 no. 542–3, pl. 63.542–3. Recent finds: F. Goddio and M. Clauss, eds., *Egypt's Sunken Treasures* (Berlin 2006), in which Menouthis called 'East Canopus'.

94. Cyril of Alexandria in Zoega *loc. cit.* (n. 92); Coptic Synaxarium 18 Babeh (15 October), ed. tr. R. Basset, *PO* I, 346–7 [132–3]; Eutychius of Alexandria, *Annales* 525–7, *PG* 111, col. 1025D–1026A; Severus ibn el-Muqaffa, ed. tr. B. Evetts, *PO* I, 426 [162]. According to Cyril's sermon the gold was behind the door of a temple with three thetas on it (for Theos, Theodosius and Theophilus). In the later versions the three

thetas were on paving under which the treasure lay. The Coptic Synaxarium also specifies Theodosius 'sent him [Theophilus] the treasure of all the temples which were in Egypt'.

95. Alexandria, Greco-Roman Museum inv. 206; F. Kayser, *Recueil des inscriptions grecques et latines (non funéraires) d'Alexandrie impériale* (Cairo 1994) 184–6 no. 53, pl. 29. Found c. 50 m south-west of Diocletian's Column. The Serapis inscription on it is dated to Septimius Severus or Caracalla.

96. Late Antique Corinthian capitals from Alexandria, references: Ch. 11 n. 303.

97. Closure of churches of Novatians: Socrates, *Ecclesiastical History* 7. 7. 5, ed. Hansen 353, tr. *NPNF* 2, 156. Cyril of Alexandria, with references: *Late Ant.* 403–4. Events leading to closure of synagogues: Socrates, *Ecclesiastical History* 7. 13, ed. Hansen 357–9, tr. *NPNF* 2, 159; John of Nikiu, 84. 89–98, tr. Charles 101–2; Faivre *loc. cit.* (n. 3) col. 324; Griggs *op. cit.* (n. 1) 190–1. It began with an argument over performances in the theatre. On the attitude of the early Church to the theatre: H. Saradi-Mendelovici, 'The Demise of the Ancient City and the Emergence of the Mediaeval City in the Eastern Roman Empire', *Échos du monde classique* 32, n.s. 7 (1988) 377–9; *Late Ant.* 719–20.

According to Socrates the church which the Jews said was on fire was the 'church named after Alexander', while John of Nikiu calls it the Church of Athanasius. This is the only reference to a Church of Alexander. Calderini (*Dizionario* vol. 1, 175) considers the Church of Alexander was the Church of St Michael, which he considers was the former temple of Kronos. See also: Martin *Athanase* 149.

98. Socrates, *Ecclesiastical History* 7. 15, ed. Hansen 360–1, tr. *NPNF* 2, 160; John of Nikiu, 84. 87–8, 84. 100–3, tr. Charles 100–2; Faivre *loc. cit.* (n. 3) col. 324–5; M. Dzielska, *Hypatia of Alexandria* (Cambridge Mass. 1995) 83–100; Haas *op. cit.* (n. 16) 307–8, 313–16; Gascou *loc. cit. Topoi* (n. 16) 393. Hypatia's body was taken to a place named Cinaron where it was burnt: John of Nikiu, 84. 102, tr. Charles 102.

John of Nikiu, 84. 45 (tr. Charles 96) refers to 'the place of the heathen philosophers' being burnt. Charles considers this is referring to the death of Hypatia, which is possible as Malalas mentions the burning of Hypatia: John Malalas, 14. 12 (359), *Ioannis Malalae Chronographia*, ed. L. Dindorf (Bonn 1831) p. 359; *Ioannis Malalae Chronographia*, ed. J. Thurn (Berlin 2000) p. 280; *The Chronicle of John Malalas*, tr. E. Jeffreys *et al.* (Melbourne 1986) p. 196. Contra: Haas *op. cit.* (n. 16) 469 n. 81.

99. Orosius, *Seven Books of History Against the Pagans* 6. 15. 32; *Orose, Histoires (Contre les païens)*, ed. Fr. tr. M.-P. Arnaud-Lindet, vol. 2 (Paris 1991) 211; Eng. tr. I.W. Raymand (New York 1936) 298.

100. Theophanes, AM 5928, ed. de Boor 92, tr. Mango and Scott 144; George Cedrenos 599, *PG* 121, col. 652B. Continuity of paganism elsewhere in the fifth and sixth centuries: Price *op. cit.* (n. 68) 169–71.

101. Theophanes, AM 5933, ed. de Boor 96, tr. Mango and Scott 149. For meaning of *kantharos* (including mark on the tongue of the apis bull) see: *LSJ kantharos* p. 874.

102. Maqrizi, tr. Malan 54. Introduction of icons elsewhere, with references: *Late Ant.* 506–7. Coptic icons: *CE* 1276–80.

103. John Malalas, 14. 11 (359), ed. Dindorf 359, ed. Thurn 279–80, tr. Jeffreys *et al.* 196. It is not clear if there is confusion between Malalas' reference to this Church of Theodosius II and John of Nikiu's reference to a church of Theodosius I (n. 87 above). A church of Theodosius is later mentioned by John Moschus in the early seventh century (n. 145 below). On Malalas and his sources: E. Jeffreys, 'Malalas' Sources', in E. Jeffreys *et al.*, eds., *Studies in John Malalas* (Sydney 1990) 167–216; *Late Ant.* 553–4. A version not accepted by Thurn mentions the church as 'having a stadium (*stadion*)'.

104. P. Batiffol, 'Les Présents de Saint Cyrille à la cour de Constantinople', *Bulletin d'ancienne littérature et d'archéologie chrétiennes* 1 (1911) 247–64; W.H.C. Frend, *The Rise of the Monophysite Movement* (Cambridge 1972) 83.

105. Bones of Cyrus and John moved from the precinct or church of St Mark to the house (*oikos*) or shrine of the evangelists: Sophronius, *Laudes in SS Cyrum et Joannem* 3, 14, 27, *PG* 87.3, col. 3384C, 3396B–C, 3413A–B, 3693B–C, 3696A–C; Faivre *op. cit.* (n. 69) 23–4, 35–7; Leclerq *loc. cit.* (n. 11a) 113–14; Bernand *op. cit.* (n. 69) 214–17, 322–3. The bodies of Cyrus and John were moved from the holy precinct (*temenos*) of St Mark to the neighbourhood of the apostles by Cyril: Sophronius, *Laudes in SS Cyrum et Joannem* 14, *PG* 87.3, col. 3396B–C. Cyril was ordered by an angel 'to transfer the famous martyr from the church (*naos*) of St Mark to the shrine (*sekos*) of the holy evangelists, which the patriarch Theophilus built in the very same village of Menouthis in which the idol (*eidolon*) was set up and the evil spirit prevailed . . .' and Cyril transferred the bones of Cyrus and John to 'the holy precinct (*temenos*) of the evangelists': Sophronius, *Laudes in SS Cyrum et Joannem* 27, *PG* 87.3, col. 3413A–B.

According to the Coptic Synaxarium, the bones of Cyrus and John in the Church of St Mark 'which is south of Alexandria' were moved under Cyril 'to the other church of St Mark which is beside the sea. They deposited the bodies, built a church there . . . Beside the church there was a temple of the idols' where the worship was abandoned for Christianity after many miracles brought about by the power of the bodies of Saints Cyrus and John: Coptic Synaxarium 4 Abib (28 June), ed. tr. R. Basset, *PO* XVII 621–2 [1163–4]; in Amélineau *Géographie* 37–8. The reference to the church at Menouthis as the Church of St Mark probably comes from an Egyptian tradition of the late ninth century that the bones of St Mark were moved to the Church of Saints Cyrus and John, because St Mark's church had fallen into disrepair under Islamic rule: Severus of Nesteraweh quoted by Faivre *op. cit.* (n. 69) 52. The reference to the church of St Mark being to the south seems to be the origin of the suggestion that there were two churches of St Mark. Martin suggests that this southern church of St Mark was the Angelion (Martin *loc. cit.* n. 16, 17, correcting earlier view in *idem loc. cit.* n. 4, 224).

Continuity of paganism of Menouthis, with pagan statues and their destruction: Zacharias Scholasticus, *Vita Severi*, ed. tr. M.A. Kugener, *PO* II, 15, 18–19, 27–35 (Zacharias studied in Alexandria with Severus who became patriarch of Antioch AD 512–18); Faivre *op. cit.* (n. 69) 37–40; Bernand *op. cit.* (n. 69) 213, 322–4; Frend *op. cit.*

(n. 104) 203–4; Wipszycka *loc. cit.* (n. 10) 138–42; C. Haas, 'Alexandria's *Via Canopica*: Political Expression and Urban Topography from Augustus to 'Amr Ibn al-'As', *BSAA* 45 (1993) 134; Bowersock *loc. cit.* (n. 66) 267–8; D. Montserrat, 'Pilgrimage to the Shrine of SS Cyrus and John at Menouthis in Late Antiquity', in D. Frankfurter, ed., *Pilgrimage and Holy Space in Late Antique Egypt* (Leiden 1998) 258, 259, 264–5. Zacharius mentions the bonfire of the statues was made 'in the middle of the city' but makes no mention of a square or an agora. Contra: Faivre *op. cit.* (n. 69) 40; Haas *loc. cit.* 134. I thank Sebastian Brock for checking Zacharius' text.

The suggestion that the shrine was not erected (and the bones of Cyrus and John not moved) until AD 488/9 (under Peter Mongos, rather than Cyril) is dependent on the assumption that the shrine was built after the temple was destroyed, rather than that they coexisted in competition for a while as the Coptic Synaxarium (quoted above) indicates: L. Duchesne, 'Le Sanctuaire d'Aboukir', *BSAA* 1 (1910) 11. Contra: Montserrat *loc. cit.* 261–3. See also: H. Delehaye, 'Les Saints d'Aboukir', *AnalBolland* 30 (1911) 448–50; Wipszycka *loc. cit.* 1988 (n. 10) 142; Martin *loc. cit.* (n. 16) 17, 20 n. 85; Gascou *loc. cit. ÉtAlex* (n. 16) 25; Frankfurter *op. cit.* (n. 25) 164–5.

Details of the healing role of the sanctuary in the early seventh century: Faivre *op. cit.* (n. 69) 40–53; Bernand *op. cit.* (n. 69) 324–6; Montserrat *loc. cit.* 266–78.

106. Frankfurter *op. cit.* (n. 25) 77–82. However, concerning the type of paganism to which Shenute is referring see: S. Emmel, 'From the Other Side of the Nile: Shenute and Panopolis', and M. Smith, 'Aspects of the Preservation and Transmission of Indigenous Religious Traditions in Akhmim and its Environs during the Graeco-Roman Period', in A. Egberts *et al.*, eds., *Perspectives on Panopolis* (Leiden 2002) 95–113 and 243–7.

107. Detailed summary: Bowersock *op. cit.* (n. 51) 41–69; *idem loc. cit.* (n. 66) 266–7. See also: J. Maspero, 'Horapollon et la fin du paganisme égyptien', *BIFAO* 11 (1914) 163–95; R. Rémondon, 'L'Égypte et la suprême résistance au christianisme (V–VIIᵉ siècles)', *BIFAO* 51 (1952) 63–78; A. Cameron, 'Wandering Poets: a Literary Movement in Byzantine Egypt', *Historia* 14 (1965) 470–509; Heinen *loc. cit.* (n. 44) 100; L. MacCoull, *Dioscorus of Aphrodito: His Work and His World* (Berkeley 1988); Bagnall *op. cit.* (n. 8) 252. There were still private pagan libraries, such as the 'rich and manifold' collection of books of the pagan Fl. Messius Phoebus Severus who was consul in *c.* AD 467–72: Damascius, *Life of Isidore*, Fr. 118, in *Damascii Vitae Isidori Reliquiae*, ed. C. Zintzen (Hildesheim 1967) p. 97; Haas *op. cit.* (n. 16) 170–1, 432 n. 80.

108. Christian textile found with Dionysos tapestry: D. Willers, 'Dionysos und Christus – ein archäologisches Zeugnis zur "Konfessionsangehörigkeit" des Nonnos', *Museum Helveticum* 49 (1992) 148–51, fig. 2; L. Kötzsche, 'Die Marienseide in der Abegg-Stiftung: Bemerkungen zur Ikonographie der Szenenfolge', in D. Willers, ed., *Begegnung von Heidentum und Christentum im spätantiken Ägypten* (Riggisberg 1993) 184, fig. 1; S. McNally, 'Syncretism in Panopolis? The Evidence of the "Mary Silk" in the Abegg Stiftung', in A. Egberts *et al.* eds., *Perspectives on Panopolis* (Leiden 2002) 145–64; S. Schrenk, *Textilien des Mittelmeerraumes aus spätantiker bis frühislamischer Zeit* (Riggisberg 2004) 185–9. The lamps from near the Serapeum consist of unused imperfect examples which appear to be wasters from a workshop: J. Mlynarczyk, 'New Data on the Chronology of Late Roman Lamps in Alexandria', *ÉtTrav* 17 (1995) 133–75.

109. Reasons for disagreement at Council of Chalcedon and events leading up to it: Frend *op. cit.* (n. 104) 1–49; Chadwick *op. cit.* (n. 22) 570–86. Monophysitism: *CE* 1669–78; *Late Ant.* 586–8.

110. W. Kolataj, *Imperial Baths at Kom el-Dikka, Alexandrie* VI (Warsaw 1992) 50.

111. AD 452/3 bath (*balaneion*) of Diocletian restored: Theophanes AM 5945, ed. de Boor 107, tr. Mango and Scott 164.

AD 456/7 bath of Trajan (*balaneion*) restored: Theophanes AM 5949, ed. de Boor 109, tr. Mango and Scott 169.

AD 464/5 'Heptabizos, the public bath (*demosion balaneion*), was restored to the city': Theophanes AM 5957, ed. de Boor 114, tr. Mango and Scott 177.

AD 468/9 the Koreion bath (*balaneion*) restored: Theophanes AM 5961, ed. de Boor 116, tr. Mango and Scott 181.

Detailed list of references to baths (*balaneia*, *thermai* and *loutra*): Calderini *Dizionario* vol. 1, 96.

112. Theophanes, AM 5957, ed. de Boor 114, tr. Mango and Scott 177; Calderini *Dizionario* vol. 1, 170.

113. Theophanes, AM 5959, ed. de Boor 115, tr. Mango and Scott 179; Calderini *Dizionario* vol. 1, 170. The cisterns are marked on the Napoleonic plan: *Description de l'Égypte* plates vol. 5, pl. 39.2. The work on the canal (*potamos*) in AD 467 is mentioned in a civil Christian metrical inscription on a marble stele found at Hagar el-Nawatieh (location marked on Tkaczow *Topography* plan II) in 1897 where the ancient canal of Alexandria separates from the canal to Canopus: Alexandria, Greco-Roman Museum inv. 14158; Botti 1899–1900 *loc. cit.* (n.12a) 279–80 no. 16; Leclercq *loc. cit.* (n. 11a) 1107; J. Ward-Perkins, 'The Shrine of St Menas in the Maryût', *PBSR* 17 (1949) 67, pl. 8.2. Great canal of Alexandria: A. Ausfeld, 'Zur Topographie von Alexandria und Pseudokallisthenes I 31–33', *RhM* 55 (1900) 368.

114. John Malalas, 18. 33 (445), ed. Dindorf 445, ed. Thurn p. 372, tr. Jeffreys *et al.* 259–60.

115. Procopius, *Buildings* 6. 1. 2–5; *Procopius*, ed. tr. H.B. Dewing and G. Downey, vol. 7 (London 1940) 362–3.

116. Ordination of Timothy Aelurus: Evagrius Scholasticus, *Ecclesiastical History* 2. 8, ed. Bidez and Parmentier p. 56 line 5–6. Death of Proterius: Eutychius of Alexandria, *Annales* 101–3, *PG* 111, col. 1055D–1056A. Background: Frend *op. cit.* (n. 104) 154–5; Chadwick *op. cit.* (n. 22) 588–9.

117. Eutychius of Alexandria, *Annales* 297–9, *PG* 111, col. 975A. It is apparently the 'gymnasium' mentioned by Maqrizi, tr. Malan 60, as burning down under Athanasius II (i.e. in AD 489–96), which narrows down the date it was burnt to 489–91. Both

sources mention that it was built by 'Ptolemy'. Chariot racing in Alexandria under Justinian and in the early seventh century: Humphrey *Roman Circuses* 512 with references; Z. Borkowski, *Inscriptions des factions à Alexandrie, Alexandrie* II (Warsaw 1981) 75–7, 97–110.

118. Maqrizi, tr. Malan 60–5; Faivre *loc. cit.* (n. 3) col. 366. More detailed account: Watterson *op. cit.* (n. 23) 47–9.

119. Cosmas Indicopleustes, *Christian Topography* 10. 64, 67 and 68; *Cosmas Indicopleustès, Topographie chrétienne*, ed. tr. W. Wolska-Conus (Paris 1968) vol. 3, 302, 304, 306. He was an Alexandrian merchant who wrote Book 10 in AD 549–66: Wolska-Conus *op. cit.* vol. 3, 305 n. 67².

120. John of Ephesus, *Historiae Ecclesiasticae Pars Tertia* 1. 40 and 4. 12; *The Third Part of the Ecclesiastical History of John Bishop of Ephesus Now First Translated from the Original Syriac*, tr. R. Payne Smith (Oxford 1860) 78 and 269; W.H.C. Frend, 'Nationalism as a Factor in anti-Chalcedonian Feeling in Egypt', in S. Mews, ed., *Religion and National Identity, Studies in Church History* 18 (Oxford 1982) 33–4; Watterson *op. cit.* (n. 23) 51. Background: Frend *op. cit.* (n. 104) 255–95.

121. Severus ibn el-Muqaffa, ed. tr. B. Evetts, *PO* I, 466–7 [202–3]; *Livre de la consécration du sanctuaire de Benjamin*, ed. Fr. R.-G. Coquin (Cairo 1975) 50–4; A. Maricq, 'Une influence alexandrine sur l'art Augustéen? Le Lageion et le Circus Maximus', *RA* 37 (1951) 39–42; Martin *loc. cit.* (n. 16) 16–17; Chadwick *op. cit.* (n. 22) 626–7. Severus refers to the Serapeum as al-Sawārī (the Columns), which is the later Arabic name for the site. He also mentions 'the 105 steps' which will be the 100 steps of the Serapeum mentioned by Aphthonius. For al-mal'ab see: Hamarneh *loc. cit.* (n. 81) 84–5.

Angelion: Calderini *Dizionario* vol. 1, 166; Martin *loc. cit.* (n. 4) 223 n. 73; Pearson *loc. cit.* (n. 1) 154; Pearson *loc. cit.* (n. 15) 242; Gascou *loc. cit. ÉtAlex* (n. 16) 43–4. The 'Church of the Mother of God, holy Mary, which is called the Angelion' was visited by the Coptic patriarch Benjamin (AD 622–61): Coquin *op. cit.* 50, 83 (fol. 7v). Angelites: Faivre *loc. cit.* (n. 3) col. 341; P.M. Fraser, 'Byzantine Alexandria; Decline and Fall', *BSAA* 45 (1993) 100 n. 30.

122. T. Orlandi, 'Coptic Literature', in B.A. Pearson and J.E. Goehring, eds., *The Roots of Egyptian Christianity* (Philadelphia 1986) 52–5, 57–64, 70–8; Bagnall *op. cit.*(n. 8) 253–5; van Minnen *loc. cit.* (n. 8) 80–4. Van Minnen (*loc. cit.*, n. 8, 84 n. 65) observes: 'The image of a by-and-large Coptic-speaking monophysite Egyptian church in late antique and early Arabic Egypt against the backdrop of a Greek-speaking imperial orthodoxy is part of the erroneous idea that nationalistic attitudes pervaded the "Coptic" church at this date'. Clarysse (*loc. cit.* n. 3, 377) states: 'From the point of view of religion there was no divide between Hellenophones and Coptic speakers: they lived together in the same monasteries and both considered the patriarch of Alexandria their leader. The monophysite church was certainly not a church of native Egyptians against native Greeks. Coptic literature consisted mostly of translations from the Greek and it is hardly possible to distinguish translated martyrologies from those that were originally composed in the native language'. See also: E. Wipszycka, 'Le Nationalisme a-t-il existé dans l'Égypte byzantine?', *The Journal of Juristic Papyrology* 22 (1992) 83–128, who concludes that it did not. Examples of use of Greek and Coptic: S.J. Clackson, *Coptic and Greek Texts Relating to the Hermopolite Monastery of Apa Apollo* (Oxford 2000).

123. J.W. Crowfoot, *Churches at Jerash* (London 1930) 24–5, plan 4, pl. 7b; F.M. Biebel in C.H. Kraeling, ed., *Gerasa, City of the Decapolis* (New Haven 1938) 341–51, pl. 67c; J. Deckers, 'Zur Darstellung der christlichen Stadt', *RM* 95 (1988) 351–5, pl. 130–131.2; M. Piccirillo, *Mosaics of Jordan* (Amman 1993) 288, pl. 504, 542. Date and inscription: Biebel *loc. cit.* 479–80 no. 306. Depiction of shrine of Saints Cyrus and John at Menouthis: Crowfoot *op. cit.* 24, pl. 7a; Biebel *loc. cit.* 328, 349–50; Deckers *loc. cit.* pl. 131.1; Piccirillo *op. cit.* pl. 505, 545.

124. Crowfoot *op. cit.* (n. 123) 28–9, pl. 12; Deckers *loc. cit.* (n. 123) 355–6, pl. 131.3; Piccirillo *op. cit.* (n. 123) pl. 543. Date and inscription: Biebel *loc. cit.* (n. 123) 336, 484 no. 327, pl. 75a.

125. R. Goodchild, 'The Finest Christian Mosaics in Libya', *ILN* (14 Dec. 1957) 1034–5; E. Alföldi-Rosenbaum and J. Ward-Perkins, *Justinianic Mosaic Pavements in Cyrenaican Churches* (Rome 1980) 59–60, 120–1, fig. 9–10, 132, pl. 17; Deckers *loc. cit.* (n. 123) 356–8, fig. 11. Date: J.M. Reynolds in Alföldi-Rosenbaum and Ward-Perkins *op. cit.* 146–8.

126. The mosaics are on the vault of the Capella Zen, and much restored, but the original version of them is probably dated to the 1270s: O. Demus, *The Mosaics of San Marco in Venice* (Chicago 1984) 2 Text 186, 191, 2 plates pl. 336, 338, 340; T.E.A. Dale, 'Inventing a Sacred Past: Pictorial Narratives of St Mark the Evangelist in Aquileia and Venice, *ca.* 1000–1300', *DOP* 48 (1994) 89–91, fig. 45.

127. The mosque is mentioned by Ibn Gubayr (AD 1145–1217) who visited it: Hamarneh *loc. cit.* (n. 81) 86.

128. The eighth-century depiction of Alexandria in St Stephen's Church at Umm er-Rassas, Jordan, is very simplified: Piccirillo *op. cit.* (n. 123) pl. 354; M. Piccirillo and E. Alliata, *Umm al-Rasas Mayfa'ah, I. Gli scavi del complesso di Santo Stefano* (Jerusalem 1994) 190–1, pl. 20.2 on p. 227. Date: *ibid.* 343. The mid-fifth-century mosaic at Bethshan has a very simple depiction of the city but includes a Nilometer: N. Zori, 'The House of Kyrios Leontis at Beth Shean', *IEJ* 16 (1966) 124, 127–32, fig. 3–4, pl. 12. Examples of mosaic depictions of Alexandria and Nilometer: R. Hachlili, 'Iconographic Elements of Nilotic Scenes on Byzantine Mosaic Pavements in Israel', *PEQ* 1998, 106–20; Deckers *loc. cit.* (n. 123) 350–61. Depiction of other Egyptian cities in mosaics, with references: P. Donceel-Voûte, 'A Geography of Orthodox Egypt in Palestinian Documents', in M. Rassart-Debergh and J. Ries, eds., *Actes du IVᵉ Congrès copte, Louvain-La-Neuve 1988* vol. 1 (Louvain 1992) 98–114.

129. Z. Weiss and E. Netzer, 'Two Excavation Seasons at Sepphoris', *Qadmoniot* 24 (1991) 113–22; E. Netzer and Z. Weiss, 'New Mosaic Art from Sepphoris', *Biblical*

Archaeology Review 18.6 (1992) 36–43; Gascou *loc. cit. ÉtAlex* (n. 16) 29. Date: Netzer and Weiss *loc. cit.* 42.

130. Textile: M.-H. Rutschowscaya, *Coptic Fabrics* (Paris 1990) 78–81. Silver dish with Nilometer in St Petersberg, mid-seventh century AD: M.J. Price and B.L. Trell, *Coins and their Cities* (London 1977) 187–8, fig. 323; F. Baratte, 'Les Orfèvres d'Alexandrie à la fin de l'antiquité', *Les Dossiers d'archéologie* 201 (1995) pl. on p. 81.

131. Agathias, *History* 2. 15. 5–7; *Agathiae Myrinaei, Historiarum Libri Quinque*, ed. R. Keydell (Berlin 1967) 60; *Agathias, The Histories*, tr. J.D. Frendo (Berlin 1975) 48. Alexandria was less effected by the earthquake than Beirut or Cos: Agathias, *History* 2. 15. 2–4, 2. 16. 1–6.

132. Tr. in J. Wilkinson, *Jerusalem Pilgrims before the Crusades* (Jerusalem 1977) 89. Date: P. Grossmann (pers. com. 2002).

133. *Life of St John the Almsgiver. Léontios de Néapolis, Vie de Syméon le Fou et Vie de Jean de Chypre*, ed. tr. A.-J. Festugière and L. Rydén (Paris 1974) 257–637 text based on John Moschus and Sophronius in ch. 1–15, followed by Leontius' long version. (Partial) Eng. tr. in E. Dawes and N.H. Baynes, *Three Byzantine Saints* (Oxford 1948) of summary based on John Moschus and Sophronius on p. 199–209, and of version by Leontius of Neapolis on p. 207–62. On how the versions were compiled: Dawes and Baynes *op. cit.* 195–7; H. Delehaye, 'Une vie inédite de Saint Jean l'aumônier', *AnalBolland* 45 (1927) 5–19; H. Chadwick, 'John Moschus and his Friend Sophronius the Sophist', *JThSt* n.s. 25 (1974) 50–1; Festugière and Rydén *op. cit.* 267; C. Mango, 'A Byzantine Hagiographer at Work: Leontios of Neapolis', in I. Hutter, ed., *Byzanz und der Westen* (Vienna 1984) 25–41; *ODB* vol. 2, 1058–9, 1213–14; V. Déroche, *Études sur Léontios de Néapolis* (Uppsala 1995) 37–95, 117–36. Mango (*loc. cit.* 38–41) points out that the version based on John Moschus and Sophronius is more reliable that that of Leontius, although his does reflect a knowledge of Alexandrian topography. Date: Mango *loc. cit.* 33.

134. Severus ibn el-Muqaffa, ed. tr. B. Evetts, *PO* I 470–1 [206–7]; Frend *loc. cit.* (n. 120) 35. Modern location of Ennaton: *CE* 954–8 Enaton.

135. John Moschus, *Spiritual Meadow* 77; *PG* 87.3, col. 2929D and 2930D; *The Spiritual Meadow (Pratum Spirituale) by John Moschos*, tr. J. Wortley (Kalamazoo 1992) 59; Calderini *Dizionario* vol. 1, 169. The location of this church 'near the Great Tetrapylon' is only in the Latin version, originally published in 1475. On the epithet 'Theotokos' which literally means 'bearer of god' (previously applied to the Egyptian goddess Isis) see: Krause *loc. cit.* (n. 15) 57; *ODB* vol. 3, 2070; *Late Ant.* 723–4.

136. John Moschus, *Spiritual Meadow* 146, *PG* 87.3, col. 3009D–3012A, tr. Wortley 119–20; Calderini *Dizionario* vol. 1, 170.

137. Severus ibn el-Muqaffa, ed. tr. B. Evetts, *PO* I, 478–80 [214–16]. So also: Coptic Synaxarium 22 Kihak (18 December), ed. tr. R. Basset, *PO* III 508 [432].

138. John of Nikiu, 108. 11, tr. Charles 173. The Drakon is mentioned as opposite Taphosiris in pseudo-Kallisthenes, 1. 31. 7, ed. Kroll *op. cit.* (n. 44) p. 30 line 12, tr. Stoneman *op. cit.* (n. 44) 64.

139. John of Nikiu, 107. 14, tr. Charles 168.

140. John of Nikiu, 107. 48, tr. Charles 172.

141. John of Nikiu, 108. 8, tr. Charles 173. Gate of 'Aoun (Heliopolis), the Sun Gate which was the eastern gate: John of Nikiu, 108. 5, tr. Charles 173; Amélineau *Géographie* 42. For the possiblity of two eastern walls by 30 BC see Ch. 4 n. 43.

142. John of Nikiu, 107. 17, tr. Charles 169. Church of St Theodore: Calderini *Dizionario* vol. 1, 169. Church of Athanasius in eastern part of the city mentioned at the time of patriarch Timothy III (AD 517–35): John of Nikiu, 91. 2, tr. Charles 144.

143. *Life of St John the Almsgiver*, tr. Dawes and Baynes *op. cit.* (n. 133) 5, p. 201. In view of the amount the Coptic patriarch Anastasius was persecuted, it is possible that the number (seven) of churches reported as in the hands of the Chalcedonians when John the Almsgiver became patriarch is a theoretical number, in order to prove how effective he was in increasing it to seventy.

144. John Moschus, *Spiritual Meadow* 77, *PG* 87.3, col. 2932B, tr. Wortley 60. Bridge (*diabathra*) of St Peter, apparently located at the west of the city: John Moschus, *Spiritual Meadow* 73, *PG* 87.3, col. 2925C; J. Drescher, 'Topographical Notes for Alexandria and District', *BSAA* 38 (1949) 13–15.

145. John Moschus, *Spiritual Meadow* 111, *PG* 87.3, col. 2976A, tr. Wortley 92.

146. John Moschus, *Spiritual Meadow* 105 and 106, *PG* 87.3, col. 2961C and 2965A, tr. Wortley 83 and 85; Calderini *Dizionario* vol. 1, 178.

147. Leontius of Neapolis, *Life of St John the Almsgiver* 38, ed. Fr. tr. Festugière and Rydén 390 line 11, 499 line 116. Martyrium of St Metra: Sophronius, *Laudes in SS Cyrum et Joannem* 13, *PG* 87.3, col. 3464C; Calderini, *Dizionario* vol. 1, 175.

148. John Moschus, *Spiritual Meadow* 77, *PG* 87.3, col. 2929D–2932A, tr. Wortley 59; Gascou *ÉtAlex loc. cit.* (n. 16) 44 n. 126.

149. Sophronius, *Laudes in SS Cyrum et Joannem* 12, *PG* 87.3, col. 3460C.

150. Sophronius, *Laudes in SS Cyrum et Joannem* 12, *PG* 87.3, col. 3461B–C: 'clerics of the so-called Gaianite heresy, about a hundred in number, came into the church (*naos*) to pray, as was customary, some doing this after the dismissal, respecting the holiness of the place, and paying the customary reverence to the Mother of God (*Theotokos*)'. See also: Chadwick *loc. cit.* (n. 133) 54; *idem op. cit.* (n. 22) 631.

151. Sophronius, *Laudes in SS Cyrum et Joannem* 36, *PG* 87.3, col. 3553B–C; Chadwick *loc. cit.* (n. 133) 54.

152. Sophronius, *Laudes in SS Cyrum et Joannem* 12, *PG* 87.3, col. 3460C–D. For *dromos* as the name of the main east-west street see Ch. 8 n. 113. Gascou (*loc. cit. ÉtAlex* n. 16, 40–2) locates the *dromos*, and consequently the Theonas Church, to the east of the city.

153. Sophronius, *Laudes in SS Cyrum et Joannen* 4, *PG* 87.3, col. 3432A.

154. G.R. Monks, 'The Church of Alexandria and the City's Economic Life in the Sixth Century', *Speculum* 28 (1953) 349–62; Déroche *op. cit.* (n. 133) 146–53. Leontius

of Neapolis, *Life of St John the Almsgiver*, tr. Dawes and Baynes *op. cit.* (n. 133) 10 p. 216–18 (including trip to Britain for tin), 13 p. 223, 28 p. 239–40.

155. Leontius of Neapolis, *Life of St John the Almsgiver* 19, ed. Fr. tr. Festugière and Rydén 367 line 33–5, 469 line 33–5, tr. Dawes and Baynes *op. cit.* (n. 133) 21 p. 230. The agora was also visited by John Moschus: John Moschus, *Spiritual Meadow* 77, *PG* 87.3, col. 2932B, tr. Wortley 60.

156. *Life of St John the Almsgiver*, tr. Dawes and Baynes *op. cit.* (n. 133) 6–7 p. 202–3, 7 p. 214, 24 p. 234, 45 p. 256.

157. Leontius of Neapolis, *Life of St John the Almsgiver* 27, ed. Fr. tr. Festugière and Rydén 378 line 2–6, 483 line 2–5, tr. Dawes and Baynes *op. cit.* (n. 133) 27 p. 237. This could perhaps have been in the precinct of the Caesareum, just as the poor lived in the courtyard of the Church of Saints Sergios and Bakchos, Istanbul, in more recent times.

158. Leontius of Neapolis, *Life of St John the Almsgiver* 18, ed. Fr. tr. Festugière and Rydén 365–6, 468, tr. Dawes and Baynes *op. cit.* (n. 133) 20 p. 229.

159. Severus ibn el-Muqaffa, ed. tr. B. Evetts, *PO* I 485 [221]; Maqrizi, tr. Malan 71. Date of Persian conquest: A.J. Butler, *The Arab Conquest of Egypt*, ed. P.M. Fraser (2nd edn Oxford 1978) xlvi; R. Altheim-Stiehl, 'The Sassanians in Egypt – Some Evidence of Historical Interest', *BSAC* 31 (1992) 87–96.

After the Persians left Egypt in AD 629, there followed persecution of the Copts by the Chalcedonian patriarch Cyrus, appointed by the emperor Heraclius: Watterson *op. cit.* (n. 23) 52; D.N. Bell, *Mena of Nikiou, The Life of Isaac of Alexandria and the Martyrdom of Saint Macrobius* (Kalamazoo 1988) 14–15.

160. Archaeological remains at Miami-Sidi Bishr: W.A. Daszewski *et al.*, 'An Unknown Christian Complex in Alexandria', in W. Godlewski, ed., *Coptic Studies* (Warsaw 1990) 87–105. Monasteries in and around Alexandria: Krause *loc. cit.* (n. 15) 57; Martin *loc. cit* (n. 16) 18; *CE* 1645–6. Christian remains from near the modern village of el-Dekhela (not necessarily identified with Ennaton (*CE* 954–5) to the west of Alexandria, including sixth-century epitaphs, marble church decoration, and the carving of St Menas: Ward-Perkins *loc. cit.* (n. 113) 65, pl. 8.1, 3, 9.1, 5. Marble capitals from el-Dekhela, fifth and first half of the sixth centuries AD: Pensabene *Elementi Aless.* 424 nos. 503, 508A, pl. 59.503, 508A, p. 428–9 nos. 518A, 521A, 522A–C, pl. 61.518A, 521A, 522A–C, p. 431 no. 537, pl. 62.537.

161. Butler *op. cit.* (n. 159) 310–27, 368.

162. John of Nikiu, 121. 3–4, tr. Charles 200.

163. John of Nikiu, 120. 20, tr. Charles 194; Butler *op. cit.* (n. 159) 320.

164. For the sources, and whether or not the Arabs burnt the Library (and with the conclusion that it is highly unlikely), if it still existed by then as one major library, see: *Relation de l'Égypte par Abd-al Latif*, tr. S. de Sacy (Paris 1810) 183, 240–4 n. 55; Butler *op. cit.* (n. 159) 401–26; M. el-Abbadi, *The Life and Fate of the Ancient Library of Alexandria* (Paris 1990) 167–78. See also ch. 4 n. 21.

165. Severus ibn el-Muqaffa cited by Zotenberg *op. cit.* (n. 25) 584 n. 2. The Arabs are also accused of destroying the Caesareum Church in: Coptic Synaxarium 12 Baounah (6 June), ed. tr. R. Basset, *PO* XVII, 560 [1102].

166. Mena of Nikiu, *The Life of Isaac of Alexandria*, tr. Bell *op. cit.* (n. 159) p. 61, p. 86 n. 81 (Mena of Nikiu was Isaac's contemporary); Severus ibn el-Muqaffa, ed. tr. B. Evetts, *PO* V, 18, 21 [272, 275]. Its Arabic name was Qamshā: Maqrizi, tr. Malan 75 note †. Isaac was also buried in it: Mena of Nikiu, Bell *op. cit.* (n. 159) 76; Severus ibn el-Muqaffa, ed. tr. B. Evetts, *PO* V, 25 [279]. See also: M. Chaine, 'L'Église de Saint-Marc à Alexandrie construite par le partriarche Jean de Samanoud', *Revue de l'Orient chrétien* 24 (1924) 372–86.

Maqrizi, tr. Malan 75, attributes the [re]building of St Mark's to John III's predecessor, Agathon (*c.* AD 661–77) but since he leaves John III out, going straight on to mention Isaac, when listing each patriarch, it is possible that this is a textual error.

167. *Adamnan's 'de Locis Sanctis'*, ed. tr. D. Meeham, *Scriptores Latini Hiberniae* 3, (Dublin 1958) 98–105. Arculf's report of his travels (*c.* AD 679–82) was recorded in *c.* 683–6 by Adamnan, who added material from other sources. Much of the description of Alexandria comes from Hegesippus, and is marked in italics in the translation of Adamnan in Wilkinson *op. cit.* (n. 132) 110–11. Date: Meehan *op. cit.* 9–11.

168. Mena of Nikiu, *Life of Isaac of Alexandria*, tr. Bell *op. cit.* (n. 159) 67.

169. Isaac 'repaired the Great Church [Cathedral] of the Holy Mark, when its walls were sloping in, and also renewed the episcopal residence': Severus ibn el-Muqaffa, ed. tr. B. Evetts, *PO* V, 24 [278]. Bell (*op. cit.* n. 159, 20) assumes Severus is referring to the Church of St Mark, although the Coptic Great Church (i.e. cathedral) was the Angelion at that time: Severus ibn el-Muqaffa, ed. tr. B. Evetts, *PO* V, 26 [280].

170. Severus ibn el-Muqaffa, ed. tr. B. Evetts, *PO* V, 29 [283]. See also Bell *op. cit.* (n. 159) 87 n. 84.

171. After the Arab conquest, the Coptic patriarch Benjamin was allowed to return, and the Copts were given sole possession of the churches to the exclusion of the Chalcedonians. In AD 729 the Chalcedonians were allowed to have their churches back, including the Church of the Annunciation. Maqrizi, tr. Malan 74 and 79; Bell *op. cit.* (n. 159) 18.

172. John of Nikiu, 120. 12, tr. Charles 192.

173. The Caesareum Church survived until the Islamic conquest, according to the Coptic Synaxarium 12 Baounah (6 June), ed. tr. R. Basset, *PO* XVII, 560 [1102].

The Coptic patriarch John IV (*c.* AD 775–99) built and restored a major church in honour of the Archangel Michael: 'He completed the church in the space of five years, and consecrated it in the name of the Archangel Michael. This church is called at the present day, in the city of Alexandria, the Church of Repentance': Severus ibn el-Muqaffa, ed. tr. B. Evetts, *PO* X, 388–90 [502–4]. His successor, Mark II (AD 799–819) rebuilt 'the church of the Saviour, which is called the *Soter*', which was then burnt down by the Spaniards: Severus ibn el-Muqaffa, ed. tr. B. Evetts, *PO* X, 431–2 [545–6].

According to Eutychius of Alexandria (*Annales* b503, *PG* 111, col. 1149A, and *Annales* 300, *PG* 111, col. 975C) the Caesareum was burnt down in AD 912 (AH 300). This is repeated in Maqrizi, tr. Malan 85–6.

Maqrizi, tr. Malan 45, also describes the destruction of the idol from the temple of Saturn by Alexander, but without mentioning the Caesareum by name, and concludes Alexander made it [the temple] into 'a church to the name of Michael. And this church in Alexandria was not injured until it was burnt down by the soldiers of Imām el-Mo'iz le-dīn-illah abu Temīm Mo'add, when they came in the year AH 358' (i.e. AD 969). Similarly: *Maqrizi – Description topographique et historique de l'Égypte*, tr. U. Bouriant, *Mémoires de la Mission archéologique française au Caire* 17.1 (Paris 1900) 442.

174. For Islamic Alexandria, with references: Faivre *loc. cit.* (n. 3) col. 356–63; L. Labib, 'al-Iskandariyya', in E. van Donzel *et al.*, eds., *Encyclopedia of Islam* (Leiden 1978) vol. 4, 132–7; M. Rodziewicz, 'Graeco-Islamic Elements at Kom el Dikka in the Light of the New Discoveries: Remarks on Early Mediaeval Alexandria', *Graeco-Arabica* 1 (1982) 35–49; A.L. Udovitch, 'Medieval Alexandria: Some Evidence from the Cairo Genizah Documents', in K. Hamma ed., *Alexandria and Alexandrianism* (Malibu 1996) 273–84; C. Décobert, 'Alexandrie au XIIIᵉ siècle. Une nouvelle topographie', in C. Décobert and J.-Y. Empereur, eds., *Alexandrie médiévale 1*, *ÉtAlex* 3 (1998) 71–100. Mediaeval pottery, with references: V. François, *Les Céramiques médiévales d'Alexandrie*, *ÉtAlex* 2 (Paris 1999). In the eleventh century the Coptic patriarchate was moved from Alexandria to Cairo: Krause *loc. cit.* (n. 15) 58 with references.

175. Background to Venetian need for relics of St Mark: Dale *loc. cit.* (n. 126) 54–8, 102–3. Their removal is later depicted in the Cappella S. Clemente (first half of twelfth century) of S. Marco, Venice, and on its facade: Demus *op. cit.* (n. 126) 1 Text 65, 83, 1 Plates pl. 63–9, 2 text 187; Dale *loc. cit.* (n. 126) 69–70, fig. 21–6, 47–50. Later history of remains of St Mark: *CE* 1531–2; G. Curatola, 'Venetian Merchants and Travellers in Alexandria', in A. Hirst and M. Silk, eds., *Alexandria, Real and Imagined* (London 2004) 187.

176. Severus ibn el-Muqaffa, ed. tr. B. Evetts, *PO* X 512–13 [626–7]; Creswell rev. Allan, *Short Account* 331.

177. Maqrizi, tr. Malan 83.

178. Maqrizi, tr. Malan 88–91. Al-Hakim 'set about demolishing all the churches', although some clearly continued in use.

179. See Ch. 1 n. 3. Amalric, King of Jerusalem, attacked Egypt in 1163 and 1164, and besieged and conquered Alexandria in 1167. In 1174 the Sicilians, under Tancred count of Lecce, assembled a large fleet in front of Alexandria. Attacks by Crusaders, with references: Faivre *loc. cit.* (n. 3) col. 356; S. Runciman, *A History of the Crusades* vol. 2, *The Kingdom of Jerusalem and the Frankish East 1100–1187* (Cambridge 1952) 367, 374–5, 403.

180. Faivre *loc. cit.* (n. 17) 72; M. Martin, 'Alexandrie chrétienne à la fin du xiiᵉ siè-cle d'après Abu l-Makarim', in C. Décobert and J.-Y. Empereur, eds., *Alexandrie médiévale 1*, *ÉtAlex* 3 (1998) 48.

181. Martin *loc. cit.* (n. 180) 45–9.

182. Faivre *loc. cit.* (n. 3) col. 360, 363; J. Faivre, 'L'Église Saint-Sabas', *Bulletin de l'Association des amis de l'art copte* 3 (1937) 60–7. Meinardus *op. cit.* (n. 21) 120–1; P. Grossmann, *Mittelalterliche Langhauskuppelkirchen und verwandte Typen in Oberägypten* (Glückstadt 1982) 132–3, fig. 55, pl. 24b; Grossmann *Architektur* 379–81, fig. 1. P. Grossmann (pers. com. 2002) considers: 'The church of St Sabas should be dated to the early 7th cent. before the Persian invasion. I doubt that the Chalcedonians were still in the 7 or 8th cent. able to erect such a huge church.'

183. When Hīsham was Caliph, AD 724–43. Eutychius of Alexandria, *Annales* b384, *PG* 111, col. 1122C; Faivre *loc. cit.* (n. 182) 65; Grossmann *op. cit.* (n. 182) 133 n. 559. St Sabas died in AD 532.

184. Faivre *loc. cit.* (n. 182) 63–4.

185. The legendary life of St Catherine has some features in common with that of the historical Hypatia: Dzielska *op. cit.* (n. 98) 12, 21–2, 101, 119, 123 n. 21, 150 n. 20–1. This is ironic as Hypatia was martyred for being a pagan and because she represented pagan scholarship.

Although built under the emperor Justinian I in the sixth century, the monastery of St Catherine in Sinai was also not associated with St Catherine until the tenth or eleventh century (*ODB* vol. 1, 392). On the identity of St Catherine see: *ODB* vol. 1, 392–3.

186. D. Behrens-Abouseif, 'Notes sur l'architecture musulmane d'Alexandrie', in C. Décobert and J.-Y. Empereur, eds., *Alexandrie médiévale 1*, *ÉtAlex* 3 (1998) 106–8, fig. 7; L. Ali Ibrahim, 'The Islamic Monuments of Alexandria', *BSAA* 45 (1993) 146–7, pl. 28.

187. The Western Mosque was 117 × 126 m. *Description de l'Égypte* vol. 5, 352–4, vol. 10, 520, vol. 18, 420–1, plates vol. 5, pl. 37. 1–3; P. de Vaujany, *Alexandrie et la Basse Égypte* (Paris 1885) 104–7; Néroutsos *Alexandrie* 66; Dolomieu en *Égypte (30 Juin 1798–10 Mars 1799)*, ed. A. Lacroix and G. Daressy, *Mémoires présentés à l'Institut d'Égypte* 3 (Cairo 1922) 20, 64; M. Meinecke, 'Zur Topographie von Alexandria nach Ewliyā Celebī', *Zeitschrift der deutschen morgenländischen Gesellschaft* Suppl. III. 1 (Weisbaden 1977) 527–9; Tkaczow *Topography* 58–9 site 7; A. Gilet and U. Westfehling, eds., *Louis-François Cassas 1756–1827: Im Banne der Sphinx* (Mainz 1994) 204–6, fig. 118; Behrens-Abouseif *loc. cit.* (n. 186) 104, fig. 2–3. The term 'porphyry' was used by some early travellers to refer to red granite. The stones are given as: imported fine white, white veined with grey, and cipollino marble, red and grey gran-ite, and black basalt by Dolomieu (Lacroix and Daressy *op. cit.* 67–8) who was later appointed to a chair in mineralogy. The earliest inscription found in the mosque was dated to AD 868–9: Meinecke *loc. cit.* 527–9.

188. G. Botti, *Plan de la ville d'Alexandrie* (Alexandria 1898) 90 no. LXXII; E. Dutilh, 'Deux colonnes de l'église de Theonas', *BSAA* 7 (1905) 55–7; M. Debanne, 'À propos de deux colonnes attribuées à l'église de Théonas', *BSAA* 42 (1967) 81–4;

Meinardus *op. cit.* (n. 21) 126; Tkaczow *Topography* 59–60 site 7A, 293–4 object 286. Botti mentions them being in the arsenal. The mosque was used as an arsenal by the French: *Description de l'Égypte* vol. 18, 421. In January 2000 the two columns were standing at the main entrance of the Faculty of Arts of the University of Alexandria, to which they were moved from the Municipal Hospital. I thank Prof. Mostafa El-Abbadi for this information. In 1999, I (like Tkaczow in 1985) was unable to find any remains of the other 153 columns of granite and marble, with their capitals, mentioned by Dutilh (*loc. cit.* 56), and by Meinardus who later reported them as then being in the courtyard of the convent of the Franciscan Sisters.

189. It was 54 × 62 m. *Description de l'Égypte* vol. 5, 369–73, 503–4, vol. 10, 516, 522–3, vol. 18, 421, plates vol. 5, pl. 35.1, 38, 39.1; de Vaujany *op. cit.* (n. 187) 107–10; Néroutsos *Alexandrie* 66; Botti *op. cit.* (n. 188) 93–5; Meinecke *loc. cit.* (n. 187) 529–30; Tkaczow *loc. cit.* (n. 25) 432 site 7; Tkaczow *Topography* 78–9 site 25; Behrens-Abouseif *loc. cit.* (n. 186) 105, 108, fig. 4–5. Inscription recording the restoration of the mosque in AD 1084: G. Wiet, 'Nouvelles inscriptions fatimides', *Bd'É* 24 (1942) 147–8.

190. Ibn Hawkal (Ibn Hauqal), *Configuration de la terre (Kitab Surat al-Ard)*, tr. J.H. Kramers and G. Wiet (Paris 1964) vol. 1, p. 148.

191. *Description de l'Égypte* vol. 5, 369–76, 504–7, vol. 10, 522–3, 525–9, vol. 18, 421–3, plates vol. 5, 38.1, 39.1, 40–1; E.D. Clarke, *The Tomb of Alexander. A Dissertation on the Sarcophagus Brought from Alexandria and Now in the British Museum* (Cambridge 1805); PM IV, 3–4; Tkaczow *Topography* 79 n. 62.

192. Pseudo-Kallisthenes, *Romance of Alexander* 1. 14, *The Greek Alexander Romance*, tr. R. Stoneman (Harmondsworth 1991) 47.

CHAPTER 11: CHURCH BUILDING IN LATE ANTIQUE EGYPT

1. The carvings were generally assumed to have come from churches, including those with a pagan subject matter, until Torp's suggestion that the niche heads came from pagan tombs, which was further developed by Severin, and most recently by Thomas: H. Torp, 'Leda Christiana. The Problem of the Interpretation of Coptic Sculpture with Mythological Motifs', in *Acta ad archaeologiam et artium historiam pertinentia* 4 (1969) 101–12; H.-G. Severin, 'Gli scavi eseguiti ad Ahnas, Bahnasa, Bawit e Saqqara: Storia delle interpretazioni e nuovi risultati', *CorsiRav* 28 (1981) 299–314; G. Vikan, 'Meaning in Coptic Funerary Sculpture', *Göttinger Orientforschungen* II, Reihe Bd. 8, *Studien zur frühchristlichen Kunst* II (1986) 15–24; *CE* 74–5; Thomas *Niche Decorations*; H.-G. Severin, 'Zum Dekor der Nischenbekrönungen aus spätantiken Grabbauten Ägyptens', in D. Willers, ed., *Begegnung von Heidentum und Christentum im spätantiken Ägypten* (Riggisberg 1993) 83–85; Thomas *Sculpture*.

2. Basic attempt at relative and absolute chronology: E. Kitzinger, 'Notes on Early Coptic Sculpture', *Archaeologia* 87 (1938) 181–215. See also: Monneret de Villard *Ahnâs*; L. Török, 'On the Chronology of the Ahnās Sculpture', *ActaArchHung* 22 (1970) 163–82; idem, 'Notes on Prae-Coptic and Coptic Art', *ActaArchHung* 29 (1977) 143–53; idem, 'Notes on the Chronology of Late Antique Stone Sculpture in Egypt', in W. Godlewski, ed., *Coptic Studies, Congress Warsaw 1984* (Warsaw 1990) 437–84; *CE* 73–7.

The problem of attributions of sculpture to a particular site based on style alone led to a group of modern (i.e. fake) sculptures being attributed to Antinoopolis (el-Sheikh 'Ibada) based on the circular argument of their similarity to each other: S. Boyd and G. Vikan, *Questions of Authenticity Among the Arts of Byzantium* (Washington 1981) 8–9; Thomas *Niche Decorations* vol. 1, 139–49.

3. W.M.F. Petrie, *Ehnasya 1904* (London 1905) 17, 23, 28–9, pl. 28. It was located south of the temple of Herishef. The construction of House L included reused blocks apparently from the temple, including one with both cartouches of an Antonine emper-or, which provides a *terminus post quem*. Petrie considered robbing out the temple blocks began about the middle of the third century and was completed by the fourth century, based on the pottery. He dated House L to c. AD 500 based on the similarity of the archi-tectural carving to that in Ravenna from about the period of Theodoric. No pottery was found in House L, except a few lamps which D. Bailey (pers. com.) notes were pub-lished in W.M.F. Petrie, *Roman Ehnasya (Herakleopolis Magna)* (London 1905) 12–13, pl. 68 no. X60 and Z62.

4. British Museum nos. 69100, 69101: Petrie *Roman Ehnasya op. cit.* (n. 3) 15, pl. 70.5–6; Thomas *Niche Decorations* vol. 2, 188–91, pl. 68–9; Thomas *Sculpture* fig. 35–6.

5. Petrie *Roman Ehnasya op. cit.* (n. 3) 15, pl. 71.9–10. The two capitals came from niches. They are the correct size to have supported the broken pediment niche heads, and their contemporaneity with them is indicated by the carving of the acanthus leaves at the apex of the half-pediments.

6. Petrie *Roman Ehnasya op. cit.* (n. 3) pl. 70.3, 7–8. The carving of the acanthus leaves of pl. 70.8 is identical to the niche capitals. The larger capital (pl. 70.3) is from the main order of a wall. The modillion cornice (pl. 70.3) has disproportionately large and wide dentils below it, and the ovolo is very wide, both reflecting their late date.

7. Karanis, semi-circular shrine niche heads in houses C51A, C71F, C119E, C123CA, mid-first to mid-third century AD: E.M. Husselman, *Karanis, Topography and Architecture* (Michigan 1979) 9, 47–8, 56, 70, pl. 72b–4; T.K. Thomas, 'An Introduction to the Sculpture of Late Roman and Early Byzantine Egypt', in F.D. Friedman, ed., *Beyond the Pharaohs* (Rhode Island 1989) 62, fig. 11. Marina el-Alamein, House 9: W.A. Daszewski *et al.*, *Marina el Alamein, Archaeological Background and Conservation Problems*, vol. 1 (Warsaw 1991) 27–8, fig. 11–13. Marina el-Alamein, House 10, room 2, niche with painting (second half of second or third century AD) framed by pediment supported by engaged columns, second half of second century or third century AD: S. Medeksza, 'Marina el-Alamein Conservation Work, 1998', *PAM* 10 (1998) 57–9, fig. 4; idem, 'Marina el-Alamein Conservation Work 1999', *PAM* 11 (1999) 50–1, fig. 1, 3–6; S. Medeksza and R. Czerner, 'Rescuing Marina el-Alamein: a

Graeco-Roman Town in Egypt', *Minerva* 14.3 (2003) 20–1, fig. 7, 12, 14. Marina el-Alamein, Hall 21N, niche: S. Medeksza *et al.*, 'Marina el-Alamein Conservation Work in the 2003 Season', *PAM* 15 (2003) 96, fig. 4a–b.

8. Cairo, Coptic Museum 7035 (44073), h. 0.23 m, w. 0.95 m; Monneret de Villard *Ahnâs* fig. 48b; Duthuit *Sculpture* pl. 18; K. Wessel, *Coptic Art* (London 1965) pl. 58; Török *loc. cit.* 1990 (n. 2) fig. 77; Thomas *Niche Decorations* vol. 2, 140–1; Thomas *Sculpture* fig. 39.

Other examples of broken pediment niche heads of low pitch with flat grooved modillions, and bead and reel motif: i) Gaia, Herakleopolis Magna, Cairo, Coptic Museum 44070, h. 0.31 m, w. 1.02 m: Monneret de Villard *Ahnâs* fig. 8–9; Duthuit *Sculpture* pl. 23; Török *loc. cit.* 1990 (n. 2) fig. 75; Thomas *Niche Decorations* vol. 2, 169–70; Thomas *Sculpture* fig. 43–4.

ii) Bust (headless) rising from leaves, Herakleopolis Magna, Cairo, Coptic Museum 7024 (46246), h. 0.32 m, w. 1.0 m: Monneret de Villard *Ahnâs* fig. 7; Török *loc. cit.* 1990 (n. 2) fig. 65; Thomas *Niche Decorations* vol. 2, 130–1.

iii) Head in shell supported by erotes and sea creatures: Berlin, State Museum inv. 4452, h. 0.39 m, w. 0.91 m: Monneret de Villard *Ahnâs* fig. 26; Thomas *Niche Decorations* vol. 2, 81–3; A. Effenberger and H.-G. Severin, *Das Museum für spätantike und byzantinische Kunst Berlin* (Mainz 1992) 152.

iv) Herakleopolis Magna ?, Cairo, Coptic Museum 7068: Török *loc. cit.* 1990 (n. 2) fig. 76.

9. Török *loc. cit.* 1990 (n. 2) 440.

10. Cairo, Coptic Museum 7075 (45942): Monneret de Villard *Ahnâs* fig. 74; Duthuit *Sculpture* pl. 13b; Thomas *Niche Decorations* vol. 2, 171–2; Thomas *Sculpture* fig. 59.

11. i) Birth of Aphrodite/Venus, Herakleopolis Magna, Cairo, Coptic Museum 7102 (44068), w. 0.80 m: Monneret de Villard *Ahnâs* fig. 18–19; Duthuit *Sculpture* pl. 27b, 28a; Kitzinger *loc. cit.* (n. 2) pl. 67.2; Thomas *Niche Decorations* vol. 2, 173–4; Thomas *Sculpture* fig. 46–8.

ii) Daphne turning into a laurel tree, Herakleopolis Magna, Cairo, Coptic Museum 7037 (45941), h. 0.40 m, w. 0.70 m: Monneret de Villard *Ahnâs* fig. 38; Duthuit *Sculpture* pl. 22b; Thomas *Niche Decorations* vol. 2, 142–3; Thomas *Sculpture* fig. 52; Török *loc. cit.* 1990 (n. 2) fig. 71.

iii) Unprovenanced example depicting Dionysos (badly defaced) standing in grapevines, Cairo, Coptic Museum 7056 (7292a), w. 0.90 m: Monneret de Villard *Ahnâs* fig. 53; Duthuit *Sculpture* pl. 19a; Thomas *Niche Decorations* vol. 2, 153–4.

iv) Nereids on dolphins (weathered): Herakleopolis Magna, Cairo, Coptic Museum 7059 (44081): Monneret de Villard *Ahnâs* fig. 23; Török *loc. cit.* 1990 (n. 2) fig. 73; Thomas *Niche Decorations* vol. 2, 159–60; Thomas *Sculpture* fig. 51.

v) Herakleopolis Magna?, Cairo, Coptic Museum 7058 (44056), w. 0.84 m: Monneret de Villard *Ahnâs* fig. 55; Török *loc. cit.* 1990 (n. 2) fig. 72; Thomas *Niche Decorations* vol. 2, 157–8.

12. Brussels, Royal Museums of Art and History, inv. E. 8220, h. 0.64 m, w. 1.70 m: M. Rassart-Debergh, *Antiquités romaines et chrétiennes d'Égypte* (Brussels 1976) 20–1 no. 5; Thomas *Niche Decorations* vol. 2, 106–7.

13. E. Naville, 'Excavations at Henassieh (Hanes)', in E. Naville *et al.*, *The Season's Work at Ahnas and Beni Hasan (1891)*, Egyptian Exploration Fund, Special Extra Report (London 1890–1) 8.

14. T. Hayter Lewis, in E. Naville, *Ahnas el Medineh (Heracleopolis Magna)*, 11 *Memoir of the Egypt Exploration Fund* (London 1894) 32–4, pl. 13–17. Naville seems to have included one example of each type of block in the photographs, also indicated by the fact that they only photographed and kept one of the six marble capitals.

15. Strzygowski *Koptische Kunst* ME 7287, 7291, 7301, 7305–6, 7310, 7313–5, 7317, 7346, 7348, 7350, p. 31–2, 35, 45, 48–9, 51–6, 72–6, fig. 36, 42, 52, 56–7, 61, 64–7, 69–70, 99, 101–2. Strzygowski accepted the identification of the building as a church.

16. All the limestone pieces can be related to each other by details. These include the carving of the acanthus leaves on the capitals, and the details of the boss on the abacus and the shape of the abacus. The long serrated leaves occur on the friezes as well as at the apex of the cornice decoration on the more fragmentary broken pediment (Naville *op. cit.*, n. 14, pl. 15 top right). The frieze pieces are related to each other by the carving of the serrated leaves both with and without V-cuts, as well as the two incised lines on their stalks. It was planned to present detailed basis for the reconstruction elsewhere.

17. The pilaster and corner capitals have cauliculi with a distinct spherical knob at the top of them. The leaves which spring from them do not completely cover the surface of the capitals, which have very small corner volutes and helices. They are smaller than those on the pilaster from Petrie's burnt House L, which would tend to suggest that they are later. Severin dates the limestone pilaster capital (7349) from Herakleopolis Magna, which is very similar to the one from the Small Church (7348), to the first half of the fourth century AD: H.G. Severin, 'Problemi di scultura tardoantica in Egitto', *CorsiRav* 1981, 320–3, fig. 2. These two capitals are dated by Török to *c.* AD 330: Török *loc. cit.* 1990 (n. 2) 439, fig. 13 (7349) and 14 (7348). By contrast, Kitzinger dated capital 7349 to not earlier than *c.* AD 450 using the work of Kautzsch and comparanda, from Jerusalem and Constantinople: Kitzinger *loc. cit.* (n. 2) 185–8, pl. 68.4; Kautzsch *Kapitellstudien*. Török considers that Kautzsch dates capitals related to the corner capital (7346) to the second third of the fourth century: Török *loc. cit.* 1990 (n. 2) 471–2.

18. Cairo, Coptic Museum 7350: Stryzgowski *Koptische Kunst* 75–6, fig. 102 (fourth or fifth century); Kautzsch *Kapitellstudien* no. 81 p. 30–1, 39, pl. 6.81 (second half of fourth century); Torp *loc. cit.* (n. 1) 102 (not later than fourth century); H.G. Severin, 'Frühchristliche Skulptur und Malerei in Ägypten', in B. Brenk, ed., *Spätantike und frühes Christentum* (Frankfurt 1977) 248, pl. 274b (late fourth century); G. and H.-G. Severin, *Marmor vom heiligen Menas* (Frankfurt 1987) 34, fig. 27; Severin *loc. cit.* 1993 (n. 1) 63 (early fifth century); Pensabene *Elementi Aless.* 414 no. 460, pl. 55 (late fourth or early fifth century).

19. Cairo, Coptic Museum 7055 (7287), h. 0.34 m, w. 0.77 m; Strzygowski *Koptische Kunst* 31–2, fig. 36; Monneret de Villard *Ahnâs* fig. 42; Duthuit *Sculpture* pl. 16b; Török *loc. cit.* 1990 (n. 2) 468, 471, fig. 58; Thomas *Niche Decorations* vol. 2, 151–2; *L'art copte en Égypte 2000 ans de christianisme* (Paris 2000) 161 no. 157.

20. A. Ovadiah, 'The Synagogue at Gaza', in L.I. Levine, ed., *Ancient Synagogues Revealed* (Jerusalem 1981) fig. on p 130.

21. Cairo, Coptic Museum 7018 (7291), h. 0.32 m, w. 0.19 m: Strzygowski *Koptische Kunst* 35, fig. 42; Monneret de Villard *Ahnâs* fig. 20; Török *loc. cit.* 1990 (n. 2) fig. 28; McKenzie and Gibson *loc. cit.* (n. 16). Like the figures on the other niche head from the Small Church her head is lacking, probably as the result of iconoclasm. As she is wearing shoes it is unlikely that she is Aphrodite/Venus.

22. Sidmant, Cairo, Coptic Museum 7044 (7292b), h. 0.40 m, w. 1.15 m, th. 0.34 m; Strzygowski *Koptische Kunst* 37, pl. 3.2; Duthuit *Sculpture* pl. 21; Severin *loc. cit.* (n. 18) 250, pl. 278a; Török *loc. cit.* 1990 (n. 2) 468, 471, fig. 59; Thomas *Niche Decorations* vol. 2, 144–6; Thomas *Sculpture* fig. 41.

23. Herakleopolis Magna ?, Cairo, Coptic Museum 7073 (7285), h. 0.39 m, w. 1.06 m: Strzygowski *Koptische Kunst* 28–9, fig. 34; Monneret de Villard *Ahnâs* 29, fig. 73; Duthuit *Sculpture* pl. 14; Kitzinger *loc. cit.* (n. 2) 192, pl. 67.1; Severin *loc. cit.* (n. 18) 250, pl. 278b; Thomas *Niche Decorations* vol. 2, 135–7; Thomas *Sculpture* fig. 58.

24. The frieze pieces from the Small Church include inhabited scrolls which had animals depicted in them. That inhabited scrolls were used in Christian (as well as pagan) carving is indicated by the frieze in Berlin which has a cross on it as well as animals, such as lions, Berlin State Museum inv. 4761 and 4456, ? from Medinet el-Faiyum (Arsinoe/Krokodilopolis): Effenberger and Severin *op. cit.* (n. 8) 159–60 no. 74; Strzygowski *Koptische Kunst* 58.

25. These are most conveniently illustrated in: Monneret de Villard *Ahnâs*; Duthuit *Sculpture*; Török *loc. cit.* 1990 (n. 2); Thomas *Niche Decorations*. With fewer examples in: Kitzinger *loc. cit.* (n. 2); Torp *loc. cit.* (n.1); Thomas *Sculpture*.

26. Herakleopolis Magna ?, Cairo, Coptic Museum 7014 (49660), h. 0.34 m: Kitzinger *loc. cit.* (n. 2) 206, pl. 74.7; Török *loc. cit.* 1990 (n. 2) 459, fig. 40. An example with more naturalistic version of this hair style on Aphrodite (the Greek equivalent of Hathor): Török *loc. cit.* 1990 (n. 2) 462, fig. 40.

27. Coptic textile subjects most conveniently illustrated in: M. Rutschowskaya, *Coptic Fabrics* (Paris 1990). Also discussed in: *CE* 2221–30.

28. References: Ch. 10 n. 107.

29. References: Ch. 10 n. 108.

30. This problem was noted as early as 1938 by Kitzinger *loc. cit.* (n. 2) 192–3.

31. Torp *loc. cit.* (n. 1) 101–5. See also: Severin *loc. cit.* 1981 (n. 1) 299–303; Severin *loc. cit.* 1993 (n. 1) 63–5. Contra: McKenzie and Gibson *loc. cit.* (n. 16). Summary of arguments: L. Török in *CE* 74–6. Most recently: Thomas *Sculpture* 16–19, 47–70. Thomas, *Sculpture* 73–80, has also suggested that the friezes, as well as some of the unprovenanced Christian niche heads, came from tombs.

32. W.M.F. Petrie, *Tombs of the Courtiers and Oxyrhynkhos* (London 1925) 16–18, pl. 41a, 45.1–3, 6–8; Grossmann *Architektur* 337–9, fig. 61. The fragments include the four columns on pedestals with capitals which have no helices or corner volutes as they are completely covered by the acanthus leaves. This is used as the basis for dating them. The impost capital has a cross carved on it indicating it was a Christian tomb. Petrie dated this cross to the sixth century, and probably the period of the emperor Justinian to which he dated the related tombs. Frieze fragments were also found as well as small pilaster capitals. There were small (w. *c.* 0.3–0.4 m) niches in the side walls and the apse which had painted marbling. He also published carved mouldings and cornices which were found in Tomb 14, of which he does not give a plan (Petrie *op. cit.* pl. 45.5, 46.4–6, 47.5–7) and a carved cross found in Tomb 17 (Petrie *op. cit.* 17, pl. 42, 46.1–2, 7–8).

33. e.g. Alexandria, tomb in Antoniadis Garden: Adriani *Repertorio* p. 65.

34. It had a brick pendentive dome. Breccia *Musée gréco-romain 1931–2*, 36–7, fig. 7–9, pl. 19.66, 20–3. Suggestion that it was a tomb: Torp *loc. cit.* (n. 1) 105–6; Severin *loc. cit.* 1981 (n. 1) 303–9, fig. 2. The crypt in the chancel of the South Church at Hermopolis Magna (el-Ashmunein) had a similar brick dome: Bailey *Hermopolis* 51–2, pl. 100a.

35. The date the Arab house above it was in use is based on the twenty intact glass vessels found in it: Breccia *Musée gréco-romain 1931–2*, 37–8, pl. 48–9. Margaret O'Hea (pers. com. 2003) has dated the glass vessels as Early Abassid, probably late eighth or early ninth century AD.

36. Breccia published the limestone fragments: Breccia *Musée gréco-romain 1931–2*, 51, pl. 28–47 of which he described those in pl. 28–42 as 'largely' from the Christian building. He also published fragments which he found to the north of the city in 1930, not *in situ*: Breccia *Musée gréco-romain 1925–31*, 63, 101, pl. 39.140–2, 41–51. A detailed study of the fragments was made by J.M. Harris who recorded *c.* 480 of them, but died before she was able to publish them. This study was being continued by A. Gonosova who recorded an additional *c.* 100 pieces in the Greco-Roman Museum, Alexandria. The two main groups, which can be identified from the published fragments were also identified in: J.M. Harris, 'Coptic Architectural Sculpture from Oxyrhynchos', *Year Book of the American Philosophical Society* (1960) 592–8.

37. Harris's Style II. These fragments lack V-cuts on the leaves, which have large dots between them, and the geometric patterns on them do not interlock. Fragments with plain flat grooved modillions: Breccia *Musée gréco-romain 1931–2*, pl. 33a–c, 34c, d, f, 35c, 47.122, 124. Plain geometric decoration which does not interlock: Breccia *Musée gréco-romain 1931–2*, pl. 47.122, 124; Breccia *Musée gréco-romain 1925–31*, pl. 46.162. Floppy leaves without V-cuts and with dots in the background: Breccia *Musée gréco-romain 1931–2*, pl. 37d–e; Breccia *Musée gréco-romain 1925–31*, pl. 47.168 visible in pl. 41.148 (a whole archivolt with an ansate cross at the top of it). Capitals found in Christian structure with floppy leaves, like on the friezes: Breccia *Musée gréco-romain 1931–2*, pl. 21.70, 43a,e. See also: Török *loc. cit.* 1990 (n. 2) 477, fig. 66–8.

38. Harris's Style I. The geometric patterns on this group interlock. Ornate cornice pieces with decorated modillions: Breccia *Musée gréco-romain 1931–2*, pl. 33d–f, 34a, 35a, g, 36c–d, f–h.

Some of the cornice fragments from Oxyrhynchus have acanthus leaves on the modillions with circular lobes: Breccia *Musée gréco-romain 1931–2*, pl. 34g, 35b, 36e, 45.118b; Török *loc. cit.* 1990 (n. 2) 484; L. Török, *CE* 76. These acanthus leaves also occur on a block with an interlocking geometric pattern: Breccia *Musée gréco-romain 1925–31*, pl. 50.185. They have been compared with those on the Theodosian porch of H. Sophia in Constantinople, *c.* AD 415, but are closer to earlier examples in Egypt, such as on the acanthus leaves on the Egyptian style capitals of the West Colonnade at Philae carved under Tiberias, and the Corinthian capital at Edfu [236, 238, 240], illustrated in: E. Drioton, 'De Philae à Baouît', in *Coptic Studies in Honour of W. E. Crum* (Boston 1950) 443–8.

Harris considered both her Styles I and II were apparently contemporary and dated them to the fifth to early sixth century. Similar unprovenanced examples of ornate cornices with decorated modillions: H. Zaloscer, *Une collection de pierres sculptées au Musée copte du Vieux-Caire* (Cairo 1948) 42–5, pl. 11.20a–12.21.

39. Cairo, Coptic Museum 4475: M.H. Simaika Pacha, *Guide sommaire du Musée copte et des principales églises du Caire* (Cairo 1937) pl. 22, no. 4475; H. Zaloscer, *Quelques considérations sur les rapports entre l'art copte et les Indes*, ASAE suppl. 6 (Cairo 1947) pl. 6; Török *loc. cit.* 1990 (n. 2) 472, fig. 63; Thomas *Niche Decorations* vol. 2, 114–15.

40. Niche heads with decoration on modillions: Breccia *Musée gréco-romain 1931–2*, pl. 46.119–20; Thomas *Sculpture* fig. 81, 83; Kitzinger *loc. cit.* (n. 2) 195, pl. 70.2–3.

Niche heads from Oxyrhynchus with vegetal frieze, instead of modillions on the cornice: Breccia *Musée gréco-romain 1925–31*, pl. 43. The cutting of the end of the sprigs of some of the leaves is the same as on one of the cornice fragments from Tomb 42, suggesting a similar date in the late fifth or sixth century: Petrie *op. cit.* (n. 32) pl. 45.7.

41. Breccia *Musée gréco-romain 1925–31*, pl. 39.142; Duthuit *Sculpture* pl. 30b; Thomas *loc. cit.* (n. 7) 58–9, fig. 6–7.

42. Fogg Art Museum, Cambridge, Mass. inv. 1975.41.83–4: *Pagan and Christian Egypt* (Brooklyn 1941, repr. 1974) 25–6 nos. 49–50, pl. 49–50, A. Gonosova, 'A Note on Coptic Sculpture', *JWaltersArtGal* 44 (1986) 10–15, fig. 1–2. She suggests these capitals (which have some odd features) came from Oxyrhynchus, as she has examined all the fragments from there in the Greco-Roman Museum, Alexandria.

43. P. Grossmann, 'New Discoveries in the Field of Christian Archaeology in Egypt', in M. Rassart-Debergh and J. Ries, eds., *Actes du IV e Congrès copte, Louvain-la-Neuve 1988*, vol. 1, Louvain (1992) 152–3, fig. 4; J.E. Knudstad and R.A. Frey, 'Kellis: the Architectural Survey of the Romano-Byzantine Town at Ismant el-Kharab', in C.S. Churcher and A.J. Mills, eds., *Reports from the Survey of the Dakhleh Oasis Western Desert of Egypt 1977–1987* (Oxford 1999) 205–8, fig. 13.12, 13.28–33; G.E. Bowen, 'The Fourth-Century Churches at Ismant el-Kharab', and C.A. Hope, 'Observations on the Dating of the Occupation at Ismant el-Kharab', in C.A. Hope and G.E. Bowen, eds., *Dakhleh Oasis Project: Preliminary Reports on the 1994–1995 to 1998–1999 Field Seasons* (Oxford 2002) 65–85 and 43–59; Grossmann *Architektur* 468–70, fig. 85. There is debate whether or not the so-called West Church was a church, although it appears to be a small chapel. It is dated to the second half of the fourth century AD.

44. Krautheimer *Byz. Archit.* 151, fig. 97. The discovery of the examples from Kellis, which are earlier than those in Syria, makes it unlikely that the Egyptian examples derived from there. Contra, Krautheimer *Byz. Archit.* 323. The term *pastophoria* is used for these side rooms in Syrian churches from the fourth century: *CE* 216–17 *pastophorium*.

45. Egyptian churches with an apse protruding from their east wall include: Church B on Ğabal Ṭāḥūna at Fayrān in Sinai, and church in Area V at Marsa Matruh: P. Grossmann and A. Reichert, 'Report on the Season in Fayrān (March 1990)', *GöttMisz* 128 (1992) 12, fig. 2; D. White, 'Marsa Matruh', in D.M. Bailey, ed., *Archaeological Research in Roman Egypt*, *JRA* suppl. 19 (Ann Arbor 1996) 79, fig. 15.

46. P. Grossmann, 'Zur christlichen Baukunst in Ägypten', *Enchoria* 8 (1978) 89–90 (135–6); idem, 'Neue frühchristliche Funde aus Ägypten', in *Actes du XI e Congrès international d'archéologie chrétienne* (Rome 1989) vol. 2, 1899–1900; G. Wagner in *CE* 2126–7, plan on p. 2127; Capuani *L'Égypte copte* 232, fig. 95, p. 98. P. Grossmann notes that the inscriptions and graffiti discovered in it do not 'tell any word that it functioned as a church' (pers. com. 2002).

47. Kellia: Grossmann *loc. cit.* 1978 (n. 46) 90 (136), pl. 12b; *CE* 1404–7, 1409–10 (with references); Capuani *L'Égypte copte* 56–8, pl. 15. Bagawat: A. Fakhry, *The Necropolis of el-Bagawāt in Kharga Oasis* (Cairo 1951); *CE* 326–7; Capuani *L'Égypte copte* 229–31, fig. 92–3, pl. 93–7.

Transverse aisle: P. Grossmann, 'Early Christian Architecture in the Nile Valley', in F.D. Friedman, ed., *Beyond the Pharaohs* (Rhode Island 1989) 85 n. 19; *CE* 355. Synagogue at Hammath-Tiberias, Level IA: L.I. Levine, ed., *Ancient Synagogues Revealed* (Jerusalem 1981) plan on p. 68. Possibly a church: D. Milson, *Aspects of the Impact of Christian Art on Synagogues in Byzantine Palestine*, DPhil thesis, Oxford University 2000. Examples of synagogues with transverse aisle, at Capernaum, Horvat Ha-'Amudim, Bar'am: Levine *op. cit* plans on p. 12–13, 51.

48. Grossmann *loc. cit.* (n. 43) 148–9; Grossmann *Architektur* fig. 55. Other churches in Antinoopolis: G. Uggeri, 'I monumenti paleocristiani di Antinoe', in *Atti del 5. Congresso nazionale di archeologia cristiana, Torino 1979* (Rome 1982) 657–88; Grossmann *loc. cit.* (n. 43) 147–9, fig. 2; P. Grossmann, 'Zur Rekonstruktion der Südkirche von Antinoopolis', *Vicino Oriente* 12 (2000) 269–81; Grossmann *Architektur* fig. 52–4.

49. B. van Elderen, 'The Nag Hammadi Excavation', *Biblical Archaeologist* 42 (1979) 225–31; P. Grossmann, 'The Basilica of St Pachomius', *Biblical Archaeologist* 42 (1979) 232–6; G. Lease, 'The Fourth Season of the Nag Hammadi Excavation', *GöttMisz* 41 (1980) 75–85; Grossmann *loc. cit.* 1989 (n. 46) 1887, fig. 19; al-Syriany and Habib *Coptic*

Churches 60–1 no. 66; *CE* 1926–9, plan on p. 1928; Grossmann *loc. cit.* (n. 43) 151–2; Capuani *L'Égypte copte* 196–7, fig. 78, pl. 69; P. Grossmann, 'Kirche oder "Ort des Feierns" – Zur Problematik der pachomianischen Bezeichnungen des Kirchenbäudes', *Enchoria* 26 (2000) 41–53; Grossmann *Architektur* 546–52, fig. 162–3. Detail of carved decoration: Grossmann *loc. cit.* 1979 pl. on p. 233. Church built by Pachomius: L.T. Lefort, *Les Vies coptes de Sainte Pachôme et de ses premiers successeurs*, Bibliothèque du Muséon 16 (Louvain 1943) 115–16.

50. Lateran Basilica (S. Giovanni in Laterano), Rome, nave 55 × 75 m, sanctuary length 20 m: Krautheimer *Byz. Archit.* 46–9, fig. 11; R. Krautheimer *et al.*, *Corpus Basilicarum Christianarum Romae* vol. 5 (Vatican 1977) fig. 15, 78, 80, pl. 1, 8.

St Peter's basilica, Rome, nave 63 × 91 m, total inner length 119 m: Krautheimer *Byz. Archit.* 57, fig. 21–2; Krautheimer *op. cit.* vol. 5, fig. 148, 198, pl. 5–6, 8.

51. Main publications: A.J. Butler, *Ancient Coptic Churches of Egypt*, vol. 1 (Oxford 1884), 351–7, fig. 26; W. de Bock, *Matériaux pour servir à l'archéologie de l'Égypte chrétienne* (St Petersburg 1901) 39–60, fig. 54–71, pl. 17–22; C.R. Peers, 'The White Monastery near Sohag, Upper Egypt', *The Archaeological Journal* 61 (1904) 131–53; S. Clarke, *Christian Antiquities in the Nile Valley* (Oxford 1912) 145–61, fig. 32–4, pl. 45–8; Monneret de Villard *Sohâg*; A.L. Schmitz, 'Das Weisse und das Rote Kloster', *Die Antike* 3 (1927) 326–50; H.-G. Evers and R. Romero, 'Rotes und Weisses Kloster bei Sohag. Probleme der Rekonstruktion', in K. Wessel, ed., *Christentum am Nil* (Recklinghausen 1964) 175–99; O.F.A. Meinardus, *Christian Egypt, Ancient and Modern* (Cairo 1965) 290–3; C.C. Walters, *Monastic Archaeology in Egypt* (Warminster 1974) 21–59 passim, 124, 158, 161, 186, 189, 191–2, 195, 241–2, 309–10, pl. 4–7b, 10a; P. Akermann, *Le Décor sculpté du Couvent blanc, niches et frieses*, Bibliothèque d'études coptes, vol. 14 (Cairo 1976); Krautheimer *Byz. Archit.* 121–4, fig. 68–71; P. Grossmann, *Mittelalterliche Langhauskuppelkirchen und verwandte Typen in Oberägypten* (Glückstadt 1982) 78–9, 115, 253, fig. 48A–B, 49; Capuani *L'Égypte copte* 177–82, fig. 73–4, pl. 62–5; P. Grossmann, 'Die klassischen Wurzeln in Architektur und Dekorsystem der grossen Kirche des Schenuteklosters bei Suhāğ', in A. Egberts *et al.* eds., *Perspectives on Panopolis* (Leiden 2002) 115–31; Grossmann *Architektur* 528–36, fig. 150–3.

52. Besa, *The Life of Shenute*, tr. D.N. Bell (Kalamazoo 1983) 49–51.

53. Summary of history: *CE* 761–6.

54. W.M.F. Petrie *et al.*, *Athribis* (London 1908) 13–15, pl. 43; M. Ali Mohamed and P. Grossmann, 'On the Recently Excavated Monastic Buildings in Dayr Anba Shinuda: Archaeological Report', *BSAC* 30 (1991) 53–63; *CE* 766–8, plan on p. 767; Grossmann *Architektur* fig. 154.

55. Inscription: G. Lefebvre, 'Inscription grecque du Deir-el-Abiad', *ASAE* 20 (1920) 251; Monneret de Villard *Sohâg* vol. 1, 18–22, fig. 22 (lintel). Lintel: F.W. Deichmann, 'Zum Altägyptischen in der koptischen Baukunst', *MDIK* 8 (1939) 36, pl. 16a.

56. Count Kaisarios (Caesarius) is mentioned in two of Shenute's letters: Monneret de Villard *Sohâg* vol. 1, 18–20; *Sinuthii Archimandritae vita et opera omnia*, ed. J. Leipoldt, vol. 3 (Paris 1908) nos. 12–13, p. 26–32; Monneret de Villard *Sohâg* vol. 1, 20 suggests that Kaisarios and Taurinos, to whom one of the letters is addressed, were part of a military expedition against Nubians or the Blemmyes (a nomadic tribe of the eastern desert). Their raids stopped in AD 451 when the emperor Marcian made a treaty with the Blemmyes: Bell *op. cit.* (n. 52) 105 n. 66.

57. Besa, *Life of Shenute* 128–30, tr. Bell 78–9. His attendance at the Council of Ephesus in AD 431 is the only definitely fixed date in Shenute's life: J. Leipoldt, *Schenute von Atripe und die Entstehung des national ägyptischen Christentums* (Leipzig 1903) 26; Bell *op. cit.* (n. 52) 7–8. He became abbot in about AD 385. It is generally agreed Shenute died in AD 466. According to Besa, *Life of Shenute* 175, tr. Bell 89, he lived to 118. On Shenute's life and its chronology: Leipoldt *loc. cit.* 26–32; K.H. Kuhn, 'A Fifth Century Egyptian Abbot', *JThSt*, n.s. 5 (1954) 36–48, 174–87; 6 (1955) 35–48; Bell *op. cit.* (n. 52) 7–9; K.H. Kuhn, *CE* 2131–3.

58. Monneret de Villard *Sohâg* vol. 1, 22–4. Coptic Version: Besa, *Life of Shenute* 30–2, tr. Bell 51–2. More detailed Arabic Version: E. Amélineau, 'Vie de Schnoudi traduite de l'Arabe', in *Monuments pour servir à l'histoire de l'Égypte chrétienne aux IV e et V e siècles*, Mémoires publiés par les membres de la mission archéologique française au Caire 4 (Paris 1888) 353–4, 392–3, 400–1, 453, 458–9. Besa was Shenute's successor who, it is generally agreed, was still alive in AD 474, although the exact dates of his birth or death are not known (Bell *op. cit.*, n. 52, 3), so it is unlikely the church was constructed before *c.* AD 420.

59. Monneret de Villard *Sohâg* vol. 1, 21–2, suggests it was constructed in *c.* AD 440 based on the reference to Kaisarios in the inscription. This would accord with the additional observations in n. 57–8 above.

60. Besa, *Life of Shenute*, Amélineau *op. cit.* (n. 58) 354. On the term used for the roof: Monneret de Villard *Sohâg* vol. 1, 23–4.

61. Trier cathedral: Krautheimer *Byz. Archit.* 49, fig. 15.

62. De Bock *op. cit.* (n. 51) fig. 59, 63; Petrie *et al. op. cit.* (n. 54) 14; Monneret de Villard *Sohâg* vol. 2, fig. 145–7, 156; PM V 31; F.W. Deichmann, *Die Spolien in der spätantiken Architektur* (Munich 1975) 54–60; P. Vernus, 'Inscriptions de la troisième période intermédiaire (II). Blocs du grand-prêtre d'Amon *'IWPWT* remployés dans le Deir-el-Abyad', *BIFAO* 75 (1975) 67–72; B. Verbeeck, 'De Kloosterkerken bij Sohag', *Phoenix ex Oriente Lux* 25.1 (1979) 95–6, fig. 22; *CE* 769.

63. Besa, *Life of Shenute*, Amélineau *op. cit.* (n. 58) 354.

64. Date of fire: P. Grossmann, 'New Observations in the Church and Sanctuary of Dayr Anbā Šinūda – the So-called White Monastery – at Suhāğ', *ASAE* 70 (1984–5) 69; Grossmann in *CE* 769. Brick repairs to nave: de Bock *op. cit.* (n. 51) pl. 19; Monneret de Villard *Sohâg* vol. 1, fig. 28–30, vol. 2, fig. 175; P. Grossmann, 'Frühchristliche Baukunst in Ägypten', in B. Brenk, ed., *Spätantike und frühes Christentum* (Frankfurt 1977) pl. 263.

65. Monneret de Villard *Sohâg* vol. 2, fig. 173; *CE* 770.

66. De Bock *op. cit.* (n. 51) pl. 21.2; Monneret de Villard *Sohâg* vol. 2, fig. 169–70.

67. Kitzinger *loc. cit.* (n. 2) 191–2 n. 4. Built by Shenute with reused material: A.J.B. Wace in A.J.B. Wace, A.H.S. Megaw and T.C. Skeat, *Hermopolis Magna, Ashmunein The Ptolemaic Sanctuary and the Basilica* (Alexandria 1959) 77–8. Akermann observed that, even if they are reused, the frieze pieces and the niches are all of one period but, following Drioton, dated them to the sixth or seventh century: Akermann *op. cit.* (n. 51) 7–9; E. Drioton, *Les Sculptures coptes du Nilomètre de Rodah* (Cairo 1942) xii. The date the inscription provides for the main period of construction of the building and its sculpture has been accepted by the scholars who have made the most detailed studies of Coptic architecture: Deichmann *op. cit.* (n. 62) 56; Severin *loc. cit.* 1981 (n. 1) 308; P. Grossmann, 'Esempi d'architettura paleocristiana in Egitto dal V al VII secolo', *CorsiRav* 28 (1981) 155–8; Grossmann *CE* 768–9; Severin *CE* 769–70.

68. This is based on firsthand observation of the building in 1992. The modillion cornice is clear along the east and south walls of the long south room, and along the north and west walls of the nave.

69. *CE* 764, 769; Grossmann *op. cit.* (n. 51) 120 n. 501.

70. De Bock *op. cit.* (n. 51) pl. 21; Monneret de Villard *Sohâg* vol. 2, fig. 201; *CE* 764.

71. De Bock *op. cit.* (n. 51) pl. 19; Monneret de Villard *Sohâg* vol. 1, fig. 10, 27–9; Evers and Romero *loc. cit.* (n. 51) fig. L, O, fig. 79; Grossmann *loc. cit.* 1977 (n. 64) pl. 262–3. The beam holes are in alignment with the nave columns.

72. De Bock *op. cit.* (n. 51) pl. 18; Monneret de Villard *Sohâg* vol. 1, fig. 18–20; Grossmann *loc. cit.* 1977 (n. 64) pl. 264. The south end of the narthex has been rebuilt. Narthexes in Coptic churches: *CE* 213–14. Galleries in Coptic churches: *CE* 210–11.

73. Grossmann *loc. cit.* 1984–5 (n. 64) 72–3, fig. 2, pl. 1a.

74. W. Crum, 'Inscriptions from Shenoute's Monastery', *JThSt* 5 (1904) 552–69; *CE* 1448. Detailed discussion of contents of library: T. Orlandi, 'The Library of the Monastery of Saint Shenute at Atripe', in A. Egberts *et al.*, eds., *Perspectives on Panopolis* (Leiden 2002) 211–31. The New Testament books were on shelves on the north wall, the Old Testament ones on the south wall, the homilies and histories on the east wall, and the biographies on the west wall. They included more than one hundred copies of the Gospels and eight of the Life of Shenute. P. Grossmann notes: 'Later the library was moved to the northern pastophorium to the right of the eastern apse. This is the place where the early European travellers discovered the books.' (pers. com. 2002). On the later fate of the monastery library which was dispersed to libraries in many other countries in the eighteenth and nineteenth centuries: *CE* 1448. On early Coptic monastery libraries in general, with references: M. Krause in *CE* 1447–50; P. van Minnen, 'The Inventory of an Egyptian Church on a Greek Papyrus', in M. Rassart-Debergh and J. Ries, eds., *Actes du IVᵉ Congrès copte, Louvain-la-Neuve 1988*, vol. 1 (Louvain 1992) 227–33.

75. T. Orlandi, 'Coptic Literature', in B.A. Pearson and J.E. Goehring, eds., *The Roots of Egyptian Christianity* (Philadelphia 1986) 69; J. Timbie, 'The State of Research on the Career of Shenute of Atripe', in *op. cit.* 264; *CE* 1453.

76. De Bock *op. cit.* (n. 51) 51, fig. 61; Peers *loc. cit.* (n. 51) 144, fig. 5; Clarke *op. cit.* (n. 51) fig. 35; Monneret de Villard *Sohâg* vol. 2, fig. 191, 195–6; Schmitz *loc. cit.* (n. 51) 339, 345, pl. 30. Line drawings of most of the niches and their positions in the building are given in: Akermann *op. cit.* (n. 51).

77. De Bock *op. cit.* (n. 51) 51–2, fig. 62; Peers *loc. cit.* (n. 51) 151, fig. 7.

78. Deichmann *loc. cit.* (n. 55) 34–7; Grossmann *loc. cit.* (n. 47) 82.

79. De Bock *op. cit.* (n. 51) pl. 17; Monneret de Villard *Sohâg* vol. 1, fig. 24; Grossmann *loc. cit.* 1977 (n. 64) pl. 265.

80. Main references: de Bock *op. cit.* (n. 51) 61–7, fig. 72–9, pl. 23–8; Clarke *op. cit.* (n. 51) 161–71, fig. 36–8, pl. 49–51; Monneret de Villard *Sohâg*; Schmitz *loc. cit.* (n. 51); Evers and Romero *loc. cit.* (n. 51); P. Grossmann, 'Die von Somers Clarke in Ober-Anṣinā entdeckten Kirchenbauten', *MDIK* 24 (1969) 156–60, fig. 3; *idem*, 'Sohâg', *Archiv für Orientforschung* 25 (1974–7) 323–5; *CE* 736–40; Grossmann *Architektur* 536–9, fig. 155–6.

81. Summary of history, with references: *CE* 736–9. Remains of rest of monastery: *CE* 740.

82. The triconch seems to have been built first: P. Grossmann, 'The Triconchoi in Early Christian Churches of Egypt and their Origins in the Architecture of Classical Rome', in *Roma e l'Egitto nell'antichità classica Cairo 1989* (Rome [1992]) 184 fig. 2; Grossmann in *CE* 740.

83. Nave alterations: Monneret de Villard *Sohâg* vol. 1, fig. 2, 33, vol. 2, fig. 114–16; Evers and Romero *loc. cit.* (n. 51) fig. G.

84. Beam holes for gallery and roof above it: Monneret de Villard *Sohâg* vol. 2, fig. 115, 123, 155; Evers and Romero *loc. cit.* (n. 51) fig. R. The present steps are in the south-east corner, giving access to the roof, but the original steps were in the south-west corner: Grossmann *CE* 740.

85. Reconstruction by Grossmann *loc. cit.* (n. 82) 184 fig. 2.

86. Capitals: de Bock *op. cit.* (n. 51) 64, fig. 75, pl. 27; Monneret de Villard *Sohâg* vol. 2, fig. 151, 157–60, 162, 165, 193; Evers and Romero *loc. cit.* (n. 51) fig. 80–1; H. Torp, 'The Carved Decorations of the North and South Churches at Bawit', in *Kolloquium über spätantike und frühmittelalterliche Skulptur Band II. Vortragstexte 1970* (Mainz 1971) 36, pl. 31.5; Severin *loc. cit.* (n. 18) 249, pl. 276d; Severin *loc. cit.* (n. 17) 320–1, fig. 4; Capuani *L'Égypte copte* fig. 75.

87. De Bock *op. cit.* (n. 51) pl. 23; Monneret de Villard *Sohâg* vol. 2, fig. 149–51; Severin *CE* 740. The carving of the acanthus leaves is similar to that on the church capitals.

88. Painted niche heads: Monneret de Villard *Sohâg* vol. 1, fig. 35–8, vol. 2, fig. 193; Evers and Romero *loc. cit.* (n. 51) fig. 80; Grossmann *loc. cit.* 1977 (n. 64) pl. 272. Niche heads over doorways of apses: Monneret de Villard *Sôhag* vol. 2, fig. 165; Severin *loc. cit.* 1993 (n. 1) 75 fig. 15.

89. P. Laferrière, 'Les Croix murales du Monastère rouge à Sohag', *BIFAO* 93 (1993) 299–310.

90. The capitals on the Red Monastery which lack the lower set of acanthus leaves due to their smaller size are close to those on the north apse of the narthex of the White Monastery: Monneret de Villard *Sohâg* vol. 1, fig. 20 (White Monastery), vol. 2, fig. 162 (Red Monastery). The Red Monastery is usually dated to the second half of the fifth century: Grossmann *CE* 740.

91. Monneret de Villard *Sohâg* vol. 1, fig. 18, 21; Akermann *op. cit.* (n. 51) pl. on p. 115, niche 45.

92. Krautheimer *Byz. Archit.* 288–9.

93. Grossmann *loc. cit.* (n. 47) 85. Some smaller churches have lateral rooms, and a single apse (rather than a triconch) which is decorated with niches and columns, such as the sixth century church at Deir Abu Fana, or just niches, as on the church of Deir al-Malak Gabriyal. Deir Abu Fana, north-west of Hermopolis Magna (el-Ashmunein): S. Adli, 'Several Churches in Upper Egypt', *MDIK* 36 (1980) 8–9, fig. 6, pl. 5b–6; al-Syriany and Habib *Coptic Churches* 122–3 no. 152; *CE* 698–700, fig. on p. 699; Capuani *L'Égypte copte* 149–52, fig. 59; Grossmann *op. cit.* (n. 51) 78, fig. 25; Grossmann *Architektur* 518–20, fig. 136. Deir al-Malak Gabriyal (Deir al-Naqlun), 15 km south of Faiyum City, on which the original structure seems to date to the seventh century, and was later altered: Adli *loc. cit.* 2–3, fig. 1, pl. 1; Grossmann *op. cit.* (n. 51) 120, fig. 49, pl. 16a; Grossmann *loc. cit.* 1989 (n. 46) 1862–5, fig. 8; al-Syriany and Habib *Coptic Churches* 144–5 no. 187; *CE* 845–6, fig. on p. 846; Capuani *L'Égypte copte* 113–15, fig. 44. Now dated to beginning of the eleventh century: W. Godlewsky, 'Les peintures de l'église de l'archange Gabriel à Naqlun', *BSAC* 39 (2000) 91.

94. I thank Sheila Gibson for drawing my attention to this. West Cemetery Church at Taucheira: J.B. Ward-Perkins *et al.*, *Christian Monuments of Cyrenaica*, ed. J. Reynolds (London 2003) 215 ill. 168.

95. *CE* 2023.

96. N. Grimal, *BIFAO* 99 (1999) 476.

97. e.g. Deir Abu Matta, in el-Dakhla Oasis, late sixth-century small church (12 × 26 m) with a small triconch: Grossmann *loc. cit.* 1989 (n. 46) 1897, fig. 24; *CE* 706; Grossmann *Architektur* 565–6, fig. 180.

98. Niche heads on Dendara church: J. Georg, *Streifzüge durch die Kirchen und Klöster Ägyptens* (Berlin 1914) fig. 149–52, 155; Monneret de Villard *Sohâg* vol. 2, fig. 164, 184, 194; J. Georg, *Neue Streifzüge durch die Kirchen und Klöster Ägyptens* (Leipzig 1930) fig. 125–9; Severin *loc. cit.* (n. 18) 250, pl. 279c; Pensabene *Elementi Aless.* 536 no. 1017, pl. 109.1017; Capuani *L'Égypte copte* 200, 217, pl. 70–3. Blocks from large ? arch: Georg *op. cit.* 1930 fig. 131. St Gereon, Cologne: Krautheimer *Byz. Archit.* fig. 43. Trier: Krautheimer *Byz. Archit.* fig. 15. The arrangement of the niches in the narthex of the Dendara church, with the apses at either end of the narthex and smaller ones in the east wall of it, is similar to that apparently in the small church (c. 10 × 20 m) at Deir Abu Hennis [John] at Mallawi, south of Antinoopolis (el-Sheikh ʿIbada), dated to the fifth century: Clarke *op. cit.* (n. 51) 185, pl. 54–6; Grossmann *op. cit.* (n. 51) 120–1, fig. 50; *CE* 701–3; Capuani *L'Égypte copte* 155, fig. 63; Grossmann *Architektur* 522–3, fig. 141.

99. J. McKenzie, 'The Architectural Style of Roman and Byzantine Alexandria and Egypt', in D.M. Bailey, ed., *Archaeological Research in Roman Egypt, JRA* suppl. 19 (Ann Arbor 1996) 137, fig. 5b.

100. Monneret de Villard *Sohâg* vol. 2, fig. 152.

101. Observation based on firsthand examination of those at the site in 1992. So also: Grossmann *CE* 690–1.

102. Observation based on firsthand observation by the writer at the site in 1992. M. Abdul-Qader Muhammad, 'Preliminary Report on the Excavations Carried out in the Temple of Luxor, Seasons 1958–1959 and 1959–1960', *ASAE* 60 (1968) pl. 39 a–b; McKenzie *loc. cit.* (n. 99) 137, pl. 5a–b; P. Grossmann, 'Frühchristliche Kirchen im Gebiet des Ammon-Tempels von Luqṣur', *Römische Quartalschrift für christliche Altertumskunde und Kirchengeschichte* 2002, 24–5, fig. 8–14.

103. Georg *op. cit.* 1930 (n. 98) fig. 80–1.

104. Severin *loc. cit.* (n. 18) 250 (second half of sixth century); Pensabene *Elementi Aless.* 536 (late fifth or first half of sixth century); Grossmann *Architektur* 443 (early sixth century).

105. Monneret de Villard *Sohâg* vol. 1, 48, fig. on p. 49; F. Daumas, *Les Mammisis de Dendara* (Cairo 1959) 301, pl. 99; Grossmann *CE* 690; Grossmann *Architektur* 445–6.

106. The church of Deir Anba Bakhum is dated to second half of the sixth century based on the plan, with later alterations destroying the north conch: *CE* 730–1; Grossmann *loc. cit.* (n. 43) 151, fig. 3; Capuani *L'Égypte copte* 184, 193, fig. 76; Grossmann *Architektur* 539–42, fig. 157.

107. Examples of Roman triconches, and of triconch churches in Egypt: Grossmann *loc. cit.* (n. 82) 181–90. Examples of triconches in churches outside Egypt, usually with the shape of the triconch visible on the outside of the building, unlike in the Egyptian examples: T. Lehmann, 'Zur Genese der Trikonchosbasiliken', in B. Brenk, ed., *Innovation in der Spätantike, Kolloquium Basel 6. und 7. Mai 1994* (Wiesbaden 1996) 317–57. Roman examples: G. Hornbostel-Hüttner, *Studien zur römischen Nischenarchitektur* (Leiden 1979) 71–2, 83–4, fig. 11, 13, 15, 32. The Roman examples consist of an approximately square room with an apse built into part of the length of each of these walls. The apse does not run the full width of these walls, whereas the apses of the triconches in the churches fill the full width of the side of the square so that these walls are absent.

108. Mt Nebo, Memorial of Moses: M. Piccirillo, *Chiese e mosaici di Madaba* (Jerusalem 1989) 149, plan on p. 150. Alacahisar, sixth century: R.M. Harrison, 'Churches and Chapels of Central Lycia', *Anatolian Studies* 13 (1963) 136, fig. 14, pl. 43a; Harrison *Temple* fig. 20. Karabel: Harrison *loc. cit.* 132, 150, fig. 11, pl. 41.

109. F. Dufey, 'Un Groupe de cinq commets-de-niche sculptés. Église d'Abba Athanasios el Apostolos à Deir ez-Zawiah', in M. Rassart-Debergh and J. Ries, eds., *Actes du IVᵉ Congrès copte Louvain-la-Neuve 1988* (Louvain 1992) 69–77; al-Syriany

and Habib *Coptic Churches* 89 no. 100; R.-G. Coquin and M. Martin in *CE* 884. Dufey suggests that the niche heads in it are dated to the first half of the fifth century (and Coquin and Martin give a similar date), while noting that Doresse had dated them to after the Arab conquest.

110. Wace *et al. op. cit.* (n. 67); M. Baranski, 'The archaeological setting of the Great Basilica Church at el-Ashmunein', in D.M. Bailey, ed., *Archaeological Research in Roman Egypt*, *JRA* suppl. 19 (Ann Arbor 1996) 98–106; M. Baranski *et al.*, *Reports From Ashmunein*, vol. 2 (Warsaw 1992) with detailed fold out site plan; Grossmann *loc. cit.* (n. 47) 82–4; *CE* 285–8; Capuani *L'Égypte copte* 152–3, pl. 60; Grossmann *Architektur* 441–3, fig. 59.

111. References Ch. 8 n. 71.

112. A.H.S. Megaw, 'Ἡ Βασιλικὴ τῆς Ἑρμουπόλεως' in *Πεπραγμενα του Θ´ Διεθνους Βυζαντινολογικου Συνεδριου. Θεσσαλονικη 1953*, vol. 1 (Athens 1955) 287–95, pl. 55.1, 56.1; Wace *et al. op. cit.* (n. 67) pl. 24.2–3; Deichmann *op. cit.* (n. 62) 60–2; Pensabene *Elementi Aless.* 396, pl. 48 nos. 388–91. Megaw considered all the capitals from the church were of one date, despite their variety, and dated them to the end of the fourth century: in Wace *et al. op. cit.* (n. 67) 64–5, 79.

113. Capitals from the upper and lower orders of the nave, and a large anta: Megaw *loc. cit.* (n. 112) fig. 56.2; Wace *et al. op. cit.* (n. 67) 64–7, pl. 24.1, 6, 27.8, 10; Severin *loc. cit.* (n. 18) pl. 276c; Pensabene *Elementi Aless.* 438–9 nos. 559–62, pl. 65.559–60, 562, 66.561. Other capitals: Pensabene *Elementi Aless.* 439–40, pl. 66 nos. 563–7. The capitals have long floppy lobes on the acanthus leaves which also occur on the acanthus column base, vine frieze and coffering: Wace *et al. op. cit.* (n. 67) pl. 26.1, 3, 6, 27.2–3A. Four of the niche heads can be related to each other based on the detail of the bead and reel on them: Wace *et al. op. cit.* (n. 67) 68–70, pl. 25.2–4; Pensabene *Elementi Aless.* 535, pl. 108 no. 1014; McKenzie *loc. cit.* (n. 99) 137, fig. 4c, 5f. The details of the beads are different, and the vine scrolls do not relate to the other fragments, on: Wace *et al. op. cit.* (n. 67) pl. 25.1; Pensabene *Elementi Aless.* 535–6, pl. 108 no. 1016. There is no reason why the four matching niche heads could not have come from the church.

114. Severin *loc. cit.* (n. 18) 249, pl. 276c; Severin *loc. cit.* (n. 17) 320–1, fig. 3; Pensabene *Elementi Aless.* 438–40.

115. In upper part of fill in well 'pottery sherds and coins from the end of the 5th century AD': M. Baranski, 'Excavations at the Basilica Site at el-Ashmunein/ Hermopolis Magna in 1987–1990', *PAM* 3 (1991) 21. Baranski dates the abandonment of the well to the mid-fifth century AD (*loc. cit.*, n. 110, 102). Excavator's expectations of date: M. Baranski, 'Preserving the Christian Basilica of el-Ashmunein', *BIFAO* 90 (1990) 42. The coins are from the end of the fifth century. D. Bailey (pers. com. 2001) considers the unpublished drawings of some of the pottery include pots dating from the mid-fourth to the fifth century AD. The basis for the construction date of previous scholars (*c.* AD 410–40) was based on the theory of a typological development of the plan, placing it between the Great Basilica at Abu Mina which was a transept church (then dated to *c.* 412) and the White Monastery near Sohag (*c.* AD 440): Wace *et al. op. cit.* (n. 67) 75–8.

116. P. Grossmann, 'Die Querschiffbasilika von Hauwarīya und die übrigen Bauten dieses Typus in Ägypten als Repräsentanten der verlorenen frühchristlichen Architektur Alexandrias', *BSAA* 45 (1993) 107 21; Capuani *L'Égypte copte* 22 3, fig. 2; Grossmann *Architektur* 393–4, fig. 9 (probably sixth century); H. Szymanska and K. Babraj, 'Marea Fourth Season of Excavations', *PAM* 15 (2003) 56–62, fig. 3–11 (provisionally fifth or sixth century AD). Other buildings at Marea: *CE* 1211–12 Hawwāriyyah; Grossmann *Architektur* 394–5.

117. Grossmann *loc. cit.* (n. 47) 84.

118. J.W. Crowfoot, *Early Churches in Palestine* (London 1941) fig. 16. A smaller church at Abila in Jordan has a related plan: W.H. Mare, 'The 1994 and 1995 Seasons of Excavations at Abila of the Decapolis', *ADAJ* 40 (1996) 263 fig. 4.

119. R. el-Taher and P. Grossmann, 'Excavation of the Circular Church at Faramā-West', *MDIK* 53 (1997) 255–62; P. Grossmann and M. Hafiz, 'Results of the 1995/96 Excavations in the North-West Church of Pelusium (Faramā-West)', *MDIK* 54 (1998) 177–82; Grossmann *Architektur* 470–1, fig. 88.

120. Grossmann and Hafiz *loc. cit.* (n. 119) 182. Although further excavations failed to reveal the location of the sanctuary, because there is a baptistery it therefore does appear to be a church complex. Thus, the architectural comparisons with circular churches, as structures, remain valid: el-Taher and Grossmann *loc. cit.* (n. 119) 255. Lateran Bapistery, Rome, first phase beginning of fourth century, diam. *c.* 20 m: A. Claridge, *Rome, An Oxford Archaeological Guide* (Oxford 1998) 347, fig. 173. S. Stefano Rotondo, Rome, consecrated AD 468–83, outer diameter *c.* 66 m: *ibid.* 308, fig. 151–2. Example at Bethshan (ancient Scythopolis), diam. *c.* 39 m: Crowfoot *op. cit.* (n. 118) 99, fig. 30; Krautheimer *Byz. Archit.* 77–8.

121. Krautheimer *Byz. Archit.* 60–6, 77, fig. 26, 27B.

122. J. Patrich, 'The Early Church of the Holy Sepulchre in the Light of Excavations and Restoration', in Y. Tsafrir, ed., *Ancient Churches Revealed* (Jerusalem 1993) plan on p. 102; M. Biddle, *The Tomb of Christ* (Stroud 1999) fig. 62, 63a.

123. Crowfoot *op. cit.* (n. 118) fig. 2; Y. Tsafrir, 'The Development of Ecclesiastical Architecture in Palestine', in Y. Tsafrir, ed., *Ancient Churches Revealed* (Jerusalem 1993) figs. on p. 7.

124. el-Taher and Grossmann *loc. cit.* (n. 119) 256. Types of baptisteries in Egypt, with diagrams: *CE* 197–200. According to P. Grossmann (pers. com. 2002) there are examples of cruciform baptisteries at Coptos and Kurum tuwal (Maryut).

125. el-Taher and Grossmann *loc. cit.* (n. 119) 256, 260, pl. 36b–f. Comparative examples, some with wind-blown leaves but the same cutting of the acanthus: Kautzsch *Kapitellstudien* 125–50, pl. 25–9; Krautheimer *Byz. Archit.* fig. 51–2, 56, 83, 91. Example from Alexandria with similar 'fine-toothed' cutting on the leaves on two-zone (zoomorphic) capital, from Mosque of Ibrāhīm at-Tarbānā: Pensabene *Elementi Aless.* 466 no. 673, pl. 76.673. The capitals at Pelusium were found reused in the mediaeval

chapel in the crypt, and the excavators use them to suggest the date of the church of the late fifth century or early sixth century: el-Taher and Grossmann *loc. cit.* (n. 119) 260; Grossmann *Architektur* 471 (second half of the fifth century).

126. Grossmann and Hafiz *loc. cit.* (n. 119) 179, pl. 17b–c. The excavators used them to suggest that the walkway of the circular structure was two storeys high, although no remains of a staircase were found.

127. *CE* 206; Pensabene *Elementi Aless.* 347 no. 158, pl. 23.158.

128. The exact identity and origins of St Menas, if he existed at all, are uncertain: Drescher *Apa Mena* i–x; M. Krause in *CE* 1589–90. Arabic texts: F. Jaritz, *Die arabischen Quellen zum Heiligen Menas* (Heidelberg 1993).

129. Z. Kiss, *Les Ampoules de Saint Ménas découvertes à Kôm el-Dikka (1961–1981)*, *Alexandrie* V (Warsaw 1989) 14–18; G.R. Delahaye, 'La Diffusion des ampoules de Saint-Menas en Gaule', *Le Monde copte* 27–8 (1997) 155–65. Types not represented at Kom el-Dikka, possibly AD 400–480, before the examples from the Kom el-Dikka strata: N.L. Lapp, 'Some Byzantine Pilgrim Flasks in the Pittsburgh Theological Seminary Bible Lands Museum', in L.E. Stager *et al.*, eds., *The Archaeology of Jordan and Beyond, Essays in Honour of J.A. Sauer* (Winonalake, Indiana 2000) 227–89.

130. The scientific excavations since 1961 have revealed that the archaeological evidence for the building phases was much more complex than previously thought. Ward-Perkins' analysis (cited below) of the chronology was based on reconciling the archaeological evidence with the then newly published written sources, which he quotes at length, without the benefit of this more recent archaeological analysis.

Archaeological explorations of the site: C.M. Kaufmann, *Die Ausgrabung der Menas-Heiligtümer in der Mareotiswüste*, vol. 1–3 (Cairo 1906–8); K.M. Kaufmann, *Die Menasstadt und das Nationalheiligtum der altchristlichen Aegypter*, vol. 1 (Leipzig 1910); Breccia *Musée gréco-romain 1931–2*, 23, pl. 8.31–10.35; F.W. Deichmann, 'Zu den Bauten der Menas-Stadt', *AA* (1937) 75–86; J.B. Ward-Perkins, 'The Shrine of St Menas in Maryût', *PBSR* 17 (1949) 26–71; P. Labib, 'Fouilles du Musée copte à Saint-Ménas, première campagne', *Bulletin de l'Institut d'Égypte* 34 (1953) 133–8; H. Schläger, 'Abu Mena. Vorläufiger Bericht', *MDIK* 19 (1963) 114–20; idem, 'Die neuen Grabungen in Abu Mena', in K. Wessel, ed., *Christentum am Nil* (Recklinghausen 1964) 158–73; idem, 'Abu Mena. 2. Vorläufiger Bericht', *MDIK* 20 (1965) 122–5; W. Müller-Wiener, 'Abu Mena. 3. Vorläufiger Bericht', *MDIK* 20 (1965) 126–37; idem, 'Abu Mena. 4. Vorläufiger Bericht', *MDIK* 21 (1966) 171–87; idem, 'Abu Mena. 5. Vorläufiger Bericht', *MDIK* 22 (1967) 206–24; W. Müller-Wiener, and P. Grossmann, 'Abu Mena. 6. Vorläufiger Bericht', *AA* (1967) 457–80; P. Grossmann *et al.*, 'Abu Mena. Siebenter vorläufiger Bericht', *MDIK* 26 (1970) 55–82; P. Grossmann, 'Abu Mena. Achter vorläufiger Bericht. Kampagnen 1975 und 1976', *MDIK* 33 (1977) 35–45; P. Grossmann and H. Jaritz, 'Abū Mīna. Neunter vorläufiger Bericht. Kampagnen 1977, 1978 und 1979', *MDIK* 36 (1980) 203–27; P. Grossmann *et al.*, 'Abū Mīna. Zehnter vorläufiger Bericht. Kampagnen 1980 und 1981', *MDIK* 38 (1982) 131–54; P. Grossmann, 'The "Gruftkirche" of Abū Mīna During the Fifth Century AD', *BSAC* 25 (1983) 67–71; P. Grossmann *et al.*, 'Abū Mīna. Elfter vorläufiger Bericht. Kampagnen 1982 und 1983', *MDIK* 40 (1984) 123–51; P. Grossmann, *Abu Mina, a Guide to the Ancient Pilgrimage Center* (Cairo 1986); G. and H.-G. Severin *op. cit.* (n. 18); Grossmann *Abu Mina* I; M. Abd'al Aziz Negm and J. Kościuk, 'The Private Roman Bath found at Abu Mina (Egypt) Nearby', in *Akten des XIII internationalen Kongresses für klassische Archäologie, Berlin 1988* (Mainz 1990) 442–5; P. Grossmann in *CE* 24–9; P. Grossmann and J. Kościuk, 'Report on the Excavation at Abu Mina in Autumn 1989', *BSAC* 30 (1991) 65–75; P. Grossmann *et al.*, 'Abū Mīnā 12. vorläufiger Bericht. Kampagnen 1984–1986', *AA* (1991) 457–86; M. Abdel-Aziz Negm, 'Recent Discoveries at Abu-Mina', *BSAA* 44 (1991) 226–33; P. Grossmann and J. Kościuk, 'Report on the Excavations at Abu Mina in Autumn 1990', *BSAC* 31 (1992) 31–41; J. Kościuk, 'Some Early Medieval Houses in Abū Mīna', in M. Rassart-Debergh and J. Ries, eds., *Actes du IVe Congrès copte, Louvain-la-Neuve 1988*, vol. 1 (Louvain 1992) 158–67; P. Grossmann and J. Kościuk, 'Report on the Excavations at Abū Mīnā in Autumn 1991', *BSAC* 32 (1993) 73–84; M. Abdel-Aziz Negm, 'Recent Discoveries at Abū Mīnā', *BSAC* 32 (1993) 129–37; P. Grossmann *et al.*, 'Report on the Excavations at Abu Mina in Spring 1993', *BSAC* 33 (1994) 91–104; P. Grossmann, 'Report on the Excavations at Abū Mīnā in Spring 1994', *BSAC* 34 (1995) 149–59; P. Grossmann *et al.*, 'Abū Mīnā. 13. vorläufiger Bericht. Kampagnen 1987–1989', *AA* (1995) 389–423; P. Grossmann *et al.*, 'Report on the Excavations at Abu Mina in Spring 1995', *BSAC* 36 (1997) 83–98; P. Grossmann, 'Prokopius zu *Taposiris Magna* eine Verwechslung mit Abū Mīnā?', *Antiquité tardive* 8 (2000) 165–8; idem, *Abū Mīnā II Das Baptisterium* (Mainz 2004).

Summary of evidence: P. Grossmann, 'The Pilgrimage Center of Abû Mînâ', in D. Frankfurter, ed., *Pilgrimage and Holy Space in Late Antique Egypt* (Leiden 1998) 281–302; Capuani *L'Égypte copte* 24–30, fig. 4–5, pl. 1; Grossmann *Architektur* 401–12, 489–91, fig. 15–22, 103–5.

131. Drescher *Apa Mena* xxxiii–xxxvi; Ward-Perkins *loc. cit.* (n. 130) 30.

132. Drescher *Apa Mena* 144–5; Ward-Perkins *loc. cit.* (n. 130) 32.

133. Drescher *Apa Mena* 145–6; Ward-Perkins *loc. cit.* (n. 130) 33.

134. Fragment of a sermon of Cyril of Alexandria in G. Zoega, *Catalogus codicum copticorum* (Rome 1810) Cod. xxix, p. 50–1.

135. The Coptic patriarch Michael I (AD 744–68) is quoted as saying: 'Theophilus founded it and set up its rows of pillars, for there is his name written upon them; and when he died, Timothy erected the remainder, since there is his name inscribed': Severus ibn el-Muqaffa, ed. tr. B. Evetts, *PO* V, 132; Ward-Perkins *loc. cit.* (n. 130) 33.

136. Drescher *Apa Mena* 146–8; Ward-Perkins *loc. cit.* (n. 130) 33–4. An Arabic version of the text has 'Ioustiānous for Anastasius: Drescher *Apa Mena* 148 n. 1.

137. The identification of early fourth-century amphora sherds has since turned out to be wrong, P. Grossmann (pers. com. 2002) correcting: Grossmann and Kościuk *loc. cit.* 1991 (n. 130) 67. Cenotaph: Grossmann, *Abu Mina* I 13, 16–17, fig. 1, pl. 3–4; *CE* 25; Grossmann *loc. cit.* 1998 (n. 130) 282.

138. Grossmann *et al. loc. cit.* 1982 (n. 130) 135, fig. 3; Grossmann *Abu Mina* I, 13–14, 17–22, fig. 2–2B, pl. 10; *CE* 25–6.

139. Grossmann *loc. cit.* 1977 (n. 130) 43; Grossmann *Abu Mina* I, 14, 23–38, fig. 54, plan 1–2, 3.1. He dates it to not before the second quarter of the fifth century in *CE* 26. He dated it to the first half of the fifth century based on the pottery: Grossmann *Abu Mina* I 23 n. 30.

140. Additional steps were cut for the entrance to the crypt as well as additional chambers in the crypt: Grossmann *Abu Mina* I fig. 57, plan 1–2, 3.6.

141. Grossmann *loc. cit.* 1983 (n. 130) 68–9; Grossmann *Abu Mina* I 14, 38–50, plan 3.4–5.

142. Grossmann dates this to the last quarter of the fifth century: Grossmann *loc. cit.* 1983 (n. 130) 69; Grossmann *Abu Mina* I, 50–60, plan 3.6.

143. North porch: Grossmann *Abu Mina* I 60–3, plan 3.6. It is stratigraphically before the Great Basilica: Grossmann *et al. loc. cit.* 1984 (n. 130) 134; Grossmann *Abu Mina* I plan 1.

144. The earliest layers belong to the late fourth century AD: Schläger *loc. cit.* 1963 (n. 130) 116; Grossmann and Kościuk *loc. cit.* 1991 (n. 130) 66.

145. Recent excavations have revealed that there was apparently a room at either end of the transept, entered from the transept, beyond what had previously been thought to be the end walls of the transept: Grossmann *loc. cit.* 1995 (n. 130) 149–51, fig. 1. These walls had a door, not columns, because the foundations would not have supported them (P. Grossmann pers. com. 2002). Earlier plan: Grossmann *Abu Mina* I plan 3.7, 3A. Grossmann notes the earliest this phase can be dated is late in the second half of the fifth century: Grossmann *et al. loc. cit.* 1984 (n. 130) 134. He also states: 'Unfortunately we still do not know the exact date of the foundation of the Great Basilica. However, it may be placed roughly in the last quarter of the fifth century': Grossmann *loc. cit.* 1983 (n. 130) 70. Grossmann *op. cit.* 1986 (n. 130) 13; *CE* 26–7. Connection to Martyr Church: Grossmann *Abu Mina* I 70–6.

146. Grossmann and Kościuk *loc. cit.* 1992 (n. 130) 32–4, fig. 1a.

147. Rooms on either side of apse: Grossmann and Jaritz *loc. cit.* 1980 (n. 130) 212, fig. 4; *CE* 27. Recent work has indicated that there were two stages to the second phase as the two new stylobates at either end of the transept do not seem to have been part of the original second phase as their masonry was different to it, but similar to the masonry foundations of the sixth-century Martyr Church. The small apses in the end of each transept were also added later: Grossmann and Kościuk *loc. cit.* 1992 (n. 130) 34–5, pl. 2.

148. The relationship of the circular openings of the cistern to the new transept walls is marked on: Schläger *loc. cit.* 1965 (n. 130) 123, fig. 1. Details of pottery from cistern, which includes types which developed by the end of the third quarter of the fifth century: Müller-Wiener *loc. cit.* 1966 (n. 130) 186–7. The evidence from the cistern should still provide a *terminus post quem* for the second phase of the Great Basilica despite the comment rejecting it as now providing any date for the Great Basilica in: Grossmann and Kościuk *loc. cit.* 1992 (n. 130) 34.

149. Müller-Wiener *loc. cit.* 1966 (n. 130) 186–7.

150. References for St Peter's Basilica and Lateran Basilica in Rome: see n. 50 above.

151. Krautheimer *Byz. Archit.* 132–5, 256–7, fig. 79, 196.

152. Grossmann *Abu Mina* I fig. 79, plan 4.

153. Grossmann and Jaritz *loc. cit.* 1980 (n. 130) 210–11, fig. 2; Grossmann *et al. loc. cit.* 1982 (n. 130) 138, fig. 5; Grossmann *Abu Mina* I 211–42, fig. 65, 79, plan 4–6, 12–13A.

154. Grossmann *Abu Mina* I 15, 97–151, 156–73, fig. 79, plan 4–8; Grossmann *loc. cit.* 1998 (n. 130) 284–6.

155. Müller-Wiener *loc. cit.* 1965 (n. 130) 133–7, fig. 3–4.

156. The tetraconch version of the Martyr Church is dated to not before AD 532, based on the pottery: Grossmann *Abu Mina* I 15, 97. The former eastern annex of it was remodelled at the same time into what Grossmann considers a narthex: Grossmann *Abu Mina* I 118. The crypt was also remodelled at the same time: Grossmann *Abu Mina* I 211–12. Baptistry rebuilt in the second quarter of the sixth century: Grossmann *Abu Mina* I 15, 116.

157. Grossmann *Abu Mina* I 151–6, fig. 42; Grossmann *loc. cit.* 1998 (n. 130) 296–7.

158. Grossmann *op. cit.* (n. 51) 107, fig. 42; Grossmann *Abu Mina* I 16, 173–86, plan 9–11. Date: Grossmann *Abu Mina* I 183; Grossmann *loc. cit.* 1998 (n. 130) 297–8.

159. Severus ibn el-Muqaffa, ed. tr. B. Evetts, *PO* V 119–32 [373–86]; Drescher *Apa Mena* xxiii–xxv; Ward-Perkins *loc. cit.* (n. 130) 33, 35.

160. Severus ibn el-Muqaffa, ed. tr. B. Evetts, *PO* X, 451 [565]; Drescher *Apa Mena* xxv–xxvi; Ward-Perkins *loc. cit.* (n. 130) 34–5.

161. Severus ibn el-Muqaffa, ed. tr. B. Evetts, *PO* X, 512–15 [626–9]; Drescher *Apa Mena* xxvi–xxvii; Ward-Perkins *loc. cit.* (n. 130) 35; Grossmann *Abu Mina* I 182. P. Grossmann (pers. com. 2002) notes the columns of the Great Basilica were so damaged by fire (by the Persians in AD 619) they were not fit for reuse and are still at the site.

162. Drescher *Apa Mena* xxviii–xxxi; Ward-Perkins *loc. cit.* (n. 130) 36–7; Grossmann *Abu Mina* I, 16, 185. On identity of Abu Salih, who mentions that it still contained the body of the saint in the late twelfth century: U. Zanetti, 'Abu l-Makarim et Abu Salih', *BSAC* 34 (1995) 85–138; M. Martin, 'Alexandrie chrétienne à la fin du XIIᵉ siècle d'après Abū l-Makârim', in C. Décobert and J.-Y. Empereur, eds., *Alexandrie médiévale* 1, *ÉtAlex* 3 (1998) 45. Archaeological evidence of occupation of the site from the eleventh century: Grossmann and Kościuk *loc. cit.* 1992 (n. 130) 40; Grossmann *et al. loc. cit.* 1995 (n. 130) 422; Grossmann *loc. cit.* 1998 (n. 130) 298. Detailed description of seventh–eleventh century occupation with plan: Grossmann *et al. loc. cit.* 1995 (n. 130) 409–22, fig. 16.

163. They were carved as one block together with an attic column base: Ward-Perkins *loc. cit.* (n. 130) 63, pl. 7.1; H.-G. Severin in Grossmann *et al. loc. cit.* 1984 (n. 130) 149–50; G. and H.G. Severin *op. cit.* (n. 18) 28, fig. 17.

164. Ward-Perkins *loc. cit.* (n. 130) 64, pl. 7.2; H.-G. Severin in Grossmann *et al. loc. cit.* 1984 (n. 130) 150; G. and H.G. Severin *op. cit.* (n. 18) 28, fig. 16; Grossmann *Abu Mina* I, fig. 20–1.

165. There are 188 capitals and fragments, of which two-thirds were found in the immediate vicinity of the Tomb Church and Great Basilica: Kaufmann *op. cit.* 1910 (n. 130) pl. 66–71; Kautzsch *Kapitellstudien* 26, 29–31, 33–9, nos. 50, 60, 73, 79, 82–3, 100, 108–9, 112, 122, 128–9, 133, 138, 152–3, pl. 6–9; Ward-Perkins *loc. cit.* (n. 130) 62–71, pl. 9.4, 10.1, 3–5; G. Severin in Grossmann *et al. loc. cit.* 1984 (n. 130) 150–1; G. and H.-G. Severin *op. cit.* (n. 18); Grossmann and Kościuk *loc. cit.* 1992 (n. 130) 38, pl. 3b–c; Pensabene *Elementi Aless.* 407–8 nos. 441–3, pl. 53.441–3, p. 413 no. 457, pl. 55.457, p. 419 no. 480, pl. 57.480, p. 420 no. 486, pl. 57.486, p. 422 no. 493, pl. 58.493, p. 428 nos. 521–2, pl. 61.521–2, p. 431 nos. 534–534A, pl. 62.534–534A, p. 433 no. 545, pl. 63.545, p. 467 no. 676, pl. 76.676, p. 468 no. 679, pl. 77.679.

166. G. Severin in Grossmann *et al. loc. cit.* 1984 (n. 130) 151. For example: G. and H.G. Severin *op. cit.* (n. 18) 34, 36, 40–2, fig. 26, 29–31, 35–40. The examples in Kautzsch (cited in n. 165) are all dated by him to this period. The dates given by Pensabene (cited in n. 165) range from the late third to the first half of the sixth century.

167. Kautzsch *Kapitellstudien* pl. 5–9; Ward-Perkins *loc. cit.* (n. 130) 66–7.

168. For example: G. and H.G. Severin *op. cit.* (n. 18) 32–3, fig. 22, 24. An example with Ptolemaic type helices: Kaufmann *op. cit.* 1910 (n. 130) pl. 66.7, 67.6. An example of the mid- to late second century AD: Kaufmann *op. cit.* 1910 (n. 130) pl. 22, 68 lower right.

169. Ward-Perkins *loc. cit.* (n. 130) 64–5. P. Grossmann (pers. com. 2002) notes 'the whole marble decoration at Abu Mina consists of reused material, except for the few octagonal pedestals in the lateral conches (only two fragments survive) of the Tomb Church'.

170. G. Severin in Grossmann *et al. loc. cit.* 1984 (n. 130) 151.

171. Grossmann *Abu Mina* I 69–70, fig. 14, pl. 55a.

172. Grossmann *et al. loc. cit.* 1970 (n. 130) 63–9, fig. 4–5; Grossmann and Jaritz *loc. cit.* 1980 (n. 130) 212, fig. 4; Grossmann *et al. loc. cit.* 1982 (n. 130) 143–5, fig. 8; Grossmann and Kościuk *loc. cit.* 1991 (n. 130) 66, 69, fig. 2; Grossmann and Kościuk *loc. cit.* 1992 (n. 130) 37–8; Grossmann *et al. loc. cit.* 1995 (n. 130) 407–8, fig. 15; Grossmann *loc. cit.* 1998 (n. 130) 290–1.

173. Grossmann *et al. loc. cit.* 1984 (n. 130) 134–8, fig. 3–4; Grossmann *op. cit.* 1986 (n. 130) 19; Grossmann *et al. loc. cit.* 1991 (n. 130) 473–6, fig. 13; Grossmann *loc. cit.* 1998 (n. 130) 288–90.

174. 'The Pilgrim Court': Grossmann *et al. loc. cit.* 1982 (n. 130) 139–41, fig. 6; Grossmann *et al. loc. cit.* 1984 (n. 130) 138–47, fig. 5–9; Grossmann *et al. loc. cit.* 1991 (n. 130) 468–73, fig. 8; Grossmann *et al. loc. cit.* 1995 (n. 130) 401–5, fig. 11.

175. Grossmann *et al. loc. cit.* 1984 (n. 130) 147–9, fig. 3; Grossmann *op. cit.* 1986 (n. 130) fig. 1; Grossmann *et al. loc. cit.* 1991 (n. 130) 458A, fig. 1; Grossmann *et al. loc. cit.* 1995 (n. 130) 390–3, fig 1–2; Grossmann *loc. cit.* 1998 (n. 130) 287.

176. Peristyle Complex and adjoining buildings: Grossmann *et al. loc. cit.* 1970 (n. 130) 59–60, fig. 2; Grossmann and Kościuk *loc. cit.* 1991 (n. 130) 67–8, fig. 1; Grossmann and Kościuk *loc. cit.* 1993 (n. 130) 78–80, fig. 3; Grossmann *et al. loc. cit.* 1994 (n. 130) 91, 95–9, fig. 4; Grossmann *et al. loc. cit.* 1995 (n. 130) 398–401, fig. 8; Grossmann *et al. loc. cit.* 1997 (n. 130) 83–6, fig. 1; Grossmann *loc. cit.* 1998 (n. 130) 287. North Baths, also called the 'Palace', finished *c.* AD 500: Müller-Wiener *loc. cit.* 1967 (n. 130) 209–16, fig. 2; T. Schioler, *Roman and Islamic Water-lifting Wheels* (Odense 1973) 135–6, fig. 96; J.P. Oleson, *Greek and Roman Mechanical Water-lifting Devices* (Toronto 1984) 174, 180, 182–3, 364, 384, fig. 39; Grossmann *op. cit.* 1986 (n. 130) 22–3, fig. 7.

The large Double Bath, also called the 'Bath-Basilica', was begun in the fifth century and altered a number of times, and completed in the sixth century: Kaufmann *op. cit.* 1908 (vol. 3) (n. 130) 7–20; Müller-Wiener *loc. cit.* 1965 (n. 130) 127–33, fig. 1; Müller-Wiener *loc. cit.* 1967 (n. 130) 209; Müller-Wiener and Grossmann *loc. cit.* 1967 (n. 130) 458–60, fig. 1; Schioler *op. cit.* 131–5, fig. 90–5; Oleson *op. cit.* 134, 174, 180–2, 203, 289, 364, fig. 37; Grossmann *op. cit.* 1986 (n. 130) 20–1, fig. 6; Grossmann *et al. loc. cit.* 1995 (n. 130) 423.

177. Grossmann *et al. loc. cit.* 1991 (n. 130) 460–8, fig. 3–7; Grossmann and Kościuk *loc. cit.* 1993 (n. 130) 74–8, fig. 2; Grossmann *et al. loc. cit.* 1994, 92–5, fig. 1–2; Grossmann *et al. loc. cit.* 1995 (n. 130) 393–8, fig. 2–7; Grossmann *loc. cit.* 1998 (n. 130) 294–5.

178. Kaufmann *op. cit.* 1907 (vol. 2) (n. 130) 81–106; Grossmann *et al. loc. cit.* 1970 (n. 130) 69–74, fig. 6–8; Grossmann *loc. cit.* 1977 (n. 130) 43–5, fig. 4; Grossmann and Jaritz *loc. cit.* 1980 (n. 130) 216–22, fig. 5; Grossmann *et al. loc. cit.* 1982 (n. 130) 145–50, fig. 9–10; Grossmann *op. cit.* 1986 (n. 130) 23–4, fig. 8; *CE* 27–8; Grossmann *loc. cit.* 1998 (n. 130) 295. Date: *CE* 28. There was an earlier structure under it: Grossmann and Jaritz *loc. cit.* 1980 (n. 130) 220–2, fig. 6. Marble Ionic and Corinthian capitals found near it: Kaufmann *op. cit.* 1907 (vol. 2) (n. 130) fig. 2, 36–7.

179. Grossmann *et al. loc. cit.* 1970 (n. 130) 76–82, fig. 9; Grossmann *loc. cit.* 1977 (n. 130) 35–8, fig. 1–2; Grossmann and Jaritz *loc. cit.* 1980 (n. 130) 222–4, fig. 7–8; Grossmann *op. cit.* 1986 (n. 130) 24–6; *CE* 28–9; Grossmann *loc. cit.* 1998 (n. 130) 296. Date: Grossmann *et al. loc. cit.* 1970 (n. 130) 79; Grossmann *op. cit.* 1986 (n. 130) 25; *CE* 29.

The first version of the East Church was a small three-aisled basilica with an apse protruding from the east wall, to which a baptistery was added: Grossmann and Jaritz *loc. cit.* 1980 (n. 130) 223–4, fig. 8, pl. 49c.

180. P. Grossmann, 'Die zweischaligen spätantiken Vierkonchenbauten in Ägypten und ihre Beziehung zu den gleichartigen Bauten in Europa und Kleinasien', in G. Grimm *et al.* eds., *Das römisch-byzantinische Ägypten* (Mainz 1983) 167–73; Grossmann *op. cit.* 1986 (n. 130) 26; *CE* 222. S. Lorenzo, Milan: Krautheimer *Byz. Archit.* 82–6, fig. 35–7. Seleucia-Pieria (Samandağ): Krautheimer *Byz. Archit.* 146–7, fig. 93.

181. Grossmann *loc. cit.* (n. 47) 82; *CE* 196. Athanasius, *Historia acephala* 5.4, ed. tr. Martin and Albert 162.

182. P. Grossman and J. Pfeiffer, 'Report on the Excavations at Abu Mina in Spring 2002', *BSAC* 42 (2003) 30–7, pl. 9–11.

183. Churches of Old Cairo: Butler *op. cit.* (n. 51); C. Coquin, *Les Édifices chrétiens du Vieux-Caire*, vol. 1, *Bibliographie et topographie historiques* (Cairo 1974); Grossmann *op. cit.* (n. 51) 13–16, 45–8, fig. 5, 15A–C, pl. 13a; Grossmann *loc. cit.* 1989 (n. 46) 1857–9, fig. 6a–b; *CE* 317–23, 557–60; G. Gabra, *Cairo, the Coptic Museum and Old Churches* (Cairo 1993) 113–39, fig. 1–19, site map on p. 112; Capuani *L'Égypte copte* 81–8, 105–8, fig. 32–40, pl. 23–30; Grossmann *Architektur* 505–7, fig. 122.

184. Coquin *op. cit.* (n. 183) 83–5, 110–11, 127–30, pl. 6–7; Gabra *op. cit.* (n. 183) 93, 96–7, 102–3; *CE* 2332, 2343. Date of al-Mu'allaqa lintel, with references: J.-L. Fournet, 'L'Inscription grecque de l'église al-Mu'allaqa. Quelques corrections', *BIFAO* 93 (1993) 237–44.

185. Identification of Apa Apollo, and dates of monastery: J. Clédat, 'Baouït', in F. Cabrol and H. Leclercq, eds., *Dictionnaire d'archéologie chrétienne et de liturgie*, vol. 2.1 (Paris 1925) col. 203–10; H. Torp, 'La Date de la fondation du monastère d'Apa Apollô de Baouît et de son abandon', *MEFRA* 77 (1965) 153–77; M. Krause, 'Bawit', in K. Wessel, ed., *Reallexikon zur byzantinischen Kunst*, vol. 1 (Stuttgart 1966) col. 568–75; *CE* 362–4. On whether Bawit and Titkooh are the same: S.J. Clackson, *Coptic and Greek Texts Relating to the Hermopolite Monastery of Apa Apollo* (Oxford 2000) 3–9. Inscription of AD 961: J. Clédat, *Le Monastère et la nécropole de Baouît*, ed. D. Bénazeth and M.-H. Rutschowscaya, *MIFAO* 111 (Paris 1999) 210 no. X.

186. History of excavations: D. Bénazeth, 'Histoire des fouilles de Baouît', *Études Coptes* IV (Louvain 1995) 53–62. History of dispersal of pieces, and list of those in Egypt: D. Bénazeth, 'Un monastère dispersé. Les Antiquitiés de Baouît conservées dans les musées d'Égypte', *BIFAO* 97 (1997) 43–66. Nothing remains of the building at the site: D. Bénazeth, 'Les Avatars d'un monument copte: l'Église sud de Baouît', in M. Krause and S. Schaten, eds., *ΘEMEΛIA, spätantike und koptologische Studien Peter Grossmann zum 65. Geburtstag* (Wiesbaden 1998) 37.

187. Chassinat *Baouît*.

188. Clédat *loc. cit.* (n. 185) col. 216–21, fig. 1257, 1260–2.

189. Clédat *loc. cit.* (n. 185) col. 219.

190. Clédat *loc. cit.* (n. 185) col. 220, 221.

191. Clédat *loc. cit.* (n. 185) col. 218–19.

192. Kitzinger *loc. cit.* (n. 2) 190; Ward-Perkins *loc. cit.* (n. 130) 61; M.H. Torp, 'Byzance et la sculpture copte du VIᵉ siècle à Baouît et Sakkara', in A. Grabar *et al.*, *Synthronon* (Paris 1968) 11.

193. H.G. Severin, 'Zur Süd-Kirche von Bawīt', *MDIK* 33 (1977) 113–24; Severin *loc. cit.* 1981 (n. 1) 309–11; A. Effenberger, 'Scultura e arte minore copta', *FelRav* 121–2 (1981) 80–7, 95–6; Pensabene *Elementi Aless.* 300; Bénazeth *loc. cit.* 1998 (n. 186) 34. Revised dates (correcting earlier suggestion that the first phase was built in the fourth century): H.G. Severin, 'Beispiele der Verwendung spätantiker Spolien', in O. Feld and U. Peschlow, eds., *Studien zur spätantiken und byzantinischen Kunst F.W. Deichmann gewidmet*, vol. 2 (Bonn 1986) 101 n. 4. Summary, with revised dates: H.G. Severin, *CE* 364.

194. Acceptance of Severin's theory: Thomas *loc. cit.* (n. 7) 61 n. 19; Török *loc. cit.* 1990 (n. 2) 438; Capuani *L'Égypte copte* 171; Grossmann *Architektur* 171, 177, 249–50, 321–2, 523–5, fig. 142. Contra: H. Torp, 'Le Monastère copte de Baouît. Quelques notes d'introduction', *Acta ad archeologiam et artium historiam pertinentia* 9 (1981) 2 n. 1.

195. C. Giroire *et al.*, 'Une église égyptienne ressuscitée au Musée du Louvre', *La revue du Louvre et des Musées de France* 5/6 (1997) 95–102 with references for earlier displays of pieces in Louvre; M.-H. Rutschowscaya, 'Conques et tympans du Musée du Louvre', in M. Krause and S. Schaten, eds., *ΘEMEΛIA, spätantike und koptologische Studien Peter Grossmann zum 65. Geburtstag* (Wiesbaden 1998) 289–95; *idem*, 'Le Monastère de Baouît au Musée du Louvre', *L'archéologue, archéologie nouvelle* 43 (August–Sept 1999) 39–41.

196. Severin *loc. cit.* 1977 (n. 193) 116, 118, 119, fig. 1, pl. 34–5, 38a. See also: Chassinat *Baouît* pl. 11.3–4, 22, 36, 79–80; Clédat *loc. cit.* (n. 185) fig. 1260. The external walls on the east end, north sides and west two-thirds of the south wall (E) are marked as ashlar in Severin *loc. cit.* 1977 (n. 193) fig. 1. Severin has the exterior of the west wall marked on his plan (fig. 1) as 'not known', but ashlars are clear on the north end of it, in Chassinat *Baouît* pl. 9–10. He also has the east end of the south wall marked 'not known', but this is of ashlars in Clédat *op. cit.* (n. 185) pl. 173. This means there are published photographs of all the exterior walls except the south end of the west wall. There is no reason to believe that these walls were not of a consistent construction technique for their full length.

197. Ashlar pilasters of main order of nave on north side (C1 and C2) and main niche in east wall (H2): Severin *loc. cit.* 1977 (n. 193) 117, 118, 119, pl. 36–7a. See also Chassinat *Baouît* pl. 8–10, 60.1–2, 61–3, 76–8.

198. Inside walls C, D and F: Severin *loc. cit.* 1977 (n. 193) 117–18, 119, pl. 34a, 35–7a. See also Chassinat *Baouît* pl. 8–10, 24, 60–1, 76–7; Clédat *loc. cit.* (n. 185) fig. 1261–2.

199. Interior wall, G: Severin *loc. cit.* 1977 (n. 193) 118, 119, pl. 34a, 36a, 37a. See also: Chassinat *Baouît* pl. 8–10, 76–7.

200. Severin *loc. cit.* 1977 (n. 193) 119–20.

201. Main niche of sanctuary H2, found *in situ*, re-erected in Louvre: Chassinat *Baouît* pl. 10, 22; Severin *loc. cit.* 1977 (n. 193) 121. Main order capitals of nave re-erected in Louvre above C1, C3, F1, F3: Chassinat *Baouît* pl. 104–5. Capital re-erected in Louvre on North doorway (B1) of sanctuary: Chassinat *Baouît* pl. 54.2. This type was also found *in situ* on one of the doorways (A1) of the courtyard: Chassinat *Baouît* pl. 13–14, pl. 54.2; Severin *loc. cit.* 1977 (n. 193) 121, pl. 38b. Location of A1 etc. marked on Severin *loc. cit.* 1977 (n.193) 115 fig. 1.

202. North doorway (B3) of nave, in Louvre: Chassinat *Baouît* pl. 24, 34–6; Severin *loc. cit.* 1977 (n. 193) 123; Pensabene *Elementi Aless.* 443–4 no. 578, pl. 67.578. South doorway (E1) of nave, in Coptic Museum, Cairo (the frieze and tympanum fragments re-erected above it were found in the North Church): Duthuit *Sculpture* pl. 37a, c;

Severin *loc. cit.* 1977 (n. 193) 123, pl. 38a; Pensabene *Elementi Aless.* 445 no. 583 (wrongly labelled), pl. 67.583. Anta G2 of wall dividing nave from sanctuary: Chassinat *Baouît* pl. 92–3; Pensabene *Elementi Aless.* 444–5 no. 580, pl. 67.580. The monolithic shafts on the nave doors have attic bases, while the simple base on the half-columns of the internal wall (Chassinat *Baouît* pl. 67; Severin *loc. cit.* 1977 n. 193, 122) is similar to that on the exterior pilaster B2 (Chassinat *Baouît* pl. 23) on the north wall which was part of the original ashlar structure.

203. Chassinat *Baouît* pl. 94–5; Pensabene *Elementi Aless.* 444 no. 579, pl. 67.579.

204. The style of cutting on the leaves of them is consistent with the lower two lobes of each part of the acanthus leaf being identical. The third (top) lobe of these is either straight or tightly curved. The cutting of the acanthus leaves on these capitals is identical to that on the pilaster capitals with both leaf types occurring on the half-columns on either side of the south door: Duthuit *Sculpture* pl. 37a, c; Kitzinger *loc. cit.* (n. 2) pl. 69.3, 5; Krautheimer *Byz. Archit.* fig. 266.

205. E1: Kitzinger *loc. cit.* (n. 2) pl. 69.4; Krautheimer *Byz. Archit.* fig. 268.

206. J1, re-erected in Louvre: Chassinat *Baouît* pl. 69, 71; Severin *loc. cit.* 1977 (n. 193) 121.

207. In storeroom of Louvre: Chassinat *Baouît* pl. 109.2; N. Bosson and S.H. Aufrère, eds., *Égyptes . . . L'Égyptien et le copte* (Lattes 1999) 308 no. 131, colour pl. 131 on p. 168.

208. Re-erected in Louvre, based on dimensions of curve of niche, found in South Church: Chassinat *Baouît* pl. 73 top left.

209. Chassinat *Baouît* pl. 85–6.1.

210. Chassinat *Baouît* pl. 83. A frieze crown with the same narrow serrated leaves, apparently from a niche, is related to other frieze crowns by the distinctive four petal rosette: Chassinat *Baouît* pl. 42.3.

211. On outside of east wall: Chassinat *Baouît* pl. 69–70. On internal wall: Chassinat *Baouît* pl. 67. Quarter circle frieze crown: Severin *loc. cit.* 1977 (n. 193) 122–3. A more complex version with three, rather than two, central strands is used on the crown moulding of the friezes on the outside north wall, which are specially cut to follow the profile on pilaster B2: Chassinat *Baouît* pl. 22–4, 36.

212. A distinctive four-leafed rosette with a button carved at the centre with a raised edge is used in the centre of the frieze crown on the outside of the east wall: Chassinat *Baouît* pl. 70. The frieze crown running over pilaster B2 also has the distinctive rosette: Chassinat *Baouît* pl. 23, 42.1.

213. Chassinat *Baouît* pl. 70. The frieze below the quarter circle crown moulding has a variety of patterns carved on it: Chassinat *Baouît* pl. 23, 33.1–2.

214. Severin *loc. cit.* 1977 (n. 193) pl. 38a.

215. Chassinat *Baouît* pl. 22–32, 36, 67, 69–70, 77.1; Severin *loc. cit.* 1977 (n. 193) 122–3, pl. 38a. The serrated cutting of the leaves on these wreaths is also observed on the section of frieze with birds on it, to the right of pilaster B2 on the north wall: Chassinat *Baouît* pl. 23, 29–31. The frieze is carved to follow the profile of pilaster B2, indicating that this section of the frieze is not made of reused frieze pieces: Chassinat *Baouît* pl. 23.

216. Niche C2, re-erected in Louvre: Chassinat *Baouît* pl. 61–3, 66; Severin *loc. cit.* 1977 (n. 193) 123. The carving of the leaves on the frieze crown of this niche is the same as that used on the jamb of the north door carved beside the half-column: Chassinat *Baouît* pl. 24. They lack the intertwined stalks down the centre used on the other frieze crowns, on the outside of the building and on the dividing wall. Although the pilasters supporting this archivolt are the correct width for it, the capitals which they support are too wide for their pilasters, suggesting that they were not originally carved for them but were added, in a repair (although possibly reused): Chassinat *Baouît* pl. 61–5; Severin *loc. cit.* 1977 (n. 193) 117, 119–20, 123. It is also notable that the style of carving of their leaves is completely different to all the examples discussed so far.

217. Archivolt pieces erected on west niche F2 in Louvre: Chassinat *Baouît* pl. 73 top right. The carving of both the frieze and crown of it is much less careful than the one in the north wall, although the same basic pattern, suggesting they were made for a later repair. Archivolt pieces erected on south niche D2 in Louvre: Chassinat *Baouît* pl. 72.1. Modillion cornice: Chassinat *Baouît* pl. 79.2. Slightly different capitals of main order, erected on D1 and D3 in Louvre: Chassinat *Baouît* pl. 107.1.

218. Wall E: Severin *loc. cit.* 1977 (n. 193) 118, 119, 123, pl. 38a. The frieze and its crown do not continue to the east beyond the panel with the cross. A repair to the wall is also visible in the lower right of the photograph. A substantial repair to this side of the church could also explain why the column bases on the south side of the nave were positioned closer to this wall, out of alignment with the pilaster in the back wall [489].

In the north court (A) the wall niches and doorway A3, A4 and A5 also seem to be later repairs. A1 has pilaster capitals identical to those on the church and the ashlar masonry ends in a clean join west of pilaster A2 (Chassinat *Baouît* pl. 13). Details: Severin *loc. cit.* 1977 (n. 193) 115–16, 123, pl. 32b–33; Chassinat *Baouît* pl. 9, 11.1–2, 13, 15–21.

219. Chassinat *Baouît* pl. 83.1 and 100; Pensabene *Elementi Aless.* 464 no. 665, pl. 75.665.

220. Chassinat *Baouît* pl. 84.2, 98–101.

221. Chassinat *Baouît* pl. 102–3; Pensabene *Elementi Aless.* 464–5 no. 667, pl. 75.667.

222. In Coptic Museum Cairo, author's photograph of detail, also visible in Severin *loc. cit.* 1977 (n. 193) pl. 38a.

223. Archaising Corinthian capital: Chassinat *Baouît* pl. 96–7; Pensabene *Elementi Aless.* 447 no. 589, pl. 68.589. On the face illustrated in pl. 96 there are three rows of bead and reel: on the abacus, below it at the top of the bell, and at the base of the capital. Two-zone basket capital: Chassinat *Baouît* pl. 39; Pensabene *Elementi Aless.* 465 no. 669, pl. 75.669. These two capitals do not otherwise have details with which to definitively relate them to the carving discussed so far.

224. Kitzinger (*loc. cit.* n. 2, 190) and Ward-Perkins (*loc. cit.* n. 130, 61) accepted the sixth-century date for the Corinthian capitals, contemporary with the impost ones. Pensabene dated the nave Corinthian column capital, archaizing Corinthian capital, the half-column capitals and vine frieze to the end of the fifth or first half of the sixth century AD, and the impost capitals to the mid-sixth century: Pensabene *Elementi Aless.* 443–5, 447, 464–5, 537.

225. One block was carved to fit pilaster B2 as it follows the profile of it, re-erected in Louvre: Chassinat *Baouît* pl. 79.

226. Chassinat *Baouît* pl. 78. This modillion cornice is contemporary with the one on the exterior of the north wall, based on the details of the modillions and the carving of the four-leafed rosettes on them.

227. h. 0.97 m, w. 1.60 m. Rutschowscaya *loc. cit.* 1998 (n. 195) 292–3, 295, fig. 13, 18; Clédat *op. cit.* (n. 185) pl. 221 on p. 224.

228. Also noted in: Drioton *loc. cit.* (n. 38) 443–8, fig. 1, pl. 1–2.

229. Clédat *loc. cit.* (n. 185) col. 221–3, fig 1263–5, 1271.

230. Severin *loc. cit.* 1986 (n. 193) 101–4, fig. 1, pl. 16–17; Clédat *op. cit.* (n. 185) pl. 184–206 on p. 207–16.

231. Severin *loc. cit.* 1986 (n. 193) pl. 17.2; Clédat *op. cit.* (n. 185) pl. 216 on p. 222. The capital, in the Coptic Museum, Cairo, was already published in Duthuit *Sculpture* pl. 41a. Another capital, which has since been lost, was also found in the North Church: Torp *loc. cit.* (n. 86) 36, pl. 31.4; Clédat *op. cit.* (n. 185) pl. 206 on p. 216.

232. J. Clédat, 'Recherches sur le Kôm de Baouît', *CRAI* 1902, 545–6, pl. 4.2; Duthuit *Sculpture* pl. 37a, c; Rutschowscaya *loc. cit.* 1998 (n. 195) 292, 294, fig. 11; Clédat *op. cit.* (n. 185) pl. 207–8 on p. 219. The blocks of the archivolt and three blocks of the tympanum were found reused and walled up in the east facade of the North Church, according to Torp (*loc. cit.* n. 86, 38–9, fig. 1, plan 1) who attributed them to the South Church. According to Clédat (*loc. cit.* n. 185, col. 225, fig. 1271) the joining block with the saintly rider from the same tympanum belonged to the North Church, but according to Torp it was found in or near the South Church. New reconstruction (1997): Giroire *et al. loc. cit.* (n. 195) fig. 4. Photograph of wall *in situ*: Chassinat *Baouît* pl. 23–4 = Severin *loc. cit.* 1977 (n. 193) pl. 34b, 35. There are no leaves on the archivolt identical to those on the rest of the carving from the South Church. If the archivolt above the tympanum is placed above the north door, as in the Louvre, the archivolt ends in a blank wall which survived above the height of the proposed reconstruction of it, suggesting this position for it is not completely certain.

233. Clédat *loc. cit.* (n. 185) pl. 208 on p. 219.

234. Possibly reused. Monneret de Villard *Sohâg* vol. 2, fig. 150.

235. Chassinat *Baouît* pl. 3–4.

236. Clédat *loc. cit.* (n. 232) 545–6, pl. 4.1; Clédat *loc. cit.* (n. 185) fig. 1271; Torp *loc. cit.* (n. 86) 39; Rutschowscaya *loc. cit.* 1998 (n. 195) 292, 294, fig. 12; Clédat *op. cit.* (n. 185) pl. 209 on p. 219.

237. Kitzinger *loc. cit.* (n. 2) 212–13, pl. 77.1; J. Beckwith, *Coptic Sculpture* (London 1963) 21–2, fig. 86–8; Torp *loc. cit.* (n. 192) 16–21, fig. 4, fig. on p. 17, fig. 5.

238. North Church: Clédat *loc. cit.* col. 223, fig. 1265; Severin *loc. cit.* 1986 (n. 193) pl. 16. South Church: Chassinat *Baouît* pl. 12–16.1, 22, 44, 36–7, 58, 62, 68.1, 69–70; M.-H. Rutschowscaya, 'Essai d'un catalogue des bois coptes du Musée du Louvre, Les bois de Baouît', *RA* (1978) 295–318; *idem*, *Catalogue des bois de l'Egypte copte au Musée du Louvre* (Paris 1986) 168–9 (indicates pieces in Louvre, including from North and South Churches); *idem*, 'Linteaux en bois d'époque copte', *BIFAO* 77 (1977) 181–91.

239. M.-H. Rutschowscaya, *La Peinture copte* (Paris 1992) e.g. pls. on p. 11–12, 16–17, 36–69; *idem op. cit.* (n. 238) pl. on p. 6; Effenberger and Severin *op. cit.* (n. 8) 98c on p. 185, pl. on p. 187.

240. Chassinat *Baouît* pl. 61–3, 66–8; Clédat *loc. cit.* (n. 185) col. 219–21; *CE* 369.

241. Clédat *loc. cit.* (n. 185) col. 222, fig. 1263–4; Clédat *op. cit.* (n. 185) pl. 185–204 on p. 208–15. Date: Bénazeth *loc. cit.* 1998 (n. 186) 34.

242. Chapels and rooms with wall-paintings: Clédat *loc. cit.* (n. 232) 525–46; J. Clédat, 'Nouvelles recherches à Baouît (Haute-Égypte). Campagnes 1903–1904', *CRAI* 1904, 517–26; *idem, Le Monastère et la nécropole de Baouît*, *MIFAO* 12 (Cairo 1904); *idem loc. cit.* (n. 185) col. 226–51, fig. 1277–86; J. Maspero, ed. E. Drioton, *Fouilles exécutées à Baouît MIFAO* 59 (Cairo 1931); Clédat *op. cit.* (n. 185). Maspero (*op. cit.* p. V) identified the buildings excavated by Clédat which had been considered tomb chapels as living quarters. Summary of subjects depicted: R. Milburn, *Early Christian Art and Architecture* (Aldershot 1988) 151–2; *CE* 367–72.

243. John of Nikiu 89. 4–15, tr. Charles 121–2; Quibell *Saqqara* III p. I–IV; Quibell *Saqqara* IV p. I–VII, 8, 12; P. Grossmann and H.-G. Severin, 'Reinigungsarbeiten im Jeremiaskloster bei Saqqara. Vierter vorläufiger Bericht', *MDIK* 38 (1982) 166–70; *CE* 773–4.

244. Quibell *Saqqara* III, 8–19, pl. 7–15; Quibell *Saqqara* IV, 2–4, 131–2, 134–5, pl. 5, 7, 10, 12, 21–6; M. Rassart-Debergh, 'La Décoration picturale du monastère de Saqqara', *Miscellanea Coptica = Acta ad archaeologiam et artium historiam pertinentia* 9 (1981) 9–124; P. van Moorsel and M. Huijbers, 'Repertory of the Preserved Wall-paintings from the Monastery of Apa Jeremiah at Saqqara', *Miscellanea Coptica = Acta ad archaeologiam et artium historiam pertinentia* 9 (1981) 125–86; M. Rassart-Debergh, 'Quelques remarques iconographiques sur la peinture chrétienne à Saqqara', *Miscellanea Coptica = Acta ad archaeologiam et artium historiam pertinentia* 9 (1981) 207–20; *CE* 777–9.

245. Grossmann and Severin *loc. cit.* (n. 243) 170–93; *CE* 776–7.

246. Interim reports: P. Grossmann, 'Reinigungsarbeiten im Jeremiaskloster von Saqqara. Vorläufiger Bericht', *MDIK* 27 (1971) 177, 179–80; *idem*, 'Reinigungsarbeiten im Jeremiaskloster bei Saqqara. (Zweiter vorläufiger Bericht)', *MDIK* 28 (1972) 146–8, fig. 2, pl. 36b–37; *idem*, 'Reinigungsarbeiten im Jeremiaskloster bei Saqqara. Dritter vorläufiger Bericht', *MDIK* 36 (1980) 196–7, fig. 2, pl. 39b, 40ab. Main discussion:

247. *c.* AD 600 Severin and Grossmann *loc. cit.* (n. 243) 158–9, pl. 23b, 24a–c; *CE* 774. Possibly early sixth century: L. Török, *Transfigurations of Hellenism* (Leiden 2005) 332 n. 329.

Grossmann and Severin *loc. cit.* (n. 243) 155–9, 166–7, 192–3, fig. 1, pl. 23a–b, 24, 26b–c; *CE* 774, fig. on p. 773; Grossmann *Architektur* 507–8, fig. 125.

248. Quibell *Saqqara* III, 1–8, pl. 1–5; Quibell *Saqqara* IV, p. I–VI, 2, pl. 1; Grossmann *loc. cit.* 1971 (n. 246) 171–80, fig. 1–2, pl. 40–1; Grossmann *loc. cit.* 1972 (n. 246) 145–6, fig. 1, pl. 36a, 38b; Grossmann *loc. cit.* 1980 (n. 246) 193–6, fig. 1, pl. 38–39a; Grossmann and Severin *loc. cit.* (n. 243) 159–62, 166–70, 184–93, pl. 2, pl. 29a–c; *CE* 774–5, fig. on p. 775, 776–7; Grossmann *Architektur* 508–10, fig. 126.

249. Quibell *Saqqara* III, 7, 30–2, 110, pl. 1–2, 44; *CE* 774.

250. Quibell *Saqqara* III, 2, marked on pl. 1.

251. Pieces photographed at the time of discovery, before removal: Quibell *Saqqara* III, 1–2, 96–8, pl. 2–5.

252. Quibell *Saqqara* III, 2–4. Marble bases: Quibell *Saqqara* III, pl. 29.5; Grossmann and Severin *loc. cit.* (n. 243) 184. Granite bases, columns and other pedestals clearly visible in: Capuani *L'Égypte copte* pl. 31. Egyptian temple block reused as south-west foundation stone: Quibell *Saqqara* IV, 45–6.

253. Quibell *Saqqara* III, 5–6; *CE* 1145. Timber screen: Quibell *Saqqara* IV, pl. 56.1.

254. Complete list: Grossmann and Severin *loc. cit.* (n. 243) 185–8.

255. Quibell *Saqqara* III, 3, pl. 23; Grossmann and Severin *loc. cit.* (n. 243) Group B 186 n. 137.

256. Grossmann and Severin *loc. cit.* (n. 243) Group D 186 n. 145–7. Three fine examples: Quibell *Saqqara* III, pl. 17–18, 20.4. Four coarse examples: Quibell *Saqqara* III, pl. 19, 20.1–3. Severin calls these capitals 'basket-shaped' and considers that because they have an abacus they 'are not to be considered impost capitals' even though he considers they were influenced by them: *CE* 207. This abacus also occurs on the fold-capitals of local stone in Egypt. Both local versions are so close to the impost capitals in their basic conception that that term will be retained for them here.

257. Engaged capitals: Quibell *Saqqara* III, pl. 21.3–4. Fold-capitals: Quibell *Saqqara* III, pl. 21.1–2, 25.

258. Quibell *Saqqara* III, pl. 22.4–6; Grossmann and Severin *loc. cit.* (n. 243) Group A 185–6 n. 134–6.

259. Quibell *Saqqara* III, pl. 26, 27.4.

260. Grossmann and Severin *loc. cit.* (n. 243) 188; M. van Lohuizen-Mulder, 'Early Christian Lotus-panel Capitals and Other So-called Impost Capitals', *BABesch* 62 (1987) 147; *CE* 776.

261. Quibell *Saqqara* III, 107, pl. 36.1. Examples from the west end of the church.

262. Quibell *Saqqara* III, 107, pl. 36.4. Curved piece found at east end of church, behind the altar.

263. Quibell *Saqqara* III, 106, pl. 35.3. Piece from north-east quarter of church.

264. Quibell *Saqqara* III, 7; Quibell *Saqqara* IV, p. II, 138, pl. 39.3, 40.

265. Quibell *Saqqara* IV, p. IV–VI, 6, pl. 9, 32.1, 34.5, 37.2–3; Grossmann *loc. cit.* 1980 (n. 246) 197–8, fig. 3, pl. 40c–41; *CE* 776; Grossmann *Architektur* 510–11, fig. 127.

266. Quibell *Saqqara* IV, 7–8, pl. 13–16.

267. Quibell *Saqqara* IV, p. V, 9–12, pl. 17–18, 34.1–2; Grossmann *loc. cit.* 1972 (n. 246) 148–50, fig. 3, pl. 38a, 39; Grossmann and Severin *loc. cit.* (n. 243) 170–83, pl. 27–8; *CE* 775, 776; Grossmann *Architektur* 342–5, fig. 124. Building 1823 was used later for burials. Its floor level is lower than the surrounding buildings. The carved decoration found in it was consistent and fitted the available plan, so that there is agreement this was its original decoration, which Severin dates to the fifth century. It had broad blocked-out capitals on the corner-piers of the colonnade. The column capitals are like Corinthian capitals, but have small corner volutes at the end of their acanthus leaves, which spring from a single cauliculus on each side. The high quality conventional cutting of their leaves would suggest they are considerably earlier than the simplified Corinthian capitals of the Main Church.

268. Quibell *Saqqara* IV, 9, pl. 1, 19, 32.2, 35.6, 37.5, 70–82; Grossmann *loc. cit.* 1972 (n. 246) 150, 152; Grossmann *loc. cit.* 1980 (n. 246) 198–202, fig. 4, pl. 42–3; *CE* 775.

269. Simplified Corinthian capitals: Quibell *Saqqara* III, pl. 24.2–4, 27.1, 32.2, 33.5; Quibell *Saqqara* IV, pl. 36.1–2. Corinthian capitals: Quibell *Saqqara* III, pl. 28.1–5, 32.1,3; Quibell *Saqqara* IV, pl. 33.1–5, 34.3, 35.1–2, 5, 36.3. Plain capitals: Quibell *Saqqara* III, pl. 24.5–6 (pl. 24.6 with traces of paint); Quibell *Saqqara* IV, pl. 35.3. Basket-shaped impost and fold capitals: Quibell *Saqqara* III, pl. 16.1–2, 22.1–3, 29.1–2; Quibell *Saqqara* IV, pl. 32.4. Capital with wind-blown leaves: Quibell *Saqqara* IV, pl. 32.5. Basket capital: Quibell *Saqqara* IV, pl. 32.5.

270. Quibell *Saqqara* III, pl. 30; Quibell *Saqqara* IV, pl. 37.1–5, 38.2–5.

271. Quibell *Saqqara* III, pl. 14.1, 33.3, 34.1, 3–4, 35.1–2, 4; Quibell *Saqqara* IV, pl. 42.1–2, 43.3.

272. Quibell *Saqqara* III, 107, pl. 37.2. Removed from site over a generation before Quibell for re-use south of Abusir village.

273. Quibell *Saqqara* III, 106, pl. 31.6.

274. Quibell *Saqqara* III, 106, pl. 34.1.

275. Quibell *Saqqara* III, pl. 14.1.

276. Kitzinger *loc. cit.* (n. 2) 189–91; Torp *loc. cit.* (n. 192) 11–12; Torp *loc. cit.* (n. 86) 37.

277. Examples which can be compared. Vine frieze: Chassinat *Baouît* pl. 85.1–2, 86.1–2; Quibell *Saqqara* III, pl. 34.4; Quibell *Saqqara* IV, pl. 40.5. Frieze with serrated leaves: Chassinat *Baouît* pl. 83.1–2; Quibell *Saqqara* III, pl. 14.1. Frieze with larger leaves: Chassinat *Baouît* pl. 82.1; Quibell *Saqqara* IV, pl. 40.3–4.

278. Compare: Chassinat *Baouît* pl. 24 with Quibell *Saqqara* IV, pl. 37.4–5. The similarity of pl. 37.5 (now in the Metropolitan Museum of Art, New York, Rogers Fund 10.175.77) to those on Bawit South Church led T.K. Thomas (in F.D. Friedman, ed., *Beyond the Pharaohs* Rhode Island 1989, 230) to attribute it to Bawit, although it

was excavated by Quibell in Building 1952 at Saqqara, as indicated by the plate caption, and photographed at the time of its discovery in Quibell *Saqqara* IV, pl. 19. The similarity between the archaizing Corinthian capitals is striking: Chassinat *Baouît* pl. 96; Quibell *Saqqara* III, pl. 26.

279. Drioton *op. cit.* (n. 67) i (with illustrations of all pieces). Nilometer: K.A.C. Creswell, *Early Muslim Architecture*, vol. 2 (2nd edn Oxford 1969; repr. New York 1979) 290–307.

280. Churches beside Serapeum enclosure in Alexandria: J.S. McKenzie, S. Gibson, and A.T. Reyes, 'Reconstructing the Serapeum in Alexandria from the Archaeological Evidence', *JRS* 94 (2004) 107–10. The South Church at Hermopolis Magna is situated 300 m south of the cathedral, and is built on a high accumulation of dump of *c.* AD 420–60. Grossmann *loc. cit.* 1989 (n. 46) 1873–5, fig. 12; Bailey *Hermopolis* 46–53, pl. 80–103; P. Grossmann and D.M. Bailey, 'The South Church at Hermopolis Magna (Ashmunein), A Preliminary Account', in K. Painter, ed., *Churches Built in Ancient Times* (London 1994) 51, 68–9, plan fig. 1, 4, 5; D.M. Bailey, 'The Pottery from the South Church at el-Ashmunein', *Cahiers de la céramique égyptienne* 4 (1996) 47; Grossmann *Architektur* 437–41, fig. 58. It has simplified Corinthian capitals with plain leaves: Grossmann and Bailey *loc. cit.* fig. 7, 9.

281. Tr. D.W. Young, 'A Monastic Invective against Egyptian Hieroglyphs', in D.W. Young, ed., *Studies Presented to H.J. Polotsky* (Beacon Hill, Mass. 1981) 348–60; D. Frankfurter, *Religion in Roman Egypt* (Princeton 1998) 265.

282. M. el Saghir *et al.*, *Le Camp romain de Louqsor*, MIFAO 83 (Cairo 1986) 20–1, pl. 1, 20; Pensabene *Elementi Aless.* 27, fig. 30–1.

283. R.S. Bagnall, *Egypt in Late Antiquity* (Princeton 1993) 263; M. el-Saghir, *Das Statuenversteck im Luxortempel* (Mainz 1992).

284. Abdul-Qader Muhammad *loc. cit.* (n. 102) 251–4, pl. 27–37, 39, 105; Grossmann *loc. cit.* 1977 (n. 64) 242, fig. 72; Grossmann *loc. cit.* 1978 (n. 46) 92–3 (138–9), pl. 14b; Grossmann *loc. cit.* (n. 67) 170, fig. 8; *CE* 1485; P. Grossmann and D.S. Whitcomb, 'Excavation in the Sanctuary of the Church in front of the Luqsur-Temple', *ASAE* 72 (1992–94) 25–34; Grossmann *Architektur* 448–50, fig. 68. Revised plan: Grossmann *loc. cit.* 1989 (n. 46) 1889, fig. 20; Grossmann and Whitcomb *loc. cit.* fig. 2–3. Date: Grossmann *loc. cit.* 1989 (n. 46) 1889; Grossmann and Whitcomb *loc. cit.* 30, 32.

285. The church at Tod (Tuphium) was built over the Montu temple of Sesostris I (Twelfth Dynasty) which had been razed and burnt for lime: U. Monneret de Villard, 'La basilica cristiana in Egitto', *Atti del 4. Congresso internazionale di archeologia cristiana, Vatican 1938* (Vatican 1940) vol. 1, 296, 314, fig. 20; *CE* 2279–80, fig. on p. 2280; Grossmann *Architektur* 457–8, fig. 75. Sixth-century church at Deir Abu Fana: references in n. 93 above.

286. Abdul-Qader Muhammad *loc. cit.* (n. 102) pl. 33; Grossmann and Whitcomb *loc. cit.* (n. 284) pl. 4a; Grossmann *loc. cit.* (n. 102) fig. 13.

287. Friezes: Abdul-Qader Muhammad *loc. cit.* (n. 102) pl. 39a–b; Grossmann and Whitcomb *loc. cit.* (n. 284) pl. 5; Grossmann *loc. cit.* (n. 102) fig. 8, 11–12, 14. The leaves on an archivolt and niche head from Luxor are very similar in style to those in the Dendara church, although it is not recorded from which building at Luxor they were found. Archivolt: Monneret de Villard *Sohâg* vol. 2, fig. 192; Duthuit *Sculpture* pl. 36c; Stryzgowski *Koptische Kunst* fig. 76. Niche head with shell and wreathed cross: Monneret de Villard *Sohâg* vol. 2, fig. 185; Stryzgowski *Koptische Kunst* fig. 47.

288. Grossmann and Whitcomb *loc. cit.* (n. 284) 25–7, 32, fig. 1.

289. Churches west of Great Court of Ramesses II: Monneret de Villard *loc. cit.* (n. 285) 296, 314, fig. 17; P. Grossmann, 'Eine vergessene frühchristliche Kirche beim Luxor-Tempel', *MDIK* 29 (1973) 167–81; *CE* 1485; Capuani *L'Égypte copte* 219, pl. 74. Date: *CE* 1485; Grossmann and Whitcomb *loc. cit.* (n. 284) 30; Grossmann *Architektur* 452–4, fig. 70–1. P. Grossmann (pers. com. 2002) dates these two churches 'to the time of the Persian occupation between 619 and 628, before the Roman re-conquest and the Arab conquest'. Building possibly identified as a church on the east side of the Sphinx Avenue with a long room on the south side, seventh century: Grossmann *loc. cit.* 1989 (n. 46) 1889, 1892, fig. 21; *CE* 1485; Grossmann *Architektur* 451–2, fig. 69.

290. Abdul-Qader Muhammad *loc. cit.* (n. 102) 260–1, pl. 66–71; *CE* 1485.

291. R.-G. Coquin, 'La Christianisation des temples de Karnak', *BIFAO* 72 (1972) 169–78; *CE* 1392–4, fig. on p. 1394; Grossmann *Architektur* 46, fig. 166–7.

292. *CE* 1494–6; Grossmann *Architektur* fig. 67.

293. *Description de l'Égypte* plates vol. 2, pl. 14; Monneret de Villard *loc. cit.* (n. 285) 296, 315, fig. 10; U. Hölscher, *The Excavation of Medinet Habu*, vol. 5 *Post-Ramessid Remains* (Chicago 1954) 51–5, fig. 57, pl. 32b–33, 45; Grossmann *Architektur* 455–7, fig. 73. Date: *CE* 1497. Smaller basilica in front of east gate, first half of eighth century: Hölscher *op. cit.* 55–6, fig. 59, pl. 46; Grossmann *loc. cit.* 1978 (n. 46) 93 (139), pl. 15b; *CE* 1497, fig. on p. 1496.

294. D.M. Bailey, 'Classical Architecture in Roman Egypt', in M. Henig, ed., *Architecture and Architectural Sculpture in the Roman Empire* (Oxford 1990) 134, fig. 8.15.

295. P. Grossmann, 'Überlegungen zum Grundriss der Ostkirche von Philae', *Jahrbuch für Antike und Christentum* 13 (1970) 41.

296. References in Ch. 10 n. 105.

297. P. Nautin, 'La Conversion du temple de Philae en église chrétienne', *Cahiers archéologiques* 17 (1967) 1–43; P. Grossmann, 'Die Kirche des Bischofs Theodoros im Isistempel von Philae. Versuch einer Rekonstruktion', *Rivista degli studi orientali* 58 (1984 [1987]) 107–17, plan fig. 1; *CE* fig. on p. 1954; Capuani *L'Égypte copte* 226, pl. 88. Closure: Procopius, *Persian War* 1. 19. 36–7 in *Procopius, History of the Wars*, ed. tr. W.B. Dewing (London 1914) 188–9; Nautin *loc. cit.* 3–8; Grossmann *loc. cit.* 108; Grossmann *Architektur* fig. 80.

298. H.G. Lyons, *A Report on the Island and Temples of Philae* (London 1896) 16, 32–3, pl. 47–8, 58–61, 66–7, plan 1, 10; Clarke *op. cit.* (n. 51) 89–90, pl. 24; Monneret

de Villard *loc. cit.* (n. 285) 298, fig. 5–6; Grossmann *loc. cit.* (n. 295) 29–41; al-Syriany and Habib *Coptic Churches* 29 no. 18; *CE* 1954–6; Grossmann *Architektur* 461–5, fig. 78–9.

299. The capitals have a distinctive lower row of leaves with rounded tops (Lyons *op. cit.* n. 298, pl. 58, 60–1) also found on those (of harder stone) in Nubia: I. Ryl-Preibisz, 'Chapiteaux en granit de Nubie', *ÉtTrav* 5 (1971) 212–14 nos. 2–4; P.M. Gartkiewicz, 'Remarks on the Cathedral at Qasr Ibrim', in J.M. Plumley, ed., *Nubian Studies 1978* (Warminster 1982) 90, fig. 5.3, 6.

300. I. Ryl-Preibisz, 'Remarques sur les chapiteaux en marbre de Faras', *ÉtTrav* 15 (1990) 335–46.

301. The various possibilities and their occurrence (or not) elsewhere in the empire are covered in H. Saradi-Mendelovici, 'Christian Attitudes towards Pagan Monuments in Late Antiquity and their Legacy in Later Byzantine Centuries', *DOP* 44 (1990) 47–61 with references.

302. Boston Museum of Fine Arts no. 91.259.

303. Kautzsch *Kapitellstudien* nos. 45–7, 52–5, 59, 69–71, 74, 98, 103, 106–7, 121, 125–7, 132, 134, on p. 24–40, 241–3, pl. 5.46,69,71, 7.98,103, 8.107, 9.126,132; W.A. Daszewski, 'Les Citernes et les chapiteaux', *BdÉ* 97 (1985) 183–5, pl. 1c–f; G. and H.-G. Severin, *Marmor vom heiligen Menas* (Frankfurt 1987) 32–3, fig. 23, 25; Pensabene *Elementi Aless.* nos. 410–14, 419–20, 423–6, 428–36, 438, 440, 444, 446–8, 451, 455–6, 458–9, 468, 472, 476–8, 481, 483–5, 487, 489–90, 497, 500, 504, 508, 512–15, 516A, 519, 523–9, 532, 535–6, 539–41 on p. 402–32, pl. 50–62. Brief summary of features of Alexandrian Corinthian capitals: P. Pensabene, 'Elementi di architettura Alessandrina', *Studi Miscellanei* 28 (1984–5 [1991]) 74, 80–5.

Summary of chronological features of Corinthian capitals elsewhere: W.E. Betsch, *The History, Production and Distribution of the Late Antique Capital in Constantinople*, PhD 1977, University of Pennsylvania (UMI Ann Arbor 1991) 183–204, 208, 217–21. The cross in a wreath with ribbons hanging below it suggests they were locally made, not imported: Ward-Perkins *loc. cit.* (n. 130) 66–8; *CE* 2113. This motif, whilst unusual elsewhere is not unique to Egypt, as it occurs (defaced) on some fourth-century capitals in Jerusalem: J. Wilkinson, *Column Capitals in al Haram al Sharif* (Jerusalem 1987) 87 no. 41, 102 no. 62.

304. Ionic impost capital, second half of fifth or first half of sixth century AD: Kautzsch *Kapitellstudien* 166 no. 536, pl. 53.536; Pensabene *Elementi Aless.* 347 no. 158, pl. 23.158. Plain imposts with crosses, fifth to sixth century AD: Pensabene *Elementi Aless.* 472 nos. 697–700, pl. 79.

305. Kautzsch *Kapitellstudien* 157 no. 494, pl. 30.494; Pensabene *Elementi Aless.* 466 no. 673, pl. 76.673.

306. Kautzsch *Kapitellstudien* 210 no. 737, pl. 44.737; Pensabene *Elementi Aless.* 436 no. 552, pl. 64.552. In Egypt there are at least twelve examples of this otherwise relatively rare type: *CE* 206.

307. Kautzsch *Kapitellstudien* 213 no. 762, pl. 45.762; Pensabene *Elementi Aless.* 466 no. 674, pl. 76.674.

308. *Description de l'Égypte* plates vol. 5, pl. 38.5; E. Breccia, *Rapport sur la marche du service du musée pendant l'année 1907* (Alexandria 1908) 11, fig. A; Strzygowski *Koptische Kunst* 77–9 no. 7352, fig. 105; Breccia *Alex. ad Aeg.* 289, fig. 200; Kautzsch *Kapitellstudien* 192 no. 632, pl. 38.632; Lohuizen-Mulder *loc. cit.* (n. 260) 133–7, fig. 1, d; Pensabene *Elementi Aless.* 462–3 nos. 657–60, pl. 74.659–60.

309. K.A.C. Creswell, *Early Muslim Architecture*, vol. 2 (2nd edn Oxford 1969, repr. New York 1979) 171, fig. 168, pl. 40c, 41, 42a, c; Parker *et al. Islamic Monuments* 50–2. Capitals: Kautzsch *Kapitellstudien* 25 no. 44, 26 no. 51, pl. 5.51, 27 no. 65, 28 no. 72, 29 no. 75, 31 no. 84, 32 no. 88, pl. 6.88, 33 nos. 101–2, pl. 7.102, 35 no. 110, pl. 8.110, 35 nos. 118 and 124, 36 no. 135, pl. 9.135, 37 no. 140, pl. 9.140, 37 nos. 144–7 and 149–50, pl. 10.142 and 144–7 and 149–50, 131 no. 420, 210 no. 736, pl. 44.736, 213 no. 761, pl. 45.761; Pensabene *loc. cit.* (n. 303) 81, fig. 85, 103, 109.

310. K.A.C. Creswell, 'Coptic Influences on Early Muslim Architecture', *BSAC* 5 (1939) 29 cites *Kitat* II p. 265, lines 29–36; Creswell *op. cit.* (n. 279) 332–3.

311. Original plan, with later extensions: K.A.C. Creswell, *The Muslim Architecture of Egypt*, vol. 1 (Oxford 1952, repr. New York 1978) 36, 58–9, plan fig. 20–1, pl. 4a, 5; Parker *et al.*, *Islamic Monuments* 181–4. Capitals: Kautzsch *Kapitellstudien* 26 no. 63, 30 no. 77, 32 no. 90, 35 no. 115, 120 no. 380, 156 no. 487, 165 no. 531; Pensabene *loc. cit.* (n. 303) 74, fig. 94–5.

312. Creswell *op. cit.* (n. 311) vol. 1, 241, fig. 141, pl. 84a.

313. Creswell *op. cit.* (n. 311) vol. 1, 275, 287, fig. 169, 172, pl. 99a, 104, 105c; Parker *et al. Islamic Monuments* 119. Capitals: Kautzsch *Kapitellstudien* 26 no. 64, 30 no. 80, 32 no. 93, 33 no. 96, pl. 6.96, 35 no. 111, 37 no. 143, 160 no. 511, 213 no. 757; Pensabene *loc. cit.* (n. 303) 85, pl. 110.

314. Creswell *op. cit.* (n. 311) vol. 2, 190, fig. 108 opposite p. 198, pl. 68–9, 71c; Parker *et al. Islamic Monuments* 196–200. Capitals: Kautzsch *Kapitellstudien* 30 no. 78, 31 no. 86, 32 no. 89, 35 no. 120, 36 no. 137, 213 no. 758; Pensabene *loc. cit.* (n. 303) 81, fig. 102.

315. Parker *et al. Islamic Monuments* 239–41. Capitals: Kautzsch *Kapitellstudien* 25 no. 42, 28 no. 68, 30 no. 76, 31 no. 85, 33 no. 99, 34 no. 105, pl. 7.105, 35 nos. 113–14, pl. 8.114, 35 no. 123, 37 nos. 141–2 and 148, pl. 10.142 and 148, 131 no. 421, 192 no. 630, pl. 38.630; Severin *loc. cit.* 1986 (n. 193) 107–8, pl. 20; Pensabene *Elementi Aless.* 403 no. 418, pl. 51.418, 415–16 nos. 466–7, pl. 55.466–7, 422 nos. 491–2, pl. 57.491–2, 434 nos. 547–8, pl. 64.547–8.

316. Parker *et al. Islamic Monuments* 124–6. Plan and details of capitals: H.G. Niemeyer, 'Wiederverwendete spätantike Kapitelle in der Ulmās-Moschee zu Kairo', *MDIK* 17 (1961) 133–46.

317. J. Jakeman, *Abstract Art and Communication in 'Mamluk' Architecture*, DPhil. Oxford University 1993, Appendix 1 Translation of *Kanz al-durar, Die Chronik*, ed. H.R. Roemer, I–IX (Cairo 1960) 382–3 = Deutsches Archäologisches Institut Kairo

Quellen zur Geschichte des islamischen Ägypten, 1 (i); V. Meinecke-Berg, 'Spolien in der mittelalterlichen Architektur von Kairo', in *Ägypten Dauer und Wandel Symposium, Kairo 1982* (Mainz 1985) 137.

318. V. Rondot, 'Note sur six chapiteaux composites réutilisés dans la mosquée al-Yūsūfī à Mellawi', *ASAE* 70 (1984–5) 143–9. Main mosque at Hermopolis Magna (el-Ashmunein): Donald Bailey pers. com. 2001.

319. V. Rondot, 'Sur le voyage de sept chapiteaux d'Antinoé vers le Caire', *Annales islamologiques* 25 (1990) 241–3.

320. P. Grossmann, 'Wiederverwendete spätantike Kapitelle aus der Moschee von Bahnasā', *DaM* 11 (1999) 185–90.

321. Pensabene *loc. cit.* (n. 303) 65.

322. Some capitals, listed by type: H.-G. Severin, 'Konstantinopler Bauskulptur und die Provinz Ägypten', in U. Peschlow and S. Möllers, eds., *Spätantike und byzantinische Bauskulptur* (Stuttgart 1998) 97–9.

CHAPTER 12: ARCHITECTURAL SCHOLARSHIP AND EDUCATION

1. Vitruvius, *On Architecture*, ed. tr. F. Granger, 2 vols. (London 1934, repr. 1979). Date of Vitruvius: M. Wilson Jones, *Principles of Roman Architecture* (London 2000) 34.

2. Didymus of Alexandria, *The Measurement of Timber* in: *Heronis Alexandrini Geometricorum et Stereometricorum reliquiae*, ed. F. Hultsch (Berlin 1864) 238–44; *Mathematici graeci minores*, ed. Ger. tr. J.L. Heiberg (Copenhagen 1927) 4–23; *Les Opuscules mathématiques de Didyme, Diophane, et Anthémius suivis du fragment mathématique de Bobbio*, tr. P. ver Eecke (Paris 1940) 3–16. Eleventh- or twelfth-century manuscript copy (Topkapi Library, Istanbul, MS 1) in *Codex Constantinopolis Palatii Veteris No. 1*, ed. tr. E.M. Bruins (Leiden 1964) vol. 1, pl. 123–7 fol. 64r–66r, vol. 2, 82–6, vol. 3, 176–81. Commentary: P. Tannery, 'Les Mesures des marbres et des divers bois de Didyme d'Alexandrie', *RA* 41 (1881.1) 152–64. On the identity of 'Didymus of Alexandria': F. Hultsch, *RE*, vol. 5 (1905) col. 474 Didymos (12); ver Eecke *op. cit.* ix–xi; Fraser *Ptol. Alex.* vol. 2, 686 n. 246; *OCD*[3] 467–8.

3. Didymus 2–11; ed. Ger. tr. Heiberg 4–7, Fr. tr. ver Eecke 4–5. On length of cubit see Ch. 2 n. 29 and Ch. 5 n. 46. Various lengths of foot in Greek architecture: J.J. Coulton, 'Towards Understanding Greek Temple Design: General Considerations', *BSA* 70 (1975) 85–9; Z. Stančič and B. Slapšak, 'The Greek Field System at Pharos: A Metric Analysis', *Revue des études anciennes* 101 (1999) 119–20. Length of Roman foot on Trajan's Markets in Rome 0.2940 m, on Trajan's Forum 0.2938 m: L. Lancaster, 'Building Trajan's Markets', *AJA* 102 (1998) 287 n. 15. Average length of Roman foot, 0.296 m: Wilson Jones *op. cit.* (n. 1) 72 with references. A length of 0.2959 m was calculated (based on Pliny and the size of the pyramids) in 1872: Mahmoud-Bey *Mémoire* 16.

4. Didymus 12–22; ed. Ger. tr. Heiberg 6–11, Fr. tr. ver Eecke 6–8. How to reduce areas to fractions of cubits when the length and breadth are in palms or digits: Didymus 26–36, ed. Ger. tr. Heiberg 10–13, Fr. tr. ver Eecke 8–10.

5. Didymus 37–8, ed. Ger. tr. Heiberg 12–15, Fr. tr. ver Eecke 10–11.

6. Didymus 39–50, ed. Ger. tr. Heiberg 14–23, Fr. tr. ver Eecke 11–16.

7. Examples using marble, which are thought to be later interpolations: Didymus 46–7, ed. Ger. tr. Heiberg 18–21, Fr. tr. ver Eecke 14. One version of the title of the work refers to marble: ver Eecke *op. cit.* (n. 2) p. 3 n. 1, p. 14 n. 4.

8. The so-called 'lithic cubit' (Didymus 23, ed. Ger. tr. Heiberg 10–11, Fr. tr. ver Eecke 8) is defined by Heron as $1\frac{1}{7}$ feet (consisting of 16 digits, i.e. Greek or Ptolemaic feet) and the same as a 'wood-cutter's cubit': Heron, Geometry 4. 10 in Heronis Alexandrini opera quae supersunt omnia, vol. 4, ed. Ger. tr. J.L. Heiberg (1912, Stuttgart repr. 1976) 190–1. It had been suggested that these cubits were slightly larger than normal, to allow for dressing: Coulton *loc. cit.* (n. 3) 86 n. 134.

9. Use of square feet in Diocletian's edict of AD 301: S. Corcoran and J. Delaine, 'The Unit of Measurement of Marble in Diocletian's Prices Edict', *JRA* 7 (1994) 263–73.

10. Column shaft in Alexandria, references: Ch. 5 n. 8. Suggestion that there is no evidence before Heron and Diophantus for the Greeks doing calculations using fractions with a single denominator ('common fractions') as opposed to submultiple fractions ('unit fractions'): D. Fowler, *The Mathematics of Plato's Academy* (2nd edn Oxford 1999) 227, 262–6.

11. On Heron of Alexandria and the works associated with his name: *Heronis Alexandrini opera quae supersunt omnia*, vol. 3, ed. Ger. tr. H. Schöne (1903, Stuttgart repr. 1976) xi–xii; Heath *Hist. Greek Math.* vol. 2, 307–54; *OCD*[3] 698–9; Cuomo *Ancient Math.* 161–8, 203–5. The date of Heron himself (as opposed to some versions of his works) was not reliably known in the late nineteenth and early twentieth century, when his works were edited. He was generally thought to date to the third century AD (e.g. Heath *Hist. Greek Math.* vol. 2, 298–307). However, the eclipse which Heron used to measure the distance from Rome to Alexandria (*Dioptra* 35) has since been identified as occurring in AD 62, and this accords with other evidence: A.G. Drachmann, 'Heron and Ptolemaios', *Centaurus* 1 (1950) 117–31; Fraser *Ptol. Alex.* vol. 2, 616 n. 396. Heron was apparently still alive in AD 84: M.J.T. Lewis, *Surveying Instruments of Greece and Rome* (Cambridge 2001) 54.

12. Heron of Alexandria, *Pneumatica* and *Automata* in *Heronis Alexandrini opera quae supersunt omnia* vol. 1, ed. G. Schmidt (1899; repr. Stuttgart 1976). *Catoptrica (Mirrors)* in *Heronis Alexandrini opera quae supersunt omnia*, vol. 2, ed. L. Nix and W. Schmidt (1900, repr. Stuttgart 1976) 316–65. Predecessors of Heron in applied mechanics: Fraser *Ptol. Alex.* vol. 1, 425–9.

13. Heath *Hist. Greek Math.* vol. 2, 307–8. On transmission of Euclid's *Elements*: Cuomo *Ancient Math.* 126–35, fig. 4.1.

14. Heron, *Metrica* in *Heronis Alexandrini opera quae supersunt omnia*, vol. 3, ed. Ger. tr. H. Schöne (1903, repr. Stuttgart 1976) 1–185; Heath *Hist. Greek Math.* vol. 2, 316–18, 320–44; Cuomo *Pappus* 180; Cuomo *Ancient Math.* 166–8.

15. Heron, *Geometry* in *Heronis Alexandrini opera quae supersunt omnia*, vol. 4, ed. Ger. tr. J.L. Heiberg (1912, repr. Stuttgart 1976) 171–449.

16. Heath *Hist. Greek Math.* vol. 2, 318–19, 344.

17. Heron, *Stereometry* in *Heronis Alexandrini opera quae supersunt omnia*, vol. 5, ed. Ger. tr. J.L. Heiberg (1914, repr. Stuttgart 1976) 1–162. The eleventh- or twelfth-century codex which includes Heron's *Stereometry* with the diagrams reproduced in Heiberg's edition is reproduced in photographs with a translation, including of the *scolia*, and commentary: Bruins *op. cit.* (n. 2). The fact that it includes Heron's *Stereometry* is not mentioned when the usefulness of the formulae and diagrams in it are unappreciated in: R. Ousterhout, *Master Builders of Byzantium* (Princeton 1999) 72–4, fig. 44. Examination of the codex provides an indication of the difficulties of editing such works. Although the standard edition remains that of Heiberg, with its rigorous analysis, Bruins *op. cit.* (n. 2) also includes much useful analysis of the calculations.

18. P. Tannery, 'La Stéréométrie d'Héron d'Alexandrie', *Mémoires de la Société des Sciences physiques et naturelles de Bordeaux*, 2nd ser. vol. 5 (1883) 305–26; *idem*, 'Études Héroniennes', *Mémoires de la société des sciences physiques et naturalles de Bordeaux*, 2nd ser. vol. 5 (1883) 347–69; Heiberg *op. cit.* (n. 17) xxix–xxxiv; Heath *Hist. Greek Math.* vol. 2, 318–19; Coulton *loc. cit.* (n. 3) 81; J. Warren, *Greek Mathematics and Architects to Justinian* (London 1976) 4–5.

19. Heron, *Stereometry* 1. 1–41, ed. Ger. tr. Heiberg 2–47. A foot defined as equal to 16 digits: Heron, *Stereometry* 2. 69, ed. Ger. tr. Heiberg 160–1. Similarly, specified in Heron, *On Measures* 25, ed. Ger. tr. Heiberg 180–1. (*On Measures* is not by Heron in its present form: Heath *Hist. Greek Math.* vol. 2, 319–20.) A foot of 16 digits is referred to as a 'Philetairic' foot, and one 'Italian' [Roman] foot equals $13\frac{1}{3}$ digits in: Heron, *Geometry* 4. 3, ed. Ger. tr. Heiberg 184–5.

20. Heron, *Stereometry* 1. 42–3, ed. Ger. tr. Heiberg 46–51, ed. tr. Bruins vol. 1, pl. 30 fol. 17v, vol. 3, 43–4 nos. 51–2.

21. Heron, *Stereometry* 1. 44, ed. Ger. tr. Heiberg 50–3, ed. tr. Bruins vol. 1, pl. 29 fol. 17r, vol. 3, 43 no. 50. Example for a hippodrome: Heron, *On Measures* 26, ed. Ger. tr. Heiberg 180–1.

22. Heron, *Stereometry* 1. 45, ed. Ger. tr. Heiberg 52–3.

23. Heron, *Stereometry* 1. 48, ed. Ger. tr. Heiberg 52–5, ed. tr. Bruins vol. 1, pl. 81 fol. 43r, vol. 3, 123 no. 1.

24. Heron, *Stereometry* 1. 49, ed. Ger. tr. Heiberg 54–5, ed. tr. Bruins vol. 1, pl. 81 fol. 43r, vol. 3, 123–4 no. 2.

25. Heron, *Stereometry* 1. 50, ed. Ger. tr. Heiberg 54–5, ed. tr. Bruins vol. 1, pl. 82 fol. 43v, vol. 3, 124 no. 3.

26. Heron, *Stereometry* 1. 40–1, 54–62, 65–75, 80–5, ed. Ger. tr. Heiberg 44–7, 56–77, ed. tr. Bruins vol. 1, pl. 20–3 fol. 12v–14r, pl. 72–4 fol. 38v–39v, pl. 75–6 fol. 40r–40v, vol. 3, 32–5 nos. 29–37, 104–6 nos. 42–9, p. 108–13 nos. 53–8; Warren *op. cit.* (n. 18) 5.

27. Heron, *Stereometry* 1. 73, ed. Ger. tr. Heiberg 68–9, ed. tr. Bruins vol. 1, pl. 73 fol. 39r, vol. 3, 105–6 no. 47.

Heron calculates the surface area of a dome using the formula $d^2 \times 4 \times 11 \times \frac{1}{28}$ explained below. This is based on half of Archimedes' surface area of a sphere, defined as $4\pi r^2 = \pi d^2$, in Archimedes, *On the Sphere and Cylinder* 1. 33, in *Greek Mathematical Works II Aristarchus to Pappus of Alexandria*, ed. tr. I. Thomas (London 1941, repr. 1980) 112–17; explained in Heath *Hist. Greek Math.* vol. 2, 38–9.
i.e. for a dome (using $\pi = \frac{22}{7}$):

$$\frac{1}{2}\pi d^2 = \frac{1}{2} \times \frac{22}{7}$$
$$= \frac{1}{2} \times 4 \times \frac{22}{7} \times d^2$$
$$= \frac{1}{2} \times 4 \times \frac{1}{4} \times \frac{(2 \times 11)}{7} \times d^2$$
$$= 4 \times 11 \times \frac{1}{28} \times d^2$$

28. Heron, *Stereometry* 1. 96–7, ed. Ger. tr. Heiberg 84–5, ed. tr. Bruins vol. 1, pl. 79 fol. 42r, vol. 3, 121 no. 69.

29. Heron, *Stereometry* 2. 1–2, ed. Ger. tr. Heiberg 84–7, ed. tr. Bruins vol. 1, pl. 79 fol. 42r, pl. 87 fol. 46r (middle diagram), vol. 3, 121–3.

30. McKenzie *Petra* 51, 138, pl. 75, 76b.

31. Menelaus of Alexandria, *Sphaerica; Die Sphärik von Menelaos aus Alexandrien in der Verbesserung von Abū Naṣr Mansūr b. 'Alī b. 'Irāq mit Untersuchungen zur Geschichte des Textes bei den islamischen Mathematikern*, ed. tr. M. Krause (= *Abhandlungen der Gesellschaft der Wissenschaften zu Göttingen Philologisch-historische Klasse*, Folge 3 nr. 17) (Berlin 1936); A.A. Björnbo, 'Studien über Menelaos' Sphärik. Beiträge zur Geschichte der Sphärik und Trigonometrie der Griechen', *Abhandlungen zur Geschichte der mathematischen Wissenschaften* 14 (1902) p. iii–154; Heath *Hist. Greek Math.* vol. 2, 260–73; *OCD*[3] 958–9.

32. Heron, *Stereometry* 2. 7–8, ed. Ger. tr. Heiberg 90–3, ed. tr. Bruins vol. 1, pl. 82–3 fol. 43v–44r, vol. 3, 124–6 nos. 4–5.

33. Heron, *Stereometry* 2. 9, ed. Ger. tr. Heiberg 92–3, ed. tr. Bruins vol. 1, pl. 83 fol. 44r, vol. 3, 126–7 no. 6.

34. Heron, *Stereometry* 2. 21–4, ed. Ger. tr. Heiberg 98–103, ed. tr. Bruins vol. 1, pl. 87–8 fol. 46r–46v, vol. 3, 131–6 nos. 18–21.

35. Heron, *Stereometry* 2. 10–12, ed. Ger. tr. Heiberg 92–5, ed. tr. Bruins vol. 1, pl. 83–4 fol. 44r–44v, vol. 3, 127–8 nos. 7–9.

36. Heron, *Stereometry* 2. 20, ed. Ger. tr. Heiberg 98–9, ed. tr. Bruins vol. 1, pl. 86–7 fol. 45v, 46r, vol. 3, 130–1 no. 17.

37. Heron, *Stereometry* 2. 17, ed. Ger. tr. Heiberg 96–7, ed. tr. Bruins vol. 1, pl. 86 fol. 45v, vol. 3, 129–30 no. 14.

38. Heron, *Stereometry* 2. 28–34, ed. Ger. tr. Heiberg 104–15, ed. tr. Bruins vol. 1, pl. 80–4 fol. 47v–9v, vol. 3, 137–44 nos. 25–31.

39. Heron, *Stereometry* 2. 35, ed. Ger. tr. Heiberg 114–17, ed. tr. Bruins vol. 1, pl. 95 fol. 50r, vol. 3, 144 no. 32.

40. Heron, *Stereometry* 2. 41, ed. Ger. tr. Heiberg 120–1. Different tr.: ed. tr. Bruins vol. 1, pl. 97 fol. 51r, vol. 3, 146 no. 1.

41. Heron, *Stereometry* 2. 43–4, ed. Ger. tr. Heiberg 122–5, ed. tr. Bruins vol. 1, pl. 98–9 fol. 51v–2r, vol. 3, 147–8 nos. 3–4.

42. Heron, *Stereometry* 2. 50–2, ed. Ger. tr. Heiberg 128–33, ed. tr. Bruins vol. 1, pl. fol. 53r–53v, vol. 3, 150–2 nos. 9–11.

43. Heron, *Stereometry* 2. 48, ed. Ger. tr. Heiberg 128–9, ed. tr. Bruins vol. 1, pl. 101 fol. 53r, vol. 3, 150 no. 8.

44. Heron, *Stereometry* 2. 69, ed. Ger. tr. Heiberg 160–2.

45. Coulton *loc. cit.* (n. 3) 77.

46. Heron, *Dioptra* in *Heronis Alexandrini opera quae supersunt omnia*, vol. 3, ed. Ger. tr. H. Schöne (1903, repr. Stuttgart 1976) 187–315, tr. in Lewis *op. cit.* (n. 11) 259–86; Heath *Hist. Greek Math.* vol. 2, 308, 345–6; Coulton *loc. cit.* (n. 3) 90; Cuomo *Ancient Math.* 164–5; Lewis *op. cit.* (n. 11) 54–6, 82–9, 126, 131–2, 136–7, 165, 180, 202–3, 228; J.J. Coulton, 'The Dioptra of Hero of Alexandria', in C.J. Tuplin and T.E. Rihll, eds., *Science and Mathematics in Ancient Greek Culture* (Oxford 2002) 150–64.

47. Heron, *Mechanics* in *Heronis Alexandrini opera quae supersunt omnia*, vol. 2, ed. Ger. tr. L. Nix and W. Schmidt (1900, repr. Stuttgart 1976) 1–299. Tr. and commentary with analysis of illustrations in: A.G. Drachmann, *The Mechanical Technology of Greek and Roman Antiquity. A Study of the Literary Sources* (Copenhagen 1963) 19–140, 199–205. Summary: Heath *Hist. Greek Math.* vol. 2, 309, 346–52.

48. D.M. Bailey, 'Honorific columns, cranes, and the Tuna epitaph', in D.M. Bailey, ed., *Archaeological Research in Roman Egypt, JRA* suppl. 19 (Ann Arbor 1996) 165–7, fig. 9, 11–12. On ancient cranes: J.G. Landels, *Engineering in the Ancient World* (London 1978) 84–98. Vitruvius (*On Architecture* 10.1–2) on cranes, tr. with commentary and diagrams: Drachmann *op. cit.* (n. 47) 141–9. Because earth mounds were used in Egyptian temple construction, Bailey (pers. com.) points out that this method could have also been used for these columns. The method using earth mounds is described in: G.R.H. Wright, 'The Works Organization of a Major Building Project in Roman Egypt', in D.M. Bailey, ed., *Archaeological Research in Roman Egypt, JRA* suppl. 19 (Ann Arbor 1996) 149–54. The lewis holes make this unlikely as they indicate lifting from above. Scaffolding round column for construction of Trajan's Column in Rome, with blocks raised up to 38.4 m above ground: L. Lancaster, 'Building Trajan's Column', *AJA* 103 (1999) 419–39.

49. R.J. Mainstone, 'Structural Theory and Design before 1742', *Architectural Review* 143 (1968) 306; Warren *op. cit.* (n. 18) 5.

50. Heath *Hist. Greek Math.* vol. 2, 310.

51. Diophantus, *Arithmetica* in: *Diophantus of Alexandria*, tr. T.L. Heath (2nd edn Cambridge 1910) 129–246; *Diophanti Alexandrini opera omnia, cum graecis commentariis*, vol. 1, ed. Latin tr. P. Tannery (Leipzig 1895) 2–449. Summary of *Arithmetica*: Heath *op. cit.* 1–13; Heath *Hist. Greek Math.* vol. 2, 448–517; Thomas *op. cit.* (n. 27) 516–59; Cuomo *Ancient Math.* 218–23.

52. According to the eleventh-century Byzantine scholar Michael Psellus, Anatolius, who became bishop of Laodicea after AD 272, dedicated his concise treatise on the Egyptian method of reckoning (mode of arithmetic) to Diophantus, suggesting the latter was active c. 250. Diophantus' dedication to Dionysius, if referring to the famous bishop of Alexandria (d. 264), would suggest the possibility that Diophantus could also have been active slightly earlier: P. Tannery, 'A quelle époque vivait Diophante?', *Bulletin des sciences mathématiques et astronomiques*, vol. 14, 2nd ser. vol. 3 (1879) 261–9; *idem*, 'Sur la religion des derniers mathématiciens de l'antiquité', *Annales de philosophie chrétienne* 34 (1896) 26–36, reproduced in J.L. Heiberg and H.G. Zeuthen, eds., *Mémoires scientifiques de Paul Tannery*, vol. 2 (Paris 1912) 537–8; *idem*, 'Psellus sur Diophante', in *Mémoires scientifiques de Paul Tannery*, vol. 4 (Paris 1920) 275–82; Heath *Hist. Greek Math.* vol. 2, 448, 453; W.B. Knorr, 'Arithmêtikê stoicheiôsis: On Diophantus and Hero of Alexandria', *Historia Mathematica* 20 (1993) 184–7; *OCD*³ 483; Cuomo *Ancient Math.* 219.

53. Possible attribution of Heron's *Definitions* to Diophantus: Knorr *loc. cit.* (n. 52) 180–92; Cuomo *Ancient Math.* 161, 218–19. Summary of *Definitions*: Heath *Hist. Greek Math.* vol. 2, 314–16; Cuomo *Ancient Math.* 162–4. A work attributed to Diophantus with practical examples of finding volumes and areas, many of which are analogous with or identical to those in Heron's *Geometry* and *Stereometry*, seems to be a Byzantine compilation (Heath *op. cit.* n. 51, 13): Tannery *op. cit.* (n. 51) vol. 2, 15–31, ed. Ger. tr. Heiberg *op. cit.* (n. 2) 25–65, Fr. tr. ver Eecke *op. cit.* (n. 2) xlv, 19–44.

54. Eusebius, *Ecclesiastical History* 7. 22. 6–14, ed. tr. Lake and Oulton 228–35; *PG* 10, col. 207–10; Tannery *loc. cit.* (n. 51) 533, 535–6. Summary of mathematical work of Anatolius: D.J. O'Meara, *Pythagoras Revived Mathematics and Philosophy in Late Antiquity* (Oxford 1989) 23–5.

55. Heath *Hist. Greek Math.* vol. 2, 448. See also n. 52 above.

56. Anatolius of Alexandria, *Fragmenta ex Libris Arithmeticorum, PG* 10, col. 233C–D; Hultsch *op. cit.* (n. 2) 278 section 82.

57. Pappus of Alexandria, *Mathematical Collection*, historical preface to Book 8, tr. from G. Downey, 'Byzantine Architects their Training and Methods', *Byzantion* 18 (1946–8) 106–7. Tr. and Greek text of whole passage: Thomas *op. cit.* (n. 27) 614–21; Cuomo *Pappus* 93–4. Discussion: G. Downey, 'Pappus of Alexandria on Architectural Studies', *Isis* 38 (1947–8) 197–200; Warren *op. cit.* (n. 18) 2; A. Cameron, 'Isidore of Miletus and Hypatia: the Editing of Mathematical Texts', *Greek, Roman and Byzantine Studies* 31 (1990) 122; Cuomo *Pappus* 95–126. Date: Cuomo *Pappus* 2. Vitruvius on the training of an architect: Vitruvius, *On Architecture* 1.1; Cuomo *Ancient Math.* 159–61, 202–3; Wilson Jones *op. cit.* (n. 1) 39–40.

58. Cuomo *Pappus*; Heath *Hist. Greek Math.* vol. 2, 356–439; Thomas *op. cit.* (n. 27) 566–621; *ODB* vol. 3, 1580; Cuomo *Ancient Math.* 223–31, 256–61.

59. Heath *Hist. Greek Math.* vol. 2, 526–8; Cameron *loc. cit.* (n. 57) 106–15; *ODB* vol. 3, 2060–1; D. Pingree, 'The Teaching of the *Almagest* in Late Antiquity', *Apeiron* 27 (1994) 77–82; M. Dzielska, *Hypatia of Alexandria* (Princeton 1995) 68–71.

60. O. Neugebauer, 'The Early History of the Astrolabe', *Isis* 40 (1949) 240–56.

61. Ammianus Marcellinus 22. 16. 17–18; Cuomo *Pappus* 45–6. Date: J. Mathews, *The Roman Empire of Ammianus* (London 1989) 23–4, 26.

62. P. Tannery, 'L'Article de Suidas sur Hypatia', *Annales de la Faculté des lettres de Bordeaux* 3 (1881) 101–4; reproduced in J.L. Heiberg and H.G. Zeuthen, eds., *Mémoires scientifiques de Paul Tannery*, vol. 1, (Paris 1912) 74–9; Heath *Hist. Greek Math.* vol. 2, 528–9; W.R. Knorr, *Textual Studies in Ancient and Medieval Geometry* (Boston 1989) 753–804; *ODB* vol. 2, 962; Dzielska *op. cit.* (n. 59).

63. Tannery *loc. cit.* (n. 51) 531–2; *ODB* vol. 1, 78–9.

64. *Archimedis opera omnia, cum commentariis Eutocii*, vol. 3, ed. Latin tr. J.L. Heiberg, rev. S. Stamatis (Stuttgart 1972) 1–2; Heath *Hist. Greek Math.* vol. 2, 540; *Diocles on Burning Mirrors The Arabic Translation of the Lost Greek Original*, ed. tr. G.J. Toomer (New York 1976) 18 n. 2; Knorr *op. cit.* (n. 62) 229; Cameron *loc. cit.* (n. 57) 104–6.

65. Summary of Eutocius' work: Cuomo *Ancient Math.* 231–4. Eutocius' methods of textual analysis: Cuomo *Ancient Math.* 257–8; Knorr *op. cit.* (n. 62) 229–39. Cameron has a lower opinion of Eutocius' editorial skills: Cameron *loc. cit.* (n. 57) 103–27.

66. P. Tannery, 'Eutocius et ses contemporains', *Bulletin des sciences mathématiques et astronomiques*, vol. 19 (= 2nd ser. vol. 8) (1884) 318; *Archimède*, vol. 4, *Commentaires d'Eutocius et fragments*, ed. tr. C. Mugler (Paris 1972) 1; *ODB* vol. 2, 757–8; Cuomo *Ancient Math.* 231.

67. Eutocius, *Commentary on the Sphere and Cylinder* 1. 44 and 2. 9; Mugler *op. cit.* (n. 66) 40 and 140. Mugler, following Tannery, treats these comments as later interpolations. Contra: Downey *loc. cit.* 1946–8 (n. 57) 112; Cameron *loc. cit.* (n. 57) 103–7, 118.

68. Downey *loc. cit.* 1946–8 (n. 57) 112; Warren *op. cit.* (n. 18) 8; Krautheimer *Byz. Archit.* 215.

69. Heath *Hist. of Greek Math.* vol. 1, 421; Downey 1946–8 *loc. cit.* (n. 57) 113; *ODB* vol. 2, 1016. Cameron (*loc. cit.*, n. 57, 120–1) suggests this was more based on Isidorus' practical experience to diminish his importance as a mathematical scholar.

70. Eutocius, *Commentary on the Sphere and Cylinder*, ed. Heiberg *op. cit.* (n. 64) vol. 3, 84 lines 8–11; Heath *Hist. Greek Math.* vol. 2, 540; Warren *op. cit.* (n. 18) 8; Cameron *loc. cit.* (n. 57) 120.

71. Dedication: Eutocius, *Commentary on the Conics* Book 1 in *Apollonii Pergaei quae exstant, cum commentariis antiquis*, vol. 2, ed. Latin tr. J.L. Heiberg (Leipzig 1893) 168–9; tr. in Thomas *op. cit.* (n. 27) 276–7; Downey 1946–8 *loc. cit.* (n. 57) 113; Cameron *loc. cit.* (n. 57) 116.

72. Tr. of Greek fragment of *On Remarkable (Paradoxical) Mechanical Devices* with commentary: G.L. Huxley, *Anthemius of Tralles: A Study in Later Greek Geometry* (Cambridge, Mass. 1959) 6–19, Fr. tr. ver Eecke *op. cit.* (n. 2) 47–56. Summary (referred to as *On Burning Mirrors*): Heath *Hist. Greek Math.* vol. 2, 541–3. Discussion: ver Eecke *op. cit.* (n. 2) xx–xxv; Downey *loc. cit.* 1946–8 (n. 57) 113; Warren *op. cit.* (n. 18) 6, 8; *ODB* vol. 1, 109. *On Remarkable Mechanical Devices*, which was translated into Arabic, survives in an unpublished revised version of about the early tenth century in Istanbul: Toomer *op. cit.* (n. 64) 20. There is another fragment the so-called *Fragmentum Bobiense*, which was sometimes attributed to Anthemius (Huxley *op. cit.* 27–30, contra: Heath *Hist. Greek Math.* vol. 2, 201, 203, 543; ver Eecke *op. cit.*, n. 2, xxv–xxx). However, as nothing like it is included in *On Remarkable Mechanical Devices*, the *Fragmentum Bobiense* cannot have been part of the former, although the style and language of this fragment indicate it dates to late antiquity: Toomer *op. cit.* (n. 64) 20. It includes mechanical handling and raising of weights about their centre of gravity.

Fragmentum mathematicum Bobiense, tr. with commentary Huxley *op. cit.* 20–6, Fr. tr. ver Eecke *op. cit.* (n. 2) 59–65. Summary: Heath *Hist. Greek Math.* vol. 2, 201–3.

73. Agathias, *Histories* 5. 7–8, *Agathias the Histories*, tr. J.P. Frendo (Berlin 1975) 142–3; Huxley *op. cit.* (n. 72) 2–3.

74. Huxley *op. cit.* (n. 72) 36–7; *ODB* vol. 1, 109.

75. Krautheimer *Byz. Archit.* 215–30, fig. 163–74; Mainstone *H. Sophia*; R. Mark and A.S. Çakmak, eds., *Hagia Sophia from the Age of Justinian to the Present* (Cambridge 1992). Summary: *ODB* vol. 2, 892–5.

76. Procopius, *Buildings* 1. 1. 22–78.

77. Procopius, *Buildings* 1. 1. 23–7, tr. (with alterations) from C. Mango, *The Art of the Byzantine Empire 312–1453* (Toronto 1986) 72–4.

78. Agathias, *History* 5. 9. 3, tr. in Mango *op. cit.* (n. 77) 78. Other descriptions after rebuilding: Mango *op. cit.* (n. 77) 78–102. Isidorus the Younger: *ODB* vol. 2, 1017.

79. *Mechanopoios*: Procopius, *Buildings* 1. 1. 50. *Mechanikoi*: Procopius, *Buildings* 2. 3. 7. On these and related terms: Downey *loc. cit.* 1946–8 (n. 57) 101–12; Mainstone *H. Sophia* 157.

80. The comparison with Christopher Wren was also made by Downey *loc. cit.* 1946–8 (n. 57) 114.

81. Cassiodorus, *Variae* 2. 5 in *The Letters of Cassiodorus*, tr. T. Hodgkin (London 1886) 323–4; Cuomo *Pappus* 19. Cassiodorus: *ODB* vol. 1, 388.

82. e.g. Krautheimer *Byz. Archit.* 215, 220.

83. Cameron *loc. cit.* (n. 57) 122–3.

84. MacDonald observed: 'Could an expert today find evidence in the Great Church [H. Sophia] of some use of the newly developed algebra set out by Diophantus of Alexandria in the late third century? He deals with equations of two or more variables, with solutions stated in whole numbers. Anyone with Anthemius' knowledge of mathematics, who was able to design and see built as complex and original a structure as the Great Church, has to be suspected of having made use of his knowledge in that enterprise. What is he likely to have known, and what practical applications might follow from that knowledge? In the history of ancient and early medieval architecture, such topics sorely need attention.' W. MacDonald, 'Roman Experimental Design and the Great Church,' in R. Mark and A.S. Çakmak, eds., *Hagia Sophia from the Age of Justinian to the Present* (Cambridge 1992) 12–13.

85. M. Whitby, 'Procopius' description of Dara (*Buildings* II, 1–13)', in P. Freeman and D. Kennedy, eds., *The Defence of the Roman and Byzantine East*, *BAR* 297 (ii) (Oxford 1986) 765–8.

86. Procopius, *Buildings* 2. 3. 2.

87. Procopius, *Buildings* 2. 3. 1–23.

88. L.S. de Camp, *The Ancient Engineers* (1963, repr. New York 1993) 265–6; N.J. Schnitter, 'Die Entwicklungsgeschichte der Bogenstaumauer', in G. Garbrecht, ed., *Historische Talsperren*, [vol. 1] (Stuttgart 1987) 79–81, table 1.

89. Remains of dam: Whitby *loc. cit.* (n. 85) 748, 768. Crow and Croke consider the dam was probably the work of the emperor Anastasius: B. Croke and J. Crow, 'Procopius and Dara', *JRS* 73 (1983) 157–8. So also: A. Cameron, *Procopius and the Sixth Century* (London 1985) 107. However, after an exhaustive comparison of Procopius's description with the archaeological evidence in Dara, Whitby (*loc. cit.*, n. 85, 752–3, 767–8) points out: 'There is no evidence to disprove Procopius' assertion that Justinian commissioned the dam.' Discussion of three surviving dams, none crescent-shaped: G. Garbrecht and A. Vogel, 'Die Staumauern von Dara', in G. Garbrecht, ed., *Historische Talsperren 2* (Stuttgart 1991) 263–76, fig. 1, 5.

Other remains at Dara: C. Preusser, *Nordmesopotamische Baudenkmäler altchristlicher und islamischer Zeit* (Leipzig 1911) 44–9, fig. 12, pl. 53–61; J.G. Crow, 'Dara, a Late Roman Fortress in Mesopotamia', *Yayla* 4 (1981) 12–20; G. Bell, *The Churches and Monasteries of the Tur 'Abdin*, rev. by M. Mundell Mango (London 1982) 102–5; M. Ahunbay, 'Dara-Anastasiopolis', *Kazi Sonuçları Toplantısı* 12.1 (1990) 391–7.

90. At Tell Kazel (with deposit dated AD 263–595) and possibly one at Tell Safroune (not dated): Y. Calvet and B. Geyer, *Barrages antiques de Syrie* (Lyon 1992) 54–8, 62–3, fig. 24–7, photo 5–7. There was a small horizontal arch dam at Saint-Rémy in Provence, France, described as Roman, but since 1891 covered by a more recent structure: Schnitter *loc. cit.* (n. 88) 78, fig. 1. I thank Michael Decker for these references.

CHAPTER 13: INFLUENCE OF ALEXANDRIA ON BYZANTINE ARCHITECTURE

1. The remains do not provide information about the rest of the design of the Theodosian church of H. Sophia, only the portico of the atrium. A.M. Schneider, *Die Grabung im Westhof der Sophienkirche zu Istanbul* (Berlin 1941) 8–17, fig. 5, pl. 4–5, 12.2, 13–22; F.W. Deichmann, *Studien zur Architektur Konstantinopels* (Baden-Baden 1956) 56–69, fig. 5–16; Mathews *Early Churches* 14–16, pl. 2; Mathews *Byz. Churches* 262, pl. 31–1 to 31–9; Müller-Wiener *Bildlexikon* 84, fig. 66–8; Krautheimer *Byz. Archit.* 108–9, 486 n. 27, fig. 53–4; Betsch *Late Antique Capital* 193–5; Strube *Polyeuktoskirche* 22. Remains from portico of atrium of church rather than porch of Theodosian church itself: Mainstone *H. Sophia* 135–6, fig. 158–9.

2. Müller-Wiener *Bildlexikon* 262, fig. 298; Krautheimer *Byz. Archit.* 74, fig. 29; R. Naumann, 'Neue Beobachtungen am Theodosiusbogen und Forum Tauri in Istanbul', *Istanbuler Mitteilungen* 26 (1976) 117–41. The capitals and cornices may be seen at the site.

3. According to the inscription on it, the column was erected by the emperor Marcian (AD 450–7). Kautzsch *Kapitellstudien* 47–9, fig. 3–4; Müller-Wiener *Bildlexikon* 54–5, fig. 33–5; Harrison *Temple* 20, fig. 12. Other evidence *c.* AD 450–510: Strube *Polyeuktoskirche* 23–42.

4. Date of AD 450 based on brickstamps: J. Bardill, *Brickstamps of Constantinople* (Oxford 2004) ch. 6 section 3 and ch. 9 section 1c. Built in 462/3: Theophanes *Chronographia* AM 5955, ed. de Boor 113, tr. Mango and Scott 175. Refuted, with suggestion it was built before 454, possibly in 453: C. Mango, 'The Date of the Studios Basilica at Istanbul', *Byzantine and Modern Greek Studies* 4 (1978) 115–22. So also: Krautheimer *Byz. Archit.* 497 n. 7; Müller-Weiner *Bildlexikon* 147.

5. Summary of plan: van Millingen *Byz. Churches* 49–55, fig. 12–17; Mathews *Early Churches* 19–27, fig. 5; Müller-Wiener *Bildlexikon* 147–52, fig. 138. Details of carved marble entablature and capitals: Deichmann *op. cit.* 69–72, fig. 17–18; van Millingen *Byz. Churches* fig. 18–19, pl. 7; Ebersolt and Thiers *Églises* 13–14, fig. 3–4; Kautzsch *Kapitellstudien* 131, 135, 167, pl. 27.434, 33.540; Mathews *Byz. Churches* 143–4, fig. 15-2 to 15-3, 15-20 to 15-24; Krautheimer *Byz. Archit.* 110; Strube *Polyeuktoskirche* 20–1. Date of introduction of Ionic impost capitals in Constantinople, first half of fifth century AD: Kautzsch *Kapitellstudien* 166–7; Deichmann *op. cit.* (n. 1) 45; Betsch *Late Antique Capital* 239–40; T. Zollt, 'Das ionische Kämpferkapitell. Definitionsprobleme', U. Peschlow and S. Möllers, eds., *Spätantike und byzantinische Bauskulptur Beiträge eines Symposions in Mainz, Februar 1992* (Stuttgart 1998) 59–65 with references. Van Lohuizen-Mulder suggests that later examples of undercutting began in Egypt, but the examples on the church of St John Studios indicate this technique already occurred in Constantinople: M. van Lohuizen-Mulder, 'Early Christian Lotus-panel Capitals and Other So-called Impost Capitals', *BaBesch* 62 (1987) 137. This also seems to be ignored in Betsch *Late Antique Capital* 246–8.

6. Harrison *Saraçane*; Harrison *Temple*.

7. Poem(s): *Palatine Anthology* 1. 10, *Anthologia graeca epigrammatum Palatina cum Planudea*, vol. 1, ed. H. Stadtmüller (Leipzig 1894) 4–7; *The Greek Anthology*, vol. 1, ed. tr. W.R. Paton (London 1916) 6–11. Fragments of poem from church: C. Mango and I. Ševčenko, 'Remains of the Church of St Polyeuktos at Constantinople', *DOP* 15 (1961) 243–7; Harrison *Saraçane* 5–8, 117–19, 407, A–B, pl. 87–9, 91, 93–100; Harrison *Temple* 33–4, 127–30, 31, 34, 86–9, 95–6, 98–9, 168. Suggestion that the poem is actually two poems with the part inside being a separate poem to that outside, based on stylistic details: M. Whitby, 'The St Polyeuktos Epigram (AP 1.10): a Literary Perspective', in S. Johnson, ed., *Greek Literature in Late Antiquity: Dynamism, Didacticism, Classicism* (London 2006).

8. Harrison *Saraçane* 418–20; Harrison *Temple* 36. Gilding roof: Gregory of Tours, *De gloria martyrum* in *Patrologia Latina* 71, col. 793–5. Latin text with tr.: Harrison *Saraçane* 8–9. Mango and Ševčenko *loc. cit.* (n. 7) 245.

9. Mango and Ševčenko *loc. cit.* (n. 7) 244–5.

10. A *scholion* on the epigram states it was built in three years and the *Patria* (which is less reliable) that it was built in four and a half years: Stadtmüller *op. cit.* (n. 7) p. 6 note to lines 5–6; *Patria Constantinopoleos* 3. 57 in *Scriptores originum Constantinopolitarum*, vol. 2, ed. T. Preger (Leipzig 1907) 237; Mango and Ševčenko *loc. cit.* (n. 7) 245; Harrison *Saraçane* 7, 10. This short construction time is not as suprising as might seem because H. Sophia was built in five years and many larger complexes in Rome, took five to ten years, such as the Baths of Caracalla and the Pantheon: L. Lancaster, 'Building Trajan's Markets', *AJA* 102 (1998) 308 n. 68.

11. Mango and Ševčenko *loc. cit.* (n. 7) 245; Harrison *Temple* 35.

12. S.J. Hill in Harrison *Saraçane* 223; Harrison *Saraçane* 111–12; Harrison *Temple* 71.

13. From analysis of Harrison *Saraçane* 221–2 and Table 2 on p. 225; J. Bardill, 'Brickstamps and the Date of St Polyeuktos', *Bulletin of British Byzantine Studies* 20 (1994) 67; G. Fowden, 'Constantine, Silvester and the Church of St Polyeuctus in Constantinople', *JRA* 7 (1994) 275. See now, for discussion of evidence and dating of substructure bricks, which carry indictions 2–5, AD 508/9 to 511/2: Bardill *op. cit.* (n. 4) ch. 6 section 5 and ch. 9 section 2a.

14. The bricks associated with the upper parts of the church carry indiction years 11–14 (August 517 to September 521). From analysis of: Harrison *Saraçane* 221–2 and Table 2 on p. 225. This construction date is obviously based on the bricks not being stored for long. See now: Bardill *op. cit.* (n. 4) ch. 6 section 5 and ch. 9 section 2a.

15. *Palatine Anthology* 1. 10. 51, ed. tr. Paton vol. 1, 10–11. Foundations: Harrison *Saraçane* B on p. 16, 20–1, A on p. 103, 406–7, A on p. 406, 413, pl. 15, 18–19; Harrison *Temple* 52, 130, fig. 39, 42, 47–8, 51, 167.

16. S.J. Hill in Harrison *Saraçane* 222–3. Contra: Harrison *Saraçane* 408.

17. Harrison *Saraçane* 410, 413–14; Harrison *Temple* 60, 131–2.

18. *Palatine Anthology* 1. 10. 57, ed. tr. Paton vol. 1, p. 10–11.

19. Gregory of Tours, *De gloria martyrum* in *Patrologia Latina* 71, col. 793–5. Latin text with tr.: Harrison *Saraçane* 8–9. Mango and Ševčenko *loc. cit.* (n. 7) 245. *Camara / camera* = vaulted roof: *OLD* 262; C.T. Lewis and C. Short, *A Latin Dictionary* (Oxford 1879, repr. 1962) 274. Date of Gregory of Tours: *ODB* vol. 2, 883.

20. M. Mundell Mango, 'The Monetary Value of Silver Revetments and Objects Belonging to Churches', in S.A. Boyd and M. Mundell Mango, eds., *Ecclesiastical Silver Plate in Sixth-Century Byzantium* (Washington D.C. 1992) 125–6.

21. Krautheimer *Byz. Archit.* 230, 263–5, fig. 209–10; Harrison *Saraçane* 407–10, fig. B on p. 408; Harrison *Temple* 127–34, fig. 167, 171; S. Ćurčić, 'Design and Structural Innovation in Byzantine Architecture before Hagia Sophia', in R. Mark and S. Çakmak, eds., *Hagia Sophia from the Age of Justinian to the Present* (Cambridge 1992) 23–5. First Justinianic phase of AD 532 of H. Irene (which was rebuilt in 564 and remodelled after 740): W.S. George, *The Church of Saint Eirene at Constantinople* (London 1913) 69–70, fig. 37; Mathews *Early Churches* fig. 42; Mathews *Byz. Churches* 102–3. Revised plan: U. Peschlow, *Die Irenenkirche in Istanbul* (Tübingen 1977) 206–8, Beil. 10–11. St Polyeuktos could have had a groin vault, rather than a dome above the centre, or three groin vaults along it, but a dome would have been preferable, as was the case in H. Sophia: Mainstone *H. Sophia* 161–2, fig. 184. Problems with details of reconstruction of St Polyeuktos in positioning of verses of the poem: C. Mango, Review of R.M. Harrison, *Excavations at Saraçane in Istanbul*, vol. 1, *JRS* 81 (1991) 238. There was apparently a dome over the nave on the east church of the monastery at Alahan, supported by squinches (not pendentives) in the corners, under the emperor Zeno (AD 474–91): Harrison *Temple* 26, fig. 19.

22. Harrison *Temple* 134.

23. *Palatine Anthology* 1. 10. 48–9, ed. tr. Paton vol. 1, 10–11.

24. R.M. Harrison, 'The Church of St Polyeuktos in Istanbul and the Temple of Solomon', *Harvard Ukrainian Studies* 7 (1983) = C. Mango and O. Pritsak, eds., *Okeanos. Essays presented to I. Ševčenko* (Cambridge, Mass. 1984) 276–9; Harrison *Saraçane* 410–11; Harrison *Temple* 137–9; M. Vickers, 'Wandering Stones: Venice, Constantinople, and Athens', in K.L. Selig and E. Sears, eds., *The Verbal and the Visual: Essays in Honour of W. Heckscher* (New York 1990) 229–31.

25. I Kings 6–7, II Chronicles 3–4; especially I Kings 6. 29 and 7. 17–22. Solomon's Temple, built in the tenth century BC in Jerusalem, was destroyed and rebuilt in the sixth century and extensively renovated in the first century BC.

26. Harrison *Temple* 139.

27. Examples of angels (specifically the archangels) with wings with peacock feathers: T.F. Mathews, 'The Early Armenian Iconographic Program of the Ējmiadcin Gospel', in N.G. Garsoïan, T.F. Mathews, and R.W. Thompson, eds., *East of Byzantium: Syria and Armenia in the Formative Period* (Washington D.C. 1982) 201–2.

28. Screen: Harrison *Saraçane* 153 no. 15d i, 416, fig. G. 15d [i] on p. 134, pl. 186–7; Harrison *Temple* 108, fig. 134. Identification of split palmette and egg motifs as cherubim: Julian Raby, pers. com., which he will publish in his detailed analysis of the iconography of the Dome of the Rock.

29. J. Wilkinson, pers. com.; R.M. Harrison, 'From Jerusalem and Back Again, the Fate of the Treasures of Solomon', in K. Painter, ed., '*Churches Built in Ancient Times' Recent Studies in Early Christian Archaeology* (London 1994) 247.

30. *Middoth* ('*Measurements*') 3. 8, in *The Mishnah*, tr. H. Danby (Oxford 1933) 595; Harrison *loc. cit.* (n. 24) 278.

31. Ezekiel 41. 13–14; Harrison *loc. cit.* (n. 24) 277; Harrison *Saraçane* 410; Harrison *Temple* 137. Although it is Solomon's Temple mentioned in the poem inscribed on St Polyeuktos, this has led to the suggestion Anicia Juliana was alluding to Exekiel's temple instead: C. Milner, 'The Image of the Rightful Ruler: Anicia Juliana's Constantine Mosaic in the Church of Hagios Polyeuktos', in P. Magdalino, ed., *New Constantines: The Rhythm of Imperial Renewal in Byzantium, 4th–13th Centuries* (Aldershot 1994) 73–81; Fowden *loc. cit.* (n. 13) 275 n. 16.

An iron measuring rod, apparently consisting of 5 cubits of 0.518 m survives from Byzantine Palestine (c. AD 610–17): C. Dauphin, 'A VIIth Century Measuring Rod from the Ecclesiastical Farm at Shelomi in Western Galilee (Israel)', *Jahrbuch der Österreichischen Byzantinistik* 32/3 (1982) 513–22. Other churches in Constantinople seem to be laid out using a Byzantine foot of c. 0.315 m: P.A. Underwood, 'Some Principles of Measure in the Architecture of the Period of Justinian', *Cahiers archéologiques* 3 (1948) 64–74. Foot on St Sophia, 0.312 m: Mainstone *H. Sophia* 177. Length of Egyptian cubit in Ptolemaic and Roman periods, generally 0.525, but ranges from c. 0.5205 to 0.531 m, references: Ch. 2 n. 29, Ch. 6 n. 46, Ch. 7 n. 87.

32. Strube *Polyeuktoskirche* 63, 67–9, 75–6; Harrison *Saraçhane* 414, 416–17 with references, 420; Harrison *Temple* 122–4; Fowden *loc. cit.* (n. 13) 278.

33. Harrison, pers. com. He later began to wonder whether there was a direct link with Jerusalem because of the occurrence of some of the motifs on the Dome of the Rock: Harrison *loc. cit.* (n. 29) 247. The Umayyad examples, such as those on the Dome of the Rock, however, are over a century later than St Polyeuktos, making a common origin elsewhere possible. Harrison noticed the connection with Egypt, but assumed the material there was later: 'what we may call the Polyeuktos repertory has a period of popularity in Coptic (Monophysite) Egypt': Harrison *Saraçhane* 418.

34. Harrison *Saraçhane* 117–21, 414, 416, fig. A.1a [ii]–[iii] on p. 118, fig. B on p. 120, pl. 91–3, 96–103; Harrison *Temple* 84, fig. 31, 34, 86–9, 91, 96–7.

35. See n. 7.

36. Harrison *Saraçhane* 119, 415, fig. A. on p. 118, fig. B on p. 120, pl. 91, 93–4, 96–102; Harrison *Temple* fig. 31, 34, 86–9.

37. Harrison *Saraçhane* 117, 415, fig. A.1a [i] on p. 118, pl. 26, 87–8, 95; Harrison *Temple* 88, fig. 98–9.

38. Dated by Carbon 14 to AD 333–545: S. Schrenk, *Textilien des Mittelmeerraumes aus spätantiker bis Frühislamischer Zeit* (Riggisberg 2004) 51. There would be at least three niche heads before the next large pier indicated by the small T-shape to the right of the second niche, so that the lower fragment of the textile, with the right pillar shaft on it, would have been positioned further to the right relative to the top fragment. Wall-hanging in Stuttgart (inv. 1984–103) with eagles in niches: S. Schrenk, 'Der Elias-Behang in der Abegg-Stiftung', in D. Willers *et al.*, *Begegnung von Heidentum und Christentum im spätantiken Ägypten* (= *Riggisberger Berichte* 1) (Riggisberg 1993) 172, 174–5, 177, fig. 4. It is related to the Elijah Tapestry (with four niches): M.-H. Rutschowscaya, *Coptic Fabrics* (Paris 1990) pl. on p. 130–1; which is dated by Carbon 14 to AD 379–543: Schrenk *op. cit.* 2004, 47.

39. J. Boardman, ed., *The Oxford History of Classical Art* (Oxford 1993) fig. 333; Schrenk *op. cit.* (n. 38) 41–5.

40. Strube *Polyeuktoskirche* 69–72, fig. 70; Harrison *Saraçhane* 121 no. 2b, 416, 417, fig. C.2b [i]–[iv] on p. 122, pl. 114–20; Harrison *Temple* 123, fig. 104–5.

41. Breccia *Musée gréco-romain 1931–2* pl. 33f, 36c.

42. Strube *Polyeuktoskirche* 69–72, fig. 71; Harrison *Saraçhane* 121 no. 2a, 416, fig. C.2a on p. 122, pl. 111–12; Harrison *Temple* 123, fig. 100, 103.

43. Breccia *Musée gréco-romain 1931–2* pl. 33d, 36b, d, f–g. Other 'Coptic' fragments, attributed to Oxyrhynchus: H. Zaloscer, *Une collection de pierres sculptées au Musée copte du Vieux-Caire (Collection Abbàs el-Arabi)* (Cairo 1948) pl. 11.20a–c, 12.21.

44. J.D. Cooney, ed., *Pagan and Christian Egypt* (Brooklyn 1941) 60 no. 177, fig. 177.

45. Polyeuktos: Harrison *Saraçhane* 146–7 no. 13a i, pl. 172; Harrison *Temple* 123, fig. 126–7, 145, 164. Silk from Antinoopolis: J.H. Schmidt, 'L'Expédition de Ctésiphon en 1931–1932', *Syria* 15 (1934) 17, pl. 6G.

46. Harrison *Saraçhane* 132, fig. F.5b [i] on p. 127, pl. 25–6, 147–8; Harrison *Temple* 132, fig. 150, 170.

47. H.G. Lyons, *A Report on the Island and Temples of Philae* (London 1896) pl. 34–5, 40.

48. Date palms with vines on capitals: K.G. Siegler, *Kalabsha, Architektur und Baugeschichte des Tempels* (Berlin 1970) fig. 62, pl. 30.1. Other capitals with vines at Kalabsha: Siegler *op. cit.* pl. 5, 30. 2, 4, B, C.

49. Strube *Polyeuktoskirche* 70, fig. 65; Harrison *Saraçhane* 128, no. 3c i, pl. 131; Harrison *Temple* fig. 109.

50. R.M. Harrison, 'The Church of St Polyeuktos in Constantinople', *Akten des VII Internationalen Kongresses für christliche Archäologie, Trier 1965* (Berlin 1969) 546–7; F.W. Deichmann, 'I pilastri acritani', *Atti della Pontificia Accademia Romana di Archeologia, Rendiconti* 50 (1977–8 [1980]) 75–89; *idem* ed., *Corpus der Kapitelle der Kirche von San Marco zu Venedig* (Wiesbaden 1981) 138–41, nos. 639–40, pl. 45–7; Harrison *Saraçhane* 131 nos. 5a i–iii, 133 nos. 6a i–ii, pl. 143–4, 154–5; Harrison *Temple* 100, fig. 118, 122, 148; M. Vickers, 'A "New" Capital from St Polyeuktos (Saraçhane) in Venice', *Oxford Journal of Archaeology* 8.2 (1989) 227–30; Vickers *loc. cit.* (n. 24) 228–9, 231, 232, fig. 2.

51. Harrison *Saraçhane* 131–2, nos. 5a i, iv, 133, fig. F 5a iv on p. 127, pl. 141–2, 145–6; Harrison *Temple* 80, fig. 31, 85, 114–17, 147–8.

52. Saqqara: Donald Bailey's photograph. Example attributed to Oxyrhynchus: Zaloscer *op. cit.* (n. 43) pl. 21.39.

53. Strube *Polyeuktoskirche* 79, fig. 63; Harrison *Saraçhane* 126–7, no. 3a, fig. F 3a [i] on p. 127, pl. 128–9; Harrison *Temple* 94, fig. 108, 124. Examples on S. Marco in Venice, probably from St Polyeuktos: Deichmann *op. cit.* (n. 50) 92 nos. 272–3, pl. 24.272–3; Harrison *Saraçhane* 258; Harrison *Temple* 94, fig. 125, 165; Vickers *loc. cit.* (n. 24) 229–30; J. Kramer, 'Bemerkungen zu den Methoden der Klassifizierung und Datierung frühchristlicher oströmischer Kapitelle', in U. Peschlow and S. Möllers, eds., *Spätantike und byzantinische Bauskulptur, Beiträge eines Symposions in Mainz, Februar 1994* (Stuttgart 1998) 48 n. 15, pl. 11.8–9. Example in garden of H. Sophia, possibly from St Polyeuktos: Harrison *Saraçhane* pl. 263; Harrison *Temple* 143, fig. 178.

54. References Ch. 11 n. 308.

55. Kautzsch *Kapitellstudien* 192 no. 630, pl. 38.630; H.G. Severin, 'Beispiele der Verwendung spätantiker Spolien. Ägyptische Notizen', in O. Feld and U. Peschlow, eds., *Studien zur spätantiken und byzantinischen Kunst F.W. Deichmann gewidmet*, vol. 2 (Bonn 1986) 107–8, pl. 20.

56. Impression of woven roof matting in mud from the workmen's village at Tell el-Amarna, c. 1350 BC, probably from two parallel strands of Dom palm (Hyphaene thebaica) based on examples found at the same excavation. I thank Willemina Wendrich for this information (pers. com. 1992). Photograph in B.J. Kemp, *Amarna Reports* II (London 1985) 10 fig. 1.8.

Van Lohuizen-Mulder (*loc. cit.* n. 5, 133–5) identifies the double strands on the capitals as the split mid-ribs of palms which were used for such widely spaced weaving. Use of material from date palm fronds from Egypt for weaving in mid-sixth century AD: John of Ephesus, *Lives of the Eastern Saints* 51, ed. tr. E.W. Brooks, *PO* XIX, 162 [508].

57. Kalabsha: Siegler *op. cit.* (n. 48) fig. 63, pl. 5, 30.III. On the lotus-panel motif and its relation to Egyptian examples: van Lohuizen-Mulder *loc. cit.* (n. 5) 133.

58. Van Lohuizen-Mulder also suggests that the lotus-panel capitals originated in Egypt, but avoids the chronolgical problem of there being no proof they are the earliest examples by dating those in the Attarin Mosque to the fourth century on the grounds that it was the converted Church of Athanasius, built c. AD 370: van Lohuizen-Mulder *loc. cit.* (n. 5) 136. However, there is no basis for the Attarin Mosque having been the Church of Athanasius.

59. Examples listed in: van Lohuizen-Mulder *loc. cit.* (n. 5) 132 n. 6.

60. Betsch *Late Antique Capital* 121; Harrison *Saraçhane* 163 no. 21h i, pl. 242; Harrison *Temple* 80, fig. 84. Similarly on H. Sophia capital *in situ*, but unfinished, suggesting final carving once in position: Strube *Polyeuktoskirche* fig. 93.

61. Betsch *Late Antique Capital* 144–7.

62. Harrison suggested that the workmen from St Polyeuktos later worked on S. Vitale: Harrison *Saraçhane* 415; Harrison *Temple* 141. Van Lohuizen-Mulder (*loc. cit.* n. 5, 140–2) suggests the workmen on S. Vitale came from Egypt. This would not explain the differences between the lotus-panel capitals on it and the examples in Egypt.

63. R.O. Farioli, '*Corpus*' *della scultura paleocristiiana bizantina ed altomedioevale di Ravenna III La scultura architettonica* (Rome 1969) 37 no. 54, fig. 53; F.W. Deichmann, *Ravenna, Hauptstadt des spätantiken Abendlandes* Band II, Kommentar, 2. Teil, (Wiesbaden 1976) 96, 99, fig. 22, Abb. 78–80; P.A. Martinelli, ed., *The Basilica of San Vitale Ravenna* (Modena 1997) 185–6, pl. 128–34, 158–220 (the photographs are too small for the raised line on the weaving to be visible). The impost blocks above the capitals have the monogram of Bishop Victor (AD 538–45) carved in relief on them: Deichmann *op. cit.* 4, 48, 100, fig. 22. Date: Krautheimer *Byz. Archit.* 244; *ODB* vol. 3, 1774.

64. The example reused in Bursa on the Mausoleum of Murad II, has a thick centre line on the weaving and a very small central panel, suggesting that it could also have been copied from a drawing: Kramer *loc. cit.* (n. 53) pl. 11.10–12. On lotus-panel motif on S. Vitale and Egyptian examples as prototype: van Lohuizen-Mulder *loc. cit.* (n. 5) 135.

65. Rutschowscaya *op. cit.* (n. 38) 40, pl. on p. 40; A. Stauffer, 'Cartoons for weavers from Graeco-Roman Egypt', in D.M. Bailey, ed., *Archaeological Research in Roman Egypt, JRA* suppl. 19 (Ann Arbor 1996) 223–30.

66. St Polyeuktos: Strube *Polyeuktoskirche* 79, fig. 62; Harrison *Saraçhane* 128 no. 3b i, pl. 130; Harrison *Temple* 94–5, fig. 110, 149. Bawit: Chassinat *Baouit* pl. 78.1–3.

67. H. Luschey, 'Zur Datierung der sasanidischen Kapitelle aus Bisutun und des Monuments von Taq-i-Bostan', *Archäologische Mitteilungen aus Iran* 1 (1968) 131 fig. 2 lower right, pl. 52.6.

68. Luschey *loc. cit.* (n. 67) fig. 2 top right, fig. 3–5. This slightly curved profile also occurs on Byzantine impost capitals in Istanbul: Luschey *loc. cit.* (n. 67) pl. 54. Some of the Sassanian examples notably have flat sides and do not curve to follow the circular shape of the column: Luschey *loc. cit.* (n. 67) pl. 51, 52.3–4.

69. K. Erdmann, 'Die Kapitelle am Taq i Bostan', *Mitteilungen der deutschen Orient-Gesellschaft zu Berlin* 80 (1943) 1–24. Arguments summarized in Luschey *loc. cit.* (n. 67) 129–42. Erdmann and Luschey agreed that the various Sassanian capitals are of similar date to Taq-i-Bustan, although they did not agree on the date itself. One of the capitals (Luschey *loc. cit.*, n. 67, pl. 51.1 = J. Kröger, *Sasanidischer Stuckdekor*, Berlin 1982, pl. 40.2) has a similar vegetal motif on it to those on the capitals and pilasters of the Taller Grotto at Taq-i-Bustan: Kröger *op. cit.* pl. 40.3; S. Fukai and K. Horiuchi, *Taq-i-Bustan* (Tokyo 1969, 1972) vol. 1, pl. 4–7, 12, vol. 2, pl. 57–9, 61–3. Erdmann thought it dated to the reign of Perez (AD 457–83): Erdmann *loc. cit.* 23–4; K. Erdmann, 'Das Datum des Tâk-i-Bustân', *Ars islamica* 4 (1937) 79–97. Luschey preferred E. Herzfeld's date in the reign of Khosrow II (AD 590–628): Luschey *loc. cit.* (n. 67) 130, 133, 136–7. Recent detailed Japanese work on it has suggested a date during and after the reign of Ardashir III (AD 628–30): S. Fukai *et al.*, *Taq-i Bustan*, vol. 4 text (Tokyo 1984) 161–2. Khosrow II more likely: B. Goldman, 'The Imperial Jewel at Taq-i-Bustan', in L. de Meyer and E. Haerinck, eds., *Archaeologia iranica et orientalis, Miscellanea in honorem L.V. Berghe* (Gent 1989) 831–46. Obviously if one of these dates in the late sixth or first half of the seventh century for Taq-i Bustan is correct, then a Sassanian origin for impost capitals cannot be suggested: Kautzsch *Kapitellstudien* 205; Luschey *loc. cit.* (n. 67) 137–8; van Lohuizen-Mulder *loc. cit.* (n. 5) 142. Deichmann also compared the vegetal decoration on the *pilastri acritani* with that at Taq-i-Bustan: Deichmann *loc. cit.* (n. 50) 86–8. The chronology of Taq-i-Bustan creates a similar problem for this suggestion.

70. Ionic impost capital in fifth century, which resulted from fusion of impost block with Ionic capital, as a stage in the development of the impost capital: Deichmann *op. cit.* (n. 1) 50–4; E. Kitzinger, *Byzantine Art in the Making* (London 1977) 78–9; Betsch *Late Antique Capital* 244.

71. Kröger *op. cit.* (n. 69) pl. 46.6.

72. Local Egyptian production of Sassanian motifs in Late Antique Egyptian textiles especially in Antinoopolis: E. Kitzinger, 'The Horse and Lion Tapestry at Dumbarton Oaks, A Study in Coptic and Sassanian Textile Design', *DOP* 3 (1946) 54–7; G. de Francovich, 'L'Egitto, la Siria e Constantinopoli: Problemi di Metodo', *RIA* 20–1, new series 11–12 (1963) 184–98, fig. 133–40, 143–5; Rutschowscaya *op. cit.* (n. 38) 24, 55, pl. on p. 56–7.

73. Examples of palmettes and symmetrical stylized plant motifs in Sassanian stucco decoration (from area of Ktesiphon): Harrison *Temple* 122, fig. 162; Schmidt *loc. cit.* (n. 45) pl. 1A–C, 2, 3D; R. Ghirshman, *Iran, Parthians and Sassanians* (London 1962) fig. 229, 231; Kröger *op. cit.* (n. 69) pl. 20.1–3, 21.1, 3, 39.3, 46.1. Date of stucco decoration from Ktesiphon: Kröger *op. cit.* (n. 69) 259–62. Harrison *Temple* 122 suggests that Sassanian motifs were transmitted via more portable forms such as textiles. Sassanian textiles as method of transmission: A. Grabar, *Sculptures byzantines de Constantinople* (Paris 1963) 64–5.

74. Procopius, *Buildings* 2. 3. 2.

75. Van Millingen *Byz. Churches* 73–4, fig. 20; Ebersolt and Thiers *Églises* 24, fig. 17, 19.

76. H. Swainson, 'Monograms on the Capitals of S. Sergius at Constantinople', *ByzZ* 4 (1895) 106–8; van Millingen *Byz. Churches* 73, 74; Mathews *Early Churches* 47.

77. Van Millingen *Byz. Churches* 62–4; C. Mango, 'The Church of Saints Sergius and Bacchus at Constantinople and the Alleged Tradition of Octagonal Palatine Churches', *Jahrbuch der Österreichischen Byzantinistik* 21 (1972) 190, 192; Mathews *Early Churches* 47; Mathews *Byz. Churches* 242; C. Mango, 'The Church of Sts Sergius and Bacchus Once Again', *ByzZ* 68 (1975) 385; *ODB* vol. 3, 1879. Suggestion construction could have been begun before AD 527 [but not completion of the inscription or monograms]: R. Krautheimer, 'Again Saints Sergius and Bacchus at Constantinople', *Jahrbuch der Österreichischen Byzantinistik* 23 (1974) 253.

78. Mainstone *H. Sophia* 157. Mango 1975 (*loc. cit.* n. 77, 392) suggests it was built AD 531–6. So also: Müller-Wiener *Bildlexikon* 177. Bardill suggests AD 530–6, possibly narrowed to AD 530–3: J. Bardill, 'The Church of Sts. Sergius and Bacchus in Constantinople and the Monophysite Refugees', *DOP* 54 (2000) 1–11.

79. Procopius, *Buildings* 1. 4. 1–8; Mathews *Early Churches* 43–51.

80. R. Browning, *Justinian and Theodora* (rev. edn London 1987) 38–41; *ODB* vol. 3, 2036; H. Chadwick, *The Church in Ancient Society, from Galilee to Gregory the Great* (Oxford 2001) 612.

81. John of Ephesus, *Lives of the Eastern Saints* 47, ed. tr. E.W. Brooks, *PO* XVIII 676–85 [474–82]; Mango *loc. cit.* 1975 (n. 77) 386; Müller-Wiener *Bildlexikon* 178. Krautheimer (*loc. cit.* n. 77, 252) considers the refugees would not have arrived until AD 537.

82. Mango *loc. cit.* 1975 (n. 77) 388.

83. Mango *loc. cit.* 1975 (n. 77) 385–92; Bardill *loc. cit.* (n. 78). Contra, Krautheimer *Byz. Archit.* 513 n. 22. Van Lohuizen-Mulder (*loc. cit.* n. 5, 149–50) uses this to suggest Coptic artisans worked on the church decoration. If Krautheimer's view (*loc. cit.* n. 77, 252) that the Monophysite refugees would not have arrived until AD 537 is correct, they could not be the reason for the construction of the church.

84. Van Millingen *Byz. Churches* 70–9, fig. 23–9; Mathews *Byz. Churches* 243, pl. 29-14 to 29-24; Krautheimer *Byz. Archit.* 233–46, fig. 180–2, 184; P. Grossmann, 'Beobachtungen zum ursprünglichen Grundriß der Sergios- und Bakchoskirche in Konstantinopel', *Istanbuler Mitteilungen* 39 (1989) 153–9.

85. Krautheimer *Byz. Archit.* 248.

86. Ebersolt and Thiers *Églises* 32, fig. 14.

87. J.B. Ward-Perkins, 'Notes on the Structure and Building Methods of Early Byzantine Architecture', in D. Talbot Price, ed., *The Great Palace of the Byzantine Emperors, Second Report* (Edinburgh 1958) 90–5, fig. 20, pl. 34–5.

88. Ward-Perkins *loc. cit.* (n. 87) pl. 32–3; Krautheimer *Byz. Archit.* 238.

89. G.W. van Beek, 'Arches and Vaults in the Ancient Near East', *Scientific American* 257.1 (July 1987) 78–85.

90. Van Millingen *Byz. Churches* 73, fig. 30, pl. 14; Ebersolt and Thiers *Églises* fig. 19–20, 25; Mathews *Byz. Churches* pl. 29-16, 29-28, 29-30; Krautheimer *Byz. Archit.* 239, fig. 184. The dedicatory inscription is inserted above the traditional vegetal frieze, rather than replacing it. To compensate for this the three fascia of the architrave are shorter. The corona of the cornice is shallower.

91. Ebersolt and Thiers *Églises* 43–4, fig. 17, 21; Kautzsch *Kapitellstudien* 186, pl. 37.587; Mathews *Early Churches* pl. 31; Mathews *Byz. Churches* pl. 29-29.

92. Ebersolt and Thiers *Églises* 44–6, fig. 22–5; Kautzsch *Kapitellstudien* 172–3, pl. 34.557; Mathews *Byz. Churches* pl. 29-26 to 29-27.

93. Ebersolt and Thiers *Églises* 42–3, fig. 17, 19–20, 25; Kautzsch *Kapitellstudien* 188, pl. 37.591; Mathews *Byz. Churches* pl. 29-16, 29-18, 29-25, 29-28.

94. Saqqara: Quibell *Saqqara* III pl. 16.1–2, 22.3, 29.1. Examples with no abacus: Quibell *Saqqara* III pl. 21.1–2, 25.

95. Kautzsch *Kapitellstudien* 189, pl. 37.601; *CE* 207–8; E. Dauterman Maguire, 'Range and Repertory in Capital Design', *DOP* 41 (1987) 352.

96. *CE* 208.

97. On first floor of north side of chancel: Kautzsch *Kapitellstudien* 188–9 no. 596. The impost blocks above them have the monogram of Bishop Victor (AD 538–45): Farioli *op. cit.* (n. 63) 39 no. 58, fig. 57; Deichmann *op. cit.* (n. 63) 4, 99, fig. 25; Martinelli *op. cit.* (n. 63) 221, pl. 283, 471, 479–86.

98. B. Molajoli, *La Basilica Eufrasiana di Parenzo* (Padua 1943); A. Šonje, 'I capitelli della Basilica Eufrasiana di Parenzo', in O. Feld and U. Peschlow, eds., *Studien zur spätantiken und byzantinischen Kunst, F.W. Deichmann gewidmet*, vol. 2 (Bonn 1986) 127–45; M. Prelog, *The Basilica of Euphrasius in Poreč* (Zagreb 1986); A.R. Terry, *The Architecture and Architectural Sculpture of the Sixth Century Eufrasius Cathedral Complex at Poreč*, PhD Illinois 1984 (Ann Arbor 1986); A. Terry, 'The Sculpture at the Cathedral of Eufrasius in Poreč', *DOP* 42 (1988) 13–64; van Lohuizen-Mulder *loc. cit.*

(n. 5) 144–5. Date: Šonje *loc. cit.* 145; Terry *op. cit.* 14, 59. It has some capitals with lotus-panels but with leaf decoration in place of basket work: Šonje *loc. cit.* pl. 24.3, 25.4; Terry *loc. cit.* 16, 21–2, fig. 14–19. Related panelled impost capitals without the lotus motifs are also used on it: Šonje *loc. cit.* pl. 24.1–2, 4; Terry *loc. cit.* 16, 18–21, fig. 3–6, 12–13. Panelled impost capitals are used on the chancel of S. Vitale: Farioli *op. cit.* (n. 63) 36–7 no. 53, 38 no. 56, fig. 52, 55.

99. Strube *Polyeuktoskirche* 81–90; Kautzsch *Kapitellstudien* 182–203, pl. 37–41; Betsch *Late Antique Capital* 243–6, 249–89, 316, 325–31, 344–56.

100. Betsch *Late Antique Capital* 243–5. This contrasts with the suggestion that the basic impost capitals resulted from Sassanian influence. See n. 69.

101. References: Ch. 11 n. 306.

102. Van Lohuizen-Mulder suggests that the examples of two-zone capitals throughout the eastern Mediterranean and Italy were the work of Coptic artisans: M. van Lohuizen-Mulder, 'The Two-zone Capitals', *BABesch* 64 (1989) 193–204. However, the lack of reliably dated examples from Egypt means there is not proof. Two-zone capitals: Kautzsch *Kapitellstudien* 162–5, pl. 31–2; Kitzinger *loc. cit.* (n. 72) 17–19; Betsch *Late Antique Capital* 210–11.

103. Mathews *Byz. Churches* fig. 31-50 to 31-51, 31-53; Mainstone *H. Sophia* fig. 6–7, 43.

104. Deichmann *op. cit.* (n. 1) 77–81; Mathews *Byz. Churches* fig. 31-50, 31-52; Mainstone *H. Sophia* fig. 46, 90; L.E. Butler, 'Hagia Sophia's Nave Cornices as Elements of its Design and Structure', in R. Mark and A. Çakmak, eds., *Hagia Sophia from the Age of Justinian to the Present* (Cambridge 1992) 57–77, with references 57–8 n. 1–2.

105. Kautzsch *Kapitellstudien* 195–6 nos. 644–5, pl. 38.644, 39.645; Mathews *Byz. Churches* fig. 31-69; Mainstone *H. Sophia* fig. 55.

106. Kautzsch *Kapitellstudien* 195 no. 644, pl. 38.644a–b; Mathews *Byz. Churches* fig. 31-73; Betsch *Late Antique Capital* 240–1; Strube *Polyeuktoskirche* 94, fig. 91; Mainstone *H. Sophia* fig. 43–6, 57, 69, 100, 216, 220, 284.

107. H.C. Butler, *Syria, Architecture, Publications of the Princeton University Archaeological Expedition to Syria*, Division II, Section B (Leiden 1920) 163, 257, ill. 174B, 270.

108. Kautzsch *Kapitellstudien* 173–4 nos. 558–9, pl. 34.558–9; Mathews *Byz. Churches* fig. 31-83, 31-84, 31-86; Deichmann *op. cit.* (n. 1) 79, fig. 24; Strube *Polyeuktoskirche* 92–4, fig. 95, 97–8; Mainstone *H. Sophia* fig. 63, 66–7, 70, 225, 284.

109. Kautzsch *Kapitellstudien* 197, pl. 39.651; Mathews *Byz. Churches* fig. 31-85; Strube *Polyeuktoskirche* 91–2, fig. 92–4; Mainstone *H. Sophia* fig. 64–5, 74.

110. Kautzsch *Kapitellstudien* pl. 38.644a; Mathews *Byz. Churches* fig. 31-72; Mainstone *H. Sophia* fig. 42, 45, 100.

111. Detailed plans at 1:100 and 1:250 in R.L. van Nice, *St Sophia in Istanbul, An Architectural Survey* (Washington, D.C., 1965). Reproduced (at smaller scale), with recent studies involving computer analyses of structure in: R. Mark and A. Çakmak, eds., *Hagia Sophia, from the Age of Justinian to the Present* (Cambridge 1992) pl. 1–44. Recent discussion: Mainstone *H. Sophia*. Summary: R. Cormack, *Byzantine Art* (Oxford 2000) 36–45.

112. Mainstone *H. Sophia* 90–1, 96, 126–7, fig. 115, 154. Only reliable account of first building with first dome, and description of its construction: Procopius, *Buildings* 1. 1. 22–78. It is sometimes suggested that the first dome continued the curve of the pendentives, but this would make the current dome 28, not 20, feet taller. Another possibility is it had the same curve as the pendentives, but could have been positioned slightly higher with a small drum like part at its base: Mainstone *H. Sophia* 126–7, 209–12, fig. 237. Written sources for the second (current) dome compared with first dome, with analysis: C. Mango, 'Byzantine Writers on the Fabric of Hagia Sophia', in R. Mark and A. Çakmak, eds., *Hagia Sophia from the Age of Justinian to the Present* (Cambridge 1992) 51–3. Written sources describing church in detail: C. Mango, *The Art of the Byzantine Empire 312–1453* (Toronto 1986) 78–102.

113. Mathews *Byz. Churches* 266–8 with references, fig. 31-40 to 31-44; Krautheimer *Byz. Archit.* 215–25, fig. 165, 167–8, 240; Mainstone *H. Sophia* 78–80, 89–98, 124–6, 215–17, fig. 88, 119a. Liturgical furnishing: Mathews *Early Churches* 95–9; Mainstone *H. Sophia* 219–35, fig. 252.

114. Mainstone *H. Sophia* 89–94, fig. 105–6. Written sources for damage: Mango *loc. cit.* (n. 112) 50–6.

115. McKenzie *Petra* 41, 51, 93, 95, 138, pl. 75, 76b. Examples of brick domes on small square rooms (*c.* 2 × 2 m) occur in Egypt as early as the Dynastic period. S. el-Naggar, *Les Voûtes dans l'architecture de l'Égypte ancienne* (Cairo 1999) text vol. p. 304–5 Doc. 308, p. 306 Doc. 308-D, p. 310 Doc. 319, plates vol. pl. 381a–b on p. 298–9, pl. 383 on p. 301, pl. 385 on p. 303.

116. R.W. Hamilton, 'The Domed Tomb at Sebastya', *QDAP* 8 (1939) 71, fig. 3; J.A. Hamilton, *Byzantine Architecture and Decoration* (2nd edn London 1956) 52–4; K.A.C. Creswell, *Early Muslim Architecture*, vol. 1 part 2 (2nd edn Oxford 1969) 450–71.

117. S. Yamani, 'Roman Monumental Tombs in Ezbet Bashendi', *BIFAO* 101 (2001) 398, fig. 10, photo. 13–14. Like the dome on the baths-building at Petra, it lacks a separate arch along the top of the ashlar walls. The small dome on pendentives in the crypt of the Tomb Church at Abu Mina, which was often cited as the earliest baked brick dome on pendentives, is now dated to the second quarter of the sixth century: Grossmann *Abu Mina* 1 211–12, 227, pl. 48c. It was thought to date to the end of the fourth century AD in earlier discussions of the development of the pendentive dome.

118. Bailey *Hermopolis* 51–2, pl. 100a. Date: D.M. Bailey, 'The Pottery from the South Church at el-Ashmunein', *Cahiers de la céramique égyptienne* 4 (1996) 47.

119. Krautheimer *Byz. Archit.* 235–6; Mainstone *H. Sophia* 157.

120. References Ch. 8 n. 180.

121. Mainstone *H. Sophia* 172, fig. 176. Summary of large imperial Roman concrete domes: J.-P. Adam, *Roman Building Materials and Techniques* (London 1994) 182–91.

122. Ward-Perkins *loc. cit.* (n. 87) 89–90. Mainstone *H. Sophia* 172; Ćurčić *loc. cit.* (n. 21) 25, fig. 22; G. Penelis *et al.*, 'The Rotunda of Thessaloniki: Seismic Behaviour of Roman and Byzantine Structures', in R. Mark and A. Çakmak, eds., *Hagia Sophia from the Age of Justinian to the Present* (Cambridge 1992) 132–57.

123. Baths of Caracalla: Mainstone *H. Sophia* 162, fig. 186; Creswell *op. cit.* (n. 116) vol. 1 part 2, fig. 415.

124. Krautheimer *Byz. Archit.* 237–8, 240, 244, 513 n. 24. Construction technique: Mainstone *H. Sophia* 165–6, 209, 212.

125. W. MacDonald, 'Roman Experimental Design and the Great Church', in R. Mark and A.C. Çakmak, eds., *Hagia Sophia from the Age of Justinian to the Present* (Cambridge 1992) 11–12.

126. References Ch. 14 n. 30 and 32.

127. Ćurčić *loc. cit.* (n. 21) 32–3.

128. R. Mark, *Light, Wind and Structure* (Cambridge, Mass. 1990) 59–67, fig. 3.12.

129. Ćurčić *loc. cit.* (n. 21) 33, fig. 29–30.

130. Ćurčić *loc. cit.* (n. 21) 33, fig. 28.

131. References Ch. 12 n. 87.

132. References Ch. 12 n. 88.

133. References Ch. 10 n. 123.

134. H. Buchwald, 'Saint Sophia, Turning Point in the Development of Byzantine Architecture', in V. Hoffmann, ed., *Die Hagia Sophia in Istanbul, Akten des Berner Kolloquiums vom 21. Oktober 1994* (Bern 1997) 41–7.

135. Mainstone *H. Sophia* 237–61; M. and Z. Ahunbay, 'Structural Influence of Hagia Sophia on Ottoman Mosque Architecture', in R. Mark and A. Çakmak, eds., *Hagia Sophia from the Age of Justinian to the Present* (Cambridge 1992) 179–94.

CHAPTER 14: PICTORIAL TRADITION OF ALEXANDRIAN ARCHITECTURE

1. Conversion *c.* AD 400 or 450: Krautheimer *Byz. Archit.* 82.

2. Mosaics, *c.* AD 450: W.E. Kleinbauer, 'The Iconography and the Date of the Mosaics of the Rotunda of Hagios Georgios Thessaloniki', *Viator* 3 (1972) 106–7; M. Vickers, 'Fifth-century Brickstamps from Thessaloniki', *BSA* 68 (1973) 294. Mosaics, late fourth century: H. Torp, 'Quelques remarques sur les mosaïques de l'église Saint-Georges à Thessalonique', in Πεπραγμενα του Θ´ Διεθνους Βυζαντινολογικου Συνεδριου. Θεσσαλονικη 1953 (Athens 1955) vol. 1, 489–98. Mosaics, not before beginning of sixth century: J.-M. Spieser, *Thessalonique et ses monuments du IV^e au VI^e siècle* (Paris 1984) 164. Previous suggestions for date summarized: P. Cattani, *La rotonda e i mosaici di San Giorgio a Salonicco* (Bologna 1972) 110–15. Recent discussion, with date in second half of fifth or early sixth century: R. Cormack, *Byzantine Art* (Oxford 2000) 26, 29–31, 33.

3. Photographs of dome mosaics: A. Grabar 'A propos des mosaïques de la coupole de Saint-Georges à Salonique', *Cahiers archéologiques* 17 (1967) 59–64 fig. 1–8. Vaults: Cattani *op. cit.* (n. 2) fig. 6, 7.

4. Identification of saints: Cattani *op. cit.* (n. 2) 77 94; Cormack *op. cit.* (n. 2) 27.

5. Interpretation of mosaics: E. Wiegand, 'Der Kalenderfries von Hagios Georgios in Thessaloniki', *BZ* 39 (1939) 116–45; Torp *loc. cit.* (n. 2) 489–98; R.F. Hoddinott, *Early Byzantine Churches in Macedonia and Southern Serbia* (London 1963) 112–13; Grabar *loc. cit.* (n. 3) 59–81; Kleinbauer *loc. cit.* (n. 2) 27–68; Kitzinger *op. cit.* (n. 3) 57–8; Cattani *op. cit.* (n. 2) 60–72; Cormack *op. cit.* (n. 2) 26–9.

6. Torp *loc. cit.* (n. 2) 493–7; Hoddinott *loc. cit.* (n. 5) 116, pl. 18; Kleinbauer *loc. cit.* (n. 2) 58–62.

7. Colour photographs: J. Lowden, *Early Christian and Byzantine Architecture* (London 1997) fig. 3–4; Cormack *op. cit.* (n. 2) fig. 10.

8. Grabar *loc. cit.* (n. 3) fig. 2–5.

9. Santa Constanza: Kitzinger *op. cit.* (n. 3) 59; R. Michel, *Die Mosaiken von Santa Constanza in Rom* (Leipzig 1912) fig. 2, pl. 2b–3.

10. Lowden *op. cit.* (n. 7) 103–5.

11. Krautheimer *Byz. Archit.* 188; Kostof *Orthodox Bapt.* 11–12; F.W. Deichmann, *Ravenna*, Band II, Kommentar, I Teil (Wiesbaden 1974) 17–19.

12. Kostof *Orthodox Bapt.* 42.

13. Kostof *Orthodox Bapt.* 32–3, fig. 5–6, 28–33.

14. Kostof *Orthodox Bapt.* 82–93, fig. 41–63.

15. Photographs of mosaics in architectural zone of dome (Zone III): F.W. Deichmann, *Frühchristliche Bauten und Mosaiken von Ravenna* (Baden-Baden 1958) fig. 62–71; Kostof *Orthodox Bapt.* fig. 65–9. Colour photographs of whole composition: Lowden *op. cit.* (n. 7) fig. 64–5.

16. Kostof *Orthodox Bapt.* 42, 94–100, fig. 77–102; Deichmann *op. cit.* (n. 11) 43–4. The suggestion that these stuccoes were made by 'Coptic' craftsmen requires more evidence to be proven: M. van Lohuizen-Mulder, 'Stuccoes in Ravenna, Poreč and Cividale of Coptic Manufacture', *BABesch* 65 (1990) 139–51.

17. Kostof *Orthodox Bapt.* 77–82; Deichmann *op. cit.* (n. 11) 41–3. The Second Style wall-paintings nearly always lack figures. Exceptions: Barbet *Peinture* 45–7; McKenzie *Petra* pl. 24a.

18. Lowden *op. cit.* (n. 7) fig. 74 compared with fig. 65.

19. Creswell *Early Muslim Archit.* 1.1, 130–1.

20. Gautier-van Berchem in Creswell *Early Muslim Archit.* 1.1, 233; R. Hillenbrand, *Islamic Art and Architecture* (London 1999) 13.

21. Rosen-Ayalon *Early Isl. Monuments* 12. Finished in AD. 691/2: Creswell *Early Muslim Archit.* 1.1, 69–70; Creswell rev. Allan *Short Account* 36. Begun in AD. 692: S. Blair, 'What is the Date of the Dome of the Rock?', in J. Raby and J. Johns, eds., *Bayt al-Maqdis, ʿAbd al-Malik's Jerusalem, Oxford Studies in Islamic Art* 9.1 (Oxford 1992)

59–85. (Blair assumes the mosaics might have been by the same craftsman as those in the Church of the Nativity, which is now known not to be the case.)

22. E.T. Richmond, *The Dome of the Rock in Jerusalem* (Oxford 1924); Creswell *Early Muslim Archit.* 1.1, 65–131, 213–322; Creswell rev. Allan *Short Account* 20–40. Recent research on the original construction: H.R. Allen, 'Some Observations on the Original Appearance of the Dome of the Rock', in J. Johns, ed., *Bayt al-Maqdis, Jerusalem and Early Islam, Oxford Studies in Islamic Art* 9.2 (Oxford 1999) 197–213.

23. O. Grabar, 'The Umayyad Dome of the Rock in Jerusalem', *Ars Orientalis* 3 (1959) 33–62; Creswell *Early Muslim Archit.* 1.1, 65–7; O. Grabar, *The Formation of Islamic Art* (rev. edn, London 1987) 51–63; N. Rabbat, 'The Meaning of the Umayyad Dome of the Rock', *Muqarnas* 6 (1989) 12–21; A. Elad, 'Why Did ʿAbd al-Malik Build the Dome of the Rock? A Re-examination of the Muslim Sources', in J. Raby and J. Johns, eds., *Bayt al-Maqdis, ʿAbd al-Malik's Jerusalem, Oxford Studies in Islamic Art* 9.1 (Oxford 1992) 33–52; J. van Ess, 'ʿAbd al-Malik and the Dome of the Rock. An Analysis of Some Texts', in J. Raby and J. Johns, eds., *Bayt al-Maqdis, ʿAbd al-Malik's Jerusalem, Oxford Studies in Islamic Art* 9.1 (Oxford 1992) 89–103; N.N. Khoury, 'The Dome of the Rock, the Kaʿba, and Ghumdan: Arab Myths and Umayyad Monuments', *Muqarnas* 10 (1993) 57–65; N. Rabbat, 'The Dome of the Rock Revisited: Some Remarks on al-Wasiti's Accounts', *Muqarnas* 10 (1993) 67–75; R. Shani, 'The Iconography of the Dome of the Rock', *Jerusalem Studies in Arabic and Islam* 23 (1999) 158–207. Summary of reasons: Creswell rev. Allan *Short Account* 19–20, 36–7; Rosen-Ayalon *Early Isl. Monuments* 14, 66–7; R. Ettinghausen, O. Grabar, and M. Jenkins-Madina, *Islamic Art and Architecture 650–1250* (London 2001) 15–16.

24. M. van Berchem, *Matériaux pour un Corpus Inscriptionum Arabicarum* II.2 *Jerusalem: 'Haram', MIFAO* 44 (Cairo 1927) 228–46 inscription 215; Grabar *loc. cit.* (n. 23) 52–6; Grabar *op. cit.* (n. 23) 58–63; Rosen-Ayalon *Early Isl. Monuments* 16; Shani *loc. cit.* (n. 23) 159, drawing 2a–b opp. p. 187.

25. Examples of circular buildings: K.A.C. Creswell, *The Origin of the Plan of the Dome of the Rock* (London 1924) 17–30; J.W. Crowfoot, *Early Churches in Palestine* (London 1941) 90–2; Creswell *Early Muslim Archit.* 1.1, 101–9; Creswell rev. Allan *Short Account* 36–7. Classical and Christian circular buildings in Italy: M. Wilson Jones, *Principles of Roman Architecture* (London 2000) 74, 214–7, table 4.1 on p. 79, fig. 4.7. Examples of octagonal baptisteries: Krautheimer *Byz. Archit.* fig. 35, 41, 47.

26. R. Avner *et al.*, 'Jerusalem, Mar Elias, the Kathisma Church', *Hadashot Arkheologiyot, Excavations and Surveys in Israel*, 113 (2001) 89*–92* (English) and 133–137 (Hebrew) esp. 134 fig. 199. Other archaeological evidence in Palestine: J. Wilkinson, 'Architectural Procedures in Byzantine Palestine', *Levant* 13 (1981) 157.

27. A. Birnbaum, 'Die Oktogone von Antiochia, Nazianz und Nyssa. Rekonstruktionsversuche', *Repertorium für Kunstwissenschaft* 36 (1913) 181–209. Nazianzus, Tyre, Alexandria: Eng. trans. (with *scolion*) of Gregory Nazianzenus, *Orat.* 18. 39 (= *PG* 35, 1037) in C. Mango, *The Art of the Byzantine Empire 312–1453* (Toronto 1986) 26–7, 27 n. 21. Antioch: G. Downey, *A History of Antioch in Syria* (Princeton 1961) 342–5; F.W. Deichmann, 'Das Oktogon von Antiocheia: Heroon-Martyrion, Palastkirche oder Kathedrale?', *ByzZ* 65 (1972) 40–56.

28. Creswell *Early Muslim Archit.* 1.1, 92–3, 95; Creswell rev. Allan *Short Account* 33, 38–9; Allen *loc. cit.* (n. 22) 206, 209.

29. Richmond *op. cit.* (n. 22) 11–13, 77–8, fig. 2, 5; Creswell *Early Muslim Archit.* 1.1, 93–7; Creswell rev. Allan *Short Account* 33; Allen *loc. cit.* (n. 22) 207.

30. E. Baldwin Smith, *The Dome* (Princeton 1950, repr. 1971) 29–30; Downey *op. cit.* (n. 27) 344 with references. Earlier (sometimes out of date) discussion of wooden domes in Syro-Palestine: Creswell *Early Muslim Archit.* 1.1, 116–21.

31. The timber types surviving on the dome in 1919 included: oak, cedar and 'pine of a kind locally known as Qatrâni, a timber not it is locally believed, subject to the attack of worms'. One of the timbers had an inscription of AD 1019 but this version of the dome was probably later, reusing material from the earlier dome: Richmond *op. cit.* (n. 22) 12–13.

32. Creswell *Early Muslim Archit.* 1.1, 121. As it became called the Golden Palace because of the dome, this suggests it was a sizeable dome. It burnt down in AD 750 indicating it was made of wood.

33. Maqrizi (AD 1364–1442): S.K. Hamarneh, 'The Ancient Monuments of Alexandria According to Accounts by Medieval Arab Authors (IX–XV century)', *Folia Orientalia* 13 (1971) 92. Similarly, Suyuti (AD. 1445–1505): D.M. Jacobson and M.P. Weitzman, 'What was Corinthian Bronze?', *AJA* 96 (1992) 245 n. 73; A.J. Butler, *The Arab Conquest of Egypt*, ed. P.M. Fraser (2nd edn Oxford 1978) 386 n. 2. According to Ibn Rusta (AD 903) the 'Hadra dome' was supported by columns and contained statues: Hamarneh *loc. cit.* 91. Ibn Rusta adds it 'is situated at the "Eastern Gate" … in the centre of the city … opposite is the market': Hamarneh *loc. cit.* 92. 'Hadra' means green, and it is possible the term here is referring to the eastern district of Alexandria which was known as Hadra in the nineteenth century, rather than the colour of the dome. As the Tychaion was a domed building in the middle of the city decorated with columns and (as late as AD 602) containing statues, it is possible the Hadra dome was the Tychaion. For the Tychaion in the classical written sources, see Ch. 10 n. 52, 73 and 105.

34. Jacobson and Weitzman *loc. cit.* (n. 33) 241–5, fig. 1. The interpretation of the 'recipe' remains valid, regardless of whether or not this was called Corinthian bronze. Its resistance to corrosion was observed in the samples made by Jacobson. The mid-first-century AD doors of the Temple in Jerusalem, which are described as made of Corinthian bronze were made in Alexandria: Jacobson and Weitzman *loc. cit.* (n. 33) 240, 245. It is possible that this was a 'lost' recipe for 'making' gold: D.M. Jacobson and J.S. McKenzie, 'Transmutation of Base Metals into Gold. A Solution to the Essential Mystery of Alchemy', *Interdisciplinary Science Reviews* 17.4 (1992) 326–31.

35. Richmond *op. cit.* (n. 22) 23–77, fig. 16–66; Creswell *Early Muslim Archit.* 1.1, 97–9, 226–7; Creswell rev. Allan *Short Account* 33–4; Allen *loc. cit.* (n. 22) 208–9, colour pl. on p. 202–3 (reconstruction of exterior with mosaics).

36. Ch. 3 n. 242.

37. Quibell *Saqqara* III, 6; *CE* 1145.

38. K. Dunbabin, *Mosaics of the Greek and Roman World* (Cambridge 1999) 160–86. See also: P. Donceel-Voûte, *Les pavements des églises byzantines de Syrie et du Liban* (Louvain-La-Neuve 1988).

39. Dunbabin *op. cit.* (n. 38) 187–208; M. Piccirillo, *The Mosaics of Jordan* (Amman 1993); A. Michel, *Les églises d'époque byzantine et umayyade de la Jordanie (provinces d'Arabie et de Palestine), Vᵉ–VIIIᵉ siècle* (Turnhout 2001); N. Duval, ed., *Les églises de Jordanie et leurs mosaïques* (Beirut 2003).

40. Thirty-six cubes from the apse of the Basilica of Photios at Apameia (AD 483–6), two-thirds of which are shades of blue, turquoise, and green, with some red in the remaining cubes: C. Lahanier, 'Étude de tesselles de mosaïques et de verre à vitres syriens', in P. and M. Canivet, eds., *Hūarte. Sanctuaire chrétien d'Apamène (IVᵉ–VIᵉ siècle)* vol. 1 (Paris 1987) 332–46, pl. 168.2; W. Gaddoni and W. Frattini, 'Resti di mosaici parietali recuperati negli scavi della chiesa dei SS Sergio, Bacco e Leonzio di Bosra', *FelRav* 123–4 (1982) 53–65. Many colours: S.J. Saller, *Excavations at Bethany (1949–1953)* (Jerusalem 1957) 326.

41. Pella, tesserae of gold glass, blue-greenish, greenish, and yellow from apse mosaics: A.W. McNicoll, 'The East Church, Area V', in A.W. McNicoll *et al.* eds., *Pella in Jordan*, vol. 2 (Sydney 1992) 160 (see also pl. 100a). Petra: T. Waliszewski, 'The Wall Mosaics', and C. Fiori, 'The Composition of the Glass Wall Mosaic Tesserae', in Z. Fiema *et al.*, *The Petra Church* (Amman 2001) 300–5, pl. on p. 328–32. I thank Margaret O'Hea for the glass mosaic references.

42. Gautier-van Berchem in Creswell *Early Muslim Archit.* 1.1, 211–322; Creswell rev. Allan *Short Account* 34–5; Rosen-Ayalon *Early Isl. Monuments* 12–24, 46–69; H. Stern, 'Notes sur les mosaïques du Dôme du Rocher et de la Mosquée de Damas', *Cahiers archéologiques* 22 (1972) 201–17. Colour illustrations: S. Nuseibeh and O. Grabar, *The Dome of the Rock* (London 1996).

43. Gautier-van Berchem in Creswell *Early Muslim Archit.* 1.1, 217–22, 224–8, 303–6, 313–20; Rosen-Ayalon *Early Isl. Monuments* 17, 20.

44. Gautier-van Berchem in Creswell *Early Muslim Archit.* 1.1, 254–5, 260, 300–2, fig. 139–50, 173–4, 361–4, pl. 11a, 14a, 15a, 18a, 20a, 21a, 31–4, 36–7; M. Gautier-van Berchem and S. Ory, *La Jérusalem musulmane* (Lausanne 1978) pls. on p. 40–1, 47, 52–4; Rosen-Ayalon *Early Isl. Monuments* ill. 35, pl. 1–16; Nuseibeh and Grabar *op. cit.* (n. 42) pls. on p. 64–5, 110–13, 118, 126–7, lower and middle photos on p. 120–1, 124–5, 128–9, 132–3.

45. Gautier-van Berchem in Creswell *Early Muslim Archit.* 1.1, 260–1, fig. 163–71; Stern *loc. cit.* (n. 42) 208–12.

46. Gautier-van Berchem in Creswell *Early Muslim Archit.* 1.1, 284, 286, fig. 307–11, pl. 6–9, 22, 35a; Gautier-van Berchem and Ory *op. cit.* (n. 44) lower pls. on p. 52–3; Nuseibeh and Grabar *op. cit.* (n. 42) pls. on p. 94–5, top photos on p. 84–7, 90–3, 96–9, 102–5.

47. Gautier-van Berchem in Creswell *Early Muslim Archit.* 1.1, 286–7, fig. 312–13; Stern *loc. cit.* (n. 42) 207; H. Luschey, 'Zur Datierung der sasanidischen Kapitelle aus Bisutun und des Monuments von Taq-i-Bostan', *Archäologische Mitteilungen aus Iran*, 1 (1968) 131 fig. 2a, pl. 51.1. On date of this capital and Taq-i-Bustan see: Ch. 13 n. 70.

48. Gautier-van Berchem in Creswell *Early Muslim Archit.* 1.1, 284, 300, fig. 283, 357, pl. 13, 16, 19; Gautier-van Berchem and Ory *op. cit.* (n. 44) pls. on p. 46; Nuseibeh and Grabar *op. cit.* (n. 42) pls. on p. 82–3, 88–9, lower photos on p. 84–7, 90–3, 96–9, 102–5. Jewellery is also depicted elsewhere, especially on other parts of the octagonal arcade: Gautier-van Berchem in Creswell *Early Muslim Archit.* 1.1, 277–8, 280–1, fig. 275–82.

49. Gautier-van Berchem in Creswell *Early Muslim Archit.* 1.1, 300–3, fig. 201–2, 358, 361–2, 364–5, pl. 37; Gautier-van Berchem and Ory *op. cit.* (n. 44) top pl. on p. 54; Rosen-Ayalon *Early Isl. Monuments* pl. 1–16 (colour plates of whole lower zone of drum); Nuseibeh and Grabar *op. cit.* (n. 42) pls. on p. 126–7, middle pls. on p. 120–1, 124–5, 128–9, 132–3.

50. Gautier-van Berchem in Creswell *Early Muslim Archit.* 1.1, 303–6, fig. 364–5; Gautier-van Berchem and Ory *op. cit.* (n. 44) top pl. on p. 54; Nuseibeh and Grabar *op. cit.* (n. 42) pl. on p. 119, top photos on p. 120–1, 124–5, 128–9, 132–3.

51. Gautier-van Berchem in Creswell *Early Muslim Archit.* 1.1, 277–81; Grabar *loc. cit.* (n. 23) 47–52, 57; Grabar *op. cit.* (n. 23) 55–8; Rosen-Ayalon *Early Isl. Monuments* 14–16, 52, 54. The crown decorating the egg shape, with wings framing a crescent, is clearly Sassanian: Gautier-van Berchem in Creswell *Early Muslim Archit.* 1.1, 278, fig. 285–6.

52. Gautier-van Berchem in Creswell *Early Muslim Archit.* 1.1, 278, 280, 302–3, fig. 284, 286; Rosen-Ayalon *Early Isl. Monuments* 15–16.

53. Rosen-Ayalon *Early Isl. Monuments* 54–5.

54. Gautier-van Berchem in Creswell *Early Muslim Archit.* 1.1, 263–5, fig. 207–13, pl. 11b, 12b–c, 14b–c, 15b–c, 30; Gautier-van Berchem and Ory *op. cit.* (n. 44) top pls. on p. 48.

55. Rosen-Ayalon *Early Isl. Monuments* 52–3, 60 with references.

56. Gautier-van Berchem in Creswell *Early Muslim Archit.* 1.1, 309–12, 319, pl. 35 (colour detail); R. Ettinghausen, *Arab Painting* (New York 1977) colour pls on p. 18, 21, 23.

57. Gautier-van Berchem in Creswell *Early Muslim Archit.* 1.1, 230, 240, 242–5, 251, 321–2. Similarly, Ettinghausen *et al. op. cit.* (n. 23) 19.

58. Rabbat *loc. cit.* (n. 23) 68–9. Presumably this is referring to the so-called Aqsa I, identified as built by ʿAbd al-Malik according to R.W. Hamilton in Creswell rev. Allan *Short Account* 79, 82.

59. Identified as Aqsa II: Hamilton in Creswell rev. Allan *Short Account* 79, 82. Contra: Creswell rev. Allan *Short Account* 73.

60. H.I. Bell, ed., *Greek Papyri in the British Museum IV the Aphrodito Papyri* (London 1910) 74, 75 no. 1403 line 4; H.I. Bell, 'Translations of the Greek Aphrodito Papyri', *Der Islam* 2 (1911) 383 no. 1403; Creswell *Early Muslim Archit.* 1.2, 373.

61. Bell *op. cit.* (n. 60) 343, 347 no. 1441 line 99; H.I. Bell, 'Translations of the Greek Aphrodito Papyri', *Der Islam* 17 (1928) 6 no. 1441.

62. Bell *op. cit.* (n. 60) 325 line 15, 328 no. 1435 line 76; H.I. Bell, 'Translations of the Greek Aphrodito Papyri', *Der Islam* 4 (1913) 93, 95 no. 1435.

63. Leontius of Neapolis, *Life of St John the Almsgiver* 18, *Léontios de Néapolis. Vie de Syméon le Fou et Vie de Jean de Chypre*, ed. tr. A.-J. Festugière and L. Rydén (Paris 1974) 365–6, 468; Eng. tr. E. Dawes and N.H. Baynes, *Three Byzantine Saints* (Oxford 1948) 20, p. 229. On Leontius of Neapolis, who wrote in AD. 641–2, as a source see Ch. 10 n. 133.

64. Creswell *Early Muslim Archit.* 1.1, 151; Creswell rev. Allan *Short Account* 46. For part of the maintenance of forty skilled workmen, AD 706/7: Bell *op. cit.* (n. 60) 288 no. 1433 line 81; H.I. Bell, 'Translations of the Greek Aphrodito Papyri', *Der Islam* 3 (1912) 373 no. 1433. For wages and keep of a sawyer, AD 709: Bell *op. cit.* (n. 60) 80 no. 1411 line 2; Bell *loc. cit.* 133 no. 1411.

65. Bell *op. cit.* (n. 60) 42 no. 1368 lines 6–7; Bell *loc. cit.* (n. 60) 374 no. 1368.

66. Creswell *Early Muslim Archit.* 1.1, 153–4; Creswell rev. Allan *Short Account* 46.

67. Creswell *Early Muslim Archit.* 1.1, 151–210; Creswell rev. Allan *Short Account* 46–73; Hillenbrand *op. cit.* (n. 20) 25–9; Ettinghausen *et al. op. cit.* (n. 23) 22–4.

68. The pedimental entrance mid-way along the long side, with three arches and arched colonnade, is strikingly similar to the palace of Theodoric depicted in Ravenna: Creswell rev. Allan *Short Account* 68, fig. 30, 41.

69. Great Mosque: Creswell rev. Allan *Short Account* fig. 28–9; Hillenbrand *op. cit.* (n. 20) 25, 28; R. Hillenbrand, *Islamic Architecture* (Edinburgh 2000) fig. 2.70 on p. 70. Later examples with a similar arrangement: Hillenbrand *op. cit.* figs on p. 50, 52–4.

70. E. de Lorey, 'Les Mosaïques de la Mosquée des Omayyades à Damas', *Syria* 12 (1931) 326–49; *idem*, 'L'Hellénisme et l'Orient dans les mosaïques de la Mosquée des Omaiyades', *Ars Islamica* 1 (1934) 22–45; Gautier-van Berchem in Creswell *Early Muslim Archit.* 1.1, 323–72; B. Finster, 'Die Mosaiken der Umayyadenmoschee von Damaskus', *Kunst des Orients* 7 (1970–1) 83–141; Stern *loc. cit.* (n. 42) 217–25; G. Hellenkemper Salies, 'Die Mosaiken der Grossen Moschee von Damaskus', *CorsiRav* 35 (1988) 295–313; F.B. Flood, *The Great Mosque in Damascus* (Leiden 2001); Ettinghausen *et al. op. cit.* (n. 23) 25–6; H. Stierlin, *Islam from Baghdad to Cordoba, Early Architecture from the 7th to the 13th Century* (Cologne 2002) colour pls. on p. 46, 48, 52–4.

71. Creswell *Early Muslim Archit.* 1.1, 333–4, 338, fig. 391–6, pl. 50d, 51c–d, 58c–e; Creswell rev. Allan *Short Account* fig. 38–9; Finster *loc. cit.* (n. 70) 100–10, fig. 41–61.

72. De Lorey *loc. cit.* 1931 (n. 70) pl. 63–71; Creswell *Early Muslim Archit.* 1.1, 339–46, fig. 399–405, pl. 54b–58b; Creswell rev. Allan *Short Account* fig. 31, 35–7; Hillenbrand *op. cit.* (n. 20) fig. 13–14.

73. De Lorey *loc. cit.* 1931 (n. 70) 331–4. Much of his argument is repeated by Gautier-van Berchem in Creswell *Early Muslim Archit.* 1.1, 367–8; Hellenkemper Salies *loc. cit.* (n. 70) 308–12.

74. Hillenbrand *op. cit.* (n. 20) 28.

75. Scene types in the wall-paintings mentioned in the written sources: McKenzie *Petra* 85–6; Gautier-van Berchem in Creswell *Early Muslim Archit.* 1.1, 367–8, fig. 438–9, pl. 55, 57a–b, 58a–b; Ettinghausen *op. cit.* (n. 56) 26. Other comments on these scenes: de Lorey *loc. cit.* 1934 (n. 70) 41, fig. 2, 3, 6–8, 19–20; Finster *loc. cit.* (n. 70) 110–17, fig. 62–6; Stern *loc. cit.* (n. 42) 220.

76. Stern *loc. cit.* (n. 42) 219. Relationship to Khasneh: de Lorey *loc. cit.* 1934 (n. 70) 42.

77. Gautier-van Berchem *Early Muslim Archit.* 1.1, 368, fig. 436.

78. Gautier-van Berchem in Creswell *Early Muslim Archit.* 1.1, 368, fig. 402, 436, pl. 53b, 58a. Pompeian examples: McKenzie *Petra* 97, pl. 229–230a, 236a.

79. De Lorey *loc. cit.* 1931 (n. 70) 336 n. 2; Gautier-van Berchem in Creswell *Early Muslim Archit.* 1.1, 368–9, fig. 435; Stern *loc. cit.* (n. 42) 219.

80. al-Muqaddasi: Gautier-van Berchem in Creswell *Early Muslim Archit.* 1.1, 233; Ettinghausen *op. cit.* (n. 56) 28. Barada River and Damascus: Gautier-van Berchem in Creswell *Early Muslim Archit.* 1.1, 370–2.

81. Stern *loc. cit.* (n. 42) 221; Hellenkemper Salies *loc. cit.* (n. 70) 306–12, fig. 24; M. Piccirillo, *Chiese e Mosaici di Madaba* (Jerusalem 1989) pl. on p. 87–93, opp. p. 97, pl. on p. 229, 233, 269, 273, 283, 288–9, 294–300; Piccirillo *op. cit.* (n. 39) 26–37, pl. 62–72, 296–310, 337, 344–5, 347–58, 504–5, 542–5, 592, 596.

82. Samhudi: Gautier-van Berchem in Creswell *Early Muslim Archit.* 1.1, 239. Detailed analysis of mosaics of Great Mosque referring to Paradise: Flood *op. cit.* (n. 70) 15–113, 238–40. On allusion to Egypt and a paradisial world in Roman wall-paintings, with references: Ch. 5 n. 157; McKenzie *Petra* 99–100; Hellenkemper Salies *loc. cit.* (n. 70) 308–13.

83. Creswell *Early Muslim Archit.* 1.1, 339–40, fig. 399–400, 402, 404, 443–4, pl. 50a,c, 51a, 52a,c, 53a,c, 54b, 55.

84. De Lorey 1934 *loc. cit.* (n. 70) fig. 9, 11–13; Creswell *Early Muslim Archit.* 1.1, fig. 385, 389–90, 398, pl. 53b,d, 54a; Finster *loc. cit.* (n. 70) 94–100, fig. 28, 33–5, 62.

85. De Lorey *loc. cit.* 1931 (n. 70) 331; Gautier-van Berchem in Creswell *Early Muslim Archit.* 1.1, 368, fig. 440–1; Stern *loc. cit.* (n. 42) 222. Livia's Garden Room: B. Andreae, *The Art of Rome* (New York 1977) pl. 45 (colour).

86. F. le Corsu, 'Un Oratoire pompéien consacré à Dionysos-Osiris', *RA* 1967, 239–254, fig. 1–2, 4–7; Andreae *op. cit.* (n. 85) pl. 48; M. de Vos, *L'egittomania in pittura e mosaici romano-campani della prima età imperiale* (Leiden 1980) 15–21, pl. 12–19.

87. R.A. Wild, *Water in the Cultic Worship of Isis and Serapis* (Leiden 1981) 103–13.

88. Reportedly from Panopolis (Akhmim). C. Lilyquist, 'Euthenia in a Garden', *Notable Acquisitions* 1984–1985, Metropolitan Museum of Art, p. 5.

89. A. Stauffer, *Textiles de l'Égypte de la Collection Bouvier* (Bern 1991) 35–53, 71–2, ill. 1–7, 9–13, pl. I on p. 55.

90. Petra Church, floral fragments and faces: Fiema *et al. op. cit.* (n. 41) 302, pl. on p. 328.

91. Choricius, *Laudatio Marciani* 1, 28–76, Eng. tr. in C. Mango, *The Art of the Byzantine Empire 312–1453* (Toronto 1986) 62–8. Date: *ibid.* 60 n. 25.

92. Choricius, *Laudatio Marciani* 2, 50, Eng. tr. in Mango *op. cit.* (n. 91) 72. Date: *ibid.* 68 n. 69.

93. Colour details in: Gautier-van Berchem in Creswell *Early Muslim Archit.* 1.1, 364–6, pl. 53d, 56b, 57b; Ettinghausen *op. cit.* (n. 56) pl. on p. 24–5, 27; Hillenbrand *op. cit.* (n. 20) fig. 13.

94. Gautier-van Berchem in Creswell *Early Muslim Archit.* 1.1, 244, 371; M. van Lohuizen-Mulder, 'The Mosaics in the Great Mosque at Damascus: a Vision of Beauty', *BABesch* 70 (1995) 193–213.

95. H. Gibb, 'Arab-Byzantine Relations under the Umayyad Caliphate', *DOP* 12 (1958) 219–33; Stern *loc. cit.* (n. 42) 223; O. Grabar, 'Islamic Art and Byzantium', *DOP* 18 (1964) 82–3.

96. Creswell rev. Allan *Short Account* 43–6; Hillenbrand *op. cit.* (n. 69) 73, fig. 2.66 on p. 72.

97. Gautier-van Berchem in Creswell *Early Muslim Archit.* 1.1, 231.

98. Gautier-van Berchem in Creswell *Early Muslim Archit.* 1.1, 231–3, 235.

99. Gautier-van Berchem in Creswell *Early Muslim Archit.* 1.1, 232.

100. Gautier-van Berchem in Creswell *Early Muslim Archit.* 1.1, 233.

101. Sources collected in: E. de Lorey and M. van Berchem, 'Les mosaïques de la Mosquée des Omayyades à Damas', *Monuments et mémoires Fondation E. Piot* 30 (1929) 123–39; Gautier-van Berchem in Creswell *Early Muslim Archit.* 1.1, 232–42.

102. Gautier-van Berchem in Creswell *Early Muslim Archit.* 1.1, 231.

103. Gautier-van Berchem in Creswell *Early Muslim Archit.* 1.1, 233.

104. Gautier-van Berchem in Creswell *Early Muslim Archit.* 1.1, 234–9.

105. Gautier-van Berchem in Creswell *Early Muslim Archit.* 1.1, 236–7.

106. S. der Nersessian, 'The Date of the Initial Miniatures of the Etchmiadzin Gospel', in S. der Nersessian, *Byzantine and Armenian Studies*, vol. 1 (Louvain 1973) 545 (= *Art Bulletin* 15, 1933, 1–34); P.A. Underwood, 'The Fountain of Life in Manuscripts of the Gospels', *DOP* 5 (1950) 41–138.

107. Paris, BN lat. 1203 fol. 3v; Underwood *loc. cit.* (n. 106) 46, 64–7, fig. 25; C. Stiegmann and M. Wemhoff, ed., *799 Kunst und Kultur der Karolingerzeit: Beiträge zum Katalog der Ausstellung Paderborn 1999* (Mainz 1999) 563, 574 fig. 3.

108. Paris, BN lat. 8850 fol. 6v: J. Strzygowski, 'Der Pinienzapfen als Wasserspeier', *RM* 18 (1903) 199–202; Underwood *loc. cit.* (n. 106) 46, fig. 26; Stiegmann and Wemhoff *op. cit.* (n. 107) 563 (date *c.* AD 800), 588 fig. 17. Eleventh-century date: V. Nersessian, *Treasures from the Ark* (London 2001) 177.

109. der Nersessian *loc. cit.* (n. 106) 544–6, fig. 294–5, 298, Underwood *loc. cit.* (n. 106) 89–91, 103, 117–18, fig. 34–8.

110. Matenadaran, Erevan, inv. no. 2374 fol. 5v; J. Strzygowski, *Das Etschmiadzin-Evangeliar, Byzantinische Denkmäler* I (Vienna 1891) 53–4, 58–62, pl. 2.1; der Nersessian *loc. cit.* (n. 106) 544.

111. Date, AD. 989: der Nersessian *loc. cit.* (n. 106) 533, 535, 546, 558; T.F. Mathews, 'The Early Armenian Iconographic Program of the Ejmiacin Gospel (Erevan, Matenadaran MS 2374, *olim* 229)', in N.G. Garsoïan *et al.* eds., *East of Byzantium: Syria and Armenia in the Formative Period* (Washington, DC 1982) 199. Sixth century: Strzygowski 1891 *op. cit.* (n. 110) 56–66. (Arguments summarized in der Nersessian *loc. cit.*, n. 106, 535–549).

112. Matenadaran, Erevan, inv. no. 9430; Underwood *loc. cit.* (n. 106) 89, fig. 38; Museum Bochum, *Armenien. 5000 Jahre Kunst und Kultur* (Tübingen 1995) 239 no. 156; Nersessian *op. cit.* (n. 108) 158, no. 81 with references, pl. 81. The paintings of some of the details on the loose page, such as the capitals and the marbling on the columns is very close to some other pages in the Etchmiadzin Gospels: Strzygowski *op. cit.* (n. 110) pl. 3.1–2; E.M. Ruprechtsberger, ed., *Armenien. Kunst und Geschichte im 1. Jahrtausend* (Linz 1989) colour fig. 3 on p. 53.

113. Florence, Biblioteca Laurenziana, Rabbula Gospels, fol. 14r; der Nersessian *loc. cit.* (n. 106) 544; C. Cecchelli, I. Furlani and M. Salmi, *The Rabbula Gospels* (Olten and Lausanne 1959) colour pl. of fol. 14r; K. Weitzmann, *Late Antique and Early Christian Book Illumination* (London 1977) 104, pl. 37.

114. J. Leroy, *Les Manuscrits syriaques à peintures* (Paris 1964), Album pl. 21, fol. 1r the election of Matthias and fol. 2r Ammonius and Eusebius.

115. D.H. Wright, 'The Date and Arrangement of the Illustrations of the Rabbula Gospels', *DOP* 27 (1973) 197–208; *ODB* vol. 3, 1769. Location of monastery of Beth Mar John of Beth Zagba where the Rabbula gospels were written: M. Mango, 'Where was Beth Zagba?', *Harvard Ukrainian Studies* 7 (1983) = C. Mango and O. Pritsak, eds., *Okeanos, Essays Presented to I. Ševčenko* (Cambridge, Mass. 1984) 405–30.

116. Jerusalem, St Thoros Depository, inv. no. 2555 fol. 7r; Underwood *loc. cit.* (n. 106) 89–90, fig. 36; Nersessian *op. cit.* (n. 108) 176–7 no. 105, pl. 105.

117. So also: der Nersessian *loc. cit.* (n. 106) 544.

118. Underwood *loc. cit.* (n. 106) 104–9, 114, fig. 53–4.

119. New York, Pierpont Morgan Library, MS 828 fol. 6r; Underwood *loc. cit.* (n. 106) 104, fig. 54.

120. der Nersessian *loc. cit.* (n. 106) 548–50.

121. Underwood *loc. cit.* (n. 106) 89, fig. 42–3, 50–2.

122. Underwood *loc. cit.* (n. 106) 93–5, 105, fig. 44. The arches are also used on a tholos on a Greek manuscript (Underwood *loc. cit.*, n. 106, 107–8, fig. 55), which is otherwise closer to the examples in the wall-paintings, with tall proportions, and a tent roof. It is used to frame a title.

123. Nersessian *op. cit.* (n. 108) 176–7.

124. Underwood *loc. cit.* (n. 106) 96–8, 105–6. His whole article explains this interpretation in detail.

125. Rossano, Cathedral Gospels, fol. 121r; A. Muñoz, *Il codice purpureo di Rossano e il frammento sinopense* (Rome 1907) pl. 15; *Codex Purpureus Rossanensis*, ed. G. Cavallo,

126. O. Kresten and G. Prato, 'Die Miniatur des Evangelisten Markus im Codex Purpureus Rossanensis: Eine spätere Einfügung', *Römische historische Mitteilungen* 27 (1985) 381–99.

127. K. Weitzmann, 'The Ivories of the So-called Grado Chair', *DOP* 26 (1972) 68–9, 77, 81, fig. 5.

128. Strzygowski *op. cit.* (n. 110) 68–74, pl. 5–6; Ruprechtsberger *op. cit.* (n. 112) 44–7, colour fig. 1–2 on p. 51–2; Nersessian *op. cit.* (n. 108) 157–8. Strzygowski (*op. cit.*, n. 110, 74) considered them Syrian work of the first half of the sixth century. Der Nersessian had thought these pages were contemporary with the text (AD 989) until she examined the manuscript firsthand, leading her to consider them Armenian work of the end of the sixth or probably the beginning of the seventh century: S. der Nersessian, 'La Peinture arménienne au VIIᵉ siècle et les miniatures de l'évangile d'Etchmiadzin', in S. der Nersessian, *Byzantine and Armenian Studies*, vol. 1 (Louvain 1973) 526–7, fig. 270–3 (= *Actes du XIIᵉ Congrès international des études byzantines*, Belgrade, 1964, vol. 3, 49–57). So also Mathews *loc. cit.* (n. 111) 199–212.

129. Strzygowski *op. cit.* (n. 110) pl. 5.

130. Matendaran, Erevan, inv. no. 2374, fol. 229r; Strzygowski *op. cit.* (n. 110) 69, pl. 6.1; der Nersessian *loc. cit.* (n. 128) 529–30, fig. 272; Ruprechtsberger *op. cit.* (n. 112) 44–7, colour fig. 1 on p. 51; Nersessian *op. cit.* (n. 108) 157–8, no. 80, fig. 80; D. Kouymjian, 'The Eastern Case: The Classical Tradition in Armenian Art and the *Scenae Frons*', in M. Mullet, and R. Scott, eds., *Byzantium and the Classical Tradition* (Birmingham 1981) 156–68, fig. 11.

131. D. Pringle, *The Crusader Churches of Jerusalem*, vol. 1 (Cambridge 1993) 138. Built between AD 560 and 603/4: Krautheimer *Byz. Archit.* 279, 517 n. 15.

132. Harvey *Ch. of Nativity* 31–51, fig. 22, 24–9, pl. 2–3, 10–12; Bagatti *Betlemme* 58–68, 79–93, fig. 21, pl. 18–28. Description, with diagrams, of complete decorative scheme of church after cleaning: G. Kühnel, 'Das Ausschmückungsprogramm der Geburtsbasilika in Bethlehem. Byzanz und Abendland im Königreich Jerusalem', *Boreas* 10 (1987) 133–49.

133. Results of cleaning: L.-A. Hunt, 'Art and Colonialism: the Mosaics of the Church of the Nativity in Bethlehem (1169) and the Problem of "Crusader" Art', *DOP* 45 (1991) 72–3. Until the recent cleaning there had been uncertainty about the date of the mosaics. Harvey had followed de Vogüé in dating them all to the twelfth century because, although the style of the illustrations varies, the epigraphy of the Greek inscriptions on them was the same as that on the bema dated to 1169: M. de Vogüé, *Les Églises de la Terre sainte* (Paris 1860) 87–92; Harvey *Ch. of Nativity* 38, 43–4, 49–50. Stern had dated those of the provincial councils to the eighth century: H. Stern, 'Les Représentations des conciles dans l'Église de la nativité à Bethléem', *Byzantion* 11 (1936) 141–52. Stern's suggestion has been revived in Folda *Art of Crusaders* 361–3. The easternmost architectural panel on the north side of the nave has a similar arrangement (with two arches) to those on the south side suggesting the current version was all made at the same time, even if the other five panels on the north side are copies of an earlier version.

134. Date of rebuilding of Church of Holy Sepulchre: M. Biddle, *The Tomb of Christ* (Stroud 1999) 95–8.

135. External facade: Harvey *Ch. of Nativity* 19–20. Bema and transept mosaics: Harvey *Ch. of Nativity* 44–8, fig. 29, pl. 3, 11; Bagatti *Betlemme* 62–3, 88–92, pl. 25–8; Kühnel *loc. cit.* (n. 132) fig. 2, 5; Hunt *loc. cit.* (n. 133) 81, fig. 11; Folda *Art of Crusaders* 357–8, 363–4, pl. 9.12a–14.

136. Harvey *Ch. of Nativity* pl. 10; Bagatti *Betlemme* pl. 18; Hunt *loc. cit.* (n. 133) fig. 2, 8.

137. Harvey *Ch. of Nativity* pl. 11; Bagatti *Betlemme* 63, 87–8, pl. 24; Hunt *loc. cit.* (n. 133) 80, fig. 8, 10; Folda *Art of Crusaders* pl. 9.23a–d.

138. De Vogüé *op. cit.* (n. 133) 70–86, pl. 3–4; Harvey *Ch. of Nativity* 33–43, fig. 24, pl. 2, 10–12; Stern *loc. cit.* (n. 133) 101–52; H. Stern, 'Les Représentations des conciles dans l'Église de la nativité à Bethléem, Deuxième partie: Les inscriptions', *Byzantion* 13 (1938) 415–59; *idem*, 'Nouvelles recherches sur les images des conciles dans l'Église de la nativité à Bethléem', *Cahiers archéologiques* 3 (1948) 82–105; Bagatti *Betlemme* 64–6, 83–7, pl. 19–24; Hunt *loc. cit.* (n. 133) 78–85, fig. 8–9; Folda *Art of Crusaders* 359–62.

139. Hunt *loc. cit.* (n. 133) 83.

140. Harvey *Ch. of Nativity* pl. 10; Stern *loc. cit.* 1948 (n. 138) 87, 92, pl. 1.4, 4.1; Bagatti *Betlemme* 83–4, pl. 21; Folda *Art of Crusaders* pl. 9.19–20a. The Farfa Bible from Spain, AD 1010–20, has a related depiction with a tholos between half-pediments in a vision of Exekial, which tends to confirm the association of this architectural composition with Paradise: Biblioteca Apostolica Vaticana, MS lat. 5729, fol. 209r; M.W. Evans, *Medieval Drawings* (London 1969) pl. 38.

141. Harvey *Ch. of Nativity* fig. 24; Stern *loc. cit.* 1948 (n. 138) 87, pl. 1.3; Bagatti *Betlemme* 82, pl. 20; Kühnel *loc. cit.* (n. 132) pl. 1.2; D.V. Ainalov, *The Hellenistic Origins of Byzantine Art*, ed. C. Mango (New Brunswick, New Jersey, 1961) (published in Russian in 1900–1) 210.

142. McKenzie *Petra* 91–2, pl. 228a, 237b, 241a. On St George's, Thessaloniki: Hoddinott *op. cit.* (n. 5) pl. 17a; Grabar *loc. cit.* (n. 3) fig. 3.

143. Harvey *Ch. of Nativity* pl. 10; Stern *loc. cit.* 1948 (n. 138) 87, pl. 2.1, 4.2; Bagatti *Betlemme* 84, pl. 22; Folda *Art of Crusaders* pl. 9.18,20a.

144. Harvey *Ch. of Nativity* 37; Stern 1948 *loc. cit.* (n. 138) 85–6; Hunt *loc. cit.* (n. 133) 83.

145. Harvey *Ch. of Nativity* pl. 10; Bagatti *Betlemme* pl. 19–23; Hunt *loc. cit.* (n. 133) fig. 9.

146. Harvey *Ch. of Nativity* pl. 10 (second and third from left); Stern *loc. cit.* (n. 133) 132, pl. 4.12; Bagatti *Betlemme* pl. 19, 20; Kühnel *loc. cit.* (n. 132) pl. 1.3; Hunt *loc. cit.* (n. 133) fig. 9 (first and second from right).

147. Harvey *Ch. of Nativity* pl. 10 (left-hand page); Bagatti *Betlemme* pl. 19; Hunt *loc. cit* (n. 133) fig. 9.

148. Stern *loc. cit.* (n. 133) 109–16, 122; Gautier-van Berchem in Creswell *Early Muslim Archit.* 1.1, 307 n. 5.

149. Harvey *Ch. of Nativity* pl. 10–11; Stern 1948 *loc. cit.* (n. 138) pl. 2.3, 3.2; Bagatti *Betlemme* pl. 19, 23–4; Hunt *loc. cit.* (n. 133) fig. 9.

150. Harvey *Ch. of Nativity* pl. 10 (right-hand page); Stern *loc. cit.* 1948 (n. 138) pl. 2.3; Bagatti *Betlemme* pl. 23.

151. Creswell *Early Muslim Archit.* 1.1, fig. 192–3, 305–6, 362, 364–5, pl. 16, 19, 22.

152. Gautier-van Berchem and Ory *op. cit.* (n. 44) top pl. of p. 77; Creswell *Early Muslim Archit.* 1.1, fig. 366.

153. Harvey *Ch. of Nativity* fig. 24; Bagatti *Betlemme* pl. 20; Kühnel *loc. cit.* (n. 132) pl. 15.1.

154. Stern *loc. cit.* (n. 133) 147 with references; Underwood *loc. cit.* (n. 106) 97–9; Rosen-Ayalon *Early Isl. Monuments* 58, ill. 38.

155. Hunt *loc. cit.* (n. 133) 83; Stern *loc. cit.* (n. 133) 116–17. For colour details of Dome of the Rock and the Great Mosque: Creswell *Early Islamic Archit.* 1.1, pl. 35, 53d, 56b, 57b. Water colours of Church of Nativity mosaics: Harvey *Ch. of Nativity* pl. 10–11.

156. Hunt *loc. cit.* (n. 133) 76–7.

157. Hunt *loc. cit.* (n. 133) 73–4. Inscription: Pringle *op. cit.* (n. 131) 154 no. 2; Folda *Art of Crusaders* 347, 350, pl. 9.8b.

158. Hunt *loc. cit.* (n. 133) 73–9, 82–3.

159. Hunt *loc. cit.* (n. 133) 79–80.

160. Hunt *loc. cit.* (n. 133) 73; Folda *Art of Crusaders* 347, 350.

161. Kühnel *loc. cit.* (n. 132) 148 n. 47, fig. 9; Hunt *loc. cit.* (n. 133) 74; Folda *Art of Crusaders* 352–3, pl. 9.9. Latin inscription: Harvey *Ch. of Nativity* pl. 10.

162. Harvey *Ch. of Nativity* pl. 11; Hunt *loc. cit.* (n. 133) 74. Doubt that the initials refer to Basilius: Folda *Art of Crusaders* 352–3, pl. 9.10.

163. Hunt *loc. cit.* (n. 133) 75.

164. Summary of earlier assumptions about Crusader art with imported craftsmen: Hunt *loc. cit.* (n. 133) 69–71, 75.

165. Hunt *loc. cit.* (n. 133) 83–4.

Bibliography

The bibliography is divided into two parts in accordance with the dual roles of this book as an introduction to students and the general reader, as well as a starting point for further study and research.

The 'basic bibliography' focuses on specific subjects appropriate to the requirements of the library of an academic institution for teaching at all levels, especially undergraduates. Consequently, works not in English (but generally with useful illustrations) are included only when they are essential or provide alternative opinions. Only those monuments in Alexandria with the most readily available and reliable evidence have been included in the basic bibliography.

It is customary at this point to refer to one or more other publications where detailed up to date compilations of the appropriate literature can be found. However, none is available elsewhere because no volume with similar coverage has been previously attempted, while the studies which cover parts of the present one are either not recent or do no have complete bibliographies. Thus, as such a bibliography is essential to further study, it has been necessary to provide it here. This 'main bibliography' focuses on the archaeological evidence in Alexandria and Egypt. Evidence from specific sites or aspects outside Egypt is included only if it is the subject of lengthy discussion. Ancient textual sources are also excluded. References for comparanda, mentioned in passing, and full bibliographies for specific buildings in the city, can be found in the notes (via the index). The list of abbreviations is given on p. 376–9.

Basic Bibliography

HISTORICAL SUMMARIES

BOWMAN, A.K., *Egypt After the Pharaohs* (London 1986).
 From Ptolemaic to Byzantine period. Good introduction to Greek and Roman interaction with the Egyptian tradition.

Ptolemaic

HÖLBL, G., 'Ptolemaic Period', in D.B. Redford, ed., *The Oxford Encyclopedia of Ancient Egypt*, vol. 3 (Oxford 2001) 76–85.
THOMPSON, D., 'The Ptolemies and Egypt', in A. Erskine, ed., *A Companion to the Hellenistic World* (Oxford 2005) 105–120.

Roman

BAGNALL, R., 'Roman Occupation', in D.B. Redford, ed., *The Oxford Encyclopedia of Ancient Egypt*, vol. 3 (Oxford 2001) 148–56.
BOWMAN, A.K., 'Egypt', in A.K. Bowman, E. Champlin and A. Lintott, eds., *The Cambridge Ancient History*, vol. 10, *The Augustan Empire, 43 BC–AD 69* (Cambridge 1996) 676–702.
BOWMAN, A.K., 'Egypt from Septimius Severus to the Death of Constantine', in A.K. Bowman, P. Garnsey, and Averil Cameron, eds., *The Cambridge Ancient History*, vol. 12, *The Crisis of Empire, AD 193–337* (Cambridge 2005) 313–26.
RITNER, R.K., 'Egypt under Roman Rule: the Legacy of Ancient Egypt', in C.F. Petry, ed., *The Cambridge History of Egypt* 1: *Islamic Egypt, 640–1517* (Cambridge 1998) 1–33.

Late Antique / Byzantine

BAGNALL, R., 'Copts', in D.B. Redford, ed., *The Oxford Encyclopedia of Ancient Egypt*, vol. 1 (Oxford 2001) 302–307.
HEINEN, H., 'Das spätantike Ägypten (284–646 n. Chr.)', in M. Krause, ed., *Ägypten in spätantik-christlicher Zeit. Einführung in die koptische Kultur* (Wiesbaden 1998) 35–56.
TÖRÖK, L., *Transfigurations of Hellenism, Aspects of Late Antique Art in Egypt AD 250–700* (Leiden 2005) 58–111.

MORE DETAILED HISTORIES

Ptolemaic history

HÖLBL, G., *A History of the Ptolemaic Empire* (London 2001).
HUSS, W., *Aegypten in hellenistischer Zeit 332–30 v. Chr.* (Munich 2001).

Roman history

LEWIS, N., *Life in Egypt under Roman Rule* (Oxford 1983).
WILLEMS, H., and CLARYSSE, W., *Les Empereurs du Nil* (Leuven 2000).

Church history

CHADWICK, H., *The Church in Ancient Society, from Galilee to Gregory the Great* (Oxford 2001).
PEARSON, B.A., and GOEHRING, J.E., eds., *The Roots of Egyptian Christianity* (Philadelphia 1986).
WATTERSON, B., *Coptic Egypt* (Edinburgh 1988).

GENERAL BOOKS ON ALEXANDRIA

EMPEREUR, J.-Y., *Alexandria Re-discovered* (London 1998).
 Popular book. Includes cisterns, underwater discoveries near Lighthouse site, and recent excavations of tombs to west of city.
EMPEREUR, J.-Y., *Alexandria, Past, Present and Future* (London 2002).
 Pocket-book on ancient and modern city with many illustrations.
GRIMM, G., *Alexandria, Die erste Königsstadt der hellenistischen Welt* (Mainz 1998).
 Semi-popular book with useful images.

DETAILED REFERENCE BOOKS ON ALEXANDRIA

ADRIANI, A., *Repertorio d'arte dell'Egitto greco-romano*, Series C, vol. 1–2 (Palermo 1966).
 Tombs, other major monuments and *in situ* archaeological evidence in catalogue format with references, but lacks the necessary maps, unlike Tkaczow *Topography* below.
FRASER, P.M., *Ptolemaic Alexandria*, 3 vols (Oxford 1973, repr. 2001).
 Still unequalled for Ptolemaic written evidence.
TKACZOW, B., *Topography of Ancient Alexandria* (Warsaw 1993).
 Detailed catalogue of archaeological evidence with essential maps. Excellent for the archaeologist intimately acquainted with the evidence. Little overview for other scholars. Maps updated in B. Tkaczow, 'Remarques sur la topographie et l'architecture de l'ancienne alexandrie à la lumière des récentes découvertes archéologiques', *Archeologia* 53 (2002) 21–37. Additional maps of Kom el-Dikka in: B. Tkaczow, 'The Historical Topography of Kom el-Dikka', in Z. Kiss *et al.*, *Fouilles polonaises à Kôm el-Dikka, Alexandrie VII* (Warsaw 2000) 131–43.

RECENT RESEARCH

Collections of papers on Alexandria and Greco-Roman Egypt

BONACASA, N., and DI VITA, A., eds., *Alessandria e il mondo ellenistico-romano, Studi in onore di A. Adriani*, 3 vols. (Rome 1983–4). Papers in English, French, German and Italian.
BONACASA, N. *et al.*, eds., *Alessandria e il mondo ellenistico-romano, Congresso Alessandria 1992* (Rome 1995). Papers in English, French, German and Italian.
CARRATELLI, G.P. *et al.*, eds., *Roma e l'Egitto nell'antichità classica, Cairo 1989* (Rome 1992). Papers in English, French, German and Italian.
EMPEREUR, J.-Y. ed., *Alexandrina* vol. 1 and 2, *ÉtAlex* 1 and 6 (Cairo 1998 and 2001).
EMPEREUR, J.-Y., ed., *Commerce et artisanat dans l'Alexandrie hellénistique et romaine, Actes du Colloque d'Athènes, 1988*, BCH suppl. 33 (Athens 1998).
GRIMM, G., HEINEN, H., and WINTER, E. eds., *Das römisch-byzantinische Ägypten*, AegTrev 2 (Mainz 1983). Papers in English, French, and German.
HAMMA, K., ed., *Alexandria and Alexandrianism* (Malibu 1996).
HARRIS, W.V., and RUFFINI, G., eds., *Ancient Alexandria between Egypt and Greece* (Leiden 2004).
HINSKE, N., ed., *Alexandrien*, AegTrev 1 (Mainz 1981).
HIRST, A., and SILK, M., eds., *Alexandria Real and Imagined* (London 2004).
MAEHLER, H., and STROCKA, V.M., eds., *Das ptolemäische Ägypten* (Mainz 1978). Papers in English, French, German and Italian.
PARIS MUSÉES, *La Gloire d'Alexandrie* (Paris 1998).

Periodicals with regular archaeological reports of excavations in Alexandria
Bulletin de correspondance hellénique [*BCH*] and
Bulletin de l'Institut français d'archéologie orientale [*BIFAO*].
 Brief reports of work involving Centre d'Études Alexandrines, with bibliographies.

Bulletin de la Société d'archéologie d'Alexandrie [*BSAA*]
 Main Egyptian periodical.
Études et travaux. Studia i prace. Travaux du Centre d'archéologie méditerranéenne de l'Académie des sciences polonaise [*ÉtTrav*]
 Lengthier articles than in *Polish Archaeology in the Mediterranean* on results of Polish excavations.
Polish Archaeology in the Mediterranean [*PAM*]
 Immediate publication of main discoveries from each year's Polish excavations.

SPECIFIC BUILDINGS AND ASPECTS OF ALEXANDRIA

Recent underwater exploration

EMPEREUR, J.-Y., *Le Phare d'Alexandrie, La Merveille retrouvée* (rev. edn Paris 2004).
 Latest edition of this pocket-book includes evidence found in sea near Lighthouse site.
EMPEREUR, J.-Y., ed., *Pharos* 1, *ÉtAlex* 9 (Cairo in press).
 Detailed scientific publication of remains of lighthouse, Pharos.
GODDIO, F., *et al.*, *Alexandria. The Submerged Royal Quarters* (London 1998).
 Preliminary results of underwater exploration of eastern part of Eastern Harbour.
GODDIO, F., and BERNAND, A., *Sunken Egypt: Alexandria* (London 2004) 146–65.
 Preliminary results of underwater exploration of western part of Eastern Harbour.
GODDIO, F., and CLAUSS, M., eds., *Egypt's Sunken Treasures* (Berlin 2006).
 Exhibition catalogue of objects found underwater by IEASM in Eastern Harbour of Alexandria, as well as at Herakleion/Thonis and Menouthis ['East Canopus'].
GOIRAN, J.-P., *et al.*, 'Évolution géomorphologique de la façade maritime d'Alexandrie', *Méditerranée* 104 (2005) 61–4.
 Geomorphology, with bibliography.
MCKENZIE, J., 'Glimpsing of Alexandria from Archaeological Evidence', *Journal of Roman Archaeology* 16 (2003) 35–61.

The Library

BAGNALL, R.S., 'Alexandria: Library of Dreams', *Proceedings of the American Philosophical Society* 146 (2002) 348–62.
BLUM, R., *Kallimachos, The Alexandrian Library and the Origins of Bibliography* (Madison 1991).
BUTLER, A.J., *The Arab Conquest of Egypt and the Last Thirty Years of the Roman Dominion*, ed. P.M. Fraser (2nd edn. Oxford 1978) 401–26.
CANFORA, L., *The Vanished Library* (London 1991).
DELIA, D., 'From Romance to Rhetoric: The Alexandrian Library in Classical and Islamic Traditions', *The American Historical Review* 97 (1992) 1449–67.
EL-ABBADI, M., *The Life and Fate of the Ancient Library of Alexandria* (Paris 1990).
EL-ABBADI, M., 'The Alexandria Library in History', in A. Hirst and M. Silk, eds., *Alexandria, Real and Imagined* (London 2004) 167–83.

Serapeum (Temple of Serapis)

KESSLER, D., 'Das hellenistische Serapeum in Alexandria und Ägypten in ägyptologischer Sicht', in M. Görg and G. Hölbl, eds., *Ägypten und der östliche Mittelmeerraum im 1. Jahrtausend v. Chr.* (Wiesbaden 2000) 163–230.
MCKENZIE, J., GIBSON, S., and REYES, A.T., 'Reconstructing the Serapeum in Alexandria from the Archaeological Evidence', *Journal of Roman Studies* 94 (2004) 73–114.
ROWE, A., *Discovery of the Famous Temple and Enclosure of Serapis at Alexandria*, Supplément aux ASAE, cahier no. 2 (Cairo 1946).
SABOTTKA, M., *Das Serapeum in Alexandria. Untersuchungen zur Architektur und Baugeschichte des Heiligtums von der frühen ptolemäischen Zeit bis zur Zerstörung 391 n. Chr.*, *ÉtAlex* 16 (Cairo, in press).

Mosaics (Hellenistic and Roman)

DASZEWSKI, W.A., 'Some Problems of Early Mosaics from Egypt', in H. Maehler, and V.M. Strocka, eds., *Das ptolemäische Ägypten* (Mainz 1978) 123–36.
DASZEWSKI, W.A., 'An Old question in the Light of New Evidence Ἐμβλήματα Ἀλεξανδρεινὰ Ψηφωτά', in G. Grimm, H. Heinen, and E. Winter, eds., *Das römisch-byzantinische Ägypten, AegTrev* 2 (Mainz 1983) 161–5.
DASZEWSKI, W.A., *Corpus of Mosaics from Egypt I: Hellenistic and Early Roman Period, AegTrev* 3 (Mainz 1985).
DASZEWSKI, W.A., 'From Hellenistic Polychromy of Sculptures to Roman Mosaics', in K. Hamma, ed., *Alexandria and Alexandrianism* (Malibu 1996) 141–54.
GUIMIER-SORBETS, A.-M., 'Alexandrie: les mosaïques hellénistiques découvertes sur le terrain de la nouvelle Bibliotheca Alexandrina', *RA* (1998) 263–90.
GUIMIER-SORBETS, A.-M., 'Le Pavement du triclinium à la Méduse dans une maison d'époque impériale à Alexandrie', in J.-Y. Empereur, ed., *Alexandrina* 1, *ÉtAlex* 1 (Cairo 1998) 115–39.
GUIMIER-SORBETS, A.-M., 'Mosaics of Alexandria', in A. Hirst and M. Silk, eds., *Alexandria, Real and Imagined* (London 2004) 67–77.
SAÏD, D., 'Deux mosaïques hellénistiques récemment découvertes à Alexandrie', *BIFAO* 94 (1994) 377–80, 487–9.

Tombs

ADRIANI, A., *Repertorio d'arte dell'Egitto greco-romano*, Series C, vol. 1–2 (Palermo 1966).
 Detailed catalogue, with references.
CORBELLI, J.A., *The Art of Death in Graeco-Roman Egypt* (Princes Risborough 2006).
 Introduction to all aspects of burial including coffins and treatment of the body.
EMPEREUR, J.-Y., and NENNA, M.-D. eds., *Nécropolis* 1 and 2, *ÉtAlex* 5 and 7 (Cairo 2001 and 2003).

Detailed reports on some recently excavated tombs to the west of the city.
GUIMIER-SORBETS, A.-M., and SEIF EL-DIN, M., 'Les Deux Tombes de Perséphone dans la nécropole de Kom el-Chougafa à Alexandrie', *BCH* 121 (1997) 355–410.
GUIMIER-SORBETS, A.-M., and SEIF EL-DIN, M., 'Life after Death: An Original Form of Bilingual Iconography in the Necropolis of Kawm al-Shuqafa', in A. Hirst and M. Silk, eds., *Alexandria, Real and Imagined* (London 2004) 133–41.
KAPLAN, I., *Grabmalerei und Grabreliefs der Römerzeit* (Vienna 1999).
 Focuses on Egyptian influences in tomb iconography in the Roman period.
RIGGS, C., *The Beautiful Burial in Roman Egypt: Art, Identity, and Funerary Religion* (Oxford 2005).
 Funerary customs in Greco-Roman Egypt concentrating on iconography of coffins, masks, and shrouds, treatment of the body, and the Egyptian contribution.
VENIT, M.S., 'The Painted Tomb from Wardian and the Decoration of Alexandrian Tombs', *JARCE* 25 (1988) 71–91.
VENIT, M.S., 'The Tomb from Tigrane Pasha Street and the Iconography of Death in Roman Alexandria', *AJA* 101 (1997) 701–29.
VENIT, M.S., *Monumental Tombs of Ancient Alexandria* (Cambridge 2002).
 Illustrations concentrate on tomb decoration, unlike Adriani *Repertorio* above.

Roman and Late Antique houses at Kom el-Dikka and elsewhere

ALSTON, R., 'Houses and Households in Roman Egypt', in R. Lawrence and A. Wallace-Hadrill, eds., *Domestic Space in the Roman World: Pompeii and Beyond* (Portsmouth, RI 1997) 25–39.
ALSTON, R., *The City in Roman and Byzantine Egypt* (London 2002) 44–127.
MAJCHEREK, G., 'Notes on Alexandrian Habitat: Roman and Byzantine Houses from Kom el-Dikka', *Topoi* 5 (1995) 133–50.
RODZIEWICZ, M., *Les Habitations romaines tardives d'Alexandrie, Alexandrie* III (Warsaw 1984).
 Kom el-Dikka houses, for which more recent discoveries reported annually by G. Majcherek in *Polish Archaeology in the Mediterranean*.

Kom el-Dikka academic complex and education

CRIBIORE, R., *Gymnastics of the Mind: Greek Education in Hellenistic and Roman Egypt* (Princeton 2001).
DERDA, T., MARKIEWICZ, T., and WIPSZYCKA, E., eds., *Alexandria: Auditoria of Kom el-Dikka and Late Antique Education, Journal of Juristic Papyrology*, suppl. 8 (Warsaw, in press 2007).
KISS, Z., 'Les Auditoria romains tardifs', in Z. Kiss *et al.*, *Fouilles polonaises à Kôm el-Dikka (1986–1987)*, *Alexandrie* VII (Warsaw 2000) 8–33.
 Final archaeological report on those teaching rooms excavated 1986–7.
SHEPHERD, A., 'Philosophy in Alexandria', in Averil Cameron, B. Ward-Perkins, and M. Whitby, eds., *Cambridge Ancient History*, vol. 14, *Late Antiquity: Empire and Successors, AD 425–600* (Cambridge 2000) 843–52.
WATTS, E.J., *City and School in Late Antique Athens and Alexandria* (Los Angeles 2006) 187–256.

Kom el-Dikka 'small theatre'

KOLATAJ, W., 'Recherches architectoniques dans les thermes et le théâtre de Kôm el-Dikka à Alexandrie', in G. Grimm, H. Heinen and E. Winter, eds., *Das römisch-byzantinische Ägypten, AegTrev* 2 (Mainz 1983) 189–94.
KISS, Z., 'Remarques sur la datation et les fonctions de l'édifice théatral à Kôm el-Dikka', in *50 Years of Polish Excavations in Egypt and the Near East, Symposium Warsaw University 1986* (Warsaw 1992) 171–8.

Kom el-Dikka baths-buildings

KOLATAJ, W., *Imperial Baths at Kom el-Dikka, Alexandrie* VI (Warsaw 1992).

Jewish Community

HAAS, C.J., *Alexandria in Late Antiquity: Topography and Social Conflict* (Baltimore 1997) 91–127.
KERKESLAGER, A., 'Jewish Pilgrimage and Jewish Identity in Hellenistic and Early Roman Egypt', in D. Frankfurter, ed., *Pilgrimage and Holy Space in Late Antique Egypt* (Leiden 1998) 99–225.
MODRZEJEWSKI, J.M., *The Jews of Egypt from Rameses II to Emperor Hadrian* (Princeton 1997).
PAGET, J.C., 'Jews and Christians in Ancient Alexandria from the Ptolemies to Caracalla', in A. Hirst and M. Silk, eds., *Alexandria, Real and Imagined* (London 2004) 143–66.

LATE ANTIQUE ALEXANDRIA

GASCOU, J., 'Les Églises d'Alexandrie: questions de méthode', in C. Décobert and J.-Y. Empereur, eds., *Alexandrie mediévale* 1, *ÉtAlex* 3 (Cairo 1998) 23–44.
GASCOU, J., review, in French, of C. Haas *Alexandria in Late Antiquity*, in *Topoi* 8.1 (1998) 390–5.
HAAS, C.J., *Alexandria in Late Antiquity: Topography and Social Conflict* (Baltimore 1997).
HEINEN, H., 'Alexandria in Late Antiquity', in A.S. Atiya, ed., *Coptic Encyclopedia* vol. 1 (New York 1991) 95–103.
HEINEN, H., 'Das spätantike Alexandrien', in M. Krause, ed., *Ägypten in spätantik-christlicher Zeit. Einführung in die koptische Kultur* (Wiesbaden 1998) 57–79.
MARTIN, A., 'Les Premiers Siècles du christianisme à Alexandrie, Essai de topographie religieuse (IIIᵉ – IVᵉ siècles)', *Revue des études Augustiniennes* 30 (1984) 211–25.

MARTIN, A., *Athanase d'Alexandrie et l'église d'Égypte au IVᵉ siècle (328–373)* (Rome 1996).

MARTIN, A., 'Alexandrie à l'époque romaine tardive: l'impact du christianisme sur la topographie et les institutions', in C. Décobert and J.-Y. Empereur, eds., *Alexandrie mediévale 1, ÉtAlex* 3 (Cairo 1998) 9–21.

EGYPTIAN CITIES AND TOWNS IN THE ROMAN PERIOD

ALSTON, R., 'Ritual and Power in the Romano-Egyptian city', in H.M. Parkins, ed., *Roman Urbanism* (London 1997) 147–72.

ALSTON, R., *The City in Roman and Byzantine Egypt* (London 2002).

BAGNALL, R.S., *Egypt in Late Antiquity* (Princeton 1993) 45–109.

BAGNALL, R.S., and RATHBONE, D.W., eds., *Egypt From Alexander to the Copts, An Archaeological and Historical Guide* (London 2004).
Site by site guide book.

BAILEY, D.M., 'Classical Architecture in Roman Egypt', in M. Henig, ed., *Architecture and Architectural Sculpture in the Roman Empire* (Oxford 1990) 121–37.
Concentrates on archaeological evidence.

BOWMAN, A.K., 'Public Buildings in Roman Egypt', *JRA* 5 (1992) 495–503.
Written evidence (papyri).

BOWMAN, A.K., 'Urbanisation in Roman Egypt', in E. Fentress, ed., *Romanization and the City, JRA* suppl. 38 (Portsmouth, RI 2000) 173–87.

BOWMAN, A.K., and RATHBONE, D., 'Cities and Administration in Roman Egypt', *JRS* 82 (1992) 107–27.

ROWLANDSON, J., and HARKER, A., 'Roman Alexandria from the Perspective of the Papyri', in A. Hirst and M. Silk, eds., *Alexandria, Real and Imagined* (London 2004) 79–111.

THE EGYPTIAN TRADITION

Egyptian temples in the Ptolemaic and Roman periods

ARNOLD, D., *Temples of the Last Pharaohs* (Oxford 1999) 143–224 (Ptolemaic), 225–73 (Roman).

BAINES, J., 'Temples as Symbols, Guarantors, and Participants in Egyptian Civilization', in S. Quirke, ed., *The Temple in Ancient Egypt* (London 1997) 216–41.

FINNESTAD, R.B., 'Temples of the Ptolemaic and Roman Periods: Ancient Traditions in New Contexts', in B.E. Shafer, ed., *Temples in Ancient Egypt* (London 1998) 185–237.

FRANKFURTER, D., *Religion in Roman Egypt: Assimilation and Resistance* (Princeton 1998).

KURTH, D., 'A World Order in Stone – The Late Temples', in R. Schulz and M. Seidel, eds., *Egypt the World of the Pharaohs* (Cologne 1998) 296–311.

Egyptian style statues of Ptolemaic kings and queens

ALBERSMEIER, S., *Untersuchungen zu den Frauenstatuen des ptolemaïschen Ägypten, AegTrev* 10 (Mainz 2002).

BOTHMER, B.V., 'Hellenistic Elements in Egyptian Sculpture of the Ptolemaic Period', in K. Hamma, ed., *Alexandria and Alexandrianism* (Malibu 1996) 215–30.

SMITH, R.R.R., 'Ptolemaic Portraits: Alexandrian Types, Egyptian Versions', in K. Hamma, ed., *Alexandria and Alexandrianism* (Malibu 1996) 203–13.

STANWICK, P.E., *Portraits of the Ptolemies, Greek Kings as Egyptian Pharaohs* (Austin, Texas 2002).

WALKER, S., and HIGGS, P., eds., *Cleopatra of Egypt from History to Myth* (London 2001).

ARCHITECTURAL STYLE

Ptolemaic

BERGMANN, M., 'Perspektivische Malerei in Stein. Einige alexandrinische Architekturmotive', in H. Büsing and F. Hiller, eds., *Bathron. Beiträge zur Architektur und verwandten Künsten. Für H. Drerup zu seinem 80. Geburtstag* (Saarbrüken 1988) 59–77.

GANS, U.-W. 'Hellenistische Architekturteile aus Hartgestein in Alexandria', *AA* (1994) 433–53.

GRIMM, G., and MCKENZIE, J.S, 'Architectural Fragments found in the Excavations of the Serapeum in Alexandria in *c.* 1901', *JRS* 94 (2004) 115–21.

LAUTER, H., 'Ptolemais in Libyen, Ein Beitrag zur Baukunst Alexandrias', *JdI* 86 (1971) 149–78.

LYTTELTON, M., *Baroque Architecture in Classical Antiquity* (London 1974) 40–60.

MCKENZIE, J., *The Architecture of Petra* (Oxford 1990, repr. 2005) 61–104.
Detailed discussion of evidence for architectural style of Ptolemaic Alexandria.

PENSABENE, P., 'Elementi di architettura alessandrina', *Studi Miscellanei* 28 (1984–5 [1991]) 29–85.
Summary of characteristics, especially of Ptolemaic period, gleaned from Pensabene 1993 below.

Continuity from Ptolemaic to Late Antique

MCKENZIE, J.S., 'Alexandria and the Origins of Baroque Architecture', K. Hamma, ed., *Alexandria and Alexandrianism* (Malibu 1996) 109–25.

MCKENZIE, J.S., 'The Architectural Style of Roman and Byzantine Alexandria and Egypt', in D.M. Bailey, ed., *Archaeological Research in Roman Egypt, JRA* suppl. 19 (Ann Arbor 1996) 128–42.

PENSABENE, P., 'Architettura imperiale in Egitto', in *Roma e l'Egitto nell'antichità classica, Cairo 1989* (Rome 1992) 273–98.

PENSABENE, P., *Elementi architettonici di Alessandria e di altri siti egiziani, Repertorio d'arte dell'Egitto greco-romano*, Series C, vol. 3 (Rome 1993).
Catalogue of nearly all architectural fragments of Ptolemaic and Roman Alexandria and Egypt, and many of Byzantine period. For summary see Pensabene 1991 above.

Late Antique ('Coptic')

SEVERIN, H.-G., 'Zum Dekor der Nischenbekrönungen aus spätantiken Grabbauten Ägyptens', in D. Willers, ed., *Begegnung von Heidentum und Christentum im spätantiken Ägypten* (Riggisberg 1993) 183–94.

SEVERIN, H.-G., 'Konstantinopler Bauskulptur und die Provinz Ägypten', in U. Peschlow and S. Möllers, eds., *Spätantike und byzantinische Bauskulptur* (Stuttgart 1998) 93–104.

SEVERIN, H.-G., 'Zur Skulptur und Malerei der spätantiken und frühmittelalchelichen Zeit in Ägypten', in Krause, M., ed., *Ägypten in spätantik-christlicher Zeit. Einführung in die koptische Kultur* (Wiesbaden 1998) 297–338.

THOMAS, T.K., 'An Introduction to the Sculpture of Late Roman and Early Byzantine Egypt', in F.D. Friedman, ed., *Beyond the Pharaohs* (Rhode Island 1989) 54–64.

THOMAS, T.K., *Late Antique Egyptian Funerary Sculpture* (Princeton 2000).

TÖRÖK, L., 'Notes on the Chronology of Late Antique Stone Sculpture in Egypt', in W. Godlewski, ed., *Coptic Studies, Congress Warsaw 1984* (Warsaw 1990) 437–84.

TÖRÖK, L., *Transfigurations of Hellenism, Aspects of Late Antique Art in Egypt AD 250–700* (Leiden 2005).

VAN LOHUIZEN-MULDER, M., 'Early Christian Lotus-panel Capitals and Other So-called Impost Capitals', *BABesch* 62 (1987) 131–51.

CHURCH ARCHITECTURE

Byzantine architecture

KRAUTHEIMER, R., *Early Christian and Byzantine Architecture* (4th edn., Harmondsworth 1986).

Egyptian Churches

CAPUANI, M., *L'Égypte copte* (Paris 1999).

GROSSMANN, P., 'Early Christian Architecture in the Nile Valley', in F.D. Friedman, ed., *Beyond the Pharaohs* (Rhode Island 1989) 81–8.

GROSSMANN, P., 'The Pilgrimage Center of Abû Mînâ', in D. Frankfurter, ed., *Pilgrimage and Holy Space in Late Antique Egypt* (Leiden 1998) 281–302.

GROSSMANN, P., *Christliche Architektur in Ägypten* (Leiden 2002).
Up to date detailed summary of archaeological evidence for all surviving churches, with plans, and related buildings in Egypt, concentrating on plans rather than sculptural decoration. Much of the information in it appears in English in A.S. Atiya, ed., *Coptic Encyclopedia* (New York 1991) under the relevant site and subject headings, but the plans lack scales.

LATE ANTIQUE EGYPTIAN ART

ARTICLES UNDER SUBJECT HEADINGS IN A.S. ATIYA, ed., *Coptic Encyclopedia* (New York 1991).

DU BOURGUET, P., *Coptic Art* (London 1971).

KRAUSE, M., ed., *Ägypten in spätantik-christlicher Zeit. Einführung in die koptische Kultur* (Wiesbaden 1998).

TÖRÖK, L., *Transfigurations of Hellenism, Aspects of Late Antique Art in Egypt* (Leiden 2005).

Main Bibliography

ABD EL-AZIZ NEGM, M., 'Recent Activities around the Ancient Walls of Alexandria', in *Alessandria e il mondo ellenistico-romano, Congresso Alessandria 1992* (Rome 1995) 124–7.

ABDEL-AZIZ NEGM, M., 'Recent Discoveries at Abu-Mina', *BSAA* 44 (1991) 226–33; *BSAC* 32 (1993) 129–37.

ABD'AL-AZIZ NEGM, M., and KOŠCIUK, J., 'The Private Roman Bath found Abu Mina (Egypt) Nearby', in *Akten des XIII internationalen Kongresses für klassische Archäologie, Berlin 1988* (Mainz 1990) 442–5.

ABD EL-FATTAH, A., 'Une Fouille récente au Sarapéion d'Alexandrie', in J.-Y. Empereur, ed., *Alexandrina 2, ÉtAlex* 6 (Cairo 2002) 25–7.

ABD EL-FATTAH, A., and ALI CHOUKRI, S., 'Un nouveau groupe de tombeaux de la nécropole ouest d'Alexandrie', in J.-Y. Empereur, ed., *Alexandrina 1, ÉtAlex* 1 (Cairo 1998) 35–53.

ABD EL-FATTAH, A., and GALLO, P., 'Aegyptiaca Alexandrina. Monuments pharaoniques découverts récemment à Alexandrie', in J.-Y. Empereur, ed., *Alexandrina 1, ÉtAlex* 1 (Cairo 1998) 7–19.

ABD EL-RAZIQ, M., *Die Darstellungen und Texte des Sanctuars Alexanders des Grossen im Tempel von Luxor* (Mainz 1984).

ABDUL-QADER MUHAMMAD, M., 'Preliminary Report on the Excavations Carried out in the Temple of Luxor, Seasons 1958–1959 and 1959–1960', *ASAE* 60 (1968) 227–79.

ABOU ZAHRA, A., 'Les Différentes Phases du développement d'Alexandrie', *Mediterraneans* 8/9 (1996) 23–30.

ADAM, J.-P., 'Le Phare d'Alexandrie', *Les Dossiers d'archéologie* 201 (1995) 26–31.

ADLER, F., *Der Pharos von Alexandria* (Berlin 1901).

ADLI, S., 'Several Churches in Upper Egypt', *MDIK* 36 (1980) 1–14.

ADRIANI, A., *Annuario del Museo greco-romano*, vol. 1 (1932–33).

ADRIANI, A., *Annuaire du Musée greco-romain* (1933–50).

ADRIANI, A., 'Osservazioni sulla Stele di Helixo e sui precedenti alessandrini del II stile pompeiano', *BSAA* 32–3 (1938–39) 112–30.

ADRIANI, A., 'Ipogeo dipinto della Via Tigrane Pascià', *BSAA* 41 (1956) 63–86.

ADRIANI, A., 'Scavi e scoperte alessandrine (1949–1952)', *BSAA* 41 (1956) 1–48.

ADRIANI, A., *Repertorio d'arte dell'Egitto greco-romano*, Series C, vol. 1–2 (Palermo 1966).

ADRIANI, A., *La Tomba di Alessandro. Realtà, ipotesi e fantasie*, ed., N. Bonacasa and P. Minà (Rome 2000).

AGNEW, H.C., 'Remarks on Some Remains of Ancient Greek Writings, on the Walls of a Family Catacomb in Alexandria', *Archaeologia* 28 (1840) 152–70.

AINALOV, D.V., *The Hellenistic Origins of Byzantine Art*, ed. C. Mango (New Brunswick, New Jersey, 1961) (published in Russian in 1900–1).

AKERMANN, P., *Le Décor sculpté du Couvent blanc, niches et frieses*, Bibliothèque d'études coptes, vol. 14 (Cairo 1976).

ALBERSMEIER, S., *Untersuchungen zu den Frauenstatuen des ptolemaischen Ägypten*, *AegTrev* 10 (Mainz 2002).

ALFÖLDI-ROSENBAUM, E., 'Alexandriaca. Studies on Roman Game Counters III', *Chiron* 6 (1976) 205–39.

ALFÖLDY, G., *Der Obelisk auf dem Petersplatz in Rom* (Heidelberg 1990).

ALI IBRAHIM, L., 'The Islamic Monuments of Alexandria', *BSAA* 45 (1993) 145–52.

ALI MOHAMED, M., and GROSSMANN, P., 'On the Recently Excavated Monastic Buildings in Dayr Anba Shinuda: Archaeological Report', *BSAC* 30 (1991) 53–63.

ALSTON, R., 'Houses and Households in Roman Egypt', in R. Lawrence and A. Wallace-Hadrill, eds., *Domestic Space in the Roman World: Pompeii and Beyond* (Portsmouth, RI 1997) 25–39.

ALSTON, R., 'Ritual and Power in the Romano-Egyptian city', in H.M. Parkins, ed., *Roman Urbanism* (London 1997) 147–72.

ALSTON, R., *The City in Roman and Byzantine Egypt* (London 2002).

ALSTON, R., and R.D., 'Urbanism and Urban Community in Roman Egypt', *JEA* 83 (1997) 199–216.

AL-SYRIANY, S., and HABIB, B., *Guide to Ancient Churches and Monasteries in Upper Egypt* (Egypt 1990).

ALTHEIM-STIEHL, R., 'The Sassanians in Egypt – Some Evidence of Historical Interest', *BSAC* 31 (1992) 87–96.

AMÉLINEAU, E., *La Géographie de l'Égypte à l'époque copte* (Paris 1893).

ARNAUD, J.L., 'Sources et méthodes de restitution les obélisques et le Césaréum d'Alexandrie', in J.-Y. Empereur, ed., *Alexandrina 2, ÉtAlex* 6 (Cairo 2002) 177–90.

ARNOLD, D., *Die Tempel Ägyptens* (Zurich 1992).

ARNOLD, D., *Lexikon der ägyptischen Baukunst* (Zurich 1994) = *The Encyclopedia of Ancient Egyptian Architecture* (London 2003).

ARNOLD, D., *Temples of the Last Pharaohs* (Oxford 1999).

ARNOLD, D., 'Holzdächer spätzeitlicher ägyptischer Tempel', in M. Bietak, ed., *Archaische griechische Tempel und Altägypten* (Vienna 2001) 107–15.

ARVANITAKIS, G., Το Καισαρειον (Cairo 1899).

ASHTON, S.-A., *Ptolemaic Royal Sculpture from Egypt, The Interaction between Greek and Egyptian Traditions, BAR International Series* 923 (Oxford 2001).

ATIYA, A.S., ed., *Coptic Encyclopedia* (New York 1991).

AUFRÈRE, S., GOLVIN, J.-C., and GOYON, J.-C., *L'Égypte restituée, sites et temples de Haute Égypte* (Paris 1991); *L'Égypte restituée 2, Sites et temples des déserts* (Paris 1994).

AUSFELD, A., 'Zur Topographie von Alexandrien und Pseudokallisthenes I 31–33', *RhM* 55 (1900) 348–84.

AUSTIN, M.M., *The Hellenistic World from Alexander to the Roman Conquest, A Selection of Ancient Sources in Translation* (Cambridge 1981).

AUTH, S., 'Luxury Glasses with Alexandrian Motifs', *Journal of Glass Studies* 25 (1983) 39–44.

AVNER, R. *et al.*, 'Jerusalem, Mar Elias, the Kathisma Church', *Hadashot Arkheologiyot, Excavations and Surveys in Israel* 113 (2001) 89*–92* (English) and 133–7 (Hebrew).

AWAD, M.F., 'Le Modèle européen: l'évolution urbaine de 1807 à 1958', *Alexandrie entre deux mondes, Revue de l'occident musulman et de la Méditerranée* 46 (1987.4) 93–109.

BACHMANN, W., WATZINGER, C., and WIEGAND, T., *Petra*, Wissenschaftliche Veröffentlichungen des deutsch-türkischen Denkmalschutz-Kommandos, Heft 3 (Berlin 1921).

BADAWY, A., 'Au grand temple d'Hermoupolis-Ouest: l'installation hydraulique', *RA* 6th ser. 48 (1956) 140–54.

BADAWY, A., 'Greco-Roman Figure Capitals from Dionysias in Egypt', *Gazette des beaux-arts* 72 (1968) 249–54.

BAGATTI, B., *Gli antichi edifici sacri di Betlemme* (Jerusalem 1952).

BAGNALL, R., 'Religious Conversion and Onomastic Change in Early Byzantine Egypt', *Bulletin of the American Society of Papyrologists* 19 (1982) 105–24.

BAGNALL, R., 'Conversion and Onomastics: a Reply', *ZPE* 69 (1987) 243–50.

BAGNALL, R.S., *Egypt in Late Antiquity* (Princeton 1993).

BAGNALL, R.S., *Reading Papyri, Writing Ancient History* (London 1995).

BAGNALL, R.S., 'Alexandria: Library of Dreams', *Proceedings of the American Philosophical Society* 146 (2002) 348–62.

BAGNALL, R.S., and RATHBONE, D.W., eds., *Egypt From Alexander to the Copts An Archaeological and Historical Guide* (London 2004).

BAILEY, D.M., 'Alexandria, Carthage and Ostia (Not to mention Naples)', in *Alessandria e il mondo ellenistico-romano*, vol. 2 (Rome 1984) 265–72.

BAILEY, D.M., 'The Procession-house of the Great Hermaion at Hermopolis Magna', in M. Henig and A. King, eds., *Pagan Gods and Shrines of the Roman Empire* (Oxford 1986) 231–7.

BAILEY, D.M., 'Classical Architecture in Roman Egypt', in M. Henig, ed., *Architecture and Architectural Sculpture in the Roman Empire* (Oxford 1990) 121–37.

BAILEY, D.M., 'Honorific columns, cranes, and the Tuna epitaph', in D.M. Bailey, ed., *Archaeological Research in Roman Egypt, JRA* suppl. 19 (Ann Arbor 1996) 155–68.

BAILEY, D.M., 'The Pottery from the South Church at el-Ashmunein', *Cahiers de la céramique égyptienne* 4 (1996) 47–111.

BAILEY, D.M., 'A Ghost Palaestra at Antinoopolis', *JEA* 85 (1999) 235–9.

BAILEY, D.M., 'Architectural Blocks from the Great Theatre at Oxyrhynchus', in A.K. Bowman *et al.*, eds., *Oxyrhynchus, a City and its Texts, Papers of the Centenary Conference* (forthcoming).

BAILEY, D.M., *et al.*, *Hermopolis Magna: Buildings of the Roman Period, Excavations at el-Ashmunein*, vol. 4 (London 1991).

BAINES, J., 'King, Temple and Cosmos: an Earlier Model for Framing Columns in Temple Scenes of the Greco-Roman Period', in M. Minas and J. Zeidler, eds., *Aspekte spätägyptischer Kultur, Festschrift für E.Winter zum 65. Geburtstag, AegTrev* 7 (Mainz 1994) 23–33.

BAINES, J., 'Temples as Symbols, Guarantors, and Participants in Egyptian Civilization', in S. Quirke, ed., *The Temple in Ancient Egypt* (London 1997) 216–41.

BAINES, J., 'Possible Implications of the Egyptian Word for Alexandria', *JRA* 16 (2003) 61–3.

BALDINI, A., 'Problemi della tradizione sulla "disruzione" del Serapeo di Alessandria', *RStorAnt* 15 (1985) 97–152.

BALTY, J.-C., 'Le "Bouleuterion" de l'Alexandrie sévérienne', *ÉtTrav* 13 (1983) 7–12.

BARANSKI, M., 'Preserving the Christian Basilica of el-Ashmunein', *BIFAO* 90 (1990) 41–9.

BARANSKI, M., 'Excavations at the Basilica Site at el-Ashmunein/Hermopolis Magna in 1987–1990', *PAM* 3 (1991) 19–23.

BARANSKI, M., 'The Archaeological Setting of the Great Basilica Church at el-Ashmunein', in D.M. Bailey, ed., *Archaeological Research in Roman Egypt, JRA* suppl. 19 (Ann Arbor 1996) 98–106.

BARANSKI, M., *et al.*, *Reports From Ashmunein*, vol. 2 (Warsaw 1992).

BARATTE, F., 'Les Orfèvres d'Alexandrie à la fin de l'antiquité', *Les Dossiers d'archéologie* 201 (1995) 78–81.

BARBET, A., *La Peinture murale romaine* (Paris 1985).

BARDILL, J., 'The Church of Sts. Sergius and Bacchus in Constantinople and the Monophysite Refugees', *DOP* 54 (2000) 1–11.

BARDILL, J., *Brickstamps of Constantinople* (Oxford 2004).

BARIGAZZI, A., 'Due epigrammi ellenistici', *Atti dell'XI congresso internazionale di papirologia, Milano 1965* (Milan 1966) 69–85.

BARRY, W.D., 'Aristocrats, Orators, and the "Mob": Dio Chrysostom and the World of the Alexandrians', *Historia* 42 (1993) 82–103.

BARTLETT, J.R., *Jews in the Hellenistic World* (Cambridge 1985).

BASTIANINI, G., 'Lista dei Prefetti d'Egitto dal 30ª al 299p,' *ZPE* 17 (1975) 262–328.

BASTIANINI, G., 'Lista dei Prefetti d'Egitto dal 30ª al 299p. Aggiunte e correzioni,' *ZPE* 38 (1980) 75–89.

BATIFFOL, P., 'Les Présents de Saint Cyrille à la cour de Constantinople', *Bulletin d'ancienne littérature et d'archéologie chrétiennes* 1 (1911) 247–64.

BAUER, A., and STRZYGOWSKI, J., *Eine alexandrinische Weltchronik* (Vienna 1905).

BAUER, H., *Korinthische Kapitelle des 4. und 3. Jahrhunderts v. Chr., AM* Beiheft 3 (Berlin 1973).

BECKWITH, J., *Coptic Sculpture* (London 1963).

BEHRENS-ABOUSEIF, D., 'Notes sur l'architecture musulmane d'Alexandrie', in C. Décobert and J.-Y. Empereur, ed., *Alexandrie médiévale 1, ÉtAlex* 3 (1998) 101–114.

BELL, H.I., 'Antinoopolis: a Hadrianic Foundation in Egypt', *JRS* 30 (1940) 137–47.

BÉNAZETH, D., 'Histoire des fouilles de Baouît', *Études Coptes* IV (Louvain 1995) 53–62.

BÉNAZETH, D., 'Un monastère dispersé. Les Antiquitiés de Baouît conservées dans les musées d'Égypte', *BIFAO* 97 (1997) 43–66.

BÉNAZETH, D., 'Les Avatars d'un monument copte: l'Église sud de Baouît', in M. Krause and S. Schaten, eds., ΘΕΜΕΛΙΑ, *spätantike und koptologische Studien Peter Grossmann zum 65. Geburtstag* (Wiesbaden 1998) 33–9.

BERGMANN, M., 'Perspektivische Malerei in Stein. Einige alexandrinische Architekturmotive', in H. Büsing and F. Hiller, eds., *Bathron. Beiträge zur Architektur und verwandten Künsten. Für H. Drerup zu seinem 80. Geburtstag* (Saarbrüken 1988) 59–77.

BERNAND, A., *Le Delta égyptien d'après les textes grecs* 1.1 (Cairo 1970).

BERNAND, A., *La Prose sur pierre dans l'Égypte hellénistique et romaine* (Paris 1992).

BERNAND, A., 'Alexandrie capitale des Ptolémées', *Les Dossiers d'archéologie*, 201 (1995) 12–17.

BERNAND, A. 'Les Veilleurs du Phare', *ZPE* 113 (1996) 85–90.

BERNAND, A. and E., 'Un procurateur des effigies impériales en Alexandrie', *ZPE* 122 (1998) 97–101.

BERNAND, A., and GODDIO, F., *L'Égypte engloutie, Alexandrie* (London 2002).

BERNAND, E., *Les Inscriptions grecques et latines de Philae* (Paris 1969).

BERNAND, E., 'Épigraphie grecque et architecture égyptienne à l'époque impériale', in H. Walter, ed., *Hommages à Lucien Lerat* (Paris 1984) 73–89.

BERNAND, E., 'A propos de l'autel dédié à Zeus Soleil, Grand Sarapis, par l'architecte Alexandrin Apollônios fils d'Ammônios, au Mons Claudianus', *ZPE* 91 (1992) 221–5.

BERNAND, E., *Inscriptions grecques d'Alexandrie ptolémaïque* (Cairo 2001).

BERNHARD, M.-L., 'Topographie d'Alexandrie: le tombeau d'Alexandre et le mausolée d'Auguste', *RA* 47 (1956) 129–56.

BETSCH, W.E., *The History, Production and Distribution of the Late Antique Capital in Constantinople*, PhD 1977, University of Pennsylvania (UMI Ann Arbor 1991).

BEYEN, H.G., *Die pompejanische Wanddekoration vom Zweiten bis zum Vierten Stil* (The Hague 1938–60).

BEYEN, H.G., 'Die antike Zentralperspektive', *AA* 54 (1939) 47–72.

BEYEN, H.G., 'The Wall-decoration of the Cubiculum of the Villa of P. Fannius Synistor near Boscoreale in its Relation to Ancient Stage-painting', *Mnemosyne* 10 (1957) 147–53.

BICKEL, E., 'Das Mausoleum der Kleopatra und des Antonius in lateinischer Dichtung', *RhM* 93 (1950) 191–2.

BING, P. 'Between Literature and the Monuments', in M.A. Harder *et al.*, eds., *Genre in Hellenistic Poetry* (Groningen 1998) 21–43.

BINGEN, J., 'Le Milieu urbain dans la chôra égyptienne à l'époque ptolémaïque', *Proceedings of the XIV International Congress of Papyrologists Oxford 1974* (London 1975) 367–73.

BIRNBAUM, A., 'Die Oktogone von Antiochia, Nazianz und Nyssa. Rekonstruktionsversuche', *Repertorium für Kunstwissenschaft* 36 (1913) 181–209.

BLANCHET, J.-A., 'Tessères antiques théâtrales et autres', *RA* 14 (1889) 64–80.

BLANCK, H., *Das Buch in der Antike* (Munich 1992).

BLOOMFIELD, R.M., 'The Sites of the Ptolemaic Museum and Library', *BSAA* 6 (1904) 27–37.

BLUM, R., *Kallimachos, The Alexandrian Library and the Origins of Bibliography* (Madison 1991).

BONACASA, N., 'Un inedito di Achille Adriani sulla tomba di Alessandro', *Studi Miscellanei* 28 (1984–5 [1991]) 5–19.

BORBEIN, A., 'Zur Deutung von Scherwand und Durchblick auf den Wandgemälden', in B. Andreae and H. Kyrieleis, eds., *Neue Forschungen in Pompeji* (Recklinghausen 1975) 61–70.

BORCHARDT, L., 'Der Augustustempel auf Philae', *JdI* 18 (1903) 73–90.

BORCHARDT, L., 'Von einer alexandrinischen Baustelle', *BSAA* 8 (1905) 1–6.

BORKOWSKA-KOLOTAJ, T., 'Wstepna interpretacja niektorych elementow dekoracji architektonicznej odkrytych w widowni teatru na Kom el-Dikka' [Preliminary interpretation of some elements of architectural decoration found in the auditorium of the theatre at Kom el-Dikka], in M.L. Bernhard, ed., *Starozytna Aleksandria w badaniach polskich* (Warsaw 1977) 35–46.

BORKOWSKI, Z., *Inscriptions des factions à Alexandrie, Alexandrie* II (Warsaw 1981).

BOSSON, N., and AUFRÈRE, S.H., eds., *Égyptes . . . L'Égyptien et le copte* (Lattes 1999).

BOTHMER, B.V., 'Hellenistic Elements in Egyptian Sculpture of the Ptolemaic Period', in K. Hamma, ed., *Alexandria and Alexandrianism* (Malibu 1996) 215–30.

BOTTI, G., *Rapport sur les fouilles pratiquées et à pratiquer à Alexandrie* (Alexandria 1894).

BOTTI, G., *L'Acropole d'Alexandrie et le Sérapeum d'après Aphthonius et les fouilles* (Alexandria 1895).

BOTTI, G., *Fouilles à la colonne Théodosienne (1896)* (Alexandria 1897).

BOTTI, G., *Plan du quartier 'Rhacotis' dans l'Alexandrie romaine* (Alexandria 1897).

BOTTI, G., 'Additions au "Plan de la ville d'Alexandrie etc." ', *BSAA* 1 (1898) 49–68.

BOTTI, G., 'Fouilles dans le céramique d'Alexandrie en 1898 [7]', *BSAA* 1 (1898) 5–24.

BOTTI, G., *Plan de la ville d'Alexandrie à l'époque ptolémaïque* (Alexandria 1898).

BOTTI, G., 'Études topographiques dans la nécropole de Gabbari', *BSAA* 2 (1899) 37–56.

BOTTI, G., 'L'Apis de l'empereur Adrien trouvé dans le Sérapeum d'Alexandrie', *BSAA* 2 (1899) 27–36.

BOTTI, G., 'Les Citernes d'Alexandrie', *BSAA* 2 (1899) 15–26.

BOTTI, G., 'Le iscrizioni cristiane di Alessandria d'Egitto', *Bessarione* 4 vol. 7 (1899–1900) 270–81.

BOTTI, G., 'Bulletin épigraphique', *BSAA* 4 (1902) 85–107.

BOTTI, G., 'L'Ancien Théâtre d'Alexandrie', *BSAA* 4 (1902) 119–21.

BOWEN, G.E., 'The Fourth-Century Churches at Ismant el-Kharab', in C.A. Hope and G.E. Bowen, eds., *Dakhleh Oasis Project: Preliminary Reports on the 1994–1995 to 1998–1999 Field Seasons* (Oxford 2002) 65–85.

BOWERSOCK, G.W., 'Late Antique Alexandria', in K. Hamma, ed., *Alexandria and Alexandrianism* (Malibu 1996) 263–72.

BOWERSOCK, G.W., *Hellenism in Late Antiquity* (Ann Arbor, Michigan 1990).

BOWMAN, A.K., *Egypt After the Pharaohs* (London 1986).

BOWMAN, A.K., 'Public Buildings in Roman Egypt', *JRA* 5 (1992) 495–503.

BOWMAN, A.K., 'Urbanisation in Roman Egypt', in E. Fentress, ed., *Romanization and the City, JRA* suppl. 38 (Portsmouth, RI 2000) 173–87.

BOWMAN, A.K., and RATHBONE, D., 'Cities and Administration in Roman Egypt', *JRS* 82 (1992) 107–27.

BOWRA, C.M., 'Palladas on Tyche', *Classical Quarterly* 54 (1960) 118–28.

BRECCIA, A., 'Il porto d'Alessandria d'Egitto studio di geografia commerciale', *Mémoires de la Société royale de geographie d'Égypte* 14 (1927) 1–22.

BRECCIA, E., 'Cronaca del museo e degli scavi e ritrovamenti', *BSAA* 9 (1907) 97–114.

BRECCIA, E., 'La necropoli di l'Ibrahimieh', *BSAA* 9 (1907) 35–86.

BRECCIA, E., 'Les Fouilles dans le Sérapéum d'Alexandrie en 1905–1906', *ASAE* 8 (1907) 62–76.

BRECCIA, E., 'Un ipogeo cristiano di Hadra', *BSAA* 9 (1907) 278–88.

BRECCIA, E., *Rapport sur la marche du service du musée: 1906–16, 1918–21* (Alexandria 1907–17; 1919–23).

BRECCIA, E., *La necropoli di Sciatbi* (Cairo 1912).

BRECCIA, E., Review of G. Jondet, *Les Ports submergés de l'ancienne île de Pharos*, *BSAA* 16 (1918) 137–43.

BRECCIA, E., *Alexandrea ad Aegyptum* (Bergamo 1922) [Eng. edn].

BRECCIA, E., *Le Musée gréco-romain 1922–23* (Alexandria 1924); *1925–31* (Bergamo 1932); *1931–2* (Bergamo 1933).

BRECCIA, E., *Monuments de l'Égypte gréco-romaine, 1. Le rovine e i monumenti di Canopo, 2. Teadelfia e il Tempio di Pneferôs*, vol. 1 (Bergamo 1926).

BRODERSEN, K., 'Ein Weltwunder auf << gläsernen Füssen >>, der Pharos von Alexandria in neuem Licht', *Antike Welt* 24 (1993) 207–11.

BROWN, B., *Ptolemaic Painting and Mosaics and the Alexandrian Style* (Cambridge, Mass. 1957).

BRUWIER, M.-C., 'Deux fragments d'une statue colossale de reine ptolémaïque à Mariemont', *Chronique d'Égypte* 64 (1989) 25–43.

BUCHWALD, H., 'Saint Sophia, Turning Point in the Development of Byzantine Architecture', in V. Hoffmann, ed., *Die Hagia Sophia in Istanbul, Akten des Berner Kolloquiums vom 21. Oktober 1994* (Bern 1997) 29–58.

BUDGE, E.A.W., *Cleopatra's Needles and Other Egyptian Obelisks* (London 1926).

BULLE, H., 'Der Leichenwagen Alexanders', *JdI* 21 (1906) 52–73.

BURASELIS, K., 'Zu Caracallas Strafmassnahmen in Alexandrien (215/6). Die Frage der Leinenweber in P.Giss. 40 II und der *syssitia* in Cass. Dio 77 (78). 23.3', *ZPE* 108 (1995) 166–88.

BURKHALTER, F., 'Le Gymnase d'Alexandrie: centre administratif de la province romaine d'Égypte', *BCH* 116 (1992) 345–73.

BUTCHER, E.L., *The Story of the Church of Egypt* (London 1897).

BUTLER, A.J., *Ancient Coptic Churches of Egypt* (Oxford 1884).

BUTLER, A.J., *The Arab Conquest of Egypt and the Last Thirty Years of the Roman Dominion*, ed. P.M. Fraser (2nd edn. Oxford 1978).

CALDERINI, A., ed., *Dizionario dei nomi geografici e topografici dell'Egitto greco-romano* (Cairo and Milan 1935–1987); Suppl. 1 (1935–1986) ed. S. Daris (Milan 1988).

CAMERON, ALAN, 'Wandering Poets: a Literary Movement in Byzantine Egypt', *Historia* 14 (1965) 470–509.

CAMERON, ALAN, *Circus Factions Blues and Greens at Rome and Byzantium* (Oxford 1976).

CAMERON, ALAN, 'Isidore of Miletus and Hypatia: on the Editing of Mathematical Texts', *Greek, Roman and Byzantine Studies* 31 (1990) 103–27.

CANFORA, L., *The Vanished Library* (London 1991).

CAPUANI, M., *L'Égypte copte* (Paris 1999).

CARILE, A., 'Giovanni di Nikius, cronista bizantino-copto del VII secolo', *FelRav* 121–2 (1981) 103–55.

CARRIÉ, J.-M., 'Les *Castra Dionysiados* et l'évolution de l'architecture militaire romaine tardive', *MEFRA* 86 (1974) 819–50.

CARUSO, G., 'Alcuni aspetti dell'urbanistica di Alessandria in età ellenistica: il piano di progettazione', in *Alessandria e il mondo ellenistico-romano, studi in onore di A. Adriani*, vol. 1 (Rome 1983) 43–53.

CASPARI, F., 'Das Nilschiff Ptolemaios IV', *JdI* 31 (1916) 1–74.

CASSON, L., *Libraries in the Ancient World* (London 2001).

CASTEL, G., DAUMAS F., and GOLVIN, J.-C., *Les Fontaines de la Porte Nord* (Cairo 1984).

CATTANI, P., *La rotonda e i mosaici di San Giorgio a Salonicco* (Bologna 1972).

CAUVILLE, S., and DEVAUCHELLE, D., 'Les Mesures réelles du temple d'Edfou', *BIFAO* 84 (1984) 23–34.

CAUVILLE, S., and DEVAUCHELLE, D., 'Le Temple d'Edfou: étapes de la construction, nouvelles données historiques', *Revue d'égyptologie* 35 (1984) 31–55.

CAVALLO, G., GRIBOMONT, J., and LOERKE, W.C., eds., *Codex Purpureus Rossanensis*, Commentarius (Rome 1987).

CECCHELLI, C., FURLANI, I., and SALMI, M., *The Rabbula Gospels* (Olten and Lausanne 1959).

CHADWICK, H., 'John Moschus and his Friend Sophronius the Sophist', *JThSt* n.s. 25 (1974) 41–74.

CHADWICK, H., *The Church in Ancient Society, from Galilee to Gregory the Great* (Oxford 2001).

CHAINE, M., 'L'Église de Saint-Marc à Alexandrie construite par le patriarche Jean de Samanoud', *Revue de l'Orient chrétien* 24 (1924) 372–86.

CHAMOUX, F., 'L'épigramme de Poseidippos sur le phare d'Alexandrie', in J. Bingen *et al.* eds., *Le Monde grec. Hommages à C. Préaux* (Brussels 1975) 214–22.

CHARRON, A., 'Sarapis, dieu tutélaire d'Alexandrie', *Archéologia* 345 (1998) 22–7.

CHASSINAT, E., *Fouilles à Baouît, MIFAO* 13 (1911).

CHASSINAT, E., *Le Temple de Dendara*, vol. 1 (Cairo 1934).

CHAUVEAU, M., 'Alexandrie et Rhakôtis: Le point de vue des Égyptiens', in J. Leclant, ed., *Alexandrie: une mégapole cosmopolite, Cahiers de la Villa 'Kérylos'*, No. 9 (Paris 1999) 1–10.

CHRISTENSEN, J., 'Vindicating Vitruvius on the Subject of Perspective', *JHS* 119 (1999) 161–6.

CLACKSON, S.J., *Coptic and Greek Texts Relating to the Hermopolite Monastery of Apa Apollo* (Oxford 2000).

CLARKE, D., 'Alexandrea ad Aegyptum. A Survey', *Farouk I University Bulletin of the Faculty of Arts* 5 (1949) 97–102.

CLARKE, E.D., *The Tomb of Alexander. A Dissertation on the Sarcophagus Brought from Alexandria and Now in the British Museum* (Cambridge 1805).

CLARKE, S., *Christian Antiquities in the Nile Valley* (Oxford 1912).

CLARKE, S., and ENGELBACH, R., *Ancient Egyptian Construction and Architecture* (= *Ancient Egyptian Masonry* Oxford 1930; repr. New York 1990).

CLARYSSE, W., 'The Coptic Martyr Cult', in M. Lamberigts and P. van Deun eds., *Martyrium in Multidisciplinary Perspective, Memorial Louis Reekmans* (Leuven 1995) 377–95.

CLAUSS, M., *Alexandria. Schicksale einer antiken Weltstadt* (Stuttgart 2003).

CLAYTON, P., 'The Pharos of Alexandria: The Numismatic Evidence', *Minerva* 7.1 (1996) 7–9.

CLAYTON, P., and PRICE, M., eds., *The Seven Wonders of the Ancient World* (London 1988).

CLÉDAT, J., 'Recherches sur le Kôm de Baouît', *CRAI* 1902, 525–46.

CLÉDAT, J., *Le Monastère et la nécropole de Baouît, MIFAO* 12 (Cairo 1904).

CLÉDAT, J., 'Nouvelles recherches à Baouît (Haute-Égypte). Campagnes 1903–1904', *CRAI* 1904, 517–26.

CLÉDAT, J., in *Dictionnaire d'archéologie chrétienne et de liturgie*, ed. F. Cabrol and H. Leclercq, vol. 2.1 (Paris 1925) col. 203–51.

CLÉDAT, J., *Le Monastère et la nécropole de Baouît*, ed. D. Bénazeth and M.-H. Rutschowscaya, *MIFAO* 111 (Paris 1999).

COMBE, E., *Rapport sur la marche du service du Musée 1916–18* (Alexandria 1917–20).

COMBE, E., 'Alexandrie musulmane. Le lac Marioût', *Bulletin de la Société royale de géographie d'Égypte* 16 (1928–9) 269–92.

COMBE, E., 'Notes de topographie et d'histoire alexandrine', *BSAA* 36 (1943–4) 120–46.

COONEY, J.D., ed., *Pagan and Christian Egypt* (Brooklyn 1941).

COQUIN, C., *Les Édifices chrétiens du Vieux-Caire*, vol. 1, *Bibliographie et topographie historiques* (Cairo 1974).

COQUIN, R.-G., 'La Christianisation des temples de Karnak', *BIFAO* 72 (1972) 169–78.

CORMACK, R., *Byzantine Art* (Oxford 2000).

COULSON, W.D., 'Chatby Reconsidered', *JEA* 73 (1987) 234–6.

COULTON, J.J., 'The Dioptra of Hero of Alexandria', in C.J. Tuplin and T.E. Rihll, eds., *Science and Mathematics in Ancient Greek Culture* (Oxford 2002) 150–64.

CRAWFORD, D., 'Hellenistic Memphis: City and Necropolis', in *Alessandria e il mondo ellenistico-romano, Studi in onore di A. Adriani*, vol. 1 (Rome 1983) 16–24.

CRESWELL, K.A.C., *The Origin of the Plan of the Dome of the Rock* (London 1924).

CRESWELL, K.A.C., 'Coptic Influences on Early Muslim Architecture', *BSAC* 5 (1939) 29–42.

CRESWELL, K.A.C., *The Muslim Architecture of Egypt*, vol. 1 (Oxford 1952, repr. New York 1978).

CRESWELL, K.A.C., *Early Muslim Architecture* (2nd edn., Oxford 1969, repr. New York 1979).

CRESWELL, K.A.C., *A Short Account of Early Muslim Architecture*, rev. edn., ed. J.W. Allan (London 1989).

CROWFOOT, J.W., *Churches at Jerash* (London 1930).

CRUM, W., 'Inscriptions from Shenoute's Monastery', *JThSt* 5 (1904) 552–69.

CUOMO, S., *Ancient Mathematics* (London 2001).

CUOMO, S., *Pappus of Alexandria and the Mathematics of Late Antiquity* (Cambridge 2000).

DABROWSKI, L., 'La Citerne à eau sous la mosquée de Nébi Daniel', *Bulletin of Faculty of Arts, University of Alexandria*, 12 (1958) 40–8.

DABROWSKI, L., 'La Topographie d'Athribis à l'époque romaine', *ASAE* 57 (1962) 19–31.

D'ALTON, M., *The New York Obelisk* (New York 1993) = *Metropolitan Museum of Art Bulletin* 50.4 (Spring 1993).

DARIS, S., 'Lo spettacolo nei papiri greci', *Aevum Antiquum* 1 (1988) 77–93.

DASZEWSKI, W.A., 'Some Problems of Early Mosaics from Egypt', in H. Maehler, and V.M. Strocka, eds., *Das ptolemäische Ägypten* (Mainz 1978) 123–36.

DASZEWSKI, W.A., 'Nouvelles découvertes dans le quartier des Basileia en Alexandrie', *ÉtTrav* 11 (1979) 91–105.

DASZEWSKI, W.A., 'An Old question in the Light of New Evidence Ἐμβλήματα Ἀλεξανδρεινὰ Ψηφωτά, in G. Grimm, H. Heinen, and E. Winter, eds., *Das römisch-byzantinische Ägypten, AegTrev* 2 (Mainz 1983) 161–5.

DASZEWSKI, W.A., 'Notes on Topography of Ptolemaic Alexandria', in *Alessandria e il mondo ellenistico-romano, Studi in onore di A. Adriani*, vol. 1 (Rome 1983) 54–69.

DASZEWSKI, W.A., *Corpus of Mosaics from Egypt I: Hellenistic and Early Roman Period, AegTrev* 3 (Mainz 1985).

DASZEWSKI, W.A., 'Les Citernes et les chapiteaux', in *Alexandriaca I, Mélanges Gamal eddin Mokhtar, Bd'É* 97.1 (1985) 177–85.

DASZEWSKI, W.A., 'The Origins of Hellenistic Hypogea in Alexandria', in M. Minas and J. Zeidler, eds., *Aspekte spätägyptischer Kultur. Festschrift für E. Winter, AegTrev* 7 (Mainz 1994) 51–68.

DASZEWSKI, W.A., 'Témoignage de l'urbanisation de la côte méditerranéenne de l'Égypte à l'époque hellénistique et romaine à la lumière des fouilles de Marina el Alamein', *Bulletin de la Société française d'Égyptologie* 132 (April 1995) 11–29.

DASZEWSKI, W.A., 'From Hellenistic Polychromy of Sculptures to Roman Mosaics', in K. Hamma, ed., *Alexandria and Alexandrianism* (Malibu 1996) 141–54.

DASZEWSKI, W.A., 'La nécropole de Marina el-Alamein', in S. Marchegay *et al.*, eds., *Nécropoles et pouvoir. Idéologies, pratiques et interprétations* (Paris 1998) 229–41.

DASZEWSKI, W.A., and ABD-EL-FATTAH, A., 'A Hellenistic Painting from Alexandria with Landscape Elements', in *Akten des XII. internationalen Kongresses für klassische Archäologie, Berlin 1988* (Mainz 1990) 441–2.

DASZEWSKI, W., *et al.*, in L. Godlewski, ed., *Coptic Studies* (Warsaw 1990) 87–105.

DASZEWSKI, W., *et al.*, in L. Krzyzanowski, ed., *Marina el-Alamein: Archaeological Background and Conservation Problems*, vol. 1 (Warsaw 1991).

DATTARI, G., *Monete imperiali greche; Numi Augg. Alexandrini* (Cairo 1901).

DAUMAS, F., and MATTHIEU, B., 'Le Phare d'Alexandrie et ses dieux: un document inédit', *Academiae Analecta, Medelingen van de Koninklijke Academie voor Wetenschappen, letteren en Schone Kunsten van België, Klasse der Letteren* 49.1 (1987) 41–55 (non vidi).

DAUTERMAN MAGUIRE, E., 'Range and Repertory in Capital Design', *DOP* 41 (1987) 351–61.

DAVOLI, P., *L'archeologia urbana nel Fayyum di età ellenistica e romana* (Naples 1998).

DE ASIN, M., and LOPEZ OTERO, M., 'The Pharos of Alexandria', *Proceedings of the British Academy* (1933) 277–92.

DE BOCK, W., *Matériaux pour servir à l'archéologie de l'Égypte chrétienne* (St Petersburg 1901).

DE FRANCISCIS, A., *Die pompejanischen Wandmalereien in der Villa von Oplontis* (Recklinghausen 1975).

DE FRANCOVICH, G., 'L'Egitto, la Siria e Constantinopoli: Problemi di Metodo', *RIA* 20–21, new series 11-12 (1963) 83–229.

DE LOREY, E., 'Les Mosaïques de la Mosquée des Omayyades à Damas', *Syria* 12 (1931) 326–49.

DE LOREY, E., 'L'Hellénisme et l'Orient dans les mosaïques de la Mosquée des Omaiyades', *Ars Islamica* 1 (1934) 22–45.

DE LOREY, E., and VAN BERCHEM, M., 'Les mosaïques de la Mosquée des Omayyades à Damas', *Monuments et mémoires Fondation E. Piot* 30 (1929) 111–39.

DE ROSSI, G.B., 'Commento sulla precedente relazione del ch. sig. Wescher', *Bullettino di archeologia cristiana* III No. 8 (1865) 61–4.

DE ROSSI, G.B., 'I simboli dell'Eucaristia nelle pitture dell'ipogeo scoperto in Alessandria d'Egitto', *Bullettino di archeologia cristiana* III No. 10 (1865) 73–7.

DE VAUJANY, H., *Alexandrie et la Basse-Égypte* (Paris 1885).

DE VAUJANY, H., *Recherches sur les anciens monuments situés sur le Grand-Port d'Alexandrie* (Paris 1888).

DE VOGÜÉ, M., *Les Églises de la Terre sainte* (Paris 1860).

DE VOS, M., *L'egittomania in pitture e mosaici romano-campani della prima età imperiale* (Leiden 1980).

DE WIT, C., 'Inscriptions dédicatoires du temple d'Edfou', *Chronique d'Égypte* 71 (1961) 56–97 and 277–320.

DEBANNE, M., 'A propos de deux colonnes attribuées à l'église de Théonas', *BSAA* 42 (1967) 81–4.

DECKERS, J.G., 'Zur Darstellung der christlichen Stadt', *RM* 95 (1988) 303–82.

DECKERS, J.G., 'Die Wandmalerei im Kaiserkultraum von Luxor', *JdI* 94 (1979) 600–52.

DÉCOBERT, C., 'Alexandrie au XIIIᵉ siècle. Une nouvelle topographie', in C. Décobert and J.-Y. Empereur, eds., *Alexandrie médiévale* 1, *ÉtAlex* 3 (1998) 71–100.

DEICHMANN, F.W., 'Zu den Bauten der Menas-Stadt', *AA* (1937) 75–86.

DEICHMANN, F.W., 'Zum Altägyptischen in der koptischen Baukunst', *MDIK* 8 (1939) 34–7.

DEICHMANN, F.W., *Frühchristliche Bauten und Mosaiken von Ravenna* (Baden-Baden 1958).

DEICHMANN, F.W., 'Das Oktogon von Antiocheia: Heroon-Martyrion, Palastkirche oder Kathedrale?', *ByzZ* 65 (1972) 40–56.

DEICHMANN, F.W., *Ravenna, Hauptstadt des spätantiken Abendlandes*, Band II, (Wiesbaden 1974–6).

DEICHMANN, F.W., *Die Spolien in der spätantiken Architektur* (Munich 1975).

DEICHMANN, F.W., 'I pilastri acritani', *Atti della Pontificia Accademia Romana di Archeologia, Rendiconti* 50 (1977–1978 [1980]) 75–89.

DEICHMANN, F.W., *Corpus der Kapitelle der Kirche von San Marco zu Venedig* (Wiesbaden 1981).

DELAHAYE, G.R., 'La Diffusion des ampoules de Saint-Menas en Gaule', *Le Monde copte* 27–28 (1997) 155–65.

DELBRÜCK, R., *Hellenistische Bauten in Latium*, vol. 2 (Strassburg 1912).

DELEHAYE, H., 'Les Saints d'Aboukir', *AnalBolland* 30 (1911) 448–50.

DELEHAYE, H., 'Les Martyrs d'Égypte', *AnalBolland* 40 (1922) 5–154.

DELEHAYE, H., 'Une vie inédite de Saint Jean l'aumônier', *AnalBolland* 45 (1927) 5–74.

DELIA, D., 'The Population of Roman Alexandria', *TAPA* 118 (1988) 275–92.

DELIA, D., *Alexandrian Citizenship During the Roman Principate* (Atlanta 1991).

DELIA, D., 'From Romance to Rhetoric: The Alexandrian Library in Classical and Islamic Traditions', *The American Historical Review* 97 (1992) 1449–67.

DEMUS, O., *The Mosaics of San Marco in Venice* (Chicago 1984).

DEN HEIJER, J., 'Réflexions sur la composition de *l'Histoire des patriarches d'Alexandrie*: les auteurs et des sources coptes', in W. Godlewski, ed., *Coptic Studies* (Warsaw 1990) 107–13.

DEPAUW, M., 'Alexandria, the Building Yard', *Chronique d'Égypte* 75 (2000) 64–5.

DERDA, T., MARKIEWICZ, T., and WIPSZYCKA, E., eds., *Alexandria: Auditoria of Kom el-Dikka and Late Antique Education, Journal of Juristic Papyrology*, suppl. 8 (Warsaw, in press 2007).

DER NERSESSIAN, S., 'The Date of the Initial Miniatures of the Etchmiadzin Gospel', in S. der Nersessian, *Byzantine and Armenian Studies*, vol. 1 (Louvain 1973) 533–58 (= *Art Bulletin* 15, 1933, 1–34).

DER NERSESSIAN, S., 'La Peinture arménienne au VIIᵉ siècle et les miniatures de l'é-vangile d'Etchmiadzin', in S. der Nersessian, *Byzantine and Armenian Studies*, vol. 1 (Louvain 1973) 525–32 (= *Actes du XIIᵉ Congrès international des études byzantines*, Beograd, 1964, vol. 3, 49–57).

DÉROCHE, V., *Études sur Léontios de Néapolis* (Uppsala 1995).

DONADONI, S., *et al.*, *Antinoe (1965–1968)* (Rome 1974).

DONCEEL-VOÛTE, P., *Les pavements des églises byzantines de Syrie et du Liban* (Louvain-La-Neuve 1988).

DOWNEY, G., 'Byzantine Architects their Training and Methods', *Byzantion* 18 (1946–8) 99–118.

DOWNEY, G., 'Pappus of Alexandria on Architectural Studies,' *Isis* 38 (1947–8) 197–200.

DRACHMANN, A.G., 'Heron and Ptolemaios', *Centaurus* 1 (1950) 117–31.

DRESCHER, J., 'Topographical Notes for Alexandria and District', *BSAA* 38 (1949) 13–20.

DRIOTON, E., *Les Sculptures coptes du Nilomètre de Rodah* (Cairo 1942).

DRIOTON, E., 'De Philae à Baouît', in *Coptic Studies in Honour of W. E. Crum* (Boston 1950) 443–8.

DUCHESNE, Q., 'Le Sanctuaire d'Aboukir', *BSAA* 1 (1910) 3–14.

DUFEY, F., 'Un Groupe de cinq commets-de-niche sculptés. Église d'Abba Athanasios el Apostolos à Deir ez-Zawiah', in M. Rassart-Debergh and J. Ries, eds., *Actes du IVᵉ Congrès copte Louvain-la-Neuve 1988* (Louvain 1992) 69–77.

DUNBABIN, K.M.D., *Mosaics of the Greek and Roman World* (Cambridge 1999).

DUTHUIT, G., *La Sculpture copte* (Paris 1931).

DUTILH, E., 'Deux colonnes de l'église de Theonas', *BSAA* 7 (1905) 55–7.

DUVAL, N., ed., *Les églises de Jordanie et leurs mosaïques* (Beirut 2003).

DZIELSKA, M., *Hypatia of Alexandria* (Cambridge Mass. 1995).

EATON-KRAUSS, M., 'A Falsely Attributed Monument', *JEA* 78 (1992) 285–7.

EBERSOLT J., and THIERS, A., *Les Églises de Constantinople* (Paris 1913, repr. London 1979).

EDBURY, P.W., 'Cyprus, Commerce and Crusade: King Peter I and the Background to the Sack of Alexandria in 1365', *BSAA* 44 (1991) 206–14.

EFFENBERGER, A., 'Scultura e arte minore copta', *FelRav* 121–122 (1981) 65–102.

EFFENBERGER, A., and SEVERIN, H.-G., *Das Museum für spätantike und byzantinische Kunst Berlin* (Mainz 1992).

EKSCHMITT, W., *Die sieben Weltwunder. Ihre Erbauung, Zerstörung und Wiederentdeckung* (rev. edn. Mainz 1991).

EL-ABBADI, M., *The Life and Fate of the Ancient Library of Alexandria* (Paris 1990).

EL-ABBADI, M., 'The Alexandria Library in History', in A. Hirst and M. Silk, eds., *Alexandria, Real and Imagined* (London 2004) 167–83.

EL-FAKHARANI, E., 'The *Kibotos* of Alexandria', *Studi Miscellanei* 28 (1984–5 [1991]) 21–8.

EL-GHERIANI, Y., 'Brief Account of the Different Excavations in Alexandria 1950–1990', in *Alessandria e il mondo ellenistico-romano, Congresso Alessandria 1992* (Rome 1995) 156–68.

EL-NAGGAR, S., *Les Voûtes dans l'architecture de l'Égypte ancienne* (Cairo 1999).

EL-NASSERY, S., WAGNER, G., and CASTEL, G., 'Un Grand Bain gréco-romain à Karanis', *BIFAO* 76 (1976) 231–75.

EL-SAGHIR, M., *et al.*, *Le Camp romain de Louqsor*, *MIFAO* 83 (Cairo 1986).

EL-SAGHIR, M., *Das Statuenversteck im Luxortempel* (Mainz 1992).

EL-TAHER, R., and GROSSMANN, P., 'Excavation of the Circular Church at Faramā-West', *MDIK* 53 (1997) 255–62.

EMMEL, S., 'From the Other Side of the Nile: Shenute and Panopolis', in A. Egberts *et al.* eds., *Perspectives on Panopolis* (Leiden 2002) 95–113.

EMPEREUR, J.-Y., 'Alexandrie (Égypte)', *BCH* 119 (1995) 743–60; *BCH* 120 (1996) 959–70; *BCH* 121 (1997) 831–47; *BCH* 124 (2000) 595–619; *BCH* 125 (2001) 679–700; *BCH* 126 (2002) 615–26.

EMPEREUR, J.-Y., 'Fouilles et découvertes récentes', *Les Dossiers d'archéologie* 201 (1995) 82–7.

EMPEREUR, J.-Y., 'Alexandria: the Underwater Site near Qaitbay Fort', *Egyptian Archaeology* 8 (1996) 7–10.

EMPEREUR, J.-Y., 'The Discovery of the Pharos of Alexandria', *Minerva* 7.1 (1996) 5–6.

EMPEREUR, J.-Y., 'Les Fouilles sous-marines du Phare d'Alexandrie', *Égypte, Afrique et Orient* 6 (1997) 2–8.

EMPEREUR, J.-Y., *Alexandrie redécouverte* (Paris 1998) = *Alexandria Re-discovered* (London 1998).

EMPEREUR, J.-Y., *Le Phare d'Alexandrie* (Paris 1998).

EMPEREUR, J.-Y., 'Sous le sol d'Alexandrie', *Archéologia* 345 (May 1998) 28–37.

EMPEREUR, J.-Y., 'Diving on a Sunken City', *Archaeology* 52.2 (1999) 36–43.

EMPEREUR, J.-Y., 'City of the Dead', *Archaeology* 52.5 (1999) 42.

EMPEREUR, J.-Y., *Le Phare d'Alexandrie, La Merveille retrouvée* (rev. edn., Paris 2004).

EMPEREUR, J.-Y., ed., *Alexandrina* 1, *ÉtAlex* 1 (Cairo 1998); *Alexandrina* 2, *ÉtAlex* 6 (Cairo 2002).

EMPEREUR, J.-Y., ed., *Pharos* 1, *Ét Alex* 9 (Cairo in press).

EMPEREUR, J.-Y. and NENNA, M.-D., eds., *Necropolis* 1, *ÉtAlex* 5 (Cairo 2001); *Nécropolis* 2, *Ét Alex* 7 (Cairo 2003).

ENGELBACH, R., *The Aswân Obelisk* (Cairo 1922).

ENGEMANN, J., *Architekturdarstellungen des frühen Zweiten Stils*, *RM* Ergh. 12, 1976.

EQUIPO DE LA MISIÓN CATALANO-EGIPCIA EN OXIRRINCO, 'Excavaciones arqueologicas en Oxirrinco Egipto', *Revista de arqueologia* 146 (June 1993) 14–19.

ERDMANN, K., 'Das Datum des Tāk-i-Bustān', *Ars islamica* 4 (1937) 79–97.

ERDMANN, K., 'Die Kapitelle am Taq i Bostan', *Mitteilungen der deutschen Orient-Gesellschaft zu Berlin* 80 (1943) 1–24.

ERDMANN, M., *Zur Kunde der hellenistischen Städtegründungen* (Strassburg 1883).

ETTINGHAUSEN, R., *Arab Painting* (New York 1977).

ETTINGHAUSEN, R., GRABAR, O., and JENKINS-MADINA, M., *Islamic Art and Architecture 650–1250* (London 2001).

EVERS, H.-G., and ROMERO, R., 'Rotes und Weisses Kloster bei Sohag. Probleme der Rekonstruktion', in K. Wessel, ed., *Christentum am Nil* (Recklinghausen 1964) 175–99.

FAIVRE, J., 'Alexandrie', in A. Baudrillart *et al.* eds., *Dictionnaire d'histoire et de géographie ecclésiastiques*, vol. 2 (Paris 1914) col. 289–369.

FAIVRE, J., *Canopus, Menouthis, Aboukir* (Alexandria 1918).

FAIVRE, J., 'L'Église Saint-Sabas', *Bulletin de l'Association des amis de l'art copte* 3 (1937) 60–7.

FAIVRE, J., 'Le Martyrium de Saint-Marc', *Bulletin de l'Association des amis de l'art copte* 3 (1937) 67–74.

FAKHRY, A., *The Necropolis of el-Bagawāt in Kharga Oasis* (Cairo 1951).

FARAG, F.R., 'The Technique of Research of a Tenth-Century Christian Arab Writer: Severus ibn al-Muqaffa', *Muséon* 86 (1973) 37–66.

FARIOLI, R.O., '*Corpus*' della scultura paleocristiana bizantina ed altomedioevale di Ravenna III La scultura architettonica* (Rome 1969).

FAVUZZI, A., 'Ancora su Caracalla e i *syssitia* degli Alessandrini', *ZPE* 121 (1998) 251–6.

FINNESTAD, R.B., 'Temples of the Ptolemaic and Roman Periods: Ancient Traditions in New Contexts', in B.E. Shafer, ed., *Temples in Ancient Egypt* (London 1998) 185–237.

FINSTER, B., 'Die Mosaiken der Umayyadenmoschee von Damaskus', *Kunst des Orients* 7 (1970–1971) 83–141.

FISHWICK, D., 'The Temple of Caesar at Alexandria', *American Journal of Ancient History* 9 (1984) 131–4.

FISHWICK, D., 'The Caesareum at Alexandria Again', *American Journal of Ancient History* 12 (1987) [1995] 62–72.

FITTSCHEN, K., 'Zur Herkunft und Entstehung des 2. Stils', in P. Zanker, ed., *Hellenismus in Mittelitalien* (Göttingen 1976) 539–59.

FLOOD, F.B., *The Great Mosque in Damascus* (Leiden 2001).

FOERTMEYER, V., 'The Dating of the Pompe of Ptolemy II Philadelphus', *Historia* 37 (1988) 90–104.

FOLDA, J., *The Art of the Crusaders in the Holy Land 1098–1187* (Cambridge 1995).

FOURNET, J.-L., Review of J.-C. Grenier, *Les Titulatures des empereurs romains dans les documents en langue égyptienne*, *Revue des études grecques* 104 (1991) 616–19.

FOURNET, J.-L., 'L'Inscription grecque de l'église al-Mu'allaqa. Quelques corrections', *BIFAO* 93 (1993) 237–44.

FRAGAKI, 'Representations architecturales de la peinture pompéienne. Évolution de la pensée archéologique', *MEFRA* 115 (2003) 231–94.

FRANÇOIS, V., *Les Céramiques médiévales d'Alexandrie*, *ÉtAlex* 2 (Cairo 1999).

FRANKFURTER, D., *Religion in Roman Egypt: Assimilation and Resistance* (Princeton 1998).

FRASER, P.M., 'A Syriac *Notitia Urbis Alexandrinae*', *JEA* 37 (1951) 103–8.

FRASER, P.M., 'The δίολκος of Alexandria', *JEA* 47 (1961) 134–8.

FRASER, P.M., 'Current Problems Concerning the Early History of the Cult of Sarapis', *OpAth* 7 (1967) 23–45.

FRASER, P.M., *Ptolemaic Alexandria* (Oxford 1973).

FRASER, P.M., 'Alexandria from Mohammed Ali to Gamal Abdal Nasser', in N. Hinske, ed., *Alexandrien*, *AegTrev* 1 (Mainz 1981) 63–74.

FRASER, P.M., 'Byzantine Alexandria; Decline and Fall', *BSAA* 45 (1993) 91–106.

FRAZER, A., *Samothrace* 10, *The Propylon of Ptolemy II* (Princeton 1990).

FREND, W.H.C., *The Rise of the Monophysite Movement* (Cambridge 1972).

FREND, W.H.C., 'Nationalism as a Factor in anti-Chalcedonian Feeling in Egypt', in S. Mews, ed., *Religion and National Identity, Studies in Church History* 18 (Oxford 1982) 21–38.

FREND, W.H.C., *The Rise of Christianity* (Philadelphia 1984).

FROST, H., 'The Pharos Site, Alexandria, Egypt', *IJNA* 4 (1975) 126–30.

FUKAI, S., and HORIUCHI, K., *Taq-i-Bustan*, vol. 1–2 (Tokyo 1969–72).

FUKAI, S., *et al.*, *Taq-i Bustan*, vol. 4 text (Tokyo 1984).

GABRA, G., *Cairo, the Coptic Museum and Old Churches* (Cairo 1993).

GALLO, P., 'Aegyptiaca Alexandrina IV. Une nouvelle statue du pharaon Hakoris retrouvée à Abouqir', in J.-Y. Empereur, ed., *Alexandrina* 2, *ÉtAlex* 6 (Cairo 2002) 7–11.

GANS, U.-W., 'Hellenistische Architekturteile aus Hartgestein in Alexandria', *AA* (1994) 433–53.

GASCOU, J., 'Les Églises d'Alexandrie: questions de méthode', in C. Décobert and J.-Y. Empereur, eds., *Alexandrie médiévale* 1, *ÉtAlex* 3 (1998) 23–44.

GASCOU, J., review of C. Haas *Alexandria in Late Antiquity*, in *Topoi* 8.1 (1998) 390–5.

GAUTIER-VAN BERCHEM, M., and ORY, S., *La Jérusalem musulmane* (Lausanne 1978).

GAYET, A., *L'Exploration des ruines d'Antinoë et la découverte d'un temple de Ramsès II enclos dans l'enceinte de la ville d'Hadrien* (Paris 1897).

GAYET, A., *Antinoë et les sépultures Thaïs et Sérapion* (Paris 1902).

GEORG, J., *Streifzüge durch die Kirchen und Klöster Ägyptens* (Berlin 1914).

GEORG, J., *Neue Streifzüge durch die Kirchen und Klöster Ägyptens* (Leipzig 1930).

GIBB, H., 'Arab-Byzantine Relations under the Umayyad Caliphate', *DOP* 12 (1958) 219–33.

GIROIRE, C., et al., 'Une église égyptienne ressuscitée au Musée du Louvre', Revue du Louvre 5/6 (1997) 95–102.

GODDIO, F., Alexandria. The Submerged Royal Quarters (London 1998).

GODDIO, F. and BERNAND, A., Sunken Egypt: Alexandria (London 2004).

GODDIO, F., and CLAUSS, M., eds., Egypt's Sunken Treasures (Berlin 2006).

GOIRAN, J.-P., et al., 'Évolution géomorphologique de la façade maritime d'Alexandrie (Égypte) au cours des six derniers millénaires', Méditerranée 104 (2005) 61–4.

GOLDMAN, B., 'The Imperial Jewel at Taq-i Bustan', in L. de Meyer and E. Haerinck, eds., Archaeologia iranica et orientalis, Miscellanea in honorem L.V. Berghe (Gent 1989) 831–46.

GOLVIN, J.-C., et al., 'Le Petit Sarapieion romain de Louqsor', BIFAO 81 (1981) 115–48.

GONOSOVA, A., 'A Note on Coptic Sculpture', JWaltersArtGal 44 (1986) 10–15.

GORRINGE, H.H., Egyptian Obelisks (London 1885).

GRABAR, A., 'A propos des mosaïques de la coupole de Saint-Georges à Salonique', Cahiers archéologiques 17 (1967) 59–81.

GRABAR, O., 'Islamic Art and Byzantium', DOP 18 (1964) 67–88.

GRABAR, O., 'The Umayyad Dome of the Rock in Jerusalem', Ars Orientalis 3 (1959) 33–62.

GRABAR, O., The Formation of Islamic Art (rev. edn., London 1987).

GREEN, P., 'Alexander's Alexandria', in K. Hamma, ed., Alexandria and Alexandrianism (Malibu 1996) 3–25.

GRENIER, J.-C., Les Titulatures des empereurs romains dans les documents en langue égyptienne (Brussels 1989).

GRIGGS, C.W., Early Egyptian Christianity from its Origins to 451 C.E. (2nd edn., Leiden 1991).

GRIMAL, N., 'Fouilles du Diana', BIFAO 96 (1996) 544–63.

GRIMAL, N., 'Travaux de l'IFAO – Centre d'études alexandrines', BIFAO 96 (1996) 544–70; BIFAO 97 (1997) 376–9; BIFAO 98 (1998) 543–50; BIFAO 99 (1999) 507–15.

GRIMM, G., 'Zur Ptolemäeralter aus dem alexandrinischen Sarapeion', in Alessandria e il mondo ellenistico-romano, Studi in onore di A. Adriani, vol. 1 (Rome 1983) 70–3.

GRIMM, G., Alexandria, Die erste Königsstadt der hellenistischen Welt (Mainz 1998).

GRIMM, G., 'Alexandria in the Time of Cleopatra', in S. Walker and S.-A. Ashton, Cleopatra Reassessed (London 2003) 45–9.

GRIMM, G., and MCKENZIE, J.S., 'Architectural Fragments found in the Excavations of the Serapeum in Alexandria in c. 1901', JRS 94 (2004) 115–21.

GROS, P., L'Architecture romain du début du III^e siècle av. J.-C. à la fin du Haut-Empire 1. Les monumens publics (Paris 1996); 2. Maisons, palais, villas et tombeaux (Paris 2001).

GROSSMANN, P., 'Die von Somers Clarke in Ober-Anṣīnā entdeckten Kirchenbauten', MDIK 24 (1969) 144–68.

GROSSMANN, P., 'Überlegungen zum Grundriss der Ostkirche von Philae', Jahrbuch für Antike und Christentum 13 (1970) 29–41.

GROSSMANN, P., 'Reinigungsarbeiten im Jeremiaskloster von Saqqara. Vorläufiger Bericht', MDIK 27 (1971) 173–80; MDIK 28 (1972) 145–52.

GROSSMANN, P., 'Eine vergessene frühchristliche Kirche beim Luxor-Tempel', MDIK 29 (1973) 167–81.

GROSSMANN, P., 'Sohāg', Archiv für Orientforschung 25 (1974–77) 323–5.

GROSSMANN, P., 'Abu Mena. Achter vorläufiger Bericht. Kampagnen 1975 und 1976', MDIK 33 (1977) 35–45.

GROSSMANN, P., 'Frühchristliche Baukunst in Ägypten', in B. Brenk, ed., Spätantike und frühes Christentum (Frankfurt 1977) 234–43.

GROSSMANN, P., 'Zur christlichen Baukunst in Ägypten', Enchoria 8 (1978) 89–100 (135–46).

GROSSMANN, P., 'The Basilica of St Pachomius', Biblical Archaeologist 42 (1979) 232–6.

GROSSMANN, P., 'Reinigungsarbeiten im Jeremiaskloster bei Saqqara. Dritter vorläufiger Bericht', MDIK 36 (1980) 193–202.

GROSSMANN, P., 'Ein kaiserzeitliches Sarapis-Heiligtum in Akoris', MDIK 37 (1981) 199–202.

GROSSMANN, P., 'Esempi d'architettura paleocristiana in Egitto dal V al VII secolo', CorsiRav 28 (1981) 149–76.

GROSSMANN, P., Mittelalterliche Langhauskuppelkirchen und verwandte Typen in Oberägypten (Glückstadt 1982).

GROSSMANN, P., 'Die zweischaligen spätantiken Vierkonchenbauten in Ägypten und ihre Beziehung zu den gleichartigen Bauten in Europa und Kleinasien', in G. Grimm, H. Heinen and Winter, E., eds., Das römisch-byzantinische Ägypten, Aeg Trev 2 (Mainz 1983) 167–73.

GROSSMANN, P., 'The "Gruftkirche" of Abū Mīna During the Fifth Century AD', BSAC 25 (1983) 67–71.

GROSSMANN, P., 'Die Kirche des Bischofs Theodoros im Isistempel von Philae. Versuch einer Rekonstruktion', Rivista degli studi orientali 58 (1984 [1987]) 107–17.

GROSSMANN, P., 'New Observations in the Church and Sanctuary of Dayr Anbā Šinūda – the So-called White Monastery – at Sūhāğ', ASAE 70 (1984–5) 69–73.

GROSSMANN, P., Abu Mina, a Guide to the Ancient Pilgrimage Center (Cairo 1986).

GROSSMANN, P., Abū Mīnā I. Die Gruftkirche und die Gruft (Mainz 1989).

GROSSMANN, P., 'Beobachtungen zum ursprünglichen Grundriß der Sergios- und Bakchoskirche in Konstantinopel', Istanbuler Mitteilungen 39 (1989) 153–9.

GROSSMANN, P., 'Early Christian Architecture in the Nile Valley', in F.D. Friedman, ed., Beyond the Pharaohs (Rhode Island 1989) 81–8.

GROSSMANN, P., 'Neue frühchristliche Funde aus Ägypten', in Actes du XI^e Congrès international d'archéologie chrétienne (Rome 1989) vol. 2, 1843–1908.

GROSSMANN, P., 'New Discoveries in the Field of Christian Archaeology in Egypt', in M. Rassart-Debergh and J. Ries, eds., Actes du IV^e Congrès copte, Louvain-la-Neuve 1988, vol. 1, Louvain (1992) 143–57.

GROSSMANN, P., 'The Triconchoi in Early Christian Churches of Egypt and their Origins in the Architecture of Classical Rome', in Roma e l'Egitto nell'antichità classica, Cairo 1989 (Rome 1992) 181–90.

GROSSMANN, P., 'Die Querschiffbasilika von Hauwarīya und die übrigen Bauten dieses Typus in Ägypten als Repräsentanten der verlorenen frühchristlichen Architektur Alexandrias', BSAA 45 (1993) 107–21.

GROSSMANN, P., 'Report on the Excavations at Abū Mīnā in Spring 1994', BSAC 34 (1995) 149–59.

GROSSMANN, P., 'The Pilgrimage Center of Abû Mînâ', in D. Frankfurter, ed., Pilgrimage and Holy Space in Late Antique Egypt (Leiden 1998) 281–302.

GROSSMANN, P., 'Wiederverwendete spätantike Kapitelle aus der Moschee von Bahnasā', DaM 11 (1999) 185–90.

GROSSMANN, P., 'Kirche oder "Ort des Feierns" – Zur Problematik der pachomianischen Bezeichnungen des Kirchenbäudes', Enchoria 26 (2000) 41–53.

GROSSMANN, P., 'Prokopius zu Taposiris Magna eine Verwechslung mit Abū Mīnā?', Antiquité tardive 8 (2000) 165–8.

GROSSMANN, P., 'Zur Rekonstruktion der Südkirche von Antinoopolis', Vicino Oriente 12 (2000) 269–81.

GROSSMANN, P., Christliche Architektur in Ägypten (Leiden 2002).

GROSSMANN, P., 'Die klassischen Wurzeln in Architektur und Dekorsystem der grossen Kirche des Schenuteklosters bei Suhāğ', in A. Egberts et al. eds., Perspectives on Panopolis (Leiden 2002) 115–31.

GROSSMANN, P., 'Frühchristliche Kirchen im Gebiet des Ammon-Tempels von Luqşur', Römische Quartalschrift für christliche Altertumskunde und Kirchengeschichte 97.1–2 (2002) 17–39.

GROSSMANN, P., Abū Mīnā II Das Baptisterium (Mainz 2004).

GROSSMANN, P., and BAILEY, D.M., 'The South Church at Hermopolis Magna (Ashmunein), A Preliminary Account', in K. Painter, ed., Churches Built in Ancient Times (London 1994) 49–71.

GROSSMANN, P., and HAFIZ, M., 'Results of the 1995/96 Excavations in the North-West Church of Pelusium (Faramā-West)', MDIK 54 (1998) 177–82.

GROSSMANN, P., and JARITZ, H., 'Abū Mīna. Neunter vorläufiger Bericht. Kampagnen 1977, 1978 und 1979', MDIK 36 (1980) 203–27.

GROSSMANN, P., and KOŠCIUK, J., 'Report on the Excavation at Abu Mina', BSAC 30 (1991) 65–75; BSAC 31 (1992) 31–41; BSAC 32 (1993) 73–84.

GROSSMANN, P., and PFEIFFER, J., 'Report on the Excavations at Abū Mīnā in Spring 2002', BSAC 42 (2003) 21–41.

GROSSMANN, P., and REICHERT, A., 'Report on the Season in Fayrān (March 1990)', GöttMisz 128 (1992) 7–16.

GROSSMANN, P., and SEVERIN, H.-G., 'Reinigungsarbeiten im Jeremiaskloster bei Saqqara. Vierter vorläufiger Bericht', MDIK 38 (1982) 155–93.

GROSSMANN, P., and WHITCOMB, D.S., 'Excavation in the Sanctuary of the Church in front of the Luqsur-Temple', ASAE 72 (1992–94) 25–34.

GROSSMANN, P., LE QUESNE, C., and SHEEHAN, P., 'Zur römischen Festung von Babylon - Alt-Kairo', AA (1994) 271–87.

GROSSMANN, P., et al., 'Abū Mīna. Vorläufiger Bericht', MDIK 26 (1970) 55–82; MDIK 38 (1982) 131–54; MDIK 40 (1984) 123–51; AA (1991) 457–86; AA (1995) 389–423.

GROSSMANN, P., et al., 'Report on the Excavations at Abu Mina', BSAC 33 (1994) 91–104; BSAC 36 (1997) 83–98.

GUÉRAUD, O., 'A propos des certificates de naissance du Musée du Caire', Études de papyrologie 4 (1938) 14–31.

GUIMIER-SORBETS, A.-M., 'Alexandrie: les mosaïques hellénistiques découvertes sur le terrain de la nouvelle Bibliotheca Alexandrina', RA (1998) 263–90.

GUIMIER-SORBETS, A.-M., 'Le Pavement du triclinium à la Méduse dans une maison d'époque impériale à Alexandrie', in J.-Y. Empereur, ed., Alexandrina 1 ÉtAlex 1 (1998) 115–39.

GUIMIER-SORBETS, A.-M., 'The Function of Funerary Iconography in Roman Alexandria. An Original Form of Bilingual Iconography in the Necropolis of Kom el Shogafa', in R.F. Docter and E.M. Moormann, eds., Proceedings of the XVth International Conference of Classical Archaeology, Amsterdam 1998 (Amsterdam 1999) 180–2.

GUIMIER-SORBETS, A.-M., and SEIF EL-DIN, M., 'Les Deux Tombes de Perséphone dans la nécropole de Kom el-Chougafa à Alexandrie', BCH 121 (1997) 355–410.

HAAS, C., 'Alexandria's Via Canopica: Political Expression and Urban Topography from Augustus to 'Amr Ibn al-' As', BSAA 45 (1993) 123–38.

HAAS, C.J., Alexandria in Late Antiquity: Topography and Social Conflict (Baltimore 1997).

HABACHI, B., 'Two Tombs of the Roman Epoch Recently Discovered at Gabbary', BSAA 31 (1937) 270–85.

HABACHI, L., The Obelisks of Egypt (London 1977).

HACHLILI, R., 'Iconographic Elements of Nilotic Scenes on Byzantine Mosaic Pavements in Israel', PEQ 1998, 106–20.

HAENY, G., 'A Short Architectural History of Philae', BIFAO 85 (1985) 197–233.

HAIRY, I., 'Analyse de pièces architecturales d'une colonnade sur le site du Sarapéion', in J.-Y. Empereur, ed., Alexandrina 2, ÉtAlex 6 (Cairo 2002) 85–98.

HAIRY, I., 'Une Nouvelle Citerne sur le site du Sarapéion', in J.-Y. Empereur, ed., Alexandrina 2, ÉtAlex 6 (Cairo 2002) 29–37.

HAIRY, I., 'Alexandrie: nouvelles découvertes autour du Pharos', Archéologia 429 (January 2006) 26–36.

HAMARNEH, S.K., 'The Ancient Monuments of Alexandria According to Accounts by Medieval Arab Authors (IX-XV century)', Folia Orientalia 13 (1971) 77–110.

HANDLER, S., 'Architecture on the Coins of Roman Alexandria', AJA 75 (1971) 57–74.

HANEBORG-LÜHR, M., 'Les Chapiteaux composites. Étude typologique, stylistique et statistique', in C. Obsomer, and A.-L. Oosthoek, ed., *Amosiadès, mélanges offerts au Professeur Claude Vandersleyen par ses anciens étudiants* (Louvain-la-Neuve 1992) 125–52.

HARRIS, J.M., 'Coptic Architectural Sculpture from Oxyrhynchos', *Year Book of the American Philosophical Society* (1960) 592–8.

HARRIS, W.V. and RUFFINI, G., eds., *Ancient Alexandria between Egypt and Greece* (Leiden 2004).

HARRISON, R.M., 'The Church of St Polyeuktos in Constantinople', *Akten des VII Internationalen Kongresses für christliche Archäologie, Trier 1965* (Berlin 1969) 544–9.

HARRISON, R.M., 'The Church of St Polyeuktos in Istanbul and the Temple of Solomon', *Harvard Ukrainian Studies* 7 (1983) = C. Mango and O. Pritsak, eds., *Okeanos. Essays presented to I. Ševčenko* (Cambridge, Mass. 1984) 276–9.

HARRISON, R.M., *Excavations at Saraçhane in Istanbul*, vol. 1 (Princeton 1986).

HARRISON, [R.] M., *A Temple for Byzantium* (London 1989).

HARVEY, W., *et al.*, *The Church of the Nativity in Bethlehem* (London 1910).

HAYWOOD, R., *Cleopatra's Needles* (London 1978).

HEATH, T., *A History of Greek Mathematics* (Oxford 1921, repr. New York 1981).

HEILMEYER, W.-D., *Korinthische Normalkapitelle*, RM Ergh. 16 (Heidelberg 1970).

HEINEN, H., 'Alexandria in Late Antiquity', in A.S. Atiya, ed., *Coptic Encyclopedia* vol. 1 (New York 1991) 95–103.

HELLENKEMPER SALIES, G., 'Die Mosaiken der Grossen Moschee von Damaskus', *CorsiRav* 35 (1988) 295–313.

HENRICHS, A., 'Vespasian's Visit to Alexandria', *ZPE* 3 (1968) 51–80.

HERZ, M., 'Les Citernes d'Alexandrie', *Comité de conservation des monuments de l'art arabe* 15 (1898) 81–6.

HERZ, M., 'La Tour de missallah, dite "des Romains", à Alexandrie près de la gare de Ramleh', *Comité de conservation des monuments de l'art arabe* 19 (1902) 158–60.

HERZ, M., 'Deux tours des fortifications d'Alexandrie', *Comité de conservation des monuments de l'art arabe* 29 (1912) 123–4.

HESSE, A., 'Arguments pour une nouvelle hypothèse de localisation de l'Heptastade d'Alexandrie', in J.-Y. Empereur, ed., *Alexandrina* 1, *ÉtAlex* 1 (Cairo 1998) 21–33.

HESSE, A., *et al.*, 'L'Heptastade d'Alexandrie', in J.-Y. Empereur, ed., *Alexandrina* 2, *ÉtAlex* 6 (Cairo 2002) 191–273.

HILLENBRAND, R., *Islamic Art and Architecture* (London 1999).

HILLENBRAND, R., *Islamic Architecture* (Edinburgh 2000).

HITTORFF, J., 'Pompéi et Pétra', *RA* 6 (1862) 1–18.

HODDINOTT, R.F., *Early Byzantine Churches in Macedonia and Southern Serbia* (London 1963).

HÖLBL, G., *Geschichte des Ptolemäerreiches* (Darmstadt 1994) = *A History of the Ptolemaic Empire* (London 2001).

HÖLBL, G., *Altägypten im römischen Reich. Der römische Pharao und seine Tempel* I (Mainz 2000).

HÖLSCHER, U., *The Excavation of Medinet Habu, vol. 5 Post-Ramessid Remains* (Chicago 1954).

HOEPFNER, W., *Zwei Ptolemaierbauten*, AM Beiheft 1 (Berlin 1971).

HOEPFNER, W., ed., *Antike Bibliotheken* (Mainz 2002).

HOEPFNER, W., and BRANDS, G., eds., *Basileia: die Paläste der hellenistischen Könige* (Mainz 1996).

HOEPFNER, W., and SCHWANDNER, E.-L., *Haus und Stadt im klassischen Griechenland* (Munich 1994).

HOGARTH, D.G., and BENSON, E.F., *Report on Prospects of Research in Alexandria*, reprinted from *Archaeological Report of the Egypt Exploration Fund 1894–5* (London 1895).

HOPE, C.A., 'Observations on the Dating of the Occupation at Ismant el-Kharab', in C.A. Hope and G.E. Bowen, eds., *Dakhleh Oasis Project: Preliminary Reports on the 1994–1995 to 1998–1999 Field Seasons* (Oxford 2002) 43–59.

HOPE, C.A., and MCKENZIE, J., 'Interim Report on the West Tombs', in C.A. Hope and A.J. Mills, eds., *Dakhleh Oasis Project: Preliminary Reports on the 1992–1993 and 1993–1994 Field Seasons* (Oxford 1999) 53–68.

HORNBOSTEL, W., *Sarapis* (Leiden 1973).

HORNBOSTEL-HÜTTNER, G., *Studien zur römischen Nischenarchitektur* (Leiden 1979).

HUMPHREY, J.H., *Roman Circuses* (London 1986).

HUNT, L.-A., 'Art and Colonialism: the Mosaics of the Church of the Nativity in Bethlehem (1169) and the Problem of "Crusader" Art', *DOP* 45 (1991) 69–85.

HUSSAM AL-DIN ISMA'IL, M., 'The Fortifications of Alexandria during the Islamic Period', *BSAA* 45 (1993) 153–61.

HUSSELMAN, E.M., *Karanis, Topography and Architecture* (Ann Arbor, Michigan 1979).

HUSSON, G., *Oikia, le vocabulaire de la maison privée en Égypte d'après les papyrus grecs* (Paris 1983).

HUSSON, G., and VALBELLE, D., *L'État et les institutions en Égypte des premiers pharaons aux empereurs romains* (Paris 1992).

HUXLEY, G.L., *Anthemius of Tralles: A Study in Later Greek Geometry* (Cambridge, Mass. 1959).

IBRAHIM, L.A., 'The Islamic Monuments of Alexandria', *BSAA* 45 (1993) 145–52.

ILBERT, R., 'Bombardement et incendie: juillet 1882. Un témoignage', *Alexandrie entre deux mondes, Revue de l'occident musulman et de la Méditerranée* 46 (1987.4) 156–67.

ILBERT, R., *Alexandrie 1830–1930* (Paris 1996).

ILBERT, R., and YANNAKAKIS, I., eds., *Alexandria 1860–1960* (Alexandria 1997).

INSTITUT DU MONDE ARABE, *L'Art copte en Égypte, exposition présentée à l'Institut du monde arabe* (Paris 2000).

IVERSEN, E., 'The Date of the So-called Inscription of Caligula on the Vatican Obelisk', *JEA* 51 (1965) 149–54.

IVERSEN, E., *Obelisks in Exile, vol. 1, The Obelisks of Rome* (Copenhagen 1968); vol. 2, *The Obelisks of Istanbul and England* (Copenhagen 1972).

JACOBSON, D.M., and MCKENZIE, J.S., 'Transmutation of Base Metals into Gold. A Solution to the Essential Mystery of Alchemy', *Interdisciplinary Science Reviews* 17.4 (1992) 326–31.

JACQUES, F., and BOUSQUET, B., 'Le Raz de marée du 21 Juillet 365', *MEFRA* 96 (1984) 423–61.

JARITZ, H., 'Ein Bau der römischen Kaiserzeit in Syene', in M. Krause and S. Schaten, eds., *ΘEMEΛIA, Spätantike und koptologische Studien Peter Grossmann zum 65. Geburtstag* (Wiesbaden 1998) 155–65.

JARITZ, H., *et al.*, *Pelusium Prospection archéologique et topographique de la region de Tell el-Kana'is 1993 et 1994* (Stuttgart 1996).

JEFFREYS, E., 'Malalas' Sources', in E. Jeffreys *et al.*, eds., *Studies in John Malalas* (Sydney 1990) 167–216.

JÉQUIER, G., *Les Temples ptolémaïques et romains* (Paris 1924).

JOHNS, J., ed., *Bayt al-Maqdis, Jerusalem and Early Islam*, Oxford Studies in Islamic Art 9.2 (Oxford 1999).

JOHNSON, A.C., *Roman Egypt to the Reign of Diocletian* (Baltimore 1936).

JOHNSON, A.C., 'Roman Egypt in the Third Century', *Journal of Juristic Papyrology* 4 (1950) 151–8.

JOHNSON, J.H., 'The Demotic Chronicle as a Statement of a Theory of Kingship', *The SSEA Journal (Journal for the Society for the Study of Egyptian Antiquities)* 13 (1983) 61–72.

JONDET, G., 'Les Ports antiques de Pharos', *BSAA* 14 (1912) 252–66.

JONDET, G., *Les Ports submergés de l'ancienne île de Pharos* (Cairo 1916).

JONDET, G., 'Les Ports antéhelléniques de la côte d'Alexandrie et l'empire crétois par M. Raymond Weill', *BSAA* 17 (1919) 167–78.

JONDET, G., *Atlas historique de la ville et des ports d'Alexandrie*, Mémoires présentés à la Société Sultanieh de géographie 2 (Cairo 1921).

JONES, M., 'An Unusual Foundation Deposit at Kom Ombo', *BSAC* 31 (1992) 97–107.

JUDGE, E.A., and PICKERING, S.R., 'Papyrus Documentation of Church and Community in Egypt to the Mid-Fourth Century', *Jahrbuch für Antike und Christentum* 20 (1977) 47–71.

KALAVREZOU-MAXEINER, I., 'The Imperial Chamber at Luxor', *DOP* 29 (1975) 225–51.

KAPLAN, I., *Grabmalerei und Grabreliefs der Römerzeit* (Vienna 1999).

KAPOSSY, B., 'Alexandrinische Münzen, Neuerwerbungen des Bernischen Hittorischen Museums 1971–4', *Jahrbuch des Bernischen Historischen Museums* 63–4 (1983–4) 171–81.

KAUFMANN, C.M., *Die Ausgrabung der Menas-Heiligtümer in der Mareotiswüste*, vol. 1–3 (Cairo 1906–1908).

KAUFMANN, K.M. *Die Menasstadt und das Nationalheiligtum der altchristlichen Aegypter*, vol. 1 (Leipzig 1910).

KAUTZSCH, R., *Kapitellstudien, Beiträge zu einer Geschichte des spätantiken Kapitells im Osten vom vierten bis ins siebente Jahrhundert* (Berlin 1936).

KAYSER, F., *Recueil des inscriptions grecques et latines (non funéraires) d'Alexandrie impériale* (Cairo 1994).

KERKESLAGER, A., 'Jewish Pilgrimage and Jewish Identity in Hellenistic and Early Roman Egypt', in D. Frankfurter, ed., *Pilgrimage and Holy Space in Late Antique Egypt* (Leiden 1998) 99–225.

KHOURY, N.N., 'The Dome of the Rock, the Ka'ba, and Ghumdan: Arab Myths and Umayyad Monuments', *Muqarnas* 10 (1993) 57–65.

KIEPERT, H., 'Zur Topographie des alten Alexandria. Nach Mahmûd Beg's Entdeckungen', *Zeitschrift der Gesellschaft für Erdkunde zu Berlin* 7 (1872) 337–49.

KISS, Z., *Les Ampoules de Saint Ménas découvertes à Kôm el-Dikka (1961–1981)*, Alexandrie V (Warsaw 1989).

KISS, Z., 'Les Auditoria romains tardifs de Kôm el-Dikka (Alexandrie)', *Acta antiqua academiae scientiarum Hungaricae* 33 (1990–92) 331–8.

KISS, Z., 'Alexandrie 1987', *ÉtTrav* 16 (1992) 345–51.

KISS, Z., 'Remarques sur la datation et les fonctions de l'édifice théatral à Kom el-Dikka', in *50 Years of Polish Excavations in Egypt and the Near East, Symposium Warsaw University 1986* (Warsaw 1992) 171–8.

KISS, Z., 'L'Évolution de la structure urbaine d'Alexandrie romaine à la lumière des fouilles récentes', *XIVᵉ congreso internacional de Arqueología clásica* (Taragona 1993) 261–4.

KISS, Z., 'Les Auriges de Kom el-Dikka', *Centenary of Mediterranean Archaeology at the Jagiellonian University 1897–1997* (Cracow 1999) 135–42.

KISS, Z., 'Les Auditoria romains tardifs', in Z. Kiss *et al.*, *Fouilles polonaises à Kôm el-Dikka (1986–1987)*, Alexandrie VII (Warsaw 2000) 8–33.

KISS, Z., 'Les cheveaux du prêtre', *Swiatowit. Rocznik Instytutu Archeologii Uniwersytetu Warszawskiego*, vol. 3 (44) fasc. A (Warsaw 2001) 77–9.

KISS, Z., 'Un portrait d'Antonia Minor dans les eaux du port d'Alexandrie', in *Studia Archeologica, Liber amicorum I.A. Ostrowski ab Amicis et discipulis oblatus* (Cracow 2001) 173–6.

KISS, Z., 'Czy "budowla teatralna" na Kôm el-Dikka (Aleksandria) sluzyla do kultu?', *Sympozja Kazimierskie* 3 (Lubin 2002) 215–23.

KITZINGER, E., 'Notes on Early Coptic Sculpture', *Archaeologia* 87 (1938) 181–215.

KITZINGER, E., 'The Horse and Lion Tapestry at Dumbarton Oaks, A Study in Coptic and Sassanian Textile Design', *DOP* 3 (1946) 1–72.

KITZINGER, E., *Byzantine Art in the Making* (London 1977).

KLEINBAUER, W.E., 'The Iconography and the Date of the Mosaics of the Rotunda of Hagios Georgios Thessaloniki', *Viator* 3 (1972) 27–107.

KNAUER, E.R., 'Wind Towers in Roman Wall Paintings?', *Metropolitan Museum Journal* 25 (1990) 5–20.

KNORR, W.B., '*Arithmêtikê stoicheiôsis*: On Diophantus and Hero of Alexandria', *Historia Mathematica* 20 (1993) 180–92.

KNORR, W.R., *Textual Studies in Ancient and Medieval Geometry* (Boston 1989).

KNUDSTAD, J.E., and FREY, R.A., 'Kellis: the Architectural Survey of the Romano Byzantine Town at Ismant el-Kharab', in C.S. Churcher and A.J. Mills, eds., *Reports from the Survey of the Dakhleh Oasis Western Desert of Egypt 1977–1987* (Oxford 1999) 189–214.

KOŚCIUK, J., 'Some Early Medieval Houses in Abū Mīnā', in M. Rassart-Debergh and J. Ries, eds., *Actes du IVᵉ Congrès copte, Louvain-la-Neuve 1988*, vol. 1 (Louvain 1992) 158–67.

KOENEN, L., *Eine agonistische Inschrift aus Ägypten und frühptolemäische Königsfeste* (Meisenheim 1977).

KOLATAJ, W., 'Recherches architectoniques dans les thermes et le théâtre de Kôm el-Dikka à Alexandrie', in G. Grimm, H. Heinen and E. Winter, eds., *Das römisch-byzantinische Ägypten, AegTrev* 2 (Mainz 1983) 187–94.

KOLATAJ, W., *Imperial Baths at Kom el-Dikka, Alexandrie* VI (Warsaw 1992).

KOLATAJ, W., 'Late Roman Baths at Kôm el-Dikka in Alexandria', in *50 Years of Polish Excavations in Egypt and the Near East* (Warsaw 1992) 179–86.

KOLATAJ, W., 'Alexandria 1993–94', *PAM* 6 (1994) 5–10.

KOLATAJ, W., 'The Kom el-Dikka Archaeological Site', in *Alessandria e il mondo ellenistico-romano, Congresso Alessandria 1992* (Rome 1995) 189–91.

KOLATAJ, W., 'Theoretical Reconstruction of the Late Roman Theatre at Kom el-Dikka in Alexandria', in C.J. Eyre, ed., *Proceedings of the Seventh International Congress of Egyptologists* (Leuven 1998) 631–8.

KOLATAJ, W. and T., 'Polish Excavations at Kom el Dikka in Alexandria, 1967', *BSAA* 43 (1975) 79–97.

KOLENDO, J., 'Le port d'Alexandrie sur une peinture de Gragnano?', *Latomus* 41 (1982) 305–11.

KOLODZIEJCZYK, K., 'Private Roman Bath at Kom el-Dikka in Alexandria', *ÉtTrav* 2 (1968) 143–54.

KOLODZIEJCZYK, K., 'Fragments d'enduits peints des fouilles polonaises', *ÉtTrav* 15 (1990) 193–202.

KOLODZIEJCZYK, K., 'Remarques sur les thermes privés à Kôm el-Dikka', *ÉtTrav* 16 (1992) 57–65.

KOSTOF, S.K., *The Orthodox Baptistry in Ravenna* (London 1965).

KÖTZSCHE, L., 'Die Marienseide in der Abegg-Stiftung Bemerkungen zur Ikonographie der Szenenfolge', in D. Willers, ed., *Begegnung von Heidentum und Christentum im spätantiken Ägypten* (Riggisberg 1993) 183–94.

KOUYMJIAN, D., 'The Eastern Case: The Classical Tradition in Armenian Art and the Scenae Frons', in M. Mullet, and R. Scott, eds., *Byzantium and the Classical Tradition* (Birmingham 1981) 155–71.

KRAELING, C.H., ed., *Gerasa, City of the Decapolis* (New Haven 1938).

KRAMER, J., 'Bemerkungen zu den Methoden der Klassifizierung und Datierung frühchristlicher oströmischer Kapitelle', in U. Peschlow and S. Möllers, eds., *Spätantike und byzantinische Bauskulptur, Beiträge eines Symposions in Mainz, Februar 1994* (Stuttgart 1998) 43–58.

KRAUS, T., and RÖDER, J., 'Mons Claudianus', *MDIK* 18 (1962) 80–116.

KRAUS, T., RÖDER, J., and MÜLLER-WIENER, W., 'Mons Claudianus-Mons Porphyrites', *MDIK* 22 (1967) 108–205.

KRAUSE, M., 'Alexandria', in K. Wessel, ed., *Reallexikon zur Byzantinischen Kunst*, vol. 1 (Stuttgart 1966) 99–111.

KRAUSE, M., 'Bawit', in K. Wessel, ed., *Reallexikon zur byzantinischen Kunst*, vol. 1 (Stuttgart 1966) col. 568–83.

KRAUSE, M., 'Das christliche Alexandrien und seine Beziehungen zum koptischen Ägypten', in N. Hinske, ed., *Alexandrien, AegTrev* 1 (Mainz 1981) 53–62.

KRAUTHEIMER, R., 'Again Saints Sergius and Bacchus at Constantinople', *Jahrbuch der Österreichischen Byzantinistik* 23 (1974) 251–3.

KRAUTHEIMER, R., *Early Christian and Byzantine Architecture* (4th edn. rev., Harmondsworth 1986).

KRESTEN, O., and PRATO, G., 'Die Miniatur des Evangelisten Markus im Codex Purpureus Rossanensis: Eine spätere Einfügung', *Römische historische Mitteilungen* 27 (1985) 381–99.

KRÜGER, J., *Oxyrhynchos in der Kaiserzeit, Studien zur Topographie und Literaturrezeption* (Frankfurt 1990).

KUBIAK, W., 'Les Fouilles polonaises à Kôm el-Dik en 1963 et 1964', *BSAA* 42 (1967) 47–80.

KÜHN, E., *Antinoopolis* (Göttingen 1913).

KÜHNEL, G., 'Das Ausschmückungsprogramm der Geburtsbasilika in Bethlehem. Byzanz und Abendland im Königreich Jerusalem', *Boreas* 10 (1987) 133–49.

KUHN, K.H., 'A Fifth Century Egyptian Abbot', *JThSt*, n.s. 5 (1954) 36–48, 174–87; 6 (1955) 35–48.

KURTH, D., 'A World Order in Stone – The Late Temples', in R. Schulz and M. Seidel, eds., *Egypt the World of the Pharaohs* (Cologne 1998) 296–311.

KYRILLOS II, 'Le Temple du Césaréum et l'église patriarchale d'Alexandrie', *Bulletin de la Société royale de géographie d'Égypte* 6 (1900) 329–54.

LABIB, L., 'al-Iskandariyya', in E. van Donzel *et al.*, eds., *Encyclopedia of Islam* (Leiden 1978) vol. 4, 132–7.

LABIB, P., 'Fouilles du Musée copte à Saint-Ménas, première campagne', *Bulletin de l'Institut d'Égypte* 34 (1953) 133–8.

LACROIX, A., and DARESSY, G., eds., *Dolomieu en Égypte (30 Juin 1798 – 10 Mars 1799)*, *Mémoires présentés à l'Institut d'Égypte* 3 (Cairo 1922).

LAFERRIÈRE, P., 'Les Croix murales du Monastère rouge à Sohag', *BIFAO* 93 (1993) 299–310.

LANCIERS, E., 'Die ägyptischen Tempelbauten zur Zeit des Ptolemaios V Epiphanes (204–180 v. Chr.)', *MDIK* 42 (1986) 81–98 and 43 (1987) 173–82.

LANE, A., 'Archaeological Excavation at Kom-el-Dik, a Preliminary Report on the Medieval Pottery', *Bulletin of the Faculty of Arts, Farouk I University Alexandria* 5 (1949) 143–7.

LANFRANCHI, G.B., 'The Library at Nineveh', in J.G. Westenholz, ed., *Capital Cities* (Jerusalem 1998) 147–56.

LAUER, J.P., and PICARD, C., *Les Statues ptolémaïques du Sarapieion de Memphis* (Paris 1955).

LAUTER, H., 'Ptolemais in Libyen, Ein Beitrag zur Baukunst Alexandrias', *JdI* 86 (1971) 149–78.

LAUTER, H., *Die Architektur des Hellenismus* (Darmstadt 1986).

LAUTER-BUFE, H., *Die Geschichte des sikeliotisch-korinthischen Kapitells* (Mainz 1987).

LE RIDER, G., 'Cléomène de Naucratis', *BCH* 121 (1997) 71–93.

LEACH, E.W., *The Social Life of Painting in Ancient Rome and on the Bay of Naples* (Cambridge 2004).

LEASE, G., 'The Fourth Season of the Nag Hammadi Excavation', *GöttMisz* 41 (1980) 75–85.

LECLERQ, H., 'Alexandrie, archéologie', in F. Cabrol and H. Leclerq, eds., *Dictionnaire d'archéologie chrétienne et de liturgie*, vol. 1 (Paris 1924) 1098–1182.

LEHMANN, P.W., *Roman Wall Paintings from Boscoreale in the Metropolitan Museum of Art in New York* (Cambridge, Mass., 1953).

LEHMANN, P.W., 'Lefkadia and the Second Style', in G. Kopcke and M. Moore, eds., *Studies in Classical Archaeology, A Tribute to P.H. von Blanckenhagen* (1979) 225–9.

LEIPOLDT, J., *Schenute von Atripe und die Entstehung des national ägyptischen Christentums* (Leipzig 1903).

LEMBKE, K., *Das Iseum Campense in Rom* (Heidelberg 1994).

LEROY, J., *Les Manuscrits syriaques à peintures* (Paris 1964).

LÉVI-PROVENÇAL, É., 'Une description arabe inédite du phare d'Alexandrie', in *Mélanges Maspero* vol. 3 (*MIFAO* vol. 68) (Cairo 1939–40) 161–71.

LILYQUIST, C., 'Euthenia in a Garden', *Notable Acquisitions 1984–1985*, Metropolitan Museum of Art, p. 5.

LING, R., 'Studius and the Beginnings of Roman Landscape Painting', *JRS* 67 (1977) 1–16.

LING, R., *Roman Painting* (Cambridge 1991).

LIS, J., 'Mosaic Conservation at Kom el-Dikka in Alexandria in 2002', *PAM* 15 (2003) 39–42.

LITTLE, A.M.G., *Roman Perspective Painting and the Ancient Stage* (Kennebunk 1971).

LITTLE, A.M.G., *Decor, Drama and Design in Roman Painting* (Kennebunk 1977).

LORTON, D., 'The Names of Alexandria in the Text of the Satrap Stela', *GöttMisz* 96 (1987) 65–70.

LOWDEN, J., *Early Christian and Byzantine Architecture* (London 1997).

LUCKHARD, F., *Das Privathaus im ptolemäischen und römischen Ägypten* (Giessen 1914).

LUKASZEWICZ, A., *Les Édifices publics dans les villes de l'Égypte romaine* (Warsaw 1986).

LUKASZEWICZ, A., 'Fragmenta Alexandrina I', *ZPE* 82 (1990) 133–6.

LUSCHEY, H., 'Zur Datierung der sasanidischen Kapitelle aus Bisutun und den Monuments von Taq-i-Bostan', *Archäologische Mitteilungen aus Iran* 1 (1968) 129–42.

LYONS, H.G., *A Report on the Island and Temples of Philae* (London 1896).

LYTTLETON, M., *Baroque Architecture in Classical Antiquity* (London 1974).

MACAIRE, K., 'Nouvelle étude sur le Sérapéum d'Alexandrie', *Bulletin de la Société Khédievale de géographie* 7 ser., no. 7 (1910) 379–421 and no. 8 (1910) 423–60.

MACCOULL, L., *Dioscorus of Aphrodito: His Word and His World* (Berkley 1988).

MA'OZ, Z., 'The Judean Synagogues – As a Reflection of Alexandrian Architecture', *Alessandria e il mondo ellenistico-romano, Congresso Alessandria 1992* (Rome 1995) 192–201.

MAEHLER, H., 'Häuser und ihre Bewohner im Fayûm in der Kaiserzeit', in G. Grimm, H. Heinen and E. Winter, eds., *Das römisch-byzantinische Ägypten, AegTrev* 2 (Mainz 1983) 119–37.

MAGI, F., 'Le Iscrizioni recentemente scoperte sull'Obelisco Vaticano', *Studi Romani* 11 (1963) 50–6.

MAHMOUD-BEY [MAHMOUD EL-FALAKI], *Mémoire sur l'antique Alexandrie* (Copenhagen 1872).

MAINSTONE, R.J., 'Structural Theory and Design before 1742', *Architectural Review* 143 (1968) 303–10.

MAINSTONE, R.J., *Hagia Sophia, Architecture, Structure and Liturgy of Justinian's Great Church* (London 1988).

MAJCHEREK, G., 'Excavation in Alexandria ', *PAM* 1 (1988–89) 75–83; *PAM* 2 (1989–90) 19–24; *PAM* 3 (1991) 5–14; *PAM* 4 (1992) 11–22; *PAM* 5 (1993) 11–20; *PAM* 6 (1994) 11–20.

MAJCHEREK, G., 'Kom el-Dikka Excavations', *PAM* 7 (1995) 13–22; *PAM* 8 (1996) 17–31; *PAM* 9 (1997) 23–36; *PAM* 10 (1998) 29–39; *PAM* 11 (1999) 27–38; *PAM* 12 (2000) 23–34; *PAM* 13 (2001) 31–43; *PAM* 14 (2002) 19–31; *PAM* 15 (2003) 25–38; *PAM* 16 (2004) 17–30.

MAJCHEREK, G., 'Notes on Alexandrian Habitat: Roman and Byzantine Houses from Kom el-Dikka', *Topoi* 5 (1995) 133–50.

MAKARONAS, C.I. and MILLER, S.G., 'The Tomb of Lyson and Kallikles', *Archaeology* 27 (1974) 249–59.

MAKOWIECKA, E., 'Acanthus-base Alexandrian Form of Architectural Decoration at Ptolemaic and Roman Period', *ÉtTrav* 3 (1969) 115–31.

MAKOWIECKA, E., 'The Numbering of the Seating Places at the Roman Theatre of Kom el-Dikka in Alexandria', *Acta Conventus XI 'Eirene'* (Warsaw 1971) 479–83.

MAKOWIECKA, E., *The Origin and Evolution of Architectural Form of Roman Library* (Warsaw 1978).

MALLWITZ, A., 'Ein Kapitell aus gebranntem Ton oder zur Genesis des korinthischen Kapitells', in A. Mallwitz, ed., *X. Bericht über die Ausgrabungen in Olympia* (Berlin 1981) 318–52.

MANGO, C., 'The Church of Saints Sergius and Bacchus at Constantinople and the Alleged Tradition of Octagonal Palatine Churches', *Jahrbuch der Österreichischen Byzantinistik* 21 (1972) 189–93.

MANGO, C., 'The Church of Sts Sergius and Bacchus Once Again', *ByzZ* 68 (1975) 385–92.

MANGO, C., 'The Date of the Studios Basilica at Istanbul', *Byzantine and Modern Greek Studies* 4 (1978) 115–22.

MANGO, C., 'A Byzantine Hagiographer at Work: Leontios of Neapolis', in I. Hutter, ed., *Byzanz und der Westen* (Vienna 1984) 25–41.

MANGO, C., *The Art of the Byzantine Empire 312–1453* (Toronto 1986).

MANGO, C., Review of R.M. Harrison, *Excavations at Saraçhane in Istanbul* vol. 1, *JRS* 81 (1991) 237–9.

MANGO, C., and I. ŠEVČENKO, 'Remains of the Church of st Polyeuktos at Constantinople', *DOP* 15 (1961) 243–7.

MANGO, M., 'Where was Beth Zagba?', *Harvard Ukrainian Studies* 7 (1983) = C. Mango and O. Pritsak, ed., *Okeanos, Essays Presented to I. Ševčenko* (Cambridge, Mass. 1984) 405–30.

MANSUELLI, G.A., 'Contributo a Deinokrates', in *Alessandria e il mondo ellenistico-romano, studi in onore di A. Adriani*, vol. 1 (Rome 1983) 78–90.

MARICQ, A., 'Une influence alexandrine sur l'art Augustéen? Le Lageion et le Circus Maximus', *RA* 37 (1951) 26–46.

MARIETTE, A., *Choix de monuments et de dessins découverts ou exécutés pendant le déblaiement du Sérapéum de Memphis* (Paris 1856).

MARK, R., and ÇAKMAK, A.S., eds., *Hagia Sophia from the Age of Justinian to the Present* (Cambridge 1992).

MARTIN, A., 'Aux Origines de l'église copte: l'implantation et le développement du christianisme en Égypte (Iᵉ–IVᵉ siècles)', *Revue des études anciennes* 83 (1981) 35–56.

MARTIN, A., 'Les Premiers Siècles du christianisme à Alexandrie, Essai de topographie religieuse (IIIᵉ–IVᵉ siècles)', *Revue des études Augustiniennes* 30 (1984) 211–25.

MARTIN, A., 'Topographie et liturgie: le problème des "paroisses" d'Alexandrie', in *Actes du XIᵉ Congrès international d'archéologie chrétienne, 1986*, vol. 2 (Rome 1989) 1133–44.

MARTIN, A., *Athanase d'Alexandrie et l'église d'Égypte au IVᵉ siècle (328–373)* (Rome 1996).

MARTIN, A., 'Alexandrie à l'époque romaine tardive: l'impact du christianisme sur la topographie et les institutions', in C. Décobert and J.-Y. Empereur, eds., *Alexandrie médiévale* 1, *ÉtAlex* 3 (1998) 9–21.

MARTIN, M., 'Alexandrie chrétienne à la fin du XIIᵉ siècle d'après Abû l-Makârim', in C. Décobert and J.-Y. Empereur, eds., *Alexandrie médiévale* 1, *ÉtAlex* 3 (1998) 45–9.

MARTINELLI, P.A., ed., *The Basilica of San Vitale Ravenna* (Modena 1997).

MASPERO, G., *Le Sérapeum de Memphis par A. Mariette-Pacha*, Atlas (Paris 1882).

MASPERO, G., 'Sur une plaque d'or portant la dédicace d'un temple', *Recueil de travaux* 7 (1886) 140–1.

MASPERO, J., 'Horapollon et la fin du paganisme égyptien', *BIFAO* 11 (1914) 163–95.

MASPERO, J., ed. E. DRIOTON, *Fouilles exécutées à Baouît MIFAO* 59 (Cairo 1931).

MATHEWS, T.F., *The Early Churches of Constantinople: Architecture and Liturgy* (London 1971).

MATHEWS, T.F., *The Byzantine Churches of Istanbul, A Photographic Survey* (London 1976).

MATHEWS, T.F., 'The Early Armenian Iconographic Program of the Ējmiacin Gospel (Erevan, Matenadaran MS 2374, *olim* 229)', in N.G. Garsoïan *et al.* eds., *East of Byzantium: Syria and Armenia in the Formative Period* (Washington, DC 1982) 199–215.

MATHIEU, B., 'Travaux de l'IFAO – Centre d'études alexandrines', *BIFAO* 100 (2000) 490–5; *BIFAO* 101 (2001) 518–26; *BIFAO* 102 (2002) 501–5; *BIFAO* 103 (2003) 542–7.

MCCREDIE, J.R., *et al.*, *Samothrace 7, The Rotunda of Arsinoe* (Princeton 1992).

MCKENZIE, J.S., *The Architecture of Petra* (Oxford 1990, repr. 2005).

MCKENZIE, J.S., 'Alexandria and the Origins of Baroque Architecture', K. Hamma, ed., *Alexandria and Alexandrianism* (Malibu 1996) 109–25.

MCKENZIE, J.S., 'The Architectural Style of Roman and Byzantine Alexandria and Egypt', in D.M. Bailey, ed., *Archaeological Research in Roman Egypt*, *JRA* suppl. 19 (Ann Arbor 1996) 128–42.

MCKENZIE, J.S., 'Keys from Egypt and the East: Observations on Nabataean Culture in the Light of Recent Discoveries', *Bulletin of the American Schools of Oriental Research*, 324 (2001) 97–112.

MCKENZIE, J.S., 'Glimpsing Alexandria from Archaeological Evidence', *JRA* 16 (2003) 35–61.

MCKENZIE, J.S., 'Temples, Tombs, and Other Discoveries from the Rose Red City', *JRA* 17 (2004) 559–68.

MCKENZIE, J.S., 'The Place in Late Antique Alexandria "where the Alchemists and Scholars sit . . . was like Stairs" ', in T. Derda *et al.*, eds., *Alexandria: Auditoria of Kom ed-Dikka and Late Antique Education, Journal of Juristic Papyrology*, suppl. 8 (Warsaw, in press 2007).

MCKENZIE, J.S., GIBSON, S. and REYES, A.T., 'Reconstructing the Serapeum in Alexandria from the Archaeological Evidence', *JRS* 94 (2004) 73–114.

MCNALLY, S., 'Syncretism in Panopolis? The Evidence of the "Mary Silk" in the Abegg Stiftung', in A. Egberts *et al.* eds., *Perspectives on Panopolis* (Leiden 2002) 145–64.

MEAUTIS, G., *Hermoupolis-la-Grande* (Lausanne 1918).

MEDEKSZA, S., 'Marina el-Alamein, Conservation Work', *PAM* 9 (1997) 72–6; *PAM* 10 (1998) 51–62; *PAM* 11 (1999) 47–57; *PAM* 13 (2001) 87–104.

MEDEKSZA, S. and CZERNER, R., 'Rescuing Marina el-Alamein: a Graeco-Roman Town in Egypt', *Minerva* 14.3 (2003) 20–3.

MEDEKSZA, S., *et al.*, 'Marina el-Alamein Conservation Work in the 2003 Season', *PAM* 15 (2003) 91–100.

MEGAW, A.H.S., 'Ή Βασιλικὴ τῆς Ἑρμουπόλεως' in Πεπραγμενα του Θ′ Διεθνους Βυζαντινολογικου Συνεδριου. Θεσσαλονικη *1953*, vol. 1 (Athens 1955) 287–95.

MEINARDUS, O.F.A., *Christian Egypt Ancient and Modern* (Cairo 1965).

MEINECKE, M., 'Zur Topographie von Alexandria nach Ewliyā Čelebī', *Zeitschrift der deutschen morgenländischen Gesellschaft* Suppl. III. 1 (Weisbaden 1977) 523–37.

MEINECKE-BERG, V., 'Spolien in der mittelalterlichen Architektur von Kairo', in *Ägypten Dauer und Wandel Symposium, Kairo 1982* (Mainz 1985) 131–42.

MERRIAM, A.C., 'The Caesareum and the Worship of Augustus at Alexandria', *TAPA* 14 (1883) 5–35.

MERRIAM, A.C., *The Greek and Latin Inscriptions on the Obelisk-Crab in the Metropolitan Museum, New York* (New York 1883).

MEYBOOM, P.G.P., *The Nile Mosaic of Palestrina* (Leiden 1995).

MICHEL, A., *Les églises d'époque byzantine et umayyade de la Jordanie (provinces d'Arabie et de Palestine), Vᵉ–VIIIᵉ siècle* (Turnhout 2001).

MIKOCKI, T., *La perspective dans l'art romain* (Warsaw 1990).

MILLER, S.G., *The Tomb of Lyson and Kallikles: A Painted Macedonian Tomb* (Mainz 1993).

MILNE, J.G., *Catalogue of Alexandrian Coins* (Oxford 1971).

MINAS, M., 'Die Dekorationstätigkeit von Ptolemaios VI Philometer und Ptolemaios VIII Euergetes II an ägyptischen Tempeln', *Orientalia Lovaniensia Periodica* 27 (1996) 51–78 and 28 (1997) 87–121.

MITCHELL, E., 'Osservazioni topografiche preliminari sull'impianto urbanistico di Antinoe', *Vicino Oriente* 5 (1982) 171–9.

MLYNARCZYK, J., 'New Data on the Chronology of Late Roman Lamps in Alexandria', *ÉtTrav* 17 (1995) 133–75.

MODRZEJEWSKI, J.M., *The Jews of Egypt from Rameses II to Emperor Hadrian* (Princeton 1997).

MONKS, G.R., 'The Church of Alexandria and the City's Economic Life in the Sixth Century', *Speculum* 28 (1953) 349–62.

MONNERET DE VILLARD, U., 'Il Faro di Alessandria secondo un testo e disegni arabi inediti da codici milanesi Ambrosiani', *BSAA* 18 (1921) 13–35.

MONNERET DE VILLARD, U., *La scultura ad Ahnâs. Note sull'origine dell'arte copta* (Milan 1923).

MONNERET DE VILLARD, U., *Les Couvents près de Sohâg* (Milan 1925–6).

MONNERET DE VILLARD, U., 'La basilica cristiana in Egitto', in *Atti del 4. Congresso internazionale di archeologia cristiana, Vatican 1938* (Vatican 1940) vol. 1, 291–319.

MONNERET DE VILLARD, U., *La Nubia romana* (Rome 1941).

MONNERET DE VILLARD, U., 'The Temple of the Imperial Cult at Luxor', *Archaeologia* 95 (1953) 85–105.

MONTEVECCHI, O., 'Vespasiano acclamato dagli Alessandrini ancora su P. Fouad 8', *Aegyptus* 61 (1981) 155–70.

MONTSERRAT, D., 'Pilgrimage to the Shrine of Ss Cyrus and John at Menouthis in Late Antiquity', in D. Frankfurter, ed., *Pilgrimage and Holy Space in Late Antique Egypt* (Leiden 1998) 257–79.

MORCOS, S.A., 'Submarine Archaeology and its Future Potential: Alexandria Casebook', *BSAA* 45 (1993) 199–216.

MÜLLER, K.F., *Der Leichenwagen Alexanders des Grossen* (Leipzig 1905).

MÜLLER-WIENER, W., 'Abu Mena. Vorläufiger Bericht', *MDIK* 20 (1965) 126–37; *MDIK* 21 (1966) 171–87; *MDIK* 22 (1967) 206–24.

MÜLLER-WIENER, W., *Bildlexikon zur Topographie Istanbuls* (Tübingen 1977).

MÜLLER-WIENER, W., and GROSSMANN, P., 'Apa Mena. 6. Vorläufiger Bericht', *AA* (1967) 457–80.

MUNDELL MANGO, M., 'The Monetary Value of Silver Revetments and Objects Belonging to Churches, AD 300–700', in S.A. Boyd and M. Mundell Mango, eds., *Ecclesiastical Silver Plate in Sixth-Century Byzantium* (Washington D.C. 1992) 123–36.

MUÑOZ, A., *Il codice purpureo di Rossano e il frammento sinopense* (Rome 1907).

MURPHY, F.X., *Rufinus of Aquileia (345–411), His Life and Works, The Catholic University of America, Washington Studies in Medieval History* n.s. 6 (Diss. 1945).

MYSLIWIEC, K., and BAKR SAID, M., 'Polish-Egyptian Excavations at Tell Atrib in 1994–1995', *ÉtTrav* 18 (1999) 179–219.

MYSLIWIEC, M., and ABU SENNA, S., 'Polish-Egyptian Excavations at Tell Atrib in 1991–1993', *ÉtTrav* 17 (1995) 205–40.

NAUMANN, R., *Der Quellbezirk von Nîmes* (Leipzig 1937).

NAUTIN, P., 'La Conversion du temple de Philae en église chrétienne', *Cahiers archéologiques* 17 (1967) 1–43.

NAVILLE, E., *Ahnas el Medineh (Heracleopolis Magna), 11 Memoir of the Egypt Exploration Fund* (London 1894).

NAVILLE, E., *et al.*, *The Season's Work at Ahnas and Beni Hasan (1891), Egyptian Exploration Fund, Special Extra Report* (London 1890–1).

NÉROUTSOS-BEY in *Bulletin de l'Institut égyptien* 12 (1872–73) 111–18.

NÉROUTSOS-BEY, *Notice sur les fouilles récentes exécutées à Alexandrie 1874–5* (Alexandria 1875).

NÉROUTSOS-BEY, *L'Ancienne Alexandrie, étude archéologique et topographique* (Paris 1888).

NERSESSIAN, V., *Treasures from the Ark* (London 2001).

NETZER, E., and WEISS, Z., 'New Mosaic Art from Sepphoris', *Biblical Archaeology Review* 18.6 (1992) 36–43.

NEUGEBAUER, O., 'The Early History of the Astrolabe', *Isis* 40 (1949) 240–56.

NIELSEN, I., *Hellenistic Palaces, Tradition and Renewal* (Aarhus 1994).

NIEMEYER, H.G., 'Wiederverwendete spätantike Kapitelle in der Ulmâs-Moschee zu Kairo', *MDIK* 17 (1961) 133–46.

NOACK, F., 'Neue Untersuchungen in Alexandrien', *AM* 25 (1900) 215–79.

NOWICKA, M., *La Maison privée dans l'Égypte ptolémaïque* (Warsaw 1969).

NOWICKA, M., 'Théophilos, peintre alexandrin, et son activité', in *Alessandria e il mondo ellenistico-romano, studi in onore di A. Adriani*, vol. 2 (Rome 1984) 256–9.

NUSEIBEH, S., and GRABAR, O., *The Dome of the Rock* (London 1996).

O'MEARA, D.J., *Pythagoras Revived, Mathematics and Philosophy in Late Antiquity* (Oxford 1989).

OLESON, J.P., *Greek and Roman Mechanical Water-lifting Devices* (Toronto 1984).

OLESON, J.P., 'Water-Lifting', in O.V. Wikander, ed., *Handbook of Ancient Water Technology* (Leiden 2000) 217–302.

ORLANDI, T., 'Coptic Literature', in B.A. Pearson and J.E. Goehring, eds., *The Roots of Egyptian Christianity* (Philadelphia 1986) 51–81.

ORLANDI, T., 'The Library of the Monastery of Saint Shenute at Atripe', in A. Egberts et al., eds., *Perspectives on Panopolis* (Leiden 2002) 211–31.

OUTSCHAR, U., 'Betrachtungen zur kunstgeschichtlichen Stellung des Sebasteions in Aphrodisias', in J. de la Genière and K. Erim eds., *Aphrodisias de Carie* (Paris 1987) 107–22.

PADRÓ, J., et al., 'Fouilles archéologiques à Oxyrhynchos, 1992–1994', in C.J. Eyre, ed., *Proceedings of the Seventh International Congress of Egyptologists* (Leuven 1998) 823–8.

PAGENSTECHER, R., *Alexandrinische Studien* (Heidelberg 1917).

PAGENSTECHER, R., *Nekropolis, Untersuchungen über Gestalt und Entwicklung der Alexandrinischen Grabanlagen und ihrer Malereien* (Leipzig 1919).

PAGET, J.C., 'Jews and Christians in Ancient Alexandria', in A. Hirst and M. Silk, eds., *Alexandria, Real and Imagined* (London 2004) 143–66.

PANCKOUCKE, C.L.F., *Description de l'Égypte; ou Recueil des observations et des recherches qui ont été faites en Égypte pendant l'expédition de l'armée française* (2nd edn., Paris 1821–29).

PARIS MUSÉES, *La Gloire d'Alexandrie* (Paris 1998).

PARKER, R., SABIN, R., and WILLIAMS, C., *Islamic Monuments in Cairo. A Practical Guide* (3rd edn., Cairo 1985).

PARKINSON, R., *The Rosetta Stone* (London 2005).

PARSONS, E.A., *The Alexandrian Library* (London 1952).

PARTHEY, G., *Das Alexandrinische Museum* (Berlin 1838).

PEARSON, B.A., 'Earliest Christianity in Egypt: Some Observations', in B.A. Pearson and J.E. Goehring, eds., *The Roots of Egyptian Christianity* (Philadelphia 1986) 132–59.

PEARSON, B.A., 'The *Acts of St Mark* and the Topography of Ancient Alexandria', *BSAA* 45 (1993) 239–46.

PEERS, C.R., 'The White Monastery near Sohag, Upper Egypt', *The Archaeological Journal* 61 (1904) 131–53.

PENSABENE, P., 'Lastre di chiusura di loculi con naiskoi egiziani e stele funerarie con ritratto del Museo di Alessandria', in *Alessandria e il mondo ellenistico-romano, Studi in onore di Achille Adriani*, vol. 1 (Rome 1983) 91–119.

PENSABENE, P., 'Elementi di architettura alessandrina', *Studi Miscellanei* 28 (1984–5 [1991]) 29–85.

PENSABENE, P., 'Architettura imperiale in Egitto', in *Roma e l'Egitto nell'antichità classica, Cairo 1989* (Rome 1992) 273–98.

PENSABENE, P., *Elementi architettonici di Alessandria e di altri siti egiziani, Repertorio d'arte dell'Egitto greco-romano*, Series C, vol. 3 (Rome 1993).

PENSABENE, P., 'Il tempio di tradizione faraonica e il dromos nell'urbanistica dell'Egitto greco-romano', in *Alessandria e il mondo ellenistico-romano, Alessandria 1992* (Rome 1995) 205–19.

PESCE, G., *Il 'Palazzo delle Colonne' in Tolemaide di Cirenaica* (Rome 1950).

PETRIE, W.M.F., *Roman Ehnasya (Herakleopolis Magna)* (London 1905).

PETRIE, W.M.F., et al., *Athribis* (London 1908).

PETRIE, W.M.F., et al., *Tombs of the Courtiers and Oxyrhynkhos* (London 1925).

PFEIFFER, R., *History of Classical Scholarship from the Beginning to the End of the Hellenistic Age* (Oxford 1968).

PICARD, C., 'Sur quelques représentations nouvelles du phare d'Alexandrie et sur l'origine des paysages portuaires', *BCH* 76 (1952) 61–95.

PICARD, C.-G., 'Origin et signification des fresques architectoniques romano-campaniennes dites de second style', *RA* (1977) 231–52.

PICCIRILLO, M., *Mosaics of Jordan* (Amman 1993).

PINGREE, D., 'The Teaching of the *Almagest* in Late Antiquity', *Apeiron* 27 (1994) 75–98.

PLAUMANN, C., *Ptolemais in Oberägypten. Ein Beitrag zur Geschichte des Hellenismus in Ägypten* (Leipzig 1910).

POLLIT, J.J., *Art in the Hellenistic Age* (Cambridge 1986).

POOLE, R.S., *Catalogue of the Coins of Alexandria and the Nomes, Catalogue of Greek Coins in the British Museum* (London 1892).

POTTS, D.T., 'Before Alexandria: Libraries in the Ancient Near East', in R. MacLeod, ed., *The Library of Alexandria, Centre of Learning in the Ancient World* (London 2000) 19–33.

PRÉAUX, C., *Les Grecs en Égypte d'après les archives de Zénon* (Brussels 1947).

PRÉAUX, C., 'Alexandrie et la Chlamyde', *Chronique d'Égypte* 85 (1968) 176–87.

PREISIGKE, F., 'Die Friedenskundgebung des Königs Euergetes II', *Archiv für Papyrusforschung*, ed., U. Wilcken, vol. 5 (Berlin 1913) 301–16.

PRICE, M.J., and TRELL, B.L., *Coins and their Cities* (London 1977).

PRINA RICOTTI, E.S., 'Le tende conviviali e la tenda di Tolomeo Filadelfo', in R.I. Curtis, ed., *Studia Pompeiana & classica in Honor of W.F. Jashemski*, vol. 2 (New York 1989) 199–239.

PRINGLE, D., *The Crusader Churches of Jerusalem*, vol. 1 (Cambridge 1993).

QUAEGEBEUR, J., 'Documents égyptiens anciens et nouveaux relatifs à Arsinoé Philadelphe', in H. Melaerts, ed., *Le Culte du souverain dans l'Égypte ptolémaïque au IIIᵉ siècle avant notre ère* (Studia Hellenistica 34) (Leuven 1998) 73–108.

QUET, M.-H. 'Pharus', *MEFRA* 96 (1984) 789–845.

QUIBELL, J.E., *Excavations at Saqqara (1907–1908, 1908–9, 1909–10)* (Cairo 1909–12).

RABBAT, N., 'The Meaning of the Umayyad Dome of the Rock', *Muqarnas* 6 (1989) 12–21.

RABBAT, N., 'The Dome of the Rock Revisited: Some Remarks on al-Wasiti's Accounts', *Muqarnas* 10 (1993) 67–75.

RABY, J., and JOHNS, J., eds., *Bayt al-Maqdis, 'Abd al-Malik's Jerusalem, Oxford Studies in Islamic Art* 9.1 (Oxford 1992).

RAEDER, J., 'Vitruv, de architectura VI 7 (*aedificia Graecorum*) und die hellenistische Wohnhaus- und Palastarchitektur', *Gymnasium* 95 (1988) 316–68.

RASSART-DEBERGH, M., *Antiquités romaines et chrétiennes d'Égypte* (Brussels 1976).

RASSART-DEBERGH, M., 'La Décoration picturale du monastère de Saqqara', in *Miscellanea Coptica = Acta ad archaeologiam et artium historiam pertinentia* 9 (1981) 9–124.

RASSART-DEBERGH, M., 'La Peinture copte avant le XIIIᵉ siècle Une approche', in *Miscellanea Coptica = Acta ad archaeologiam et artium historiam pertinentia* 9 (1981) 221–85.

RASSART-DEBERGH, M., 'Quelques remarques iconographiques sur la peinture chrétienne à Saqqara', in *Miscellanea Coptica = Acta ad archaeologiam et artium historiam pertinentia* 9 (1981) 207–20.

REDDÉ, M., 'La Représentation des phares à l'époque romaine', *MEFRA* 91 (1979) 845–72.

REDDÉ, M., 'Le Phare d'Alexandrie', *Les Dossiers d'archéologie* 202 (1995) 60–5.

REINACH, A.J., 'ΔΙΟΣΚΟΥΡΙΔΗΣ Γ ΤΟΜΟΙ', *BSAA* 11 (1909) 350–70.

RÉMONDON, R., 'L'Égypte et la suprême résistance au christianisme (V–VIIᵉ siècles)', *BIFAO* 51 (1952) 63–78.

RIAD, H., 'Quatre tombeaux de la nécropole ouest d'Alexandrie', *BSAA* 42 (1967) 89–96.

RIAD, H., 'Vestiges d'un édifice ptolémaïque en bordure de la voie canopique à Alexandrie', *BSAA* 42 (1967) 85–8.

RIAD, H., 'Anciens Bains d'Alexandrie', *BSAA* 43 (1975) 113–22.

RICE, E., *The Grand Procession of Ptolemy Philadelphus* (Oxford 1983).

RICHMOND, I., *The Dome of the Rock in Jerusalem* (Oxford 1924).

RINK, H., *Strassen und Viertelnamen von Oxyrhynchos* (Giessen 1924).

ROBERTS, C.H., *Manuscript, Society and Belief in Early Christian Egypt* (London 1979).

RODZIEWICZ, E., 'Bone Carvings Discovered at Kom el-Dikka, Alexandria, in 1967', *ÉtTrav* 3 (1969) 147–52.

RODZIEWICZ, E., 'Reliefs figurés en os des fouilles à Kôm el-Dikka', *ÉtTrav* 10 (1978) 317–36.

RODZIEWICZ, E., 'Late Roman Auditoria in Alexandria in the Light of Ivory Carvings', *BSAA* 45 (1993) 269–79.

RODZIEWICZ, E., 'Archaeological Evidence of Bone and Ivory Carvings in Alexandria', in J.-Y. Empereur, ed., *Commerce et artisanat dans l'Alexandrie hellénistique et romaine, Actes du Colloque d'Athènes, 1988, BCH* suppl. 33, (Athens 1998) 135–58.

RODZIEWICZ, E. and M., 'Alexandrie', *ÉtTrav* 12 (1983) 263–75; *ÉtTrav* 14 (1990) 285–315.

RODZIEWICZ, M., 'Un quartier d'habitation gréco-romain à Kôm el-Dikka', *ÉtTrav* 9 (1976) 169–210.

RODZIEWICZ, M., 'Nouvelles données sur le quartier de Kopron à Alexandrie', *ÉtTrav* 11 (1979) 79–89.

RODZIEWICZ, M., 'Thermes romains près de la Gare centrale d'Alexandrie', *ÉtTrav* 11 (1979) 107–38.

RODZIEWICZ, M., 'Graeco–Islamic Elements at Kom el Dikka in the Light of the New Discoveries: Remarks on Early Mediaeval Alexandria', *Graeco-Arabica* 1 (1982) 35–49.

RODZIEWICZ, M., *Les Habitations romaines tardives d'Alexandrie, Alexandrie* III (Warsaw 1984).

RODZIEWICZ, M., 'Le Débat sur la topographie de la ville antique', in R. Ilbert, ed., *Alexandrie entre deux mondes, Revue de l'occident musulman et de la Méditerranée* 46 (1987.4) 38–48.

RODZIEWICZ, M., 'Remarks to the Peristyle House in Alexandria and Mareotis', *Πρακτικα του xii Διεθνους Συνεδριου Κλασικης Αρχαιολογιας* ('Twelfth International Congress of Classical Archaeology 1983) (Athens 1988) 175–8.

RODZIEWICZ, M., 'La Stratigraphie de l'antique alexandrie à la lumière des fouilles de Kôm el-Dikka', *ÉtTrav* 14 (1990) 145–51.

RODZIEWICZ, M., 'A Brief Record of the Excavations at Kom-el-Dikka in Alexandria from 1960 to 1980', *BSAA* 44 (1991) 1–70.

RODZIEWICZ, M., 'Excavations at Kom-el-Dikka', *BSAA* 44 (1991) 71–118.

RODZIEWICZ, M., 'On Alexandrian Landscape Paintings', in *Roma e l'Egitto nell'antichità classica, Cairo 1989* (Rome 1992) 329–37.

RODZIEWICZ, M., 'Painted Narrative Cycle from Hypogeum No. 3 in Wardian, Alexandria', *BSAA* 45 (1993) 281–90.

RODZIEWICZ, M., 'Ptolemaic Street Directions in Basilea (Alexandria)', in *Alessandria e il mondo ellenistico-romano, Congresso Alessandria 1992* (Rome 1995) 227–35.

RODZIEWICZ, M., and ABDEL FATAH, A., 'Recent Discoveries in the Royal Quarter of Alexandria', *BSAA* 44 (1991) 131–50.

RODZIEWICZ, M., and ABDO-DAOUD, D., 'Investigation of a Trench near the Via Canopica in Alexandria', *BSAA* 44 (1991) 151–68.

ROEDER, G., ed., *Hermopolis 1929–1939* (Hildesheim 1959).

RONCHI, G., 'Il papiro Cairense 65445 (vv. 140–154) e l'obelisco di Arsinoe II', *Studi classici e orientali* 17 (1968) 56–75.

RONCZEWSKI, K., 'Variantes des chapiteaux romains', *Latvijas Universitates Raksti, Acta Universitatis Latviensis* 8 (1923) 115–71.

RONCZEWSKI, K., *Les Chapiteaux corinthiens et variés du Musée gréco-romain d'Alexandrie*, *BSAA* suppl. du fasc. 22 (1927).

RONCZEWSKI, K., 'Kapitelle des El Hasne in Petra', *AA* 1932, 37–90.

RONCZEWSKI, K., 'Kapitellfragmente aus Hermopolis', *MDIK* 6 (1936) 88–102.

RONDOT, V., 'Note sur six chapiteaux composites réutilisés dans la mosquée al-Yūsūfī à Mellawi', *ASAE* 70 (1984–1985) 143–9.

RONDOT, V., 'Sur le voyage de sept chapiteaux d'Antinoé vers le Caire', *Annales islamologiques* 25 (1990) 241–3.

ROSEN-AYALON, M., *The Early Islamic Monuments of al-Ḥaram al-Sharīf*, *Qedem* 13 (Jerusalem 1989).

ROSTOVTZEW, M., 'Interprétation des tessères en os avec figures, chiffres et légendes', *RA* 5 (1905) 110–24.

ROULLET, A., *The Egyptian and Egyptianizing Monuments of Imperial Rome* (Leiden 1972).

ROUVERET, R., *Histoire et imaginaire de la peinture ancienne (v^e siècle av. J.-C. – I^er siècle ap. J.-C.)* (Rome 1989).

ROUX, G., *L'Architecture de l'Argolide aux IV^e et III^e siècles avant J.-C.* (Paris 1961).

ROWE, A., 'Preliminary Report on Excavations of the Institute of Archaeology, Liverpool, at Athribis', *Annals of Archaeology and Anthropology* 25 (1938) 123–37.

ROWE, A., 'A Short Report on Excavations of the Greco-Roman Museum made during the Season 1942 at "Pompey's Pillar" ', *BSAA* 35 (1941–2) 124–61.

ROWE, A., 'Excavations of the Graeco-Roman Museum at Kôm el-Shukafa during the Season 1941–1942', *BSAA* 35 (1942) 3–45.

ROWE, A., *Discovery of the Famous Temple and Enclosure of Serapis at Alexandria*, *Supplément aux ASAE*, cahier no. 2 (Cairo 1946).

ROWE, A., 'A Contribution to the Archaeology of the Western Desert: II–III', *BullJRylandsLib* 36 (1954) 484–500; *BullJRylandsLib* 38 (1955) 139–61.

ROWE. A., and REES, B.R., 'A Contribution of the Archaeology of the Western Desert: IV. The Great Serapeum of Alexandria', *BullJRylandsLib* 39.2 (1957) 485–520.

ROWLAND, I.D. and HOWE, T.N., tr., *Vitruvius, Ten Books on Architecture* (Cambridge 1999).

ROWLANDSON, J. and HARKER, A., 'Roman Alexandria from the Perspective of the Papyri', in A. Hirst and M. Silk, eds., *Alexandria, Real and Imagined* (London 2004) 79–111.

RUBENSOHN, O., 'Aus griechisch-römischen Häusern des Fayum', *JdI* 20 (1905) 1–25.

RUMSCHEID, F., *Untersuchungen zur kleinasiatischen Bauornamentik des Hellenismus* (Mainz 1994).

RUNCIMAN, S., *A History of the Crusades* vol. 2–3 (Cambridge 1952–4).

RUTSCHOWSCAYA, M.-H., 'Linteaux en bois d'époque copte', *BIFAO* 77 (1977) 181–91.

RUTSCHOWSCAYA, M.-H., 'Essai d'un catalogue des bois coptes du Musée du Louvre, Les bois de Baouît', *RA* (1978) 295–318.

RUTSCHOWSCAYA, M.-H., *Catalogue des bois de l'Egypte copte au Musée du Louvre* (Paris 1986).

RUTSCHOWSCAYA, M.-H., *Coptic Fabrics* (Paris 1990).

RUTSCHOWSCAYA, M.-H., *La Peinture copte* (Paris 1992).

RUTSCHOWSCAYA, M.-H., 'Les Arts de la couleur', *Dossiers d'archéologie* 226 (Sept. 1997) 32–41.

RUTSCHOWSCAYA, M.-H., 'Conques et tympans du Musée du Louvre', in M. Krause and S. Schaten, eds., ΘΕΜΕΛΙΑ, *spätantike und koptologische Studien Peter Grossmann zum 65. Geburtstag* (Wiesbaden 1998) 289–95.

RUTSCHOWSCAYA, M.-H., 'Le Monastère de Baouît au Musée du Louvre', *L'archéologue, archéologie nouvelle* 43 (August-Sept 1999) 39–41.

RYL-PREIBISZ, I., 'Chapiteaux en granit de Nubie', *ÉtTrav* 5 (1971) 209–41.

RYL-PREIBISZ, I., 'Remarques sur les chapiteaux en marbre de Faras', *ÉtTrav* 15 (1990) 335–46.

SABOTTKA, M., 'Ausgrabungen in der West-Nekropole Alexandrias (Gabbari)', in G. Grimm, H. Heinen, and E. Winter, eds., *Das römisch-byzantinische Ägypten, AegTrev* 2 (Mainz 1983) 195–203.

SABOTTKA, M., *Das Serapeum in Alexandria. Untersuchungen zur Architektur und Baugeschichte des Heiligtums von der frühen ptolemäischen Zeit bis zur Zerstörung 391 n. Chr.* (diss. Technische Universität Berlin 1985, microfiche Berlin 1989), *ÉtAlex* 16 (Cairo, in press).

SAÏD, D., 'Deux mosaïques hellénistiques récemment découvertes à Alexandrie', *BIFAO* 94 (1994) 377–80, 487–9.

SAMUEL, A.E., *From Athens to Alexandria: Hellenism and Social Goals in Ptolemaic Egypt* (Louvain 1983).

SAMUEL, A.E., *The Shifting Sands of History: Interpretations of Ptolemaic Egypt* (London 1989).

SARADI-MENDELOVICI, H., 'Christian Attitudes toward Pagan Monuments in Late Antiquity and their Legacy in Later Byzantine Centuries', *DOP* 44 (1990) 47–61.

SARTRE, M., 'Alexandrie romaine', *Les Dossiers d'archéologie* 201 (1995) 50–7.

SATZINGER, H., *Das Kunsthistorische Museum in Wien, die ägyptisch-orientalische Sammlung* (Mainz 1994).

SAUNERON, S., 'Les Querelles impériales vues à travers les scènes du temple d'Esné', *BIFAO* 51 (1952) 111–21.

SCHEFOLD, K., 'Der Zweite Stil als Zeugnis alexandrinischer Architektur', in B. Andreae and H. Kyrieleis, eds., *Neue Forschungen in Pompeji* (Recklinghausen 1975) 53–9.

SCHEFOLD, K., 'Spuren alexandrinischer Theologie in römischen Wandmalereien', in E. Berger and H.C. Ackermann, eds., *Wort und Bild* (Basel 1975) 111–19.

SCHRENK, S., *Textilien des Mittelmeerraumes aus spätantiker bis frühislamischer Zeit* (Riggisberg 2004).

SCHRIØLER, T., *Roman and Islamic Water-lifting Wheels* (Odense 1973).

SCHLÄGER, H., 'Abu Mena. Vorläufiger Bericht', *MDIK* 19 (1963) 114–20; *MDIK* 20 (1965) 122–5.

SCHLÄGER, H., 'Die neuen Grabungen in Abu Mena', in K. Wessel, ed., *Christentum am Nil* (Recklinghausen 1964) 158–73.

SCHMID, S.G., 'The Nabataeans: Travellers between Lifestyles', in B. MacDonald *et al.* eds., *The Archaeology of Jordan* (Sheffield 2001) 367–426.

SCHMIDT, F., *Die Pinakes des Kallimachos (Klassisch-philologische Studien* vol. 1) (Berlin 1922).

SCHMIDT-COLINET, A., 'Nabatäische Felsarchitektur', *BJb* 180 (1980) 61–101.

SCHMIDT-COLINET, A., 'Exedra duplex. Überlegungen zum Augustusforum', in *Hefte des Archäologischen Seminars der Universität Bern* 14 (1991) 43–60.

SCHMIDT-COLINET, A. *et al.*, ' "Arabischer Borock" Sepulkrale Kultur in Petra', in T. Weber and R. Wenning, eds., *Petra Antike Felsstadt zwischen arabischer Tradition und griechischer Norm* (Mainz 1997) 87–98.

SCHMITZ, A.L., 'Das Weisse und das Rote Kloster', *Die Antike* 3 (1927) 326–50.

SCHMITZ, H., 'Die Bau-Urkunde in P.Vindob. gr. 12565 im Lichte der Ergebnisse der deutschen Hermopolis Expedition', in *Papyri und Altertumswissenschaft*, ed. W. Otto and L. Wenger, *Münchener Beiträge zur Papyrusforschung und antiken Rechtsgeschichte* 19 (1934) 406–28.

SCHREIBER, T., ed., *Die Nekropole von Kom-esch-Schukafa* (Leipzig 1908) vol. 1.

SCHWARTZ, J., 'La Fin du Serapéum d'Alexandrie', in A.E. Samuel, ed., *Essays in Honour of C. Bradford Welles* (New Haven 1966) 97–111.

SCHWARTZ, J., et al., *Fouilles franco-suisses rapports II, Qasr-Qārūn/Dionysias 1950* (Cairo 1969).

SCHWEITZER, B., 'Ein Nymphäum des frühen Hellenismus', *Festgabe zur Winckelmannsfeier des Archäologischen Seminars der Universität Leipzig* (Leipzig 1938).

SETTIS, S., 'Descrizione di un ninfeo ellenistico', *Studi classici e orientali* 14 (1965) 247–57.

SEVERIN, G. and H.-G., *Marmor vom heiligen Menas* (Frankfurt 1987).

SEVERIN, H.-G., 'Frühchristliche Skulptur und Malerei in Ägypten', in B. Brenk, ed., *Spätantike und frühes Christentum* (Frankfurt 1977) 243–53.

SEVERIN, H.-G., 'Zur Süd-Kirche von Bawīt', *MDIK* 33 (1977) 113–24.

SEVERIN, H.-G., 'Gli scavi eseguiti ad Ahnas, Bahnasa, Bawit e Saqqara: Storia delle interpretazioni e nuovi risultati', *CorsiRav* 28 (1981) 299–314.

SEVERIN, H.-G., 'Problemi di scultura tardoantica in Egitto', *CorsiRav* 28 (1981) 315–36.

SEVERIN, H.-G., 'Beispiele der Verwendung spätantiker Spolien. Ägyptische Notizen', in O. Feld and U. Peschlow, eds., *Studien zur spätantiken und byzantinischen Kunst F.W. Deichmann gewidmet*, vol. 2 (Bonn 1986) 101–8.

SEVERIN, H.-G., 'Zum Dekor der Nischenbekrönungen aus spätantiken Grabbauten Ägyptens', in D. Willers, ed., *Begegnung von Heidentum und Christentum im spätantiken Ägypten* (Riggisberg 1993) 183–94.

SEVERIN, H.-G., 'Konstantinopler Bauskulptur und die Provinz Ägypten', in U. Peschlow and S. Möllers, eds., *Spätantike und byzantinische Bauskulptur* (Stuttgart 1998) 93–104.

SEVERIN, H.-G., 'Zur Skulptur und Malerei der spätantiken und frühmittelaltelichen Zeit in Ägypten', in Krause, M., ed., *Ägypten in spätantik-christlicher Zeit. Einführung in die koptische Kultur* (Wiesbaden 1998) 297–338.

SHANI, R., 'The Iconography of the Dome of the Rock', *Jerusalem Studies in Arabic and Islam* 23 (1999) 158–207.

SHEEHAN, P., 'The Roman fortress of Babylon in Old Cairo', in D.M. Bailey, ed., *Archaeological Research in Roman Egypt, JRA* suppl. 19 (Ann Arbor 1996) 95–7.

SHENOUDA, S., 'Alexandria University Excavations on the Cricket Playgrounds of Alexandria', *Opuscula Romana* 9 (1973) 193–205.

SIDEBOTTOM, H., 'The Date of Dio of Prusa's Rhodian and Alexandrian Orations', *Historia* 41 (1992) 407–19.

SIMAIKA PACHA, M.H., *Guide sommaire du Musée copte et des principales églises du Caire* (Cairo 1937).

SJÖQVIST, E., 'Kaisareion, A Study in Architectural Iconography', *Opuscula romana* 1 (1954) 86–108.

SKOWRONEK, S., and TKACZOW, B., 'Le Culte de la déesse Déméter à Alexandrie', in L. Kahil and C. Augé, eds., *Mythologie gréco-romaine, mythologies périphériques* (Paris 1981) 131–44.

SLY, D., *Philo's Alexandria* (London 1996).

SMITH, M., 'Aspects of the Preservation and Transmission of Indigenous Religious Traditions in Akhmim and its Environs during the Graeco-Roman Period', in A. Egberts *et al.* eds., *Perspectives on Panopolis* (Leiden 2002) 233–47.

SMITH, R.R.R., 'Ptolemaic Portraits: Alexandrian Types, Egyptian Versions', in K. Hamma, ed., *Alexandria and Alexandrianism* (Malibu 1996) 203–13.

SOCIÉTÉ ARCHÉOLOGIQUE D'ALEXANDRIE, *Les Bas-Reliefs de Kom el Chougafa* (Munich n.d.).

ŠONJE, A., 'I capitelli della Basilica Eufrasiana di Parenzo', in O. Feld and U. Peschlow, eds., *Studien zur spätantiken und byzantinischen Kunst, F.W. Deichmann gewidmet*, vol. 2 (Bonn 1986) 127–45.

SPENCE, K., *et al.*, 'Archaeological Survey Drawings of the Fortress of Babylon', and P. Sheehan, 'The Roman Fortification', in P. Lambert, ed., *Fortifications and the Synagogue: the Fortress of Babylon and the Ben Ezra Synagogue, Cairo* (London 1994) 40–7.

STANLEY, J.-D. *et al.*, 'Submergence of Ancient Greek Cities Off Egypt's Nile Delta – a Cautionary Tale', *GSA Today* 14.1 (2004) 4–10.

STANWICK, P.E., *Portraits of the Ptolemies, Greek Kings as Egyptian Pharaohs* (Austin, Texas 2002).

STAUFFER, A., *Textiles de l'Égypte de la Collection Bouvier* (Bern 1991).

STAUFFER, A., 'Cartoons for weavers from Graeco-Roman Egypt', in D.M. Bailey, ed., *Archaeological Research in Roman Egypt, JRA* suppl. 19 (Ann Arbor 1996) 223–30.

STEEN, G.L., ed., *Alexandria the Site and its History* (New York 1993).

STERN, H., 'Les Représentations des conciles dans l'Église de la nativité à Bethléem', *Byzantion* 11 (1936) 101–52; 'Deuxième partie: Les inscriptions', *Byzantion* 13 (1938) 417–59.

STERN, H., 'Nouvelles recherches sur les images des conciles dans l'Église de la nativité à Bethléem', *Cahiers archéologiques* 3 (1948) 82–105.

STERN, H., 'Notes sur les mosaïques du Dôme du Rocher et de la Mosquée de Damas', *Cahiers archéologiques* 22 (1972) 201–32.

STIERLIN, H., *Islam from Baghdad to Cordoba, Early Architecture from the 7th to the 13th Century* (Cologne 2002).

STROCKA, M.V., *Casa del Labirinto (VI 11, 8-10), Häuser in Pompeji* vol. 4 (Munich 1991).

STROCKA, V.M., *Das Markttor von Milet* (Berlin 1981).

STRUBE, C., *Polyeuktoskirche und Hagia Sophia: Umbildung und Auflösung antiker Formen, Entstehen des Kämpferkapitells* (Munich 1984).

STRZYGOWSKI, J., *Das Etschmiadzin-Evangeliar, Byzantinische Denkmäler* I (Vienna 1891).

STRZYGOWSKI, J., 'Der Pinienzapfen als Wasserspeier', *RM* 18 (1903) 185–206.

STRZYGOWSKI, J., *Catalogue général des antiquités égyptiennes du Musée du Caire, Koptische Kunst* (Vienna 1904).

STUDNICZKA, F., *Das Symposion Ptolemaios II* (Leipzig 1914).

SWAINSON, H., 'Monograms on the Capitals of S. Sergius at Constantinople', *ByzZ* 4 (1895) 106–8.

SZYMANSKA H., and BABRAJ, K., 'Marea Fourth Season of Excavations', *PAM* 15 (2003) 53–62.

TAHER, M.A., 'Les Séismes à Alexandrie et la destruction du phare', C. Décobert and J.-Y. Empereur, eds., *Alexandrie mediévale* 1, *ÉtAlex* 3 (1998) 51–6.

TANNERY, P., 'A quelle époque vivait Diophante?', *Bulletin des sciences mathématiques et astronomiques*, vol. 14, 2nd ser. vol. 3 (1879) 261–9.

TANNERY, P., 'Les Mesures des marbres et des divers bois de Didyme d'Alexandrie', *RA* 41 (1881.1) 152–64.

TANNERY, P., 'Études Héroniennes', *Mémoires de la société des sciences physiques et naturalles de Bordeaux*, 2nd ser. vol. 5 (1883) 347–69.

TANNERY, P., 'La Stéréométrie d'Héron d'Alexandrie', *Mémoires de la Société des Sciences physiques et naturelles de Bordeaux*, 2nd ser. vol. 5 (1883) 305–26.

TANNERY, P., 'Eutocius et ses contemporains', *Bulletin des sciences mathématiques et astronomiques*, vol. 19 (= 2nd ser. vol. 8) (1884) 315–29.

TANNERY, P., 'L'Article de Suidas sur Hypatia', *Annales de la Faculté des lettres de Bordeaux* 3 (1881) 101–104; reproduced in J.L. Heiberg and H.G. Zeuthen, eds., *Mémoires scientifiques de Paul Tannery*, vol. 1, (Paris 1912) 74–9.

TANNERY, P., 'Sur la religion des derniers mathématiciens de l'antiquité', *Annales de philosophie chrétienne* 34 (1896) 26–36, reproduced in J.L. Heiberg and H.G. Zeuthen, eds., *Mémoires scientifiques de Paul Tannery*, vol. 2 (Paris 1912) 527–39.

TANNERY, P., 'Psellus sur Diophante', in *Mémoires scientifiques de Paul Tannery*, vol. 4 (Paris 1920) 275–82.

TELFER, W., 'St Peter of Alexandria and Arius', *AnalBolland* 67 (1949) 117–30.

TERRY, A., 'The Sculpture at the Cathedral of Eufrasius in Poreč', *DOP* 42 (1988) 13–64.

TERRY, A.R., *The Architecture and Architectural Sculpture of the Sixth Century Eufrasius Cathedral Complex at Poreč*, PhD Illinois 1984 (*UMI* Ann Arbor 1986).

THELAMON, F., *Paiens et chrétiens au IVᵉ siècle. L'Apport de l' 'Histoire ecclésiastique' de Rufin d'Aquilée* (Paris 1981).

THIERSCH, H., *Zwei antike Grabanlagen bei Alexandria* (Berlin 1904).

THIERSCH, H., *Pharos* (Leipzig 1909).

THIERSCH, H., 'Die alexandrinische Königsnecropole', *JdI* 25 (1910) 55–97.

THOMAS, T.K., 'An Introduction to the Sculpture of Late Roman and Early Byzantine Egypt', in F.D. Friedman, ed., *Beyond the Pharaohs* (Rhode Island 1989) 54–64.

THOMAS, T.K., *Niche Decorations from the Tombs of Byzantine Egypt (Heracleopolis Magna and Oxyrhynchus, AD 300–500)* PhD New York University 1990 (UMI, Ann Arbor 1991).

THOMAS, T.K., *Late Antique Egyptian Funerary Sculpture* (Princeton 2000).

THOMPSON, D., 'Ptolemaios and the 'Lighthouse': Greek Culture in the Memphite Serapeum', *Proceedings of the Cambridge Philological Society* 213 (1987) 105–21.

THOMPSON, D., *Memphis under the Ptolemies* (Princeton 1988).

TIMBIE, J., 'The State of Research on the Career of Shenute of Atripe', in B.A. Pearson and J.E. Goehring, eds., *The Roots of Egyptian Christianity* (Philadelphia 1986) 258–70.

TKACZOW, B., 'La topographie des nécropoles occidentales d'Alexandrie', *Eos* 70 (1982) 343–8.

TKACZOW, B., 'Remarques sur la topographie et l'architecture de l'ancienne Alexandrie dans les textes antiques', *Archeologia* 35 (1984) 1–25.

TKACZOW, B., 'Archaeological Sources for the Earliest Churches in Alexandria', in W. Godlewski, ed., *Coptic Studies* (Warsaw 1990) 431–5.

TKACZOW, B., 'Observations préliminaires sur les fragments de décoration architectonique à Kôm el-Dikka', *ÉtTrav* 16 (1992) 225–56.

TKACZOW, B., *Topography of Ancient Alexandria* (Warsaw 1993).

TKACZOW, B., 'An Imitation of *opus alexandrinum* in Wall Painting?', *ÉtTrav* 17 (1995) 319–26.

TKACZOW, B., 'The Historical Topography of Kom el-Dikka', in Z. Kiss *et al.*, *Fouilles polonaises à Kôm el-Dikka, Alexandrie* VII (Warsaw 2000) 131–43.

TKACZOW, B., 'Topographie et architecture de l'ancienne Alexandrie. Nouvelles recherches et découvertes', *ÉtTrav* 19 (2001) 329–36.

TKACZOW, B., 'Remarques sur la topographie et l'architecture de l'ancienne alexandrie à la lumière des récentes découvertes archéologiques', *Archeologia* 53 (2002) 21–37.

TOD, M.N., 'A Bilingual Dedication from Alexandria', *JEA* 28 (1942) 53–6.

TOMLINSON, R.A., 'The Ceiling of Anfushy II.2', in *Alessandria e il mondo ellenistico-romano, Studi in onore di A. Adriani*, vol. 2 (Rome 1984) 260–4.

TOMLINSON, R.A., 'Alexandria: the Hellenistic arrangement', *Numismatica e antichità classiche* 25 (1996) 155–67.

TÖRÖK, L., 'On the Chronology of the Ahnās Sculpture', *ActaArchHung* 22 (1970) 163–82.

TÖRÖK, L., 'Notes on Prae-Coptic and Coptic Art', *ActaArchHung* 29 (1977) 125–53.

TÖRÖK, L., 'Notes on the Chronology of Late Antique Stone Sculpture in Egypt', in W. Godlewski, ed., *Coptic Studies, Congress Warsaw 1984* (Warsaw 1990) 437–84.

TÖRÖK, L., *Transfigurations of Hellenism. Aspects of Late Antique Art in Egypt AD 250–700* (Leiden 2005).

TORP, H., 'Quelques remarques sur les mosaïques de l'église Saint-Georges à Thessalonique', in Πεπραγμενα του Θ´ Διεθνους Βυζαντινολογικου Συνεδριου. Θεσσαλονικη 1953. (Athens 1955) vol. 1, 489–98.

TORP, H., 'La Date de la fondation du monastère d'Apa Apollô de Baouît et de son abandon', *MEFRA* 77 (1965) 153–77.

TORP, H., 'Byzance et la sculpture copte du VIᵉ siècle à Baouît et Sakkara', in A. Grabar *et al.*, *Synthronon* (Paris 1968) 11–27.

TORP, H., 'Leda Christiana. The Problem of the Interpretation of Coptic Sculpture with Mythological Motifs', in *Acta ad archaeologiam et artium historiam pertinentia* 4 (1969) 101–12.

TORP, H., 'The Carved Decorations of the North and South Churches at Bawit', in *Kolloquium über spätantike und frühmittelalterliche Skulptur Band II. Vortragstexte 1970* (Mainz 1971) 35–41.

TORP, H., 'Le Monastère copte de Baouît. Quelques notes d'introduction', *Acta ad archeologiam et artium historiam pertinentia* 9 (1981) 1–8.

TOUSSOUN, O., 'Les Ruines sous-marines de la Baie d'Aboukir', *BSAA* 29 (1934) 342–54.

TRAN TAM TINH, V., *Sérapis debout, Corpus des monuments de Sérapis debout et étude iconographique* (Leiden 1983).

TURNER, E.G., 'Roman Oxyrhynchus', *JEA* 38 (1952) 78–93.

TURNER, E.G., 'Oxyrhynchus and Rome', *Harvard Studies in Classical Philology* 79 (1975) 15–16.

TYBOUT, R.A., *Aedificorum figurae. Untersuchungen zu den Architekturdarstellungen des frühen zweiten Stils* (Amsterdam 1989).

TYBOUT, R.A., 'Die Perspektive bei Vitruv: Zwei Überlieferungen von *scaenographia*', in H. Geertman and J.J. de Jong, eds., *Munus non ingratum, Proceedings of the International Symposium on Vitruvius' De Architectura and the Hellenistic and Republican Architecture, 1987* (Leiden 1989) 55–68.

TYBOUT, R.A., 'Malerei und Raumfunktion im zweiten Stil', in E.M. Moormann, ed., *Functional and Spatial Analysis of Wall Painting* (Leiden 1993) 38–50.

TYBOUT, R.A., 'Roman Wall-painting and Social Significance', *JRA* 14 (2001) 33–57.

UDOVITCH, A.L., 'Medieval Alexandria: Some Evidence from the Cairo Genizah Documents', in K. Hamma ed., *Alexandria and Alexandrianism* (Malibu 1996) 273–84.

UGGERI, G., 'I monumenti paleocristiani di Antinoe', in *Atti del 5. Congresso nazionale di archeologia cristiana, Torino 1979* (Rome 1982) 657–88.

UNDERWOOD, P.A., 'The Fountain of Life in Manuscripts of the Gospels', *DOP* 5 (1950) 41–138.

VALENTIA, G., *Voyages and Travels to India, Ceylon, the Red Sea, Abyssinia and Egypt in the Years 1802–1806*, vol. 3 (London 1811).

VALLOIS, R., *L'architecture hellénique et hellénistique à Délos*, vol. 1 (Paris 1944).

VAN BERCHEM, M., 'Note sur les fondations du Phare d'Alexandrie', *CRAI* 4.26 (1898) 339–45.

VAN ELDEREN, B., 'The Nag Hammadi Excavation', *Biblical Archaeologist* 42 (1979) 225–31.

VAN HAELST, J., 'Les Sources papyrologiques concernant l'église en Égypte à l'époque de Constantin', *Proceedings of 12th International Congress of Papyrology* (Toronto 1970) 497–503.

VAN LOHUIZEN-MULDER, M., 'Early Christian Lotus-panel Capitals and Other So-called Impost Capitals', *BABesch* 62 (1987) 131–51.

VAN LOHUIZEN-MULDER, M., 'The Two-zone Capitals', *BABesch* 64 (1989) 193–204.

VAN LOHUIZEN-MULDER, M., 'Stuccoes in Ravenna, Poreč and Cividale of Coptic Manufacture', *BABesch* 65 (1990) 139–51.

VAN LOHUIZEN-MULDER. M., 'The Mosaics in the Great Mosque at Damascus: a Vision of Beauty', *BABesch* 70 (1995) 193–213.

VAN MILLINGEN, A., *Byzantine Churches in Constantinople* (London 1912).

VAN MINNEN, P., 'The Inventory of an Egyptian Church on a Greek Papyrus', in M. Rassart-Debergh and J. Ries, eds., *Actes du IVᵉ Congrès copte, Louvain-la-Neuve 1988*, vol. 1 (Louvain 1992) 227–33.

VAN MINNEN, P., 'The Roots of Egyptian Christianity', *Archiv für Papyrusforschung* 40 (1994) 71–85.

VAN MOORSEL, P., and HUIJBERS, M., 'Repertory of the Preserved Wall-paintings from the Monastery of Apa Jeremiah at Saqqara', in *Miscellanea Coptica = Acta ad archaeologiam et artium historiam pertinentia* 9 (1981) 125–86.

VAN NICE, R.L., *St Sophia in Istanbul, An Architectural Survey* (Washington, D.C., 1965).

VANDERBORGHT, E., 'La Maison de Diotimos, à Philadelphie', *Chronique d'Égypte* 33 (1942) 117–26.

VANDERSLEYEN, C., 'Le Préfet d'Égypte de la colonne de Pompée à Alexandrie', *Chronique d'Égypte* 33 (1958) 113–34.

VASSILIKA, E., *Ptolemaic Philae* (Leuven 1989).

VENIT, M.S., 'Two Early Corinthian Alabastra in Alexandria,' *JEA* 71 (1985) 183–9.

VENIT, M.S., 'The Painted Tomb from Wardian and the Decoration of Alexandrian Tombs', *JARCE* 25 (1988) 71–91.

VENIT, M.S., 'The Painted Tomb from Wardian and the Antiquity of the *Saqiya* in Egypt', *JARCE* 26 (1989) 219–22.

VENIT, M.S., 'The Tomb from Tigrane Pasha Street and the Iconography of Death in Roman Alexandria', *AJA* 101 (1997) 701–29.

VENIT, M.S., 'Ancient Egyptomania: the Uses of Egypt in Graeco-Roman Alexandria', in E. Ehrenberg, ed., *Leaving No Stones Unturned, Essays in Honor of D.P. Hansen* (Winona Lake, Indiana 2002) 261–78.

VENIT, M.S., *Monumental Tombs of Ancient Alexandria* (Cambridge 2002).

VERBEECK, B., 'De Kloosterkerken bij Sohag', *Phoenix ex Oriente Lux* 25.1 (1979) 91–102.

VERNUS, P., 'Inscriptions de la troisième période intermédiare (II) blocs du grand-prêtre d'Amon *'IWPWT* employés dans le Deir-el-Abyad', *BIFAO* 75 (1975) 67–72.

VERSLUYS, M.J., *Aegyptiaca Romana. Nilotic Scenes and the Roman Views of Egypt* (Leiden 2002).

VICKERS, M., 'Fifth-century Brickstamps from Thessaloniki', *BSA* 68 (1973) 285–94.

VICKERS, M., 'A "New" Capital from St Polyeuktos (Saraçhane) in Venice', *Oxford Journal of Archaeology* 8.2 (1989) 227–30.

VICKERS, M., 'Wandering Stones: Venice, Constantinople, and Athens', in K.L. Selig and E. Sears, eds., *The Verbal and the Visual: Essays in Honour of W. Heckscher* (New York 1990) 225–47.

VIKAN, G., 'Meaning in Coptic Funerary Sculpture', *Göttinger Orientforschungen* II, Reihe Bd. 8, *Studien zur frühchristlichen Kunst* II (1986) 15–24.

VOLKMANN, H., 'Kritische Bemerkungen zu den Inschriften des Vatikanischen Obelisken', *Gymnasium* 74 (1967) 501–8.

VON HESBERG, H., 'Zur Entwicklung der griechischen Architektur im ptolemäischen Reich', in H. Maehler and V.M. Strocka, eds., *Das ptolemäische Ägypten* (Mainz 1978) 137–45.

VON HESBERG, H., *Konsolengeisa des Hellenismus und der frühen Kaiserzeit*, RM Ergh. 24 (Mainz 1980).

VON HESBERG, H., 'Lo sviluppo dell'ordine corinzio in età tardo-repubblicana', in *L'art décoratif à Rome à la fin de la république et au début du principat, Table ronde, Rome 1979* (Rome 1981) 19–33.

VON HESBERG, H., 'Temporäre Bilder oder die Grenzen der Kunst. Zur Legitimation frühhellenistischer Königsherrschaft im Fest', *JdI* 104 (1989) 61–82.

VON SIEGLIN, E., ed., *Die griechisch-ägyptische Sammlung Ernst von Sieglin, Expedition Ernst von Sieglin*, vol. 2, part 3 (Leipzig 1913).

VON SIEGLIN, E., and SCHREIBER, T., *Die Nekropole von Kôm-esch-Schukâfa, Expedition Ernst von Sieglin*, vol. 1 (Leipzig 1908).

VÖRÖS, G., *Taposiris Magna Port of Isis, Hungarian Excavations at Alexandria (1998–2001)* (Budapest 2001).

VÖRÖS, G., *Taposiris Magna 1998–2004* (Budapest 2004).

WACE, A.J.B., 'Greek Inscriptions from the Serapeum', *Farouk I University, Bulletin of the Faculty of Arts, Alexandria* 2 (1944) 17–26.

WACE, A.J.B., 'The Sarcophagus of Alexander the Great', *Farouk I University, Bulletin of the Faculty of Arts* 4 (1948) 1–11.

WACE, A.J.B., 'Excavations on the Government Hospital Site, Alexandria', *Farouk I University, Bulletin Faculty of Arts Alexandria* 5 (1949) 151–6.

WACE, A.J.B., MEGAW, A.H.S., and SKEAT, T.C., *Hermopolis Magna, Ashmunein The Ptolemaic Sanctuary and the Basilica* (Alexandria 1959).

WALTERS, C.C., *Monastic Archaeology in Egypt* (Warminster 1974).

WARD-PERKINS, J.B., 'The Shrine of St Menas in Maryût', *PBSR* 17 (1949) 26–71.

WARD-PERKINS, J.B., 'Notes on the Structure and Building Methods of Early Byzantine Architecture', in D. Talbot Price, ed., *The Great Palace of the Byzantine Emperors, Second Report* (Edinburgh 1958) 52–104.

WARD-PERKINS, J.B., *Roman Imperial Architecture* (London 1981).

WARD-PERKINS, J.B., and BALLANCE, M.H., 'The Caesareum at Cyrene and the Basilica at Cremna', *PBSR* 26 (1958) 137–94.

WARD-PERKINS, J.B., et al., *Christian Monuments of Cyrenaica*, ed. J. Reynolds (London 2003).

WARREN, J., *Greek Mathematics and Architects to Justinian* (London 1976).

WATTERSON, B., *Coptic Egypt* (Edinburgh 1988).

WATTS, E.J., *City and School in Late Antique Athens and Alexandria* (Los Angeles 2006).

WEILL, R., 'Les Ports antéhelléniques de la côte d'Alexandrie et l'empire crétois', *BIFAO* 16 (1919) 1–37.

WEINSTEIN, J.M., *Foundation Deposits in Ancient Egypt*, PhD University of Pennsylvania 1973 (*UMI* Ann Arbor).

WEISS, Z., and NETZER, E., 'Two Excavation Seasons at Sepphoris', *Qadmoniot* 24 (1991) 113–22.

WEITZMANN, K., 'The Ivories of the So-called Grado Chair', *DOP* 26 (1972) 43–91.

WEITZMANN, K., *Late Antique and Early Christian Book Illumination* (London 1977).

WENDEL, C., 'Die bauliche Entwicklung der antiken Bibliothek', *Zentralblatt für Bibliothekswesen* 11/12 (1949) 407–28.

WENNING, R., 'The Rock-cut Architecture of Petra', in G. Markoe, ed., *Petra Rediscovered* (New York 2003) 133–42.

WESCHER, C., 'Un ipogeo cristiano antichissimo di Alessandria in Egitto', *Bullettino di archeologia cristiana* III No. 8 (1865) 57–61.

WESSEL, K., *Coptic Art* (London 1965).

WESSELY, C., *Die Stadt Arsinoë (Krokodilopolis) in griechischer Zeit* (Vienna 1902; repr. Milan 1975).

WHITBY, M., 'Procopius' description of Dara (*Buildings* II,1–13)', in P. Freeman and D. Kennedy, eds., *The Defence of the Roman and Byzantine East*, BAR International Series 297 (ii) (Oxford 1986) 737–83.

WHITBY, M., 'The St Polyeuktos Epigram (AP 1.10): a Literary Perspective', in S. Johnson, ed., *Greek Literature in Late Antiquity: Dynamism, Didacticism, Classicism* (London in press 2006).

WHITE, D., 'Marsa Matruh', in D.M. Bailey, ed., *Archaeological Research in Roman Egypt, JRA* suppl. 19 (Ann Arbor 1996) 61–81.

WHITE, J., *The Birth and Rebirth of Pictorial Space* (3rd edn., London 1987).

WHITE, J.W., *The Scholia on the Aves of Aristophanes* (Boston 1914).

WHITEHOUSE, D., 'Begram, the *Periplus* and Gandharan Art', *JRA* 2 (1989) 93–100.

WHITEHOUSE, H., and COULTON, J.J., 'Drawing a Fine Line in Oxyrhynchus: Egyptian and Graeco-Roman Draughtsmanship on Papyrus', in A.K. Bowman et al., eds., *Oxyrhynchus: A City and its Texts* (in press).

WIEGAND, E., 'Der Kalenderfries von Hagios Georgios in Thessaloniki', *BZ* 39 (1939) 116–45.

WILCKEN, U., 'Die griechischen Denkmäler vom Dromos des Serapeums von Memphis', *JdI* 32 (1917) 149–203.

WILD, R.A., 'The Known Isis-Serapis Sanctuaries from the Roman Period', *ANRW* II 17.4, 1739–851.

WILD, R.A., *Water in the Cultic Worship of Isis and Serapis* (Leiden 1981).

WILKINSON, J., *Column Capitals in al Haram al Sharif* (Jerusalem 1987).

WILL, E., et al., *'Iraq al Amir: le château du tobiade Hyrcan* (Paris 1991).

WILLERS, D., 'Dionysos und Christus – ein archäologisches Zeugnis zur "Konfessionsangehörigkeit" des Nonnos', *Museum Helveticum* 49 (1992) 141–51.

WILSON JONES, M., *Principles of Roman Architecture* (London 2000).

WINLOCK, H.E., *The Temple of Hibis in el Khargeh Oasis* (New York 1941).

WINTER, E., *Untersuchungen zu den ägyptischen Tempelreliefs der griechisch-römischen Zeit* (Vienna 1968).

WINTER, E., 'Die Tempel von Philae und das Problem ihrer Rettung', *AW* 7.3 (1976) 2–15.

WINTER, E., 'A Reconsideration of the Newly Discovered Building Inscription on the Temple of Denderah', *GöttMisz* 108 (1989) 75–85.

WINTER, F.E., and CHRISTIE, A., 'The Symposium-Tent of Ptolemy II: a New Proposal', *Echos du monde classique* 29 (1985) 289–308.

WIPSZYCKA, E., *Les Ressources et les activités économiques des églises en Égypte du IV^e au VIII^e siècle* (Brussels 1972).

WIPSZYCKA, E., 'La Valeur de l'onomastique pour l'histoire de la christianisation de l'É-gypte', *ZPE* 62 (1986) 173–81.

WIPSZYCKA, E., 'La Christianisation de l'Égypte aux IV^e–VI^e siècles. Aspects sociaux et ethniques', *Aegyptus* 68 (1988) 117–65.

WIPSZYCKA, E., 'Le Nationalisme a-t-il existé dans l'Égypte byzantine?', *The Journal of Juristic Papyrology* 22 (1992) 83–128.

WRIGHT, D.H., 'The Date and Arrangement of the Illustrations of the Rabbula Gospels', *DOP* 27 (1973) 197–208.

WRIGHT, G.R.H., 'Architectural Fragments from the Peristyle', in J.H. Humphrey, ed., *Apollonia, the Port of Cyrene* (Tripoli 1976) 189–223.

WRIGHT, G.R.H., 'The Works Organization of a Major Building Project in Roman Egypt', in D.M. Bailey, ed., *Archaeological Research in Roman Egypt, JRA* suppl. 19 (Ann Arbor 1996) 143–54.

YAMANI, S., 'Roman Monumental Tombs in Ezbet Bashendi', *BIFAO* 101 (2001) 393–414.

YOUNG, D.W., 'A Monastic Invective against Egyptian Hieroglyphs', in D.W. Young, ed., *Studies Presented to H.J. Polotsky* (Beacon Hill, Mass. 1981) 348–60.

YOUNG, E., 'Sculptors' Models or Votives?', *The Metropolitan Museum of Art Bulletin* 22 (1964) 246–56.

YOYOTTE, J., et al., *Strabon, le voyage en Égypte* (Paris 1997).

YOYOTTE, J., 'Guardian of the Nile: Thonis Rediscovered', *Minerva* 13.3 (May/June 2002) 32–4.

ZALOSCER, H., *Quelques considérations sur les rapports entre l'art copte et les Indes, ASAE* suppl. 6 (Cairo 1947).

ZALOSCER, H., *Une collection de pierres sculptées au Musée copte du Vieux-Caire (Collection Abbàs el-Arabi)* (Cairo 1948).

ZANETTI, U., 'Abu l-Makarim et Abu Salih', *BSAC* 34 (1995) 85–138.

ZAYADINE, F., et al., *Le Qasr al-Bint de Pétra* (Paris 2003).

ZOLLT, T., 'Das ionische Kämpferkapitell. Definitionsprobleme', U. Peschlow and S. Möllers, eds., *Spätantike und byzantinische Bauskulptur. Beiträge eines Symposions in Mainz, Februar 1994* (Stuttgart 1998) 59–65.

ZORI, N., 'The House of Kyrios Leontis at Beth Shean', *IEJ* 16 (1966) 123–34.

Glossary

This glossary includes only the terms as they are used in the present work. Where suitable standard terms have been lacking it has sometimes been necessary to use new terms. Abbreviations are given on p. 376–379.

More comprehensive general glossaries of architectural terms may be found in D.S. Robertson, *Greek and Roman Architecture* (Cambridge 1945) 379–90 (including ancient terms); J.B. Ward-Perkins, *Roman Imperial Architecture* (Harmondsworth 1981) 491–7; Krautheimer *Byz. Archit.*, 451–5; R. Ginouvès and R. Martin, *Dictionnaire méthodique de l'architecture grecque et romaine*, Vol. 1 (Rome 1985); McKenzie *Petra* 181–5.

More detail concerning Greek and Roman deities can be found in *OCD³*; on Egyptian gods: G. Hart, *A Dictionary of Egyptian Gods and Goddesses* (London 1986); and G. Pinch, *Egyptian Mythology, A Guide to the Gods, Goddesses, and Traditions of Ancient Egypt* (Oxford 2002); and on the Christian Church in: *The Oxford Dictionary of the Christian Church*, ed. F.L. Cross (third edit., ed. E.A. Livingstone) (Oxford 1997).

abacus (*-i*). (Latin) Flat member forming the top of a *capital* [123].

acanthus column base. Ring of acanthus leaves around the *base* of a column, often with an *attic base* below [137].

acanthus leaves. Leaves resembling those from the acanthus plant used to decorate the lower part of a *Corinthian capital*, and other elements such as *acanthus column bases*, friezes and *consoles* [123].

acroterion (*-ia*). (Greek) Decoration, such as vases or eagles, which stands on the *acroterion bases* at the lower corners or apex of a *pediment* [625].

acroterion base. Small projection which may support an *acroterion* [625].

adytum. (Latin) (Greek, *adyton*) Innermost sanctuary of a temple.

agora. (Greek) Open space at the centre of a town used as a market place. In Greek cities also used for political functions.

aithrion. (Greek) Open space or light well at the centre of a house.

akra. (Greek) Projecting piece of land (promontory) or high ground (citadel).

akropolis. (Greek) Citadel.

alabaster. Fine grained translucent yellow or white gypsum.

Alexandrian Corinthian capitals. See *Types I, II, III and IV Alexandrian capitals*.

ambon. (Greek) Pulpit, usually in centre of church, for reader of passages of scripture.

amphitheatre. Oval-shaped Roman building with raked seating for watching gladiatorial and related spectacles.

Amun. Primaeval deity and supreme god of the Egyptian pantheon.

andron. (Greek) Room in a Greek house reserved for men, especially for dining.

ansate cross. Egyptian cross with a circle at the top, based on the Egyptian hieroglyphic symbol ankh representing life.

anta (*-ae*). (Latin) *Pilaster* forming the front end of the side wall of a temple. When there are *columns* between the antae the columns are said to be *in antis*.

Anty. Egyptian hawk-god.

Anubis. Egyptian canine-god of cemeteries and embalming.

Aphrodite. (Greek) Goddess of love, beauty and fertility. Equivalent of Roman *Venus*.

Apis bull. Egyptian bull god, living manifestation of *Ptah* of Memphis.

apodyterium (*-a*). (Latin) Changing room of a baths-building.

apse. Recess with semi-circular plan.

apse-shaped niche. Niche of semi-circular plan, often with a *conch* at the top.

arch. Curved structure, originally free-standing and formed by *voussoirs* to bear weight.

arched entablature. *Entablature* vertically curved into a complete semi-circle [146b].

architrave. Lowest member, below the *frieze* and *cornice*, of a classical *entablature* [124].

archivolt. Outer face of an *arch* where it rests directly on columns of classical style and therefore receives the carving and *moulding* appropriate to a classical *architrave*.

Arsinoeion. (Greek) (Latin, *Arsinoeum*) Temple in honour of Arsinoe, in Alexandria the temple in honour of the wife of Ptolemy II Philadelphus.

Artemis. (Greek) Greek goddess who was a virgin and a huntress who presided over women's rites of passage and hunting.

ashlar. Single block of large squared rectangular stones laid in horizontal courses.

Asklepios. (Greek) (Latin, *Asclepius*) Hero and god of healing.

astragal. Small convex *moulding* of half round profile. Often used below an *ovolo* and sometimes decorated with *bead and reel* [626]. Also used around the base of *capitals* or top of a *column* shaft.

Athena. (Greek) Patron goddess of Athens, warrior-goddess and protector of cities.

atrium (*-a*). (Latin) Entrance room in a Roman house, usually with an open roof and rooms opening off it. Also used for a hall, or the colonnaded forecourt of a church.

attic. Plain area above an *entablature* in which a *pediment* may be placed.

attic base. *Base* consisting of a *torus*, *cavetto* and torus [116].

aule (*-ai*). (Greek) Court yard. Also refers to the palace in Alexandria.

Bacchus. (Latin) Equivalent of *Dionysos*.

baptistery. Part of a church or separate building with container for water for baptism.

barrel vault. *Vault* of approximately semi-circular cross-section.

basalt. A dark fine grained igneous rock.

base. Lowest member of a vertical *support* [625].

basic impost capital. Capital tapering from a square at the top to a circle at the bottom.

basilica. (Latin) Long rectangular building with internal colonnades supporting a *clerestory*. Term used for either a hall or church of this plan.

basileia. (pl., Greek) Royal palace.

basket-capital. Capital of approximately hemispherical shape decorated with imitation wicker work.

basket-shaped impost capital. Capital of approximately hemispherical shape with an interlocking pattern covering its whole surface, except the *abacus* [513].

Bastet. Egyptian cat- or lioness-headed war goddess.

bay. Area between two vertical *supports* [625].

bead and reel. Pattern of alternating long and short beads carved in an *astragal* moulding, often below an *ovolo* moulding [626].

bema. (Greek) *Chancel* part of a Greek church. Also a raised platform.

Bes. Egyptian dwarf-god with plumed crown, broad face, beard, and lion's mane over his forehead, plays music.

biblia. (pl., Greek) 'Books', i.e., papyrus scrolls.

birth house. (Arabic *mammisi*) Building in Egyptian temple complex in which the birth of the god was celebrated.

boss. Projection on the *abacus* of a *Corinthian capital* decorated with a flower [127].

boule (*-ai*). (Greek) Town council.

bouleterion (*-a*). (Greek) Council chamber.

breccia. Rock consisting of angular fragments cemented together.

broken forward entablature. *Entablature* which is articulated so that sections of it jut forward, supported by free-standing *columns* or *pilasters*. The jutting forward sections are said to be broken forward, those between are said to be broken back [146c].

broken lintel. Lintel with its middle section missing. Usually found framing the entrance to an Egyptian (outer) *hypostyle hall* [200].

broken pediment. *Pediment* consisting of two half pediments. These may consist of two sections of gabled pediment of single pitch [145b] or with the *cornices* raked towards the back [145c]. The half pediments may have a space between them or be joined at the back by the middle part of the pediment or straight cornices.

Caesareum. (Latin) (Greek, *Kaisareion*) Temple dedicated to a Roman emperor.

caldarium (*-a*). (Latin) hot room(s) in a baths-building.

Canopi. *Osiris* and *Isis*, each with the form of a jar with the god's head on top. *Osiris* in this form was worshipped at Canopus.

capital. Top member of a vertical *support* [625].

cartouche. In Egyptian hieroglyphs a long oval, with a bar at the base, containing the names and titles of rulers.

catacomb. Underground cemetery.

cathedra (*-ae*). (Latin) Arm chair; bishop's chair in a church.

cathedral. Principal church of a diocese, containing the bishop's throne.

cauliculus (*-i*). (Latin) Ribbed sheath on *Corinthian capital* from which *helix* and/or *corner volutes* spring [127].

cavea (*-ae*). (Latin) Auditorium or seating area of a theatre.

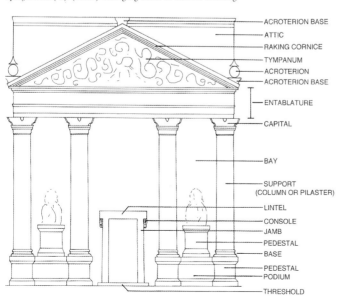

ACROTERION BASE
ATTIC
RAKING CORNICE
TYMPANUM
ACROTERION
ACROTERION BASE
ENTABLATURE
CAPITAL
BAY
SUPPORT (COLUMN OR PILASTER)
LINTEL
CONSOLE
JAMB
PEDESTAL
BASE
PEDESTAL
PODIUM
THRESHOLD

625. Architectural terms

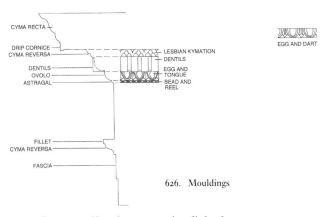

626. Mouldings

cavetto. Concave *moulding* of quarter round profile [200].

cavetto cornice. Large concave *moulding* of quarter round profile. Usually used above a *fascia* and *torus* in an *Egyptian cavetto cornice*.

cella (-ae). (Latin) Central chamber of a temple.

cenotaph. (from Greek for empty tomb). Sepulchral monument for someone not buried there.

centaur. Creature with body and legs of a horse, and torso, arms and head of a man.

Chalcedonian. Pertaining to the Church which accepted the canons of the Council of Chalcedon of AD 451 (unlike the *Monophysite Churches*).

chancel screen. Screen dividing off chancel – the part of the church reserved for clergy.

cherubim. Winged creatures surrounding the throne of god.

church. Public building for Christian worship.

ciborium. Canopied shrine; shrine-shaped container for reservation of the Eucharist.

circus. (Latin) Racecourse for chariot-racing, with a *spina* or central dividing barrier and raked seating with a curve at one and carceres or starting gates at the other end.

clerestory. Upper row of windows above the central row of columns lighting a *basilica*.

codex (-ices) Manuscript book [with pages].

coffering. Design of geometric shapes with recessed centres decorating ceilings or *conches*.

coffin. Container in which a corpse is buried. In Egypt it might be placed in an outer rectangular container, such as a *sarcophagus*.

colonnade. Structure supported by a row of *columns*.

column. Free-standing vertical *support* with circular cross-section.

column drum. One of the cylindrical blocks which constitute a *column*.

composite capital. In Egyptian architecture capitals with different plant forms combined on a single capital [203]. In Greco-Roman architecture capital with its top part *Ionic* (with *Ionic corner volutes*) and its lower part *Corinthian* (with a collar of *acanthus leaves*) [480].

concave entablature. *Entablature* which is curved inwards [146d].

conch. Interior surface of quarter section of a sphere (semi-dome). Used at the top of an *apse-shaped niche*. The *conch* may be decorated with a clam shell or *coffering*.

console. S-shaped bracket, usually occurring as a vertical bracket on either side of a doorway, supporting the cornice [625]. Also used as a horizontal bracket on *modillions* on Roman *cornices* [118].

Coptic Church. Oriental Orthodox (or Monophysite) Church in Egypt which rejected the Christological teaching of the Definition (of the two natures in the incarnate Christ) of the Council of Chalcedon in AD 451.

Corinthian capital. Bell-shaped capital with a collar of acanthus leaves around its base and spirals on the corners [123, 127].

Corinthian order. The order characterized by the use of *Corinthian capitals* which in early Greek examples were used in an otherwise *Ionic order*. The *entablature* became distinctive in Roman architecture [118].

corner volute. Large spiral on the corner of a *Corinthian capital* [123], or on an Ionic corner capital.

cornice. The upper member, above the *architrave* and *frieze*, of a classical *entablature* [124].

corona (-ae). (Latin) Projecting member of a *cornice* [124].

crown moulding. Top *moulding* of a *frieze*, *architrave* or other element.

crypt. In a church, a chamber beneath the main floor, usually for graves or relics.

cubiculum (-a). (Latin) Bedroom.

cubit. Unit of measure, especially used by the Egyptians for measuring land and height of Nile River flood. The Egyptian cubit is *c.* 0.525 m long. The Greek and Roman cubit was divided into 6 palms (24 digits).

cupola. Small dome forming the roof, or part of one, of a structure.

curved entablature. *Entablature* vertically curved into segment of circle or ellipse [146a].

cyma recta. *Moulding* with a double curve profile, concave above and convex below [626].

cyma reversa. *Moulding* with a double curve profile, convex above and concave below [626].

dado. Lower part of a wall when clearly marked off from the upper part, for example by mouldings like those of a *pedestal*.

deme(s). (from demos, Greek) District, and its citizens; used for the smallest political divisions in ancient Greece.

Demeter. The Greek goddess of Corn (Ceres in Italy).

demos. (Greek) Popular assembly of a Greek city.

Demotic. Simplified form of Egyptian hieroglyphic script.

dentils. Small rectangular blocks, usually carved at the base of a *cornice* [626].

destrictarium. (Latin) Room in a baths-building for rubbing down.

Dionysos. (Greek) (Latin, *Dionysus*) Greek god of wine and intoxication, as well as the theatre and of the dead. Adopted by Romans as Bacchus.

diorite. Specific type of dark coarse-grained igneous rock.

Dioskourion. (Greek) Sanctuary of *Dioskouroi*.

Dioskouroi. (Greek) (Latin, *Dioscuri*) Castor and Pollux (Polydeuces), twin sons of Zeus, associated with horses.

dome. Roof covering of hemispherical shape on a circular, polygonal or square base.

Doric capital. *Capital* characteristic of the *Doric order* [93].

Doric frieze. *Frieze* of the *Doric order*, decorated with alternating *triglyphs* and *metopes* [115].

Doric order. Conventional Greek system of *columns* and *entablature* such as on the Parthenon. For the forms, see [115].

dromos (-oi). (Greek) In Egypt a broad avenue or processional way leading to an Egyptian temple.

Dynastic period. Period, from *c.* 2950 BC, during which Egypt was ruled by native pharaohs, before the conquest of Egypt by Alexander the Great in 332 BC.

ebony. Hard black or very dark brown timber.

egg and dart. Decoration on an *ovolo* moulding consisting of egg shapes with a dart, rather than a small wedge, between them [626]. This is the Roman form of *egg and tongue*. Often with a *bead and reel* below.

egg and tongue. Decoration on an *ovolo* moulding consisting of egg shapes with a small wedge between them; Greek. Often with a *bead and reel* below [626].

ekklesia. (Greek) Sovereign assembly of a Greek city. Also, the Church or a church building.

Elpis. (Greek) Personification of hope.

emporium. (Latin) (Greek, *emporion*) Commercial market.

engaged column, half-column. Engaged vertical *support* with semi-circular cross-section.

entablature. Horizontal element of an architectural *order* consisting of an *architrave*, *frieze* and *cornice*, carried by vertical *supports* [124].

epigraphic evidence. Evidence coming from the study of inscriptions (epigraphy).

epigram. Short poem.

epitaph. Inscription on a tomb.

Eros. (Greek) God of love.

exedra (-ae). (Latin) Recess with a semi-circular or rectangular plan, opening its full width into a larger room or space, or a large niche.

facade. Front face of a building. At Petra, building front carved out of living rock.

fascia (-ae). (Latin) Long large flat band. An *architrave* may be decorated with one, two or three fasciae [124]. Fasciae may also be used on the *jambs* and *lintel* of a doorway.

fillet. Small flat *moulding* [626].

First Style Roman wall-painting. The style of wall-painting consisting of the imitation in low relief stucco of a masonry wall with *orthostats* and *ashlars* positioned on the wall above a *dado*.

flat grooved modillion. Narrow flat bracket with a groove down the centre on the underside (*soffit*) of the *corona* of a *cornice*, e.g. [117]. They may alternate with *square hollow modillions*, or have a diamond shape or rosettes between them.

flutes, fluting. The concave vertical grooves decorating a *column* or *pilaster* [127].

fold-capital. Sometimes called 'melon capital'. Capital consisting of eight large lobes tapering to the base of the capital [579].

foot. One Greek foot equals *c.* 0.27 to 0.35 m; one Ptolemaic foot, 0.35 m; one Roman foot *c.* 0.296 m.

Fourth Style Roman wall-painting. The style of wall-painting conceptually similar to the *Third Style*, but with complex variations so that scholars have traditionally divided them into two separate styles.

frieze. The middle member, between the *architrave* and cornice, of a classical *entablature* [124].

frigidarium. (Latin) Cold room in a baths-building.

Gaia. (Greek) The goddess Earth.

Gaianite. Followers of Gaianus, rival patriarch of Alexandria in AD 537, who believed the flesh of Christ was incorruptible by nature. They continued with their own bishops into the seventh century.

granite. Broad class of granular crystalline igneous rocks.

greywacke. Any coarse grained dark sandstone containing angular fragments in a fine grained matrix.

griffin. Mythical creature with the body of a lion and the head and wings of an eagle.

groin vault. Vault created, over a square, by two intersecting *barrel vaults* of equal size.

gutta (-ae). (Latin) Small cone-shaped block, six of which decorate the underside of a *regula* on a *Doric architrave* [115]. They also decorate the *mutules*.

Gymnasium (-a). (Latin) (Greek, *gymnasion*) Greek place for exercise. In Hellenistic and Roman periods they also functioned as schools. Later merged with Roman baths-buildings, to which the term was applied.

Hades. (Greek) King of the Underworld; husband of *Persephone*.

Hadraneion. (Greek) Temple in honour of the Roman emperor Hadrian.

haikal. Sanctuary of a Coptic Church.

half-column, engaged column. Engaged vertical *support* with semi-circular cross-section.

half-pediment. See *broken pediment*.

Harpokrates. Egyptian god 'Horus the child.' Depicted as a young child with his forefinger in his mouth and a side lock. Child of Isis and Osiris.

Hathor. Universal Egyptian cow goddess, symbolic mother of the pharaoh.

heart-shaped pier. Pier with heart-shaped cross-section formed by engaging to a pier two *half-columns* at right angles to each other.

Helios. (Greek) The sun god.

helix (-ices). (Greek) Spirals on the face, between the *corner volutes*, of a *Corinthian capital* [123].

Heptastadium. (Latin) (Greek, *heptastadion*) The seven *stade* long causeway in Alexandria joining the island of Pharos with the mainland.

Herakles. (Greek) (Latin, *Hercules*) Greek hero who performed twelve labours. Identified by his equipment of lion skin, club and bow.

Hermanubis. Anubis, in Ptolemaic and Roman periods, associated with *Hermes* reflecting the relationship between Anubis and *Thoth.*

Hermaion. (Greek) Sanctuary of the Greek God *Hermes.*

Hermes. (Greek) Messenger god and guide. Identified by caduceus (the herald's sign with facing snakes), traveller's hat (sometimes with wings) and winged sandals.

hieroglyphics. Writing, especially used by ancient Egyptians, representing figures of objects directly or figuratively representing syllables and words.

hieron (-a). (Greek) Sanctuary or temple.

hippodrome. (from Greek *hippodromos*) Racecourse for horse racing or chariot races.

hollow pediment, open-based pediment. A pediment which lacks a continuous *entablature,* i.e., with the middle vertical section of the entablature missing [145d].

Homerion. (Greek) Sanctuary in honour of the Greek poet Homer.

horizontal arch dam. Dam formed by placing an arch across a river against its flow.

Horus. Egyptian hawk-headed or hawk-god, lord of the sky and symbol of divine kingship. The king was the living Horus under the throne of Egypt.

hypogeum (-a). (Latin) Underground tomb with one or more chambers.

hypostyle hall. Columned hall at front of an Egyptian temple. If there are two of these halls the inner one is the inner hypostyle hall, and the outer hypostyle hall is the one at the front which also is usually taller [200].

impost. Block placed between the *capital* of a *column* and the arches it supports.

impost capital. Late Antique capital consisting of a tapering drum, sometimes of approximately hemispherical shape, and sometimes square at the top tapering to circular at the base. They can have a variety of decoration. Types include *basic impost capital, basket-capital, basket-shaped impost capital, fold-capital, leaf-capital,* and *lotus-panel impost capital* .

Ionic capital. Capital characteristic of the *Ionic order.* For shape, see [92, 116].

Ionic impost capital. Impost capital with Ionic volutes below the *impost* ([418] right hand capital).

Ionic order. Conventional system of *columns* and *entablature* used originally in Asia Minor and the nearby islands. For the forms, see [116].

Isis. Egyptian goddess with immense magical power, wife of *Osiris,* symbolic mother of the king, and mother of *Horus.*

Jacobites. Adherents of the Syrian Orthodox Church (one of the Oriental Orthodox or Monophysite Churches) which emerged as a separate Church after the Council of Chalcedon in AD 451.

jamb. Vertical member on either side of a doorway supporting the *lintel* [625].

Kaisareion. (Greek) (Latin, *Caesareum*) Temple dedicated to a Roman emperor.

katoikos (-oi). (Greek) Greek soldier settler.

key-stone. Top centre *voussoir* of an arch.

Khnum. Egyptian ram-god; creator of life on the potter's wheel.

khurus. Room in a Coptic Church between the *sanctuary* and the *nave.*

kiosk. In an Egyptian temple complex a bark station or processional resting place for the god's bark or boat.

kline (-ai). (Greek) Couch, used for reclining on while dining, also in burial chambers.

komasterion (-a). (Greek) Procession house of a temple in Egypt.

Kore. (Greek) The goddess Persephone, daughter of *Demeter* and wife of *Hades.* Her attributes include torches, grain and sceptres.

Koreion. (Greek) Sanctuary of *Kore.*

Kronos. (Greek) (Latin, *Cronus*) Youngest of Titans, from whom Olympian gods born.

Lageion. (Greek) Racecourse in Alexandria, named after Lagos, father of Ptolemy I.

leaf-capital. Late Antique capital with tapering circular drum covered with leaves, and a plain *abacus* [501].

lesbian kymation. Decoration carved on a *cyma reversa* usually consisting of a heart-shaped leaf in a grooved casing, alternating with tongues or darts [626].

Leto. (Greek) Titianess who was the mother of Apollo and Artemis.

Letoon. (Greek) Sanctuary of *Leto.*

lintel. Horizontal beam across the top of a doorway [625].

loculus (-i). (Latin) Long recess cut in tomb chamber in which to place the body; sometimes with shelves, or with one or more graves carved into the floor.

loculus slab. Flat, rectangular covering stone for a *loculus.*

lotus. Blue, white and pink water lilies which grew in the Nile River in antiquity.

lotus-panel impost capital. Impost capital of the basic type covered with carved basket weaving with a panel, with a lotus motif, on each of its four sides [571].

ma'at. Ancient Egyptian word for world order, justice and harmony, referring to the ideal state of the universe and society.

macellum (-a). (Latin) Market building for provisions.

maenad. Woman inspired by ecstatic frenzy of *Dionysos.*

mammisi. See *birth house.*

martyrium (-a). (Latin) Church in honour of a martyr, usually containing his/her tomb or relics.

mausoleum (-a). (Latin) Tomb of Mausolus at Halicarnassus; large monumental tomb.

mechanikos (-oi). (Greek) Architect and/or engineer.

Medusa. (Latin) Gorgon in Greek mythology with snakes for hair and a gaze which turned the beholder to stone.

Melkites. Christians in Syria and Egypt who accepted the Definition of Faith of the Council of Chalcedon of AD 451, unlike the *Monophysites.*

Mercurium. (Latin) Temple of Mercury, Roman god identified with Greek *Hermes.*

metope. (Greek) Plain or decorated panel between the *triglyphs* on a *Doric frieze* [115].

metropolis (-eis). (Greek) 'Mother city' used for the forty or so regional capitals of Egypt in the Ptolemaic and Roman periods.

Mithraeum (-a). (Latin) Temple of *Mithras,* an Indo-Iranian deity adopted by the Romans as a sun god and 'bull-killer'.

mixed order. Architectural *order* consisting of a combination of elements from different orders, *Doric, Ionic* and *Corinthian,* usually with Corinthian capitals, a Doric frieze and an Ionic cornice.

modillion. Bracket on the underside *(soffit)* of the *corona* of a *cornice.* Some writers refer to modillions as *consoles* [117–118].

Monophysite. Pertaining to the Churches which accepted the doctrine that there is only one, not two, natures in the Incarnate Christ; i.e., those who rejected the canons of the Council of Chalcedon of AD 451.

Montu. Egyptian hawk-headed war god of area of Luxor (Thebes).

moulding. Continuous profile given to the edge of an architectural member.

Museum. (Latin) (Greek, *Mouseion*) The famous academic institution in Alexandria named after its dedication to the Muses, the goddesses who provided inspiration to scholars.

mutule. Small slab carved on the underside of a *Doric cornice,* one above each *triglyph* and each *metope* [115]. They are usually decorated with *guttae.*

Nabataean. Pertaining to the kingdom in modern Jordan, northern Saudi Arabia and southern Syria of which the capital was Petra ruled by kings from the third century BC until AD 106, when it became a Roman province.

naos (-oi). (Greek) Temple, i.e., building containing a cult statue. Also used for a church, especially if it contained the bones of a saint.

narthex. (Greek) Vestibule (entry hall) of a church, usually located across its west end.

nave. Main part of the church for the laity, as opposed to the *sanctuary.*

necking band. Band, sometimes decorated, around the base of a *capital,* or the top of a *column* or *pilaster.*

Nemesis. (Greek) Goddess of retribution.

nereid. A sea nymph (semi-divine spirit perceived as a young woman).

niche head. Single carved block forming the top of a niche (recess) with either semi-circular or rectangular plan.

Nilometer. A well with measurements marked on it, or a measuring stick, for measuring the height of the annual flood of the Nile River.

Nilus. (Latin) The Nile River.

nome. Egyptian administrative district in the *Dynastic period.*

Novatian. Member of the Novatianist Church (followers of Novatian, a Roman presbyter martyred in AD 257–8), which was a schism rigorously against those who had compromised with paganism and, although doctrinally orthodox, its members were excommunicated.

nymphaeum (-aea). (Latin) (Greek, *nympheion,* meaning shrine to the Nymphs) Public fountain house.

obelisk. Tapering stone pillar with four flat sides and a pyramidal top.

odeion. (Greek) (Latin, *odeum*) Small roofed building with raked seating, for musical concerts and recitations.

oecus (-i). (Latin) Saloon; large room.

opus africanum. Masonry, common in North Africa, with framework of large rectangular stone uprights and horizontals, with panels of lighter masonry.

opus sectile. Paving or wall veneer of coloured stone tiles.

oracle. Agent or means by which the gods could speak or prophesy.

oratory. From Latin for place of prayer. In antiquity churches and private chapels.

orchestra. (Latin) Semicircular space in front of the stage of a theatre.

order. The total assemblage (distinctively *Doric, Ionic, Corinthian* or *Mixed*) of architectural members comprising vertical *support* and its appropriate *entablature.*

orthostat. Very large upright slab of stone used on the lower course of a wall.

Osiris. Egyptian god of the Underworld, represented in human form with his body in mummy bandages holding a sceptre and flagellum. Wears the Atef' crown which has plumes and rams horns at its base.

Osiris of Canopus. Osiris as worshipped at Canopus. This Osiris took the form of a jar with the god's head (with crown) on top.

ossuary. Container for bones of the dead.

ovolo. Convex *moulding* of quarter round or quarter ellipse profile receding downwards. Often decorated with *egg and dart* or *egg and tongue* [626].

palaestra. (Latin) Colonnaded court used for athletic exercise, surrounded by changing rooms etc. Originally a wrestling ground.

palm capital. Capital decorated with palm leaves. The details of the fronds were sometimes painted [517], and now often no longer visible making the capitals plain.

papyri. Fragments of (or complete) *papyrus* 'books' (either scrolls or *codices*) or of single sheets (documents, letters, etc.).

papyriform column. Egyptian column shaped like papyrus with closed heads plant [201a].

papyrus. 'Paper' made in Egypt from the marsh plant (Cyperus papyrus) which was the main writing material of the Graeco-Roman world.

Parian marble. White marble from Greek island of Paros.

pedestal. Platform on which a statue or *column* stands.

pediment. The part (originally triangular in shape) crowning the front of a building, especially the entrance porch. Also used to decorate niches or doorways.

pedion. (Greek) Area of flat land or plain (like Campus Martius, the Field of Mars in Rome).

pendentive dome. These are of two types. A 'dome with continuous pendentives' results when a section of a sphere is placed over a square base whose diagonal is the same length as the diameter of the sphere [541]. A 'dome on pendentives' is formed when a dome is placed on a square base on a circle or ring with the same diameter as the lengths of the sides of the square [542].

pendentives. The concave triangles on a spherical surface enabling the transition from a building of square or polygonal plan to a circular dome [542].

peridot. A green gemstone.

peribolos. (Greek) Enclosure.

peristyle. Open court or garden with a *colonnade* around it. Also, the colonnade around the outside of a building.

Persephone. See *Kore*.

Petbe. Egyptian personification of retribution, in Ptolemaic, Roman, and later periods.

pier. Free-standing vertical *support* with square or rectangular cross-section.

pilaster. Engaged vertical *support* with a rectangular, rather than semi-circular, cross-section. Unlike a *pillar*, it has a *Doric*, *Ionic*, or *Corinthian capital* or their derivative.

pillar. Engaged, usually narrow, vertical *support* of flat rectangular cross-section crowned by a *moulding*, unlike a *pilaster* (which is crowned by a *Doric*, *Ionic*, or *Corinthian capital* or their derivative).

pitched-brick vaulting. Vault formed by the use of bricks set on edge with their long axis running across the vault, not along it, and not requiring the use of a wooden frame (centering) [577]. Also used in domes by the bricks being placed round the dome, pitched on their sides, in a spiral of ever decreasing radius [578].

plateia. (Greek) Wide street or avenue. Used for main east-west street of Alexandria.

plethron. (Greek) (*plethrum*, Latin) Unit of length of 100 ancient feet.

plinth. Lower square member on which a *column base* stands.

podium (*-a*). (Latin) Platform supporting *columns* or *pilasters*, usually decorated with *mouldings* along the top and bottom.

polis (*-eis*). (Greek) city. Used as a technical term for Greek city or state which was the characteristic form of Greek urban life, with political autonomy.

Pompeian wall-painting. See *First*, *Second*, *Third* and *Fourth Style Roman wall-painting*.

Pontifex Maximus. (Latin) Roman 'High Priest', the position of most prominent and influential priest held by the Roman emperors from Augustus until Gratian.

porphyry. Hard purple stone quarried in ancient Egypt.

Poseidon. Greek god of earthquakes and of water, prominent as a sea god, carries a trident.

pozzolana. Volcanic ash of central Italy used as a hardening agent in Roman concrete, which could set under water.

prefect. Civil governor of a Roman province or city.

presbyter. In early Church, one of a group of people overseeing affairs of a local church.

Proconnessian marble. Marble from the Greek island of Proconnesus (Map 4).

pronaos. (Greek) Vestibule or porch of a temple.

propylon. (Greek) Entry gate or porch to a monumental building.

prytaneion. (Greek) Town hall.

Ptah. Egyptian creator god of Memphis, found throughout Egypt. Represented in anthropomorphic form with a tightly fitting cap.

ptera. Greek for 'wings', used for *pylon* of Egyptian temple.

pylon. On Egyptian temple monumental gateway with inward sloping faces [40].

quadriga (*-ae*). (Latin) Four horse chariot.

quarter column. Engaged support consisting of a quarter of a *column*.

raking cornice. The sloping *cornice* on a *triangular pediment* [625].

register. One of the bands into which a wall decoration is divided.

regula (*-ae*). (Latin) Small projecting bar below the *taenia* on a *Doric architrave*. There is one below each *triglyph*, and usually decorated with *guttae* [115].

relieving arch. Arch incorporated within the masonry of a wall to distribute the load over a particular point.

ridge beam. Beam along the top of a pitched roof.

rinceaux. Scroll-like patterns of flowers and vegetal tendrils. Often on frieze.

rotunda. Building or room with a circular plan.

Saite period. Period of twenty-sixth dynasty of the kings of Egypt, 664–525 BC.

sanctuary. Part of the church (usually at the east end) which contained the altar.

saqiya. Water-lifting device involving a chain of pots or a wheel turned by a geared wheel at right angles to it, powered by one or two oxen.

sarcophagus. Stone coffin.

Sassanian. Pertaining to, or characteristic of, the period when the Sassanian kings ruled Persia, AD 224–651.

Saturn. Roman god of agriculture, identified with Greek *Kronos*.

Sc(a)enae frons (pl. *scenae frontes*). (Latin) Facade of the stage-building (*scena*) of a Roman theatre.

'Scherwand'. (German 'shorn wall') Screen wall depicted in *Second Style Roman wall-painting* above which an architectural vista is sometimes depicted.

scolion (*-a*). (Greek) Marginal note in an ancient manuscript.

screen wall. Wall between columns which is only about half (or sometimes two-thirds) their height, especially on front of Ptolemaic and Roman Egyptian style temples.

Sebasteion. (Greek) (Latin, *Sebasteum*) Temple of Sebastos, i.e., the Roman emperor Augustus.

Second Style Roman wall-painting. Style of wall-painting involving realistic depiction of architectural scenes, frequently with space beyond wall indicated in blue.

segmental pediment. Pediment with the *raking cornices* replaced by a segment of a circle or ellipse [145a].

Seleucid. Pertaining to the Seleucid dynasty which ruled Syria, 312–65 BC.

Sema. (Greek) Enclosure in Alexandria for tombs of Alexander and Ptolemies.

semi-dome. *Vault* consisting of a quarter section of a sphere.

Serapeum. (Latin) (Greek, *Serapeion*) Sanctuary of *Serapis*.

Serapis. (Latin) (Greek, *Sarapis*) Graeco-Roman Egyptian god of Greek appearance (a draped figure with a beard, a bushel on his head and holding a sceptre), apparently derived from Osiris-Apis, the Egyptian Lord of the Underworld. He was also identified with Pluton or Hades, was responsible for the annual Nile flood and the grain supply. He had aspects of Zeus and was assimilated with Helios.

shaduf. (Arabic) Device consisting of a pole with a bucket at one end and a counterweight at the other used in Egypt for lifting water.

shaft. The part of a vertical *support* (*column* or *pilaster*) between the *base* and *capital*.

sima. (Latin) Crown (top) *moulding* of a *cornice*.

Sobek. Egyptian crocodile- or crocodile-headed-god.

sockle. Lower part of a wall.

soffit. Visible underside a horizontal member, such as the *corona* of a *cornice* [124] or a *lintel*.

sphinx (*-es*) Creature with a human head and a lion's body.

spina. (Latin) Central dividing barrier or spine of a *circus*.

square hollow modillion. Square with a recessed centre on the underside (*soffit*) of the *corona* of a *cornice* [117]. They may alternate with *flat grooved modillions*. They are distinctively Alexandrian.

squinch. Arched structure across the corner of a square room to form the side of an octagon to support an octagonal vault or the spring for a dome.

stade. Unit length of 600 ancient feet.

stadium (*-ia*). (Latin) (Greek, *stadion*) race track usually one *stade* long for athletic games and foot-racing.

stele (*-ai*). (Greek) Upright slab, usually of stone, decorated with inscriptions and/or reliefs.

string course. Single horizontal course of a wall consisting of wooden beams Also course of exceptionally long *ashlars*. Usually not as high as the other courses.

stoa. (Greek) Colonnaded portico, covered hall with its roof supported by one or two rows of columns parallel to the rear wall.

stylobate. Course of masonry at ground level, on which a row of columns is placed.

sudatorium. (Latin) Room in baths-building for steam bath.

support. The vertical member of an architectural *order* or structure which carries the *entablature* or *architrave* [625]. These may be divided into *columns* or *piers* if freestanding, or *engaged columns* or *pilasters* if engaged.

Syrian pediment. *Pediment* consisting of a *triangular pediment* with an *arched entablature* in place of a continuous horizontal *entablature* [145e].

taenia (*-ae*). The flat band projecting along the top of a *Doric architrave* [115].

temenos (*-oi*). (Greek) Precinct or sacred enclosure.

tepidarium. (Latin) Warm room in baths-building.

terminus post quem. Latin for 'date after which.' Used as a technical term to denote that there is a fixed date after which something must be dated.

tessera (*-ae*). (Latin) Small stone or glass cube from which mosaics are made.

tetraconch. Centrally designed building consisting of four parts, each with a semi-circular plan.

tetrapylon (*-a*). (Greek) Monumental arch-like structure straddling the intersection of two streets.

tetrastylon (*-a*). (Greek) Set of four columns, usually placed at street intersection.

theatre. Large un-roofed building with raked seating of approximately semi-circular plan and a stage building.

Theoi Adelphoi. (Greek) The 'sibling gods', the deified Ptolemy II Philadelphus and his wife Arsinoe I.

Theoi Euergetai. (Greek) The 'benefactor gods', the deified Ptolemy III Euergetes I and his wife Berenice II.

Thesmophoreion. (Greek) Sanctuary of *Demeter* and *Kore* (Persephone).

Third Style Roman wall-painting. The style of wall-painting involving the treatment of the wall as a purely decorative surface with no attempt at the depiction of real architecture. Architectural motifs are reduced to linear decoration used to sub-divide the wall. The paintings may include gardens with a lattice fence, or Egyptian motifs.

tholos (*-oi*). (Greek) Circular columnar structure or circular room.

Thoth. Egyptian ibis- or baboon-headed moon god of writing, scribes and knowledge, with a crown of a crescent moon and full moon disk. His major cult centre was at el-Ashmunein (Hermopolis Magna).

torus (*-i*). (Latin) Large convex *moulding* of half round profile. Also on *attic base*.

transept basilica. Church with cross-shaped plan.

transverse aisle. Aisle formed by a colonnade across the west end of a *basilica*. Common in Egyptian basilical churches.

triangular pediment. Triangular part originally crowning the front of a building, especially the portico [144]. Also used to decorate niches or doorways.

triclinium (*-a*). (Latin) Room with benches around three sides, on which to recline while dining.

triconch. Structure or part of a building, consisting of three joining parts of semi-circular plan.

triglyph. Grooved panel alternating with *metopes* on a *Doric frieze* [115].

two-zone capital. *Impost capital* with two distinct halves, an upper and a lower one, e.g., with animals protruding from a basket.

Tyche. (Greek) Goddess of fortune. She also served as a city goddess.

Tycheion. (Greek) Temple of fortune (*Tyche*).

tympanum (*-a*). (Latin) Central part of a *pediment* bounded by the *raking* (or curved) *cornices* and the top of a *entablature* [625].

Type I Alexandrian capital. *Corinthian capital* with the *helices* springing from directly beside the *corner volutes* and facing each other [125a].

Type II Alexandrian capital. *Corinthian capital* with the *helices* back to back, facing away from each other, and springing together from the collar of acanthus leaves [125b].

Type III Alexandrian capital. *Corinthian capital* with the *helices* back to back, facing away from each other springing from beside the *corner volutes* [125c].

Type IV Alexandrian capital. *Capital* with a small leaf under the *corner volutes* which curl back on themselves into two spirals back to back [126].

Umayyad. Pertaining to the caliphate which ruled the Islamic world AD 661–750.

vault. Continuous arch; vertically curved roof. Usually of brick, stone or concrete.

Venus. (Latin) Roman goddess of beauty and love.

volute pediment. *Pediment* formed by two S-shaped curves or volutes [145f].

voussoir. Wedge-shaped stone block which forms an *arch*.

Zeus. Chief god of the ancient Greeks, equivalent of Roman Jupiter.

Index

Numbers in *italic* refer to pages on which illustrations occur. References to the Notes are only given where a reading of the text will not lead directly to a subject under discussion in the Note. Such references are given to the page on which the Note occurs, followed by the number of the note. Thus 390n14 indicates page 390 note 14. Locations and buildings etc. in Alexandria are indexed under 'Alexandria'. Ancient authors and sources can be found in the index of them on p. 458–9.

Locations of other sites can be found on the maps on p. xvi–xx. Dates of emperors and patriarchs are given in the chronological tables on p. xiv–xv. Architectural terms and gods etc. can be found in the glossary on p. 457–8.

Aachen 367
Abd al-Aziz 358
Abd al-Latif 9
Abd al-Malik 356–7, 358, 362
Abd ar-Rahman 362
Abila, church 416n118
Abu l-Fida 24, 25
Abu l-Makarim 257
Abu Mina 288–95, *292*, 316; capitals *290*, 293, *315*; colonnaded street *292*, 293; East Church 233, 290, 293–5, *294*, 319, 321; Eastern Court 293; Great Basilica 247, 262, *289*, 290–3, 295, 416n115; House with portico 295, *295*; Large Double Bath 293; North Basilica 290, 293–5, *294*, 321; North Baths ('Palace') 293, 295; Peristyle Complex 293; 'Pilgrims' Court' 293; semi-circular plaza 293; Tomb/Martyr Church and baptistery *289*, 290–3, *291*, 295, 425n117
Abu Salih 417n162
Abuqir, see Canopus
Abusir, see Taposiris Magna
Abydos 275
Achillas, patriarch 406n18
Achilles Tatius 188
Achilles temple 163
Acre, see Akko
Actium, battle of 78, 148
Adonis, festival 49
Aezani, stadium 204
Agathias 253, 327
Agathocles 67
Agathon, patriarch 411n166
agoras 68, 148, 152, 158, 164; see Alexandria
Akhmim, see Panopolis
Akko (Acre) 338
Akoris (Tihna el-Gebel); Serapis sanctuary propylon 398n80; tetrapylon *225*, 227
Akragas 382n36; Zeus temple 391n36
alabaster 71, 75, 74
Alacahisar, church 283
Alahan 334
al-Bagawat, funerary chapel 270
alchemists 214; alchemy 426n34
Alexander IV 40
Alexander Severus 154, 170; temple 158
Alexander the Great 32, 37–9, 40, 49, 122, 148, 179, 244, 255; funeral wagon 40; priest of 52; Tomb of, see Alexandria
Alexander, patriarch 242

Alexandria

agora 39, 41, 47–8, *66*, 74, 149, 182, 244, 255; 408n46, 409n105; Sebaste 177; see Forum
akra, see citadel
akra Lochias (el-Silsila) 12, 13, 18, 26, 37, 49, 66, 68, 69, 71, 76, 77, 175
Alabaster Tomb *26*, 28, 74
Alexander; Altar 39, 188; place of 188; Tomb (Sema) 8, 34, 40, 64–5, 74, 75, 119, 149, 173, *174*, 175, 184, 185, 205, 220, 259, its destruction 244
American Cultural Centre 389n247, 400n32e
amphitheatre 149, 182, 244
Anfoushy *26*, 29, 192; Hypogeum 5 402n124f; Tomb 2 *63*, 71, 93, 116
Anotinos pandotos, Island 180
Anti(r)rhodos 37, 45, 46, 175, 177, 180, 184
Antoniadis Garden *26*, 29, 192; tomb 193, 413n33
Arab city 8, 9, *11*, 16, 256–8, 412n174; walls 9, *10*, *11–13*, *15*, 16, *19*, 25, *192*, 254, *255*, 380n43, 399n17

Alexandria (cont.)

Arab descriptions 9, 24, 150, 214, 257, 258, 246; of lighthouse 42, *44–5*; 184
banqueting tent of Ptolemy II 33, 49, 74
basilica, public 407n40
baths 181, 182, 218, 205, 220, 249–50, 256, 400n32e; Cure (Isis), Diocletian, Health (Hygeia), Heptabizos 250; Kantharos 249; Koreion 250; Severium 205, 220; Trajan 250; see Kom el-Dikka
Bendideion 180, 407n44
Bibliotheca Alexandrina 17, *18*, 26, 44, *47*, 69, 69, 389n249
Billardo Pallace 17, 389n247, 403n159
Boukolou 240, 242
British Consulate grounds 17, *18*
Broucheion (Brucheion) 209, 244, 326
Bull's horn 41
Caesareum 4, 15, *17*, 18, 20, 23, 30, 48, 78, 149, 173, 175, 177–8, *178*, 180, 181, 187, 188, 209, 220, 236, 389n247, 401n76; temple of marble Venus 177; see Cleopatra's Needles; churches
Canal of Alexandria (Mahmudiya Canal) *15*, 16, *19*, 24–5, *25*, 26, *33*, *36*, 58, 77, 220, 250, 254; no eastern branch 25
Canal; of Augustus 179; New 180; Pidriakôn 254
canals, see also water channels
Catechetical School 237
cathedral; see churches, Angelion, Caesareum, St Sabas, Theonas
Cecil Hotel 8
cemeteries 16, 27–9, 34; Christian *236*, 237–8, 240, 255; Ptolemaic *26*, 71–4; Roman *26*, 176, 192–4
Chantier Finney 17, *18*, 66; building 23, 71, 81, *81*, 86–7, 89, 95, 103, 134; mosaics 69, *69*
churches 231–59; Alexander 407n25, 409n97; Angelion 251, 254, 255, 256, *257*, 409n105; Annianos 244; Annunciation 411n171; Arcadia 246, 248; Athanasius 242–4, 248, 255, 256, 424n58; Baukalis 242, 244; built by Mother Theodora 244; Caesareum (St Michael) 240, 242, 244, 248, 249, 250, 255, 257, 258, 259, 409n97, 411n165; Cosmas and Damian (Honorius) 246, 247, 251, 254, 255, 259; Elisha (bones) 246; Evangelium 257; Kyrinos (Cyrinus) 231, 242, 250; Mary (Theotokos) Dorothea 255; Mary east of the city 247; Saviour 411n173; Three Young Men 247; Dionysius 233, 242, 244, 248, 295, 321; in Dionysos temple 245, 247, 248, 259, 315; Dizya, 244; in 'Hadrianon' 242; Honorius, see Cosmas and Damian; Mendidion 244; Pereos (Peraios) 408n48; Persaia 244; Peter I 247, 251, 406n21; Pierios and Isidore 244; Raphael 247; St Antony (bones) 232, 253, 409n82; St Epimachus (bones) 232, 253; St Faustus 253, 255; St George 249, 255; St John the Baptist 9, 246, 248, 250, 254, 256, 257, 287, 319, 357; St Julian outside city 254; St Mark 240–2, 248, 254, 256, 409n105; St Metra 255; St Michael, see Caesareum; St Sabas 218, *236*, 256, 257–8, 255; St Sarapammon 251, 255; St Sophia 255; St Theodore 255; St Victor 251, 255; Serapion 244; Theodosius 255; Theodosius I 246, 248; Theodosius II 249, 255; Theonas (Virgin Mary) 8, 16, *236*, 240, *241*, 242, 244, 248, 255, 256, 258, 259
circus, see Lageion

Alexandria (cont.)

cisterns 13, 24–5, *25*, 30, 39, 77, 173, *208*, 214–17, *218–19*, 220, 250
citadel (*akra*) 39, 49, 66, 195, 199–200, 206
city plans; before Alexander *36*; Keipert's *15*, 20; Late Antique *21*, *236*; Mahmoud-Bey's *19*; Ptolemaic *21*, *28*, *36*, *38*; Roman *29*, *36*, *175*; Strabo *174*; see streets
city walls 9, *9*, 13, 16, 18, 20, *21*, 25–8, *26*, 28, 30, 32, 38, 39, 40–1, 66, 71, 74, 76, 179, 181, 209, 244, 252, 254, 389n253; location of eastern wall 28, 78, 254; see Arab city walls
Claudeium 149, 184, 220
Cleopatra, suburb *26*, 28–9, 192
Cleopatra; Needles 8, *13*, 15, 16, *17*, 23, 25, 26, *51–2*, 69, 78, 149, 166, *176–8*, 177, 232, 242, 257; palace 75–6, 78; Tomb 78
Copron *15*
Corniche 16
council house (*bouleuterion*) 210, 220
Cricket Ground 17, *18*, 69, 400n39a
Delta quarter 180, 406n19, 407n45
Diocletian's Column (Pompey's Pillar) *8*, 8, 9, *12*, *15*, 23, 149, 193, 195, 198, 200–1, *203*, 205, 209, *242–3*, 246
diolkos 184
Dioskourides block 50, *50*
dockyards 48, 51, 52, 64, 75, 76, 77; dock near Serapeum 68; dry dock and slipway 64
drains, see sewers
dromos 190, 255; see main east-west street
dromos of the Great God Serapis 39
Eleusis 41, 67, *176*, 187, *190*, 387n169
Emporium 48, 52, 173, 175, 407n28
Eurylochou 187, *190*
Eutycheum 244
Ezbet el-Mahlouf *26*
floating palace (river boat) of Ptolemy IV 34, 61, 62–4, 74, 129
Fort Qait Bey *8*, *11*, 16, 18, 42, *44*
Fort Saleh, see Gabbari
Forum 18, 48, 51, 79, 177–8, *178*, *236*, 407n36; Augusti 149, 177, 220; Julium (in Alexandria or Nikopolis) *78–9*, 79, 177, 185
fountain houses 74, 149, 173, 184, 186, 190, *192*; of Arsinoe 61–2, *61*, 64
Gabbari *26*, 29, 71–4, *74*, 192–3, *236*, 238; Fort Saleh 389n254, 402n124a; Tomb 1 193; Tomb VII *239*; Tomb IX *74*; Thiersch's Hypogeum 2 *92*, 93, 116; Trier Tomb 3 *88*
garrison 67
gates; Canopic 66, 78, 175, *176*; eastern 78, 254; Moon 188, *190*, *236*; monumental 184; Rosetta *11*, *13*, *15*, 16, 190, *192*, *236*, 254, 255; Sun 188, 190, 232, 244, 255, 411n141; on street R1 26, *66*; see city walls
granaries 77, 180
Great Atrium 182
Great Court (peristyle) 66, 67
groves 75
gymnasia 34, 67, 74, 77, 79, 80, 149, 175, 205, 214, 220, 242; 403n158, 410n117
Habachi Tomb A *26*, 193
Hadra *26*, 27, 28, 68, 71, 193, *236*, 238, 358, 399n9; capitals *86*; 'stele of Helixo' 109; tomb of Stephanos 108, *109*
Hadrianeion 149, 184, 220
'Hadrianon' 185, *185*, 242, 244
Hadrianos quarter 180

INDEX OF ANCIENT AUTHORS AND SOURCES

The number of the chapter and the note are given: **ch3 n5** means chapter 3 note 5. Full citations of editions of Byzantine authors or papyri can be found in the list of abbreviations or the note, as applicable (see Notes for the Reader on p. xiii). Not all inscriptions cited appear below, so that sometimes it may be necessary to look for them under the relevant monument in the main index. Arab authors (except Severus, below) can be found in the main index.

Acknowledgements

To structure such a diverse body of often fragmentary evidence into a single coherent volume, while also retaining a clear argument within each chapter was very difficult. This has benefited greatly from the unstinting help of Roger Moorey. Jim Coulton read chapters 1–10, 12 and 14 and his architectural expertise has tightened up some of the arguments, as well as saving me from some errors, as did Zsolt Kiss and Alan Bowman who read all chapters. My mother also waded through various drafts. It was only possible to treat such a diverse range of fields in which I did not always have expertise, because other scholars who were more expert in them kindly agreed to read specific chapters, for which I am very grateful. I hope I have incorporated their comments accurately. Martina Minas corrected two drafts of the chapter on the Egyptian style temples, about which John Baines answered innumerable questions. Donald Bailey read the Roman and Late Antique chapters. Andres Reyes did much work providing more precise translations of texts, especially in the chapter on the written sources for church building in Alexandria. John Wilkinson provided many useful suggestions for it. It was read by Elizabeth Jeffreys and Alan Bowman, who saved me from mistakes. Henry Chadwick kindly read it and the chapter on the Egyptian churches, as did Peter Grossmann who provided his latest thoughts on them, and permission to reproduce his plans. Jim Coulton made many improvements to the chapter on the Alexandrian mathematicians and *mechanikoi* which Serafina Cuomo kindly read. Hugh McKenzie gave help with scientific terms. Sebastian Brock kindly read chapter 14 and Julian Raby read chapters 5, 13 and 14. Jonathan Bardill kindly corrected the sections on St Polyeuktos, and David Blackman those on the harbours, while Helen Whitehouse and Roger Ling read those concerning Roman wall-painting. I am grateful to Cyril Mango for very fruitful discussion concerning the relationship of the architecture of Alexandria to that of Constantinople; and to Oleg Grabar for crystallizing the role of Alexandria in the East. Zsolt Kiss has sent me innumerable Polish publications over the years, while his jazz record collection increased.

Other colleagues have answered my questions on specific details, or provided other help, and I apologize to any I have forgotten to mention in a project taking so long. They include: Mostafa El-Abbadi, Jane Armstrong, Susanne Bangert, Richard Beacham, Dominique Bénazeth, Martin Blazeby, Glen Bowersock, Chris Brandon, Margaret Browne, Amanda Claridge, Graeme Clarke, Jonathan Cole, Daniela Colomo, Patricia Crone, Deanna Cross, Wiktor Daszewski, Michael Decker, Janet Delaine, Diana Delia, Jacqueline Dentzer, Mervat Seif el-Din, Jean-Yves Empereur, Klaus Fittschen, Peter Fraser, Honor Frost, Craig Gibson, Franck Goddio, Anna Gonosova, Richard Green, Tim Greenwood, Günter Grimm, David Gwynn, Christian Habicht, Tom Hardwick, Elizabeth Harrison, Martin Harrison, Andrea Hawlik, John Healey, Colin Hope, Chris Howgego, Monica Jackson, Irene Kaplan, Sean Kingsley, Ernst Kitzinger, Hans Lauter, Kevin Lee, Emma Libonati, Jaimie Lovell, Christiane Lyon-Caen, Marlea Mango, Archbishop Torkom Manoogian, Fergus Millar, Marcus Milwright, Ann Moffatt, Ehud Netzer, Alistair Northedge, Olga Novoseltceva, Margaret O'Hea, Peter Parsons, Daniel Potts, Simon Price, Shaher er-Rababah, Tessa Rajak, Ellen Rice, Christina Riggs, Roberto Rossi, Charlotte Roueché, Andreas Schmidt-Colinet, Arthur Segal, Bert Smith, Margareta Steinby, Rolf Stucky, Richard Tomlinson, Edda Vardanyan, Jeri Wagner, Susan Walker, Alan Walmsley, Bryan Ward-Perkins, Lindsay Watson, Patricia Watson, Ernie Wickens, and Dietrich Willers. Last minute research assistance was provided by Christopher Beall, Galit Goldshmid, Priscilla Lange, Mark Merrony, Margaret Sasanow, Lukas Schachner and Lucy Wadeson. Some of those mentioned provided help with obtaining photographs, while others are acknowledged in the sources of illustrations. I owe a particular debt of gratitude to Professor Sen Arevshatyan, Director of the Mashtots' Institute of Ancient Manuscripts, Matenadaran, Erevan, Armenia for permitting the use of images from two manuscripts in the Matenadaran's collection.

With a project so diverse, most of the material was workshopped in innumerable seminars, in particular in Oxford in Jim Coulton's Ancient Architecture Discussion Group, the Byzantine Studies Seminar, the Byzantine Art and Archaeology Seminar, and the seminar for the Ancient Near East and Egyptology; as well as seminars and lectures in Australia at the Australian National University, Macquarie University, Monash University, and Sydney University, and at the University of Trier, Germany. The participants in these provided useful suggestions, which they will sometimes recognize as being incorporated.

I am particularly honoured and lucky that Sheila Gibson, whose axonometric drawings are one of the attractions of John Ward-Perkins' *Roman Imperial Architecture*, was able to do those in the present volume, even though she was over eighty by the time we finished. The word-processing was done by Basil Hennessy's secretary Pat Smith in her retirement, who observed that the only more difficult writing than mine she deciphered was the manuscript written by Jim Stewart while he was a prisoner of war. Helen Whitehouse kindly arranged space for me to draw in the Ashmolean Museum at a critical time. Most of the photographs were printed by Jane Inskipp, and I am also grateful to Ian Cartwright and Robert Wilkins for photographic assistance. Maps 1–5 were prepared by Andres Reyes and drawn by Alison Wilkins.

The material involved, especially for the Byzantine period, was in a variety of places and firsthand observation of it was essential. Consequently, a considerable amount of travel was necessary, not only to sites in Egypt, but also to Paris, Brussels, Bern, Berlin, Vienna, Frankfurt, London, Venice, Ravenna, Turkey and Provence. Most of this travel was done while I was Rhys-Davids Junior Research Fellow, and later British Academy post-doctoral Research Fellow at St Hugh's College, Oxford, with an intense period of activity from 1990 to 1993 when most of the material was collected and the initial analysis done. Much of the second stage of the analysis was done while I was a Queen Elizabeth II Research Fellow based at the University of Sydney. It was completed while I was a Research Associate of the Institute of Archaeology, Oxford University. The travel and other research expenses were generously funded by the British Academy, which also contributed towards photographic fees, the Australian Research Council, the Seven Pillars of Wisdom Trust, Miss Rhys-Davids' bequest to St Hugh's College, and the T.W. Greene, Craven, Griffith Egyptological, and Wainwright Funds of Oxford University. The research expenses of Andres Reyes were covered by the Dillon Fund of Groton School.

To study such a diverse range of material at such a minute level of detail was only possible due to the Ashmolean Library (now the Sackler Library) of Oxford University which, thanks to the adjoining Griffith Institute, had all the Egyptological and Coptic references, as well as the papyrological ones. For the Byzantine period the Bodleian, Pusey House and Wolfson College Libraries were also used, and the Radcliffe Science Library for the mathematical texts. I am grateful to the various staff of these, in particular Diane Bergman, Jane Bruder and Graham Piddock, and the two previous Griffith Librarians, Sheila Hönigsberg and John Taylor.

Finally, I have to give particular thanks to Jim Coulton, Sheila Gibson, Pat Smith and my mother for putting up with this tome for so long, and especially Roger Moorey and Andres Reyes. Like Sheila, Pat and my mother, Roger sadly did not live to see it published. He and Andres were unfailing in their belief in the project. Without their encouragement and that of Julian Raby it would not have appeared.

I would also like to thank Sally Salvesen for her patience through such a lengthy project, and Emily Winter for her skills in seeing the book through its design and final stages.

Sources of Illustrations

Where no source is indicated the photograph or drawing is by Judith S. McKenzie, who retains the copyright for them and those of A.T. Reyes and †Sheila Gibson. Those images may be reproduced (with acknowledgement) in academic printed articles, and up to ten in any one academic book, without the need to contact her. References can be found in the Main Bibliography

Ch. 1–2: 3–4, 9 G. Braun and F. Hogenberg *Civitates Orbis Terrarum* (1572–90); 6 H. Salt in Valentia 1811 IV foldout map with additional captions; 7 Unidentified German publication of 1835 pl. 386; 10–11, 13–14 L. Mayer *Views in Egypt* (1804) pl. 13, 19, 16, 15; 12, 32 F.–L. Cassas *Voyage pittoresque* (1799) pl. 54, 53; 15 Kiepert 1872 pl. 5; 16 M. Rodziewicz in J.–Y. Empereur ed. *BCH* suppl. 33 (1998) 148 fig. 18; 17 Felix Bonfils; 18, 24 F. Noack, Sieglin Expedition Archive in the Forschungszentrum Griechisch-Römisches Ägypten of the Zentrum für Altertumswissenschaften an der Universität Trier no. 149–50; 19 Details added to part of 1934 Survey of Egypt 1:10,000 map; 20 Jondet 1921 fig. 37; 21 Based on [15]; 25 Incorporating Rowe and Rees 1957 plan opp. p. 492 and *Description de l'Égypte* V pl. 39.2; 26 Based on Kolataj 1992 plan 3 updated with G. Majcherek *PAM* 16 (2004) 18 fig. 1; 27 Based on [20], W. Sieglin in Rodziewicz 1984 pl. 2, and Empereur 1998 fig. on p. 129. K. Kaminski in Daszewski 1979 100 fig. 5. Noack 1900 259 fig. 13; 30 Jondet 1916 fig. 4; 31 Hilti Foundation/Franck Goddio; 34 Overlaid on detail of 1934 Survey of Egypt 1:10,000 map
Ch. 3: 35 Based on R.J.A. Talbert ed. *Barrington Atlas of the Greco-Roman World* (2000) map 74, with corrections and additions including from Goddio and Clauss 2006 maps on p. 79, 89, 93; 39, 43, 71, 83 Dattari 1901 pl. 30.1972, 28.553, 30.3803, 3568; 42 Reddé 1995 pl. on p. 63; 44 Vienna, Kunsthistorisches Museum; 45 A. Schmidt-Colinet; 46a–b, d, 47, 48b, 49 Thiersch 1909 pl. 4, frontispiece; 46c Based on de Asin and Lopez Otero 1933 pl. 1–2; 48a Based on Hairy 2006 fig. on p. 31; 50 A.T. Reyes; 51 D. Delia; 52 Frost 1975 129 fig. 3; 58 E. Winter; 60 Detail of [3]; 62, 64 Rowe 1946 fig. 2, pl. 3.1; 63 G. Grimm; 69 Sieglin Expedition Archive in the Forschungszentrum Griechisch-Römisches Ägypten of the Zentrum für Altertumswissenschaften an der Universität Trier no. 390; 70 Handler 1971 pl.11.17; 74 K. Fittschen; 75 Based on Wace *et al.* 1959 pl. 3 and Baranski 1996 106 fig. 8; 76 Megaw Archive, British Museum; 78 Wace *et al.* 1959 pl. 1; 80 P.C. Sonnini *Voyage dans la haute et basse Egypte* I (1799) pl. 6; 84 Schweitzer 1938 title page; 86 Clarke and Engelbach 1930 fig. 203; 90 Alexandria, Greco-Roman Museum; 93–4 Hoepfner 1971 pl. 17c, Beil. 30–1; 97 Joseph Wilkins based on *La gloire d'Alexandrie* (1998) 229 fig. 5 and J.-Y. Empereur *Archéologia* 345 (1998) 29; 98 D. Johannes DAI Cairo neg. F17445; 100 Alexandria, Greco-Roman Museum; 101 Thiersch 1904 pl. 2; 102 Breccia 1912 pl. 14; 103 Adriani *BSAA* 32–3 (1938–9) pl. 15; 104 Rodziewicz 1992 332 fig. 1; 107 Adriani *Annuaire* 1933–5 pl. 25; 108 D. Johannes DAI Cairo in G. Grimm *et al. AegTrev* 2 (1983) pl. 39.1. **Ch. 4:** 109 C. Rollin *The Roman History* (1754) I pl. opp. p. 26; 110 V. Meszaros; 111 Iversen 1968 fig. 1. **Ch. 5:** 112, 152 Breccia 1922 fig. 103; 113 Adriani *Annuaire* 1935–9 pl. 18.3, 15.5, 16.5, 17.2, 17.4, 18.1, 16.6; 114 Breccia 1912, pl. 19.21; 119 Mallwitz 1981 fig. 101; 120 J. Charbonneaux and K. Gottlob *Le Sanctuaire d'Athéna Pronaia, Fouilles de Delphes* II.4 (1925) pl. 25; 122 Bauer 1973 Beil. 11; 123 Frazer 1990 pl. 53; 129 Breccia *Musée gréco-romain 1925–31* pl. 23.83; 131 Adriani *Annuaire* 1933–5 fig. 85; 132 Ronczewski 1927 pl. 5.1; 134 Breccia 1912 pl. 19.21; 138 M. Pillet in *Mélanges Maspero* I *MIFAO* 66 (1935–8) 65 fig. 3; 139 D. Johannes DAI Cairo neg. 14841; 147 Based on Thiersch *BSAA* 3 (1900) 28 fig. 7; 148 Pensabene 1993 pl. 136; 150 Pensabene 1983 fig. 8–9, von Hesberg 1981 fig. 35; 151 Pensabene 1993 pl. 96.916; 153 W. Daszewski; 154 J. Radzik in L. Krzyzanowski ed. *Marina el-Alamein: Archaeological Background and Conservation Problems* I (1991) fig. 11 and cover; 155–6 F. Larché in Will *et al.* 1991 fig. 100, 66; 158, 160 Pesce 1950 pl. 10, fig. 16; 159 McKenzie 1990 pl. 221a; 161 Photograph: 1996 Metropolitan Museum of Art. Rogers Fund 1903 (03.14.13); 165–6 Beyen 1938 fig. 194, 1960 fig. 184; 173 Thiersch 1904 pl. 3; 175–6 G.E. Rizzo, *Le pitture della 'Casa dei Grifi' (Palatino). Monumenti della pittura antico scoperti in Italia* III. Roma 1 (1936) pl. 5–6 details; 177, 181, 183 Adriani *BSAA* 32–3 (1938–9) 121 fig. 3, pl. 14–15; 180 Adriani 1966 fig. 135; 182, 184–5 Adriani *Annuaire* 1933–5 fig. 82, pl. 10.2, fig. 12; 186 U. Outschar in J. de la Genière and K. Erim eds. *Aphrodisias de Carie* (1987) 111, fig. 2; 187 Staatliche Museen zu Berlin, Antikensammlung, Bodestr. 1–3, 10178 Berlin. Photograph: Jürgen Liepe; 191, 194 Schreiber 1908 I text fig. 206, Beiblatt 7.1; 192 Ronczewski 1927 title page; 196 Lauter 1986 pl. 41a. **Ch. 6:** 197 Detail of Mariette 1856 pl. 4; 198 A. Schmidt-Colinet in Grimm 1998 fig. 67a–b; 199, 243 A. Walmsley; 200 J. McKenzie incorporating [223]; 201 L. Borchardt, *Die ägyptische Pflanzensäule* (1897) fig. 55, 66a, G. Jéquier, *Manuel d'archéologie égyptienne, les éléments de l'architecture* (1924) fig. 121; 202–205d Borchardt, *op. cit.* fig. 68, Jéquier *op. cit.* fig. 176, 179, 167, 180, 158–9; 205e–f Borchardt, *op. cit.* fig. 17, 13; 206 Arnold 1992 fig. on p. 107; 207 Photograph: Harry Burton 1924 in Winlock 1941 pl. 6; 208 Image © Metropolitan Museum of Art. Museum Excavations 1912–13, Rogers Fund 1912 (10.177.2); 209–10 *Description de l'Égypte* IV pl. 51, 40; 211–12 Jéquier 1924 pl. 4.3, pl. 9; 213–15 Haeny 1985 fig. 3–4 with captions added, 229 fig. 5 with additions based on Lyons 1896 plan 1; 216–22, 224–32, 234–42, 245, 248–50, 254–5 A.T. Reyes; 223, 233, 244 Arnold 1992 figs. on p. 100, 127, 164; 246 S. Sauneron *Le Temple d'Esna* (1959–82) II fig. on p. XLIII; 247 Jéquier *op. cit.* fig. 170. **Ch. 7:** 256 *BGU* VII, pl. 1; 257 Davioli 1998 158 fig. 70; 258 Sheila Gibson; 259–60, 262–8 *Description de l'Égypte* IV pl. 54.1, 53, 59.1–2, 57, 58.9, 61.8–10, 55, 53 detail; 261, 268 Mitchell 1982 fig. 3, pl. 2.2, detail of fig. 1; 267, 273, 284–5, 293, 295 D.M. Bailey; 269 A.J. Spencer *Excavations at el-Ashmunein* ii *The Temple Area* (1989) pl. 92 with additions; 270–2, 274 Bailey *et al.* 1991 pl. 23, pl. 22b, 20b, 19c; 273 J. Baines; 276 A. Walmsley; 277–80 Petrie *et al.* 1925 pl. 35.1, 38, 37.6–8, 37.5; 281–2, 288, 290 A.T. Reyes; 283 Husselman 1979 33 top left, 31 lower left, 32 lower left; 286 Sheila Gibson based on Borchardt 1903 73 fig. 1; 287 Based on Borchardt 1903 80 fig. 7 and pl. 5; 291 Clarke and Engelbach 1930 fig. 225–6; 292 Based on Kraus *et al.* 1967 fig. 18 with revisions; 294 J.C. Golvin in el-Saghir *et al.* 1986 pl. 20; 297 Deckers 1979 fig. 34. **Ch. 8:** 300, 329, 331, 336 L. Mayer *Views in Egypt* (1804) pl. 11, 18, 46, 10; 301–2 Gorringe 1885 pl. 29, 5; 305 B. Tkaczow in Z. Kiss *et al. Alexandrie* VII (2000) plan XII with corrections, plus [306, 309–10]; 306 Rodziewicz 1984 plan 9; 309 Based on Z. Solarewicz, G. Majcherek and M. Budzanowski in *PAM* 10 (1998) 35 fig. 4, 38 fig. 7 with scale added; 310a Based on R. Sobolewski in Rodziewicz 1984 374 pl. 12, G. Majcherek *PAM* 6 (1994) 12 fig. 1, and *PAM* 11 (1994) 33 fig. 5; 310b Based on G. Majcherek *PAM* 5 (1993) 16 fig. 1; 311 Joseph Wilkins based on *La gloire d'Alexandrie* (1998) fig. on p. 293 and Empereur 1998 135 fig. 6–7, 138–9 fig. 10–11, 13–14; 314 J. McKenzie based on Alföldi-Rosenbaum 1976 pl. 24 no. 52; 319 Adriani *Annuaire* 1935–9 pl. 59.1; 321, 333 Dattari 1901 pl. 29.3051,

28.1101; 325 Vienna, Kunsthistorisches Museum; 326–7 Paris, Bibliothèque Nationale 338 Incorporating *Description de l'Égypte* V pl. 39.2 and details from Schreiber 1908 I pl. 1; 339 Adriani 1966 fig. 330–1; 342 Based on Rowe 1942 pl. 4; 343 Schreiber 1908 pl. 62; 345 A. Walmsley; 353 Detail of [349] with passages from H. Thiersch in Sabottka 1989 III fig. 41; 357 Detail of B. Tkaczow in Z. Kiss *et al. Alexandrie* VII (2000) plan 12 with additions; 358 Based on G. Majcherak *PAM* 16 (2004) 18 fig. 1 and Kolataj 1992 182 plan 2; 361 D. Bielinska in Kiss 1992 fig. 1–2; 366 Based on Kolataj 1992 unnumbered loose 'Section C'–C' reconstructed'; 367 Based on Kolataj 1992 loose plan 11 and G. Majcherek *PAM* 16 (2004) 18 fig. 1; 368 Sheila Gibson based on W. Kolataj 1992 fig. 53 with additions; 371 Sheila Gibson based on Rodziewicz 1991 115 pl. 3; 372 Sheila Gibson and J. McKenzie based on Rodziewicz 1984 plan 3, G. Majcherek *Topoi* 5 (1995) 148 fig. 4 and *PAM* 11 (1999) 36 fig. 8; 375 N.L. Norden *Voyage d'Égypte et de Nubie* I (1755) pl. 10; 376 Stephanecompoint.com. **Ch. 9:** 377–9, 384 A.T. Reyes; 380 Lyons 1896 pl. 64 detail; 382 Castel *et al.* 1984 pl. 15f; 385–6 Schwartz *et al.* 1969 pl. 26b, 24a; 387 Kraus *et al.* 1967 177 fig. 19; 388 *Description de l'Égypte* IV pl. 58.4 detail and 58.13; 390 M. O'Hea; 395 Hilti Foundation/Franck Goddio. Photograph: C. Gerigk; 398 Bailey *et al.* 1991 pl. 14a; 399 Oxyrhynchus Papyri Project Oxford, interim no. P.Oxy. 8 1B.199/H (1–2) c [i]. **Ch. 10:** 401–2 A. Goldschmidt ed. *Die Elfenbeinskulpturen aus der romanischen Zeit XI.–XIII. Jahrhundert* IV (1926) pl. 39.113–14; 403 Detail of [338]; 404 Wescher 1865 pl. 5; 405 G. Grimm; 406 H. Lewak in Rodziewicz 1984 fig. 236; 407 Joseph Wilkins based on L.-F. Cassas in A. Gilet and U. Westfehling eds. *Louis-François Cassas 1756–1827* (1994) fig. 118; 408 M. el-Abbadi; 409 A. Wilkins based on Dutilh 1905 fig. 20–1; 411 Bauer and Strzygowski 1905 pl. 6; 413, 420–1 *ILN* 23 Nov. 1929; 414 Berlin, Museum für Spätantike und Byzantinische Kunst; 419 Abegg Stiftung, CH–3132 Riggisberg. Photograph: 1987 Hans Kobi; 422 Scala; 423 E. Netzer; 424 Photograph: Musée du Louvre/G. Poncet; 427 Grossmann 2002 fig. 1; 429 *Description de l'Égypte* V pl. 39.1. **Ch. 11:** 431 Petrie 1905 pl. 70.6, 71.10; 433–5, 448 Duthuit *Sculpture* pl. 13b, 18b detail, 17b, 30b; 437–8 Naville 1894 pl. 14, 17; 443 Petrie *et al.* 1925 pl. 45.1; 444 Grossmann 2002 fig. 61 based on Petrie *et al.* 1925 pl. 46 no.42 445 Breccia *Musée gréco-romain 1925–31* pl. 41.148; 446–7 Breccia *Musée gréco-romain 1931–2* fig. 4, pl. 47.124; 449 J. Dobrowolski and J.E. Knudstad in C.A. Hope and G.E. Bowen eds. *Dakhleh Oasis Project: Preliminary Reports 1994–9* (2002) 66 fig. 2; 450 P. Grossmann *CE* fig. on 2127 with scale added; 455 P. Grossmann *Vicino Oriente* 12 (2000) 278 fig. 2; 455 Sections Sheila Gibson. Plan Grossmann 2002 fig. 150; 460 Akermann 1976 niches 51, 54–56, 26, 32, 37, 9, 18, 13, 8, 36; 462 Monnert de Villard 1925–6 II fig. 123; 463, 470, 486–7 Grossmann 2002 fig. 155, 63, 22, 104; 468 Based on Laferriere 1993 fig. 4, 5b, 6b, 7b, 8b, 9b, 12b, 14, 21; 469 A. Walmsley; 473 F. Daumas *Les Mammisis de Dendara* (1959) pl. 99, detail of [470] and [463], Grossmann 2002 fig. 157; 474 J. Baines; 475 Grossmann 2002 fig. 59 with additions from M. Baranski in D.M. Bailey ed. *JRA* suppl. 19 (1996) 106 fig. 8; 476–7 Megaw Archive British Museum; 478–9 Grossmann 2002 fig. 9 with alterations, fig. 88; 480 el-Taher and Grossmann 1997 pl. 36b; 481 Grossmann 1989 plan 3.1, 5.5, 3.6 and Grossmann 2002 fig. 17, 20, 19; 484, 488 P. Grossmann; 485 P. Grossmann in D. Frankfurter ed. *Pilgrimage and Holy Space in Late Antique Egypt* (1998) diag. 1 with additions from P. Grossmann *BSAC* 43 (2004) 34 fig. 1; 489 Chassinat 1911 pl. 7 detail and Torp 1981 pl. 1; 490 Chassinat 1911 pl. 9; 490 Bénazeth 1998 fig. 2; 497, 502 Chassinat 1911 pl. 71, 82.1; 509 P. du Bourguet *Coptic Art* (1971) pl. on p. 53. Photograph: A. Held; 510, 518–20 Quibell 1912 pl. 1, 39.3, 40.3, 40.5; 511 Grossmann 2002 fig. 125–6 with captions added; 515 New York, Metropolitan Museum of Art. Gift of Arthur S. Vernay Inc. 1922 (22.124.3); 521 Quibell 1909 pl. 37.2; 522 el-Saghir *et al.* 1986 pl. 1; 527–8 Grossmann 2002 fig. 73, fig. 80 with additions from Arnold 1999 fig. 139; 533–6 A. Walmsley. **Ch. 12:** 537–40, 543–4, 545c *Codex Constantinopolis Palatii Veteris No. 1* ed. tr. E.M. Bruins (1964) I pl. 126, 29, 22, 87, 85–6, 91–2, 94; 541–2 Based on J.A. Hamilton, *Byzantine Architecture and Decoration* (1956) fig. 20. **Ch. 13:** 549 van Millingen 1912 fig. 16 and 13; 551 Mathews 1976 fig. 15–24 (M317) and 15–20 (M14750); 552 Section Sheila Gibson in Harrison 1986 fig. 169 and 48; 550 U. Peschlow *Die Irenenkirche in Istanbul* (1977) Beil. 11 and based on Beil. 10; 553, 562, 572 Harrison 1989 fig. 167, 145, 149; 555 Akermann 1976 niche 42; 556 Abegg Stiftung, CH–3132 Riggisberg. Photograph: 2002 Christoph von Viràg; 557 Harrison 1986 fig. 119; 558, 560 Breccia *Musée gréco-romain 1931–2* pl. 36c–d; 561 Washington DC, Textile Museum 71.23. Acquired by George Hewitt Myers in 1929; 563 J.H. Schmidt *Syria* 15 (1934) pl. 6g; 573, 580 Henri Stierlin; 574 H. Stierlin *Byzantinischer Orient* (1988) section, and based on plan on p. 65; 575 Section Deichmann 1976 Band II.2 Kommentar, 2 Teil, Beil. 35. Plan J.B. Ward-Perkins *Proceedings of the British Academy* 1947 pl. 3.8; 576 Scala; 577 Clarke and Engelbach 1930 fig. 214; 578 Grossmann 2002 fig. 193b based on Clarke 1912 29 fig. 5; 581 Section Sheila Gibson based on E.H. Swift, *Hagia Sophia* (1940) pl. 3. Plan based on *ibid.* 1; 582 H. Kähler and C. Mango *Hagia Sophia* (1967) pl. 70. Photograph: Raoul Laer, Archaeological Institute of Cologne; 583 J. McKenzie and Sheila Gibson based on Swift *op. cit.* pl. 4 and Mainstone 1988 fig. 154; 584 K. de Fine Licht *The Rotunda in Rome* (1968) fig. 105; 586 S. Curcic in Mark and Çakmak 1992 34 fig. 30 from R. Heindenreich and H. Johannes; 585 From C. Panfil in S. Curcic in Mark and Çakmak 1992 32 fig. 28. **Ch. 14:** 589 Kitzinger 1977 pl. 99; 590 Hoddinot 1963 fig. 47; 593 Scala; 594 F.W. Deichmann, *Ravenna, Kommentar* (1976) Band II Plananhang plans 1–4; 596 1994 Said Nuseibeh; 597 Based on A. Choisy *Histoire de l'architecture* (n.d.) II 96 fig. 7 with additions; 598 Creswell Archive Ashmolean Museum Oxford. After Creswell 1969 I.1 fig. 364; 599–604 1992 Said Nuseibeh; 605 C. Burns in Hillenbrand 2000 70 fig. 2.70; 606, 621 A. Walmsley; 607 A.T. Reyes; 608 E. Pfuhl *Malerei und Zeichnung der Griechen* (1923) III fig. 315; 609 St Petersburg, State Hermitage Museum; 610–1 Paris, Bibliothèque Nationale; 613–4, 620 Sen Arevshatyan, Director of the Mashtots' Institute of Ancient Manuscripts, Erevan, Matenadaran; 616 Jerusalem, Armenian Patriarchate. Nersessian 2001 177 fig. 105; 617 New York, Pierpont Morgan Library. Photograph: 2006 Joseph Zehavi; 619 A. Goldschmidt ed. *Die Elfenbeinskulpturen aus der romanischen Zeit XI.–XIII. Jahrhundert* IV (1926) pl. 40.120; 622–4 Harvey 1910 pl. 11, 10, fig. 24